Northern Renaissance Art

JAMES SNYDER

Northern Renaissance Art

PAINTING, SCULPTURE, THE GRAPHIC ARTS FROM 1350 TO 1575

HARRY N. ABRAMS, INC., PUBLISHERS, NEW YORK

For Kim

Project Director: Margaret L. Kaplan
Editor: Joanne Greenspun
Designer: Dirk J. van O. Luykx
Photo Editor: Eric Himmel

Library of Congress Cataloging in Publication Data

Snyder, James.
 Northern Renaissance art.

 Bibliography: p. 534
 Includes index.
 1. Art, Renaissance—Europe, Northern. 2. Art—
Europe, Northern. I. Title.
N6370.S6 1985 709′.02′4 84-11435
ISBN 0-13-623596-4
ISBN 0-8109-1081-0 (Abrams)

Printed and bound in Japan

Contents

Preface and Acknowledgments 7

Maps 9

PART ONE
THE INTERNATIONAL STYLE

I. *The Backgrounds* 15

II. *Bohemia* 23

III. *The Valois Courts* 41

 CHARLES V AND PARIS 41

 JOHN OF BERRY 52

 PHILIP THE BOLD OF BURGUNDY 64

IV. *The Rhenish-Mosan Crescent* 74

PART TWO
PAINTING, GRAPHICS, AND SCULPTURE IN THE NETHERLANDS, GERMANY, AND FRANCE FROM 1425 TO 1500

V. *Jan van Eyck* 88

VI. *Robert Campin and Rogier van der Weyden* 119

VII. *The Northerners* 140

VIII. *Two Mystics* 169

IX. *The Late Gothic Dream* 182

X. *Gardens of Heaven and Hell in the Art of Bosch* 195

XI. *Diversity Along the Rhine* 218

XII. *The Impact of Netherlandish Art on German Painting of the Later Fifteenth Century* 227

XIII. *Painting in France During the Second Half of the Fifteenth Century*　239

XIV. *Graphic Arts Before 1500*　266

XV. *Developments in Sculpture in the Fifteenth Century*　293

PART THREE

THE RENAISSANCE IN GERMANY, THE NETHERLANDS,
AND FRANCE FROM 1500 TO 1575

XVI. *Albrecht Dürer and the Renaissance in Germany*　316

XVII. *The* Isenheim Altarpiece *and Matthias Grünewald*　348

XVIII. *Danube Landscapes and Witches: Albrecht Altdorfer
and Hans Baldung Grien*　357

XIX. *Lucas Cranach the Elder: The Conflicts of Humanism and the Reformation*　370

XX. *Hans Holbein the Younger and the Renaissance Portrait*　385

XXI. *Antwerp: Quentin Metsys, Joachim Patinir, and Joos van Cleve*　399

XXII. *Two Currents in Later South Netherlandish Painting: The
"Romanists" and the "Specialists"*　419

XXIII. *Holland: Amsterdam, Delft, and Haarlem*　446

XXIV. *Lucas van Leyden*　455

XXV. *Jan van Scorel, Maerten van Heemskerck, and Antonis Mor*　467

XXVI. *The* Theatrum orbis terrarum *of Pieter Bruegel the Elder*　484

XXVII. *Fontainebleau and the Court Style in France*　511

Notes　524

Select Bibliography　534

Genealogy of the House of Valois　538

Timetable of the Arts, History, and Science 1300–1575　538

Index　546

Photographic Credits　560

Preface and Acknowledgments

When viewed as a broad, international phenomenon in cultural history, the florescence of the arts in Europe during the fifteenth and sixteenth centuries, the Renaissance, is truly astonishing. The idea of the Renaissance in Northern Europe has been obscured somewhat by the attention given to the developments of Italian art during this period. This is understandable since the Renaissance (renascence), when defined as the rebirth of the classical heritage, to which ages of academic scholarship have been directed, is best exemplified by the arts of Florence, Rome, and Venice during those centuries. And yet the term Renaissance has clearly outgrown the narrow definition of antique revival it once had, and, as we know, such titles are often vague and useful only as general names for periods in art history.

For some scholars, Renaissance is only applicable to the arts of Dürer, Holbein, Metsys, and their generations in the sixteenth century, when the revival of antiquity clearly emerges in the North. The art of the fifteenth century has been variously characterized. French scholars frequently refer to artists of the fifteenth century as *les primitifs* (a most unfortunate name in English translation for Jan van Eyck), while in most German studies the designation for the period is *Spätgotik* or Late Gothic. Both terms are not only confusing but, indeed, contradictory for fifteenth-century art. The former, *les primitifs*, implies an auspicious beginning; the latter, *Spätgotik*, a splendid finale. In truth, when surveyed as a flow of cultural currents, the arts of the fifteenth and sixteenth centuries in the North display a rich pattern and a logical evolution, although the turns and shifts in the journey may seem abrupt and disquieting at times. It is to this glorious epoch in art history that this book is addressed.

I have divided the text into three parts to clarify the stages in the cycle we may call Northern Renaissance. Part One deals with the arts of the International Style of the Late Gothic period (a comparable prelude can be described in Italian art), roughly from the middle of the fourteenth century through the first quarter of the fifteenth. The *ars nova* or new art, dominated by the Netherlandish painters active from about 1425 to 1490, is

treated in Part Two, and here I have expanded the study to include the accomplishments in sculpture, particularly in Germany, and the revolution in the arts born with the new graphics medium. Part Three, finally, concerns itself with the paths through the complex sixteenth century when the continuing traditions of the North meet head on with those of Renaissance Italy. This history is exciting and filled with surprises and dramatic byways, and in my essays I have tried to keep the genius of the dramatis personae vivid and distinct. To aid the students of art history, I have added notes and appended a bibliography, a timetable, a genealogy, and maps. The illustrations and colorplates will make the journey more enhancing for every reader.

The broader view of Northern art presented here will not be kaleidoscopic, it is hoped, and I am much indebted to the examples of many scholars, teachers, and friends for what focus and perspective the chapters may have. As a student I was fortunate to study Northern art under three great teachers and scholars: Erwin Panofsky, Jan Gerrit van Gelder, and Robert Allan Koch. Whatever shortcomings this book may have surely cannot be attributed to their influences or examples, as anyone in the field knows.

My colleagues have been very helpful and generous. In Amsterdam Joos Bruyn has been a source of much information and a friend with similar interests. I have learned much from Albert Châtelet and Susan Urbach, among many other colleagues in Europe. Three of my former students, Yoko Mori in Japan, Pieter Biesboer in Holland, and Jetske Sybesma Ironside in Canada, were especially helpful in earlier stages of my research. In America I found valuable my exchanges of ideas and information with Charles Minott, Walter Gibson, Joel Upton, Kenneth Craig, Lotte Brand Philip, Charles Cuttler, Phyllis Bober, Charles Mitchell, Charles Dempsey, Diane and Charles Scillia, John Hand, Barbara Lane, Anne van Buren, Molly Faries, David Cast, Joseph Barone, Ellen Jacobowitz, Chiyo Ishikawa, Sarah Lehrman, Ellen Konowitz, and Vida Hull.

The students at Bryn Mawr, both undergraduate and

graduate, have been responsive and inspiring at every stage of my researches, and I give them special thanks. Mary Campo has been helpful in getting my materials to the press, and my typist, Laurie Greaves, is to be recommended to anyone writing in the field. Eileen Markson and Babette Bauerle, librarians in art history and archaeology at Bryn Mawr, were patient and generous with their time in easing many problems in my research. Finally, I want to thank Margaret Kaplan and the staff at Harry N. Abrams for making this task so enjoyable. Dirk Luykx did the admirable design and layout for the book. Joanne Greenspun, who read and edited the manuscript, was understanding, sympathetic, and very helpful at every step in the preparation of the text, and Eric Himmel, who arduously sought out the fine photographs and colorplates reproduced, was most conscientious. To all of these fine people I am much indebted.

James Snyder
Bryn Mawr
May 1984

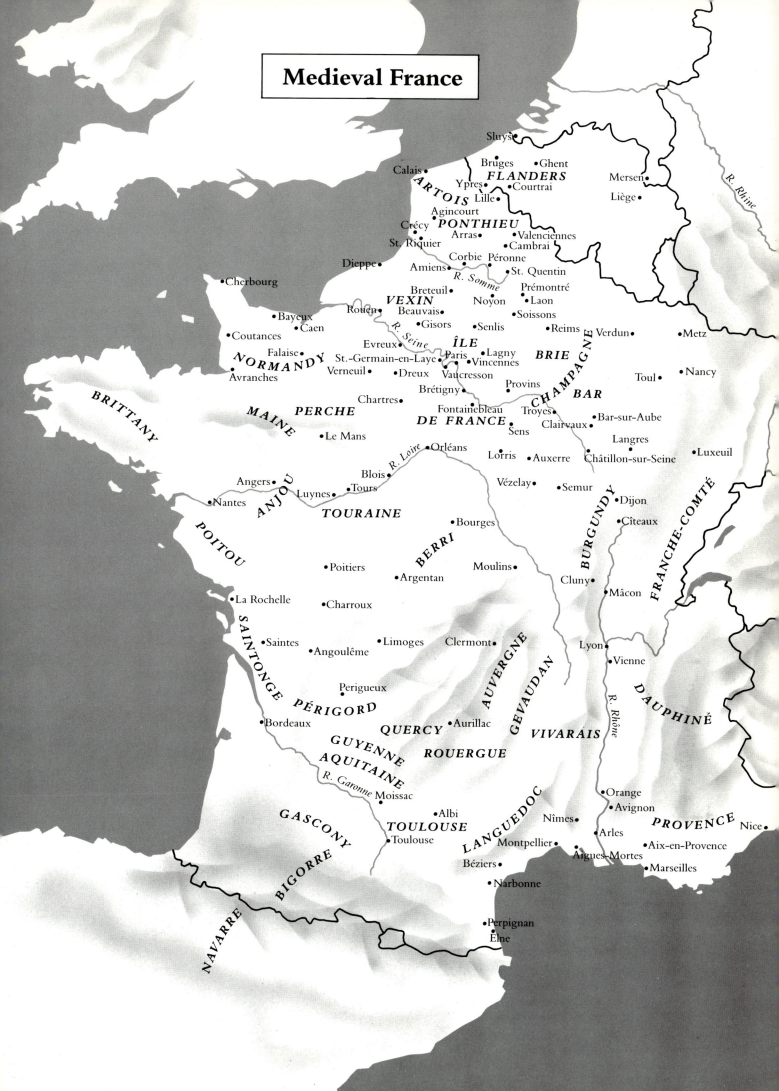

Medieval France

Sluys
Calais • Bruges • Ghent
ARTOIS FLANDERS Mersen
Ypres Courtrai Liège
Lille
Agincourt
Crécy PONTHIEU
Arras • Valenciennes
St. Riquier Cambrai
Corbie Péronne
Dieppe • Amiens St. Quentin
R. Somme
Cherbourg Prémontré
Breteuil Noyon • Laon
VEXIN Soissons
Bayeux Rouen Beauvais
Caen R. Seine Gisors Senlis • Reims Verdun • Metz
Coutances ÎLE Lagny BRIE
Evreux Paris Vincennes CHAMPAGNE Toul • Nancy
Falaise St.-Germain-en-Laye BAR
NORMANDY Verneuil Dreux Vaucresson
Avranches Brétigny Provins
BRITTANY Chartres Fontainebleau Troyes
MAINE PERCHE DE FRANCE Sens Clairvaux Bar-sur-Aube
Langres
Le Mans R. Loire Orléans Lorris Auxerre Châtillon-sur-Seine • Luxeuil
Angers Blois Vézelay • Semur BURGUNDY Dijon
Nantes ANJOU Luynes Tours Cîteaux FRANCHE-COMTÉ
POITOU TOURAINE Bourges
BERRI Moulins Cluny Mâcon
Poitiers Argentan
La Rochelle
Saintes SAINTONGE Limoges Clermont AUVERGNE Lyon
Angoulême GEVAUDAN Vienne
PÉRIGORD Perigueux DAUPHINÉ
Bordeaux QUERCY Aurillac VIVARAIS R. Rhône
GUYENNE ROUERGUE
AQUITAINE
R. Garonne Moissac Orange PROVENCE
GASCONY Albi Avignon Nice
TOULOUSE LANGUEDOC Nîmes
Toulouse Montpellier Arles Aix-en-Provence
BIGORRE Béziers Aigues-Mortes Marseilles
NAVARRE Narbonne

Perpignan
Elne

R. Rhine

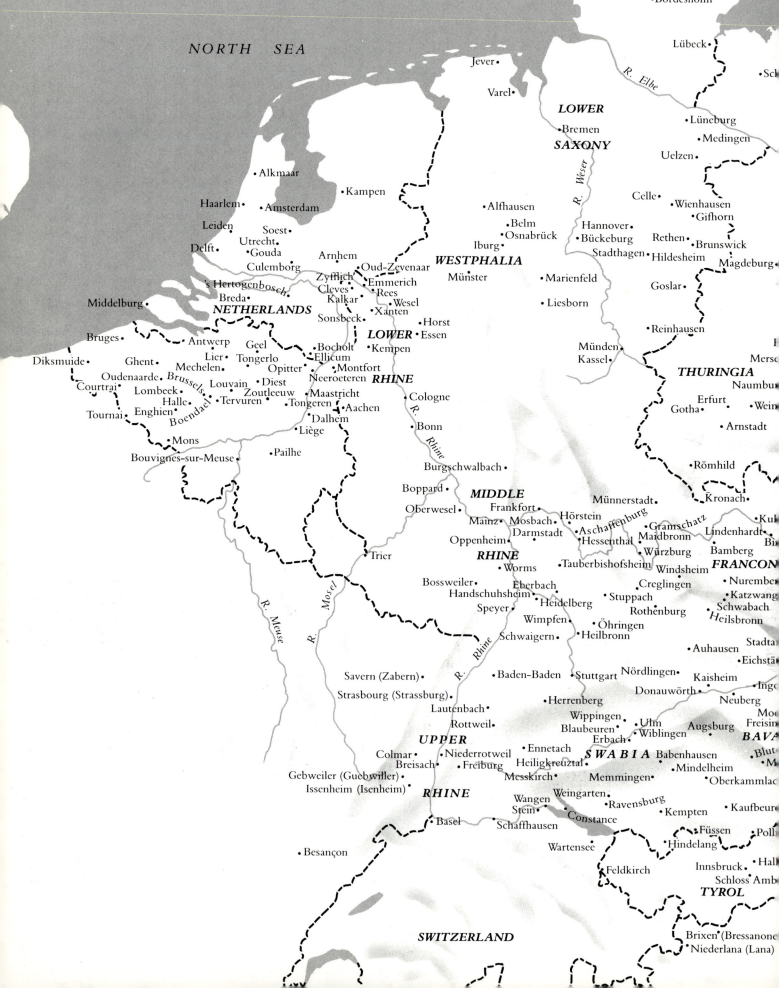

The Germanic Provinces

NORTH SEA

Husum • •Schleswig

•Bordesholm

Lübeck•

R. Elbe

Jever •
Varel•

LOWER

•Bremen

SAXONY

•Lüneburg
•Medingen
Uelzen•

Celle• •Wienhausen
•Gifhorn
Hannover• Rethen• •Brunswick
•Bückeburg
Stadthagen •Hildesheim •Magdeburg

•Alkmaar
•Kampen
Haarlem• •Amsterdam
Leiden• Soest•
Utrecht•
Delft• •Gouda
Culemborg Arnhem•
's Hertogenbosch Zyfflich •Oud-Zevenaar
Breda• Cleves• Emmerich
• Kalkar• Rees
NETHERLANDS Sonsbeck• •Wesel
Middelburg• •Xanten
•Horst
Bruges• **LOWER** Essen•
Antwerp• Geel• •Bocholt •Kempen
Diksmuide• Ghent• Lier• Tongerlo Ellicum
Mechelen• Opitter• •Montfort
Oudenaarde• Diest• Neeroeteren **RHINE**
Courtrai• Lombeek Louvain• Zoutleeuw• •Maastricht
Halle• Tervuren• •Tongeren
Tournai• Enghien• Boendael •Dalhem
Mons• •Liège
Bouvignes-sur-Meuse• •Pailhe

•Alfhausen
•Belm
•Osnabrück
Iburg•
WESTPHALIA
Münster• •Marienfeld
•Liesborn

Goslar•
•Reinhausen

Münden•
Kassel• **THURINGIA**
Merse
Naumbu
Erfurt• Wein
Gotha• •Arnstadt
•Römhild

Cologne•
R.
Rhine
Burgschwalbach•
Boppard• **MIDDLE**
Oberwesel• Frankfort• •Münnerstadt• •Kronach
Mainz• •Mosbach Hörstein•
Darmstadt• •Aschaffenburg •Gramschatz Lindenhardt•
Oppenheim• •Hessenthal Maidbronn• Bi
RHINE •Würzburg Bamberg•
•Worms •Tauberbishofsheim Windsheim **FRANCON**
Bossweiler• Eberbach• •Nurembe
Handschuhsheim• •Creglingen •Katzwang
Speyer• •Heidelberg •Stuppach Schwabach•
Wimpfen• Rothenburg• Heilsbronn
Schwaigern• •Öhringen Stadta
•Heilbronn •Auhausen •Eichstä
Savern (Zabern)• Nördlingen• Ingo
Strasbourg (Strassburg)• •Baden-Baden •Stuttgart •Kaisheim Neuberg
Lautenbach• •Herrenberg •Donauwörth Moc
Rottweil• Wippingen• Freisi
UPPER Blaubeuren• •Ulm Augsburg• **BAVA**
Colmar• •Niederrotweil Erbach• •Wiblingen
Breisach• •Freiburg Ennetach• **SWABIA** Babenhausen•
Gebweiler (Guebwiller)• Heiligkreuztal• •Mindelheim Blut
Messkirch• Memmingen• •Oberkammlac
Issenheim (Isenheim)• **RHINE** Weingarten•
Wangen• Weingarten• •Ravensburg •Kaufbeure
Stein• •Constance •Kempten
•Basel Schaffhausen• •Füssen
Wartensee• Hindelang• Poll
•Besançon •Feldkirch Innsbruck•
Schloss Amb
TYROL

SWITZERLAND
Brixen (Bressanone)•
•Niederlana (Lana)

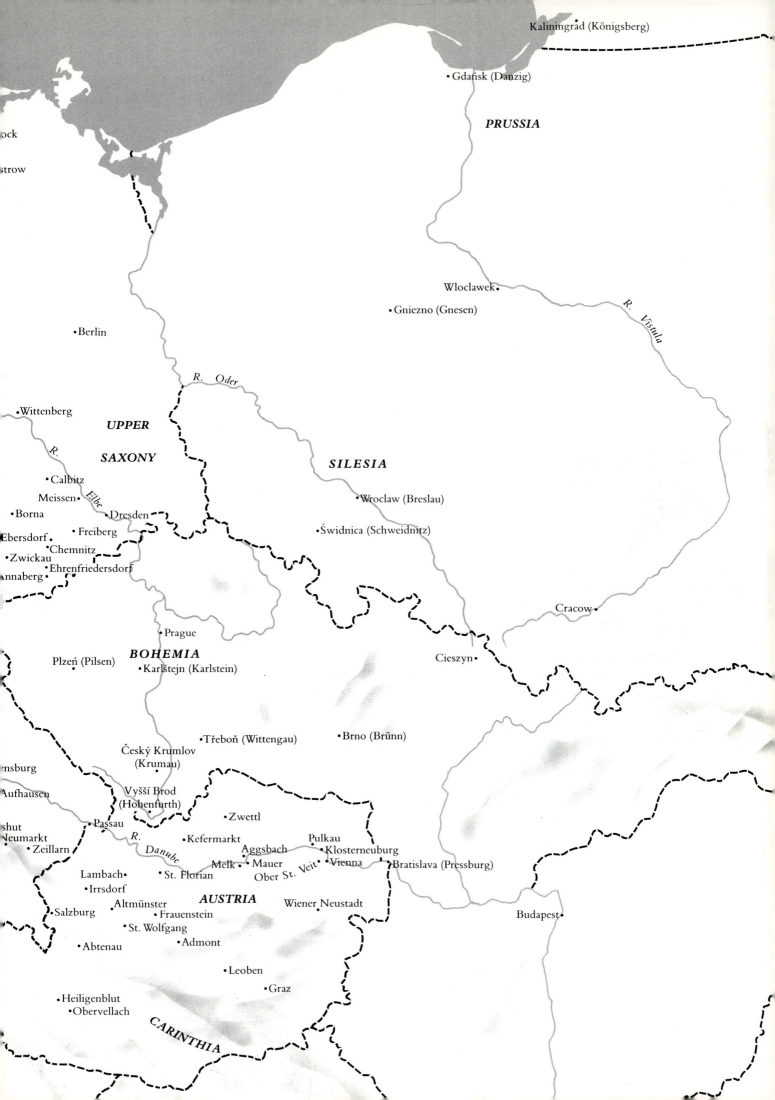

Kaliningrad (Königsberg)

PRUSSIA

• Gdańsk (Danzig)

• Wloclawek

• Gniezno (Gnesen)

R. Vistula

• Berlin

R. Oder

• Wittenberg

UPPER

R.

SAXONY

• Calbitz

SILESIA

Meissen •

Elbe

• Borna • Dresden • Wroclaw (Breslau)

Ebersdorf • Freiberg • Świdnica (Schweidnitz)

• Chemnitz

• Zwickau

Annaberg • Ehrenfriedersdorf

Cracow •

• Prague

BOHEMIA

Plzeň (Pilsen) Cieszyn •

• Karlštejn (Karlstein)

• Třeboň (Wittengau) • Brno (Brünn)

Český Krumlov
(Krumau)

ensburg

Vyšší Brod
(Hohenfurth)

Aufhausen • Zwettl

shut • Passau • Kefermarkt Pulkau

Neumarkt R. Aggsbach • Klosterneuburg

• Zeillarn Danube Melk • • Mauer • Vienna • Bratislava (Pressburg)

Lambach • • St. Florian Ober St. Veit

• Irrsdorf **AUSTRIA** Wiener Neustadt

• Salzburg Altmünster • Frauenstein Budapest •

• St. Wolfgang

• Abtenau • Admont

• Leoben

• Graz

• Heiligenblut

• Obervellach

CARINTHIA

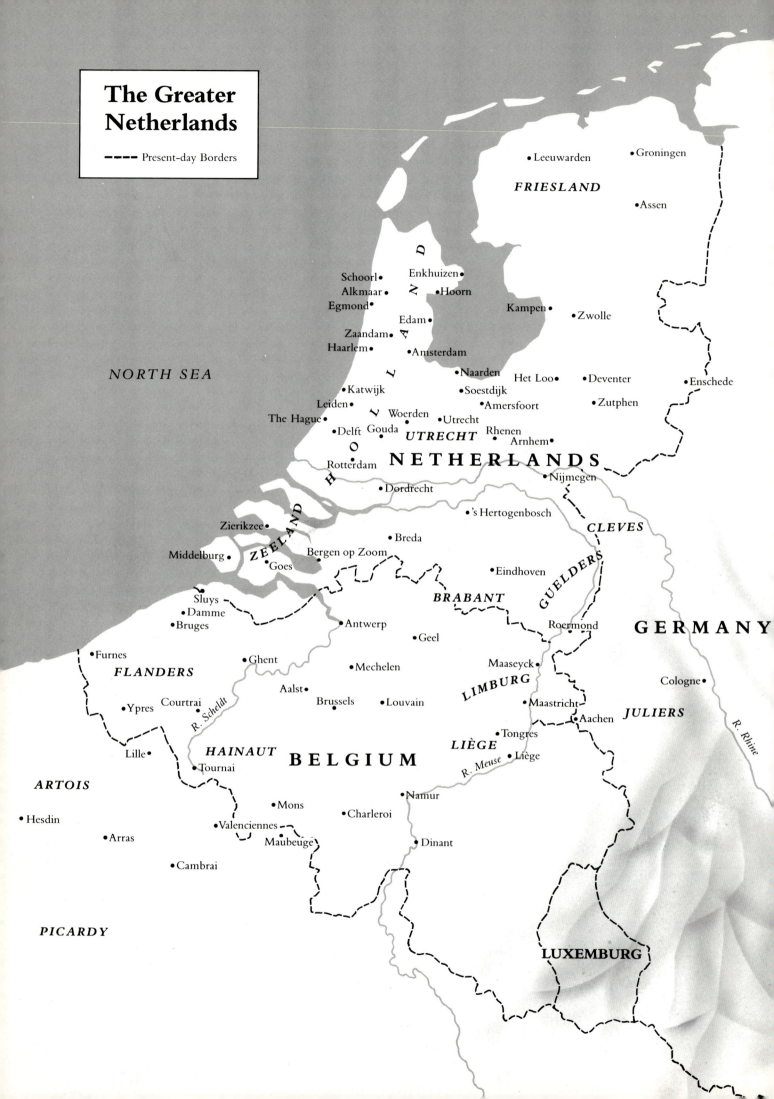

The Greater Netherlands

----- Present-day Borders

NORTH SEA

FRIESLAND

• Leeuwarden • Groningen

• Assen

Schoorl• Enkhuizen•
Alkmaar• • Hoorn
Egmond• Kampen• • Zwolle
Edam•
Zaandam• • Amsterdam
Haarlem•
• Naarden Het Loo• • Deventer • Enschede
• Katwijk • Soestdijk • Zutphen
Leiden• • Amersfoort
Woerden• • Utrecht
The Hague• *UTRECHT* Rhenen•
• Delft Gouda• Arnhem•

H O L L A N D

NETHERLANDS

Rotterdam•
• Dordrecht • Nijmegen

• 's Hertogenbosch *CLEVES*

Zierikzee• • Breda
Middelburg• Bergen op Zoom• • Eindhoven *GUELDERS*
• Goes *BRABANT* Roermond•

ZEELAND

GERMANY

Sluys• • Antwerp • Geel
• Damme Maaseyck•
• Bruges • Mechelen *LIMBURG* Cologne•
• Furnes Ghent• • Maastricht
FLANDERS Aalst• • Aachen *JULIERS*
Ypres• Courtrai Brussels• • Louvain Tongres•
R. Scheldt *LIÈGE*
HAINAUT **BELGIUM** • Liège
Lille• *R. Meuse*
Tournai• • Namur

ARTOIS
• Mons • Charleroi
• Hesdin Valenciennes•
Maubeuge• • Dinant
• Arras
• Cambrai

PICARDY

R. Rhine

LUXEMBURG

PART ONE

THE INTERNATIONAL STYLE

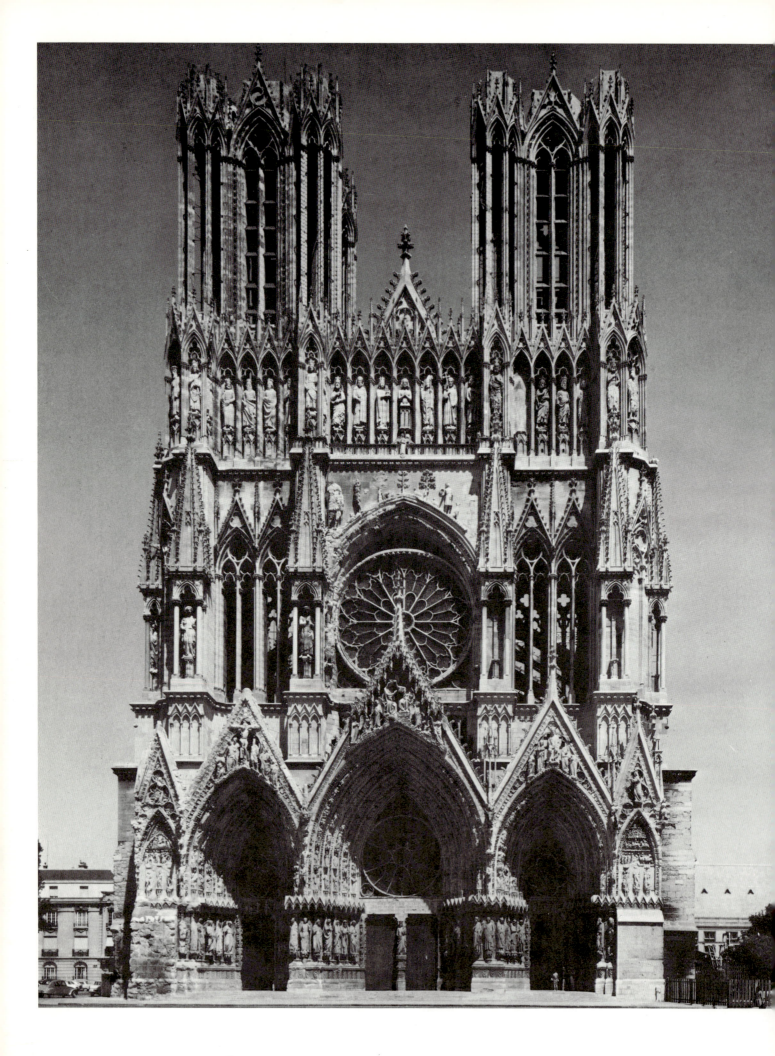

I.

The Backgrounds

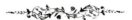

In many ways the Gothic of the thirteenth century can be likened unto a Golden Age of medieval Western art much as the fifth century B.C. has come to represent the apogee of classical culture. In both, the arts were subordinated to architecture (fig. 1). Sculpture, painting, and stained glass were more the embellishments of the lofty cathedral than independent creations (see fig. 2). The intrinsic analogies between the Gothic cathedral and the religious philosophy we know as Scholasticism have frequently been discussed in terms of form and content, and it is tempting to agree with scholars who see the intricate scaffolding of parts and the resolution of building techniques into an ideal formula to be comparable to the systemized dialectic of the all-encompassing *Summa theologica* by Thomas Aquinas, written during the very years when Gothic architecture achieved its sublime form at Amiens and Reims.[1] And so it has been that thirteenth-century Gothic has come to be considered the majestic moment in Latin Christendom.

The following 150 years proved to be a disappointing denouement for the historian. Late Gothic signified a breakdown in society and the arts as well as in aspects of religion. The fourteenth century was marked by wars and plagues—one important text for Italian art of the period is entitled, in fact, *Painting in Florence and Siena After the Black Death*[2]—and in general a decadence and decline of the arts have been described. Only fifty years ago one would find lantern slides and photographs of manuscripts and ivories of the fourteenth century (if there were any) under the label ''decadent art'' in the collections of some of our major universities. But now all that has changed. When tallied, the number of outstanding contributions in the arts and literature of the fourteenth century is impressive, and rather than viewing the period as some sad relapse into the Dark Ages, the *objets d'art* of costly materials worked with subtle craftsmanship are seen as bright lights enhancing an otherwise dim reflection in a ''distant mirror,'' as Barbara Tuchman has vividly described it.[3]

In a like manner the social and political history of the period has been reexamined with more sympathetic eyes

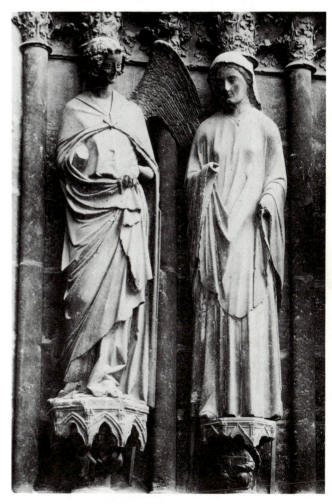

opposite: 1. West facade, Reims Cathedral. c. 1225–99

above: 2. SMILING ANGEL MASTER AND MASTER OF AMIENS. *Annunciation* group. c. 1225–45. Reims Cathedral

and has come to be considered a necessary and exciting transition between the Middle Ages and the modern world announced throughout Europe in the fifteenth century. In philosophy too, the rise of the new nominalism of William of Ockham and the gradual development of codified forms of mysticism are viewed as inevitable

changes in religious beliefs and practices. Nominalism, with its emphasis on the individual, the particular facts in our world in contrast to the universal ideas of Scholasticism, is analogous to the disintegration of the communal spirit of Gothic expression and the emergence of individual art forms. Mysticism, calling for the direct experience rather than the understanding of religion, as did Scholasticism, brought with its popular appeal new forms and patterns of religious devotion and imagery.

In the arts the term "International Style" is a fitting one for the crucial period that stretches from the last decades of the fourteenth century to the first years of the fifteenth. For one thing, the dimensions of style are truly international when one considers the similarities in the arts in France, Germany, the Low Countries, England, Bohemia, and, indeed, in a number of centers in Italy and Spain. It was foremost an art of the courts. Artisans were easily traded or borrowed from one court to another, and the taste of the nobility dictated the style and often the subject matter of works of art. The fluidity of this world of art must be kept foremost in mind.

In his fascinating study, *The Waning of the Middle Ages*, Johan Huizinga analyzed in detail the confluence of the forms of life, thought, art, and literature of the courts in France and the Netherlands and presented a rich tapestry of a world in which contrasts and conventions in art echo sharply the violent tenor of life in general and where new types of religious devotion necessitated new forms of religious art and literature. Society itself became something of a work of art, a grandiose *tableau vivant*. Conspicuous waste and ostentation were part of the courtly aesthetic. Their lives unfolded in a series of rituals, often playful routines focusing on the fine art of the tournament, the noble art of falconry and hunting, and the conventions of the art of courtly love. Through all of this runs a certain romanticism that expresses itself in the taste for giant tapestries of mythological stories or woodland scenes bedecked with millefleurs with grotesque wild men, an exoticism that characterizes even the more intimate *objets d'art*, the *joyaux*, so popular in the courts.

The dukes, counts, and courtiers were ardent collectors of these *joyaux*, or precious little items in gold and silver incrusted with costly gems and cameos, and in their vanities they openly competed with one another. The new devotional manual, the Book of Hours, became a status symbol. These personalized prayer books with calendars, prayers to Mary, along with other daily devotions, were frequently given as gifts for special occasions such as weddings. Outfitted with a costly binding and filled with precious miniature paintings surrounded by flowery borders with drolleries and heraldic devices spangled about the page, the Book of Hours had a special role in the development of the Late Gothic style. Eustache Deschamps, the court poet of Charles V, composed the following ballade for a court lady on the eve of her wedding:

A Book of Hours, too, must be mine
 Where subtle workmanship will shine,
Of gold and azure, rich and smart,
 Arranged and painted with great art,
Covered with fine brocade of gold;
 And there must be, so as to hold
The pages closed, two golden clasps.[4]

The feverish passion for collecting items of luxury often resulted in a flamboyant mixture of costly gems and metals in small objects rendered in a highly detailed but somewhat confusing pseudorealistic style. The virtuosity of goldsmiths and enamelers in creating small reliquaries, shrines, chalices, and the like is particularly displayed in a tiny gold triptych in the Rijksmuseum (colorplate 1) with the centerpiece depicting a Man of Sorrows (*Schmerzensmann*) executed in three different techniques and mediums. The corpus is a sculptured group of the suffering Christ in gold and covered with white enamel held in the arms of an angel. The two side wings are colorful enamels with Mary and an angel carrying the cross on the left, John the Evangelist with an angel holding the lance on the right. Above the centerpiece is a diminutive sculptured group in gold with the Coronation of Mary. The reverse sides of the wings depict Saint John the Baptist and Saint Catherine incised and covered with a transparent enamel glaze.

The unusual iconography, a Eucharistic theme, is indicative of the inventiveness of the International Style. The subject matter is not a simple narrative of the Passion but rather a kind of contemplation picture (*Andachtsbild*) to evoke in the viewer memories of the eternal suffering of Christ for his salvation and the reexperience of it in the daily Mass.[5]

This exquisite piece was the work of a Parisian goldsmith about 1400, as is another, the *Goldenes Rössel* (*Golden Pony*; fig. 3), an even more astonishing tour de force in metalwork, which presumably was a New Year's gift for Charles VI from Queen Isabel in 1404. This elaborate *joyau* is made of gold and precious gems. Above a subchamber that serves as a stage, the Madonna and Child with angels are enframed in an arbor of golden latticework adorned with pearls and other gems. Before Mary kneels Charles VI at a *prie-dieu* with his own tiny Book of Hours in gold. Opposite is the king's marshal, who holds his helmet. Below, in the subchamber, the king's courtier stands holding the reins of the elegant "Golden Pony," which is pure gold enameled white, the appropriate color for a royal steed. The combination of glitter, gold, and realism in the rendering of the figures

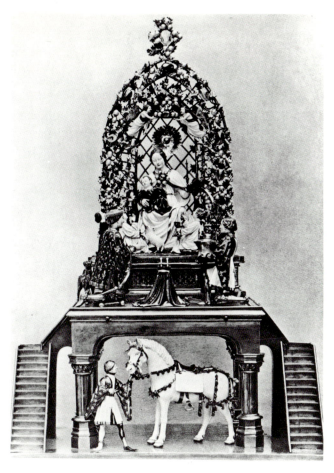

3. PARISIAN GOLDSMITH. *Goldenes Rössel*. c. 1400.
Gold and enamel reliquary, height about 35".
Collegiate Church, Altötting

and the horse may strike one as a bit bizarre if not overly sumptuous, but it was just such rich objects as this that appealed to the patrons of the time.

Heraldry was a mania too. The exclusive man of distinction (and this includes the wealthier members of the *nouveaux riches*) decorated all of his possessions with the family armorials: capes, pillows, bedcovers, chairs, bridles, saddles, prayer books, etc. Everything was exclusively his, and the family coat of arms was painted, pressed, or carved on everything. While it might be easy to criticize the motivation or mentality of these new tycoons of the art world, it remains a fact that they had exceptional taste and demanded perfection in craftsmanship. Just as the rituals and routines of daily life became mannered, so did their art. Their lavish costumes, as seen in many miniatures, were overly elegant with colorful mantles and coats with wasp waists, choking collars, frills and bells, and long, graceful drapery folds that emphasize the tall, elegant lines of these very noble people.

Richness and mannerism, then, are salient characteristics of the art of the International Style, but they are not the only basic features of the new art. The interest in embellishing secondary areas, as in the margins of manuscripts, led the artist to exploit entertaining drolleries

that are frequently rendered with astonishing naturalism. The decorated strips at the bottom of the page (*bas-de-page*) present us with realistic depictions of games of the court, hunting, tournaments, etc., often without meaning for the main image of the page. This interest in realistic drolleries has its roots in earlier, particularly English, Gothic. This second characteristic, what might best be termed "marginal realism," eventually spread to the miniature itself in the treatment of architectural settings and landscapes in the backgrounds that formerly were gold leaf or colorful diaper patterns. It is interesting to note, however, that the main figures in a narrative, unless they be peasants, retain the elegant conventions of the draped Gothic figures and often appear *retardataire* in contrast.

To achieve the semblance of a natural extension of space, whether it be an architectural interior or a landscape, the Northern artist—his own Northern heritage had neither—turned to Italy and more specifically to Siena for models. The masterpiece of Sienese painting, the *Maestà* by Duccio, completed in 1311, must be reckoned the most influential work in this process. In the numerous narrative panels on the reverse of the *Maestà*, Duccio meticulously repeated the settings whenever the events took place in the same location. His interiors, such as that of Christ Before Pilate (fig. 4), are fashioned as dollhouse interiors or space boxes with the perspective projection of the side walls and the ceilings converging along diago-

4. DUCCIO DI BUONINSEGNA. *Christ Before Pilate*,
from the *Maestà* altarpiece. 1309–11. Panel,
17½ × 18⅛". Museo del Opera del Duomo, Siena

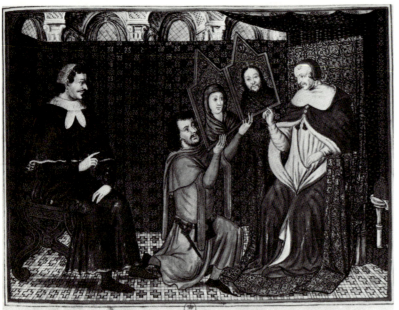

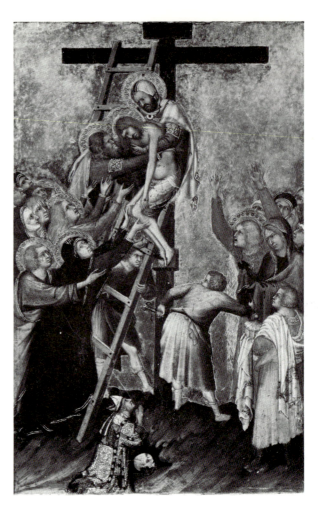

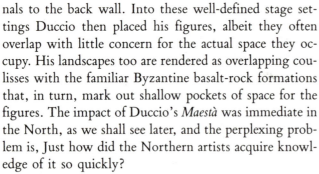

above: 5. 18TH-CENTURY COPY. *John the Good and Clement VI or Urban V.* c. 1365–70. Illumination. Bibliothèque Nationale, Paris. Gaignières Collection

right: 6. SIMONE MARTINI. *Deposition.* 1342. Panel, $9^5/_8 \times 6^1/_8''$. Musée Royal des Beaux-Arts, Antwerp

nals to the back wall. Into these well-defined stage settings Duccio then placed his figures, albeit they often overlap with little concern for the actual space they occupy. His landscapes too are rendered as overlapping coulisses with the familiar Byzantine basalt-rock formations that, in turn, mark out shallow pockets of space for the figures. The impact of Duccio's *Maestà* was immediate in the North, as we shall see later, and the perplexing problem is, Just how did the Northern artists acquire knowledge of it so quickly?

No doubt many works of Sienese painters, including the countless followers of Duccio, were imported to the North during the period of the "Babylonian captivity" of the papacy at Avignon, from 1305 to 1378. Panels from Tuscany and northern Italy were known at the court of Charles IV at Prague by the middle of the century, and we have a pictorial record (fig. 5) of the French king, John the Good, presenting a diptych with the busts of Christ and the Virgin, "a souvenir from Italy," to the French pope Clement VI in Avignon in 1342.[6] The close ties between Avignon and Italy during the Babylonian captivity no doubt account for the pervasive influence of Italian art in the North. The huge Palais des Papes there was built as a fortress for the church, and the decorations for its severe walls and chambers were entrusted for the most part to Italian ateliers.

Simone Martini (1283–1344), one of the foremost suc-

cessors of Duccio in Siena, established a workshop in Avignon sometime in the 1330s and continued to work there until his death in 1344. Of his mural projects only the faded fragments of a Madonna of Humility remain, but an important polyptych painted by Simone for the Italian cardinal Napoleone Orsini in Avignon has been partially recovered. These panels include two works in Antwerp, the *Deposition* (fig. 6) and *Crucifixion,* an *Entombment* in Berlin, and the *Carrying of the Cross* in the Louvre. The Louvre panel has the Orsini coat of arms, and the cardinal himself kneels at the foot of the cross in the Antwerp *Deposition.*[7] Of special interest is the later history of the altarpiece. Sometime near the end of the fourteenth century, three of the panels were in the Carthusian monastery in Dijon, and very likely they were acquired by Duke Philip the Bold and served as models for his court artists, Jean de Beaumetz and Jean Malouel.

Working side by side with the Sienese were other Italians, most notably Matteo Giovanetti from Viterbo, who executed the graceful figures of standing prophets in the Audience Hall and extensive narratives of Saint John the Baptist and Saint Martial in side chapels of the palace, all of which are typical mid-trecento frescoes in style (fig. 7). No doubt French assistants worked with the Italians, but the fresco remains are so scant that the nature of such workshop collaboration is difficult to assess. Only the delightful hunting and fishing frescoes in

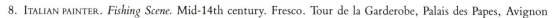

7. MATTEO GIOVANETTI. *Prophets Ezekiel, Jeremiah, Isaiah, and Moses*. 1342–52. Fresco. Audience Hall, Palais des Papes, Avignon

8. ITALIAN PAINTER. *Fishing Scene*. Mid-14th century. Fresco. Tour de la Garderobe, Palais des Papes, Avignon

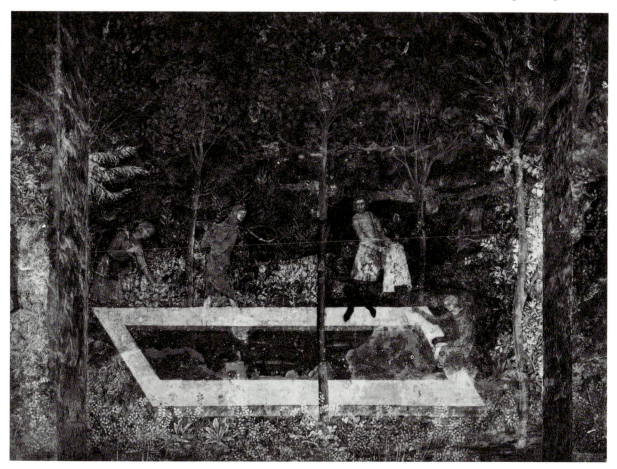

the Tour de la Garderobe are in good condition (fig. 8), but these secular scenes belong to a broad tradition that includes tapestry work both north and south.[8]

In the history of the International Style the illustrated book, in particular the Book of Hours (*Horae* in Latin), played a special role. Being a portable object, the Book of Hours was easily moved from patron to patron or from court to court. Surprisingly, the characteristics of the In-

ternational Style—mannered drapery, marginal realism, and Italian space—were anticipated nearly fifty years before the great Parisian manuscript ateliers introduced the International Style around 1375.

Jean Pucelle, a leading Parisian miniaturist, whose activity can be documented in part, is to be credited with a revolutionary new style in the North comparable to his contemporary in Italy, Giotto. One of Pucelle's masterpieces is the *Hours of Jeanne d'Évreux*, today in the Cloisters in New York, datable 1325–28 (figs. 9, 10). The tiny Book of Hours, three and one-half by two and one-half inches, has twenty-five miniatures executed in a grisaille (gray-tone) technique with faint tints of color washed into some of the backgrounds.

The Book of Hours was a condensed and personalized form of a psalter (book of Psalms) and a breviary (the general service book for the church) that came into vogue during Pucelle's time, and he was largely responsible for its progressive and experimental character. Normally the Book of Hours opens with a calendar, a page or two for each month, listing the saints and feasts celebrated throughout the year and illustrated with the appropriate zodiac signs and depictions of the labors or pastimes of the month. The calendar is followed by readings excerpted from the four Gospels. The major part of the book is the Little Office (or Hours) of the Virgin Mary, from which it takes its name, with the readings that accompany the daily devotions ranging roughly three hours apart, from dawn through nightfall. Each hourly devotion came to be associated with episodes from the Infancy and Passion of Christ (the Joys and Sorrows of the Virgin):

above: 9. JEAN PUCELLE. *November*, from the calendar of the *Hours of Jeanne d'Évreux*. 1325–28. The Metropolitan Museum of Art, New York. The Cloisters Collection, Purchase, 1954

right: 10. JEAN PUCELLE. *Arrest of Christ* and *Annunciation*, from the *Hours of Jeanne d'Évreux*. 1325–28. The Metropolitan Museum of Art, New York. The Cloisters Collection, Purchase, 1954

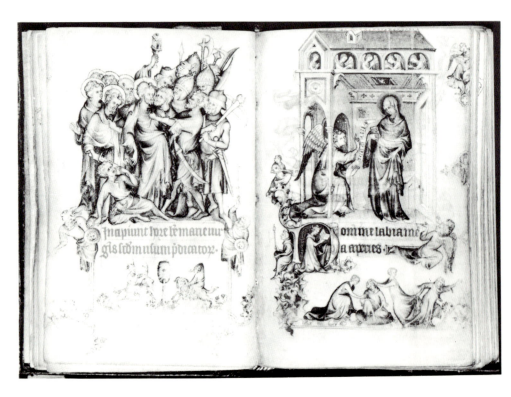

I. *Calendar:* Zodiac signs and Labors of the Month
II. *Gospel Readings:* Portraits of the Evangelists
III. *Little Office of the Virgin (Hours)*

	Infancy (Joys)	Passion (Sorrows)
1. Matins:	Annunciation	Judas's Betrayal
2. Lauds:	Visitation	Christ Before Pilate
3. Prime:	Nativity	Scourging of Christ
4. Terce:	Adoration of the Shepherds	Carrying the Cross
5. Sext:	Adoration of the Magi	Crucifixion
6. None:	Presentation	Deposition
7. Vespers:	Flight into Egypt	Entombment or Lamentation
8. Compline:	Coronation of Mary	Resurrection

IV. *Hours of the Cross and the Holy Spirit:* Crucifixion, Pentecost
V. *Penitential Psalms:* David Before the Lord
VI. *Litanies*
VII. *Office of the Dead:* Funeral services in the church and the Last Judgment
VIII. *Suffrages of the Saints:* Hierarchies of the saints (archangels to local saints) with attributes

Due to the overwhelming popularity of Mary, most Books of Hours illustrate the Infancy cycle where the Virgin's role is more obviously manifest. The Hours of the Passion or of the Cross then usually follow, repeating the same hourly prayers. The Hours proper are followed by the seven Penitential Psalms, the Office of the Dead, and finally the Suffrages of the Saints. These sections too display appropriate illustrations.

In spite of its small size, Pucelle's *Hours of Jeanne d'Évreux* is an ambitious project. The calendar has two pages for each month with the labor or pastime on one folio, the zodiac sign on the following, both presented at the bottom of the page. The Hours of Devotion are much elaborated with antithetical episodes for each hour, that of the Passion on the left (verso) and the Infancy on the right (recto of the following folio). Pucelle's *Hours* begins with scenes of the *Arrest of Christ* facing the *Annunciation* for matins. The compact grouping and the rhythmic overlapping of the figures about Christ in the *Arrest* are typical of the traditional Gothic compositions with the figures executed in a delicate and very elaborate style with the draperies modeled in grisaille that adds to the sense of their plastic qualities more so than the usual linear silhouettes of Gothic figures. Otherwise, surface

pattern predominates with no indication of a garden setting or a real space for the figures.

The *Annunciation*, however, presents us with a new concept in French book illustration. Mary and Gabriel are delicately modeled with elegant draperies that fall in long, lyrical arcs and complex, overlapping cascades. By using the grisaille technique here, Pucelle was able to accentuate the bolder shadows in the drapery folds and create figures that resemble tiny ivory statuettes rather than flat silhouettes. But more startling is the treatment of ample space in which Pucelle places his figures. The tiny dollhouse opens with amazing clarity formed by the receding side walls and a ceiling with beams projecting diagonally toward the back wall. Gabriel kneels within a portico of the room, and his body is clearly placed in space as if moving from the doorway into the side opening of Mary's chamber. Above is an attic, flattened in the traditional fashion, with adoring angels appearing in five arched windows. However, Mary's chamber is meant to be an actual room, and to underscore this naturalism, Pucelle opens a trapdoor in the ceiling through which the Holy Ghost in the form of a dove flies downward.

There can be little doubt that the ultimate source for Pucelle's *Annunciation* was Duccio's composition of the *Annunciation of the Death of the Virgin* in the *Maestà*, executed only about fifteen years earlier in Siena (fig. 11). It has been suggested that Pucelle must have traveled to Italy before painting his precocious miniatures, thus accounting for the numerous Sienese elements in this and other scenes (the *Crucifixion* and *Entombment* are also very dependent on Duccio). Finally, Erwin Panofsky has

11. DUCCIO DI BUONINSEGNA. *Annunciation of the Death of the Virgin*, from the *Maestà* altarpiece. 1309. Panel, 21¼ × 22⅞" Museo del Opera del Duomo, Siena

12. JEAN PUCELLE. *December*, from the calendar of the *Belleville Breviary*. 1323–26. Bibliothèque Nationale, Paris

suggested that the addition of the tiny angel carrying the lower corner of the chamber reflects the popular Italian legend that angels transported the house of Mary in Nazareth to Dalmatia and then to Italy, where it was enshrined as the Santa Casa di Loreto.[9]

The quaint additions to the perspective box may strike one as being somewhat frivolous or playful, and there are other indications that Pucelle intended to add a touch of humor in many of his miniatures. The drolleries in the margins of the two miniatures are entertaining if not clever visual puns. Two caryatids in the form of old men with shields support the weightless groundline of the *Arrest*, while, below the text, in the *bas-de-page*, two men on goats practice tilting at a barrel raised on a post. In the margins of the *Annunciation* appear angels, a cleric sitting against the letter *D*, and below, a lively court game known as "Frog in the Middle" or "Hot Cockles," a playful contest of love resembling tag. Within the initial *D* the diminutive figure of the patroness, Queen Jeanne d'Évreux, wife of Charles IV of France, appears kneeling at a *prie-dieu* reading her Book of Hours. The "tiny book of prayers in black and white," recorded among her possessions in the court inventories, was probably commissioned by her between 1325 and 1328.

In 1370 the *Hours of Jeanne d'Évreux* passed into the collection of Charles V in Paris and from there into the library of John of Berry, the king's brother, the famous bibliophile who commissioned the *Très Riches Heures* in 1412. Another manuscript, the *Belleville Breviary* (Paris, Bibliothèque Nationale, MS Lat. 10483–10484) executed by Pucelle between 1323 and 1326, had the same itinerary, and its rich calendar pages (see fig. 12) were very influential for the miniaturists at the end of the century, as we shall see later.

In Pucelle's miniatures the basic stylistic features of the International Style at the end of the century appear with amazing suddenness. He had a large atelier in Paris and his followers imitated his style well into the 1340s, but, for the most part, Parisian book illuminators were not prepared to follow his lead and remained true to the conservative, linear traditions of late French Gothic. Only by the fourth quarter of the century were Pucelle's paintings restudied by Netherlandish miniaturists working for John of Berry, and they initiated what might be cautiously termed a "Pucelle Renaissance" that was a major incentive for the development of the International Style in France.

Bohemia

During the fifty years that separate the innovations of Jean Pucelle and the emergence of the International Style in the workshops of Paris and the ducal capitals at Dijon, Bourges, and Angers, another remarkable anticipation of the new art was realized in the remote Bohemian capital at Prague. The sponsor was Charles IV (1316–1378), an outstanding representative of the devout and cultured leadership of the later medieval courts. Charles, king of Bohemia, was determined to transform the slumbering Slavic city into an enlightened court center to rival any of those in Europe, and he had good models to follow.[10] His father, John of Luxemburg (died 1346), had inherited Bohemia from the earlier Přemyslide dynasty through his marriage to Elizabeth, sister of Wenceslaus III, but John chose to keep his affiliations with France secure and resided for only short periods in his new domain.

In 1323, at the age of seven, Charles was sent to Paris to be educated at the Valois court of Charles IV. There the young prince became so enamored by the elite French court that he not only mastered five languages to show off his learned cosmopolitanism, but he even changed his own Bohemian name, Wenceslaus IV, to Charles IV, in reverence and admiration of the French monarch. Before he settled permanently in Prague in 1333, Charles was betrothed to Blanche of Valois, the daughter of the king.

Charles's power as the new leader of the Bohemians grew rapidly, and his political aspirations were filled with dreams of glory that culminated in his coronation as the Holy Roman Emperor in 1349 at Aachen and in 1355 at Milan and Rome. His political ambitions were further proclaimed in the issuance of the famous Golden Bull in which Charles reinstituted and reformed the constitution of the chaotic empire he had inherited. By clever diplomacy he managed to either compromise or avoid the political entanglements that had enmeshed Italy, the papal authorities at Avignon, and the shrewd German Electors who had raised him to power in the first place.

His alliances with Popes Clement VI and Urban V in Avignon were especially significant. Prague was soon raised to an archbishopric, independent of Mainz, and there is evidence that Clement VI was instrumental in promoting an ambitious cultural program for Prague. It was Clement who suggested to Charles an architect for his project, Matthias of Arras, the French builder of Narbonne Cathedral, and there can be little doubt that at Avignon the young emperor was exposed to works of Italian art that later could serve as models for the ateliers to be established in Prague. Charles's connections with Italy grew stronger, and during his two trips there (for coronation and political consolidation), he must have been greatly impressed by the splendor of trecento art that he saw in Lombardy, Tuscany, and Rome, rivaling that of Paris, which he had earlier experienced.

According to an early chronicle, "In the year of Our Lord, 1348, on the day of Saint Mark, Our Lord Charles, King of the Romans and Bohemia, laid the first stones and founded the new city of Prague." His first projects were to rebuild the old Castle of Prague, whose foundations dated to the ninth century, and to replace the Romanesque basilica of Saint Vitus, where the relics of Saint Wenceslaus, the heroic leader of early Bohemia, were preserved, with a modern French Gothic cathedral worthy of an archbishop.

Realizing that "our land should be armed with learned men," Charles next established a worthy center of learning in the form of a university. Some of Europe's finest scholars were brought to Prague to enhance his court program and to advance the literary prestige of Bohemia by instituting an improved version of High German, the *Kanzleisprache*, which was to further establish the Bohemian flavor of Charles's court. The Caroline University soon attracted students from all over Europe with classes separated into Bohemian, Polish, Bavarian, and Saxon schools. The curriculum was modeled after that of the University of Paris, which Charles had attended, and, later, the law school at Bologna. About the same time, he founded a guild for the artists to assure the city of the enrichments befitting a court capital and residence of the Holy Roman Emperor.

Thus Charles IV emerges in history as the model of the international prince, powerful and ambitious, with

13. Golden Portal, Saint Vitus Cathedral, Prague. Date of mosaic, 1370

cultural ties to the major centers in Europe: Paris, Avignon, and Rome. And Prague was his capital, and it was to outshine all other court cities. What a dream! Had events not led to the sudden demise of Charles's empire after a half-century of vigorous activity, Bohemia might well have become one of the leading centers for the arts of the fifteenth century.

Matthias of Arras was summoned by Charles to build the new cathedral (fig. 13), but work on Saint Vitus was interrupted in 1352 by his death. Charles next called in the illustrious Peter Parler, the outstanding architect from Swabia whose family had become internationally known as builders of modern Gothic. Just what Parler, the architect and sculptor, accomplished at Prague is difficult to determine, but he no doubt was the leader of a vast workshop, a ''lodge'' in the sense of a large group of craftsmen of all arts working closely under the direction of a master builder who dictated the operations of all

25

the arts involved in the erection and refurbishing of the
cathedral complex. The cathedral itself is a stunning ex-
ample of Flamboyant Gothic architecture, although only
the choir was finished during Parler's lifetime. The
Golden Portal (*Porta Aurea*), on the southern flank of the
choir leading into the Chapel of Saint Wenceslaus, was
embellished with a huge mosaic of the Last Judgment, an
undistinguished and crude example of pseudo-Italo-
Byzantine work referred to as an ''opere maysaico more
Grecorum'' (mosaic in the Greek manner) in the archives
of 1371.[11]

The choir was designed as a kind of memorial mauso-
leum for Charles's Bohemian ancestors, with stone effi-
gies resting atop huge sarcophagi. After the Romanesque

15. Rhenish sculptor of the 14th century. *Christ and Mary.*
c. 1330. Choir, Cologne Cathedral

14. Peter Parler and shop. *Tomb of Ottocar I.* c. 1377.
Limestone. Choir, Saint Vitus Cathedral, Prague

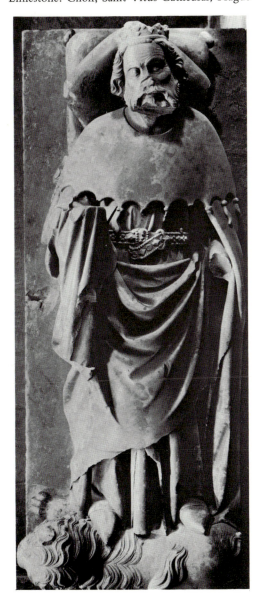

basilica was pulled down, in which the Přemyslide rulers
had been interred, Charles ordered six new tombs to be
set up in Parler's polygonal choir. The new style of
Parler's sculpture is immediately apparent in the impres-
sive figure of Ottocar I (fig. 14), the thirteenth-century
Přemyslide leader who established the hereditary line of
the Bohemian dynasty.

In contrast to the prevailing style of sculpture exempli-
fied by the swaying figures in the choir of Cologne Ca-
thedral (fig. 15), the effigies designed by Parler display a
robust realism and monumentality. The lyrical calli-
graphic sweeps of arcing lines that describe the draperies
on the tall, weightless figures with dimpled faces in the
Rhenish sculptures give way to simplified contours that
underscore the rotundity and massiveness of stumpy fig-
ures with broad folds encasing the body like heavy cur-
tains thrown about pillars. The new vigor and plasticity
not only convey a sense of weighty substance to the drap-
eries of the body, but they appear with surprising vitality
in the treatment of the heads as well. Ottocar is surely no
portrait, but the powerfully modeled facial planes with
the delicate carving of the features give his countenance
an immediacy that reveals the real presence of a powerful
man and not merely that of another Gothic head type.
Parler's achievements in plastic bulk and realism, in fact,

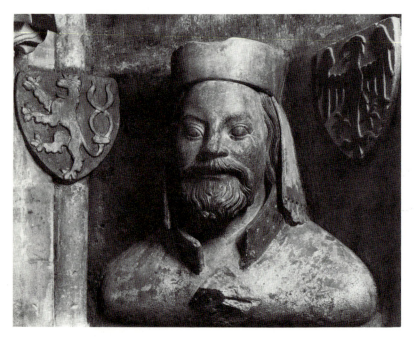

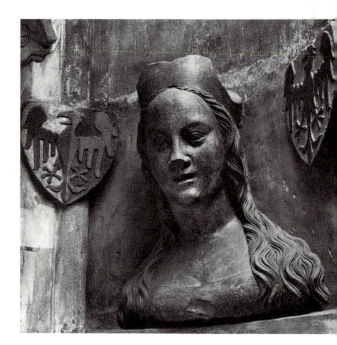

above: 16. PETER PARLER AND SHOP. *Charles IV.* 1375–79. Triforium bust sculpture. Saint Vitus Cathedral, Prague

above right: 17. PETER PARLER AND SHOP. *Anna von Schweidnitz.* 1375–79. Triforium bust sculpture. Saint Vitus Cathedral, Prague

below: 18. PETER PARLER AND SHOP. *Self-Portrait of Peter Parler.* 1375–79. Triforium bust sculpture. Saint Vitus Cathedral, Prague

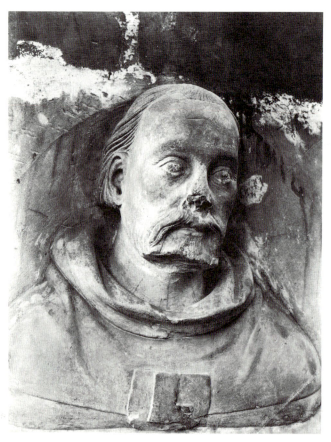

anticipate the revolutionary style of sculpture soon to be carved by Claus Sluter for Philip the Bold in Dijon.

Along with monuments to past leaders, Parler also introduced sculptured memorials to the living in a series of superb portrait busts that line the triforium of the choir (figs. 16–18). Here we find amazing likenesses of the members of the imperial family—Charles IV, his son Wenceslaus, his third and fourth wives (Anna von Schweidnitz and Elisabeth of Pomerania)—presented with all the freshness of true portraits. Included among these busts are those of the directors of the lodge, Matthias of Arras and Peter Parler himself. To what extent Bohemian sculpture of the later fourteenth century owes its conception to Parler and his shop is difficult to assess, but it all happened suddenly in Prague under the eager eyes of Charles IV.

The cathedral had some sixty altars which were to be outfitted with altarpieces displaying appropriate paintings of the saints and their legends. In Charles's day the church must have glistened brightly with numerous gilded frames encasing some of the most colorful paintings executed in the fourteenth century. Bohemian painting is distinguished above all by its unusual color, featuring a combination of pastel and mixed, broken hues that seem at first sight almost gaudy when compared to the primary triads of most European painting.

How this weird but fascinating beauty came about in Bohemia is a mystery. It cannot be accounted for by any known sources—Italian, French, or German—but seems indigenous. There is something almost oriental in the juxtaposition of colorful patterns and shapes of violets, pale greens, rose, limes, and teals that float across the

surface of these panels. The forms and compositions, on the other hand, are easy to trace, and, in fact, the obvious reliance on different foreign models for the figures and settings has led scholars to distinguish three distinct styles in Bohemian painting which have, in turn, been described as successive stages of development between approximately 1350 and 1400. There is some validity in ranging the three styles chronologically, but there are no common factors of style, other than color, to suggest a natural development from shop to shop in Bohemian painting. We are more likely dealing with three distinct masters of the art who had their own workshops and spheres of influence and who drew upon their own favored models.[12]

The three styles can be conveniently studied in two large altarpieces, partly intact, and in numerous panels and frescoes that cover the walls of Charles's Chapel of the Holy Cross at Karlštejn Castle in the hills some twenty miles south of Prague. The earliest style is represented by the paintings of the master who executed a large polyptych, now dismantled, for the Cistercian monastery at Vyšší Brod (Hohenfurth in German) in southern Bohemia commissioned by a member of the aristocratic Rosenberg (Rozmberk) family, who owned vast estates there. The nine panels that survive depict traditional scenes of the Infancy and Passion of Christ painted on wood covered with canvas that display a mixed Italian and Northern iconography.

The *Nativity* (colorplate 2) has all the flavor of a provincial Italo-Byzantine work at first sight, but it is masterfully executed. The head types are distinctly Byzantine with almond eyes, tapering noses, pinched lips, and contour modeling on the outer cheeks. The colors, on the other hand, are unusual. Mary, the infant, and the angel have rosy cheeks and strawberry-blond hair, while the male heads, Joseph and the shepherd, are given a ruddy complexion. A light pink tonality distinguishes the colorful mantle bordered in gold wrapped about the Virgin under which she wears a light blue dress spangled with golden patterns. Joseph is garbed in a soft pink mantle lined with bright yellow. His deep red shirt is lined with a soft blue, the same shade as his cap. The handmaid, who prepares the bath water with Joseph's help, wears an orange blouse over a violet-pink skirt. The costume of the little shepherd to the right features an orange-yellow mantle, a teal-blue cape, and a bright red hat. No one would confuse the palette of our artist with the basic red-blue-yellow (or gold) of the Italo-Byzantine schools.

Likewise recognizable are the Italo-Byzantine landscape conventions, the cracked basalt-rock formations, but unlike those in Duccio's panels the jagged angularity of the broken edges here takes on a colorful allover pat-

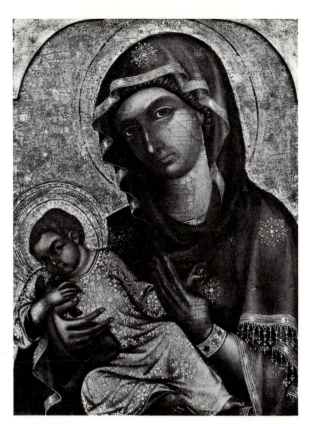

19. BOHEMIAN ARTIST. *Madonna of Most.* c. 1350. Tempera on canvas-covered panel, 20⅞ × 15¾″. Capuchin Monastery Church, Most, Czechoslovakia

tern of decorative crystalline facets meandering about the figures. The cloud formation around the angel flying in from the top right is fashioned as a giant flower of scalloped petals in green outlined in white. The background retains the traditional gold.

In the right foreground a member of the Rosenberg family, carrying a model of the church at Vyšší Brod, kneels before the family coat of arms. The last distinguishing features are the somewhat humorous and delightful touches of everyday genre that appear here and there. Joseph does not sit to the side and ponder the mystery of the birth of the Child as he is presented in Byzantine art, but rather he actively partakes in the preparation of the bath by pouring water into a wooden tub from a greenish pitcher. The ox and ass, resembling stuffed toys, are moved far behind the bed and munch eagerly on hay. Finally, the shepherd's dog reels back in a startled fashion to bay at the angel in the sky. The setting of the birth in an open shed (not the shed-grotto of Duccio) suggests that the painter was familiar with other Tuscan versions of the theme, such as Giotto's. A number of attractive panels, including the *Kladsko Madonna* and the *Kaufmann Crucifixion*, both in Berlin, are evidence of the prodigious output of the Master of the Vyšší Brod's atelier.[13]

The dependence of the Bohemian artists on Italian prototypes is nowhere more evident than in a series of half-length Madonna and Child compositions, the so-

20. BOHEMIAN MINIATURIST. *Annunciation*, from the *Liber Viaticus*. c. 1355–60. Illumination. National Library, Prague

commissioned by a small circle of learned clerics connected with the imperial chancery. One of the finest, the *Liber Viaticus* (Prague, National Library), of about 1355–60, was commissioned by Jan of Středa, the bishop and chancellor for Charles IV and a distinguished scholar of literature, reformer of the Czech language, and compiler and composer of hymns to the Virgin.

The elegant miniature of the *Annunciation* (fig. 20) repeats the same composition found in the *Vyšší Brod Altarpiece* with the delicately modeled figures, dressed in bright reds, greens, and blues, placed before a high throne of hybrid structural elements. The borders of the page are surprisingly advanced, with elegant acanthus leaves sprouting from a blue and gold bar and serving as settings for busts of the prophets. Bishop Jan of Středa kneels in the circle of richly colored leaves in the lower left corner. The acanthus motif is derived from Bolognese manuscripts of the period, but the enchanting figures of wild men attacking a lion and a dragon below the text are remarkably close to such *bas-de-page* details in Parisian illuminations, to be discussed later. It is important to note, however, that these foreign influences have been fully assimilated and synthesized into a distinctive Bohemian style much as they were in the panel paintings.

For the decorations in the Chapel of the Holy Cross in Karlstejn Castle (fig. 21), consecrated in 1357 and 1367, Charles employed one of the leading artists in the painters' guild in Prague, a Master Theodoric.[14] His name, variously spelled Dittrich, Dětřich, Jetřich, in the documents, does not help us determine his nationality, but it has been argued that he must have immigrated to Bohemia from Austria. His project at Karlštejn was indeed demanding. The upper walls of the chapel were to be covered with panels, stacked one over the other in rows. Above them were frescoes including scenes from the Apocalypse, and the dado below was lavishly incrustated with stone inlays of cross patterns, alternating red and blue, against a gold background filled with rectangular pieces of cut stone. The technique, while somewhat crude, is effective. Over 130 panels are lined above the dado in two or three tiers. Bust-length portraits of the apostles, evangelists, and angels adorn the wall behind the altar; Holy Virgins, bishops, Benedictine abbots, hermit saints, popes, and kings are displayed in the gridlike divisions of the side walls. Such a program is, indeed, unusual, and it all resembles some gigantic Byzantine iconostasis arrangement of icons disassembled from the screen before the altar and transferred to the church walls.

The figures depicted are startlingly different from those in the Vyšší Brod panels. The contours are extremely simplified and the bodies and heads, coarsely modeled, fill the picture surface. Aside from beards and

called Czech Miraculous Madonnas, that were produced by workshops closely related to the Master of the Vyšší Brod Altarpiece. One of the earliest of these, the *Madonna of Most* (Brüx) (fig. 19), which once hung over the entrance of the parish house of the monastery there, displays the rich Bohemian colors applied to a somewhat slavish copy of a familiar Italian Madonna holding a sprawling Child in her arms who squeezes a goldfinch in his right hand, a cult image thought to be related to the plague. The Child is dressed in scarlet laced with a golden filigree pattern while his mother wears a purple mantle lined in green with a darker green maphorium replacing the usual white veil. The head types, however, with oriental eyes, arched noses, and pinched lips, clearly indicate the derivation of the composition from one of the many Madonna icons imported from Italy.

Closely related to the painters of the first Bohemian style were the book illuminators of the imperial scriptoria. These manuscripts, some of the finest produced anywhere in Europe in the mid-fourteenth century, were

left: 21. MASTER THEODORIC AND SHOP. Interior, Chapel of the Holy Cross, Karlštejn Castle. 1357–67

below: 22. MASTER THEODORIC AND SHOP. *Crucifixion.* c. 1360–65. Tempera on canvas-covered panel, 87¼ × 68⅞". Chapel of the Holy Cross, Karlštejn Castle

costume details, the heads are not individualized, nor do they follow the usual Byzantine facial conventions. Many have no attributes by which to identify them. The largest panel, the *Crucifixion* in the third row directly above the altar, is the most impressive (fig. 22). The huge, massive figures of Mary and John tightly flank the stocky body of Christ on the cross, filling the surface with only a nondescript groundline to indicate Golgotha beneath them. A few touches of unusual color—the green lining of Mary's somber blue mantle, the scarlet of John's muddy green cloak—bring to mind the style of earlier Bohemian painting, but otherwise Master Theodoric's figures in no way resemble the delicate and detailed actors in the *Vyšší Brod Altarpiece.*

The drastic change in style has been explained as the response to new influences from North Italy, namely, the more summary, tubular figures of Tommaso da Modena and his shop where the intricate patterning and elegant linearisms of the Sienese school were discarded for a static plasticity and somber tactility. Tommaso has been linked directly to Prague. Below the *Crucifixion* are two triptychs. One, with the *Imago Pietatis* (Christ as Man of Sorrows) flanked by angels and the three Marys, is in the style of Theodoric's shop; the other, below it, presents the Madonna and Child in the center with Saints Wenceslaus and Dalmasius in the outer panels and is clearly in a more polished style. The central panel, in fact, is signed by Tommaso da Modena and his son, and it is certainly more than a coincidence that the Italian master's triptych appears in such a prominent place among the many undistinguished portrait panels of Master Theodoric's atelier.

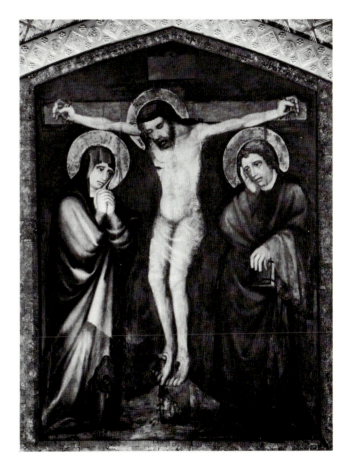

Very likely Charles IV commissioned the triptych when traveling in Italy in 1355. There is no evidence that Tommaso da Modena had any direct contact or influence in Bohemia. In another light, the stockiness of Theodor-

ic's figures with large heads and short, thick necks can be seen as a parallel to the physical solidity and rugged realism in the figures executed in Parler's sculpture workshop in Prague.

Following the death of Charles IV in 1378, cultural life in Prague changed drastically. His son, Wenceslaus IV, was forced to play the role of a political mediator more than a patron of the arts in face of the civil disorders generated by the Hussite movement in Prague. In South Bohemia, however, artistic activity continued to spread and develop. One of the greatest painters of the next generation was the anonymous master whose finest works are the panels that once belonged to the main altarpiece of the Church of Saint Giles in the Augustinian monastery at Třeboň (Wittingau in German), executed about 1385–90. Three of these, today in the National Gallery at Prague, represent episodes from the Passion: the Garden of Gethsemane, the Entombment, and the Resurrection (colorplate 3).

The provocative painting of the lithesome Christ rising mysteriously from a sealed sarcophagus is a masterpiece of early expressionism. Affinities with earlier Bohemian painting can be discerned in conventions of the landscape and in the metallic colors of the tomb and the armor of the soldiers juxtaposed with the bright red of the sky and the mantle unfurling about Christ's body. But this style cannot be easily reconciled with that of the Vyšší Brod panels or those of Master Theodoric. It has been argued that the Master of the Třeboň paintings was familiar with current styles in western Europe, but nowhere in France or Germany do we find the same intense figure types aglow with eerie colors that mark the erratic compositions of the Třeboň Altar. Christ's tall, thin body is placed slightly off center; the sarcophagus thrusts its disturbing weight diagonally across the lower half of the composition; and the grotesque forms of the four soldiers, only one asleep, turn and move about Christ like deformed creatures of the night. In the lower left, the henchman seated on the ground is depicted in harsh, cutting, angular lines; his arms, legs, and head are encased in tight metallic sheathings of chain mail; his shield is accentuated with a piercing spike that points to the foot of Christ.

The heads of the soldiers are particularly disturbing with their enigmatic grimaces and staring eyes, and the strange landscape, dark and sinister, is curiously punctuated, here and there, with tiny birds and delicate plants. The sky is deep red, the color of blood, against which golden stars sparkle. But it is the flamelike contours and lines of Christ's mantle, flaring in and out of his emaciated body, that impart a truly awesome image of release, like the flickering flames of a fire that reach upward into the scarlet sky. The combinations of intense reds, metallic grays, and shifting, depthless dark tonalities evoke a frightening image of Christ's return to life in some satanic rather than earthly setting.

It is no wonder that many art historians have seen this exceptional painting as one of the forceful harbingers of more contemporary German Expressionism. The pathos and despair embodied in such works as this are like the frightening dreams that swept through Bohemia after the death of Wenceslaus and the revolt of the Hussite factions in 1419. Following the Master of the Třeboň Altarpiece, who was probably still active at that time, Bohemian art gradually lost its forceful and disturbing beauty and gradually dissipated into diluted reflections of its early enchantment.

But all was not pathos or despair in late Bohemian art. Juxtaposed with the Třeboň panels are the sweet images that pervaded court art with a surprisingly different mode of expression. The "Beautiful Style" had its flowering in a number of images of the Madonna and Child, both in painted panels and sculptures. The paintings, of which there is a remarkable series, continue the tradition of the "Miraculous Madonnas" discussed earlier. The workshop of the Master of the Třeboň Altarpiece produced a number of these, including one unusual panel, the *Madonna Aracoeli*, which reproduces in a slavish manner the features of a small icon in the Treasury of Saint Vitus Cathedral which, according to tradition, was given to Charles IV by Pope Urban V in 1368.

But the finest of the painted Madonnas was the prototype created by the Třeboň Master reflected in a number of versions of which the so-called *Roudnice Madonna* (fig. 23), with its attractive face modeled in soft chiaroscuro, is the best. A certain charm and sweetness replace the harsher characterizations seen earlier, and the Child rests back in a relaxed position in the Virgin's arms. The costume has changed as well. Mary wears a nearly transparent crown of gold incrusted with real stones, and a lacy veil hangs in two cascades from the nape of her neck across her sloping shoulders. A huge brooch serves as a clasp to secure the ample mantle that falls in great arcing folds between her arms. The numerous versions of the new Madonna type indicate the widespread response to the intense devotion to the Virgin that ushered in an aesthetic sentiment steeped in the vision of Mary as the lovely princess who served as the model of femininity in Bohemian court circles.

The finest image of this ideal Madonna was realized by sculptors in Bohemia in the refined and genteel portrayal of Mary as a comely young princess delicately holding her rosy-cheeked baby, a type known as the "Beautiful" or "Fair" Madonna (*Schöne Madonna* in German).[15] This new type is closely connected with patronage in South Bohemia and was very likely created as a cult image for

23. *Roudnice Madonna.* c. 1400. Panel, 35½ × 26¾″. National Gallery, Prague

the precious devotion that developed in the courts there. The ultimate sources for the style of these Madonnas are to be found in the general development throughout Europe of what has been loosely called the "Soft Style" in sculpture. This mode presents itself as an affected manifestation of the elegance and grace that gradually emerged from the thirteenth-century *Smiling Angel* of Reims (fig. 2) and the *Vièrge Dorée* of Amiens, where graceful arcing drapery with cascading zigzag frills cover a demure female figure poised in an exaggerated "S" stance.

Much controversy obscures the problems of direct stylistic origins, however. A number of scholars see the *Schönen Madonnen* as final manifestations of the Parler workshop, even assigning their conception to Parler's sons, Wenceslaus and John, who were perhaps the "Prague bachelors" (*Junkers, panici*) recorded in documents in Prague and elsewhere. But this theory implies sudden changes in sentiment of expression, style, and technique in carving that are irreconcilable with what are

generally considered the products of the Parler lodge as we know them in Saint Vitus Cathedral.

More convincing are the arguments of those who relate the sculptured Beautiful Madonnas to the icons of late Bohemian painting, which, as we have seen, served as cult images. Although the paintings present only the bust of the Virgin, the head types are very close in conception to the statues. The draperies visible in the painted versions show the same fullness of rhythmic folds and cascades that descend from the elbows and the wrists. The tender and coy characterization of the Child who wriggles in his mother's careful embrace is the same, as are details of the costume such as the repeated appearance of a large quatrefoil brooch that serves as a clasp at the Madonna's neck. There can be no question concerning the aesthetic ties of the paintings and sculptures, as we shall see.

At least three basic prototypes of the "Beautiful Madonna" have come down to us, and they seem to have served as the models for countless other statues. These are the Madonnas from Krumau, Thorn, and Breslau. With the exception of the position of the Child, they are very similar, displaying the same graceful postures and loving expressions enhanced by the elegant flowing rhythms of falling drapery. They are carved from limestone (or cast limestone) that preserves traces of polychromy, and they are approximately the same height, about three and one-half feet. Finally, they all date about 1400.

The *Madonna of Krumau* (fig. 24) is the most accomplished and, deservedly, the most famous of the three. A document of 1400, recording the indulgences for the Chapel of Saint George in the Castle at Krumau, names the statue "de pulchro opere imago virginis Mariae Gloriosae," and, indeed, she embodies the *beau ideal* of the chaste princess of the Late Gothic age. One is immediately attracted to the charming, girlish face of Mary with her smooth, high forehead, her delicately rendered chin and lips, and her feline eyes. The Child turns aside in her arms and pulls at the Madonna's mantle with his left hand (now broken off). Mary's head is inclined to the right and is elegantly poised on a long, thin neck that gracefully emerges from the contours of her narrow shoulders. Her long, tapering fingers gently press into the soft flesh of the nude infant, who turns to look down at the viewer.

Beneath the graceful and slightly capricious articulation of the upper body of Mary and the Child, there descends one of the most poetic and engaging passages of drapery ever created in terms of pure abstraction. The central part of Mary's torso is enveloped in melodious arcs, repeated one within the other and nestled within a deeply carved hollow that descends from her waist to her

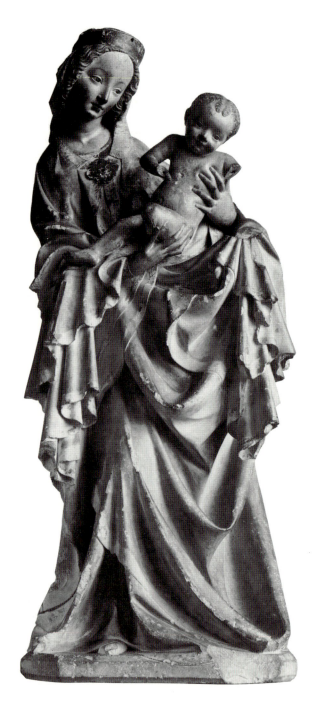

24. BOHEMIAN SCULPTOR OF THE *Schöne* MADONNAS.
Madonna of Krumau. c. 1390–1400. Stone, height 4′ 3″.
Kunsthistorisches Museum, Vienna

feet on the right and up again. This enchanting rhythmic consonance is sustained and languorous, uninterrupted by the contrapposto of fussy, cramped pocket folds that one usually finds in Late Gothic sculpture. The gentle flow of the "S" stance of the statue then allows for elegant cascades of unfurling draperies to drop from the projecting elbows on either side, enframing the broader sweeps of the mantle within. Finally, a graceful triangle of curved ridges, to the left of center, anchors the figure

to the base with the foot of the supporting leg just visible.

Aside from the charm and grace that are so effectively realized throughout the lines of the sculpture, other features, aesthetic and psychological, are at work on the viewer here. It has been suggested that the Krumau Madonna has affinities with certain Mannerist paintings of a much later date, such as the *Madonna of the Long Neck* by Parmigianino, in its languorous pose and low-keyed eroticism evoked by the prettiness of the youthful Madonna. There is something of a fairytale characterization in the capriciousness, fantasy, and fragility of the statue.

John Huss, the Bohemian revolutionary who was to bring an end to the refined and, what he considered, debased devotion of the court, criticized just such images as this, which he charged were admired only for their engaging beauty that aroused sexual excitement in the viewer rather than pious concern for salvation. This is, of course, difficult to assess, but there does seem to be some truth to it. The aesthetics of the diminutive, an aspect of Late Gothic art that needs more serious investigation, is certainly involved here. These beautiful female figures are all about three and one-half feet high, large enough to seem part of our own world, but nevertheless tiny in comparison to our scale. Our first response to the *Madonna of Krumau*, whether we would like to admit it or not, is likely to be, "What a charming little Madonna!"

The sudden emergence of the Beautiful Madonnas in Bohemia has been seen as a response to changing patterns of religious devotion that swept through Europe, devotions of a more personal and mystical character such as the *devotio moderna* promoted by the Augustinian Brethren of the Common Life, to be discussed later. Mystical devotion frequently swings between two poles. On the one, the happiness and pleasures of the Madonna are called forth in images such as this, the loving young mother with her healthy baby in her arms; and, on the other, the despair of the mother, grief-stricken and lonely, is evident as she holds her son's lifeless body across her lap again at the end of his life, the *Vesperbild*.

It is not surprising, then, that these same workshops produced numerous examples of the *Vesperbild*, or *Pietà*, for these same patrons. The Bohemian *Vesperbild* (color-plate 4) has a totally different expression from those produced further west in Germany, however. The basic compositional scheme formed by the seated Madonna and the diagonal marked by the rigid body of Christ is the same, but the characterization of Mary is not that of a bereaved matronly mourner. Rather, she is the same youthful Madonna with delicate features and elegant draperies that we find in the Krumau statue. The *Schöne Madonna* seems out of place in such a tragic context.

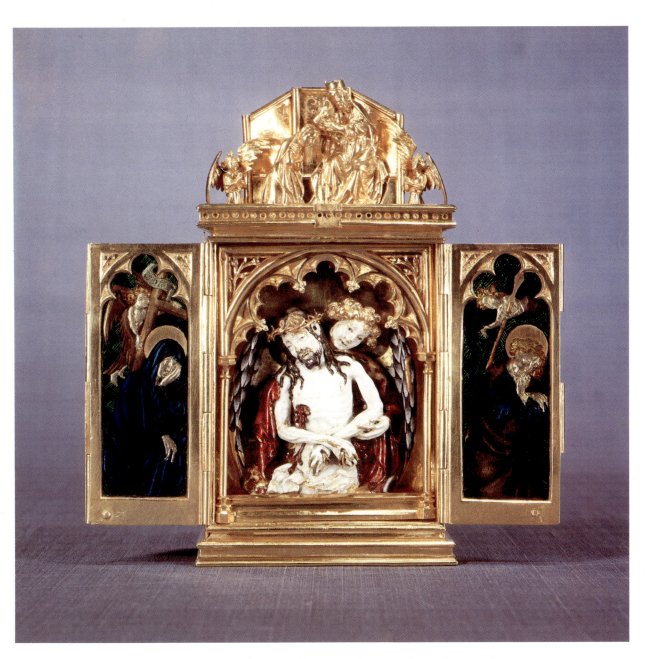

Colorplate 1. Parisian Goldsmith. *Man of Sorrows with Mary and John the Evangelist*. c. 1400.
Enamel triptych, 5 × 5″. Rijksmuseum, Amsterdam

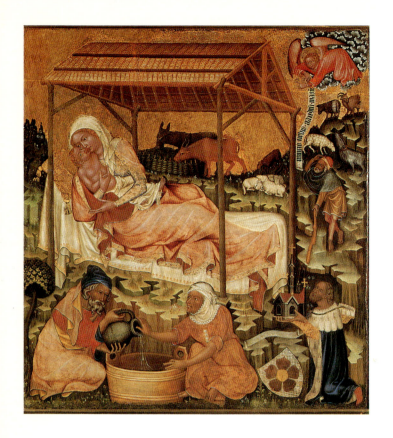

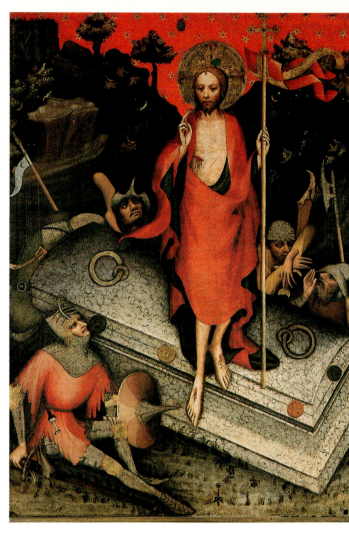

above: Colorplate 2. MASTER OF THE VYŠŠÍ
BROD ALTARPIECE. *Nativity.* c. 1350.
Tempera on canvas-covered panel,
37⅜ × 33⅝″. National Gallery, Prague

above right: Colorplate 3. MASTER OF THE
TŘEBOŇ ALTARPIECE. *Resurrection.*
c. 1385–90. Panel, 52 × 36¼″.
National Gallery, Prague

right: Colorplate 4. BOHEMIAN SCULPTOR
OF THE LATE 14TH CENTURY. *Jihlava Pietà
(Vesperbild).* c. 1400–1410. Stone. Saint
Ignatius Church, Jihlava

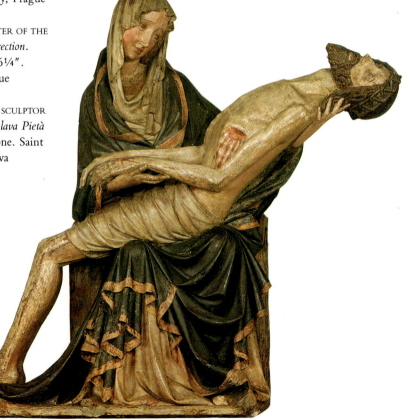

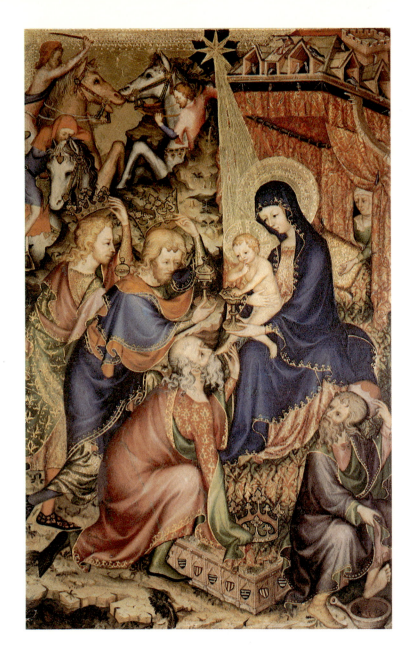

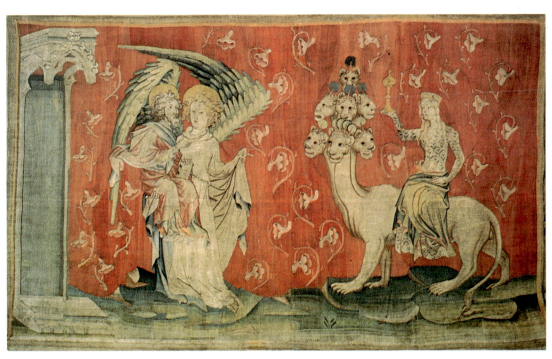

left: Colorplate 5. FRENCH PAINTER OF THE LATE 14TH CENTURY. *Adoration of the Magi,* from the *"Small Bargello Diptych."* c. 1385. Panel, 19¾ × 12¼″. Museo Nazionale, Palazzo del Bargello, Florence

below: Colorplate 6. JEAN BONDOL AND NICOLAS BATAILLE. *The Harlot Seated on the Beast,* part of the *Angers Apocalypse Tapestries.* c. 1375–79. Musée des Tapisseries, Angers

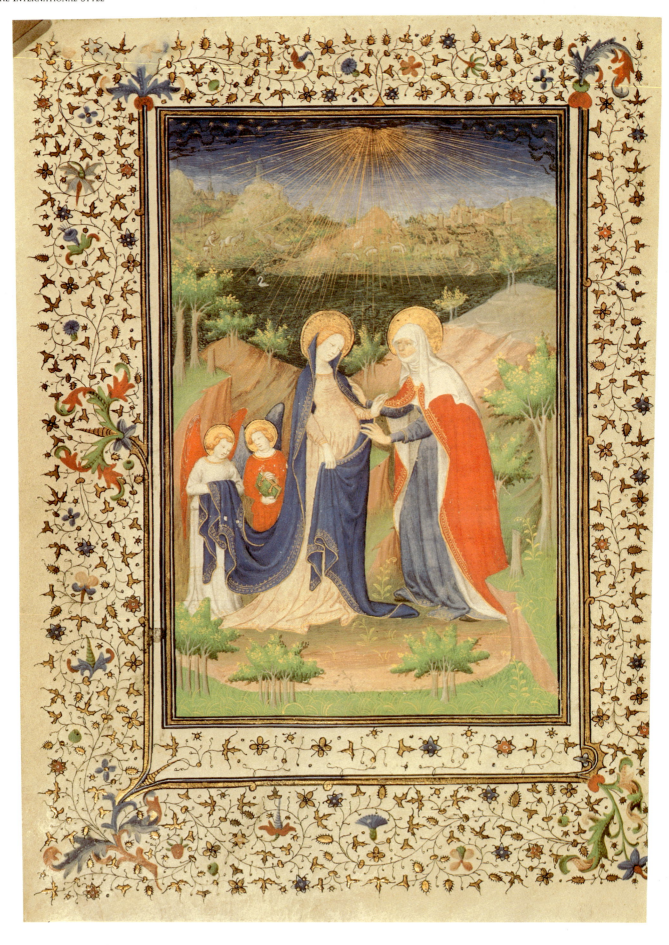

Colorplate 7. THE BOUCICAUT MASTER. *Visitation*, from the *Boucicaut Hours*. c. 1408–10.
Musée Jacquemart-André, Paris

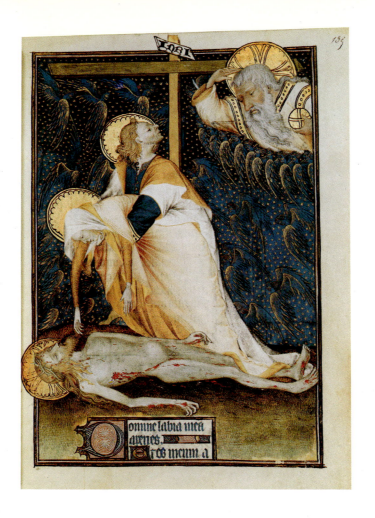

left: Colorplate 8. THE MASTER OF THE ROHAN HOURS. *Lamentation*, from the *Rohan Hours*. c. 1420. Bibliothèque Nationale, Paris

below: Colorplate 9. JACQUEMART DE HESDIN. First dedication page in the *Brussels Hours*. c. 1400. Bibliothèque Royale, Brussels

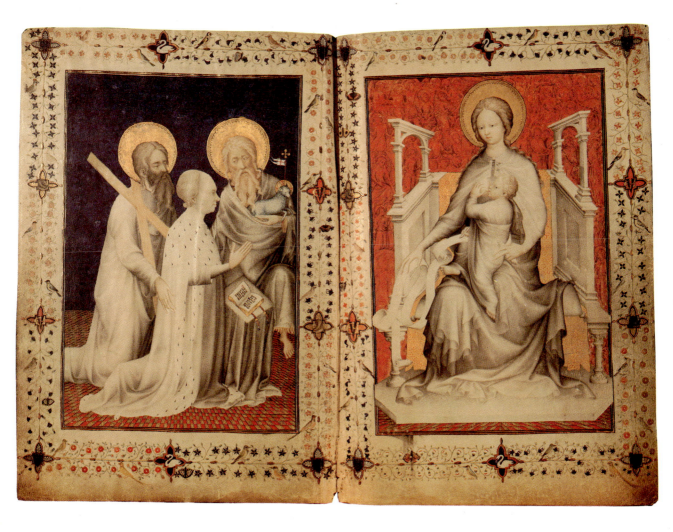

Colorplate 10. LIMBOURG BROTHERS. *January,* from the calendar of the *Très Riches Heures du Duc de Berry.*
Before 1416. Musée Condé, Chantilly

Colorplate 11. JEAN MALOUEL AND HENRI BELLECHOSE? *Martyrdom of Saint Denis with the Trinity.*
c. 1415–16. Panel, 63⅜ × 82⅝″. The Louvre, Paris

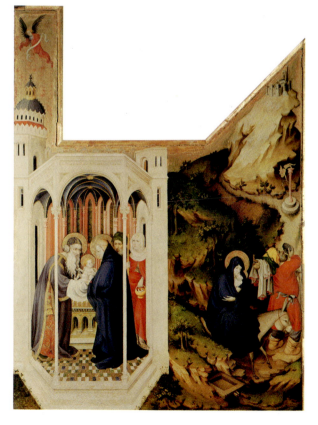

Colorplate 12. MELCHIOR BROEDERLAM. Outer wings of the *Retable de Champmol: Annunciation and Visitation;*
Presentation and Flight into Egypt. Installed 1399. Panels, each 65¾ × 49¼″. Musée de la Ville, Dijon

Colorplate 13. RHENISH MASTER OF THE PARADISE GARDEN. *Garden of Paradise*. c. 1410–20. Panel, 9½ × 12¼″. Städelsche Kunstinstitut, Frankfort

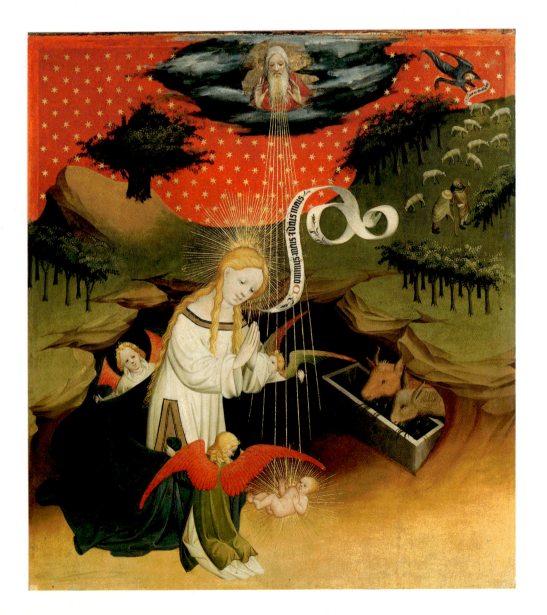

Colorplate 14. MASTER FRANCKE. *Nativity*, from the *Englandfahrer Altarpiece*. 1424. Panel, 39 × 35″. Kunsthalle, Hamburg

The Valois Courts

CHARLES V AND PARIS

John II the Good (1319–1364), son of the first Valois king of France, Philip VI, has the distinction of being the father of the International Style in France through his four sons, Charles V, Louis of Anjou, John of Berry, and Philip the Bold of Burgundy—the founders.[16] The duchies (*apanages*) granted to his sons were rich territories surrounding the Île-de-France, where the capital of the monarchy, Paris, was located. John the Good, as he is known in most histories, was an ineffectual ruler, just as his father before him, and, following the devastating defeats of the French by the English at Crécy in 1346 and Poitiers in 1356—the first disastrous phase of the Hundred Years' War—he left his eldest son Charles with a France that was weak and strife-ridden with political and civil disobedience. During the reign of John the Good, the France of the great Golden Age of Gothic, the France of Louis IX, had thus disintegrated, losing its force and prestige both politically and culturally in Europe. At the battle of Poitiers, John was taken prisoner and held for ransom in England for three years.

What happened during the last third of the fourteenth century was tantamount to a miracle in French history. Through the masterful statesmanship of the son, Charles V, Paris was strengthened and regained its preeminence, and, at the same time, there were initiated in the Valois duchies cultural programs that rival any in the history of Western art. One always looks for beginnings and influences in history, but however these factors are to be reckoned, one cannot escape the fact that four brothers, very close in age, brought it all about with astonishing quickness. To be sure, John the Good had planted the seeds for this Late Gothic flowering, but little remains to judge his role as patron of the arts.

An eighteenth-century watercolor copy of a painting which once hung in the sacristy of Sainte Chapelle in Paris (fig. 5) depicts John the Good presenting a diptych, the bust of Christ and a Madonna of Intercession, to a pope in Avignon. This could be Pope Clement VI,

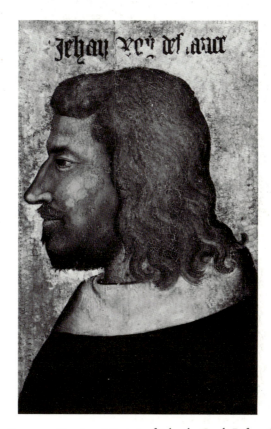

25. GIRARD D'ORLÉANS? *Portrait of John the Good*. Before 1356. Tempera on canvas-covered panel, 21⅞ × 13⅜″. The Louvre, Paris

whose coronation John attended in 1342, or Urban V, who received the French king in 1363. On the basis of the style reflected in the copy, the latter visit would seem to be the occasion, but it is not likely that the devotional diptych being presented by John was actually a product of Parisian ateliers. He also had secured strong ties with his cousin, Charles IV of Bohemia, who, as we have seen, initiated a grandiose cultural program in Prague.

John had a court painter, Girard d'Orléans, who accompanied him during his captivity in England, and who, according to many French scholars, painted the king's portrait (fig. 25), a profile head in tempera on a

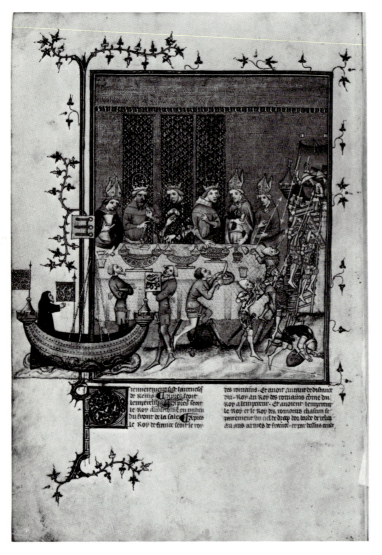

26. PARISIAN MINIATURIST OF THE LATE 14TH CENTURY. *The Banquet of Charles IV of Bohemia and Charles V of France in Paris*, from *Les Grandes Chroniques de France*. 1375–79. Bibliothèque Nationale, Paris

canvas-covered panel, the earliest surviving easel painting in France.[17] Above the large imposing head, which nearly fills the panel, is the inscription "jehan Roy de France." The likeness, today in the Louvre, has been heavily restored and little of the paint surface can be trusted for analysis of modeling or other stylistic details, but the general outline and the broader aspects of the head and costume are clear indications of a new mode of art in the North, the profile portrait. Furthermore, it is important to note that this first monumental likeness of a French monarch in panel painting revives an old tradition for imperial portraiture that reaches back to coins, medallions, and panels of ancient Rome.

Whether or not the profile portrait was introduced from Italy, where it appears frequently in the quattro-

cento, is an issue of considerable controversy, but our main concern for the present is the iconography of such portraiture. Was the carefully outlined face of John the Good meant to serve as an effigy of the king as an embodiment of his magical presence? Or was it the first example in a long line of dynastic portraits that had a state function in recording the genealogy of the Valois house? The latter is surely closer to the truth.

That such dynastic portrait galleries were commonplace is affirmed when we look into the state archives of his son, Charles V. In the inventories of Charles that list his paintings, there is a description of a quadriptych comprised of portraits of John the Good, Edward III of England, Charles IV of Bohemia, and the dauphin himself, Charles V of Valois, that was displayed in the king's favorite residence, the Hôtel Saint Paul in Paris. His brother, John of Berry, also had a collection of such dynastic portraits in the gallery of his Château de Bicêtre near Paris which unfortunately perished in a fire in 1411.[18]

Charles V the Wise (1337–1380) inherited the throne of an exhausted monarchy following the death of his father in 1364. Within sixteen years Charles distinguished himself as an exemplary ruler, cunning and effective in matters of diplomacy and a master at rebuilding and refurbishing a France that once sparkled brightly during the High Gothic leadership of Louis IX, the true Christian king of the thirteenth century. The magic powers of Charles can be appreciated even more dramatically when one pauses to note that immediately following his death, France and Paris were plunged again into a humiliating state of disorganization and confused authority.

Charles's important position in the political history of France has often been obscured and overshadowed by his fame as a learned connoisseur and promoter of the arts. That he is known today as Charles the Wise is a just tribute, however, since he was by far the most learned of the Valois brothers. Petrarch, who met the dauphin when he was young, admired him for his intelligence, and later, after his projects for consolidating his monarchy were realized, it is known that Charles frequented the company of the scholars associated with the University of Paris, no doubt considering himself one of them more so than a knight in shining armor leading forces in battle or winning at the tournament.

Christine de Pisan, famed daughter of the court astrologer in Paris, provides us with an eloquent biography of Charles. She tells us that he was handsome—he had a high forehead, a long nose, shoulder-length hair—and that he was an impressive speaker who was a forceful defender of the church. Christine describes his daily routine with obvious respect. In the morning, after finishing his toilet, Charles would first complete early morning devo-

tions by hearing a Mass set to music, after which he would receive his council and hear petitioners. After taking his breakfast at ten, accompanied by cheerful music, he would enter the state apartments in the Louvre for a regular two-hour assembly with visiting ambassadors, magnates, and other state officials. During the early afternoon, when the sun was still high, he went into retreat to peruse his manuscripts, jewelry, and paintings. Later in the day, he would stroll in the garden—on some days the queen and his children were allowed to join him—and during the winter, when it turned dark and cold early, Charles would read books in his impressive library (which forms the core of the present Bibliothèque Nationale in Paris). He attended vespers at sundown and afterwards took a moderate meal in the company of the nobles in residence.

Occasionally, Christine tells us, Charles would relax his scholarly pursuits and plan an elaborate banquet with entertainment in the Palais Royale. Such festivities are recorded and illustrated in *Les Grandes Chroniques de France* (Paris, Bibliothèque Nationale, MS Fr. 2813) of 1375–79, where a sequence of miniatures illustrates the great state visit of Charles IV of Bohemia held in honor of the restoration of the French monarchy. The climax of the visit was the great banquet on January 6 held in the Hall of the Parlement with eight hundred invited guests. The event is colorfully recorded in *Les Grandes Chroniques* (fig. 26), where the two emperors, Charles IV of Bohemia and Charles V of France, in the company of celebrated archbishops of France, are portrayed behind a banquet table covered with costly gold vessels.

To commemorate the victory of the First Crusade, a lavish *tableau vivant* was created that transformed the hall into a theater. The staged spectacle was the capture of Jerusalem. According to the text and the miniature, a body of water was created in the hallway in which crusaders' ships, with real masts and rigging, floated slowly down the hall toward the stage, where the crusaders were unloaded and then reenacted the siege of Jerusalem with ladders set against reconstructed battlements of the city.

Such elaborate pageants were common, and the unusual mechanical devices displayed in the unraveling of the action served the curious obsession for realism during the period. It should be remembered too that the guest, Charles IV of Bohemia, was the heroic leader who established Prague as an international capital and fostered the arts there in his ambitious cultural programs. With this in mind, the close ties and connections between the court centers of the International Style come more clearly into focus.

One of Charles V's early projects was to expand the palace apartments in the Louvre, built by Philippe

Auguste two centuries earlier. The present Louvre, the museum, built during the Baroque period, covers the site of the Gothic structure, but some idea of the appearance of the fourteenth-century Louvre can be gleaned from the representation of the walled palace in the background of the *October* page in the calendar of the *Très Riches Heures du Duc de Berry*, where its white walls and towers rise majestically from the quay of the Seine. Excavations of 1863 substantiated the general ground plan of the square structure with its central court (figs. 27 and 57).

Originally the Louvre was entered from the north, where a bridge crossed the moat that surrounded the palace. Lofty towers marked the corners and the cross axes of the building, and to the wings of apartments on the east and south sides, built by Philippe Auguste, the architect of Charles, Raymond du Temple, added four stories of apartments on the north and west flanks of the square. In one tower Charles housed his great library. In another, the Great Tower, he placed dynastic portraits in the form of full-length statues against the walls of the spiraling staircase that connected the apartments. Those of Charles V and his wife Jeanne de Bourbon were entrusted to the sculptor Jean de Liège.

The statues adorning the staircase, including those of his three brothers, no longer survive, but some idea of

27. Ground plan of the Louvre in the 15th century

them is preserved in two handsome figures, today in the Louvre, that portray the king and queen (fig. 28). The Louvre statues, long believed to come from the portal of the Church of the Célestins founded by Charles, might be, in fact, accurate reproductions of those originally in the staircase. The head of Charles is handsome, his expression benevolent, and the facial features clearly resemble those in countless other portraits of the king seen in the dedication pictures of his manuscripts.[19] The noble stance, relieved by a slight "S" curve traditional in Gothic sculpture, instills a sense of quiet dignity and composure to the figure, and the ample arcs of the mantle, somewhat simplified in their design, add a low-keyed elegance and stability to the characterization.

Another impressive statue of Charles V was commissioned by Cardinal Jean de La Grange, sometime between 1373 and 1375, to join those of other dignitaries and patron saints adorning the buttressing of the north tower of Amiens Cathedral. For his tomb in Saint Denis, Charles commissioned the Flemish master André Beauneveu to execute the *gisant*, or reclining portrait, for the lid of the sarcophagus (fig. 29). The powerful realism in the head of Charles by Beauneveu, with its precise detail subordinated to the softly modulated planes and deepened eye sockets, reminds one of the fresh naturalism in the heads of the triforium portrait busts by Peter Parler in Prague, and while the Parisian sculptures, approximately contemporary with Parler's work for Charles IV of Bohemia, display more graceful lines in the treatment of drapery, the striking immediacy of the individual portrait heads indicates the wide diffusion of a new mode of realism in sculpture at the end of the century.

Charles V and Jeanne de Bourbon appear again in a remarkable painting, the *Parement de Narbonne* (figs. 30,

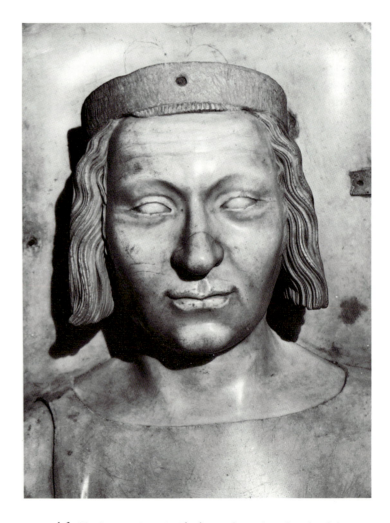

left: 28. JEAN DE LIÈGE? *Charles V*, from the Church of the Célestins? c. 1375–80. Stone, height 76¾". The Louvre, Paris

above: 29. ANDRÉ BEAUNEVEU. *Gisant Portrait of Charles V* (detail). c. 1375. Saint Denis Cathedral

30. FRENCH PAINTER OF THE LATE 14TH CENTURY. *Parement de Narbonne*. Before 1378. Silk, 2' 6¾" × 9' 4⅝". The Louvre, Paris

31), discovered early in the last century and recognized immediately as a work commissioned by the king on the basis of the portrait and the initial *K* (Karolus) adorning the borders. The long silk hanging (more than nine feet in length), painted in grisaille with delicate brushstrokes resembling a drawing, has been described as an altar frontal. The central section depicts the royal couple kneeling in profile on either side of a crowded composition of the Crucifixion. Above them, within painted Gothic niches, stand a personification of Ecclesia (Church Triumphant) with the prophet Isaiah to the left and Synagoga (the vanquished Jews) with David to the right. On either side elaborate trefoil arches divide the silk into sections. Three additional scenes of the Passion of Christ are presented right and left: the Betrayal, Flagellation, and Carrying of the Cross, to the left; the Lamentation at the Tomb, Harrowing of Hell, and *Noli me tangere*, to the right.

The portrait of Charles exhibits his usual features—high forehead, long nose, shoulder-length hair—but those of his wife seem generalized and, in fact, resemble those of her husband in profile. The use of the black, gray, and white technique of grisaille has added to the mystery of the piece. Some have thought that the *parement* was an unfinished preparatory drawing for an embroidery in color, but the most likely explanation is that the cloth served as a somber hanging for the altar during the Lenten season, when black would appropriately allude to the funerary nature of the services.

In terms of style the *Parement de Narbonne* is most instructive. It was very likely commissioned before 1378, the year the queen died, and the slender, calligraphic figures that fill the compositional fields with their twisting postures and intricate drapery patterns of cascades and softly falling loops and arcs resemble those found in some contemporary manuscripts produced in Paris. The anonymous master of the work has been identified as one of the leading miniaturists at court on the basis of these striking stylistic similarities. The technique, grisaille, as if simulating stone sculptures in paint, effectively con-

31. FRENCH PAINTER OF THE LATE 14TH CENTURY. *Crucifixion*, from the *Parement de Narbonne* (detail of fig. 30)

veys a sense of plasticity in the draperies, much as it did in the *Hours of Jeanne d'Évreux*, painted by Jean Pucelle some fifty years earlier (see fig. 10), but there is little real bulk to the tall, thin, swaying figures, and the space is reduced to a single plane described by graceful two-dimensional contours even where the figures overlap. An emphatic sense of Gothic *horror vacui*, or fear of empty spaces, characterizes each composition, but everything displays an extreme refinement and elegance achieved by the precious touch and delicate line that are so characteristic of the finest Gothic productions in Paris.

The iconography of the Passion cycle repeats the same

Sienese or Italo-Byzantine traditions that we have seen in Pucelle's work. The Crucifixion, fully historiated with the tormentors to the right, the faithful to the left, brings to mind Duccio's composition for the *Maestà*, but the clarity of presentation of the many figures in Duccio's stage space is overwhelmed by the intricate interplay of flowing lines in one plane in the French piece. In much the same fashion, the Sienese *Lamentation at the Tomb*, with the horizontally placed sarcophagus, the fervent embrace of the Madonna, and the Magdalen who waves her hands in despair above her head, has been transformed into a sweeping arc that encloses the many gesticulating mourners about the tomb into a single surface pattern of interweaving lines. Pathos is tempered by grace, reflecting the precious devotion of the Parisian court where everything was ritualized and theatrical.

A charming diptych in the Bargello in Florence with a *Crucifixion* (fig. 32) and *Adoration of the Magi* (colorplate 5) is closely related in style to the *Parement de Narbonne* with nearly identical figure types integrated in a colorful surface pattern. The bright hues are reminiscent of the gaudy colors of Bohemian painting, but the palette, with its glowing reds, blues, and yellows in place of the mixed and broken shades, resembles more the refined primary colors of the illuminator's art in France. Delicate touches, such as the maid who offers a cushion for Mary in the *Adoration*, add to the charm and appeal of the diptych. Mary is, after all, the very model of a young Gothic princess.

Charles V was an ardent bibliophile, and it is not surprising therefore that the miniaturists employed in the royal scriptoria were the most gifted painters available, some of whom were called to Paris from centers to the north and west of France. André Beauneveu (who was also a sculptor, as we have seen) and Jean Bondol were miniaturists brought in from Flanders; Jean Malouel and the famous Limbourg brothers, Jean, Pol, and Herman, came to Parisian workshops from Nijmegen in Guelderland. Following the king's early death in 1380, many of the most accomplished artists entered the service of his brothers, John of Berry and Philip the Bold of Burgundy, where they created the masterpieces they are best known for today; others maintained their ateliers in Paris.

For the most part Charles's Parisian miniaturists were conservative, and many of the illustrated books in his library display a style typical of fourteenth-century French illumination in general. The innovations of Jean Pucelle, discussed in Chapter I, were to lay dormant following his death in 1334, with little effect on the traditional currents of Parisian book illustration, but with the sudden influx of fresh talent from the Netherlands, new directions surprisingly appear in Charles's workshops that indicate the response of these foreigners to the exciting but

lost art of Pucelle to be found in a few books in the royal library.

In this light, it is instructive to consider here imperial portraits found in the dedication pages of Charles's manuscripts and to contrast one typical of the general court style with one created by the fresh vision of a Fleming who entered his service in 1368. The profile portrait of Charles in the book of instructions for kings and princes, *L'Information des rois et des princes* (Paris, Bibliothèque Nationale, MS Fr. 1950), dated 1379, with the monarch enthroned beneath a small conical baldachino symbolizing a setting in a royal reception chamber, is typical of the conservative tradition prevalent in Paris in the last quarter of the century (fig. 33).

Charles is recognized by his distinctive profile, here somewhat lined and harsh, perhaps due to his age. He wears a crown and the imperial state robe of blue with gold fleurs-de-lis, trimmed in ermine, that is rendered as

32. FRENCH PAINTER OF THE LATE 14TH CENTURY. *Crucifixion*, from the *"Small Bargello Diptych."* c. 1385. Panel, 19¾ × 12¼". Museo Nazionale, Palazzo del Bargello, Florence

33. FRENCH MINIATURIST OF THE LATE 14TH CENTURY. *Charles V Receiving the Book from Jean Golein*, from *L'Information des rois et des princes*. 1379. Bibliothèque Nationale, Paris

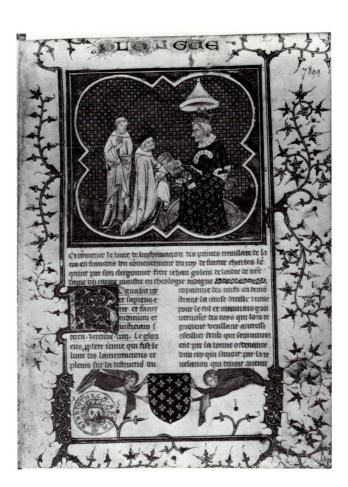

a flat shape with only a few faint lines to mark out the folds and the sleeves. The throne, moreover, is placed on an undulating groundline, with sprays of grass, suggestive of an out-of-doors environment rather than a palace interior. The translator, the cleric Jean Golein, and an assistant appear before him, the former kneeling and offering the book in both hands. The two clerics are types and not portraits as such, and their bodies, again flat shapes, are covered with long white robes across which a few dark lines are drawn to indicate the articulation of the drapery. No attempt is made to render the figures realistically in a meaningful space. The background is the traditional abstract diaper pattern of red and blue squares, and the entire composition is enframed by an elegant quatrefoil border typical of French dedication pictures.

In striking contrast to this miniature is the frontispiece in Charles's *Bible historiale* in the Hague (Museum Meermanno-Westreenianum, MS 10 B 23), dated 1371 and signed by the artist Jean Bondol of Bruges (fig. 34). Charles is again enthroned in profile to the left under a canopy. He receives a huge book, opened to an impressive illustration of the Lord enthroned, from the donor, Jean de Vaudetar, kneeling on the right. The two figures are seen through an elegant Gothic arch that is set illusionistically before them—the background can be seen between the trefoil cusps in the upper corners—and are painted in a soft monochrome chiaroscuro of grisaille with fully modeled bodies protruding through their grayish costumes. The background is treated as a bright blue curtain with gold fleurs-de-lis, and the foreground is clearly marked as a deep stage of green tiles that recede in converging diagonal lines to indicate the spatial projection. Above the king hangs a translucent canopy decorated with a smaller pattern of fleurs-de-lis.

The whole is set within a simple gold border that serves as a picture frame on the surface of the page. Jean Bondol has thus reintroduced bulk in the figures and implied space by the tile floor and diaphragm arch of the frame. Furthermore, the king is given a vivid likeness, with the planes of the face softly modeled and the features delicately integrated into the contours of the head. But there is more than just aspects of realism in this dedication portrait. Bondol has characterized Charles much as the man he considered himself to be and not as some symbol of state. He wears a simple mantle, his throne has no royal insignia (cf. the lions in the previous manuscript), and his crown has been replaced by a transparent *béguin*, a tight-fitting cap or bonnet that identifies him as

34. JEAN BONDOL. *The Presentation of a Bible to Charles V by Jean de Vaudetar*, from the *Bible historiale*. 1371. Museum Meermanno-Westreenianum, The Hague

LOVIS·D·DÁN·OV·R·DE·NAPLE·SICILE·&

35. FRENCH PAINTER OF THE EARLY 15TH CENTURY. *Portrait of Louis II, Duke of Anjou.* c. 1412–15. Watercolor on paper, 8½ × 6¾". Cabinet des Estampes, Bibliothèque Nationale, Paris

a scholar and not a royal potentate. Perhaps the costume is meant to resemble the cap and gown of a University of Paris Master of Arts, perhaps not, but the characterization by Bondol has a refreshing informality about it when compared to the previous dedication picture.

Some six years after Bondol executed this portrait of Charles, he was hired (or borrowed), so to speak, to execute a project for the king's brother, Duke Louis of Anjou (fig. 35). Louis was not an enthusiastic patron of the arts, as were his other brothers, but he did make one significant contribution to the International Style in a monument of considerable proportions, the *Angers Apocalypse Tapestries* (colorplate 6; fig. 36), measuring over 16 feet high and over 470 feet in length. The impressive hangings, consisting of seven sections with scenes from the Book of Revelation, were to decorate the walls of his palace in Angers, and just why Louis should want to be surrounded by apocalyptic images forever warning him of final judgment—something he had very good reason to fear—is not clear.

Jean Bondol was employed to compose the cartoons in line drawings for the series, and Charles's tapestry weaver, Nicolas Bataille, executed them in his Parisian workshop sometime between 1377 and 1379. Bondol apparently took his inspiration from an illustrated Apoca-

lypse manuscript in Charles's collection, although he obviously exercised many liberties in composing the ninety-odd scenes. The tapestries resemble, in fact, magnified miniatures adjusted in scale for mural presentation. The rectangular compositions, in two tiers, have alternating blue and red backgrounds, and they unravel in order like some huge comic book with boxed illustrations for the lines of the text. In nearly every scene the figure of John the Evangelist, the author of the Book of Revelation, stands to the side in the company of an angel who interprets the action that appears before them. For the most part the illustrations are easy to read, and the figures and settings rhythmically swing one into the other against the steady beat of blue and red, blue and red, in the background.

Although greatly enlarged, the pictorial qualities of Bondol's miniature style are clearly discernible in the soft shading of the draperies and the colorful patterns of clouds, rivers, trees, and miniature architectural settings. Altogether, however, the colorful tapestries are too charming and childlike to express the horrors of the destructions and explosive glories of the heavenly visions they illustrate, but they are wholly in the spirit of the elegant court style of the International period. The scenes where John is introduced to the Whore of Babylon are typical of the sentiment and expression throughout the tapestries. In one, the cunning harlot is portrayed as some sweet, young Lorelei seated on her rocky haunt in the Rhine and combing her long golden tresses as she glances into a mirror, the symbol of *vanitas*, to see her girlish reflection. In the other, she appears as a haughty queen enthroned on a many-headed beast.

The political history of the French monarchy ended in disaster during the reign of Charles VI (1380–1422) with the English occupation of Paris after the battle of Agincourt in 1415, yet the capital remained the center of manuscript illustration well into the fifteenth century. For the most part these artists were employed in workshops in the city and, chartered as "illuminators" by the university, they worked on commission much as other craftsmen. A few were members of the painters' and sculptors' guild of Saint Luke, established in Paris in 1391. From the few contemporary accounts we have of the illuminators, they appear to have been not too unlike the Parisian Bohemians of the nineteenth century. Christine de Pisan, writing in 1406, described their life-style as "intemperate" and "unruly" in the "excesses and luxuries in which they habitually indulge." Yet Christine highly praised their works, and in one passage she remarked that women too were often gifted artists among them. However, the vast production is rather homogeneous in style and it is difficult to isolate personalities, as is often the case in large workshop production.[20]

36. JEAN BONDOL AND
NICOLAS BATAILLE. *The
Whore of Babylon, Seated
on the Waters,* part of the
*Angers Apocalypse
Tapestries.* c. 1375–79.
Musée des Tapisseries,
Angers

One style that is pervasive has been attributed to the master who illustrated a huge breviary for John of Lancaster, duke of Bedford, the regent of Henry VI of England in Paris after the death of Charles VI in 1422. The so-called Bedford Master must have headed a vast workshop, active between 1400 and 1425, and attempts to sort out the various miniaturists who emerged from this milieu have been frustrating and, to a degree, misdirected attempts at that. The style of these miniatures, while charming and colorful, appears naive and *retardataire.* Rather than continuing the interests in naturalism and landscape, the "Bedford" illuminators tended to formalize a decorative style that was effective as a form of narrative and pleasing to the eye. In fact, this interest in storytelling was adopted for the illustrations of many new texts, from hunting manuals to ancient and contemporary mythologies, many of which were translated into French for the first time. The interest in things "antique" was particularly strong during the first decades of the fifteenth century, and an illustrated Virgil or Boccaccio was deemed a very precious gift among the members of the court.

The French translation of Boccaccio's *De mulieribus claris* (*Concerning Famous Women*) came out in 1401 and was immediately illustrated by a capable Parisian illuminator, usually called the Master of 1402, and presented as a New Year's present to Philip the Bold, the youngest of the four Valois brothers, in 1403 (Paris, Bibliothèque Na-

tionale, Fr. 12420). A similar illustrated edition of the new text (*Des cleres et nobles femmes,* Paris, Bibliothèque Nationale, Fr. 598) was presented the following year to John of Berry. An inscription in Dutch in the latter suggests that the miniaturist was probably of Netherlandish origin, but his style differs little from that current in Paris at the time.

The illustrated books of Boccaccio are particularly interesting to us because they include portraits of four famous women artists of antiquity, although they have been thoroughly Gothicized (Thamyris is portrayed painting a Madonna while she should be engaged in a portrait of Diana of Ephesus). The ancient source for Boccaccio was the Roman writer Pliny, and it is interesting to note the emendments he made. *Marcia Paints a Self-Portrait* is a charming example (fig. 37). Pliny tells us, "Marcia painted a portrait of herself with a looking glass. No one else had a quicker hand in painting, and her artistic skills were such that in the prices she far outdid the most celebrated painters of the time." To this, Boccaccio added that she never portrayed men: "Modesty was the cause of this, because the ancients mostly figured people nude, so that Marcia would either have to render men imperfect, or if perfect, she would have been obliged to abandon the modesty of a virgin."

It is no surprise then that it is during these decades that we encounter the first professional female artists and writers in northern Europe. Christine de Pisan is one of

37. FRENCH MINIATURIST OF THE EARLY 15TH CENTURY. *Marcia Paints a Self-Portrait*, from *Des cleres et nobles femmes*. c. 1403. Bibliothèque Nationale, Paris

trayed perusing the frescoes of the fortress, a rare example of an authoress actually responding to her own literary imagery in a visual form (fig. 38). No doubt Christine de Pisan was a fine connoisseur of art as well as an accomplished court writer.

For the most part, the style of the illuminations in these books reflects the general anonymity of expression that characterizes much Parisian art during the first decades of the fifteenth century. The vigor of the International Style had run its course, it seems, but two distinctive productions of the period, the *Hours of Jean le Meingre, Maréchal de Boucicaut* (Paris, Musée Jacquemart-André, MS 2), and the *Rohan Hours* (Paris, Bibliothèque Nationale, MS Lat. 9471) deserve special discussion here.

The Maréchal de Boucicaut was a heroic figure in French history. He had fought against the Turks at Nicopolis (1396) and Constantinople (1399), served as governor of Genoa (1401) and then the provinces of Guyenne and Languedoc (1409), and was taken prisoner in the battle of Agincourt in 1415 and died in England in 1421. The sumptuous *Boucicaut Hours*, executed between 1408 and 1410, contains forty-five full-page illustrations.[21] The interest in space and landscape anticipates the slightly

the most renowned of these. While still young, Christine took to writing ballades and love poems. Later in life she became a serious student of literature and a feminist of sorts in her fervent abhorring of the inferior status afforded women in her society and how they were considered impure and unreliable temptresses of men throughout history. This she set out to put right.

Among her most famous treatises is *La Cité des dames* (*The City of Women*), written in 1405, as a vindication of the worth of women in history. Inspired by Boccaccio's work on famous women, Christine sets out to build a special city for virtuous women (among the worthy included in her city were Valois duchesses, female saints, and famed ladies of antiquity), and at one point she remarks that she herself had employed a woman painter, Anastaise, "so skilled in painting the borders of manuscripts and backgrounds of miniatures" that she had no rival in Paris, "the center of the best illuminators in the world."

In an illustrated edition of another of Christine's works, *Mutacion de fortune* (*Change of Fortune*; Brussels, Bibliothèque Royale, MS 9508), given to Philip the Bold in 1404, she describes famous paintings of "good and bad deeds" in history that she had seen in the rooms of the imaginary Castle of Fortune. In a slightly later manuscript of the *Mutacion de fortune* (Munich, Bayerische Staatsbibliothek, MS Gall. II) Christine has herself por-

38. FRENCH MINIATURIST OF THE EARLY 15TH CENTURY. *Christine de Pisan Views the Paintings in the Castle of Fortune*, from the *Mutacion de fortune*. c. 1405–10. Bayerische Staatsbibliothek, Munich

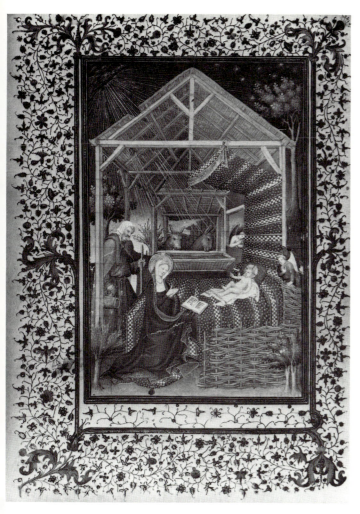

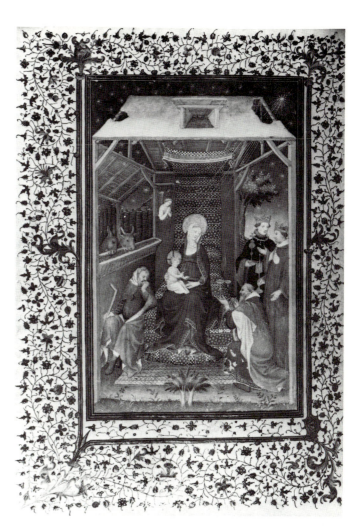

39. THE BOUCICAUT MASTER. *Nativity*, from the *Boucicaut Hours*. c. 1408–10. Musée Jacquemart-André, Paris

40. THE BOUCICAUT MASTER. *Adoration of the Magi*, from the *Boucicaut Hours*

later miniatures in the *Très Riches Heures*. Deep, complex interiors and filmy atmospheric landscapes are introduced wherever possible, and the figures, while retaining the graceful lines and conventionalized features current in Parisian illumination, are imbued with a greater sense of bulk and monumentality achieved through the sketchy modeling technique employed. The figures are generally placed in the immediate foreground on an artificial stage, but in the backgrounds the true interests and talents of the miniaturist are at once apparent. In fact, he seems at times to tease the viewer.

The *Nativity* (fig. 39), for instance, shows Joseph and Mary attending the Child, who reclines on a horizontal bed with a canopy seen from the side. The perspective of the setting focuses on a shed opening in the rickety stable where the ox and ass feed from a trough. Above, to the left, rays of sunlight stream in through the holes in the thatched roof of the stable. For the following miniature, the *Adoration of the Magi* (fig. 40), the Boucicaut Master presents the same setting turned ninety degrees, so that now the bed, seen from the front, appears as a throne with the canopy serving as a cloth of honor. The ox and

ass are now placed on the left, and the roof is illumined not by the natural light through the dormer but by the mystical star of Bethlehem above the Magi. The manner in which the Boucicaut Master painstakingly recorded these marginal details clearly reveals his delight in elaborating the dollhouse interior of earlier illuminators.

In the *Visitation* (colorplate 7) the artist goes yet a step further. Two modes of rendering space are presented here. The foreground stage with the large figures of Mary and Elizabeth is merely an artificial prop, framed on either side with Italianate hills and dwarf trees in the foreground. But beyond this platform, where one would usually find a gold foil or diapered curtain, the Boucicaut Master paints a deep vista of the Flemish countryside with a lake, fields with laborers, distant village towers, all seen through a soft haze as if filtered through a dense atmosphere. If one were to mark off the top third of this miniature it would be difficult to attribute the landscape to the same hand that executed the more conventional figures and setting below.

Another device employed by the Boucicaut Master to heighten the sense of the illusion of space is the dia-

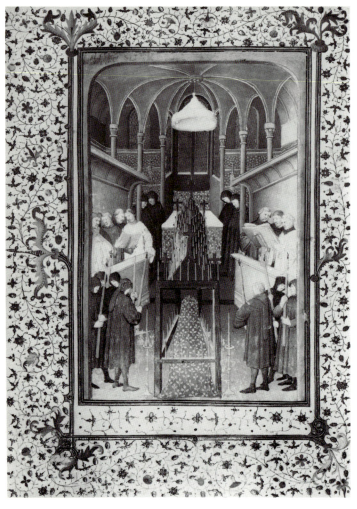

41. The Boucicaut Master. *Vigils of the Dead*, from the *Boucicaut Hours*

phragm arch, an architectural pseudoframe dividing the world of miniature from that of the viewer. In the *Vigils of the Dead* (fig. 41), the diaphragm arch appears as a painted frame within the borders of the miniature that merges with the vaults of a church interior beyond and yet remains independent from it.

A wholly different artistic personality is encountered in the miniatures of the enigmatic *Rohan Hours* (Paris, Bibliothèque Nationale, MS Lat. 9471), executed about 1420. While the sequence of illustrations follows the traditional selection of episodes in a Book of Hours, the treatment of these scenes departs dramatically from the conventional style and iconography. The origins of the style remain enigmatic if not mysterious.

In the miniature for the opening of the Hours of the Cross, the *Lamentation* (colorplate 8), the psychological impact of varied states of mourning is forcefully conveyed through a sharply descending arc of heads and bodies composed as spokes on a wheel. Below, lying in a supine position on the barren ground, is the emaciated corpse of Christ, his pearly flesh tinged with phosphorescent green. Mary swoons as if dead; falling limp in the

arms of John the Evangelist, her torso sinks downward and her thin arms hang lifelessly toward her dead son. John's body emerges just above her waist, and he turns abruptly and looks up toward the giant head of God the Father in the heavens with a strange, defiant stare as if reproaching the Father for the painful tragedy that has occurred. Although he makes the sign of blessing with his right hand, God looks puzzled and disturbed over the human anguish his divine act has precipitated. The poisonous greens and browns of the earth contrast dramatically with the radiant blue sky spangled with sprays of gold stars, fluttering wings, and sorrowful faces of angels forming a shower of divine grief raining down on the human suffering below. The Master of the Rohan Hours stands out amid the Parisian miniaturists of his time as a macabre expressionist.

JOHN OF BERRY

In 1380, at the age of forty-three, Charles V died, leaving the monarchy to his son Charles VI. Had he lived another ten or fifteen years, the story of International Style book illustration would undoubtedly have been even more dominated by Parisian ateliers. By that time foreign artisans and Parisians had initiated one of the most glorious chapters in the history of the illustrated book, and while a number of leading miniaturists remained in Paris, the patronage shifted to the ducal courts of Charles's brothers, in particular that of John, duke of Berry, who gathered about him in Bourges some of the luminaries of the Parisian workshops.

John of Berry (1340–1416) lived a long and productive career as a patron of the arts. His life, although plagued constantly by the delicate political issues precipitated by the death of Charles, was one given over to more peaceful pursuits than that of his younger brother, Philip the Bold of Burgundy, and he concentrated his energies on the building and embellishment of his numerous castles and residences, priding himself especially on his extensive libraries (over three hundred manuscripts are recorded in his inventories) and his exquisite collection of costly *joyaux*, jewels, and curios from the world over.

Among the numerous miniaturists called from Paris to Bourges was the Master of the Parement de Narbonne, who directed the workshop that provided profuse illustrations for the manuscript known as the *Très Belles Heures de Notre-Dame* (Paris, Bibliothèque Nationale, nouv. acq. MS Lat. 3093), sometime between 1380 and 1390. This rich manuscript was subsequently divided into two parts, the unfinished half, later elaborated into the problematic *Turin-Milan Hours* (see p. 96).[22] Another artist employed by Charles, André Beauneveu (who, it will be recalled, executed the tomb effigy of Charles V),

was enrolled to provide the beautiful grisaille figures of prophets and apostles for the duke of Berry's *Psalter* (see fig. 42; Paris, Bibliothèque Nationale, MS Fr. 13091) and to execute sculptured statues of prophets for the piers of John's new Sainte Chapelle in Bourges, modeled after the famed palace chapel of Louis IX in Paris. Beauneveu also provided cartoons for impressive stained-glass windows portraying the prophets for the chapel. Jean de Cambrai, another sculptor for the king, was entrusted with the duke's effigy for his tomb in the Cathedral at Bourges. Unfortunately, little remains of these sculptures.

The inventories of Berry, admirably recorded by the court librarian, Robinet d'Étampes, list a mind-boggling assortment of *objets d'art*, manuscripts, paintings, and curios from all corners of the Mediterranean, testifying to the enthusiasm of John as a collector of art in the modern sense. His palace chapel in Bourges, Sainte Chapelle, was virtually a museum of art, and his beautiful residence in Paris, the Château de Bicêtre, and the elegant Château Mehun were famed for their vast collections of manuscripts and works of art. Many of the fabled *joyaux* owned by the duke were later melted down, while others have simply disappeared or have been dispersed over the centuries, but the contents of his libraries are preserved in Robinet's inventories, usually with the illuminators named, and it is in these records that we find the great names in French book illustration. Among other precious manuscripts of an earlier age, the duke acquired the two masterpieces of Jean Pucelle, the *Belleville Breviary* and the *Hours of Jeanne d'Évreux*, already discussed in Chapter I, both of which inspired the leading illuminator at Bourges in the last two decades of the fourteenth century, Jacquemart de Hesdin.

An unsettling problem in attribution often accompanies Robinet's descriptions, however. A number of books containing miniatures of uneven or totally different quality and style are listed as productions of Jacquemart de Hesdin. No doubt he headed a large atelier, and many of the miniatures attributed to him must be regarded as workshop productions. These problems are clearly presented in three of the most famous Books of Hours ascribed to Jacquemart: the *Petites Heures du Duc de Berry* (Paris, Bibliothèque Nationale, MS Lat. 18014), the *Très-Belles Heures de Jehan de France, Duc de Berry* (Brussels, Bibliothèque Royale, MS 11060–61), and the *Grandes Heures du Duc de Berry* (Paris, Bibliothèque Nationale, MS Lat. 919).[23]

Jacquemart de Hesdin came from the district of Artois, bordering Flanders, and is first recorded as the *peintre* of John at Bourges in 1384. He very likely had some experience in the shops in Paris as well as training in those of his homeland, and his style displays a marked

42. André Beauneveu. *Prophet Isaiah*, from the *Psalter of Jean, Duc de Berry*. c. 1380–85. Bibliothèque Nationale, Paris

development during his thirty years of activity at Bourges, so much so that his own personal style is frequently lost among or confused with those of miniaturists who were his chief assistants. However we assess Jacquemart's style, it was certainly his ingenuity that sparked the productions of the atelier, and it is due to his interests that two basic ingredients were to enrich the International Style: the recovery of the innovations of Pucelle and the renewed interest in Italianate compositions. Both are very evident in the *Petites Heures*, which he executed along with three gifted assistants sometime shortly after entering the duke's service in 1384.

The elaborate calendar pages in the *Petites Heures* were copied after those in the *Belleville Breviary* of Pucelle (or perhaps from a similar set in the *Hours of Yolande de Flandre*, which the duke also possessed) with the complex typology of the Old and New Testaments (see fig. 43). The *bas-de-page* with the apostles unveiling the prophets, month by month, and the gradual tearing down of the synagogue, are repeated nearly exactly, as are the strips of illustrations at the top. To the left, Saint Paul preaches to people gathered outside the city gate above which the

43. Jacquemart de Hesdin and shop. *February*, from the calendar of the *Petites Heures du Duc de Berry*. c. 1385. Bibliothèque Nationale, Paris

Virgin stands waving a decorated banner. The zodiac sign, a traditional motif in calendar illustration, as we have seen, is placed in the opening of the portal below Mary. The right side repeats the Pucelle arch within which the landscape of the month appears—the first pure landscapes in Northern art—with trees and sky changing appearance as we progress from the barren ground of January, the rains of February, through the warmth of budding leaves in the springtime.

A text which prefaces the *Belleville Breviary* elucidates the confusing array of figures and settings:

> For each of the twelve months there is one of the twelve apostles and one of the twelve Prophets, in such a way that the prophet gives a veiled prophecy to the Apostle and the Apostle uncovers it and makes it an article of faith. And since we speak of the Synagogue in the time of the Old Testament and the Church in the time of the New Testament in two different ways, in the broad and material sense and in the subtle and spiritual sense, I am putting both ways since at the back of each is a material synagogue from which the prophet draws a stone that he gives to the apostle with the prophecy and the synagogue crumbles away as the days move forward and the articles of faith increase as you can see in the pictures.
>
> And since the articles of faith are the way and the gates to enter into Paradise, I am putting the twelve gates of the heavenly Jerusalem above the twelve apostles, and the Virgin Mary, through whom the door was opened to us, holding a panel over each of the gates on which is painted in a picture the article of faith which the apostle has made below in words.[24]

The preface is written in the same hand as the text, and very likely this scribe was given explicit instructions by the one who devised the intricate program, Jean Pucelle himself.

In the Hours of the Virgin in the *Petites Heures*, matins is introduced with a very elaborate full-page painting of the *Annunciation* (fig. 44) placed within a broad frame divided into niches in which standing apostles appear against red and blue backgrounds, on the sides, and, at the top, a triptych of sorts with the Man of Sorrows flanked by Mary and the Christ Child and John the Baptist. Two apostles sit flanking a prophet in the lower margin, and in the initial *D* of *Domine* in the first line of the text, the kneeling figure of Duke John appears (one of twenty-two diminutive portraits of him in the manuscript).

44. Jacquemart de Hesdin and shop. *Annunciation*, from the *Petites Heures du Duc de Berry*

The elegant *Annunciation* is placed within the lofty elevation of a church or chapel with the rib vaults over the altar clearly indicated in gold and the walls and floor receding in a carefully constructed perspective scheme. The lively pose of Gabriel, pointing upward to the figure of God the Father who peeks over the ramparts of the chapel, and the exaggerated sway of the wispy Madonna are enhanced by the delicately modeled draperies. A small vase of lilies appears between the two standing figures, and the armorials of Berry adorn the front of the altar behind them. The overall effect is one of harmonious blondish tones and elegant detail, with the graceful mantle folds echoing the somewhat affected poses of the two figures.

The delicate and diminutive qualities of the miniatures in the *Petites Heures* give way to more solid and monumental features in the illuminations attributed to Jacquemart in the *Très-Belles Heures de Jehan de France*, better known as the *Brussels Hours* (fig. 45). The graceful Pucellesque borders with ivy tendrils accented with tiny birds and drolleries are replaced with sumptuous frames of quatrefoils bearing the armorials and devices of Berry superimposed over the traditional floriate patterns. In each miniature the corner quatrefoils display the coat of arms of Berry, the center top and bottom are decorated with a wounded swan in profile, while those on the sides of the miniature contain playful bears and two enigmatic initials, an *E* and *V*, superimposed. All are familiar devices in the manuscripts and *joyaux* of John of Berry. The *E* and *V* have never been adequately explained, but the swan and the bear are related to a charming legend that deserves note here.

According to the story, while the duke was imprisoned as a hostage for his father in England, from 1360 to 1367, he fell in love with a maiden named Oursine, whom he never forgot. He carried her name in picture form as a device: the bear (*ours* in French) and the swan (*cygne*). Such a romantic pun is by no means unusual for the French court of the period, and while some have recently argued for a more pious derivation for the meaning of the two animals, the old legend holds more appeal. That the duke was quite an elegant lady's man is recorded. Following the death of his wife, Jeanne d'Armagnac, in 1388, he petitioned for the hand of a charming maiden of twelve years, Jeanne de Boulogne, and while some eyebrows were lifted at the prospect of the forty-eight-year-old duke marrying such a young princess, the wedding took place in 1389.

The Brussels manuscript is listed in the 1402 inventories as "une très belles heures, richement enluminées et ystoriées de la main Jaquemart de Odin." The calendar that usually precedes the Hours of the Virgin is curiously missing, and in its place appears an elaborate dedication

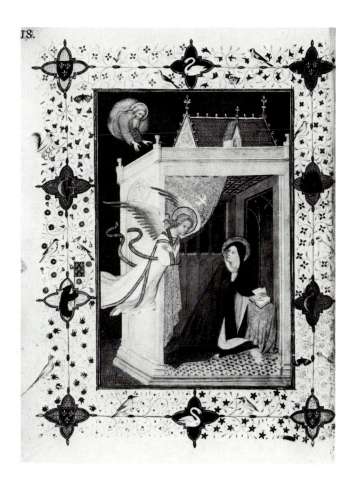

45. JACQUEMART DE HESDIN AND SHOP? *Annunciation*, from the *Très-Belles Heures de Jehan de France, Duc de Berry (Brussels Hours)*. c. 1400. Bibliothèque Royale, Brussels

diptych painted on parchment and bound into the volume but clearly not an integral part of the original decoration. The eighteen miniatures for the Hours, the "ystories" attributed to Jacquemart, are full-page compositions with simplified figures executed in broader brushstrokes that subordinate the usual fussy costume details into large color shapes. The intricate, mannered draperies of the *Petites Heures* are reduced to simple contours that mark out a heavier form. Gestures are restrained and folded inward when possible, and the faces are also less individualized. These more monumental figures are surprising departures from the elfin acrobats that enliven the earlier manuscript, so much so that if not given the entries in the inventory, the association of hands in the two books would be unthinkable.

The illuminator of the *Brussels Hours* furthermore was more concerned with placing his sturdy figures in convincing spatial environments. For one of the first times, blue is used for the background sky, suggesting a natural illumination, and the austere, boxlike interior for the poetic *Annunciation* scene is placed diagonally in space (although the front and the gabled roof retain the usual planar projection). The miniaturist is also much aware of expanding a more natural space in the episodes with

46. JACQUEMART DE HESDIN AND SHOP? *Flight into Egypt*, from the *Brussels Hours*

47. JACQUEMART DE HESDIN AND SHOP? Second dedication page in the *Brussels Hours*

landscapes. In the *Flight into Egypt* (fig. 46) Joseph leads the donkey through a deep ravine formed by the familiar Byzantine basalt rocks toward a winding road in the distance, while islands of Phrygian-cap shapes rise from the inclined plane formed by the sea beyond. The sense of overlapping landscape forms is convincing, and even more striking is the artist's keen sense of the effects of the cold winter climate on the landscape. The field beyond the crevice is frosty in appearance, and the miniature trees that sprout up like bushes here and there are stark and barren. Some illustrations, such as the *Road to Calvary* and the *Coronation of Mary*, are indebted to Tuscan compositions, especially those of Simone Martini, but, in general, the stories display a restraint, and the avoidance of the emotional and theatrical characterizes the tempo of the narratives.

Introducing the Hours is a dedication page with the duke, accompanied by Saints Andrew and John the Baptist, presented to a Madonna and Child seated on a high throne placed diagonally in the left foreground (fig. 47). This presentation picture, wholly in the style of the narratives, differs considerably from the inserted diptych, mentioned above, that marks the impressive opening of the manuscript (colorplate 9). The dedication diptych is truly a work of more monumental art as if it were origi-

nally meant to be framed and hung on a wall. To the left, the duke, superbly portrayed with delicate modeling and refined physiognomy, kneels between Saints Andrew and John, who are moved slightly back into space on small tiles of the floor that appear to recede in one-point perspective to a blue background of floral patterns enlivened by tiny figures climbing about. The three main figures are painted in a refined grisaille technique with soft shading in the mantle falls on the right side that imparts a sense of plasticity to them.

The monumental Virgin on the page opposite them, clothed in a rich mantle with long, curling tubular cascades and deeply scooped-out hollows of arcing folds, resembles a sculptured *Schöne Madonna*. She sits on an impressive throne, reminiscent of those in the duke's *Psalter* by Beauneveu, and tiny musical angels fill the red background behind her. The treatment of space is more archaic in the floor tiles. The unusual iconography of this Madonna, a type known as the Madonna of the Writing Christ Child, points to some special devotion: the Virgin as the *Sedes sapientiae* (Throne of Wisdom) and the Child who nourishes at the breast of Mary, awkwardly writing on a long, unraveling scroll, as the *Logos*, the Word or Wisdom, itself.[25]

Very likely this impressive group was derived from

some sculptured cult object (an ivory statue of the same composition is in the Louvre), appropriate for the veneration of the lover of books and learning, John of Berry. Whatever the original destination of the diptych may have been, it was provided with the same quatrefoil border when tipped into the manuscript. The painter of these two pages is surely not the same miniaturist of the picture cycle that follows, and while names like Beauneveu have been suggested for the authorship, the diptych remains a mystery and an enigma in the painting of the period. It is interesting to note that sometime before his death, John of Berry made a gift of the manuscript to the duke of Burgundy, either Philip the Bold or his son, John the Fearless.

The last and, by far, largest production of the Jacquemart atelier is *Les Grandes Heures*, executed between 1406 and 1409 (fig. 48). The general format repeats that of the *Petites Heures*, with a calendar that copies the Pucelle pages in the *Belleville Breviary* and extensive illustrations in the Hours by one of the chief assistants in the *Petites Heures* as well as other recognizable hands. Not only are the pages huge, but the new quatrefoil borders employed in the Brussels manuscript are elaborated as if gone to seed, with added escutcheons of bears, swans, coats of arms, and the initials *V E* intermeshed in a florid growth of vine tendrils and flowers on which countless birds perch. The manuscript was rebound in 1488 by a later owner, and at some early date seventeen large paintings, each marking a major division in the text, were cut out and have since disappeared. These must have been the works done by Jacquemart himself since the other miniatures are column pictures. A large composition of the *Way to Calvary* on parchment in the Louvre has been attributed to Jacquemart and thought by some to be a survivor of the missing folios. A number of details, including the measurements, seem to preclude this possibility.

In 1404 the duke of Berry called into his service three brothers, Pol, Herman, and Jean Limbourg, who were formerly in the employ of the duke's brother, Philip the Bold of Burgundy, who died in that year.[26] The brothers came from a family of artisans in Nijmegen in the North Netherlands. Their uncle, Jean Malouel, court painter for Philip, no doubt was instrumental in promoting their careers in the French courts. They are first mentioned as apprentices to a Parisian goldsmith. In 1399, when traveling back to Nijmegen from Paris, they were seized as hostages at Brussels (due to political conflicts between Brabant and Guelders), and were held there until Philip the Bold paid their ransom at the request of the uncle, Malouel. For Philip the Limbourg brothers executed a number of miniatures in an ambitious *Bible moralisée* (Paris, Bibliothèque Nationale, MS Fr. 166, fols. 1–24)

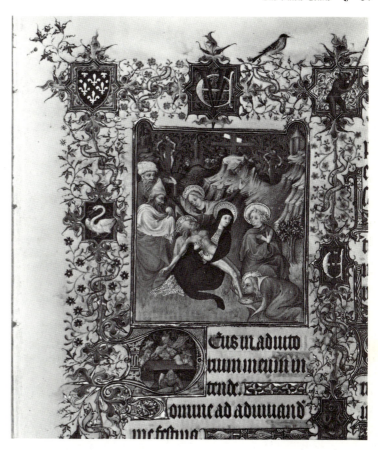

48. JACQUEMART DE HESDIN AND SHOP? *Lamentation*, from *Les Grandes Heures*. c. 1406–9. Bibliothèque Nationale, Paris

with numerous tiny narratives serving as pictorial footnotes for commentaries on the scriptures. It was not until after entering the employ of John of Berry in 1404 that their artistic talents were fully exploited, however. Their first major project for him was the *Belles Heures* (also known as the *Heures d'Ailly*), today in the collection of the Cloisters in New York (fig. 49). This book is especially interesting for its unusual cycles of illustrations of the legends of Saints Jerome, Gregory the Great, Bruno, Paul, and Anthony. The handsome matins *Annunciation* is distinguished by the ornate borders of flowery acanthus rinceaux, which were clearly inspired by Italian models.

Their masterpiece, the *Très Riches Heures du Duc de Berry* (Chantilly, Musée Condé), is one of the most memorable creations in Western art and a showpiece for Northern art of its period much as the frescoes in the Brancacci Chapel in Santa Maria del Carmine by Masaccio are for Florentine art of the early fifteenth century. In fact, the contrast is a very apt one in many respects. Italian Renaissance painting grew mainly from the fresco, in which broader aspects of formal design and composition could be exploited. The *Très Riches Heures*, on the other hand, displays the proclivities of the Northern artist in the precision of detail and bright color that lead to the

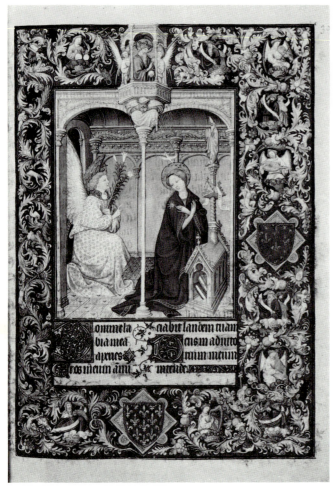

49. LIMBOURG BROTHERS. *Annunciation,* from the *Belles Heures du Duc de Berry* (*Heures d'Ailly*). c. 1410. The Metropolitan Museum of Art, New York. The Cloisters Collection, 1954

incredible vision of Jan van Eyck. The one is to be viewed from some distance and to be appreciated as a monumental mural art for public decoration; the other, the art of the book, is to be held up close so that we may peruse the details at leisure in a personal and intimate fashion. The aesthetic experience is vastly different in the two art forms, and it is no surprise that Michelangelo could later criticize Flemish painting for being too fussy and detailed with no sense of order and harmony. The great paintings of Italy belong to a tradition of public art fashioned in antiquity. Netherlandish—and Northern painting in general—has its seeds in the intricate patterns of the *Book of Kells* and the portable objects of the early wandering tribes. Moreover, Northern artists prefer involved and intimate storytelling to grandiose public proclamation.

It is ironic indeed that the masterpiece of the International Style also marks its demise. The three brothers and their patron all (?) died in the same year, 1416, at which point the *Très Riches Heures* was left unfinished, to be

completed some seventy years later by another court illuminator, Jean Colombe. The emancipation of the painting from the text (much as anticipated in the *Brussels Hours* by Jacquemart) is finally realized. Of the 130 miniatures, half are full page, and among these a number are unique paintings inserted in the traditional cycle of the Hours presumably at the whim of the patron. Personal touches abound in the manuscript, not only in the form of delightful puns, such as the bear and the swan, or diminutive portraits of the duke kneeling within initials, but in numerous topographical landscapes that present his famed châteaux and residences in sparkling detail.

Matins, in the Hours of the Virgin, is illustrated with an unusual diptych of paired miniatures (figs. 50, 51). The main illustration, the *Annunciation,* appears on the right page in all the splendor of the International Style. The draperies of the angel are brightly colored and the calligraphy of their lines and that of the banderole seems to initiate the counterpoint echoed in the floating acanthus rinceaux with diminutive musical angels in the margins. Mary kneels before a fancy lectern within a Gothic chapel complete with leaded windows, gargoyles, and stone statues of Old Testament prophets.

Rays of golden light stream through the glass panes to the left from God the Father, who appears in an aureole of angels in the top left corner. This golden light is a pictorial metaphor of the Madonna's virginity much as it appears in mystic literature of the fourteenth century. Saint Bridget, the Swedish authoress of the *Revelationes,* describes it thusly: ''As the sun, penetrating a glass window, does not damage it, so the virginity of Mary is not spoiled by Christ's assumption of human form.'' In a Nativity poem of the same period it is: ''As the sunbeam through the glass passes but not stains, so the Virgin, as she was, a virgin still remains.'' The Annunciation, thus, is not just a pronouncement to Mary, but the actual moment of the Incarnation when the Holy Ghost (here in the form of the dove amid the gold rays) overshadows her, and the Child is conceived in her womb. In his left hand, Gabriel holds three lilies, symbolizing that this is the very moment when the Trinity comes into being.

The Virgin and her Child also symbolize the New Eve and New Adam sent to redeem mankind from the sins of the first parents. This is alluded to in the painting of the *Fall of Adam and Eve* on the page facing the *Annunciation.* Eden is verdant with trees and bushes nourished by a towering Gothic fountain. A circular wall with an elegant portal separates the garden from the outside world. The story unfolds from the left in four acts. Eve, whose idealized nude body is marked by the protrusion of her stomach, the child-bearing part of her anatomy, reaches into a tree to receive the apple from a serpent in the form of her girlish alter ego. Below, Eve hands the apple to

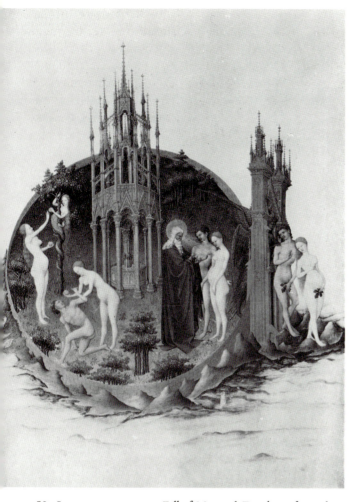

50. LIMBOURG BROTHERS. *Fall of Man* and *Expulsion*, from the *Très Riches Heures du Duc de Berry*. Before 1416. Musée Condé, Chantilly

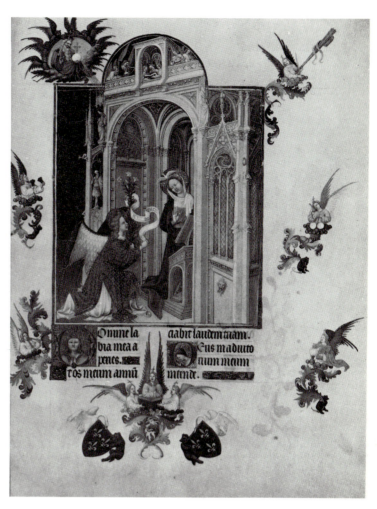

51. LIMBOURG BROTHERS. *Annunciation*, from the *Très Riches Heures du Duc de Berry*

Adam, darker in tone, who turns upward from a half-kneeling position to confront her.

The unusual articulation of Adam has prompted much controversy as to its source, and the consensus of opinion today favors the theory that the Limbourg brothers had modeled him after some Italian figure that, in turn, revived a posture in ancient art. If so, this would be a rare instance of antique revival in French art of the period. To the right, God the Father admonishes the couple and counts out the punishments with his golden fingers. Following the tradition familiar in medieval art, Adam then "passes the buck" by pointing to Eve as the initiator of the crime, and she, in turn, gestures behind her to conceal the guilty hand that took the forbidden fruit from the serpent, the true culprit in the story. Finally, a many-winged seraph pushes them through the High Gothic portal into the cold and rugged world of brown peaks and blue waves outside the paradise garden. History begins on a bitter note.

Another pair of full-page miniatures appears for sext in the Hours of the Virgin, the *Meeting of the Magi at the Crossroads* and the *Adoration of the Magi* (figs. 52, 53). These resplendent pages typify the most sumptuous and elegant qualities in the book, with the elaborately costumed Magi and their colorful entourages, complete with dromedaries and cheetahs, converging on the rickety stable in Bethlehem to pay homage in the decorous manner of court etiquette. In the *Adoration*, Mary, attended by six charming maidens, sits frontally to the left while her nude infant blesses the eldest Magus kneeling before him. The second king prostrates himself and kisses the ground, while the third quietly kneels and offers his gift. The fabulous headgears and gifts of the Magi are held by court attendants behind them. The elegant composition with its rich surface pattern and bright colors, so appropriate for a pompous court reception, was to become a standard formula for the *Adoration of the Magi*, north and south, replacing the more simplified

52. LIMBOURG BROTHERS. *Meeting of the Magi at the Crossroads*, from the *Très Riches Heures du Duc de Berry*

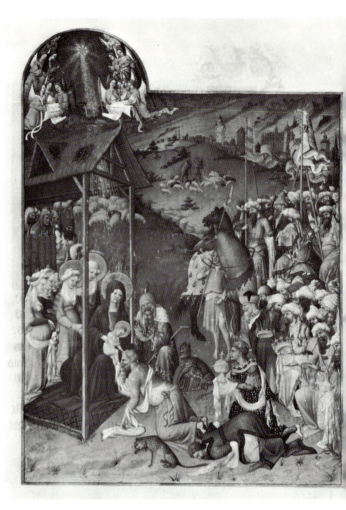

53. LIMBOURG BROTHERS. *Adoration of the Magi*, from the *Très Riches Heures du Duc de Berry*

versions in which only the three kings appear before the stable.

The same three kings are repeated in equestrian portraits on the left leaf, which depicts their meeting at the *montjoie* (cairn) that marks the crossroads leading to Bethlehem. This scene is unprecedented in Books of Hours, and it was probably based on the colorful description of the Magi's journey related in the *Liber Trium Regum* (*Book of the Three Kings*), written about 1370 by a Carmelite monk, Johannes of Hildesheim. In the miniature the meeting occurs not on the site of Golgotha, as the story goes, but instead far beyond the city walls of Paris with the Cathedral of Notre Dame, Sainte Chapelle, and Montmartre visible on the horizon to the left. This change was no doubt intentional, and very likely it was meant to refer to the historic meeting that took place sometime between 1400 and 1402 in Paris between Charles VI and the Byzantine emperor Manuel II.

It has been suggested that the oldest king on the white horse in the foreground is an actual portrait of Manuel II, while the youngest, upper right, is Charles VI. The second Magus, in the upper left, was copied directly

from a medal purchased by John of Berry from a Florentine merchant in 1402. The medallion portrays Constantine the Great, the first Roman emperor to officially accept Christianity as the state religion of his Eastern and Western capitals in the fourth century. Here, appropriately, the contemporary rulers of Eastern and Western Christendom meet again in the company of their spiritual ancestor.

Another unique miniature appears for sext in the Hours of the Passion, the darkness that took place at noon at the *Crucifixion* (fig. 54). The scene is bathed in a grayish tonality that imparts the effect of a true nocturne following the miraculous eclipse of the sun and the moon, "Now from the sixth hour there was darkness over all the land," described in Matthew (27:45). Aside from the astonishing night effect created, a number of mysterious iconographic details appear in the margins. In the upper right the small figure of an astronomer is depicted scanning the heavens to find some clue for the sudden eclipse. Below him other details illustrate the three miracles that followed according to Matthew (27:51, 52, 54). Below the astronomer is a building with curtains

"torn in two, from top to bottom"; directly below the cross the scattered rocks of an earthquake appear, "and the earth shook, and the rocks were split"; and, finally at the bottom of the page are the tiny figures of the "many bodies of the saints who had fallen asleep [and] were raised, and coming out of the tombs." To the left, directly beneath the cross itself, the converted centurion (identified as Longinus in later commentaries) appears wiping his eye as he, "filled with awe . . . said, 'Truly this was a son of God!'"

In a number of miniatures in the Hours of the Virgin and the Cross the influence of Italian, more specifically Tuscan, painting is clearly discernible. It would seem, for instance, that the *Presentation in the Temple* in the *Très Riches Heures* was based directly on the fresco of the *Purification of the Virgin* by Taddeo Gaddi in the Bardi Chapel in Santa Croce in Florence, and the crowded street scene before the walls of Jerusalem in the *Carrying of the Cross* is indebted to the familiar composition of that theme by Simone Martini. The Italian references are so numerous and specific that a good case for an art tour to Italy on the part of one or more of the Limbourgs could be easily mustered. One unique miniature, at the beginning of the Passion cycle, is a map of Rome with numerous identifiable buildings and landmarks, ancient and medieval, placed within an elliptical wall. This highly detailed *Map of Rome* closely resembles one by Taddeo di Bartolo painted in the Sala di Mappamundi of the Palazzo Pubblico in Siena just a few years before the miniature. Very likely, both maps share a common model that had widespread circulation.

The topographic accuracy of the landscape backgrounds in many of the miniatures is amazing at this early date. Beneath the battling *Saint Michael and the Dragon* in the Masses for the Liturgical Year, a vivid portrait of Mont-Saint-Michel appears rising majestically on the Breton coast, and the miniature depicting the *Temptations of Christ* is dominated by the huge Château of Mehun, John's favorite residence, where he stored many of his manuscripts and *joyaux*. Other residences are accurately recorded in the landscapes of the calendar pages, the part of the *Très Riches Heures* that has received the most attention by students of art.

Each month features a full-page depiction of the landscape and secular activity of the month, expanded far beyond anything so far seen in Books of Hours. Indeed, these famous landscapes have been described as the links between the traditional labors of medieval calendars and the famous cycle of the month landscapes by Pieter Bruegel. The zodiac signs are relegated to a small arch that caps each composition. Only the winter feast in *January* lacks a landscape (colorplate 10). Here, the traditional motif of an old man eating before a fire has been ex-

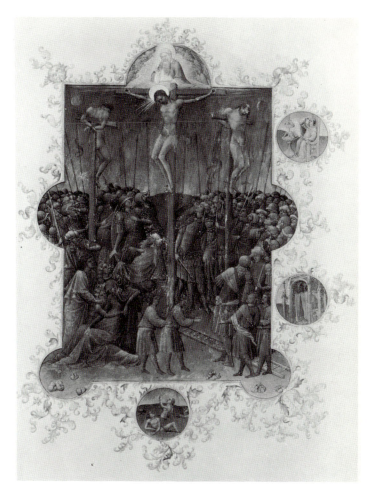

54. LIMBOURG BROTHERS. *Crucifixion in the Darkness of the Eclipse*, from the *Très Riches Heures du Duc de Berry*

panded into a lavish court banquet held in one of the châteaux of the duke, possibly that of the Hôtel Bicêtre in the environs of Paris. Only the left wall and the ceiling of the broad hall are visible, with John of Berry seated to the right in profile before a huge fireplace with the screen forming a great halo to distinguish his presence. Beside him stands his *chasseur* or page, who calls, "Approche, approche" to the servants bringing more food to the already laden table. A cloth of honor, appropriately adorned with armorials, rises to the ceiling above the duke, and on the back wall colorful tapestries, depicting some heroic or mythological battle, provide a decorative setting for the bustling activities.

Courtiers, all tall, thin figures elegantly attired in long gowns, gather in two rows on either side of the table. Some of those in the more distant row appear to be warming their hands before the fire. John himself wears a warm houppelande and fur cap. One distinguished figure, seated down the table from the duke, has been identified as the Chartres bishop, Martin Gouge. There are no women present. The duke's rich tablewares, including the golden boat with the bear and the swan, are

62

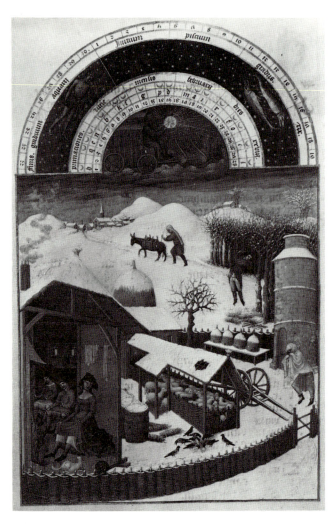

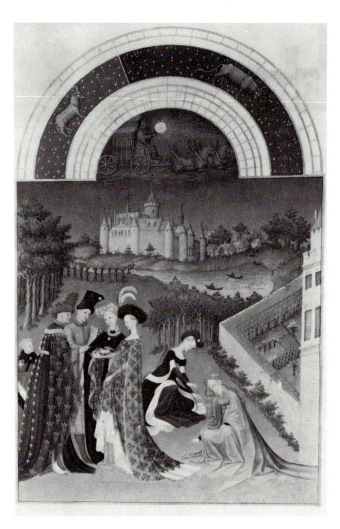

55. LIMBOURG BROTHERS. *February*, from the calendar of the *Très Riches Heures du Duc de Berry*

56. LIMBOURG BROTHERS. *April*, from the calendar of the *Très Riches Heures du Duc de Berry*

prominently displayed, and two puppies, no doubt John's pets (they grow larger as one progresses through the months), lap from a plate directly before him. The elegant pattern of bright colors with golden touches lends an air of frivolity and merriment to the scene, and it was no doubt the surface glitter and richness of color that inspired our artist and not the accuracy of projecting space or clarity of organization in this page.

A very different impression and sentiment are made by the peasant activities in *February* (fig. 55). The peasants too enjoy the warmth of a hearth—except for the few who labor outside in the snow—but they are clearly disheartened by the climate of this raw month, and the more accidental or informal arrangement of their dilapidated chambers, moving back in three abrupt projections, accentuates the disorder and discomfort they experience. Indecorously they lift their skirts and breeches to benefit from the meager heat afforded them. The landscape outside the hut, a bitterly cold expanse of fields and hills blanketed by snow, has often been considered the earliest realistic winter scene in Western art.

The countryside is organized in three zones. A wicker

fence encloses the foreground with its sheepfold, cart, barrels, beehives, and storage tower. From the right a diagonal road leads us along hills in the middle zone, and in the far distance the snow-covered spires and roofs of a village beneath a threatening gray sky mark the horizon. The effects of a freezing day weighed under a heavy blanket of snow are admirably achieved. Footprints in the snowy foreground can be discerned as one poor fellow, grasping tightly his ragged mantle, hurries in from the right, his warm breath chasing a frosty cloud before him. The sheep huddle together for warmth, and magpies take the opportunity to enjoy the grain scattered about the ground.

In *April* courtiers and their lady friends go outside and enjoy the freshness of spring in a garden across the river Orge from the Château Dourdan, another of the duke's residences (fig. 56). Except for the very distant view, with peasants fishing in the river before the château, the landscape in this month is surprisingly archaic and disappointing in terms of the actual spatial projection. A garden wall to the right rises upward at an impossible angle beside the company of young court people, who form a

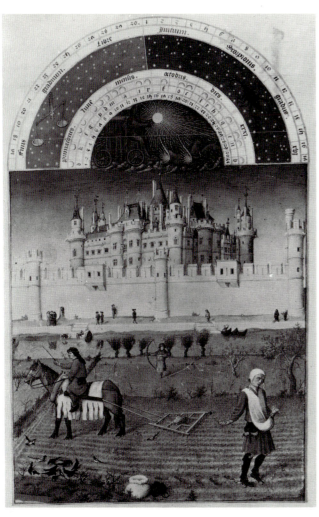

57. LIMBOURG BROTHERS. *October*, from the calendar of the *Très Riches Heures du Duc de Berry*

graceful foreground pattern. Even the illumination of sunlight is lacking, with only the flat, disembodied shapes of the figures, with their incredibly tall and tapered bodies describing elegant rhythmic designs, forming a colorful pattern on the green carpet behind them. There is preciousness and ostentation in the courtiers, but no substance, structure, or naturalism weighs them down. Like flimsy cloth puppets they seem to sway in cadence to some mannered court ballade. The *April* scene depicts an actual court ritual, an engagement party. It has been suggested that these couples are celebrating the engagement of the duke's granddaughter, Bonne d'Armagnac, and the wealthy Charles d'Orléans.

One of the most accomplished landscapes appears in *October*, where we return once more to peasants laboring on a chilly, frosty autumn day in the fields across from the palace of the Louvre in Paris (fig. 57). Not only is this miniature valuable for the accuracy in the rendering of the earlier Louvre, now lost beneath the museum, but it also presents us with a most vivid landscape in terms of naturalism and space. Informality once again characterizes the foreground with the workers defying any sense

of centralized planar design by moving out of the picture to either side. The precise details again attract our attention, from the faint indentations of the footsteps in the cold fields, the hoary frost on the furrows, the nonchalance of daring birds who flutter down to feed on the strewn wheat, to the soiled cloth that covers the shabby horse to the left. Cast shadows enhance the effects of a natural illumination across the foreground, and a crispness is felt in the air with the tall, white walls of the Louvre glistening majestically in the bright sunlight.

Until recently the beauty of the illuminations in the *Très Riches Heures* had attracted scholars more than the intriguing iconography of many of the unprecedented subjects presented. The problem of which brother—Pol, Herman, or Jean—painted which miniature has, of course, been a major issue, and in the most recent study, that of Millard Meiss, an exhaustive analysis of the division of hands was made.[27] He rightly noted that the style of the months depicting aristocrats at play is different from those in which peasants labor. The former he assigns to Jean Limbourg, whom he characterized as a more conservative artist relying on gay colors and sweeping drapery lines to achieve elegant compositions. The latter are Pol's, the leader of the threesome, whose style is more progressive and naturalistic, especially in landscapes.

This may be so, but one must also reckon with stylistic modes in such comparisons. Miniatures glorifying the opulence of the noble life with the elegant costumes and ritualized activities, would, it seems to me, necessarily be executed in a more traditional and archaic court style to preserve the dignity and elevated status of the patrons. Those describing the life of the peasant, often in crude dress and dwellings, could cast conventions to the wind, so to speak, and scatter the staffage—little more than animal life in comparison to the nobility—casually about in spacious landscapes, where they serve as little more than activators of the spatial compartments, little more than blemishes on the landscapes that unravel with unprecedented freshness and naturalism.

For the court figures, a sacred frontal plane must be maintained in their honor. Their companies must be presented with sophisticated compositions of planar design, and their colors must be purer and not subject to the breakdown of tones, shadows, and textures that result from natural illumination. The two modes, thus juxtaposed, may not then reflect two different artists' styles but simply two different conventions much as we see in present-day fashion advertising. At any rate, who is to know which of the three brothers was the most advanced in terms of the new naturalism? Would it necessarily be the oldest, who obviously would take precedence in the documents? Or was it perhaps the youngest, who could

work with more exuberance in the atelier? Or was it a matter of modes that were beginning to express themselves in different stylistic conventions with which the same artist could vacillate?

PHILIP THE BOLD OF BURGUNDY

The youngest of the four Valois brothers was Philip the Bold (1342–1404), duke of Burgundy. His official residence was the ducal palace in Dijon, but Philip rarely stayed there for long periods, preferring Paris, where he established his ducal household (*hôtel*) after 1394. From what the records indicate, his last visit to Dijon was in 1396. This is all the more surprising when we realize that some of the most memorable monuments of the International Style, commissioned by the duke for the Carthusian monastery in Dijon, were probably never seen in their finished state by Philip.

There is no evidence that Philip established a court scriptorium comparable to those of Charles V and John of Berry, although he did employ the Limbourg brothers in 1402 to illustrate a *Bible moralisée*, their first known commission as illuminators, and he maintained a sizable collection of books in Paris. As we have seen, Philip was presented with Boccaccio's *De mulieribus claris* with miniatures by the Master of 1402 and an illustrated *Mutacion de fortune* by Christine de Pisan, and he possibly was the recipient of the famous *Brussels Hours* illuminated by

Jacquemart de Hesdin given to the Burgundians by the duke of Berry.

Most of his books were gifts or purchases, and it is doubtful that he established his own atelier of illuminators in Paris or elsewhere. Instead he centered his interests as a patron of the arts on a large and beautiful religious foundation at Dijon, the Chartreuse (Charterhouse) de Champmol. Through shrewd political maneuvers Philip gained rich new territories for Burgundy. In 1369 he married Margaret, daughter of the count of Flanders, Louis de Mâle, and following the death of his father-in-law in 1384, he inherited Flanders and Artois as well as four other counties in the Netherlands. It was at this moment that his plans for the huge project in Dijon were laid.

The Chartreuse de Champmol, dedicated to the Holy Trinity, was founded "two arrow shots" from the city walls. The impressive complex of monastic buildings included two cloisters, a chapel, and a double row of cells to house twenty-four Carthusian monks instead of the usual twelve. It was no doubt Philip's desire to ensure his spiritual comfort that led him to choose the most ascetic of monastic orders of the period, the white-robed Carthusians, who were well known for their dedication to long hours of prayer and meditation. The foundation had, then, two purposes for Philip: to assure the duke that someone would be praying on his behalf at all hours of the day—and he needed such assurance—and, sec-

ondly, it was to serve as his own private mausoleum. What better spiritual comfort could he have than to be buried amid the austere walls of the chaste Carthusians? The Chartreuse was also to be a showplace to rival in richness the monuments of his brothers.[28]

The architecture of the Chartreuse is a somewhat conservative modification of the Late Gothic buildings of Paris. The architect, in fact, was Drouet de Dammartin, a Parisian who had previously worked on the palace of the Louvre for Charles V. But while the buildings themselves may be typically French, the artists who provided the decorations were called to Dijon from the Netherlands, and they represent the most progressive sculptors and painters of the day. Philip appointed Jehan de Marville (Jan van Mergem in Flemish), a sculptor from Flanders, as his official supervisor of the works with the title of *valet de chambre*. Marville was to plan and execute a magnificent tomb for Philip, and he further was to decorate the facade of the chapel with lifesize statues of the Madonna and Child for the trumeau, Saints John the Baptist and Catherine for the outer door jambs, and portraits of Philip and Margaret kneeling on the inner jambs before the Virgin (figs. 58, 59).

Among the sculptors in Marville's workshop was the famous Claus Sluter. Born in Haarlem in Holland, Sluter worked for a time in Brussels, from 1379 to 1385, before he was made an assistant to Marville in Dijon. When Marville died in 1389, Sluter assumed the role of *imagier*

(artificer) and *valet de chambre* and continued the sculptural projects that Marville had initiated and perhaps carried out to some degree. The portal sculptures for the chapel were in place by 1397. In the tradition of Gothic portal decoration, the general scheme includes a major figure on the trumeau, here the Madonna, and secondary figures on the side jambs, but that is as far as similarities between the past and present extend.

Jamb figures from the time of Chartres' Portal Royale (c. 1145), likened to column-figures because of their complete subordination to the architecture, had gradually been emancipated from their role as structural members of the fabric, until they gained the independence as figures on or before an architectural stage, such as we find them in the central portal of Reims Cathedral (figs. 1, 2). Although the statues gradually acquired the freedom to turn and interact across the portal, they nevertheless were secondary, decorative elements accenting the overwhelming monumentality of the facade. Sluter's statues, on the other hand, have not only gained complete freedom—they can even kneel in their niches, thus denying any structural role—but the relationship between sculpture and architecture has been reversed: the sculptured figures are now the dominating visual elements, the architecture has shrunken to a mere backdrop and is subordinated to them. Furthermore, the two kneeling figures on the inner jambs are not members of the community of saints, but are actual portraits of contemporary earthlings, the duke and duchess of Burgundy, rendered with exacting likenesses. The realism astonishingly displayed in these patrons is carried over in the powerful treatment of the other figures as well.

There is a new drama and life in Sluter's treatment of the Virgin on the trumeau. Mary is no longer characterized as the young Gothic princess, the *Schöne Madonna*, but as a robust and matronly woman. She carries the child easily and attends him with a fixed gaze almost nervously. The psychological rapport between mother and child is not the playful and coy relationship seen earlier, but is one of seriousness if not urgency. Mary's head is that of a French peasant, her face is lined with taut creases, and this new vitality is carried through in Sluter's remarkable drapery that swirls about her stocky body with a dynamism that departs from the graceful, gently falling lines of traditional patterns. The lines here are fast moving and very deeply cut, creating pockets of dark that contrast vividly with the highlighted ridges, lending a rich pictorial effect to the draped figure. The statue is a study in motion with the plastic lines of force converging on the child held out in the mother's arm. The deep folds not only swirl about the body but seem to smother it, yet we are aware that a solid core lies beneath the weighty mantle that Mary wears.

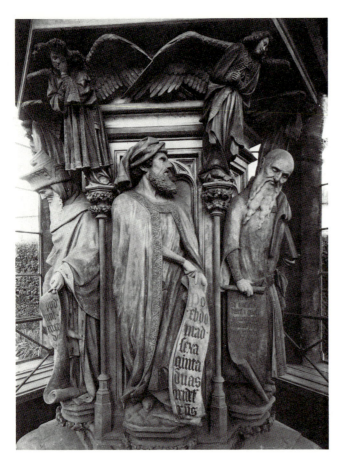

60. CLAUS SLUTER AND SHOP. *Well of Moses*. 1395–1406. Height of figures, about 6′. Chartreuse de Champmol, Dijon

Sluter's drapery style is truly original although some scholars have searched for sources in sculptures of Rhenish or Mosan origin, and it has sometimes been noted that the severe style of the Bohemian tomb effigies by Parler's shop anticipates the robust monumentality of Sluter's figures. What is definitely new here is the combination of monumentality and pictorial expression. It is the drapery that first attracts our attention, and here it can be said that Sluter achieved the ultimate solution for the draped figure in the North. In classical art, drapery is subordinate to the expressive qualities and formal beauty of the nude body it lightly covers. In general it can be said that in Mediterranean art the nude body is foremost, while in the North, from earliest times, it is the drapery.

The expressive role of the figure is conveyed through hands, eyes, and dynamic drapery patterns. Rich stuffs, rendered with elaborate border embroideries, often sparkling with incrustated jewels, fascinated the Northern artist. Heavy folds with hard ridges break from the weight and stiffness of the material itself rather than from the protrusion of the human body beneath it. Perhaps this is merely a matter of climate since the further north one goes, the heavier the drapery seems to become. At any rate, Sluter's draped figures were so widely imitated that a new school of sculpture developed in Burgundy that lasted for many decades and was influential not only in sculpture but in painting as well.

The two standing saints presenting the patrons are similarly treated as husky figures wrapped in layers of blankets. Saints John the Baptist and Catherine are refined peasant types with vigorous realism in the modeling of their heads. John carries a realistic looking lamb on his left arm; Catherine holds a full-sized wheel and not a toy as her attribute. The most astonishing display of Sluter's keen sense of realism, however, appears in the portraits of Philip the Bold and Margaret of Flanders. Margaret, a heavily proportioned woman, dignified if not a bit proud and arrogant, kneels far out on her console. In spite of the fashionable court costume she wears with its low-cut neckline and form-fitting skirt, she is not characterized as a beauty of the court. Her face conveys her austerity in its directness and immediacy. Philip the Bold, his great cloak creating a massive pyramidal form on the console, is likewise a true portrait. From this and other profile portraits of the duke we have no difficulty in recognizing his distinct personality. His furled brows, long curving nose, pinched lips, and protruding jaw are distinctive facial features of Philip. A short, stocky man, he exudes a boldness and confidence even when confronting the Virgin directly.

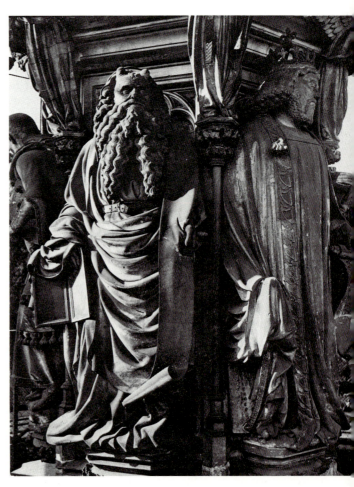

61. CLAUS SLUTER AND SHOP. *Moses* (detail of fig. 60)

Inside the Great Cloister of the monastery, over one hundred yards square, Sluter placed a huge monument known today as the *puits de Moïse,* or *Well of Moses* (fig. 60). Originally a Crucifixion group rose some twenty-five feet with Mary, John the Evangelist, and Mary Magdalen about the cross. This group rested atop a huge hexagonal pedestal with lifesize figures of six prophets in niches rising from a font-shaped pool eleven feet deep. The iconography of the *Well of Moses* was thus a complex fusion of the idea of man's salvation through the death of Christ on the cross and the Fountain of Life whereby his sins were washed away in the waters of Baptism. From later paintings of this unusual subject we know that the symbolism of salvation was further enhanced by showing the blood from the wounds of Christ fill the basin, thus bringing together the meaning of the two principal sacraments, the Eucharist and Baptism.

Only a few fragments of the Calvary group survive, and the best of these is the startlingly realistic head of the dead Christ. The pedestal survives in its entirety *in situ* and is one of the most famous ensembles of sculpture of the late fourteenth century. Six prophets—Moses, David, Jeremiah, Zechariah, Daniel, and Isaiah—are placed in elaborate niches on the six sides of the hexagon. The complete presentation must have had a staged, theatrical appearance. One scholar, Emile Mâle, has suggested that Sluter's program was directly influenced by Gothic mystery plays. Even the mourning angels who serve as pseudocaryatids above the ornate colonettes that enframe the niches appear here in the guise of the choirboys who would take the role of mourners in religious dramas. Between each act in the play, an appropriate prophet would appear on stage and read from his text Old Testament prophesies of the New Testament event to be acted out. Mâle cites one famous French mystery play, the *Trial of Christ,* where the prophets appear as members of the jury, and their lines are remarkably close to the inscriptions painted on the banderoles unraveled by our statues. Indeed, the prophets look like real actors on a rotary stage.

In earlier art the prophets were seldom individualized. Sluter gives them distinct character and personality, and their features are so individualized that it has been suggested that he may have sought out models for them among the Jews in Dijon, but this is doubtful. To add to their realistic appearance, the statues were originally painted and gilded by the court painter, Jean Malouel, and the figure of the studious Jeremiah was outfitted with a pair of real copper spectacles. In general, they are portrayed as the weary Old Testament ancestors of the New. King David appears as a tired, contemplative king. Jeremiah, the scholar, looks like a scholar, wearied by his prodigious learning. Others are alert and defiant. Daniel

62. Claus Sluter and shop. *Tomb of Philip the Bold,* from the Chartreuse de Champmol. Finished by 1414. Musée des Beaux-Arts, Dijon

turns abruptly as if angered and ready to act, and it may be that Sluter had in mind some contrast between the more militant or active types and the contemplative, a common dualism for the ways to attain salvation: the *vita activa* and the *vita contemplativa.*

The most famous of the six figures, Moses, represents the active prophet who is angered at his people (fig. 61). This majestic figure, the lawgiver of the Old Testament, is draped in a voluminous robe that cascades downward in great scooped-out arcs. The extraordinary sculptural qualities of Moses are further enhanced by the pictorial effects created by the rapid play of light across the many ridges of the robe. Our eyes follow this flow of deep, shadowy hollows and highlighted ridges, and somehow we can sense that there is a solid body beneath this massive tour de force in overlapping drapery. Considering that Moses' mantle was originally polychromed—gold with a blue lining—the final effect combined the sculptural or plastic qualities with the pictorial in what might seem today to be verging on the bizarre. The head of Moses is powerfully modeled in precise detail, so much so that it is no wonder that some believe these figures to be based on living models. He carries the tablets of the Law in his right hand and a long bulging scroll in his left. His anger is underscored by the text that unravels on it: "The children of Israel do not listen to me."

The *Tomb of Philip the Bold* has been heavily restored (fig. 62). The project was begun by Marville, but it is doubtful that he did little more than make preliminary designs. Sluter very likely carved the effigy of the duke for the lid of the sarcophagus and a number of the forty *pleurants,* or mourning figures, placed along the sides.

left: 63. CLAUS SLUTER AND SHOP. *Pleurant*, from the *Tomb of Philip the Bold* (see fig. 62). Alabaster, about 15¾"

below: 64. CLAUS SLUTER AND SHOP. *Pleurant*, from the *Tomb of Philip the Bold* (see fig. 62). Alabaster, about 15¾"

The work was not finished until 1414, ten years after Philip's death. Claus de Werve, Sluter's talented nephew who became director of the atelier after his uncle's death in 1405, is responsible for the final appearance of the tomb. The effigy of the duke has been completely restored, but the general composition of the tomb has not been altered. Sluter elaborated the idea of having mourners depicted on the sides of the sarcophagus, usually angels carved in low relief, by fashioning the sides of the tomb into an architectural corridor in which freestanding alabaster sculptures of the mourners were seen in a funeral procession. Here again, the realistic approach of Sluter to conventional projects is surprisingly original. A reenactment of the actual funeral procession that took place in 1404 is captured, with members of clergy and state dignitaries leading a host of Carthusian monks in and out of the arcaded corridors as they repeat their prayers for the duke.

We know a great deal about Philip's funeral. He died in the Stag Inn at Hal, a village near Brussels, on April 27, 1404. Following the ritual for royal burials, Philip's corpse was embalmed, and his viscera and entrails were immediately buried in the Church of Notre Dame at Hal. His heart was removed and sent to the royal burial church of France, Saint Denis, on the outskirts of Paris. His body was then wrapped in Carthusian vestments and placed in a leaden coffin. It was decided to bury Philip's mortal remains in the chapel of the Chartreuse in Dijon, some 250 miles from Hal. The draped coffin was then placed on an elaborate hearse drawn by six horses caparisoned in black, and on May 1 the cortège of his relatives, chaplains, and administrative members of his court, all dressed in black, set out. Behind this impressive parade of dignitaries there followed some sixty mourners. The slow and tedious procession to Dijon took six weeks, and the duke's body was finally interred in the monastery on June 16.

The *pleurants* of Sluter thus reenact such a procession with the clerical and court dignitaries leading a company of Carthusian monks in various states of mourning (figs. 63, 64). The appeal of Sluter's figures is universal. Their diminutive scale—about one and one-quarter feet high—adds to the charm of their characterization. They seem like pious dwarfs weighed down in their sorrows and mantles, and one can sense a certain touch of humor in a number of them, who, weary and tired from such a long march in hot weather, reflect their different states of

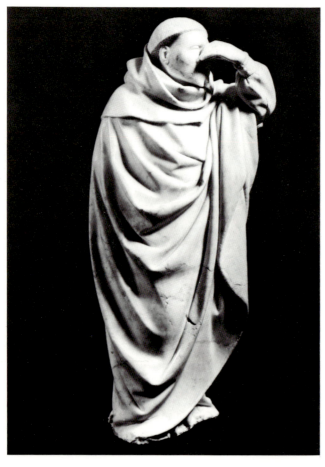

mind. Some remain pious to the end, covering their heads as they recite prayers for Philip's salvation. Others appear a bit disenchanted by the ordeal, and one even holds his nose from the stench of the dead flesh of the duke cooking in the summer sun.

The Chartreuse de Champmol housed twenty-four monks, each with his own cell that was decorated with a devotional painting. In 1395 Jean de Beaumetz, the resident painter whom Philip called in from Flanders, was ordered to paint twenty-six panels (one for each monk, two for the prior?) for these chambers. Beaumetz apparently had a sizable workshop—some nineteen names are listed as working in his atelier in 1388—that was engaged in a number of projects for the Chartreuse from painting murals to decorating banners. In 1390 Beaumetz had been commissioned to execute a triptych with the *Coronation of the Virgin* flanked by an *Annunciation* and *Visitation* on the wings, but no trace of the altarpiece remains except for a possible reflection of the *Coronation* in a drawing in the Louvre.

Recently, two panels have been identified as Beaumetz works for the monastic cells. Both represent the Crucifixion with a Carthusian monk kneeling before the cross in the company of Mary and John the Evangelist (fig. 65). These works are interesting documents of the early phase of Burgundian panel painting since they display pronounced Sienese features (it will be remembered that Philip acquired works by Simone Martini from Avignon) with tooled backgrounds of gold and typical Italo-Byzantine conventions for the facial features and drapery patterns. Stylistically, they are of mediocre quality, and no doubt the two panels were by two different artisans working under the supervision of Beaumetz.

In 1396 Beaumetz died and his position as *valet de chambre* in Dijon was passed on to Jean Malouel (Jan Maelwel), an accomplished painter from Nijmegen in Guelders. Malouel was the uncle of the Limbourg brothers, it will be recalled, whom he introduced to Duke Philip the Bold sometime around 1400. From the archives it is known that Malouel executed several panels for the Chartreuse until his death in 1415. No certain works by Malouel are known, but a handsome tondo (fig. 66), originally in the duke's collection, is generally attributed to him because of its high quality and its date, about 1400–1415.

The coat of arms of Burgundy is painted on the reverse of the painting, and the unusual iconography of the piece clearly links it to the Carthusian monastery. Directly in the center of the tondo the torso of the dead Christ appears resting in the arms of God the Father, and a small white dove, the Holy Spirit, hovers between their heads. Thus the subject is more than simply a Pietà as generally given due to the presence of Mary, John, and mourning

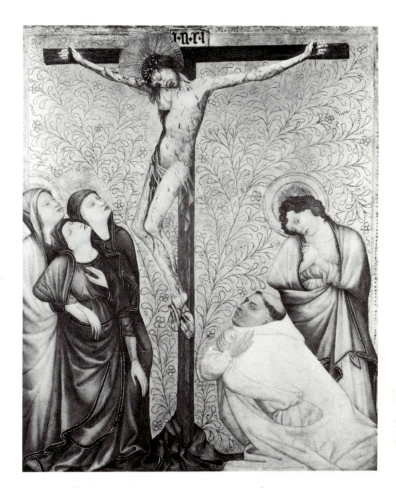

65. JEAN DE BEAUMETZ AND SHOP. *Crucifixion*. c. 1395. Panel, 22¼ × 17⅞″. The Cleveland Museum of Art. Leonard C. Hanna, Jr. Bequest

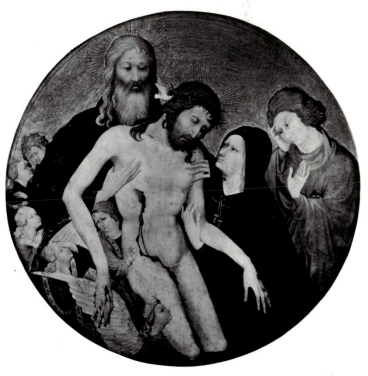

66. JEAN MALOUEL. *Lamentation of the Holy Trinity*. c. 1400–1415. Tondo, diameter 20½″. The Louvre, Paris

angels around the perimeter of the tondo; it is more specifically the *Lamentation of the Holy Trinity*, a curious theme related to the Germanic *Gnadenstuhl* (Throne of Grace), which will be discussed later in detail. It will be recalled that the Chartreuse de Champmol was dedicated to the Holy Trinity, and for that reason the unconventional iconography of the tondo is appropriate for Philip's monastery.

The style of the *Lamentation of the Holy Trinity* displays a splendid fusion of the graceful linearism of French Gothic and the distinctive Italo-Byzantine conventions for the features of the figures. The heads of the six tiny angels to the left and Mary and John to the right are remarkably close to those of the angels in Duccio's works. The elegant head of God the Father with the soft, silken beard reminds one of Simone Martini's elderly saints, and the carefully tooled haloes on the bright golden background are Sienese conventions as well. But one would not mistake this work as Sienese. The profiles (note especially the line of the forehead, nose, and chin of the Virgin) are clearly Northern, and the suppression of space for an allover calligraphic design is a trait one associates with figure compositions in the French International Style.

Recently a Madonna and Child, typically Sienese in composition but displaying these same Northern traits, was discovered in a storage room of the Berlin Museum in Dahlem and attributed to Malouel. It seems that the *Madonna and Child*, bust length, was a wing of a diptych that featured a profile portrait of John the Fearless, Philip's successor after 1404, on the second panel. If so, this would be one of the earliest examples of a type of devotional diptych that became very popular with later Netherlandish painters.

It is very likely too that Malouel painted the original *Portrait of Philip the Bold*, which exists today in a number of later copies (fig. 67). Philip appears in advanced age, suggesting a date sometime around 1400 for the original. In 1398 Malouel was commissioned to execute no less than five altarpieces for the monastery, but unfortunately no descriptions of them appear in the documents.

A large panel (colorplate 11) in the Louvre, originally from the Chartreuse, depicting two episodes from the life of Saint Denis flanking the hieratic image of the Trinity with Christ on the cross supported by God the Father (a tiny dove appears between their heads again), could well be associated with these commissions, but the style of some of the figures is harsher than that of the tondo. Another document, dated 1416, the year after Malouel's death, informs us that his successor, Henri Bellechose from Brabant, was ordered to complete (*parfaire*) a "tableau de la vie de S. Denis," and it has been suggested that the large panel in the Louvre is to be identified with

67. AFTER JEAN MALOUEL? *Portrait of Philip the Bold.* c. 1400. Panel, 16½ × 11¾". Musée National du Château de Versailles

the painting in this document. This is convincing insofar as there are distinct changes in the figure style. At any rate, the fact that the panel came from the Chartreuse and the prominence of the Trinity—here presented much as it appears on the seals of the monastery—link the work to Dijon and the Carthusians.

The delicately tooled gold background, the heads of the small angels, and the figure of Christ on the cross exhibit the Sienese traits found in the tondo attributed to Malouel, but the figures of the henchmen to the right, who execute Denis and his two companions, and the head of the Lord are harsher and more vigorously modeled. To the left of the Trinity, Christ himself administers last rites to Saint Denis, who is imprisoned in a dwarfish building with a bizarre anthropomorphic elevation.

The main altarpiece for the chapel of the Chartreuse is well documented and preserved in excellent condition in Dijon today. The so-called *Retable de Champmol* was a collaborative project executed by Flemish artists in Flanders, and interestingly enough the work displays traits in both style and iconography that we associate with later Flemish art more so than with the French International Style (fig. 68 and colorplate 12). In 1392, on one of his trips through the Netherlands, Philip the Bold commis-

sioned a leading wood-carver, Jacques de Baerze of Termonde near Bruges, to execute two large sculptured shrines for his monastery in Dijon. One of these was to have painted exterior panels, and for this work, Philip called on his special *varlet de chambre*, Melchior Broederlam, who was attached to his castle at Hesdin. Broederlam's shop was in Ypres (he formerly had served as painter to Philip's father-in-law, Louis de Mâle), where the sculptured panels were shipped from Termonde. Having completed the paintings by 1399, Broederlam then carted the panels to Dijon, where he supervised the installation of the altarpiece in the chapel.

For the interior of the shrine, De Baerze had carved representations of a *Crucifixion* flanked by an *Adoration of the Magi* and an *Entombment* on the centerpiece and rows of saints for the wings, all of which were encased in elaborate Gothic tabernacles. De Baerze's carvings will be discussed in another chapter, but the paintings by Broederlam must be discussed here because of their unusual position in the development of Franco-Flemish art.

The subject matter for the two shutters—the *Annunciation and Visitation*, the *Presentation and Flight into Egypt*—

forms an appropriate prelude, with the Infancy cycle complementing the Passion scenes on the interior. One can find in these paintings many traits characteristic of the International Style in general: the mannered drapery displayed especially in the robe of the angel Gabriel, the use of the Italian space-box interiors, and the marginal realism in secondary details. But these features are overwhelmed by the more naturalistic treatment of figures in space together with a new awareness of a natural lighting that models the space in a dramatic fashion.

It should be noted, first of all, that nearly half of the painted surface is devoted to free space, alternating interior and landscape across the two panels. The *Annunciation* takes place in a curious hybrid building set at an angle in the left foreground. Behind it, to the far left, are the walls of another building with an open annex beside it that plunges backward in an exaggerated fashion emphasized by the sharply receding swastika-like floor tilings. The side walls of this architectural complex are in shadow, while the fronts are bathed in a bright light enhancing even more the effects of deep spatial projection.

But there is much more. Broederlam exploits second-

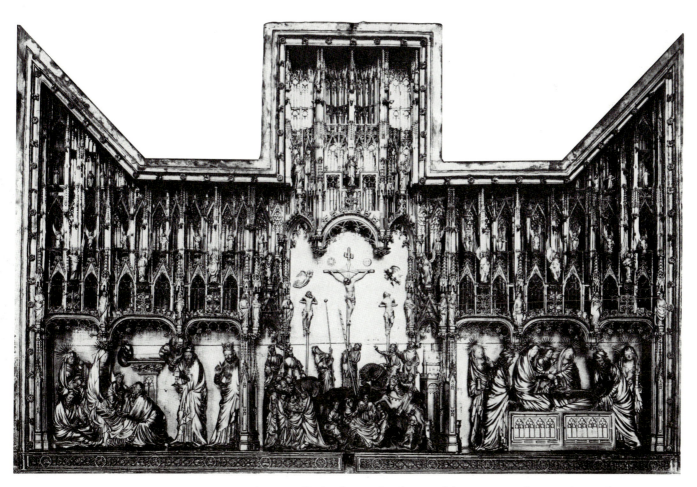

68. Jacques de Baerze. Central relief of the *Retable de Champmol*: *Adoration of the Magi*, *Crucifixion*, and *Entombment*. Before 1399. Musée de la Ville, Dijon

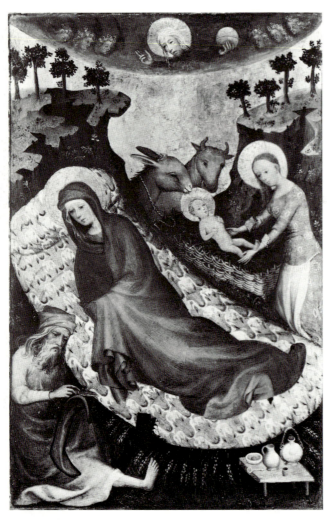

69. MOSAN PAINTER OF C. 1400. *Nativity* from a quadriptych.
c. 1400–1410. Panel, 13 × 8⅜″. Musée Mayer van den Bergh,
Antwerp

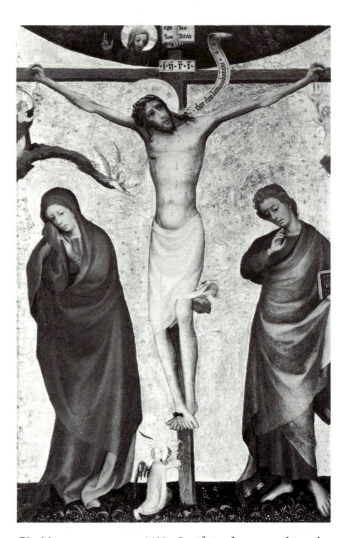

70. MOSAN PAINTER OF C. 1400. *Crucifixion* from a quadriptych.
c. 1400–1410. Panel, 13 × 8⅜″. Walters Art Gallery, Baltimore

ary, symbolic details for this setting. Just behind Gabriel is an enclosed garden, the *hortus conclusus* symbolic of Mary's virginity, within which are numerous flowers that refer to other Marian virtues. The chamber in which Mary is placed features two different architectural styles. The nearer room, where Mary sits before a lectern, is a fragile Flamboyant Gothic porch, open and full of light. Adjoining the Gothic antechamber is a heavy stone rotunda, reminiscent of Romanesque buildings, and through the open door we can see that its interior is dark and mysterious.

The juxtaposition of these two units refers to the Old Testament (the rotunda) and the New (the Gothic porch) and informs us that Mary—the link between the Old and New Testaments—has just emerged from the darkness of the former to enter the light-filled chamber where the Incarnation of Christ is not only announced but is, in fact, taking place. The golden rays sent down by the Lord in the top left pass through the window to fall

upon the Virgin, and it is at this very moment when the Child is conceived in her womb. Between Gabriel and Mary is a large vase with white lilies, symbolizing the Virgin's purity and her role as the flower of the Tree of Jesse, and above her, atop the empty building, rises a triple-arched tabernacle, a reminder that at this very moment the Trinity has come into being.

The *Visitation* takes place in a deep landscape that builds upward with overlapping peaks to fill the high projection of the panel to the right. The softly modeled mountains still retain qualities of the Italo-Byzantine rock landscapes but are more in keeping with those of later Sienese painters such as Giovanni di Paolo, who excelled in producing fairyland vistas that stretch far into the background. The use of gold for the sky may seem archaic, but the fact that Broederlam allows a hawk to fly across it between the lower peak and the rotunda indicates that he thought of this as a real space as well as the celestial habitat for angels.

For the *Presentation*, Broederlam turned again to the Sienese for the elaborate temple setting. Both Ambrogio Lorenzetti and, after him, Bartolo di Fredi popularized just such an elaborate central-type structure with complex vaulting for the scene. The *Flight into Egypt* is one of the most charming interpretations of the theme in Western art. Here Joseph and Mary pass through a crevice in the foreground and turn to follow a winding road that leads back to a tall mountain surmounted by a walled city. Two unusual details found in the landscape owe their presence to the apocryphal account of the Flight in the gospels of Pseudo-Matthew. Below Mary and the charming donkey is the well or cistern that miraculously appeared in the desert to nourish the thirsty family, and along the road an idol is seen falling from its high base, another display of the divine powers of the Christ Child to destroy things pagan.

Joseph, stocky and heavily garbed in a colorful costume, stretches backward to take a deep draft from a canteen which he has just filled at the cistern below. But it is Mary on the lively donkey who captures our attention here. With an endearing gesture she cradles the Child tightly in her arms, and as if to point out that humanity and motherly concern rule over divinity in this episode, Broederlam allows her blue mantle to overlap the golden halo of her son. Broederlam's Dijon altarpiece wings thus announce a new world of naturalism and disguised symbolism that will be further refined in the works of his successors in the Netherlands, Jan van Eyck and Rogier van der Weyden.

A number of small panels dating in the first decades of the fifteenth century have been attributed to artists active in the ducal atelier in Dijon, but they are mostly of uneven quality. Four panels (two painted on both sides) of a small quadriptych, today divided between the Musée Mayer van den Bergh in Antwerp and the Walters Art Gallery in Baltimore (fig. 69), however, deserve to be mentioned here as they present clearly the thorny problems encountered in determining the provenance of Late Gothic paintings. The altarpiece, when reassembled, juxtaposes two panels of the Infancy with two of the Passion (*Annunciation*, *Nativity*, *Crucifixion*, and *Resurrection*), and, on the exterior, two panels related to Baptism and water (*Baptism of Christ* and *Saint Christopher*).

All four panels have been traced to the Chartreuse de Champmol, and it comes as no surprise therefore that at one time or another they have been attributed to Malouel, Broederlam, or simply, a "Burgundian" painter. Closer study of the color and style of the compositions as well as some unusual iconographic details leads us in other directions, however. The elongated proportions of the figures, their simplified bodies modeled in bright colors, and the doll-like nature of the faces are more characteristic of early panels executed in the environs of the Lower Rhine and Mosan valleys.

Iconographic clues corroborate the evidence for this provenance. In the charming *Nativity*, Joseph busies himself in the lower left corner converting one of his stockings into a swaddling cloth for the newborn Child. This curious touch could well have been inspired by a legend associated with Aachen and the Lower Rhine, where such a relic was venerated. Another unusual detail is found in the otherwise simplified scene of the *Crucifixion* (fig. 70). The long torso of Christ hangs listlessly on the cross between tall figures of Mary and John the Evangelist, but his head is turned upward to the right and from his lips there issues a banderole inscribed "Eloy eloy lama sabatani." This poignant motif is derived directly from the *Revelationes* of the Swedish mystic, Saint Bridget, who writes of Christ's despair at the Crucifixion, when "Deeply from his breast, raising his head, his weeping eyes turned heavenward, he gave a cry, saying, 'My God, My God, why hast thou forsaken me?'" As we shall see, Rhenish art was nurtured on such direct contact with intense mystical devotion. However the Antwerp-Baltimore quadriptych reached Dijon, it thus seems much more likely that it was imported from some center northeast along the Rhine-Mosan crescent.

IV.

The Rhenish-Mosan Crescent

The regions to the west, north, and east of the French provinces had a hardy artistic heritage that provided much of the impetus for the arts of the Valois courts, as we have seen. The miniaturists Jacquemart de Hesdin, Beauneveu, and Bondol were from the area of Flanders, as were the sculptors De Baerze and Marville and the painters Beaumetz and Broederlam. Claus Sluter was from Haarlem; Malouel and the Limbourg brothers from Nijmegen. It was the lucrative commissions that brought these artists to the French courts, and it is now our task to investigate their homelands, which present very different aspects of patronage. With some exceptions the dominant patrons of the arts were members of the bourgeoisie and clergy rather than aristocratic nobility, and their projects were of a civic and religious rather than a courtly nature. It is now that we encounter the guild artist, not the *valet de chambre*.

The guilds were powerful labor organizations that controlled the activities of their professions with an iron hand. The guild of the painters, dedicated to Saint Luke, the first Christian painter according to legend, controlled the commissions in the city, banning anyone who was not a member of the local guild from receiving a contract. It set the standards for the training of apprentices and the requirements for being admitted to the profession as a master. They also approved the prices for works of art and the quality of the materials used. By the early fifteenth century many of these guilds became, as labor unions are today, powerful political forces within the city, with their deacons often assuming the roles of city regents.[29] This will be discussed in more detail below, but for now it is important to note that we step out of the polished palace chambers of the dukes and into the streets and workshops of the people.

The most meaningful geographic unit to consider here is what I would like to call the Rhenish-Mosan crescent (comprising today Belgium, Holland, and Germany) that was part of the archdiocese of Cologne and Mainz. This includes the major cities that lie along the Rhine and Maas (Meuse) rivers and in the adjoining valleys

stretching from Basel to Leiden and Rotterdam on the Rhine and from Liège to Dordrecht along the Maas. The major centers on the Rhine include Basel, Strasbourg, Mainz, Cologne, Cleves, Nijmegen, Arnhem, and Utrecht. Following the Maas from Liège we pass through Maastricht, Maeseyck, and 's Hertogenbosch. The capital of this area was Cologne, the largest city in Germany and the archbishopric of territories today in Belgium and Holland as well as Germany.

Aside from the geographic factor, another should be considered here, the linguistic ties. For the most part, the languages spoken along these commercial routes were German and Dutch. Still a third factor is the religious. It was along the Rhine that mysticism, as we define it today, had its flowering. The so-called negative mysticism of Eckhardt, Tauler, and Suso radiated from the schools in Cologne; positive mysticism of the Brethren of the Common Life, the *Devotio moderna*, spread from centers in Holland, especially Nijmegen, Deventer, and Haarlem.[30] The impact of these new types of devotion transformed the arts in terms of both style and iconography in a most fascinating manner.

The political makeup of the area is confusing. Holland belonged to the Bavarian dynasty until 1436 and had its capital in the Hague. Limburg was part of the duchy of Brabant until 1406, when it was taken over by the Burgundians. Maastricht belonged to the bishopric of Liège, and Guelders (comprising Arnhem, Nijmegen, and Roermond) was ruled by Renaud IV, who was married to a noble lady of the French Valois court, Marie d'Harcourt. Cologne was a free city controlled by the archbishop and the guilds. It is not surprising, therefore, that the confluence of French, Dutch, and Germanic artistic traditions frequently appears in Rhenish-Mosan art.

A fine example of this mingling of styles can be studied in the sumptuous *Book of Hours of Marie of Guelders* (Berlin, Staatsbibliothek, MS Germ. quart. 42), dated 1415, with six full-page miniatures and eighty-six smaller pictures executed by a number of hands (fig. 71). The Hours of the Passion begins with an unusual pair, a

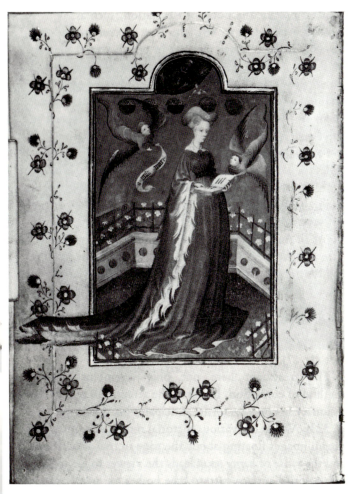
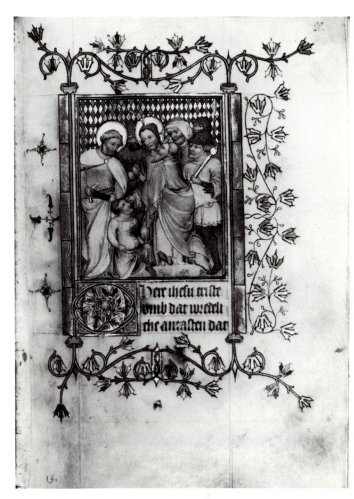

71. *Marie, Duchess of Guelders* and the *Arrest of Christ*, from the *Book of Hours of Marie of Guelders*. 1415. Staatsbibliothek, West Berlin

curious *Annunciation* and a more traditional *Arrest of Christ* (cf. the paired scenes for matins in the *Hours of Jeanne d'Évreux* discussed above, p. 21). The smaller miniature of the *Arrest* with its stocky figures, ruddy faces, and suspended gestures cramped into a shallow space conforms to the style of other Dutch illustrations of the early fifteenth century, but the *Annunciation* is executed with the grace, aristocratic mannerism, and elegance of French miniatures such as those in the *Très Riches Heures*. Mary wears a long, flowing mantle of blue trimmed with white ermine that flutters from her elbow and is picked up in the train of her gown that overlaps the frame of the miniature. The delicate head of Mary and the dainty angels that fly to her also remind one of Parisian book illustration of the same period.

How does one explain this surprising juxtaposition of styles? Marie d'Harcourt, for whom the manuscript was destined, belonged to the inner circle of the Valois—her aunt was the wife of Charles V—and her marriage to Renaud IV of Guelders was arranged by Charles VI and Louis of Orléans in 1405 to strengthen the northern boundaries against the expanding Burgundian empire. Marie inherited from the Valois, especially the duke of Berry with whom she corresponded, a fine taste for books. No doubt Marie brought to Guelders a refreshing breath of French taste in the arts, and perhaps this accounts for the mannered elegance of the *Annunciation* page, which, incidentally, is inserted into the manuscript.

Her Book of Hours was completed in the Augustinian monastery of Marienborn near Arnhem which belonged to the Brethren of the Common Life, and one could argue that the curious iconography of the *Annunciation* is in part due to a mystical identification of the patroness and the Virgin that is quite apparent. God the Father appears at the top of the page dispatching the Holy Ghost in the form of a dove. The angel that approaches the Madonna from the left carries a banderole, but the text does not carry the traditional greeting of "Ave Maria," but rather "O milde Maria" (Oh gracious Mary). The second angel has offered Mary a Book of Hours, which she reads in a garden and not the usual chamber. Finally, it

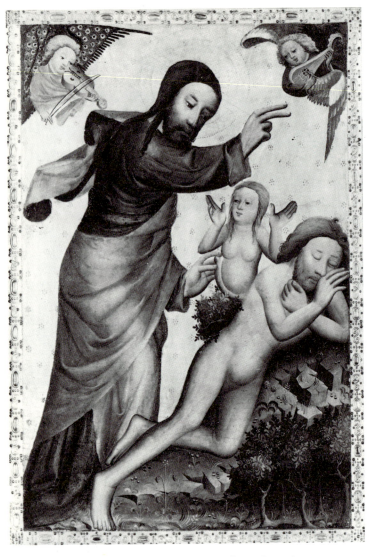

75. MASTER BERTRAM. *Creation of Eve*, from the *Saint Peter Altarpiece*. 1379. Panel, 33½ × 22½". Kunsthalle, Hamburg

76. MASTER BERTRAM. *Annunciation*, from the *Saint Peter Altarpiece*. 1379. Panel, 31½ × 21⅝". Kunsthalle, Hamburg

Gothic period. It has been pointed out that these earliest "German" paintings share not only sources common to Mosan art, such as the French, but also the added ingredient of the Bohemian International Style, in particular the second Bohemian style of Master Theodoric (see pp. 28–29).[32]

The earliest documented painter for whom we have extant panels is one Master Bertram from Minden in Westphalia. His name appears in documents in Hamburg, the thriving Hanseatic town on the Elbe in northwestern Germany, from 1367 to 1415, where he settled and was highly esteemed. The head of a large workshop there, he was elected deacon of the painters' guild in 1410. One of the documents, dated 1390, is of special interest: "I, Bertram the painter, have the desire to betake myself to Rome for the comforting of my soul." Just what Bertram saw and experienced on his journey to Italy is not reflected in his work, but his stocky figures softly modeled with simple drapery folds have been lik-

ened to those of Master Theodoric of Prague, and some have even argued that Bertram's initial training must have been in the Bohemian workshop that decorated Karlštejn Castle.

Master Bertram's most impressive work is a huge polyptych, the *Saint Peter Altarpiece* (originally in the Church of Saint Peter in Hamburg), dated 1379, that measures twenty-four by six feet when opened, one of the largest Gothic shrines extant (figs. 75, 76). The giant double-winged altar includes a carved shrine, predella, headpiece, and twenty-four painted panels. The sculptured parts of the altarpiece, including a *Crucifixion* with forty-four statues of prophets, saints, and apostles, were very likely designed if not partially carved by Bertram, and when the first wings are opened, twenty-four painted panels, a solid screen of color, are displayed with narratives placed in two rows, one over the other.

In the top row on the left the story of the Creation begins with the *Separation of Light and Darkness*, and it

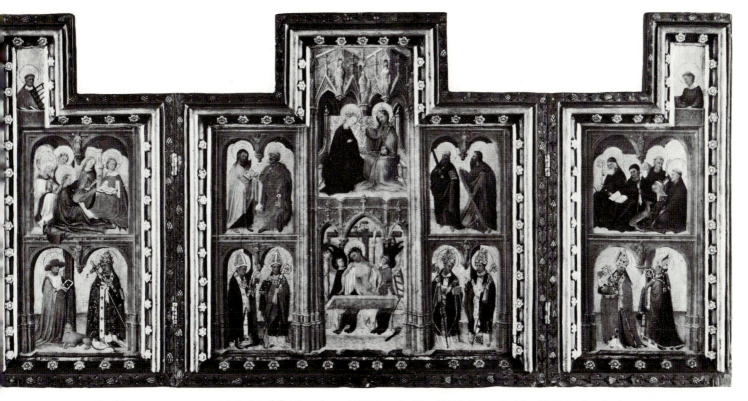

73. Mosan master of c. 1415. *Norfolk Triptych*. c. 1415. Panel, 13 × 12¾″ (center); 13 × 5¼″ (each wing). Museum Boymans-van Beuningen, Rotterdam

the numerous seated and standing saints suggests Parisian influence, but the placement of the figures in space, especially the saints who are given ample ground on which to stand, is more in keeping with Rhenish style, as we shall see. Also, the childlike facial types with small, pinched mouths, pointed noses, and curly hair—particularly in the angels about Christ—are features common in early Rhenish painting. The *Norfolk Triptych* is thus an excellent example of the skills of the Mosan artists in absorbing current styles with ease. Of the twenty-three saints portrayed in the interior, five were definitely venerated in the Maas valley: Saints Hubert, Martin, Lambert, Servatius, and Remaclus.

The same successful blending of styles appears in sculpture as well. The handsome *Coronation of the Virgin* in stone from the Church of Saint Jacques in Liège dates in the first years of the fifteenth century (fig. 74). The deep-cut folds and the sense of bulk suggest the influence of Claus Sluter with their strong plastic qualities combined with a dynamic flow of shadows. The powerful treatment of the head of Mary also brings to mind Sluter. The *Coronation* group in Liège represents the finest in monumental Mosan sculpture, and, at the same time, a melodious echo of Sluter's pictorial style outside of Burgundy.

For historians who are inclined to attend present national boundary lines, the Lower Rhine, Cologne, and the neighboring province of Westphalia have been considered the centers of German panel painting of the Late

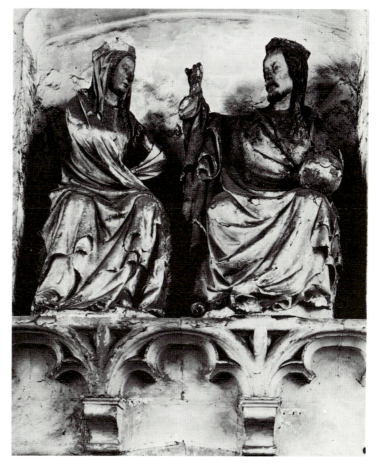

74. Mosan sculptor of c. 1410. *Coronation of the Virgin*, from the portal of the Church of Saint Jacques, Liège. c. 1400–1410

75. MASTER BERTRAM. *Creation of Eve*, from the *Saint Peter Altarpiece*. 1379. Panel, 33½ × 22½". Kunsthalle, Hamburg

76. MASTER BERTRAM. *Annunciation*, from the *Saint Peter Altarpiece*. 1379. Panel, 31½ × 21⅝". Kunsthalle, Hamburg

Gothic period. It has been pointed out that these earliest "German" paintings share not only sources common to Mosan art, such as the French, but also the added ingredient of the Bohemian International Style, in particular the second Bohemian style of Master Theodoric (see pp. 28–29).[32]

The earliest documented painter for whom we have extant panels is one Master Bertram from Minden in Westphalia. His name appears in documents in Hamburg, the thriving Hanseatic town on the Elbe in northwestern Germany, from 1367 to 1415, where he settled and was highly esteemed. The head of a large workshop there, he was elected deacon of the painters' guild in 1410. One of the documents, dated 1390, is of special interest: "I, Bertram the painter, have the desire to betake myself to Rome for the comforting of my soul." Just what Bertram saw and experienced on his journey to Italy is not reflected in his work, but his stocky figures softly modeled with simple drapery folds have been lik-

ened to those of Master Theodoric of Prague, and some have even argued that Bertram's initial training must have been in the Bohemian workshop that decorated Karlštejn Castle.

Master Bertram's most impressive work is a huge polyptych, the *Saint Peter Altarpiece* (originally in the Church of Saint Peter in Hamburg), dated 1379, that measures twenty-four by six feet when opened, one of the largest Gothic shrines extant (figs. 75, 76). The giant double-winged altar includes a carved shrine, predella, headpiece, and twenty-four painted panels. The sculptured parts of the altarpiece, including a *Crucifixion* with forty-four statues of prophets, saints, and apostles, were very likely designed if not partially carved by Bertram, and when the first wings are opened, twenty-four painted panels, a solid screen of color, are displayed with narratives placed in two rows, one over the other.

In the top row on the left the story of the Creation begins with the *Separation of Light and Darkness*, and it

71. *Marie, Duchess of Guelders* and the *Arrest of Christ*, from the *Book of Hours of Marie of Guelders*. 1415. Staatsbibliothek, West Berlin

curious *Annunciation* and a more traditional *Arrest of Christ* (cf. the paired scenes for matins in the *Hours of Jeanne d'Évreux* discussed above, p. 21). The smaller miniature of the *Arrest* with its stocky figures, ruddy faces, and suspended gestures cramped into a shallow space conforms to the style of other Dutch illustrations of the early fifteenth century, but the *Annunciation* is executed with the grace, aristocratic mannerism, and elegance of French miniatures such as those in the *Très Riches Heures*. Mary wears a long, flowing mantle of blue trimmed with white ermine that flutters from her elbow and is picked up in the train of her gown that overlaps the frame of the miniature. The delicate head of Mary and the dainty angels that fly to her also remind one of Parisian book illustration of the same period.

How does one explain this surprising juxtaposition of styles? Marie d'Harcourt, for whom the manuscript was destined, belonged to the inner circle of the Valois—her aunt was the wife of Charles V—and her marriage to Renaud IV of Guelders was arranged by Charles VI and Louis of Orléans in 1405 to strengthen the northern

boundaries against the expanding Burgundian empire. Marie inherited from the Valois, especially the duke of Berry with whom she corresponded, a fine taste for books. No doubt Marie brought to Guelders a refreshing breath of French taste in the arts, and perhaps this accounts for the mannered elegance of the *Annunciation* page, which, incidentally, is inserted into the manuscript.

Her Book of Hours was completed in the Augustinian monastery of Marienborn near Arnhem which belonged to the Brethren of the Common Life, and one could argue that the curious iconography of the *Annunciation* is in part due to a mystical identification of the patroness and the Virgin that is quite apparent. God the Father appears at the top of the page dispatching the Holy Ghost in the form of a dove. The angel that approaches the Madonna from the left carries a banderole, but the text does not carry the traditional greeting of "Ave Maria," but rather "O milde Maria" (Oh gracious Mary). The second angel has offered Mary a Book of Hours, which she reads in a garden and not the usual chamber. Finally, it

72. Dutch miniaturist of c. 1400. *John the Evangelist Before the One Enthroned and the Seven Churches of Asia*, from the *Paris Apocalypse*. c. 1400. Bibliothèque Nationale, Paris

illustrations for the Book of Revelation, such as the Angers tapestries (see p. 48), the *Paris Apocalypse* presents us with large full-page pictures in which several separate episodes are brought together in one unified setting rather than being isolated in a series. Opposite each illustration is the appropriate text written in Dutch. In all there are twenty-two miniatures more or less related to the twenty-two chapters of the Book of Revelation.

For chapter one the artist conflated four different episodes in a visionary landscape that revolves about the One enthroned in heaven (fig. 72). In the lower right John appears on the island of Patmos surprised by an angel with a scroll. To the left the artist added the colorful figure of the ferryman pushing off from the shores to assure us that John was exiled there. Above, surrounding the central figure, are the seven churches of Asia whom John first addressed, and the One in heaven whom he then described as enthroned behind seven lamps of gold with a two-edged sword issuing from his lips. Kneeling before him is John, repeated a second time: "I fell at his feet (1: 17)."

The treatment here not only resembles Dürer's method of conflation, but even the attempt to render the visionary in concrete forms anticipates his *Apocalypse* (see p. 323). While the various pictorial motifs may resemble dream images floating about the page in free association, and the sense of *horror vacui* leads the viewer to see it all as one colorful surface pattern, the bodies are solidly modeled and ruggedly characterized and the buildings recede with a sense of perspective. Thus there is an outright contradiction of a flat, allover surface pattern and objects rendered with bulk and dimension in space. And, like Dürer, the miniaturist realized the value of the use of white areas, here seen against smoky red and violet tints, that enhance the sensation of the mystical light in the heavens.

The panel paintings associated with this same general Mosan area are somewhat problematic. The *Norfolk Triptych*, today in the Boymans-van Beuningen Museum in Rotterdam, dating about 1415, is an excellent example of the selective adaptation of styles typical of Mosan art (fig. 73). The tiny altarpiece has been described, in fact, as "half Parisian, half Rhenish," and the hagiographic evidence provided by the numerous saints honored in the painted galleries of the central panel and wings points specifically to its production in the area of Liège and Maastricht. The central panel with a simulated Gothic tabernacle features the *Coronation of the Virgin* above a *Man of Sorrows*.

Later the complex meaning of the latter theme (*Schmerzensmann* in German, *Nood Gods* in Dutch) will be analyzed in detail, but more significant for this discussion is the style of the triptych. The delicate treatment of

should be noted that the elegant blue mantle and the elaborate headgear hardly comply with the usual costume of the Annunciate. Is this, in fact, the Virgin Mary or Marie d'Harcourt in the guise of the Madonna?

This identification normally would be unacceptable, but the circumstance of this marriage may help explain it. Part of the large dowry was paid by Louis of Orléans with the stipulation that it be returned in default of a male heir. After ten years of marriage to Renaud, Marie had no children, and it is known that noble wives who lacked sons often invoked the aid of Mary, mother of Christ. Hence the picture is not simply a narrative of the Annunciation but a portrait and invocation of Marie d'Harcourt's desire to bear a son.

In contrast to the elegance and grace of the *Annunciation* in the *Hours of Marie of Guelders* is the style of another important manuscript, the *Paris Apocalypse* (Paris, Bibliothèque Nationale, MS Néer. 3), dating about 1400, that Panofsky has localized in the nearby area of Liège and described as "the only genuine anticipation of Dürer's 'Apocalypse.'"[31] The comparison is, at first, a bit forced, but it is true that unlike other early cycles of

continues through the top twelve panels to the *Expulsion of Adam and Eve from Eden* and the *Labor of the First Parents* on the far right. The lower register resumes the drama of Genesis across six panels with the stories of the *Offering of Cain and Abel*, the *Murder of Abel*, the *Building of the Ark*, the *Sacrifice of Isaac, Jacob and Esau*, and *Jacob's Blessing*. The final six paintings are dedicated to the Infancy of Christ, from the *Annunciation* to the *Rest on the Flight into Egypt* in the lower right. Although attempts have been made to read some special meaning in this narrative sequence as a program of Old and New Testament typology, it is unlikely. Individual panels have unusual iconographic features, to be sure, but the whole scheme is simply that of the additive, narrative cycles of the earlier Middle Ages with an appendix of New Testament scenes of the Infancy.

One's first impression of the paintings is that they resemble enlarged miniatures with a direct statement of the narrative presented in bright colors against a golden background. The scenes are reduced to the essential elements, and the stout figures are large and rendered with very simple contours. The bulky draperies are softly modeled in long arcs adding to the monumentality, and gestures and movements are restrained to enhance the physical presence of the weighty figures. There is little indication of space or setting with the exception of an occasional tabernacle added artificially above the actors to indicate an interior setting. In these features Master Bertram's paintings do, in fact, bring to mind the voluminous, simplified figures of Master Theodoric of Prague, and the flesh parts—the tubular fingers, the simplified, doll-like heads with oval contours, sleepy eyes, and tiny mouths—resemble those of the iconic portrayals of the saints in the Chapel of the Holy Cross in Karlštejn. To what extent these similarities can be explained as the result of some direct association of the two masters or simply as provincial qualities in their works that appear in many early German paintings is difficult to assess.

There is definite charm in the naïveté of these compositions that makes Master Bertram's art endearing. In the *Annunciation* the figure of God the Father dissolves in the golden background, his features lightly sketched in red, suggesting his pure being. Gabriel has a modeled head seen in harsh profile, but his mantle merges with the gold and is modeled with the same soft red tints, perhaps alluding to the angel as someone between human and divine natures. The tiny figure of a nude infant carrying a cross follows the dove of the Holy Ghost dispatched by the Father in heaven.

The composition is effective with softly flowing arcs and circles in the wings of the angel, the contours of the figures, and the banderole which ride over the harsher diagonals formed by the *prie-dieu*, the bookstand (and Mary has a good number of books to read), and the emphatic diagonal line of the dove and the Child that issues from the top left corner. Master Bertram's childlike style had an immediate impact on the artists of Hamburg and its environs that lasted for two generations, after which the style of another artist who settled in Hamburg from the Lower Rhine, Master Francke, became the model for North German painters.

Cologne, lying some sixty miles east of Maastricht, was the largest city and cultural hub of the Middle Rhine. From Carolingian times, Cologne was the archbishopric of the See that included the diocese of Liège, Utrecht, Münster, and Minden. After joining the Hanseatic League in the thirteenth century, Cologne became a thriving commercial center, and due to its ecclesiastical status and excellent cathedral schools, it became one of the most active and influential religious centers in the Rhineland as well. The guilds, including that of the painters, were powerful political forces and after 1396 regularly elected their members to the city government.

Two important points of history in the religious life of Cologne were the acquisition in 1164 of relics of the three Magi from Milan that were to be housed in the sacristy of the cathedral later in the fourteenth century and the rapid development of a school of mysticism promoted by Master Eckhardt and other leading theologians who taught and preached regularly in Cologne. Later in the fifteenth century, about 1475, the first Confraternity of the Rosary, a direct product of this mystical devotion, was founded in Cologne and rapidly spread to Haarlem in Holland and Douai in the South Netherlands. The nature of this mystical devotion and its impact on the arts of Cologne will be discussed in detail below.

One main project was the building of the cathedral in the style of French Gothic architecture. The cornerstone was laid in 1248, the sanctuary was finished in 1322, and the nave was completed in 1388, the year the University of Cologne was founded. The project was so ambitious with its huge towering facade, however, that work on the cathedral was not finished until the nineteenth century. The statues of Christ, Mary, and the apostles that were placed in the choir, built between 1322 and 1330, are typical examples of Cologne's dependence on French Gothic (fig. 15). The dimpled faces that smile down at us are derived ultimately from the Smiling Angel Master of Reims, but their features are exaggerated to the point of cuteness, and the bodies are thin and tall and sway with a pronounced "S" curve that allows the draperies to fall gracefully from their weightless bodies as if they were costumes hanging from a rack. This extreme manneristic treatment of the thirteenth-century model parallels a similar development in Paris, and their closest counter-

part is the *White Virgin* in Notre Dame, Paris, dating about 1320.

The same strong dependence on French Gothic can be noted in one of the earliest panel paintings in Cologne, an *Annunciation* dated 1300–1310 (fig. 77). Gabriel and Mary, placed against a tooled gold background, stand on the lower border of the panel and completely fill the field. Their mantles, delicately modeled and outlined in black, suggest that they were based on manuscript models, and, above all, their faces have the coy, diminutive features with tapered eyes and rosebud lips that are hallmarks of French Gothic miniatures. The Cologne artist displays a keen sense of design in the manner in which the angel's wings complement the frame and in smaller touches such as the way in which the curious spout added to the vase of lilies curves upward toward the Virgin, echoing the lines of the banderole carried by the angel.

Toward the end of the fourteenth century a very distinctive personality emerges from the guild artists in Cologne. This painter, the Master of Saint Veronica (Hermann Wynrich von Wesel?), executed a number of panels, including a new type of historiated *Crucifixion*, that were very influential in establishing a lasting style in

78. MASTER OF SAINT VERONICA. *Saint Veronica*. c. 1400. Panel, 30⅜ × 18⅞″. Alte Pinakothek, Munich

Cologne. The work from which he takes his name, the *Saint Veronica* in Munich (fig. 78), dating about 1400, was much praised by Goethe for its serene beauty and pious expression and became a model for German Romantic artists in the nineteenth century. Veronica, seen against a gold background, holds before her a huge sudarium, or veil, with an oversized face of Christ wearing a crown of thorns imprinted on it. Groups of three tiny angels sit in the lower corners, right and left, singing like young choirboys. The image of the sudarium of Saint Veronica established a type of *Andachtsbild* that became extremely popular in Cologne.

The veil of Veronica is usually associated with the narrative of the Carrying of the Cross, where she stops to dry the face of Christ and the imprint of his features is stained into it, but in this instance the subject seems also to refer to the *vera icon* (true icon), from which the name Veronica is derived, of the face of Christ as related in Jacobus de Voragine's *Legenda Aurea* (*Golden Legend*): "As Jesus was always travelling about to preach, and I [Veronica] could not always enjoy His presence, I once was on my way to a painter to have the Master's portrait drawn

77. MASTER OF THE COLOGNE ANNUNCIATION. *Annunciation*. c. 1300–1310. Panel, 17⅛ × 14″. Wallraf-Richartz Museum, Cologne

on a cloth which I bore with me. And the Lord met me in the way, and learning what I was about, pressed the cloth against His face, and left His image upon it.''[33]

The composition is simple and yet a certain subtlety underlies its abstraction. The hieratic scale and perfect symmetry induce a magnetic attraction to the head of Christ. His features are modeled in dark tones. The costumes of Veronica and the angels are of soft pastel shades, and these pure colors are seen against the white of the cloth and the bright gold of the background, creating a restful and quiet harmony to the starkness of Christ's features.

The head of Veronica is the ideal Cologne female type. The mannerisms of the early French Gothic faces completely relax into a serene expression of absolute quietism and a sweet-sad modesty suggested by the heavy-lidded and downcast eyes. The mouth is no longer a pinched rosebud, but a delicate and articulate shape. The ideal of feminism in Cologne became an image of submission and humility appropriate for a religious community steeped in negative mysticism.

The Veronica Master had a number of followers. One of these executed the charming panel of the *Madonna Enthroned Between Saints* in the Johnson Collection in Philadelphia (fig. 79). Seven female and five male saints are grouped about Mary in an open court. To the left, reading upward, are seated Saints Catherine, Barbara, Clare, and Mary Magdalen, and standing behind them are Saints Peter and Paul. To the right are Saints George, Margaret, Agnes, and Cecilia (?), and standing are Saints John the Evangelist and John the Baptist. The relaxed symmetry and use of pure color evoke an image of quietism and harmony in the gentle rotary movement of images about the Virgin and Child.

The theme of the Philadelphia panel is closely related to that of one of the most popular of all early Rhenish paintings, the *Garden of Paradise* (*Paradiesesgärtlein*) in Frankfort, dating about 1410–20 (colorplate 13). Here again the Virgin and her Child are in the company of female and male saints, but now within a *hortus conclusus* which symbolizes Mary's purity and virginity. The female saints comport themselves to the left. Saint Dorothy (?) picks cherries from a tree with a twisted trunk; another virgin scoops water from a well, the familiar image of the purifying waters of gardens; while Cecilia tenderly offers her stringed instrument to the playful Christ Child, who has left his mother sitting on a huge red cushion just beyond, reading a book. An octagonal table with fruit and a glass of refreshment is placed to the right of Mary, and below, in the corner, rest three militant saints—the world of evil has been conquered and tamed by them—looking like young cadets home from military academy. George, wearing chain mail, sits above

his slain dragon, here reduced to a stuffed toy, while Michael muses over the monkey, a symbol of man's lust, chained to the tree. Behind the two seated saints stands another, perhaps Sebastian.

The charm of the painting lies in its tapestry-like colors. The garden resembles the popular millefleurs tapestries of French Gothic, and no doubt symbolic meanings can be associated with the numerous varieties of flora. The relaxed informality of the composition also lends the little panel a certain comforting and dreamy playfulness. The garden motif, whether it be the garden of Eden or the garden of love, was very popular throughout the Gothic world in art, literature, and music. It must always have its protecting walls, so that it is closed off from the real world, its fountains or waters that are pure, its trees and flowers for refreshment. As an image of paradise it is the proper retreat for the virgin maidens, who playfully enjoy themselves under the guard of the soldier saints, who keep their distance (and, in fact, seem a bit bored here). Mary, crowned queen, and her attendants rest in peace, and the courtly flavor of the love poetry of

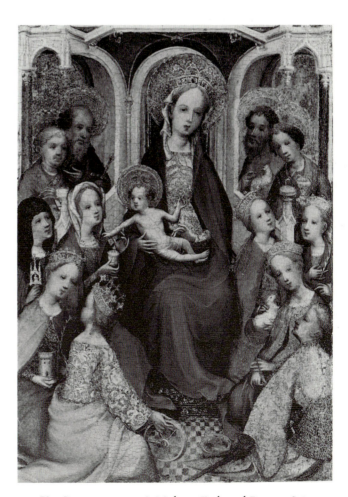

79. Cologne painter? *Madonna Enthroned Between Saints.* c. 1410–20. Panel, 13¼ × 9¼″. The John G. Johnson Collection, Philadelphia

80. FOLLOWER OF THE SAINT VERONICA MASTER. *Holy Kinship.*
c. 1420. Panel, 33⅝ × 37⅜″. Wallraf-Richartz Museum,
Cologne

the secular world is faintly echoed in the little masterpiece. Formerly the Frankfort panel was attributed to the school of Cologne, but more recently scholars have provided good evidence, based on subtleties of stylistic details such as head types, to place the painting in the Upper Rhine area, possibly in Basel.

Another interesting variation on the theme of the closed garden is the *Holy Kinship,* painted by a close follower of the Veronica Master (fig. 80). The subject matter is a new one but typically Rhenish in sentiment. Rather than commemorating the royal lineage of Christ as the popular French Tree of Jesse did for the High Gothic period, the Holy Kinship was a portrayal of the immediate family of Christ and Mary depicting a comforting reunion of brothers, sisters, aunts, uncles, and cousins.

The legend arose in northern Europe during the course of the twelfth century, and the intimate family relationships, based for the most part on mistranslations of Greek into Latin of the numerous "brethren" of Christ mentioned in the Gospels, accredited Anna with three marriages (*trinubium Annae*). Particularly popular in the Mosan-Rhenish area, the legend was expanded to include a cadet branch, which added Elizabeth and John the Baptist (Elizabeth was mentioned as a "cousin" of Mary in the Gospels) as well as three generations of relatives ending with Saint Servatius, bishop of Tongeren and Maastricht.

The ladies are seated on a grassy bench within a low

garden wall. The husbands appear behind them, apparently chatting about their families or whatever men discuss at such reunions. In the center are Anna, Mary, and the Christ Child, with Joachim (Anna's first husband) and Joseph directly behind them. To the left are gathered the other offspring of Anna, all named Mary, with their children and husbands. According to the legend, Anna married Cleophas after the death of Joachim and bore him Mary Cleophae. She in turn was betrothed to Alphaeus and gave birth to Judas Thaddeus, Joseph the Just, Simon, and James the Less. Following the death of Cleophas, Anna took a third husband, Salomas, by whom she bore Mary Salome, wife of Zebedee and mother of James the Great and John the Evangelist. An illustrious but cozy family of Christ and his apostle-cousins thus resulted.

To the right is the cadet branch of the family. Next to Mary sits Elizabeth, her "cousin," holding her son John the Baptist, who gestures eagerly toward Christ: "Behold the Lamb of God." Beside Elizabeth are her relatives Esmeria and Emilia, who holds the infant Servatius, and behind are the male members including Zacharias (Elizabeth's husband), Efra (?), Eliud, and Emin, father of Servatius. The unusual legend had a lasting appeal in the Rhineland, as we shall see, until the Council of Trent put an end to the spurious genealogy. Rather than confronting the worshiper with a hieratic and pompous display of kings seated in a decorative Tree of Jesse, the Holy Kinship presented them with a folksy and *gemütlich* gathering of a close-knit family whose mothers and fathers chat and gossip while their children play about them.[34]

A painter closely related to the Cologne artists but a personality in his own right, Konrad von Soest, had an atelier in Dortmund, seventy-five miles east of Cologne. His name appears in the records of a religious confraternity in Dortmund from 1413 to 1422, and there is evidence that his family had resided there for over a hundred years. For the parish church in nearby Niederwildungen, Konrad painted an impressive triptych with a *Crucifixion* flanked on either side by superimposed scenes of the *Last Supper* and *Resurrection,* left, and the *Prayer in the Garden of Gethsemane* and *Pentecost,* right (fig. 81).

An inscription informs us that Konrad painted the altarpiece in 1404, although there is some controversy in reading the date. The centerpiece, the *Crucifixion,* is closely related to one executed by the Master of Saint Veronica. It is a historiated type (as opposed to the iconic) very popular in Germany throughout the fifteenth century in which the scene is crowded with details from the Gospel accounts and includes the motif of the centurion, Longinus, plunging his lance into the side of Christ. According to legend related in Voragine's *Legenda Aurea,*

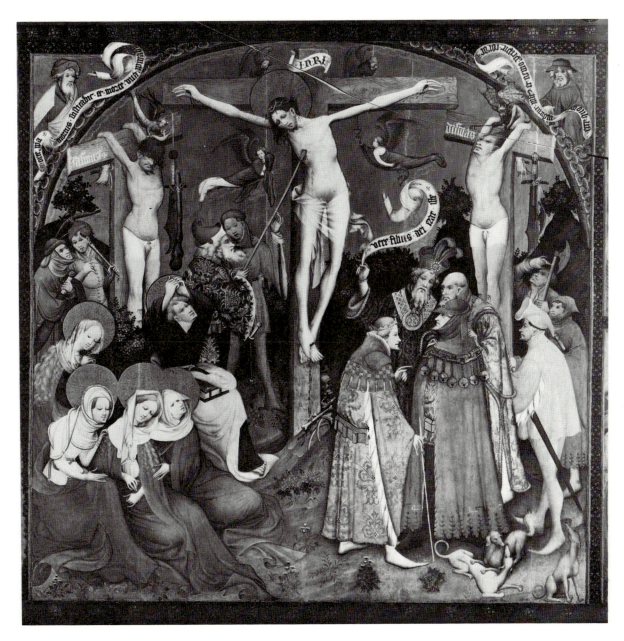

81. KONRAD VON
SOEST. *Crucifixion*,
from the
*Niederwildungen
Altarpiece*. 1403?
Panel, height
78¾". Church,
Niederwildungen

blood spurted from the wound inflicted by Longinus into his one blinded eye and restored his vision. Thus the Roman soldier was converted to Christianity. The two thieves are also presented along with a group of five of the faithful, including Mary and John the Evangelist, to the left of the cross and a throng of ornately dressed tormentors boldly standing to the right. Four mourning angels fly about the head of Christ, one catching blood in a chalice as it drips from his pierced arm.

The composition is much the same as that of earlier Cologne artists, but important differences are to be noted. In contrast to them, Konrad von Soest exploits the emotional drama of the event by placing the figures of the mourners on the ground comforting the swooning Madonna while John clutches his hands and looks upward in despair. The bodies of the two thieves are contorted, and Christ's torso twists painfully off to the

right. The villainous role of the soldiers and other tormentors, who are bedecked in some of the most ornate costumes of the International Style, is forcefully presented in profile. They stand erect with their harsh, pointed features prominently displayed in contrast to the mourners, to the left, who are simply clad and form a closely knit group described in a softly undulating system of curves and arcs that underscores the pathetic posture of the swooning Mary. Konrad's treatment of space and scale is more convincing than his Cologne models, and the ground, although cluttered with objects and people, recedes more naturally. This harsher treatment of the staffage, the expressive distortions, and the realism in the *Niederwildungen Altarpiece* distinguish it from the productions in Cologne.

In this altarpiece, and in others attributed to Konrad von Soest, scholars have discerned the influence of Pari-

82. MASTER FRANCKE. *Carrying of the Cross*, from the *Englandfahrer Altarpiece*. 1424. Panel, 39 × 35″. Kunsthalle, Hamburg

sian artists, especially in the bright colors and decorative effects, and some have even suggested that he must have had some training in France. These arguments are not convincing. Any reflections of the courtly French style could well have been transmitted through the medium of manuscript illuminations.

A similar confusion over stylistic sources characterizes the scholarship of one of the most gifted of early Rhenish artists, Master Francke. His extant works are few and late paintings at that, executed after the artist had settled in Hamburg. The appeal of his art in Hamburg was overwhelming, and the earlier style of Master Bertram, who had dominated the ateliers until Francke's arrival, was soon considered passé and archaic. What Francke brought to Hamburg was an art nurtured on the developments of French book illustrations and the paintings of the Rhineland, although it is uncertain just where he received his training.

Generally it is argued that he worked in Paris for some time, absorbing the technical and stylistic developments of the leading illuminators there. It has also been suggested that he was influenced by the art of Konrad of Soest, but any direct link to Master Francke's sources is wanting. The problem was thoroughly reviewed by Bella Martens (1929) and more recently by Heinrich Reineke (1959).[35] Martens found evidence to identify Master Francke with a painter, Frater Franco of Zutphen in

Guelderland, a town lying some twenty-five miles northwest of Arnhem, and Reineke's research led him to conclude that the artist was a member of the Dominican community in Hamburg.

Although there are a number of contradictory aspects concerning his actual birthplace, these identifications make sense in a number of respects. For one thing, he apparently had no workshop and trained no apprentices in the guild; for another, his art has an intense spiritual content that swings between the poles of religious experience, the joys of the Infancy and the agony of the Passion, that suggests that the artist was a man of deep religious convictions.

Nowhere is this pious sentiment better revealed than in his huge altarpiece painted for the company of the merchants in Hamburg who traded with England, the so-called *Englandfahrer Altarpiece*, originally placed in their chapel in the Church of Saint John in Hamburg after its completion in 1424 (colorplate 14). When closed, the double-winged altarpiece displayed four scenes of the Infancy of Christ above four relating the martyrdom of Saint Thomas à Becket, the patron saint of the company.

The exquisite *Nativity* (actually *Mary Adoring the Newborn*) has a tenderness and charm that surpass other representations of the Holy Night and is equaled only by the famous *Night Nativity* of Geertgen tot Sint Jans painted in the late fifteenth century (see p. 178). The faces of the

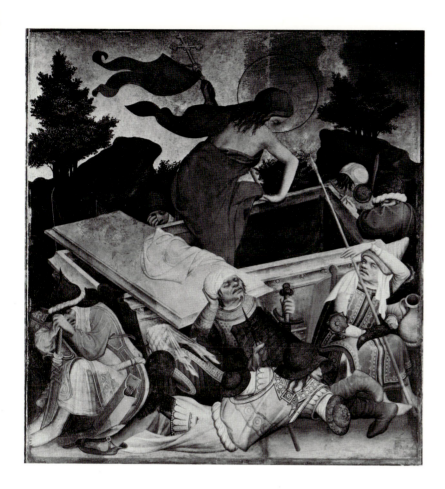

83. MASTER FRANCKE. *Resurrection*, from the *Englandfahrer Altarpiece*. 1424. Panel, 39 × 35⅛″. Kunsthalle, Hamburg

Virgin and the angels bring to mind Konrad von Soest, and the hushed quietism evokes moods that we associate with the Veronica Master and the early Cologne school. The red sky, sparkling with golden stars, is symbolic of the coming Passion, but it in no way detracts from the nocturnal effect.

Other aspects of the iconography are enigmatic. Mary, dressed in white, kneels before her newborn, who lies naked on the ground with rays of golden light radiating from his body. Three small angels lift Mary's discarded mantle to form an enclosure as they attend her in adoration. Above, in a cloudy opening in the heavens, appears God the Father with seven sprays of light issuing from his lips down to the Child. On the steep hillside to the right, figures of shepherds can barely be discerned in the darkness that is suddenly broken by the tiny phosphorescent angel who announces the birth. In place of the usual shed for the *Nativity*, Master Francke reverted to the earlier Byzantine grotto. The ox and ass feed from a trough in the lower right, resembling stage props.

Master Francke must have had recourse to different textual sources for his interpretation of the night *Nativity*, and one of these would have been some mystical narrative related to the *Revelationes* of Saint Bridget, who tells us that the birth took place at night in a grotto and that Mary, dressed in white, knelt before her nude son, whose mystical radiance surpassed any natural lights of

this world including that of the candle that Joseph held nearby. But where is Joseph? According to Bridget, Joseph removed himself from the cave soon after the birth to allow Mary to spend time alone in adoration of her Child. A banderole issues from the Virgin's lips informing us of what her loving adoration is about: "My Lord, My Son."

In contrast to the serene and tender sentiment of the *Nativity*, the scenes of the Passion (figs. 82, 83), displayed when the altarpiece was opened for special days of the church year, are of a totally different style and expression. There is nothing hushed and subdued in the *Carrying of the Cross*. Rather, it is the brutality and agony of the torturous trip to Golgotha that is depicted. The harsh diagonals of the cross set the tempo with the crushed body of Christ bent under its weight and the vile henchmen pulling, pushing, and leering at their victim in a most grotesque fashion. Their stocky proportions and shaggy costumes reduce them to little more than animals swarming about their prey, and the exaggerated, pinched profiles convey even more alarmingly the baseness of a mad mob on the rampage.

Surprising too is Master Francke's version of the *Resurrection*. This is no mysterious vision of a majestic Christ who floats heavenward as the Bohemian Master of the Třeboň Altarpiece presented it (see colorplate 3), but rather a very physical act with Christ, his back turned to

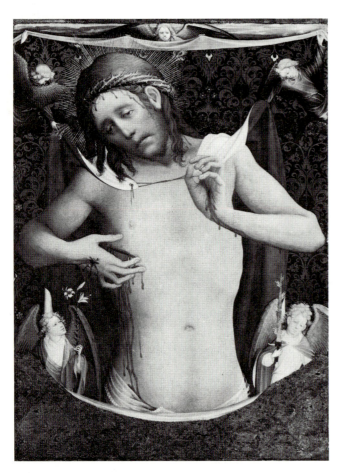

84. MASTER FRANCKE. *Christ as Man of Sorrows*. c. 1425–30.
Panel, 36⅜ × 26⅜″. Kunsthalle, Hamburg

ter Francke's *Crucifixion* for the *Englandfahrer Altarpiece* was the historiated type that one usually encounters in Rhenish art.

In one of his last works, painted about 1425–30, *Christ as Man of Sorrows*, Master Francke ennobled the grotesque with a gentle serenity (fig. 84). This strange theme, an *Andachtsbild* which we have encountered before (see p. 16), has a complicated background which has been traced to the miraculous vision of Pope Gregory the Great (sixth century) when, during Mass, the actual body of the crucified Christ pouring blood appeared on the altar as a sign of the miracle of transubstantiation, that the host and the wine in the chalice were truly the body and blood of the Savior. The vision was recorded in an iconic portrayal of the torso of the nude Christ, head inclined and arms crossed before him. Later an engraving by Israhel van Meckenem (see pp. 289–90) that copies the famous icon will be discussed.

The Hamburg version of the *Man of Sorrows* differs from the traditional *Andachtsbild* in important details. A cloth of honor carried by three tiny angels replaces the usual abstract background. The torso of Christ is draped from behind by a mantle held up by two of the angels. Christ's head is crowned with thorns and his right hand indicates the gaping wound in his side made by the lance of Longinus. His left hand is raised, displaying the puncture mark of the nail. Below, two angels lift a crescent curtain across his loins and in their hands they carry a branch of lilies, left, and a sword, right. It was common in High Gothic sculptured representations of the Last Judgment to find just such a suffering Christ appearing as the supreme judge of mankind associated with the words, "Behold what I have suffered for you; what have you suffered for me?"

Master Francke has brought these two traditions together in this haunting painting. The figure of Christ conforms to that in the vision of Saint Gregory, as testimony to the validity of transubstantiation of the elements of the Eucharist, and the angels carrying the lilies and the sword, "judgment tempered by mercy," long associated with the Last Judgment, and the cloth of honor held up behind him, point out the role of the Man of Sorrows as the judge of mankind in his Second Coming.

In many respects the art of Master Francke epitomizes the International Style of the Rhenish-Mosan crescent. His mystical expression swings between two poles, that of the expressionistic *Andachtsbild*, on the one hand, and the radiant colorism of quiet mysticism, on the other. During the course of the fifteenth century, the artists of the Rhineland will come more and more under the influence of the *ars nova* created by the next generations of painters who settled in the provinces of Flanders.

us, pushing himself up from the tomb and stepping out amid the throng of sleeping guards, only one of whom seems to have been awakened by Christ's efforts. It may seem strange that the mystical content is reversed in Master Francke's painting with the human and mundane aspects of the Passion stressed, but this is in keeping with the brand of mysticism in the Rhineland promoted by Tauler, Suso, and mystics who counted every drop of blood on Christ's body during his execution. It also conforms to the violent distortions frequently encountered in Rhenish *Andachtsbilder* such as the *Vesperbild*, where Christ's broken body with blood gushing from his wounds creates a disturbing but effective image for the contemplation of the agony of his death.

The central panel of the altarpiece when opened was a huge *Crucifixion* of which only a fragment from the lower left corner, the mourning followers of Christ, survives. From this detail, however, we can detect that Master Francke's composition was essentially the same as that of Konrad von Soest's Niederwildungen *Crucifixion*, discussed above. The female mourners and the young Saint John are huddled together on the ground in much the same way in both. It thus seems very likely that Mas-

PART TWO

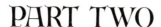

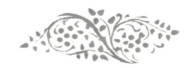

Painting, Graphics, and Sculpture in The Netherlands, Germany, and France from 1425 to 1500

<p style="text-align:center">V.</p>

Jan van Eyck

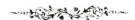

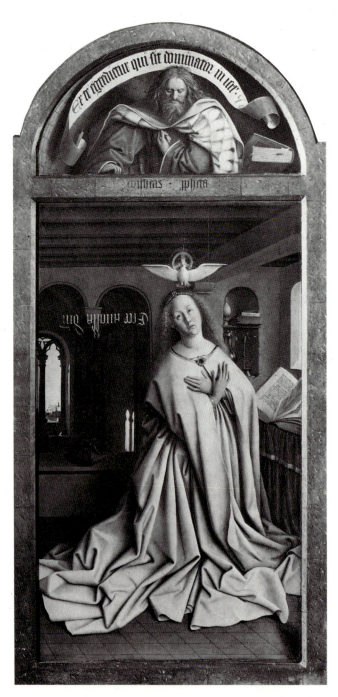

85. JAN AND HUBERT VAN EYCK. *Annunciate Virgin*, from the *Altarpiece of the Lamb* (see colorplate 15)

And smiling she said: I much wish to know, since we are on the subject, what Flemish painting may be and whom it pleases, for it seems to me more devout than that in the Italian manner.

Flemish painting, slowly answered the painter, will generally speaking, Signora, please the devout better than any painting of Italy, which will never cause him to shed a tear, whereas that of Flanders will cause him to shed many; and that not through the vigour and goodness of the painting but owing to the goodness of the devout person. It will appeal to women, especially to the very old and the very young, and also to monks and nuns and to certain noblemen who have no sense of true harmony. In Flanders they paint with a view to external exactness or such things as may cheer you and of which you cannot speak ill, as for example saints and prophets. They paint stuffs and masonry, the green grass of the fields, the shadow of trees, and rivers and bridges, which they call landscapes, with many figures on this side and many figures on that. And all this, though it pleases some persons, is done without reason or art, without symmetry or proportion, without skilful choice of boldness and, finally, without substance or vigour. Nevertheless there are countries where they paint worse than in Flanders. And I do not speak so ill of Flemish painting because it is all bad but because it attempts to do so many things well (each one of which would suffice for greatness) that it does none well.[1]

Thus spoke Michelangelo to the gracious and learned Vittoria Colonna, according to Francisco de Hollanda in his *De Pintura Antigua* (*Dialogues on Painting*, 1548). Michelangelo's critique of Flemish art may seem, at first, damning and harsh, but his words are to the point and sharply focus on the two qualities that distinguish it from Italian painting: It awakens the emotions of the pious, causing them to shed many a tear, and it records in great detail such things as landscapes. Indeed, the Florentine's remarks seem to be directed at the two honored "princes" of Northern painting, Jan van Eyck and Ro-

gier van der Weyden. It was Van Eyck who established the meticulous style, sometimes characterized as ''microscopic-telescopic vision,'' that amazingly records the ''external exactness'' of things. And it was Rogier van der Weyden who invented the tears that flow down the cheeks of his grieving mourners in scenes of the Passion, imploring the compassion of the viewer.

Surprisingly, the first praises of Van Eyck and Rogier came from Italian humanists, historians, and artists of the fifteenth century.[2] The antiquarian and explorer Cyriacus of Ancona, writing about 1450, lists among the most renowned painters of his time one ''Joannen praeclarum Brugiensem'' (the famous Jan of Bruges) and ''Rugerius in Brusella'' (Rogier in Brussels). About 1456, Bartolommeo Facio, in his *De viris illustribus* (*Book of Famous Men*), described ''Jan of Gaul'' as the ''prince of painters'' of his time, recalling paintings he had seen where not only execution of the figures testified to the perfection of his art but also the treatment of landscapes and mirrors. Antonio Filarete, the famous architect, discussed at length the excellent works painted by Master ''Giovanni da Bruggia'' and ''Master Ruggieri'' in his *Trattato della Architettura* (*Treatise on Architecture*) written in 1461, in which a new manner of mixing pigments in oil was applied that was later named the invention of Jan van Eyck by the art historian Giorgio Vasari (*Le vite [Lives of the Artists]*, 1550), initiating a legend that was to be perpetuated until very recent times.

For those who had actually visited Flanders, however, all praises were directed at one of the great masterpieces of Flemish art, the *Altarpiece of the Lamb* in Ghent by Hubert and Jan van Eyck (colorplates 15, 16; figs. 85–89). A doctor from Nuremberg, Hieronymus Münzer, described it in his diary in 1495 and especially praised the panels of *Adam* and *Eve*. Also from Nuremberg, the great Albrecht Dürer recorded in his diary of April 10, 1521, that he had viewed the rich and costly altar by Jan with the fine figures of Eve, Mary, and God the Father. A few years earlier, 1517–18, the cardinal Luigi d'Aragona traveled extensively throughout northern Europe, and his secretary, Don Antonio de Beatis, recorded his enthusiasm for the great Ghent altarpiece, which according to the canon who was their guide in the church where the polyptych was placed, was made by a master from Germany named Robertus who died and left its completion to his brother, ''also a great painter.'' The ''maestro Roberto'' was no doubt the ''meester Hubertus'' van Eyck mentioned in later Flemish chronicles as the elder brother of Jan (see especially Marcus van Vaernewyck, *De Historie van Belgis*, Ghent, 1568).

In 1550 the altarpiece was cleaned and restored by two leading painters of the time, Lancelot Blondeel of Bruges and Jan van Scorel of Utrecht, and it was probably at

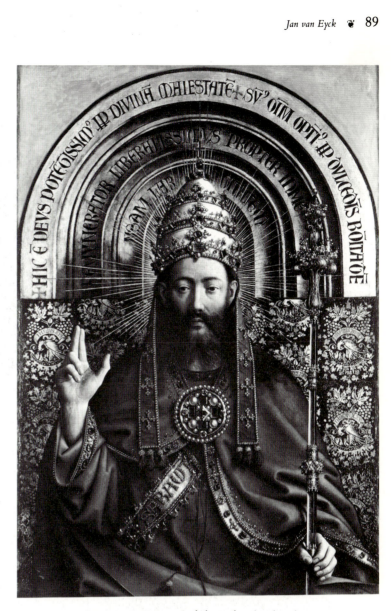

86. JAN AND HUBERT VAN EYCK. *God the Father* (head and upper torso), from the *Altarpiece of the Lamb* (see colorplate 16)

that time that an inscription on the frame was uncovered, a quatrain that still appears in a questionable state of preservation on the outside of the lower frame:

Pictor Hubertus e Eyck • maior quo nemo repertus
Incepit • pondus • q[ue] Johannes arte secundus
[Frater perfunctus] • Judoci Vijd prece fretus •
Versu sexta mai • vos collocat acta tueri.

This unusual refrain has been variously read and interpreted, and, in fact, some authorities have questioned the accepted spelling of certain words (*pictor* has been read as *fictor* by one scholar), but the generally accepted translation reads:

The painter Hubert van Eyck, greater than whom no one was found, began [this work]; and Jan, his brother, second in art, having carried through the task at the expense of Jodocus Vyd, invites you by this

verse, on the sixth of May, to look at what has been done.

The year 1432 is given in the red chronogram of the last line, here underscored.[3]

Hubert van Eyck died sometime before September 18, 1426, when his heirs were taxed for properties he left behind in Ghent. Very little is known about his activity other than that he headed an atelier in Ghent, and no works, other than the Ghent altarpiece, bear a signature or certain ascription to him. In fact, some have considered Hubert a fictitious figure invented by Ghent patriots in the sixteenth century to rival "Jan of Bruges." The only painting generally accepted as a work by his hand is the *Three Marys at the Tomb* in Rotterdam (fig. 90), which certainly appears at first sight to be early "Eyckian" in style. Strong reminiscences of the International Style appear in the treatment of some of the draperies and in the somewhat archaic juncture of the foreground and the distant landscape by the rocky coulisses. However, the heavily restored panel in Rotterdam remains an enigma and can by no means be considered a starting point for establishing Hubert's style.[4]

Jan van Eyck arrived in Flanders in May 1425 to join the court of Philip the Good in Bruges as a special *valet de chambre*. His activities as a court artist are well documented, and aside from being the duke's official painter,

he also was a regular member of embassies that made a number of "distant and secret journeys" for the duke in 1426, 1427, and a lengthy sojourn in Portugal and Spain from October 1428 to Christmas 1429. If then we assume that Jan had inherited the project left unfinished by Hubert in Ghent, we have only the short period between January 1430 and May 1432 for his participation in the completion of the Ghent altarpiece. Because of the vast scale and complexity of the polyptych, it would seem that the various panels that make up the work were in relatively advanced stages of completion when left in the deceased brother's studio. Why they would have been stored away so long, from 1426 to 1430, is a perplexing question. No works by Jan (aside from the Ghent altarpiece) are dated before 1433, and attempts to sort out his juvenalia have created more problems than they have solved, as we shall see later. Hence, when looking at the Ghent altarpiece we have very little to go on in determining the division of hands of the brothers. There are no other certain works by Hubert, and none of Jan's can be considered as acceptable precursors of the giant polyptych.

Not only the stylistic issues raised by the collaboration in the work (and it must be remembered that the panels were damaged and restored on at least six occasions), but the iconographic program of the whole is perplexing. Early accounts refer to it as the Altar of Adam and Eve, the allegory of the Beatitudes, the Ascension of the Ma-

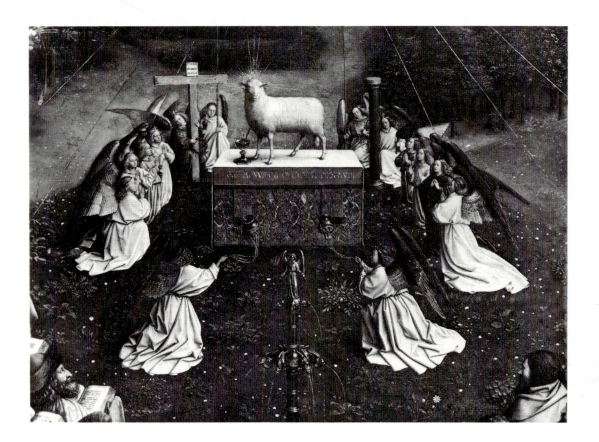

87. JAN AND HUBERT VAN EYCK. Lamb on the altar, from the *Altarpiece of the Lamb* (see colorplate 16)

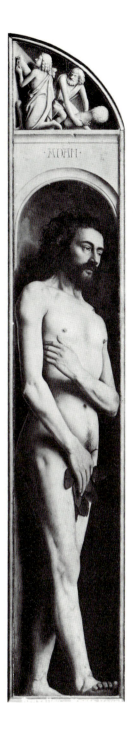

left: 88. JAN AND HUBERT VAN EYCK. *Adam* and *Eve,* from the *Altarpiece of the Lamb* (see colorplate 16)

below: 89. JAN AND HUBERT VAN EYCK. Singing angels, from the *Altarpiece of the Lamb* (see colorplate 16)

donna, the Triumph of the Lamb of God, or, most accurately, the Glorification of God and All Saints. And just as the problems of the hands in the altarpiece have not been resolved, so the encyclopedic program presented remains, in part, a mystery in spite of numerous attempts to pin down precise texts for its inspiration. Recent theories that the subject matter was programmed by some erudite theologian who had special knowledge of the literature of Rhenish mystics such as Hildegard of Bingen and Rupertus of Deutz are helpful but too restrictive. As we shall see, Jan van Eyck himself was such a learned scholar of theology.[5]

At first glance, the interior of the Ghent altarpiece resembles two independent sets of panels stacked atop one another. In the upper register, the central corpus portrays

God the Father with Mary and John the Baptist enthroned within a sumptuous golden shrine. On the inner pair of wings, right and left, are angels seen against a blue sky, singing and playing musical instruments, and in the end panels of the upper zone appear the nude figures of Adam and Eve standing in slim stone niches. Above Adam is a grisaille representation of the Offering of Cain and Abel, and above Eve is the Murder of Abel. No single textual source accounts for the presence of these various figures aligned in a single row in this fashion, although it has been pointed out that the central group resembles the familiar Byzantine representation of the Deësis where Mary and John intercede for mankind before Christ. Indeed, similar elaborations on the theme of the Deësis appear in large altarpieces in Italian trecento

90. COPY AFTER
HUBERT VAN EYCK?
*Three Marys at the
Tomb.* c. 1440.
Panel, 28⅛ × 35″.
Museum
Boymans-van
Beuningen,
Rotterdam

art such as Andrea Orcagna's *Strozzi Altarpiece* in Florence.

Across five panels in the lower register the Adoration of the Lamb by the rank and file of saints takes place in the verdant pastures of paradise. In the broad centerpiece the lamb stands on an altar; from a wound in its side blood pours into a chalice. Immediately about the altar are small angels presiding as altar boys at a Mass. The Eucharistic symbolism of this central motif is further enhanced by references to the Trinity and Baptism on the central axis. Above the lamb, the Holy Ghost in the form of the dove descends within a resplendent aureole, and below is an octagonal baptismal font, the *fons vitae.* To the right of the font are gathered the apostles and numerous red-robed martyrs. To the left are the blessed Old Testament and pagan peoples who lived in the era before Christ's coming. Beyond them, in the sloping meadows of the distant landscape, a procession of confessors dressed in blue emerges from an orchard, and opposite them, on the right, Virgin martyrs carrying palm branches approach the mount with the lamb. Other categories of saints are relegated to the four side panels. The Just Judges (following the inscription on the frame, *Iusti Iudices*) and the Holy Warriors (*Cristi Milites*) appear on horseback against a rocky landscape on the left, and to

the right of the central panel the Holy Hermits (*Heremite*) and Holy Pilgrims (*Peregrinis sancti*) proceed on foot through the sands of a Mediterranean desert. Except for the Just Judges, the groups of holy people are those familiar in most medieval categories of sainthood.

The textual sources for the lower panels are well known. The Adoration of the Lamb by All Saints is described in the great Mass in heaven in several passages of the Book of Revelation. Chapter 5, the Adoration of the Lamb, is the main reading for the vigil of All Saints' Day, November 1 (All Hallows' Eve or Halloween is the preceding evening), and other images culled from the Apocalypse appear in details such as the *fons vitae* and the river of the water of life flowing from the throne of the lamb (cf. Revelation 5, 7, 8, and 22). The glorification of the lamb in the divine Mass held in heaven by the multitude was a familiar image in service books from Carolingian times, when the feast was first introduced. Here the divine Mass in heaven mirrors the actual Mass held at the altar in Vijd's chapel. A shallow stream issuing from the base of the baptismal font flows down to the very frame of the panel and assures the celebrant that he too will be cleansed by the waters of life. According to a sixteenth-century description, the altarpiece had a base, a kind of predella, that had a representation of hell painted in tem-

pera. This piece was later destroyed and cannot be reconstructed, but it is doubtful if such an addition was an original part of the Eyckian program.

With the shutters closed, the exterior presents a unified setting comparable to a cross section of a church facade. In a shallow arcade in the lower register are the donors, Jodocus Vijd and Isabel Borluut, kneeling before John the Baptist and John the Evangelist, both painted as stone sculptures much in the style of Sluter's figures for the Chartreuse in Dijon. Above, in the "upper room," the Annunciation is solemnly performed by Gabriel and the Virgin, dressed in broad white mantles, within a deep chamber. This low-ceilinged room has often been described as a domestic interior, but it is not. This too is part of a church facade, often referred to as a solarium (sun-room) or *Kaisersloge* (room of the king) in early texts that described the upper chambers of *Westwerk* (westwork) churches that were squeezed in by two towers, the distinctive features of Northern Gothic architecture. The projections of the two flanking towers can be clearly discerned beyond the figures of Gabriel and Mary.

Between the towers, in the panels corresponding to those with Adam and Eve on the interior, are two enigmatic "empty" views. These, I believe, were necessary gaps that Van Eyck had to fill, and it is indicative of his genius that he maintains a proper symmetrical and symbolic division in this awkward void. The panel before Gabriel gives us a remarkable view across the rooftops of a Netherlandish city, suggesting that the angel has come to this holy chamber from the outside world. Next to Mary is an ecclesiastical piscina or niche in which the instruments for the preparation of the Mass are housed. The basin and the towel for the washing of the priest's hands are appropriate allusions to the sacerdotal role of the Virgin as the embodiment of the purified house of divine service.

In the semicircular projections above the chamber, in the attic, so to speak, Old Testament prophets Zechariah and Micah, and pagan sibyls, the Cumaean and Erythrean, look downward. Their scrolls are inscribed with ancient prophesies of the coming of Christ. In so structuring his facade for the altarpiece, Van Eyck anticipated the glorious presentation of the Mass of All Saints in adoration of the Trinity of the Father, the Son, and the Holy Ghost that unfolds so majestically in the interior, which, as we shall see, also resembles a cross section through a Gothic church. What better introduction, formally and thematically, could be fashioned for this resplendent altarpiece?

Concerning the scale of such a project, it seems likely that much of the planning and painting of the Ghent altarpiece had already been completed by Hubert before his death, but it does not imply that the present state of the

work was entirely his own invention since a number of discrepancies are apparent in its overall makeup. The most obvious are those of the scale and conception in the upper and lower stories of the interior. As mentioned above, the horizontal division across the polyptych clearly marks off very different sets of paintings. The figures are of totally different scale, and the settings are not unified or even seen from the same angle. Furthermore the vertical divisions do not match on the side shutters (nor does the thickness of the wood). For this reason some scholars have argued that the polyptych as we see it today was a makeshift ensemble put together by Jan from panels left in the shop of Hubert in various stages of completion and originally destined for different projects.

This theory, strongly presented by Panofsky, at first offers a logical solution to the mystery of the heterogeneous character of the Ghent altarpiece particularly because a number of subtle iconographic problems could thus be explained away.[6] The central group above the Adoration originally would have been a separate devotional triptych in itself, a kind of Deësis. When moved atop the lower corpus, the Adoration of the Lamb, Jan transformed the theme into an Adoration of the Trinity by adding the Holy Ghost in the form of the dove to the central axis. The upper side panels were independent additions to fill out the top zone. The singing and playing angels, accordingly, were originally destined for organ shutters, and, finally, the bold figures of Adam and Eve were wholly executed by Jan to fit the narrow endpieces (thus accounting for the curious emptiness of the two inner panels in the Annunciation on the exterior). Panofsky further suggests that Jan was responsible for the unity of the exterior. Thus for a new patron, Jodocus Vijd, Jan had in effect made up an imposing pastiche, a clever "super-altarpiece," from leftovers in his brother's studio.

As we have seen, the complex subject matter does have meaning especially if one considers the patron saints presented here: the two Saint Johns. In the fifteenth century the church was dedicated to Saint John the Baptist and not Saint Bavo, for whom the cathedral is now named, hence the preeminence of the precursor of Christ in the upper "triptych" and his presence as a statue next to the donor on the outside. Next to him is Saint John the Evangelist. The expansive apocalyptic theme of the interior, in turn, is predicated on the mystical visions of the Mass in heaven and the Adoration of the Lamb written down by John the Evangelist on Patmos in the Book of Revelation. Moreover, it will be remembered that the altarpiece was officially dedicated on May 6, the day for the commemoration of the martyrdom of John the Evangelist at the Porta Latina in Rome. The saints commemorated here and the general sacramental theme are,

91. Reconstruction of the *Altarpiece of the Lamb* (exterior) by Lotte Brand Philip

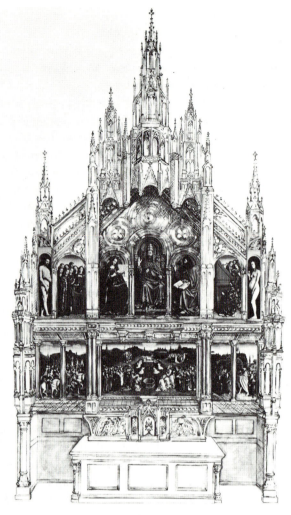

92. Reconstruction of the *Altarpiece of the Lamb* (interior) by Lotte Brand Philip

therefore, remarkably appropriate for an altarpiece in the Church of Saint John in Ghent.

As for the physical discrepancies in the polyptych, a recent proposal by Lotte Brand Philip provides the solution in part.[7] The simple wooden frame that now borders the panels hardly suffices for a display so elaborate. Philip has brought forth evidence to suggest that the various paintings were originally housed in a huge, tiered tabernacle that resembled a cathedral elevation commonly seen in numerous Late Gothic carved altarpieces (*Schnitzaltäre*), especially in Germany (figs. 91, 92). When opened, the central corpus in the upper register was thus encased as one unit within a golden shrine resembling a huge reliquary or church interior. The musical angels would then be seen as choirs against a blue sky in the open areas formed by the flying buttresses that reach from the outer walls to the vaults of the enclosed shrine. The tall figures of Adam and Eve, placed as they are in shallow stone niches, appear as lesser figures decorating the outer wall buttressing far removed from the inner sanctuary, a much more appropriate position for them.

Exactly how such an elaborate framework would operate within the confines of a small chapel is something of a problem—it presumably was hinged to allow the various panels to move—but such an imposing architectural setting would have displayed the paintings in a more meaningful context of the divine service, the cathedral being the earthly reflection of the City of God in heaven.

In light of this reconstruction of the frame for the altarpiece, it is instructive to look closely at the large *Fountain of Life* in the Prado (fig. 93), long recognized as a Spanish copy of a lost Eyckian composition resembling the Ghent altarpiece. An elaborate architectural structure, here simulated in paint, partitions the various parts of the composition into definite sections. Above, in what is equivalent to the upper tier of the Ghent altarpiece, Christ appears enthroned within an elegant Gothic tabernacle. Mary and John the Evangelist sit to the sides before cloths of honor. At Christ's feet the lamb rests on a podium, and below, to the sides in the open air are choirs of angels playing musical instruments while others appear singing from towers beside them. In the lower regis-

ter, on a kind of tiled stage, is the *fons vitae*, and to either side are groups of people.

In place of the hierarchies of saints who participate in the adoration of the lamb, the figures in the Prado *Fountain of Life* witness a different vision: the allegory of the triumph of the Church over the Synagogue. In the lower left a pope, clerics, and noblemen kneel in reverence of the font, acknowledging their salvation through Baptism and the Eucharist, which is symbolized by the hosts that float into the basin from water proceeding from the throne above. Opposite the faithful, the personification of the Synagogue, blindfolded and carrying a broken staff, confronts an agitated crowd of despairing Jews. The Prado altarpiece is the only Eyckian work comparable in scale and thematic complexity to the great polyptych in Ghent, and it no doubt is based on a similar work that had its origin in the studios of the Van Eyck brothers.[8]

According to Philip, the inscription on the frame of the Ghent altarpiece has been misread. "Hubertus Pictor" should be "Hubertus Fictor," designating his role as the maker of the sumptuous stone frame whose hinged wings would move back and forth to the accompaniment of music played by a mechanical organ within it. How grand this would be! The problem of the division of hands could thus be put aside. Hubert did the frame, Jan executed the painted parts. This conclusion to her otherwise brilliant study will find few adherents, and the thorny issues of style will no doubt continue to vex the students of Van Eyck's art.

Standing before the altarpiece, one is struck by the harmony in style between the disparate panels. To be sure, areas of lesser quality can be isolated here and there, but it must be remembered that several restorations have been made. In 1950 thorough chemical analyses of the pigments and exhaustive X-ray studies of the paintings were conducted, and, more recently, a new method of detecting underdrawings, spectrography, was applied to the panels, but little evidence for distinguishing the style of two hands was uncovered.[9] Furthermore, due to the complexity of workshop procedures in a project so vast, stylistic problems are even more obscure. It is probably safe to conclude that what we see of Hubert's art is filtered through that of Jan's. The broader aspects of the composition were very likely laid out by the elder brother, who must have employed assistants to carry out rudimentary undercoats on many of the panels. The final glazes and surface details would have been executed or retouched by Jan, who would certainly not allow a disparity of style to exist side by side in such an important commission.

Certain details can be attributed outright to the younger brother. The sumptuous brocades worn by the

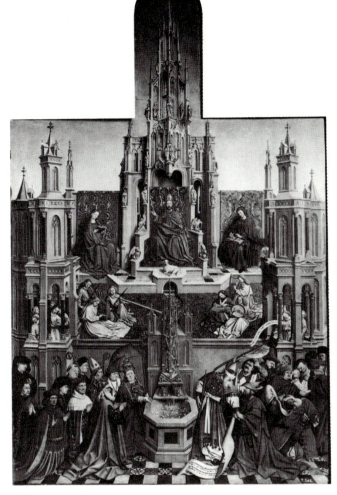

93. SPANISH FOLLOWER OF THE VAN EYCKS. *Fountain of Life.*
c. 1440. Panel, 71¼ × 45¾". The Prado, Madrid

musical angels are painted over white capes and are undoubtedly Jan's, as are details of the crowns, the lectern, the organ (the first black-and-white keyboard recorded in history?), and the marvelous faces of the singing angels, where one can distinguish between the altos and sopranos, as Carel van Mander had already noted. The chamber of the Annunciation on the exterior was the only area drastically changed. X-rays show that originally Gabriel and Mary were placed beneath trefoil arches identical to those in the arcade below. Thus the uncanny view of the rooftops seen through the window and the furnishings of the chamber behind the figures are surely Jan's contributions.

Before taking over the project in 1430, Jan had twice been on missions to Iberia to paint portraits of prospective brides for the duke. The second journey was a success. Van Eyck's portrait of the Infanta of Portugal, Isabella, pleased the duke, and the embassy returned with her for the wedding held on January 7, 1430. On this second trip, Van Eyck spent over a year in Portugal and Spain, and he made a number of trips, one to the pil-

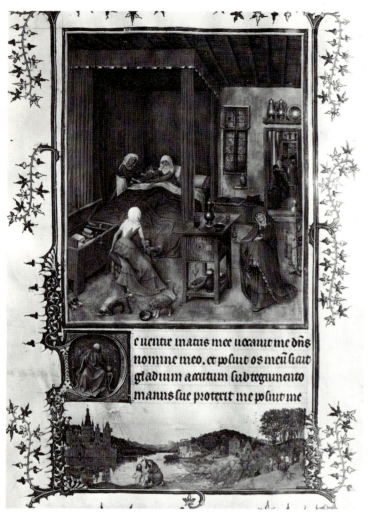

94. "Hand G" of the *Turin-Milan Hours. Birth of Saint John the Baptist*, from the *Turin-Milan Hours* (*Très Belles Heures de Notre-Dame*). c. 1435. Museo Civico, Turin

grimage shrine at Santiago de Compostela in Galicia and another through central Spain to Granada.

He was undoubtedly fascinated by what he saw in the Mediterranean peninsula, and some of these interests are reflected in the Ghent altarpiece. A number of the plants and trees in the paradise setting for the lamb are species that he had seen and probably sketched during his journeys. This is particularly evident in the side wings of the Adoration, where he places the hermits and pilgrims in a sandy, semitropical landscape with orange trees, date palms, cypresses, and other southern flora. The distant city behind the pilgrims may, in fact, be based on a silhouette of Santiago de Compostela. Moreover, the curious fruit held by Eve, a bulbous, bumpy, round object of a greenish-yellow color that has always defied identification, turns out to be a rare citrus specie common to Portugal and the Canary Islands and known there as a *Pomo d'Adamo* or "Adam's apple," believed to be the actual forbidden fruit picked by Eve from the Tree of Knowledge in Eden.[10]

However one apportions the paintings of the Ghent

polyptych, the monument remains a lasting tribute to the style and genius of the Van Eycks. It is not surprising that it was referred to as one of the wonders of the world in the sixteenth century, and it has made Ghent, then as today, a venerable shrine for those on a cultural pilgrimage.

We know more about Jan van Eyck than many other Netherlandish painters of the fifteenth century.[11] He was born sometime in the last decade of the fourteenth century and very likely received his early training in the Mosan valley somewhere between Liège, Maastricht, and Maeseyck (from which he takes his name), an area of Limburg and the county of Kempen that had a rich artistic heritage, as we have seen. His name first appears in documents of the Hague dated October 24, 1422, to September 11, 1424, as "meyster Jan de maelre." He served at the court of John of Bavaria, formerly the unconsecrated bishop of Liège, who might well have been his patron there before usurping the Dutch territories of his brother, Willem VI, after the latter's death in 1417. Some argue that Jan had already served the count of Holland about 1415 to 1417.

What exactly the young painter accomplished during these years is unknown, although there is much speculation that he painted a number of miniatures in the so-called *Turin-Milan Hours*, acquired by Willem sometime before 1417. These miniatures, referred to as "Hand G" in the dispersed manuscript, originally the *Très Belles Heures de Notre-Dame* of John of Berry (see p. 52), are indeed Eyckian in the style that we know, and it has been frequently pointed out that such illuminations as the *Birth of Saint John the Baptist* (fig. 94) anticipate in many ways the style of the *Arnolfini Wedding Portrait* for the interior and the landscape background of the *Madonna with Chancellor Nicolas Rolin* in the *bas-de-page*.

This theory is particularly attractive since it implies that Jan began his career as a miniaturist and then developed as a panel painter sometime after moving to the Netherlands. A number of details in the "Hand G" miniatures, however, show them to be less precocious than they first appear, and probably they are the works of a talented imitator of Van Eyck's style, executed about 1435 or later.[12] Be that as it may, we know that in 1425, the year that John of Bavaria died, Jan initiated his illustrious career in the South Netherlands as a *valet de chambre* for Duke Philip the Good of Burgundy. Jan received an annual salary of one hundred *livres parisis* plus all the "honneurs, prérogatives, franchises, droits, prouffis et émoluments," including lodgings and tax exemptions proper to such a court appointment.

Jan van Eyck's genius as a painter was augmented by his talents as a court diplomat, and the duke highly regarded him as a friend and companion as well as a ser-

vant. An unusual tribute was paid Van Eyck in 1435 when Philip the Good sharply responded to a request from his exchequer in Lille to reduce the painter's salary and pension in accordance with a general program of austerity: "This would greatly displease us, as we are about to employ Jan for certain works and can find no other painter equal to our taste nor so excellent in matters of art and science." Van Eyck received his pension, and his pay was raised from 100 to 360 *livres* per year.

Between 1426 and 1430, Jan made no fewer than three "distant and secret journeys" with Philip's embassy, and after the marriage of the duke on January 7, 1430, Van Eyck moved to Bruges permanently, took a wife there, and purchased a fine house. Much of his activity between January 1430 and May 1432 must have been devoted to the completion of the Ghent altarpiece. After that, his position at the court—the duke assured of absolute priority in his production—brought him commissions from aristocrats and ecclesiastics in Bruges, and we also know that in 1435 he gilded and colored eight statues of the counts of Flanders for the new *stadhuis* (city hall) in Bruges. In that year a child was born to the Van Eycks, and the duke himself presented six silver cups to the baby at her baptism. In 1436 Jan was assigned to another "secret journey," about which we know nothing. He died prior to July 9, 1441, the day on which receipts for his burial fees in the Church of Saint Donation were received.

During the brief period of sixteen years that Jan van Eyck served as *valet de chambre* for Philip the Good, he perfected a style that has become the consummate expression of Early Netherlandish painting. The content of his paintings is a well of information for the religious thought of his period and a source of bafflement for his critics to this day. What kind of man was he? When judged in comparison to that of his contemporaries in Italy, Masaccio and Donatello, Van Eyck's art is found lacking in the features that define a true "Renaissance" style—the revival of antique form and subject matter—but when viewed as an art with historic revelance, it far surpasses that of any artist. Through visual imagery Van Eyck explains more than the volumes of the literati of his day provide, and, as in most peaks in art history, both style and subject matter are inseparable aspects of the content of his images.

The detection of precise meaning in his painting will be dealt with presently, but first we must look briefly at the artist's technique and method of presenting the world about and above us. It was Panofsky who coined the phrase "microscopic-telescopic vision" in Van Eyck's art. What exactly is meant by that? Microscopes and telescopes were not put to practical use until the seventeenth century. First of all, it should be stated that Van

Eyck transposed the visual world to a wood panel through personal, empirical means and not by scientific formulae. His perspectives are not mathematically accurate, and his allusions to times past are not archaeologically true. Perspective lines, such as we find them in his interiors, converge not on a single point but in a small area, which is actually more in keeping with our vision, and references to antique or Old Testament periods are more symbolic than authentic. As examples, one might note his allusions to the antique in portraiture and landscape.

The enigmatic *Portrait of Tymotheos* (fig. 95) presents us with a curious combination of a specific individual and an allegorical portrayal of his position in society. Who

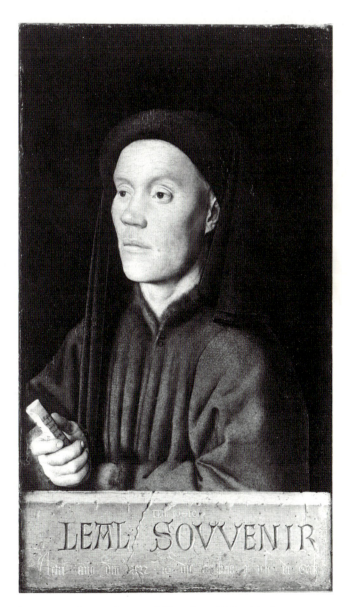

95. JAN VAN EYCK. *Portrait of Tymotheos* (Gilles Binchois?). 1432. Panel, 13⅛ × 7½". National Gallery, London

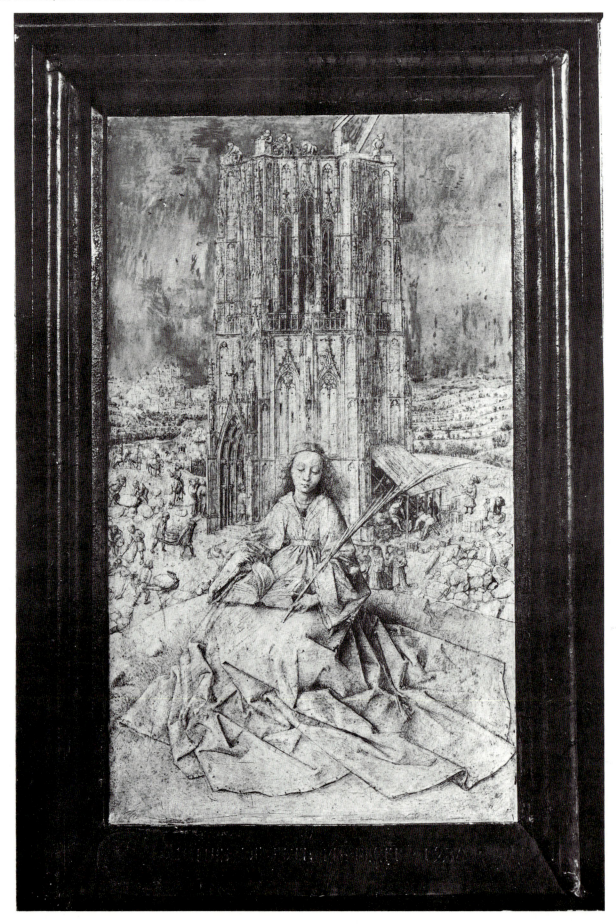

96. Jan van Eyck. *Saint Barbara*. 1437. Drawing on panel, 12¼ × 7⅛″. Musée Royal des Beaux-Arts, Antwerp

was Tymotheos? It was common in the Burgundian court circles to assume the names of famous people in antiquity. Philip the Good was likened to Alexander the Great; Jan van Eyck was heralded as Apelles, the court painter of the Greek emperor; and Tymotheos in the later Middle Ages was considered Alexander's revolutionary court musician. The face of the bland young man with a squarish jaw, prominent cheekbones, a short nose, and a fixed gaze rises above a small stone parapet painted to look weathered and incised with the French motto "Leal Souvenir" (Faithful Memory), resembling ancient memorial plaques commonly used in funerary portraits. The name Tymotheos is lightly painted in a quasi-Greek script above the carved letters and below them Van Eyck has signed and dated the work October 10, 1432.

In his right hand Tymotheos carries a rolled scroll or sheet of parchment on which only a few strange marks are discernible. The faint markings resemble early musical notation found in manuscripts of the eleventh and twelfth centuries long before the staff had been introduced, and perhaps Van Eyck placed this curious attribute in his hand to underscore the antique references to the sitter much as the stone parapet does. For Van Eyck antiquity simply meant remote times. Should it be a Burgundian court musician portrayed here as the new Tymotheos, then two such revolutionary figures come to mind, Guillaume Dufay and Gilles Binchois, both of whom were in the service of Philip the Good during these years. The somewhat sorrowful expression of the sitter would fit nicely the melancholic mood of much of their music.[13]

If it is true that Van Eyck used Romanesque music notation as a very "old" form of such writing (he could not have known any Roman music), it would be in keeping with his use of Romanesque or exotic Eastern architecture to suggest ancient pagan buildings or those of the Old Testament. An excellent example of such use appears in the background of the tiny framed drawing of *Saint Barbara* in Antwerp, signed and dated 1437 (figs. 96, 97). According to the legend familiar in the Netherlands, that of the Flemish hagiographer Jan de van Wackerzeele, Barbara's martyrdom took place in Nicomedia, and to suggest the pagan world of the East, Van Eyck added a tiny walled city in the far left background that builds up in several stories much as a ziggurat.

It is possible that Jan had read some description of the city, but it is more likely that his exotic town was based on a familiar model of such ziggurats in contemporary Old Testament illustration, namely, the Tower of Babel. Directly behind Barbara, the laborers are busy constructing a new edifice in the latest Gothic style for her imprisonment, a Christian tower. Specific symbols of the church appear in the three lancet windows added to the

second level, the Trinity, and the octagonal (or hexagonal) foundation of the structure, the Baptism. Such use of contemporary Gothic architecture to signify the Christian world and old-fashioned or exotic Eastern types to represent pagan or non-Christian times was anticipated in Broederlam's *Annunciation* in the Dijon altarpiece. What is astonishing in Van Eyck's setting is the convincing appearance of these architectural intrusions, which seem like real aspects of the landscape and not artificial attributes of the story.

Another illustration of Van Eyck's use of the antique is found in his personal motto often added to the inscriptions on the frames: "ΑΛΣ ΙΧΗ ΧΑΝ" (*Als ich can*—As I can; see fig. 107).[14] The quasi-Greek letters again allude to ancient usage, and in this instance more specifically to a Greek and Latin jingle expressing modesty on the part of the writer or artist: "ut potui, non sicut volui" ("as I can, but not as I would," or, more simply, "the best I can do"). Such a motto strikes one as an extreme case of false modesty at first, but such sentiment was commonly

97. JAN VAN EYCK. *Saint Barbara* (detail of fig. 96)

expressed in the courts, and the very fact that Van Eyck often dates his pictures to the day and the month as well as the year indicates that he regarded them as not only visual images but as official documents, appropriate for such humble courtesies.

The Italians who praised Van Eyck for his keen realism often remarked about his new technique of painting in an oil medium. Bartolommeo Facio (*De viris illustribus*, 1456) wrote that Jan discovered this technique by reading Pliny on the uses of color in antiquity, and Vasari (*Le vite*, 1550) specifically tells us that the invention of oil varnishes was made by Apelles, the court artist of Alexander the Great, to whom Van Eyck was frequently compared. In a book on famous painters (*Effigies*, Antwerp, 1572), Dominicus Lampsonius of Bruges put the following words in the mouth of Van Eyck: "I demonstrated the method of mixing lively colors with linseed oil, together with my brother Hubert, and very shortly amazed Bruges with this invention. Perhaps Apelles himself could not have achieved this feat. Rapidly our fame spread all over the world."

Oil painting was no invention of Jan van Eyck, however. Mixing pigments in an oil base was practiced earlier in the Middle Ages, but the systematic use to which Jan applied several coats of glazes with pigments in linseed oil, one over the other, and his final coats of varnish, enabled him to build up an enamel-like surface that had the depth and translucency of precious gems. The new medium also enabled him to blend countless tiny brushstrokes to the point where they were imperceptible, building up the painted image gradually to reconstruct a complete world in colors that glow. And even the glow of the pigments, the light that glistens through the superimposed glazes, has symbolic meaning in his works.

A striking example of Van Eyck's blending of form, color, light, and symbol is the precious little panel in Berlin, the *Madonna in the Church* (colorplate 17). Hardly larger than a picture postcard, it seems impossible at first that Van Eyck was able to reconstruct on such a small scale the world of a lofty church interior with the majestic Mother of God standing within it. As with so many of his paintings, the details of the cathedral are so precise that scholars have been tempted to identify it with some actual monument. It has been proposed that the interior is that of the Cathedral of Tournai by some, Saint Lambert in Liège by others, and the choir of the Dom in Utrecht by still others. But the quests for topographical identities in Van Eyck's paintings are misguided games at best. Van Eyck the architect is at work here, and he fashions in paint the best possible Gothic interior for his Madonna. Everything refers to Mary. An alabaster statue of the Virgin stands between candles in a niche of the rood screen behind her; the structure itself is decorated with carved tympanum reliefs of the Annunciation and Coronation; and above the screen another statue of Mary appears as part of a Calvary group.

A bright light floods the nave, casting two pools of white on the floor to the right as it passes through the lofty stained-glass windows in the clerestory. Another burst of sunlight streams in from the northern portal to the left. This light has a definite symbolic role in the painting. Words from an inscription that weaves in and out on the border of her red dress can be identified with a passage from the Book of Wisdom that was read at Lauds on the Feast of the Assumption of the Virgin according to Bruges usage: "She is more beautiful than the sun, she is found before it. For she is the brightness of eternal light and the unspotted mirror of God's majesty."

The frame of the panel has been missing since a theft in 1877, but an early catalogue entry mentions part of a lengthy inscription that went around it with words from a popular Nativity hymn that ended with the lines, "As the sunbeam through the glass passes but not stains, so the Virgin, as she was, a virgin still remains." Thus the bright light streaming through the stained-glass windows symbolizes the virginity of the Madonna, while the sunlight flooding the north portal alludes to Mary as the "brightness of eternal light," above that of the sun. It is impossible for a natural light to shine from the north, but it does so here (the choir was always associated with the east, the direction of the rising sun). This supernatural "northern light" is to be associated with Mary too, who, as the inscription on her dress reads, is above and before the natural light of the sun, being the "brightness of eternal light."[15]

Van Eyck's disguised symbolism extends beyond the levels of meaning in the furnishings and illumination of the church, however. At first viewing it may strike one that Mary is far too large for the interior. In this case, Van Eyck has elaborated another familiar metaphor for the Virgin: She is not only *in* a church, she *is* the church, or, in keeping with Gothic thinking, she personifies the church and, vice versa, the church is the physical embodiment of Mary on earth, her attribute.

This identity was a familiar one long before Van Eyck. Commentators of the Song of Songs in the Old Testament, which is an epithalamium, or a nuptial song in honor of the bride and bridegroom, found in it an allegory on Christ, the church, and Mary. The bridegroom of the poem was Christ, the bride was the church and, in turn, Mary. Of this mystical marriage a thirteenth-century authority, Honorius of Autun, writes that "Everything that is said of the church can also be understood as being said of the Virgin herself, the bride and mother of the Bridegroom." If we return to the inscription that

98. Jan van Eyck. *Madonna and Child with Saints Michael and Catherine*. 1437. Panel, 10⅞ × 8½″ (center); 10⅞ × 3⅛″ (each wing). Gemäldegalerie, Dresden

went around the frame of the Berlin panel, we find that the second stanza of the hymn begins, ''This mother is the daughter, this father is born . . . ,'' thus adding even more levels of meaning to Notre Dame: Mother, Mother and Daughter, Daughter and Bride, Queen of Heaven (she wears a crown), and the Church on earth. Mary is all of these and more in a Gothic age when every major cathedral was dedicated to Notre Dame.

The lovely *Madonna* in Berlin has been dated very early in Van Eyck's career by nearly every authority, but its smallness and preciousness are no criteria for chronology here, as we shall see. It should be noted that the Virgin is a dainty *Schöne Madonna* type, and in her tiny hands she holds a fragile infant who seems only a few hours old. The graceful curves and turnings of her beautiful blue mantle repeat the undulations of the earlier Madonnas, whose pronounced ''S''-shape stances enhanced the flow of cascading drapery. However, whether or not these refined pictorial qualities are evidence of an early or a late style in Van Eyck's art must, for the present, be left an open question.

The Madonna and Child, sitting or standing in an ecclesiastical or domestic interior, was one of Van Eyck's favorite themes. The Madonna in the Church was elaborated in a small triptych, today in Dresden, with Saint Michael and a kneeling donor and Saint Catherine placed in the side aisles of a church of which the nave, the central panel, forms a sumptous throne room for Mary (fig.

99. Jan van Eyck. Head of Saint Catherine, from the *Madonna and Child with Saints Michael and Catherine* (detail of fig. 98)

98). The shutters, when closed, present an Annunciation in grisaille.

A church interior could hardly be more glittering with rich furnishings than it is here. The Madonna is again presented as the church; she is also the Throne of Christ, the altar of the church, and the seat of Holy Wisdom (*Sedes sapientiae*) in keeping with the many-leveled symbolism of Mary and the Church. About the frame, painted to resemble marble, is inscribed Van Eyck's favorite passage from the Book of Wisdom: "She is brighter than the sun . . . the spotless mirror of God's majesty."

Mary is the same fragile princess whom we saw in the Berlin panel, and the setting has the same airiness and spacious qualities of a vast church interior. The tiny figures in the shutters resemble precious ivory statuettes. Saint Michael presents the donor (Michele Gustiniani?) with all of the grace of a young cadet in his best military dress. Saint Catherine is a lovely maiden whose facial features, crown, and fluffy tresses closely resemble those of the Berlin *Madonna* (fig. 99). In fact, the two works are so close in style that they are placed together in Van Eyck's development by most scholars.

Frail, courtly figures placed in sumptuous throne rooms and churches with a resplendent glitter of costly objects seemed a natural early phase in Van Eyck's emergence from an International Style to a more monumental phase in his mature works. His art, it is reckoned, moved naturally from the novel and manifold to the restrained and simplified, from early exuberance to austerity. Such is usually the pattern for "late" styles in art, but it does not work here. In 1959 the Dresden triptych was cleaned, and along with the inscription on the frame his signature suddenly came to light: "Johannes De eyck me fecit et complevit Anno 1437 als ixh xan." Thus the Dresden triptych was completed five years after Van Eyck's work on the Ghent altarpiece and only four years before his death.[16]

The earliest dated painting is the charming *Ince Hall Madonna* in Melbourne (fig. 100). In the top left corner we find a tiny inscription, "copletu ano D. 1433 p Iohem de Eyc Brugis," which seems to be a muddled transcription of a proper Eyckian signature from the frame, which is lost. At any rate, the inscription is highly suspect since only on one occasion (the *Arnolfini Wedding Portrait*) did Jan sign and date the picture directly on the panel for reasons that we shall discuss below. Indeed, some believe the work to be a copy—the Madonna's head has been repainted—but its charming qualities, much in tune with his later works, seem to affirm the attribution, although the date must be wrong.[17]

Mary sits on a low bench near the floor with an elegant array of fan-shaped folds spreading about her with crisp, angular pleats and creases. The golden-haired Child is the same charming babe that Mary holds in the Dresden triptych. Here he is engaged in reading the holy writ, while his mother, characterized as a "Madonna of Humility," more than a crowned Queen of Heaven, attentively keeps his place in earlier passages of the text. In place of the church interior, Van Eyck gives us a cozy domestic interior with only a beautiful green and gold cloth of honor to distinguish it.

The ample treatment of space and the delicate textures and shining metal objects are in keeping with the fluency and richness of style of Jan's later Madonnas. The rhythmic movements of the drapery folds closely resemble those of the *Saint Barbara*, dated 1437. To the left is a carafe "through which the sunbeams pass," and two pieces of fruit, reminders of the first Adam and Eve, rest above on the windowsill. Atop a locked chest on the right a candlestick and ewer are placed, and a basin of water rests on the floor: all symbolic of the more sacerdotal nature of this otherwise homey domestic interior. A dainty "S" pattern in gold on the cloth of honor behind Mary echoes her relaxed, curvilinear pose.

The *Lucca Madonna* in Frankfort (fig. 101) can be dated a few years after the completion of the Ghent altarpiece, about 1434–35. The setting is much the same as in the *Ince Hall Madonna*, but the Virgin is more matronly, the Child is older and more rigid even while nursing, and the domestic interior is governed by a stricter symmetry and more compact distribution of objects with the canopy flush with the upper border and the oriental carpet extending to the lower. Although the Madonna type, the *lactans*, or nursing mother, would seem to be an earthy touch to her characterization, Mary is elevated on a true throne with four regal lions on the arms. Here Van Eyck's style is harder and more stereometric, much as it is in the *Madonna with Canon George van der Paele*.

The final panel to be considered in this series is the tiny *Madonna by the Fountain* in Antwerp, signed and dated 1439 (fig. 102). The setting this time is the *hortus conclusus* with a floral arbor and a fountain of life complementing the Marian symbolism. The Virgin stands before a red cloth of honor held up by two small angels. In this late painting we once again encounter stylistic features of the Berlin *Madonna in the Church* and the Dresden triptych. Elegant folds cascade from Mary's right elbow, and her features are those of the sweet, youthful types in the later Madonna paintings. The Child too is a tiny infant, just born, and he tenderly embraces his mother with his right arm and holds a string of beads, precursors of the later Rosary beads, in his left hand. The roses behind Mary also anticipate the new devotion, that of the Rosary, that swept through northern Europe later in the century.

above left: 100. JAN VAN EYCK. *Ince Hall Madonna*. 1433? Panel, 10⅜ × 7⅝". National Gallery of Victoria, Melbourne. Felton Bequest

above: 101. JAN VAN EYCK. *Lucca Madonna*. c. 1434–35. Panel, 25¾ × 19½". Städelsches Kunstinstitut, Frankfort

below left: 102. JAN VAN EYCK. *Madonna by the Fountain*. 1439. Panel, 7½ × 4¾". Musée Royal des Beaux-Arts, Antwerp

The ingenuity of Jan van Eyck in creating a world in paint that is at the same time vividly real and multi-leveled in symbolic meaning is even more astonishing when we turn to themes of more complexity. The *Annunciation* in Washington (fig. 103) is the left shutter of a triptych that very likely featured a *Nativity* and *Presentation* in the missing central and right panels, and after considering the complex iconography of the remaining panel, one can only wonder in amazement how saturated with symbolism the whole altarpiece must have been.[18]

Staging the Annunciation in a church was common in earlier miniatures, as we have seen, but never before was the idea elaborated as it is here. The significance of the

left: 103. Jan van Eyck. *Annunciation* (left wing of a triptych?). c. 1435–37. Panel transferred to canvas, 36½ × 14⅜″. National Gallery of Art, Washington, D.C. Andrew Mellon Collection

below: 104. Jan van Eyck. *Madonna with Chancellor Nicolas Rolin* (*Virgin of Autun*). c. 1435. Panel, 26 × 24⅜″. The Louvre, Paris

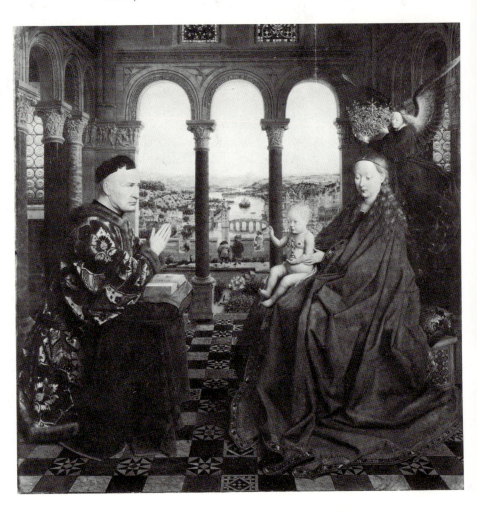

Madonna *as* the church has already been discussed, but here the narrative imposes an even richer interpretation of the symbolic meanings of architectural details. It will be remembered that the Annunciation was not just a communication to Mary, it was also the very moment of the Incarnation when the Holy Ghost overshadowed the Virgin and the Child conceived in her womb, the consummation of her marriage to God. As the initial mystery in Christian history, it also marked the moment when the Old Dispensation became the New, and it is to that point that Van Eyck addresses us in the setting.

Reading down from the clerestory of the church (here a transept north of the chevet), we see the image of Jehovah, the one God of the Old Testament, standing in the single stained-glass window high above Mary. He is accompanied by two seraphim, the angelic creatures described in Isaiah's vision of the Lord, and he holds a tablet inscribed "I am the Light" (*Ego sum Lux*). As the Holy Ghost descends along seven rays of light from the clerestory window on the north wall and Mary raises her hands in acceptance of the role she has assumed as bearer of God, the one window of Jehovah is transformed into the three of the Trinity directly behind her. Faint lines of frescoes painted in an archaic style on either side of the upper window can be deciphered as scenes related to the infancy of Moses and to his role as the sponsor of the Old Law. These fading frescoes give way now to Christ's infancy and his role as the giver of the New Law to the Christians.

In the immediate foreground to the right is a stool with an elegant cushion, an allusion to Isaiah's words, "Heaven is my throne, the earth is my footstool," and it is bathed in a natural light from the south, unlike the divine light that shines down on Mary from the north.

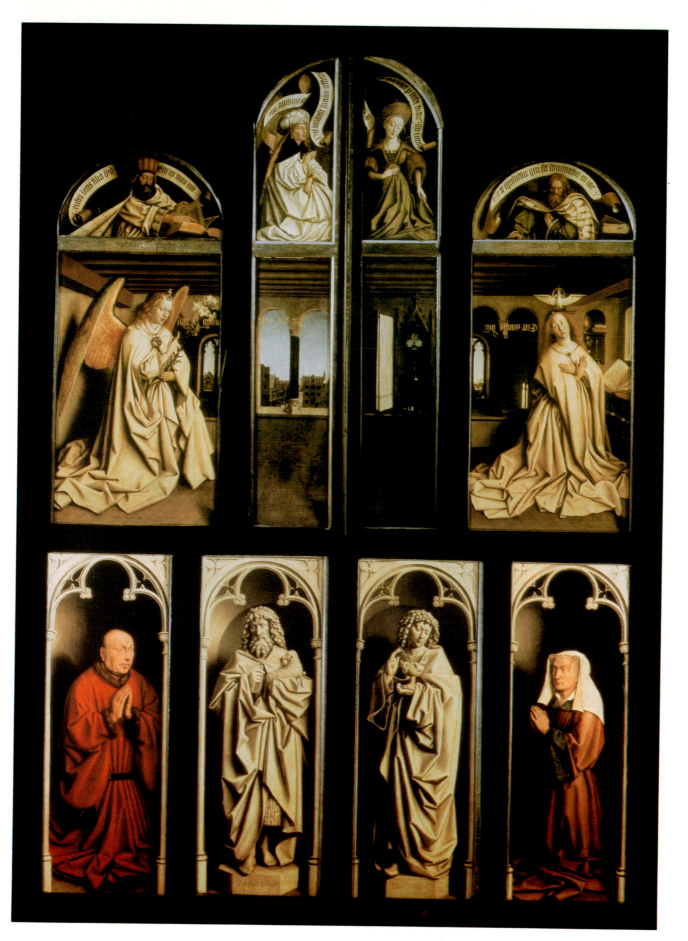

Colorplate 15. JAN AND HUBERT VAN EYCK. *Altarpiece of the Lamb* (exterior). 1432.
Panels, 11′ 5¾″ × 7′ 6¾″. Cathedral of Saint Bavo, Ghent

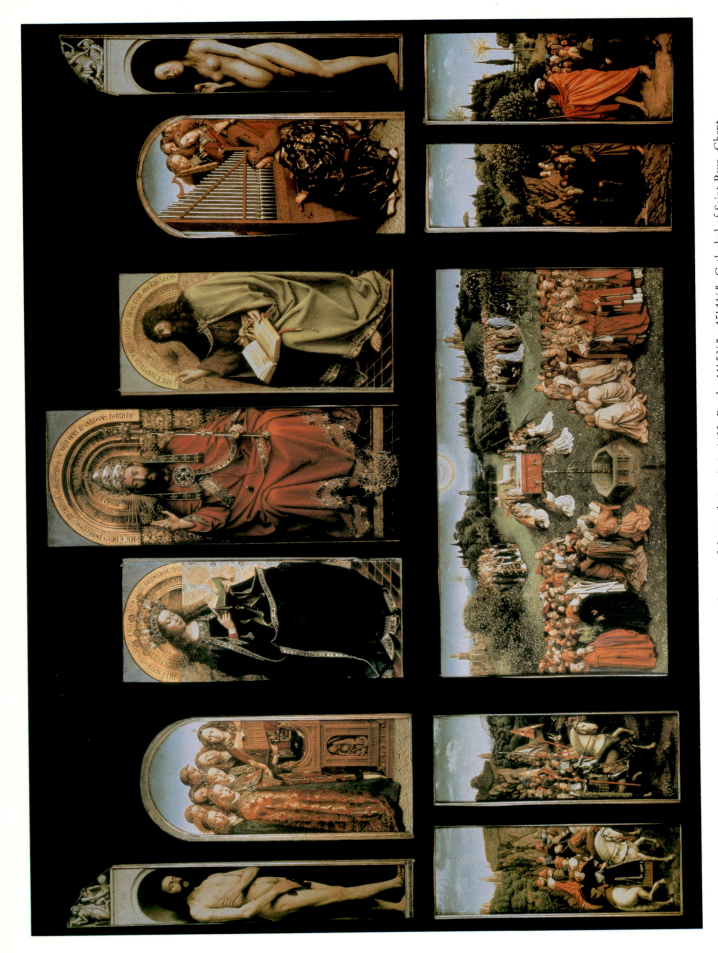

Colorplate 16. Jan and Hubert van Eyck. *Altarpiece of the Lamb* (interior). 1432. Panels, 11′ 5¾″ × 15′ 1½″. Cathedral of Saint Bavo, Ghent

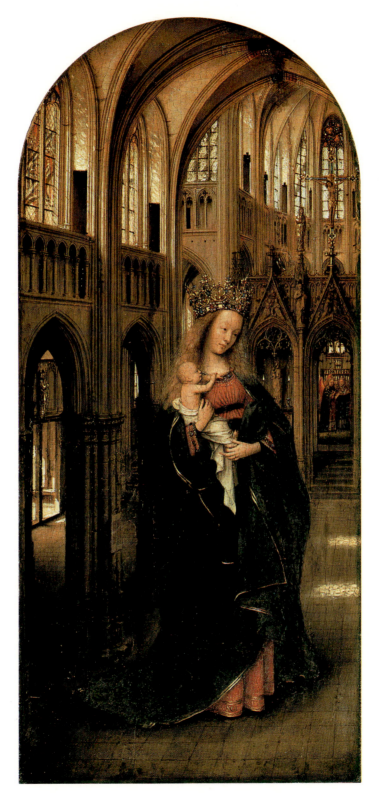

Colorplate 17. Jan van Eyck. *Madonna in the Church*. c. 1437–38.
Panel, 12¼ × 5½″. Gemäldegalerie, Staatliche Museen, West Berlin

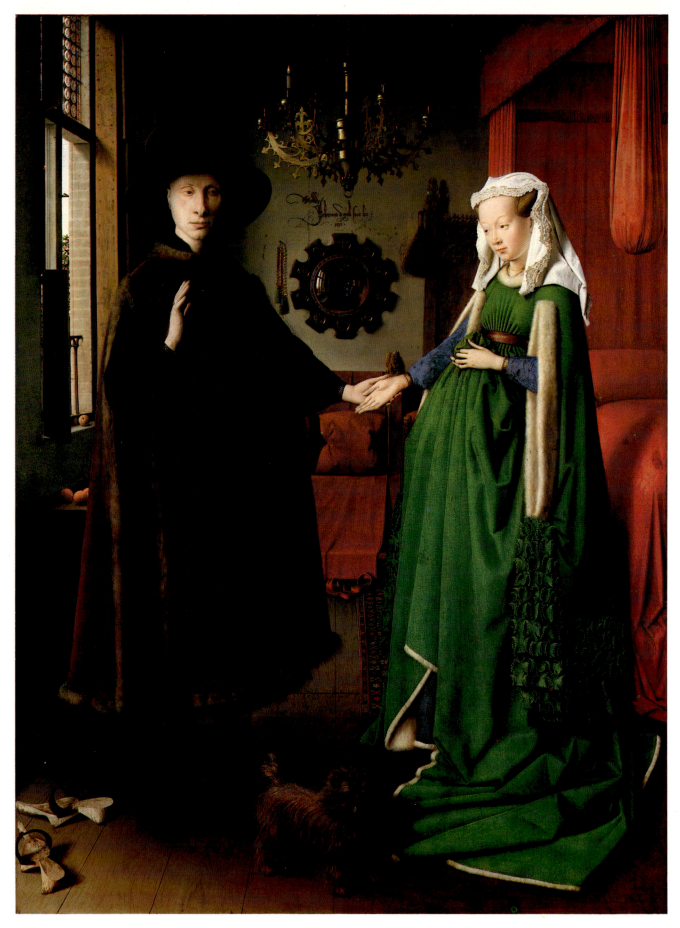

Colorplate 18. JAN VAN EYCK. *Arnolfini Wedding Portrait*. 1434.
Panel, 32¼ × 23½″. National Gallery, London

Behind the stool is a vase filled with elegant white lilies. Usually interpreted as a symbol of Mary's purity, the motif here also refers to the "sweet flower" in the Tree of Jesse (Isaiah 11) which was interpreted as the royal genealogy of Christ through the Old Testament kings of Judah. Two tiny roundels in the spandrels of the nave arcade above Mary have bust portraits of Isaac and Jacob, the earliest ancestors of Christ according to the genealogy given in Matthew's gospel (1: 2). Hence Christ's ancestry from the One God, the kings, and the tribes of the Old Testament is subtly incorporated in the ecclesiastical setting.

Finally, the floor of the church is paved with colorful niello tiles with illustrations, again painted to look old-fashioned, depicting the triumphs of Samson and David, Old Testament prototypes of the victorious Christ. The medallions at the corners of these narratives are decorated with the signs of the zodiac. According to the sequence visible, it has been reckoned that Gabriel stands above the sign of the ram, March 25 being the time of the Annunciation, while Mary kneels appropriately over Virgo.

The subtle interweaving of Old and New Testament typology in the *Annunciation* gives way to a more personal iconography in votive panels where the donor's role is prominent. The famous *Madonna with Chancellor Nicolas Rolin*, also known as the *Virgin of Autun* (fig. 104), in the Louvre is a splendid example.[19] Nicolas Rolin, chancellor of Flanders from 1421 to 1451, was born about 1385 in Autun of a well-established family. During his lifetime he made several donations to his hometown, enriching the Collegiate Church of Our Lady there and founding the Hôtel Dieu, or hospital, in nearby Beaune for which he commissioned Rogier van der Weyden to execute the famous *Last Judgment* polyptych still to be seen there.

The handsome panel in the Louvre was no doubt painted for the Church of Notre Dame in Autun, where it was hanging in the sacristy as late as 1768, and it may have been offered to the church in tribute to Rolin's son, Jean, who was made bishop of Autun in 1436. In terms of style the work can be dated about 1435 since its balanced composition and elegant figure types are comparable to the paintings dated 1434 and 1436, to be discussed below. Judging from the appearance of the donor, a date in the mid-1430s, when Rolin would have been about fifty, seems justifiable.

The seemingly bold manner in which the donor kneels at his *prie-dieu* directly before the Madonna and Child without the benefit of a patron saint has been an issue of considerable debate. How, it has been asked, could Rolin be granted access to the Virgin's own throne room without an intercessor? However, a very subtle modification of the setting is to be noted here. It is not Rolin who visits the Virgin in her chamber, but, to the contrary, Mary has joined the donor in his. Furthermore, hers is a mystical visitation. Rolin has been reciting his hourly devotions—the missal lies open before him—and now in quiet meditation the Virgin mysteriously appears in the room as a very tangible manifestation of his thoughts.

It is important to note that his line of vision is focused in front of Mary and that she sits at a slight angle to the side on a low bench that is not a throne. Her stately Child is characterized as Christ Logos or Creator holding the globe of his domain in his left hand while blessing the donor's world with his right. How emphatically Van Eyck has kept the world of the earthly worshiper and that of his divine vision separated! An empty row of tiles clearly forms this line of demarcation in the chamber and this division is further elaborated in the details that fill the landscape background beyond, as we shall see.

Through the three arches of the loggia a resplendent landscape stretches along the banks of a broad river in the center of the picture. Two men casually stand and peruse the sprawling panorama from a high parapet beyond the loggia. The one in profile, in the exact center of the composition who wears a red turban, has often been identified as Jan van Eyck himself. This could well be, since Van Eyck sometimes included his self-portrait in reflections in his painted world (e.g., in armor in the *Madonna with Canon George van der Paele*, the mirror in the *Arnolfini Wedding Portrait*, and the pearl of the papal tiara worn by God the Father in the Ghent altarpiece), and the exotic red turban marks the so-called *Self-Portrait* in London.[20]

It would seem that Van Eyck's world is so real that he could place himself in it. Certainly, the details of Van Eyck's settings are so infinite and detailed that it is tempting to see them as specific topographical sites. The background landscape in the Rolin Madonna has been identified as Bruges, Autun, Liège, Maastricht, and Geneva. But as with his architectural interiors, Van Eyck is his own architect and city planner here, fashioning a convincing setting that at the same time serves as a symbolic backdrop for the figures. The city on the right bank, behind Mary, is filled with countless churches including one huge cathedral, all of which are proper attributes of Notre Dame once again. Beyond Rolin is a rustic setting with a few houses, a modest monastic quarter, and hills filled with workers busy gathering grapes. This is the more secular world of the donor, and it is joined with that of the church by an imposing bridge of arches across which tiny figures are moving. The spring of the bridge on the right is precisely at the point where the blessing hand of the Child rises. Hence a strong bilateral symmetry divides Van Eyck's picture both realistically and symbolically.

On another level the landscape has special meaning as a display of the grandiose creation of the *logos*, Christ. The text of Rolin's missal is not clear, but Van Eyck provides us with a hint as to the nature of his devotion in an inscription along the border of Mary's red robe. The text is clearly that from Ecclesiasticus 24, where the figure of Wisdom is glorified in her own creation: as Jerusalem, the cedars of Lebanon, the cypress of Mount Sion, the palm of Cades, the rose of Jericho, the fragrance of the vines and the beauty of her flowers; and from Wisdom pours forth the rivers that nourish the meadows and the fields of the lower world just as Wisdom nourishes the faithful with the true doctrine. Mary, accordingly, is the Throne of Holy Wisdom, the *Sedes sapientiae*, as well as the Queen of Heaven. It was this very passage that was read in the Little Office of the Virgin in the Netherlands. The glorious landscape then honors its maker, Christ *logos*, and from him flows the river that nourishes his creation. The peacocks and flowers of the shallow *hortus conclusus* outside the loggia are symbols of Mary, Queen of Heaven and Throne of Holy Wisdom.

It is tempting to see the dichotomy right and left on still another, more personal, level. The floriated capitals of the columns connect two heavy piers with capitals carved with narratives directly above the heads of Rolin and the Virgin. Above Rolin are episodes from Genesis that, appropriately, serve as examples of man's failings: the Expulsion of Adam and Eve, the Murder of Abel, and the Drunkenness of Noah. Above Mary only one scene can be discerned clearly, and that is the Meeting of Abraham and Melchizedek. Both the Drunkenness of Noah, directly above Rolin, and the Meeting of Abraham and Melchizedek have one important feature in common: both deal with wine. Noah was the first to plant the grapevine and make wine from it. Acting as some Old Testament Bacchus, he promptly overindulged and was reduced to the shameful figure of a drunkard. A stylized grapevine appears just behind Noah's body, and it rises upward through the abacus to clammer about the arches toward the right.

The Meeting of Abraham and Melchizedek was viewed from the time of Augustine as a type par excellence of the institution of the Eucharist since Melchizedek was the first Old Testament priest to administer the bloodless offering of wine and bread, the very elements of the Christian sacrifice, to the conquering Abraham. The role of wine on either side is thus prophetic of the secular and the religious. Above the earthly donor, man is debased by wine; above Mary and Christ, wine serves as the substance of man's salvation.

It is further tempting to find in this unusual concern for wine a more personal meaning for Rolin. It is well known that members of the Rolin family were among the most important entrepreneurs of wine in Burgundy, and their vineyards were of major importance for the economic well-being in the area around Autun. Could not the prominent vineyards that cascade so abundantly in the hills beyond be seen as personal references to the business of the Rolin family? Nowhere else in Van Eyck's painting do they appear as major features of a landscape.

A similar mystical vision is presented in Van Eyck's largest votive picture, the *Madonna with Canon George van der Paele*, signed and dated 1436, formerly in the Church of Saint Donatian in Bruges (fig. 105). The lines from the Wisdom of Solomon 7 comparing the Virgin to the eternal light of God's majesty here appear on the frame above the figures, and on the left and right borders the saints, Donatian and George, are identified. The elderly canon, portrayed with utter realism, was gravely ill for some years when the picture was commissioned for his church. He kneels beside the throne of the Madonna, missal in hand, and gazes out across the space before her toward the imposing figure of Donatian. Here the symmetry is more formally stated with large figures filling the space. The Madonna and Child are on the central axis on a giant throne-altar within the confines of an apse recognizable by the circular ambulatory behind the figures. The Madonna is a weighty pyramidal form with the sharp, angular folds of her red mantle marking out a definite ledge on which the husky Child sits. The colorful canopy and the oriental rug come flush with the upper and lower frame, further enforcing the severe monumentality of the composition.

The content of the Van der Paele painting is more complex than that of the Chancellor Rolin, with the Madonna backstaged, so to speak. As a canon of the Church of Saint Donatian, Van der Paele is presented by his patron saint, Saint George, to Saint Donatian, the first archbishop of Reims, and not to Mary, although his devotions are undoubtedly directed to her. Mary and the Christ Child look down at the devout donor with affection. Saint George, dressed in a stunning suit of armor, lifts his helmet in tribute to the priest opposite him. Reflections of the Madonna and Child are clearly discernible in his shining helmet, and in the buckler worn on his back the image of the artist, again in a red turban, standing at his easel appears.

The separation of two worlds, united in their devotion to *Maria Ecclesia*, takes the form of the two basic bodies of the church, the priestly and the militant. On the side of Saint George, warrior for Christ, the minor details depict heroic Old Testament feats: Samson slays the lion on the arm of the throne, and above in the capitals Abraham, on horseback, vanquishes the armies of Chedorlaomer, and David slays Goliath. On the side of the priestly Donatian the arm of the throne is decorated with

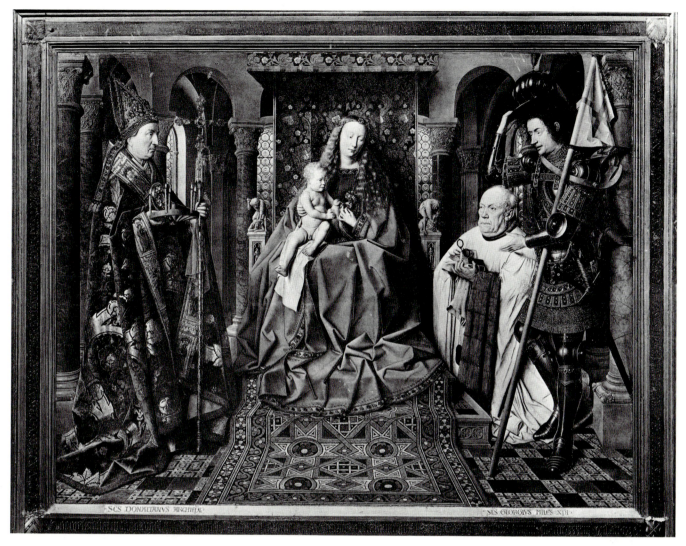

105. JAN VAN EYCK. *Madonna with Canon George van der Paele*. 1436. Panel, 48 × 61⅞″. Groeningemuseum, Bruges

a representation of the Murder of Abel by Cain, an act that served as a type for the sacrifice of Christ presented in the Mass, while the capitals display the stories of the Meeting of Abraham and Melchizedek and the Sacrifice of Isaac, both types for the Eucharist, as we have seen. Hence the worlds of the priestly and the militant are both juxtaposed and united in their common devotion to Mary and Christ.

The vivid portraits of the donors in these paintings are astonishing reconstructions of distinct, individual faces that are amazingly lifelike and yet somewhat remote from us as personalities. Perhaps the most engaging and enigmatic of all are the portraits of an Italian merchant and his young wife in the famous *Arnolfini Wedding Portrait* in London (colorplate 18).[21] This double portrait depicting a couple taking marriage vows in the bedchamber of a Flemish town house is unique in Netherlandish art. The husband and wife have been identified as Giovanni Arnolfini and Giovanna Cenami, and the occasion is their

marriage in a civil ceremony held in Bruges in 1434, the date inscribed on the rear wall. Giovanni was one of several wealthy Italian merchants who settled in Flanders. Rich and powerful, he became an influential figure in the economic policies of the court. In fact, Arnolfini was appointed a special knight by Duke Philip the Good, and perhaps in this way he came to know Van Eyck. His young wife was the daughter of a compatriot who had settled in Paris and married a French lady.

Due to the uniqueness of the representation, a number of fanciful if not humorous interpretations have been put forth over the years, particularly with regard to the identity of the couple and the condition of the bride. Good evidence, however, confirms the present identification— it is so listed in the inventories of Margaret of Austria in 1516, when it was in her collection at Mechelen—and Erwin Panofsky has ingeniously interpreted the *Arnolfini Wedding* as an unusual double portrait of a marriage ceremony that not only glorifies the sacrament of matrimony

106. Jan van Eyck. *Arnolfini Wedding Portrait* (detail of colorplate 18)

but, surprisingly, serves as a pictorial certificate for an actual wedding that took place in Bruges, although it should be noted that the date, 1434, is not accompanied by the month and day which should appear on any document (perhaps it was on the now-lost frame?).

A cozy Flemish bedchamber is the setting for the ceremony rather than a church since such a civil ceremony was permissible in the fifteenth century if it were witnessed by two officials of the city or court. For this reason, Van Eyck has made a special effort to elaborate the ceremony as a sacrament of the church through the use of disguised symbols. Both Giovanni and his wife-to-be have removed their shoes and covered their heads as the sacred vows are taken, for this chamber, however domestic in appearance, is hallowed ground on this occasion. Arnolfini raises his right hand in taking the vow, and in the next moment he will lower it to join Giovanna's right in the tradition of the ceremony.

Along the vertical axis through the center, marked by the two hands, Van Eyck arrays a number of eye-catching details: the dog, the red slippers, the mirror, the artist's elaborate signature, and, finally, the glistening chandelier. There is a certain magnetism in these intricate objects that commands our attention, and they also serve as disguised symbols that glorify the sacrament of marriage as well as allude to the more erotic connotations of the

nuptial ceremony much as expressed in early *epithalamia*, or marriage poems. The setting is, after all, a *thalamus*, or bedchamber, and from early inventories we learn that the original frame carried verses from Ovid, the Roman poet of erotic love.

A single candle burns in the chandelier symbolizing the presence of Christ-priest at the ceremony and also alluding to the "marriage candle" that was carried in the bridal procession and then placed in the nuptial chamber of the couple to burn until the consummation of the marriage. The crystalline beads and the spotless mirror are symbols of the immaculate nature of the young bride, while the statuette on the chair, Saint Margaret, one of the patron saints of mothers, refers to Giovanna's new role in society as a wife and bearer of children. The somewhat swollen contour of Giovanna formed by the heavy robe held before her is perhaps another allusion to this role in symbolic form, not in fact, as many seem to believe. It should be remembered that the conventions for the nude female in Late Gothic art also exaggerated the child-bearing part of the body.

The little dog presents something of a problem. The dog was often a symbol of fidelity, which certainly would be appropriate here, but the type of lapdog that Van Eyck placed at Giovanna's feet was usually associated with erotic longings. It is unusual too that this famous little dog was actually an afterthought, added when Jan made other changes in the lower part of the composition. It is the one conspicuous object in the room that is not reflected in the mirror. Finally, it may be added that even the colors of the wife's costume, the green mantle, the blue dress, and the white ermine trim symbolized for the Late Gothic age the amorous affection of the lover, her faithfulness, and her purity.

The painting holds more secrets. As Panofsky has demonstrated, it may be considered a legal document in picture form attesting to the legality of the marriage much as a written certificate. The unusual signature of Van Eyck, directly between the heads of the couple, is written in the florid Gothic script of court documents: "Johannes de eyck fuit hic." The replacement of the usual phrase "me fecit" (made this work) with "fuit hic" (was present) indicates that the artist signed the picture as a legal witness to the marriage. In the mirror directly below the signature is the reflection of the artist at his easel at the opposite end of the chamber accompanied by a second person, the second witness needed to authenticate a civil ceremony.

In the *Arnolfini Wedding Portrait* Van Eyck balanced the composition with a simple symmetry about an open central axis. Just as in the *Madonna with Chancellor Nicolas Rolin*, this vertical axis is not empty but filled with a number of intriguing little objects, and our eyes con-

stantly return to this axis through the curious magnetic attraction they possess. In a subtle fashion, this same center of focus divides the picture into two different worlds, each appropriate for the figure placed there. To the left, Giovanni, somber in expression and rigidly posed, is dressed in very dark robes and seems to stand out sharply in the room as a vivid silhouette. On his side are the open windows and the mud-stained wooden clogs (klompen), both attributes of the world outside the domestic quarters, the domain of Arnolfini the businessman. On the right, Giovanna fits like a piece from a jigsaw puzzle into the warm and colorful pattern of the oriental rug, the tester bed, the deep brown chair and duster, blending with it since this is her domestic environment. In the very center of the painting these two worlds are joined in the hands of marriage much as the great bridge in the *Rolin Madonna* links one world with the other. Again medieval symbolism and the new realism are ingeniously reconciled in Jan van Eyck's art.

The artist gives us a clue to his own concept of realism in the mirror on the back wall (fig. 106). Within its tiny convex surface Van Eyck reproduces the chamber for a second time seen from the reverse, and he seems to be showing off his incredible talent by accurately painting the distortions of the figures and forms that would naturally result from a reflection on a curved surface. In fact, we see more of the room in the reflection than actually exists in the painted world, and it is in this extension of space outside the picture where the artist once again portrays himself. Indeed, it must be a very real world.

This uncanny mirror also reflects a world of changing themes and meanings in religious subject matter. Around the frame appears a series of diminutive medallions, executed purposefully in an earlier Gothic style, that narrate ten episodes of the Passion of Christ in the traditional iconographic fashion. Nearly unobserved in the painting, they are merely decorative motifs and embellishments in a very secular interior. They appear as marginal reminders of a fading tradition in Christian art, that of the stereotyped religious pictures of the Middle Ages. In the art of the International Style the real world was marginal; the traditional religious image remained the dominant pictorial feature. Anticipating Rembrandt's art by over two hundred years, Van Eyck reverses these priorities. The real world has taken over, and the themes, whether religious or secular, are now wholly translated into the mother tongue.

Approximately two-thirds of Van Eyck's paintings have portraits in them. With few exceptions, Jan avoided the hallowed profile portrait that was the norm for the International Style, and the reasons for that seem clear. The more the head is turned from the strict silhouette toward a more frontal view, the more the immediacy of

107. JAN VAN EYCK. *Man in a Red Turban* (Self-Portrait?). 1433. Panel, 10¼ × 7½″. National Gallery, London

the personality becomes for the viewer. The profile portrait can be likened to an elegant contour map that has an abstract beauty; the three-quarter likeness is more like a textured landscape with a definite topography that has individual personality and character.

One-half of Jan's works are single, bust-length portraits, two of which, both early pieces, have already been cited, *Tymotheos* (fig. 95) and the *Man in a Red Turban* (fig. 107), the former dated October 10, 1432, the latter October 21, 1433. The later portrait, as we have seen, is considered a self-portrait of the artist for good reasons. He wears an exotic red turban and looks directly out at the spectator with stern eyes that show tiny dots of light from the studio windows in the irises. Furthermore, this is the only portrait where the marbleized frame does not identify the sitter but carries only the artist's signature, date, and motto: "Als ich kan Joh. de Eyck me fecit."

Both portraits are placed against an amorphous background of darkness from which the likeness seems to emerge, much as later in the portraits of Rembrandt. Nothing interferes with or detracts from the statement of the face, and a very specific face at that, with all details, including the stubble of a beard or the marks of a scar, painstakingly rendered in microscopic detail. Portraits of this nature can only be regarded as lasting first

108. JAN VAN EYCK. *Portrait of Baudouin de Lannoy.* 1435. Panel,
10¼ × 7⅞″. Gemäldegalerie, Staatliche Museen, West Berlin

109. JAN VAN EYCK. *Portrait of Jan de Leeuw.* 1436. Panel,
9⅝ × 7½″. Kunsthistorisches Museum, Vienna

impressions. It has often been argued that Van Eyck's people are static, impersonal beings presented to us much as a piece of still life, but I disagree. Surely Arnolfini was a cool, calculating businessman (the same frosty expression is found in an independent portrait of him in Berlin); Tymotheos was a rather sullen and melancholic musician; the man in the turban was a self-assured master of his world. In Van Eyck's paintings only angels and saints can smile, and the individuals who occupy the here and now reflect that serious melancholy and pessimism of the age that Huizinga described so vividly in his classic history, *The Waning of the Middle Ages.*

Attempts to discern a stylistic development in Van Eyck's portraits have been quite futile.[22] The *Portrait of Baudouin de Lannoy,* lord of Molembaix, known as the "stammerer," has been dated early and late, for instance (fig. 108). Van Eyck undoubtedly knew this prestigious court figure very well. Lannoy was governor of Lille, where Jan resided between 1427 and 1429, and he was also one of the leaders of the embassy sent to Spain and Portugal which the artist attended. The earlier dating has the favor here, however. We know that Philip the Good founded the Order of the Golden Fleece on January 10, 1430, following his marriage to Isabella, and Lannoy was a charter member, receiving the distinguished collar that

he wears here the following year. The portrait quite likely commemorates that occasion.

The Bruges goldsmith Jan de Leeuw was portrayed by Van Eyck in 1436 at the age of thirty-five (fig. 109). The original frame carries an interesting inscription: "Jan de Leeuw [figure of a small lion—*leeuw*], who first opened his eyes on Saint Ursula's Day in 1401; here I am painted by Jan van Eyck in 1436." Two aspects of this portrait have been described as indications of Van Eyck's late style: the enlargement of the head seen against the dark background and the turning of the eyes directly on the viewer. The latter trait was already seen in the *Man in a Red Turban,* dated 1433, and in his last dated portrait, that of his wife Margaretha, 1439, the format is that of the earlier works (fig. 110).

The inscription on the frame of *Margaretha* informs us that Van Eyck portrayed his wife on June 17, 1439, at the age of thirty-three. How much closer the artist has observed the features of his wife than those of Giovanna Arnolfini! Although not attractive, Margaretha personifies those qualities of homey virtues that we associate with the magnificent female portraits of Frans Hals. Her eyes are turned coolly on the viewer and her thin lips, tightly closed, convey the inner sense of an able and determined mind. The elegant Bruges lace of her headpiece

110. JAN VAN EYCK. *Portrait of Margaretha van Eyck*. 1439. Panel,
13⅛ × 10½". Groeningemuseum, Bruges

111. JAN VAN EYCK. *Cardinal Nicolas Albergati*. c. 1435. Panel,
13⅜ × 10¾". Kunsthistorisches Museum, Vienna

and the fur collar of her dress mark her well-being and comfort as the artist's wife. The somewhat stunted right arm has been attributed to later restoration, but, nevertheless, the extraordinary feminine individuality of the sitter marks this as a masterpiece of portraiture.

Through a remarkable accident of history, we are allowed to follow Van Eyck's method of reconstructing a personality in paint. Two portraits of Nicolas Albergati, cardinal of the Church of the Holy Cross (Santa Croce) in Rome and papal diplomat, survive, and one is in the form of a preparatory drawing (figs. 111, 112). Albergati was instrumental in arranging the conditions for the Treaty of Arras in 1435, but he had visited Philip the Good in Bruges earlier, from December 8 to 11, 1431. It was probably at that time when Van Eyck made the sketch.

The silverpoint drawing is extremely delicate and sensitive with fine lines marking out his features, his short cropped hair, slightly bulbous nose, and soft eyes. Faint inscriptions in a Limburg dialect appear in the margins noting the appropriate colors and shades of his face for the later painted version: ocherous gray hair, yellowish cast in the white of the eyes, fairly grayish tinge in his stubbled beard, etc. The unusually benevolent face in the drawing evokes the image of the cardinal as one whose

112. JAN VAN EYCK. *Cardinal Nicolas Albergati*. 1431?
Silverpoint, 8⅜ × 7⅛". Kupferstichkabinett, Staatliche
Kunstsammlungen, Dresden

warmth and understanding were much welcomed in the North during the turbulence of the French wars.

The painted version, usually dated later (1435), is handsome in its own right, but when compared to the initial impression captured in the sketch, his features appear to be hardened and sharpened and his expression somewhat muted. Something of the cardinal's benevolence and warmth was lost in translation. Albergati also figures in another painting by Van Eyck that has caused undue controversy, the *Saint Jerome in His Study* in Detroit (fig. 113).[23] This tiny painting has a spurious date added in the upper left corner, 1442, which, as with the *Ince Hall Madonna*, is not original and can only be considered a transcription of an inscription on the original frame, now lost.

Such a painting by Van Eyck was described by Facio in a collection in Naples, but good evidence suggests that the Detroit panel was in the collection of Lorenzo de' Medici in Florence in the fifteenth century (Albergati was buried near Florence in 1443). Frescoes of Saints Jerome and Augustine in the Church of Ognissanti in Florence, executed by Ghirlandaio and Botticelli respectively, were influenced by Van Eyck's consummate portrayal of the scholar in his study. Furthermore, a minuscule note on the desk in the painting is addressed to "The most reverend father and lord in Christ, Lord Jerome, Cardinal-Priest of the Holy Cross in Jerusa-

above: 113. JAN VAN EYCK. *Saint Jerome in His Study.* 1442? Panel, 8 × 5¼". Detroit Institute of Arts. City of Detroit Purchase

right: 114. JAN VAN EYCK AND FOLLOWER. *Madonna and Child with Saints and a Carthusian Monk.* 1441–43. Panel, 18⅝ × 24⅛". Copyright The Frick Collection, New York

115. JAN VAN EYCK. *Crucifixion* and *Last Judgment* (diptych). c. 1438–40. Panel transferred to canvas, each 22¼ × 7¾". The Metropolitan Museum of Art, New York. Purchase, Fletcher Fund, 1933

lem.'' Such a salutation would be proper for Nicolas Albergati, cardinal-priest of the Church of Santa Croce in Gerusalemme in Rome, and perhaps the panel was intended to be a gift to the papal legate by Philip the Good.

That it is an actual portrait of the cardinal must be ruled out, however. It bears no resemblance to the Vienna panel, and the weary Jerome is much too young to be Albergati. As a tribute to the cardinal and his titular church, however, it is most appropriate. The tired scholar, his fingers marking passages in his text, continues to plod through his exhaustive reading of the Bible. The one problem is the date. Van Eyck died in 1441, and because of this, many authorities have suggested that the picture was finished by Petrus Christus, an artist who is usually credited with problematic Eyckian paintings. The muddy reds of the cardinal's habit were thus ascribed to Christus, but after the panel was cleaned in 1956, these pigments proved to be repaint of a much later date. Christus has received shoddy treatment by some Van Eyck scholars, and that problem will be reviewed presently. Another painting from Van Eyck's studio, the *Madonna and Child with Saints and a Carthusian Monk* in the Frick Collection in New York (fig. 114), was certainly known to Christus, but it is unlikely that he had a hand in the rather mechanical treatment of the drapery folds and the dry execution of the landscape.[24]

116. Jan van Eyck. *Saint Francis Receiving the Stigmata*. c. 1438–40. Panel, 5 × 5¾″. The John G. Johnson Collection, Philadelphia

More troublesome are two other Eyckian paintings in America, the *Crucifixion* and *Last Judgment* diptych in New York (fig. 115) and the small *Saint Francis Receiving the Stigmata* in Philadelphia (fig. 116). Both are, in my mind, works by Jan van Eyck in his later years. The New York diptych will be discussed later, but the *Saint Francis* panel deserves special mention as a conclusion to our study of Van Eyck. The incredible detail in the little painting is as microscopic and refreshing as in any of the works described so far. It was, furthermore, a very influential painting (an enlarged copy is in Turin), and while there are some discrepancies in the position of Saint Francis's legs with regard to his draperies, the usual criticism of the bland inattention of the saint to the stigmata that hovers before him is no shortcoming on Van Eyck's part. As in other paintings of mystical visions by Van Eyck, Francis is experiencing the event in a passive manner, and the lack of theatrics in his ecstasy is wholly in keeping with the "negative" mysticism of Van Eyck's interpretations.[25] It is, in fact, this passivity in Jan van Eyck's expression that distinguishes him from his rival in Netherlandish painting, Rogier van der Weyden.

Robert Campin and Rogier van der Weyden

Since the fifteenth century, Jan van Eyck and Rogier van der Weyden have been considered the founders of the Early Netherlandish school of painting. Their art represents the poles within which the *ars nova* of the Netherlands vacillates throughout the fifteenth century, and the marked differences in their styles have usually been explained as a matter of geography and patronage. Jan van Eyck came from the northeastern province of Limburg to settle in the court center of Philip the Good, Bruges, where he perfected a style that reflected the aristocratic and intellectual tastes of his patrons. Rogier van der Weyden was from the southeast, Hainaut, and after moving to Brussels, about 1435, he became "painter to the city" and established a large workshop that dispersed his Gothic style rapidly north and east to the Rhine valley and beyond.

The doyen of Early Netherlandish studies, Max J. Friedländer, explained the basic differences in the art of the two masters as one of racial temperament: "It would be tempting to regard the contrast between Jan van Eyck, who came from the East, and Rogier, who came from the South, as a conflict between the German and the Latin temperament with the towns of Flanders providing the battleground."[26] In perspective, this seems like an unfortunate judgment, and surely the persistence of the artistic traditions established by these two great artists had little to do ultimately with racial backgrounds. It was, in fact, Rogier's style that impressed the Germanic centers to the east, while Van Eyck's art left its imprint on painting in southern France and Spain.

It is true that Rogier van der Weyden had his training in the French-speaking Walloon province of Hainaut, but it must be remembered that the cultural and economic life of Tournai (Doornik) depended on Flanders and not France. The major fair in Tournai, held annually in September, was represented by thirty-six towns; twenty of them were Flemish. There was no court in Tournai, and, as far as we know, the artists there received few commissions from the nobility. Unlike the *valets* of the Burgundian courts, the painters were members of a guild who worked for the city and for patrons of the *nou-*

veaux riches. The guilds, the great ancestors of modern labor unions, were important institutions in the political life of the Netherlands, and they usually reflected the more progressive, middle-class factions in the city who were opposed to the old guard aristocracy. In Tournai, curiously enough, it was the middle class who mostly favored the crown of France. The nobility feared the power of the Burgundian dukes and paid them favor to avoid any hostility. To ensure their position they negotiated a costly treaty of peace with Philip the Good in 1421. The lower classes quickly rebelled and, in turn, demanded more representation in the city government. Strikes, mass meetings, and vociferous parades followed.

Tournai teetered in an uneasy balance. In 1423 the people openly revolted. Led by representatives of the craft guilds, they took over the city and set up their own democratic government. The guilds became all powerful in the new constitution, and the leadership of civic life rested on their deacons and subdeacons for a great part.

ROBERT CAMPIN

The story of Rogier van der Weyden begins with Robert Campin, a subdeacon of the guild of goldsmiths at that crucial time. Campin was the head of the painters' guild as well as a member of the stewards (*eswardeurs*) of the city, one of the Committee of Six entrusted with the accounts and finances of Tournai, the warden of a parish, the captain of a city quarter, and the bursar of the church. In every respect Robert Campin's life was one that emerged from the new bourgeois environment. He apparently was not a native of Tournai. His name, Campin, or Kempen in Dutch, suggests that he had ancestry in the very district of the North Netherlands from which Van Eyck emigrated.

He is first mentioned in the city archives of 1406, when he must have been about thirty years old and no doubt already an accomplished artist. Several documents record his activity in Tournai until his death in 1444. Notable among these are the lists of his apprentices in 1427 in which one Rogelet de la Pasture (Roggie van der

Weyden) is named. In the following year old factions in the city regained control and Campin was in trouble. He was twice arrested, being charged with violating a moral code: "Master Robert Campin, painter, one year [of exile] for the filthy and dissolute life which he, a married man, has for a long time led in this city with Laura Polette."[27]

Jacoba of Bavaria, the lone survivor of the Dutch-Bavarian rulers of Hainaut and herself harassed by the Burgundians, later intervened and had the sentence commuted, but by that time Campin's reputation in the city was gravely defiled, and after 1432 little is heard of his activity. In fact, just two days after the sentence was passed, Campin had his chief apprentice, Rogier van der Weyden, promoted to the status of master, no doubt to protect him from the adverse effects of the arrest. A day later, a second apprentice, whom we know only as Willemet N, was also made a master, and two months later, a third painter, Jacques Daret, was elevated to the rank of master and, curiously enough, elected deacon of the guild at the very same time. The puzzling relationships between Campin and his apprentices will be reviewed later, but there can be little doubt that they worked with Campin more as collaborators in a big workshop than as pupils.

There is no longer any reason to doubt that the works of the so-called Master of Flémalle (after a set of paintings wrongly ascribed to an Abbey of Flémalle in the Lower Rhine) are to be attributed to Campin, but there remain a number of problems as to the roles that his collaborators played in their production. The triptych known as the *Mérode Altarpiece* in the Cloisters in New York is one of the most significant works of Campin's atelier (colorplate 19). That Campin was determined to translate the holy stories into the "mother tongue," so to speak, is clearly attested to in the central panel, where one of the earliest examples of an *Annunciation* placed in a domestic interior is seen.

The *Mérode Altarpiece* has usually been dated about 1425, and therefore it has been assumed that the composition of the *Annunciation* on the outside shutters of the Ghent altarpiece was influenced by it to a degree. A careful comparison of the two versions reveals the basic differences between the two painters, however. In place of the orderly and tidy ecclesiastical chamber in which Van Eyck placed the Virgin, Campin fashioned a crowded and cluttered domestic interior with an obvious delight in reproducing the material existence of household objects.

With painstaking detail he delineated object after object. A sacerdotal note may be discerned in the conspicuous kettle in the niche behind Gabriel, but it is domesticated by a white towel (a Jewish prayer shawl?) that

hangs in a disorderly manner from a rack with a grotesque head next to it. The right side of the rear wall is interrupted by window shutters flung open in a somewhat casual fashion. Two metal candlestick holders, one with an extinguished candle, adorn a wide, projecting fireplace on the right wall before which a long bench stretches the entire length of the room.

Into this busy interior Campin crowds other objects. A round table completely fills the gap between the angel and Mary. On it are a number of objects. A colorful majolica vase with a quasi-Hebraic inscription holds three white lilies. One is merely a bud, suggesting that beyond alluding to the symbolism of the Virgin's purity and lineage, Campin also wanted to point out that at this very moment the Trinity was coming into being. Below it is a bronze candlestick holder with a taper that has just been snuffed out, and on the lower edge an open book rests on a large purse. The unusual tilt of the table evokes the uncomfortable sensation that these objects might tumble from their place at any moment. The *horror vacui* created by the very abundance of objects is further heightened by the diving perspectives of the room. The walls, ceiling, and furniture recede at breakneck speed. A bright shaft of light floods the interior from the top left, but double shadows are cast by many objects as if another light source were illuminating the interior.

Into this deep, crowded box Campin places his figures. Both the angel and the Virgin are big and bulky and assume their positions rather awkwardly along the foreground plane. Mary sits on the floor and leans back against the footrest of the long bench. Gabriel, unlike the gracefully posed angel in Van Eyck's *Annunciation*, moves quickly into the chamber and with his left hand planted firmly on his knee gestures boldly to the Virgin with his right. But Mary continues to read as if unaware of the angelic presence. Indeed, Campin's holy figures display the same material weight and presence as the everyday objects with the heavy draperies that enshroud them. Unlike the more organic folds of Van Eyck, Campin's are purposefully contrived to mark out the geometric bulk of the body. The knees of the Virgin project forward and the drapery folds are marked out in the fashion of a star that has its center at them. To emphasize the radial turning of the folds in space, Campin paints stark white highlights along their ridges to effect the form of a striated cone tilted in space.

The iconography of the *Mérode Altarpiece* has received much attention since it was brought out of relative obscurity in 1957.[28] The notion of staging the Annunciation in a domestic interior has parallels in popular devotional literature of the time. Mary's chamber becomes an intimate household setting that is pretty and neat, and the Virgin, as any good mother, busies herself

by reading the Bible. Her position on the floor is unquestionably due to the popularity of humility as a major feminine virtue. As early as Saint Bernard in the twelfth century we are told that virginity is indeed worthy of praise but humility was just as virtuous. Without her humility Mary would not have been so pleasing to God.

For the rest, Campin's symbols can be read in an orderly fashion, one after the other, just as his objects are so frankly placed one beside the other. The rays of the Holy Spirit descend from the round window in the upper left, but in place of the dove, Campin paints the tiny image of a nude infant carrying a cross. This is clearly an anticipation of Christ's future sufferings for mankind. The snuffed-out candle on the table has been variously interpreted. A Gothic treatise by Durandus on the meaning of the parts of the church informs us that the wax of the candle represents Christ's human nature, the wick his soul, and the flame his divinity. Thus one scholar sees the extinguished flame as an emphasis on Christ's human nature to underscore the fact that he was God born in the flesh. Another suggests that the motif derives from the writings of Saint Bridget where we read that the divine radiance of the Child obliterated the natural lights of the world.

It should be remembered that a single candle was lit in the marriage chamber of the *Arnolfini Wedding Portrait*, and while it might have meant the mystical presence of Christ at the ceremony, it also was the marriage candle, the *Brautkerz*, that was brought by the bride to the wedding chamber to be snuffed out at the consummation of the marriage. Perhaps, in what may seem a bold manner today, Campin here alludes to the moment when the first marriage of the Virgin to God is fulfilled, when the Holy Spirit overshadows Mary and the Christ Child is conceived.

The right panel of the altarpiece is an interesting piece of subject matter to study. The setting is a tightly confined space box that represents a carpenter's workshop facing the city streets with wares displayed for sale. At first sight, the subject appears to be a secular one. The elderly man busy drilling holes into a rectangular wooden board is Joseph in the role of a carpenter. On the table are numerous instruments of his trade.

Joseph rarely appears in representations of the Annunciation, and his presence here may be accounted for on the basis of the popularity that the cult of Saint Joseph had attained in the Netherlands. With the exception of a few paintings in the Lower Rhine, Joseph rarely had a positive role in the scenes of Christ's infancy. He was usually depicted as a weary old man pondering the mystery of the virginal birth, but here he has acquired status as a member of the family, as a proper husband with a respectable trade and a responsible position in society. Jo-

seph is a man who labors in earnest for his family, and this point alone is evidence of the rising middle class for whom Campin painted. And yet, the surprising thing about Campin's secular genre scene is that it too partakes of the intricate disguised symbolism found in Van Eyck's world.

What is Joseph making and what is he selling? He is drilling holes in a board. Is this the spike board that Christ will carry on his way to Golgotha or is it a miniature winepress, both being anticipations of Christ's shedding of blood for man's salvation? Are the curious objects on his table and the window mousetraps? These strange details have their source in early patristic writings concerning the mystery of the Incarnation. Why did Mary need a husband at all? According to some early theologians, the marriage of Mary and Joseph was staged to make the miraculous birth of Christ less conspicuous to Satan by hiding the fact of his divine parentage. According to Saint Augustine, the marriage took place to fool the devil just as mice are fooled by the bait of the trap. Augustine further wrote that the mousetrap and bait for Satan, by which he was caught, symbolize the Lord's death on the cross. Thus, within this seemingly secular environment, Campin has ingeniously concealed the mysteries of a much earlier medieval tradition.

The male donor kneeling in the forecourt in the left panel is a member of the Ingelbrechts family of Mechelen if the identification of the coat of arms in the window of the *Annunciation* can be accepted. Behind him kneels his wife—perhaps a later addition—carrying Rosary beads in her folded hands. Here Campin changes the setting again. The patrons are outside the Virgin's chamber. The door is, however, opened so that they may view the mystery, indicating that Campin was familiar with the story that the gates of paradise were once again opened for mankind by the Incarnation.

Within the enclosed garden are numerous flowers that are symbols of Mary. One detail that has eluded interpretation is the mysterious figure in exotic costume who stands beside the portal of the garden. He has been identified as a self-portrait of the artist, as a servant of the family of the patron, as the prophet Ezekiel, and as the broker who arranged the marriage of the young donor. None of these identifications is acceptable. He is very likely meant to be the prophet Isaiah, whose writings figure strongly in the Annunciation iconography, as Charles Minott has pointed out.[29]

Campin's intriguing altarpiece thus shows the subtlety of themes that one would associate with Jan van Eyck. But there is one major difference. Where Van Eyck's disguised symbolism presented a unified iconographic message, Campin's tends to fall into separate pools of meaning just as his settings change with each panel.

117. ROBERT CAMPIN (MASTER OF FLÉMALLE). *Entombment Triptych*. c. 1415–20. Panel, 23⅝ × 19¼″ (center); 23⅝ × 8⅞″ (each wing). Courtauld Institute Galleries, London. Princes Gate Collection

Only the import of Isaiah's prophesy of the Annunciation unites the three panels. It is also evident that Campin's forte is in reproducing the commonplace objects of this world. He labors to capture the material details whether the object be a saw at Joseph's feet or the lock on the door of Mary's intimate chamber.

The development of Campin's style can be traced more easily than can Van Eyck's. Since 1940 two important works by Campin have been discovered that can be dated in the early years of the fifteenth century. The first of these is an impressive triptych formerly in the collection of Count Antoine Seilern in London featuring an *Entombment* (fig. 117). The side wings display, to the left, a donor kneeling in a garden below Golgotha where the two thieves are seen writhing on crosses, and, to the right, the Resurrection in a landscape. The triptych dates between 1415 and 1420. The heads and elaborate draperies of the two angels flying against an abstracted background in the middle panel are reminiscent of the Italianate types found in the works of Malouel and Bellechose, suggesting that there might have been some connection between Campin and the earlier artists of the Burgundian court. The suppression of space for a more archaic, sharply rising ground plane in the wings together with the richly decorated surface of the panels in general also point to the arts of the northeast, in the territory of the Rhine, as a possible background for Campin's early style.

The bulky figures that displace space like blocks of stone with their twisting pyramidal draperies are familiar aspects of Campin's style, and nearly a hallmark of his compositions are the colorfully garbed women seen from the back along the foreground plane. Campin's realism is a bit rugged, but the pronounced emotionalism in the *Entombment* is delicately accented by such details as the angel to the right who tenderly brushes a tear from his cheek with the back of his hand.

The second panel, only a fragment with the bust of *Saint John the Baptist*, was acquired by the Cleveland Museum in 1966 and displays the same elaboration of the facial types of the International Style together with the richly ornamental backdrops. The *Nativity* in Dijon, datable about 1425, is the next in line from the point of view of stylistic development (fig. 118). The delicate angels hovering over the shed of the *Nativity* wear the same calligraphic draperies found in the Seilern triptych, and the colorfully draped figure seen from the back appears again in the lower right. Other characteristics of the International Style appear in the twirling banderoles carried by the angels and in the mannered landscape in the left background with peaks swelling upward like a series of Phrygian caps.

But Flemish realism now predominates. The rotting wood of the stable with its weatherbeaten slats and posts, symbolic of the old world, are observed with the intensity of one well-versed in carpentry. The lighting effects are more pronounced too, with special emphasis given to the long shadows cast by the trees in the distant landscape to the right, while the sun is symbolic of the rising of a new age marked by the birth of Christ. The background to the right is far more advanced than the earlier view of Golgotha in the Seilern triptych. Com-

posed like some toy landscape, a winding road peopled by busy peasants leads back to a village bathed in sunlight.

It is in the iconographic treatment of the *Nativity* that Campin once again sets himself apart from other artists of his day. Here he reverts to an Early Christian account of the birth of Christ found in the apocryphal gospels of the sixth century where the midwife Salome tested the virginity of Mary, whereupon her hand withered. Also the ominous presence of the ox and ass seems to indicate that Campin was familiar with early legends that associated the ox—who knows his master, according to Isaiah —with the Gentiles, and the unruly ass—who knows his master's crib and eats hay from it—with the Jews. Finally, it is also apparent that Campin was familiar with Gothic mystical treatises on the Nativity, such as that of Bridget of Sweden, where the Madonna is described as dressed in white and kneeling in humility before her nude newborn, whose radiance annihilates the light of the candle that Joseph holds nearby.

The vigor of Campin's art waned considerably after the troubles of 1432. The engaging originality of his earlier compositions is lacking in the *Salting Madonna* in London (fig. 119). The same healthy, robust Madonna sits on the floor of her cozy domestic quarters much like that of the *Mérode* triptych. Bold white highlights on the Virgin's mantle mark out the heavy form that rests back somewhat sluggishly against the long bench with lion armrests. Although seated on the floor and nursing her Child, the Madonna of Humility is not so convincing a characterization. Behind her full face and cascading hair appears a giant round fire screen, forming a very overt halo. But this symbolism, compared to that of Van Eyck, is admittedly heavy-handed. And if the restorations of the right edge of the painting can be trusted, then we can note that Campin did not bother to disguise his symbol at all. On the chest upon which the Virgin leans is a chalice, another overt sign of man's salvation in the Eucharist. Here again he includes a charming toy landscape, seen through a window in the left background. Unlike Van Eyck, who gave us a view across the rooftops in the *Annunciation* of the Ghent altarpiece, Campin changes his angle of vision, and lifting us up by the ankles, so to speak, we look down upon a more cartographic view.

In the one dated work by Campin, the side shutters of a triptych painted for Heinrich von Werl in 1438, the inspiration seems to come from his associates and contemporaries. The central motif in the donor's panel is the round mirror like that in the *Arnolfini Wedding Portrait*, while the engaging figure of his patron saint, John the Baptist, seems to be a quotation from a figure in an altarpiece by his illustrious apprentice, Rogier van der Weyden.

118. ROBERT CAMPIN (MASTER OF FLÉMALLE). *Nativity.* c. 1425. Panel, 34¼ × 28¾". Musée des Beaux-Arts, Dijon

119. ROBERT CAMPIN (MASTER OF FLÉMALLE). *Salting Madonna.* c. 1430. Panel, 24¾ × 19¼". National Gallery, London

ROGIER VAN DER WEYDEN

Rogier van der Weyden's *Deposition*, today on loan from the Escorial to the Prado Museum, was one of the most influential paintings in all Early Netherlandish art (color-plate 20). It is also the best documented work by Rogier (who signed and dated no paintings), since it is listed in the inventories of the Escorial in 1574 as a central panel of a triptych by Rogier, and we can trace it back to 1443 when a dated copy (the *Edelheer Altarpiece*) was made. It is further known that it was made for the crossbowmen's guild in Louvain for the Church of Notre Dame hors-les-Murs, as the tiny crossbows in side spandrels indicate.

A masterpiece of design, Rogier's *Deposition* in many respects is the epitome of Late Gothic expression in painting, and yet it differs greatly in style from the works of Jan van Eyck and those of his master, Robert Campin. For one thing, deep space and infinite detail of the everyday world are not found here. Rogier tightly interlocks ten monumental figures, nearly lifesize, across a shallow foreground plane emphatically marked off by a golden stage. While it may be going too far to say, as some have done, that Rogier has consciously returned to the earlier planar compositions of the Gothic—that his art is "Neo-Gothic" in that it displays a dominant surface pattern enriched with a basic linearism while projecting large sculptural figures—it is true that we are reminded here of the impressive thirteenth-century tympana more so than of the Ghent altarpiece or the Mérode *Annunciation*.

It is also true that the general expression is one of a community of emotions so characteristic of High Gothic art. The bold "S" curves formed by the bodies of Christ and Mary dominate the center of the composition, and on first viewing the work, they evoke a strong feeling of instability in the spectator. This impression is soon relieved, however, when we take in the whole picture. The figures of the mourners behind Christ and Mary and the truncated cross form a row of regularly spaced verticals that anchors the dynamic surface movement, while in the very same plane with the swooning bodies, the figures of John the Evangelist and Mary Magdalen form beautifully designed parenthesis marks to contain the entire group. This is a masterpiece of design in every respect, and it is no wonder that it was copied so many times in the fifteenth and sixteenth centuries.

Space, depth, light, landscape, and realistic detail seem to have been of little interest to Rogier. The shallowness of the setting and the concentration of the design were surely intentional. Rogier can paint landscapes and detailed interiors, as we shall see, but here those concerns are put aside for purposes of the dramatic content of the Deposition, a highly emotional theme that nearly replaced the Crucifixion as the major event in the Passion

120. Rogier van der Weyden. *Madonna and Child*. c. 1432. Panel, 7¼ × 4¾″. Kunsthistorisches Museum, Vienna

during the course of the fifteenth century. The shallow, artificial stage and the golden background seal off any indications of secondary details and push the impressive figures in painful proximity to the spectator. They are right before us, and it is as if some great sculptural presentation had suddenly come to life, and our whole attention is sharply focused on one dramatic moment: the compassion of those nearest to Christ at this final moment.

A comparison of other fifteenth-century representations of the *Deposition* with that in the Prado will immediately reveal the genius of Rogier van der Weyden in conveying emotions. In many of the variations and copies of his work the same actors are placed not on a stage but in a deep landscape that tempers the immediacy and poignancy of the content. In contemporary Italian versions, such as the famous *Deposition* by Fra Angelico in Florence, where a similar "S" position of Christ's body appears, it is difficult to determine just what the central theme is. Dispersed in a sweeping panorama are several

groups of figures apparently discussing the tragedy, but one is more attracted to the charming details of Fra Angelico's world and his treatment of the individual figures than to any pervading statement of an emotion.

There is no question as to what Rogier's *Deposition* is meant to convey. All but the essential elements of the story are eliminated. The mother, the relatives, and the close friends of Christ weep real tears over the parting of a loved one. The theme here is compassion, and the mourners show their grief openly. And yet, with the exception of the writhing Magdalen to the right, Rogier's people display a suffering that is more eloquent and dignified than the painful contortions of despair often expressed in fifteenth-century art. Furthermore, all figures respond in the same fashion. Rather than a tableau of actors reacting individually, as we shall find in Hugo van der Goes's paintings, Rogier's *personae* contribute to one emotional experience of compassion. The idea of the Gothic community of emotions is thus superbly recaptured.

In no other Early Netherlandish painting of the Deposition was the Virgin depicted as falling into a lifeless swoon. The pose is Rogier's invention, and one is at first surprised that Mary collapses into the same pose as that of her son. It is as if Mary too were being deposed in death—she too is held up by two figures—and that her own suffering was far greater than that of the other mourners. Rogier did not invent this poignant motif solely for design purposes, however. The idea of Mary's total compassion for her son in the Passion became a favorite theme in Late Gothic mystical literature.

Already in the writings of Saint Bernard in the twelfth century there can be found anticipations of this special concern for her personal sufferings, and by the thirteenth century the eminent theologian Albertus Magnus wrote that Mary felt in her heart the same wounds that Christ suffered in his body. By the fifteenth century, Mary's compassion had acquired doctrinal significance. She too had a role in man's redemption. Denis the Carthusian provides us with a literary parallel to Rogier's interpretation. In one work, on the "Dignity of Mary," Denis underscored the important role the Virgin played in the redemption of man, especially in the Passion. In a passage concerning Mary's presence at the Crucifixion, Denis admitted that it was not easy to believe earlier traditions that relate her acceptance of the sacrifice of her son as part of a divine plan, an inevitable act of fate. He asks the reader if her sufferings in that hour were not as grave as bodily martyrdom, as bitter as death itself. For Denis, Mary herself was near death when Christ gave up his spirit, and that was her share in the divine sacrifice.[30]

Whether or not Rogier was familiar with the writings of Denis the Carthusian, it is clear that both men express a Late Gothic sentiment that culminated in the *Imitatio Christi* (*The Imitation of Christ*), the mystical devotion summed up beautifully by Thomas à Kempis in his treatise so well known today. One of the features of Late Gothic piety was namely this preoccupation with the personal identification of the worshiper with the sufferings of Christ and Mary. In this respect, Mary's *imitatio* of Christ in the Prado *Deposition* quickens the viewer's response to compassion for Christ. The theatrical nature of such an act of empathy is obvious. Rogier's figures are on the stage before us, and nowhere can one find a more powerful or moving drama enacted in Netherlandish art.

Carel van Mander wrote very little about Rogier in his *Het Schilder-boeck* (*Book of Painters*), but the little he gives us tells a lot: "He [Rogier] improved our art of painting greatly, through his works, by depicting the inner desires and emotions of his subjects whether sorrow, anger, or gladness were exhibited."

Robert Campin is not mentioned in the early histories of Netherlandish painting, but Rogier van der Weyden was considered by chroniclers, north and south, even during his own lifetime, to be second only to Jan van Eyck among Northern artists. In fact, much confusion arose out of the close association of the two painters, the "princes" of Gothic art. Already in 1456 an Italian, Bartolommeo Facio, remarked in his *De viris illustribus* that "Roggero" was a disciple of Jan van Eyck, and in Vasari's first edition of *Le vite* (1550), Rogier's personality was split between a Rogier of Brussels and a Rogier of Bruges. This confusion, repeated by Van Mander in 1604, has led to a number of conflicting theories up to the present time concerning Rogier's background and training. There is, however, no evidence of any close association between Van Eyck and Van der Weyden; stylistic and iconographic aspects of their art rule out any such relationship.

One of Rogier's earliest paintings, the tiny *Madonna and Child* in Vienna, probably dating before his appearance in Brussels in 1435, gives us clear insight into the issue of his training (fig. 120). The fleshy face of the Virgin and her portly proportions are reminiscent of Campin's Madonnas, but the graceful sway of her body and the elegant cascades of drapery that fall from her right arm are features that Rogier will gradually elaborate. Mary stands in a shallow Gothic niche with a spray of delicate tracery and grisaille sculptures of Adam and Eve on the embrasures and God the Father with the Dove on the soffit of the arch.

More revealing is Rogier's early *Annunciation* in the Louvre, which once formed the central panel of a triptych (fig. 121). The setting closely resembles the bourgeois interior of Campin's *Mérode Altarpiece*—many of the furnishings are identical—and the position of Mary

seated on the floor (or on a small bench) is similar too. The differences, however, are just as obvious. The poetic qualities of Rogier's *Annunciation* are at once manifest in the graceful postures and rhythmic lines of drapery. A hushed stillness pervades the cozy room as Gabriel floats gracefully into the chamber and Mary, with downcast eyes and a slight smile, gently turns to acknowledge his presence. In place of the wholesome peasants who maneuver clumsily in Campin's works, Rogier portrays elegant people who move with the grace of ballet dancers.

The interior also partakes of this intimate lyricism. The furnishings may be those of Campin, but the plunging perspectives, the bold lighting effects, and the vibrant presence of material objects are veiled as if they were seen through a soft haze. In effect, the chamber is tidier, quieter, more intimate and subdued in contrast to the brilliance of the two figures. The room has been transformed into a marriage chamber, a *thalamus virginis*, with the symbolic bridegroom, Christ, portrayed in a medallion on the back hanging of the bed. According to Gothic thinking, this was Mary's first marriage to God (her second being the Coronation), and thus this intimate association, much as in Van Eyck's *Arnolfini Wedding Portrait*, would be an enhancement of the sacred story.

The influence of Van Eyck can be seen in the fragile vase on the fireplace and in the rich brocades of the angel's robes, but these are minor points of comparison and only indicate that Rogier was very much in the mainstream of Netherlandish painting. Nowhere in Van Eyck's paintings will one find draperies that float with the lyrical grace of Gabriel's; they have the musical qualities of counterpoint in the consonance of folds that at once keep the melody—the body—clearly stated and, at the same time, the effect of slowly alighting—the denouement—so enhancing.

That Rogier was an admirer of Van Eyck is demonstrated in one of his earliest works executed in Brussels, perhaps a "master" work presented to the Guild of Saint Luke for their chapel, the *Saint Luke Portraying the Virgin* (colorplate 21). Several replicas of this panel exist, the best being in Boston, which indicates that it initiated a tradition for depicting the artist in his studio that we will have occasion to return to later.[31] Luke, who painted the first icons of Mary, was likened unto a Christian Apelles, and thus was the natural patron saint for the artists' guild. It has been suggested, but by no means convincingly demonstrated, that the features of Saint Luke are those of Rogier, and there can be no question that the subject here was a Gothic statement of the immortality

121. Rogier van der Weyden. *Annunciation*. c. 1435. Panel, 33⅞ × 36¼". The Louvre, Paris

122. ROGIER VAN DER WEYDEN. *Miraflores Altarpiece*. c. 1440–44. Panel, each 28 × 16⅞″. Gemäldegalerie, Staatliche Museen, West Berlin

of divinely inspired art. The Madonna and Child, which Luke sketches in silverpoint, is the type that Rogier portrays frequently in smaller devotional diptychs.

Rogier's painting is closely related to the *Madonna with Chancellor Rolin* painted by Van Eyck a few years earlier (fig. 104). The same tripartite loggia gives us a view of two people—here Joachim and Anna, Mary's parents—looking over a parapet with a view of a broad river and valley. In contrast to Van Eyck, Rogier is less interested in secondary details. The studio is a simple vaulted box; the little garden beyond has only a few symbolic flowers and no peacocks; and the distant landscape is composed with no direct observation of nature, a pale reflection of those of Van Eyck and Campin.

As in other works discussed so far, Rogier's primary concern is with the figures and their rhythmic design. With the exception of the tiny figurines of Adam and Eve on the arm of Mary's throne, Rogier avoids disguised symbolism. He masterfully abstracts the lines of the drapery of both figures and the structure of the chamber itself to create circular patterns that revolve about an architectonic core of horizontal and vertical axes. The melodious arcs repeated in the lower right of the Virgin's mantle (the left half has been heavily restored) create graceful abstract patterns, and the half genuflection of Saint Luke not only imparts an air of reverence but also initiates the gently curving arcs on his side of the composition that are continued in the vaulted room, the circular window, and the canopy.

Rogier's Madonna types have now acquired their own special personalities. While she belongs to the same fam-

ily as the maidens of Van Eyck and Campin, his Mary is different from them in her tender, downcast glance, her quiet and shy expression, that imbue her with the affectionate and sensitive nature of a good mother. Van Eyck, in his mature works, portrayed the Virgin as a frail and dainty princess, Campin gave her the wholesomeness of a rugged peasant, and Rogier paints Mary as the good Flemish wife of noble background.

It is difficult to construct a chronology for Rogier's paintings, but it can be said that within a short time after establishing himself in Brussels as the official "city painter," he attained considerable fame and received numerous commissions from the city and private patrons, including those of the Burgundian court. His atelier must have grown in size within a decade, employing a number of apprentices, and his style soon spread far beyond the workshops of Brussels. Rogier, more so than Van Eyck, was the influential figure in the transmission of the *ars nova* through the Netherlands and to the east, and this influence was due not only to the lyrical aspects of his style but to his inventions of broader compositional schemes.

One of Rogier's most engaging inventions appears in two non-folding triptychs devoted to the Virgin with identical compositions (fig. 122). Much has been written about the precedence of one set, today in collections in New York and Granada, over the other, the so-called *Miraflores Altarpiece* in Berlin. In fact, they are so close in style that one can conclude that they are both excellent workshop productions, replicas for two different patrons. Elaborate painted arches, simulating the stone ar-

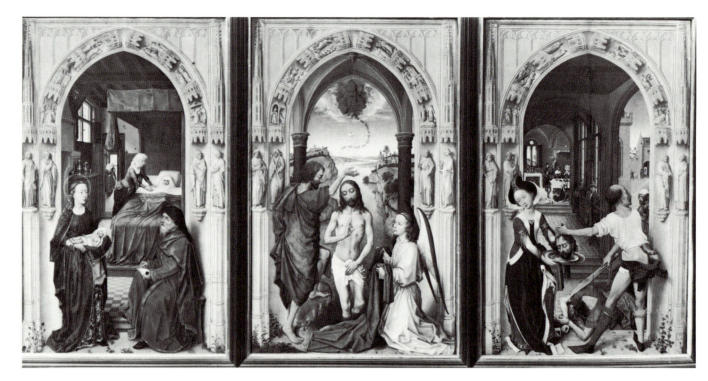

123. Rogier van der Weyden. *Saint John the Baptist Altarpiece*. c. 1440s. Panel, each 30¼ × 19″.
Gemäldegalerie, Staatliche Museen, West Berlin

chitecture of a cathedral facade, enframe the three panels. In keeping with Rogier's theatrical interests, these arches serve as the proscenium settings for the narratives enacted beneath them. All three are exceptional subjects for the period: the Holy Family, the Pietà, and the Final Appearance of Christ to His Mother. Furthermore, all three are reduced to the barest essentials of the stories reminiscent of the mystery plays of the period. In fact, Rogier's condensed figure groups bring to mind earlier sculptured *Andachtsbilder* where only the most important figures in a familiar narrative were extracted from the setting, monumentalized, and placed as very real people before the worshiper as aids for mystical devotion. All attention is focused on the emotional and heartrending relationships of the stories, and secondary references to specific time and place are omitted.

The inspiration for each episode in Mary's life comes from different sources. In the *Holy Family* the tender characterization of the young Virgin, dressed in white and seated on the ground, certainly owes something to the mystical vision of the Nativity described by Saint Bridget of Sweden. The dramatic *Pietà*, on the other hand, is a painted version of the poignant German *Vesperbild*, where Mary appears dissolved in tears as she holds the same son to her bosom at the end of his life. The third panel, the *Final Appearance*, is very rare. Perhaps inspired by the writings of a Spanish mystic, the composition recalls the more common depiction of a moving farewell in Christian art, the *Noli me tangere*, where

Christ makes his last appearance to the repentant Mary Magdalen.[32]

To assure us of the dramatic content of these poignant episodes in the Joys, Sorrows, and Glories of the Virgin, Rogier provides us with the complete narratives in the simulated sculptural archivolts in the arches above them.[33] Above the *Holy Family* are the stories of the Infancy (reading from the summit of the arch, first down on the left, then down on the right) with the traditional representations of the Annunciation through the Presentation in six groups. Above the *Pietà* the archivolts display scenes from the Passion, and over the third composition, Rogier footnoted events from the post-Passion culminating in the Assumption and Coronation of Mary. To underscore the theatrical nature of these presentations, Rogier painted fluttering angels in the summit of each arch who unravel banderoles informing us that Mary received the "crown of life" through her purity, her faith, and her perseverance, much as those same virtues were extolled to audiences of the mystery plays. Even the colors of the robes that she wears in each act of this drama are symbolic of these virtues: white for her purity in the Nativity; red for her bodily suffering in the Passion; and blue for her faith in the Last Farewell.

The Berlin altarpiece was recorded as being presented to the Carthusian monastery of Miraflores (near Burgos) in 1445, and no matter whether it was the original or a shop replica, it is clear that Rogier's composition would date much before his trip to Italy during the jubilee year

of 1450. For some reason or other this trip has been considered a turning point in his stylistic development, and after experiencing Italian Renaissance art firsthand, it is argued, Rogier returned home to enlarge and improve his ideas of monumental composition and religious content. But with the Prado *Deposition* and the Miraflores-Granada altarpieces behind him, how could that be? Another set of panels with similar simulated architectural frames, the *Saint John the Baptist Altarpiece* (Berlin and Frankfort), has been described as indications of this expanded vision (fig. 123).

The facts usually cited for Rogier's awakening to Italian monumentality in composition are the high, pointed arches that replace the round ones of the Mary Altarpieces, the more straightforward presentation of narratives in the three major scenes and in the archivolts, and the placement of the large figures *before* rather than *within* the painted facades. But does this make sense? In the *Miraflores Altarpiece* Rogier was concerned with presenting a pageant and glorification of the virtues of the Virgin almost as a sequence of *Andachtsbilder*, and this he did splendidly. The *Saint John the Baptist Altarpiece*, on the other hand, is much more a direct presentation of themes related to the Baptist's life that focus on the major scene, the Baptism of Christ, in the center. On either side are episodes of the birth of the Baptist and his beheading. The strange contrapposto of the executioner and the somewhat shy Salome, who meekly turns away from the violent act, are also cited as evidences of Italian influence, but why? Certainly the artist who invented the hieroglyph of mourning seen in the Magdalen of the Prado *Deposition* was capable of composing this twosome without recourse to outside influences.

There is, however, one bit of evidence of Italian influence in the triptych, but it is an iconographic one. In the *Birth of John the Baptist*, it is Mary with the halo who presents the newborn to his father Zacharias, and this single detail can be traced to the influence of an Italian text, the *Vitae Patrum* (*Lives of the Church Fathers*) of Domenico Cavalca, and we know furthermore that its earliest appearance in art is in the bronze panel of the Birth of John on the doors of the Baptistry in Florence executed by Andrea Pisano. This evidence is very meager for claiming a change of spirit in Rogier's art. The style of the Mary and the John the Baptist triptychs is very close when studied carefully, and for that reason I am inclined to put both sets in the early years of the 1440s.

For Jean Chevrot, bishop of Tournai and influential member of the Burgundian court, Rogier and his atelier executed a large triptych, the *Altarpiece of the Seven Sacraments* (fig. 124).[34] Although the work is damaged and a number of the heads have been repainted, the composition and the grouping of the figures are surely Rogier's

design. Here the simulated arches of the altarpieces of Mary and John the Baptist have been expanded to form the cross section of a lofty Gothic cathedral recalling the setting for the *Madonna in the Church* by Jan van Eyck (see colorplate 17). The church has been identified as Saint Gudule in Brussels, but it certainly was destined for the Cathedral of Tournai. Coats of arms of Chevrot and the bishopric of Tournai appear in the spandrels of the central panel, and Bishop Chevrot appears in the left panel administering the second sacrament, Confirmation. The unprecedented arrangement of the seven sacraments appearing simultaneously within one elaborate ecclesiastical setting is surprising considering Rogier's usual tendency to reduce figures and space, but it is an instructive piece for displaying the solemn, everyday rites of the Christian society that participates in them from infancy to old age and death. The role of the church as the mysterious body unifying their lives could hardly be more clearly stated.

The left, or north, aisle of the church is the setting for the first three sacraments: Baptism, Confirmation, and Penance. Baptism, the "door of the church," is represented in the first bay with the baptizing of an infant in a font. Chevrot, the donor, then appears as the bishop who administers Confirmation, the rite that grants the full privileges of the church gained through baptism to the young members of the congregation. The confession of sins and absolution of the sacrament of Penance appear, finally, in the end bay and choir. Small angels, vested in appropriate liturgical colors, hover above each rite and carry banderoles with inscriptions from the scriptures and the Church Fathers that explain the mystery of the sacrament.

The natural ease with which people and dogs mill about the church interior is a pleasant contrast to the more rigid ceremonial activities. This is particularly apparent in the three sacraments presented in the right panel. Barely visible in the end bay, another bishop confers Holy Orders (Ordination) on a young priest; the sacrament of Marriage next appears; and in the nearest bay of the right aisle the Last Rights, or Extreme Unction, is administered to a dying man, thus completing the life cycle that began on the left with the baptism of an infant.

The holiest and most mysterious sacrament, the Eucharist, is placed in solemn solitude in the central panel, the nave, at the far end of the chevet before an altar with an elegant altarpiece. To underscore the true meaning of transubstantiation, the transformation of the host and wine into the body and blood of Christ in Communion, Rogier placed an awesome Crucifixion scene with mourners in the very entrance to the nave. While many problems surround the actual execution of numerous fig-

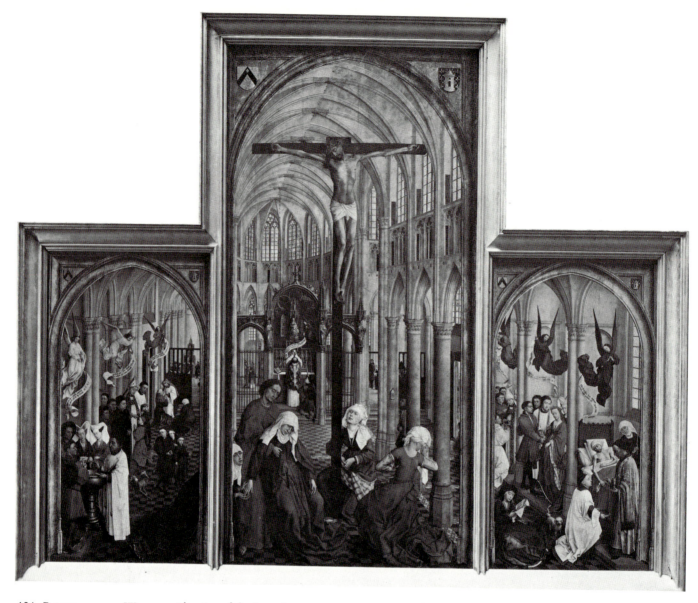

124. ROGIER VAN DER WEYDEN. *Altarpiece of the Seven Sacraments.* c. 1453–55. Panel, 78¾ × 38¼″ (center); 46⅞ × 24¾″ (each wing). Musée Royal des Beaux-Arts, Antwerp

ures, the *Altarpiece of the Seven Sacraments* remains an impressive and instructive contribution to Catholic faith by Rogier van der Weyden.

The only documentary evidence that we have concerning Rogier's trip to Italy is a brief reference by Bartolommeo Facio (*De viris illustribus*, 1456) in his account of the career of Gentile da Fabriano: "When, in the year of the Jubilee [1450], Roger of Gaul, the outstanding painter, visited the Church of Saint John in Laterano, he was, so they say, seized with admiration of the works there [Gentile's frescoes since destroyed], asked the name of the painter, heaped praise upon him, and deemed him superior to all other Italian painters." If Rogier was so enamored of Gentile's works, then, one must admit, he was curiously uninfluenced by his style. Two paintings, the *Farewell at the Tomb* in the Uffizi and the *Medici Madonna* in Frankfort, provide more substantial evidence for an Italian sojourn.

The *Medici Madonna* clearly demonstrates some contact with Italy (fig. 125). The theme itself, the so-called *sacra conversazione*, is very common in quattrocento Italian art with saints grouped about the Madonna and Child, who are elevated on a dais within a curtained canopy of honor. To the left stand Saints Peter and John the Baptist, and opposite them, Saints Cosmas and Damianus, the patron saints of the Medici family in Florence. A further reference to the Medici is the fleur-de-lis, the insignia of Florence, on the central escutcheon on the stone podium. Thus Rogier's work was very likely commissioned by the Medici and conforms to a type of Madonna altarpiece familiar in Tuscany. But Rogier's Virgin and four saints are wholly Flemish in appearance, and the broad, horizontal format of the typical Tuscan *sacra conversazione* with a frieze of figures placed in a sturdy architectural setting gives way here to a Gothic composition whereby the emphasis is on the vertical with the figures staggered within a rising triangular scheme.

The *Farewell at the Tomb* in the Uffizi is even more de-

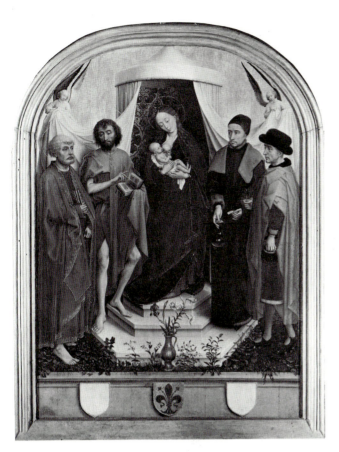

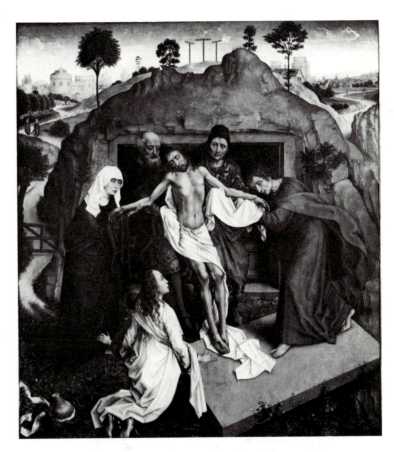

125. ROGIER VAN DER WEYDEN. *Virgin and Child with Four Saints* (*Medici Madonna*). c. 1450. Panel, 20⅞ × 15″. Städelsches Kunstinstitut, Frankfort

126. ROGIER VAN DER WEYDEN. *Farewell at the Tomb.* c. 1450. Panel, 43¼ × 37¾″. Uffizi, Florence

pendent on Italian models (fig. 126). The composition is closely related to a work attributed to Fra Angelico in Munich, and the theme itself was only popular in Italy. But here again, if the iconography and general compositional scheme are Italian, the painting of the figures and the landscape are Flemish. The ample foreground and the impressive stone slab (the stone of unction?) are meticulously treated with plants and flowers, and the figures of the Magdalen and Saint John repeat favorite poses invented by Rogier much earlier. And while Rogier places his figures before a rounded mound that serves as the grotto for the entombment, the background landscape is added with the winding roads and overlapping coulisses that looks much more like the Netherlands than the hills of Tuscany.

Both the Frankfort *Madonna* and the Uffizi *Farewell* are weaker productions in Rogier's oeuvre, in my mind, but they do provide good evidence that Rogier responded to the Italian art he saw during the jubilee year of 1450. One will seek in vain for reflections of Italian influence in Rogier's art after these two paintings, however. We may be reminded of Gentile's exuberant and colorful style in the late *Adoration of the Magi* (*The Columba Altarpiece*) in

Munich or Masaccio's monumentality and Fra Angelico's mysticism in the late Crucifixions, but these features are more likely aspects of Rogier's own development or those dictated by the conditions of the commission.

A good case in point is the giant *Last Judgment* polyptych that Rogier painted for Chancellor Nicolas Rolin for his hospital in Beaune in which Italian influences have been noted (figs. 127, 128). The history of the Hôtel Dieu, or hospital, provides us with fairly complete information. Rolin founded the hospital in 1443 and at that time dedicated it to Saints Anthony and Sebastian, two saints commonly evoked for sufferers of the plague. The structure was completed in 1452, at which time the major chapel was rededicated to Saint John the Baptist.

Rogier's altarpiece for the chapel was no doubt meant to rival the great Ghent altarpiece by Jan van Eyck in terms of scale and sumptuousness, and to make the point clear, Van der Weyden followed the format and program of the exterior wings of Jan's work. What we find there are the portraits of Rolin and his second wife, Guigone de Salins, kneeling in the exterior lower panels much as Jodocus Vijd and his wife were presented on the outer wings of the Ghent altarpiece. Above, in two smaller

127. ROGIER VAN DER WEYDEN. *Last Judgment Altarpiece* (interior). c. 1445–48. Panel, 7′ 4⅝″ × 17′ 11″. Musée de l'Hôtel Dieu, Beaune

128. ROGIER VAN DER WEYDEN. *Last Judgment Altarpiece* (exterior)

panels is a representation of the *Annunciation* in grisaille. Rolin and his wife kneel before grisaille statues of Saints Sebastian and Anthony. If the giant work was commissioned after Rogier's trip to Italy in 1450, then surely Saint John the Baptist would have been included, but he is not. Rogier must have completed the costly project before his trip south, and the commission probably provided the money he needed for a lengthy trip that apparently was not sponsored by the court.

If Van Eyck's influence is prominently displayed when the altarpiece is closed, a whole new world—Rogier van der Weyden's world—beams out at us when the wings are opened. The *Last Judgment* follows the traditional Gothic composition with Christ the Judge seated on a rainbow and surrounded by angels carrying instruments of the Passion in the upper zone. Directly below Christ is the resplendent figure of Saint Michael carrying the scales of judgment in his right hand, and, to the left and right, are the intercessors Mary and John the Baptist behind whom are seated the apostles and various saints. On the narrow stage below, the nude figures of the resurrected emerge from crevices of a barren landscape.

For the rest, Rogier dramatically departs from convention. The battle of the angels and demons over the resurrected is curiously missing, and one of the most fascinating but horrifying episodes of the Last Judgment, the gruesome exhibition of Satanic creatures torturing the sinners and thrusting them into the bowels of hell, is nowhere to be found. Why should these horrifying but eye-catching details be so purposefully avoided?

Rogier's broad but shallow composition brings to mind the Last Judgment sculptures that dominated the portals of thirteenth-century cathedral portals. The tiers of figures are seen against a semi-abstract background, and the symmetry of heaven and hell is markedly stated left and right. Saint Michael is the dominating figure on the central axis. The damned soul in the pan of his scale weighs *down* not *up* as usually depicted (it is vice not virtue whose gravity rules here), and the resurrected are a piteous lot. To be sure, Christ judges with justice and mercy, the sword and the lily issue from his face, but the grandiose finale of human history is stated with an emphatic certainty as the words that issue beneath the sword indicate: Those who have led the blessed life will find eternal comfort in heaven while those found wanting in piety will suffer eternal damnation in hell.

There is little hope for mankind in Van der Weyden's vision of doomsday. Few of the resurrected are empowered to move toward the paradise of the elegant Gothic cathedral in the far left panel. So few are they, in fact, that the nave is disturbingly silent and empty. On the sinister side of the judge, a chaotic crowd of screaming sinners stumbles painfully to the right and the flaming pit of hell. And here is where the unusual absence of angels to assist in this separation is most disturbing. Those few who move slowly toward the portal of the City of God do so as if pulled by some magnetic force, while the damned, with horrifying grimaces and agonizing gestures, scream wildly and fight helplessly to pull back but are forced under their own power toward their fate. No demons are needed to pull man into the inferno, no angels will appear to rescue him. The damned lead themselves to their destiny, a pessimistic proclamation that in some respects anticipates the negative character of mankind later expressed so vividly by Hieronymus Bosch. The only demons in Rogier's *Last Judgment* are those concealed within our own conscience, and they will out. How different the message of this *Last Judgment* is from the one in Danzig painted by Hans Memlinc, which, curiously enough, was largely based on Rogier's composition.

As Van Mander noted, Rogier excelled in depicting the inner feelings and emotions of people whether they be ones of sorrow, anger, or gladness. Two late works are particularly jubilant expressions of the joyous events in the life of Christ and Mary: the *Nativity Altarpiece of Pieter Bladelin* in Berlin (fig. 129) and the *Columba Adoration of the Magi* in Munich (colorplate 22). Bladelin was an enterprising member of Philip the Good's court, and shortly after attaining the rank of chief tax collector in Flanders, he founded not only a hospital but an entire village, Middelburg, near Bruges, as a gesture of his devotion to the welfare of the Flemish citizens. It is not known whether his triptych was commissioned for his private chapel in the castle he had built in 1448 or for the Church of Saint Peter, begun in 1451 and consecrated in 1460 in Middelburg, but it is generally dated shortly after 1450. Some have questioned the identity of the donor, but the triptych has been associated with Middelburg for some time.

The Bladelin altarpiece is based for the most part on the story of the Nativity as related in Jacobus de Voragine's *Legenda Aurea*. When opened, the three panels depict the *Nativity* in the center with Pieter Bladelin prominently included in the event; the seldom seen representation of the three Magi kneeling in the hills outside of Bethlehem adoring the star, here given in the form of the "beautiful child" of Voragine's account, on the right shutter; and the vision of Augustus and the Tiburtine Sibyl, also from Voragine, on the left. Not only the exotic kings from the corners of the world bow in awe before the vision of the new leader of the world, but even the Roman emperor Augustus, at the instruction of the wise sibyl of the Tibur, beholds the new ruler in the form of the *ara coeli*, the throne of Christ and Mary in the heavens.

129. ROGIER VAN DER WEYDEN. *Nativity Altarpiece of Pieter Bladelin*. 1452–55. Panel, 35¾ × 35″ (center); 35¾ × 15¾″ (each wing)
Gemäldegalerie, Staatliche Museen, West Berlin

The vision of the three Magi is unique, and the Nativity of the central panel deserves special discussion here. Reminiscences of Campin's Dijon *Nativity* (fig. 118) can be found in the elderly Joseph holding a candle, the rays of light about the small nude Child, the costume and position of Mary adoring her newborn, and the angels that flutter above. All of these details come from Saint Bridget's vision as discussed in the analysis of Campin's work.

The introduction of the donor into the major scene and certain unusual details of the stable are Rogier's additions. In keeping with the idea that the new replaces the old, Rogier places the Adoration in a ruined structure of stone with a dilapidated thatched roof. In the center, below the figures, appear two cisterns, one grated, that are no doubt references to the grotto in Bethlehem and the well that miraculously sprung from the light of the star cast there. The prominent marble column between Mary and Joseph is very likely a token of the site too, since early pilgrim accounts mention the column that Mary grasped when in childbirth. Bladelin, unlike a patron in Van Eyck's works, is involved directly in the scene. Not only will the three Magi and Augustus experience visions of the birth, but Pieter Bladelin actually witnesses it all. One senses that for more reasons than one, Bladelin selected a Nativity for his personal devotion. The Bladelins had been childless, and this was his image of hope for a child in his new city.

The large Columba altarpiece in Munich has some-

times been linked to Bladelin's patronage on the evidence of a detail in the left background of the *Adoration of the Magi* where the castle of Middelburg can be identified (if indeed this is an accurate topographic detail). However, the Columba altarpiece is known to have been in Cologne very early, where it influenced German painters in the area by 1462. The huge work is one of the most majestic creations of Rogier. The splash of bright colors and the richness of the surface design bring to mind Facio's statement concerning Rogier's admiration of Gentile da Fabriano, but the details of Rogier's world are wholly Flemish.

One can find figures and features that bring to mind Italian art, such as the handsome maiden to the left in the *Presentation* on the right wing who resembles a figure by Ghirlandaio, but Rogier's own personality clearly dominates with the bigness of conception, the rhythmic surface pattern, and the elegance of color that indicate more a development of mood than foreign influences in style. The theme of the Adoration of the Magi has always been a colorful, pompous event for artists. It is this jubilant mood, in contrast to the quietism of the Nativity, that Rogier captures.

The application of rich colors allowed Rogier to maintain a steady stream or fan of bright forms across the foreground from the handsome third Magus to the right (considered by some a portrait of Charles the Bold) to the gently bending king and, finally, the eldest Magus who fully kneels and tenderly kisses the hand of the in-

fant. Mary is one of the most elegant Madonnas that Rogier ever painted and commands our attention. Joseph keeps his place, his red coat echoing the crimson splashes of color in the costumes to the right.

Behind this rich tapestry of surface pattern and color, a deep landscape stretches for miles. The stable, now seen from the front, is a much more monumental structure than that of the Bladelin *Nativity*. Although in ruins, it is the regal reception room of kings appearing more like a palatial than a rustic setting. The chamber also serves as an appropriate throne room for the Queen of Heaven and her divine son. The rising sun, symbolic of the birth of a glorious new age, replaces the guiding star in the upper left, and to the sides of the thatched roof green sprouts spring forth to announce a new life as well. But even here a tragic note is struck. Above the abacus of the central pier behind the Madonna is a tiny representation of the Crucifixion, a sad forecast of the consequences of this joyous event.

Rogier's linear rhythms are nowhere more melodic than in the Columba altarpiece, for the "unending melody of Gothic line," to borrow a phrase from Wilhelm Worringer, is the quintessence of Northern art. In the left panel, the languorous and softly billowing draperies of the angel of the *Annunciation* create an image of Gabriel truly floating into Mary's tidy chamber with his feet just coming to rest on the floor. Yet, within this masterpiece one can detect the workmanship of more than one hand. Rogier's atelier had no doubt grown by the fifties, and a number of his gifted assistants were responsible for much more than the undercoats and landscape details by this time. One can, in fact, find good evidence for the participation of one of Rogier's most illustrious disciples, Hans Memlinc.[35] One suspects, for instance, Memlinc's soft touch in the draperies of the handmaid carrying the basket in the *Presentation*, and in the central panel, Memlinc's hand stands out very clearly in the portrait of the donor to the far left. Whether or not the original patron is depicted here, it is obvious in the use of pigments as well as the morphology of facial features that we are dealing with Memlinc here.

The richness and exuberance of the Columba altarpiece give way to restraint and austerity of color and design in Rogier's late Passion scenes. Two Crucifixions, one in the Johnson Collection in Philadelphia, the other in the Escorial, exhibit an iconic character in the reduction of the figures, the abstraction of the setting, and the hieratic effects. Rogier's earlier *Crucifixion Altarpiece* in Vienna (fig. 130), dating about 1440, already anticipates the discreet abstraction of these works, as does the Prado *Deposition*, in the rejection of the multifigured historiated Crucifixion types that were so popular in the fifteenth century.

Only Mary and John the Evangelist appear under the cross. The two figures kneeling to the right are the donor and his wife, and their anachronistic presence imparts an aura of profound and timeless devotion to the deep sorrow of the Virgin. Unusual too is the fervent manner in which Mary clutches the base of the cross, an act traditionally given to the more emotional Magdalen, who is here moved to the left wing, where she stands alone silently catching tears in the sleeve of her mantle. Opposite her, in the right panel, Saint Veronica displays the sudarium. A rolling landscape unites the three panels—one of the earliest examples of a continuous setting across an altarpiece—and tiny angels flutter mournfully in the sky, the only features that detract from Rogier's otherwise iconic statement. In the Philadelphia and Escorial panels everything but the barest essentials is eliminated.

The Philadelphia *Crucifixion* is a large diptych (not the reverse side of triptych wings as sometimes described; fig. 131). Mary swoons backward into the arms of Saint John in the left panel. The draperies of the attenuated bodies fall into long, open arcs and are painted in a grisaille technique with only light tints of pink and blue brushed into the white. The trail of the Virgin's mantle overlaps the right panel, where the figure of Christ on the cross appears as some monumental sculpture. The setting is abstracted except for a narrow undulating stage with a skull and thighbone indicating Golgotha. Behind the three figures a high wall of gray stone bars any view of a landscape, and a red cloth of honor further isolates the figures on each panel. The sky surprisingly reverts to an abstract expanse of gold leaf. Such Crucifixion groups, placed against red hangings, were commonly found in fifteenth-century churches, where the figures are large sculptures placed against the wall or over an altar as iconic objects of devotion.

Abstraction is carried to the ultimate phase in the giant *Crucifixion* in the Escorial (fig. 132). The heavily restored painting originally hung in the Charterhouse in Scheut, near Brussels, and very likely it was a gift to the Carthusians from Rogier. All implications of the narrative are suppressed in favor of an iconic Crucifixion that harks back to the earlier Middle Ages and Byzantine art, recalling types such as the famous mosaic in Daphnē.

The powerful motif of Mary's tears flowing into her mantle—anticipated in the Magdalen in the Vienna triptych—in fact resembles eleventh-century Anglo-Saxon drawings such as that in a *Crucifixion* in the handsome Psalter, Harley 2904, in the British Museum, where even the startled and angry expression of John is repeated. This is not to say that Van der Weyden had recourse to such medieval models, rather that his own intense involvement in the religious drama somehow expressed it-

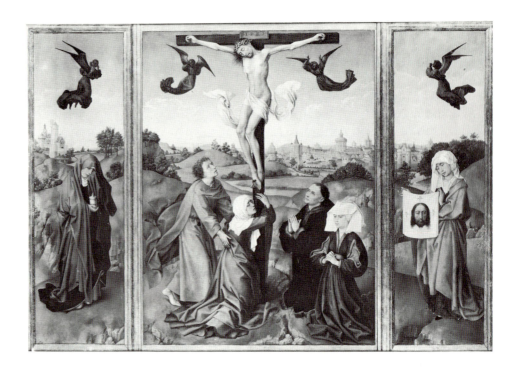

130. ROGIER VAN DER
WEYDEN. *Crucifixion
Altarpiece*. c. 1440. Panel,
39¾ × 27½″ (center);
39¾ × 13¾″ (each
wing). Kunsthistorisches
Museum, Vienna

131. ROGIER VAN DER WEYDEN.
Crucifixion Diptych. c. 1455.
Panel, each 70½ × 36¼″.
The John G. Johnson
Collection, Philadelphia

self with the poignancy and verve of an earlier faith. The
red cloth now covers nearly the entire wall, the capri-
cious fluttering of Christ's loincloth is arrested, and the
skull and bones are omitted. Three huge figures, treated
again in semi-grisaille, imbue the hieratic composition

with the powerful monumentality of a great sculptured
monument.

From what has been said of Rogier van der Weyden's
expression in his thematic inventions, it would seem that
his bust portraits would exhibit warmer, more emotion-

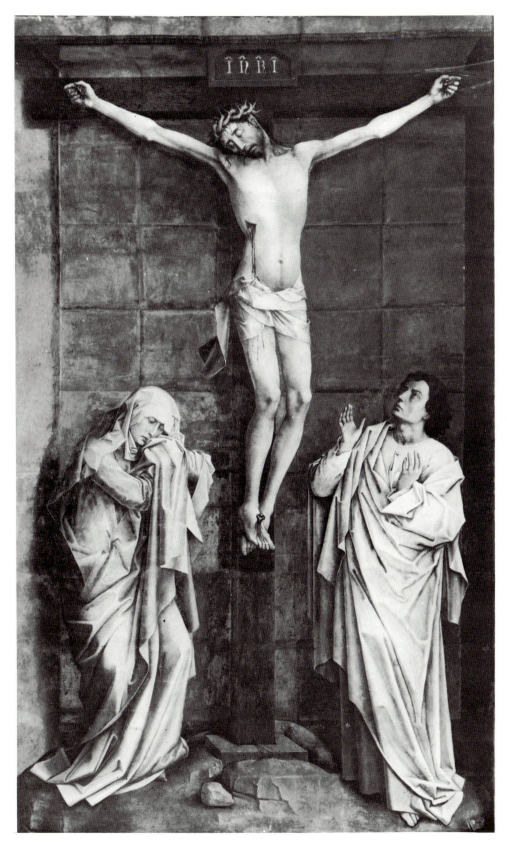

132. ROGIER VAN DER WEYDEN. *Crucifixion*. 1454–64. Panel, 10′ 8″ × 6′ 3½″. Nuevos Museos, Monastery of the Escorial

al characterizations than Van Eyck's intensely objective and descriptive portrayals. Both artists place their sitters against abstract backgrounds. Van Eyck's portraits emerge mysteriously from an amorphous darkness; Rogier's stand out in bold relief against a flat background of light or dark hue. His superb *Portrait of Francesco d'Este*, the bastard son of Lionello d'Este of the court in Ferrara, is an instructive example to compare with Van Eyck (fig. 133). With Jan the highly detailed face is a richly textured ''landscape'' of precise features bathed in light and

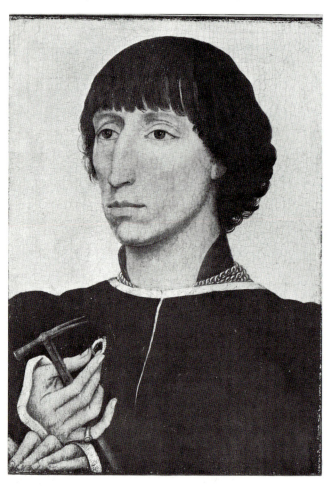

133. Rogier van der Weyden. *Portrait of Francesco d'Este.*
c. 1455–60. Panel, 11¾ × 8″. The Metropolitan Museum of
Art, New York. The Michael Friedsam Collection, 1931

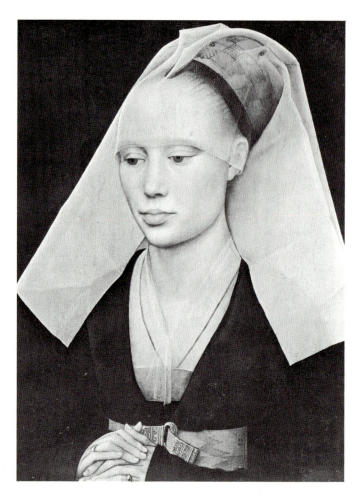

134. Rogier van der Weyden. *Portrait of a Lady.* c. 1455.
Panel, 14½ × 10¾″. National Gallery of Art,
Washington, D.C. Andrew Mellon Collection

atmosphere with subtle shadows and glazes. In contrast, Rogier's faces are more like contour maps where it is line more than modeling that gives a general character to his people. Van Eyck's sitters often confront the viewer directly as distinct individuals; Rogier's rarely regard the viewer, remaining decorative abstractions of aristocratic types with an aloofness and detachment.

Rather than exploring the inner blood and being of his people, Rogier preferred to display their status in society as dignified, well-bred members of the aristocracy. Thus something of the natural and individual gives way to a "type" in his characterizations. No doubt the thin face, long aquiline nose, and pursed lips of Francesco d'Este are accurate features of this highly sophisticated young courtier from Italy, but the accidents and blemishes in his haughty countenance are smoothed away as if he were heavily made up. The details of his face are not rendered as fleshy textures but as simple planes that block out the fine bone structure over which sure, crisp lines delineate the contours of the eyes, nose, and lips while a bold outline describes the undulating profile of his cheek and jaw. In his thin fingers Francesco delicately holds a ring and

small hammer—perhaps references to a motto or government status—in an affected manner that reflects his countenance in general. This is truly a highly cultivated and self-satisfied son of the Estes of Ferrara.

The same elegance and detachment characterize the *Portrait of a Lady* in Washington (fig. 134). Here the use of line and contour contributes to a masterpiece of Gothic portraiture with its emphatic vertical format and bold triangular design of the white headpiece seen against a dark background. Surely this lady is of some well-to-do Flemish family, but surprisingly her psychological state is quite different from that of the gentleman from Ferrara. Her downcast eyes convey a sense of haunting piety, but the tense intertwining of the fingers that seem to be squeezed together and the strong chin and full, sensuous lips betray some troubled inner emotion that we shall never understand. What a contrast in personality and enigma this Northern Gothic lady makes with Leonardo's confident Renaissance *Mona Lisa* painted a few decades later!

One of Rogier's most endearing inventions was the devotional diptych that presents a bust of the Madonna

and Child opposite a male patron. These paired panels with female and male counterparts probably descend from bust-length marriage portraits of man and wife. Mary, however, receives priority and thus is placed on the left-hand side where the husband traditionally would appear. Otherwise the sentiments of love and devotion are maintained.

In the diptych of the *Virgin and Child* with *Philippe de Croy*, one of the finest of Rogier's creations, the effect is particularly attractive (figs. 135, 136). Philippe, seigneur of Breda and chamberlain to Philip the Good, strikes the pose of a quiet but very cultured gentleman of the court. His lean face and long nose are somehow more attractive features than those of Francesco d'Este, and his elegant praying hands carrying prayer beads mark him as a nobleman of unquestioned faith. The Madonna, placed against a gold background to distinguish her celestial domain, is one of the tenderest and most loving among his many

portrayals of Mary. Her long fingers support the tiny infant gently as he plays with the clasp of a manuscript held near Philippe. Perhaps Rogier here alludes to the pious character of the patron who was known as a lover of illuminated Books of Hours.

The poles of style and expression between which Netherlandish art will vacillate during the course of the fifteenth century are now established. The magic realism and refinements of Van Eyck will continue to set the standards of execution, particularly in Bruges, and the inventions and pious expression of Rogier van der Weyden will echo through the hills and valleys of the Netherlands, resounding dramatically far to the east, in the Rhineland and beyond. However, the founders' heritage was to be enriched and expanded in diverse directions, as we shall now see, when we turn to the next generation of artists who had strong ties with Holland in the North Netherlands.

135. ROGIER VAN DER WEYDEN. *Virgin and Child* (left half of fig. 136). c. 1455–60. Panel, 19½ × 12½". Henry E. Huntington Library and Art Gallery, San Marino, California

136. ROGIER VAN DER WEYDEN. *Philippe de Croy* (right half of fig. 135). c. 1455–60. Panel, 19¼ × 11⅞". Musée Royal des Beaux-Arts, Antwerp

The Northerners

In 1432 Philip the Good annexed the provinces of Holland, Zeeland, and Hainaut to his Burgundian empire, demoting the rightful heir of these territories, his niece Jacoba of Bavaria, to the insignificant role of Lady Forester of the Teylingen hunting lodge in the woods near Haarlem in North Holland. The Bavarians, first under Jacoba's father Willem VI and then his successor Jan of Liège (Van Eyck's first recorded patron), had been avid promoters of the arts. Artists either trained by Jan van Eyck during his residence at the Hague or much influenced by him established workshops at the capital, which were channels through which the Eyckian style was transmitted to the provinces in the North Netherlands. The influence of Campin can also be traced, perhaps due to his connections with the Dutch since Tournai was, prior to 1432, part of the Bavarian duchy. It is known that Jacoba personally came to his defense on certain court charges on at least one occasion (see p. 120). Precious little remains of the arts of the Hague, however. The capital suffered the same fate as most other

137. COPY AFTER AN EARLY DUTCH ARTIST. *Fishing Party at the Court of Willem VI*. Original, before 1436. Drawing, two sheets glued on wood, 9⅝ × 15¼". Cabinet des Dessins, The Louvre, Paris

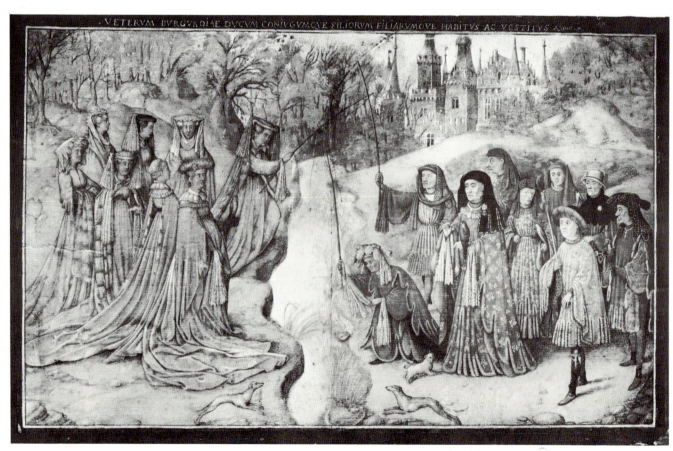

Dutch centers during the peasant and Spanish wars of the sixteenth century, but from what evidence we have, in the form of drawings and engravings after tapestries, miniatures, and court portraits, it is clear that the cultural life in Holland rivaled that of the Burgundians in taste.

Predating the miniatures by "Hand G" in the *Turin-Milan Hours*, usually attributed to Jan van Eyck when he was in the Hague, is the unusual composition of a *Fishing Party at the Court of Willem VI*, count of Holland, Zeeland, and Hainaut who resided in the Hague, preserved in a sixteenth-century drawing in the Louvre (fig. 137). The sketch reproduces an early-fifteenth-century tapestry or painting that apparently was at one time displayed in the palace. It is a rare example of a *scène de genre* in which female members of the court, including the young Jacoba, stand on the left bank of a stream and the male courtiers are grouped about Willem VI on the right. A number of the heads are recognizable portraits, and while the style of the drawing cannot be trusted in detail, it is clearly Eyckian.[36]

Evidence of South Netherlandish influence in early Dutch art is more obvious in the *Book of Hours of Catherine of Cleves*, executed sometime between 1434 and 1440 by an extraordinary miniaturist who was probably active in Utrecht. A number of his miniatures, such as the *Deposition* (fig. 138), are derived from paintings by Robert Campin, but in many of the illustrations of the suffrages of the saints, the surprising whimsical and realistic drolleries in the margins, where genre motifs with no apparent relationship to the main miniature are found, anticipate the unusual marginal illustrations developed in the Ghent-Bruges school of book illumination some fifty years later (see p. 194). Mussels, clams, fish, pretzels, birdcages, feathers, and other such mundane objects are strewn about the margins with an obvious delight on the part of this talented artist (colorplate 23). Other Dutch miniatures of the early fifteenth century testify to the high quality of the art in the North Netherlands. The precocity of early Dutch book illustration has only recently been appreciated, but the problem of localizing their production remains a thorny issue.[37]

More is known about Haarlem, a thriving city nestled in the woods on the river Spaarne some thirty miles north of the Hague. It was to the environs of Haarlem that Jacoba was banished in 1432, and there is good evidence that from about that time on Haarlem became a flourishing center of the arts with a distinctive local style of its own. The legend of Haarlem's preeminence is one that was elaborated in histories of the sixteenth and seventeenth centuries, especially regarding painting and the graphic arts, and, it will be recalled, the great sculptor Claus Sluter was from Haarlem and perhaps trained there

138. MASTER OF THE HOURS OF CATHERINE OF CLEVES. *Deposition*, from the *Book of Hours of Catherine of Cleves*. 1434–40. The Pierpont Morgan Library, New York

before moving to Brussels. Laurens Janszoon Coster, acclaimed inventor of movable type and printer of some of the earliest books illustrated with woodcuts, was a Haarlemer, and a number of leading painters of the second half of the fifteenth century were either from Haarlem or closely associated with artists there.

In *Het Schilder-boeck*, Van Mander, himself a Haarlemer, highly praised the cultural contributions, especially in painting, of the city, remarking that it was very early known as a center "for good artists—if not for the best painters of the entire Netherlands," one that he claimed dated as far back "as the period of the van Eycks." Van Mander singled out Albert van Ouwater, Dieric Bouts, and Geertgen tot Sint Jans as leaders of the Haarlem school, and he further wrote that they excelled in landscape painting.

Very few Haarlem paintings survived the wanton destruction by peasant iconoclasts (1566) or the looting by Spanish soldiers (1572–73), and for that reason it is very difficult to trace the development of early Dutch art. In fact, the very existence of local or regional schools in both Haarlem and the Hague has been contested more

than once, but the evidence that has been mounting makes it possible to define a Dutch or North Netherlandish style, and while it is clear that much of the original inspiration came from the south, it is also apparent that the Dutch school made significant contributions to the later generations of Flemish painters. The development of an early Dutch art as a regional, not a national, style thus seems more and more to be an important chapter in the history of Netherlandish art in general.

ALBERT VAN OUWATER

The founder of the Haarlem school of painting, according to Van Mander, was Albert van Ouwater. Only one painting can be attributed to Ouwater with certainty, but this work, the *Raising of Lazarus* in Berlin (colorplate 24), datable about 1455 to 1460, fortunately gives us keen insight into the characteristics of style and iconography in early Dutch painting. Ouwater's treatment of the theme is very unusual in many respects. Perhaps the most obvious departures from the style of Van Eyck and Rogier are found in the passive figure types and the treatment of space. The people in the mausoleum are posed mechanically, like so many pieces on a circular checkerboard. To the left are the solemn group of followers of Christ, including Mary and Martha, sisters of Lazarus, who, dressed in simple costumes, barely respond to the miracle they view. The Jews, to the right, are garbed in ornate costumes and turn with jerky movements as they pull back from Lazarus rising from his tomb. Peter occupies the center of the composition and forms the link between the right and left, and, in spite of the lack of theatrics, the dramatic nature of the event is expressed in the simple juxtaposition of the figure groups: the hushed opposite the restless, the composed across from the agitated, the good versus the evil.

Ouwater's figures, unlike those in Van Eyck's *Madonna with Canon van der Paele* (fig. 105) where the architectural backdrop is very similar, occupy only the lower half of the composition; the upper part of the panel displays the empty space of a huge rotunda with an outer ambulatory encircling it. Rather than concerning himself with a composition of large, monumental figures that fill the picture plane, Ouwater preferred to place them one behind the other like so many objects aligned on diagonal axes. The figures are reduced to little more than functions of the space, and the very emptiness of the upper half of the painting evokes a hushed and solemn mood for the picture as a whole. This is a recurring trait in early Dutch painting. The expressive qualities of the figures are often avoided, and the amplitude of the setting, whether it be a landscape or an interior, greatly affects the mood and content.

Another important aspect of Ouwater's style is the unusual color scheme. Although a few splashes of the primary colors are used, Ouwater prefers milder tonalities of greens, grays, and browns. The rotunda is painted in subdued, neutral hues very different from the gemlike local colors employed by most Flemish artists. The warm browns of the wall and the dome provide a muted background for the more colorful figures.

Ouwater's interpretation of the theme is another unique feature of the painting. In the fashion of Jan van Eyck, whose art he surely must have known, Ouwater reveals his interest in disguised symbolism in the capitals of the ambulatory. The two capitals on the left unravel the story of the sacrifice of Isaac, unquestionably a reference to man's salvation, whether Lazarus or Everyman, through Christ's sacrifice. To the right, on the side where Peter proclaims to the disbelievers the inevitability of the new era of law under Christ, the capitals display the story of Moses receiving the old law on Mount Sinai and displaying the tablets to the Israelites. The rotunda, an unusual setting for this miracle, is perhaps an allusion to the holy sepulcher where Christ himself rose from the dead, adding yet another dimension to this simple drama of one man's salvation. Furthermore, the spectators, the Dutch burghers who would have prayed before the altarpiece, are also included in the painted world.

Across the rotunda, directly opposite the viewer, one finds himself as part of the crowd who presses near to

139. DIERIC BOUTS. *Infancy Altarpiece*. c. 1445. Panel, 31½ × 41⅜" (center); 31½ × 22" (each wing). The Prado, Madrid

witness the miracle, and the resurrection of Lazarus is presented not only as an act of one man's salvation, but as an anticipation of all men's salvation at the Last Judgment. In fact, the composition resembles a Last Judgment with Peter, in the place of Saint Michael, forming the pivotal point between good and evil, the blessed and the damned. One is reminded of the chants of the Early Christian worshipers, ''Save us as thou saved Lazarus, O Lord,'' or the words of Christ when informed by Mary and Martha of their brother's death: ''Your brother will rise again. . . . I am the resurrection and the life; he who believes in me, though he die, yet shall he live'' (John 11: 23–25).

The authorship of the *Raising of Lazarus* is attested to by a lengthy description of its composition by Van Mander, who was particularly interested in the inclusion of the people peering in through the screen. He also praised Ouwater's talents as a landscape painter—''the first and the best method of landscape painting was begun in Haarlem''—and he described an altarpiece in Saint Bavo, called the ''Roman altar,'' with a painting of ''an interesting landscape in which many pilgrims were painted, some walking, others resting, eating, or drinking.'' The painting is lost, but Ouwater's landscape style can be reconstructed to a degree on the basis of German copies of it, to be discussed below (fig. 230), and the manner or method of composing landscape is surprisingly similar to that of another Haarlemer, Dieric Bouts.[38]

DIERIC BOUTS

If we did not have Van Mander's account of Ouwater, the *Raising of Lazarus* in Berlin would be catalogued as a work of an unknown artist in the close circle of Dieric Bouts. The same might be said of an *Infancy Altarpiece* in Madrid that has been attributed to Ouwater, Bouts, and Petrus Christus at various times (fig. 139). The settings and figure types in the Prado altarpiece (*Annunciation*, *Visitation*, *Nativity*, and *Adoration of the Magi*) are close to other works attributed to Bouts's early Haarlem period.

Van Mander tells us that ''Dirk of Haarlem'' was one of the founders of the Haarlem school along with Ouwater. Unfortunately, he knew nothing of his training. Another reference to Bouts's activity in Haarlem is found in an entirely different source, the descriptions of the Low Countries by the Italian scholar Lodovico Guicciardini (*Descrittione di tutti i Paesi Bassi*, 1567), who noted that he had seen a painting by Bouts in which a topographical view of a site in Haarlem was represented. Van Mander further informs us that Bouts also lived in Louvain, in Brabant, and, indeed, in the archives of that city were found documents dated between 1457 and 1475 that record his activity there. His wife, Caterina, was from a wealthy Louvain family, and in time Bouts established a large atelier in which his two sons, Dieric and Aelbrecht, were employed. He was appointed painter of the city of Louvain in 1468. He died there in 1475.[39]

140. DIERIC BOUTS. *Altarpiece of the Deposition*. c. 1450–55. Panel, 75 × 56¼″ (center); 74 × 22⅞″ (each wing). Capilla Real, Granada

Just when Bouts left Haarlem is not known, but one can surmise that he arrived in Louvain as an established master sometime around 1444, perhaps driven out of Haarlem by the peasant wars that erupted about that time in the city. The Prado *Infancy Altarpiece*, if we accept it as a work by Bouts, is most instructive in defining his early Dutch style. Although a triptych, the arrangement of the subjects is unusual. The *Annunciation* appears on the left panel, the *Visitation* and *Nativity* share the centerpiece, and the *Adoration of the Magi* adorns the right wing. It is clear that Bouts was attracted to the art of Rogier van der Weyden as well as that of Jan van Eyck. The idea of placing the four scenes within four painted church portals is based on Rogier van der Weyden's pseudo-*Schnitzaltar* compositions, such as the *Miraflores Altarpiece* in Berlin (fig. 122), and the compositions of the *Annunciation* and *Visitation* are also derived from Rogier's Infancy scenes.

Yet the panels are not the works of a slavish imitator. The Dutch qualities—those that link these panels to Ouwater—are distinctive. The proportions of the figures are much stockier than Rogier's, and the irregular patterns of the drapery around the arms depart from the lyricism of Van der Weyden. The squat figures in the

Adoration of the Magi are rather mechanically constructed, their heads seem to be inserted into the heavy mantles, and their gestures are arrested so that they appear as isolated figures placed about the circular table. Further, the minuscule carvings are widely spaced in the round proscenium arches, which appear quite barren when compared to the florid and lyrical integration of sculpture and architecture achieved by Rogier. The colorful landscape backgrounds in the panels and the emphatic focus of light on the heads that gives them a stereometric quality are very likely aspects of Van Eyck's influence.

Closely related in style to the Prado panels is the huge *Altarpiece of the Deposition* in Granada (replica in Valencia) in which again the impact of Rogier's art on Bouts is very evident in the painted architecture (fig. 140). A number of other quotations from Rogier's works can be found in the three panels. Rogier's famous swooning Madonna (Prado *Deposition*) here appears at the foot of the cross in the *Crucifixion* panel on the left, and the figures of John the Evangelist and the despairing Magdalen in the Prado *Deposition* are borrowed, slightly altered, for the central panel of the *Deposition*.

The Granada triptych surely dates later than the *Infancy Altarpiece* in Madrid, probably being executed after

Bouts had settled in Louvain. The figures have assumed taller proportions in keeping with Rogier's canon, but the heads for the most part retain the cold stereometric quality, modeled sharply in shadows along one cheek, that appears in the earlier work. Although Rogier's compositional motifs are quoted with little change, they still lack the dramatic expression of their models, a Dutch trait that Bouts never overcame. His figures are isolated units like puppets on strings who must not get their lines entangled and who seem unable to move of their own volition.

The tightly organized surface patterns of Rogier's compositions are pulled apart with the figures placed on axes that move back into space to function as perspective posts mapping out the landscape. In fact, the expansive landscapes in the backgrounds of the panels are some of the most impressive and original features of Bouts's art. The colorful terrain stretches continuously across all three panels, moving gradually under an afternoon sky in the *Crucifixion* to one of late evening in the *Deposition* and, finally, to a brilliant morning sunrise in the *Resurrection* on the right wing. Landscape rather than figures is used dramatically in Bouts's works, creating a undefinable mood, or *Stimmung*, of nature, as one scholar put it, that attracts our attention. It is this very predilection for landscape that has always been a special trait of Dutch painting.

It was very likely Bouts who introduced a popular variation on Rogier's half-length Madonna types by placing Mary and her Child in an interior with a window and a deep landscape. A weak copy of such a work by him is in the Metropolitan Museum of Art in New York, and numerous variations of the type appear in his later works and those of his followers. Another *Madonna and Child* in New York by Bouts displays the sturdier Dutch qualities of his early style (fig. 141). Mary's stubby fingers cradle her loving Child, and the strong and smooth modeling of the face and the downcast eyes with cupped sockets heavily modeled give the Virgin a sleepy look characteristic of Bouts's people.

A slight change can be noted in the *Madonna and Child* in London, dating about 1465 (fig. 142). Mary and her Child are seen through the frame of a window. Mary's fingers are longer and more delicately posed, and the Child is sprightly and active. Behind them is a brocaded cloth of honor and an open window with a view of a city and its cathedral tower. This particular half-length type was to become a favorite for later generations in the Netherlands and the Rhineland. By placing the Virgin in the immediate environment of the viewer rather than in the abstract realm of Rogier's Madonnas, the artist has greatly changed the characterization. She and her Child are very much part of our world, and the awesome aus-

141. DIERIC BOUTS. *Madonna and Child*. c. 1450. Panel, 9½ × 7⅞". The Metropolitan Museum of Art, New York. The Theodore M. Davis Collection. Bequest of Theodore M. Davis, 1915

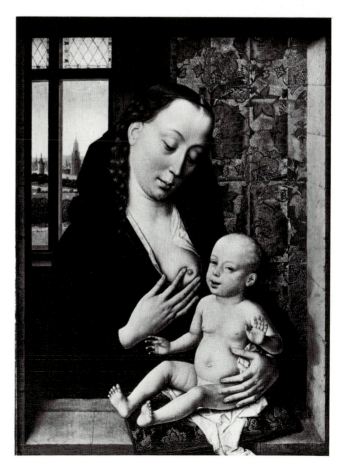

142. DIERIC BOUTS. *Madonna and Child*. c. 1465. Panel, 15¼ × 11⅜". National Gallery, London

terity of the holy pair is tempered by a comforting intimacy.

The encroachment of the real world on the personality of the sitter is also seen in Bouts's *Portrait of a Man*, dated 1462 (fig. 143). Placed in the corner of a room with a poetic landscape seen through a window, the sitter glances slightly upward with the bland expression of a "mild curate of souls," to borrow a phrase from Friedländer. His face is delineated with the minute precision of Van Eyck, his glance is directed away from the viewer and thus disregards him as do those by Rogier, but his world is very much the same one we occupy. With fierce objectivity Jan van Eyck gives us a lasting first impression of a very real person with whom we can hardly identify; Rogier places before us handsome but abstract types of nobility; but Bouts paints Everyman. The more solidly entrenched the sitter seems in the real world, the more his temporal ties, social class, and calling will temper our impression. These are simple people who find themselves alongside us, and we must accept them for that and nothing more.

In 1464 four members of the Brotherhood of the Holy Sacrament of Saint Peter's Church in Louvain contracted Bouts to make a costly altarpiece in honor of their confraternity (colorplate 25). Two theologians were appointed special consultants to advise the painter in matters of iconography for the unusual theme, the Holy Sacrament of the Eucharist.[40] In 1468 the altarpiece was complete as specified in the contract with the centerpiece depicting the Last Supper and the wings carrying two scenes each of Old Testament episodes related as "types" of the Eucharist.

The Last Supper is a rare theme in Netherlandish panel painting, and Bouts laid out the composition along the most obvious lines for depicting figures gathered in a banquet hall. The twelve apostles are placed mechanically about a large square table that dominates the center of a high, spacious Flemish interior. The angle of vision is high. We look down at the gathering from a distant balcony, and the lines of the interior converge at a point just below the chandelier and well above the head of Christ, who marks the very center of the composition. The vast open hall thus dominates the scene, and it is clear that Bouts attempted to expand the sense of space as much as possible. Two tall Gothic windows on the left wall give us a view of the city outside, and on the rear wall a window opens to the kitchen, where two men are portrayed observing the Last Supper. To the right a number of complex chambers and corridors give us a view of a distant garden.

To clarify the central area, Bouts placed the big table squarely in the middle of a checkerboard floor with the benches and chairs for the apostles aligned exactly parallel

to its four sides. Even the grouping of the apostles is markedly rigid and symmetrical. According to the terminology of Heinrich Wölfflin, the composition of the *Last Supper* displays multiplicity but not multiple unity. Each object in the still life on the table is painstakingly executed as an object in itself, nothing overlaps, and this is true to an extent of the figures in the room.

By necessity the apostles must overlap on the sides of the table, but one senses that Bouts composed them one by one following his standard types. They are the lean, narrowed-shouldered men with weightless bodies covered by thin, fussy draperies that we find in all of Bouts's works, with long faces, thin noses, shallow eye sockets, and hollow cheeks. They repeat the same gestures. In fact, so anonymous are they that only a few can be identified. The youngest, sitting to the right of Christ, is John the Evangelist, while the man to his left with the short white beard is Peter, and the one in the left fore-

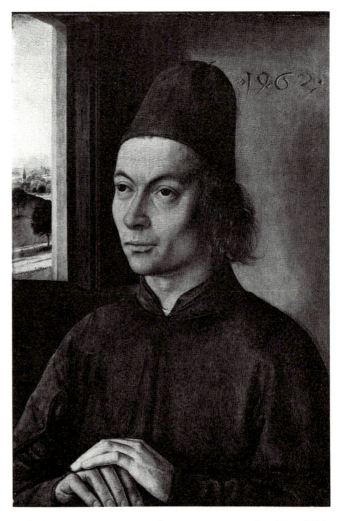

143. Dieric Bouts. *Portrait of a Man*. 1462. Panel, 12¾ × 8⅜″
National Gallery, London

ground with the darkened profile, his back turned to us, is undoubtedly Judas.

Four extra figures appear in the background. Differentiated in appearance and costume, they are, unlike the apostles (except for the young Saint John), unbearded and are carefully stationed at posts that do not interfere with the main action. Formerly it was thought that the dignified man standing to the far right was a self-portrait of the artist and that the two men looking through the window were his painter sons. A more recent identification, and probably the right one, makes them portraits of the members of the confraternity who commissioned the altarpiece. The hierarchy of their rank is not clearly indicated by their placement, but certainly one of the two heads peeking in through the kitchen window is to be identified as Eustachius Roelofs, who was called a baker in the contract, and the older servant directly behind Christ is most likely the elder of the organization, Erasmus van Baussele.

Bouts depicts the solemn moment when Christ announces that the host, or bread, is his body, the wine his blood, a simple and direct statement of the institution of the sacrament of the Eucharist at the Last Supper with the apostles. There is no dramatic or psychological interplay among the figures, nor are there any symbolic additions to engage our attention other than the cross behind Christ or the statuette of Moses in the arch of the doorway to the right. The new Flemish space and perspective effectively focus our attention on Christ, and everyone within the painting quietly shares the same serious concern for this most sacred moment.

Had Van Eyck composed this panel, he most assuredly would have added details somewhere in the room that would relate the Last Supper to Old Testament types. With Bouts such disguised symbolism is replaced by typology that is overt and obvious. Four types of the Last Supper were selected for Bouts's painting, but rather than being hidden, they were painted on independent panels in the side wings as giant pictorial glosses: (1) the Meeting of Abraham and Melchizedek (Genesis 14), the first offering of bread and wine by a priest; (2) the Gathering of Manna (Exodus 6), the lifesaving bread that was sent from heaven for the starving Israelites; (3) Elias in the Desert (I Kings 19), who was brought bread and wine by an angel; and (4) the Feast of Passover (Exodus 12), the Jewish equivalent for the sacrament itself.

The two theologians who were appointed to direct the iconographic program of the altar were probably responsible for this particular selection of themes, and their choice, with the exception of the episode with Elias, was taken from the popular picture manual of the day, the *Speculum humanae salvationis* (*Mirror of Human Salvation*), where three Old Testament events are given for each ma-

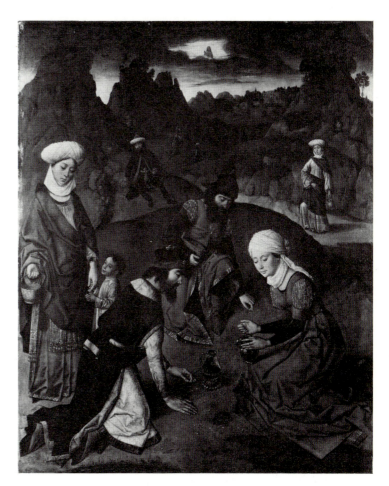

144. DIERIC BOUTS. *Gathering of Manna*, from the *Last Supper Altarpiece* (see colorplate 25)

jor event in the life of Christ. It was just at this period that editions of the *Speculum* were being mass-produced with woodcut illustrations in block books in the Netherlands (see fig. 270).

Three of the Old Testament types are set in landscapes, and it is in this genre that Bouts excelled (fig. 144). Only a century after his death, a professor at the University of Louvain, Johannus Molanus, hailed him as the "famous inventor in depicting the countryside," and it should be remembered that Van Mander claimed that Haarlem was well known as the center of a new school of landscape painting.

The landscapes in the side panels of the *Last Supper Altarpiece* are excellent examples of this specialty. A number of stylistic features in Bouts's landscapes set them apart from the Eyckian tradition. Van Eyck's passion for recording every blade of grass or every crack on a stone with meticulous brushwork was shared by Bouts, but whereas the allover composition of Van Eyck's landscapes was quite natural in its free and fluid extensions of space right and left, Bouts imposed a strict schematic order on

nature and framed his landscapes on either side with high rocks or trees. Having established the borders, he then set about adding the details into a well-constructed progression of space along a tilted plane seen from a high angle. Crisply delineated flowers and plants, finely grained stones, and dwarfish trees with each leaf clearly rendered are set down one after the other with the loving care and meticulousness of a naturalist but with little attention given to the broader, more general impressions of nature and light out-of-doors. That is not to say that there are no atmospheric effects in his landscapes. There are, but they are mostly restricted to the sky and not to the terrain itself. The sky sets the mood, the earth provides the viewer with a pictorial catalogue of nature's diverse and wonderful forms.

It was in the mechanics or "method" of plotting spatial recession that Bouts (and possibly Ouwater) made significant contributions to the art of landscape. Many of Bouts's devices were already known to the artists of the International Style, but with them (and this is true to an extent with Van Eyck) the extension of landscape in depth was a two-step process artificially adjoined. While it would be wrong to argue that Bouts's landscapes are more progressive than Jan's, he did make an important contribution to the solution of one of the most vexing problems for painters of his time. It was his aim to create a protraction of space that moved logically from the foreground gradually back through the middle to the distant horizon. First of all, he used the winding road that leads the eye through the landscape; secondly, he multiplied the number of coulisses, employing them not only to mark off the space in the foreground, but to establish steps along the way into the background as if they were so many overlapping stage sets placed one behind the other on an inclined plane.

But even more important were the changes Bouts introduced for composing the figures in space. The *Gathering of Manna* is typical. Rather than aligning them along a shallow foreground, coplanar with the surface of the picture, Bouts placed his figures along diagonal axes that move back into space in a zigzag fashion. The figures thus pulled away from the surface are placed carefully in smaller groups or singly in the tiny space cells established by the overlapping coulisses. It is surprising, indeed, to find the Dutch painter depart so drastically from the traditional, time-honored mode of figure composition in fifteenth-century art. The conventional relationships between the figures and their setting are thus reversed. Rather than being the main compositional units in the foreground with the landscape providing a colorful backdrop for them, the figures are now merely elements of a carefully contrived landscape; they lead us step by step along the winding road activating the isolated space

pockets. Bouts gives us not figures with a landscape added, but landscapes with figures. Of all the Netherlandish paintings of the fifteenth century, his are the most removed from the basic principles of Renaissance Italy.

Nowhere is the tendency in Bouts's paintings to disassociate the personality from the dramatic content more apparent than in his group portraits. The origins of the group portrait in Netherlandish art can be traced to the development of corporate patronage of the middle class. One of the interesting categories of this patronage was that of town officials who commissioned paintings for the city hall. By the mid-fifteenth century it was common to decorate the main chamber, usually the assembly room where law suits were presented and judged, with paintings of famous trials and judgments to serve as examples and lessons for those who presided there. The paintings were aligned on the wall in a series of such stories or, more commonly, as pendants with one set illustrating examples taken from pagan mythology or ancient history juxtaposed with the major act of justice in the eyes of the Christians, the Last Judgment. Such civic projects were given Rogier van der Weyden in Brussels, Dieric Bouts in Louvain, and Gerard David in Bruges, and in each commission group portraits of the city authorities were involved.

But how does one introduce contemporary personages into a narrative setting (no local portraits would likely be introduced into paintings of the Last Judgment)? Rogier's secular judgment panels for the city hall in Brussels, the *Justice of Trajan* and the *Justice of Herkinbald* (an early count of Bourbon), were unfortunately destroyed, but copies of them survive in drawings and tapestries that allow us to reconstruct the general lines of the compositions. According to firsthand descriptions the paintings were filled with a number of "bystanders" who probably were portraits of the magistrates (including a self-portrait of the artist), but the exact formula Rogier employed for placing them within the story is not clearly indicated in any of the copies.[41]

The formula for the group portrait is very obvious, however, in the panels of justice that Bouts executed for the city hall of Louvain. After being appointed city painter in 1468, Bouts received two important commissions, the one, a *Last Judgment*, survives only in part; the other, the *Justice of Emperor Otto III* (figs. 145, 146), is preserved today in two tall panels in Brussels (four panels were originally commissioned). The story, recorded by Godfrey of Viterbo, a twelfth-century historian, deals with the hapless fate of a count at Otto's court who was unjustly accused of seducing the empress (a version of the Biblical tale of Joseph and Potiphar's wife). He was found guilty and beheaded, and his wife, taking his sev-

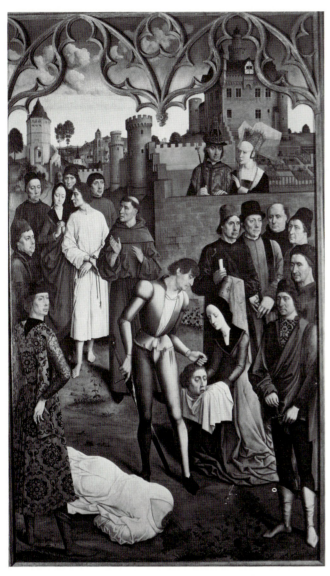

145. DIERIC BOUTS. *Wrongful Execution of the Count* (pendant to fig. 146). 1470–75. Panel, 12′ 11″ × 6′ 7½″. Musées Royaux des Beaux-Arts, Brussels

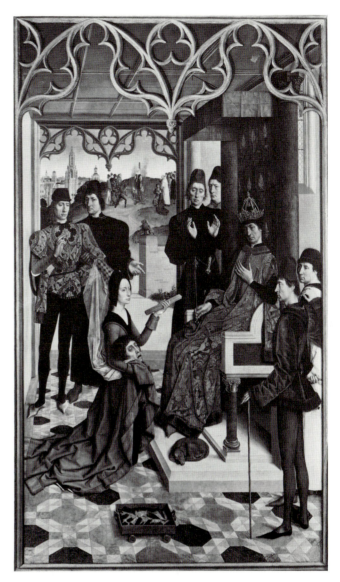

146. DIERIC BOUTS. *Justice of Emperor Otto III* (pendant to fig. 145). 1470–75. Panel, 12′ 11″ × 6′ 7½″. Musées Royaux des Beaux-Arts, Brussels

ered head in her hands, requested that she be given the trial by fire to prove her husband's innocence. In the second panel the wife takes the trial before Otto and survives, and in retribution the empress, who had made the false accusation, is burned at the stake in the fields outside the city walls.

This rather gruesome example of justice was ordered by Bouts's advisor for the city hall panels, one Jan van Haeght, a Louvain theologian. A number of the heads of the bystanders witnessing the events appear to be portraits, in particular the six men standing to the right in the foreground of the *Wrongful Execution*. With Bouts we have here the beginnings of an effective but somewhat boring tradition in group portraiture that was followed by Netherlandish painters for two centuries.

Bouts's solution was, in fact, little more than a rigid and mechanical regimentation of single portraits placed to the side of the narrative scene. The form and position of the body itself are unimportant; only the faces need be particularized, and, furthermore, it was necessary that each member be isolated from any narrative context lest such action detract from his individuality.[42]

Dieric Bouts died in 1475. The panels of the *Justice of Emperor Otto III* were finished by members of his workshop, which had grown considerably over the years. Two of these were his sons, Dieric Bouts the Younger (c. 1448–1491) and Aelbrecht (c. 1455–1549), and the attribution of the vast stock of Boutsian paintings has become a thorny if not impossible issue to resolve. One of the most charming altarpieces to be associated with

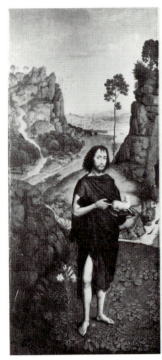
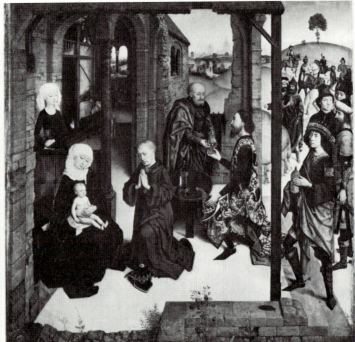

147. DIERIC BOUTS THE YOUNGER? *Adoration of the Magi Triptych with Saints John the Baptist and Christopher (Pearl of Brabant).* c. 1470–80. Panel, 24⅝ × 24⅝″ (center); 24⅝ × 10⅞″ (each wing). Alte Pinakothek, Munich

Bouts is the elegant *Pearl of Brabant*, in Munich, with a poetic Adoration of the Magi with Saints John the Baptist and Christopher on the side wings (fig. 147).

In many respects Bouts's style was more influential than Rogier's in spreading the Netherlandish art eastward. His more homespun translation of Rogier's intricate lyricism and his refreshing landscapes had a popular appeal to artists at the end of the century, who were more concerned with telling stories than expressing emotions. While Rogier's people overwhelm us in their beauty and expressive design, those of Dieric Bouts are simply more comfortable to live with.

PETRUS CHRISTUS

The recovery of the art of Petrus Christus, the third member of this group of northerners, has been slow and difficult. Van Mander does not mention Christus, and the earliest references to his art, those of Italian writers in the sixteenth century, are distressingly vague and inaccurate. Yet at least six paintings are signed and dated by Christus, and searches in the archives of Bruges have yielded some important facts about his activity there between 1444 and 1472–73, when he died.[43] The entries of 1444 in the *Poorterboeken* (visitors' register) of Bruges record that "Petrus Christus, son of Pieter, born in Baerle, purchased his citizenship on the sixth of July, sponsored by Joos van der Donc, in order to be a painter."

A number of specialists see Christus as a painter closely related to Bouts and Ouwater in an intimate workshop situation in his early years. His hometown, Baerle, is very likely Baerle-le-Duc in North Brabant on the present Dutch-Belgian border, not far from Breda, and this proximity with Haarlem and other Dutch centers in Holland adds credibility to the theory that Christus received his training and apprenticeship in circles dominated by the Haarlem school. The later developments of his style are described as strongly influenced by Rogier van der Weyden during the forties, after he presumably settled in the south (as did Bouts) and then by Jan van Eyck following his establishing residence in Bruges after 1444. It will be remembered that the early works attributed to Dieric Bouts, the Prado *Infancy Altarpiece* and the Granada *Deposition* triptych, have also been attributed to Christus, and both works show very clearly the strong influence of Rogier van der Weyden. It would thus seem logical that Christus and Bouts had close associations in their early years.

Other authorities, Friedländer and Panofsky especially, have reversed the periods of influence and also disregarded the role that the Haarlem school played in the development of Christus's art. Christus, they claim, was first of all a pupil of Jan van Eyck in Bruges. As the inheritor of his workshop after Jan's death in 1441, Christus finished at least two major paintings left in the studio, the *Saint Jerome* in Detroit and the *Madonna and Child with Saints and a Carthusian Monk* in the Frick Collection. Only later, it is then reckoned, did Christus come under the spell of Rogier's new style. If there are any similarities between his paintings and those of the

Haarlem artists, this argument continues, then it was Christus who influenced them and not vice versa.

Two glaring facts discredit Panofsky's elaborate theory. Christus is first mentioned in Bruges in 1444, when he purchased his citizenship in order to be a painter in the city. It is very unlikely that this "outsider" (*vreemdling*) could have been a practicing artist on his own for three years or more prior to the signing of the petition. According to the statutes of the city, Christus would automatically have received citizen status after a residence of a year and one day. Secondly, the two panels considered to be works of Van Eyck finished by Christus after his death have little to do with Christus.

A comparison of the Frick *Madonna with a Carthusian Monk* (fig. 114) and its variant in Berlin, the *Exeter Madonna* (fig. 148), to be discussed below, will dispel any doubts concerning that point. Van Eyck surely had workshop assistants and followers in Bruges who produced the many Eyckian works dated in the middle of the fifteenth century, but Christus is not to be a scapegoat for the attributions. Joseph Duverger has recently published the names of painters recorded in Bruges between 1406 and 1457.[44] They number over seventy, and yet only a meager few of these names are recognizable to us today. What, then, did all of these artists produce? Why has none of their works survived? The answers are simply that they painted numerous works and many are extant but have been attributed to the better-known names in Flemish art history for obvious reasons.

The earliest signed and dated works by Christus are two portraits executed in 1446. The identity of the *Portrait of Edward Grymestone* (fig. 149) in the collection of the Earl of Verulam at Gorhambury is established on the basis of the coat of arms in the painting. Grymestone, an agent for the English king Henry VI, had been sent to the Netherlands in 1445–46, during which time Christus executed his portrait. The bust of the sitter appears in the corner of a room that is illuminated by light shining through an oculus window, the type of corner-space portrait that Bouts employed later. The costume and headgear are stiff and rigid, and Grymestone stares coolly off to the left. Above, the beams of the ceiling recede sharply to deepen the extension of the chamber, and the light playing across the back wall further models the space. The well-defined domestic setting places the spectator on a new, intimate relationship with the sitter for the first time.

The encroachment of the real world on the sitter is handled in a more subtle fashion in Christus's remarkable *Portrait of a Carthusian*, also dated 1446 (fig. 150). Here the bust appears behind a simulated parapet within the darkened confines of his cell. A spotlight plays across the bearded face and strikes the upper left corner of the room. As with the Grymestone portrait, the sitter's features are hard and strongly modeled. The presence of a halo (it may not be original) has led some to believe that the monk here depicted wished to identify himself with Saint Bruno, the founder of the Carthusian order. Others have identified him as Denis the Carthusian (Dionysius of Louvain), whom we have already met in connection with Rogier van der Weyden. An eye-catching detail is the tiny fly that has alit on the parapet before the monk. The insignificant insect, short-lived, is probably a type of *memento mori* (remember that you too must die) but it also serves as a clever *trompe l'oeil* to fool the eye of the spectator. At first one is not certain whether a real fly has been fooled by the painting or a painted fly has deceived the viewer.

In 1449 Christus signed and dated a unique painting, *Saint Eloy in His Studio* (colorplate 26). Sometimes referred to as the first major secular painting in Netherlandish art, it is an enigmatic panel that was very likely commissioned for the goldsmiths' guild for their chapel

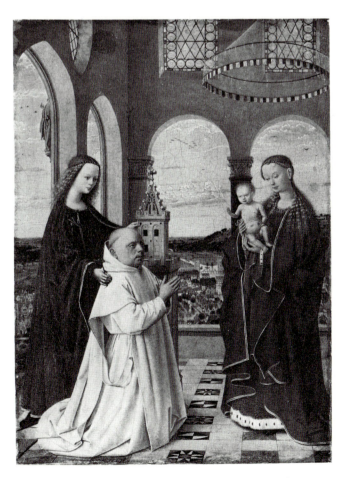

148. PETRUS CHRISTUS. *Madonna with a Carthusian Monk* (*Exeter Madonna*). c. 1450. Panel, 7½ × 5½". Gemäldegalerie, Staatliche Museen, West Berlin

149. PETRUS CHRISTUS. *Portrait of Edward Grymestone*. 1446. Panel, 13¼ × 9¾″. The Gorhambury Collection, by permission of The Earl of Verulam (on loan to the National Gallery, London)

150. PETRUS CHRISTUS. *Portrait of a Carthusian*. 1446. Panel, 11½ × 8″. The Metropolitan Museum of Art, New York. The Jules S. Bache Collection

or guild hall as a glorification of their trade. Eloy was a mintmaster who suffered martyrdom in Flanders in the ancient Merovingian period. He is depicted dressed in the garb of a common craftsman but distinguished by a halo, seated in his workshop in the company of two elegantly attired people who seem to be negotiating business with him. In the foreground is a window ledge upon which Eloy displays his wares. On the shelves behind him are more objects sold by the members of the goldsmiths' guild, including rings, decanter, ewers, jewelry, and a decorated purse.

It is apparent that the saint is about to sell a wedding ring to a young lady, who is accompanied by her husband-to-be. A bridal girdle is prominently displayed before her and the young man tenderly embraces her. It is a type of marriage portrait—the mirror from the *Arnolfini Wedding Portrait* stands at an angle to the right—but it is not likely a particular marriage commemorated here, rather, a generalized one. The figures, including Eloy, do not appear to be portraits. Their features are much like those in the Prado *Infancy Altarpiece* and the modeling of the heads displays a similar stereometric quality usually associated with Ouwater and early Bouts.

It has been suggested that a particular event in the life of Saint Eloy is presented here. We read in the *Acta Sanctorum* (*Lives of the Saints*) that Eloy arranged for Saint Godeberta of Noyon to be betrothed to Christ in the presence of the Merovingian king Clothaire II, in order to preserve her chaste character. In this context, Saint Eloy appears as a champion of virginity as a virtue, but in no way can the New York panel be considered a depiction of that legend. The lady has no halo and the male figure is certainly not Christ or the king. It is, in a way, an occupational painting for the guild of the goldsmiths, an advertisement for their business to be on display in their chapel.

Rather than a spokesman for chastity, Saint Eloy appears here as a representative of the virtues of a normal marriage and the sacrament of Holy Matrimony. The reflection in the tilted mirror supports this. Instead of showing us the image of the young bride and her fiancé, it is turned toward the streets outside, capturing the figures of two dandies, one carrying a falcon, a familiar attribute of the leisure class which was much scorned by the middle-class burghers of Flanders. A faint crack can be detected along the right edge of the mirror, further

indicating that it symbolizes *vanitas* and not purity as the *speculum sine macula* (spotless mirror) of the *Arnolfini Wedding Portrait* does.

The Brussels *Lamentation* (fig. 151), clearly indebted to Rogier van der Weyden's compositions of the theme, has been dated early, about 1445–50, because of the striking similarities of the head types with those in the *Saint Eloy* and the portraits dated 1446. It is in the *Lamentation,* moreover, where one finds stylistic features that are remarkably close to those in Bouts's early works, especially the Granada *Altarpiece of the Deposition.* The figures, mostly derived from Rogier's types, are pulled apart, so to speak, and dispersed in the broad horizontal landscape. The Magdalen is isolated on the far left, the elderly attendant and Mary Cleophae stand off to the side on the right, thus disrupting the lyrical flow and compact integration of figures on the surface as they appear in those designed by Van der Weyden.

The *Nativity* in Washington is one of Christus's most accomplished paintings (colorplate 27). Perhaps the central panel of a large triptych, the imposing painting not only displays his attractions to Rogier van der Weyden and Jan van Eyck, but also his basic Dutch temperament. The impressive treatment of the huge arch that introduces us to the scene was certainly inspired by Rogier's simulated architectural setting in the Mary and John the Baptist altarpieces and the tender characterization of the Madonna, the local color, and the crisp landscape bathed in a bright light are derived from Van Eyck; but the clarity of space and the geometrics of the composition are features of his Dutch heritage. The proscenium arch functions not as a theatrical setting for the narrative but as a giant diaphragm arch that establishes the position of

the spectator with regard to the rigid compositional and spatial construction of the Nativity beyond it. It also serves as a provocative introduction to the iconography, the Birth of Christ as the priest of man's salvation.[45]

The sculptures adorning the jambs and arch of the portal clearly mark it as the domain of the profane world "before the Law" was established. The jamb figures, Adam and Eve (quotations of those on the Ghent altarpiece), proclaim the fall of man through the transgressions of the first parents. They stand on columns that, in turn, rest on the hunched backs of atlantes-like figures who represent those burdened by the fall, while the fighting warriors in the spandrels of the arch are reminders of the conflict and chaos that followed. The archivolt sculptures spell out the consequence for the first family from the expulsion of Adam and Eve, the story of Cain and Abel and the first murder, to God's reproach of Cain and his setting out for Nod, the land of the unredeemed, to which he was banished.

The clearly constructed cubic space just beyond it formed by the stable represents the world under Grace with the coming of Christ, the "New Law." The ruined back wall of the stable then forms a barrier behind the holy scene, where four shepherds stand but do not seem to understand what has happened. They are those who listen but do not hear (left) and look without seeing (right), and perhaps refer to the state of man under the Jewish law of Moses (cf. Psalm 94).

The Nativity or, better, the Adoration of the Holy Family, thus occupies an isolated and sanctified ground between the two profane worlds. Joseph of the Old Testament has removed his shoes in honor of the hallowed spot for he, like Moses before the Burning Bush (an Old

151. PETRUS
CHRISTUS.
Lamentation.
c. 1445–50. Panel,
39¾ × 75⅝″. Musées
Royaux des
Beaux-Arts, Brussels

Testament type for the virginal birth of Christ), has seen God. The image of the nude Child lying on the ground, a golden disk or paten beneath him, can thus be associated with Christ as the host in the Mass, the "living bread which came down from heaven" (John 6: 51). It has been pointed out that the vested angels kneeling about Christ signify that this is the "first Mass" on earth with Christ as both priest and sacrifice.[46]

Two unusual details mark the upper and lower limits of the stable. Below, in the foreground, are four unhewn rocks at the entrance to the scene. These signify the sins of Cain (Genesis 4: 7) and of man in general: "the stones that he bids us throw out from our way are our sins" (Jerome, *Homily xvii*, 48, 134), lest we stumble on them when Christ calls for us. Above, in the triangle formed by the rafters, a green sprout grows up from the king post against the soft morning sky. Traditionally this sprig symbolizes the new life that springs from the old, but it also could refer to the root of Jesse (Isaiah 11: 1) and the flowering rod of Aaron (Numbers 17: 6), both Old Testament types of the virginal birth in Gothic typologies.

How much Christus's complex iconography reminds us of the *Raising of Lazarus* by Ouwater! The men peering in from the wall of the shed have a function similar to that of the spectators beyond the rotunda in Ouwater's work. Furthermore, both are stylistically similar. The oval grouping of the main figures in Christus's *Nativity* within the beautifully constructed space box of the stable reminds us of the clarity of figures in deep space found in the *Raising of Lazarus*, and the subdued tonalities of browns and grays punctuated with areas of brighter reds, yellows, and blues reinforce this association.

A similar clarity of space and soft tonalities characterize the *Virgin and Child in a Chamber* in Kansas City (fig. 152). Laid out with a precise perspective (the vanishing area lies near the cushion on the tester bed to the right), the room telescopes in well-marked boxes: the furthest, with Saint Joseph entering through an open court, is flooded with light; in the lofty foreground bedchamber, where Mary and the Child appear resting before an open window, the light is modulated in soft tones of brown and gray, giving it a simple cubistic appearance uncluttered by objects and details in bright local color.

How different this is from Van Eyck's Madonnas in Melbourne and Frankfort! The unadorned expanses of the walls, the floor, and the furniture lend the picture a humble serenity and transmit this homeliness to the beautiful young Mary, whose face is reduced to a smooth sphere as she sits directly in the warm sunlight. Just what the picture is meant to represent is not clear; except for the Child who holds an orb in his left hand, the subject matter could easily be just a virtuous mother with her child in a scrubbed-clean home.

It has been suggested that Christus here depicts Mary and Joseph at home in Bethlehem preparing for the flight into Egypt, but it matters little what specific moment is involved. The beauty of the composition in basic horizontal and vertical lines, with the modulating effects of the light across the space and the figures, anticipates in many respects the pristine compositions of the "lady before the open window" by Johannes Vermeer some two hundred years later.

If the Dutch traits predominate in these two works, selective eclecticism characterizes other paintings by Christus between 1450 and 1460, making it extremely difficult to work out a precise chronology. It should also be noted that the size of the panels necessitated changes in his style. The tiny *Exeter Madonna* in Berlin is a notable example of these fluctuations (fig. 148). It has been dated either very early, about 1444, or very late, about 1460. Here, as in other panels of a diminutive format, Christus's style departs from the stereometric simplicity and monumentality of the larger works for a precious miniature-like treatment of figures and setting with brighter colors sparkling and overwhelming the broader tonalities.

152. Petrus Christus. *Virgin and Child in a Chamber.* c. 1450–55. Panel, 27⅜ × 20″. Nelson Gallery-Atkins Museum, Kansas City, Mo. Nelson Fund

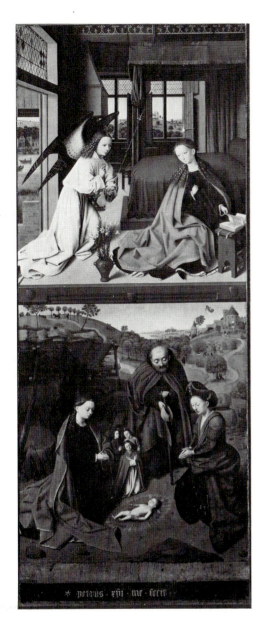

153. PETRUS CHRISTUS.
*Annunciation and Nativity; Last
Judgment* (wings of a triptych).
1452. Panel, each 52¾ × 22″.
Gemäldegalerie, Staatliche
Museen, West Berlin

The *Exeter Madonna* has often been described as a creative copy of the larger *Madonna and Child with Saints and a Carthusian Monk* in the Frick Collection (fig. 114) and to an extent this is true. The kneeling donor is certainly the same Carthusian in each panel, posed in identical postures with the draperies of his white habit repeating the same patterns. He is introduced by Saint Barbara in each case, and the setting of both is a high chamber of a loggia overlooking a detailed far-distance landscape. The donor has been tentatively identified as Jan Vos, prior of the Carthusian monastery of Genadedal (Valley of Grace) near Bruges from March 30, 1441, to 1450, when he was transferred to Nieuwlicht (the New Light) convent outside of Utrecht. The Frick painting has often been associated with the ''image of the Most Blessed Mary, Mother of God, Saint Barbara and Saint Elizabeth'' which was dedicated by a visiting Irish bishop, Martin of Mayo, on September 3, 1443.

Since Jan van Eyck died only three months after Jan

Vos's accession to the priorship at Genadedal (the assumed occasion for the commission of the Frick painting), the artist could have only begun the composition, and a workshop assistant would then have finished it. But, contrary to the opinion of Panofsky and others, the workshop assistant was not Christus. Vos took the painting with him to Nieuwlicht where, as the chronicler tells us, it was placed on the altar of Saint Barbara. As compensation, it is further argued, the *Exeter Madonna* was commissioned for Genadedal as a replacement in 1450. This makes some sense, to be sure, but the tiny format of the Berlin panel rules out its function as an altarpiece, and it seems much more likely that it was commissioned as a portable devotional piece for the prior. At any rate, the date 1450 probably is right since the prior appears some ten years older in the Christus painting.[47]

The eclecticism of Petrus Christus is blatant in other works painted between 1450 and 1460. Two tall panels in Berlin (fig. 153), signed and dated 1452, were origi-

154. PETRUS CHRISTUS. *Madonna and Child*. 1457? Panel,
18⅜ × 17½″. Städelsches Kunstinstitut, Frankfort

155. PETRUS CHRISTUS. *Madonna of the Dry Tree*. c. 1462. Panel,
5¾ × 4⅞″. Thyssen-Bornemisza Collection,
Lugano-Castagnola

nally the side shutters of a large altarpiece, but the central panel is missing. The left wing has an *Annunciation* atop a *Nativity*, both of which are clearly indebted to compositions by Robert Campin and Rogier van der Weyden. The stocky angel in the *Annunciation* reminds one of Gabriel in the *Mérode Altarpiece* while the clearly constructed domestic interior with the tester bed behind the Virgin depends on the *thalamus*, or marriage chamber, in Rogier's Louvre *Annunciation*. The *Nativity* below is a simplified version of the Dijon *Nativity* of Campin with the nude Child placed on the ground before his kneeling mother and the adoring midwife from apocryphal sources looking on from the right. The right panel is an abridged version of Van Eyck's *Last Judgment* in New York (fig. 115).

The differences in style between the two works are instructive to study. The rich, highly detailed surface pattern and flow of countless tiny figures up and down, in and out of space in Van Eyck's dense composition have been drastically reduced and strictly organized by Christus. The demarcations of heaven, earth, and hell are clearly indicated and the atmosphere has been pumped out, giving the whole a barren quality.

The *Madonna and Child* enthroned between Saints Jerome and Francis in Frankfort is signed and dated 145[7?] (fig. 154). The inspiration for this curious picture was surely Jan van Eyck's Madonna paintings with an elegant throne room, rich brocaded cloth of honor and canopy, colorful oriental rug, and view of a distant landscape through a doorway. Although the panel has been cut down on the left, it is evident that the chamber was laid out as a spacious cubistic interior with receding lines similar to other Christus settings.

Sometime around 1462 Christus and his wife became members of an elite confraternity, Our Lady of the Dry Tree. It was probably for that occasion that he painted the tiny panel of the *Madonna of the Dry Tree*, today in Lugano (fig. 155). Here again Christus fashioned his demure Virgin on much earlier Eyckian types, as he did in the *Exeter Madonna*. Mary and her Child stand in the fork of a crown of thorns formed by the leafless branches of the dry tree that enframes them. The iconographic sources for this image are complex and obscure, but the dry tree itself no doubt is an allusion to the Tree of Life in Eden that had withered and died at the Fall of Man. But with the coming of Christ, the new Adam, its branches will once again flower and live for man's salvation.

Two meanings are associated with Christus's spiky crown of thorns. One refers to the Passion by which means mankind was redeemed by Christ; the other symbolizes the crown of Mary, who was the instrument of the Incarnation. Fifteen *A*'s hang from the various

Colorplate 19. ROBERT CAMPIN (MASTER OF FLÉMALLE). *Mérode Altarpiece.* c. 1425–30. Panel, 25¼ × 24⅞″ (center); 25¼ × 10¾″ (each wing). The Metropolitan Museum of Art, New York. The Cloisters Collection

Colorplate 20. ROGIER VAN DER WEYDEN. *Deposition.* c. 1435–38. Panel, 7' 2⅝" × 8' 7⅛". The Prado, Madrid

Colorplate 21. ROGIER VAN DER WEYDEN. *Saint Luke Portraying the Virgin.* c. 1435–40. Panel, 54¼ × 43¾″.
Museum of Fine Arts, Boston. Gift of Mr. and Mrs. H.L. Higginson

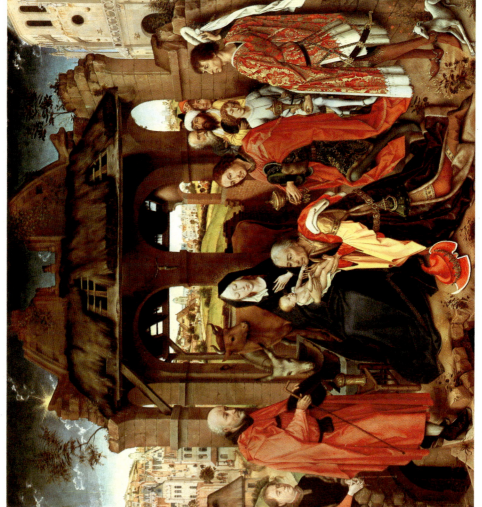

Colorplate 22. ROGIER VAN DER WEYDEN. *Columba Adoration of the Magi.* Before 1464. Panel, 54⅜ × 60¼" (center); 54⅜ × 27½" (each wing). Alte Pinakothek, Munich

Colorplate 23. MASTER OF THE HOURS OF CATHERINE OF
CLEVES. *Saint Ambrose*, from the *Book of Hours of
Catherine of Cleves*. 1434–40. The Pierpont Morgan
Library, New York

Colorplate 24. ALBERT VAN OUWATER. *Raising of Lazarus*. c. 1455–60.
Panel, 48 × 36¼″. Gemäldegalerie, Staatliche Museen, West Berlin

Colorplate 25. DIERIC BOUTS. *Last Supper Altarpiece*. 1464–67.
Panel, 72 × 60⅛″ (center); 34⅞ × 28⅛″ (each wing). Church of Saint Peter, Louvain

Colorplate 26. PETRUS CHRISTUS.
Saint Eloy in His Studio. 1449.
Panel, 39 × 33½″. The Metropolitan
Museum of Art, New York.
Robert Lehman Collection

Colorplate 27. PETRUS CHRISTUS.
Nativity. c. 1445–50. Panel, 51¼ × 38¼″.
National Gallery of Art, Washington, D.C.
Andrew Mellon Collection

Colorplate 28. Hugo van der Goes. *Portinari Altarpiece* (center). 1475–76.
Panel, 8′ 3⅝″ × 9′ 10⅝″. Uffizi, Florence

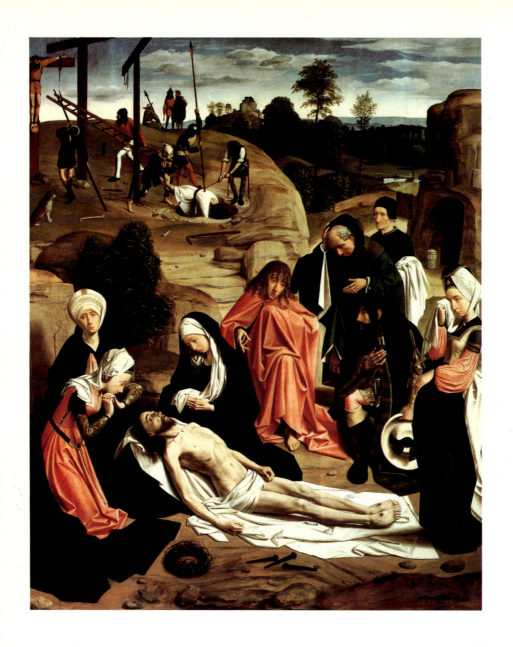

Colorplate 29. GEERTGEN TOT SINT JANS.
Lamentation (right wing of a triptych).
After 1484. Panel, 67¾ × 54¾".
Kunsthistorisches Museum, Vienna

Colorplate 30. GEERTGEN TOT SINT JANS.
Madonna of the Rosary. c. 1480. Panel, 10 × 7
Museum Boymans-van Beuningen, Rotterda

branches of the crown of thorns, an obvious reference to the fifteen Aves repeated in Rosary devotion, a new form of personal devotion that was rapidly developing in the North.

Although Christus's style seems to have waned in his later years, one of his most enchanting portraits, the young lady in fine attire in Berlin (fig. 156), dates in the last years. Never have the bold stereometric qualities of the face been more effective. One would like to think that this young, pouting woman was one of his own daughters. The smooth countenance and the oriental cast to her eyes that glance sharply to the right make this one of the most provocative portraits in Netherlandish art.

JOOS VAN WASSENHOVE

If it is true that Dieric Bouts's works may be said to show "Western art at its maximum distance from classical antiquity," as Panofsky has characterized it, then it is surprising indeed that one of his most gifted followers, Joos van Wassenhove (Justus van Ghent), perhaps a Dutchman himself, was one of the first major Netherlandish artists to travel to Italy and accommodate his Northern style to the tastes of the humanist patrons there. His name appears in the records of the painters' guild in Antwerp for the year 1460. We next encounter him in the archives of Ghent as a free master in 1464. Ghent, unlike Bruges, had not maintained a reputation as a center of painting. In fact, little can be said of art in Ghent between the completion of the *Altarpiece of the Lamb* in 1432 and the arrival of Joos van Wassenhove. He

156. PETRUS CHRISTUS. *Portrait of a Young Lady*. c. 1470. Panel, 11 × 8¼". Gemäldegalerie, Staatliche Museen, West Berlin

became the sponsor and guarantor for the entry of Hugo van der Goes into the painters' corporation in 1465 and for the miniaturist Simon Bening in 1468. For reasons unknown, Joos left the Netherlands about 1469–70 to settle in Italy. His activity in Urbino for Duke Federigo

157. JOOS VAN GHENT. *Adoration of the Magi*. c. 1465. Tempera on linen, 43 × 63". The Metropolitan Museum of Art, New York. Bequest of George Blumenthal, 1941

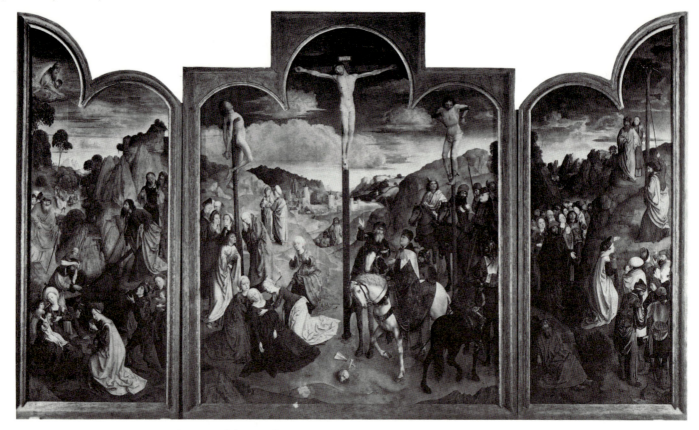

158. Joos van Ghent. *Altarpiece of the Crucifixion*. c. 1467–69. Panel, 85¼ × 67½″ (center); 85¼ × 31⅞″ (each wing).
Cathedral of Saint Bavo, Ghent

da Montefeltro and the Confraternity of Corpus Domini is recorded in documents dating between April 1473 and March 1475, where he is named "Giusto da Guanto," Joos van Ghent.

On the basis of the style of the *Communion of the Apostles* altarpiece that he painted for the confraternity in Urbino (which is clearly documented), a number of panels, many of uneven quality, have been attributed to Joos. The *Adoration of the Magi* in New York has usually been considered one of his earliest works, dating about 1465 (fig. 157). The painting was executed in tempera on linen, not oil on panel, and partly for that reason the surface has lost much of its luster and brightness over the years. However, it is not the finish of the work that interests us here, rather the composition and figure style, which are clearly Boutsian. The format is elongated and horizontal with the major figures drawn far apart and placed on a huge barren stage that serves as a deep stable.

Slightly later, about 1467–69, is the large *Altarpiece of the Crucifixion* in Saint Bavo Cathedral in Ghent (fig. 158). Although seriously damaged by fire in 1822, the triptych with its broad and sweeping landscape is an impressive, almost symphonic, extension of the smaller altarpieces of Dieric Bouts. Joos multiplied the succession of space cells activated by figures to panoramic proportions in the deep, tonal landscape, and the doll-like fig-

ures are even more loosely scattered in pools that lead the eye in an arbitrary fashion in and about the rocky hills and deep valleys.

Joos too, like Bouts in the Louvain *Last Supper Altarpiece*, departs from the chronologically related narratives that usually run across the three panels of the triptych and presents instead Old Testament types for the centerpiece, the *Crucifixion*, on the wings. On the right appears the story of Moses raising the brazen serpent on the staff as a sign of salvation for the Israelites (Numbers 21: 8). The left panel presents the rare story of Moses sweetening the bitter waters of the Mara for the thirsting followers in the desert (Exodus 15: 23).

Both scenes were discussed as prototypes of the Crucifixion by Durandus in the *Rationale divinorum officiorum* (V. 2. 10), written in the thirteenth century. That the mode of style and choice of subject matter developed by Bouts and other North Netherlandish artists could have made such an impressive entry in Ghent, the very home of the Eyckian style, indicates the abrupt shift in taste that followed the death of Jan van Eyck in 1441. An Eyckian shop continued in Bruges until the end of the century, but Ghent slumbered. The return to Van Eyck's style was to come in time, however, in the art of Hugo van der Goes, who was, interestingly enough, a friend and perhaps even a pupil of the artist to whom the *Altar-*

piece of the Crucifixion has been attributed, Joos van Wassenhove.

Vespasiano da Bisticci of Florence, a friend of the duke of Urbino, Federigo da Montefeltro, reports that the duke, a lover of books and humanistic studies and a connoisseur of painting, being unable to find masters in Italy after his taste, turned to Flanders for a worthy master whom he then summoned to Urbino to execute pictures and decorate his *studiolo*, or scholarly den. One of the pictures in which the duke figures is the huge *Altarpiece of the Communion of the Apostles* (fig. 159), which originally was placed in the Church of the Corpus Domini. This work was commissioned by the Confraternity of Corpus Domini on February 12, 1473, and the artist was one "Giusto da Guanto," or Joos van Ghent. The altarpiece had formerly been entrusted to Paolo Uccello about 1467–68, but later he was dismissed, after completing only the predella for the altarpiece with six small scenes narrating the story of the profanation of the host by Jews in Paris in 1290 and its miraculous recovery, an event that provoked much anti-Semitic hysteria throughout Europe.

The Communion of the Apostles is very closely related to the Last Supper thematically, both being the institution of the sacrament of the Eucharist, but the painting by Joos little resembles the *Last Supper* that Dieric Bouts executed for the Brotherhood of the Holy Sacrament in Louvain only a decade earlier. Bouts presented the Last Supper in a domestic interior with Christ and the apostles seated about a large dining table at the moment when the wine (chalice) and the bread (host) were blessed by Christ. In the Urbino panel Christ stands before the table and administers the hosts to the apostles, who kneel in a semicircle about him, nine on the left, three on the right. John the Evangelist stands behind the table to the left holding a carafe of wine before a chalice. Somewhat isolated to the far left, Judas appears clutching the purse with the coins, while Peter is apparently the kneeling figure directly before Christ receiving the host.

The setting is different too. The nearly barren table is placed as an altar in the apse of a church. Two angels flutter in awe and admiration in the top corners of the choir. This more ritualistic presentation of the Communion is based on an earlier Byzantine type of the Last Supper, the *Koinonia*, that sometimes appears in Italian

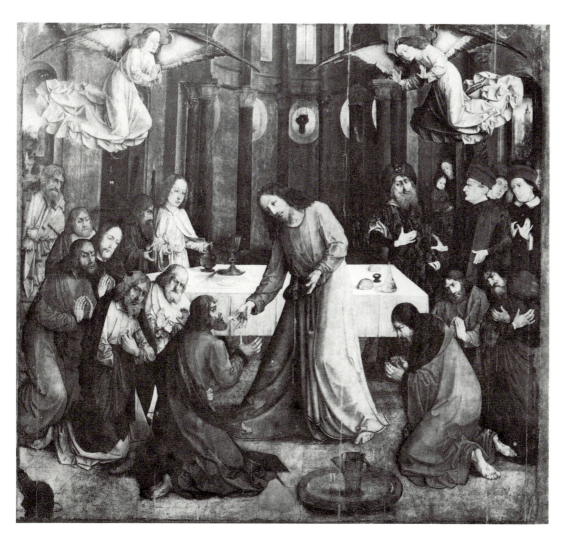

159. JOOS VAN GHENT.
*Altarpiece of
the Communion
of the Apostles.*
1473–74. Panel,
9' 5⅜" × 10' 6".
Galleria Nazionale
delle Marche, Ducal
Palace, Urbino

art and has a more timeless message to convey, that discussed by Saint Paul in his Epistle to the Hebrews, which informs us that Christ was a priest after the order of Melchizedek. Thus the *Koinonia* was not just a historical narrative described in the Gospels, but more emphatically the mystical archetype of the sacrament of the Eucharist repeated in every Mass.

The artist of the Urbino painting is surely the same one who executed the *Adoration of the Magi* and the *Altarpiece of the Crucifixion* discussed above. The kneeling poses of the apostles, the curious striding posture of Christ, and the soft drapery patterns are features found in the earlier works of Joos van Wassenhove, and the exotic bearded figure wearing a turban standing by the table to the right is a quotation of the executioner in Bouts's *Erasmus Altarpiece* in Louvain.

To the right, behind the apostles, stand five figures

160. JOOS VAN GHENT. *Plato*, from the series of "Famous Men" in the studiolo of Federigo da Montefeltro. c. 1473–74. Panel, 40 × 27⅛". The Louvre, Paris

and a woman holding a child. The foremost of these, the man in profile with the hawk-beak nose, is Federigo da Montefeltro, who served as protector of the confraternity in Urbino. The woman and child are very likely the duke's wife, Battista Sforza, and their son, Guidobaldo. Battista Sforza died in 1472 following the birth of Guidobaldo, the duke's only son, and the remoteness of the two suggests that their inclusion was a tribute to the deceased wife, who provided Federigo with a proper heir. The bearded man in exotic costume has been identified as the Persian ambassador "Isaac," who was in Italy and converted to Christianity in 1473. In a biography of Federigo, published in 1604, we are informed that Uzun Hasan, king of Persia, sent to the duke a mission of ambassadors, who presented him with very rich gifts. "To keep alive the memory of that fact [Federigo] had full-scale portraits of himself and the ambassadors painted in the panel of the main altar of the Confraternity of Corpus Domini in Urbino by Joos Tedesco, famous painter of those times and of whom it is said that he was the first to bring to Italy the modern use of painting in oils."[48]

The painted decorations of the *studiolo* of Federigo, mentioned by Vespasiano da Bisticci, have been identified with twenty-eight bust portraits of famous men in history (and possibly a portrait of the duke kneeling in devotion with his young son) preserved today in Urbino and Paris (see fig. 160). The panels were aligned in two tiers about the walls of the study forming a "Hall of Fame" to inspire the learned Federigo. Above were portraits of the sages of ancient times from Plato and Aristotle to Solon and Hippocrates and below were the luminaries of the Christian world, including church fathers, popes, confessors, Dante, and Petrarch.

There is much confusion regarding the attribution of these portraits since some scholars believe that an assistant from Spain, Pedro Berruguete ("Pietro Spagnuolo" in the documents), was largely responsible for finishing the series.[49] Our understanding of the collaboration in workshop production in such projects is too meager to make any conclusion regarding attribution convincing, although most authorities tend to favor the attribution of the portraits, or at least their design, to the painter from Ghent.

Joos van Wassenhove was one of the first in a long line of Netherlandish painters to make Italy his adopted land, and his last works represent an impressive blending of Northern skill in the execution of detail and color in the oil medium and the scale and grandeur of Italian monumental mural decoration. It is no wonder, then, that these works have had such an erratic history in scholarship.

Two Mystics

HUGO VAN DER GOES

Sometime between 1475 and 1476 a wealthy Italian businessman, Tommaso Portinari, representative for the Medici family in Bruges, ordered a huge and costly altarpiece for his family chapel in Florence (colorplate 28; fig. 161). A bold and daring man, Tommaso was proud of his success in the Netherlands, and probably for that reason he wanted to place in Florence a token of his achievements and good fortune in the form of an altarpiece that would impress everyone there. The surprising thing is, contrary to what one would expect, Tommaso did not entrust the work to one of the leading Florentine artists of the time, but commissioned instead the Ghent painter Hugo van der Goes.[50]

The great altarpiece Hugo executed for the Portinari family is much more than a sumptuous painting, however; there is also embodied in it a hidden autobiography of one of the most fascinating and complex personalities in art history. Hugo, painter for dukes and companion of the nobility, was an artist much troubled with his own vanity and ambition, and, like Rembrandt and Vincent van Gogh, he was a Netherlandish painter keenly aware of the tragic sense of life basic to the Christian faith that is so easy to read in the faces of the poor and humble of heart. The *Portinari Altarpiece* is Hugo's own personal comment on life, and it is a noble, albeit sad, warm, and intensely human confession. A few years after its completion the artist retired to the monastery of the Red Cloister (Roode Klooster) near Brussels to find peace with himself, but he enjoyed little solace even there.

The giant *Portinari Altarpiece* (8½ × 19 feet) is usually entitled a Nativity, which it is in a general sense, but to be more precise it represents the moment of the Adoration of the Holy Family and the Shepherds according to the account given by Luke (2: 10–19):

And the angel said to them [the shepherds], "Be not afraid; for behold, I bring you good news of a great joy which will come to all the people; for to you is born this day in the city of David a Savior, who is Christ the Lord. And this will be a sign for you: you will find a babe wrapped in swaddling cloths and lying in a manger." And suddenly there was with the angel a multitude of the heavenly host praising God and saying, "Glory to God in the highest, and on earth peace among men with whom he is pleased!" . . . And they went with haste, and found Mary and Joseph, and the babe lying in a manger. And when they saw it they made known the saying which had been told them concerning this child; and all who heard it wondered . . . But Mary kept all these things, pondering them in her heart.

There are a few significant departures from the text in Hugo's interpretation—the Child is not wrapped in swaddling clothes and lying in a manger—but in general Hugo has superbly captured the spirit of wonder and awareness given in this brief account of Christ's first epiphany to man on earth, and, no less important, the mood of his mother, who truly does ponder the words from heaven in her heart, and, as a mother, sadly understands and accepts, here at the very birth of her Child, the fate he will endure for every man's salvation.

Hugo's masterpiece impressed the Italians, but aside from its great size and monumentality, it is very unlike anything Italian in terms of style and content. The birth of Christ was traditionally depicted as one of the Joys of Mary, but here it appears more as an event tinged with sorrow, as a solemn and grave episode and not a jubilant one, as the Italians presented it; this melancholic mood as well as the emphasis on peasants and humility rather than royalty and sumptuousness provide us with the key to the meaning of Hugo's painting.

One can easily describe the Flemish characteristics in the *Portinari Altarpiece*. The art of Jan van Eyck has been restated with a true understanding of his technique. Not only has Hugo rivaled Jan in his ability to reproduce the real world with infinite detail, but he has also matched him in the use of disguised symbolism. The keen sense of light and space, the naturalism of the wintry landscape, far surpass the accomplishments of Bouts and Christus,

161. HUGO VAN DER GOES. *Portinari Altarpiece* (wings). 1475–76. Panel, each 8′ 3⅝″ × 4′ 7½″. Uffizi, Florence

but more important is Hugo's ability to produce a painting that has monumentality in conception comparable to Rogier van der Weyden. In this great synthesis there are, however, a number of mystifying contradictions that indicate a very personal and original mind at work.

The first difference to be noticed is the vivid characterization of the people in Hugo's painting. Unlike the actors in Rogier's works, who share a communal response to the drama, or those by Jan van Eyck, who stare silently, Hugo's people react to the event before them as intensely concerned individuals. The delicate angels are pious choirboys at a Mass. Joseph is dumbfounded but respectful, not suspicious of how the birth came about, as he is often characterized. The three shepherds respond, each in turn, with the warmth of a father for a newborn, the awareness of a miracle by an unexpecting witness, and the astonishment and awe of someone who has sensed something much more than he can understand but knows that it is good. And then there is Mary: humble and melancholic, she looks down sadly but affectionately at her fragile baby on the ground.

Not only are the faces in Hugo's painting vividly differentiated, but their postures and gestures are too. Hands are always important in Hugo's art. Enlarged, they accent the picture like so many arrows pointing

toward a single target, and each response is an individual one. Panofsky brilliantly summed up Hugo's characterizations in the following words:

> . . . we face, to borrow an Erasmian term, the emergence of a *totus homo* no longer subject to that medieval dichotomy of body and soul which had forced Jan's and Roger's personages into a kind of dilemma between existing and acting, being themselves and doing justice to the part assigned to them within the narrative. Much as the modern actor, as opposed to the performer in a medieval mystery play—and we should bear in mind that drama, as we know it, did not exist in the Middle Ages—Hugo's characters have acquired what may be called, for want of a better expression and with due caution against derogatory implications, a "stage presence."[51]

An umbra of blue veils the scene of the Nativity unifying the tone of the composition, which at first seems simple and obvious, but which is contradictory and perplexing upon closer study. A subtle contradiction between the design of the figures on the surface and their position in space is apparent in Hugo's painting, an understandable result of combining Rogier's and Bouts's

modes of organization. But this conflict is deliberate and expressive. A relative symmetry of figures revolves about Mary, whose downcast hands mark the very center of the composition. The axes for this symmetry are not bilateral, as they usually are, but diagonal. The heavy, inert form of Joseph balances the silhouette formed by the three shepherds; the angels in the lower left echo those in blue just behind Mary; and the richly brocaded angels in the lower right are matched by the fluttering angels in the top left. Thus the compositional axes move like spokes on a giant wheel or sphere whose hub is the Madonna and Child. And like some fragile casing, the well-defined circle of actors magnetically encloses and isolates them. The only figure who could violate this circle of sanctity and cross it is the awestricken third shepherd, whom Hugo has carefully placed behind his companions.

And just as Hugo's use of diagonal axes for the figures sets up a tension between them in space, an unbalanced illumination creates a tension between the right and left halves of the composition. Sunlight, more than being a natural illumination, also contributes to the dramatic expression. On the left, the heavy, dark forms of Joseph and the beasts are veiled in the darkness of the stable from which emerge the glowing angels and the eerie head of a demon just over the horns of the ox. These somber forms on the left oppose the fragile and emotional elements on the right. There the architecture itself is broken and flimsy, and the shepherds are barely able to keep their positions along the circumference of the circle about Mary. The Virgin bridges the gap between the two halves. Her dark blue silhouette continues the dark outline of the wall of the stable, but her glance is directed toward the new light that radiates from her son. The delicate, courtly figures of the diminutive angels, alternating with the coarse peasant folk, also serve as unifying links in this contrast. The courtly and the humble are thus reconciled.

A similar contrast is evident in the setting. A dark ruined stable, fit only for beasts, is the place of the birth of the nude Child on the ground. Beyond this rustic setting appear the deserted remains of another building, the palace of David who, it will be remembered, was also born in Bethlehem. This contrast between the barren and lowly birthplace of Jesus and the regal house of David, one of the most popular Old Testament types of Christ, would underscore the humble, human origins of the true Messiah of the Christians and Jews alike. The coat of arms of King David, the harp, appears on the portal of the palace just above the head of Mary together with the initials PNSC and MV, which have been interpreted as *Puer nascetur salvator Christus* and *Maria Virgo*, direct references to the fact that the savior Christ was born here of the Virgin Mary. Finally, it should be noted that this contrast between the regal and the humble is found even in the still-life detail that so elegantly dominates the foreground.

In the manner of Jan van Eyck, Hugo has placed in his very real world symbols that unveil on a second level of meaning the intricacies of doctrine and liturgy for the beholder. Much scholarship has been devoted to the disguised symbolism of the painting, so much, in fact, that one questions the ability of the typical fifteenth-century viewer, much less the modern one, to understand all that Hugo has stated here. The basic intent, it seems to me, is to elucidate the doctrine of the Incarnation, God made flesh at the Nativity, the joining of the human-humble and the divine-regal in Christ's birth.

The still-life detail sums up the content of Hugo's painting. Two vases with flowers appear before a sheaf of wheat. To the left is an elegant Spanish albarello holding three irises and a scarlet lily, flowers that symbolize the passion, purity, and royalty of Christ. Beside it is a small glass vessel—through which sunlight passes but does not break—in which are seven blue columbines and three red carnations. The drooping columbines and the blue violets scattered about the glass on the ground are familiar symbols of Mary's humility and sorrows. Thus the two vases and their flowers represent the divine Christ born of a humble virgin. The albarello is decorated with a pattern of vine scrolls and grapes, representative of the wine or blood of Christ in the Eucharist, and the sheaf of wheat directly behind it is obviously a reference to the body, the bread: "I am the bread which came down from heaven" (John 6: 41). The very birthplace, Bethlehem, moreover means "house of bread."[52]

The liturgical nature of the *Portinari Altarpiece* has been thoroughly studied.[53] Christ, the sacrificial offering in the Eucharist through the transubstantiation of the bread and wine, is thus placed above the sheaf of wheat, the bread and body, and the jar with the grapevines, the wine and blood.

The Christ Child is more than the sacrifice, however. He is also the priest of the first Mass on earth. It has been pointed out that the vestments worn by the angels about the newborn are the very ones prescribed for the assistant ministers at the first solemn High Mass for a priest. The angels are Christ's attendants, and Hugo's humble stable becomes the stage for the Mass. The grapes and the wheat symbolize his blood and body offered in Communion after the saying of the Trisagion, the "Sanctus, Sanctus, Sanctus," which can be read along the border of the angel's cope in the lower right. Thus, as in the *Nativity* by Petrus Christus (colorplate 27)—it should be noted that Joseph again discards his patten on this sacred ground—Hugo presents a profound moment in the liturgy.

The contrasts between the human and the divine, the humble and the exalted, are superbly interwoven throughout Hugo's triptych. On the left wing, behind the hieratic, iconic saints, Hugo introduced an unusual detail in the landscape showing the physical pain of Mary in childbirth getting down from the donkey to rest in the arms of Joseph, and on the right shutter, the three Magi, confused and lost, ask peasants the way to Bethlehem. Another unusual note of pessimism appears in the weird demon lurking in the shadows of the stable. The phosphorescent head is no doubt that of Lucifer, the Prince of Darkness, who witnesses the Incarnation,[54] which according to the *Legenda Aurea* was staged for the confusion of demons and to enable man "to obtain pardon from sins, to cure his weaknesses, and to humble his pride," the very anxieties suffered by Hugo, according to a contemporary account by Brother Gaspar Ofhuys, who knew the artist during his residence in the Roode Klooster.

Ofhuys praises Hugo for his high esteem as an artist—"he had no peer this side of the Alps"—and remarks how he was visited by men of highest rank, including the "illustrious Archduke Maximilian." He further relates how during a trip to Cologne with other brothers, Hugo was seized with a "strange illness of his mind" and was returned to the cloister with difficulty, whereupon the prior, "remembering that Saul was relieved when David played the harp," at once had music played before the demented painter to drive away his fantasies. Brother Ofhuys then offers an unusual diagnosis:

> We can speak of two possible assumptions concerning the illness of our painter-brother converse. The first is that it was a natural one, a kind of frenzy. There exist various natural species of this disease: sometimes it is caused by "melancholy" victuals [an excess of black gall such as meat and lentils], sometimes by imbibing strong wine; then again by passions of the soul such as anxiety, sadness, overwork, or fear. Sometimes such illness stems from the malignity of corrupt humors [see below, discussion of Dürer, p. 317] that predominate in the human body. As regards those passions of the soul, I know for certain that this converse brother was much afflicted by them. For he was deeply troubled by the thought of *how he could ever finish the works of art he wanted to paint*, and it was said at that time that nine years would hardly suffice for it. Again and again, he was steeped in reading a Flemish book [*Imitatio Christi* of Thomas à Kempis?]. I also fear that his illness was aggravated by the drinking of wine—though this was undoubtedly done for the sake of his guests. It is therefore possible that in this way, in the course of time, the basis was laid for his grave illness.

The second possibility of explaining this disease is that it was sent by Divine Providence which, as it is written in the second Epistle of St. Peter, ch. 3, "is long-suffering to us-ward, not willing that any should perish, but that all should come to repentance." For this converse brother was highly praised in our order because of his special artistic achievements—in fact, he thus became more famous than he would have been outside our walls; and since he was only human—as are all of us—the various honors, visits, and accolades that came to him made him feel very important. Thus, since God did not want him to perish, He in His compassion sent him this humiliating disease which indeed made him very contrite. . . . He lies buried in our cloister, under the open sky.[55]

An anticipation of his growing illness is thus subtly presented in the *Portinari Altarpiece*. Be that as it may, Hugo also proclaims here his respect and trust in the poor and humble of heart. The contradictions that emerge from the *Portinari Altarpiece* do not render it a work of despair or pessimism, although those elements are present, but rather one of love and hope. Hugo seems to be telling us, in a most intricate fashion, that truly the meek shall inherit the earth. It is the humble peasant who sees and hears, finds and understands; it is the prince who is lost and confused. Above and beyond the complex symbolism of the Incarnation and the liturgy of the Mass, it is the human experience that Hugo has captured so astonishingly. This interweaving of mystery, on the one hand, and human emotion, on the other, are traits that characterize much of the religious movement, loosely referred to as mysticism, that swept westward into the Netherlands from the Rhineland in the last quarter of the century.

The *Portinari Altarpiece* has usually been dated 1475–76 on the evidence of the Portinari children portrayed in the side wings. The eldest, Margherita, born on September 15, 1471, appears kneeling with her mother, Maria Baroncelli, and their patron saints, Mary Magdalen and Margaret, on the right shutter. The two sons, Antonio and Pigello, born in 1472 and 1474, are portrayed with their father and Saints Anthony and Thomas on the left. A third son Guido, not present, was born in 1476, and it may have been for that very occasion that the triptych was commissioned. Hugo entered the monastery of the Roode Klooster sometime between 1476 and 1478 for reasons that probably will never be known, but a few theories do make sense.

Panofsky regarded Ofhuys's account as a "masterpiece of clinical accuracy and sanctimonious malice," and there are good reasons to agree with his judgment. For one thing, Ofhuys states that Hugo's madness was a kind of

melancholy brought on by his sense of inadequacy in both his personal and professional life. The specific psychosis has been analyzed as *pusillanimitas*, a malady involving fears of damnation due to inadequacy in devotion, by Rudolf Wittkower.[56] But Hugo's loss of self-esteem and his inner conflicts in competing with an earlier painter, Jan van Eyck, whose masterpiece was constantly before his eyes in Ghent, are also important factors here. A German traveler, Hieronymus Münzer, wrote in his diary of 1495 concerning the Ghent altarpiece that he was told "another painter came to this work, wanted to imitate it and became melancholic and foolish." That artist no doubt was Hugo van der Goes. Whether or not it was the haunting image of the great polyptych in Saint Bavo that drove Hugo to despair, one thing is certain: Hugo was an artist who suffered acutely from his own self-searching, and this suffering made him peculiarly sensitive to the emotions of those about him. These emotions are transferred to the people in his paintings.[57]

Evidence of Hugo's melancholic temperament already appears in one of his earliest paintings, the *Monforte Altarpiece*, usually dated about 1472 (fig. 162). The big panel, cut down at the top, was the centerpiece of a triptych that originally featured the Nativity and Circumcision on the side wings. Boldly arranged across the foreground along zigzag axes are the imposing figures of Joseph, the Madonna, and the three Magi. The mood is somber and one of quiet adoration and not of colorful and joyous pomp, however, with a sullen Madonna tenderly holding her Child before the visitors. The second Magus, who kneels and holds his right hand before his chest, is particularly impressive as a figure of absolute devotion, anticipating the devout shepherds of the *Portinari Altarpiece*.

While the dramatic movement of the big figures across the shallow stage of ruins brings to mind Rogier van der Weyden, the richness and precision of detail of objects and landscapes are surely indebted to Jan van Eyck. Behind the oddly posed Joseph, on the left, an enchanting glimpse of the distant streets of Bethlehem shows the entourage of the Magi leading their horses across a bridge; a curious group of young and old observers appears in the center behind a wooden wall that marks off the foreground; and scattered across the composition are elegant still-life objects, including a splendid spray of Hugo's fa-

162. HUGO VAN DER GOES. *Adoration of the Magi (Monforte Altarpiece)*. c. 1472. Panel, 57⅞ × 95¼". Gemäldegalerie, Staatliche Museen, West Berlin

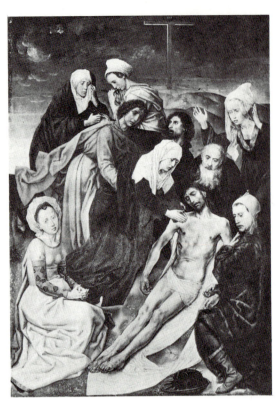

right: 163. HUGO VAN DER GOES. *Fall of Man* (left wing of a diptych). c. 1470. Panel, 13¼ × 9″. Kunsthistorisches Museum, Vienna

far right: 164. HUGO VAN DER GOES. *Lamentation* (right wing of a diptych). c. 1470. Panel, 13¼ × 9″. Kunsthistorisches Museum, Vienna

165. HUGO VAN DER GOES. *Dormition of the Virgin.* c. 1480. Panel, 57¾ × 47⅝″. Groeningemuseum, Bruges

vorite flowers, the iris to the left, the columbine to the right, symbolic of the Passion and of humility, anticipations of the intriguing floral passages of the *Portinari Altarpiece.*

The inspiration of Jan van Eyck and Rogier van der Weyden is clearly manifest in another early work, the Vienna diptych, with the *Fall of Man* on the left and the *Lamentation* on the right (figs. 163, 164). The nude figures of Adam and Eve and the verdant garden of Eden surely owe something to the Ghent altarpiece, while the dramatic poses of the figures in the *Lamentation,* their gestures and the drapery patterns, are indebted to Rogier. But beyond these obvious borrowings one senses a totally individual mind at work here.

Both compositions are marked by a somewhat disturbing ''X'' pattern in the alignment of figures and setting. The landscape of Eden slides abruptly down from left to right with Adam, Eve, and the salamander serpent positioned asymmetrically about the Tree of Knowledge. In the *Lamentation,* the spatial unclarity is even more pronounced with a diagonal row of mourners cascading down the steep hill of Golgotha. The counter diagonals formed by the outstretched hand of Eve and the position of Christ's body give the two panels a precarious balance, and, in general, expressionistic tendencies in Hugo's style are foremost. The curious pairing of the *Fall of Man* and the *Lamentation* is significant. Hugo's message would seem to be that the result of Adam and Eve's sin

166. Hugo van der Goes. *Nativity*. c. 1480. Panel, 38¼ × 96½″. Gemäldegalerie, Staatliche Museen, West Berlin

was the pathetic death of Christ. The bright and colorful paradise of the springtime garden, lost because of man's failings, becomes the barren hillside of Golgotha with stormy skies filled with blackbirds, the domain of death and sterility.

Expressionistic tendencies are most apparent in two of Hugo's last works, the *Dormition of the Virgin* (fig. 165) in Bruges and the *Nativity* in Berlin (fig. 166). The tensions are no longer restrained or held in check. The magnetism that held the actors in the *Portinari Altarpiece* to their positions collapses, and no longer able to control their emotions, they violate their stage presence and stumble and fall about the Virgin. In the *Dormition* even the space becomes ambiguous with the receding diagonals of the bed converging in some arbitrary area of a shallow interior with no windows or doors. The three figures in the foreground fall about as if struck by the blinding vision of Christ in the aureole above the bed, much as they do in early medieval representations of the Transfiguration. Only Peter, dressed as a priest and holding out a taper to mark the death of the Virgin, seems in control of his emotions. The tonalities are somber blues against which the phosphorescent glow of the aureole with Christ and the pallor of Mary's white face form eerie foci. Another curious feature of the *Dormition* is the manner in which many of the apostles are cut off at the margins, contributing to the general claustrophobic impression of the setting.

An affirmation of Hugo's growing awareness of his infirmity appears in the *Nativity* in Berlin, perhaps Hugo's last painting. Along the lower border of the curiously shaped panel, plants of new species appear that are not symbols of Christ and Mary, but medicinal herbs used as cures for certain illnesses, in particular the geranium, which was believed to cure melancholy. The Child holds

an unusual flower, the *Solanum* or Nightshade, symbolic of heartache. These were very likely some of the herbs and flowers that grew in the garden of the Roode Klooster that were known and used by Hugo.[58]

In this unusual painting, the expressionistic tendencies in his art reach the point where they appear nearly manneristic. The treatment of space is ambiguous and contradictory as it seems to slide and shift as one moves across the unusually broad panel. The angels about the crib are densely packed and transmit their own vibrancy to the somewhat spastic movements of the Child lying diagonally in the sharply foreshortened crib. Joseph too is pulled into the compact central area, and Mary is no longer the sorrowful mother of his earlier works, but looks down at her son proudly. The shepherds who hold their ground so tenuously in the *Portinari Altarpiece* now rush into the stable, racing and stumbling before the Holy Family.

No doubt Hugo intended to present a joyous interpretation of the Nativity in this final treatment of the theme, but the movement is too frantic, the excitement too erratic. Two foreground figures, fractional figures as in the *Dormition*, come charging out of the picture directly toward the spectator as if to ask us to witness the miracle of the birth with their dramatic gestures. These are two Old Testament prophets who perform the functions given them in medieval mystery plays, announcing the event enacted by literally unveiling the meaning of their prophesies by drawing back a painted curtain that hangs from a stucco rod on the top edge of the panel.

To characterize Hugo van der Goes as a "mystic" is, of course, questionable since the term "mysticism" is, as we have seen, an extremely vague one. In a general sense, mysticism in art can be described as the more personal and more intimate approach to the representation of spir-

167. Geertgen tot Sint Jans. *Man of Sorrows*. c. 1480–85.
Panel, 9⅝ × 9½″. Centraal Museum, Utrecht

itual beliefs as opposed to the impersonal, didactic statements of dogma and doctrine. Rather than displaying a simple pictorial illustration of the facts of his religion or recording the unraveling of its history, the mystic artist will present a personal experience of it. Rather than depict an event from the life of Christ, Mary, or the saints, the mystic offers the way to reexperience it.

Mystic painters will attempt to convey situations that will seem immediate and real, not abstract and artificial, not illustrations but direct confrontations. To convey this very personalized content, Hugo van der Goes employed a number of new stylistic devices. First of all, to heighten the emotional experience for the spectator he cast his actors not as Gothic types but as individuals who seem very real and human to us. Secondly, Hugo experimented with ways in which to break down the idea of a framed picture that had a complete unity unto itself closed off from the viewer. In order to open the drama out to us, he sometimes introduced fractional figures about the borders of the painting, implying that these figures are entering the painted world from ours or leaving it to join us. Furthermore, the monumentality of his compositions, the bigness of his figures, the large scale of his altarpieces that seem to enclose us, also heighten the sensation of reality and spectator participation. Thirdly, he emphasized certain poignant motifs or subjects such as the Adoration and the Lamentation.

To be sure, the relationship of Hugo van der Goes to

the movement we label mysticism in the North needs to be carefully qualified since we have no evidence of his mystical leanings other than the report of Ofhuys. Perhaps it is enough to point out that the paintings of Hugo van der Goes and those executed by others of mystical persuasion simply share one common and essential goal: to present a very personal and real experience to those who stand before the work of art.

GEERTGEN TOT SINT JANS

If in Hugo van der Goes we discover an artist who captures in very personal terms the tragedies in the life of Christ, in the Dutch painter Geertgen tot Sint Jans we find someone who, with a distant but sonorous echo of Hugo's style, presents not despair but sweet sadness. Geertgen's people respond individually as do Hugo's, and, in fact, he borrowed a number of them directly from Hugo, but they do not react so dramatically. In that respect, Geertgen's people are some of the most appealing, most likable in Netherlandish art. His Madonna, youthful and innocent, is the most lovable Mary in Northern art, and it is in the art of Geertgen tot Sint Jans that the effects of mysticism can be most clearly discerned.[59]

As a servant painter (*famulus et pictor*) for the wealthy Commandery of Saint John in Haarlem, Geertgen was exempt from most of the guild regulations in the city. Just where he was trained is uncertain—Van Mander reports that he was a disciple of Ouwater, which is unlikely—but there can be no doubt that the art of Hugo van der Goes made a deep impression on Geertgen. It has been suggested that he actually worked in Flanders for a brief period. There is a "Gheerkin de Hollandere" listed in 1475 in the records of the Bruges illuminators' guild, and since Geertgen's smaller panels are painted in a technique much like that employed in book illustration, it is tempting to identify him with the "Gerry" in the document.[60] However, if one can trust Van Mander's statement that he died very young, "about twenty-eight," it seems very unlikely that he was in the south at such an early date.

It is no surprise that the two themes of Hugo that most influenced Geertgen were those of the Adoration and the Lamentation. At least four variations of Hugo's *Monforte Altarpiece* by Geertgen's hand are known, and in each the figure that is reproduced most faithfully is the imposing second king, who kneels and holds his hand across his chest. In the one authenticated painting by Geertgen, the *Lamentation* in Vienna (once part of a huge triptych for the Chapel of the Knights of Saint John in Haarlem), Geertgen ingeniously combined Hugo's concept of the Lamentation and the *Monforte Altarpiece*

whereby the kneeling Magus appears in the guise of Joseph of Arimathea (colorplate 29). His Lamentation thus becomes an Adoration with Mary holding in her lap the son who is revered.

Other Flemish influences can be discerned here, especially that of Rogier van der Weyden's grieving Magdalen, but what is truly Geertgen's own contribution to the interpretation of the theme is found in the intricate fashion in which the mourners are placed about the body of Christ. Directly opposite the Madonna is the Magdalen, at the head of Christ sits Mary Cleophae, while at his feet stands Mary Salome. Four figures in mourning are thus spotted about the body of Christ at right angles much like the mourners depicted about the body of Christ in the medallions placed on the extremities of the familiar metal devotional crucifixes. Thus a common devotional object worn by many, the crucifix, is the basis for the composition. For Geertgen, it was common to refashion and re-create painted devotional images from other devotional images as if the religious content of his paintings were to have meanings on various levels. Even in the tightly knit group of mourners in the *Lamentation*, the portrayal of Mary and Christ resembles closely the familiar *Vesperbild*, so common in German and Bohemian art.

In Geertgen's paintings there appear similar stylistic traits, arrived at independently, that characterize the mystical features of Rhenish art: the use of *Andachtsbilder* motifs, the denial of the picture frame, and the use of pure color to suggest an otherworldly environment or being. In the *Man of Sorrows*, today in Utrecht (fig. 167), Geertgen portrays Christ as the eternally dying Savior (the perpetual Passion) as a unique pictorial metaphor on the recurring sacrifice in every Mass through the transubstantiation of the host and wine into the body and blood of Christ. For the central image Geertgen turned to the *Andachtsbild* known as the *Schmerzensmann*, or Man of Sorrows, familiar in German sculpture. The bleeding Christ displays himself directly to the spectator, reminding him of the sufferings he underwent for man's salvation. Carrying the cross with the crown of thorns pressed into his forehead, he indicates the wound in his side made by the lance at the Crucifixion.

A macabre presentation, Christ eternally dying, it is most effective as a compositional motif. In fact, this very type of *Andachtsbild* had been taken over by artists before Geertgen for representing the theme of the Mass of Saint Gregory (see pp. 289–90). According to the legend, the miraculous vision of Christ as the sacrificial victim appeared on the altar before Saint Gregory during the Mass. Christ stands on the altar, blood streaming from his wounds to fill the chalice to signify that the wine in the Eucharist was truly the blood of Christ. The appro-

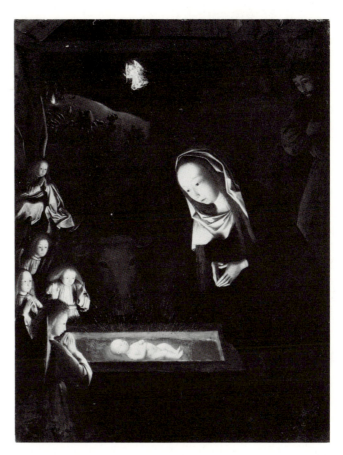

168. GEERTGEN TOT SINT JANS. *Night Nativity*. c. 1480–85. Panel, 13⅜ × 9⅞". National Gallery, London

priateness of the Man of Sorrows for this miracle is so obvious that one wonders if the image of the *Schmerzensmann* had its origins in this particular legend.

In many instances it is clear that *Andachtsbilder* such as this were simply poignant figures extracted from a narrative and monumentalized to form a type of Gothic "icon." Geertgen created a fresh and significant variation on the theme of the Mass of Saint Gregory. His Man of Sorrows is turned out toward the individual worshiper, not Gregory, and regards him directly. Standing in a stone sarcophagus and placed against a gold background that seals off any references to time or place, the broken body of Christ is pushed outward in painful proximity to the spectator. Geertgen seems to tell the pious who knelt before the altar that the vision of Saint Gregory was, in effect, a continually recurring miracle at every Mass.

The second stylistic device, the breakdown of the picture frame, is as surprising a feature in Geertgen's painting as is the archaic gold background against which the Man of Sorrows is placed. In order to make the mystery of the transubstantiation even more immediate, Geertgen employed fractional figures for the Magdalen, John the

Evangelist, and the Virgin herself. They are so abruptly cut off at the edges of the panel that some scholars have argued that it must have been drastically cut down, although there is no physical evidence of this. On the other hand, such truncated figures have their presence in our world. It is as if the spectator, along with Mary, John, and the Magdalen, actually experienced this vision of Christ's perpetual passion and with them he too weeps, prays, and remembers.

Fortunately, Geertgen's mysticism, like that of the Rhenish artists, swings between two poles. In one of his most tender and poetic works, the *Night Nativity* in London (based in part on a lost work by Hugo van der Goes), the artist employs fractional figures again in the wondrous appearance of the Child on Christmas night (fig. 168). The delicate angels placed in the lower left serve a role similar to that of the figures placed before the sarcophagus in the *Man of Sorrows*. They bring the viewer into the picture, allowing him to look over their shoulders at the bright and mysterious light that radiates from the newborn. By concentrating the source of light for the stable in the form of the Child, Geertgen was able to focus all of our attention on this one spot. The young mother is completely absorbed in the miracle of her newborn as his radiance beams outward, spotlighting the hands and faces of those about him. The mystical glow, as Saint Bridget wrote, outshines all of the natural lights of the world, including the candle that Joseph held nearby.

It is no wonder that the treatment of light in Geertgen's *Night Nativity* has been the subject of much attention. Whether it should be identified as non-solar or spiritual light is, however, not so important. No one term can explain the mystery that such illumination conveys since the function of the mystical radiance is to transform the figures in the composition into images of pure devotion. The bodies of the angels and Mary are completely lost in the darkness, but their expressive hands and astonished faces emerge as if a part of the spiritual essence emanating from the Child. The astonishing characterization of Mary as the pure and truly immaculate mother is further achieved by allowing the bright light to reduce her countenance to an unadorned geometric shape as if, as Friedländer put it, her head had been turned on a lathe. The connotations of such extreme abstraction only add to the purity of Mary as a form.

In another small masterpiece by Geertgen, the *Madonna of the Rosary* in Rotterdam (colorplate 30), a different type of illumination was created to suggest the purity of celestial forms.[61] This tiny panel was very likely painted for a member of the newly founded (1478) Confraternity of the Rosary in Haarlem, the first to be established in the Netherlands. Rosary devotion was a direct

development of the mystical practices of the Rhineland, especially in Cologne, where the first confraternity was founded in 1475. The Rosary Madonna is based on another *Andachtsbild*, the Madonna in the Sun, a type which was derived from the description of the Apocalyptic Woman clothed in the sun with the moon beneath her (Revelation 12) that was later taken over as an image of the Madonna of the Immaculate Conception.

The radiant burst of golden light about the Madonna funnels outward, changing its hues in a spectrum of rainbow colors, and within this swirling eddy tiny forms of translucent angels, the luminaries of the heavens, are barely perceptible. In the first circle, that of the golden light of the sun, appear six-winged seraphim who carry the crown of roses placed on Mary's head. In the scarlet aureole are vested angels carrying the instruments of the Passion, Rosary beads, and banners inscribed "Sanctus, Sanctus, Sanctus." Finally, in the dark world on the perimeter are numerous angels singing and playing musical instruments.

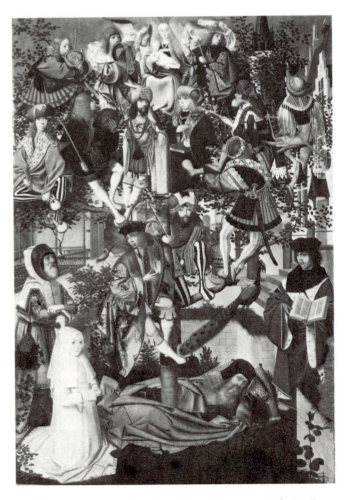

169. Geertgen tot Sint Jans. *Tree of Jesse*. c. 1490. Panel, 35 × 23¼". Rijksmuseum, Amsterdam

These three spheres correspond to the three aspects of Rosary devotion: the joys, sorrows, and glories of the Madonna, and at the same time evoke a world of the harmony of the spheres in both music and color. The Christ Child, who rings handbells, initiates the heavenly harmony. It is significant that Geertgen placed angels carrying the banners with the Sanctus above the two displaying Rosary beads and six bearing the instruments of the Passion in the aureole of red. This refers to a precise moment in the Mass, after the Rosary prayers, when bells are rung to end the preface and the elevation of the host takes place in the service. The monstrance that contains the host for all to see is thus Mary and her Child. In terms of mystical ritual, Geertgen's painting is a little gem reflecting the changing character of Late Gothic devotion.

Rosary beads are prominently displayed in another work by Geertgen, the *Tree of Jesse* (fig. 169). Within an enclosed garden of a tidy Dutch convent, a charming *kloosterling* (sister), pale and innocent, kneels in prayer and her contemplation of the virtues of Mary is suddenly manifest in the form of a living tree of Jesse, who lies asleep in the lower edge of the garden. The twelve kings of Judah assume precarious positions in the limbs of the tree. To the sides of the tree two prophets look on. One, to the right, must be Isaiah, who holds open the text of his prophesy: "And there shall come forth a rod [*virga*] out of the root [*radice*] of Jesse, and a flower [*flos*] shall rise up out of his root. And the spirit of the Lord shall rest upon him" (11: 1–2).

The Tree of Jesse became a popular theme in the arts of the thirteenth century, particularly in the margins of manuscripts and in stained-glass windows. But Geertgen paints a real tree with figures, in unusually exotic dress, clambering about its branches. In the crown of the tree sits Mary, the true flower of Jesse, holding her Child. Aside from being especially colorful in a decorative sense, the Tree of Jesse also pointed out the royal lineage of Christ, that he had descended from the kings of Judah.

The floral symbolism is underscored by several references to Rosary devotion. An elegant king holding a falcon wears a string of beads about his neck; another, further down wears a crown and bandelier of white and red roses; and the nun in white carries Rosary beads on her right wrist. Other Marian symbols are cleverly disguised in the setting. The *hortus conclusus* is the wall of the cloister garden, the *porta coeli* opens into the garden from the top left, the regal porch with carved capitals to the right may allude to the *templum Solomonos*, and the distant church tower brings to mind the *turris Davidica*. Finally, the peacock perched on the wall of the garden symbolizes the role of Mary as the Queen of Heaven.

Geertgen was much more at home with another depic-

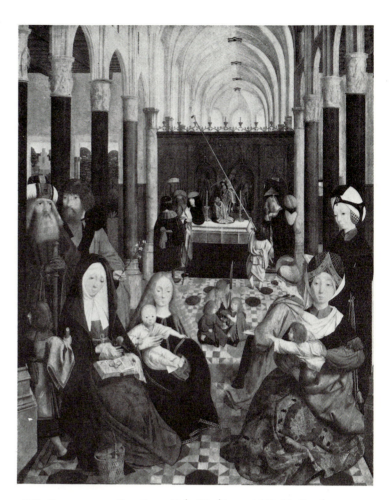

170. GEERTGEN TOT SINT JANS. *Holy Kinship*. c. 1480–85. Panel, 54⅛ × 41⅜″. Rijksmuseum, Amsterdam

tion of the genealogy of Christ, the *Holy Kinship*, which hangs beside the *Tree of Jesse* in the Rijksmuseum (fig. 170). This theme as depicted earlier in Rhenish art was a rather prosaic group portrait, but Geertgen transforms it into a fascinating allegory of the foundation of the church wherein the family ties of Saint John (the patron of his order) are emphasized. According to a spurious legend, the *trinubium Annae*, Mary's mother, Anna, had three husbands: Joachim, Cleophas, and Salomas, by whom she bore three daughters, all named Mary (see above, p. 82).

The usual representations of the "Holy Kinship" portrayed the family circle of seventeen members, which included Christ's cousins James the Less, Simon, Judas Thaddeus, Joseph the Just, John the Evangelist, and James the Great. However, an eleventh-century addition to the genealogy, originating in the area of Limburg, grafted a cadet branch to the family tree which included John the Baptist, son of Elizabeth, who is named a "cousin" of the Virgin in the Gospels. In the right fore-

180

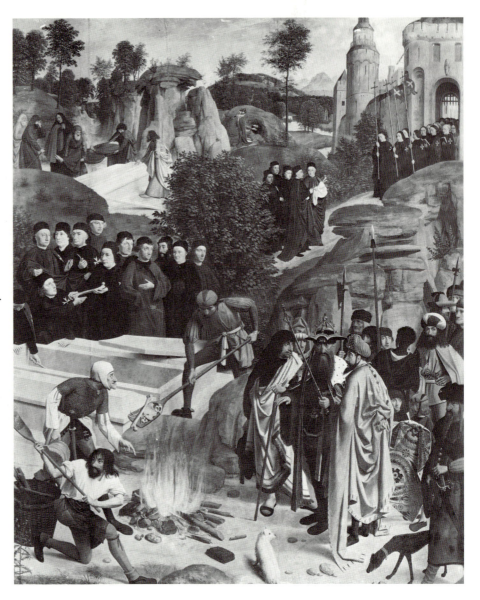

171. GEERTGEN TOT SINT JANS. *Burning of the Bones of Saint John the Baptist* (exterior of the right wing of a triptych). After 1484. Panel, 67¾ × 54¾". Kunsthistorisches Museum, Vienna

ground sits Elizabeth with her son, John the Baptist, who points across to Christ on Mary's lap: "Behold the Lamb of God, behold him who taketh away the sins of the world."

Beside Mary sits Anna and behind her stand Joachim and Joseph. The boy, James the Less, with the fuller's club, stands beside his grandmother, and on the right side of the nave, behind Elizabeth, are the other daughters, Mary Cleophae and Mary Salome. In the center of the nave are four other cousins, John the Evangelist holding a chalice into which James the Great pours wine from a canteen. Behind them stand Simon with the saw and Judas Thaddeus, who is busy lighting the third candle (the Trinity) atop the rood screen. The husbands of the other Marys along with Zacharias, Elizabeth's husband, stand in the rear before an altar that has a sculpture of the Sacrifice of Isaac and a rood screen with carvings of the Fall and Expulsion of Adam and Eve, all prominent types for Christ's sacrifice.

The nave of the church, which resembles some old-fashioned Romanesque basilica, is suddenly transformed at the rood screen into a radiant Gothic nave flooded with light. The Romanesque nave with the adult members of the Holy Kinship thus represents the Old Testament; their children, Christ and the apostles, and the bright Gothic choir beyond announce the coming of the New. The children in the middle ground, who play with their attributes as if they were toys, will make this transference from the Old to the New much as the young James the Less in the lower left looks eagerly outward to commence his pilgrimage. Here then is the very purpose for which Anna bore her family. What more appropriate and meaningful statement could be displayed by the Knights of Saint John in their chapel dedicated to Mary, Elizabeth, and Saint John?

Now we should return to the high altarpiece of Saint John's convent in Haarlem. The *Lamentation*, discussed above, was the inner right wing of a huge triptych; its

reverse, which is preserved in Vienna, depicted the legend of the burning of the bones of John the Baptist and their recovery by the original Knights of Malta (fig. 171). The monumental work was very likely commissioned for the special visit of the grand prior of the Order of the Knights of Saint John to Haarlem in 1484. A document records the visit and includes the names of the five officers of the Haarlem commandery. They are the five figures standing beside the open sarcophagus wearing the Maltese cross on their habits. They appear a second time on the path that leads to the church in the right background carrying the relics, a thighbone and a finger, that were presented to the Order in Rhodes in 1482–83.

Six other figures appear to the right of those in Maltese uniform, and they very likely are the lay members of the Haarlem commandery. The one to the extreme right, gazing dreamily into space, is our artist, Geertgen tot Sint Jans. In this most unusual group portrait, Geertgen surpassed the efforts of Dieric Bouts discussed earlier. Here the solemnity of their poses and costumes contrasts with the flamboyant exoticism of Julian the Apostate and his entourage in the lower right.

A soul-searching comment on Geertgen's personality can be detected in his painting of *Saint John the Baptist in the Wilderness* (fig. 172), a work that can be likened to what Panofsky would have called a "spiritual self-portrait."[62] Pledged to some awesome destiny, the worried and perplexed Baptist has fled the city to take refuge to think and ponder amid the softly rolling meadows and green forest of a cozy woodland clearing. Here the natural growth of an abundant world blossoms, sings, and freshens the air about him. John sits quietly on a bank of rocks beside a sparkling brook. He is withdrawn, huddled and encased in the heavy protective folds of his coarse woolen mantle. His thoughts, like his physical body, press in on him, and in the peace and quietude of the comforting landscape he finds solace to reflect on issues beyond the measure of man. The Nordic lyrical surrender to the natural woods, to the assurance of a setting of peace of mind, creates a new species of pictorial thinking.

At this point it may be well to quote Panofsky's eloquent words in his comparison of this little masterpiece with another famous "spiritual self-portrait" (to be discussed below, p. 318), the *Melencolia* of Albrecht Dürer:

Although the posture of the thinker in repose, his elbow on his knee and his chin in his hand, is almost as 'old as Western art itself, no two other examples of this widespread type so closely resemble one another. Geertgen's and Dürer's figures agree, not only in general form and outline but also in that they convey the

172. GEERTGEN TOT SINT JANS. *Saint John the Baptist in the Wilderness.* c. 1490. Panel, 16½ × 11″. Gemäldegalerie, Staatliche Museen, West Berlin

feeling of an almost physical depression which makes the body sag, allows the knees to draw apart and causes the free hand to lie on the lap like a lifeless thing. The quality of this depression is, needless to say, entirely different. Dürer's Melencolia, an embodiment of frustrated human effort, acutely suffers from her intellectual insufficiency; Geertgen's St. John, a visionary chosen by God, is dreamily immersed in sweetly-sad contemplation.[63]

On another level, Dürer's spiritual self-portrait also testifies to his frustrations and agonies as the new man of the Renaissance (*uomo universale*) in the North who pits his own genius against the powers of a supreme Creator, while Geertgen admits his nostalgia as being one of medieval piety weighed down by some Late Gothic dream.

The Late Gothic Dream

HANS MEMLINC

Present-day Bruges slumbers in the charm of the late fifteenth century and one hopes it will remain so always. This is the Bruges of Hans Memlinc and Gerard David, and it is as Gothic and Flemish as could satisfy anyone with romantic inclinations and love for Netherlandish art. The notary of the Church of Saint Donatian in Bruges in Memlinc's time, Rombout de Doppere, left the following tribute in his diary following the artist's death in 1494: "Johannes Memlinc was the most accomplished and excellent painter in the entire Christian world."[64] Nineteenth-century critics agreed. William H. J. Weale wrote that Jan van Eyck saw with his eyes, "Memlinc with his soul."[65] But in the past few decades this evaluation has been reversed. Friedländer first disturbed the waters by stating that his popularity derived "from a period that was sadly lacking in knowledge and understanding of early Netherlandish art," and even more damning was Panofsky's characterization of Memlinc as a "major minor master" and wrote that "while the Romantics and the Victorians considered his sweetness the very summit of medieval art, we feel inclined to compare him to a composer such as Felix Mendelssohn: he occasionally enchants, never offends and never overwhelms." One of the most recent books on Early Netherlandish painting, by Leo Puyvelde, has a chapter entitled the "Insipid Hans Memlinc."

Why this variety of opinion on the art of Memlinc? Perhaps it is that our age is caught in the *Sturm und Drang* of the modern world and Memlinc's art is too peaceful, but the fact remains that his paintings epitomize Flemish expression. His sweet-sad Madonnas still dwell in secluded Gothic loggias. His quiet people move in idyllic Flemish landscapes where swans sail gracefully on small ponds framed by trees all pruned to the same size. His martyrs, like those of Bouts, do not really suffer agony, and his narratives unravel slowly and are never punctuated with exclamation marks. The problem of evaluating Memlinc's art is much the same as the one

that once enshrouded that of Raphael, an artist to whom he has often been compared, but the truth is that Hans Memlinc offers us the last glimpse and vision of an ideal Christian world, a Late Gothic dream if you like.

Memlinc paints with a consummate skill and, in many respects, his works sum up the expression of his period with the clarity of a reflection in a spotless mirror. His art is at once the summation of that of his Netherlandish predecessors as well as the pictorial document of a society that was rapidly becoming passé, a world that was no longer linked intimately with the chapel and cloister, a culture no longer nurtured on the elegance and taste of rich Burgundian courts. Memlinc's pictures are the first reflections of the period of *détente* and *denouement* at the end of a remarkable golden age.

That Memlinc was no innovator but an eclectic is not entirely a just evaluation. It is true that he copied compositions of Rogier van der Weyden and Hugo van der Goes and he frequently quoted motifs from Van Eyck, but his works are creative copies and often introduce new aspects of style, especially in narration, that influenced generations of later Netherlandish painters. In one of his most popular works, the *Madonna and Child with Martin van Nieuwenhove* in Bruges (figs. 173, 174), the marks of his predecessors can be peeled off one by one.

In the left panel of the diptych with Mary, Van Eyck's brocades and round mirror appear. The idea of such a devotional diptych derives from Rogier, and the setting, a domestic interior with a view of a landscape out of a window, is indebted to the Northerners. Finally, one can even perceive shades of the sweet-sad mysticism of Hugo and Geertgen, but the unusual aspect of Memlinc's expression is that it neither has the personal anguish of Hugo nor the innocent wonder of Geertgen. Memlinc's lovely Madonnas are self-conscious and shy as if they knew they were posing before us.

It has been suggested that Memlinc's mysticism was derived not from Hugo or any other Netherlandish source but from Stephen Lochner of Cologne (see p. 220). Memlinc was a German by birth (Seligenstadt

173. HANS MEMLINC. *Madonna and Child* (left wing of a diptych). 1487. Panel, 17⅜ × 13″. Hospital of Saint John, Bruges

174. HANS MEMLINC. *Martin van Nieuwenhove* (right wing of a diptych). 1487. Panel, 17⅜ × 13″. Hospital of Saint John, Bruges

bei Main) and he undoubtedly spent some time in Cologne, but there are few traits in his style that can be linked directly to that city or any other centers east of the Rhine. His style is a harmonious melding of a number of Netherlandish modes, and the one artist from whom he learned most was Rogier van der Weyden. There is good evidence, in fact, to put the young Memlinc in Rogier's studio in Brussels during the sixties. The great *Columba Adoration* (colorplate 22), one of Rogier's last major productions, provided Memlinc with models for at least two of his own commissions, and one can detect the hand of Memlinc in the portrait of the donor to the far left of the *Columba Adoration*.

After Rogier's death in 1464, Memlinc moved to Bruges and obtained citizenship to establish a workshop. The fact that Memlinc is rarely mentioned in archives of the painters' guild may indicate that he received some special appointment to Charles the Bold. This is unknown, but a number of his paintings were commissioned by wealthy burghers, including Italians and Englishmen and members of the religious order of the Hospital of Saint John in Bruges, where a number of his finest works can still be seen.[66]

One of the most impressive paintings by Memlinc in the Hospital of Saint John is the *Altarpiece of the Virgin with Saints and Angels* (colorplate 31), signed and dated

1479. The donors, two brothers and two sisters of the order, are portrayed on the reverse of the side wings of the triptych. The central panel is an expansion of a theme frequently painted by Memlinc, the Madonna and Child enthroned and flanked by two angels, one holding a book for Mary to read, the other playing a portative (a small portable organ). To this central group Memlinc added two female saints, Catherine and Barbara, seated in the foreground of the lofty loggia, and standing behind them are the patron saints John the Baptist and John the Evangelist.

Aside from the Rogierian figure types and the Van Eyck brocades, a number of stylistic traits mark this as typical of Memlinc's art. One is immediately impressed by the serenity and calmness that pervade the compositon. Soaring Gothic verticals are there, but rather than inciting a dramatic movement they lend the composition a stable grid before which the lithesome figures, arranged in obvious symmetry, are placed, never too close to one another and hardly cognizant of each other's presence. Hushed, immobile figures, they register no emotions; in fact, they barely move.

The same restraint characterizes the narratives on the side wings, where action and anguish are certainly expected: the beheading of John the Baptist and the exploding visions of the Apocalypse seen by the Evangelist on

175. HANS MEMLINC. *The Joys of Mary*. c. 1480. Panel, 31⅞ × 74⅜″. Alte Pinakothek, Munich

Patmos. Based on Rogier's treatment of the theme, the decapitation of the Baptist is, however, not convincing dramatically. With the exception of the executioner, who turns his back to us, the figures of the onlookers and Salome stand like posts across the foreground. Behind them appears a spacious courtyard in which a few people stroll, and in the adjoining palace, whose banquet hall is conveniently open for us, Salome performs before Herod the most sedate dance ever depicted in this legend of lust. Other narrative details, tiny in scale, are sprinkled in the far distance and spill over into the distant vistas seen through the loggia of the central panel.

One of the hallmarks of Memlinc's settings is the idyllic quality of his late summer landscapes. As if designed by an English gardener, everything is carefully placed and trimmed to form a comforting and charming park, and the same stretch of landscape continues across the altarpiece into the right panel, where John the Evangelist witnesses the destruction of the world! What is remarkable, however, is the painstaking patience that Memlinc displays in recording every possible moment in the background narratives. Seated comfortably in the foreground, John seems to stare unconcerned right past the apocalyptic vision filled with the *Maiestas Domini* and the lamb enthroned within the circle of twenty-four elders, below which appear the four horsemen who ravage the earth, the seven plagues, the woman of the Apocalypse pursued by the dragon, the victory of Michael over the demonic forces, and several other details stretching to the distant horizon.

This unusual interest in spelling out stories as fully as possible was one of the many new traits characteristic of Netherlandish painting at the end of the fifteenth century, and Memlinc is one of the assiduous innovators in this genre. True, his narratives hardly ever excite or con-

vince us, but they provided models for a number of painters throughout the Netherlands. It is therefore not surprising that Memlinc borrowed from and contributed to the last flowering of book illustration in Bruges. When one of the leading miniaturists, Willem Vrelant, decided to commission an altarpiece for the chapel of his guild, dedicated to Saint John the Evangelist and Saint Luke, he gave the project to Memlinc. This altarpiece, long thought to be the *Passion Altarpiece* in Turin, is lost, but the panoramic Turin panel and one very much like it depicting the so-called *Seven Joys of Mary*, today in Munich (fig. 175), very likely give us a good idea of the type of altarpiece the book illuminators wanted since they both are, in effect, intriguing ensembles of miniatures carefully unwound in scroll fashion about the city walls and hillocks of a panoramic landscape.

The title *Seven Joys of Mary* is not exactly right, but the implications of that subject matter are appropriate for its function as an altarpiece. With the rapid spread of new devotional practice, such as that instituted by the Confraternity of the Rosary, new types of altarpieces were needed. What more appropriate aid could the worshiper find for meditating on the episodes in the lives of Christ and Mary than to repeat his prayers before an unwinding panorama that presented the very subjects of his meditation? Memlinc's narrative unfolds chronologically from the top left, down and around the center of the broad panel, culminating in the top right.

The event most emphasized is that of the visit of the three Magi. The legend of the kings commences in the far distance on the horizon to the left, where they appear kneeling atop mountains to witness the miraculous star that will lead them to the birthplace of Christ. Below they appear again leading their entourage on horseback toward Jerusalem, the elaborate domed city in the top

center of the painting. After converging near a bridge, they visit Herod, and, in the lower center of the composition, they arrive before the stable in Bethlehem and offer their gifts to the Holy Family in the traditional manner of Adoration of the Magi paintings. To the right, they appear again riding off toward the distant harbor where, finally, they are seen sailing off to their homelands.

To the sides of this central area appear numerous other events. The Annunciation, Flight into Egypt, and Massacre of the Innocents are neatly tucked into the landscape on the far left, while the Nativity with the donor, Pieter Bultync, and his son kneeling beside the stable is placed in the lower left corner. Complementing these scenes from the Infancy are others on the right illustrating episodes that followed the Passion of Christ including Christ's resurrection, the *Noli me tangere*, the trip to Emmaus, the last appearance of Christ to his mother, and the Ascension. The final scenes to the far right are ones in which Mary figures very prominently. Just above the portrait of the donoress is the chamber of the Pentecost with Mary amid the apostles, and in the upper right corner the Dormition of the Virgin and her Assumption into heaven conclude the cavalcade of events strewn across the panel.

The emphasis given to the story of the three Magi and the fact that no events from the ministry or Passion of Christ are depicted here clearly indicate that there was some special Marian devotion dictating the iconographic makeup of the Bultync altarpiece. It was presented to the guild of the tanners in Bruges and placed in their chapel in the Church of Our Lady. Perhaps the guild had acquired some relic of the three Magi or had close ties with Cologne, where the major shrine to the three kings was located (see p. 79).

The acquisition of unusual relics by the Hospital of Saint John in Bruges led to a commission for Memlinc that involved an even more ambitious display of narratives. In October of 1489 Giles de Bardemaker, bishop of Sarepta, deposited relics of Saint Ursula and her eleven thousand virgin companions in an elaborate reliquary shrine made by Memlinc for two nuns of the hospital (figs. 176, 177). The reliquary is in the form of a miniature church and in the areas where stained glass would appear illustrations of the story of Ursula are painted, three narratives on the sides, two images of Mary and Ursula on the ends. The sequence follows quite closely the account in Voragine's *Legenda Aurea*, although other texts were very likely involved.

This story is a typical Gothic romance, sad and tragic in the end. Ursula, of awesome beauty, daughter of the king of Brittany, was sought in marriage by the son of a pagan king of England. She resolved the issue by insist-

176. Hans Memlinc. *Shrine of Saint Ursula*. 1489. Gilded and painted wood, 34 × 36 × 13″. Hospital of Saint John, Bruges

177. Hans Memlinc. *Martyrdom of Saint Ursula*, from the *Shrine of Saint Ursula* (see fig. 176)

right:
178. HANS MEMLINC.
Tommaso Portinari (left
wing of a diptych).
c. 1480. Panel,
17⅜ × 13¼″. The
Metropolitan Museum
of Art, New York.
Bequest of Benjamin
Altman, 1913

far right:
179. HANS MEMLINC.
Maria Baroncelli (right
wing of a diptych).
c. 1480. Panel,
17⅜ × 13⅜″. The
Metropolitan Museum
of Art, New York.
Bequest of Benjamin
Altman, 1913

ing that the pagan prince accompany her on a trip to Rome, where he would be baptized by the pope and thus converted to the faith, in the company of eleven thousand virgin friends of Ursula. He consented, and the story begins with the "wondrous sight," as Voragine put it, of Ursula and the maidens (reduced to eleven for obvious artistic reasons) landing in Cologne on their trip down the Rhine. It is there that Ursula had a dream warning her of a sinister fate at the hands of the barbarous Huns. Next the ladies are depicted in Basel, and the right side of the casket concludes with Ursula, her maidens, and her husband-to-be greeted by Pope Cyriacus at the Vatican in Rome. The left side depicts the tragic story of the maidens' return north, culminating in the execution of Ursula in Cologne (and all the virgins as well) when she rejects the marriage offer of Julian, prince of the Huns.

In three of the six side panels the action takes place in Cologne with an astonishingly accurate depiction of the cathedral (under construction), Saint Martin, Saint Maria Lyskirch, the Bayenthurm, and the Romanesque church of the Holy Apostles. The other sites involved in the story, Basel and Rome, are clearly imaginary cityscapes. With the exception of their reception by the pope in Rome, the little maidens do little more than climb in and out of boats, and although the paintings are colorful and charming, the story of Ursula and her companions seems more like a Sunday school play than a tragedy. Even the dramatic end of Ursula, with her downcast eyes and the faint whisper of "never, never" on her lips, is a mild martyrdom at best.

Memlinc's acquaintance with Cologne was certainly an intimate one judging from the accuracy of the cityscape he painted. That he had been to Italy and experienced Italian art and landscape, as has sometimes been claimed, seems much less certain. There is no question, however, that Italian works were known to Memlinc and that he borrowed from them too, but the spirit of the Italian Renaissance was not assimilated. In a number of panels depicting his favorite theme, the Madonna and Child enthroned with angels, such as the beautiful panel in the National Gallery in Washington (colorplate 32), the old Rogierian arch motif appears but it has been curiously Italianized. In place of the intricate Gothic archivolts with narratives that Rogier painted, a heavier and more classical arch appears with Italian *putti* often holding garlands so familiar in Renaissance art. The Child, too, often appears in a sprawling pose on his mother's lap that derives from spandrel figures in Roman sculpture, but aside from these few borrowings, Memlinc's awareness and understanding of Italian art merely announce the waking impact that the Italians were to have on Northern art.

When Memlinc died in 1494 he was one of the wealthiest citizens in Bruges. Much of his success stemmed from his exquisite portraits. In these too Memlinc fashioned an idealized veneer on the traditions of the past. One need only compare his portraits of Tommaso Portinari and his wife, Maria Baroncelli (figs. 178, 179), with the nearly contemporary images of them in the side panels of the *Portinari Altarpiece* by Hugo van der Goes (see p. 172) to understand how endearing his style was to the patrons of Flanders at the end of the century.

GERARD DAVID

The influence of Italian Renaissance art is more evident in the works of Memlinc's successor in Bruges, Gerard

David. Like Petrus Christus, David was a lost personality in art history for nearly three centuries. He is only briefly mentioned in Van Mander's *Het Schilder-boeck*, and the one clearly documented work by him, the *Virgo inter Virgines* (Virgin among Virgin Saints) in Rouen, to be discussed below, was for a long time attributed to Memlinc. Thanks to the researches of W. H. J. Weale, we now know that one "Gheerardt Jans filius David" was admitted to the guild of the painters in Bruges as a master on January 14, 1484, and that he remained active there for nearly forty years until his death in 1523. Copies of the epitaph on his tomb further inform us that he was born in Oudewater, a town in Holland near Gouda.[67]

David received his apprenticeship in or near Haarlem, where he soon assimilated the style of Geertgen tot Sint Jans, although some believe that he was older than Geertgen and had his initial training with miniaturists of the Utrecht school. One of the earliest works attributed to David is the *Crucifixion* in the Thyssen-Bornemisza Collection in Castagnola which was formerly attributed to Geertgen (fig. 180). The Thyssen panel is very unusual in style and iconography. The mourners to the left of the cross, forming a descending group culminating with the swooning Virgin, are based on a composition by Dieric Bouts, while the tormentors to the right are borrowed from a lost composition by Robert Campin preserved in a miniature by the Master of the Hours of Catherine of Cleves, a prolific book illuminator active in Utrecht around 1430 to 1460 (see p. 141).

The background landscape with the impressive view of Jerusalem, on the other hand, is indebted more specifically to the school of Jan van Eyck. The complexity of these lines of influences reaching the young painter is too overwhelming to disentangle, but the artist is surely the young David. On the extreme right edge behind the tormentors stands the artist, engaging the spectator directly as he often appears in his paintings. The eye-catching detail of the dogs sniffing the skull of Adam is another motif that David employed in other works. This unusual eclecticism in the Thyssen *Crucifixion* is good evidence that it is perhaps his earliest surviving work and a good forecast of his artistic personality.

In the slightly later *Crucifixion* (fig. 181) in the Oskar Reinhart Collection, based in part on a composition by Rogier van der Weyden, the quietism and the delicate rendering of the faces are features that are surely linked

180. GERARD DAVID. *Crucifixion*. c. 1480. Panel, 34⅝ × 22″. Thyssen-Bornemisza Collection, Lugano-Castagnola

181. GERARD DAVID. *Crucifixion*. c. 1480–85. Panel, 19⅝ × 13⅜″. Collection Oskar Reinhart "Am Romerholz," Winterthur

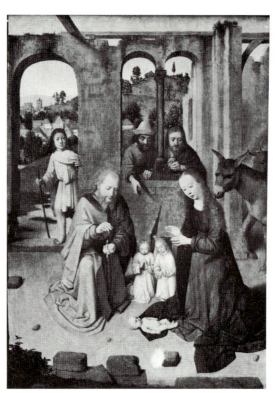

182. GERARD DAVID. *Nativity*. c. 1480–85. Panel, 18¾ × 13½″ (center); 18¾ × 6¼″ (each wing). The Metropolitan Museum of Art, New York. Bequest of Michael Friedsam, 1931. The Friedsam Collection

to Geertgen tot Sint Jans. In fact, one would be tempted to attribute the panel to Geertgen were it not for the doll-like angels and the more Eyckian landscape background, which are traits of David's juvenilia.

How much the young David assimilated the style of Geertgen is clearly revealed in three early *Nativity* altarpieces. The earliest of these is the triptych in the Friedsam Collection in New York (fig. 182). The small altarpiece is not in good condition (there is some question as to whether or not the three panels originally belonged together), but the figure types and composition indicate David's authorship. Doll-like figures are placed in the tightly confined space of a stable that is set in an Eyckian landscape. Cramped between the young Mary and the elderly Joseph are two tiny angels, hallmarks of David's early style. A defiant donkey paws the ground behind the Virgin, the ox barely visible behind it, and two shepherds look in through a window formed by two arches on the back wall of the ruins. A third, much younger shepherd stands in the doorway to the left, another distinctive member of David's early Nativities. A hushed and solemn atmosphere pervades the tidy composition with the diminutive actors, almost like porcelain figurines, carefully placed in the *mise-en-scène*. The soft, rosy tonality and the delicate landscapes in the two side panels with Saint John the Baptist and Saint Francis in Ecstasy are clearly in the Haarlem tradition.

A slightly later *Nativity* in Budapest is even more Geertgenesque in its expression of hushed adoration (fig. 183). The two diminutive angels, here wingless, are brought out front to complete a circle that includes two shepherds on the left. The engaging figure of the boy now moves closer to the Holy Family, and the shepherd in the lower left corner strikes an unusual pose as if he were frozen to his spot in such sacred ground. The portrait-like features of the second shepherd have prompted some to regard him as a self-portrait of the artist, but this is not likely. The meticulous rendering of the heads of the two shepherds may be due to David's desire to emphasize the earthiness of these peasant adorers, another characteristic trait which he gradually abandoned after settling in Bruges.

The unusually high format enabled David to expand the landscape background with an elaborate view of Jerusalem and its lofty temple at the left. A sandy road leads from the stable to the village of Bethlehem, where the diminutive figures of Mary and Joseph can be discerned inquiring about lodging before an inn. Above the stable, which projects diagonally from right to left, enhancing the sense of deep space, David added the angel announcing the birth to shepherds, who watch over their flocks on a steeply inclined hill.

The Budapest *Nativity* can be dated between 1483 and 1485, executed just before or after his departure from Haarlem for Bruges, and represents the peak of his Dutch style before he adopted the more elegant and monumental manner of the Bruges masters. When David arrived at his new home in 1483–84, Hans Memlinc and his atelier dominated the art market. He must have sensed immediately that he was now in a far different environment from what he had experienced in Holland, with patrons who had more aristocratic tastes.

His inborn capacity for assimilating the art of others, however, enabled him to acquire quickly the mellowness of Memlinc, and this talent grew and grew and he produced some of the loveliest paintings of the Late Gothic *détente*.

In many ways it is fitting that Gothic painting in the Netherlands had its last great spokesman in David since he had the natural talent to revive, reconcile, and reshape the two mainstreams of their culture, the "Dutch" and the "Flemish." What he borrowed from Van Eyck and Memlinc was thoroughly assimilated into his own personal manner. His understanding of Rogier van der Weyden and Hugo van der Goes was faltering. But it was his initial experience of Haarlem that kept his visual sense keen throughout his long career. His figures are solid, three-dimensional bodies that occupy a real space with a sedate and serene presence. And while David's people may seem too hushed and expressionless, it is the fresh breeze and the exuberance of his landscapes that make his paintings so endearing.

After the death of Memlinc in 1494, Gerard David acquired full status as painter of the city, and his workshop grew immensely. For the city hall in Bruges he was commissioned to execute two large panels of the *Judgment of*

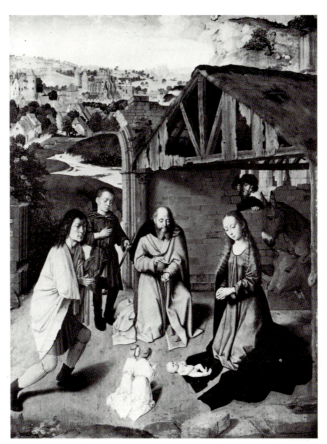

183. GERARD DAVID. *Nativity*. c. 1483–85. Panel, 30⅛ × 22¼″. Museum of Fine Arts, Budapest

184. GERARD DAVID. *Judgment of Cambyses* (left panel). 1498. Panel, 71¾ × 62¾″. Groeningemuseum, Bruges

185. GERARD DAVID. *Judgment of Cambyses* (right panel)

Cambyses (figs. 184, 185) for their council room, no doubt to rival the judgment paintings in the town hall of Brussels by Rogier van der Weyden and in Louvain by Dieric Bouts. The commission included another painting, the ''judgment and sentencing of Christ,'' but it is lost to us today.

The paintings from secular history, that of Cambyses, are based on an obscure legend related in the *Historiae* of Herodotus and retold by Valerius Maximus, a Roman author well known in the Netherlands. The story is an especially harsh one involving the trial and execution of the unjust judge, Sisamnes, by the Persian king Cambyses in the sixth century B.C. In the first panel, which is dated 1498, a worried Sisamnes appears enthroned before the king, who counts off his accusations in scholastic fashion, and a crowd of citizens, many of whom are probably portraits of the city regents in Bruges and include the artist himself directly behind Sisamnes. To the left in the background is the *poortersloge* (citizens' lodge or hall) of Bruges and the stoop of a town house where we see Sisamnes receiving the bribe from a client for which he was convicted. The second panel displays the gruesome execution of Sisamnes by flaying him alive.

It is interesting to compare David's representations with the similar panels of the *Justice of Otto* by Dieric Bouts, painted a quarter of a century earlier in Louvain (see p. 148). Both sets are huge, but while Bouts maintains a sense of verticality and spaciousness, David presents a broad and more horizontal setting with sturdy, monumental figures forming a compact frieze across the center of the composition. It is also obvious that David attempted, somewhat unsuccessfully, to present an antique setting for the legend. Sisamnes is en-

throned within a loggia decorated with Italianate *putti* holding garlands and oval medallions set into the wall.

The subject matter of the two medallions has been a point of some controversy, and while they were very likely based on Italian cameos that David had seen, they serve here as exotic references to virtue and vice.[68] In the one to the left a figure who resembles Hercules, a type for man's virtuous conduct, stands before a seated female holding a cornucopia. This has been interpreted as the legend of Hercules and Deianira as related by Ovid in the *Metamorphoses*, but more likely it is meant merely to present a virtuous man before a personification of abundance, the fruits of a just government. The right medallion has been identified as the legend of Apollo and Marsyas. This would be appropriate since the punishment meted out to Sisamnes, to be flayed alive, is the same suffered by Marsyas, but the standing figure is female, very likely Venus with Cupid beside her. The older man seated and fettered can thus be interpreted as some unjust man who yielded to lustful temptations. Along this same line, the two battling *putti* on the column in the top center are probably vague allusions to the popular Renaissance story of the conflict between Eros and Anteros, lust and virtue personified as Cupid and his alter ego. David's sense and understanding of Italian Renaissance iconography are clearly lacking.

The same loggia, without the medallions, appears in the background of the second panel with the gruesome execution of Sisamnes taking place in the city square. Stretched out diagonally on a plank, the false judge is skinned alive before the townspeople, and in the loggia beyond, the new judge—ironically the son of Sisamnes—sits on the throne of judgment draped with his father's

186. Gerard David. *Virgo inter Virgines.* 1509. Panel, 46⅞ × 83½". Musée des Beaux-Arts, Rouen

187. GERARD DAVID. *Nativity*. c. 1515–20. Panel, 36 × 24″. The
Metropolitan Museum of Art, New York. The Jules Bache
Collection, 1949

188. GERARD DAVID. *Landscapes* from a triptych (cf. fig. 187).
Panel, each 35½ × 12″. Rijksmuseum, Amsterdam, on loan to
the Mauritshuis, The Hague

skin, as Cambyses decreed. The two panels were thus
meant to present a harsh warning to the jurors who
gathered for judgment in the council chamber. If they re-
sponded with the same passivity as the townspeople in
David's paintings, one would question their conscience.
This was not a theme for David.

The one clearly documented work by David, the *Vir-
gin inter Virgines* in Rouen (fig. 186), was executed in
1509 for the Carmelite monastery of Sion in Bruges as a
donation by David and his wife, Cornelia Cnoop, daugh-
ter of the head of the goldsmiths' guild. It is a master-
piece exhibiting the artist's Renaissance orientation.
When compared to a comparable work by Memlinc,
such as the *Virgin with Saints* in the Hospital of Saint
John (colorplate 31), these proclivities are immediately
apparent. For one thing, the format is horizontal and the
picture is filled with a frieze of statuesque figures with
heavy draperies falling in shallow folds that mark out
sculpturesque mass. The central group, Mary and the
Child flanked by musical angels, repeats the old formula
popularized by Memlinc, but that is where any similarity
ends. There are no soaring loggia, no landscape vistas,
no vertical placement of the saints, who are here clus-
tered into a compact group. And David's palette is dis-
tinctive with its predominance of blues and darker
tonalities accented by sprays of rich Eyckian brocades.

The costumes have changed too, and in a clever fashion

David introduces attributes of some of the saints in a new
manner, as details of the jewelry they wear. To the far left
Catherine sits with her wheel displayed in her golden
crown; to the right, opposite her, is Barbara with the
tower in hers. Many of the figures appear to be portraits,
and the two figures on the extreme edges are portraits of
the donors; David, the only male in the composition, ap-
pears top left, while the woman directly opposite him
must be his wife, Cornelia.

By 1509 David had a large and productive workshop
that turned out countless repetitions on the same themes
such as the Madonna and Child with angels, the Nativ-
ity, the Adoration of the Magi (which he borrowed from
Hugo van der Goes), and the Crucifixion. A fine exam-
ple of the *Nativity* is today in the Bache Collection in
New York (fig. 187), where it can be easily compared to
the earlier *Nativity* triptych in the same museum, dis-
cussed above. The increased monumentality is at once ap-
parent and the characterization of the Holy Family is no
longer that of the diminutive innocence of the earlier.

The reverse of the two wings (fig. 188), today in the
Hague, also displays his contribution to the landscape
genre, which was rapidly becoming popular, especially in
Antwerp, where David might have spent some time
since there is a "Master Gerard" in the records of the
guild there in 1515. These two panels present us with
what are probably the first pure landscapes in Nether-

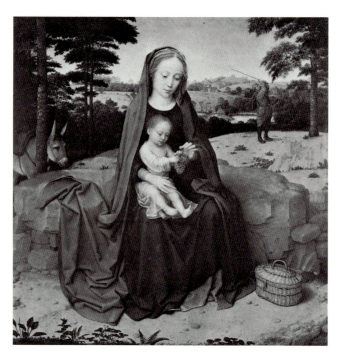

189. GERARD DAVID. *Rest on the Flight*. c. 1500–1510. Panel, 17¾ × 17½″. National Gallery of Art, Washington, D.C. Andrew Mellon Collection

landish painting. There are no human figures at all, only intimate views of a pasture with the trees towering over us. Two tiny details, however, relate these charming woodland views to the Nativity in the central panel. Under a tree in the left panel rests the donkey, and in the stream on the right is the ox; apparently both beasts strayed away from the stable during the night.

The great triptych that David painted for Jan de Trompes of Ostende, sometime between 1502 and 1507, the *Altarpiece of the Baptism of Christ* (colorplate 33), is a superb example of all the best aspects of his mature style. The central panel with the Baptism is a rich, nearly succulent, screen of bright colors across a verdant landscape. There is a lack of drama once again, but the execution is meticulous beginning with the richly brocaded angel kneeling in the lower left, who effectively anchors and initiates the movement through the beauty of the landscape setting with two details from the story of Saint John, his preaching on the left, the *ecce agnus dei* on the right.

Landscape dominates the side panels as well. On the left Jan de Trompes and his son are presented by John the Evangelist; on the right appears his first wife, Elizabeth van der Meersch, who died in 1502, with her patron saint and four daughters (his second wife, Madeleine Cordier, and her first child appear on the reverse of the wings kneeling before the Madonna). With David one does not simply view a distant landscape but actually

wanders through it. The details of nature are rendered with such accuracy that a number of the plants and trees can be easily identified; but more than that, David brings the woodland up so close that it seems to grow out of his picture.

With David there also commences the practice of selecting themes, usually of secondary importance in the drama of Christ's life, for exploiting landscape painting for general marketing. David's favorite theme was the Rest on the Flight into Egypt. The green of the woodland setting is enhanced by a distinctive blue tonality in the mantle of the Virgin that lends a comforting quietism to the setting. There are a number of these charming landscapes attributed to David; one of the finest is in the Mellon Collection in the National Gallery in Washington (fig. 189). The details are nearly always the same. In the foreground Mary sits on a rocky ledge and feeds her infant, and in the background Joseph usually appears knocking down fruit from the trees to refresh his family. This practice of supplying special genre for the common market rather than being a religious commission was rapidly gaining preeminence in Antwerp. The function of these charming works is no longer one of religious devotion but of a collector's appreciation in the modern sense.

Another indication of the internationalism that charac-

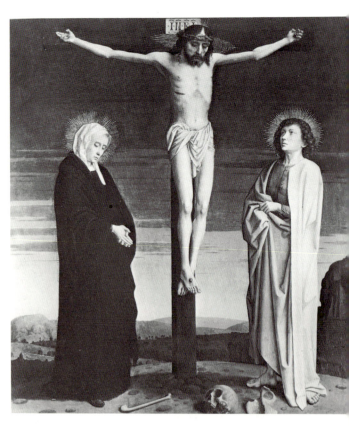

190. GERARD DAVID. *Crucifixion*. c. 1515–20. Panel, 40⅛ × 34⅝″. Galleria di Palazzo Bianco, Genoa

terizes much late-fifteenth- and early-sixteenth-century art in Flanders is the increase of commissions for the Italian market. David painted a number of impressive works for patrons in Genoa, including a large *Altarpiece of the Virgin* that perhaps featured the majestic late *Crucifixion* in the Palazzo Bianco (fig. 190). One need only compare this monumental icon with David's earlier *Crucifixions* to understand the growth and development of his Renaissance style. The figures of Mary and John flanking the cross are large and statuesque and display an unusual dignity seen against a landscape with a low horizon and a striated sky with a haunting tonality. Flemish detail and emotion are clearly giving way to the monumentality of the Italian Renaissance.

MASTER OF MARY OF BURGUNDY

If the art of Memlinc and David reflects a fading Gothic world, then the final flowering of book illustration in Bruges and Ghent presents a picture of a courtly society that managed to retain a charming sense of caprice and wit on a miniature scale reminiscent of that painted by the Limburg brothers fifty years earlier. The developments in late-fifteenth-century miniature painting in Flanders represent some of the more interesting and progressive movements in Late Gothic painting, but it too gradually succumbed to new Italian modes after a few generations. Nor could it keep pace with the rapid growth of printed books with woodcuts, as we shall see below.

The interest in extensive narration was clearly displayed in Memlinc and David's works, and it is not surprising that both artists had close contacts with the illuminators' guild. David has often been described as a miniaturist as well as a panel painter, and illustrations in a few books, especially the elegant *Breviary of Isabella of Spain* (London, British Museum, add. MS 18851), are so much in the style of his early period that it is tempting to accept them as part of his oeuvre.[69] For the most part, however, the miniatures attributed to David are, in a broader sense, in a style that is associated with the Ghent-Bruges school of illumination that developed during the last decades of the fifteenth century.

During the middle years of the century most of the centers for illumination were located further south in Hesdin and Valenciennes. The major innovator of the Bruges school, Willem Vrelant, came from Utrecht, where he was trained in the progressive style of the Dutch illuminators. In Ghent no significant illustrated book is known to have been produced until the late 1460s, and the artist, David Aubert, had worked previously in Hesdin. In West Flanders book illustration had simply dropped to a secondary position since the growing patronage of the civic bourgeois required imagery on a more public and monumental scale than that of the precious court.

The river of influence reversed itself with the miniaturists copying the panel painters and attempting to emulate their accomplishments in realism. Hence the very *raison d'être* for book decoration, to enhance the text, was gradually refuted with the book becoming a tiny gallery of pictures and the written word shrinking to a mere collection of prayers that everyone knew by heart anyway. The violation of the integrity of the written page was inevitable (especially with the development of the printed book); the conflicts and contradictions between the beauty of the written word on the flat surface and the attempt to cut a hole in that surface to give the reader a view into some distant vista where tiny narratives unfold could only result in an interest in preciousness and a delight in tiny detail as a tour de force for the artist. When the miniature becomes little more than a tiny panel painting, book illustration as the Middle Ages knew it as an art form committed suicide, as one scholar so aptly put it. And it did. But the innovations of one great artist, whether or not they were long lasting, are so ingenious that they merit discussion here.

The artist is known to us by the melodious title of the Master of Mary of Burgundy, and his style was so influential that he may well be called the founder of the famed Ghent-Bruges school of illumination that dominated the market from the last quarter of the fifteenth century through the first decades of the sixteenth.[70] Certain stylistic features of his miniatures provide us with clues to his identity. Frequently the head types and compositional schemes suggest an intimate knowledge of the art of Hugo van der Goes, also active in Ghent during the same period. Some of his landscapes with lively figures scattered about with an uncanny sense of naturalism closely resemble details in the Ghent *Altarpiece of the Crucifixion* by Joos van Wassenhove (see p. 166).

The leading miniaturist in Ghent, Alexander Bening, entered the guild in Ghent in 1469 and his two guarantors were Hugo van der Goes and Joos van Wassenhove, suggesting that there was an intimate rapport among the three. Alexander Bening also belonged to the guild in Bruges and probably controlled the market there as well. His son, Simon, worked in Bruges until his death in 1561, and the style of his miniatures clearly reflects that of the Master of Mary of Burgundy, whom we should identify as Alexander.

Aside from the incredible refinement of detail on such a small scale that his miniatures display, one is also struck by his inventiveness when treating traditional themes such as the Infancy, the Crucifixion, and the Last Judgment. Not only are deep spatial recessions superbly

achieved with countless tiny figures strewn about the landscape in a most natural fashion, but he employs an impressionistic technique in the rendering of atmosphere and light that rivals that of Geertgen tot Sint Jans. On occasion he invents totally new themes to exploit landscape settings such as the charming and poetic miniature of *Mary Going over the Hills to Visit Elizabeth* (fig. 191), replacing the usual *Visitation* in the Book of Hours preserved in the Bodleian Library in Oxford (MS Douce 219) originally made about 1485 for Engelbert of Nassau, lieutenant of the realm under Philip the Fair. The peacock feathers in the margins are part of the heraldic emblems of Engelbert, a clever *trompe l'oeil* effect.

As if admitting that his new art of book illustration was in conflict with the earlier planar decoration befitting an illuminated text, the Master of Mary of Burgundy devised new *trompe l'oeil* techniques by manipulating the immediate foreground that establishes the very presence of the page and the framed distant view which annihilates it. In the first instance the surface of the page is utilized as a positive but neutral surface that separates two illusionistic worlds (anticipated by the Master of the Hours of Catherine of Cleves; see p. 141). The marginal decorations are no longer filled with flat, decorative ivy scrolls but become floors upon which are strewn realistic objects such as feathers, flowers, and butterflies or shelves for the display of relics, skulls, jugs, and other still-life objects, rendered illusionistically with cast shadows as if they actually existed on our side of the page.

On the other hand, the miniature narrative is a diminutive view through the frame as if it were a window. Sometimes, as in his masterpiece in the Book of Hours in Vienna (Nationalbibliothek, Cod. 1857), it literally becomes an illusionistic window ledge through which we look (colorplate 34). On our side of the page the donoress, Mary of Burgundy, sits reading her Book of Hours. On the ledge beside her are still-life objects, including Rosary beads, and through the opening of the casement windows above we view a church interior where the Virgin is enthroned ·before an altar. The pa-

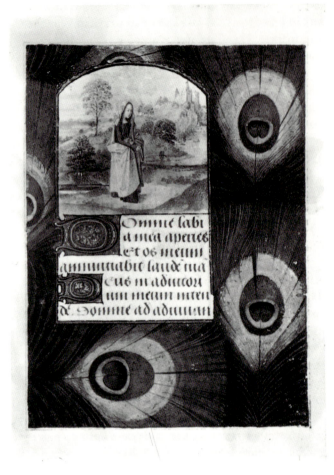

191. Master of Mary of Burgundy. *Mary Going over the Hills to Visit Elizabeth*, from the *Hours of Engelbert of Nassau*. c. 1485. Bodleian Library, Oxford

tron, Mary of Burgundy, appears a second time in devotion before the Madonna. No doubt the intent of the miniature was to present the patroness in devotion in the world before the page and the revelation of her devotion made manifest within the book. Not since the imagery of Jan van Eyck, exemplified by the *Rolin Madonna* (fig. 104), has such a complex interplay of the real and the mystical been so effectively presented within one picture.

Gardens of Heaven and Hell in the Art of Bosch

Among the numerous masterpieces of Northern art in the Prado Museum in Madrid, one stands out that is so surprising, so overwhelming, that we momentarily forget all others we have seen, a work that seems to have no place in the history of Netherlandish art that we have studied so far: the *Garden of Earthly Delights* by Hieronymus Bosch (colorplate 35). Filmy atmospheric hues and fresh, bright colors float and flare up before our eyes like the marvels of some modern science-fiction film, and amid this throbbing, panoramic landscape hundreds of tiny, nude figures swirl and move as if caught up in some endless dance of the senses. Ponds, large and small, both cultivated and swamplike, come into focus among the eerie crags and crests of crystalline, metallic, and earthen protuberances that rise from a giant tapestry of meadowlands. Natural scale is inverted with huge birds and waterfowl, giant crustaceans with gaping valves, berries, cherries, and grapes of enormous size, bulbous pods with fragile casings bursting open; and among all of these strange, exotic fruits and fauna of the mysterious garden cavort minuscule male and female nudes, all the same age, who engage communally in countless frivolous activities—dancing, prancing, eating, swimming, playing, making love—as if it were all one universal orgiastic picnic of mankind. The garden is an aphrodisiac in paint, as one scholar put it, that exudes fragrance as well as color in its weird but enchanting beauty.

But where are the saints and the pious folk that we usually meet in summer landscapes or in scrubbed-clean interiors of half-timbered houses? What kind of world is this and what does it all mean? And then, gradually, another perplexing question comes to mind: For what purpose and for whom would such a bewildering panorama be painted in the first place? It is as if the vats and crucibles of witches and alchemists were stirred again and mysteriously there precipitated an intoxicating solution of gentle hues and bright, fragile particles, a truly surrealistic image that defies any rational description or explanation. But there is a purpose and a program that secretly unravels in Bosch's sprawling garden, a meaning that changes for each viewer but, nonetheless, can be partially decoded. It is no wonder, however, that more studies of iconography have been devoted to Bosch than to any other Netherlandish artist, and that his reception in art history has been baffling and contradictory for every specialist in the field. So we must step slowly and carefully into his world.

Bosch has been characterized variously as a painter of bitter social polemic; a heretic who concocted his imagery from knowledge of witchcraft, alchemy, and astrology; a clever punster who tricks us with his play on words and images from folklore in Dutch, German, French, Latin, and Greek; a provincial madman and fanatic, and, more recently, a highly intellectual painter of puzzling and erudite pictures for learned secular patrons.[71]

We know surprisingly little about his life. The documents are scant, but he apparently spent his entire career in 's Hertogenbosch in North Brabant, an important ecclesiastical center in the fifteenth century lying between Breda and Nijmegen about five miles south of the Maas River. An active member of the Catholic church, he is listed in the records of the Brotherhood of Our Lady (*Onze Lieve Vrouwe Broederschap*), a pious and exclusive religious confraternity.

Bosch came from a family of painters. In all likelihood, he was trained in his father's studio, and after becoming a master on his own assumed the name "Bosch" after his hometown, as was often the custom, to avoid confusion with other members of the Van Aken family who were also painters. In his obituary in the archives of the Brotherhood of Our Lady for 1516 he is named "Jheronimus Aquen alias Bosch insignis pictor" (Jerome Aken, called Bosch, illustrious painter). His wife, Aleyt van der Meervenne, a patrician lady of considerable means, was the daughter of pharmacists in 's Hertogenbosch, and it was no doubt through his in-laws that Bosch acquired a keen knowledge of the secrets and apparatus of the alchemists that appear in many of his mature works.

As to his commissions, we have very little evidence. For the Brotherhood of Our Lady he painted the shutters

above: 192. HIERONYMUS BOSCH. *Cure of Folly*. c. 1480–85. Panel, 18⅞ × 13¾″. The Prado, Madrid

right: 193. HIERONYMUS BOSCH? *Table of the Seven Deadly Sins*. c. 1480–85. Panel, 47¼ × 59″. The Prado, Madrid

of a carved altarpiece that had been executed earlier by Adriaen van Wesel, the leading Utrecht sculptor (see p. 298), and by far the most intriguing commission recorded is that of a large Last Judgment altarpiece ordered by the emperor Philip the Fair in 1504. Unfortunately, none of the Last Judgment paintings (copies) attributed to Bosch can be linked to this commission with certainty.

One cannot avoid the fact that the themes of most of Bosch's paintings were highly unusual for his period. In a number of works he seems to have drawn heavily from the popular moralizing literature of the day that was often illustrated in prints. Such is the case with the *Cure of Folly* in the Prado (fig. 192), where a fool has consented to let a quack doctor and his phony attendants cut the stone of folly (insanity) from his head, a subject concerning quackery and stupidity in Dutch proverbs. In this case, a clue to Bosch's source in folk sayings is given in the inscription: "Meester snijt die keye ras/Mijne name is Lubbert Das" (Master, cut out the stone/ My name is Lubbert Das). Lubbert Das was the name given the castrated fool (*lubber*).

Along more traditional lines, Bosch often took his inspiration from Proverbs or the parables in the Bible. One popular theme, updated from the Middle Ages, was that of the virtues and vices. The *Table of the Seven Deadly Sins*, formerly in the collection of Philip II, is now in the Prado (fig. 193). The form of a huge eye stares out from the square panel, and the inscription around the pupil

warns the viewer, "Beware, beware, the Lord sees." The seven major vices (*gula, acedia, luxuria, superbia, ira, invidia,* and *avaritia*) are represented in the cornea, not in the form of conventional personifications but as domestic scenes that remarkably anticipate the earthy genre of seventeenth-century Dutch painting. The details of Bosch's domestic vices may be vague or general, but the point is clear: These same everyday vices are the damning liabilities we must account for on judgment day before a Lord "who sees all."

To underscore this message, Bosch spells out the more traditional drama of the Last Judgment or the "Four Last Things" in medallions in each corner of the table. Above, to the right, appears Christ at his second coming judging the dead rising from their earthen graves. Below, the blessed are greeted by Saint Peter at the portal of a Gothic church representing heaven, and in the lower left those who are damned suffer gruesome fates in the fiery terrain of hell, where each sin is labeled and the "punishment fits the crime." *Luxuria* and her nude lover must continue forever their amorous activities while being harassed by spiny demons in their bed; *Superbia*, exhausted, is tempted by a nude lover as a witch holds a mirror before her and a toad clambers up her body; a winged demon attacks *Ira* with a sword as he is sprawled out on a table over a cauldron in which *Avaritia* is boiled and basted; *Acedia* is imprisoned at a forge where a spook dressed as a nun administers a quickening punishment

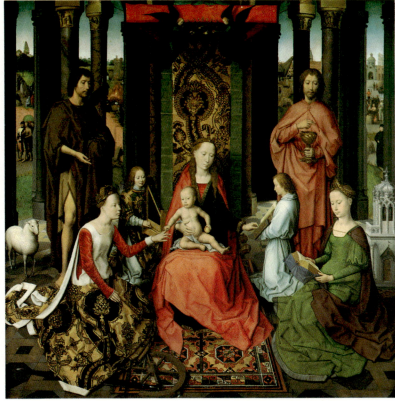

above: Colorplate 31.
HANS MEMLINC.
*Altarpiece of the Virgin
with Saints and Angels.*
1479. Panel,
67¾ × 67¾" (center);
67¾ × 31⅛" (each
wing). Hospital of Saint
John, Bruges

left: Colorplate 32. HANS
MEMLINC. *Madonna and
Child with Angels.*
c. 1485. Panel,
23⅛ × 18⅞". National
Gallery of Art,
Washington, D.C.
Andrew Mellon
Collection

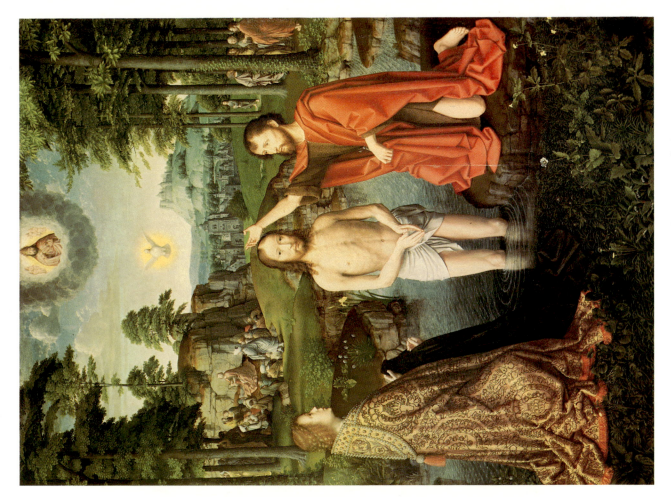

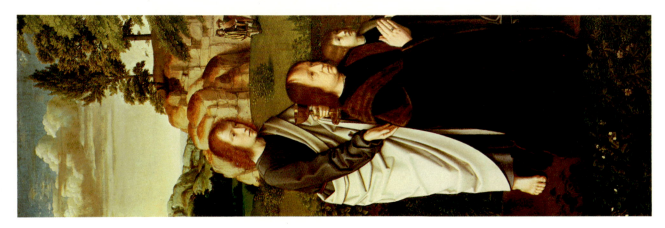

Colorplate 33. Gerard David. *Altarpiece of the Baptism of Christ.* c. 1502–7.
Panel, 52 × 37¾" (center); 52 × 16⅞" (each wing). Groeningemuseum, Bruges

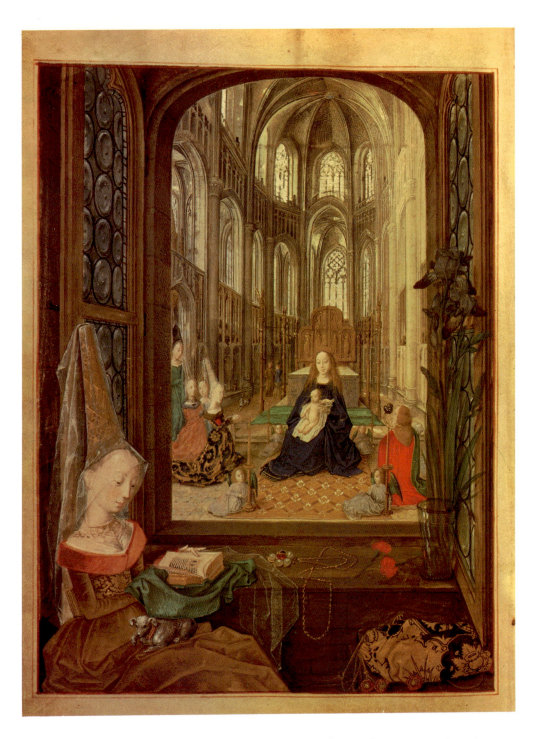

Colorplate 34. MASTER OF MARY OF BURGUNDY. *Mary of Burgundy in Devotion*, from the *Hours of Mary of Burgundy*. c. 1480. Österreichische Nationalbibliothek, Vienna

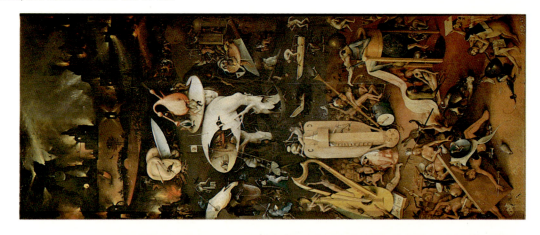

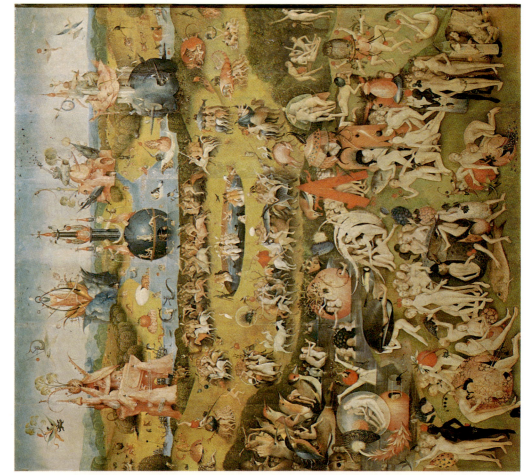

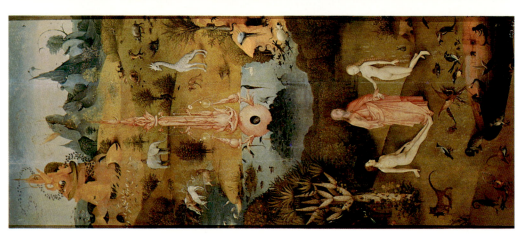

Colorplate 35. Hieronymus Bosch. *Garden of Earthly Delights*. c. 1510–15.
Panel, 86⅝ × 76¾" (center); 86⅝ × 38¼" (each wing). The Prado, Madrid

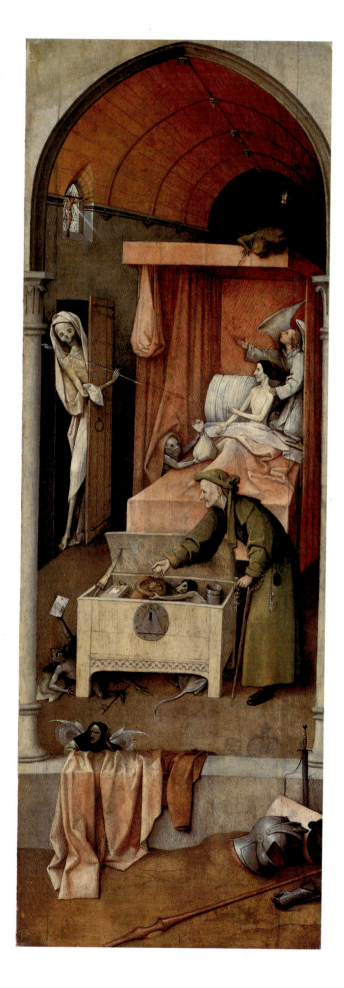

Colorplate 36. HIERONYMUS BOSCH.
Death of the Miser. c. 1500.
Panel, 36½ × 12¼". .
National Gallery of Art,
Washington, D.C.
Samuel H. Kress Collection

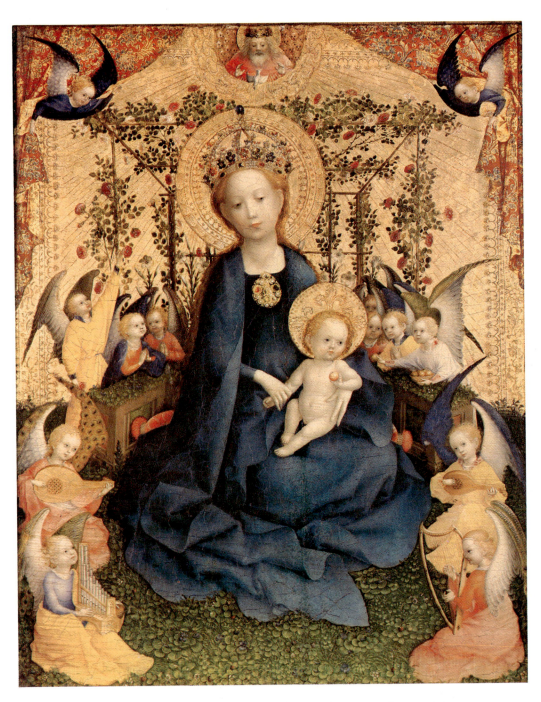

Colorplate 37. STEPHAN LOCHNER. *Madonna in the Rose Garden*. c. 1440.
Panel, 19⅞ × 15¾″. Wallraf-Richartz Museum, Cologne

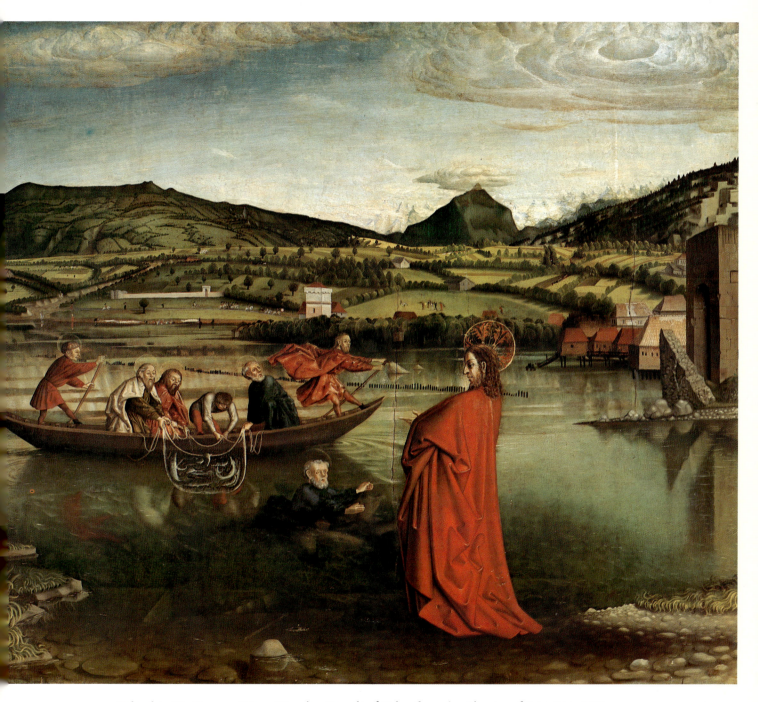

Colorplate 38. KONRAD WITZ. *Miraculous Draught of Fishes*, from the *Altarpiece of Saint Peter*. 1444.
Panel, 52 × 60⅝″. Musée d'Art et d'Histoire, Geneva

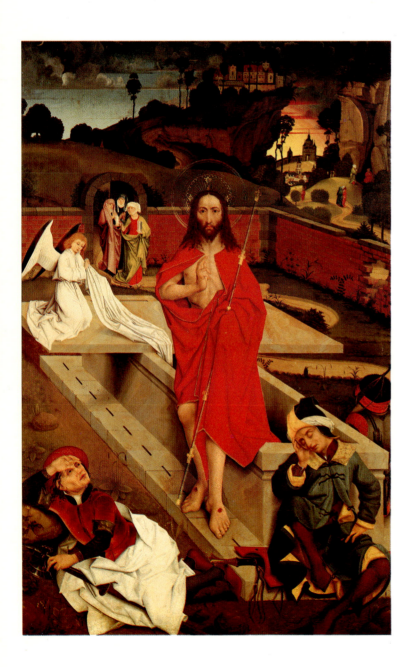

above: Colorplate 39.
Master of the Saint Bartholomew Altarpiece.
Virgin and Child with Saint Anne. c. 1480.
Panel, 17 × 11¾″. Alte Pinakothek, Munich

left: Colorplate 40.
Michael Wolgemut (attributed).
Resurrection, from the *Hofer Altarpiece.* c. 1485.
Panel, 68½ × 43¾″.
Alte Pinakothek, Munich

with a hammer. The fourth roundel, in the top left, is a subject taken from the popular manual, the *Ars moriendi*, where the dying man is given last rites before his family while Death, a demon, and an angel look on from behind his bed. The Prado tabletop has been heavily restored—underdrawings in the scene of *Superbia* are visible and indicate major changes in the composition at some stage—and the attribution to Bosch is not accepted by everyone, although surely the general program of the iconography is his invention.

The depiction of the last rites of the dying man served Bosch as an independent composition in another work, the *Death of the Miser*, today in the National Gallery in Washington (colorplate 36). Special emphasis is given the large trunk of earthly riches before the bed of the dying man which is being plundered by little creatures of Satan. Another demon boldly steals a bag of money from the miser's hands, while the skeleton of Death, arrow in hand, fixes his mark on the startled old man. Behind him and unobserved, an angel kneels imploring him to attend the divine light of Christ that filters through a crucifix in a small window in the top left.

The painting, mostly in neutral shades of tans and grays, is thin in application and much of the underdrawing is visible. It is clear from the directions of the parallel shading lines that it was sketched with the left hand (the strokes move from top left to bottom right rather than the reverse as a right-handed draftsman would add them), a piece of technical evidence that could help determine the authorship of a number of problematic attributions.[72] A drawing in the Louvre has long been thought to be a preparatory sketch for the Washington painting, but the shading lines there are reversed in direction, indicating that it is an anonymous work after the original (fig. 194).

The same is true of a so-called preparatory drawing for another painting by Bosch, the *Ship of Fools* (fig. 195). In a rudderless boat without a pilot, a company of rowdy nitwits, singing, eating, brawling, vomiting, floats aimlessly through a swamp overgrown with shrubs and trees. The idea of such an allegory on the vanity of sensuous delights appeared already in an early-fifteenth-century poem, *De Blauwe Scuut* (*The Blue Ship*) by the Netherlandish poet Jacob van Oestvoren, and woodcuts illustrating such a vessel served as frontispieces for the much celebrated *Narrenschiff* (*Ship of Fools*) by Sebastian Brant, published in many editions in the last years of the century. Further textual sources, including the presence of the monk and the nun singing, can be found in the satire of the "Ship of Religion" that was issued with woodcuts in some Dutch editions of Guillaume de Deguilleville's *Le Pélerinage de l'âme*. It is very probable that Bosch was extremely well-versed in such genre and that

194. AFTER HIERONYMUS BOSCH. *Death of the Miser*. c. 1500. Drawing, 10 × 5⅞″. The Louvre, Paris

195. HIERONYMUS BOSCH. *Ship of Fools*. c. 1495. Panel, 22 × 12⅝″. The Louvre, Paris

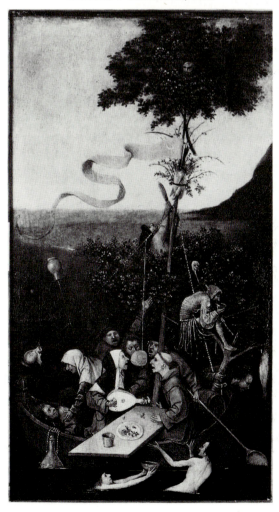

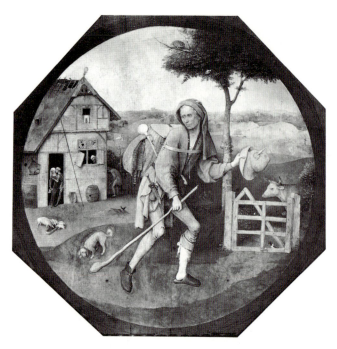

196. HIERONYMUS BOSCH. *Landloper* (Tramp). c. 1510. Panel, 28 × 27¾". Museum Boymans-van Beuningen, Rotterdam

he had access to a large library of popular literature.

The idea of the pilgrimage of man in a senseless world of corruption was treated in other works by Bosch where a striding tramp, representing Everyman, stumbles along the road of life, the most ambitious and complex of which is the *Landloper* or *Tramp* in the Boymans-van Beuningen Museum in Rotterdam (fig. 196), usually mistitled the *Prodigal Son*. There is little agreement among scholars on the proper identification of the striding figure. He has been called a peddler, a vagabond thief, a drunkard, a wayward shepherd, a personification of sloth, or the child of Saturn.[73] Perhaps he is all of these, but in the broader sense, the idea that the tramp represents Everyman and his sins passing through life is more acceptable.

In the *Landloper*, all details reinforce the condemnation of the errant tramp in society: the ragged clothes, the wrapped leg, the odd assortment of tools and gadgets that he packs, the catskin, the club, and the curious hat, mark him as a dissolute hobo, a fugitive. The snarling dog testifies to his irascible character; the pigsty, the amorous couple in the doorway of the crumbling tavern of the White Swan (the sign of a house of prostitution), and the man relieving himself are all reminders of his wanton behavior and filthy habits. And the path beyond the strange freestanding gate leading to a distant hill of gallows indicates the outcome of it all. A sinister owl, hidden in the tree directly above him, knows.

One of the earliest critics of Bosch, Fra José de Sigüenza, writing about 1600–1604, had studied Bosch's works in the collection of Philip II at the Escorial and was impressed by their inventiveness and profound orthodox content—how else could Philip place them in his apartments and chapels? Sigüenza described three basic categories of subject matter treated by Bosch: "The first comprises devotional subjects such as events from the life of Christ and His Passion—the Adoration of the Kings and the Carrying of the Cross. . . . Several times he painted the Temptation of Saint Anthony (this is the second category of his paintings) . . . [and] besides these pictures there are others, very ingenious and no less profitable, although they seem to be more 'macaronic,' and these constitute the third category of his work" (*Historia de la Orden de San Jeronimo*, 1605).[74]

The *Adoration* to which Sigüenza referred is the triptych in the Prado Museum (figs. 197, 198). One scholar, Charles de Tolnay, has likened the representation of the Magi presenting gifts to Mary and the Child to the offertory in the liturgy of the Feast of the Epiphany, wherein Mary is the altar, the first king, Balthasar, the officiating priest. His gift is decorated with a metal sculpture of the Sacrifice of Isaac, an Old Testament type for Christ's sac-

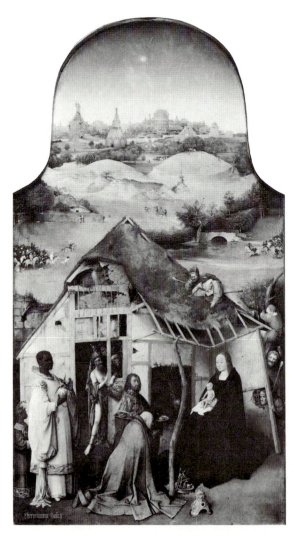

197. HIERONYMUS BOSCH. *Adoration of the Magi.* c. 1510. Panel, 54⅜ × 28⅜". The Prado, Madrid

rifice in the Mass, while the other two kings wear vestments or carry offerings adorned with other types of the Epiphany taken from such manuals as the *Speculum humanae salvationis.*

Furthermore, De Tolnay continues, the wings when closed present the unusual theme of the Mass of Saint Gregory, the story of the transubstantiation of the bread and wine into the body and blood of Christ that the Pope so vividly experienced in Mass (see p. 290). Thus Bosch's *Adoration of the Magi* has a positive meaning incorporating the Feast of the Epiphany and the Eucharist of the Mass wherein the Old Testament promises of a Messiah in the Incarnation of Christ are fulfilled.

Regardless of the liturgical associations presented, however, it must be admitted that unlike the usual festive paintings of the Epiphany, Bosch's has not a joyous but a distinctly somber mood about it that is further tainted by a number of sinister touches scattered about the holy group. Most bizarre is the shed in the foreground. A dilapidated eave propped up by a roughly hewn tree branch hangs precariously over Mary and her Child. The Virgin is solemn and still, and she and the Child are discreetly isolated from the other figures by the flimsy architectural box in which they are placed. Vulgar shepherds peer menacingly through a break in the wattle wall while others climb up on the thatched roof to stare down on the Holy Family. Through a rupture in the side wall the diabolic head of an ass, a common symbol of the Jewish disbelievers, is visible.

The ramshackle hut is falling apart. In the gable over the entrance the wall has rotted away, and a bundle of dried thistle is tied there in imitation of the star of Bethlehem, the indicator of the holy site. In the right corner of the gable a fierce owl stares out from the darkened interior. This is no haven for rebirth and illumination but a grim reminder of the ruinous state of the world before the coming of Christ.

Even more menacing is the group of six shady figures, grotesque and sinister, that look out from the dark interior at the entrance. They are led by a bizarre chieftain, nude except for a red robe draped across his shoulders (fig. 198). He wears an elaborate metal crown with a filigree pattern of intertwining thorns (the crown of thorns), and he holds an inverted bowl (a cauldron?) decorated with a row of toads. A strange transparent bandage covers his right ankle and lower leg through which sores are visible, indicating that he is leprous. Middle-aged and bearded, this diabolic leader is no doubt meant to be the false Christ, the Old Testament Messiah as a prefiguration of the New, or, more precisely as Lotte Brand Philip has argued, the Antichrist who leads the evil forces in the world at the coming of the Savior.[75]

The life of Christ thus hardly seems a promise of re-

198. HIERONYMUS BOSCH. *Adoration of the Magi*
(detail of fig. 197)

demption for Bosch. There is no happy omen, no jubilation, no rejoicing in his vision of a tragic world caught firmly in the grips of Satan; in fact, there is no hope for salvation at all, only impending doom for mankind. This extreme pessimism pervades his representations of the traditional Passion scenes to an even greater degree. Bosch concentrates on themes of extreme torture, agony, and humiliation: the Arrest of Christ, the Crowning of Thorns, the Ecce Homo, and the Carrying of the Cross. In many details he draws upon Germanic sources, perhaps through prints and miniatures in the numerous devotional books where the "Way of the Cross" is the predominant theme.

In the *Carrying of the Cross* in Ghent (fig. 199), a late work, Bosch made use of a new stylistic device known as the dramatic close-up to intensify the agony of the torturous trip to Golgotha.[76] The surface is filled with the snarling, grimacing heads of the evil throng so common in German paintings of these scenes. Mankind's bitterness and hatred confront the viewer immediately in painful proximity, with frightening profiles of bulging eyes, hooked noses, and gnashing teeth cramped tightly about

199. HIERONYMUS BOSCH. *Carrying of the Cross*. c. 1515. Panel, 30¼ × 327/8″. Musée des Beaux-Arts, Ghent

the peaceful visage of Christ placed in the center of it all.

One could argue for the influence of Leonardo's fascinating studies of grotesques, but, in truth, numerous examples in German art of Bosch's period are nearer at hand. The basic colors of the panel, sinister reds and metallic blues glowing out from an intense darkness verging on black, heighten the emotional distress of the expression of the individual figures. And if one looks closely, another stylistic device, aside from the dramatic use of fractional figures, can be discerned in Bosch's subtle use of two diagonals that intersect in the head of Christ.

A strange moralizing intent underlines this unusual design. One diagonal is boldly stated in the arm of the cross that extends downward from the top left to the savage profile of the bad thief in the lower right, who turns back mocking his tormentors. The second diagonal moves slowly from the lower left to the upper right. The eerie, waxlike mask of Veronica is pallid and hushed. Her eyes are closed as if in resignation to the ugliness all about her. Veronica's veil or sudarium is just visible with the frontal icon of Christ turned on the viewer: "My people, what have I done to you, why have I distressed you so, answer me!" From Veronica we move through Christ to the good thief in the upper right. It was he who gained redemption through his sudden recognition of Christ as the Son of God while still hanging on the cross next to him. His eyes are nearly closed too, but his tortured expression with mouth agape and eyes rolled backward is one of pain and suffering and not peaceful surrender.

The second category of subject matter, according to

Sigüenza, was the temptations of the hermit saint, who under great adversity and beset by countless threats to his flesh and spirit could prove that through meditation he would be elevated by God to a state of grace. Foremost among these was the prince of the hermits, Saint Anthony, to whom Bosch devoted many panels.

Four paintings of Anthony were owned by Philip II, one in the chapter house, another in the prior's cell, two in the gallery of the Infanta, and Sigüenza himself had a "fine one in my own cell in which I sometimes read and lose myself." He particularly admired Bosch's ingenious imagination in giving shape and form to so many diverse ideas in these works. Fantasies and weird creatures conjured by Satan to harass Anthony are described as "wild chimeras, monsters, conflagrations, images of death, screams, threats, vipers, lions, dragons, and horrible birds of so many kinds . . . [which] to the outer and inner eye . . . can excite laughter or vain delight or anger."

The triptych in Lisbon (figs. 200–202) is Bosch's most ambitious treatment of the story with the unraveling of three or four major episodes of his life as we know them from literary sources available to the artist. These include the accounts given by Voragine in the *Legenda Aurea*, the *Vita S. Antonii* by Saint Athanasius (as incorporated in the *Vitae Patrum* or *Vaderboek*), and certain Arabic legends of the saint translated into Latin by the Dominican monk Alphonsus Bonihominis, but these texts by no means account for all of the details. The episodes, furthermore, are not placed in an orderly chronological sequence from left to right. On the left wing, in the foreground, is the rescue of Anthony by three companions after he had collapsed in exhaustion under the physical strain of the temptations, and above, in the skies, is the levitation of Anthony where he is transported into the heavens while demons battle to claim his soul.

The central panel features a catalogue of diverse temptations that beset the hermit's soul and spirit as he prayed and meditated alone in his cell, a tomb in the deserts of the Upper Nile; and the right shutter depicts the carnal excitement aroused by the Devil-Queen. All are major events in Anthony's biography, but never before have they been so elaborated. The reverse of the wings illustrates in grisaille two of Bosch's favorite themes in the Passion of Christ, the Arrest in the Garden and the Carrying of the Cross, moments of intense spiritual and physical pain much as those suffered by Anthony. Thus Anthony's life was an extreme example of the *imitatio Christi* in his Passion, the very core of the *devotio moderna* of the mystics.

It should be noted that the deep landscape setting is continuous through all three panels, as it usually is in his altarpieces. Essentially there are three divisions in the

200. HIERONYMUS BOSCH. *Triptych of Saint Anthony*. c. 1505–10. Panel, 51¾ × 46⅞" (center); 51¾ × 20⅞" (each wing). Museu Nacional de Arte Antiga, Lisbon

spatial projection. Across the immediate foreground, a river flows slowly from a great lake in the distance on the right wing, past Anthony seated on a rocky ledge, then about the moat of his strange ruined shelter in the central panel, and, finally, under a bridge—now the water is icy—across which Anthony is carried by his companions in the left panel.

Hilly terrain with parched dips and rises stretches across the second zone, and the far distance is marked by a stormy sea on the left, a burning village in the center,

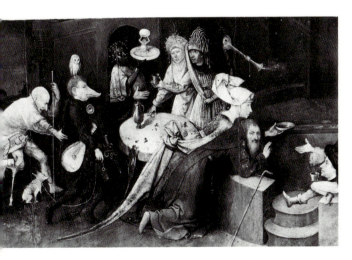

above: 201. HIERONYMUS BOSCH. *Triptych of Saint Anthony* (detail of fig. 200)

right: 202. HIERONYMUS BOSCH. *Triptych of Saint Anthony* (exterior shutters of fig. 200)

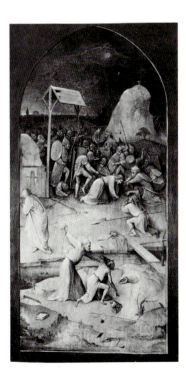
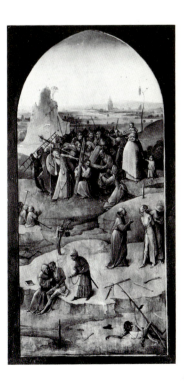

and a desolate city-fortress with an immense courtyard on the right. In the nearer waters various fishes, amphibians, waterfowl, and strange mermen swim, sail, and skate in the murky marshes and stagnant pools, the proper home for sterile heresies and malpractices of the church, as well as a fitting swamp for the dregs of society, from the most repulsive hybrids to the dying flowers of a corrupt aristocracy.

Bosch seems obsessed with the idea of hybrid forms as the offspring of mismating and unnatural union in the world. Horrid, malformed creatures with distended torsos or none at all wave insect-like appendages; bulbous bodies turn into fish or sharp-beaked birds; animal, mineral, and vegetal hybrids mix and squirm from rotting vestments, cracked eggs, and metallic casings. The early Spanish critics were fascinated by Bosch's *grilli*, a grotesque form of grasshopper with which they were familiar, and, indeed, that insect often comes to mind when perusing Bosch's surrealistic terrarium.

The stories are presented more directly in the side wings than in the central panel. On the left, the limp body of the saint is carried back to his hut with considerable effort by two brothers of the Antonine order and a third dressed in burgher's clothes (his face resembles other portrait types in Bosch's works and is believed by some to be a self-portrait). The right panel illustrates, more or less, the story related by Athanasius of a nude temptress, whom Anthony encountered twice, one being the beautiful but deceptive Devil-Queen of a great city on the Nile. She was bathing when the hermit met her, and after befriending him the Devil-Queen invited Anthony to her city, where she performed a number of seemingly virtuous miracles. But then the queen propositioned Anthony and tried to persuade him to follow a more "active life." This he steadfastly refused to do, and after a fierce battle with her demon army, he emerged triumphant while the city burned in its own sinful rage.

This story describes what were no doubt mad hallucinations of the most lustful sort that blinded the saint for a time. To the left the nude queen stands in the murky bog within a rotted tree trunk draped with a red curtain, a clear allusion to the death and sterility of prostitution. But all is not lust in Anthony's ugly nightmare. He holds fast to the scriptures he has been reading and now stares down troubled at a banquet table prepared for him, a glutton's altar concocted by witches and supported by acrobatic caryatids of nude men.

The action in the central panel revolves around the Mass prepared in the outer court of Anthony's fortress-like abode—another extension of his hallucinations, a weird structure transformed into an alchemist's laboratory and a palace-church at the same time with its tube-towered entrance, dark inner sanctum, raucous bridge-nave, and bulbous oven-choir. Indeed, a church service is being performed beside the hermit, but it is a Black Mass of heretics and witches. At a round altar, resembling a gaming table, a magician-priest wearing a serpentine miter holds up a cup with the sacramental potion. He is attended by a priestess in white and a negress who brings in a paten holding a toad offering an egg-shaped host. Below, standing in the swamp beside the platform, an unholy priest with a snout and spidery fingers reads from a black book to a pair of hybrid companions. The perverse and sterile teaching of this false pig-minister is made even more repulsive by the bloody skeleton and viscera of his body, visible through a rip in his vestment.

The satanic communion is joined on the left by Saturn's band of vile earthlings led by a hog carrying a lute and an old man on crutches with a hurdy-gurdy, musical instruments that excite human passions. Behind them follows a mob of disgusting hybrid forms representing the peasant classes armed for battle marching fanatically to their church. To the far right the nobility, also depicted as hybrid types wearing archaic Burgundian costumes, pay no attention for they care not what happens to the church so long as they can enjoy the hunt and the banquet. They are mounted on steeds turned into ceramic ware and rodents.

The dandy with his back to the viewer has already been transformed into a butterfly with a clover head, while the queen mother of this sterile clan has an ashen face peering from a rotted tree-body placed sidesaddle on a rat. Her arms have withered into dead branches that cuddle her offspring, a dead child, to her cold, barren bosom. Every type of depravity and corruption known in Bosch's society has thus joined the church of the Black Mass, and behind them their villages are plundered and razed to the ground like Sodom. Perhaps the predominance of fire here also refers to the sufferers of Saint Anthony's Fire, the disease caused by ergotism that devastated Europe and for which the Antonine hospitals were the only refuge.

Through it all Anthony perseveres; in fact, he does not seem part of the hellish activity at all. This illustrates the triumph of the saint—to which Grünewald alluded in his terrifying scene of the temptation in the *Isenheim Altarpiece* (colorplate 55). Anthony looks up, disregarding his hallucinatory nightmares, and confronts the viewer directly. With his right hand he makes the gesture of benediction while at the same time directing our vision to the minuscule figure of Christ standing beside a crucifix on the altar of the darkened inner chapel.

Much recent scholarship on Bosch has been devoted to the diabolic threesome of alchemy, astrology, and witchcraft, and for good reasons.[77] As mentioned above, Bosch

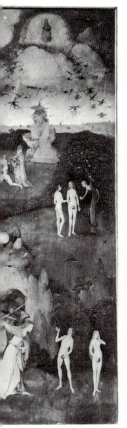
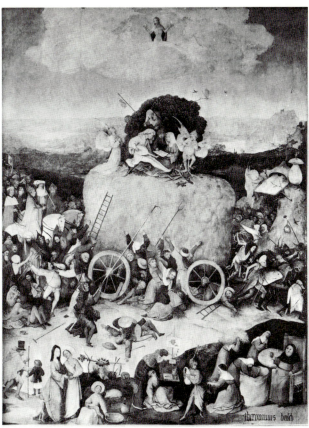

left: 203. HIERONYMUS BOSCH. *Triptych of the Haywain*. c. 1500–1505. Panel, 53⅛ × 39⅜″ (center); 53⅛ × 17¾″ (each wing). The Prado, Madrid

below: 204. HIERONYMUS BOSCH. *Triptych of the Haywain* (detail of fig. 203)

would have known the science of alchemy intimately through his in-laws, who were wealthy pharmacists, and the host of forms resembling apparatus in their practice—retorts, ovens, bowls, flasks, egg-vessels, distillation tubes, stills, furnaces, etc.—are commonplace objects underlying many of Bosch's inventions. Also, the chemical theories of generation and multiplication of hybrid forms, of putrification and purification of the basic elements in nature, would seem to account for the strange transmutations that spontaneously emerge in his landscapes. In turn, these elemental animal, mineral, and vegetal substances and the ensuing humors they effect were linked directly to planetary influences, in the case of Saint Anthony, to Saturn, the child of the dark earth: melancholic, crippled, and evil. It is no surprise, therefore, that his people and their activities are those governed by the children of the planets. The Black Mass, the potions and incense, the demons and witches that administer them, and the hellish sabbaths that follow, are reminders of the perversions of witchcraft.

The paintings described by Sigüenza as macaronic (an Italian word meaning a burlesque composition of mixed, confused hybrid terms) were so named after a popular genre of literature inspired by an Italian, Teofilo Folengo under the pen name Merlin Cocajo, who was a forerunner of the Cordovan poet Don Luis de Góngora (1561–1627). Gongorism, the style expounded by the Cordovan writer and his circle, was an unusual and bizzare form

that featured a mixture of obscure languages, often Latinized, displaying an extravagant use of abstruse idiomatic phrases and verbal images that could be understood by those within the *cultos* of the new literature. Because of the many cryptic references and symbols, concrete meanings were veiled beneath illusive ideas, and because of this obscurity, Sigüenza compared Bosch to Folengo, "not because he knew him, but because he was inspired by the very same thoughts and motives."

The first example discussed by Sigüenza is the *Triptych of the Haywain* (figs. 203, 204), which belonged to Philip II and today, like many others, is in the Prado (a replica is at the Escorial). In many respects this work, and many

others in the macaronic category, are very personal interpretations of the traditional Last Judgment programs, a theme that Bosch also treated in a more conventional manner (copies in Bruges, Vienna, and Munich). When the side panels of the triptych are closed, we see a representation of the tramp or *Landloper*, somewhat simplified compared to the Rotterdam tondo discussed earlier. In this context, the pilgrimage of Everyman stumbling hopelessly through life is a fitting prelude to the program on the interior. The left panel of most Last Judgment triptychs displays the return of the blessed to paradise, either in the form of the Garden of Eden restored or the New Heaven of the church in the form of a cathedral. Bosch represents Eden, but it is not the goal of the elect; rather, it is the original setting where Adam and Eve sinned and were cast out.

In the right panel hell is presented as a burning, parched plateau in reds, yellows, and russet-tans, with the black silhouettes of smoldering towers on the horizon. In place of a fiery pit, the second feature of hell's terrain in most representations, Bosch paints a huge round tower under construction perhaps, as Sigüenza tells us, because there were not enough chambers for the vast numbers of sinners entering hell, and "the stones that are raised in the construction . . . are the souls of the miserable damned here transformed into instruments of their own punishment." At the base of the tower, a crowd of figures and composite creatures proceeds from the central panel as they pull the wagon of hay into the gateway of hell on the far right.

The deadly sins are catalogued in the central panel, the *Haywain*, although there is no systematic ordering of evil deeds and no personifications. The dominating motif is a hay wagon, a familiar sight in any countryside setting, but here the commonplace becomes a biting metaphor on the vanities and greed of all men as familiarized in the proverb "All the world is a haystack and each man plucks from it what he can."[78] Rather than cattle pulling the wagon, which is headed, as we noted, straight for hell, we find a ghastly assortment of mutations, a tree-man, a fish-man, mouse-men, and bat-men, all of whom are, as Sigüenza informs us, "symbols and embodiments of pride, lust, avarice, ambition, bestiality, tyranny, instinct, and brutality." Furthermore, in Netherlandish folklore "hay" was often a symbol of the transient nature of the delights of the flesh and the brief endurance of earthly possessions acquired by greed. Hay then represents the material riches of the world, here heaped high in a pile that moves, and everyone grabs what he can.

The ride of the hay wagon is, in fact, the image of a continuing Last Judgment, where man himself is the judge. Far above the wagon, in the clouds, Christ as judge appears as a tiny Man of Sorrows whom no one

205. Hieronymus Bosch. *Garden of Earthly Delights* (exterior panels of colorplate 35)

sees or hears ("They have eyes, but cannot see; they have ears, but cannot hear"—cf. Luke 10: 24) save one small angel who kneels atop the haywain. His role as intercessor is clearly futile. Below the wagon a pandemonium of *ira*, *invidia*, and *avaritia* takes place with acts of violence and deception scattered everywhere.

And now let us return to the *chef d'oeuvre*, the *Garden of Earthly Delights* (colorplate 35). The giant triptych is in many respects a lexicon of Bosch's personal symbolic language and a *summa* of his lore. The problem is: Who can decipher the symbols and read the stories? For the most part, the *Garden of Earthly Delights* has been described as a polemic against the weaknesses of mankind and its inevitable fate in hell, and the countless eye-catching details and illusive symbols are summarized as surrealistic images of man's insatiable lust and gluttony.

In recent years, however, two solutions to the iconography have precipitated from the murky data. On the one hand, those who see the message of Bosch as a fiery sermon on and condemnation of perdition have gone through the panels explaining every detail as negative and evil, with the result that the sweet beauty of much of the altarpiece appears to be only a trap in a carnival of Satan to deceive us. Conversely, others have turned to astrol-

ogy, alchemy, and witchcraft for solutions that are positive programs of the restoration of man's humors to a natural balance after the Fall in Eden or through his acceptance of strange, heretical beliefs as the only means for salvation. Wilhelm Fraenger, the spokesman for the latter argument, sees the triptych as a glorification of the teachings of the heretical Adamite sect in the Netherlands that called for the return of man to the state of free love in nature as it was in the original Garden of Eden.[79] Thus, for Fraenger, the garden of earthly delights depicted in the central panel illustrated the return to paradise after the millennium, which was considered imminent by almost everyone in Bosch's day.

Fraenger's positive reading was then qualified by others who emphasized astrological symbolism, usually basically lunar or saturnine, for essentially the same state of redemption. In a recent study, Laurinda Dixon has explained it all under the umbrella of alchemy in the clear references to the fanciful apparatus, animal-mineral-vegetal forms, of the chemist's laboratory and in their secrets of creation and restoration of life and health.[80]

The complex program can be deciphered in part if we first examine it along more traditional lines. As a triptych it resembles the altarpieces of the Last Judgment that appear in such abundance during the fifteenth century. But rather than presenting us with a single moment in Christian history, it, in fact, illustrates four. It begins when the triptych is closed. On the exterior, painted in green-gray grisaille on a dark nebulous background, is a giant transparent sphere that represents the earth (fig. 205). Within the orb is a plateau encircled by waters, just as the earth would appear on the third day of creation with the separation of light and darkness, land and water, and the first signs of organic growth, trees and plants.

The final acts of creation—fishes, fowl, animals, and man—appear on the left wing when the panels are opened. But all is not idyllic even at this early moment in the Lord's creation. Along the shores of the plateau strange malformed rocks and flora can be discerned, almost secretly emerging and sprouting about the peaceful landscape. In the upper corner the tiny form of the Creator appears in the dark umbra surrounding the globe, and inscriptions from Psalm 33 accompany the Lord: "He spoke, and it came to be; he commanded, and it stood forth."

According to commentaries of Saint Augustine on these verses, we are told that bitter thoughts against God are stored within man like the salty waters that corrode the shores of the earth as if it were in a bottle. Augustine's writings were well known, especially in the monastic schools of the Brethren of the Common Life in 's Hertogenbosch, and very likely Bosch's hybrid forms

on the third day are the corrosive elements in this innocent new world, dooming it already on the third day. This, then, is the first portent of the apocalypse.

When opened, the misty gray world of the third day changes into a resplendent panorama of bright colors—reds, greens, yellows, and variegated hues—floating across warm fields under fresh blue skies in the left and central panels, and then turning to sinister scorched scarlets and ochers in the sulphurous cityscape exploding and burning at night, its flashes and bursts spotlighting the myriad of weird forms and shapes scattered in the devastated terrain. The basic elements of the continuous landscape are repeated in each panel. On the horizon, mountainous earthen shapes on the left become metallic and crystalline forms in the center and ruinous towers and buildings on the right. In all three there is a central pond, lake, or swamp, each with a dominant fountain or vertical figure in its midst. But the seasons change. From left to right, our eyes move across an overripe springtime jungle, through a hot, sensuous summer park, to a dark, freezing winter wasteland on the right.

Eden, a luscious expanse of trees, waters, and hills with animals galore, forms the setting not for the Fall of Adam and Eve as usual, but for their marriage. The Creator, in the form of Christ, checks the pulse of the newly formed Eve with his left hand and places his right foot under Adam's as if to ensure that the divine spark of life flows into her form. Eve has just awakened; Adam sits erect eagerly anticipating the arrival of his new companion. Thus it is the union of Adam and Eve, not their transgression, that is the true subject, which is the conjunction of opposites, male and female, in the first act of alchemistic creation. That this is a sexual union is stated explicitly in the postures of the two nudes. But all is not love and peace in the garden. A cat carries off a mouse, two exotic birds squabble over a dead frog, a toad-bird swallows down another, a duck-billed fish confronts a unicorn-fish, etc.

In the lake in the center rises an elaborate fountain of life shaped like an inverted crab (a lunar sign?) with colorful plastic-like appendages from which four streams of water (the four rivers of Paradise) spout. Its base is a pink disk with an oculus in which an owl perches. The traditional medieval meaning of the owl as the bird of perverted wisdom that sees only in the darkness suggests that its presence here, in the very center of the panel, is an evil not a favorable omen.

Swimming in the lake are numerous varieties of water birds. An odd assortment of hybrid amphibians, including the three-headed emoris, creep out of the water on the banks to the right, and, to the far left, deer, horses, and a unicorn water along the shore. In the rolling fields beyond are many more exotic animals including a giraffe,

a remarkably lifelike elephant, a porcupine, a two-legged dog, etc. Ominous touches appear here too. A boar attacks a giant lizard, a lion feeds on a downed gazelle while black birds swarm about to feed on the carcass. This is not God's "peaceful kingdom."

Further in the distance, to the left, a strange house-shaped mountain formation and egg-shaped chambers rise while black and white birds circle uniformly in and out of the apertures as if engaged in some instinctive mating ritual. The hybrid mountain has been likened to the stone furnaces of the alchemists in which foul gases (blackbirds?) are transformed into cleansed vapors (white birds?) in a process of distillation. Three more such mixed mineral shapes appear in the bluish zone of the far horizon, the one to the extreme right resembling two giant grinding stones or millstones conjoined, suggesting that these curious land formations are meant to represent the generative organs of nature.

It should be noted that just behind Eve, a model of Netherlandish beauty with her strawberry-blond tresses cascading down her slim nude body, a rabbit sits motionless not yet having found its mate. Bosch thus presents us with an overripe Eden in all its splendor on the very eve of the sin of the first parents. Soon, very soon, Adam and Eve will be thrust from this paradise of springtime into the cruel world outside, where Eve will bear her children in pain and Adam will forever labor.

But all is not labor and pain in the next panel, the centerpiece of the triptych, where a frivolous and joyous carnival of the senses unfolds before our eyes. These young people, all about the same age, are the descendants of Adam and Eve, and the message, once again, is apocalyptic in a little-known theme that sometimes appears in prints of the sixteenth century entitled "Thus it was in the days of Noah" (*sicut erat in diebus Noe*), following Biblical and exegetical references to the condemnation of the unchaste and lustful behavior of Adam and Eve's generations in the days before the great flood. "And God said to Noah, 'I have determined to make an end of all flesh; for the earth is filled with violence through them; behold, I will destroy them with the earth'" (Genesis 6: 11–13), and in Matthew's account of the Last Judgment (24: 36–39) where Christ announces, "But of that day and hour no one knows, not even the angels of heaven, nor the Son, but the Father only. As were the days of Noah, so will be the coming of the Son of man. For as in those days before the flood they were eating and drinking, . . . until the day when Noah entered the ark, and they did not know until the flood came and swept them all away, so will be the coming of the Son of man."[81]

For Sigüenza the title of the painting was the *Strawberry Plant* since it evokes an image of the "vanity and glory and the passing taste of strawberries or the straw-berry plant and its pleasant odor that is hardly remembered once it has passed." Indeed, strawberries, along with numerous other seedy, succulent fruits—grapes, cherries, pomegranates, etc.—abound. In the immediate foreground one nude male voraciously bites into a huge strawberry; in a giant pomegranate a pair of lovers float by in the pond; another veined fruit of round shape in the lower left is the fragile chamber of a threesome, described by some scholars as homosexuals; and other couples cavort within huge transparent pods or snuggle inside oversized mussels. Numerous nudes tease or are teased by birds and animals with cherries and other tasty fruits.

That Bosch had the descendants of Adam and Eve in the days of Noah specifically in mind is suggested by the six figures standing attentively in the lower left corner with their backs turned to the others. They are new initiates to the order (compare the similar group on the far right), being instructed by a guide who emphatically gestures upward out of the picture to the figures of Adam and Eve in the left panel, their distant ancestors.

The landscape is divided roughly into three zones. The participants react accordingly as we step back into space from the chaos in the foreground, the frenzied cavalcade around the circular pond in the center, and the relaxed communal activities in the distance where the Fountain of Life rises between four gaily colored floral mountains.

All in the prime of life, the revelers resemble tiny ivory figurines disporting themselves in acrobatic poses across the bright colors and soft pastel hues of the meadows merging with it to form an ornate pattern like the mille-fleur tapestries so popular in the courts of Europe. Not surprisingly, Bosch's triptych was copied in a tapestry (Escorial) perhaps for the decoration of a banqueting or festival hall of the emperor. Enhancing the decorative colors are the playful antics of the participants. They engage in all sorts of amorous activities, dancing, swimming, and resting here and there in the spongy grounds and ponds inhabited by huge birds and teeming with oversize fruits. Only the owl, if you can find him, remains scowling and forlorn in the hot summer sun.

The second zone of the landscape, that of the circular pond, is devoted to the initial stage of courtship. Proud, excited males ride and perform crazy acrobatic acts on the backs of wild animals, described so vividly by Sigüenza, as if in some gigantic circus merry-go-round. The young men clearly show off their virility and skills while driven by their animal instincts, literally illustrated in the unbridled beasts that prance and strut about the maidens waiting in the pond, some hardly able to contain themselves.

A curious intrusion in the hectic afternoon pastime appears in the lower right corner (fig. 206). Four young people stand about a man who, considering his gesture,

206. HIERONYMUS BOSCH. *Garden of Earthly Delights* (detail of colorplate 35)

207. HIERONYMUS BOSCH. *Garden of Earthly Delights* (detail of colorplate 35)

seems to be instructing them. They are very likely new initiates, as were their counterparts to the far left, but unlike all other participants in the garden, they are differentiated as to type, four types to be exact, which very likely represent the four humors or temperaments that upset the balanced and harmonious constitution of Adam and Eve after the Fall.

Behind them, in the bottom corner, is a mysterious group of figures, bust length, glancing out from an underground cave masked by two crystalline pillars resembling test tubes. A nude female leans on one elbow at the mouth of the cave and clutches a bitten fruit—an apple?—in her right hand. Behind her stands a male in a hair shirt pointing toward her shoulder, while the face of a third figure is barely visible over his right shoulder. Fraenger, cited above, identified the couple within the grotto as the grand master of the Adamite sect of the Brethren and Sisters of the Free Spirit and his wife on the day of their wedding in the "Cave of Pythagoras," the womb of the eternal mother.[82]

The man in the cave should be identified as Adam, the resting woman is surely Eve, and Bosch, by way of introduction here, tells us that the first couple, Adam and Eve, who violated the instructions given them in the original Garden of Eden, now realize that their descendants in the "days of Noah" repeat their transgressions and that they too, unknowingly on the eve of the great flood, will suffer another such fate.

The final period of this historical progression in the degradation of the world is that of Bosch's own day represented in the horrifying finale on the right wing of the triptych. Eves of judgment and damnation are the links that connect the four paintings, and the final apocalypse is exploding in the contemporary urban world of the Renaissance. In time, we have moved from springtime to winter, and in place, from a primeval garden to an urban ghetto.

In Bosch's panel of hell, the vices that dominated man's nature from the very beginning now turn violently against him, and he is forced forever to experience his earthly delights for what they really are. The refreshing gardens of heaven have changed into the dark infernal chambers of Tartarus. Joys are now punishments. Virility and youth give way to sterility and decay. In a hellish winter setting, the temperatures are extreme, ranging from frigid ponds of ice, the sterility of man's desires, to parched buildings burning beyond, the gruesome agony and hysteria that follow. The ravished city on the horizon is an image of Sodom, the infamous capital that suffered God's wrath for the unholy conduct of its citizens, a city that represented perverted love in the Middle Ages.

And now the ponds in hell are dominated by two grotesque creatures, the frightening Satan the Devourer and the Tree-Man of death (fig. 207). The Tree-Man, the counterpart of the *fons vitae* and the "marriage chamber," the crucibles of all life, is now caught fast in the

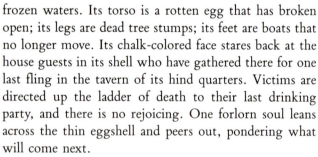

208. HIERONYMUS BOSCH. *Inferno* and *Fall of the Damned.*
c. 1500–1505. Panel, each 34¼ × 15¾″.
Palazzo Ducale, Venice

209. HIERONYMUS BOSCH. *Terrestrial Paradise* and the *Ascent into
the Celestial Paradise.* c. 1500–1505. Panel, each 34¼ × 15¾″.
Palazzo Ducale, Venice

frozen waters. Its torso is a rotten egg that has broken open; its legs are dead tree stumps; its feet are boats that no longer move. Its chalk-colored face stares back at the house guests in its shell who have gathered there for one last fling in the tavern of its hind quarters. Victims are directed up the ladder of death to their last drinking party, and there is no rejoicing. One forlorn soul leans across the thin eggshell and peers out, pondering what will come next.

In German folklore, this is the "tavern of lost souls." The strange headgear, a red bagpipe on a disk, is a barren ballroom where the sinners with ugly demons for partners perform a slow rondo in this, their last dance. The bagpipe squeals its sensuous melodies, and below on the banks it is joined by an assortment of other lustful musical instruments—hurdy-gurdy, lute, and drum—adding to the cacophonous quartet under the direction of a squat demonic conductor. The gay melody has become a wedding dirge for our lovers, and the musicians are literally crucified on their instruments.

Replacing Christ the Creator in the left panel is Satan the Devourer, a wicked bird-beaked frog who wears the pot of gluttony for a crown as he gobbles down his prey. His appetite is voracious and unending, his digestion is

rapid and continuous, and the sinners he consumes experience a disgusting union in his excrement. Mechthild of Magdeburg describes him as the greedy devourer in "whose bowels the sinners receive their just rewards and celebrate a weird marriage."

What was the purpose of the triptych and who was the patron? We are accustomed to regard the triptych format, with moveable wings that provide a cover for the centerpiece, to be characteristic of church altarpieces, and, to be sure, it is. There is good evidence, however, to believe that the *Garden of Earthly Delights* was different, that it was commissioned by a secular member of the aristocracy and not a religious body, orthodox or heretical. A number of documents, recently published, attest to this.

By 1517 (Bosch died in 1516) the triptych was known to be hanging in the hotel of the House of Nassau in Brussels, where it was briefly described by a visitor that year, one Antonio de Beatis.[83] It was still there in 1566, when it was copied for Antoine Perrenot, cardinal de Granvelle, to serve as a model for tapestries, one of which still hangs in the Escorial. It seems, therefore, that the triptych was part of the original decorative program for the hotel, perhaps for the state room, and very likely

commissioned by Hendrik III of Nassau, who built the palace.

Another such painting, *sicut erat in diebus Noe*, was in the palace of the grand duke Ernst of Austria in Brussels, and a copy of the *Garden of Earthly Delights* in tapestry was owned by Francis I, king of France. Hendrik's possessions passed into the collection of William the Silent and were later confiscated by Don Fernando of Toledo in 1568 and taken to Spain, eventually to pass into the royal collection of Philip II. As a secular commission, the *Garden of Earthly Delights*, rather than serving as a holy shrine for pious devotion, was a showpiece for intellectual discussions and a novelty for guests at the palace. In that respect, it belongs to the new domain of the private *Kunstkammer*, or museum, and not the world of the church.

In Bosch's *Garden* no one returns to paradise; indeed, there is no heaven. But we must not leave our painter on such a pessimistic note. Very likely as part of the new Antwerp trade in art, to be discussed below, four panels by Bosch came to rest in the famous collection of the Venetian Cardinal Grimani, where they are recorded in 1521: the *Fall of the Damned*, the *Inferno*, the *Terrestrial Paradise*, and the *Ascent into the Celestial Paradise* (figs. 208, 209). The subject matter of the first three panels is familiar enough in Last Judgment iconography, but the *Ascent into the Celestial Paradise* is unprecedented. After purification in the earthly garden of the third panel, the souls ascend to the glorified realm of heavenly paradise. Freed of all earthly contamination, they float slowly upward, guided by gentle angels, through the darkness to a glowing funnel of light. As the redeemed enter the long tunnel of divine light, the angels depart and they are on their own.

This vision of heaven is a most unusual departure from earlier representations and was no doubt inspired by mystical writings and not scripture. For the mystics, heaven was Light and the Unknown, and the ascent was the dissolving of one's ego into the oneness of God. The image of the tunnel also stems from mystical descriptions. The source of All is pure light, pure color, here a golden glow that filters down as if seen from the bottom of a deep, dark well, the earth. Bosch paints this resplendent source as a blinding brightness, the *coelum empyreum* or flaming heaven, that Heinrich Suso vividly described as nine circles of heavenly light following the hieratic divisions set forth in mystical treatises of Early Christian theologians such as Dionysius the Areopagite (*Celestial Hierarchies*).

The same imagery is found in the literature of the Brethren of the Common Life, and perhaps Bosch was inspired by one of its foremost spokesmen, Jan van Ruysbroeck, who related how the radiance of God irresistibly draws up the elect as a "supreme invocation, an appeal that calls to us from the depths of the chasm and says, 'Come,' like some immense effusion of essential light which encircles and attracts us" (*De ornatu spiritalium nuptiarum* [*Ornament of Spiritual Marriage*]). The *Ascent into the Celestial Paradise* is one of the most awesome and poetic representations of this mystical return to the One, the Source, the Light, ever created in paint.

Diversity Along the Rhine

STEPHAN LOCHNER

Stephan Lochner left his home, Meersburg on Lake Constance, sometime around 1430 and settled in Cologne, where he found the style of the Master of Saint Veronica wholly compatible with his temperament.[84] In many respects, Lochner brought the earlier master's mystic style to its most sublime climax. It is not surprising, therefore, that he has been called the Fra Angelico of the North, since the quietism and enchantment of a world of pure color, characteristic of the painter of the San Marco frescoes in Florence, evoke a similar spiritual content in Lochner's colorful paintings.

Little is known concerning Lochner's activity in Cologne other than he must have been the leading city painter by 1440 and that he merited an appointment to city councillor, representing the guild of the painters, in 1447 and again in 1450. Lochner signed none of his works, but one major commission, the altarpiece for the chapel of the city council in the cathedral, is secure. Albrecht Dürer, on his trip down the Rhine to the Netherlands in 1520, relates in his diary how he paid to see the "panel which was painted by Master Stephan in Cologne." Much later, in 1816, Goethe highly praised the altarpiece in his essay *Über Kunst und Altertum in den Rhein- und Main-Gegenden* (*On Art and Antiquity in the Region of the Rhine and Main*), remarking on its sublime mystical content and comparing it to works of Jan van Eyck that he had seen. Interestingly, he further noted that its composition was Byzantine in character but that Lochner had observed nature more directly.

The huge altarpiece, known as *Das Dombild*, is the fa-

210. STEPHAN LOCHNER. *Das Dombild* (*Adoration of the Magi Triptych*). 1442–45.
Panel, 7' 9¾" × 8' 7½" (center); 7' 8⅛" × 3' 10½" (each wing). Cathedral, Cologne

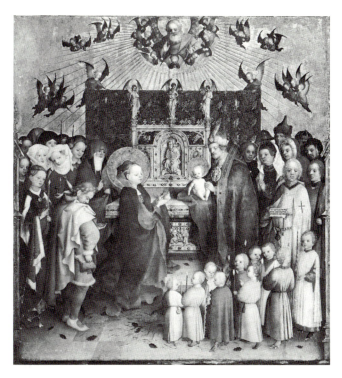

211. STEPHAN LOCHNER. *Presentation in the Temple.* 1447. Panel, 54¾ × 49⅝″. Hessisches Landesmuseum, Darmstadt

mous triptych of the three Magi (fig. 210), still in the cathedral today. An example of his mature style, it is to be dated between 1442 and 1445. The central panel displays a majestic burst of colors with the three Magi and their retinue placed symmetrically about the enthroned Madonna and Child. The wings present two of the foremost saints of Cologne, Saint Ursula and her company of virgins on the left, Saint Gereon and his companions on the right. The most valued relics in Cologne were those of the three Magi, brought there from Milan in the twelfth century, those of Saint Ursula, who suffered martyrdom in Cologne in the third century, and those of Gereon, the patron saint of Cologne. Hence, Lochner's great altarpiece was a commemoration of the most famous relics of the city, appropriate for the chapel of the city council.

Many features of Lochner's style bring to mind those of the Veronica Master. The doll-like figures of the Child, the angels, the young virgins accompanying Ursula, and the younger courtiers with the Magi are much like those of the Veronica Master and his followers. Their small heads display the same sweet features, but Lochner's figures have more bulk and rotundity and are modeled with more attention given to intricate drapery folds that are, however, rendered in pure colors, the deeper pockets simply painted in more saturated hues of the same color.

The Madonna, slightly larger in scale than the other figures, is the ultimate refinement of the Veronica Master's ideal female types. Her head is nearly a perfect cir-

cle, her eyes are almost closed, her expression is one of serene quietism and meditation. A green grassy stage serves as the setting for the compact frieze of figures, but it is obvious that Lochner was not concerned with mapping out space or depth; the figures to the sides of the Madonna are aligned in tight rows, and the background is the familiar golden sky of Cologne painting. Behind the Madonna tiny wispy angels in blue hold an azure and gold brocaded cloth of honor.

Of special interest is Lochner's palette. Avoiding the intense local colors of the Flemish painters, he employed four basic colors for his harmonies: the primary hues of red, blue, yellow (or gold), and the secondary color, green, for the earthly setting. But these pigments are subdued and toned down with deeper hues of the same color added to indicate shading, a technique sometimes referred to as "pure color." The application of paint is supple and smooth, so much so that many of his figures have a pearly and iridescent finish that makes them resemble ivory figurines. Secondary details, such as Mary's crown, the gifts offered by the Magi, and the sword hilts, are rendered with the exacting detail of Van Eyck, although they are more opaque. A golden radiance filters through and around all of his figures and objects.

One of Lochner's later paintings, dated 1447, the *Presentation in the Temple* (fig. 211) was commissioned by the Knights of the Teutonic Order for their church, Saint Catherine's in Cologne. The *Presentation* was the central panel of a triptych which has been reconstructed with an *Annunciation* on the left wing, an enthroned Christ and Mary (*Coronation*) on the right. The Presentation (or Purification) was a popular scene in the Infancy cycle, but Lochner has gone far beyond any earlier interpretation of the event by combining the narrative account in the Bible with the pageantry of the actual Festival of Lights, Candlemas, as it is known in the church, a theme that would naturally appeal to the painter.

The Feast of the Presentation and Purification was celebrated on February 2. At that time, following Jewish custom, forty days after the birth of a child, the mother was to present her newborn in the temple and be herself redeemed of all sins. According to the account in the Gospel of Saint Luke (2: 22–39), the aged Simeon, a man "righteous and devout," who had been consoled by God that he should not die before he had seen the Lord's Anointed One, took the Child of Mary in his arms and declared him to be the "light of the world." Also present were the maid who presented the two pigeons or turtledoves for sacrifice and the aged prophetess Anna, who also gave thanks to the Lord for the redemption of Israel.

Mary, Joseph, Simeon, Anna, and the handmaid are usually the only figures included in scenes of the Presen-

tation, but here Lochner has added throngs of people. Female churchgoers appear to the left, males to the right, including the prominent figure of a Teutonic knight standing frontally and carrying a scroll upon which the date of the painting is inscribed. From right to left, across the forestage of the temple, is a procession of young choirboys, all carrying candles, with the smallest in the center ranging upward to the older boys to the right in a charming procession that must have been familiar to Lochner's contemporaries. Mary herself offers the two doves at the altar; Joseph, behind her, reaches in his purse for coins to add to the offering; and Simeon, here shown as blind, receives the Child as he is about to be illuminated and witness the divinity of Christ. The elderly woman, dressed as a nun directly behind Mary, is undoubtedly the prophetess Anna.

The elaborate altar upon which Simeon holds the Child has a golden retable with a relief of Moses, the giver of the law in the Old Testament, holding the tablets as a prefiguration of Christ, the giver of the law under Grace. Below, on a golden antependium, the depiction of the Sacrifice of Isaac is presented, the prototype for the sacrifice of Christ in the Eucharistic service in the Christian church. Above the altar, within an aureole of tiny angels, appears the Lord sending down his blessing, while against the bright gold ground little angels in blue flutter in adoration of Mary and her Child.

After the ceremonies were completed, the blessing of the candles—the "lights"—took place, and following the presentation of the candles to the clergy and laity, there was a solemn procession of the candles out of the church. Here again we encounter the wonderful fairytale world of Stephan Lochner, a world distilled in color and held within a strict symmetry that is broken only by the echelon of the tiny choirboys. Here too Lochner's colors take on a special iconographic significance. Pure color signified pure light; the bright light of his pigments thus is likened to the spiritual brightness that pervades the Festival of Lights.

Lochner's masterpiece is the small *Madonna in the Rose Garden* in Cologne (colorplate 37). The mystical content of his art can nowhere be better seen than in this late painting. The theme, a very popular one in the Rhineland, is perfected here and expresses better than any others the sentiments of a community steeped in mystical devotion. The mysticism of the Rhine was derived in part from the teachings of Eckhardt, Tauler, Suso, and others who wrote and preached of the denial of self, of ego, of the "I and Me," for a complete absorption of one's being in the oneness of God, an exercise likened unto the "flight of the one to the unknown" or, more frequently, to the "light of pure being."

How beautifully Lochner's *Madonna in the Rose Garden*

presents this world of self-denial and quiet contemplation of things divine! While tiny angels sing and play about the Madonna and Child, their music does not disturb the absolute quietism of the colorful little rose garden with its delicate arbor of white and red flowers seen, once again, against a radiant golden background. This is the still and purified world of Mary and her Child, and two angels in the top corners have lifted red curtains aside so that we are invited to contemplate the heavenly scene. Once again Lochner has employed stylistic and formal devices to ensure the serenity of the vision. The softly modeled draperies are rendered in pure color, reds, yellows, and blues, and the delicate objects are organized with the absolute symmetry that we have come to associate with Lochner and his insistence on stillness and timelessness.

Mary wears a brooch incrustated with gems and decorated with a golden relief of a unicorn resting in the lap of a maiden, a familiar image of purity and virginity, and on her head she wears a splendid crown of pearls and roses, anticipating the later *Rosenkranz*, or Rosary crown, that distinguishes her as the Queen of Heaven. Above, God the Father appears within a circle of countless little angels with only their round heads discernible as if they were petals of some beautiful flower. The Dove of the Holy Ghost descends to Mary not only to bless her, but also to complete the image of the Trinity—the Father, the Son, and the Holy Ghost—in this ethereal setting.

We have seen how Lochner's use of pure color and absolute symmetry served as stylistic means for capturing the aura of these hushed worlds, but here another stylistic feature appears that not only adds to the tranquility of the image but actually induces a hypnotic trance in the viewer. As mentioned above, Lochner reduced many forms, especially heads, to circles. Here the circle assumes a major formal role in the composition. In the real space of the garden the angels are placed about Mary in a loose circle that seems to revolve slowly. This quiet rotation is then repeated in the Virgin and the Child. The infant holds up a round apple; his head is a perfect circle within another perfect circle, his halo. A circular brooch is affixed to Mary's mantle between the two, and, above, God the Father appears within a circle. But the center of our focus comes again and again to rest on the lovely face of the Madonna. And here again we have circle within circle, and as our eyes move slowly from the angels to the Child, we are caught up in the hypnotic attraction of the revolving circles around Mary. This formal device may not work for the casual observer, but if one spends time before Lochner's painting, then he will slowly be drawn into empathy with the revolving forms and become quiet and contemplative too.

212. Lucas Moser. *Magdalen Altarpiece* (exterior). 1431. Panel, 10′ × 6′ 6″. Church, Tiefenbronn

LUCAS MOSER

If Lochner's art reflects the mystical sentiments of Cologne and other communities in the Middle Rhine, the works of artists in the Upper Rhine and in the area of Ulm in Swabia, east of Strasbourg and Basel, present a very different temperament. Considered a pioneer in the new realism of the fifteenth century, Lucas Moser presents a perplexing problem for art historians. Too little is known about him and his background. If we can trust an inscription on his major work, the *Magdalen Altarpiece* (fig. 212) in Tiefenbronn (near Pforzheim), then we learn that Moser was a painter from Weil: "Weep, art, weep, yourself deplore. No one loves you anymore. 1431, Lucas Moser, painter from Weil, master of this work, pray to God for him."[85]

Just what the lamentation voiced so passionately means has been an issue of considerable debate. It has been suggested that Moser was referring to the drop in patronage following the Council of Constance (1414–18), but this simply is not true. Possibly it was a personal outcry against the infiltration of new Netherlandish techniques and styles, or a lament directed at his fellow artists, Hans Multscher or Konrad Witz, both of whom broke dramatically with medieval traditions. Or it may simply have been a response to the loss of earlier guild standards. Whatever the answer, it seems that the verse expresses the general sentiment and humility of an artist who is in transition from being a member of a community of guild artisans to one who is gaining independence in a rapidly changing art world.

The *Magdalen Altarpiece* in the parish church of the Magdalen in Tiefenbronn is a strange construction. Four panels form the body of the altarpiece, and the two inner panels swing open to display a sculptured figure of the Magdalen ascending into the heavens (now lost). On the reverse of the wings are standing figures of Martha and Lazarus, considered the sister and brother of Mary Magdalen in the Late Middle Ages. The exterior presents five scenes from the life of the Magdalen, following the account of Voragine in the *Legenda Aurea*. Above, in the gable, Moser depicts the conversion of the Magdalen as she washes Christ's feet at supper.

The four panels across the body of the work illustrate the exile of a group of Christians in Bethany by the pagan infidels. To the left, five figures—Mary Magdalen, Maximinus, Martha, Cedonius, and Lazarus—sit in a toy boat without a rudder in which the pagans had placed them and set them adrift. In the distance the shores of Marseilles in south France appear. Two scenes are superimposed in the central panels. Below, asleep within the porch of what should be a pagan temple, are Cedonius, Maximinus, Martha, and Lazarus. They were refused accommodations by the pagan citizens and forced to take up quarters as best they could. Above, in the bedroom of the ruler and his wife, the Magdalen appears and implores the wife to intervene with her husband to respect the Christians. This, of course, took place, and the pagan temple, later converted into a church, forms the setting for the final episode. After years, Mary retired to the mountains to live as a hermit, dressed only in her hair shirt. When it came time for her to join her Father in heaven, angels miraculously carried her to the church in Marseilles to receive last rites from her old companion, Bishop Maximinus.

In the predella the Man of Sorrows appears between busts of the Five Wise and Five Foolish Virgins, a favorite parable in Germany for the Last Judgment. Here it undoubtedly also refers to the conversion of an archetypal female sinner, the "foolish" Magdalen, to a new life of wisdom of the Lord.

The style of Moser's paintings is difficult to analyze.[86] The gable painting with the washing of the feet is an effective and balanced composition with the four male figures at the table seated before a rose arbor on a deep green ground against a gold background. Moser's figures are well-proportioned, the heads are sharply individualized, and the draperies are treated with much more detail than those of Lochner. Moser also has a keen eye for detail. The sleeping whippet, the still life on the table, and the utensils on the ground to the right are carefully described.

The four compositions below are charming but less successful, probably because the artist had no established tradition to follow for the story. He was keenly aware of the spatial setting, however, and presents a continuous sea- and landscape across the four. This is a relatively new idea in German art, and the meticulous treatment of the setting brings to mind similar effects in the works of Robert Campin. A soft pink tonality, established in the buildings, pervades the altarpiece, and while Moser's painting may strike us as being naive and disjointed, his art clearly represents a totally different world from that of the symmetry, hieratic scale, and pure color of the Cologne school. Moser's figures find themselves in the real world enacting events that happen in specific time and place and not in some supernatural context of timeless abstractions. Moser, like his contemporaries in the Netherlands, turns his eyes directly on nature, and while his perspective may still be in an experimental stage, at least the first attempts are made.

HANS MULTSCHER

Working also at Ulm, where Moser probably spent much of his life, was another revolutionary artist whose style not only continues these same interests in naturalism and direct observation, but also introduces us to another trait frequently found in German painting of the fifteenth century: a dramatic, if not painful, expressionism. Hans Multscher, from Reichenhofen in Allgäu, near the Alps, settled in Ulm by 1427. He established a large shop there, and was entrusted with many major projects for the town council and the Cathedral of Ulm. In the documents he is always listed as a sculptor and a "maker of panels," which probably means he was a contractor for altarpieces. Nowhere is he mentioned as a painter.

The one set of painted panels usually attributed to Multscher, those of the *Wurzach Altarpiece* (now in Berlin), are the inner and outer wings of a large triptych that once featured a sculptured centerpiece, now lost. The inner panels were dedicated to Mary with a *Nativity* and *Adoration of the Magi*, left, and the *Pentecost* and *Dormition*, right. The scenes from the Passion—the *Arrest in the Garden of Gethsemane* and *Christ Before Pilate*, left, the *Carrying of the Cross* and *Resurrection*, right—were on the exterior. The inscription on the frame, "Pray to God for Hans Multscher of Reichenhofen, citizen of Ulm, who has made this work in 1437," implies that the artist executed both the sculpture and the painted panels, but it is ambiguous.

The style of the paintings is unusual. Large figures fill the compositions with a disturbing immediacy; their forms are heavy and bulky and their gestures and expressions are exaggerated and tense and not in the least ideal-

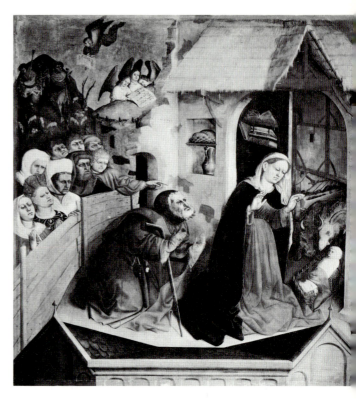

213. HANS MULTSCHER. *Nativity*, from the *Wurzach Altarpiece*. 1437. Panel, 58¼ × 55⅛". Gemäldegalerie, Staatliche Museen, West Berlin

ized. Mary, in the *Nativity* (fig. 213), is a coarse peasant type who stares intently at her Child wrapped in swaddling clothes within the tightly compressed space of a shed. Multscher had little concern for perspective and landscape projection, and, in fact, he places a strong barrier, a wooden fence, behind the Holy Family to keep the onlookers to the left from encroaching on their sacred circle.

Rather than the joyous shepherds who usually peer in from the outside, Multscher cramps two rows of coarse figure types, an evil throng more in keeping with the tormentors in a Passion scene, who seem more resentful than joyous with their snarled lips and piercing stares. Joseph, kneeling behind the Madonna, gestures awkwardly as he regards her with an intense gaze. The touch of landscape in the upper left corner with the shepherds is archaic and merely serves as a barrier behind the grimacing onlookers. Multscher was interested in details such as the loaves of bread and the pitcher in the niche above Joseph, rather coarse symbols of the Eucharist in this context, and he paints them with care, but his real concern lies in the emotion and drama of the event, which he presents in an indecorous and derisive manner. His facial types are nearly caricatures of the vulgar and the ugly, the opposite pole from Stephan Lochner.

In the *Resurrection* (fig. 214), Multscher's heavy style is more effective and powerful. Again he restricts the space by placing a heavy wooden fence about the shallow fore-

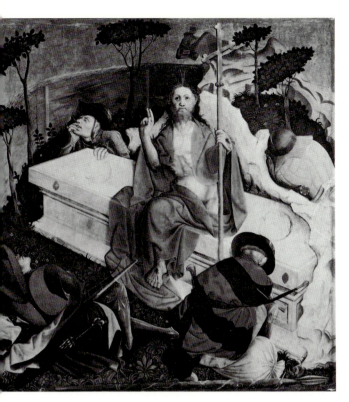

214. HANS MULTSCHER. *Resurrection*, from the *Wurzach Altarpiece*. 1437. Panel, 58¼ × 55⅛". Gemäldegalerie, Staatliche Museen, West Berlin

ground, which is filled with plants, trees, and a rocky ledge executed in the archaic manner of the fourteenth century. Christ is a commanding figure in the center of the composition but his pose is not adequately defined as he seems to be seated on the sarcophagus with his left leg bent under him. His eyes, wide open, stare menacingly toward the upper left, and his huge hands and foot, dripping with blood, emerge from a ponderous mantle that breaks into crisp, angular folds. The four guards, deep in sleep, are disposed as inert, amorphous shapes at each corner. Unlike the mysterious *Resurrection* of the Trébon Master in Prague (see p. 30), there is little that is awesome and mystical about Multscher's frank statement of the miracle.

In his paintings Multscher shows himself as one not prone to idealize or commemorate, but rather he presents the brutal, the ugly, and the vulgar with unflinching directness. The relief-like quality of his big figures, which have no deep space in which to move, and the rather muddy palette employed with dull browns, greens, and somber reds are features that one could well associate with someone who was primarily a sculptor. It is difficult to believe that the lyrical *Magdalen Altarpiece* in Tiefenbronn by Lucas Moser and the harsh *Wurzach Altarpiece* could have been produced within a few years of each other in the same town. Perhaps it was this new style that provoked Moser's lament: ''Weep, art, weep, yourself deplore. No one loves you anymore.''

KONRAD WITZ

From 1431 to 1434 Basel was the hub of religious activity in northern Europe. The Council of Basel held during those years addressed itself primarily to the controversy concerning the ecclesiastical supremacy of the popes over the general councils in determining church doctrine and implementation of reforms. The council itself was something of a failure, but the prestige it brought to Basel through the traffic of cardinals, legates, and lesser church officials was lasting. Among the dignitaries present, whom we have already met, were Cardinal Albergati, whom Van Eyck painted, and Heinrich von Werl, bishop of Cologne, who commissioned an altarpiece from Robert Campin. It was then, too, that Konrad Witz from Rottweil on the Neckar (Swabia) immigrated to Basel, where he established a workshop that soon became famous in the city. He is mentioned in records of the painters' guild (*Himmelzunft*, later Saint Luke's Guild) in 1434, and was accepted as a citizen in 1435. In 1437 Witz married the niece of a leading painter from Tübingen, Niklaus Rausch, with whom he collaborated on mural projects which have unfortunately all but disappeared. Fragments of a *Dance of Death*, painted by Witz on the walls of the Dominican cloister in Basel, are preserved, but they are practically useless in recovering his fresco style.[87]

It is not known where Witz was trained, and much confusion has risen out of arguments that his first teacher was one Hans von Constance, who had worked in Bruges in 1424 and 1426 for Philip the Good, but it now appears that this association is false. Witz died prematurely, possibly of the plague, in 1446, and hence his activity in Basel could hardly span more than twelve years, but from that short period a remarkable number of paintings survive, including those of three major altarpiece commissions. From the beginning, Witz's style is surprisingly original and accomplished, and the problems of determining his background probably will never be fully resolved.

The earliest extant paintings by Witz are those that decorated the *Heilspiegel Altarpiece*, executed about 1435–38. The patron is not known. Some have suggested that it was a gift to the Cloister of Saint Leonhard by the presiding president of the Council of Basel, the cardinal legate Cesarini, who lived there until 1438. More recently it has been linked to Canon Heinrich von Rumersheim of the Seminary of Saint Peter in Basel. Whoever the donor may be, the program of the *Heilspiegel Altarpiece* is a complex Old-New Testament typology that is befitting a learned ecclesiastical authority. The central piece of the huge triptych is missing, but it very likely displayed one or more scenes from the Infancy, including the Adoration

215. KONRAD WITZ. *Synagogue*, from the *Heilspiegel Altarpiece*. c. 1435–38. Canvas on panel, 33⅞ × 31⅞″. Kunstmuseum, Basel

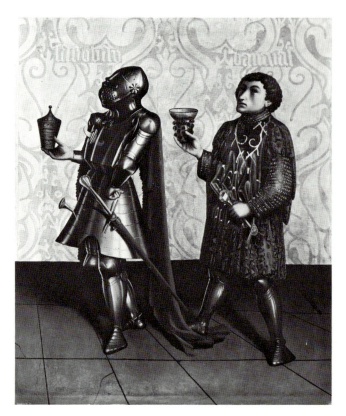

216. KONRAD WITZ. *Sabobai and Benaiah*, from the *Heilspiegel Altarpiece*. c. 1435–38. Canvas on panel, 33⅝ × 31¼″. Kunstmuseum, Basel

of the Magi, for reasons to be explained below. The side wings were divided into four panels, both inside and out, and of the original sixteen paintings, thirteen are preserved, nine of them today in the Kunstmuseum in Basel.

The inside panels are dedicated to important kings of antiquity and the Old Testament. On the left, superimposed in two rows, are Antipater before Caesar, Esther before Ahasuerus, and Augustus and the Tiburtine Sibyl. On the inner right we find the Queen of Sheba before Solomon, Abraham and Melchizedek, and (across two panels) the story of David and the waters from the well in Bethlehem (I Chronicles 11: 17–19) with his generals Abishai, Sabobai, and Benaiah approaching the enthroned David much as the three Magi approach Mary. Iconographically, these royal confrontations suggest that the typology was associated with the Adoration of the Magi. In one of the most popular typological handbooks of the period, the *Speculum humanae salvationis* (see p. 271), two of these are presented as types of the Adoration, the Visit of the Queen of Sheba to Solomon and the story of David and the three heroes fetching the water. The Tiburtine Sibyl and Augustus appear in the *Speculum* with the Nativity.

The exterior, with single standing figures placed in

tight cell boxes, include, across the top of both panels when closed, Ecclesia (church) and Synagoga flanking the Annunciation on two panels (the Virgin Annunciate is missing), and, in the bottom row, standing Church Fathers and saints (only Augustine and Bartholomew are extant). The standing figures on the exterior provide us with excellent examples for studying the basic vocabulary of the artist's style. The figure of *Synagogue* (fig. 215), dressed symbolically in a simple yellow mantle, blindfolded, and carrying the tablets of the Mosaic laws inscribed with fanciful quasi-cuneiform marks, holds the broken lance, symbolic of the defeat of the Synagogue. Witz's figures are short and stocky, and harsh sculptural qualities are achieved by bold modeling with the sharp angular folds of a mantle picked out by a strong light that reduces them to simple shapes.

Physical presence is all important for Witz, not the preciousness of detailed brocades, intricate belts, and brooches. His head types are consistently unattractive. The stereometric head, rather pyramidal in shape, is flattened for the front plane of the face, and the nose appears as a sharp wedge placed on it. Eye sockets are shallow and the mouth is a small slit in the plane of the face. Witz then places this simplified physical form in a tight geometric space box, unadorned, to emphasize its real

presence. Finally, a strong light, here from the right, floods the figure in the box, casting shadows on the floor and back wall and highlighting the ridges of the heavy, angular drapery folds. In order to maintain this simple monumentality, Witz restricts his palette to a few basic colors, here yellow, against a neutral, gray background.

This sober and severe treatment is dramatically illustrated in the two figures of David's heroes, Sabobai and Benaiah, on the interior of the altarpiece (fig. 216). Here the setting is more colorful but no less severe. On a simple stage Witz places his robot-like figures. The same stocky proportions maintain, the same simple silhouettes and awkward gestures describe their mechanical movements. In the figure of Sabobai, Witz proclaims his interest in the physical presence of objects by portraying him as a standing suit of armor—only his hands emerge from the geometric casing formed by the shining metallic volumes of the armor; otherwise the figure is completely anonymous.

An *Annunciation* panel in Nuremberg dates slightly later, about 1440, and may have been part of an altarpiece commissioned for the convent of the Dominican nuns in Basel (fig. 217). Faced with a more traditional subject matter, Witz, however, remained true to his principles of volumetric figures supported by a rational space flooded with light. Mary and Gabriel are the same figures we meet in his other paintings. Here the space box is extended diagonally to emphasize the position of the seated Virgin, and Witz has taken much care to delineate the textures of walls and rafters, which are reduced to basic shapes with only a door handle above Gabriel intruding into the cubic vacuum of the room.

The usual colorful details are missing in this *Annunciation*. There is no *prie-dieu* or bench for Mary; there is no vase of lilies; and, most surprisingly, there is no Dove of the Holy Ghost. One need only compare the *Annunciation* of Witz with those of Robert Campin and Jan van Eyck to appreciate the power of his statement: two physical bodies in a room, nothing more. Only the gestures and the scroll with the inscription in Gabriel's hand remain in his stark interpretation of one of the most colorful, symbolic scenes in Christian art.

The last large-scale commission that Witz contracted was the *Altarpiece of Saint Peter*, requested by the bishop François de Mies for his Chapel of Notre-Dame des Maccabées in the Cathedral of Saint Peter's in Geneva. It is signed and dated in an inscription on the frame: "Hoc opus pinxit magister Conradus sapientis de basilea MCCCCXLIIII [1444]." As in so many commissions, the centerpiece is now lost, but the side panels of the triptych are preserved in the Musée d'Art et d'Histoire in Geneva. The interior displays the Adoration of the Magi on the left wing, the kneeling donor presented by

217. Konrad Witz. *Annunciation*. c. 1440. Panel, 63½ × 51½". Germanisches Nationalmuseum, Nuremberg

Saint Peter to an enthroned Madonna and Child on the right. The reverse sides were dedicated to scenes of Saint Peter: the Miraculous Draught of Fishes and the Calling of Peter on the left, the Freeing of Saint Peter from Prison on the right, this latter scene being possibly a response to the rulings on the primacy of the papacy, founded by Peter, that had so occupied the legates to the Council of Basel ten years earlier.

The masterpiece of the altar is the *Miraculous Draught of Fishes* (colorplate 38). In what has often been described as the first topographical landscape in Northern painting, Witz presents us with a stunning view of the Swiss countryside. The Sea of Galilee, in fact, is Lake Geneva seen in the environs of Mont Blanc with the Petit Salève across the lake and the dark mountain, the Môle, appearing directly over the head of Christ. The episode depicted by Witz actually conflates a number of the accounts of the calling of the apostles and the miraculous draught of fishes. Six figures appear in the boat and all are given halos that mark them as apostles. Peter appears

between the boat and Christ, wading through the quiet waters to greet him. The majestic figure of Christ standing on the surface of shallow waters is seen in profile in a massive bright red mantle. He beckons Peter to join him.

From what we have seen of the artist's concern for space and detail, it would seem that this panoramic landscape is a complete contradiction in his art. Indeed it is so, but as one carefully studies the construction of this view, the basic principles of his style gradually reveal themselves. The landscape is carefully structured. Four horizontal bands mark the steps into space. The first is that of the shoreline with the tongues of the grassy banks on either side dropping off to rocky ledges submerged in a few feet of water. Witz remarkably observes the transparency of the glimmering greenish shore and the refraction of light passing through the water. In the second zone Witz captures the silvery sheen of rippled areas and the translucent shadows of the boat and the men in it. To the right a cluster of stone towers and buildings in echelon firmly closes the composition. The third zone is that of the grassy planes sweeping across the landscape at the foot of the distant hills and mountains.

The details here are tiny, but obviously Witz took delight in activating the space by sprinkling washerwomen along the distant shores, archers and knights cavorting in the meadows, and hidden roadways marked by lines of trees. The final step into space takes us to the solidly structured hills and distant mountain peaks on the horizon. Clouds float slowly across the bright blue sky. Witz thus gives us a landscape whose broader silhouettes echo and support the composition of the figure groups, and while light plays a major role in modeling the individual forms and objects in nature, it is important to note that the artist makes little attempt to suggest the graying effects of atmospheric perspective. Once again, it is as if the figures and their space were seen in a vacuum with unimpeded light firmly marking out their volumes.

Many attempts have been made to link the realism of Witz to that of the Netherlandish masters, but, as we have seen, the realism of this master is of quite a different sort: It is to glorify physical presence and not to encumber his compositions with microscopic details or elaborate them with disguised symbols. Witz stands apart from all other early-fifteenth-century painters.

The Impact of Netherlandish Art on German Painting of the Later Fifteenth Century

The developments of the arts in the German-speaking territories during the course of the fifteenth century have been described and analyzed for the most part in terms of the propensities of the German painters to absorb and assimilate the *ars nova* of the Netherlandish artists. No doubt Netherlandish influence is a foremost factor to be considered, but it is not the only, and the arts of many regions along the Rhine and beyond have intrinsic values and qualities of their own. The major problem here is the vast size of the territories we think of today as Germany. There is no *one* German style, but many. There do appear, however, some rather constant features in both the style and iconography that stamp these arts with a distinctive "Germanic" flavor, and they should be briefly reviewed before turning to the more specific expressions of western, central, and southern German painters.

In terms of style, the following traits are a few that can be described as recurring characteristics of the Rhineland and the east:

Line. Much of German art displays a proclivity for graphic expression over plastic. The "unending melody of Northern line," as Worringer described it, was a constant feature from the arts of the wandering tribes to Holbein and later.[88] Line is one of the basic formal elements of expressionistic art because it is dynamic, it moves the eye, it can be restless, and it makes the heart beat faster. "Dynamic linearism" is one basic feature.

Color. Another stylistic element of expressionism is color. Whether it be the serenity of pure color or the clashing juxtaposition of arbitrary or symbolic colors, the tendency to diminish or embellish the local color of much Netherlandish art creates an aura of unworldliness.

Surface pattern. German artists were quick in mastering the principles of perspective projection, but usually their basic figurative compositions come to the surface, creating an uneasy contradiction between surface pattern and figures in a logical space. Landscape usually appears as a distant backdrop.

Horror vacui. The emphasis on surface pattern often brought with it a desire to fill up every available space with objects or ornamentation. This "fear of empty places" is as old as the pre-Romanesque arts of the Germanic world. Hence many paintings are characterized as being crowded and cramped and lacking in clarity of design.

Iconographically, German art has generally been high-keyed, with emotions expressing the extremities of the poles between which human expression swings: violence and pain versus peace and comfort; ugliness and the grotesque versus beauty and the ideal. The power behind much German imagery results from the artists' abilities to express these extremes in emotions through distortion of the subject matter. With these interests in physical sensation through a style of dynamism and distortion the German artists had little concern or need for the subtleties of disguised symbolism, the intellectual twist to the subject matter perfected by Jan van Eyck. Symbols are, of course, everywhere present, but they are by no means concealed to the extent they are in Flemish art.

These few traits are, to be sure, vague generalizations at best.[89] There are a number of styles in German art, just as there are a number of dialects in their language, and we must more carefully investigate these differences now and not always focus on the similarities. We will begin our journey with a trip down the Rhine, the most productive and prosperous stretch of western Germany.

THE COLOGNE SCHOOL

Painters of the Cologne school of the later fifteenth century were very susceptible to the influences of Netherlandish art, partly due to the geographic proximity of the regions. It is believed that a number of Cologne artists had direct connections with the western territories and that some of them may have been born and trained there. No matter how strongly Flemish influences appear in their art, however, some of the Cologne heritage remains.[90] A good representative of the later Cologne artists is the Master of the Life of Mary (active c. 1460–95), who executed a large altarpiece with eighteen panels illustrating the life of the Virgin commissioned by Doctor

Johann Schwartz-Hirtz for the Church of Saint Ursula in Cologne in 1463.

The *Visitation* (fig. 218) typifies his style with the tall, stately figures of Mary, Elizabeth, and a maid placed sedately in a broad landscape. The composition resembles that of the Leipzig *Visitation* by Rogier van der Weyden with the landscape and figures stretched out from a vertical to a horizontal format. The figures of the Master of the Life of Mary, on the other hand, partake of that quiet immobility that we associate with Dieric Bouts, so much so that they seem hardly to move or breathe. But our master has not completely abandoned his Cologne precursors. The sky is gold, and tiny blue angels, reminding

above: 218. MASTER OF THE LIFE OF MARY. *Visitation.* 1463. Panel, 33½ × 42⅞″. Alte Pinakothek, Munich

right: 219. MASTER OF THE HOLY KINSHIP. *Holy Kinship Altarpiece.* c. 1500. Panel, 55½ × 73¼″. Wallraf-Richartz Museum, Cologne

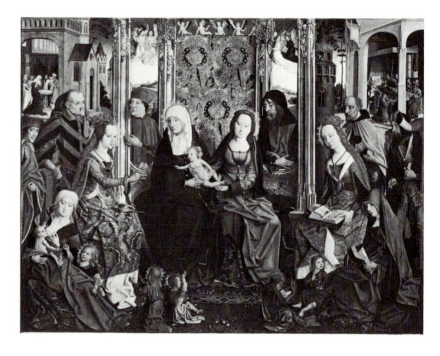

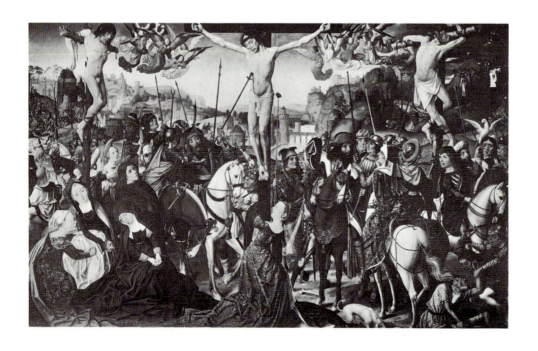

220. MASTER OF THE HOLY KINSHIP. *Crucifixion.* c. 1510. Panel, 52 × 83″. Musées Royaux des Beaux-Arts, Brussels

us of Lochner, fly in a semicircle above the heads of Mary and Elizabeth. The landscape is meticulously rendered with Boutsian coulisses staggered back along a number of winding roads. With the bright sky of gold, there is little focused light to cast shadows, and the sense of atmospheric perspective is minimal except for the bluish hues of the distant mountain peaks. The donor kneels in the lower left corner with his elaborate coat of arms.

The style of the Master of the Life of Mary pervades a number of works by anonymous Cologne painters at the end of the century, although some show distinctive traits of their own. One of these, the Master of the Holy Kinship, must have organized a huge workshop judging from the number and diversity of the paintings attributed to him. Named after the *Holy Kinship Altarpiece* in Cologne (fig. 219), painted about 1500 for Nicasius Hackeney and his wife, he returned to a theme beloved in Cologne, and, in general, the composition follows the earlier types with seventeen intimate members of Anna's family, women sitting, husbands standing, and children playing, about the central group of Anna, Mary, and the Christ Child enthroned before a cloth of honor (see pp. 179–80). But compared to the earlier versions, the composition is much more crowded and lavish.

The treatment of the individual figures is Flemish, and the drapery patterns with intricate angular overlaps and accordian creases show the influence of Rogier van der Weyden and his followers. Two extra figures are added to the clan assembled here. To the right sits Saint Barbara dressed in an ornate costume and crowned. Opposite her is Saint Catherine, who leans forward to receive a tiny ring offered by the Child. Hence the subject matter is a rather complex conflation of the themes of the Holy Kinship, the Virgo inter Virgines, and the Mystical Marriage of Saint Catherine. This master's love for filling his panels with interweaving narratives does not end here, however. In the distant background, left and right, are more stories including the Presentation in the Temple and the Dormition of the Virgin.

Elaborate historiated paintings characterize many late Cologne pieces. In another work by the same master, the *Crucifixion* in Brussels (fig. 220), the earlier Cologne historiated *Crucifixion* has been much elaborated, with a cramped frieze of figures spread across the broad foreground stage, and in the distant landscape more episodes related to the Passion fill every available space. It is a busy world that the Master of the Holy Kinship paints, but it is colorful and bright in tonality and thoroughly fascinating to wander about at leisure.

Another gifted painter with a large workshop was the anonymous master who executed a cycle of nineteen narratives on canvas, today dispersed among a number of museums, illustrating the legend of Saint Ursula. Some

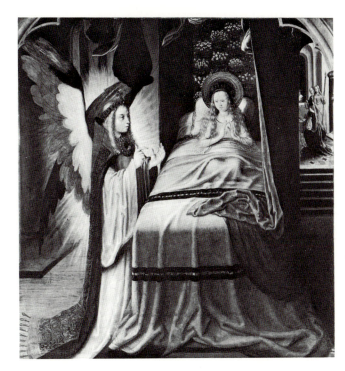

221. MASTER OF SAINT URSULA. *Dream of Saint Ursula*. c. 1495. Canvas, 48⅜ × 44⅞″. Wallraf-Richartz Museum, Cologne

scholars have linked him to Hugo van der Goes and Geertgen tot Sint Jans on the evidence of stylistic affinities and compositional patterns. Indeed, one German authority, Alfred Stange, believes that he was a Dutchman by birth and training, but by the end of the century the influences from the Netherlands were so ubiquitous that such speculation is quite unnecessary. One of his most famous paintings from the Ursula cycle—which is unrelated to Memlinc's series (see p. 185)—the *Dream of Saint Ursula* in Cologne (fig. 221) is a charming semi-nocturnal scene with a lovely angel, aglow with bright light, standing by Ursula's canopied bed warning her of the tragic events that will occur when she returns to Cologne from the pilgrimage to Rome. There is a stillness and doll-like charm in his figures that remind one of Geertgen, but the treatment of space is arbitrary and the palette is brighter and higher keyed.

The style of another anonymous painter, the Master of the Saint Bartholomew Altarpiece (after a work today in Munich), is so distinctive that his chronology can be traced from a period of early activity in Utrecht or Arnhem, about 1465–80, to the mature phases of his art in Cologne. It seems that this master did not head a workshop of any size. His paintings are uniform in style throughout with no indications of workshop assistance, and he had no immediate followers. Because of the somewhat mannered intensity of religious expression in his works, it has been suggested that he was perhaps a monk associated with the Carthusians in Cologne. It is known that some of his paintings were, in fact, destined for Carthusian chapels.

The mysticism in his art, if indeed that be an appropriate characterization, is markedly different from that of earlier Cologne painters. Replacing the quiet symmetry and pure colors of Stephan Lochner are sumptuous patterns of interwoven forms with intricate turnings of fussy drapery folds and a palette that gives the impression of restrained splendor with a mastery of a broad range of mixed colors, especially in the ornate costumes. At times his mannerism seems almost bizarre but his technique is brilliant and sophisticated. His curious oval head types with sleepy eyes and small protruding chins are very different from other Cologne painters too and seem more akin to those of the Lower Rhenish artists.

The style of the Master of the Bartholomew Altarpiece is already evident in his miniatures in a Book of Hours of Sophia von Bylant, executed about 1475 in Utrecht or Arnhem. His early works in Cologne, such as the *Virgin with Child and Saint Anne* (*Anna Selbdritt*) in Munich (colorplate 39), are charming examples of tender devotional pictures with the youthful faces of Mary and her mother smiling at a joyous Child who playfully turns the pages of an illuminated manuscript. The exaggerated lyricism in the overlaps and turnings of Mary's dark blue mantle accentuates her youthful, diminutive body and delicate gesture as she offers a rose to her tiny son.

For the most part, the paintings of the Bartholomew Master are joyous and happy hymns of devotion, and when he turned to events from the Passion, the pathos and brutal expression of earlier German masters in treating such themes are toned down for statements of simple sadness. A good example is his *Deposition* in the Louvre (fig. 222), apparently painted for the Saint Anthony *Gasthuis* (hospital) in Arnhem. The composition is clearly descended from Rogier van der Weyden's famous painting in the Prado (colorplate 20), but the power of Rogier's unique interpretation is weakened and relaxed. The swooning Mary does not fall into an inverse curve that repeats that of the body of Christ—one of Rogier's most effective inventions—nor do the mourners retain the stately postures and attentiveness. They turn and gesture in a more theatrical manner. The Magdalen looks out directly at the viewer. Replacing the unusual rhythms of the Prado *Deposition* by Rogier, with its complex play of two sweeping curves across the horizontal alignment of the figures, is one spiraling diagonal that follows the line of the sturdy ladder placed against the cross. In spite of these shortcomings in expression, the *Deposition* by the Master of the Bartholomew Altarpiece remains one of the more successful and original interpretations of a theme immortalized by Van der Weyden.

MARTIN SCHONGAUER

One of the outstanding painters of Colmar, the Alsatian city in the Upper Rhine, was Martin Schongauer.[91] Although Schongauer's fame today rests almost wholly on his contributions to the graphic arts (see pp. 280–86), in his own time his renown was due to his painting. One sixteenth-century report states that he was "so excellent an artist that his paintings were carried to Italy, Spain, France, and England, and other parts of the world."

Schongauer's family were goldsmiths. His father had moved to Colmar from Augsburg about 1440, and two of his brothers continued their father's profession in Colmar. Another brother, Ludwig, and Martin began their careers as painters, however, and it is believed that their apprenticeships were served in the shop of Caspar Isenmann, a leading painter in Colmar who died in 1472. Little evidence of this training appears in Martin Schongauer's paintings, however. In fact, Schongauer's art is so attuned to the style of Rogier van der Weyden that Panofsky wrote that Rogier's "very spirit was resurrected on German soil by Martin Schongauer," and much earlier, in the 1565 edition of his *Vite,* Vasari actually thought he was Flemish or Dutch, referring to him as "Martin of Antwerp" or "Martin of Holland."

It should be remembered that Colmar, near Strasbourg, was on the crossroads of trade between Germany,

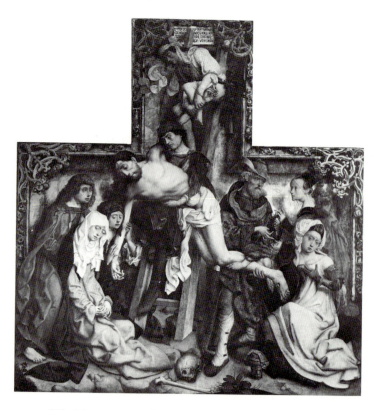

222. MASTER OF THE SAINT BARTHOLOMEW ALTARPIECE. *Deposition.* c. 1500. Panel, 89⅝ × 82⅝". The Louvre, Paris

223. MARTIN SCHONGAUER. *Madonna and Child in a Rose Arbor.* 1473. Panel, 78¾ × 45¼″. Church of Saint Martin, Colmar

France, and the Low Countries, and that Alsatia had been for centuries disputed territory between Germany and France. In the case of Schongauer, however, the stylistic affinities with Rogier van der Weyden are so overwhelming that some direct contact with the Flemish painter or his works is inescapable. Schongauer, born about 1450, would have been too young to have served as an apprentice to Rogier, who died in 1464, although as early as 1565, Lambert Lombard, a painter from Liège, wrote that Rogier was his master (*suo maestro*).

The graphics of Martin Schongauer will be treated in Chapter XIV. Of the numerous paintings attributed to him, only a few can be considered as *Eigenhändig,* or by "his own hand." Many are clearly workshop productions or the paintings of his followers and imitators. None are signed, but one handsome piece, a huge *Madonna and Child in a Rose Arbor,* in the Church of Saint Martin in Colmar, is dated 1473 and has been accepted as an authentic work of the young artist (fig. 223). The panel has been cut down on the sides and top, but its entire composition can be reconstructed on the basis of a copy by a follower in the Isabella Stewart Gardner Museum in Boston.

Schongauer's composition repeats the famous "Madonna in the Rose Garden" popular in Cologne and perfected by Stephan Lochner. The missing portion at the top included the image of the Lord in heaven and the dove of the Holy Spirit just as in Lochner's work, the only major difference being the omission of the musical angels in the foreground, although two do hover over Mary's head holding a golden crown. But no one would mistake this piece for a work of the Cologne school. The dignified face of the Madonna with its polished modeling and delicate features brings to mind the Madonnas of Rogier, such as the Mary in the *Columba Adoration* (colorplate 22), and the charming Child, here nude as in many of Rogier's versions, has the same alert and energetic pose that Flemish artists preferred. Even more so, the intricate pockets of drapery with their elegant arcs, triangular flanges, and crumpled overlaps are wholly in the Rogierian tradition.

A later work, closely related to his engravings, is the charming little *Holy Family* in the Kunsthistorisches Museum in Vienna (fig. 224), dating in the 1480s. The Madonna is seated within the interior of a stable and offers a bunch of grapes to her coy Child, who stands and wriggles in her lap. Joseph, who must have fetched the grapes, appears in the back chamber to the left. He has

224. MARTIN SCHONGAUER. *Holy Family.* 1480s. Panel, 10¼ × 6¾″. Kunsthistorisches Museum, Vienna

just attended to the ox and ass and now steps forward carrying a bundle of wheat.

The diminutive scale of the panel, together with the precious sweetness of the young Virgin, make this panel a favorite among Schongauer's many versions of the Infancy theme. Here the details contribute to the content in the fashion of Flemish disguised symbolism. The emphasis on grapes is surely no accident. The reference to the "true vine" also alludes to the wine of the Eucharist, the blood of Christ; while the wheat, an attribute of Bethlehem, "House of Bread," also associates itself with the host, the body of Christ. As Charles Minott has pointed out, the canteen of water in the niche behind the Virgin alludes to the Marian epithets, "fountain of the gardens," "well of living waters," and the "sealed fountain" of the Song of Solomon.

MASTERS OF THE LOWER RHINE AND WESTPHALIA

The commercial centers in the Lower Rhine and Westphalia—Münster, Soest, Wesel—while not belonging to the Hanseatic League, were prosperous enough to promote art workshops, which were usually dominated by one master. In Münster Johann Koerbecke, active between 1446 and 1491, headed such an atelier that pro-

above: 225. Johann Koerbecke. *Christ Before Pilate*. 1457. Panel, 36¼ × 24⅝″. Landesmuseum, Münster

right: 226. Master of 1473. *Holy Kinship*. 1473. Panel, 47¾ × 64¾″. Church of Santa Maria zur Wiese, Soest

duced a number of altarpieces, including a principal work for the monastery of Marienfeld, dated 1457, with eight scenes of the Life of Mary on the interior, eight of the Passion on the exterior. Koerbecke's style displays a strong dependence on the Flemish, especially in his angular treatment of the drapery and the rather exaggerated perspective plunges with deep, complex interior settings. In contrast to Cologne painters of the period, Koerbecke preferred more unstable compositions based on diagonals and often asymmetrically massed to the right or left, as seen in his *Christ Before Pilate* (fig. 225) in Münster, which depicts the judgment scene as if it had taken place in some provincial Rhenish village.

Among Koerbecke's more talented followers was the Master of 1473, named after a large altarpiece in the Wiesenkirche in Soest that displays no fewer than twelve scenes from the lives of the Virgin and her parents, Anna and Joachim, six in two rows on either side of a large representation of the *Holy Kinship* (fig. 226). The impressive groupings of the families of Anna and her daughters are here placed in the deep nave of a church, resembling the interior of Geertgen's famous *Holy Kinship* in Amsterdam (fig. 170).[92] The costumes, note especially Mary Salome seated to the left, and the headgears of the husbands standing behind the huge throne for Mary and Anna are also very close to Geertgen, although here the play of the children and the details of the architecture do not seem to have any pointed symbolic significance as in the Amsterdam piece.

One would normally think that the Master of 1473 was influenced by Geertgen's unusual representation, but the Amsterdam version is later by at least five years. One scholar has recently suggested that both paintings depend on a common model probably painted by Albert van Ouwater and now lost. This is a tempting theory but hardly demonstrable. That the style of the Master of 1473 is, indeed, closely related to the Dutch painters of his own generation reaffirms the strong ties between the Rhine valley and the Netherlands.

The importance of Wesel as an art center in the Lower Rhine has only recently been demonstrated with the recovery of the oeuvre of Derik Baegert. His style is related to that of Koerbecke too in its curious perspective plunges and wealth of secondary detail. Baegert's treatment of the tubular, angular drapery patterns is exaggerated to the point that the lines for heavy ridges are raised directly from the planes of the body, as seen clearly in the figures in his *Saint Luke Painting the Madonna* in Münster (fig. 227), a work that must date in the 1480s.

His head types are distinctive too. Mary is a sweet, round-faced doll of diminutive proportions who turns her head coyly to the side as she smiles down at her Child. Luke has a distinctive profile in Baegert's paint-

227. Derik Baegert. *Saint Luke Painting the Madonna.* c. 1485. Panel, 44½ × 32¼". Landesmuseum, Münster

ing, so much so that one may consider it a self-portrait. He sits quietly at Mary's side as he puts the finishing touches of paint on her portrait—an exact replica of the Madonna and Child here—which, interestingly, rests on the easel already within its frame. Various Flemish details fill the crowded interior, including a majolica jar with the initials BAEG serving as the artist's signature, a round convex mirror with bright reflections, and a copper urn resting on a highboy in the fashion of Robert Campin. A view through the open loggia to the left shows the city square (of Wesel?) with its fountain, city hall, gateway, and elegant town houses with stepped-gable roofs.

More problematical is the career of Heinrich Funhoff from Westphalia. He settled in Hamburg sometime before 1475, and after marrying the widow of the leading Hamburg painter, Hans Bornemann, took over his large atelier and immediately began receiving commissions from the city. Funhoff must have been highly successful in the Hanseatic city. He was alderman for the Hamburg artists' association (brotherhood of Saint Thomas Aquinas) from 1480 to 1482, but his career was cut short when he died in 1484.

One of his major commissions was his last, the high

228. HEINRICH FUNHOFF. *Death of John the Baptist.* c. 1482.
Panel, 84 × 63″. Church of Saint John, Lüneburg

International Style, mostly derived from Bohemia, into a more vigorous and naturalistic art. Linear design and tendencies toward exaggerated expressionism with little concern for accurate perspective characterize many of these paintings. In Ulm the major workshops were headed by Hans Schüchlin and Bartholomäus Zeitblom; in Augsburg Thoman Burgkmair (the father of Hans Burgkmair), Ulrich Apt, and Hans Holbein the Elder were the leading painters. Friedrich Herlin headed a large and influential atelier in Nördlingen. Developments in Nuremberg are typical of these regional variations, and we shall concentrate our attention in this chapter on these artists, partly in tribute to Albrecht Dürer, who was born and had his early training in this chief Franconian commercial center.

Hans Pleydenwurff moved from Bamberg to Nuremberg sometime around 1450 and established one of the first major workshops there. It has been suggested that Pleydenwurff had traveled to the Netherlands, and perhaps he did so, but the Rogierian and Boutsian features in his paintings can be explained more easily as a natural response to the general wave of Netherlandish influences that rapidly flowed across Germany during the second half of the century. A large, compact *Crucifixion* in Munich (fig. 229), executed about 1470, is representative of

altar for the Church of Saint John in the nearby town of Lüneburg. Funhoff painted four panels (for an earlier *Schnitzaltar* that was retained as the centerpiece) with narratives of the lives of Saints Cecilia, John the Baptist, George, and Ursula composed in the fashion of the large multi-scene panels of the Haarlem school, and, indeed, there is something of the charm and grace of his female figures, especially their face types, that brings to mind Geertgen tot Sint Jans. The mossy greens of his palette also point to familiarity with the North Netherlandish schools, and the elegance of his drapery and the elongation of his figures, often posed from the back, indicate close connections with the school of Bouts. In the story of the *Death of John the Baptist,* still in Saint John's in Lüneburg (fig. 228), the elegantly attired executioner, with his tall proportions and erect stance, reminds one of Bouts's late works, so much so that Stange has argued strongly that Funhoff must have served as an assistant in Bouts's studio in the early 1470s and worked on the large *Judgment* panels for the Louvain city hall.

THE EASTERN TERRITORIES

The infiltration of the Netherlandish styles is likewise found in the arts of the territories to the east in Germany. In Swabia a number of painters transformed the earlier

229. HANS PLEYDENWURFF. *Crucifixion.* c. 1470. Panel,
74¾ × 71¼″. Alte Pinakothek, Munich

Pleydenwurff's refined style. The composition is based on Netherlandish types with many figures under the cross and a sprawling landscape. The figures, many based on Rogier's, are aligned along a narrow foreground stage. The corpus of Christ is more subtly modeled than in most German examples, and Pleydenwurff's understanding and mastery of the elegant draperies and postures of Van der Weyden's figures are thoroughly and beautifully expressed through a more linear style.

Golgotha is marked off by dark hills, serving as coulisses, directly behind the foreground frieze of figures, and the far distant landscape beyond them is highly detailed and varied in topography. Jerusalem has been given the appearance of the sprawling city of Nuremberg itself with numerous Romanesque and Gothic church spires breaking the horizon in place of the more exotic domed structures seen in Flemish works. Indeed, the fine landscape, bathed in a bright light that obliterates the atmospheric perspective, is much like the countryside of Franconia with its half-timbered inns and the colorful château rising on the hill to the right.

Pleydenwurff died at the height of his career in 1472. A gifted assistant, Michael Wolgemut, married his widow, Barbara, and (a familiar story) inherited Pleydenwurff's workshop. The number of drawings from the Pleydenwurff-Wolgemut shop testify to the vast knowledge these German painters had of Netherlandish compositions and also provide us with valuable reflections of lost Flemish and Dutch paintings.

One of the last commissions that Pleydenwurff contracted was the so-called *Hofer Altarpiece* for the Church of the Holy Trinity in Hof, which again featured painted wings with the Life of Christ for a sculptured central shrine. It is not likely that any of the panels were executed by the master before his death in 1472, however, and it is generally assumed that Wolgemut and his shop were responsible for the paintings. One of the finer compositions, that of the *Resurrection* (colorplate 40), today in Munich, has been attributed to Wolgemut's hand, and while the attribution is not certain, the style of this colorful panel represents the fine fusion of Netherlandish and Germanic that characterizes the heritage of Pleydenwurff. The composition is based on panels by Bouts, such as that on the right wing of the Granada *Altarpiece of the Deposition* (fig. 140; and the recently acquired work in the Norton Simon Collection in California). The German artist was much impressed with Bouts's accomplishments in space and landscape. He deepens the brick court in which the sarcophagus is placed and, like Bouts, isolates the three sleeping guards resting around the tomb. In an arched opening at the rear of the wall, the three Marys, in dainty costumes of rich color, slowly approach the graveyard.

The distant landscape also echoes the chromatic backgrounds of Bouts with layers of blue-gray cumulus clouds catching the rays of the morning with bright vermilion streaks while the sky beneath them turns a lemon yellow in the refracted sunlight of the dawn. The hill formations are highly detailed cliffs and valleys with winding roads developed by Bouts, but here their elevations are exaggerated as they soar on either side, opening a fantastic gorge between them along which the tiny figures of Christ and the pilgrims to Emmaus are barely discernible moving along a road. On the crest of the towering hill in the center of the picture a compact walled town is bathed in early-morning rays. Whether by Wolgemut or not, the *Resurrection* of the *Hofer Altarpiece* is a masterpiece of fifteenth-century German painting in Nuremberg, examples of which Albrecht Dürer would have been familiar with, especially since he received his apprenticeship in Wolgemut's shop.

The attraction of Boutsian figure types and landscape in Nuremberg is a tribute to the painters of Haarlem and Louvain. In the nearby city of Bamberg, where Pleydenwurff was born, this blending of styles continued. One interesting example attributed to a late disciple in Bamberg is the unusual *divisio apostolorum,* or *Farewell of the Apostles,* in the Kunstgalerie in Bamberg (fig. 230). Dispersed in a broad panorama of hills about a river valley, the eleven apostles are scattered in a fashion similar to the figures in the *Gathering of Manna* by Bouts (see p. 148).

230. BAMBERG MASTER. *Farewell of the Apostles.* c. 1490. Panel, 57½ × 60¼". Kunstgalerie, Bamberg

Rather than portraying the apostles in some hieratic frieze, as was the custom of earlier medieval representations, the Bamberg painter dwelt on the more humble and tender aspects of their parting as close friends. Each has his destination inscribed on his halo, and some now fill their flasks and take nourishment, for they will need more than spiritual comfort on their arduous missions. More touching is their realization that they are bidding farewell to friends and cousins for the last time. Bartholomew and Andrew embrace tenderly near the center of the panel. Thaddeus turns to take one last look at Matthew. And the group of two figures in the right foreground, Saint John kneeling at the spring with James the Great looking down on him, is a transformation of one of the most touching farewells in Christian art: *Noli me tangere.*

It has been observed that the head types, the draperies, as well as the landscape echo the style of Geertgen tot Sint Jans, but perhaps we can pin down the lineage of the original composition more accurately. It will be recalled that in Van Mander's account of the life of Albert van Ouwater (see p. 143), he described an altar of the Roman pilgrims in Saint Bavo in Haarlem that had as a base (predella), "an interesting landscape in which many pilgrims were painted, some walking, others resting, eating, or drinking. Albert painted the faces well, also the hands, the feet, the draperies, and the landscape."

Van Mander would not have recognized the unusual subject matter of the Farewell of the Apostles, but the Bamberg painting remarkably corresponds to his description of pilgrims in a landscape. After all, the apostles were considered the first pilgrims and crusaders of Christ. From this German copy, one might then conclude that the lost landscape style of Ouwater, which Van Mander highly extolled, was essentially the same as that followed by his compatriot, Dieric Bouts, and one that was to have broader influence than the microscopic loggia views of Van Eyck. Here again, the Bamberger artist adds something of his own in the sprawling German city along the banks of the distant river.

THE SOUTHERN TERRITORIES

It is difficult to determine boundaries between German as opposed to Netherlandish art, particularly with reference to modern political borders, and in many respects it makes more sense to describe the arts that flourished in the Rhine valley between Basel and the coastal centers of Holland as "Rhenish" more so than Swiss, German, Belgian, or Dutch, as many scholars do today. The geographic lay of the land made this sweeping crescent one continuous cultural region, and the ties of commerce and language held these people together in a common mode of communication. It is interesting to test this idea with a similar comparison of the arts produced in Germany's southernmost territories, those sharing present boundaries with Austria and Italy. One of the most outstanding contributors to Late Gothic art in the south is Michael Pacher.[93]

Pacher was born near Brixen (Bressanone) on the southern slopes of the Tyrolian Alps in the territory of the Alto Adige of modern Italy. Between 1469 and 1496 Pacher was a citizen of Bruneck (Brunico), some twenty-five miles east of Brixen. He died in 1498, presumably in Salzburg. Pacher was a consummate artist: a sculptor, painter, and an architect of complex wood, stone, and painted structures for altarpieces on a magnitude unprecedented in North European art. We will discuss him later as a sculptor.

Fortunately, one of his most ambitious projects remains intact and *in situ,* the famous *Saint Wolfgang Altarpiece* in the Church of Saint Wolfgang on the Abersee in Austria (see fig. 324). Commissioned for Abbot Benedict Eck of Mondsee in 1471 and completed in 1481, the giant polyptych has two sets of wings that can be closed across the inner corpus with the sculptured *Coronation* presenting a majestic array of huge Gothic figures dominated by the beautiful kneeling Madonna. Caught up in some mysterious interplay of swirling draperies and shadowy spaces, the intertwining pinnacles and elaborate canopies seem to grow miraculously up from the altar some thirteen feet into the vaults of the church. Pacher's *Coronation of the Virgin* will be discussed later in the context of other Gothic sculptures. Let us first consider the paintings.

Pacher's explosive personality is just as evident in his paintings as in the carving and architecture. The outer shutters when closed present four episodes from the life of Saint Wolfgang (died 994), the learned Benedictine bishop of Regensberg who built a cell for his retirement on the site where the church and village associated with him later grew up. With the outer wings open, eight panels of the life of Christ are displayed (see fig. 231), and with the inner panels open, the great sculpture of the *Coronation of the Virgin* flanked by statues of Saints Wolfgang and Benedict appears. The inner surfaces of the second shutters, on either side of the sculptured corpus, are painted with scenes from the life of the Virgin (see fig. 232).

A project of such scale must have required the help of a number of assistants, and it is believed that the paintings illustrating the legend of Saint Wolfgang, displayed when the altarpiece is closed, were executed wholly by an assistant, possibly Friedrich Pacher, his brother. The inner paintings, however, seem to have been by Michael Pacher himself. His style is marked by unusual vigor and

231. MICHAEL PACHER. *Marriage at Cana*, from the *Saint Wolfgang Altarpiece*. 1471–81. Panel, 68⅞ × 55⅛″. Church of Saint Wolfgang, Austria

232. MICHAEL PACHER. *Nativity*, from the *Saint Wolfgang Altarpiece*. 1471–81. Panel, 68⅞ × 55⅛″. Church of Saint Wolfgang, Austria

expression with dynamic figures moving and reacting in strained postures, their sharp-edged draperies whipped into cascades that turn and break into intricate folds that seem to defy any notion of gravity or protrusion of the body parts. The general organization of the figures is just as erratic, with some organized with a certain symmetry, others aligned on dramatic diagonals, and still others bunched together on one side in the foreground.

This apparent contradiction of the basic rules of figurative composition, however, is amazingly forceful and effective, and much of the success of Pacher's paintings is to be credited to the unusual painted architectural settings that envelop the figures and that through their own complexity and lofty scale impose an uneasy order on the actors within them. Diagonal arrangements are accentuated by deep plunges into space along the lines of the architecture. Narrowing perspectives hold the figures in place like magnets in the middle ground and far distance, and the flow of spaces seems infinite and continuous with a telescoping effect whereby the figures diminish in scale at an astonishing rate from foreground to far distance.

Surely these experiments in perspective and low-horizon projection cannot be attributed to Netherlandish influence, where rational perspective was achieved largely through an empirical process and where a low angle of vision rarely occurs. Pacher's interest in these devices

must stem from some direct knowledge of the mathematics of spatial projection, and there can be no doubt that these interests were nurtured by what he had seen in the paintings of the North Italian masters, especially those of Andrea Mantegna in Padua.

But there is a major difference between the perspective of the Italians and that of Pacher. In Italy the perspective is orderly and static, enhanced by the severity and regularity of classical orders and cubic, mural surfaces. Pacher's, on the other hand, is dynamic and capricious, reflecting those qualities in the German flamboyant architecture which served as his models. The Late Gothic Hall Church with its slender and intricate tracery, its crazy vaults, and its countless openings and penetrations lend a quality of continuous becoming and growing in Pacher's lofty interiors, but beneath it all, the construction is accurate and mechanical.

It has been suggested that Pacher's interest in the mathematics of space may have been influenced by the writings of a leading theologian, Nicholas of Cusa, who created an ideational world of the universe based on science and mathematics. Nicholas was the bishop of Brixen between 1450 and 1460, and thus Pacher could have known him and been impressed by his sermons and writings along those lines, but it is not likely that the philosophical mathematics of the theologian could have been readily translated into lines on a panel. It perhaps is

right: 233. Michael Pacher. *Jerome, Augustine, Gregory, and Ambrose*, from the *Altarpiece of the Church Fathers*. c. 1483–84. Panel, 85 × 77⅛″. Alte Pinakothek, Munich

below: 234. Michael Pacher. *Saint Wolfgang in Prayer*, from the *Altarpiece of the Church Fathers*. c. 1483–84. Panel, 40½ × 35¾″. Alte Pinakothek, Munich

just another example of the intrinsic analogies that frequently appear in art history.

A later project, the *Altarpiece of the Church Fathers,* destined for the Collegiate Church at Neustift in the Alto Adige for their dean, Leonard Pacher (a relative?), dates about 1483–84. The original frame is missing and the panels are today displayed in the museum in Munich. But even without the enframement, which must have been elaborate, the paintings have a remarkable architectonic appearance. Across the central corpus are the four Church Fathers: Jerome, Augustine, Gregory, and Ambrose, each blessed by the dove of holy inspiration as they

sit at their lecterns writing (fig. 233). Pacher again uses a low angle of vision with views into complex stone and wooden canopies that serve as architectural settings for the monumental figures. The tiled floors, lecterns, pilasters, and ogival traceries of the tabernacular niches are rendered meticulously with a bright light flooding the portraits, creating a dramatic sense of highlights and shadows. The four figures, dressed in richly brocaded vestments, are engaged directly with the somewhat unusual attributes placed on the floor before them. Saint Augustine, for example, his left hand marvelously foreshortened, points with his right hand to a small boy kneeling at his feet holding a spoon. This is taken from the obscure vision related by Augustine as he was walking along the seashore meditating on the true meaning of the Trinity. He came upon a boy (Christ) who had dug a hole in the sand and with a spoon was vainly trying to fill it with water. Augustine informed him that his task was futile and impossible, whereupon the child answered, "No more so than for a human intelligence to fathom the mystery [Trinity] you are meditating."

On the outside the wings are painted with episodes from the life of Saint Wolfgang. Pacher's mastery of perspective and foreshortening is nowhere so evident as in the panel imploring the Lord for some miraculous sign approving his decision for the strict reforms he was about to impose on nunneries (fig. 234). While Saint Wolfgang swoons in his prayer for guidance, an angel suddenly flies down and places a pyxis with a host on the altar before him, a certain sign of divine approval of his reforms. The abrupt diagonal flight of the angel and the dramatic foreshortening of the altar and ciborium are examples of Pacher's expertise in perspective. Thus Pacher's art displays a curious amalgam of Italian Renaissance and Northern Gothic, but while he may have learned a new vocabulary from the Italians, his accent and expression remain undeniably Northern.

Painting in France During the Second Half of the Fifteenth Century

The disastrous political circumstances in France between 1415, the battle of Agincourt, and 1455, the end of the Hundred Years' War, created a climate that was not conducive to the arts.[94] When Charles VI died in 1422, Paris fell to the regency of the Englishman, John, duke of Bedford. The dauphin Charles VII had taken exile in Bourges, capital of the duchy of Berry. The romantic saga that centers on the Maid of Orleans, Jeanne d'Arc, then follows, with the coronation of Charles VII at Reims. Paris was recaptured in 1436, and with the demise of the Burgundian dukes, Philip the Good in 1467 and Charles the Bold in 1477, one of the monarchy's greatest inner threats gradually subsided. Charles VIII, the last of the Valois rulers, died childless in 1498 and was succeeded by Louis XII, a Bourbon. French art under the Bourbons was to take new paths, and largely through close ties to Italy, French culture was to acquire a Renaissance character based in great part on contemporary artistic movements in Italy.

During the second half of the fifteenth century, art patronage quickened, but, as if shaking itself awake from a long slumber, France was slow to respond to the dramatic changes that occurred during the crucial interim in the Netherlands and Italy.

The royal courts still constituted the major sponsors of the arts along with the church, but a new type of patron emerged with the rise of the *nouveaux riches,* such as Jacques Coeur, the rich financier of the king who was appointed master of the mint and steward of royal expenditure in 1438. Jacques Coeur built a grand hôtel in Bourges that stands today in secluded splendor as a token of the impact of the wealthy bourgeoisie in the arts (fig. 235). The fine decorations on the exterior and interior show the influence of a strong-willed patron who was not to be outdone. The sculptures that survive display a curious medley and an imaginative assortment of anecdotal themes, emblems, allegories, and *trompe l'oeil* scenes with sham windows on the walls with reliefs of well-dressed courtiers and their ladies leaning on imaginary windowsills in conversation (see fig. 236). Were the sculptors French? Perhaps not, as we shall see in a later chapter.

In the vaults of the chapel of the hôtel, twenty graceful angels, "Les Anges de Bourges," were painted on a blue ground spangled with golden stars (fig. 237). These frescoes are precious fragments of French painting in the middle of the century, but they are often ignored or not even mentioned by art historians. Stylistically we can see in the languorous swaying postures and elegant draperies fluttering around their tall forms the influence of Rogier van der Weyden. The workmanship is excellent, and although this and other works commissioned by Jacques

235. Court, House of Jacques Coeur, Bourges. 1443–51

236. Men and women looking out of windows (interior of fig. 235)

237. "Les Anges de Bourges," Chapel vaults. House of Jacques Coeur

Coeur have been heavily restored, the role of this unusual character, the "wealthiest man in France," deserves more serious study by historians of French art. In 1451 Jacques Coeur was disgraced and fell from favor. He was imprisoned and then escaped to Provence, where he was received by King René of Anjou, another unusual patron who will be discussed later.

SIMON MARMION

Netherlandish influence is more discernible in centers north of Paris, especially in Picardy and Artois, that border Flanders. A representative of the north French response to the *ars nova* is Simon Marmion, heralded as the "prince d'enluminure" by Jean Lemaire in his famous poem written in honor of Margaret of Austria, *Couronne Margaritique (Crown of Pearls,* 1504). Marmion was active in Amiens from 1449 to 1454 and after that in Valenci-

ennes until his death in 1489. A number of miniatures have been attributed to him, and generally these have been discussed in the context of Ghent-Bruges illumination of the late fifteenth century (see p. 193). It must be admitted, first of all, that evidence linking Marmion to miniatures or painted panels is circumstantial, but the stylistic proclivities of the oeuvre attributed to him do clearly point to a north French artist of special talent.

The most important paintings to which Marmion's name have been linked are two shutters that served as wings for a sculptured retable of gilded silver (which has been destroyed) painted for Guillaume Fillastre, abbot of the Abbey of Saint Bertin in Saint Omer. The triptych was installed on the high altar in 1459. The two panels are today in Berlin, and two fragments of the tops of the shutters are in the National Gallery in London (figs. 238, 239). The unusually broad wings carry ten scenes from the life of Saint Bertin that are placed before and within a

right: 238. SIMON MARMION. *Saint Bertin Altarpiece* (left wing). 1454–59. Panel, 22 × 57⅞". Gemäldegalerie, Staatliche Museen, West Berlin

opposite right: 239. SIMON MARMION. *Saint Bertin Altarpiece* (right wing). 1454–59. Panel, 22 × 57⅞". Gemäldegalerie, Staatliche Museen, West Berlin

quasi-continuous architectural facade of ecclesiastical and secular interiors with the innermost episodes placed in outdoor courts with landscape backgrounds.

The capricious settings that make little sense architecturally are, however, charming dollhouse compartments opened to the viewer with tiny figures enacting a solemn and low-keyed drama of the life of the Benedictine saint. To the far left the donor, Guillaume Fillastre in his role as bishop of Toul, kneels in a shallow chapel before a *prie-dieu*. The birth of Bertin follows in the next compartment in a domestic bedroom, and then, within a deep nave, Bertin in the company of others receives the robes of the Benedictine order in the convent of Luxueil. In the next episode Bertin appears in the forecourt of a church being received as a pilgrim at Thérouanne, and the left shutter ends with the dedication of a church that takes place outside the cloister walls with a deep landscape extending back to a distant towered city on the banks of a broad river.

In a similar manner, the five episodes on the right shutter are presented: the separation of water and wine in a barrel; a convert kneels in a monastery forecourt (nearly a repetition of Saint Bertin's receiving the robes on the left wing); the vows of four noblemen with a view of a cloister with frescoes of the Dance of Death; ''temptation'' (in the form of a claw-footed woman) expelled by Saint Martin of Tours; and, finally, Saint Bertin receiving last rites.

The story of the saint's life could hardly be presented with more reserve and decorum. At first viewing, in fact, the narratives seem little more than scenes of daily monastic life. The arrangements of the figure groups are simple and direct with no emotional or emphatic gestures to inform us of the import of the stories. The enamel-like quality of the tiny actors suggests that our master was a miniaturist accustomed to working on a diminutive scale. In spite of the artist's hesitancy in presenting dramatic action and emotion, the two panels are

240. SIMON MARMION. *Crucifixion*, from the *Pontifical of Sens*. c. 1465. Bibliothèque Royale, Brussels

masterfully executed. In contrast to the deeper, more saturated colors of the Flemish school, Marmion's hues are brighter, as was common in miniature painting. It is reported that when Rubens saw the paintings he was so impressed that he offered to cover the surface of the panels with ducats if he were allowed to purchase them. Formerly the two paintings were attributed to Memlinc, and the fact that Memlinc's restful *détente* style should have been associated with Marmion's adds even more dimensions to the enigmatic master's art.

Of the miniatures attributed to Marmion, two will be illustrated here. One is a full-page *Crucifixion* which has been inserted into an earlier manuscript, the *Pontifical of Sens* (Brussels, Bibliothèque Royale, MS 9215, fol. 129), which takes for its compositional model a work from the Netherlandish milieu of Rogier van der Weyden and Dieric Bouts (fig. 240). The Madonna wrings her hands in grief while Saint John looks intently at the corpus of

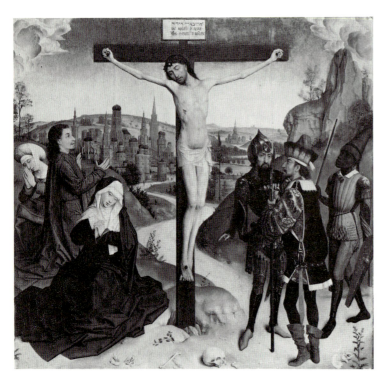

241. SIMON MARMION. *Crucifixion*. c. 1480. Panel,
35¾ × 37½″. The John G. Johnson Collection, Philadelphia

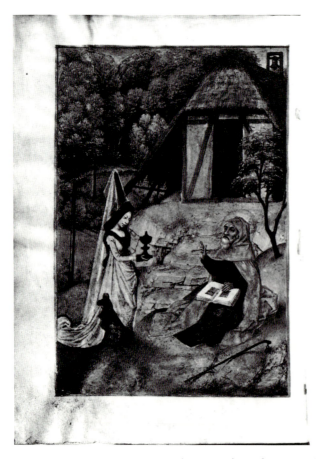

242. SIMON MARMION. *Temptation of Saint Anthony*, from a Book
of Hours. c. 1470. British Library, London

Christ. Other than these two borrowings, however, the theatrics of his model have been played down. A panel of the *Crucifixion* in the Johnson Collection in Philadelphia (fig. 241) has been attributed to Marmion on the basis of its similarity to the miniature in Brussels.

The charm of Marmion's childlike world is exemplified by a miniature from a Book of Hours now in the British Library (Add. MS 38126), the *Temptation of Saint Anthony* (fig. 242). In a warm woodland clearing, bathed in a soft light, the dwarfish figure of the saint sits before his cozy cabin. He has been reading from a large manuscript when "temptation" in the form of a Gothic lady wearing a high hennin appears before him to the left, offering him a chalice of wine.

Only the claw feet of the temptress give us a clue as to her demonic character. With downcast eyes, she meekly approaches the hermit, holding the chalice before her. Marmion's landscape here is especially attractive in the shimmering quality of the light that plays across the trees and the undulating foreground with a soft pastel tonality and an impressionistic touch to the details. These last features characterize the style of a second master who also was much attuned to Flemish art, the Master of Saint Giles, so named after two panels illustrating the life of Saint Giles in London, dating at the end of the fifteenth century.

MASTER OF SAINT GILES

Certain architectural details in the works of the Master of Saint Giles indicate his familiarity with monuments in Paris, and for that reason he has recently been identified as Jean Hay, a painter associated with the royal court in Paris whom Jean Lemaire praised highly, comparing him to Leonardo da Vinci, Gentile Bellini, and Perugino in *La Plainte du désiré* (*The Lament of "Desire,"* 1509). Hay's one documented painting, an *Ecce Homo* in Brussels, however, displays no stylistic affinities with the works of the Master of Saint Giles, whose style is so steeped in art nearer the borders of the Netherlands that his origins there seem irrefutable. Like Marmion, the Master of Saint Giles delighted in rendering charming narratives with clusters of people placed in dense landscapes or exacting architectural settings that generally are regarded as accurate topographical records of sites. His colors too are the brighter and more opaque hues of Marmion, but a number of the postures and gestures of his figures reveal borrowings from the slightly later generations of Flemish artists such as Dieric Bouts and Hugo van der Goes.

In *Saint Giles Protecting the Hind from the Hunters of Charlemagne* (Charles Martel in some versions of the legend) in London (fig. 243), the small figure of the aged saint seated in a dense woodland thicket reminds one of

the miniature of Saint Anthony in the London Book of Hours discussed above. Saint Giles, his hand wounded by an arrow meant for the hind, gently soothes the frightened creature as a prince(?) and a bishop kneel down before him asking forgiveness for the hunters.[95] A courtier, in the lower left, turns his back to the viewer and lifts his mantle much as foreground figures in Bouts's paintings often do. The two kneeling figures, on the other hand, remind one of the kneeling Magi in *Adorations* by Hugo van der Goes, and the delicate treatment of their fleshy hands that have a subtle phosphorescent quality also brings to mind the treatment of fleshy parts by Hugo.

Hugo's influence, whether direct or not, also pervades the master's special handling of the landscape. The organization of space is not exactly clear, but the precise details of the flora, botanically accurate as if taken from a contemporary herbal, are studied with the loving attention that Hugo displays in his meticulous rendering of plants.

A companion piece, the *Mass of Saint Giles,* also in London (colorplate 41), transports us into the lofty choir of a church identified as Saint Denis, just outside Paris at that time. The artist aligns his figures along two diagonals. In the left foreground Charlemagne kneels before the altar where Saint Giles officiates at a Mass given to soothe the emperor's feelings of guilt. An angel flies in from the top left carrying a letter upon which is written the condition of penance due for Charlemagne's forgiveness as the legend records it. Not only has the interior been identified as that of the royal Abbey of Saint Denis, but the furnishings of the altar are accurate pictorial records of Carolingian donations that are described in the archives of the ancient church. The great golden altarpiece with Christ enthroned in an ''8''-shaped mandorla and the elegant bejeweled cross that surmounts it are well-documented masterpieces of Carolingian metalwork once housed at Saint Denis. On the reverse of this panel is the figure of Saint Peter in grisaille.

Similar depictions of Gothic structures in Paris appear in another set of panels, of the same dimensions as the Saint Giles paintings, illustrating the legend of Saint Remi, today in the National Gallery in Washington. According to early photographs, on the back of one was a grisaille figure of Saint Giles, on the other was Saint Denis (now both lost). There can be no doubt that two sets of paintings, the legend of Saint Giles and that of Saint Remi, originally formed the side wings of a large altarpiece that very likely had representations of Saint Denis (and Saint Peter?) for its broad centerpiece. In one of the Washington panels (which must have formed the right wing), Saint Remi baptizes Clovis in a chapel that resembles the lower level of Sainte Chapelle in Paris, and in the other, Saint Remi gives benediction to the infirm

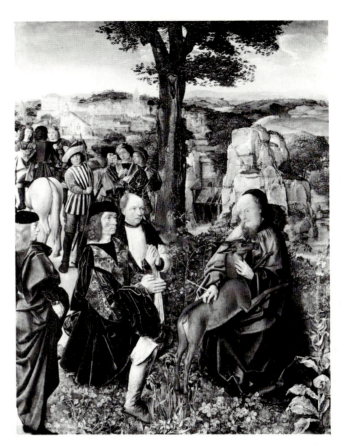

243. MASTER OF SAINT GILES. *Saint Giles Protecting the Hind from the Hunters of Charlemagne.* c. 1480–90. Panel, 24¼ × 18¼". National Gallery, London

244. MASTER OF SAINT GILES. *Saint Remi Gives Benediction Before Notre Dame de Paris.* c. 1480–90. Panel, 24 × 18". National Gallery of Art, Washington, D.C. Samuel H. Kress Collection

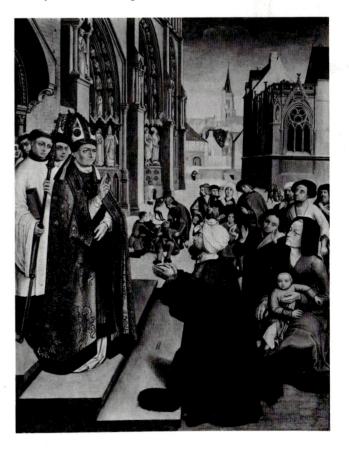

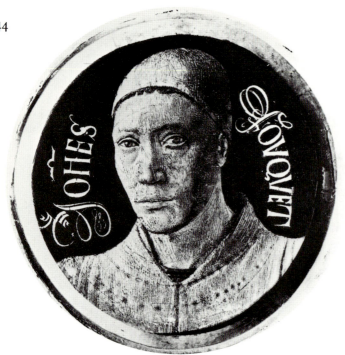

245. JEAN FOUQUET. *Self-Portrait.* c. 1450. Enamel, diameter 3".
The Louvre, Paris

and poor of Paris (fig. 244) from the steps of Notre Dame. Throngs of people have gathered in the parvis before the facade to receive his blessing. In the center background an evil spirit is exorcized. At one time, the *Altarpiece of Saint Denis,* as we may now call it, must have been one of the most fascinating treasures of the abbey church, which, as legend has it, had been founded by Charles Martel and Clovis and aggrandized in 775 by Charlemagne.

JEAN FOUQUET

The foremost painter for the royal court in the second half of the fifteenth century was Jean Fouquet, a native of Tours. Born about 1420, Fouquet probably received his training as a miniaturist in a Parisian atelier. Not much is known about his life—only one manuscript is documented—but he may have been the "Johanni Fouquet Juniori clerico Turonensis diocesis" to whom Pope Nicholas V sent a letter, dated August 8, 1449, acknowledging dispensation from illegitimacy (the son of a priest and an unmarried woman), but this is not certain. He may also have been the artist whom Antonio Filarete (*Trattato della Architettura,* 1461) referred to as "Giachetto Francioso," who painted a portrait of Pope Eugenius IV (died 1447) with two prelates that he (Filarete) had seen in Rome and praised "truly as if they were alive." It has been presumed that this provides evidence for a sojourn in Italy for Fouquet sometime between 1445 and 1447. This visit may also account for the special dispensation granted by Nicholas V in 1449.

Fouquet, at any rate, had established an atelier in

Tours by 1450, and was commissioned to execute a number of diverse projects for the monarchy, including paintings on leather, architectural decorations, and designs for a tomb of Louis XI. In 1474–75 he is mentioned as "peintre du roi." On November 8, 1481, Fouquet's wife is listed as a widow in accounts of Saint Martin in Tours; he left behind two sons who were also artists.[96] That is all we know of his career from the documents. One rather unusual piece of evidence appears in the form of a small circular *Self-Portrait* in the Louvre (fig. 245) executed on copper covered on one side with black enamel with the portrait painted in gold with scratched-out lines for some of the facial features. This strange technique was known in Italy, but it also was practiced in Limoges, hence the artist need not have learned it from Filarete, as some have claimed. The head is boldly presented, even on such a small scale, but due to the limitations of the unusual medium it is difficult to ascertain any specific stylistic features peculiar to Fouquet other than its solid modeling and directness. The inscription about the head, also painted in gold, identifies the face as that of "IOHES FOVQVET."

The one secure document of Fouquet's work is found in a note left by his contemporary, Francois Robertet, secretary and librarian of Pierre II of Bourbon, in an illustrated manuscript of *Les Antiquités Judaïques* (Flavius Josephus, *De antiquitatibus Iudaeorum*). Robertet informs us that nine miniatures in the book were "by the hand of the good painter and illuminator for King Louis XI, Jehan Fouquet, native of Tours." Although the number of miniatures attributed to Fouquet is incorrect (there are eleven), the reference to his participation in the illustrations is surely reliable. In fact, our basic notions of his style as a miniaturist and an easel painter rest on Robertet's authority.

Fouquet's miniatures in Josephus's *Antiquités Judaïques* were commissioned by Jacques d'Armagnac, duke of Nemours, sometime between 1470 and 1476. Many of the narratives are massed battle scenes and sieges in the Old Testament as described by Josephus (colorplate 42). The frontispiece, preceding part ten of Josephus's text, illustrates the taking of Jerusalem by Nebuzar-Adan, general of Nebuchadnezzar, with the destruction of the Temple of Solomon in the background. The massacre of the city's inhabitants in the foreground is typical of Fouquet's melées with stocky soldiers, dressed in fifteenth-century armor, on foot and horseback, thrusting lances and swinging swords with great zest.

Although the scene is packed, it is clear that detail in itself did not concern Fouquet. Rather, his soldiers are generalized and rendered as solid forms in space. In the middle ground soldiers besiege the palace, to the left, and set fire to the great Temple of Solomon within a walled court in the center. In this miniature Fouquet repeats the

 Étienne Chevalier and Saint
en, from the *Hours of Étienne Chevalier*.
1452–60. Musée Condé, Chantilly

247. JEAN FOUQUET. *Madonna and Child
Enthroned*, from the *Hours of Étienne Chevalier*.
1452–60. Musée Condé, Chantilly

248. JEAN FOUQUET. *Martyrdom of Saint Apollonia*,
from the *Hours of Étienne Chevalier*. 1452–60.
Musée Condé, Chantilly

topography of Jerusalem as he depicted it in an earlier
frontispiece, in which the building of the temple is viv-
idly presented with workers engaged in the activities of
the medieval mason's lodge.

In keeping with the Old Testament description, the
temple is cubic in form, but the elevation is wholly
French Gothic with great open portals filled with sculp-
tured jamb figures, clustered piers, pointed arches, and
galleries, all capped by an exotic dome that is meant to
convey to the viewer that the building, however Gothic
in detail, is ancient and Eastern. The entire facade is gilt.
Behind the temple, the square of Jerusalem is laid out as
some village in the Touraine, and beyond the pitched
roofs the undulating pastures of the Loire Valley stretch
to a distant château on a hill. Fouquet's vision of land-
scape is much different from what we have seen before.
While the details of his world are French and contempo-
rary, the expansive space with broad tonal sweeps of
color reminds one more of his contemporaries in Italy,
Paolo Uccello and Piero della Francesca.

With its masterful blend of Northern and Italian ele-
ments, Fouquet's style is distinctive and easy to recog-
nize. His most famous illustrations appear in the *Hours of
Étienne Chevalier*, the wealthy ambassador, *trésorier* (trea-
surer of France), and controller for Charles VII (as well
as the special advisor for Agnes Sorel, the king's famed
mistress). Here the experiences and influences of Italy are
manifest not only in matters of style but in the numerous
topographical references in many of the miniatures, espe-
cially to Rome: the Castel Sant'Angelo, Trajan's Col-
umn, the Triumphal Arch of Marcus Aurelius, and Old
Saint Peter's. The striking monumentality and spiritual

calm in the illustrations also are ordered with an Alber-
tian sense of *perspettiva legittima* in the formal construc-
tion of space.

Forty of the miniatures, today mounted on wood, are
in Chantilly, and their proper order is not clear. Unfortu-
nately, the entire calendar section is missing, and the
proper sequence of the first illustrations for the Hours of
the Virgin seems disturbed. Surely, the diptych with the
donor, Étienne Chevalier and his patron saint, Stephen,
kneeling before the Madonna and Child enthroned before
a great Gothic portal amid a host of angels, must be
reckoned as the introductory illustration in the manu-
script (figs. 246, 247). One need only compare this elab-
orate diptych with that in the *Brussels Hours* for John,
duke of Berry (colorplate 9), painted some fifty years ear-
lier, to get some sense of the overwhelming attraction
that the Italian Renaissance held for Fouquet.

The spacious setting is a lavish Italian hallway with
quasi-Corinthian pilasters, marble paneling, an entabla-
ture with a classical architrave across which the donor's
name is inscribed in Roman uncials, and above the en-
tablature a sequence of *putti* carrying garlands and coats
of arms. Behind Étienne an angel concert performs on
lutes, blockflöte, and other medieval instruments. The
edge of an ornamental carpet, just visible before Étienne,
joins the right side of the diptych, where Mary nurses
the Christ Child before an elaborately carved Gothic por-
tal. The features of the Madonna are simplified and
rounded, giving her body considerable bulk. The surpris-
ing juxtaposition of the Renaissance architecture in the
background and the Gothic portal enframing the Ma-
donna is an effective way of placing our affluent official

249. JEAN FOUQUET. *Portrait of Charles VII*. After 1451? Panel, 33⅞ × 28⅜″. The Louvre, Paris

250. JEAN FOUQUET. *Étienne Chevalier* (left half of the *Melun Diptych*; see colorplate 43). c. 1450. Panel, 36⅝ × 33½″. Gemäldegalerie, Staatliche Museen, West Berlin

in the enriched world of his business while imbuing him with a spiritual presence before the Madonna as the church.

A number of the miniatures are placed on a stage with the action taking place above a parapet that serves a symbolic or emblematic role for the narrative. One of the most interesting of these is the miniature with the Martyrdom of Saint Apollonia in which a medieval mystery play is enacted (fig. 248). Before a wicker fence that serves as a parapet for the stage, four wild persons, two female and two male—sit or kneel holding coats of arms and a cartouche announcing the beginning of the play. Above them, on stage, the drama is enacted with Apollonia, the Alexandrian martyr, being ruthlessly prepared for immolation. Beyond are the tiers of box seats for the spectators. A staircase on the left, guarded by two angels, marks the realm of heaven to which the tortured Apollonia will ascend. To the right are those with a box seat in hell; while the center stall, for the One in Heaven who judges, has been vacated as the almighty Judge has stepped down to stand beside and comfort the suffering martyr. To the left, another familiar participant of such open-air festivals appears: the comic jester who makes obscene gestures at the crowd with his right hand; and, to the right, a stage director, dressed in priestly vestments, conducts the music with a baton.

All of these details re-create the lively environment of

the popular theatrical presentations of Fouquet's time, which were no doubt both sacred and profane in nature. Such festivals of the church year, much as they were in Bruegel's day and even in modern times, were not solely for pious instruction and observance but also provided the populace a legitimate opportunity for a raucous party. We know that Fouquet himself was involved in staging presentations of such mysteries for Louis XI, and his fascinating miniature gives us a candid picture of just such a celebration.

The *Hours of Étienne Chevalier* provides important stylistic evidence for the attribution of at least two painted panels to Fouquet: the *Portrait of Charles VII* in the Louvre (he appears in the miniature of the *Adoration of the Magi* in the *Hours*) and the stunning *Melun Diptych* with the portrait of Étienne Chevalier on the left and the Madonna and Child on the right. In the *Portrait of Charles VII* (fig. 249), the bust of the morose king appears lifesize in a shallow green chamber with green curtains. His heavy doublet is a dark claret with fur trim; his hat is deep blue with a running ''V''-shaped cord of gold adorning it. On the old frame is an inscription: ''le très Victorieux Roy de France Charles Septiesme de ce nom.'' Charles, tawny and ruddy in complexion, looks out with a sad expression, hardly that of a ''très Victorieux Roy'' as the inscription identifies him. It has generally been assumed that the portrait commemorates the

251. JEAN FOUQUET. *Portrait of Guillaume Jouvenel des Ursins.*
c. 1455–60. Panel, 36¼ × 29⅛". The Louvre, Paris

252. JEAN FOUQUET. *Portrait of Guillaume Jouvenel des Ursins.*
c. 1455–60. Drawing, 10½ × 7⅝". Kupferstichkabinett,
Staatliche Museen, West Berlin

Treaty of Arras (1444) as a victory for the monarchy, thus dating the panel to the years 1444–45, an early work of Fouquet executed before his contact with Italian art. However, Charles appears older here than in his portrait in the *Hours of Étienne Chevalier,* executed after 1452. Perhaps it is a tribute to the French victory in the battle of Guyenne in 1451.

The *Melun Diptych* (fig. 250; colorplate 43) has long fascinated art historians, not only because the left portrait of Étienne Chevalier and his patron saint, Stephen, correspond closely to these figures in the dedication diptych of the *Hours,* discussed above (fig. 246), thus maintaining the continuity of Fouquet attributions, but also because of the tradition transmitted by many historians that the unusual Madonna displays the features of Agnes Sorel, mistress of Charles VII. One seventeenth-century historian, Denys Godefroy, gives a detailed description of the diptych when it was still in the Cathedral of Melun, Chevalier's birthplace, in which he states that the features of the Madonna were those of Agnes Sorel, known at court for her beauty. An eighteenth-century inscription on the back of the *Madonna and Child* further informs us that the panel was a vow (*un voeu*) fulfilled by Chevalier at the death of Agnes Sorel, for whom he served as executor. This would date the *Melun Diptych* to 1450, the year of her death, or shortly after.

''La Belle Agnès'' may, indeed, have inspired the aus-

tere and inscrutable countenance of the Madonna, who prominently offers her full breast to the equally severe Child. The flesh colors of both are ashen and lifeless, and the outlines and contours of their bodies are simplified and reduced to geometric volumes with little detail to mar the smooth surfaces. The Madonna's head is shaped like an egg, her breasts (widely spaced) are spheres, and the Child's body is constructed of a number of interlocking cylinders. The Madonna's dress is steel-blue in color, her mantle a chalky white, adding to the general grisaille effect. Only the bejeweled crown and the garish throne seen against a curtain of plump cherubs painted in pure red and blue give the panel color.

As a type of icon, Fouquet's *Madonna and Child* is, indeed, something exceptional, but it is difficult to see the features of the Virgin as those of an outright portrait. Rather the conventions and canons of courtly beauty reside in the high shaven forehead, the long neck, and the high and slender waist. In this respect, then, the tradition behind the legend may be right to an extent. Denys Godefroy further described an elaborate blue velvet frame that went about the diptych with the initial *E* in pearls interwoven with love knots of silver and gold threads. If there is any truth behind the legend of the *Madonna and Child,* it would seem that Chevalier not only felt a duty to Agnes Sorel at court but a passion as well, a passion which he obviously did little to conceal.

The left side of the diptych contrasts sharply with the Légeresque *Madonna and Child,* but it is no less austere and stately. Chevalier wears a bright red houppelande described in simple arcs. His face is ruddy in complexion and the detailed features of his face correspond closely to those in the portrait miniature in his Book of Hours. He is introduced by Saint Stephen, whose features also appear to be portrait-like, although his complexion is paler and his pose less rigid. His attribute, the stone carried on the back of a book, is delineated with the care that Fouquet reserved for the jewels and inlays of the throne in the right panel, as if it were an actual relic. Here the setting is not abstract and otherworldly but a resplendent Renaissance hall with classical pilasters and inlaid marble paneling that form an elegant foil for the monumental figures. An inscription repeating his name, [CHEVAL]IER ESTIEN[NE], runs along the top of the dado that carries the pilasters.

A similar austere dignity characterized Fouquet's *Portrait of Guillaume Jouvenel des Ursins* in the Louvre (fig. 251). Guillaume came from an illustrious court family, originally bourgeois immigrants from Italy, who assumed the coat of arms of the famous Orsini family of Rome. He served as chancellor of France under both Charles VII and Louis XI until his death in 1472. This portrait, judging by the age of the sitter, would have been executed between 1455 and 1460, when Guillaume was fifty-five to sixty years old. Wearing a bulky coat of red velvet, the chancellor kneels in prayer at a *prie-dieu.* His attribute of office, the large money purse—called an *escarcelle*—hangs from his belt. The Renaissance backdrop is here painted gold and among the scroll patterns that frame the marble inlays, bear cubs climb among the tendrils, puns on the adopted family name, Ursin, which means bear. Considering the pose of the sitter, it would seem that this portrait, like that of Chevalier, was originally the left wing of a diptych that included the Madonna and Child.

A fine drawing in Berlin (fig. 252) has been considered a preparatory sketch by Fouquet for the portrait of Guillaume. The drawing is precise and detailed, much as the Albergati study by Van Eyck (see p. 115; fig. 112), but the effect is softer due to the use of crayon. If it is indeed Fouquet's own study (and this has been seriously doubted), then it would be one of the earliest known examples of the use of crayons, preparing the way for the

253. Jean Fouquet. *Nouans Pietà.* c. 1470–80. Panel, 57⅞ × 92⅞". Parish church, Nouans

pastel techniques employed by later French portraitists.

In 1931 an imposing painting, a *Descent from the Cross,* was discovered in the small parish church of Nouans, a village in the Touraine not far from Tours (fig. 253). Known today as the *Nouans Pietà,* the large panel was immediately described as a masterpiece by Fouquet, painted late in his career, about 1470–80. At first viewing, it seems difficult to accept this impressive painting as Fouquet's since there is so little to compare it to in his oeuvre. Some still doubt the ascription and prefer to regard it as "School of Fouquet," but there can be no doubt concerning its quality and power, and a careful study of the heads and treatment of the draperies supports the original attribution. The colors are subdued in this solemn enactment of the lowering of the body of Christ to the ground. Aside from light shades of red in the costumes of Joseph of Arimathea and Nicodemus (who lower the body on a shroud), John the Evangelist, and the patron saint (Saint James the Great?) on the far right, the colors are pearly whites and metallic blues, giving the composition a sculptural effect as if it were a tinted relief from some Gothic tympanum. The stately rhythm of the figures, mostly vertical accents, stabilizes the harsh diagonal lines of Christ's bent body.

Like Rogier van der Weyden's famous *Deposition* in the Prado (colorplate 20), time and place are abstracted. Only the crown of thorns and the three nails in the immediate foreground remind us that this is Golgotha, and in place of the timeless gold background of Rogier's painting, Fouquet places his frieze of figures against a light-bluish sky. The drama of *compassio* in this death also is maintained by Fouquet, but by a very different means from Rogier's. There are no eye-catching brocades or transparent tears, there are no gestures of anguish or contortions of the body writhing in grief; Fouquet presents the Deposition-Lamentation with a calm and quiet dignity, and rather than swooning in imitation of her son's death, Fouquet's Virgin is meditative and restrained in her grief.

MASTER OF RENÉ OF ANJOU

Approximately sixty miles west of Tours, in the Loire Valley, lies Angers, capital of the province of Anjou. It was there, under the direction of René—duke of Anjou, king of Sicily, Jerusalem, and Provence—that a captivating style of painting, unrelated to Fouquet or any other notable French artist, burst out like some exotic flower for a short period of time and then quickly faded. René was noted for his cultural interests as an enterprising promoter of the arts in Anjou and later in Provence. He was something of a *littérateur* and amateur painter himself, and he was well traveled, spending four years in Naples (1438–42) and residing for a time in Florence, where he was befriended by the Pazzi family. It was René, it will be remembered, who gave refuge to Jacques Coeur after the latter escaped from prison in 1453. After his death in 1478, René's territories in France were partitioned and gradually taken over by the monarchy. We hear no more of his short-lived cultural programs.

The masterpiece of René's court is the awesome illustrated manuscript, *Livre du cuer d'amours espris,* or *Book of the Heart Seized by Love,* an allegorical romance, typical of the literature of courtly love, that was written by King René himself. The story vaguely relates the adventures of the knight "Cuer" accompanied by "Désir" in his quest to rescue the gentle lady "Doulce Mercy" from her captors and win her love by gallant deeds. The miniatures in the deluxe Vienna edition (Nationalbibliothek, cod. 2597) were executed soon after the completion of the text by René in 1457, and were commissioned by the king, who very likely had a hand in the supervision if not the actual execution of them. There were no established picture cycles to follow for such an erudite romance, and the details of the allegories demanded that the artist contend with unusual lighting effects for times of the day, night and dawn. What distinguishes these miniatures are the uncanny sensory effects of light that are achieved through the use of artificial light sources, introduced in the night scenes, and the radiance of a burst of sunlight near the horizon at daybreak.

The most famous miniature is that illustrating Amour, god of love, taking the heart of the love-sick king, who is bedridden, and offering it to the personification of Desire, dressed in a white Italianate costume (colorplate 44). The setting is a mysterious, darkened bedroom at night. The only light source is the meager fire in the lower right corner, and its rays bathe the figures of Désir and the face of Amour, who takes the heart from the sleeping king. A dramatic shadow is cast by Désir across the room with only the golden threads in the oriental carpets, the yellow weave of the floor mat, and the embroideries on the costume of Amour reflecting the fading rays of light from the fire.

The technique of the Master of René is sketchy but very controlled with flecks of light playing softly across the wine-colored bed curtains and flickering along the creases of the white bed sheets. The effect is amazingly poetic and sensuous in its soft phosphorescence, and while comparisons have been made to night scenes by Piero della Francesca and Geertgen tot Sint Jans, the eerie illumination in the miniature is one of a soft light filtered through various textures. It is unfortunate that a more complete oeuvre for this mysterious master of Angers cannot be assembled, but like his patron, King René, he seems to have passed quietly into oblivion.

MASTER OF MOULINS

Perhaps no other painter better represents the spirit of Late Gothic painting in central France than the Master of Moulins. His paintings are like flowers cross-pollinated with a mixture of the finest colors that France offered. In his works the orderly balance and clarity of Fouquet's compositions are continued; the bright opaque colors—reds, blues, and whites—of the earlier French schools are masterfully combined with the more transparent hues of the Flemish painters; and the synthesis of Netherlandish piety and French reserve results in a style that is at once highly personal and, at the same time, the epitome of Late Gothic expression in France.

Who is this remarkable painter? There are enough names of esteemed artists in the archives of the courts, and Jean Lemaire's poem, *La Plainte du désiré,* written for Margaret of Austria in 1503–4, mentions many French painters with high praise, yet few works can be assigned these masters. The games of scholarship have made the identity of the Master of Moulins even more obscure. He has been identified as one Jean Perréal, mentioned by Lemaire. Finding little favor among the French historians, Perréal was then replaced by Jean Hay, also praised by the poet; and more recently Jean Prévost, "artist and glass painter for the Cathedral of Lyon."

In the first monograph on the Master of Moulins, published in 1961, the gaming table was overturned when the author rejected all identifications and, furthermore, buried his identity by describing the oeuvre of the Master as that of more than ten different artists.[97] What does seem clear is that we have a body of some ten or eleven masterpieces, painted between 1480 and 1505, that are in the same style and that, on the basis of recent X-ray studies (1963), display an unusual technique so precise and uniform throughout the works that the attribution of the corpus to the Master of Moulins now seems verified whether or not he has a name.

One of the earliest in this series is the *Nativity of Cardinal Jean Rolin* in Autun (fig. 254). The donor, Jean Rolin, was the son of Nicholas Rolin, the chancellor for whom Jan van Eyck and Rogier van der Weyden painted memorable altarpieces. Jean was the confessor of Louis XI. He died in 1483 at the age of seventy-five, hence a date around 1480 would agree with the appearance of the aged donor, who kneels to the right in the painting. It is apparent that the youthful Master of Moulins was attracted to the art of Hugo van der Goes. The face of the Virgin and those of the shepherds closely resemble their counterparts in the *Portinari Altarpiece* (colorplate 28), dating about 1476, and the slightly later *Nativity* in Berlin (fig. 166).

The heads of Mary and the two angels have the same slanted eyes, pursed lips, and phosphorescent flesh tonali-

254. MASTER OF MOULINS. *Nativity of Cardinal Jean Rolin.* c. 1480. Panel, 21⅝ × 28″. Musée Rolin, Autun

255. MASTER OF MOULINS. *Portrait of a Young Princess.*
c. 1495–1500. Panel, 13½ × 9½″. The Metropolitan Museum
of Art, New York. Robert Lehman Collection, 1975

ter twelve of the Book of Revelation—as an image of the Immaculate Conception. Not to be outdone by his late brother, Pierre II of Bourbon, who was duke from 1488 to 1503, commissioned the beautiful Madonna of the Immaculate Conception triptych, painted by the Master of Moulins about 1498, to serve as the altarpiece in the chapel (colorplate 45).

The donor and his family are presented in the inner wings of the triptych. To the left, kneeling within a richly adorned chamber with curtains, is Pierre de Bourbon accompanied by a giant Saint Peter wearing a bejeweled papal tiara and a brocaded dalmatic with the impresa of the Bourbon family: "Esperance." Within a similar theater box on the right kneels the duchess, Anne de France, daughter of Louis XI, and her daughter Suzanne in the company of the towering Saint Anne. Suzanne was born in 1491, and judging by the age of the frail girl, the execution can be placed about 1498, when she would have been seven years old. The reverse of the wings presents a grisaille *Annunciation* with the Madonna kneeling in the left wing and accompanied by two small angels who introduce her to the handsome Gabriel on the right, who is followed by four smaller angels.

The central panel is a burst of bright colors with the Madonna enthroned in the center holding her nude Child. Mary wears a deep blue dress lined in ermine under a bright red mantle that falls in long pleats with angular breaks from her lap. Beneath her feet is a crescent moon, and behind her is an aureole of concentric circles of light ranging from a bright gold in the center to blue and violet hues on the perimeter. Thus the central panel seems like some spinning disk of pure colors. The strict symmetry and the agile movements of the angels about Mary create a pulsating vision of the "Madonna in the Sun," as this type was known in the Netherlands and Germany, a type which served as the central image for the enchanting *Madonna of the Rosary* by Geertgen tot Sint Jans (colorplate 30).

As one French scholar (Châtelet) has suggested, a more fitting and poetic name for our anonymous master would be "The Master of the Angels," for it is in his depiction of these languorous and agile figures that he expresses his rapturous delight in childhood, and their innocent charm and grace remind one of French children attentively serving Mass in some parish church.

This inborn talent in rendering the innocent world of children—another trait that he shares with Hugo van der Goes—made the Master of Moulins a painter par excellence of children's portraits. The charming *Portrait of a Young Princess* in the Lehman Collection in New York (fig. 255) can be compared with Hugo's *Margherita Portinari* in the Uffizi altarpiece (fig. 161). In both, the freshness and warmth of these little ladies are conveyed as

ties and pallor that characterize Hugo's figures, and the eccentric projection of space also brings to mind the unusual settings of the Flemish artist. The tonalities here are, in general, cooler and more subdued, except for the red of the cardinal's robe. Mary wears a light blue dress under a darker blue mantle, and her pearly white face is covered by an opaque white veil with faint blue shading. The Autun *Nativity* displays a grave elegance in the quiet figures who make no sounds or dramatic gestures, and, unlike Flemish versions of the theme, there is no attempt to incorporate disguised symbolism. The only intruder, the little pudgy dog sitting on the edge of Rolin's robe, is surely a personal pet and not an abstract symbol of fidelity. The serene landscape in the distance lends a restful touch to the composition, much as it does in Memlinc's hushed paintings.

The radiant triptych in Moulins, after which the master is named, has an interesting history. Duke Jean II of Bourbon (died 1488) presented the Collegiate Church of Moulins in 1474 with an altar dedicated to the Immaculate Conception highlighted with a stained-glass window of the Glorification of the Virgin in a burst of sunlight with the crescent moon under her feet and wearing the crown of twelve stars—the Apocalyptic Woman in chap-

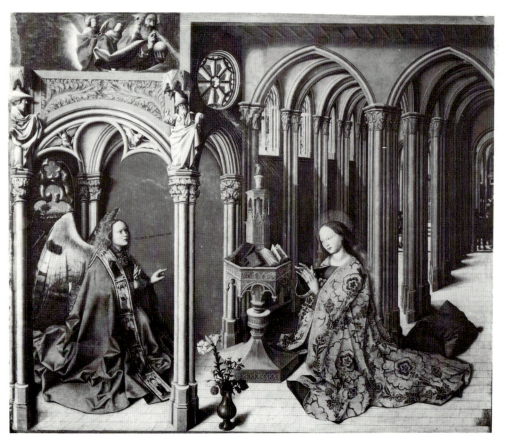

256. MASTER OF THE AIX ANNUNCIATION. *Altarpiece of the Annunciation*
(central panel of a triptych). 1445. Panel, 61 × 69¼″.
Church of the Magdalen, Aix-en-Provence

257. MASTER OF THE AIX ANNUNCIATIO[N]
Jeremiah (right wing of fig. 256). 14[]
Panel, 59⅞ × 33⅞″. Musées Royaux
Beaux-Arts, Brussels

well as their seriousness and propriety. The portrait is
usually identified as Suzanne de Bourbon, but she bears
no resemblance to the daughter of Anne de France, who
kneels beside her mother in the Moulins triptych. The
suggestion that she is the young Margaret of Austria,
who already at this age was nominally betrothed to
Charles VIII and thus "Queen of France," is more con-
vincing. The hapless circumstances surrounding Marga-
ret's childhood in France seem to be reflected in the
somewhat downcast eyes of the girl. Dressed in red vel-
vet and wearing an elegant headpiece, she fondles a Ro-
sary with beads of pearl. From her necklace hangs a
stunning fleur-de-lis pendant of gold decorated with ru-
bies and pearls. Beyond the window a softly undulating
countryside with a château mirrored in a lake is bathed in
a warm summer sunlight, reminding one of Memlinc's
courtly portraits.

MASTER OF THE AIX ANNUNCIATION

Provence, the southernmost region of France, had en-
joyed relative peace and calm during the turmoil of the
wars that disrupted central and northern France, and
while it is true that Avignon had been abandoned as the

papal capital since the late fourteenth century, there was
no lack of patrons in the prosperous south, where
wealthy landowners and merchants were avid and imagi-
native devotees of the arts. Such we know was the case
with the earliest well-known masterpiece of Provence in
the fifteenth century, the *Altarpiece of the Annunciation* in
the Church of the Magdalen in Aix-en-Provence (fig.
256).[98]

In a will dated December 9, 1442, a wealthy draper of
the city, Pierre Corpici, commissioned an altarpiece of
the Annunciation to be installed in his burial chapel in
the Cathedral of Saint Sauveur in Aix. The triptych was
finished and installed in 1445, four years before the do-
nor's death. The central panel, the *Annunciation,* the only
part of the altarpiece to remain in Aix, is an imposing
statement of the hallowed theme that has defied the in-
terpretations of experts as to its precise meaning and
authorship. The side wings, now dispersed among muse-
ums in Brussels, Rotterdam, and Amsterdam, portray
figures of two prophets, Isaiah and Jeremiah (fig. 257),
standing on pedestals in shallow niches. The lunettes
above their heads display a disarray of books and objects
seen from below and are some of the finest and most ar-
tistic examples of still life known in the fifteenth century.

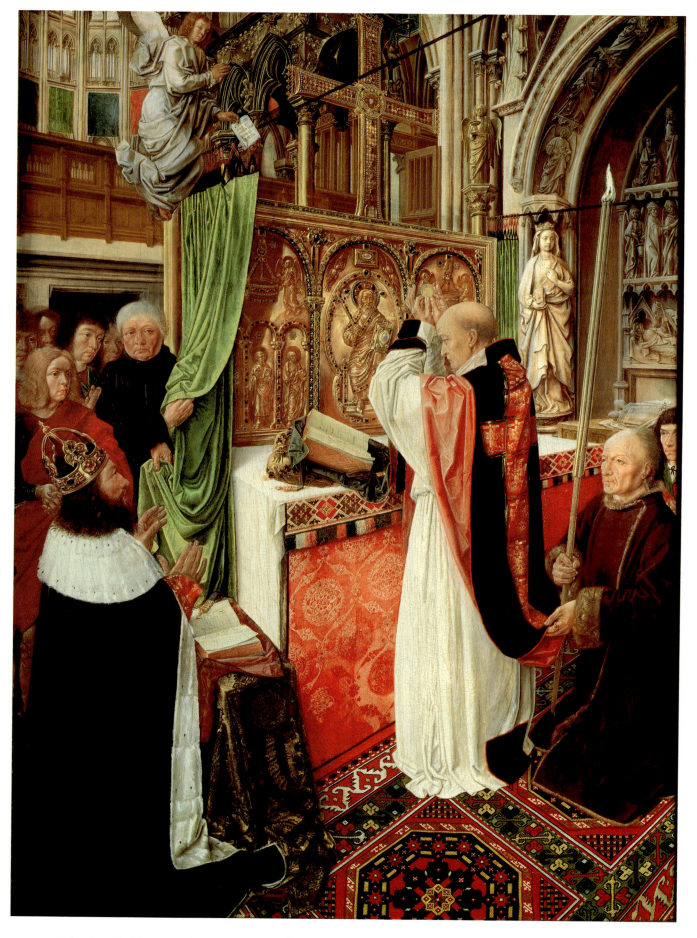

Colorplate 41. MASTER OF SAINT GILES. *Mass of Saint Giles*. c. 1480–90. Panel, 24¼ × 18″. National Gallery, London

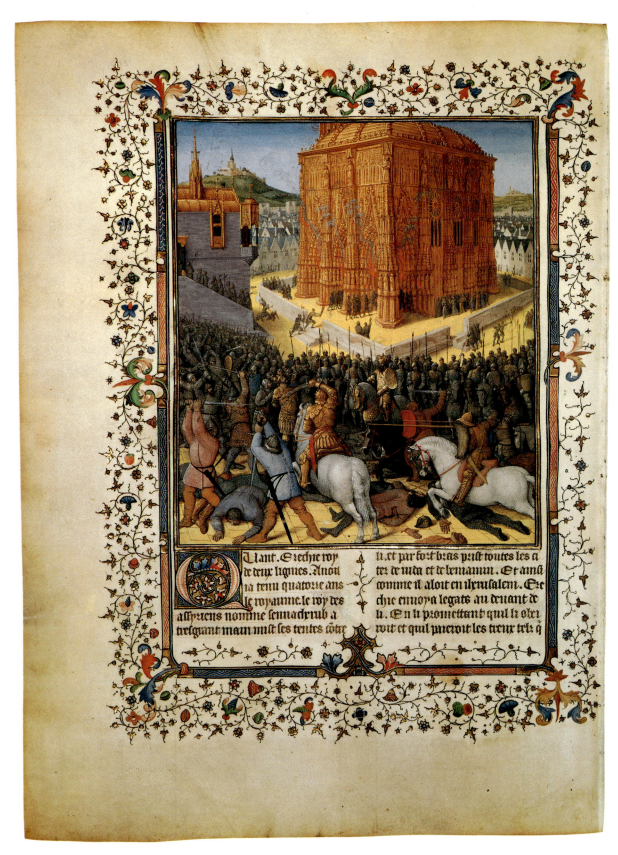

Colorplate 42. Jean Fouquet. *Taking of Jerusalem*, from *Les Antiquités Judaïques*. 1470–76.
Bibliothèque Nationale, Paris

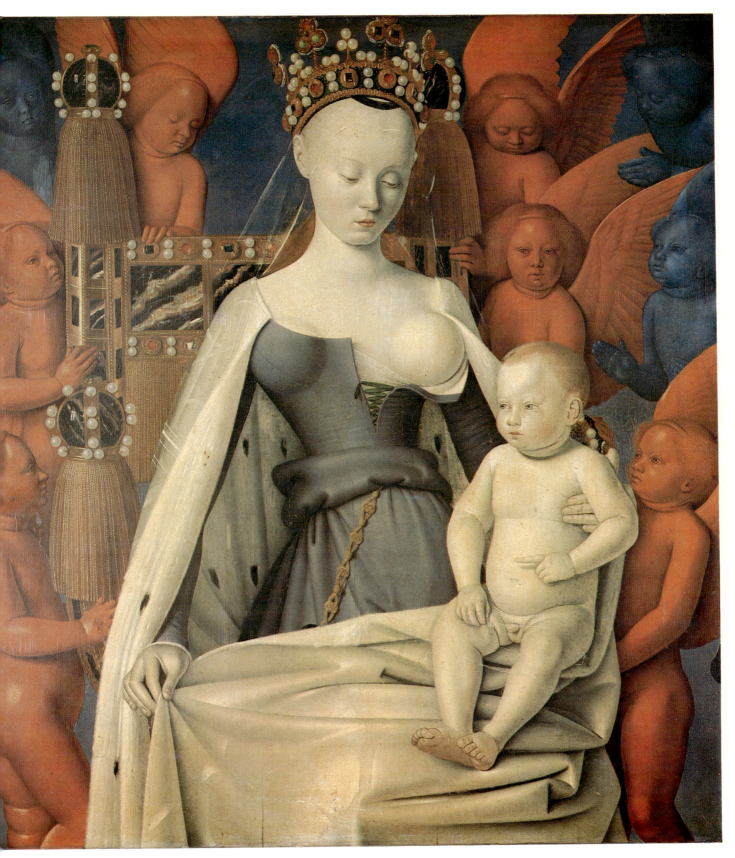

Colorplate 43. JEAN FOUQUET. *Madonna and Child* (right half of the *Melun Diptych*; see fig. 250). c. 1450.
Panel, 36⅝ × 33½″. Musée Royal des Beaux-Arts, Antwerp

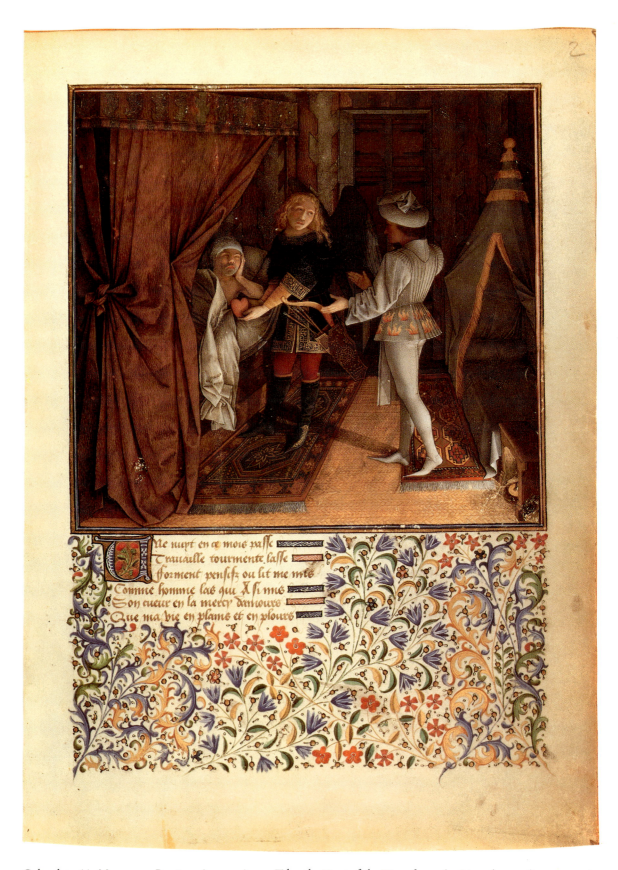

Colorplate 44. MASTER OF RENÉ OF ANJOU. *Amour Takes the Heart of the King*, from the *Livre du cuer d'amours espris*. c. 1457–65. Österreichische Nationalbibliothek, Vienna

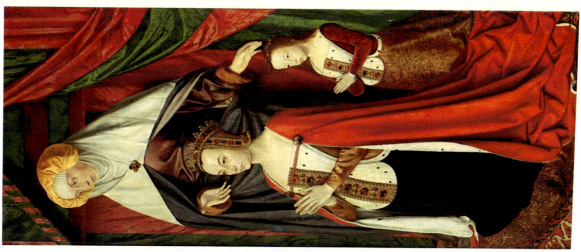

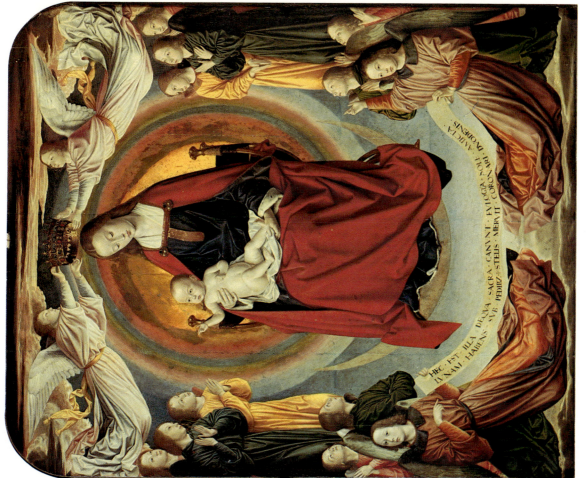

Colorplate 45. MASTER OF MOULINS. *Moulins Triptych.* c. 1498. Panel, 4' 11½" × 9' 3⅜" (whole). Cathedral, Moulins

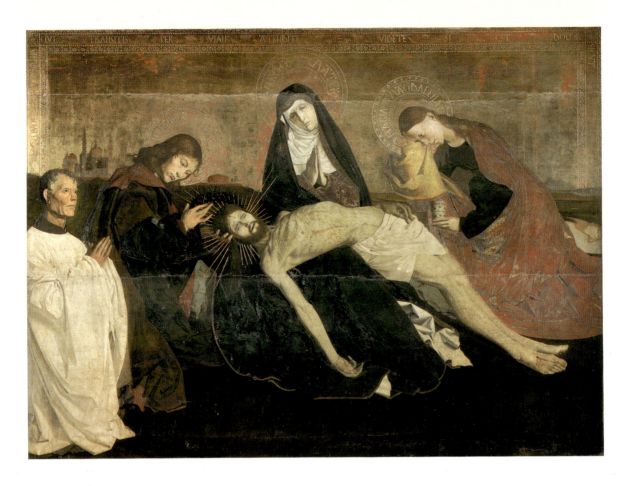

opposite above: Colorplate 46. MASTER OF THE AVIGNON PIETÀ. *Pietà.*
c. 1460–70. Panel, 63¾ × 85⅞″. The Louvre, Paris

opposite below: Colorplate 47.
ENGUERRAND CHARONTON. *Coronation of the Virgin.* 1454.
Panel, 72 × 86⅝″. Musée de l'Hospice, Villeneuve-lès-Avignon

Colorplate 48. JOSSE LIEFERINXE? *Saint Irene Nurses Saint Sebastian.*
1497–98. Panel, 32½ × 21¾″.
The John G. Johnson Collection, Philadelphia

260

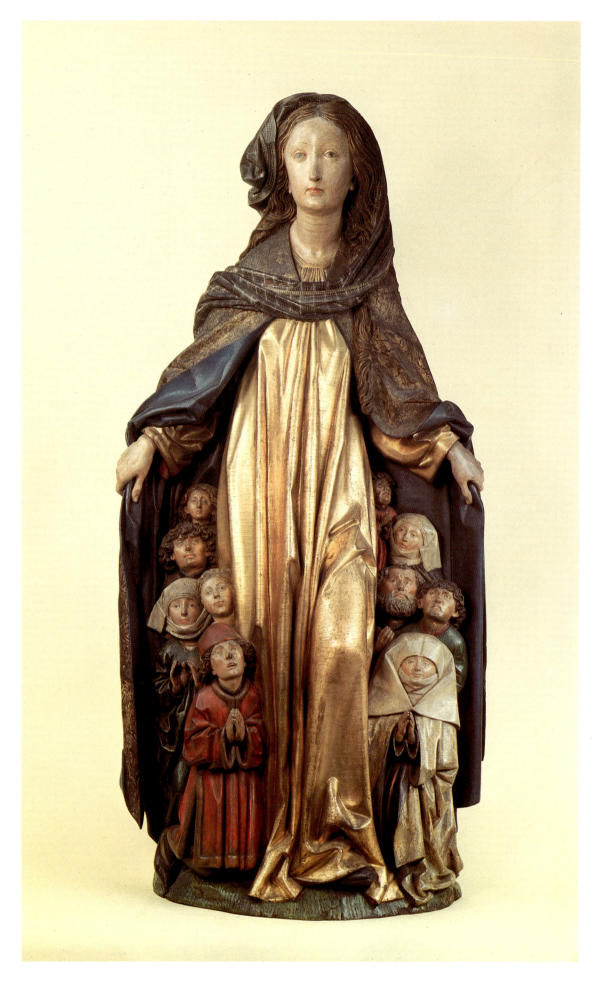

Colorplate 49.
MICHEL ERHART.
Virgin of Mercy,
from Ravensburg
c. 1480–90. Limewo
height 53⅛".
Staatliche Museer
West Berlin

The *Annunciation* is a haunting and mysterious painting. Within the outer porch of a deep, double-aisled church interior (perhaps one side of a vast cathedral), the monumental figure of Gabriel appears encased in a massive plum-colored mantle trimmed with an embroidered border. His head is powerfully modeled and his expression is intense. The portico is decorated in an unusual fashion with two Sluteresque prophets on the upper consoles and a trefoil arch with a bat and a demon. Much has been read into these eccentric additions and their heretical implications, but are these not only more imaginative references to the Old Testament (the prophets) and the evils (the demons) in the world before the period under Grace that we encounter frequently in Netherlandish paintings?

Directly above Gabriel's porch, God the Father appears accompanied by two angels. From his lips, gold rays shower down on the Virgin through a rose window, clearly symbolic of the divine light of Incarnation in which the tiny body of the infant Christ appears. Kneeling before the two aisles of the church and bathed in a bright light is Mary. She wears an elegant gold brocade mantle over a red dress. Before her is a golden ewer filled with symbolic flowers—lilies, columbines, and carnations—and an elaborate wooden lectern that repeats the design of a drawing of Saint Jerome in his study by the Limbourg brothers with the exception of the chained monkey on the pinnacle that replaces the pelican in the drawing. The monkey, subdued and controlled by the virtues of Mary, has been encountered in this context before and should not be considered another aspect of the master's heretical leanings, as has been suggested. The borrowing of a motif from the shop of illuminators for the duke of Berry is not that troublesome either. Such details of furniture were common property and passed about freely in workshop pattern books.

The deep nave is painted in a slate-gray color with masterful modeling of the plunging space. Light pours in through the stained-glass windows to the left, and at the far end of the aisles figures can be seen milling about as if they were about to attend the first Mass, now to be realized with the miracle of the Incarnation. The architectural setting here is simply a variation on the old theme of the Madonna as the church that we have seen many times before, but the gravity and profundity of the meaning of the Annunciation have rarely been more forcefully stated.

MASTER OF THE AVIGNON PIETÀ

Even more enigmatic is the famous *Pietà* from Villeneuve-lès-Avignon, the masterpiece of Provençal painting (colorplate 46).[99] Much effort has been made to pin down the sources of the composition and offer names for the unknown genius who produced it, but to no avail. Some have proposed the name of Nuño Gonçalvez, a Portuguese painter distinguished by his intensely realistic portraits, but for the most part the unmistakable Provençal quality of the painting has led historians to scramble through the local archives for some clue as to his identity. As yet, no documentation on the Avignon *Pietà* has been uncovered. We do not even know who the donor, kneeling to the left, may be other than that he was probably a canon of a local church.

The archaistic features of the panel have often been pointed out: the shallow, barren setting on which the actors have assembled, the use of a gold background, and the angular articulation of the figures. But these features are by no means shortcomings in style. The panel is to be regarded as a magnificent statement of the *Vesperbild* and a visionary one at that as borne out by the inscription incised around the outer border of the gold background: "Oh, all of you who pass by, look and see, what my sorrow is," a passage paraphrased in the improperia sung at Good Friday service as the priest contemplates the cross. It will be noted that the ecclesiastical donor does not turn his eyes on the group about Christ but stares off into space as if in some enlightened trance as the vision of his meditation materializes behind and above him in a timeless, abstract space.

The few architectural details that so mysteriously rise along the horizon have yet to be properly interpreted. Above the head of the canon a domed complex resembling Byzantine architecture is perhaps a dreamy allusion to Jerusalem and the Holy Sepulcher. Above the head of Christ appears a round structure, a type of amphitheater, and behind the Magdalen a somber mountain rises, very likely a reference to the place of her assumption in southern France.

The central group is a masterful statement of the *Vesperbild* with its imposing triangular composition with the aged mother in a dark blue mantle, her face very pale, and the beautifully designed body of the dead Christ across her knees. The dramatic curve of the emaciated body of Christ and the tilt of the head of the grieving mother are contained within the enclosing convex outlines of the youthful John the Evangelist on the left, dressed in somber blues and reds, and Mary Magdalen, in a muted wine-red mantle, on the right. Her pose echoes the descending lines of Christ's legs, and she lifts a yellow veil to her eyes to catch tears.

The restrained sense of plasticity in these heavily draped figures may be due in part to the condition of the panel, but no doubt somber tones were intended. The figures, in fact, seem to be carved from wood and then lightly tinted, especially the heads. The donor's head, on

the other hand, is finely chiseled with his features sharply delineated and his flesh tones ruddier and more forcefully modeled. His habit, the white surplice, also is more detailed in terms of drapery patterns. The contrast between the man in this world and the mystical pyramid within an elongated oval of the *Andachtsbild* that is the subject of his intense devotion, his inner vision, so to speak, has rarely received such a poignant treatment.

ENGUERRAND CHARONTON

At one time the *Pietà* of Villeneuve-lès-Avignon hung alongside another unusual masterpiece of Provençal art in the Chartreuse there, the *Coronation of the Virgin,* an ambitious work that can be attributed and dated with certainty to Enguerrand Charonton (Quarton) and commissioned by Jean de Montagnac, a priest in the Chartreuse, on April 25 (the Feast of the Annunciation), 1453 (colorplate 47). By some rare fortune the entire contract for the commission has been preserved, and it gives us unusual insight into the close collaboration of donor and painter for an altarpiece of complex iconography. The contract was signed in the "spice shop" of Jean de Bria, a wealthy merchant, and it was destined for the church of the Carthusians (Chartreuse du Val de Bénédictione) in Villeneuve.[100]

On first reading this lengthy document, one is somewhat bewildered by the diverse aspects of the iconography prescribed, but it is clear that the contract called for a threefold program. The Trinity with the Coronation of the Virgin is central and foremost and was surely painted entirely by the hand of Charonton (as stipulated in the contract); the Adoration of the Trinity in heaven by all saints and estates is clearly another (cf. Van Eyck's Ghent altarpiece; see p. 93); and a third meaning is that of the condition of man at the Last Judgment with the emphatic division of purgatory and hell. Charonton took advantage of the liberties given to him in the contract. Some episodes were shifted about in the final composition, while a few others were omitted entirely, but as a document of the collaboration between a learned donor and a gifted artist, the contract is extremely revealing.

The stylistic features of Charonton's painting remind one of Romanesque and Gothic *Last Judgment* compositions with its strict symmetry and centrality. The central figures are the largest with a gradual diminution of scale distributed as we move out from the center, the smallest figures being the tiny ones that clamber about in purgatory and hell at the bottom as if aligned in a frieze. In keeping with earlier medieval modes, the smaller the figures, the more agitated they appear. The majestic group of Mary and the Trinity is thus painted in broad areas of basic colors, the smaller figures of the saints shift and move in their varicolored costumes, while those confined to purgatory and hell are agitated nudes painted *alla prima* (spontaneous brushstrokes) in the manner of Hieronymus Bosch, to underscore their fragility and slightness when compared to those in heaven.

The most impressive aspect of the huge altarpiece, however, is the beauty of the bright colors in harmony in the heavens—pure colors for the most part—overwhelming the dingy earthen tones of those suffering below. Aside from the hierarchy in scale, there clearly exists a hierarchy in color as we move from the darkened strip of our world into the resplendent burst of light in the heavens. In the larger figures, Charonton's modeling is bland, opaque, and simplified with little shading or detail. His drapery patterns are Netherlandish in their complex angular pleats (can one note a harsher treatment and angularity in the robes of God the Father, on the left, compared to the softer arcs of the Second Person, Mary's son, to the right?), but it is the bright color that remains the essential characteristic of his style.

NICOLAS FROMENT

A very different personality is presented in Nicolas Froment, born in Uzès in the adjoining province of Languedoc. Froment's style seems to have nothing in common with other Provençal painters nor any leading French artist for that matter. In an early work, the altarpiece with the *Raising of Lazarus* in the Uffizi (fig. 258), signed and dated 1461, one is at first surprised to see a style more closely related to contemporary German artists than to French. Froment turned to Netherlandish models for his figure types and drapery patterns, but he had little understanding or concern for Flemish spatial concepts.

As we have seen, the story of the Raising of Lazarus was popular in Haarlem during the fifteenth century, but Froment's composition in no way reflects those of Ouwater or Geertgen tot Sint Jans. He arranges his figures about the central core of the *Raising of Lazarus* in two friezes with the two sisters of Lazarus brought to the fore on the left, the Jewish disbeliever about to cover his nose on the right. Between them Christ stands frontally on the central axis against a garish golden brocade. Froment's head types are pinched and harshly modeled, some grotesquely grimacing. His draperies fall in shallow and stiff angular folds that mark him as an artist of lesser refinement. It may be that Froment based his rigid composition on a sculptural group such as the one that decorated the Lazarus tomb in Autun.

The triptych, the *Virgin in the Burning Bush* in the Cathedral of Saint Sauveur in Aix-en-Provence, dated 1476, is testimony to the assimilation of Netherlandish style by Froment over the fifteen years that separate it from the

258. NICOLAS FROMENT.
Raising of Lazarus. 1461.
Panel, 68⅞ × 52¾".
Uffizi, Florence

Uffizi panels (fig. 259). While the faces of the saints and donors are still sharply delineated and spatial relationships are clumsy and misproportioned, the central scene of the angel and Moses before the burning rose bush that serves as Mary's throne is beautifully conceived and executed in bright green and red colors. This unusual triptych was commissioned by René of Anjou for the Church of the Carmelites in Aix, where it remained until 1791. The donor appears on the left wing in the company of Saints Mary Magdalen, Anthony, and Maurice. On the right panel René's second wife, Jeanne de Laval, is presented by Saints John the Evangelist, Catherine, and Nicolas. Closed, the shutters display a grisaille *Annunciation* placed in tall niches with discomforting tabernacles hanging high above the heads of the angel and Mary.

The appearance of Mary in the burning bush is unusual. The burning bush was witnessed by Moses (Exodus 3:2) but the mother of God was not mentioned. Her appearance here is very likely a conflation of imagery (perhaps due to a poetic program dictated by the learned René, but this is not likely), in which two or three levels

of meaning can be discerned. The Old Testament provides us with the two figures in the foreground and the burning bush:

Now Moses was keeping the flock of his father-in-law, Jethro, the priest of Midian; . . . and the angel of the Lord appeared to him in a flame of fire out of the midst of a bush; and he looked, and lo, the bush was burning, yet it was not consumed. And Moses said, "I will turn aside and see this great sight, why the bush is not burnt." When the Lord saw that he turned aside to see, God called to him out of the bush, "Moses, Moses!" And he said, "Here am I." Then he said, "Do not come near; put off your shoes from your feet, for the place on which you are standing is holy ground." And he said, "I am the God of your father, the God of Abraham, the God of Isaac, and the God of Jacob." And Moses hid his face, for he was afraid to look at God (Exodus 3: 1–6).

This is precisely what we see in Froment's painting: the angel, the flocks, Moses removing his shoes and hiding his eyes from the vision of the burning bush. In keeping

with Carmelite legends, God the Father does not appear in the bush; rather, Mary and the Christ Child are there. From the eleventh century, the unconsumed burning bush often served as a symbol of Mary's immaculateness and virginity.

The dual meaning of the typology here—as symbol of the Immaculate Conception of the Virgin and the virginal birth of Christ—is further underscored by a Tree of Jesse (a type for the Immaculate Conception) painted on the golden frame of simulated architecture of the central panel, and by the grisaille *Annunciation* on the exterior shutters. Froment fashioned the burning bush into a rose arbor, a familiar setting—the Madonna in the Rose Gar-

den—for Rhenish mystics, and he placed a round mirror in the hand of the Child that reflects mother and infant as yet another familiar allusion to the spotless character of the Virgin, the *speculum sine macula*.

MASTER OF SAINT SEBASTIAN

If the style of Froment seems to break the fine continuity of Provençal art, that of the last painter to be considered here, the Master of Saint Sebastian, admirably recaptures the pristine beauty of that tradition. The identity of the Master of Saint Sebastian as Josse Lieferinxe, a painter from Cambrai active in Marseilles and Aix between 1493

259. NICOLAS FROMENT. *Virgin in the Burning Bush.* 1476. Panel, 13' 5½" × 10' (entire altarpiece).
Cathedral of Saint Sauveur, Aix-en-Provence

and 1508, has been recently established on good grounds. The Saint Sebastian panels—seven survive in collections in Philadelphia, Baltimore, Leningrad, and Rome—are unique compositions that surely belong to one project. A document of 1497 records an altarpiece with eight pieces from the life of Saint Sebastian flanking a centerpiece depicting Sebastian between Saints Anthony and Roch (all related to the plague) for the prior of the Confrérie du Luminaire de Saint Sébastian associated with the Church of Notre-Dame-des-Accoules at Marseilles. Two artists were named in the contract, Josse Lieferinxe and Bernardino Simondi of Piedmont. After the death of Simondi in the following year, Lieferinxe completed the project alone.

There is no reason to question the union of these panels since they are all of approximately identical dimensions, and they all display the same style with solid figures reduced to simple geometric volumes enhanced by a smooth shaping of their mantles in broad planes and a charming stereometric quality in their simplified heads (colorplate 48). These quiet figures move hesitantly in a clearly ordered space with the barren interior setting stated by the tile-floor projection and side walls dramatically lit with a bright light. The cubic quality of his compositions together with the simplification and generalization of figures and objects in a strong light rather anticipate the later Baroque works of Georges de la Tour, and although Lieferinxe came from Cambrai in the north, his art was beautifully attuned to the orderly classicism of Provence.

His ties with Italy cannot be missed either. In the *Death of Saint Sebastian* in Philadelphia (fig. 260), the unusual view of Rome with the Colosseum and triumphal arches dominating the setting has an Italianate look about it with lucid perspective and lighter tones for the clearly defined architectural forms. For Lieferinxe the settings come first, the figures are then cautiously ac-

260. JOSSE LIEFERINXE? *Death of Saint Sebastian.* 1497–98. Panel, 32½ × 21¾". The John G. Johnson Collection, Philadelphia

commodated to space, and all are rendered in cool or light colors that enhance the clarity and balance of his pictures. With Lieferinxe we come to the end of a gracious and dignified century of French painting.

Graphic Arts Before 1500

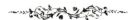

WOODCUTS

In the Middle Ages few people, other than those educated at the courts or in monastic schools, could read, but during the course of the fifteenth century a revolutionary breakthrough in the arts took place that was to have lasting consequences in the history of man's visual communication: the illustrated printed page. It all began rather meekly with the woodcut, which was inked and then pressed on paper. Surprisingly, the techniques involved in woodcut printmaking were long known in decorating textiles, but it was not until the introduction of rag paper from the Orient that it became an economical manner in which to reproduce multiple pictures for the common market.

Essentially, the woodcut is a block on which the design drawn on the surface is isolated by cutting away the wood between the lines, leaving them in high relief, which when inked can be transferred to paper. As the art of the woodcut rapidly developed, three or four stages in the production of relief printing were distinguished: (1) the design produced by the artist (*Reisser*), (2) the transfer of the design to the surface of the block, (3) the cutting of the block by the *Formschneider* or *printsnyder,* and (4) the printing by the *Drucker* or *drukker.* In many productions a fifth step involved the hand-coloring of the printed image by the *verwere* or *tinctor.*

The earliest of the single-sheet woodcuts (*Einblattdrücke*) appear about the turn of the century in Austria and France. It was the emblematic features of the early woodcut that were important, not the sophistication of style, since the prints had a popular and utilitarian role in their initial stages. They often served as inexpensive objects for veneration such as pilgrims' souvenirs purchased at shrines and fairs. As amulets to protect the traveler from the plague or other misfortunes on his journey or in his home, a number of the earliest woodcuts have been found pasted into small travelers' chests.

The woodcuts also served as objects of amusement in the form of playing cards and as greeting cards. One popular New Year's greeting was a picture of the Christ

261. FRENCH? *Le Bois Protat* (fragment), showing tormentors at a Crucifixion. c. 1380–1400. Wood block, 23½ × 9″. Collection Émile Protat, Mâcon, France

Child holding a cuckoo, the prophetic bird whose first notes heard in the new year signaled the number of years the listener had left in life. For the most part, however, the early woodcuts illustrate religious themes associated with the hours of devotion or images of the saints venerated at the pilgrimage sites. Often the same craftsman designed, cut, and printed the block himself. He often was a member of a religious order (who also sold the prints) or a secular workman in the carpenters' guild. As in many commercial enterprises, conflicts and lawsuits sometimes resulted over the legality of who had priority in issuing the woodcuts.

In spite of the anonymity of the artisans, the few early examples of woodcuts to come down to us are surprisingly pleasing aesthetically for their simplicity, direct-

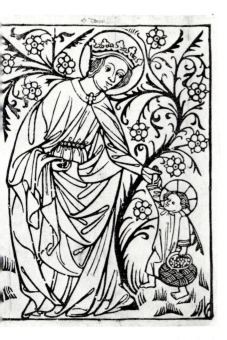

262. GERMAN. *Saint Dorothy.* c. 1420.
Woodcut, 10⅝ × 7½"

263. GERMAN-BOHEMIAN. *Agony in the
Garden.* 1410–20. Woodcut, 10¼ × 7¼"

264. GERMAN, UPPER RHINE. *Buxheim Saint
Christopher.* 1423? Woodcut, 11⅜ × 8⅛".
Johns Rylands Library, Manchester

ness, and clarity of design. Considered to be the earliest known woodcut is *Le Bois Protat,* a block with a fragment of the *Crucifixion* (obverse) and *Annunciation* (reverse), dated between 1380 and 1400 and believed by many to be French, possibly Burgundian in origin (fig. 261).

Interestingly, a document from Dijon informs us that in 1393 a carpenter, Jehan Baudet, was paid for cutting molds (*moles*) for decorations in a chapel of the Chartreuse after designs of Beaumetz, court painter to Philip the Bold (see p. 69). Perhaps *Le Bois Protat* as well as the designs of Beaumetz were for printing textiles, but the style of the figures and their costumes compares favorably with the earliest dated woodcuts from the Tyrolean area of Germany and Austria. Arthur M. Hind, the author of many useful studies and catalogues of these early impressions, divided the development of fifteenth-century woodcuts quite mechanically into four phases chronologically, and while Hind admits that there are insurmountable problems regarding dates and provenance, his analysis of the steps involved is worth noting.[101]

The earliest phase, about 1400–25, concentrated mostly in Upper Bavaria and Austria, is distinguished by bold, thick lines often emphasizing a certain rhythmic sway through long curves that end in tiny hairpin bends and loops with no internal modeling or shading lines. The print of *Saint Dorothy* (fig. 262) is a good example of this early style with its elegant play of drapery lines ending in graceful loops reminiscent of works of the International

Style. Dorothy was especially venerated in Austria, and the print was very likely issued for sale at fairs there.

Another fine example of Hind's first phase is the *Agony in the Garden* (fig. 263), a work closely derived from Austrian and Bohemian painting, especially those of the Master of the Vyšší Brod Altarpiece (see p. 27) whose painting of this theme is composed in a nearly identical manner. The outlines of the woodcut are thicker and bolder but no less melodic with hairpin bends and loop folds repeated throughout. The impression is velvety black, and the figures are hand-tinted in tones of browns and yellows while the background has been painted a deep black to enhance the contours of the landscape and the body of Christ, a practice quite common in early woodcuts.

The *Buxheim Saint Christopher* in the John Rylands Library (fig. 264) is dated 1423 in the inscription carved into the block at the bottom of the print. This handsome print, no doubt a favorite amulet for travelers, is representative of Hind's second phase, which involves not only a difference chronologically but also a change in provenance to the Upper Rhine area. It is distinguished by thinner lines executed with shorter strokes and fewer sweeping curves. Pinhooks and loops are not so predominant, and much more attention is given to the pictorial effects in the detailed landscape setting. The most striking difference appears in the new technique of modeling with short parallel lines. Although shading is used somewhat hesitantly in Saint Christopher, it appears in the

265. NETHERLANDISH. *Madonna in the Sun.* c. 1450–60.
Woodcut, 13¾ × 10⅛″

266. NETHERLANDISH. *Exercitium super Pater Noster.* 1435–40.
Chiro-xylographic book

elongation of the Madonna together with the complex angularity of the draperies of the angels confirm, in my mind, the later dating. Stylistically it is close to the elegant figures in later Dutch block books, to be discussed below, that can be dated between 1460 and 1475.

Here too we find the use of parallel strokes for shading purposes, and the earlier rounded pinhook breaks in the drapery, especially around the feet, are now sharp "pothooks," as Hind calls them. So it appears that the art of the woodcut had a strong beginning in South Germany, Austria, and possibly Bohemia, and then activity in the new art form, corresponding to the general development in the arts, shifted to the Upper Rhine and then down the river to the Netherlands. The third phase of Hind's development centers in the Netherlands, especially in Holland, and is represented by prints displayed in a new format: the block book.

A number of single-sheet woodcuts have been preserved as insertions pasted into manuscripts and book covers, and their adaptability to the book, as illustrations to replace the costly hand-painted miniatures, was inevitable. Some of the earliest fragments of block books with text and pictures carved from the block (xylographic) and the chiro-xylographic editions (meaning by hand and woodcut), where the text is handwritten below, above, or within the prints, were manuals of instruction for the poorer and less literate communities. The Brethren of the Common Life were particularly active in promoting such popular educational tools, and many of their houses in the North Netherlands (Deventer, Gouda, Utrecht, Zwolle, 's Hertogenbosch) and in the south (Abbey of Groenendael near Brussels, Louvain) owned presses that produced books of illustrations with abridged texts that served as simple forms of religious instruction for the unlearned.

What a boon this meant for education! Early sheets with illustrations of the Apostles' Creed (*Symbolum Apostolicum*) were issued in Germany as rudimentary books, and one of the earliest chiro-xylographic books, the *Exercitium super Pater Noster* (*Exercise on Our Father's Prayer*), about 1435–40, has texts written in Flemish below striking woodcut illustrations that nearly fill the page with graceful figures in a style related to that of Robert Campin and early Rogier van der Weyden (fig. 266).

One of the most popular and influential of these instruction books for the clergy was the *Biblia pauperum,* or *Poor Man's Bible,* issued in some eleven editions in the fifteenth century (fig. 267). A compendium and harmony of Old and New Testament themes, the *Biblia pauperum* was a handy manual for composing sermons. As stated in the prefaces of similar typological treatises, it was produced for the "glory of God and for the instruction of

hollows of his mantle, in the thatched roofs, and in the landscape.

A print of the *Madonna in the Sun* (fig. 265), a work of considerable artistic merit, has been dated as early as 1430 and as late as 1460, indicating the precarious nature of the criteria available for the style critics. The inscriptions in the corners of the print are in Dutch, and the

those who, being ignorant, should be taught with pictures.'' The illustrations are printed two up on a single sheet that is then folded, forming facing pages. The sheets are printed on one side only. The compositions repeat those of earlier manuscript versions of the *Biblia pauperum* with one major scene from the New Testament and two side illustrations from the Old that serve as types. Above and below the architectural borders that separate the three scenes, two prophets appear under arches with unraveled scrolls carrying their predictions. The brief explanatory text is added right and left at the top of each page flanking the groups of prophets.

The cycle in the *Biblia pauperum* runs for forty or fifty pages, beginning with the Annunciation, flanked by prototypes from the Old Testament: Eve receiving the apple from the serpent in Eden and Gideon's fleece. The New Testament then continues through the Infancy, Ministry, Passion, to the Resurrection in the same fashion, each episode flanked by two Old Testament parallels and four prophets. Thus, much as an artist could draw upon such exempla for typological programs (cf. Dieric Bouts's *Last Supper Altarpiece,* see p. 146), the preachers could compose impromptu sermons for their parish.

While it is generally agreed that the printed *Biblia pauperum* originated in the North Netherlands, there is still much controversy over just where and when. It has been claimed that the famous ''forty-page'' edition of the *Biblia* was issued in Haarlem by Laurens Janszoon Coster, a well-known printer there, but there is little agreement on the date, which has wavered between 1430 and 1465. In a recent study, Robert Koch has convincingly linked the Old Testament iconography with miniatures in a Utrecht Bible of 1460, and he further suggests that it was first printed in a Carthusian atelier in or near Utrecht.[102] This makes good sense. Other Utrecht manuscripts, dating about the same time, are illustrated with pen drawings that are close to woodcuts in style and expression.[103]

On the other hand, it should be pointed out that in terms of the articulation of the figures, their draperies and costumes, and the settings, both interiors and landscapes, the *Biblia pauperum* illustrations are very much in the tradition of Ouwater and Bouts, and they could well have been designed by an artist trained in Haarlem. The cutting is much more precise and pictorial than in earlier woodcuts with delicate facial features, and the use of parallel-line shading is effective not only in the modeling of the fussy draperies but also in the architectural frames, which seem to project from the page like diaphragm arches commonly found in miniatures of the mid-fifteenth-century. The whole page has acquired a sophisticated unity that resembles the compositions of portable triptychs with predellas and headpieces.

267. NORTH NETHERLANDISH. *Annunciation with the Fall of Eve and Gideon's Fleece,* from the *Biblia pauperum.* c. 1465. Woodcut from the block book

268. NETHERLANDISH. *Impatience of a Sick Man,* from the *Ars moriendi.* 1460–65. Hand-colored woodcut from the block book, 8½ × 6⅛"

Also popular as a pictorial manual of instruction was the *Ars moriendi,* or *Art of Dying Well,* which served as a guidebook for the clergy in comforting and counseling the dying (fig. 268). In all there are eleven full-page woodcuts with alternating scenes showing the various temptations of demons to incite vice in the infirm (Infi-

delity, Despair, Impatience, Vainglory, and Avarice) followed by angels comforting and instructing the dying man. On the last page, virtue triumphs over all the temptations in the final hour of death. Stylistically, the finest edition, presumably the first, is closely related to the *Biblia pauperum,* although the figures are taller in proportions and the compositions are more monumental and dramatic. The precision of the cutting and the delicate modeling exemplify the style of the *Biblia pauperum,* and the first edition of the *Ars moriendi* should be thus dated to the years around 1460 to 1465.

The problem of the origins of these unique designs is somewhat complicated by a nearly identical set of illustrations in engravings by the Lower Rhenish Master E.S., who will be discussed later. For the present, however, it should be noted that the woodcut edition is as aesthetically pleasing if not more so than the engravings, and the case for priority (and by implication the original designs) is difficult to resolve. Both sets were probably derived in part from earlier illuminated models.

Included in this group of block books is the charming *Canticum canticorum,* an allegorical treatise of the Song of Solomon with Christ and Mary as the principal actors (fig. 269). The elegant female figures, tall and lithesome, are beautifully presented with their graceful movements and demure behavior imbuing the compositions with a serene harmony. The thin lines are masterfully controlled, especially in the softly cascading folds and the sharper features. There is something tranquil and dreamlike in the arrested movements and hushed actions of the figures. All erotic and sensuous overtones of the famous Old Testament song in honor of love in marriage (*epithalamium*), where the meeting and embracing of the bride and bridegroom are poetically described, are here repressed. Mary Ecclesia, the bride, is in the company of her virgin attendants, while Christ, youthful and beardless as the young groom, offers his bride only the most gentle solace and comfort.

269. NETHERLANDISH. *Canticum Canticorum.* 1470–75. Woodcut from the printed book

270. NETHERLANDISH. *Last Supper* with Old Testament types, from the *Speculum humanae salvationis.* 1470–75. Woodcuts from the printed book

Another typological book, much like the *Biblia pauperum,* which received a wide audience in northern Europe, the *Speculum humanae salvationis,* introduces us to Hind's final phase (fig. 270). The original text has been attributed to a Carthusian monk, Ludolphus of Saxony, who presumably composed the manual in Strasbourg sometime around 1320. As the preface clearly states, this picture book was intended to be an aid in illustrating the harmony of the Old Testament and the Gospels for the teaching of the "poor preachers" (*pauperes praedicatores*). More complicated than the *Biblia,* the *Speculum* contains twenty-three New Testament scenes, each accompanied by three Old Testament parallels or types extending across two open pages. Usually these are preceded by eight scenes from Genesis relating the story of the creation and the Fall of Man and appended with two illustrations of the Last Judgment with its types. In all, fifty-eight blocks are used, printed on one side of the paper, as was common in most block books. The text, in Latin and Dutch editions, printed below the illustrations, however, is not cut out of the block but is printed with movable type.

A fierce debate has long raged over the invention of movable type, the final step in the evolution of the printed book in the fifteenth century.[104] Some Dutch historians as well as others have long argued for the primacy of the Haarlem printers in the discovery of cast metal type and have attributed the invention to Laurens Janszoon Coster sometime around the middle of the century. This would explain the sudden appearance of cast type in the *Speculum humanae salvationis,* if he, indeed, were the printer. On the other hand, German scholars and most others have favored the theory that Johann Gutenberg of Mainz on the Rhine first printed books with movable

type. The issue is in many respects a hopeless one to resolve, although generally today Gutenberg's priority is accepted.

Soon after the publication of the famous Gutenberg or Mazarin Bible, sometime between 1450 and 1456, the spread of this style of printing was very rapid across Europe, and by the 1470s printing presses were established in the major cities in Germany, France, Italy, and the Netherlands. One point that the historians of typography have not properly addressed is just what the invention meant in terms of the illustrated book. None of Gutenberg's books and texts or those of his immediate successors, Johann Fust and Peter Schöffer, was illustrated (aside from painted initials or drolleries), while many of the typographic (in contrast to the xylographic) publications in fifteenth-century Holland were. Wherever the printer of the *Speculum humanae salvationis* acquired his font (an assortment of cast type of one size and style), his introduction of cast type initiated a new phase in the Dutch illustrated book that was quickly adapted in Utrecht, Haarlem, Leiden, Delft, Louvain, Bruges, Antwerp, and elsewhere in the Netherlands.

The *Speculum humanae salvationis* can be dated between 1470 and 1475. The style of the woodcut illustrations is much like that of the pictures in the *Canticum canticorum* with the same refinements and precision in details, but the *Speculum* woodcuts seem more advanced in these pictorial features. Within a decade, the *Speculum* blocks (as well as those in the *Biblia pauperum*) were cut up to supply illustrations in diverse book formats for various abridged devotional texts such as the popular *Epistelen en Evangelien* (*Letters and Gospels*), issued in Utrecht in 1481 by Jan Veldener, considered by some the original printer of the *Speculum.* As the spread of printing presses acceler-

271. MASTER OF BELLAERT. *Early History of Man and the Baptism of Christ*, from *Der Sonderen Troest*. 1484. Hand-colored woodcut frontispiece

272. MASTER OF BELLAERT. *The Earth and Its Division*, from *De proprietatibus rerum*. 1485. Woodcut frontispiece for Books 14 and 15

273. MASTER OF BELLAERT. *Animals*, from *proprietatibus rerum*. 1485. Woodcut frontispi for Book 18

ated in Holland, more and more fragments of illustrations in the typological books were passed from shop to shop to be reused in a new text or simply to serve as models for them. One of the more interesting of these is the *Leven ons Heeren* (*Life of Our Lord*), written by Ludolphus of Saxony, the same fourteenth-century monk accredited with the text of the *Speculum humanae salvationis*.

With the rapid development in the illustrated printed book came increasing demands for more deluxe editions with leading painters participating more and more in the designing of the woodcuts. Coster left Haarlem in 1483, and his position as a city printer was immediately filled by one Jacobus Bellaert, who between 1483 and 1487 published some of the finest Netherlandish books of the century. The designs for illustrations in at least five of his books were provided by a leading Haarlem painter, the Master of the Tiburtine Sibyl, and his shop.

In the frontispiece for *Der Sonderen Troest* (*Trial of Belial*; fig. 271), an allegorical trial of Christ written by Jacobus di Theramo, Bellaert's master designer composed a complex typology of man's salvation through the waters of Baptism as the introduction of Theramo's text explains it. The reasons for man's fall from Grace are footnoted at the top of the illustration with the Fall of the Rebel Angels and the Fall of Adam and Eve in Eden. Below, in a panorama of a deep landscape, three examples of salvation by water are illustrated with the ark of Noah floating on a quiet sea, the Crossing of the Red Sea by

Moses and the Israelites, and, finally, the Baptism of Christ by Saint John in the Jordan. The Haarlem artist was particularly gifted in composing cosmic views of this nature with separate episodes conflated in one unifying vista much as we find in Haarlem painting of the period.

In another book, *De proprietatibus rerum* (*On the Properties of Things*), by Bartholomaeus Anglicus, a very deluxe edition was published by Bellaert perhaps for some special occasion. It was issued on Christmas Eve, 1485, and most of the known editions are beautifully hand-colored. Bellaert also had a new type font designed for it. In the nature book by Bartholomaeus, the artist had an opportunity to exploit his interests in landscape and nature rather than narrative. In the unusual illustration for the chapter on the divisions of the world, the Bellaert master designed a deep panoramic vista (fig. 272), a pure landscape without figures, shimmering under a cloud-filled sky, that amazingly anticipates the cosmic visions of such Antwerp Mannerists as Joachim Patinir nearly fifty years later.

Another surprising illustration is the frontispiece for Book 18, on animals (fig. 273). Earlier nature books simply line up the animals like processions of cutout silhouettes across the page, such as those in the Gouda *Dialogus creaturarum* (*Fables*) of 1480 where the beasts resemble stuffed toys more than living creatures. In contrast, the Bellaert designer presents us with an open-air zoo with a parade of animals scattered in a landscape. Astonishing too is the naturalism. The artist must have known the

animals by firsthand observation and not convention. The elephant is surprisingly lifelike and dominates the composition in the lower right. Where did our artist find such an exotic model? Had he actually seen an elephant? It seems very likely. In the *Cronycke van Hollandt*, printed in 1517 by Jan Seversoen, it is recorded that in the year 1484, "A living elephant was conducted round Holland from town to town, to the great profit of the owner . . . it drowned near Muiden when embarking for Utrecht." The year before, 1483, the owner had taken his exotic exhibit down the Rhine, where, as we shall see later, it was probably studied by Martin Schongauer.[105]

Of special interest in deluxe Dutch illustrated books are the colorful illustrations in an allegorical romance in verse, *Chevalier délibéré*, or the *Resolute Knight*, published in Gouda sometime between 1486 and 1490 (fig. 274). This complex poem, written by the Burgundian court poet Olivier de la Marche in 1483, relates the life of the author (*l'auteur*) in his golden years as he sets out for fulfillment of life and encounters the evil knights "Weakness" and "Accident." He later retires to the sheltered hut of the hermit "Understanding" and then meets the fair lady "Fresh Memory." After attending a tourney in which the dukes Philip and Charles of Burgundy participate, he makes his final preparations for death.

The sixteen woodcuts illustrating the strange saga are difficult to understand without recourse to the text of De la Marche. The figures are big, well-articulated, and fill the page with their lively actions, and the landscape settings are much advanced in terms of spatial projection and scale relationships. Many figures and beasts are dramatically foreshortened, and all are rendered in great detail. The astonishing originality of these woodcuts has led to much speculation as to the identity of the designer. He has been identified as Hugo Jacobsz (the father of Lucas van Leyden) and as Jacob Cornelisz van Oostsanen (see p. 448), but his personality evades us, regrettably. Perhaps Olivier de la Marche had the designs prepared in Flanders and then sent them to the shop in Gouda for cutting and printing. French and Dutch editions were published.

In 1441 an Englishman, William Caxton, traveled to Bruges as a representative of the cloth merchants' guild. Highly successful as a businessman, Caxton served as governor of the English Merchant Adventurers in the Netherlands between 1465 and 1469, and it was about that time that his literary interests came to the fore. Caxton began to translate French texts into his "rude English" as it was considered by Margaret of York (sister of Edward IV), the duchess of Burgundy, to whose household Caxton was attached sometime between 1471 and 1476.

Caxton returned to England to set up a publishing

left: 274. NORTH NETHERLANDISH. *Combat Between the Actor and Age*, from the *Chevalier délibéré*. c. 1486–90. Woodcut

below: 275. ENGLISH. "Wife of Bath," from the *Canterbury Tales*. c. 1484. Woodcut

house in Westminster, where he continued to translate French works into English, of which over eighty editions were published before his death in 1491. Some of these were illustrated in the fashion of the Netherlanders, and it is not surprising that the designers and woodcutters lagged behind their contemporaries on the Continent. Caxton's chief assistant and foreman of his presses was an Alsatian with the charming name of Wynkyn de Worde, and together they published numerous books popular abroad, including the *Mirrour of the World* (1481), the *Game of Chesse* (1483), the *Legenda Aurea* of Voragine (1484), as well as many legends of English saints and Chaucer's *Canterbury Tales*.

The "Wife of Bath" is typical of these early English woodcuts (fig. 275). The cutting is coarse and stiff with simplified contours and shading, obviously the work of a novice learning his craft in Caxton's shop. The pilgrims in the *Tales* are mounted on horseback as the *dramatis per-*

276. ERHARD REUWICH. *View of Venice*, from the *Sanctae peregrinationes*. 1486. Woodcut

sonae for the illustration of the Prologue and then repeated before their own stories. The Wife of Bath has a certain promiscuous look about her as she sits rigidly sidesaddle while prominently displaying her Rosary. One cannot help but respond warmly to the naive charm expressed in the simplified woodcut. Within a decade, however, English illustrations were hardly distinguishable from those on the Continent.

Woodcut illustration in printed books flourished in Germany and the Rhineland during the last quarter of the fifteenth century. The major presses established in Bamberg, Augsburg, Ulm, Basel, Strasbourg, Speier,

277. ERHARD REUWICH. Animal page from *Sanctae peregrinationes*. 1486. Woodcut

Mainz, Cologne, Nuremberg, and Leipzig turned out a great variety of texts with illustrations ranging from the classics (Vergil, Terence, Boccaccio) to nature books and satirical or moralizing treatises such as Sebastian Brant's *Narrenschiff*. One of the most interesting and original publications was Bernhard von Breydenbach's *Sanctae peregrinationes* (*Holy Pilgrimages*), issued in Mainz in 1486 by the Utrecht artist and printer Erhard Reuwich (see fig. 276).

Breydenbach, an aristocrat of considerable means, had made a pilgrimage to the Holy Land in 1483–84 as a sort of penance for "loose living in his youth," as he informs us in the introduction. For this trip, Breydenbach took along Reuwich as his personal artist to record the various sites and peoples and another, Felix Fabri, to keep an accurate log and journal of the trip. In all, some 150 people embarked from Venice in Breydenbach's ship. The resulting travelogue, printed upon Breydenbach's return, is a fascinating account of the geography, history, and manners of the peoples he encountered, historic battles, and the exotica in flora and fauna of the foreign lands. Reuwich's illustrations are equally captivating and remain to this day valuable contributions to our knowledge of the east Mediterranean and the impressions Europeans formed of the land and its people.

The woodcuts, including a magnificent allegorical frontispiece, are especially distinguished in the seven folding plates of the major cities visited: Venice, Parenzo, Corfu, Modon, Candia, Rhodes, and Jerusalem. In Venice the view is taken across the Grand Canal with the Doges' Palace, the Piazza of San Marco, the campanile, and the five domes of San Marco clearly presented, although their precise settings are somewhat obscure. Six plates illustrate the varieties of races (Saracens, Jews, Greeks, Syrians, Abyssinians, and Turks), seven present the different alphabets of the Near East (Hebrew, Greek, Syrian, Coptic, Ethiopian, Armenian, and Arabic), two

others give a view of the Holy Sepulcher in Jerusalem and, finally, an illustration of the exotic animals believed to have been seen by Reuwich but were, for the most part, fanciful hybrids designed to satisfy Western beliefs and interests. The unicorn figures prominently among them (fig. 277).

As in the Netherlands, the sophistication of the later illustrated books required the services of accomplished painters for their designs. The woodcuts of two outstanding books published in Nuremberg, the *Schatzbehalter* (*Treasury of the True Riches of Salvation*) of 1491 and the *Weltchronik* (or *Nuremberg Chronicle*) of 1493, were entrusted to the leading city painter, Michael Wolgemut (see p. 235), who was also Albrecht Dürer's teacher. Wolgemut's name appears in the colophon of the *Weltchronik* along with that of his assistant, Wilhelm Pleydenwurff (son of Hans Pleydenwurff, Wolgemut's master), as "painters" of the pictures, and it is generally agreed that the stylistic features of the woodcuts in the earlier *Schatzbehalter* confirm their attribution to the same shop.

The *Schatzbehalter* was written by Father Stefan Fridolin and published by Anton Koberger, Dürer's godfather. It contains ninety-six full-page woodcuts illustrating episodes from the Bible. The highly detailed prints are obviously translations of the painting style in Nuremberg into crisp line, with the same sharp angularity and sense of *horror vacui* throughout with numerous episodes frequently conflated within a landscape. The costumes and conventions for landscape are nearly identical to those in the more famous *Weltchronik* of 1493.

The *Weltchronik*, published by Hartmann Schedel in Latin and German editions, is larger and much more profusely illustrated than the *Schatzbehalter*. In all there are some 1,810 illustrations of Biblical events, genealogies, maps, and views of towns. Neither the portraits nor the topographical views can be taken as historically accurate

since, in many instances, they are simply repeated in a different context. A number of the illustrations, widely varying in size, seem to be scattered arbitrarily on the page with little regard for an allover design. The quality of the cutting also varies considerably in this enormous tome, but in a number of the larger illustrations a more gifted and inventive designer is evident.

Such is the case with the *Fall of Man and the Expulsion* (fig. 278). Here the two episodes are conflated with Adam and Eve yielding to temptation in the walled Garden of Eden to the right and an angry angel chasing the two nudes from the Flamboyant Gothic portal to the

278. MICHAEL WOLGEMUT? *Fall of Man and the Expulsion*, from the *Weltchronik*. 1493. Woodcut

279. FRENCH. *May*, from the calendar of a Book of Hours printed by Simon Vostre. c. 1515. Metalcut

left. Eden is verdant and crowded with details. A fountain to the right is the source for the four rivers that issue from a towered bridge and flow into the world outside. Three elegant trees grow within the garden. The Tree of Knowledge, which is flanked by Adam and Eve, is clearly a small apple tree. To the left of it a spreading date palm grows, and, to the right, the unusual dragon tree appears with its exotic trunk and leaves.

The text of the *Weltchronik* informs us that in order to beautify Eden, God placed three kinds of trees there. One was the palm, "to sustain life through its nourishment," another was the apple, the Tree of Knowledge of Good and Evil, and the third was the Tree of Life, whose fruit ensured good health and immortality. The exotic dragon tree, native to North Africa, is surely meant to be the Tree of Life, a rare instance in the tradition of the flora of Eden. Such a bulbous tree with sharp, swordlike leaves appears for perhaps the first time in Martin Schongauer's engraving of the *Flight into Egypt*. In Dürer's early-sixteenth-century woodcut of the same theme in his *Life of the Virgin* series it appears as a tropical plant along with the date palm.[106]

The *Weltchronik*, which purports to be a history of the world from the days of creation to events in the year 1493, alas, makes no mention of Columbus or the discoveries of the New World which were just under way. Within thirty years, however, the treasures and exotica of the Americas will appear with more and more frequency in the arts, as we shall later see.

The printing of illustrated books in France lagged behind the Netherlands and Germany until the very end of the century. By the 1490s Lyons, Rouen, and Paris had important publishing houses. In Paris, Guy Marchant published a *Danse macabre* (*Dance of Death*) and a *Kalendrier des Bergers* (*Shepherds' Calendar*) between 1491 and 1493, with lively illustrations, and the printers Jean Dupré and Simon Vostre issued Books of Hours exhibiting the grace and elegance exemplary of Parisian taste of an earlier age (fig. 279). For the most part, these *Petites Heures* are printed in pocket-size format with decorations relegated to the four borders, separately cut and beautifully designed in the tradition of earlier illuminated Hours in France. In fact, the conservative character of the Parisian printed books is also apparent in the narrative scenes, which repeat the makeup of fourteenth-century Books of Hours. The devotion, unlike similar books in the Netherlands and Germany, where the life and passion of Christ were usually emphasized, remains true to Mary.

The delicacy of the lines and dots in these small cuts and their splendid balance on the page testify to the high quality of these Parisian editions. Often copperplates were used in place of wooden blocks to effect an even more sensitive line, such as we find in engravings. Intertwining ivy and other floral runners swirl about tiny grotesque drolleries, intricate flamboyant pinnacles enframe tiny miniature narratives placed one over the other, but all of this is tamed and rigidly systematized into typical Italian candelabra, cartouches, garlands, and urns attended by *putti*. The capricious and fanciful world of the Gothic North is held in check by the cold severity and regularity of the Renaissance.

The metalcut is a peculiar medium to describe since it displays features common to both woodcuts and engravings. However, the metalcuts discussed above were essentially relief prints, inked and printed as the woodcuts, and since graphic arts are generally classified according to the processes and methods of inking and printing, they are included here.

ENGRAVINGS

The woodcut is produced by a relief printing process, that is, the lines of the design are raised, inked, and then stamped on the paper. The reverse process, intaglio printing, led to the development of the engraving, where lines are cut into the surface of a plate, usually copper, with a sharp instrument called a burin or graver. The plate is then inked and wiped clean, leaving the ink only in the cavities formed by the burin. Paper, usually dampened, is then pressed or rolled into the plate, where it picks up the ink from the engraved lines. The design of the finished engraving thus has a raised surface where the ink

stands in relief on the paper. In time a number of subtle variations evolved from the intaglio technique, including the *drypoint,* in which the design is drawn with a needle-like instrument, leaving a slight burr that imparts a soft effect on the paper when inked. Slightly later, *etching* became an even finer technique for the graphic artists. Here the design is scratched into a waxlike coating on the plate, which is then bathed in acid. The acid eats only the exposed parts of the metal. In all of these techniques, the actual printing or pressing of the impression is a delicate one requiring accurate alignment of the paper on the plate and an even pressure throughout in the press or roller.

Engravings, like the woodcut, had a simple and practical beginning. Whereas the woodcut illustration was a natural development of textile printing after rag paper became more plentiful, engraving grew naturally from the art of the goldsmith and the maker of jewelry, where designs were incised on the surface of the metal. At first the designs were filled with ink, and proof impressions were taken on paper to check the accuracy of pattern or to serve as models for later works. It did not take long, however, for the goldsmith to realize the potential of prints made in this fashion, and they virtually monopolized the field of line engraving until the last quarter of the century when, just as with the woodcut, the painters took up the craft.

Thus, while woodcuts were developed by woodcarvers or carpenters, so engravings were the by-products of the designer of jewelry and precious metal objects, and it is easy to see how engraving was very suddenly raised to the status of a ''fine art'' as opposed to the more utilitarian woodcut. There are other reasons for this. The engraving technique allowed for a much more delicate design and more intricate techniques for modeling and variety in the thickness of lines. It was simply a more pictorial medium to begin with and could easily compete with the painted miniature and even the easel painting itself as a work of art. Furthermore, since fewer proofs were possible due to the rapid wearing of the plate, unlike the woodcut, engraved impressions were not so accessible.

It was, in fact, about the third quarter of the fifteenth century that ''the collector'' came into being. Formerly artists themselves often collected prints and drawings of others for their own reference or as mementos; now the educated and cultivated connoisseur of art made his appearance, and fine engravings, like drawings, were highly valued. Where King Charles V could spend his late afternoon hours leisurely perusing his exquisite Books of Hours in his study in Paris, now the wealthy Hapsburg merchant could show off his collection of prints to his clients.

280. MASTER OF THE PLAYING CARDS. *King of the Wild Men.* c. 1440. Engraving, 5¼ × 3½"

Interestingly, the first engraver for whom an oeuvre can be assembled is the anonymous Master of the Playing Cards, active in the Rhineland between 1435 and 1450. Some have located his shop in Mainz, where it is believed he illuminated some of the marginal decorations in Gutenberg's giant Bible. Others have placed him in Cologne, and, more recently, the Upper Rhine has been considered his home ground on the basis of style and costumes as well as the repeated use of a floral motif, the cyclamen or Alpine violet. One scholar has, in fact, identified him as Konrad Witz![107]

The popularity of playing cards has already been noted in the discussion of early woodcuts. The new game from the Orient was much like card games today and similarly decorated. The usual deck consisted of forty-eight cards divided into four or five suits with plants, animals, and various figure types used in place of the hearts, diamonds, spades, and clubs that we know today. Eight or nine cards of each suit were numbered, while three or four were designated ''court'' cards. The woodcut playing cards frequently have very summary designs that served as identification only, but with the introduction of the engraved card, the artistic value of the deck was greatly enhanced.

The *King of the Wild Men* is a good example of the Master of the Playing Cards's work (fig. 280). The stocky, hairy man-creature of the forest, the brunt of much coarse humor, is superbly characterized in the short, sketchy strokes describing his rough contours and textures. The variety of strokes, including the quick

flecks and short parallel shading lines, are amazingly pictorial when compared to the simple lines of the woodcuts. To be sure, contours and outlines are still emphasized, but the sensation of light playing across shapes and volumes is captured in the tiny strokes that lend a soft tonality to the surface much as in a shaded drawing. The origins of the Master of the Playing Cards in the goldsmith's art are evident, however, in the precise rendering of the plants in the foreground, where they appear more like intricate designs for jewelry than natural details of a rustic setting.

Closely related to the engravings of the Master of the Playing Cards are those of another anonymous artist, the Master of the Garden of Love, who apparently left the Rhineland sometime around 1430–40 to work for the Bavarian court in the Hague.[108] *The Large Garden of Love* (fig. 281)—there are three versions attributed to the artist—is a variation of the garden theme so popular in the Rhineland. Here the garden is transformed into a secular park with aristocratic lovers engaged in drowsy, amorous games in a forest clearing behind the castles seen on the horizon. The proper attributes of the garden are all here, although a bit relaxed in plan, with the fenced enclosure, the life-giving waters, and the verdant meadows teeming with flora and fauna of many varieties. Six pairs of young lovers amuse themselves by weaving garlands, playing cards, strumming on musical instruments,

and dallying about a table bedecked with refreshments.

The mood of the garden party is reminiscent of that of the *April* miniature in the *Très Riches Heures* (fig. 56), and, indeed, some similar engagement may well be commemorated here. The two central figures are elegant International Style types dressed in costumes of the 1430s. The graceful lady who receives a gift from her lover wears a pendant with a bell and cross, the insignia of the Order of Saint Anthony founded in the Hague by Albert of Bavaria in 1382. The lady is very likely Jacoba of Bavaria, the hapless countess who by 1436 had experienced four such engagements. For that reason it has been surmised that the engraving copies some monumental representation of a tapestry or painting, displayed in the royal residence in the Hague (cf. the *Fishing Party*, p. 141).

Some have suggested, in fact, that it preserves a lost composition designed by Jan van Eyck, who was active there between 1422 and 1424, but the stylistic features of the engraving are at best vague reflections of Jan's art. On the other hand, the general impression is that of works of the Master of the Playing Cards. The technique with short lines, stipples, and cramped parallel strokes imparts a rich pictorial quality much as it appears in the playing cards, and the plants filling the meadow are the same stylized varieties seen in the cards but here contributing to the general *horror vacui* characteristic of the millefleurs tapestries so popular in Late Gothic art.

281. MASTER OF THE GARDEN OF LOVE. *The Large Garden of Love.* c. 1460? Engraving, 8⅝ × 11″

MASTER E.S.

The anonymity of the engraver was not to last long. The next important master signed his engraving with the initials E.S., a very common type of signature among painters of the late fifteenth century as well. Also active in the Upper Rhine, Master E.S. was much attracted to the new Flemish style that permeated the Rhineland as well as the plastic expression of Nicolaus Gerhaerts van Leyden, a leading sculptor who worked in Constance in 1465–66 (see p. 301). His training in the goldsmith's trade, however, reveals itself in the firm, crisp outlines he gives his figures and in the frequent use of goldsmith's punches on garments and armor. Two of his engravings depict Saint Eloy, patron saint of goldsmiths, busy at work in his cluttered studio.[109]

Over three hundred engravings have been attributed to Master E.S. with subjects ranging from playing cards, ornamental devices, and grotesque alphabets to numerous representations of the Madonna and Child. As an example of his more fanciful inventions, the fantastic alphabet of about 1465 displays the excellence of his refined engraving technique as well as his delight in humor through satire. Twenty-three capricious letters form the complete set of a Gothic minuscule (lowercase) alphabet, which seems to have been a popular exercise with graphic artists, and while no definite purpose seems to stand behind their production, they probably served as models and motifs for a "grotesque" vocabulary that was popular in all the arts.

Bizarre combinations of monsters, hybrids, wild men, peasants, and the like are cramped and squeezed in the attenuated bars and arcs that make up the script, and often a clever satire emerges from these "funny" letters. The letter G, for instance, seems to evoke a biting comment on the licentious life-style of the lesser clergy (fig. 282). A vulgar monk, baring his backside, pursues two nuns, one riding piggyback. On her outstretched arm rests an owl, the sinister bird of the night. The nuns are led by two monkeys, obvious symbols of carnal lust, one of whom plays music to add to the erotic tone of the caper, and between them a dog bites a bone, a motif frequently related to the vice of jealousy.

The delicacy of the engraved line, however, is what stands out in these initials. Short shading strokes are multiplied endlessly, creating a soft, textural effect. One of Master E.S.'s most significant contributions to the art of shading is the "crosshatch," a complex combination of parallel strokes in two directions executed one over the other, allowing for a more intense and dramatic contrast of light, shade, and texture.

The best known engraving of the Master E.S. is the *Large Einsiedeln Madonna* (fig. 283), one of three prints commissioned by the Benedictine monks of the abbey in

282. MASTER E.S. *Letter G*, from the *Fantastic Alphabet*. 1465. Engraving, 5¾ × 3¾"

283. MASTER E.S. *Large Einsiedeln Madonna*. 1466. Engraving, 8¼ × 4⅞"

Einsiedeln near Lake Constance for their five-hundredth anniversary celebration of the dedication of the original chapel of Saint Meinrad to the Virgin. The elaborate architectural setting with the Madonna and Child placed on an altar in a frontal position suggests that the engraving was a true "site" picture that reproduced the actual setting for the pilgrims and worshipers who attended the celebration. In the balcony of the ornate chapel Mary appears again surrounded by the Trinity and a concert of angels. The parapet of the balcony is decorated with a cartouche upon which the coat of arms of the Vatican is displayed, indicating the sanction of the papacy and the subsequent indulgences given to the pilgrims who visited Einsiedeln in 1466. On the intrados of the arched opening to the chapel an inscription announces the celebration: "This is the dedication of the angels to Our Blessed Lady of Einsiedeln." About the altar on which the Madonna and Child are enthroned between Saint Benedict and an angel, pilgrims are seen standing and kneeling in adoration of the image of the Virgin.

The Madonna and Child have a sculptural and iconic appearance with the heavy angular folds of Mary's mantle marking out an imposing monumentality much like the sculptures of Nicolaus Gerhaerts van Leyden, with whom he was probably acquainted. Another smaller ver-

sion of the *Einsiedeln Madonna* repeats the central group of the Virgin and Child almost exactly, and it seems very probable that Master E.S. did indeed reproduce an imposing sculptured group at the site, as suggested above.

The same expression appears on the Madonna's face enframed by long curls reaching to her waist; she wears the same costume with a heavy mantle over a dress with a colorful floral brocade; and the nude Child assumes the same playful dancing pose in Mary's lap. The Master E.S.'s charming Madonna and Child types, in turn, served as models for a number of Rhenish mother-of-pearl (*Perlmutter*) medallions, a precious medium that has the rather eerie effect of a negative with the light reflecting from the deeper pockets, rather than the reverse, enhancing the luster of the surface patterns. A fine example of this unusual art is in the museum at Princeton University.[110]

Master E.S. was one of the most influential engravers in the third quarter of the fifteenth century, and his compositions were frequently copied. One interesting follower, the Master of the Banderoles (so named for his frequent use of inscribed scrolls), copied not only Master E.S. but the Master of the Playing Cards as well. Working north of the Lower Rhine, this eclectic artist also copied compositions of German and Netherlandish painters. His version of Rogier van der Weyden's *Deposition* (fig. 284) is typical of his work. It must be remembered that the idea of plagiarism hardly existed in the fifteenth century. Once a composition was displayed it became public domain, so to speak, and through engravings it could be spread far and wide for other artists to copy or adapt.

MARTIN SCHONGAUER

Martin Schongauer of Colmar in Alsace in the Upper Rhine, painter and engraver, was one of the outstanding German artists of the fifteenth century. His paintings have already been discussed (see pp. 230–32), and while he was preeminent as a painter in his own time, his renown today rests on his engravings. Through his neighbor and presumably his first master, Caspar Isenmann, Schongauer learned the craft of painting, and through his father, who headed a goldsmith's atelier, he acquired the techniques of metal engraving, to which he devoted much time.

It is interesting to speculate on the young Martin's *Wanderjahre,* made, as was usual for promising young artists, after his initial apprenticeship was completed. Whether or not Schongauer first traveled down the Rhine to Cologne, as many surmise, we cannot be sure, but it is very probable that his wanderings eventually led him west, to Burgundy and the Netherlands, pulled by

284. MASTER OF THE BANDEROLES. *Deposition* (after ROGIER VAN DER WEYDEN). c. 1465. Engraving, 9 × 7¹/₁₆"

285. MARTIN
SCHONGAUER.
*Madonna and Child
with the Parrot.*
c. 1470–75.
Engraving,
6¼ × 4¼"

the magnetic attraction of Rogier van der Weyden. He must have seen a number of Rogier's works firsthand. The Beaune *Last Judgment* (fig. 127) and the Bladelin *Nativity Altarpiece* (fig. 129) made strong impressions on him, and no doubt he studied paintings by Dieric Bouts and Hugo van der Goes along the way. As we have seen, Rogier's influence was strong and enduring in the Rhineland and can be traced in nearly every painter of the later fifteenth century there. But never had his style been so fully assimilated and beautifully harmonized with local traditions than in Martin Schongauer's art. Indeed, it is as if the roots of Rogier's art were transplanted and cultivated anew among the lindens of Alsace.[111]

One of Schongauer's earliest prints is the *Madonna and Child with the Parrot,* dating about 1470–75 (fig. 285). The inspiration for the charming group in half-length is certainly Rogier van der Weyden, but in this case more specifically Rogier filtered through Dieric Bouts. The unveiled head, the cushion on the window parapet, and the view of a landscape out the rear window, all point to types such as Bouts's elegant *Madonna and Child* in London (fig. 142) as a likely source.

Evidence for an early date for the engraving in terms of style and technique is not too difficult to pin down. The modeling of the Virgin's face is a bit sketchy and unsure. The same is true of the angular pleats of the cloth under the Child and in the book held by Mary. It appears that Schongauer also had trouble understanding the spatial projection of the chamber, resulting in the clumsy juncture of the side and rear walls with the open window. Otherwise, Schongauer's early print displays his excellence in capturing textural effects, particularly evident in the lower left corner with the overlapping drapery, the parchment, and the brocaded cushion. Also to be noted is the manner in which Schongauer's modeling lines often follow the shape and plasticity of the individual parts, a technique referred to as "contour modeling" whereby

the line follows the turnings and swellings of the forms, replacing the earlier straight parallel hatching given all objects.

Among Schongauer's early prints are four that may have been intended for a larger series illustrating the life of the Virgin. In these (the Nativity, Adoration of the Magi, Rest on the Flight into Egypt, and Dormition of Mary) Schongauer reveals his mastery in absorbing Netherlandish influences without resorting to direct copying. Motifs from Rogier van der Weyden, Dieric Bouts, and Hugo van der Goes are at once apparent, but the finished compositions are his own.

The *Nativity* (fig. 286) is one of his most endearing statements of this popular theme. Two compositions by Rogier must have been known to him. One of them, the *Nativity* of the *Granada-Miraflores Altarpiece* (fig. 122), inspired the general composition with the quasi-*Schnitzaltar* frame here translated into the architecture of an actual Gothic ruin of large masonry blocks covered with ivy; the other, the Bladelin *Nativity* (fig. 129), provided Schongauer with details of the Madonna's drapery and

286. MARTIN SCHONGAUER. *Nativity.* c. 1470–75. Engraving,
10⅛ × 6¾"

287. MARTIN SCHONGAUER. *Rest on the Flight into Egypt.*
c. 1475. Engraving, 10 × 7⅝″

288. MARTIN SCHONGAUER. *Temptations of Saint Anthony.*
c. 1475. Engraving, 12¼ × 9″

the figure of Joseph holding the candle, here placed within a lantern. Schongauer's treatment of drapery folds is more complicated, with Rogier's melodic lines breaking into numerous angular pockets and arcing overlaps. His technique is nearly perfected in terms of crosshatching and contour modeling, and the faint lines of the burin in the background make the distant shepherd on the hillside shimmer in the atmospheric perspective.

The *Rest on the Flight into Egypt* (fig. 287) is likewise one of the most poetic interpretations of this landscape theme. Joseph and Mary have paused on their journey to rest for a while, nourish themselves, and ponder the recent events that brought about their exile. The donkey stops to graze on grasses while Joseph, with the help of five tiny angels, pulls down clusters of dates from a palm tree. Mary offers one to the Child, as she, with downcast eyes, leads the donkey to the ferns in the right foreground.

The landscape background is rich in details of a rather exotic nature, and perhaps Schongauer knew the medieval symbolism discussed above in the trees of paradise in the *Weltchronik.* The date palm was the tree that nourished life. The dragon tree, on the left, was the Tree of Life in Eden. Lizards scurry about its trunk from which resin seems to ooze from scars. This "dragon blood," as it was called, was a special elixir in the Middle Ages used for conjuring, while the parrot in the topmost branches of the tree was sometimes associated with wisdom. Two prominent plants in the foreground, the mullein and the thistle, were medicinal herbs used to drive away melancholy brought on by satanic spirits. Just what Schongauer had in mind with his plant symbolism is not at all clear—nor can we be sure of the specific meanings of them—but in some respects he anticipates Dürer's elaborate use of such iconographic features.

The quiet composure and tender restraint usually associated with Schongauer's prints are blown asunder in another early work, the *Temptations of Saint Anthony,* one of his most capricious and dynamic Gothic compositions (fig. 288). But even here, in spite of the contortions and acrobatics of the wild creatures pulling and tugging at the bearded saint, all forms are contained within a single circumference in which the angles of Anthony's body and draperies form an "X" pattern. The throbbing contours of the outer circle convey the sensation of a vibrating spinning wheel about to fly apart. It is the grotesque demons that we attend to, nonetheless, and these bizarre hybrid creatures attacking the wearisome saint are amazingly lifelike and real, much like those later painted by Bosch and Grünewald. Fish heads, bats, wild dogs, and birds are grafted naturally to winged bodies of lizards, toads, fish, and wild men, whose hands and feet are menacing clusters of claws and talons. Dürer was fascinated

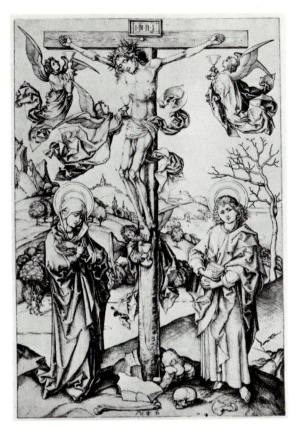

289. MARTIN SCHONGAUER. *Crucifixion.* c. 1475–80. Engraving,
11⅜ × 7⅝″

290. MARTIN SCHONGAUER. *Carrying of the Cross to Calvary.*
c. 1475–80. Engraving, 11¼ × 16⅞″

by this print as was Michelangelo, who Vasari tells us
made a copy of it.

Two large engravings, the *Crucifixion* and the *Carrying
of the Cross to Calvary,* present us with the next major
step in Schongauer's development, both dating between
1475 and 1480. In the former, Schongauer treats the
more iconic Crucifixion type with only Mary and John
standing beneath the cross reminiscent of Rogier's late
treatments of the subject (fig. 289). But the severity of
the icon is overwhelmed by the rich pictorial effects
achieved in the draperies of Mary and John, the dancing
loincloth of Christ, and the fluttering mantles of the
four angels who catch blood in chalices from Christ's
wounds. Schongauer was aware of the story of the wood
of the cross being that of the Tree of Life in Eden since its
lower trunk is a half-hewn tree, and, to the right in what
is the sinister side of the composition, a lonely "dry
tree," symbol of death and sterility and the antithesis of
the Tree of Life and salvation, is placed.

Over fifty figures are stretched across the curving path
in the large *Carrying of the Cross to Calvary* (fig. 290).
Here Schongauer draws upon an earlier Flemish tradi-
tion, traceable to the Van Eycks, in which the panoramic
aspects of the landscape are exploited with the suffering
Christ stumbling along a treacherous path leading from
the walls of Jerusalem, on the right, to the mound of
Golgotha on the left. Anecdotal elements abound. Chil-

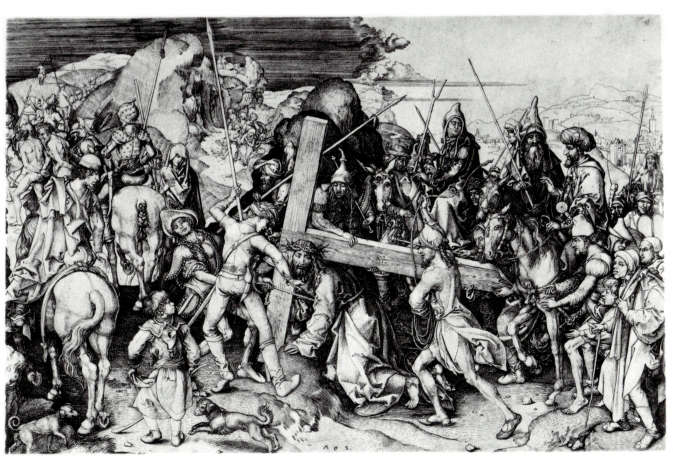

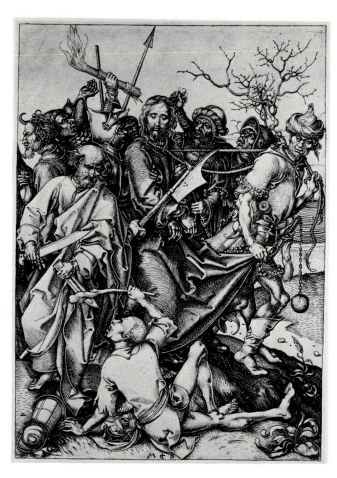

291. MARTIN SCHONGAUER. *Arrest of Christ.* c. 1480.
Engraving, 6⅜ × 4½"

292. MARTIN SCHONGAUER. *Apprentices Fighting.* c. 1485.
Engraving, 2¼ × 2⅞"

dren and their dogs scurry about the densely packed procession. Townspeople of all estates clamor in confusion behind the mounted persecutors dressed in ornate costumes. Henchmen with violent gestures and grotesque facial expressions pull and harass Christ while the pious Nicodemus, barely visible, helps carry the heavy base of the cross. Just ahead stands a despairing Veronica holding the veil (sudarium) with which she will dry Christ's face.

An important detail for the later iconography of this popular landscape theme is the appearance of Mary, John, and the other three Marys in a gorge just beyond the foreground procession. They took the "shorter way" according to some legends, and here their swooning positions forecast their sorrow and agony under the cross after it was raised on Golgotha. Schongauer's subtle use of the burin allows him to play masterfully with lighting effects. On the right, the figures are lighter, bathed in the sunlight of a cloudless sky. To the left, denser strokes of the burin suggest the impending storm and the landscape darkens.

Schongauer's interest in the Passion culminated in a series of twelve scenes, from the *Prayer in the Garden of Gethsemane* to the *Resurrection,* which he executed about 1480. The *Arrest of Christ* (fig. 291) is typical of the com-

positions in the cycle with its cramped and crowded foreground pattern of figures. In general he abandoned the rhetoric of Rogier and Bouts in these prints (except for the *Entombment*) and turned instead to more Germanic traditions for expressing the pathos and torture by bringing the figures up to the surface. He suppressed any indications of landscape setting for an energy-packed closeup view of Christ harassed by a motley gang of henchmen wearing bizarre costumes and gesturing wildly and grimacing like half-animals about the resigned Christ, whose pitiful eyes are downcast.

As if to mark the brutality of the event, Schongauer puts special emphasis on Peter, who is about to strike the sprawling Malchus. Directly behind and above, on the far left, emerges the brutish profile of Judas, still clutching the purse of coins he received for the betrayal. While Schongauer's technique is awesome in the precision of details, one is somewhat disappointed by the artificial theatrics of the display. His engravings of the Infancy are delicate and appropriate for the tender sentiment evoked by them, but his temperament did not seem to accommodate itself easily to the uglier aspects of the Passion.

It is with Schongauer's generation that purely secular genre, once restricted to the marginal areas in works of art, began to receive treatment on its own. Most of these are of modest format, and the subjects reflect the motifs of earlier drolleries: scenes of peasants working, playing, fighting, or animals cavorting and prancing. A good example is his tiny print of *Apprentices Fighting* (fig. 292) with two young boys wrestling and pulling hair. The presence of tongs, a crucible, and bellows suggests that this might be a droll reminder of a familiar scene in the goldsmith's shop of his father, where such rowdy behav-

293. MARTIN SCHONGAUER. *Elephant*. c. 1485. Engraving,
4¼ × 5¾"

294. MARTIN SCHONGAUER. *Ornament with Owl*. c. 1485–90.
Engraving, 5¾ × 4¹/₁₆"

ior among the lesser apprentices must have been frequent and often amusing.

Surprising too is Schongauer's meticulous representation of the *Elephant* (fig. 293), a rare subject in Northern art before Dürer, although, as we have seen, a much more realistic one appeared in Bartholomaeus Anglicus's nature book, *De proprietatibus rerum,* published in Haarlem in 1485 (see p. 272 and fig. 273). Compared to the Dutch version, Schongauer's elephant is more stylized, especially in the treatment of the ear and trunk. The reason for the sudden interest in elephants in Germany and Holland at this time probably has a simple and practical answer that has little to do with any exotic symbolism. We know that between 1483 and 1484 a certain Hans Filshover and his "helffandt" traveled about the Rhineland to the great profit of the owner. It was in Frankfort in September of 1483 and, unfortunately, it drowned in a canal near Muiden when embarking for Utrecht. No doubt the oddity stirred the interests of the artists as well as the townspeople, and it was very likely Filshover's elephant that served as the model for these striking representations.[112]

Schongauer also engraved a number of purely ornamental subjects which were no doubt intended to be models for other artists and goldsmiths. In one ornamental print (fig. 294) a florid spiraling plant is intertwined with elegant leaves, and a number of small birds, perched amid its foliage, challenge a fearsome owl in the lower branch who has a feathery victim in its mouth. This curious motif, seemingly pure genre, was, in fact, a popular allegory. The owl in the Middle Ages was not Athena's bird of knowledge, but rather the evil and cunning predacious bird of the night who shunned daylight and car-

ried on its cannibalism in darkness. The birds who screech and mock it are symbols of the virtuous souls who fly in the true light of the heavens and attack the forces of evil.

The final stage of Schongauer's development, about 1485–90, is marked by a simplification of composition and a reduction of detail in the secondary areas. His figures assume a lofty elegance and composure, and, in general, an enchanting tranquillity pervades his graphic expression. This has sometimes been described as Schongauer's "classical" phase, but that word means little considering the purely Gothic elegance displayed in these late works. Rather the term *"détente"* seems more appropriate, much as we have characterized it in paintings of the Netherlands at the end of the century.

This relaxation in expression, in fact, strikes one as something of a denouement in Late Gothic art. The strivings and experimentation of the founders, having been exploited and elaborated by their inheritors, now begin a gradual shift toward restrained moderation and simplification, on the one hand, or the development of an elegant mannerism, on the other. Schongauer's two prints of the *Annunciation* (figs. 295, 296) are stunning examples of both tendencies. The simple contours of the

295. MARTIN SCHONGAUER. *Annunciate Angel Gabriel.* c. 1485–90. Engraving, 6⅝ × 4⅝"

296. MARTIN SCHONGAUER. *Annunciate Madonna.* c. 1485–90. Engraving, 6¾ × 4⅝"

297. MARTIN SCHONGAUER. *Madonna and C in the Courtyard.* c. 1490. Engraving, 6½ ×

angel and the standing Madonna are relatively calm and unruffled. The setting has been eliminated except for a single groundline, and Schongauer isolates each figure on a single sheet. The exquisite treatment of light and shade that flickers across their garments gives them a nearly sculptural appearance. Schongauer is in complete control of his medium at this stage, and his style is a tour de force of subtle refinement with the flamboyant richness of his line contained within the monumental forms.

These tendencies are beautifully presented in one of Schongauer's last prints, the *Madonna and Child in the Courtyard* (fig. 297). Mary sits on the ground of a wide and empty courtyard, her mantle fanned out about her in a variety of complex overlaps and pockets so familiar in his art. Her knees are boldly indicated and form a sturdy shelf for the nude Christ Child. All is still. The wall behind Mary is barely indicated so as not to distract from her monumentality. A small portal is the only architectural feature executed in detail. A dry, leafless tree rises behind her.

One can, of course, find much to analyze in this seemingly simple statement of the Madonna and Child. The Virgin seated on the ground is the traditional image of humility. The walls of the court represent the *hortus conclusus,* the closed garden signifying her purity and virginity. The gatehouse too is a *porta clausa,* and, finally, the dry tree reminds us that from its sterile roots new sap will soon flow now that the humble giver of life, Mary, sits beneath its branches. Somehow one can sense the

profundity of this Madonna and Child without recourse to complex symbolism, however. Having seen Schongauer's print just once, one will never forget its haunting and poetic mystery.

THE HOUSEBOOK MASTER

One of the most original and prolific engravers of Schongauer's generation was the Housebook Master, a Rhenish artist who was very likely trained in the progressive book illuminators' ateliers centered in Utrecht.[113] Like Schongauer, the Housebook Master was also a gifted painter, but that is where the comparison ends. Where Schongauer is elegant and refined, the Housebook Master is coarse and unsophisticated. The dignity and austerity of the engraver from Colmar are replaced by the Dutch artist with an earthiness and a fanciful wit and humor. And whereas Schongauer perfected the technique of crisp line engraving, the Housebook Master invented a new sketchy method of engraving called drypoint. Instead of applying the burin in a controlled cutting of the metal surface, the Housebook Master scratched his designs directly into the metal plate with a sharp needlelike instrument. His technique is therefore more spontaneous and impromptu with the uneven burrs left by the needle on the plate imparting a slight blurring effect to the contours of the finished print. His drypoints thus resemble a quick pencil or pen sketch more than a finished engraving.

right: 298. HOUSEBOOK MASTER. *Planet Mercury,* from *The Housebook.* c. 1475. Pen drawing, 9¼ × 5⅝". Graf von Waldburg-Wolfegg Collection, Schloss Wolfegg, Germany

far right: 299. HOUSEBOOK MASTER. *Planet Venus,* from *The Housebook.* c. 1475. Pen drawing, 9⅛ × 5⅝". Graf von Waldburg-Wolfegg Collection, Schloss Wolfegg, Germany

His name is derived from a set of pen drawings of "subjects useful and curious" in a *Housebook* (a manual of miscellaneous secular patterns and motifs), dating about 1475 and today preserved in the Waldburg-Wolfegg Castle Collection in Germany. In the sixty-eight leaves (originally ninety-eight?) a variety of subjects ranging from the activities of the Children of the Planets to scenes in brothels, the hunt, imperial battle marches and encampments, and other diverse subjects are rendered in fascinating detail with numerous anecdotal footnotes in the form of vignettes scattered about loosely composed settings. The seven sketches of the Children of the Planets preface his own original compositions of various secular activities.

Conforming to a well-established tradition, the Housebook Master presents the personifications of the planets on horseback in the skies in the company of their "houses" or zodiac signs. Below, in a tilted landscape, the various occupations associated with the planet are assembled with tiny figures busily engaged in their activities. An explanatory text faces each drawing. Mercury, in the house of Gemini (two nude infants playing) and Virgo (a maiden grooming herself before a hand mirror much as *vanitas* does), is bearded and wears a heavy mantle while his prancing steed is draped in an ornate coat with wide ribbon-like frills twirling about its legs (fig. 298).

Mercury governs the arts and sciences. Reading clockwise from the upper right we see a painter busy at work on an altarpiece of the Virgin; behind the artist a young girl distracts him with her teasing caresses. In the lower right, we find a sculptor at work on a Man of Sorrows. He reaches out to take a goblet of wine from his coy mistress, who sits at a round table bedecked with meats, cheeses, and wines, in the intimate company of another, perhaps the sculptor's journeyman apprentice. In the lower left a bespeckled metalsmith busies himself at an anvil, disregarding his nagging wife behind the forge who shouts at him. A schoolteacher, in the top left, representing grammar, stops his instruction to whip the bare bottom of an unruly pupil, and directly above him a clockmaker-astrologer sits at his worktable taking measurements of the position of the planet above. Finally, in the upper center, an organ maker, representing music, has his apprentice operate the bellows of an organ that he tests and adjusts.

Venus, seen from behind, rides sidesaddle on her colorfully draped mount between Libra and Taurus above a deep landscape filled with the amorous pastimes that she governs (fig. 299). In the lower right four pairs of young lovers dance to a rondo performed by a trio. In a shaded arbor to the left a nude man helps his partner into a bathtub for their pleasures, while an older woman, the procuress, brings in wine and fruit for their refreshment. Above them three more young people sit on the ground playing cards, and in the upper left a musician beats on a drum as two acrobatic performers execute a somewhat obscene and grotesque Moorish dance. In the top right another couple plays a hurdy-gurdy and horn before a table with fruit and wine, and in the bushes beyond another pair on the ground look up, apparently distracted from their lovemaking by all the noise.

300. HOUSEBOOK MASTER. *Holy Family in a Garden.* c. 1500.
Drypoint, 5⅛ × 4½"

302. HOUSEBOOK MASTER. *Aristotle and Phyllis.* c. 1480.
Drypoint, diameter 6⅛"

301. HOUSEBOOK MASTER. *Carrying of the Cross.* c. 1480–90.
Drypoint, 5 × 7⅛"

303. HOUSEBOOK MASTER. *Old Bulldog Scratching Himself.*
c. 1485. Drypoint, 4½ × 4⅜"

The artist who made the drawings in the *Housebook* also executed a number of fascinating drypoint prints, most of which are today in the Prentenkabinet of the Rijksmuseum in Amsterdam (hence he is often called the Master of the Amsterdam Cabinet). The *Holy Family in a Garden* (fig. 300) is typical of his treatment of traditional religious subjects. The blurring effect of the drypoint can be discerned in the somewhat ragged appearance of the contours and creases of Mary's mantle. Seated on a low stone bench, she lovingly supports her son, who eagerly reaches out for an apple that lies on the ground before him. Joseph, always decorous and well behaved in Schongauer's prints, appears as some dwarfish old man lurking and leering behind the bench, out of sight of the Child,

teasingly rolling apples before him. As with Schongauer's *Madonna and Child in the Courtyard,* Marian symbolism can forcibly be read into the distant church (*Maria ecclesia*), the circular tower (*turris Davidica*), the gateway to the left (*porta coeli*), the stone wall (*hortus conclusus*), the rose bush, and the apple tree, but clearly the emphasis here is on the earthly humor exhibited by Joseph and on the homespun characterization of the Holy Family in general. This relaxed and comforting mood is conveyed by the informality of the composition and the soft tonal effects of the drypoint medium.

One of the Housebook Master's most ambitious prints is the *Carrying of the Cross* (fig. 301) placed in a broad landscape with a frieze of figures moving diagonally from the left to the foreground right. The clarity and monumentality of Schongauer's engraving of the theme (fig. 290), a composition that had widespread influence, are here sacrificed for a cramped and uneven organization of the figures. In Schongauer's print, Christ stumbles as he steps into a rise in the terrain, but in the Housebook Master's version he collapses on the flat ground, exhausted by the weight of the huge cross. Two henchmen with grotesque features poke and pull at Christ, while a third attacks Simon of Cyrene carrying the foot of the cross. To the far left a despairing Mary reaches frantically for her son, and in the distance behind the hillside several pikes and lances can be seen that give evidence of the great number of tormentors who have joined the gruesome parade.

A more refined line characterizes the roundel of *Aristotle and Phyllis* (fig. 302), where the wise old man of antiquity, on all fours, plays horsy for his charming young mistress. With whip in hand, she controls and guides her steed with a pull on the bridle. The story of Aristotle and Phyllis was one of the many popular themes at the end of the Middle Ages that illustrated the folly of famed wise men of ancient times and the Old Testament and collectively formed the story of the ''Power of Women.'' The subject is closely paralleled in Germanic carnival plays of the period such as the popular *Spil von Meister Aristotiles* (*Play of Aristotle*), a satirical comment on the foolishness of the ancient philosopher (and Thomism, based on Aristotelian method, as well). Aristotle, praised for his indifference to beautiful women, was seduced by a charming princess who preferred to play games with him than to be educated in matters of logic, dialectic, and philosophy. As the old fool carried her about the courtyard, the lady mused over the pleasure of riding a horse so stuffed full of knowledge (hay). The king and his companion (perhaps the young Alexander the Great?) look on, surprised and amused by the shameful conduct of one so wise who is thus outwitted by the charms of a lady.

The Master of the Housebook executed a number of purely secular themes, focusing on what were the most trivial of daily sights such as the *Old Bulldog Scratching Himself* (fig. 303) and *Romping Children* who cavort on the ground picking their feet and turning somersaults. The motivation behind such trivia is not clear, but lowlife genre grew in popularity at the end of the fifteenth century, testifying to an undercurrent of healthy humor on the part of the artists and their patrons. There is nothing satirical or derisive in such genre with the Housebook Master. Rather, it seems that he delighted in the rustic charm of the commonplace as part of life's lighter moments. With a warm sense of humor nourished by a genuine love for the world about him, the Housebook Master recorded the objects, figures, and activities of the everyday world with the sensitivity of his Dutch descendants of the seventeenth century.

ISRAHEL VAN MECKENEM

The refreshing originality of the Housebook Master is exceptional in the works of most Rhenish engravers at the end of the century. His younger contemporary, Israhel van Meckenem, active in Bocholt near the Dutch border, was a blatant plagiarist who copied works by the Housebook Master, Master E.S., Schongauer, the young Dürer, and others, with an alert eye on the rapidly growing market in prints. Of the 624 engravings, usually signed IM, IVM, or Israhel v M, less than a quarter are compositions of his own invention, and some of those may also be imitations that simply have not been traced. Meckenem was trained by his father, also an engraver, and he practiced the goldsmith's craft as so many others before him who took up the art of the burin.

The smug countenance of the successful artist appears in an unusual engraving of the *Artist and His Wife Ida* (fig. 304), executed about 1490 when Meckenem's reputation peaked (he was elected to the town council in 1489). The hazy, heavy-lidded eyes, the large nose and drooping lower lip are executed with a sharpness of line that lends his face a metallic cast, and the eyes and mouth of his wife characterize her as a shrewd and contented citizen. This double portrait is the earliest known example of a self-portrait in the graphic arts, but its basic composition has precedents in paintings of South Germany. An inscription along the lower border informs us: ''A picture of the faces of Israhel and his wife Ida IVM.''

The *Mass of Saint Gregory,* of about 1490–95, a favorite theme of Meckenem, is one of his most ambitious religious prints (fig. 305). The story takes place in an elegant Gothic church around a huge altar atop which the half-length figure of the nude Christ as Man of Sorrows appears. Several members of the clergy crowd about

304. ISRAHEL VAN MECKENEM. *Artist and His Wife Ida.* c. 1490.
Engraving, 4⅞ × 6¾″

the sides of the altar to witness the miraculous vision of
Saint Gregory, who kneels in the company of two dea-
cons assisting him in the Mass. Gregory, a sixth-century
pope and one of the four Church Fathers, was famed as a
liturgist and authority on church music and education.

The Mass of Saint Gregory served as an illustration of
the validity of transubstantiation, or the transformation
of the bread (host) and the wine (chalice) into the true
body and blood of Christ that forms the core of the sac-
rament of the Eucharist (see p. 147). Once, during a
Mass in the basilica of Santa Croce in Rome, one of
Gregory's assistants expressed grave doubts as to the
truth of the miracle, when suddenly there appeared on
the altar the Man of Sorrows, his blood streaming from
the lance wound directly into the chalice placed there,
thus confirming the miracle of transubstantiation of
blood into wine before the eyes of those present.

The vision of Gregory was reportedly preserved in a
painted icon that remains in Santa Croce today, an *imago
pietatis,* or Man of Sorrows, that Meckenem himself re-
produced in another engraving that included the follow-
ing inscription: ''This image was copied in likeness and
similitude of the original *imago pietatis* preserved in the
church of Santa Croce in Rome, which the pope Saint
Gregory the Great caused to be painted in accordance
with the form taken by a vision that appeared to him
from above.''[114]

The figure of Christ in Meckenem's *Mass of Saint
Gregory* repeats that very icon and further elaborates the
story of the miraculous vision. Directly behind Christ is
a triptych with three scenes of the Passion (Carrying of
the Cross, Crucifixion, and Resurrection), an appropri-
ate allusion to the Eucharistic meaning of Gregory's vi-
sion. A tall cross rises behind Christ, and, on the back
wall, a number of the instruments of the Passion have

been added: the column of the flagellation, the whip, the
sponge, the lance, the crown of thorns, the sudarium,
etc. By the fifteenth century the papacy awarded indul-
gences to those who prayed before the image of Grego-
ry's Mass. An inscription along the lower border of the
print informs the worshiper that ''Whoever recites in
the presence of the arms of Christ [instruments of the
Passion] the Apostles' Creed, the Pater Noster, and the
Ave Maria, and as often as he does so, shall be pardoned
20,000 years of punishment in purgatory.''

Another of Meckenem's more inventive prints is the
Dance at the Court of Herod (fig. 306). Here the traditional
subject matter has gone through a reversal in priorities.
The main story is that of the beheading of John the Bap-
tist and the presentation of the severed head by Salome to
Herod in his banquet hall. Both episodes have been re-
duced and removed to distant back chambers of the main
event, the dance of Salome—she and her partner are
those to the right of center who break into a wilder

305. ISRAHEL VAN MECKENEM. *Mass of Saint Gregory.* 1490–95.
Engraving, 18¼ × 11⅝″

306. Israhel van
Meckenem. *Dance
at the Court of Herod.*
c. 1500. Engraving,
8½ × 12⅜"

step—and the merry group of patricians who perform a sedate dance resembling the later polonaise that accompanied festive ceremonies and processions of the court. A trio atop the high podium in the center provides the music on horns, blockflöte, and drums.

The idea of adding extra narratives in the backgrounds is not new, as we have seen, but the placement of the main events in the marginal areas and the lesser, secular happenings in the forefront is evidence of the growing popularity of secular themes over traditional religious subject matter. This practice became increasingly popular in the sixteenth century, when it is sometimes referred to as "Mannerist inversion." The patrician couples are purposely dressed in archaic Burgundian costumes—high hennins for the women, pointed shoes and short jackets for the men—striking a nostalgic note for the remembrance of a more glorious past. As in his other works, Meckenem's engraved line is crisp, sharp, and beautifully controlled, although little sense of natural illumination or atmosphere is conveyed in his abrupt and arbitrary tonal transitions.

Interest in the secular and the commonplace, treated only in humorous vignettes by Schongauer and the Housebook Master, reaches programmatic proportions in Meckenem's works. Sometime between 1495 and 1500 he executed a series of "Twelve Scenes of Daily Life" where couples, pursuing everyday activities, illustrate some aspect of the social world they represent. Six of these are placed in detailed domestic interiors with a wealth of detail of household furnishings displayed.

A good example is the *Visit to the Spinner* (fig. 307). Within a vaulted chamber a courtier dressed as some fif-

307. Israhel van Meckenem. *Visit to the Spinner*, from the
Scenes of Daily Life. c. 1495–1500. Engraving, 6⅜ × 4⅜"

teenth-century dandy with feathers in his exotic turban sits on a stool before a young lady busy spinning thread. Behind them is a high chest on which lie several utensils, pitchers, flasks, and books. An oval box with spindles rests near the spinner, and her cat curls up smugly before

308. Master I.A.M. of Zwolle. *Last Supper.* c. 1485.
Engraving, 13⅝ × 10½"

the dandy. Meckenem has introduced a bit of moralizing satire here. The proud courtier, his right hand placed conspicuously on the hilt of his sword, seems to be propositioning the young lady, but, alas, to no avail. Spinning was considered a virtuous activity of the lady at home (not in the spinning factories, however), and no doubt

the maiden will continue her occupation for the rest of the day. The prudish look on the cat tells us as much.

Toward the end of the fifteenth century a number of Dutch and Flemish goldsmiths turned wholly to engraving, but few were distinguished contributors to the development of the art. An exception is Master I.A.M. of Zwolle, identified by some as Jan van Mijnnesten, a goldsmith recorded in Zwolle in the northeastern Netherlands in 1462. There is good evidence that Master I.A.M. was active later in centers in Holland—Gouda and Delft—where the influences of Dieric Bouts and other Dutch masters helped to shape his eccentric, pre-Mannerist style featuring crowded compositions of animated figures twisting and bending in contorted postures as the high-keyed dramas unfold with an exaggerated intensity.

His remarkably refined line marks out fussy angular pleats and folds with sharply engraved contours and delicate tonal shading that give his style curious pictorial as well as sculptural effects. As in the *Last Supper* (fig. 308), one of his more restrained compositions, he frequently enframed the story with piers, columns, and tiny arches to establish the foreground space. Behind the main episode—the crowded assembly of apostles about a round table—glimpses into the distant background, right and left, offer us views of related events: the washing of the feet to the right, Christ and the apostles entering the Mount of Olives to the left.

The history of woodcuts and engravings goes through a dramatic change in the course of the sixteenth century. No longer are the innovators drawn from the ranks of carpenters and goldsmiths. Accomplished painters, intrigued by the subtleties of the art and attracted to the lucrative markets that prints created, turned to the graphic arts. The major graphic works are now the products of such consummate artists as Albrecht Dürer, Lucas van Leyden, and Pieter Bruegel.

Developments in Sculpture in the Fifteenth Century

With the rise of panel painting as a fully independent art in the fifteenth century, so too did sculpture acquire the status of an autonomous craft, especially wood carving, during this period.[115] As with the painters, a number of important factors contributed to this new freedom for the sculptors. The gradual liberation of sculpture from its subordinate role to architecture has already been noted, especially with regard to stylistic developments of the jamb or column figures of cathedrals and churches in northern Europe. From the imprisoned column figures on the facade of Chartres Cathedral, about 1145–55, through the mature Gothic figures of Amiens, about 1220–30, to the freestanding statues in the central bay of the facade of Reims, about 1230–50, one can trace the gradual emancipation of the standing figures step by step (see fig. 2). On the facade at Chartres they are subordinate members of the architecture; at Amiens they begin to move and interact with each other across the space of the portal; and at Reims they appear in the central bay of the facade as virtually independent statues that move freely across the portal, which now serves as an elaborate architectural backdrop for a religious pageant or play in which the figures participate.

On the facade of the Carthusian chapel in Dijon (fig. 58), at the end of the fourteenth century, their complete freedom has been realized. The roles of architecture and sculpture have been reversed, in fact. The large figures carved by Claus Sluter have not only acquired their individuality completely, but they even deny or disregard their architectural function; the duke and duchess themselves kneel in the jambs, leaving vast empty spaces above their heads. Rather than sculpture being subservient to the building, at Dijon the architecture is reduced to little more than a huge enframement or stage for the figures.

Another factor in the developing autonomy of the sculptor and his works was the shift from the organization and status of the artisans as members of a cathedral lodge or court workshop to independent craftsmen governed by the regulations of local city guilds or unions.[116] The structure of the guild imposed a sense of autonomy

through a rigid control over specialization in craft. With few exceptions, the painter was not permitted to carve, and the sculptor was not allowed to paint his works or even make the frames for them.

This strict division of labor, however, presented a number of problems. The stringent restrictions of the guild, on the one hand, protected the artist, but, on the other, they often suffocated his spirit of creativity and originality. The guild members, especially the old, established guard, prohibited by their laws the sale or manufacture of works by any non-citizens or foreigners not bound to the local guild, thus creating a quasi-monopoly on style, especially in the large art centers where the elders were often powerful members of the city council. This nourished a climate of regionalism, often stifling, and the conditions for an indigenous city style, often conservative.

Finally, with the rise of the new middle-class economy in northern Europe, a different type of patron and a new market soon emerged. Merchants and wealthy patricians more and more replaced the church and the court as major patrons, and the rise of the third estate brought with it eager new buyers of art works. Objects were created commercially as well as by commission, and annual fairs were established in the cities for the mass sale of art to the public. It was for this new market that smaller and more intimate objects came into vogue. The expanding market also led to the mass production of standard works for export, although here too such trade was often suppressed by the guilds.

As with painting in the fifteenth century, so too in sculpture the preeminence of the Netherlands must be first considered although, due to the paucity of remains, this claim does not recommend itself without serious reservations. One need only review the list of leading sculptors employed by the Valois dukes at the end of the fourteenth century: Jehan de Marville was Flemish, Claus Sluter was from Haarlem in Holland, Jacques de Baerze was active in Termonde near Bruges, André Beauneveu came from Hainaut, Jean de Liège and Jean de Cambrai hailed from the borderlands of France and the Nether-

lands, and Claus de Werve, Sluter's successor at Dijon, was also from Haarlem. Due to the turbulent and destructive events of the sixteenth century in the Netherlands, so little in the form of sculpture survives there that it is difficult if not impossible to discern clearly any specific regional styles.

Of interest is the production of Netherlandish altarpieces, where the collaboration of a sculptor and a painter is evident. It will be recalled that Philip the Bold was so impressed by works that he had seen in Flanders by De Baerze that he ordered replicas for his Carthusian monastery in Dijon. Generally these early sculptured altarpieces (called *Schnitzaltäre* in German) featured sculptured figures in the interiors, usually for the inner wings as well as the central panel (corpus), while the exterior of the side panels were painted. Melchior Broederlam (see p. 71) from Ypres executed the paintings which through the course of time have been more studied and praised than De Baerze's sculptures.

The subject matter of the sculptures was usually dictated by the dedication of the chapel for which the piece was destined. The central corpus often presented a hieratic assembly of saints, carved in the round, while the inner side wings were decorated with relief sculptures of narratives appropriate for the saint or saints honored. In the Netherlands, however, the interior carvings often presented a sequence of narratives from some major Christological cycle or scenes from the life and martyrdom of the saint venerated. These historiated types often bring to mind staged presentations reminiscent of mystery plays so popular at this time with many doll-like actors exuberantly presenting their drama within a boxed architectural frame before the audience. The total effect, thus, is one of some miniature theatrical production. The figures are richly polychromed or gilded (by a painter, not the sculptor), and they are packed within a triptych frame with tiers of pinnacles and arches rising high above their heads, evoking an image of a cross section through a diminutive cathedral, which the frames were no doubt meant to represent.

THE NETHERLANDS

Only a few fragments of Early Netherlandish winged altarpieces in wood survive, but judging by the numerous fine examples, many intact, dating from the end of the

309. NETHERLANDISH.
Altarpiece of the Passion
(triptych).
c. 1480–90. Wood,
8′ 6½″ × 9′. Church
of Saint Dymphna,
Geel

310. JAN BORMAN THE ELDER. *Altarpiece of Saint George*. 1493. Wood. Musée du Cinquantenaire, Brussels

fifteenth century, it seems certain that there was a continuous tradition for such works from De Baerze through the early sixteenth century. The *Altarpiece of the Passion* (fig. 309) in the Church of Saint Dymphna in Geel, dating about 1480–90 and bearing the mark of the workshops of Brussels, is a magnificent example of these later *Schnitzaltäre*. The central corpus depicts the Crucifixion within an elaborate architectural frame that features tiny sculptures in the moldings that illustrate related scenes of the Passion much as the painted voussoirs in Rogier van der Weyden's simulated painted *Schnitzaltäre* do (cf. figs. 122, 123). The corpus itself is crowded and cramped with countless agitated figures richly gilded and painted. Aside from the figure of Christ raised high above their heads, the overlapping and density of the tiny figures, together with their florid colorism, give the work the impression of a sumptuous metalwork more so than a carved object, and this impression was no doubt what the patrons wished.

Jan Borman the Elder, the leading wood-carver in Brussels and Louvain, also produced *Schnitzaltäre* that resemble complex theatrical sets for packed compositions of elegantly attired actors who move laterally across the interior in boxlike compartments capped with intricate canopies or tabernacles of lacy scrolls and pinnacles. His *Altarpiece of Saint George* (fig. 310), dated 1493, originally placed in the Church of Our Lady of Ginderbuyten at Louvain, presents no fewer than seven compartments of the life of Saint George across the interior. While technically impressive, the compositions tend to become somewhat routine and monotonous, anticipating the countless workshop productions of carved altarpieces in Antwerp and Brussels in the first decades of the sixteenth century. Much of Borman's work and that of his followers was destined for churches in northern Germany and Scandinavia.

The dramatic sense of space and the colorful pictorial qualities of Netherlandish carved retables can, in part, be attributed to the close alliance of sculpture and painting in the workshops of Flanders, Brabant, and Hainaut. This curious blend of bold three-dimensionality and heightened pictorial effects can be found in the larger figurative sculptures as well. The lifesize *Annunciation* group in the Church of Mary Magdalen in Tournai (fig. 311) is well documented and offers more testimony to the interplay between the two arts in the early fifteenth century. According to an account by the widow Agnes Piétarde on behalf of her deceased husband, payment was

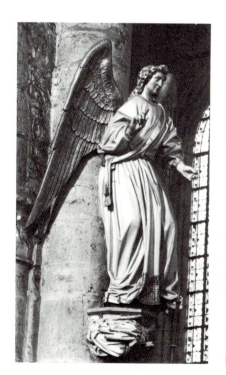

311. Polychromed by ROBERT CAMPIN. *Annunciation* group. 1428. Stone, height 72⅞". Church of Mary Magdalen, Tournai

312. NETHERLANDISH. Dead Christ Supported, detail from the *Deposition* (copy after ROGIER VAN DER WEYDEN). c. 1465–80. Wood, height 14½″. Walters Art Gallery, Baltimore

statues for the city hall in 1434 which he might also have designed. Van Eyck's simulated statues of Saints John the Baptist and John the Evangelist in grisaille on the exterior of the Ghent *Altarpiece of the Lamb* (colorplate 15) further indicate the exacting knowledge the painter had of the techniques of the sculptor's workshop, since it was not until the third quarter of the fifteenth century that such works, in stone or wood, were left without coloring.

Perhaps the most dramatic evidence of collaboration, however, is presented in the career of Rogier van der Weyden. The elegant sculptural qualities of his style are hallmarks of Rogier's art. It has been argued that Rogier's father, Henri, was a sculptor by trade, and it is not unlikely that the son was well informed if not trained in the techniques of the sculptor's art. Surely his painted versions of *Schnitzaltäre*, such as the Granada *Miraflores Altarpiece* and the Berlin-Frankfort triptychs of Saint John the Baptist (see pp. 127–29), are intimately related to prevailing formats in sculpture.

But with Rogier the influence runs strongly in the reverse direction as it did in the graphic arts. As a designer par excellence, Rogier provided the sculptors and engravers with elegant compositions admirably suited to the needs and tastes of their arts. Hardly any major sculptor in the Netherlands or the Rhine valley, for that matter, resisted the magnetic attraction of Rogier's graceful postures and magnificent drapery with its many interlocking pockets and angular couplings. In fact, a number of mid-

to be made to the sculptor of the two statues, "the tailleur et ouvrier d'ymaiges, Jehan Delemer," and to the painter who "added the several colors to the images, Maistre Robiert Campin," the Master of Flémalle (see p. 119). Documents from Bruges inform us that Jan van Eyck was employed by the city to polychrome eight

313. JACQUES DE GÉRINES? AND RENIER VAN THIENEN? Figures from the *Tomb of Isabella of Bourbon*. 1476. Bronze, height about 22″. Rijksmuseum, Amsterdam

and late-fifteenth-century sculpture groups in the Netherlands are outright copies or close variants of Rogier's compositions (fig. 312).[117]

There is good evidence that leading painters such as Van Eyck and Rogier provided designs for metalworkers. In 1458 Philip the Good commissioned bronze tombs of his ancestors Johanna of Brabant (died 1406) and Willem I of Brabant (died 1410) from the sculptor Janne de le Mer (*beeldsnijder*), Jacques de Gérines (brass founder), and Rogier van der Weyden (*polychromeur*). Only sketches after the tombs survive, but from them we learn that the bronze effigy was laid atop a sarcophagus that had arcades along the sides wherein statuettes of the deceased's ancestors and descendants were placed as if participating in some solemn funerary ceremony, a direct revival of the Dijon tomb of Philip the Bold by Sluter with its display of courtly mourners and Carthusian *pleurants* in procession along the base. Ten such funerary statuettes in bronze are exhibited in the Rijksmuseum in Amsterdam that are believed to be from the *Tomb of Isabella of Bourbon* (died 1465), commissioned by Mary of Burgundy in 1476 and executed by Jacques de Gérines and the sculptor Renier van Thienen (see fig. 313). The charming Amsterdam bronzes could well be replicas of an earlier set designed for Gérines's foundry since they are clearly in the costume and style of the mid-century, but there is little agreement concerning their identities.[118]

In the North Netherlands the wanton destruction wrought by the peasant iconoclasts in 1566 (see p. 450) obscures any clear picture of the activities of the sculptors there, although there is good reason to believe that in Haarlem a tradition of sculpture had been established very early. Claus Sluter came from Haarlem, it will be remembered, and from the city archives we learn that in 1424 the regents of the Church of Saint Peter in Leiden sent four citizens to Haarlem to inspect and ultimately to purchase a sculptured altarpiece for their church. The rebuilding of Saint Bavo in Haarlem during the fifteenth century necessitated the commission of many sculptures, both in stone and wood, as the documents of the church clearly indicate, but only a few fragmentary remains of these works survive today. The appearance of a beautifully carved and polychromed group of the Sacrifice of Isaac in the painting of the *Holy Kinship* by Geertgen tot Sint Jans (fig. 170) provides good evidence that the wood-carver's art was well established in Haarlem.[119]

There is more substantial evidence for establishing Utrecht as a major center for stone and wood sculpture. The destruction of the numerous stone wall reliefs in the Dom at Utrecht is still painfully evident to anyone who visits the cathedral, and, furthermore, the high quality of the fragmentary remains indicates the activity of a masterful workshop there. Of the smaller objects, much

314. NORTH NETHERLANDISH (UTRECHT?). *Madonna and Child*. c. 1460. Pijpaarden relief, 16½ × 8⅝". Centraal Museum, Utrecht

315. NORTH NETHERLANDISH. *Joachim and Anna Meeting*. c. 1460. Oak, height 18¼". Rijksmuseum, Amsterdam

more survives. Many statues of the Madonna and Child produced in Utrecht are hardly distinguishable from works further up the Rhine. Utrecht's diocese was governed by Cologne, and no doubt its cultural heritage was more attuned to that of the Lower Rhine than the South Netherlands; in fact, it appears that Utrecht was one of the major centers for the dissemination of Netherlandish art to the east.

A special type of cheaper commercial sculpture known as *pijpaarden* (pipe-clay) reliefs (fig. 314) was one of the chief exports of the city, a trade it shared with Cologne. As to wood-carvers, the anonymous Master of Joachim and Anna (fig. 315) was presumably active in Utrecht around the middle of the century. A number of small relief carvings and statuettes related to the Master of Joachim and Anna display a rugged Dutch quality, unlike the Dom stone sculptures, especially in the stumpy proportions and the cumbersome carving of the draperies, which are reminiscent of Dieric Bouts and Ouwater. The rather homey and tender embrace of Mary's parents also brings to mind the sentiment of the Haarlem artists, and perhaps he should be more properly associated with that Dutch center. A small wooden relief in the Rijksmuseum in the same style is a creative copy of the central group in Geertgen's *Lamentation* in Vienna.

One of the leading Utrecht sculptors, known to us only as the Master of Saint Martin, after the handsome group in the Centraal Museum in Utrecht, worked in sandstone and produced a number of graceful statuettes

right: 316. NORTH NETHERLANDISH (UTRECHT?). *Mary Magdalen,* from the *Altarpiece of Saint Martin.* c. 1455–65. Limestone, height 26″. Centraal Museum, Utrecht

far right: 317. ADRIAEN VAN WESEL. *Three Musical Angels and Saint Joseph,* from a Nativity group. c. 1475. Oak, 17½ × 14¾″. Rijksmuseum, Amsterdam

(for the Dom?) that date around 1460–65. On a miniature scale, his lively and alert figures, such as that of *Mary Magdalen* (fig. 316), exhibit the courtly charm of the earlier *Schönen Madonnen* of Bohemia, especially in the youthful faces, the sweeping arcs of the deeply cut draperies, and the refined carving technique. No doubt this gifted sculptor was one of the leaders of a Utrecht atelier that established the more elegant courtly style that persisted in Utrecht for more than four decades and distinguishes it from the more bourgeois style of the Lower Rhine and Holland.

A notable compromise between these styles and temperaments is seen in the work of one of the most gifted of all Utrecht sculptors active in the third quarter of the century, Adriaen van Wesel.[120] In 1480 he was busy at work on three statues for the Dom in Utrecht; between 1484 and 1486 he executed the high altar for the Nieuwe Kerk in Delft; but his most notable commission, one of the earliest (1475–77), was a wooden shrine, the *Altarpiece of the Virgin,* for the Chapel of the Brotherhood of Our Lady in Saint John's Cathedral in 's Hertogenbosch.

These sculptures are today dispersed, and the reconstruction of the shrine is uncertain, but the fragments very likely were placed in deep architectural niches much like those of the South Netherlandish *Schnitzaltäre.* The figures have an unusual appeal in their graceful articulation and lively expression. Indeed, Adriaen van Wesel strikes one as a painter or graphic artist (cf. the Housebook Master, pp. 286–89) more so than a sculptor. Every turning surface of the reliefs is textured and highly detailed.

In the endearing fragment of the *Three Musical Angels and Saint Joseph* in the Rijksmuseum (fig. 317) the diminutive angels kneel and twist in melodious postures, their smiling faces are dimpled and childlike, their cheek bones are pitched high, and their squinting eyes are heavily lidded. The kneeling Joseph behind them is coarser in expression but nonetheless charming and docile. The *Altarpiece of the Virgin* in 's Hertogenbosch must have been a masterpiece in its time, and the fragments can give us only a hint of its quality. It is no surprise that the members of the Brotherhood of Our Lady, ten years after its completion and installation, commissioned one of their own members, Hieronymus Bosch, to paint the outer shutters for the sculptured corpus. Another Dutchman, Nicolaus Gerhaerts van Leyden, to be discussed shortly, was to spread the lyricism, the sense of dynamic movement, and the delicacy of carving of Adriaen van Wesel to the sculptors of the Middle and Upper Rhine in the last quarter of the century.

GERMANY

Although much more German sculpture of the fifteenth century survives than in other Northern countries—and much of it is of high quality—it is difficult to characterize distinctive regional styles. Rather, what appears is a blending in various degrees of stylistic ingredients from the west (Burgundy and the Netherlands) and the east (Bohemia). A more realistic sculptural style resulted, supplanting the ubiquitous mannerism so prevalent throughout Germany often referred to as the "soft

style'' (*weichen Stil*), where the structure and articulation of the figure are obscured behind the abundance of gentle (soft) and melodic flowing draperies that are arbitrary and undefined as to the body beneath them.

HANS MULTSCHER

One of the earliest personalities to emerge is Hans Multscher, active in Ulm (Swabia) until his death in 1467. It will be recalled that Multscher headed a huge workshop that involved painters and sculptors (see p. 222), and while it is often assumed that Multscher himself practiced both arts, it remains an open question as to whether or not he actually executed the works or merely served as general contractor of a large workshop that monopolized the arts of Ulm and its environs. It is, in fact, about this time, 1430–60, that the rise of large secular workshops employing various kinds of artisans occurs throughout Germany which were clearly distinct from the earlier cathedral lodges.[121]

In documents he is often named *Tafelmacher*, or ''maker of panels,'' although he is also referred to as *Bildhauer* or *Bildschnitzer*, terms that specifically mean ''carver of panels,'' but nowhere is he designated as a painter (*Maler*). Multscher very likely had his apprenticeship in sculpture in the spheres of Burgundian and Netherlandish workshops before settling in Ulm in 1427. An early work, the *Man of Sorrows* (*Schmerzensmann*) on the west portal of Ulm Cathedral carved in stone in 1429, is a striking example of the new vigor and realism that Multscher introduced to Swabia (fig. 318). The dramatic stance of the semi-nude Christ, whose right hand points to a wound made by the lance, and the sharp and forceful expression of his thrusting head instill an immediate tension in this traditional *Andachtsbild*.

Multscher's best known sculptures are a series of standing female saints, executed in limewood and originally richly polychromed, that flank an imposing Madonna and Child in the center of an altarpiece destined for the parish church in Sterzing (Tyrol) sometime between 1456 and 1458. The side wings and the sculptures of the corpus are today dispersed, but the ensemble must have been the traditional winged shrine with painted narratives augmenting the more iconic sculptural images of the saints. The figure of *Saint Ursula* (fig. 319) is especially impressive with its firm stance and angular draperies breaking down and across the body in a forceful fashion that has affinities with the draped saints in Rogier van der Weyden's paintings more so than with the *weichen Stil*. The head of Ursula too, in Multscher's personal fashion, is serious and very much more that of a healthy German maiden than the cherubic countenances of the earlier face types.

above: 318. HANS MULTSCHER. *Man of Sorrows* (*Schmerzensmann*), from Ulm Cathedral. 1429. Sandstone, height 66⅛". Württembergische Landesbildstelle, Stuttgart

left: 319. HANS MULTSCHER. *Saint Ursula*, from a shrine. 1456–59. Limewood, height 57½". Unserer Lieben Frau im Moos, Sterzing

320. Nicolaus Gerhaerts van Leyden. *Monument of Canon Conrad von Busnang*. 1464. Limestone wall relief. Cathedral, Strasbourg

321. Nicolaus Gerhaerts van Leyden. *Crucifixus*. 1467. Sandstone, height 86⅝". Old Cemetery, Baden-Baden

322. Nicolaus Gerhaerts van Leyden. *Bust of a Man (Self-Portrait?)*. 1467. Sandstone, height 17⅜". Musée de l'Oeuvre Notre-Dame, Strasbourg

323. Nicolaus Gerhaerts van Leyden? *Madonna of Dangolsheim*. c. 1470. Walnut, height 40⅛". Staatliche Museen, West Berlin

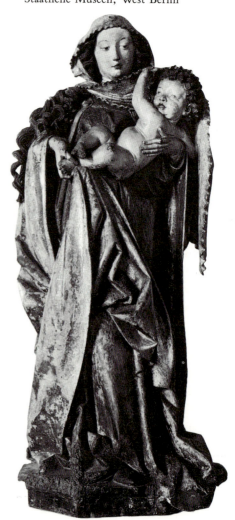

NICOLAUS GERHAERTS VAN LEYDEN

The most influential link between Germany and the west is Nicolaus Gerhaerts van Leyden, one of the most gifted sculptors to work in the Rhineland (and later in Austria) during the third quarter of the fifteenth century.[122] His career can be traced from his birthplace, Leiden, down the Rhine to Strasbourg, and thence to Vienna, where he died in 1473. Throughout his career his style shows a great affinity to Rogier van der Weyden (and possibly to the engraver Master E.S.) in the delicate and lyrical play of angular folds that break in and out across the figures, and a comforting sense of harmony pervades the lively movement of the figures in space.

For the canon Conrad von Busnang, Nicolaus executed a charming wall plaque in stone for the Cathedral in Strasbourg in 1464 (fig. 320). The busts of Mary and the canon are boldly carved so that they project nearly in three dimensions from the Flamboyant Gothic niche in which they are placed. The lively movement of the Child is eye-catching. His direct confrontation with the donor and the energetic manner in which his right hand, grasping the veil of Mary, initiates a sweeping movement of arcs across the relief joining the unfurling banderole behind and above the canon to the ogee arch of the niche itself impart an exciting rhythm across the stabilized verticals of the figures.

For a surgeon in Baden-Baden, Nicolaus carved a huge *Crucifixus* (fig. 321) in sandstone, signed and dated 1467, that today is placed in the Old Cemetery there. The figure of Christ, over lifesize, is a tour de force in the realistic presentation of the anatomy of his emaciated body on such a large scale, and the sunken cheeks and gaping mouth resemble the stunning treatment of the head of Christ that remains from the Calvary executed by Sluter in Dijon nearly three-quarters of a century earlier. Without resorting to contortions of the body, as so many Rhenish sculptors before him had done, Nicolaus presents a truly dignified version of the suffering and death of Christ on the cross. There is, in fact, something of a quiet dignity in the basic vertical and horizontal axes, an austerity gently relieved by the rhythmic fluttering of the loincloth.

The *Bust of a Man* in Strasbourg is a striking study in stone of an intricately posed figure in half-length with interlocking arms winding about the torso and supporting the sensitively poised head of a weary, sleeping man (fig. 322). Should this engaging figure be a self-portrait, as many have suggested, then the originality and freshness of Nicolaus's sculpture are all the more apparent.

The influence of Nicolaus Gerhaerts van Leyden was immediate and widespread along the Rhine, and it is no surprise that a number of undocumented pieces of exceptional quality have been attributed to him. It is most tempting to place in his oeuvre the engaging *Madonna of Dangolsheim* in Berlin (fig. 323). This beautiful statue, carved in walnut wood, stands about three and one-half feet high and strikes a commanding pose before the spectator as Mary leans back supporting the weight and energy of her overly active Child. According to a local tradition of Dangolsheim, which is some twelve miles west of Strasbourg, the statue originally belonged to the nearby Benedictine monastery at Schwarzach, and therefore it could well be a piece executed during Nicolaus's residence in Strasbourg sometime before 1469. That it is the work of an unknown local artist, either a precursor or follower of Nicolaus, seems unlikely. The *Madonna of Dangolsheim* is a masterpiece in every sense of the word, and the intricate disposition of the great sweep of drapery in two giant arcs descending from the right hand of the Virgin and the whimsical play of the wriggling Child playing peek-a-boo with the trailer of her headpiece suggest that this was Nicolaus's ultimate statement of the theme of the *Schöne Madonna* which lived so long in the Rhineland.

MICHAEL PACHER

It will be recalled that one of the leading painters in the South Tyrol, bordering Italy on the south and Austria to the northeast, was Michael Pacher, who between 1471 and 1481 executed the imposing wooden shrine for the parish church of Saint Wolfgang in Austria (figs. 324, 325). The contract for the altarpiece clearly stipulates that the work is to be consistent with drawings prepared by Pacher and certain verbal agreements made with the abbot of Mondsee. The huge structure, nearly a work of architecture itself, stands some forty feet high and with its double wings measures over twenty feet wide. The paintings with scenes from the life of Saint Wolfgang as well as an extensive cycle of the lives of Christ and the Virgin that adorned the wings have already been discussed (see p. 236). The central corpus is an elaborate *Coronation of the Virgin* flanked by statues of Saints Wolfgang and Benedict carved in limewood and elaborately polychromed and gilded.

There can be no question about the employment of a rather large workshop for the complex piece as both the carvings and the paintings reveal different hands at work. Pacher was the contractor and supervisor of an atelier in Bruneck which, in the fashion of Multscher in Ulm, worked on large commissions to be completed in his own studio and later were installed personally by him in the destined church. What marks this altarpiece as an exceptionally important product of Pacher's shop is the amazing unity in the overall design, especially considering the

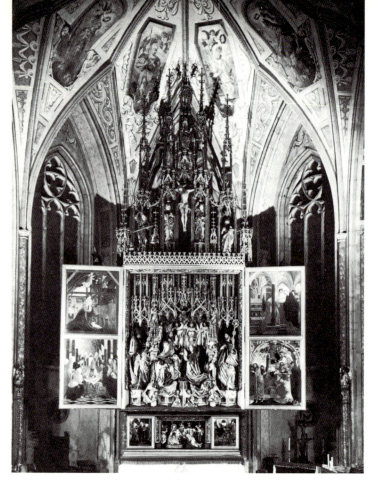

324. MICHAEL PACHER. *Saint Wolfgang Altarpiece*. 1471–81.
Limewood and pine, 12' 9½" × 10' 4" (center). Church of
Saint Wolfgang, Austria

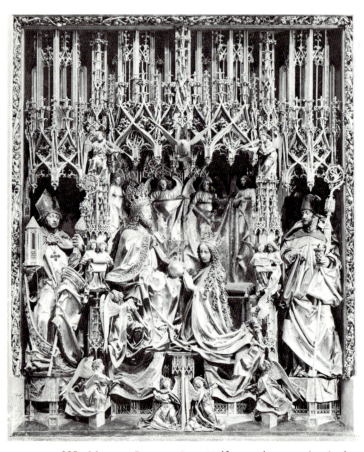

325. MICHAEL PACHER. *Saint Wolfgang Altarpiece* (detail of
fig. 324)

number of pieces, and the personal qualities of Pacher's own "florid" style, as it sometimes is characterized.

The treatment of the figures enveloped in swirling draperies can be seen as a synthesis of the styles of Nicolaus Gerhaerts and Hans Multscher, and it has been argued that Pacher had his training in the Upper Rhine, but these comparisons are vague at best. The remarkable theatrical effects of the sculptures and the towering frame with which the corpus merges as if caught up in some rising crescendo of church music are overpowering when first viewed. The initial vision is one of complete orchestration of sculptured figures, throne, canopies, and pinnacles soaring majestically to fill the entire choir as an integral part of the giant web of Flamboyant Gothic architecture. Then slowly the individual pieces emerge with more and more clarity as contrapuntal passages of a fugue in sculpture.

The majestic figures of the enthroned Christ and the kneeling Virgin dominate the corpus. About them flutter numerous small angels singing and playing instruments, and, resembling Art Nouveau bookends, the large figures of Saints Wolfgang and Benedict form the transition between the sculptures and the architecture of the frame. The draperies are deeply carved with scooped-out arcs and elegant angular pockets that create a fascinating play of deep shadows and dynamic highlights across the painted figures. While the painted panels on the wings may display the influence of North Italian painting, the total impression of the altarpiece is that of a glorious statement of flamboyant Northern Gothic expression.

The present boundaries of Germany (East and West) are vast and sprawling for modern Europe, and the term "German art" is quite meaningless since dialects, geography, and economics vary widely. Some historians have divided earlier regional styles into ecclesiastical areas. Among the major districts—the archdiocese—are Cologne (the Lower Rhine), Mainz (the Upper Rhine, Swabia, and Franconia), and Salzburg (Bavaria, Austria, and Tyrol), but even these seemingly basic divisions do not account for the major centers in which the arts of Germany were truly created.

It was in the thriving commercial centers where the workshops were nurtured just as it was in the Netherlands. Five cities, existing as chartered "free" imperial sites, are most notable. In the Upper Rhine, Strasbourg was an important center for the dissemination of arts and ideas between Italy (via Basel) and the Netherlands (down the Rhine). In the fifteenth century the last major bridge for heavy traffic over the Rhine before the seacoast was at Strasbourg. Nuremberg was another "free" city, and its trade in textiles and metalworks made it the chief city in the province of Franconia. In Swabia, Ulm and

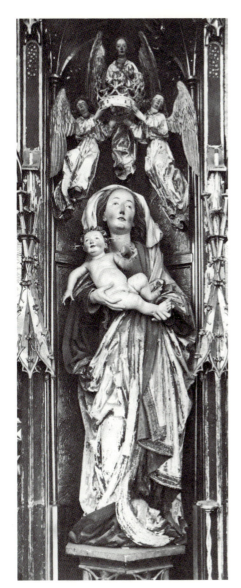

326. MICHEL AND GREGOR? ERHART. *Madonna*, from a shrine. c. 1493–94. Limewood, height 72″. Benedictine Monastery, Blaubeuren

Augsburg were the leading centers for trade and the arts. Cologne, strategically located between the Middle and Lower Rhine, commanded similar importance especially since it was also the center of an archbishopric extending its ecclesiastical control far to the west into the Netherlands.

And how does the artist fit into this structure of cities? Essentially there were four or five divisions of citizenry in the community during the waning Middle Ages: the patricians or survivors of the old noble families; the *Ehrbaren,* or wealthy and honorable merchants; the middle class made up mostly of merchants, craftsmen (including the artists), and city employees; and the lowest estate, consisting of the sick, the lame, and the general outcasts of city life. Hence the cities that nurtured the arts placed their craftsmen at a relatively low position in the hierarchy.[123]

Within this sprawling domain called Germany, Ulm in the province of Swabia distinguished itself as a major center for sculpture. Hans Multscher established one of the earliest workshops of shrine makers there. His successor in Ulm was Michel Erhart, whose activity can be dated between 1469 and 1522. It is known from documents that he was engaged in a number of major commissions in and around Ulm, but it is difficult to establish his oeuvre.

One work that has been almost unanimously assigned to him is the elegant *Virgin of Mercy,* today in Berlin, dating about 1480–90 (colorplate 49). Like much of the sculpture in the area, the statue is carved from limewood, a particularly fine-grained tree that allowed the sculptor to exploit the natural curves of the figure with ease. The delicately posed Madonna steps slightly forward with her left foot, allowing the folds to break across her projecting knee in discrete angular pockets that beautifully contrast with the more severe vertical ridges that descend from her breasts. In her extended hands she holds up her comforting mantle under which the tiny figures of ten townspeople kneeling in prayer are nestled. They are not likely portraits of individuals but anonymous members of the confraternity for which the sculpture was commissioned.

The Virgin of Mercy (or *Schützmantel Madonna* in German) was the beloved guardian-mother of the pious who hoped and longed for divine protection from the plagues, famines, or other evils attributed to satanic forces. How intent are their stares upward, and Mary, too, glances to the top left as if imploring her Son for mercy. The countenance of Mary is benevolent and serene. In contrast to the Madonnas of Flemish art, in Erhart's marvelous sculpture she is the epitome of Germanic femininity, as charming as the maidens of Lorelei and as devoted and loving as the *heilige Mutter.*

Michel Erhart's most famous work is the large carved retable for the high altar of the cloister church in Blaubeuren (fig. 326), dating about 1493–94, with the standing Madonna raised on a podium and flanked by four saints. Very likely, his son, Gregor Erhart, collaborated with his father on this commission, and it was the son who transmitted Erhart's style to Augsburg, where Gregor moved in 1494. Augsburg had grown into a large commercial center (40,000 inhabitants), and due to the influence of the wealthy Fugger family entrenched there, Italianism and its variations (referred to as *Welsch* in German) established the taste for the city patrons supplanting that of the more indigenous German (*Deutsch*) style.[124] Erhart's eloquent Madonnas and saints made little impression in Augsburg itself, but rapidly spread to the environs, where the indigenous Germanic expression still held sway.

Erasmus Grasser, a contemporary of Michel Erhart, settled in 1474 in Munich, where he directed a large workshop until his death in 1518. Grasser was a prominent citizen who also worked for the city as an architect and engineer. During his last five years he was a member of Munich's outer council. The sculptures attributed to Grasser are uneven in style and quality, but one set of limewood statues, ten *Morris Dancers* (originally sixteen), commissioned by the city to serve as decorations along the base of the vaults in the *Tanzsaal,* or dance hall, in the old Rathaus, established his fame in art history (fig. 327). The dancing figures, about two feet tall, are astonishingly lifelike and expressive with their wild gyrations, grotesque facial expressions, and bizarre gestures. With this genre Grasser could give full vent to his interests in lively movement as well as exaggerated realistic effects.

The most renowned sculptor in northern Germany during these same years was Bernt Notke, a gifted painter and goldsmith as well. Notke settled in Lübeck, where his activities are first recorded in 1467. In 1483 he moved to Stockholm, where he gained considerable prestige and was appointed master of the Swedish mint in 1490. Notke's most impressive work is the elaborate, over-lifesize *Saint George and the Dragon* executed in 1489 for the Storkyrka in Stockholm (fig. 328). The imposing monument is a combination of an equestrian portrait and a funerary epitaph. It commemorates the victory of the Swedish army under the regent Sten Sture over the Danes in 1471, at which battle the protection of Saint George was invoked by the Swedes.

The huge base was to serve as a tomb for Sture placed in the entrance of the choir, where the regent allegedly prayed for the assistance of Saint George on the eve of the battle. While the features of the saint are generalized, the giant horse was supposedly a portrait of Sture's charger and the armor too was a reproduction of his own suit worn in the engagement. Thus, Saint George, as an example of the true *eques christianus,* or knight of Christ, was the spiritual ancestor of Sten Sture himself, and, at the same time, served as a votive monument in the heart of the church, where Sture prayed and was destined to be buried. The towering monument is garish but imposing. Beneath the rearing hoofs of the mount, a huge dragon is sprawled out in a most fantastic form. The spiky horns

above: 327. Erasmus Grasser. *Morris Dancer.* 1480. Limewood, height 25⅝". Stadtmuseum, Munich

left: 328. Bernt Notke. *Saint George and the Dragon.* 1489. Wood, 9' 11¼" × 7' 5¾". Storkyrka, Stockholm

329. TILMAN RIEMENSCHNEIDER. *Ascension of the Magdalen*, from the *Altarpiece of the Magdalen*, from Münnerstadt. 1490–92. Limewood, height 73⅝". Bayerisches Nationalmuseum, Munich

covering the dragon were fashioned from real elk antlers. Scattered about the ground are bits and pieces of the victims of the menacing creature. The princess who was saved from a gruesome fate by George kneels to the left on a console, giving the whole group a truly bizarre theatrical appearance.

The theatrical presentations of Erasmus Grasser and Bernt Notke are somewhat exceptional in late-fifteenth-century sculpture in Germany, but they serve as good evidence of the diversity of styles encountered there. The more traditional modes of expression of Nicolaus Gerhaerts van Leyden and Michel Erhart reached their culmination in two sculptors active in Würzburg and Nuremberg: Tilman Riemenschneider and Veit Stoss.

TILMAN RIEMENSCHNEIDER

Tilman Riemenschneider's name appears in the records of the Guild of Saint Luke in Würzburg in 1483 as a "journeyman" sculptor; in 1485 he is listed again as a "master."[125] Where and with whom he received his initial training are not known, but the eclecticism of his early works suggests that he was well versed in the traditions of the Upper Rhine and Swabia. It is also evident that Riemenschneider had a thorough knowledge of the prints of Martin Schongauer and, ultimately, the art of

Rogier van der Weyden. The documents further inform us that he had a long and prosperous career in Würzburg as director of a large, productive workshop. He also held a number of posts with the city council there, serving as *Bürgermeister* (mayor) in 1520. His sympathy for the cause of the burghers and peasants in their strife with the bishop and his campaigns to stamp out Reformation sympathizers resulted in his expulsion from the council in 1525, when he was fined and imprisoned. He died in Würzburg in 1531.

Among his early works are the *Altarpiece of the Magdalen* for the parish church in Münnerstadt, commissioned in 1490, and the sandstone figures of *Adam* and *Eve* originally placed on the market portal of the Marienkapelle in Würzburg of 1491–93. The Münnerstadt altarpiece, now dismantled and dispersed, was composed in the traditional *Schnitzaltar* format with a large central corpus with the *Ascension of the Magdalen* surrounded by six angels (fig. 329) and flanked by figures of Saint Kilian and Saint Elizabeth of Hungary. The side wings (*Flügelen*) had four relief sculptures illustrating episodes in the life of the Magdalen. The predella-like base (*Sarg*) originally displayed seated statues of the four Evangelists, while the crown (*Aufzug*) of the shrine was adorned with the Trinity flanked by the Virgin and John the Evangelist. Surprisingly, the sculptures were left in their natural limewood finish with no polychromy, a practice that Riemenschneider usually followed, but one that was perhaps a bit too modern for the tastes of his patrons.

The aesthetic issues raised by natural-finish statuary are difficult ones. It will be recalled that Van Eyck painted the two Saint Johns on the exterior of the Ghent altarpiece in grisaille in order to underscore the point that these figures were simulated sculptures. It was not until Riemenschneider's generation, however, that wood and stone sculptures were actually left unpainted. This new practice has been considered the outcome of a changing aesthetic attitude toward sculpture on the part of the artists and patrons, who grew to appreciate the texture of the natural wood or stone as something beautiful in itself. If this were the case, it seems odd that only ten years after the installation of the *Altarpiece of the Magdalen* in Münnerstadt, another artist, Veit Stoss, was called in to paint and gild the sculptures of Riemenschneider. Perhaps the tastes of the city council were somewhat provincial.

Another, more practical explanation has been suggested. To leave the wood unpainted was simply much cheaper. We have seen how frequently altarpieces were contracted by both sculptors and painters, with the latter often receiving the higher wages. Apparently Riemenschneider had no painters attached to his workshop, however big it may have been, and, hence, he initiated

right: 330. Tilman Riemenschneider. *Altarpiece of the Holy Blood.* 1499–1505. Limewood, height 29' 6⅜". Church of Saint Jacob, Rothenburg

below: 331. Tilman Riemenschneider. *The Last Supper,* from the *Altarpiece of the Holy Blood* (detail of fig. 330).

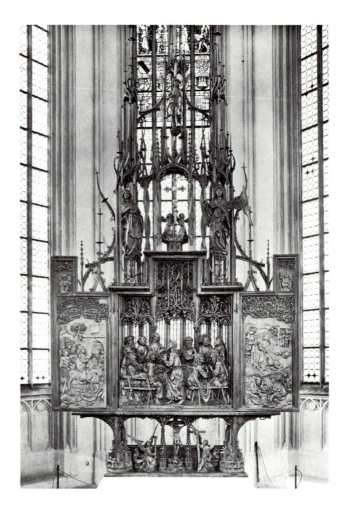

the new fashion quite independently. By the end of the century the popularity of black-and-white line prints also had tempered the taste for lavish color reproduction. Finally, one could argue that in this practice there was a muffled ring of the Protestant abhorrence of the painted idol. Whether or not Riemenschneider's natural-finish sculptures were a concession to rising iconoclastic feelings or not, it remains a fact that they are left as natural wood or stone and not as realistic human figures.

In 1499 the city council of Rothenburg, some forty miles southeast of Würzburg, acting as wardens of the Church of Saint Jacob, commissioned a local shrine maker to construct in fir wood a giant frame to be placed over the altar of the nearby Chapel of the Holy Blood, which housed one of the important relics of the city and thus drew much pilgrimage traffic. Riemenschneider was contracted to provide the sculpture, which was in-

stalled in the frame sometime between 1502 and 1505 (figs. 330, 331).

The contract, which survives, explicitly states the iconography for all parts of the shrine. With respect to the valued relic—a drop of Christ's blood—the central corpus was to feature the Last Supper with figures about "four feet tall." On the side panels the narratives of the Entry into Jerusalem and the Agony in the Garden were to be carved in relief "about three fingers deep." Other figures, including angels about the "Holy Cross," Gabriel and the Annunciate Virgin, and a Christ as Man of Sorrows, decorated the crown. Located as it is, the elaborate structure resembles a towering monstrance. The crowning image, the Man of Sorrows, is, as we have seen before, a very appropriate *Andachtsbild* intimately associated with the wine and blood of the Eucharist, and the major representation in the corpus, the Last Supper, portrays the actual institution of the sacrament of the Eucharist.

Riemenschneider's composition is unusual. Normally Christ, holding the sleeping John the Evangelist to his bosom, is the central figure about which the apostles are symmetrically grouped. Here Christ stands to the left behind the table and gestures toward Judas, moneybag in hand, who assumes the central position and about whom all the figures turn. It would seem, therefore, that the major point of Riemenschneider's *Last Supper* was not so

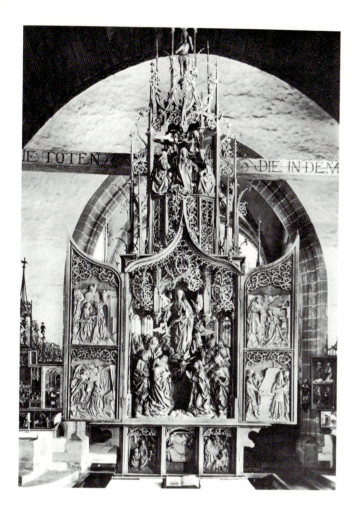

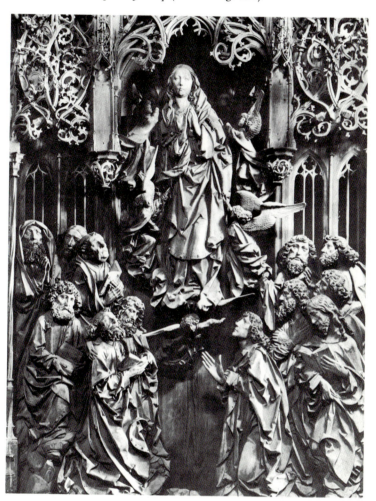

left: 332. TILMAN RIEMENSCHNEIDER. *Altarpiece of the Assumption of Mary.* c. 1505–15. Limewood, height of corpus 98⅜".
Herrgottskirche, Creglingen

below: 333. TILMAN RIEMENSCHNEIDER. *Altarpiece of the Assumption of Mary* (detail of fig. 332)

much the institution of the Eucharist as the announcement by Christ that "one of you will betray me. . . . It is he to whom I shall give this morsel when I have dipped it." And when he had dipped the morsel, "he gave it to Judas, the son of Simon Iscariot" (John 13: 21–30). The moment then is the recognition of a traitor amid the brotherhood of Christ. As if to accommodate the standard iconography, the seated figure of the youthful Saint John, to the left of Judas, indicates with his left hand the offering of the Pascal lamb on the table before Christ and with his right points downward to the spot in the Chapel of the Holy Blood where the chalice would be placed during the Mass.

The richly carved figures together with the overgrown pinnacles and spires of the wooden frame contribute to an impression of what has been aptly called the "florid style" of Late Gothic sculpture in Germany. Certain conventions for the heads and the drapery have been clearly established by Riemenschneider that make his style personal and distinctive. The long, thin faces with sunken cheeks are easily recognizable as his types, and the weightless bodies that serve as racks for descending mantles broken into countless angular couplings and restless fret folds seem fussy and exaggerated when compared to the serene drapery of Michel Erhart. And while Riemenschneider seems to repeat affected gestures and stock head types over and over again, the final effect is

one of a rippling pattern in wood inspired by the elegant compositions of Schongauer and Rogier van der Weyden.

One of the most glorious examples of Riemenschneider's genius as a maker of imposing shrines is the famous *Altarpiece of the Assumption of Mary* (figs. 332, 333), executed about 1505–15, in the Herrgottskirche in Creglingen, a village a few miles down the Tauber River from Rothenburg. This shrine too was destined to decorate a popular pilgrimage site. The wings and predella are decorated with limewood reliefs of the Joys and Sorrows of the Virgin, and atop the depressed ogival frame, within an elaborate tabernacle, appear the Coronation of Mary, and, in the summit, Christ as Man of Sorrows. The main corpus displays a majestic Assumption of the Virgin with the apostles gathered in a semicircle, their restless draperies even more agitated than before, beneath the elegant

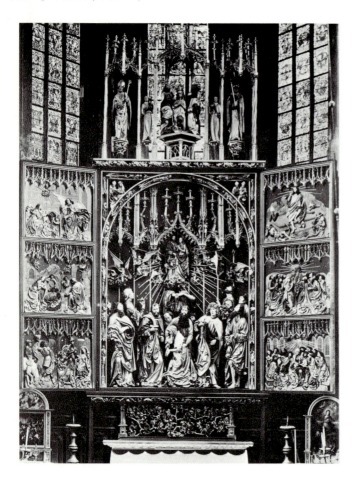

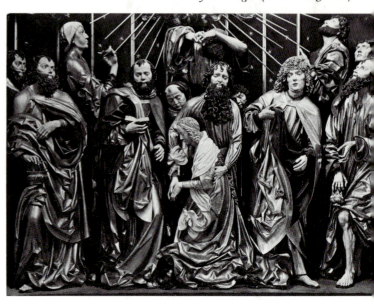

left: 334. VEIT STOSS. *Death of the Virgin*, from the high altar. 1477–89. Wood, height of corpus 23′ 9″. Church of Saint Mary, Cracow

below: 335. VEIT STOSS. *Death of the Virgin* (detail of fig. 334)

Madonna, who is lifted upward by a number of tiny angels. The figure of Mary is one of Riemenschneider's finest creations. Her lithesome stance adds to the weightlessness of the body, and her beautiful head is elegantly poised on her long neck with cascading strands of hair falling across her shoulders. One can say that what Rogier van der Weyden is to Late Gothic painting and Martin Schongauer to engraving, Tilman Riemenschneider is to fifteenth-century sculpture.

VEIT STOSS

If the late sculpture of Tilman Riemenschneider can be placed in one of the last phases of Northern Gothic known as *détente* with its placid restraint and sentimental sweetness, the works of Veit Stoss represent the emotional and expressionistic current that is sometimes called "Late Gothic Baroque."[126] In contrast to the prosperous career of Riemenschneider, that of Stoss was a tragic melodrama of a true individual who made concessions to no popular tastes and was, in his later years, practically an outcast in the artistic community of Nuremberg.

Born in 1450, Stoss apparently had his training in the Strasbourg-Ulm area, as did Riemenschneider, but this is not certain. We first find his name in the archives of Nuremberg in 1477, when he gave up his citizenship

there to take up residence in Cracow, Poland. Stoss was called there by the German merchant community to execute the sculptures of the high altar of their church dedicated to Mary (figs. 334, 335). The theme was a glorious tribute to the Virgin, her joys, sorrows, and glories in keeping with the popular Marian devotion of the time. The huge work, forty feet high and thirty-five feet wide, fills the choir and features double wings with dramatic relief sculptures, all polychromed. The central corpus is an amazing version of the death and assumption of Mary executed with large sculptures in the round. The outer set of wings, which are fixed, displays twelve scenes from the apocryphal life of the Virgin and the Passion of Christ.

During the weekdays the central corpus remained covered. On holidays and festivals the inner wings would be opened over the outer, revealing the Death of the Virgin. The six reliefs on the inner side of the open wings illustrate episodes from the Joys of Mary in the Infancy and post-Passion, complementing the exterior program. The *Sarg,* or predella, is decorated with sculptures of the Tree of Jesse, Mary's royal ancestry in the Old Testament; and the crown, or *Aufzug,* with its fragile tabernacle presents the Coronation of the Virgin, her ultimate Glory. It is probable that Stoss led a large workshop for the execution of the retable and that he was in charge of every detail, including the polychromy and gilding. The Cracow altarpiece was completed in 1489, twelve years after the initial contract was signed.

Stoss's treatment of the *Death of the Virgin* is wholly original. Rather than depicting Mary expiring in a bed surrounded by the apostles who miraculously returned for her funeral, Stoss places Mary in a swooning position, falling to her knees, at the very last moment of her life when she murmurs prayers to her son for the last time. A heavily bearded apostle stands behind her and grasps her relaxed body. Two others, Peter and John, on either side of Mary, and three more behind the central group openly grieve over the loss. Three apostles are gathered on the extremities and gaze upward toward the tabernacle in the summit of the corpus where Mary is carried into heaven by angels to join Christ. Thus Stoss has ingeniously restated the tripartite drama of the Virgin's last hour: the Dormition or death, the Assumption, and (in the crown) her Coronation—the very iconography of thirteenth-century portals dedicated to Mary in France.

More so than the remarkable iconographic unity, however, it is the individual style of Veit Stoss that has drawn the attention of most scholars. A harmony of sculpture, painting, and architecture is achieved, certainly a characteristic that justifies the use of the term "Gothic Baroque," and as we move closer to the shrine our attention is overwhelmed by the expressionistic features of the individual figures, from the gracefully swooning Madonna to the highly perturbed expressions and agitated postures and gestures of the apostles. Stoss is a master of turbulent drapery. The explosive gestures and tense energy of the figures are underscored by the feverish flutter and rhetoric of the twisting drapery edges. Closer inspection of the faces reveals an almost caricature-like expression on them—no two respond in the same fashion—but the treatment of the anatomy is exacting down to the bulging veins in their hands and legs. Stoss is to be reckoned as one of the most gifted and individual masters of Late Gothic sculpture.

The virtuosity of Veit Stoss in the creation of expressive drapery patterns is particularly evident in his single figures such as the limewood *Saint Roche* (fig. 336) in the Church of the Annunziata in Florence, probably commissioned by an Italian merchant about 1510. The drapery is a tour de force of sweeping arcs that undulate and spiral in three dimensions down the body, turning with thin and fragile overlaps whose broader surfaces are punctuated with depressed angular pockets and cavities that enrich the pictorial effects with a restless design of dynamic if not confusing highlights. And yet the gentle and submissive characterization of this saint is somehow preserved in the slow and languorous turnings of his body, which is eloquently maintained through the gestures of the arms and projection of his right leg that appears as part of the convoluted mantle itself. In the second edition of his *Vite* (1568), Vasari highly praised

this work—although he misattributed it—as a masterpiece of subtle carving with graceful and hollow folds that need no color to enhance the pictorial effects and superbly capture the beauty of Italian *disegno*. A recent scholar has compared the drapery with its three-dimensional lines that create a calligraphy in wood to the linearity of the florid Gothic script.[127]

By 1496 Veit Stoss had reestablished his residence in Nuremberg. He returned as a wealthy and famous sculptor, but circumstances were to turn against him, leading to his conviction on forgery charges in 1503 and his flight to Münnerstadt, during which time he polychromed the *Altarpiece of the Magdalen* of Tilman Riemenschneider. In 1506 he received a pardon from the emperor Maximilian and resettled in Nuremberg. But Stoss was never to reclaim his prestige as a great artist and was shunned by the public and the city as a "troublesome" character. His commissions came mostly from private patrons such as the Italian merchant who ordered the Saint Roche.

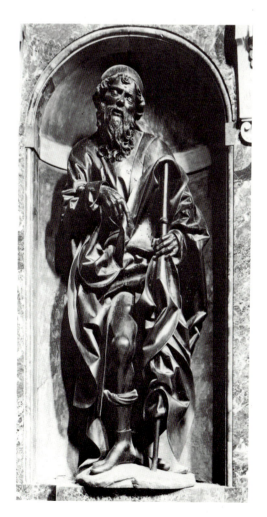

336. Veit Stoss. *Saint Roche*. c. 1510–20. Limewood, height 67". Church of the Annunziata, Florence

337. VEIT STOSS. *Annunciation of the Rosary.* 1517–18.
Limewood, 12′ 2″ × 10′ 6″. Church of Saint Lawrence,
Nuremberg

One of his more familiar works during these times was executed for a Nuremberg administrator, Anton II Tucher, in 1517–18, for the choir of the Church of Saint Lawrence (fig. 337). The new devotion of the Rosary was widespread in Germany, and Stoss was commissioned by Tucher to carve an enormous Rosary to hang from the vaults before the choir. The composition that Stoss followed was one familiar in Rosary manuals: a circular *Rosenkranz* with the Annunciation, the first Joy of Mary, placed within it. The huge circle is seen against the radiance of the stained glass of the church choir. About the perimeter of the Rosary, Stoss placed five scenes from the Joys of Mary: the Nativity, the Adoration of the Magi, the Resurrection, the Ascension, and Pentecost. Two extra medallions were added to the top of the Rosary with relief representations of the Dormition and Coronation of the Virgin. While the Rosary was meant to be viewed from some distance, the two major statues, Gabriel and Mary, are splendid examples of his style with an abundance of fluttering draperies. Here, however, decorum is obeyed in the quiet, unobtrusive gestures of the figures, and the flamboyant drapery is the result of having tiny angels lift the outer mantles of the

Annunciate and Gabriel to the sides, creating a purely arbitrary pattern of folds and creases without disturbing the sobriety of their confrontation.

While Stoss's giant Rosary was being lifted into place before the choir of the Church of Saint Lawrence, another costly, monumental sculpture was being readied for the Church of Saint Sebaldus in Nuremberg, the *Tomb* or *Shrine of Saint Sebaldus,* cast in bronze by the leading founder in the city, Peter Vischer the Elder (fig. 338). The problems of the designs and the casting of the huge monument are complex, since work was frequently interrupted on the project before its completion in 1519. Furthermore, the role of Peter Vischer in the actual designing of the tomb and its sculpture is extremely vague. The florid crown of the shrine, culminating in three heavy Gothic pinnacles resting on eight slender supports, rises high above the raised box-tomb within. Aside from a few accessory statuettes along the base and some of the ornamental motifs applied to the architecture of the shrine, Vischer's huge *Tomb of Saint Sebaldus* is essentially "Gothic Baroque" in appearance.

338. PIETER VISCHER THE ELDER. *Tomb of Saint Sebaldus.*
1507–19. Bronze, height 15′ 5½″. Church of Saint Sebaldus,
Nuremberg

A marked change in style can be seen in the nearly contemporary sculptures in the Fugger sepulchral chapel in the Church of Saint Anna in Augsburg (fig. 339). Little documentation comes down to us concerning this ambitious project, but it is evident that a new generation of sculptors arrived in Gregor Erhart's hometown of Augsburg and introduced a definite "Italianizing" style and iconography to German Gothic traditions. It has been argued, in fact, that an Italian artist must have had a role in the design and carving of the stone figures and reliefs. The austere central group above the altar, the *Lamentation* or *Last Farewell to Christ* with Mary, John the Evangelist, and a third mourner supporting the dead Christ, clearly reflects Italian compositional schemes for this poignant scene in the Passion, with the restraint and passivity of the figures coming as something of a relief in the general emotional and lyrical tenor of German sculpture of the period. The classical heads and the calm drapery remind one too of Italian sculpture of the late fifteenth century, but the Fugger Chapel sculptures remain an intrusion in the mainstream of German sculpture.

This is not to say that German sculptors were unaware or unresponsive to Renaissance Italy. Peter Flötner, an engraver and sculptor, added the following verses under a woodcut of a soldier, addressing himself as a sculptor, "Veyt Pildhawer," who became a mercenary: "Many fine figures have I carved / With skill in *Welsch* and *Deutsch* manners." The terms refer to two opposing modes or styles of sculpture current in Germany during the first decades of the sixteenth century. *Welsch* was the Italian style (usually transmitted to the Northern workshops by prints and plaquettes); *Deutsch* was obviously the traditional mode of "Gothic Baroque" so prevalent in German art. Flötner brags that he, as an accomplished sculptor, could work in either conventional style with ease.

If the Fugger Chapel sculptures can thus be viewed as representing the *Welsch* or Italian mode, the works of another contemporary sculptor, Master H.L., possibly of Rhenish origin, epitomize the *Deutsch* tradition.[128] His masterpiece, the limewood altarpiece in the Church of Breisach, dated 1526, is a gigantic shrine dedicated to the Coronation of the Virgin (fig. 340). A virtuoso in wood carving, Master H.L. deeply undercut his churning drapery ridges with loops and intricate turnings multiplied endlessly. The result is a rich tapestry effect of arabesques and swirls from which the heads and tiny wriggling *putti* emerge here and there. The three figures, after one makes them out, are smothered under the florid lattice border at the top of the corpus. As we shall see, the response to Italian Renaissance style had no such opposition in French sculpture of the same period.

ve: 339. ADOLF DAUCHER? *Altarpiece of the Fugger Chapel.*
517. Marble and limestone reliefs, height 58¼". Church of
Saint Anna, Augsburg

ght: 340. MASTER H.L. *Coronation of the Virgin,* from the
Breisacher Altarpiece. 1526. Limewood, height of corpus,
10' 10". Church of Breisach

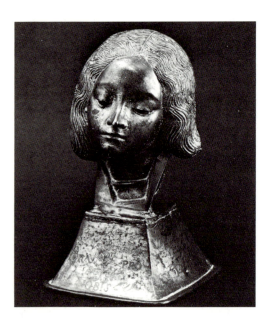

far left: 341. BURGUNDIAN? *Saint John the Baptist*, from Poligny. c. 1420–30. Limestone, height 59¼″. The Metropolitan Museum of Art, New York. Purchase, 1934, Joseph Pulitzer Bequest

left: 342. FRENCH. *Notre-Dame de Grâce*, from an *Adoration* group? c. 1430–40. Stone, height 43¾″. Musée des Augustins, Toulouse

below: 343. FRENCH. *Reliquary Head of Saint Fortunade.* c. 1450–60. Bronze, height 9⅞″. Church of Saint Fortunade, Corrèze

FRANCE

The developments of sculpture in France are difficult to chart through the fifteenth century, but much of the impetus for local variations of style came ultimately from the well-established tradition of Sluter in Burgundy. The works of the immediate followers of Sluter are numerous and uneven in quality, but such figures as those of *Saint John the Baptist* and *Saint Paul* from Poligny, forty miles south of Dijon, are remarkable examples of the force that Sluter's heavy drapery style and realistic head types exerted on the more accomplished stone carvers (fig. 341).

Burgundian influence can be traced to a group of sculptures associated with Toulouse. One of the more impressive of these is the *Notre-Dame de Grâce* (fig. 342) of about 1430–40 that comes from the pilgrimage church of the Dominicans in Bruguières near Toulouse. One is first struck by the charming radiance and sweetness of the faces and the somewhat eccentric poses—perhaps this is only a part of a larger *Adoration of the Magi* group?—but unlike the *Schönen Madonnen* of Bohemia, there is a sense of compactness and bulk that surely owes something to the deeply carved draperies of Sluter's tradition. The charming Madonna has a childlike freshness, and this latent French expression can be found in numerous centers during the course of the century.

The bronze *Reliquary Head of Saint Fortunade* in the church dedicated to her in Corrèze is an engaging example of the power and clarity of the more simplified lines and abstract finish of French sculpture when compared to the highly detailed and somewhat mannered expressions of German female types (fig. 343). The morphology of her features can be traced back to the *Smiling Angel* of Reims (see fig. 2), and the poignant immediacy perhaps owes something to the style of Jean Fouquet, who was active at Tours where this captivating bust was probably cast, and to the Master of Moulins.

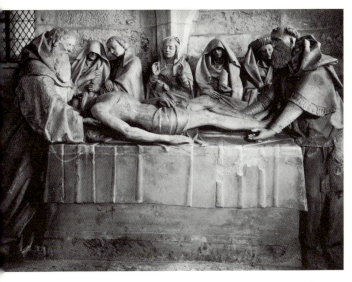

344. JEAN MICHEL AND GEORGES DE LA SONNETTE. *Entombment* group. 1451–54. Stone. Hospital, Tonnerre

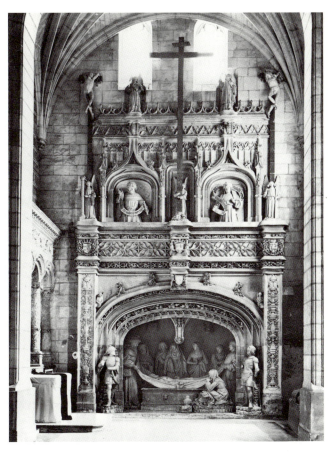

345. FRENCH. *Entombment* group. 1496. Stone. Abbey Solesmes

One does not encounter the multitiered shrines and many-figured altarpieces in France as one does in Germany. However, in the funerary arts a distinctive French contribution to the crosscurrents of styles culminated at the end of the century, especially in the numerous *Entombment* groups in chapels throughout France. The sculptors Jean Michel and Georges de la Sonnette executed such a group for the hospital chapel at Tonnerre between 1451 and 1454 that was commissioned by a wealthy citizen, Lancelot de Buonfosse (fig. 344). Atop a huge sarcophagus the body of Christ is deposed by Nicodemus and Joseph of Arimathea. Directly behind this presentation of the burial, a row of mourners appears: Mary, John, the Magdalen, and the other two Marys (the last three carrying or balancing ointment jars for the anointing and preparation of the corpse for burial that is a typical French variation on the theme).

The figures are freestanding and placed behind the sarcophagus like actors on a stage. In fact, the entire presentation brings to mind the mystery plays of the time that were so popular, and without the distraction of elaborate enframements, the group appears before us as some solemn *tableau vivant*. And rather than emphasizing the extreme emotions in such tragic scenes through wild gestures and contorted features, these actors are embodiments of serenity and understanding. The clarity and simplicity of the outlines of the figures and the group seen together also remind us of much earlier French art. There is something typically French in these mourners, and this trait is in keeping with the Late Gothic style discussed earlier—the *détente*—where a comforting relaxation pervades the expression of the figures.

The sequence of fifteenth- and early-sixteenth-century *Entombments* culminates in the haunting group in the Abbey of Solesmes, presented by the prior Guillaume

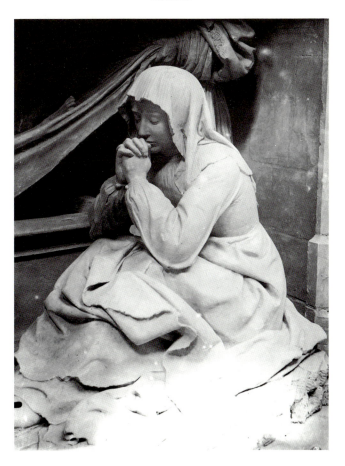

346. FRENCH. *Entombment* group (detail of fig. 345)

Cheminart in 1496 (figs. 345, 346). The most touching figure is the mourning Magdalen seated before the sarcophagus weeping silently into her clenched hands. Here, however, another dimension of expression enters French art in the form of the decorated frame and the side figures. The ornamental vocabulary of these marginal areas is that of the Italian Renaissance with its static scrollwork and elaborate urns. The course of art in France brought about a fusion of Italian styles and those of the North. Around 1500 a number of itinerant Italian artists began to appear in France importing their Renaissance style to serve the tastes of the ostentatious French courts. In the majestic *Entombment* of Solesmes the long tradition of Gothic piety and the sentiment of Gothic communal expression are held subtly in check within the framework of the Renaissance style of Italy.

A final statement of the tradition of Burgundian funerary art that began with Sluter is the *Monument to Philippe Pot,* lord high steward of Burgundy (died 1493), for his burial chapel in the Abbey of Cîteaux (fig. 347). The decoration of the tomb with figures of *pleurants* shown in procession at the funeral was established by Claus Sluter a hundred years earlier in the *Tomb of Philip the Bold* of Burgundy (see fig. 62), but now the realism of the ceremonial spectacle is vividly presented to the viewer with hooded figures, lifesize, marching in solemn procession, their heads hidden and inclined in prayer, bearing the tomb slab for Philippe Pot's sarcophagus on their shoulders. The mourners can be identified only by the coat of arms affixed to their habits. Here too, the traditions of the past are being reshaped for another, very different, age in French art.

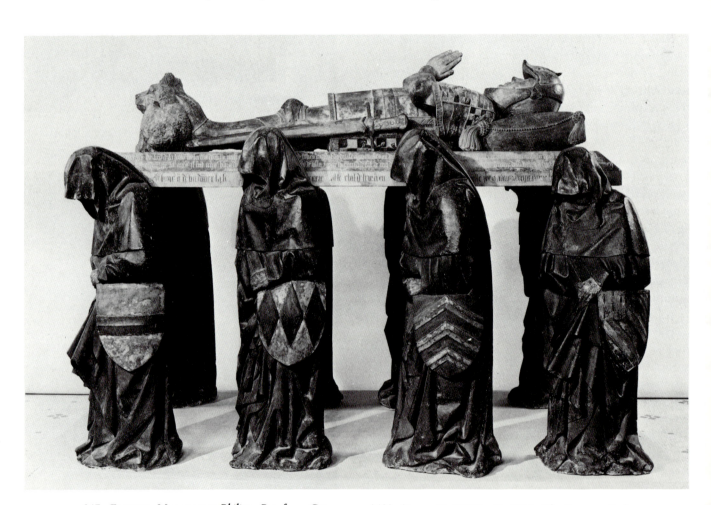

347. French. *Monument to Philippe Pot*, from Cîteaux. c. 1480. Stone, 5′ 10⅞″ × 8′ 8⅜″. The Louvre, Paris

PART THREE

The Renaissance in Germany, The Netherlands, and France from 1500 to 1575

Albrecht Dürer and the Renaissance in Germany

As with many great artists whose stature rises high above those of his generation, the genius of Albrecht Dürer has changed meaning for each new school and generation of art historians. Dürer has been described as an exemplar Nordic artist by some, as the most Italianate of German artists by others. He has been likened to Leonardo da Vinci for his never-ending search into the secrets of man's physical and psychological makeup. He wrote and illustrated treatises on the ideal proportions of the human body, but he was also fascinated by the effects of the humors or temperaments on the nature of man. Thus, for many, Dürer has been acclaimed the first true humanist in the North, but for others, his personality has been characterized as the embodiment of a Northern Faustian spirit expressing itself in a restless craving and search for a perfection never to be attained. This dualism between the man-centered—the Italian pole—and the romantic mystic—the Northern Gothic—cannot be easily reconciled, but one must try.[1]

Dürer visited Italy twice, in 1494 and 1505, and we know that he fervently studied the arts and ideas of Giovanni Bellini, Pollaiuolo, Mantegna, Alberti, and others, but these famed Renaissance artists were not really responsible for Dürer's dual personality. He was always probing and seeking with open eyes the world about him, and the accomplishments of the Italians merely made him self-conscious of his conflicting interests and ambitions, and they inspired him to be articulate about them. He was, in many ways, the founder of the Northern Renaissance, but he was also a child of a Gothic mother and father whose genes determined his true artistic makeup. Before discussing Dürer's development as a painter, graphic artist, and theorist, it would be instructive to let Dürer illustrate his complex personality through two works of art: the *Adam and Eve* (1504) and the *Melencolia I* (1514), both engravings (figs. 348, 349).

With Dürer begins the tradition of the grand tour of Italy by Northern artists, although he was not the first to visit there for inspiration (see p. 130). One can follow Dürer's preparation for his trips south and assess the results of his Italian experiences easily. In many studies and finished works the Italian elements are blatantly presented; in others, his more accomplished works, the layers of Italian influence must be carefully peeled away from those of the Northern Gothic to properly interpret his ''Renaissance'' style and content if, indeed, they can be.

The famous engraving of *Adam and Eve* was executed only months before his second trip south, and, in many ways, it seems to be a preparatory excursion into the Italian manner that he had absorbed in his earlier visit (1494). In sharpening this vision Dürer had turned directly to what he had learned from artists such as Mantegna and Pollaiuolo concerning the theories of ideal beauty in the human body. Dürer was familiar with the writings of the ancient authority Vitruvius concerning classical proportions, and in his rendering of Adam and Eve as ideal types, he chose as models the two favorite examples of male and female beauty in antiquity, the *Apollo Belvedere* and the *Medici Venus* (figs. 350, 351).

With minor changes in the positions of the arms, Dürer repeats the stance for both with the chiastic balance of the body parts—right arm and left leg under stress, left arm and right leg relaxed in Adam (reversed for Eve)—that was the norm in much ancient statuary. The taut and muscular torso of Adam with the anatomy of the chest, stomach, thighs, and legs carefully modeled contrasts with the softer lines and fleshier body of Eve in keeping with ancient canons. In the branch of the tree to the left, grasped by Adam, hangs a *cartellino*, or little plaque, with the Latin inscription, ''Albertus Durer Noricus faciebat 1504,'' prominently displayed. This is one of the first and last instances of Dürer's use of Latin for his signature (his usual 𝕬 is inconspicuously added to the end), and the fact that he added ''Noricus'' (Latin for Nuremberg) indicates his pride in his Northern home, where Italian humanism was rapidly making inroads.

Our classical Adam and Eve (Apollo and Venus) find themselves in a ''garden'' that belongs not to the Mediterranean world, however, but to the dense overgrowth

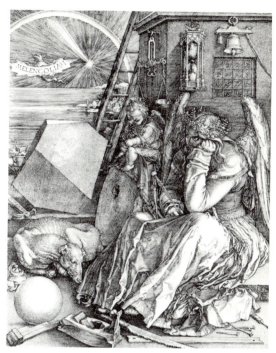

right: 348. ALBRECHT DÜRER. *Adam and Eve.* 1504. Engraving, 9⅞ × 7⅝"

far right: 349. ALBRECHT DÜRER. *Melencolia I.* 1514. Engraving, 9⅜ × 6⅝"

below left: 350. Roman copy of Greek Hellenistic original. *Apollo Belvedere.* Marble, height 7' 4". Vatican Museums, Rome

below right: 351. Roman copy of Greek Hellenistic original. *Medici Venus.* Marble, height 4' 7⅛". Uffizi, Florence

of a capricious Gothic forest replete with a distant mountain peak upon which a goat teeters precariously. The details of this thick woodland are rich and filled with a variety of flora and fauna, and the statuesque forms of the first parents seem, at first, to be smothered by the profusion of natural growth of a garden in keeping with Northern iconographic traditions. To the left is the Tree of Life with the parrot (symbolic of the wise and benevolent?) perched directly over Adam's shoulder. The Tree of Wisdom marks the central axis, and it is from this curious tree that Eve receives the forbidden fruit (apple)

from the serpent. However, Dürer's tree is a hybrid. The fruit may be an apple, but the leaves are those of the fig tree associated with the shame of Adam and Eve after the Fall (Genesis 3: 7: "Then the eyes of both were opened, and they knew that they were naked; and they sewed fig leaves together and made themselves aprons"). Now, as Adam is about to acquire the knowledge of good and evil by eating forbidden fruit, he will lose his innocence and his immortality, and both parents, after being driven from the eternal springtime of Eden, will be subjected to the pains and death of the harsher world outside the closed garden. With paradise lost, human history begins.

The consequences of the Fall are cleverly symbolized by the sedentary animals grouped about the tree.[2] According to Northern natural history, as Dürer surely would have known it, the curse of mankind was the unleashing of the humors or temperaments within us. In Eden, before the Fall, these states were held in check and had no consequence, but once the fruit of knowledge was bitten, they suddenly were manifest much as the evils released when Pandora opened her box. Hildegard of Bingen, a Northern mystic, wrote that "Had man remained in Paradise he would not have had those noxious fluids [humors] loose in his body."

The word "humor" meant the "fluids of the body" that affect our personalities, and in the fifteenth century, as today, there were four: two from the liver, one from the lungs, and one from the blood. The two secreted by the liver were black gall or bile, which prompted the vices of despair and avarice, the causes of bitterness of spirit that brings on the humor of *melancholy,* and yellow bile. The latter caused hot temper and impatience, resulting in the vices of pride and wrath or the *choleric* humor. In the Late Middle Ages, an elk often symbolized melan-

choly because of its lonely existence; the cat represented the choleric humor due to its quick temper and aggressiveness. Both animals are found resting quietly before and behind the Tree of Knowledge. *Phlegm*, carried by the lungs, resulted in laziness, sluggishness, and apathy representing the vices of gluttony and sloth, here symbolized by the lethargic ox to the right. The *sanguine* humor, finally, was the product of an excessively active blood circulation, bringing with it an overly active, sensuous, and fertile spirit provoking the vice of lust or lechery. The rabbit, fertile and quick, was the familiar symbol of the sanguine humor.

In Eden, before the Fall of man, these humors were controlled by the innocence and purity of the undefiled body, but once Adam bit the apple of knowledge of such things, all four were immediately activated. The sleeping cat (choleric) will soon pounce on the mouse that sleeps before it, and the rabbit (sanguine) will jump up and quickly hop away in search of a mate. Nowhere in Italian art is the pessimism of history so cleverly elucidated. Italian humanism and Gothic disguised symbolism, conflicting attitudes in the representational arts, are precariously held in balance in Dürer's *Adam and Eve*.

The second print, *Melencolia I* (fig. 349), was executed in 1514, seven years after Dürer's return from his second trip, when he had fully absorbed the spirit of the Italian Renaissance especially with regard to the idea of the elevated status of the artist as someone divinely inspired and not merely a well-trained craftsman. Dürer was much preoccupied with this notion, but the same confidence and self-esteem made him vulnerable to the frustrations of one determined to rival in art the beauty of the divine creator. Adam and Eve were fashioned after the hallowed images in antiquity of the perfect man and woman, but theirs were borrowed canons of perfection and hardly absolute beauty at that.

Dürer wrote, ''What absolute beauty is, I know not. Nobody knows it except God.'' And so in his *Melencolia I* Dürer sums up the anxieties and vanities of the artist in an unusual and provocative spiritual self-portrait: not the painter in his studio actively pursuing his craft, as did Saint Luke, but the artist weighed down by thoughts, dejected and disheartened, in the form of a personification of melancholy, the plight of those gifted with creative genius and susceptible to the debilitating effects of divine frenzy, or *furor melancholicus*.[3] The bat of twilight, the diabolic beast of melancholy herself, darts across the eerie night sky carrying a banner, ''Melencolia I.'' Another day has ended and little has been accomplished. Dürer himself warned his pupils of the danger of too intensive thinking about art: ''It can lead to the mind becoming overcast and the melancholy spirit taking the upper hand.''

Much has been written about the complex iconography of *Melencolia I*, and this print is, indeed, one of Dürer's finest inventions. To simplify these various interpretations somewhat, one might say that he has ingeniously fused three disparate traditions into a single image: the melancholic despair of the creative genius. First of all, the pose assumed by the female personification is that of the perplexed thinker, with knees spread apart, the right hand, here holding a compass, resting like some lifeless thing across the lap, the dejected and weary head held up by the clenched fist of the left arm, which is rigidly posed with elbow on knee. This is the same pose assumed by Adam after his expulsion from Eden, Joseph in Byzantine Nativity scenes (who can't figure it all out), Saint John the Baptist in the painting by Geertgen tot Sint Jans (fig. 172), and, ultimately, Rodin's *Thinker*, all of whom are characterized as souls puzzled and confused in their troubled reflections on past events. The same sentiment is echoed in the image of melancholy in a poem by Dürer's contemporary, Walther von der Vogelweide, the *Reichsgedicht*: ''I sat upon a stone / and placed my one leg on the other. / On it I rested my elbow / and cupped into my hand my chin / and my cheek. / Then I thought very hard, / how one ought to live in this world.''[4]

The same dejected pose with the head resting on hand appears in medieval personifications of *acedia*, or sloth, a state of inactivity and weariness that is caused by the melancholic humor and often leads to despair and insanity. According to medieval thinking, melancholy was the most feared and debilitating of all the humors and was characterized as one of the quaternities of bodily fluids: the dry and the cold induced by black gall, the element earth (as opposed to fire, water, and air), the times of the day and year (evening and autumn), and the ages of man (about sixty). The melancholic was thus a greedy, bad-natured individual banished to a solitary existence in the twilight zone of life.

All of this changed with the emergence of the Renaissance conception of the divinely inspired genius born under the sign of Saturn, the highest and darkest of the planets. Marsilio Ficino (*De vita triplici*, 1482–89) described melancholy as the mark of a great man beset by the *furor melancholicus*, or frenzy of the genius of the arts, poetry, and philosophy. The same ideas were voiced by Dürer's compatriot, Agrippa of Nettesheim, in his *De occulta philosophia* (1509–10), a text that Dürer surely must have known, and in a belated tribute by his old friend Philip Melanchthon (*De anima*, 1548), he was described as one possessed by the most noble of the states of melancholy (''melancholia generosissima Dureri'').

This leads to the final image to be absorbed into *Melencolia I*, that of the arts, which appears here in the various

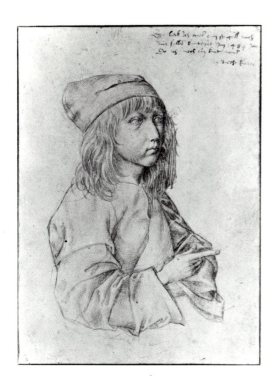

left: 352. ALBRECHT DÜRER. *Self-Portrait.* 1484. Silverpoint, 10⅞ × 7¾".
Albertina, Vienna

below: 353. ALBRECHT DÜRER. *Wire-Drawing Mill.* c. 1489? Drawing and
watercolor, 11¼ × 16¾". Kupferstichkabinett, Staatliche Museen, West Berlin

instruments and objects strewn haphazardly about the winged figure. The arts were variously represented in medieval art, but those of the true creator, the consummate artist, were ultimately personified as a *typus geometriae*, or architect whose creations encompassed all other arts. Just as God, the architect of the universe, had "ordered everything by measure and number and weight" (Wisdom of Solomon 11: 20), so the architect with his instruments was compared to the creator of worlds beyond.

A number of the objects at the feet of *Melencolia I* relate to the technical and applied aspects of the artist: the hammer, plane, saw, nails, and tongs which fashioned the perfect but unstable forms that can roll or tilt; the wooden sphere, the stone rhomboid, and the millstone upon which rests a sleepy little *putto* who seems to scribble in a tablet, perhaps representing the craft of the artist that unfortunately yields nothing here. The more intricate instruments, the compass held by the figure, the hourglass above her head, the scales, and the enigmatic magic square hanging on the wall behind are all devices for accurate measurement and the theory of pure geometry as personified in the frustrated *Melencolia I*. It was just those aspects of artistic genius that cannot extend its imagination beyond the measurable limits of space that were attributed to Melencolia "I" by Agrippa.

The attraction of Dürer's famous engraving was lasting, and it is no wonder that the many-leveled personality of his winged figure has had special appeal for artists to this day. And thus the Renaissance artist is born in the North, but unlike many of his contemporaries to the South, Dürer's awareness of the limitations of the "divinely inspired" artist has a definite Faustian shadow cast

across the path toward true beauty and perfection. It is also interesting to note that the original Doctor Johann Faustus, who sold his soul to the devil for such secrets, lived in the Rhine valley during the very years that Dürer was in quest for that absolute beauty that only God knows.

Dürer was born in Nuremberg in 1471 at a time when the Franconian city was rapidly shedding its Gothic past for a new and progressive style of Renaissance humanism, equaled only by Basel and Vienna in northern Europe. The son of a goldsmith from Hungary and a mother from Nuremberg, Dürer was the third of eighteen children, and his exceptional talents and promise as an artist must have been manifest from his earliest years. No doubt he learned the basic techniques of engraving from his father, and, at the age of fifteen, the young Dürer was apprenticed to Michael Wolgemut (see p. 235), the leading painter in Nuremberg and the head of a large workshop that produced woodcuts for the local printers as well as painted altarpieces on commission. He was to remain with Wolgemut for three years, 1486 to 1489, before he began his year of wandering (*Wanderjahre*), as was the custom for apprentices seeking new ideas and techniques from outside masters before submitting their own *Meisterstück*, or masterpiece, to the guild for acceptance as a licensed artist within the city.

A unique document of Dürer's youth appears in the form of a silverpoint drawing, a self-portrait, executed in 1484 when he was thirteen years old (fig. 352). The inscription, which was added later, informs us that the drawing was "made from a mirror." Silverpoint was a very exacting technique (employing a stylus of silver as a pencil) in which any errors are difficult to conceal and

above: 354. ALBRECHT DÜRER? *Ulysses and Circe,* from the *Nuremberg Chronicle.* 1493. Woodcut, 3¾ × 5⅜″

above right: 355. ALBRECHT DÜRER. *Holy Family.* c. 1491–92. Pen drawing, 11⅜ × 8⅜″ Kupferstichkabinett, Staatliche Museen, West Berlin

right: 356. ALBRECHT DÜRER. *Saint Jerome in His Study.* 1492. Woodcut, 6½ × 4½″

left: 357. ALBRECHT DÜRER. *Agnes Dürer.* c. 1495. Pen drawing, 6⅛ × 3⅞″. Albertina, Vienna

nearly impossible to erase, yet the engaging face of young Dürer is amazingly vibrant and free from the cramped control and tight outlines that one usually finds with such juvenalia. Furthermore, his features, recognizable in all later self-portraits, are already set. Dürer's face is long and somewhat triangular with a high-bridged nose, a small and delicate mouth, and slightly tapered eyes that reflect the oriental background of his Hungarian father.

Only a few of Dürer's works dating from the time of his apprenticeship to Wolgemut are known, and they are pen-and-watercolor sketches of views of Nuremberg that record the charming but casual impressions of a sensitive child observer. His *Wire-Drawing Mill* (fig. 353) of about 1489 is a panorama of half-timbered buildings clustered about a mill nestled in the valley of the quiet Regnitz River outside the city. In Wolgemut's shop Dürer would have learned the essentials in the craft of painting and preparing panels; however, during these years, Wolgemut was also engaged in designing woodcuts for the *Schatzbehalter* (1491) and the *Weltchronik* (1493), the former published by Anton Koberger, Dürer's godfather,

and it seems inevitable that the young apprentice was thoroughly familiar with numerous woodcuts in these and other Nuremberg publications. It has been suggested, in fact, that Dürer executed some of the woodcut designs himself, although it would seem that the demands on an apprentice would have been too widespread to allow him time to engage in activities normally undertaken by the master. The illustration of *Ulysses and Circe* in the *Nuremberg Chronicle* has been attributed to Dürer's hand (fig. 354) by many authorities, and one thing is certain: the new pictorial richness and illusionism in Wolge-

mut's woodcuts, as well as the amazing expertise of the gifted cutters of the designs (see p. 275), had a deep impact on Dürer's own graphic production.

Sometime in 1489 the young Dürer, now eighteen, set out on the second stage of his education, the *Wanderjahre*. After a year or two that are unaccountable, Dürer traveled to Colmar intent on working for the famed painter and engraver Martin Schongauer, but he arrived too late. Schongauer died in 1491. It has been surmised but not proven that he first traveled down the Rhine as far as Holland and that it was there that he was influenced by the revolutionary style of the Housebook Master. An early pen drawing of the *Holy Family* (fig. 355) is reminiscent of the Housebook Master's folksy treatment of the theme (fig. 300) with the sleeping Joseph reclining on the bench beside the Madonna and Child. The fussy, intricate treatment of the draperies as well as the verdant landscape setting are similar in both compositions, and the unusual spacing of the trees in the landscape bring to mind the style of Geertgen tot Sint Jans of Haarlem. In his *Het Schilder-boeck* (1604), Carel van Mander reported that Dürer had been to Haarlem, where he was much impressed by Geertgen's art, remarking that "Geertgen must already have been a painter in his mother's body."[5] Apparently Dürer was warmly received by Schongauer's brothers upon his arrival in Colmar, and it seems that they were responsible for sending him on to Basel, recommending the young artist to Martin's brother Georg, who was an engraver there.

Dürer's contacts in Basel were soon established and designs in many of the illustrated books published there between 1492 and 1494 have been attributed to him, including those in the 1494 edition (Johann Bergmann von Olpe) of Sebastian Brant's famous *Narrenschiff*. The one certain attribution to Dürer is the frontispiece for the *Letters of Saint Jerome* published by Nikolaus Kessler in 1492 (fig. 356). Following a long-established tradition for the scholar in his study, Dürer places the weary Jerome, dressed in a heavy cardinal's habit, within the crowded confines of his cell. Jerome has worked long hours. The bed is messed and the shelves and cabinet are cluttered with books and other objects. He turns from his Latin translation of the Hebrew Old Testament and the Greek New, both clearly indicated, to extract a thorn from the paw of a lion, who assumes a profile position not unlike those of the rampant beast in heraldic devices. It is apparent that an ambitious carver cut this design since the outlines are less severe than usual in Basel woodcuts, with shading, more dense and pictorial, that follows the natural turnings and contours of the figure and objects, especially in the mantle, the desk, and the niche, with occasional cross-hatching such as that in the deeper folds of the cascading drapery in the lower left.

Following a brief sojourn in Strasbourg in 1493, Dürer painted his *Self-Portrait with a Spray of Eryngium* (colorplate 50). The inscription above the head—"My affairs must go as ordained on high"—and the delicate spray of the Eryngium held in his right hand, the sea holly considered as an aphrodisiac and symbolic of luck in matters of the heart, suggest that the likeness was painted in anticipation of his marriage to Agnes Frey, arranged by Dürer's parents in that year. The portrait is one of his finest, distinguished by a free brushstroke and a fluid application of paint that impart a tender wistfulness and sensuousness to his features that his later portraits lack.

Dürer is now twenty-one, but his facial features have changed little from those of his silverpoint drawing of 1484. Physically and psychologically he seems much more the child in the drawing than the pretentious dandy that we encounter in the Madrid *Self-Portrait* (fig. 361), painted only five years later in 1498. The pose, the slightly inclined stare, and the informality of his dress reveal Dürer as a handsome young artist growing up with a serious mind perhaps tinged with a touch of poetry and romantic curiosity about just what lies ahead.

Dürer's marriage to Agnes Frey (fig. 357), daughter of a wealthy Nuremberg burgher, has been the topic of much interest since there seems to have been an utter lack of marital bliss and tenderness between the two, even considering the circumstances of the arranged commitment. They had no children, and it is surprising that only after being with his bride for a few months—they were married in Nuremberg in July 1494—Dürer took off with friends for Italy, where he stayed for approximately one year. It must be admitted that it would have been a rather unpleasant task for any young lady, no matter what her background, to face life as the loving wife of a melancholic genius who considered himself an exclusive member of the intellectual circles of Nuremberg, a proud individualist who was never satisfied with anything in life, especially if she were his wife by appointment and not affair.[6]

Dürer was more than ready to experience Italy in 1494. Through his friendship with the Nuremberg humanist Willibald Pirckheimer, Dürer had been introduced to the wonders of the ancient world, including Greek and Roman coins, and his knowledge of Italian art was spurred on by the prints of Mantegna, Pollaiuolo, and others which he avidly copied. His pen drawing after Mantegna's *Battle of the Sea Gods* (figs. 358, 359) seems a slavish copy at first sight, but Dürer's proclivities for a more lyrical calligraphy appear in the softer tonalities and the graceful swirling of the waves. Mantegna's blocky volumes conveyed in the torsos with a hard outline and emphasis on planar modeling by parallel strokes give way

358. ANDREA MANTEGNA. *Battle of the Sea Gods*. c. 1493. Engraving, 11⅝ × 15⅝"

359. ALBRECHT DÜRER. *Battle of the Sea Gods* (copy after MANTEGNA). 1494. Pen drawing, 11⅜ × 15". Albertina, Vienna

to a more subtle undulation of the flesh by means of Dürer's delicate shading techniques with fine cross-hatching that follows the contours of the rounded forms, especially evident in the rendering of the female nude seen from the back on the right.

Much of the evidence for Dürer's sojourn in Italy, more specifically Venice, is found in the numerous drawings and watercolors made in 1495 after his return to Nuremberg. A drawing of a female nude from the back (fig. 360), dated 1495, must be based on sketches of classical statuary (cf. the earlier drawing of the *Bather*, fig. 379), and others of Venetian courtesans, where his primary interest was in their lavish costumes, suggest that Dürer was introduced to more than the beauty of antique

360. ALBRECHT DÜRER. *Nude* (from behind). 1495. Pen and wash, 12⅝ × 8⅜". The Louvre, Paris

art while in Italy. More remarkable are the delicate landscape sketches in watercolor that he made during his trips across the Alps (colorplate 51). These filmy panoramas are conceived as finished works, not merely topographical studies, with their free-flowing compositions, often unframed in the fashion of seventeenth-century Dutch landscapes, and low horizon lines visible through a soft atmospheric perspective.

Dürer's views of the Tyrolean mountains in *plein air* announce a new species of landscape painting even more advanced than the famous Alpine drawings of Pieter Bruegel (see fig. 572) executed some fifty-five years later. The towns and valleys are accurately recorded as seen through a soft mist and dramatically picked out by a raking sunlight passing through the clouds here and there, and the spontaneity of the impressions testifies to their being sketched on the spot, a practice already anticipated in Dürer's early drawings of the environs of Nuremberg.

How Dürer changed following his year in Venice! A *Self-Portrait* (fig. 361), dated 1498, proudly announces the artist as an aristocrat and gentleman. For one thing, Dürer has acquired proper manners. His erect posture emphasizes the elegance and lithesome qualities of the well-bred. He wears expensive clothes and his long hair has been meticulously groomed. Self-assurance and confidence are conveyed through the rigid position of the right arm, the tightly clasped fingers of his joined hands, the poised head with alert eyes and pursed lips, and, in general, in the severity of the composition itself with the cold, vertical lines of the interior, the broad sill of the window, and the barren landscape view beyond.

The austerity of the portrait is especially evident when compared to the romantic likeness painted only five years earlier (colorplate 50). Harsh linearism and precise detail

have replaced the softer painterly qualities of the portrait in the Louvre, and the somewhat nervous mien of the younger Dürer with his nimble fingers gently fondling the root and flower of the Eryngium is here transformed into a determined stare and a clenched fist. This is Dürer as the successful businessman as well as the proud artist. Upon his return to Nuremberg, Dürer was elevated to a status rivaling that of a member of the upper social circles of the city, the *Ehrbaren*, or wealth merchants. In this same year, 1498, he had just completed the German and Latin editions of the illustrated *Apocalypse*, a lucrative investment considering the psychological impact that the year 1500, the projected millennium marking the Last Judgment, had on the Gothic North.

In the years immediately following his return from Venice, Dürer's technique in the graphic arts went through an astonishing development in terms of line with an incredible refinement of modeling forms and defining textures. The modeling or descriptive lines are further enhanced with a new sense of luminosity whereby the dynamic calligraphy that swells and tapers freely conveys tension and relaxation while the use of half- and middletones creates an unusual effect of highlights and shadows. No doubt Dürer realized that his prints had a promising future on the market, and it is apparent that he was aware of the potential of graphics as an appropriate medium for the awakening Renaissance and humanist interests in the North that relied on the profusion of illustrated printed books.

Sometime around 1496 Dürer undertook one of his most ambitious projects, the illustrating, printing, and financing of the famous *Apocalypse* book. The first edition, in German and Latin texts, was issued in 1498, and no doubt Dürer realized the timely value of such a picture book at that time. The Apocalypse (Book of Revelation) was one of the most influential Biblical texts in Christian art from the fourth century on, serving as the source for monumental mural decorations, especially those of the portals and facades of churches, and for a number of the richest manuscript cycles. The popularity of such colorful illustrations of the Book of Revelation returned again, as we have seen (see p. 76), in the Late Gothic period, and their appeal was very likely based on prevailing millennial fears that were associated with certain multiples of the year 1000 (500, 1000, 1500, etc.) as the moment of the Last Judgment as prophesied in the Bible. In the years preceding the year 2000 the Apocalypse has become popular again.

Dürer's models are clear. In the influential Cologne Bible published by Wilhelm Quentell in 1479 (republished by Koberger in Nuremberg in 1483) and the Strasbourg Bible of 1485 issued by Johann Reinhard de Grüninger, the core of Dürer's illustrations can be found for

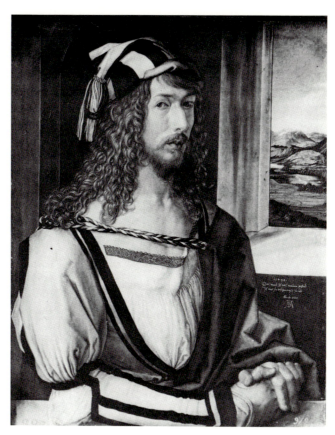

361. ALBRECHT DÜRER. *Self-Portrait*. 1498. Panel, 20½ × 16⅛". The Prado, Madrid

nearly every block, although the conflation of the various episodes on the page frequently differs.[7] In fact, Dürer used Koberger's typeset (and possibly his presses) as well as the German translation.

The first sheet illustrates the martyrdom of John at the Porta Latina in Rome with the cruel Emperor Domitian instructing his henchmen to boil the Evangelist alive in a vat of oil before a crowd of onlookers. The illustrations for the Book of Revelation that follow are masterfully condensed in fourteen woodcuts following, more or less, the pattern of sevens repeated throughout the text (seven churches, seven seals, seven trumpets, seven plagues, etc.) here presented in two basic contextual divisions: the wisdom of the Lord symbolized in the seven sealed book of the lamb and the unfolding drama of the power of the Lord over Satan and his peoples, victims of the seven plagues. The cycle has a certain symmetry about it in Dürer's distribution of the scenes. The eighth illustration (fig. 364)—the middle one—forms the pivotal point with the secret of his revelation and visions revealed in the book (the Word) given to John to eat and digest by the "strong" angel (Christ), and it concludes with the glorious triumph of Christ with the New Jerusalem coming down to earth following the Last Judgment. Some, in fact, have suggested that Dürer was influenced by the mystical structures in the writings of Nicholas of

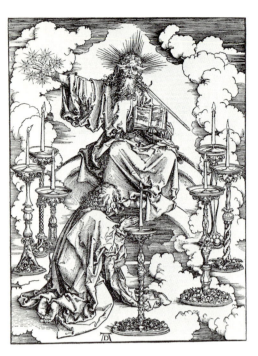

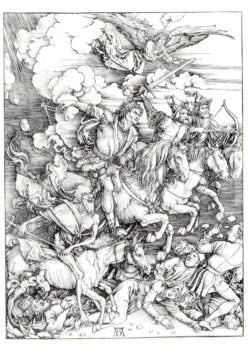

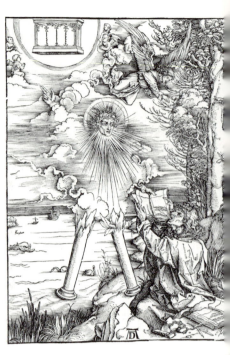

362. ALBRECHT DÜRER. *John's Vision of the Seven Candlesticks*, from the *Apocalypse* series. 1498. Woodcut, 15½ × 11″

363. ALBRECHT DÜRER. *Four Horsemen*, from the *Apocalypse* series. c. 1497–98. Woodcut, 15½ × 11″

364. ALBRECHT DÜRER. *John Devouring Book*, from the *Apocalypse* series. c. 149 Woodcut, 15⅜ × 11⅛″

Cusa (see p. 237), where the glory of God is envisioned in a spheroid universe based on symbolic numbers and astronomy.[8] Others have argued that Dürer selected his program with an anti-papal message in mind, but this interpretation is vague and very unlikely.[9]

The first scene, John's Vision of the Seven Candlesticks (fig. 362), is one of the most beautiful and effective in the set. Dürer followed the illustrations in the Quentell-Grüninger Bible:

> Then I turned to see the voice that was speaking to me, and on turning I saw seven golden lampstands, and in the midst of the lampstands one like a son of man, clothed with a long robe and with a golden girdle round his breast; his head and his hair were white as white wool, white as snow; his eyes were like a flame of fire, his feet were like burnished bronze, refined as in a furnace, and his voice was like the sound of many waters; in his right hand he held seven stars, from his mouth issued a sharp two-edged sword, and his face was like the sun shining in full strength [1: 12–16].

The marvelous effect of the visionary appearance of the One enthroned among the candlesticks in heaven is achieved through Dürer's use of a middle- or halftone for the background established by fine parallel lines from which the empty white wreath of cumulus clouds, forming a divine aureole, shines forth. Also Dürer places the kneeling Evangelist and the seven candlesticks in a projected space that moves in a semicircle beneath the clouds without disturbing the basic surface pattern of the vi-

365. NUREMBERG WOODCUTTER. *Four Horsemen*, from the Quentell-Grüninger Bible. 1485. Woodcut

sion. Thus the apparition partakes of the real and the mystical at once: the two figures and the candlesticks are highly detailed and exist as objects in space, while the setting is enframed by a mystical light that radiates from the One as a decorative surface pattern.

The third woodcut, the *Four Horsemen* (fig. 363), is the most famous in the set. Here Dürer transforms the somewhat spotty composition of the riders across the page as seen in the Quentell-Grüninger Bible (fig. 365) into a dramatic cavalcade set along a diagonal that dominates the page.

[After the opening of the first seal of the book by the lamb]: And I saw, and behold, a white horse, and its rider had a bow; and a crown was given to him, and he

366. ALBRECHT DÜRER. *The Babylonian Whore*, from the *Apocalypse* series. 1498. Woodcut, 15⅞ × 11″

went out conquering and to conquer. When he opened the second seal, I heard the second living creature say, ''Come!'' And out came another horse, bright red; its rider was permitted to take peace from the earth, so that men should slay one another; and he was given a great sword. When he opened the third seal, I heard the third living creature say, ''Come!'' And I saw, and behold, a black horse, and its rider had a balance in his hand; . . . When he opened the fourth seal, I heard the voice of the fourth living creature say, ''Come!'' And I saw, and behold, a pale horse, and its rider's name was Death, and Hades followed him; and they were given power over a fourth of the earth, to kill with sword and with famine and with pestilence and by wild beasts of the earth [6: 1–8].

Again Dürer establishes a basic middletone of parallel lines for the scene, but in this case the thundering motion of the overlapping horses followed by swirls of white clouds sets up a pulsating rhythm with the forms of the driving mounts, their gesturing riders, and the victims beneath their hooves spotlighted dramatically from the right as they move across the darkened earth.

The mystical visions of the Apocalyptic Woman (12) and the Divine Service with the Multitude Adoring the Lamb (14) are intrusions in the drama of the struggle and fall of Babylon (the archetypal domain of evil on earth), and the appearance of the harlot dominates the rest of the text. The Apocalypse concludes with the victory of the Lamb over the beast and the dragon, and here the symbolism acquires more of an historical context. The Lamb,

representing the purity and gentleness of Christ, the sacrificial victim, now confronts the beast and the dragon that symbolize the cruelty of the Roman emperors, especially Nero (represented by the cipher 666 in the text?); the whore of Babylon stands for the idolatry of those who worship the Caesars and fornicate with her. This last scene is also crowded with disparate images, but the elaborate representation of the whore on the dragon dominates (fig. 366).

Thus Dürer superbly brings together three major textual events in one panorama of heaven and earth. The group of people standing at the lower left are an interesting lot who are introduced to the harlot by an elaborately dressed king. It is not by accident that this exotic potentate closely resembles the emperor Domitian in the page with the martyrdom of Saint John at the Porta Latina in the introductory woodcut. The whore of Babylon, on the other hand, is characterized as one of the Venetian courtesans whom Dürer had sketched only a few years earlier.

Two of the woodcuts are variations on the hallowed theme of the *Maiestas Domini* in heaven with the One or the Lamb between the four beasts and adored by angels, elders, and the multitudes which was so popular in earlier medieval art. With these more hieratic compositions Dürer alludes to another important vision that is repeated throughout the text of Revelation: the Divine Mass in Heaven that serves as the prototype for the Mass on earth in the churches, but, in general, it is the explosive unraveling of the encounters between heavenly and earthly forces that sets the relentless pace for the apocalyptic holocaust that was believed would devastate the world at any time in Dürer's age. Hieronymus Bosch was obsessed with the same horrendous arenas of death and destruction, but the triumph and glorification of the church were not part of his vision.

With the publication of the *Apocalypse*, Dürer's reputation as the foremost Renaissance artist in Nuremberg was firmly established, and his companionship with Pirckheimer and other literati in the elite inner circle of humanists there nurtured his pride. It is at this time that he executed an astonishing self-portrait that blatantly reveals his self-esteem as one especially gifted, the artist as Christ (fig. 367). It is signed ''Albrecht Durer of Nuremberg . . . age twenty-eight,'' and while the panel has been heavily repainted in parts, the hieratic composition with the austere head posed frontally and the right hand held in a position approximating a gesture of benediction is undoubtedly original.

This iconic portrait of the artist clearly raises some enigmatic questions. The appearance and features are remarkably like those of images of Christ popular in Germany and the Netherlands, the *Salvator Mundi* or

367. ALBRECHT DÜRER. *Self-Portrait.* 1500. Panel, 25⅝ × 18⅞".
Alte Pinakothek, Munich

Dürer's self-characterization as one of a creative genius with divine inspiration bestowed on him by Christ, the ultimate creator. Surely Dürer was responding to the growing conflicts between the artist as craftsman and the artist as genius, and at this point in his life he was convinced that he was one selected for the latter honor. In his notes on the arts, Dürer wrote that "The more we know, the more we resemble the likeness of Christ who truly knows all things." Thus for Dürer, his creative powers were derived from Christ, and he must strive for even greater perfection far beyond the mastery of a technique or craft.

The chiliastic anxieties of northern Europe at the end of the century continued to stir Dürer's interests and imagination. His small engraving of *Sol Iustitiae* (Sun of Righteousness), about 1499, is a good example of his ability to transform mythological personifications into Christian symbols (fig. 368). The supreme sun-god, *Sol Iustitiae*, enthroned on a lion was described by late medieval encyclopedists as a counterpart to the Son of Man before John in the first chapter of Revelation: "The Sun of Righteousness shall appear ablaze when he will judge mankind on Doom's Day, and he shall be burning and grim. For as the sun burns the herbs and flowers in summertime when he is in the Lion [the astrological sign for July], so Christ shall appear as a fierce and lion-like man in the heat of judgment and shall wither the sinners." To complete the image of Christ the judge as *Sol Iustitiae*, Dürer added the sword of justice in his right hand, the scales in his left.

Even Dürer's fascination with the bits and pieces of flora and fauna that he so lovingly recorded in his colored drawings (see p. 340) turned to the macabre at times during these years. The grotesque representation of the *Mon-*

Holy Face, but it is doubtful if Dürer intended any such outright identification with the sacred icon. He was, it should be remembered, still living in the age of the *imitatio Christi* in northern Europe in which the pious strove to identify himself mystically with the model of Christ as an ideal. In other words, it would be fairer to judge

left: 368. ALBRECHT DÜRER. *Sol Iustitiae.* c. 1499. Engraving, 4⅛ × 3"

right: 369. ALBRECHT DÜRER. *Monstrous Pig of Landser.* c. 1496–97. Engraving, 4⅝ × 5"

strous Pig of Landser (fig. 369) was based not on actual observation of the freakish beast but on an illustration that accompanied a description of it by Sebastian Brant published in a broadsheet by Bergmann von Olpe in Basel in 1496. The four-eared, two-bodied, eight-footed, two-tongued creature was born in the Austrian village of Landser in March 1496, and although it died soon after birth, it was recognized as a bad omen for events about to be unleashed on the world in 1500. Brant wrote that "the beast would be the symbol of the Anti-Christ were he to come now."

In the engravings produced between 1496 and 1502 the rapid development of Dürer's technique with the burin is astonishing. In the treatment of female nudes his precise line and sensitive modeling of flesh become more and more detailed, and by establishing a middletone for the background with extremely fine parallel lines, he exploits a broader range of light and dark tonalities, much as he did in the woodcuts. Now the delicacy of his line and the refinement of the dense shading produce an effect of softly reflected light bathing truly three-dimensional forms.

This rapid mastery of the medium can be followed year by year. In one of his earliest engravings, the *Holy Family with the Butterfly* (fig. 370), of about 1495–96, he repeats a favorite Marian theme with the young mother and her child seated on a grassy bench and Joseph slumbering nearby much as in the drawing in Berlin (fig. 355) dating about four years earlier. A certain hesitancy and immaturity can be detected in the irregularities in the

cross-hatching of the drapery folds with the rather unconvincing patterns of light and shade and the fussy and, in part, erratic angular coupling of folds and pockets, especially noticeable in the long diagonal that marks the harsh contour of Mary's mantle on the right. Her arms are clumsily articulated, and similar inconsistencies are found in the landscape background where the middle distance on the left awkwardly meets that of the far distance on the right at a wall. Even the tiny insect in the lower right corner is confusing as to species. It has been called a butterfly, a dragonfly, a grasshopper, and a praying mantis, although it seems to be none of these. As one naturalist put it, Dürer has given us a "humbug."

In contrast, the *Virgin and Child with the Monkey*, executed some two or three years later, is a remarkably clear presentation of a draped figure in a deep landscape (fig. 371). The lines in the dress and mantle of Mary are no longer straight diagonals and short horizontals but curve to follow the contours of the drapery covering protruding body parts. The knees of the Virgin are brightly highlighted and the delicate turnings of the folds are modulated in subtle tonalities, ranging from the white patches on the knees and upper shoulder to the dark recesses of the pockets and overlaps to the left. One can even sense a marked difference in the textures of the heavier mantle and the softer fabric of the dress that Mary wears.

The landscape too projects diagonally along the banks of a winding river with sunlight breaking through the filmy cirrocumulus clouds here and there, casting a uni-

fying illumination to the steps back into space. Interestingly too, Dürer has omitted the hieratic forms of God the Father and the Dove found in the earlier version. The Child playfully teases a bird, while a moody monkey, chained to the wooden fence, glares out at the viewer as if resigned to its unwelcomed captivity. As a symbol of the lust of man, here a prisoner of its bodily pleasures, the monkey has been subdued by the New Adam and Eve, and his angry scowl contrasts with the gentle fluttering of the tiny bird, a symbol of the soul voluntarily captured by Christ, its savior.

A similar comparison and contrast can be made with two engravings that are ambitious studies of kneeling figures in a deep landscape confronting a variety of animals. The earlier, the *Prodigal Son* (Luke 15: 11–32), dating about 1496, is an intriguing illustration of a rather uncommon theme in German art at this date (fig. 372). After pondering his wasted life, the remorseful penitent abandons himself and dwells for a time in the lowly pigsty of a ramshackle farm. His eyes are focused on a distant church spire at the top right. There is a lack of clarity in the prodigal's kneeling pose and in the placement of the piglets about him. The swine are bunched in a confusing manner, and the rear end of a cow protrudes indecorously into the space to the left. The farmyard is deep and very picturesque, but the steps into space from the low mound in the foreground to the dilapidated buildings along the sides and in the distance are awkward, and the deeply slanted rooftops impose a strong

"X" formation on the composition that seems too mechanical.

The *Vision of Saint Eustace*, of about 1500–1501, is Dürer's largest and most ambitious engraving in terms of pictorial detail (fig. 373). Dürer probably based his illustration on Koberger's *Lives of the Saints* (Voragine) published in 1488. Eustace, like his Netherlandish counterpart, Saint Hubert, who was converted to Christianity during a hunt, was the patron saint of confraternities of huntsmen. Dürer depicts him at the moment when he dismounts and kneels before the magnificent stag, the object of his hunt, who bears the image of the crucified Christ between its antlers. What a bountiful supply of flora and fauna Dürer presents here! The engraving is a tour de force in technique and pictorial richness nearly rivaling a painting in the elaborate juxtapositions of textures, poses, and the daring landscape that rises sharply to the left with huts, towers, gateways, and a château spiraling up a dramatic mountain.

While Dürer's treatment of the animals may seem contrived and the landscape a bit too dense and overpowering, the illusionism of a wild Gothic forest is indeed impressive. The animals—the stag, the horse, the hunting dogs (a variety of the whippet)—are as mechanically studied as an anatomical exercise by Mantegna or Pollaiuolo. Leading downward, diagonally from the top right, the stag, the horse, and the two whippets in the lower left are animal studies in profile. In the lower right, three more dogs are mechanically arranged in a tri-

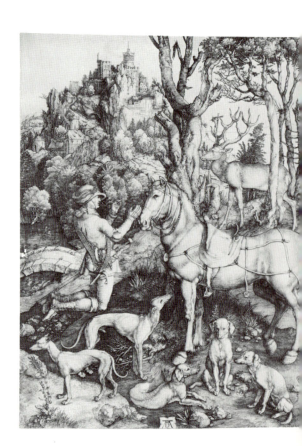

left: 372. ALBRECHT DÜRER. *Prodigal Son.* c. 1496. Engraving, 9⅝ × 7½"

right: 373. ALBRECHT DÜRER. *Vision of Saint Eustace.* 1500–1501. Engraving, 14 × 10¼"

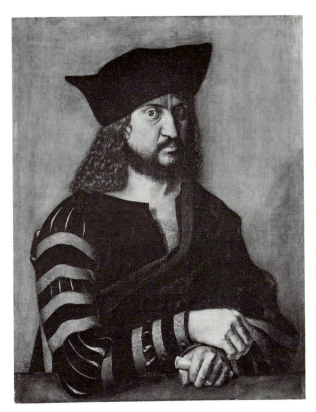

374. ALBRECHT DÜRER. *Frederick the Wise, Elector of Saxony.*
c. 1496. Canvas, 29⅞ × 22½″. Gemäldegalerie, Staatliche
Museen, West Berlin

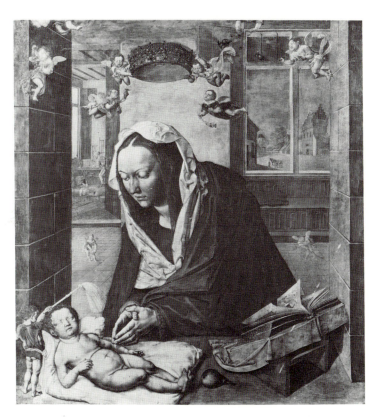

375. ALBRECHT DÜRER. *Madonna and Child*, central panel of
the *Dresden Altarpiece.* c. 1496. Canvas, 42⅛ × 38″. Staatliche
Kunstsammlungen, Dresden

angle with a profile left and right and a frontal view in
the center. The *Saint Eustace* is too contrived and fanciful
to be reckoned among Dürer's more profound works, to
be sure, but technically he was seldom more overwhelm-
ing or interesting.

One of Dürer's important patrons during these early
years was Frederick the Wise, elector of Saxony, who
had earlier commissioned the artist to paint his portrait
(fig. 374) and an altarpiece with an enigmatic Flemish
Madonna adoring her Child, who seems to sleep in death
before her (fig. 375). Both paintings depend on contem-
porary stylistic modes that, except for the unusual ico-
nography of the latter, reveal little of Dürer's personal
style. More successful is the *Adoration of the Magi* (fig.
376) commissioned in 1504 by Frederick the Wise for his
castle church (*Schlosskirche*) at Wittenberg. The *Adoration*
displays a masterful composition with the imposing py-
ramidal grouping of the Madonna, in profile, and the
three Magi raised on a stagelike platform before a theatri-
cal landscape projected along a coasting diagonal perspec-
tive that leads the eye back into space through the
repeated arches of Roman ruins. The dominating arch
motif is first stated in the heavy millstone beside Mary,
repeated in the arch of the stable, then in the arches of
the ruins in the middle ground that lead back to the gate-
way, where the entourage of the Magi has gathered. The

only awkward aspect in Dürer's precise spatial organiza-
tion is found in the lower right corner, where a page
stands before the hill upon which the adoration takes
place. In spite of the monumental composition, however,
Dürer's painting clearly shows him to be more reliant on
linear design than on color. The figures and especially the
landscape are executed in terms of a graphic artist, and
the general effect is that of a brilliant engraving, to
which color has been added.

It is at this time that Dürer engraved the famous *Adam
and Eve* discussed earlier, a work that in many respects
suggests that he was honing up on his mastery of the
antique manner of the Italian artists in preparation for his
second trip to Venice in the fall of 1505. Dürer, the gen-
tleman and scholar as well as now a world-famous artist,
confidently encountered his Venetian rivals. In a letter to
Pirckheimer he wrote that Venetian artists pestered him
excessively so that he had to hide himself at times to en-
joy some privacy: ''They imitate my work . . . wherever
they get hold of it; then they blame it and say that it's
not really 'antique' art.''

Between February and September 1506, Dürer was
busy at work on his major commission in Venice, the so-
called *Feast of the Rose Garlands* destined for the altar of
the fraternity of German merchants in the Fondaco dei
Tedeschi (fig. 377). The theme of the large panel is the

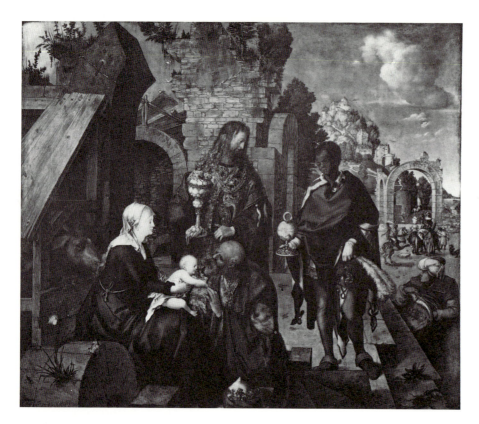

left: 376. ALBRECHT DÜRER. *Adoration of the Magi*. 1504. Panel, 37⅝ × 44⅞″. Uffizi, Florence

below: 377. ALBRECHT DÜRER. *Feast of the Rose Garlands*. 1506. Panel, 63⅝ × 75⅝″. National Gallery, Prague

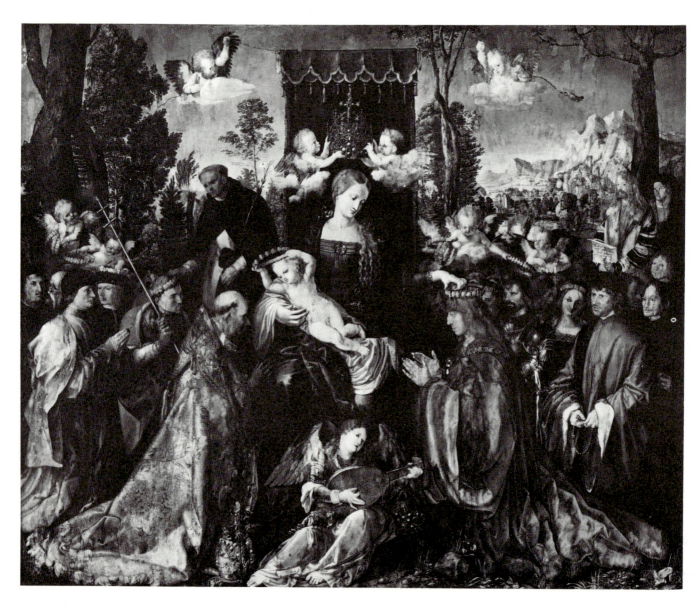

universal brotherhood of all Christians in their celebration of the Feast of the Rosary by its founders and followers. The Confraternity of the Rosary, as we have seen, became one of the most popular lay organizations in the North after its foundation in Cologne in 1474 by Jacob Sprenger.[10] United in their new devotion to the Virgin that featured the "saying of the beads" according to instructions given directly to Saint Dominic by Mary, the brotherhood spread rapidly through Germany and the Netherlands. Geertgen tot Sint Jans had treated the same theme in a more narrative manner climaxing with Dominic personally distributing the Rosary beads (*Rosenkranz*) and instructing the common folk as well as the nobility in their proper use.

Dürer elaborated the act of distributing the *Rosenkranz* by presenting it as a type of *sacra conversazione*, a colorful Italian subject that featured the Madonna and Child enthroned amid numerous saints and donors in a frieze composition. In the center of a sweeping pyramidal design, Mary and the infant Christ, enthroned under a canopy, offer the rosaries in the form of garlands of white and red roses to the heads of the church and state, Pope Julius II kneeling on the left, Emperor Maximilian on the right. To the left other members of the clergy kneel beside Saint Dominic, standing behind the throne of Mary, who distributes more rosaries. Behind Maximilian, on the right, Dürer portrayed various members of the German community, including members of the Fugger clan (?), receiving the rosaries from an angel in the guise of an Italian *putto*. At the foot of the throne is seated a beautiful angel playing a lute, a favorite motif of Giovanni Bellini ("very old but still the best painter of them all," Dürer wrote).

In this impressive work, unfortunately in a much damaged condition, Dürer strove to prove, once and for all to the Italians, that he was not only the master of the graphic arts, but an accomplished painter and colorist as well, and in some of the better preserved areas of the panel, his color does show a surprising richness with a velvety application of paint that is unusual in his paintings. This was no doubt an attempt by Dürer and the German community to demonstrate the supremacy of the Northern artist over the Venetians. Dürer included a self-portrait in the right background, where he stands proudly before a tree holding a sheet of parchment with the date and his signature, here appropriately "Albertus Dürer Germanus." According to Dürer's testimony, the *Feast of the Rose Garlands* was much admired by fellow artists and the aristocratic community in Venice, including the Doge. To Pirckheimer he rashly proclaimed "that there is no better image of the Virgin in the country."

A few portraits have been ascribed to Dürer's sojourn

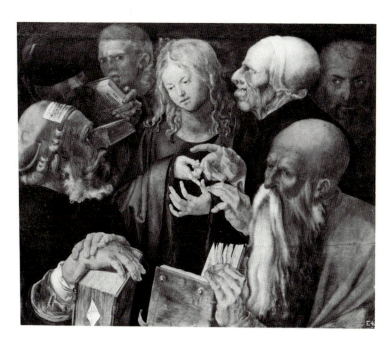

378. ALBRECHT DÜRER. *Young Christ Among the Doctors*. 1506. Panel, 25⅝ × 31½". Thyssen-Bornemisza Collection, Lugano-Castagnola

in Venice, and perhaps one of his most unusual paintings, the *Young Christ Among the Doctors*, is dated 1506 (fig. 378). Here he exploits the drama of the closeup composition with half-length figures clustered menacingly about the beautiful young Jesus in a semi-twilight world. The composition has often been described as one indebted to a lost painting by Leonardo da Vinci because of the grotesque caricatures of some of the wicked doctors pressing in on the twelve-year-old, especially the old man in profile hissing arguments into the youthful Christ's ear. The center of this swirling array of ugly, menacing forms is marked by four hands in argumentative gestures. The index finger of Christ's right hand clearly counts out his points of debate on his left before the doctors, while the gnarled fingers of the adversary next to him, resembling entangled roots, bespeak the latter's muddled confusion and perversion. An inscription on the panel informs us that it was executed in five days, and according to a letter to Pirckheimer, it was a "painting the like of which I have never done before."

The work remains unique in Dürer's oeuvre—although he returned to studies of grotesque heads much later—and more important for his development were the studies for the proportions of idealized nudes that preoccupied him at this period. Studies of Eve are often little more than simple outline drawings following the proportions of her body as determined by square grids, or circles and arcs traced with a compass. A comparison of these drawings with one of Dürer's earliest nudes, the

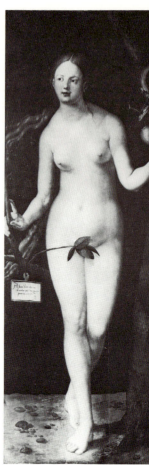

left: 379. ALBRECHT DÜRER. *Bather.* 1493. Pen drawing, 10¾ × 5⅞". Musée Bonnat, Bayonne

right: 380. ALBRECHT DÜRER. *Adam* and *Eve.* 1507. Panel, each 82¼ × 31⅞". The Prado, Madrid

Bather (fig. 379) with a towel wrapped about her head and wearing sandals as she steps from a pool, is instructive, revealing how much his sharp eye for realism was compromised for his interest in Renaissance proportions. The little bather of 1493 seems awkward and a bit clumsy even in her pose, and her bony shoulders are emphatically described along with the slightly bumpy contours of her torso. Undecided on what to do with her knotty arms and hands, Dürer arbitrarily lifted them upward in the fashion of classical nude studies he had seen, but what he presents is simply a charming young girl from Nuremberg who has taken off her clothes.

Dürer's experiments with the ideal proportions of the female and male nude culminated in two large paintings of *Adam* and *Eve* (fig. 380) executed after his return to Nuremberg in 1507. Compared to the engraving of 1504 (fig. 348), however, it is apparent that he was attracted to the pre-Mannerist canons found in Italian and German painting in the early years of the sixteenth century. The

fashionable nude becomes slenderer and more lithesome. Both assume rather affected postures, and their contours are resilient with attenuated undulations. Their bodies are soft and pliable with little indication of structure and firmness. Eve trips cautiously forward, while Adam looks upward dreamily with open mouth and flowing hair. The distinctions between the male and female nudes, so emphatically rendered in the earlier print, have been surprisingly suppressed in favor of a more androgynous and insipid appearance. Whether or not this change is the result of a conscious return to the more Gothic attenuation and lyricism imposed on sturdier classical forms, as some have suggested, is very questionable, but

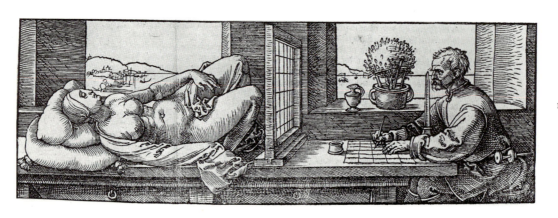

381. ALBRECHT DÜRER. Artist drawing a reclining model, from *A Course in the Art of Measurement with Compass and Ruler.* 1525. Woodcut, 3 × 8⅜"

Dürer's taste has clearly turned in favor of the early Mannerists' canons of ideal beauty in Italy.

For some time Dürer had been preparing a study on theories of human proportions based in part on canons established by Italian theorists and by his own empirical gathering of data taken from detailed measurements of living models. The book of instructions, the *Vier Bücher von menschlicher Proportion* (*Four Books of Human Proportions*), was, however, not published until a few months after his death in 1528. Woodcuts were added to the text, and it is interesting to note that after his second trip to Italy, when he discovered the studies of Leonardo da Vinci, Dürer became convinced that there were several canons of proportions for the variety of individuals in the world: men and women were normal, tall, stocky, lean, and fat types which he further expanded into figures that were noble or rustic, leonine, canine, and those governed by the humors: choleric, phlegmatic, melancholic, or sanguine. Measurements became so multiplied that a sister of Pirckheimer (who helped publish the text), also a painter, remarked that "I can paint as well without it," and Dürer himself acknowledged that his studies were basically scientific in nature and of little practical value for the artist.

In a like manner Dürer had studied Italian theories of perspective, including the *construzione legittima* of Alberti, and published *Underweysung der Messung mit dem Zirckel und Richtscheyt* (*A Course in the Art of Measurement with Compass and Ruler*) in 1525 with sections on various types of geometrical perspective projection, including instructions for building mechanical aids such as the netlike grid through which the artist sights his foreshortened model and then transfers the units to his paper, which is similarly divided by lines (fig. 381). It was, it seems, the color theories of the Italians that most vexed him, but he devoted no treatise to that study.

During these same years Dürer was also involved in a costly project for Jacob Heller, a merchant of Frankfort, who commissioned it for the altar of Saint Thomas in the Dominican church there. The theme was a combination of the Assumption and Coronation of the Virgin with the apostles (including the doubting Thomas) gathered about her empty tomb looking upward into the clouds, where Mary is crowned by the Trinity in heaven, a composite iconography perhaps indebted to a similar painting by Raphael in the Vatican. The altarpiece, originally a triptych, was destroyed by fire in Munich in 1729, and the central panel is known to us only in a mediocre copy made by a Frankfort painter, Jobst Harrich, in the seventeenth century (fig. 382). However, over twenty preparatory sketches for the composition survive, among them the famous *Praying Hands* (fig. 383), which is one of the most famous and hallowed images of Dürer's art for the

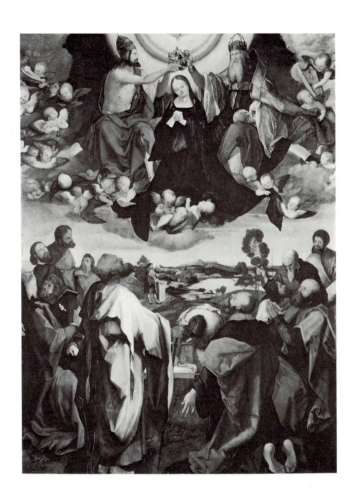

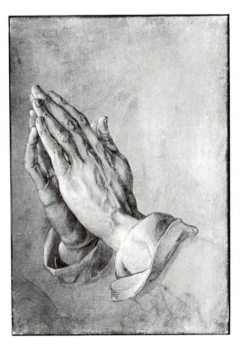

above: 382. JOBST HARRICH, copy after ALBRECHT DÜRER. *Heller Altarpiece.* 1614 (original 1508–9). Panel, 74⅜ × 54⅜". Historisches Museum, Frankfort

left: 383. ALBRECHT DÜRER. *Praying Hands*, study for the *Heller Altarpiece.* 1508. Drawing, 11½ × 7¾". Albertina, Vienna

world public. In the nimble fingers, slightly arched and delicately touching with a slight quiver like the elegant ribs of cathedral vaults, the quintessence of Christian devotion of the Gothic age is summed up.

The project for Heller frustrated Dürer immensely, if we are to judge by the evidence of his correspondence with his patron. In one letter, dated August 26, 1509,

left: 384. ALBRECHT DÜRER. *Saint John Before the Apocalyptic Woman*, from the *Apocalypse* series. 1511. Woodcut, 7¼ × 7³/₁₆"

right: 385. ALBRECHT DÜRER. *Coronation of Mary*, from the *Life of the Virgin* series. 1510. Woodcut, 11⅜ × 8⅛"

the artist expresses his willingness to compromise on the price of the commission rather begrudgingly. He apparently wanted his great work to be displayed publicly in Frankfort for a time, where, it should be pointed out, it would serve as an impressive advertisement in one of the largest European fairs at which Dürer's prints were sold. The graphic arts were a more lucrative business by far. Dürer complains to Heller that "no one shall ever compel me to paint a picture again with so much labor. . . . henceforth I shall stick to my engraving, and had I done so before I should today have been a richer man by 1000 florins."[11]

It is clear that Heller's altarpiece demanded too much of Dürer's time with rewards not commensurate with the labor. In fact, about 1508 Dürer made plans to publish at least three more picture books with texts, hoping to realize a profit comparable to that he enjoyed from the first edition of the *Apocalypse*. He decided to reissue the famous block book, augmented by a new frontispiece featuring an author-portrait of John the Evangelist witnessing the vision of the Apocalyptic Woman (Revelation 12), one of the most popular Marian motifs in the sixteenth century serving as a type of the Immaculate Conception (fig. 384). This second edition was published in 1511, and in the same year he issued three more picture books, the *Life of the Virgin* (twenty plates), the *Large Passion* (twelve plates), and the *Small Passion* (thirty-seven plates). In each the colophon was appended with a statute of copyright: "Secret begrudgers and thieves of labor and invention of others: keep your audacious hands off this work. Per privilege accorded by Emperor Maximilian, no one may copy these pictures nor reprint them from spurious blocks, nor sell the prints within the boundaries of the Empire. Whoever acts contrary to this command, be it in disregard or avarice, will

expose himself to great danger and risks the confiscation of his properties."

Texts for the three new books were written by Benedictus Chelidonius, a literary-minded theologian who was a member of the circle of elite Nuremberg intellectuals with whom Dürer associated. A number of the prints were previously issued as independent woodcuts (c. 1500–1504) even before his second trip to Italy, and the selection of the illustrations in the three cycles frequently betrays the piecemeal production of the programs. In the *Life of the Virgin* the impressive *Coronation of Mary* (fig. 385), dating 1510, is closely related to the lost central panel of the *Heller Altarpiece*, with the apostles gathered about the sarcophagus of the Virgin in the lower zone much as they are in the copy by Harrich discussed above. For the most part, however, a certain coziness and charm pervade the unraveling of events in Mary's story, unlike the explosive visions designed for the *Apocalypse*. But, as if to compensate for the folksy genre, Dürer exploits his knowledge of perspective by placing many of the scenes within huge enframing arches opening on grandiose architectural settings that suggest the influence of monumental Italian architecture comparable to that found in the paintings of Mantegna.

An exceptional print is that entitled by Chelidonius *The Sojourn of Mary and Joseph in Egypt* (fig. 386), a rare event that was very likely renamed after an earlier woodcut, the "Holy Family at Home in Nazareth," issued about 1501–2 as an independent devotional picture. The setting with its impressive diagonal projection of ruins

far left:
386. ALBRECHT
DÜRER. *The Sojourn
of Mary and Joseph in
Egypt*, from the *Life
of the Virgin* series.
c. 1501–2. Woodcut,
11¾ × 8¼″

left: 387. ALBRECHT
DÜRER. *Carrying of
the Cross*, from the
Large Passion series.
1498–99. Woodcut,
15⅛ × 11⅛″

and domestic buildings culminating in a Roman arch reminds one of the background in the Uffizi *Adoration of the Magi* (fig. 376) of 1504. In the right foreground, Mary, in the company of angels, rocks the wooden cradle of the infant while working the spindle and distaff, the occupation of the virtuous housewife, while Joseph, regarding the viewer directly, is busy at work as a carpenter, an honest breadwinner for the family. His labors are helped by a band of *putti*-angels, who scurry about to pick up slivers and chips of wood and deposit them in a large basket. Chelidonius's text tells us that "As a new Daedalus the husband of the Virgin practiced and taught the wonderful arts and crafts," a clear reference to a passage in the *Icones* (1: 16) of Philostratus where *putti* are described as helping the mythical architect at his work. That Dürer should have incorporated a colorful motif from an ancient Roman writer is evidence of his knowledge of such pastoral literature and his close collaboration with the writer Chelidonius.

Dürer was a shrewd businessman. In the *Large Passion,* which is often bound together with the *Apocalypse* and the *Life of the Virgin* in a large economy-sized edition, his emphasis is on the dignity and magnanimous posture of Christ in the face of his tormentors. In twelve scenes the heroic tragedy is completed, and the frontispiece verses of Chelidonius clearly state the mood: "These cruel wounds I bear for thee, O Man, and cure thy mortal sickness with my blood . . . thy death with mine—a God who became a man for thee." One of the most impressive cuts in the *Large Passion* is the *Carrying of the*

Cross (fig. 387). Christ lifts himself under the burden of the heavy cross to glance gently back to Veronica, who holds the sudarium.

The *Small Passion*, executed between 1509 and 1511, was directed to a different market and collector. In thirty-seven compressed compositions, many staged as close-ups with little attention given to the settings or landscapes, Dürer presents the agony and the intense emotion of the ordeal. It is introduced with four scenes of the *Fall of Adam and Eve*, their *Expulsion from Eden*, the *Annunciation* (a type of the Fall, as we have seen), and the *Nativity*, scenes that serve as a prologue for the redemption and salvation of man through Christ's passion. The verses of the frontispiece (fig. 388) below the forlorn image of the *Man of Sorrows*, seated on a stone block— the so-called Perpetual Passion of Christ—relate the reader to a more poignant and human message in this suffering:

Oh cause of such sorrows to me;
Oh bloody cause of the cross and death;
Oh man, is it not enough that I suffered these
 things once for you?
Oh stop crucifying me with your new sins.

In contrast to the heroic pose of Christ in the *Carrying of the Cross* in the *Large Passion*, that in the smaller octavo edition is remarkably pathetic and agonizing (fig. 389). Christ falls exhausted to the ground and with much effort lifts himself on his right arm to look up at Veronica with a torturous look and gaping mouth underscoring

388. ALBRECHT DÜRER. *Man of Sorrows*, frontispiece from the *Small Passion* series. 1509–11. Woodcut, 5 × 3⅞"

389. ALBRECHT DÜRER. *Carrying of the Cross*, from the *Small Passion* series. 1509. Woodcut, 5 × 3⅞"

390. ALBRECHT DÜRER. *Carrying of Cross*, from the *Small Engraved Pass* 1512. Engraving, 4⅝ × 3"

the physical pain he is experiencing. The density of the shading lines contrasting with the open highlights cast by a hard-driving sun shining in from the left further intensifies the earthy pathos of the gruesome journey to Golgotha. Throughout the woodcuts of the *Small Passion*, the more painful and human aspects are emphasized, suggesting that it was directed toward a more pious audience for more emotional devotional usage.

In 1512 Dürer issued his *Small Engraved Passion* with fifteen tiny plates (4½ by 3 inches) originally published without a text as a collector's item. Designed more for the pleasures of the intellectual artlover than for the pious response of the devout, the *Small Engraved Passion* is clearly a production for a new species of art patron. The fact that a number of editions were later hand-colored also suggests that the engravings were to be valued as precious works of art, much as some of the sumptuous Books of Hours were in an earlier age. For the more aesthetic pleasures of the wealthy collector, Dürer exploited the intricate details of exotic costumes and the subtle tonal transitions in the modeling of figures in space and light. These prints were meant to serve as miniature works of fine art. Each is signed and dated.

The engraving of the *Carrying of the Cross* (fig. 390), when compared to the two previous examples in the woodcut editions of the *Passion*, exemplifies this change in the mode of style. Cast in a mellow twilight, the figures move slowly and, except for the colorfully garbed henchman in the lower right tugging at Christ's mantle, physical torment is minimized. Christ now stands and while he turns toward Veronica, his gaze is heavenward. Mary quietly clasps her hands in prayer as she follows

close behind the cross. Rather than the heroic or emotional suffering of Christ presented in the woodcuts, here the cycle of events presents the spiritual significance of an act that was divinely ordained for mankind.

Between 1513 and 1514 Dürer executed three large prints that have become known as the "three great engravings."[12] Although it is generally acknowledged that the three are closely interrelated and complementary, it seems probable that Dürer did not consider them a triptych or trilogy in the strict sense. The first, the famous *Knight, Death, and the Devil* (fig. 391), called simply the *Reuter* (Rider) by Dürer, was very early described as a "Christian Knight" (Sandrart, 1675) whom Erasmus addressed in his handbook, *Enchiridion militis Christiani* (*Instructions for the Christian Soldier*), published in 1504: "In order that you may not be deterred from the path of virtue because it seems rough and dreary . . . and because you must constantly fight three unfair enemies—the flesh, the devil, and the world—this third rule shall be proposed to you: all of those spooks and phantoms which come upon you as if you were in the very gorges of Hades must be deemed for naught after the example of Virgil's Aeneas. . . . Look not behind Thee."

That Dürer was familiar with Erasmus and his writings is suggested in an entry in his diary of 1521, to be discussed below, when, responding to rumors that Martin Luther had been kidnapped and was in danger of death, he wrote: "Oh Erasmus of Rotterdam, where wilt thou stop? . . . Hear, thou knight of Christ! Ride on by the side of the Lord Jesus. Guard the truth. Attain the martyr's crown."

Numerous attempts have been made to identify

391. ALBRECHT DÜRER. *Knight, Death, and the Devil*. 1513.
Engraving, 9⅝ × 7½"

Dürer's Christian knight more specifically, but it is unlikely that Dürer had a definite person in mind and rather took as a model one of the many heroic equestrian portraits that he had seen in Italy (i.e., Donatello's *Gattamelata* in Padua, Verrocchio's *Colleoni* in Venice, Uccello's fresco of *Sir John Hawkwood* in Florence, Leonardo's studies for the Sforza monument, etc.), where the glory of the Renaissance warrior was commemorated. In fact, the superb horse that dominates the composition, a logical development from that in the *Saint Eustace* engraving (fig. 373), is carefully constructed along geometric lines in the body and given a *contrapposto* stride. High-spirited and disciplined, Dürer's elegant horse epitomizes animal sensuality and power tamed by the higher reason and intellect of the knight.

Dürer's Christian soldier finds himself riding steadfastly through a deep and dark Nordic gorge, much like the setting of the *Adam and Eve* of 1504. The obedient hound that keeps close pace with the rider no doubt symbolizes faith in his mission. Death on a Pale Horse approaches sneering and reminds the knight of the brevity of life by holding out an hourglass, his downtrodden steed hangs his head wearily toward a skull in the lower left, while the scaly, horned, pig-snouted Devil follows behind Death. But the knight looks not behind him, for he is the embodiment of moral virtue and the *vita activa*, or active life, of the true *miles Christi* much as expressed in the more contemporary hymn "Onward Christian Soldiers."

The second engraving, *Saint Jerome in His Study* (fig. 392), represents the ecclesiastical counterpart to the militant according to Christian thinking of the time: the embodiment of theological virtue and the *vita contemplativa*, or contemplative life, of the monk and confessor. Jerome, who had a new popularity in the pre-Reformation years in northern Europe, is busy at work on his Latin translation of the Bible (the Vulgate) from Hebrew and Greek. How simple and still his world seems with its warm sunlight, its coziness and lived-in comforts. The bright sunlight flooding the mullioned windows plays across the form of the old monk (the hat on the back wall indicates his cardinal status) with the drowsy lion—more an oversized house cat than a proud heraldic beast—lying comfortably beside a little dog who snoozes unperturbed in a curled-up position. But symbolic reminders of the transience of this life are here too—the skull on the window ledge and the hourglass on the back wall—yet they cause no worry to one who has the assurance and comfort of his spiritual calling.

When compared to the early *Saint Jerome* woodcut of

392. ALBRECHT DÜRER. *Saint Jerome in His Study*. 1514.
Engraving, 9⅝ × 7⅜"

393. ALBRECHT DÜRER AND OTHERS.
Triumphal Arch of Maximilian I. 1515.
Woodcuts (192 blocks), 11′ × 9′ 7″

above: 394. Copy after ALBRECHT
DÜRER. *Allegory of Maximilian I.*
c. 1513. Drawing, 8⅛ × 6″.
Nationalbibliothek, Vienna

left: 395. ALBRECHT DÜRER.
Triumphal Chariot of Maximilian I
(detail). 1522. Woodcut

1492 (fig. 356), the 1514 engraving displays an incredible refinement and mastery of the graphic technique. Textures, modeling, atmosphere, space, and light are superbly captured. Vasari praised the print for its technical excellence, especially in the way Dürer rendered the soft

reflections of light shining through the bottle-glass panels on the embrasures of the walls and window niches. The dramatic use of diagonal perspective also contributes to the informality and roominess of the chamber—perhaps inspired by the artist's own studio in his house in

Nuremberg?—by placing the vanishing point of the perspective low and to the far right directly below the beads hanging there at Jerome's eye level, thus placing the viewer on one of the lower steps that leads upward into the sunlit study.

Knight, Death, and the Devil and the *Saint Jerome*, representing the active and the contemplative ways to salvation, thus form meaningful pendants. *Melencolia I*, which has already been discussed at length, embodies the tragic and unproductive frustrations of the artist as creator. Both the knight and Saint Jerome refer to life in the service of God, while Melancholy, on the other hand, is an image of the gloomy and defeated secular creator who challenges in vain God's divine gifts. Unlike Jerome's study, Melencolia's setting is uncomfortable, with discarded objects of her art scattered about, and unlike the proud knight she lacks the determination and confidence to cope with her disorderly surroundings that benefit from no clear light of divine wisdom. Thus Dürer's three prints, whether originally conceived as a trilogy or not, present most admirably the state of affairs in Dürer's own conscience.

In 1515 Dürer was appointed court artist to the emperor Maximilian, and the projects for which Dürer provided designs present us with an entirely different facet of his art. They display a curious mixture of medieval German romance and Renaissance pageantry befitting a powerful monarch convinced that his kingdom was fully capable of rivaling the humanistic culture of Italy. Many German artists and literati were involved. The first project was a mammoth *arcus triumphalis*, or triumphal arch, realized in the form of 192 woodcuts pieced together to form a tableau eleven by nearly ten feet (fig. 393). The framework for the triumphal arch, devised by the court architect Jörg Kölderer, resembles a Mannerist Italian church facade gone to seed more than an antique structure; the iconographic program, entrusted to the court astronomer and historiographer, is a complex assembly of historical narratives, personifications, portraits, and armorials overlaid with the "mysteries of Egyptian letters," or hieroglyphs, of dubious derivation.

Dürer's design for the imperial portrait that capped the structure (fig. 394) depicts Maximilian enthroned in profile surrounded by an array of symbolic animals, including a lion (power), an eagle (Rome), a dog (prince), a falcon (victor), and a basilisk (eternity). To complement the arch, a grand triumphal procession, over fifty-seven yards of woodcuts, was designed with tableaux, chariots, and personifications. Dürer's design for the triumphal chariot of Maximilian (fig. 395), not issued until 1522, three years after the emperor's death, is inscribed: "That which the sun is in heaven, the emperor is on earth."

It is little wonder that few scholars, with the excep-

tion of those versed in Hapsburg history, have expressed any appreciation for these pompous displays. To what use were such huge woodcut murals intended? To be sure, the better Albrecht Dürer is not revealed in these designs, but one project in which he was involved, the imperial prayer book or *Book of Hours of Maximilian*, presents us with a novel and accomplished work of art (fig. 396).[13] Dürer, along with Cranach, Altdorfer, and Burgkmair, executed the marginal illustrations for the text printed on parchment (Johann Schönsperger, Augsburg, 1513) in red, green, and violet inks that were to simulate the costly illuminations in the famed Books of Hours of the regal patrons of Late Gothic times.

The sketches are often masterfully composed on the page and delicate in execution, but the faint impressions they give are in marked contrast to the bold face of the type. And unlike most earlier illuminated books, there seems to be little program to the selection of themes for the marginalia other than the isolated image of a saint venerated in the text that appears now and then. Dürer's drawing for folio 39 verso is typical. Interrupting the delicate quasi-Renaissance scrolls in the margins are the figures of Hercules and the Stymphalian birds with whom he battles following the classical story that has no apparent significance here. Other marginal and *bas-de-page* motifs include fables, such as that of the rooster and the fox, and vignettes of a purely genre nature.

Maximilian died in 1519 and his grandson, Charles V, was elected his successor. In order to attend the coronation of Charles in Aachen, the legendary capital of Carolingian and later German kings, and to obtain an extension of his pension as a court artist, Dürer planned

396. ALBRECHT DÜRER. *Hercules Killing the Stymphalian Birds*, from the *Book of Hours of Maximilian*. 1513? Colored ink drawing, 11 × 7⅝". Staatsbibliothek, Munich

above: 397. ALBRECHT DÜRER. Lion in two positions, from the *Silverpoint Sketchbook*. 1520. Drawing, 5⅛ × 7½". Kupferstichkabinett, Staatliche Museen, West Berlin

right: 398. ALBRECHT DÜRER. *Rabbit*. 1502. Watercolor, 9⅞ × 8⅞". Albertina, Vienna

an extensive trip to western Germany and the Netherlands. He left Nuremberg on July 12, 1520, with his wife and maid Susanna, shipping with him a number of coffers filled with works of art—his block books, engravings, and paintings—to be sold, bartered, or serve as gifts.

After a five-day overland trip, Dürer arrived at Antwerp on August 3 and took lodgings. Antwerp was the commercial and artistic capital of the Netherlands, if not all of northern Europe, when Dürer arrived. He encountered various riches, elaborate palaces and churches—"the like of which I have never seen in Germany"—as well as progressive guild organizations that surely must have impressed him. Dürer attended the coronation of Charles V in Aachen on October 23 and, "after great labors," had his pension renewed by the emperor's agents in Cologne. Having that settled, he returned to Antwerp. During the next months he traveled about seeking out curios, exotic objects, and famed works of art by the Flemings. He made a special trip to Zeeland to see a huge whale that washed ashore there but arrived too late since it had been carried out to sea.

Interestingly, his enthusiasm for the Ghent altarpiece was matched by his interest in the lions (fig. 397) kept in Ghent, which he sketched in silverpoint in his little sketchbook (*mein Büchlein*), a charming souvenir of the Netherlandish trip and a pictorial diary of sorts of the people, places, and curios that captured his attention.[14] Throughout his career, Dürer's observations wavered between theory and the empirical recording of the details of the real world about him. A series of watercolor sketches of plants, insects, and animals are some of his most precious remains. The resting *Rabbit* of 1502 (fig. 398) is an endearing portrait of the furry little animal who seems to

have hopped into his studio for a minute without fear, and the meticulous care with which Dürer lovingly reproduced the *Great Piece of Turf* (colorplate 52) reveals the true sentiment of the lover of nature more so than the artist in quest of ideal human proportions.

Dürer was also attracted to the unusual objects sent to Charles V in 1519 from Mexico, gifts given to Cortes by the Mexican emperor Montezuma, which were on display in Brussels while Dürer was there: "All the days of my life I have seen nothing that rejoiced my heart so much as these things, for I saw amongst them wonderful works of art, and I marvelled at the subtle *Ingenia* of men in foreign lands. Indeed I cannot express all that I thought there."

Aside from the many fellow artists with whom Dürer shared companionship in the Netherlands, he also met scholars such as Erasmus of Rotterdam and Peter Aegidius, and a wealthy silk merchant from Genoa, Tommaso Bombelli, frequently had Dürer for dinner. In July 1521, Dürer met at request King Christian of Denmark, who was traveling through Antwerp on his way to Brussels and invited the artist to execute his portrait in oils. For this Dürer was well paid and entertained.

Many of his acquaintances were portrayed in charcoal sketches, and a number of sites he visited are recorded in the *Büchlein* and in independent drawings that seem finished works of art. One of the most memorable of these is the *Harbor of Antwerp* (fig. 399) which, in a way, shows the final step in Dürer's development as a landscape artist. The pen sketch at first looks unfinished but it very likely was meant to convey the impression of a poetic view of the boats and the cluster of buildings with sharply pitched roofs along the quay. The detailed rendering of the harbor along converging lines of perspec-

above: Colorplate 50. ALBRECHT DÜRER.
Self-Portrait with a Spray of Eryngium. 1493.
Parchment on linen, 22¼ × 17½″.
The Louvre, Paris

above right: Colorplate 51. ALBRECHT DÜRER.
View of the Alps ("Wehlsch Pirg"). c. 1495.
Drawing and watercolor, 8¼ × 12¼″.
Ashmolean Museum, Oxford

right: Colorplate 52. ALBRECHT DÜRER.
Great Piece of Turf. 1503.
Drawing, 15¾ × 12⅜″.
Albertina, Vienna

Colorplate 53. Matthias Grünewald. *Isenheim Altarpiece* (closed position). 1515. Panel (with framing), 9′ 9½″ × 10′ 9″ (center);

Colorplate 54. MATTHIAS GRÜNEWALD. *Isenheim Altarpiece* (middle position)

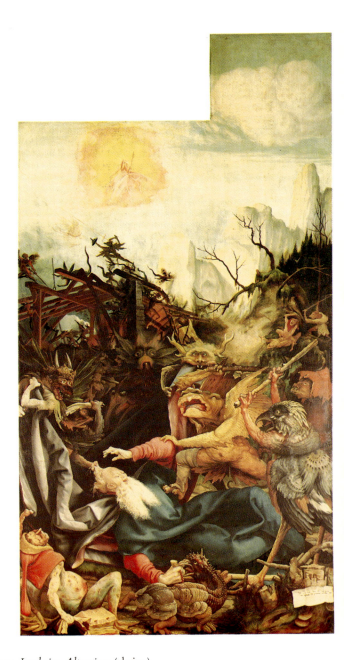

Colorplate 55. Matthias Grünewald. *Isenheim Altarpiece* (shrine)

above: 399. ALBRECHT DÜRER. *Harbor of Antwerp.* 1520.
Drawing, 8⅜ × 11¼". Albertina, Vienna

right: 400. ALBRECHT DÜRER. *Erasmus of Rotterdam.* 1526.
Engraving, 9⅞ × 7⅝"

tive gives a sharp focus to the center right, while the untouched areas in the lower right and upper left lend the spacious view the spontaneity of a quick, total view, where details are subordinated to an impressionistic vision.

On July 12, 1521, Dürer started his trip home via Louvain, Maastricht, Cologne, and down the Rhine. Two important incidents of the past year were still fast in his mind. He had heard rumors that Martin Luther, while being escorted home from Worms, had been kidnapped and was believed to be in grave danger. In his diary he wrote the following lamentation (*Lutherklage*):

On Friday before Whitsunday [May 17] in the year 1521, came tidings to me at Antwerp, that Martin Luther had been so treacherously taken prisoner; . . . And whether he yet lives I know not, or whether they have put him to death; if so, he has suffered for the truth of Christ and because he rebuked the unchristian Papacy . . . And if we have lost this man, who has written more clearly than any . . . and to whom Thou hast given such a spirit of the Gospel, we pray . . . [that] Him wilt thou quicken again. . . . Oh all ye pious Christian men, help me deeply to bewail this man, inspired of God, and to pray Him yet again to send us an enlightened man. Oh Erasmus of Rotterdam, where wilt thou stop? . . . Hear, thou knight of Christ! Ride on by the side of the Lord Jesus. Guard the truth. Attain the martyr's crown.[15]

This anguished lamentation has often been cited as proof of Dürer's high esteem for Martin Luther, but what were his sympathies with the greatest Netherlandish humanist, Erasmus of Rotterdam, whom he had met three times and, in fact, sketched in charcoal at least

twice? Dürer no doubt had great respect for Erasmus, who was, after all, a close friend of Pirckheimer and other German humanists. It is known too that Erasmus likewise had great admiration for Dürer, whom he likened to Apelles in a eulogy or "Monument to the Memory of Albrecht Dürer" (*De recta Latini Graecique sermonis pronuntiatione*), praising him as a graphic artist par excellence: "And is it not more wonderful to accomplish without the blandishment of colors what Apelles accomplished with their aid?"[16] Why then did Dürer wait so long (1526) before engraving his famous likeness of the Netherlandish humanist (fig. 400)? We know that Pirckheimer had received a letter from Erasmus regarding the portrait and suggesting that Dürer follow a medallion of 1519 designed by Quentin Metsys (which Pirckheimer owned) for the engraving, and Dürer did so, even copying the inscription that read "A better portrait his writings show."

Indeed, Dürer's likeness of Erasmus is disappointing and unflattering when compared to the sensitive portrait painted by Hans Holbein a few years earlier (see p. 388; fig. 452). Erasmus was disappointed with it. He wrote to Pirckheimer somewhat apologetically, saying that it was not a striking likeness because "I am no longer the person I was five years ago," and to a close friend, Henricus Bottens, Erasmus stated flatly that Dürer's engraving did not look like him at all.

Dürer had always desired to do a portrait of Luther, but, surprisingly, the two never met. In a letter dated

401. ALBRECHT DÜRER. *Last Supper*. 1523. Woodcut,
8⅜ × 11⅞"

1520 to the court chaplain, Georg Spalatin, Dürer wrote: "If ever I meet Dr. Martin Luther, I intend to draw a careful portrait of him from life and engrave it on copper, for a lasting remembrance of a Christian man who helped me out of great distress. And I beg your worthiness to send me at my expense anything new that Dr. Martin may write." The "great distress" to which Dürer refers very likely was his own agonizing indecision as to which course to follow in his own religious convictions. Dürer avidly collected Luther's writings, and that he understood and accepted some of Luther's more radical changes in liturgical practices is suggested by an unusual woodcut of the *Last Supper* (fig. 401) executed in 1523, the only illustration completed for a projected ten-picture set for a new *Passion* book of oblong format.

Details of the composition, which Dürer had treated in his earlier *Passion* series, constitute important departures from the usual representations of the Last Supper as the moment of the institution of the Holy Sacrament, the Eucharist, when Jesus offered the twelve apostles the bread and the wine, saying, "this is my Body . . . this is my Blood" (Matthew 26: 26–28), or the pronouncement of the betrayal of Judas, who was usually placed across the table from Christ: "One of you will betray me" (Matthew 26: 21). Most noticeable is the absence of Judas, who has already departed. Only eleven disciples are grouped about Christ. For his new version Dürer chose the text of John's Gospel (Luther's favorite) where the importance of the wine and bread is downplayed and the New Commandment is given instead: "A new commandment I give to you, that you love one another; even as I have loved you, that you also love one another. By this all men will know that you are my disciples, if you have love for one another" (John 13: 34–35).

The oratorical gesture made by Christ further under-

scores the declaration of the evangelical spirit bestowed on the community of the apostles. The astonished look on the face of Peter, who sits to the right of Christ, interestingly enough, may allude to the failings of the prince of Rome (Peter) at this poignant moment, for in the next verses of John's Gospel, Christ announces that Peter will deny him three times before the crow of the cock in the morning.

A second departure is evident in the removal of the charger, the wine, and the bread from the table to the floor in the immediate foreground as if these sacramental elements were secondary. Especially significant is the empty charger. In his earlier prints Dürer prominently displayed the carcass of the Paschal Lamb (the Last Supper was, after all, a Passover feast) on the plate before Christ to point out that the blood sacrifice, explicit in the Jewish ritual, is to be replaced by the bloodless sacrifice of wine and bread. Again Dürer, echoing Luther here, tells us that the Holy Mass was not a sacrifice as such but a testament or the promise of redemption to be commemorated.

In thus treating the *Last Supper*, Dürer proclaimed his faith in Luther's theology, and while Lutheranism brought with it the extreme iconoclasm promoted by the radical adherents of the Reformation in Germany, Luther himself was by no means so vehement concerning the arts in the service of the church. In fact, in one of his commentaries on the Psalms, written in 1530, Luther wrote: "Whoever is inclined to put pictures on the altar ought to have the Lord's Supper of Christ painted, with these two verses written around it in golden letters: 'The gracious and merciful Lord has instituted a remembrance of His wonderful works.' Then they would stand before our eyes for our heart to contemplate them, and even our eyes, in reading, would have to thank and praise God. Since the altar is designated for the administration of the Sacrament, one could not find a better painting for it. Other pictures of God or Christ can be painted somewhere else."[17] Iconoclasm, however, was widely preached by colleagues of Luther at Wittenberg. The loudest and most influential preacher against the arts in the church was Andreas Bodenstein von Karlstadt, who published a pamphlet in 1522 entitled *Von Abtuhung de Bylder* (*On the Abolishing of Images*).

Dürer's last major painting, *The Four Apostles*, 1526, is a memorial of sorts of the Reformation. First of all, it should be noted that the two panels are not the wings of a triptych, nor were they destined for an altar in a church. The history of the two panels (fig. 402) is indeed unusual and revealing in terms of the iconoclastic controversy.[18] Given to the magistry of Nuremberg, who just eighteen months earlier had adopted Lutheranism as the official religious creed of the city, the painting was re-

402. ALBRECHT DÜRER. *The Four Apostles.* 1526. Panel, each
84½ × 30″. Alte Pinakothek, Munich

ferred to in Dürer's letter of dedication, dated in 1526:
"A Remembrance in respect for your wisdom." No-
where does Dürer give a more specific title to the panels,
and the modern name, *The Four Apostles*, is not precise
since one of the four standing saints, Mark, was not an
apostle but an evangelist.

An introductory text for scriptural verses written in
German below the figures informs the viewer that "All
worldly rulers in these dangerous times should give good
heed that they receive not human misguidance for the
Word of God, for God will have nothing added to His
Word nor taken away from it. Hear therefore these four
excellent men, Peter, John, Paul, and Mark, and their
warning." The verses beneath the figures taken from
Luther's New Testament of 1522 are from the Epistles of
Peter, John, Paul, and the Gospel according to Mark, and
all four refer to the danger of false prophets, blasphem-
ers, false accusers, traitors, and false scribes who are lust-
ful and unable to understand the true word of God.

More surprising is the imputed hierarchy of the four-
some. Normally Peter and Paul, the "princes of the apos-
tles" as they were called, take priority, but here Saint

John replaces Peter's primacy and stands fully visible be-
fore the latter. Peter, the first bishop of Rome, would
stamp the authority of Rome and the papacy on the pro-
gram, and for that reason he has been moved to the back-
ground. Saint John, furthermore, was Luther's favorite
evangelist due to his teachings on the nature and person
of Christ ("The one fine, true, and chief Gospel,"
Luther wrote). Instead of the usual attribute of the chal-
ice, Dürer puts into John's hands his open Gospel with
the first word, "In the beginning was the Word, and the
Word was with God, and the Word was God," clearly
legible on the page which he reads. By implication,
John's word, as written in the Bible, was true, while the
declarations of the papacy (Saint Peter) were often in
error.

On the right panel the imposing figure of Saint Paul
fills the composition as he stares menacingly out toward
the viewer as if warning him. Paul was the "apostle of
the Reformation," and for Luther he was the wisest wit-
ness after Christ and the very best teacher of Christian-
ity. Dürer's panels have often been discussed as outright
anti-papal or anti-Catholic in intent, and no doubt this is
an important factor in the iconography, but is it only the
Roman Catholics that Dürer castigates here? Returning
to Dürer's introductory lines warning rulers not to fol-
low the misguided for the true Word of God "in these
dangerous times," it would seem that the artist alluded
to more than one enemy and pointed his message to the
radical left and right camps of Luther's followers who
had twisted and inverted his teachings, leaving Germany
a miserable battleground with their extreme practices af-
ter the springtime of Luther's moderate reforms had
passed.

In another light *The Four Apostles* can be seen as a per-
sonal testament on Dürer's part as well as a justification
of his art in the community. The year before, 1525, the
trial of the so-called godless painters had taken place
in Nuremberg in which three of Dürer's co-workers,
Georg Pencz and Sebald and Barthel Beham, were ex-
pelled from the city for their irreverent talk reflecting un-
orthodox views that denied the holy person of Christ.
Perhaps, in this way, Dürer was proclaiming his own po-
sition and clearing his name from any such accusations
since he too was an artist in a city left without patrons
for religious art. Similarly, Dürer was justifying the va-
lidity of Christian art in the face of iconoclasm. At least
we know that he responded in words: "For a Christian
would no more be led to superstition by a picture or ef-
figy than an honest man to commit murder because he
carries a weapon by his side. He must indeed be an un-
thinking man who would worship picture, wood, or
stone. A picture therefore brings more good than harm,
when it is honourably, artistically, and well made."[19]

The Isenheim Altarpiece *and Matthias Grünewald*

In the foothills of the towering *Grand Ballon d'Alsace* on the outskirts of the village of Isenheim, halfway between Colmar and Basel, lies the Monastery of Saint Anthony. Dedicated to the venerable saint who founded the original anchorite order with communities of hermits living in the deserts of Egypt, the Antonine monastery of Isenheim was one of the most distinguished of its order in the Upper Rhine. The hermit monks were renowned for their ascetic way of life, their quiet devotion, and their humble *vita contemplativa*. The Antonines were well-attuned to the mystical way of life, the *imitatio Christi*, so widespread in the Rhineland. And they were also hospitalers of a very special sort, who treated the fearsome skin diseases, including the gangrenous disorders brought on by the plague. Ergotism, a devastating skin disease, often fatal, caused by eating ryes and other grains or grasses infected with ergot fungus, was, in fact, commonly known as Saint Anthony's Fire. Not only did the monastery administer a hospital for such victims, but in time it became a popular pilgrimage site for those suffering or fearing such infirmities.

At the end of the fifteenth century Isenheim was blessed by two wealthy and devoted preceptors and benefactors, Johan de Orliaco (Jean d'Orliac) and his successor, the Sicilian Guido Guersi. After the rebuilding of the choir of the chapel, about 1470–1500, a magnificent altarpiece was ordered by Orliaco. The inner sculptures were entrusted to Nicolas Hagenau of Strasbourg and were probably finished by 1505 (fig. 403). The nine painted panels for the triple wings were commissioned later by Guido Guersi and completed before the abbot's death in 1516. Matthias Grünewald, active in Seligenstadt and Aschaffenburg, received the commission, and the paintings that he executed for the giant shrine have made it one of the most imposing and awesome altarpieces ever painted in northern Europe (colorplates 53–55). It was before Grünewald's impressive paintings that the first stages of healing the patient would commence, with a direct confrontation with the broken body and lacerated flesh of the crucified Christ looming directly

403. NICOLAS HAGENAU. *Saint Anthony Enthroned between Saints Augustine and Jerome*. Shrine of the *Isenheim Altarpiece*. c. 1505. Musée d'Unterlinden, Colmar

above him. After this dramatic encounter the medical treatments began, and the miracles of the healing of his own flesh were awaited.[20]

During weekdays the polyptych would be closed, exhibiting in painful proximity to the beholder the huge corpus of Christ on the cross and the two patron saints, Anthony and Sebastian. (also a saint for the plague), painted on the wings as living sculptures standing on consoles that are part simulated architecture and part floral supports. On Sundays and special feasts, Christmas,

Easter, etc., the first set of wings was folded back, revealing the surprisingly joyous representations of the *Annunciation*, the *Incarnation*, and the *Resurrection*; and, finally, on days that marked the celebration of Saint Anthony and other patron saints of the order, the second set of wings would be opened, exposing the sculptures of Anthony enthroned like some divine judge between Saints Augustine and Jerome, the works of Hagenau. The wings of the third position featured paintings by Grünewald of the *Temptation of Saint Anthony*, right, and the *Meeting of Saint Anthony and the Hermit Paul* in the desert, left. The three stages of the altarpiece thus display a startling range of subject matter juxtaposing extreme contrasts of dark hues and bright colors, suffering and joyous exhilaration, terror and peaceful repose, iconic and discursive narration, florid architectural settings and dreamy landscapes.

Today the altarpiece is exhibited in the Unterlinden Museum in Colmar, and the three sets of wings have been separated and are displayed in a row in the main hall of the museum so that the visitor can view them simultaneously, perusing the various panels as he wishes. For our purposes, however, they should be studied in the proper sequence dictated by the church calendar. We begin, therefore, with the closed position and the *Crucifixion* since this view was normally exhibited on weekdays.

The *Crucifixion* is overpowering in its size and frightening realism. An eerie twilight world veiled behind a dark curtain of evening is the setting, but the details of the figures are painted so vividly that they glow out from the ominous black-green sky and the barren, cold-brown terrain of Golgotha. The lonely *Crucifixion* is unlike any ever painted before. Three figures, John the Evangelist, the Virgin, and the Magdalen, appear in different states of despair and pallor to the left. One figure, the proud and noble John the Baptist, stands alone with the lamb on the right. Natural scale has been ignored. The huge body of Christ fills the entire central area with an overpowering monumentality. With a surprising disinterest in hieratic scale, Grünewald makes the Baptist next in size, then the Evangelist and the Virgin, and, finally, the tiny figure of Mary Magdalen, weeping convulsively and wringing her hands in grief, is placed at the foot of the cross. Emotional states, not doctrine, seem to dictate the scale here.

The body of Christ, while heroic in proportions, is one of the most gruesome and disturbing ever painted with a gangrenous green coloration of the dead flesh, the countless sores and pricks in the torso, the distorted limbs torn from their sockets and joints, and the agonizing rigor mortis that has twisted and contorted Christ's hands and feet. The crossarm of half-hewn wood bends under the tremendous weight of the dead body. Christ's

404. RHENISH. *Plague Crucifix*. c. 1390? Wood, height about 61″. Santa Maria im Kapitol, Cologne

head collapses on his shoulder, his eyes are closed, and his gaping mouth is filled with blood.

How unlike the dignified Christ in Dürer's *Large Passion* or any others one can bring to mind! And yet there is a prototype for Grünewald's dead Christ that can be traced in the literature and the art of the mystics of the fourteenth century. A similar emaciated and deformed image of Christ on the cross is found in the so-called Plague Crucifixions, a type of *Andachtsbild* in sculpture such as the expressionistic *Crucifix* in the Convent of Santa Maria im Kapitol in Cologne (fig. 404) that served as mystical devotional pieces.

The painful state of total martyrdom with Christ's body stretched on a rack so that his limbs are ripped from their joints is described in a text by Bonaventura and by the very influential Swedish mystic, Bridget, in her *Revelationes*, written in the fourteenth century and very likely known in some form by Grünewald: "The crown of thorns was impressed on his head; it was pushed down firmly covering half of his forehead, and the blood, gushing forth from the prickling of thorns, ran down in many rills over his face, hair, and beard so that it seemed like a river of blood. . . . The dead body sagged. The color of death spread through his flesh, and after he breathed his last human breath, his mouth gaped open so that one could see his tongue, his teeth, and the blood in his mouth. His knees then contracted bending to the

side. His feet were cramped and twisted about the nails of the cross as if they were on hinges. . . . The cramped fingers and arms were stretched out painfully'' (*Revelationes*, Book 4).

Saint Bridget goes on to count the hundreds of wounds and drops of blood that covered his body. She misses no gory detail, even describing the way the chest cage protruded so that the ribs could be counted: ''After the moisture in the body was consumed the stomach muscles contracted and the flesh receded to his back.'' This, according to Bridget, was the Virgin's description of the gruesome ordeal on Golgotha that was witnessed, but Mary in Grünewald's painting, dressed in the white habit of a nun, has swooned and in imitation of her son's death falls backward into the arms of the Evangelist and closes her eyes from the terrible sight of her son's extreme suffering.

In contrast to the swooning Madonna in Rogier van der Weyden's *Deposition* in the Prado (colorplate 20), the pose of the Virgin here combines two aspects of her compassion. While falling backward in her experience of physical pain and grief (*agonia*), she still has her hands lifted toward Christ as a gesture of mourning (*lamentatio*). Her pale countenance and the pure white mantle she wears contrast dramatically with the varicolored costume and violent throes of the throbbing Magdalen kneeling before her who wrings her hands torturously and throws her head back as she sobs convulsively in overwhelming despair (fig. 405). Through the many cascading ripples in her bright yellow-orange mantle and her streaming blond tresses, Grünewald has achieved one of his most colorful and expressionistic statements of an extreme moment in grief and heartache. Before her rests a large ointment jar, the attribute of the Magdalen, that carries the date 1515.

The tall, elegant form of John the Baptist, the second largest in the hieratic scale of the figures, appears alone against the barren landscape to the right, calm and stoic. He is not properly a mourner but a witness and precursor who dramatically points with his elongated index finger to the dead Christ and announces that he is the lamb of God ''who takes away the sin of the world'' (John 1: 29). His attribute, the lamb, stands before him as a symbol of the sacrifice of Christ on the cross. The lamb carries a diminutive cross and from a wound in its side blood gushes forth into a chalice, an emphatic reference to the transubstantiation of wine into Christ's blood in the sacrament of the Eucharist. Over the Baptist's right shoulder appears the declaration of John's role in redemption: ''He must increase, but I must decrease'' (John 3: 30), a quotation also found in Bridget's *Revelationes* on the Passion.

The Baptist, who was beheaded while Christ was still

405. Matthias Grünewald. *Isenheim Altarpiece* (detail of colorplate 53)

a young minister, has been resurrected here as a prophet and, as Georg Scheja has pointed out, he appropriately represents the archetypal anchorite who dwelled in the wilderness and desert, the ''voice calling out in the wilderness,'' and an example of monastic *humilitas* so important for the anchorites. As a prophet John the Baptist represents the witness of doctrine—''He who believes in the Son of God has eternal life''—in contrast to the role of the other mourners suffering under the cross opposite him. Grünewald thus presents us with an ingenious fusing of both the historiated and the iconic Crucifixion types.

When the outer wings were opened on Sundays and special feast days, a splendorous array of four brightly colored panels presented the viewer with an even more unorthodox program of familiar Christian themes: the Annunciation, the Incarnation (Angel Concert and Madonna and Child in a Garden), and the Resurrection of Christ. Aside from a few obvious stylistic devices such as the sliding diagonal that moves upward from the Annunciate Virgin in the lower left of the first panel, through the angel choir and the Madonna in the two central paintings, to the aureole of the resurrected Christ on the right, the compositional unity of the interior is impos-

406. MATTHIAS GRÜNEWALD. *Isenheim Altarpiece*
(detail of colorplate 54)

sible to discern. Instead there seems to be a conscious attempt on Grünewald's part to present contrasting and conflicting patterns.

The settings differ markedly in all four. On the left, an austere and unadorned Gothic chapel for the Annunciation gives way to an ornate temple for the musical angels that seems constructed more of gaudy vegetal forms than of stone. The Madonna and Child—the largest figures in the curious medley—are placed in a spacious landscape beneath a bright sky and a yellow cloudburst with God the Father and the angels in heaven showering golden rays downward, while another landscape appears in the Resurrection under a dark night sky sparkling with tiny stars into which the bright aureole of Christ rises. Drapery patterns are likewise varied. Kneeling and seated figures are draped in simple, pyramidal folds of heavy fabrics, while other, more active figures, such as the angel of the Annunciation and the risen Christ, are clothed in colorful diaphanous costumes that swirl, turn, and flutter with a graceful calligraphy.

At first sight the *Annunciation* appears to be rather conventional. Mary, kneeling before a prayer bench, has been reading the Old Testament prophet Isaiah: "Behold, a young woman shall conceive and bear a son"

(Isaiah 7: 14). The semi-transparent sculpture of Isaiah, a ghostly figure, adorns the spandrel of the arch above her head. Two details of the church interior are unusual: directly beside Mary a bright red curtain hangs from a rod that extends across the chamber, and further back another curtain, this time green, likewise appears. Both have been pulled back to unveil the mystery of Isaiah much in the fashion of the drapes of staged plays performed in the church service on certain occasions such as the Golden Mass, a popular liturgical drama in which actors in the aisles were concealed behind curtains until the proper time, when the curtains would be pulled back at the reading of the Gospel account of the Annunciation (Luke 1: 26–28) while a dove was lowered from the vaults.

The most enigmatic panel is the second from the left. Here a multitude of strange, hybrid angels perform a concert within a florid temple enclosure featuring ogival arches, floriate columns and capitals, and colorful hangings. The scene bursts with bright colors, pure colors for the most part, to achieve the impression of a mystical, heavenly realm. Three angels in the foreground accompany the choirs of singers on stringed instruments playing music that must be of a very high "celestial" pitch judging by the positions of their bows. As with Geertgen tot Sint Jans's enchanting *Madonna of the Rosary* (colorplate 30), it is clear here that Grünewald intended to paint a heavenly world expressing the harmony of the spheres through music and pure color.

One angelic creature stands out. In the entrance to the temple on the right, between two golden columns, kneels the beautiful form of a young maiden wearing a flaming crown and extending a gesture of adoration to the right (fig. 406). A brilliant gloriole of gold and red radiates from her face, nearly obliterating her features and hair. Much scholarship has been devoted to the identification of this mysterious addition to the angelic concert. That she is Mary seems uncontestable, but just how does she relate to the very earthy Madonna in the worldly landscape to the immediate right whom she attends so tenderly? For some, the figure represents Mary visited by angels in the temple before the Incarnation, but this seems highly unlikely since she is portrayed as a mystical vision and not an historical figure of the youthful Virgin. Another, more convincing, theory proposes that she is the "idea of Mary" before time in the mind of God, who looks upon her fulfillment as the Madonna within historical time at the birth of Christ.

Such sentiment is expressed by Saint Bridget (*sermo angelicus*) in which she reveals the role of the Madonna in the history of Redemption in a sequence of meditations, including one describing the jubilant celebration of the angels at God's decision to create Mary before time.

Bridget describes her soul as a "lantern from which light streams forth" and "a glowing flame of love," and her body as "a vessel of purest crystal." This is the language of the mystics, and Grünewald has translated the poetic image of the lantern of light and flame of love into paint in the lovely apparition of the Virgin. The "vessel of purest crystal," describing her body, is placed on the step directly before her. Thus, the idea of Mary in the mind of God before time and history is here juxtaposed with the Madonna who gave birth on earth to the Savior, as the vehicle of God's destiny on earth. Would it be going too far to interpret the praying infant in glowing golds and reds in the chamber just behind her as the "idea of Christ before time"?

A more recent theory based on Dante's vision of Paradise (see Scheja) inverts the temporal aspects of the Bridgetine interpretation. The Madonna in the gloriole is rather to be related to the Resurrection of Christ with her joy and glory in anticipation of what the future holds at her coronation in heaven. These curiously complementary and contradictory interpretations of the mystical text and Grünewald's pictorial images only enhance and mystify his expression. One detail should be carefully noted here, however. Directly in front of the tabernacle of the mystic Virgin is another curtain rod from which a dark green curtain hangs. As we have seen, the use of curtains to express the act of unveiling the Old Testament is very familiar in medieval drama and the arts in general, and it would seem that the associations with the "idea of Mary" in the mind of God before time adoring the "Madonna as fact" on earth at the Incarnation are the more meaningful and convincing.

The beautiful Virgin on the right side of the center corpus, while placed in a position of humility, is foremost an image of the Madonna of Incarnation in this context. Many of the familiar signs and symbols of purity encircle the Madonna, who sits on the low wall of a *hortus conclusus* (closed garden): the fig tree, which was believed to produce without fertilization; the *porta clausa* (closed gate); the cedar of Lebanon; and the *rosa mystica* ("Like a rose planted on the rivers I have borne fruit"— Ecclesiasticus 24: 14). The "vessel of purest crystal" before the portal of the temple (*templum Salomonis*) also is a symbol of the virginal birth, and, finally, the Child fondles Rosary beads of coral as he gazes affectionately toward his mother.

But there is a touch of gloom even in this joyous terrestrial paradise. The tattered cloth on which the Child rests is the same that covers his loins in the Crucifixion: "Just as the blessed Virgin was more full of joy than all other mothers each time she gazed on her newborn child in that she knew him to be truly God and truly man, mortal in his earthly frame, immortal to all eternity in

his divinity, so was she in the foreknowledge of his most bitter sufferings at the same time the most grieved of all mothers" (Bridget, *Revelationes*). Below Mary, to the left, are various objects that remind us of the corporeality of the Child: the tub, cruet, and cradle.

The fertile springtime landscape behind the Virgin not only contrasts with the barren and sterile terrain of Golgotha in the *Crucifixion*, but it is also a proper allusion to the paradise landscapes associated with the anchorites. The monastery on the banks of a stream to the far right is snuggled in the foothills of a high mountain in a "blooming desert" much as the hermitage is described in the literature of the hermits.

One of the great masterpieces of mystic expression in art is Grünewald's *Resurrection* on the final panel of this series. From the gloom of the tomb near Golgotha, the lithesome figure of Christ rises in a burst of light so bright that the soldiers are struck down and cannot face his radiant glory. Here Grünewald turns once again to pure colors, a rainbow spectrum in fact, that transforms all corporeal matter into divine light. The giant glory about Christ radiates in nearly imperceptible circles from the golden yellow at the center through the spectrum of colors to darker blues, violets, and purplish-black of the night sky. In turn, these colors transform the long, unfurling shroud into a translucent train of delicate draperies floating above the harsher and more metallic costumes of the guards and earthbound forms of the landscape. The figure of Christ truly seems to rise upward as an earthly being transfigured in the bright light.

But there is more than mystical light to be reckoned with here. The body of the risen Christ is not one of the well-proportioned classical types that Dürer envisioned but rather a translucent form dissolving in its own light. The legs and arms are white and glowing; the head of Christ dissolves into a sun with the facial features barely traced across it; and the festered wounds of his body are now sparkling rubies of pure red. What a lesson for those afflicted with terrible skin diseases: if they only keep their faith in Christ then they too can be so cleansed. In the more earthy colors of the *Annunciation* panel, opposite the *Resurrection*, the idea of the humanization of the divine, the Incarnation of God made flesh, is stated with a poetic freshness. In the *Resurrection* we witness the deification of the human, the return of flesh to the divine in most majestic terms.

Perhaps it is too much to ask the reader, but cannot one perceive in the rising lines of the vaults and the horizontal accents in the Annunciate chamber the form of the letter "A" or Alpha, while the outstretched arms of Christ in the *Resurrection* form, with his face, the Omega "ω": the Alpha and Omega, the beginning and the end of the history of the Incarnation? In the final chapter of

Revelation (22: 13) Christ tells John: "Behold, I am coming soon . . . I am the Alpha and the Omega, the first and the last, the beginning and the end."

When the second set of panels was opened, the worshiper looked upon the large inner corpus of sculptures by Nicolas Hagenau with the imposing figure of Saint Anthony enthroned between Saints Augustine and Jerome, two of the four Latin Church Fathers who were much influenced by the founder of the anchorites. The preceptor, Johan de Orliaco, who originally commissioned the shrine, kneels in profile before Augustine in adoration of the patron saint. The predella has bust figures of Christ flanked by the twelve apostles (the two outer set of wings share a painted representation of the Pietà or Lamentation). The wings, painted by Grünewald, present two episodes in the life of Anthony: the *Temptation* on the right, the *Meeting with Saint Paul the Hermit* on the left.

The *Temptation of Saint Anthony* is well known due to the myriad of incredible demons that attack the saint and the dancing spooks battling angels on his hut beyond. While Grünewald's painting is often compared to Schongauer's print (fig. 288) and Hieronymus Bosch's agonizing versions of the story (fig. 200), it should be noted that the event here is not the same. It is an earlier confrontation of Anthony with the monstrous creatures. Rather than being lifted into the sky and tormented, Anthony is very much on the ground in Grünewald's panel. Following the biography written by Saint Athanasius in the fourth century (*Vita B. Antonii*), Anthony first took refuge in a tomb in the desert that he converted into a training ground for his *vita contemplativa*. There he challenged the demons that had harassed him in his first stage of becoming a hermit: "Here I am, Anthony, and all of your torments will not drive me away from the love of Christ."

The wild creatures swarmed about him, and while Anthony experienced great bodily pains, he remained vigilant and ultimately survived the terrible ordeal. Athanasius describes apparitions of frightening animals—lions, leopards, bears, lizards, scorpions, and serpents—that tormented Anthony, but Grünewald transformed them into hybrids of the most grotesque shapes who claw, pull, and beat the saint into a prostrate position. On a piece of paper in the lower right corner are inscribed the words addressed to Christ by Anthony after the hellish attack: "Where were you, why did you not appear at once to spare me these torments?"

The ruins and the desert were the secret abodes of demons, ghosts, and spooks, who would often ape the clergy (as they do in Bosch's version) to fool and mislead the anchorite. At any rate, Anthony passed his first test, which humbled him greatly (*humilitas* was the basic vir-

tue of the Antonines), and as Christ informed him: "You held your ground and did not give in, so shall I make you a helper-in-need at all times, and it shall be that your name will be announced in all places." The sickly, deformed creature in the lower left corner is probably not one of the demons but an earthling whose body is rotting and festering with gruesome sores and lacerations, an example of the patient whose skin diseases will be healed eventually through his faith in Christ. He grasps the leather cover of Anthony's book in his leprous right hand.

The left panel depicts the meeting of Saint Anthony and the hermit Paul (not the apostle) in the desert. The textual source for this rather obscure episode is the *Vita B. Pauli* attributed to Saint Jerome. Paul of Thebes and a hermit of the Thebaid in Upper Egypt was allegedly the first to take up a life of contemplation in the desert, although he did not found an order. The holiest of all hermits, Paul lived deeper in the wilderness, and in a dream Anthony was informed of his humble existence and exemplary asceticism and set out to pay homage to him. The setting again is a type of anchorite landscape with a cave and an open chamber, a palm tree for nourishment, and a stream before towering mountains. Two deer, the animal often associated with hermits, are companions of Paul, and scattered about the clearing are numerous medicinal herbs—white clover, germander, plantain, ribwort, poppy—some of which were undoubtedly used to cure Saint Anthony's Fire at the hospital in Isenheim.

In the story of Anthony this meeting represents the final goal of the anchorite: "I have seen Paul in paradise," Anthony stated according to Jerome's *Vita*, referring to the mystical Eden that blossoms from the wastelands where Paul settled. Anthony sits to the left and gestures to the hermit Paul, dressed in a coat made from palm fronds, who looks upward and greets the raven that brought him a loaf of bread daily for sustenance. On this day, the winged visitor brings two loaves, one for the guest, Saint Anthony. It has been suggested that the two figures are portraits, that of Saint Paul being Grünewald himself and that of Anthony as Guido Guersi since his coat of arms appears on the rock on which he sits. These identifications seem unlikely.

The genius who created this masterpiece, Matthias Grünewald, remains a shadowy figure in art history. In fact, his actual name, Mathis Gothardt, called Nithardt, was not uncovered until the late nineteenth century. Joachim von Sandrart, a seventeenth-century compiler of an important source book on German art, *Teutsche Academie der Edlen Bau-, Bild- und Mahlerey-Künste* (*The Academy of the Arts of Architecture, Sculpture, and Painting*, Nuremberg, 1675), christened him Matthias Grünewald on the basis of spurious sources or confusion with Hans

Baldung Grien, and the sonorous name "Green Wood" has been adopted by most recent scholars.[21]

Master Mathis, as he is usually named in the documents, was born between 1470 and 1475 in Würzburg in Franconia. Between 1500 and 1525, he was apparently active as a painter in the nearby village of Seligenstadt, and he served as a court painter for the archbishop of Mainz, Uriel von Gemmingen, and his successor, Albrecht von Brandenburg.[22] For the residence of the archbishop, the Castle of Aschaffenburg, he designed a fireplace and painted an altarpiece for the church dedicated to Saint Mary of the Snows.

For some reason—some believe that he was harassed because of religious problems involving the Peasants' Revolt—he moved to Frankfort in 1526, and the following summer he settled in Halle, where he died in 1528. In certain late documents he is referred to as "Maler und Wasserkunstmacher" (painter and maker of fountains), and he designed fountains for Magdeburg and Halle, but it is uncertain whether or not he was an accomplished hydraulic engineer as some have suggested. As to his religious convictions, it seems certain, on the basis of his paintings and patronage, that Grünewald was a devout, orthodox Catholic, although the contents of a chest that he left in Halle contained writings by Martin Luther.

407. Matthias Grünewald. *Saint Cyriacus*, from the *Heller Altarpiece*? c. 1508–10. Panel, 39 × 17". Städelsches Kunstinstitut, Frankfort

The backgrounds of Grünewald's style and the nature of his training are illusive and uncertain. He definitely was not closely associated with the Nuremberg workshop of Albrecht Dürer; in fact, his art is at the opposite pole from Dürer's. Grünewald was a Late Gothic artist through and through with no concern for Renaissance theory, classical proportions or perspectives, antique touches, or mythological themes. In contrast to Dürer he was no graphic artist and produced no woodcuts or engravings that are known. He was a painter and colorist par excellence.

Expressionism and Mannerism, both traits of "Late Gothic Baroque" in Germany, characterize his intensely personal and subjective expression as opposed to the clarity and systematic construction of Dürer's art. His figures are not studies in anatomy or proportion but throbbing forms distorted to convey inner emotions; his architectural settings are not rationally structured or classical in detail but organic and capricious; his landscapes are not carefully composed topographic views but filmy and romantic vistas with intoxicating colors and lights that shine forth as if seen through stained glass, fleeting and changing. It is color, not form and space, that Grünewald exploits for expressionistic effects: the glaring hues that convey the hotness of noon in the *Temptation of Saint Anthony*; the fresh, cool atmosphere of sylvan calm in the *Meeting of Saint Anthony and the Hermit Paul*; the somber, dreary darkness that pervades his frightening *Crucifixion*; or the radiance of noisy, exhilarating reds and yellows that provide the joyous harmonies for his angelic concerts and Madonnas.

The narrow range of Grünewald's subject matter is also a striking feature when compared to other German artists of his day. A true mystic, he preferred themes expressing the extremes of religious emotions. Sandrart tells us that Grünewald "lived a solitary and melancholic life and was unhappily married," and there seems to be the ring of truth in that statement. Four grisaille paintings that Sandrart saw in the Dominican church in Frankfort (part of the *Heller Altarpiece* for which Dürer painted the missing centerpiece) were attributed to Grünewald, but Sandrart's memory was vague, and the panel he identified as a Saint Stephen is, in fact, Saint Cyriacus (fig. 407), a rather obscure martyr of ancient Rome who cured Artemia, the mad daughter of Diocletian, through exorcism. Although painted in grisaille, the figures with their rich, calligraphic draperies, strike one as being more painterly than sculptural, and the delicate lines turning within the costume of the woman are familiar to us from the weeping Magdalen in the Isenheim *Crucifixion*.

These early panels, including a *Mocking of Christ* in Munich, dated 1503, give us little insight, however, into

in his late Passion pictures, but the eerie phosphorescence of glowing reds and blues in the draperies impart a mysterious otherworldly atmosphere to the sinister domain of death.

While Grünewald's late Passion pictures become more iconic and are staged in a darker and more barren world than before, his later treatment of the Infancy is lyrical with the Madonna and Child placed in a lush and refreshing garden landscape (fig. 409). What a feast for the eyes is the poetic *Madonna and Child in a Garden* in the parish church in Stuppach near Mergentheim! Warmth and bright light fill the landscape with the fragrance of countless flowers and shrubs. Beyond the *hortus conclusus* in the foreground unravels a rich and varicolored landscape with meadows, beehives, a pond, mill, a sleepy village at the foothills of towering mountains, and a huge church of pink stone to the right. It has just been raining, a rainbow encircles the setting, and one can almost sense the moisture in the air as the bright sun draws back the water from the meadows. Few versions of this beloved German theme have the idyllic charm and serenity of Grünewald's. The rainbow forms a gigantic halo that unites mother and child, and seen as a sign of the new covenant that the Lord, in the top left, has sent to man,

408. Matthias Grünewald. *Crucifixion*. c. 1525–26. Panel, 77 × 56⅛″. Staatliche Kunsthalle, Karlsruhe

the sources of Grünewald's early style. The one theme that is instructive to study for his development is the Crucifixion. Aside from the gigantic *Crucifixion* on the exterior of the *Isenheim Altarpiece*, three other paintings of the theme (Basel, Washington, Karlsruhe) and a drawing (Karlsruhe) are attributed to Grünewald, and they all display the same disturbing features of a truly dead corpse with blood streaming from countless sores and pricks made by sharp thorns (see fig. 408). Rigor mortis has set in and distorted his limbs and fingers, and the pallor of death, a gangrenous green-gray, pervades the twisted, emaciated body. The dead weight of his torso causes the crossarms to give and bend downward. From a shallow stage of barren brown against a midnight blue-black sky, all life on earth has ceased, all lights have been dimmed.

The Karlsruhe *Crucifixion* is huge, the figures lifesize, and on its reverse was painted the *Carrying of the Cross*, no doubt as part of some much larger program. Both stylistic and documentary evidence support a late date, about 1525–26. In the series of his *Crucifixions* one can detect a growing sense of monumentality and iconic severity. The compositions are reduced in the number of figures, here to just Mary and John, that fill the field with their awesome presence. Colors darken even more

409. Matthias Grünewald. *Madonna and Child in a Garden*. c. 1518–20. Canvas transferred to panel, 72⅞ × 59″. Parish church, Stuppach

410. MATTHIAS GRÜNEWALD. *Miracle of the Snows*. 1519. Panel, 70½ × 36″. Augustinermuseum, Freiburg im Breisgau

411. MATTHIAS GRÜNEWALD. *Saint Dorothea*. c. 1520. Chalk and watercolor, 14⅛ × 10⅛″. Kupferstichkabinett, Staatliche Museen, West Berlin

it also links the Virgin directly to the great church on the right, the Madonna as the Church thus colorfully stated.

There was a special reason for Grünewald to make this last point so emphatically. The occasion for the commission was the introduction of the cult of *Maria-Schnee*, or the Madonna of the Snows, in the archbishopric of Mainz by Albrecht von Brandenburg, which celebrated the founding of the first and major church dedicated to Mary in Rome, Saint Mary of the Snows, known today as Santa Maria Maggiore. The legend of the founding is illustrated in a companion panel (today in Freiburg im Breisgau) with the fourth-century benefactor, John, and his wife accompanying Pope Liberius to mark out the foundations of the great church to honor the Virgin after they had experienced the same vision of the miraculous snow on the Esquiline in mid-summer (fig. 410). Among the parade of high-ranking ecclesiastics accompanying the pope, Albrecht von Brandenburg can be identified as the deacon holding the train of the papal mantle.

It seems clear that the introduction of the cult of *Maria-Schnee* by the archbishop of Mainz at this time was an overt display of the importance of the Virgin in orthodox devotion, one that was being vehemently attacked by the Protestants of Franconia, as we shall see later. Once again, it is in the writings of Saint Bridget (*Revelationes* 4: 78) where Mary, the Mother of God, is likened to "the guardian of the church in times of gravest danger" and is described with a rainbow and a church.

Some mention should be made concerning Grünewald's drawings, of which over thirty-five survive.[23] Executed on lightly tinted paper with a soft black crayon, these drawings are study sketches and not finished works, as were many of Dürer's. Grünewald's strokes are spontaneous and quick with a wide variety of lines and shading techniques that give them a distinct painterly quality in comparison to the sharper graphic effects that Dürer achieved. Dürer's drawings are precise and very controlled, executed with a studied and systematic technique, whereas Grünewald's softer tonalities and contrasts in light and dark with few distinct outlines are informal sketches with only the illusion of form indicated. Draperies stir, shimmer, and flutter with a captivating transitory and momentary life about them. Rather than being accurate records of objects, Grünewald's sketches are lyrical and musical, as fleeting as some light fantasy. The charming *Saint Dorothea* in Berlin (fig. 411) is one of his more complete and finished drawings, but even here it is the ripples that cascade so delicately down her accordian-pleated mantle that lend a fragile characterization to this lithesome young saint who sways demurely on her pedestal. No doubt this was a preparatory drawing for a wing of an altarpiece, but taken alone it conveys the sensitive touch of a highly personal style.

Danube Landscapes and Witches: Albrecht Altdorfer and Hans Baldung Grien

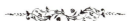

The Danube has its source near Baden in the Rhineland and flows gently northeast past Ulm, through Bavaria to Regensberg, and from there, gradually broadening and gaining swiftness in current, it bends southward through the verdant valleys of Austria to Vienna, and finally, turning still more to the right, transverses Hungary and joins the Black Sea. The river valleys of Austria and western Bavaria have often been praised as the land of the ''Beautiful Danube'' and not just in song but in the pictorial arts as well. Meandering through hills and dales enshrouded by mountains and deep forests, the Danube is a colorful thread in an enchanting tapestry of nature, and it is no wonder that one of the earliest and most romantic schools of landscape in Northern art was born on its gentle banks.

As we have seen, the river and forest had a mysterious attraction for German artists. Dürer's knight rides from a distant valley through a dense forest toward his destination. Grünewald placed Saint Paul's abode in a slumbering twilight woodland with misty vapors rising amid the deep browns, greens, and blacks of the dripping mosses and ragged conifers that enframe his aboriginal retreat. Relieved only by a few exotic plants in the foreground and icy blue mountain peaks in the far distance, Grünewald's magic setting has a dreamlike quality about it, but the reverie can turn to nightmare in the scary coves of the temptations, where sinister formations evoke the centuries-old lairs of Beowulf: ''In the darkness dwells a demon whose heart is filled with hate.''

Altdorfer's *Danube Landscape* (colorplate 56), to be sure, is not menacing, nor is it overwhelmed by demons. Reminders of man's presence can be found in the distant château, and the pervasive mood, or *Stimmung* as it is called in German, is peaceful and comforting. Nature does not threaten, but it does control and govern the Danube valley. Far from being the measure between nature and god, as man was in Greco-Roman thinking, he is at best a blemish in this world. Nature, not man, is the measure of all things here. The Gothic castle nestled amid dense woods and high hills fits naturally into its primeval environment; it does not rise proudly as a sign of man's achievement on a flat plain or plateau as do the temples of antiquity. Surely there is something basically pantheistic in this overwhelming commitment to nature, and pantheism, as a variety of religious experience, nurtures mysticism and romanticism, not logic and restraint. It is, in some respects, a charming fairytale world that Altdorfer presents, a poetic vignette of nature yet to unravel in the fashion of a folk story by the brothers Grimm.

If the sentiment of Altdorfer's landscape is wholly different from what one usually encounters in Western art, it is not, however, entirely his invention. The landscape is small and executed on parchment affixed to a panel and belongs to the tradition of the watercolor views of Dürer in some respects; that is, landscape is here just emerging as a genre in its own right. In fact, Altdorfer's picture is not as advanced as pure landscape as are many of Dürer's Alpine sketches.

The small format is markedly vertical, and the view is carefully composed with a tall tree in the left foreground serving as a repoussoir; another, slightly further back on the right edge, performs the same function there, and a winding road leads diagonally through the middle ground to the distant mountain range that serves as a focus on the horizon to the far left. His colors too are brighter, local hues not entirely diminished by atmospheric conditions, although the soft rays of sunlight rake the leaves and branches of the trees and the slopes of the distant hills. The horizon is low, which is surprisingly true to natural vision, and the fading blue sky of the evening hours is filled with gossamer clouds whose silken contours reflect the dispersed rays of the setting sun. All of these features—the rugged mountain terrain, the towering fir trees, and the dramatic lighting effects of sunset or dawn—characterize the landscapes of the early Danube school, and Altdorfer is to be reckoned as its most accomplished master.

Too little is known about the early years of this remarkable artist.[24] We have no documents concerning his

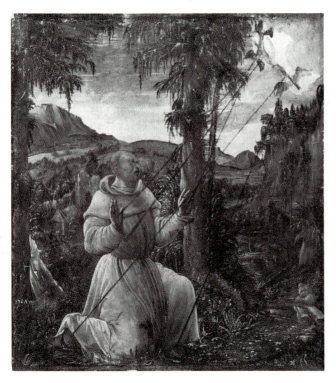

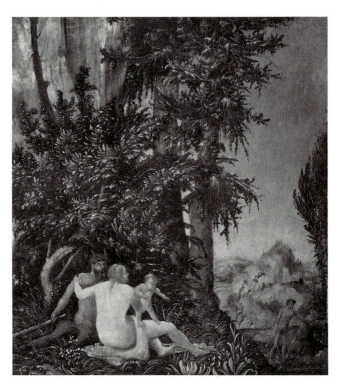

412. ALBRECHT ALTDORFER. *Saint Francis*. 1507. Panel, 9¼ × 8″. Gemäldegalerie, Staatliche Museen, West Berlin

413. ALBRECHT ALTDORFER. *Satyr Family*. 1507. Panel, 9 × 7⅞″. Gemäldegalerie, Staatliche Museen, West Berlin

birth or training, although he must have been familiar with the graphic works of Dürer and the paintings of Lucas Cranach the Elder. He is listed in the archives of Regensberg (Bavaria) in 1505 as a painter from Amberg, a town nearby, and he apparently remained a citizen of Regensberg for the rest of his life. In 1526 he was appointed to the senior council and named architect of the city. In the latter capacity he designed and built a number of structures including wine cellars, a slaughterhouse, and fortifications for the walls of Regensberg, which were sorely in need of repair in accord with preparations for the impending invasion of the Turks, who were, however, turned back at Vienna in their relentless march westward in 1529.

The *Danube Landscape* has usually been dated between 1520 and 1525 as a product of Altdorfer's mature years. Among his earliest dated works are two small panels of 1507 that form a diptych, with *Saint Francis* (fig. 412) and *Saint Jerome* kneeling in the woods. These panels show the influence of Lucas Cranach's paintings of hermit saints (see p. 372), although Altdorfer's emphasis on a more romantic and mysterious ambience for the anchorites is already manifest. His vision of the *Urwald*, or primeval forest, is even more poetic and enchanting in another early work usually mistitled the "Satyr's Family in a Landscape" (fig. 413). The left foreground, with its towering firs and huge coppice bursting forth like fire-

works of green punctuated with sprays of colorful leaves glistening in the sunlight, forms the entry into a misty woodland. Here, safely concealed from the bright meadows, sits a nude woman holding a child. With her left arm she embraces a grotesque satyr, who resembles a wolf-man with goat's feet. The corpulent female nude is no doubt a wild woman, and she glances furtively to the right and watches her husband, a towering nude, pursue an elderly man in monk's habit. This manhunt has allowed the primitive temptress to evade her mate and seek a clandestine affair with a lustful animal lover, one still closer to the natural world.

In another small landscape, *Saint George Slaying the Dragon* (fig. 414), dated 1510, the great Christian hero finds himself engulfed in an impenetrable forest of thickets and dense trees forming countless webs of lines that seem to swell and move so much that the silhouettes of the trees are blurred and fused. George, like some toy tin soldier attacking a floundering sparrow in a giant shrub, is hardly visible; only his white steed escapes the natural camouflage that blends the setting into one landscape motif. The *ritterliche Geist*, or spirit of chivalry, so prominent in German literature of the day, here is muted by the surrender of man to the awesome power of the deep, dark world of nature, to the spirit of pantheism.

This primitive and uncultivated world characterizes many of Altdorfer's settings. His version of the Nativity,

414. ALBRECHT ALTDORFER. *Saint George Slaying the Dragon*. 1510. Parchment on panel, 11⅛ × 8⅞″. Alte Pinakothek, Munich

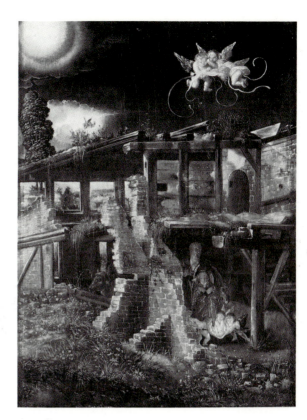

415. ALBRECHT ALTDORFER. *Night Nativity*. c. 1510–15. Panel, 14⅛ × 10″. Gemäldegalerie, Staatliche Museen, West Berlin

for example, is an ecstatic occurrence at night (fig. 415) in a forlorn farmyard, but unlike the protective cloak that darkness provides the Holy Family in Geertgen tot Sint Jans's Christmas story (fig. 168), the mysterious night scene by Altdorfer is aglow with mystical lights from a giant sun-moon and phosphorescent angels that play across the mortared junctures of brick walls and dripping mosses of a ruinous stable. Life is reborn from darkness and decay through the chemistry of light.

Altdorfer painted at least three such *Night Nativities* (Bremen and Vienna). In another early work, dated 1510, the *Rest on the Flight into Egypt* (fig. 416), the figures appear in bright daylight, but, considering the tradition of this theme, the interpretation is no less mysterious and unusual. The Holy Family has interrupted its journey to rest and refresh itself at a tall pagan fountain that dominates a sweeping vista with ruined farmhouses in a valley stacked diagonally along a road leading from the middle ground along the banks of a wide river to the hazy mountains beyond, a typical Danube view. The huge basin, a *fons vitae*, is filled with water, the source of all life, and the Child coyly splashes and plays with tiny angels who swim, play music, and cavort about the rim of the fountain.

Rising from the center of the basin is a spindly column adorned with sculptured *putti* holding garlands, and atop its strange Corinthian capital stands the tall statue of

416. ALBRECHT ALTDORFER. *Rest on the Flight into Egypt*. 1510. Panel, 22⅞ × 15½″. Gemäldegalerie, Staatliche Museen, West Berlin

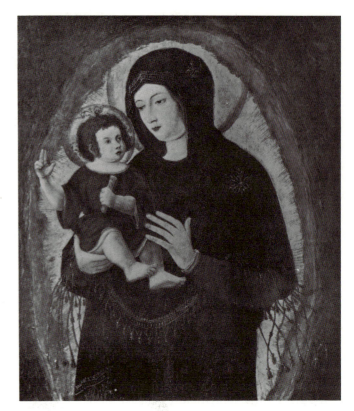

419. Albrecht Altdorfer. *Schöne Maria of Regensberg.*
c. 1520. Panel, 29⅞ × 25⅝". Collegiate Church of Saint John,
Regensberg

417. Albrecht Altdorfer. *Christ in the Garden of Gethsemane,*
from the *Saint Florian Altarpiece.* c. 1518. Panel, 50⅝ × 37".
Church of Saint Florian, Linz

420. Albrecht Altdorfer. *Birth of the Virgin.* c. 1521. Panel,
54¾ × 51¼". Alte Pinakothek, Munich

418. Michael Ostendorfer. *Pilgrimage to the
Church of the Beautiful Virgin at Regensberg.* c. 1520.
Woodcut, 21⅜ × 15³/₁₆"

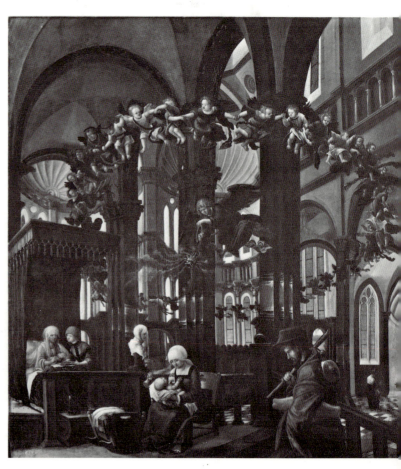

Mars (identified by some as Lucifer or Saturn), who holds a curious egg-shaped bird in his left hand (an owl, the bird of perverted wisdom?) and with his right touches the head of a blindfolded cupid, who is about to release an arrow from his misdirected bow, an image of inverted love. This idol should be toppling, according to the legend of the Flight, and no doubt it soon will succumb to the true love and wisdom of the innocent Child who brings peace to a troubled world for at least a while. Again, Altdorfer juxtaposes figures and objects of ruin and rejuvenation, of old and new, of pagan and Christian, within carefully composed planes that move dramatically backward in clearly defined steps of space.

One of Altdorfer's most ambitious commissions involved the execution of panels for the altarpiece in the Collegiate Church of Saint Florian near Linz, which was installed in 1518.[25] Originally the ornate shrine must have resembled the great altarpiece of Saint Wolfgang by Michael Pacher (figs. 324, 325) with an elaborate framework intricately carved about painted panels and inner sculptures, but only the paintings remain intact. When the wings are opened, eight episodes from the Passion of Christ appear in two registers; closed, four scenes in the life of Saint Sebastian are presented. The predella displays four more painted panels including the *Entombment* and *Resurrection, Saints Margaret and Barbara*, and the donor, *Provost Peter Maurer*. Altdorfer's drama of the Passion is intensified in emotional expression and superbly composed with four scenes that take place in pitch darkness and heat opposing four on the right, that occur in glaring daylight.

The first of the series, *Christ in the Garden of Gethsemane* (fig. 417), is one of the finest examples of the artist's expressionistic style in treating themes of betrayal and violence. The threatening darkness of the night sky striated by intense layers of red does not conceal the nature of the sinister landscape of Gethsemane. This is not the Holy Land. In the foreground an eerie grotto of stalactite forms provides the uneasy stage for Christ and his three apostles: Peter, James, and John. Dark moss and spiky branches cover the enclosure. Suddenly, on the far left, we plunge deeply into a spectral valley, where Judas appears leading a band of soldiers carrying glaring torches and lanterns. A silent village slumbers in the darkness beyond.

The poses of the figures at first seem awkward and clumsy, but the group as a whole is organized within a compact oval in which their bodies flow languorously one into the other. Distortions in the contrasts of darkness and fiery highlights, of abrupt spatial plunges and close-ups of the foreground figures, of attenuated draped forms and staccato-like punctuation marks of the tiny henchmen following Judas, create a disturbing picture of this last quiet moment in the life of one about to be executed.

As an artist of religious themes, Altdorfer strikes us at times as one of contradictory convictions. In 1519 the Jews were expelled from Regensberg and their synagogue destroyed (Altdorfer executed two etchings of the barren interior of the cross-vaulted structure in that year). On its site was erected a special pilgrimage chapel dedicated to "Mary the Beautiful" with a statue of the *Schöne Madonna* prominently displayed in the courtyard before the chapel facade and a Byzantine icon of Mary adorning the altar within. Michael Ostendorfer, a local artist, executed a woodcut of the new shrine depicting a procession of pilgrims, some orderly, others in fits of mental anguish, gathered there to benefit from the miracles which the statue and icon were believed to bestow (fig. 418). The keys of Saint Peter and the papacy are prominently displayed on a banner hanging from the bell tower.

This is but one form of the cult of images that rapidly spread through Germany in the early sixteenth century, a movement that Martin Luther strongly opposed: "The chapels in forests and the churches in fields, such as Wilsnack, Sternberg, Trier, the Grimmenthal, and now Regensberg and a goodly number of others which recently have become the goal of pilgrimages, must be leveled. . . . The miracles that happen in these places prove nothing, for the evil spirit can also work miracles, as Christ has told us in Matthew 24." In 1523 Albrecht Dürer added a note to a copy of Ostendorfer's print that he had seen that expressed much the same sentiment: "This specter has risen against Holy Scripture at Regensberg with the permission of the Bishop, and has not been abolished because of worldly usefulness. Lord help us that we should not dishonor his dear Mother by separating her from Christ Jesus."[26]

Apparently Altdorfer had no such qualms about the new devotion in Regensberg as he, himself, issued woodcut souvenirs of the Byzantine Madonna that was venerated there, and he executed a copy of the icon, today in very bad repair, that is preserved in the Collegiate Church of Saint John in Regensberg (fig. 419). On the other hand, it seems that the artist had no difficulty in converting to Protestantism. He was, in fact, a member of the senior council that officially established Lutheranism as the city religion in 1533.

More significant for this study is the intriguing painting of the *Birth of the Virgin* (fig. 420), perhaps destined for the Cathedral in Regensberg. Unusual is the eccentric setting in the side aisle of a lofty church (a pen drawing of the interior of a church much resembling that in the painting is in the Kupferstichkabinett in Berlin). About the arcade separating the side aisle from the nave

of the church singing angels holding hands merrily in a huge ring flutter high in the vaults above the Virgin's mother, Anna, in bed and the nurse holding the infant Mary before a rocking crib. In the immediate foreground, right, Joachim, carrying a staff and canteen, appears partly cut off by the lower border of the frame as he steps up to join his family. The composition of the figures is haphazard and casual, and, in general, the free-flowing space, the centrifugal motion of the angels, and the strange perspective through the arcade contribute to a bewildering presentation that defies all rules of classical picture organization.

Altdorfer's *Birth of the Virgin* was a favorite of Heinrich Wölfflin, the famous Viennese historian, who established the vocabulary of style for earlier generations of art historians.[27] For him the work displayed a complete denial of the tectonic clarity and order in classical relief composition where the figures reinforce the picture plane. Here, conversely, an undefined and contradictory flow of figures is found in a confusing space. For Wölfflin, the painting was ''completely German'' as opposed to classical or Italian Renaissance in conception. Wölfflin's observations are indeed very perceptive and they tell

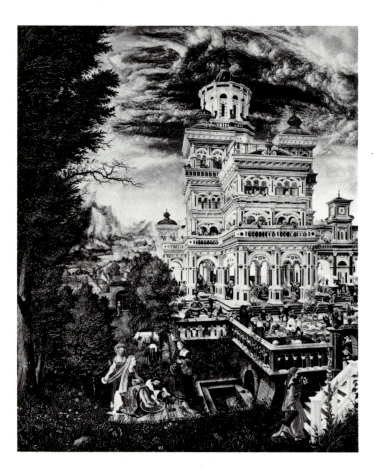

421. Albrecht Altdorfer. *Susanna at the Bath*. 1526. Panel, 29½ × 24″. Alte Pinakothek, Munich

us a great deal about the basic modes of visualization in Altdorfer's art.

Altdorfer's interests in fanciful architecture no doubt were quickened by his role as city architect after 1526. One wonders just what sort of triumphal arch he would have designed for Maximilian. We may gain some insight into his vision of imperial architecture if we turn to one of his most surprising paintings, *Susanna at the Bath*, dated 1526, the very year he received the appointment as architect (fig. 421). What kind of a building is this? In truth, it is not pure fantasy but is meant to be an actual royal palace. A highly detailed preparatory drawing of the structure by Altdorfer is preserved in Berlin, and its design is inspired, in part, by no less an architect than Bramante.

We look down on the expansive marble floor of the great courtyard behind the palace. It has all the charm and attraction of one of those giant dollhouses, complete with miniature furniture and people, that one frequently finds in the upper rooms of European museums. One wonders, in fact, if Altdorfer had something more than an episode from the Old Testament in mind when he composed this extravaganza. And what about the chaste Susanna? She appears seated in the lower left corner, fully clothed, having her feet washed by an attendant.

Altdorfer had more important commissions during these years, and one, executed for the city at the request of the duke of Bavaria, the *Battle of Alexander* (colorplate 57), is an outstanding monument of German Renaissance painting.[28] The *Alexanderschlacht*, as it is called in German, was commissioned in 1528 by Duke Wilhelm of Bavaria to inaugurate campaigns against the Turkish armies invading Austria and threatening Regensberg on the frontiers of Bavaria. Our first impressions on looking at Altdorfer's huge panorama are ones of exhilaration and awe as well as confusion and bewilderment. Someplace down there on the vast plains are the Greek armies pursuing the Persian forces of the emperor Darius, but which is which? It is only with considerable concentration that we finally make out the figures of the principals: Alexander, dressed in exotic Gothic armor on his famous white horse Bucephalus, pursuing Darius, who flees in a troika, both leaders clearly identified by inscriptions on shields. A resplendent cartouche, swaying slightly in the wind, hangs from the top of the painting (which has been cut down) and carries an inscription that briefly states the theme: the triumph of Alexander the Great over the Persian Darius. The allegory implied is obvious. Just as Alexander had repulsed the invincible armies in their quest for world conquest, so the Hapsburg emperor and his troops will vanquish the awesome forces of the Turks in their ambitious campaign to conquer all of Europe.

Altdorfer's textual sources were near at hand. Johannes Aventinus, a German scholar and historian, was commissioned in 1527 by Duke Wilhelm to write a lengthy history of Bavaria, a multivolumed opus beginning with ancient history, as part of his anti-Turkish program. Following earlier histories, Aventinus tells us that after defending the Hellenistic borders along the Danube in 335 B.C., Alexander encountered the Persian military camps on the Illus River bordering Syria. After a devastating battle, he won a dramatic victory over the vast army of Darius—a million soldiers were reportedly involved—and pursued his enemy into the hinterlands.

Aventinus relates how the battle was a bloody all-day holocaust, and that God, the sun, was triumphant in the end. Hence Altdorfer dramatically included the setting sun over the conquering Greeks—Alexander was the "sun-god" (as was Maximilian according to Dürer's inscription on the triumphal chariot he designed; see p. 339)—and the faint crescent of the moon (the sign of the Near East) over the retreating Persians on the left. Thus the event as well as the setting and action were of cosmic proportions.

Not surprisingly, several attempts have been made to identify the landscape as a view of Venice, Padua, or as a pastiche of landmarks leading from the Danube to the Adriatic Sea, where the Turks first encountered the Christians. That we have here a mind-boggling expansion of the Danube landscapes found in Altdorfer's paintings is apparent: the divisions of the panorama, the icy-blue mountain ranges, the Gothic villages nestled in the hills and valleys, and the drama unfurling among the elements in the sky are all part of the artist's landscape vocabulary. But here, forsaking the conventional foreground stage with the major figures seen up close, the landscape is one sweeping expanse of middle ground and far distance that covers all, with its broad plateau in the lower half of the panel serving as a platform for the actual battle.

Such battle scenes were common subjects for imperial patrons. The Housebook Master, Dürer, Cranach, and others before Altdorfer were often busied by such themes of military encampments and campaigns of battle, but there is something astonishingly new and refreshing in this elaborate display. Flemish and German versions of the battle were usually monotonous pictorial catalogues of men, horses, carts, weapons, and machines mechanically aligned in frieze formation. In Italy we see the same motifs treated in a more or less theatrical fashion by Simone Martini, Paolo Uccello, and Leonardo. But Altdorfer's battle is different. This is a conflict of worlds not men, of the universe not cities.

Altdorfer's painting brings to mind some super-tabletop enactment of an entire campaign with countless toy

422. WOLF HUBER. *Mondsee Landscape with Bridge.* 1510. Drawing, 5 × 8⅛". Germanisches Nationalmuseum, Nuremberg

soldiers appointed their positions by an ambitious schoolboy playing war. And what a show! Everything is here: the foot soldiers, the cavalry, the bannerets, the dead, the debris, as well as the encampments and the preparations. But this staffage is only the beginning of Altdorfer's sublime war games. The setting is truly cosmic, a vast panorama in roiling flux wherein the details are lost and mean little. It is the flowing *cosmos* at war in which *man* (those engaged in the chaotic battle on the plain of the Illus), *nature* (the sprawling mountains, valleys, and waters that overwhelm the closer plateau-stage for the countless tiny figures), and *God* (the fundamental elements in the deep, nearly infinite universe with its spiraling sun and swift rotation of dark blue clouds) provoke an awesome response that we cannot quite articulate.

"Cosmic" is perhaps not the proper word to use insofar as it implies a universe conceived as an orderly and harmonious system, as something vast but structured and constant, and it is not so here. Altdorfer's universe is turbulent, changing impetuously, moving dramatically, and it will never be the same once this eventful day has passed. It is, after all, the sun, still vibrating, that is victorious, creating the light from its spiraling nebula that announces the ultimate superiority of Alexander, son of suns, while the crescent moon of the Persians, whose light can only dimly reflect that of the sun, retreats to its deep, dark hole in the upper left over the fleeing Darius.

Altdorfer established the romantic and fantastic "Danube" landscape as nature's domain in Northern painting, and his influence was far-reaching. Even when the views seem almost topographical, as in the refreshing sketches by Wolf Huber, one of the most gifted of Altdorfer's followers (see fig. 422), the deep valleys, snow-capped mountains, and eerie trees hanging with moss convey the sense of someplace wild and untouched.

423. Hans Baldung Grien.
Coronation of the Virgin. 1512–16.
Panel, 9′ 2¼″ × 7′ 10¼″.
Cathedral, Freiburg im Breisgau

Combine this spirited woodland with the spooky glow of lanterns, moon, and stars, such as Altdorfer paints in his *Christ in the Garden of Gethsemane* or *Night Nativity*, and the excitement and disquietude of the romantic haunts reach a fevered pitch. It is no wonder, then, that night scenes in paintings or the chiaroscuro woodcut, where crisp lines are veiled beneath dark, amorphous tonalities, became so popular. And it is in this chaos of darkness and deep, threatening forests where the abodes of the witches are found and where their weird Sabbath is performed. With witchcraft we enter the dark dens of black magic and alchemy.

The quest for knowledge in an expanding world took on diverse and strange forms in the Northern climes, and together with the rational modes of scientific investigation—those of mathematics, geometry, and astrolabes—the obscure practices of magic and alchemy must be reckoned with seriously. Alchemy was not just some bizarre, fanatical quest for the transformation of lead into gold, as is so often generalized, but a disciplined science, based on metallurgy, that has more recently found its proper place in the pre-history of chemistry.

The most colorful practitioner and theorist of alchemy in the early years of the sixteenth century was Theophrastus Bombastus von Hohenheim, better known as Paracelsus (1493–1543), who claimed authority over all others, ancient and modern, including Hippocrates, Galen, and Celsus, in his knowledge of the natural sciences.[29] For Paracelsus the world and its elements are in constant flux from growth and decay to rejuvenation, and much of this process can be studied in the chemist's retort. The influence of Paracelsus in the arts is admittedly vague and speculative, yet there can be no question regarding the general impact that alchemy had on artists and members of the humanist circles in the North.

Paracelsus was but one of many new scientists of his day to associate with the humanists, many of whom were practicing alchemists themselves. Among these,

left: 424.
HANS BALDUNG GRIEN.
Rest on the Flight.
c. 1512–15.
Panel, 18⅞ × 14⅝".
Germanisches
Nationalmuseum,
Nuremberg

right: 425.
HANS BALDUNG GRIEN.
Death and the Maiden.
1509–11.
Panel, 15¾ × 12¾".
Kunsthistorisches
Museum, Vienna

well known today is the quasi-legendary Doctor Johann Faustus (c. 1480–1540), the magician and astrologer who made a pact with the devil for the knowledge of nature's inner secrets. Faustus lived in the Middle Rhine at the same time that Dürer was active in Nuremberg. Several of Dürer's prints testify to his interests in alchemy, and one leading authority has written a lengthy study in which it is demonstrated that alchemistic ideas and methods are overtly presented in the famous engraving of *Melencolia I.*[30]

The world of witchcraft and alchemy had its most vivid representation in the art of Hans Baldung Grien.[31] A member of an affluent, learned family of professionals—his father was an attorney of some renown, his brother was a professor at the University of Freiburg—Baldung received part of his artistic training in Dürer's shop, 1505–7, as a designer of graphic illustrations. After leaving Dürer, he returned to the Rhineland, where he soon became a respectable city artist and wealthy property owner who took an active role in the civic life of Strasbourg, where he lived for the greater part of his life. This same Hans Baldung Grien, who painted a sumptuous altarpiece of the *Coronation of the Virgin* for Freiburg (fig. 423), was also the highly imaginative illustrator of the activities of practitioners of the occult arts that were never before considered the domain of the artist, although Altdorfer and the Swiss painters Urs Graf and Nikolaus Manuel Deutsch had treated the theme of witches in random drawings. Strasbourg was an active center of humanism, headed by Sebastian Brant, the famed satirist of the *Narrenschiff*, and was represented by a variety of scholars, some of whom were actively in-

volved in the study of witchcraft, much to the chagrin of conservative churchmen, Catholic and Protestant alike.

Baldung's larger religious works, such as the *Coronation of the Virgin*, have received adverse criticism for the rather heavy-handed manner in which he portrays the holy personages and the pronounced manneristic effects they display. Clearly heaven was not the domain of Hans Baldung Grien. The artist was more successful in treating smaller devotional panels, such as the very charming *Rest on the Flight*, of about 1512–15 (fig. 424), wholly in the tradition of the Danube school pictures of Altdorfer and Cranach (figs. 416, 433) while faintly echoing the melodious types in Schongauer's engravings. The composition is simple and the mood lovable with Mary cuddling the Child who plays on her lap, Joseph studying the next directions of their journey, and a small bird, perched in a branch above, providing the rustic melody for their recess. Mary's mantle is full and modeled in bold, broad areas accentuating her pyramidal bulk, and the background is a less fanciful version of the familiar Danube forest valleys.

Baldung's experiments with the macabre were initiated early in Strasbourg, 1508–12, before his sojourn in Freiburg to complete the commission for the cathedral there, and one of these is the enchanting *Death and the Maiden* or, more properly, *Death and the Three Ages of Woman* (fig. 425). In a rugged woodland clearing four figures have gathered, the central one being a fair-skinned and voluptuous nude maiden gazing into a hand mirror as she carefully arranges her long golden tresses. A sheer veil is draped across her thighs; one end loosely wrapped around her right arm falls to the ground where

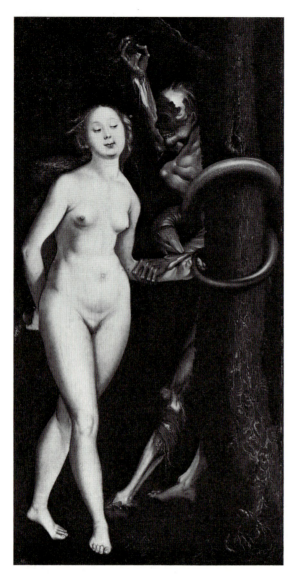

426. HANS BALDUNG GRIEN. *Eve, the Serpent, and Death.*
c. 1520–25. Panel, 25¼ × 13″. The National Gallery of
Canada, Ottawa

her infant counterpart, having dropped a hobbyhorse, hides and holds the transparent cloth across its body and looks furtively upward at the maiden. The other end of the veil is held by a grotesque skeletal figure of Death, skin and flesh hanging from its bones and skull, holding an hourglass over the girl's head. A third female, the woman in old age, strides in abruptly from the left and gestures to ward off the claim of haggard Death. Her body is emaciated and drawn and her skin has darkened with age.

In this curious painting, Baldung has culled elements of three popular stories of the macabre: the Dance of Death, whereby the skeletal Death confronts and mocks its victim; the image of *Vanitas*, suggested by the mirror held by the maiden that reflects the ghoulish features of

Death's skull and not her own pretty face; and the allegory of the Ages of Man, here presented in abbreviated form as three stages in the life of the maiden, from birth to old age. Other than conflating three images of the vulnerability of youthful flesh and the vanity of it all, Baldung has not presented an original iconography here. The combination is imaginative and the setting in the eerie landscape is unusual, but otherwise the figures are all familiar ones, although various iconographic interpretations have been suggested for the curious ensemble.[32]

The maiden, whom we may safely call *Vanitas*, is cast in the form of a seductive Venus-Eve. It was probably in Dürer's workshop where Baldung developed his interest in the female nude, and, in a general sense, the figure of the maiden is an adaptation of the Venus-Eve in the 1504 engraving of *Adam and Eve* (fig. 348), executed by Dürer when Baldung was in his studio. It is interesting, however, that Baldung enhances the sensuous and erotic appeal of the maiden. For one thing, she is definitely younger and more approachable with her coy smile and inviting eyes. The soft flesh of her body more so than the solid corpulence of Eve is also conveyed through the softer outline of her hips, the fullness of her breasts, and the suppression of darker modeling tones in her creamy-white flesh. The girl is unaware of Death who quietly creeps up behind her; she is wholly occupied in the grooming of her long, silken hair.

Time soon runs out for our seductive young maiden, and in a later version of the theme (colorplate 58), dated 1517, soon after the artist's return from Freiburg, the unexpected results of her vanity suddenly appear, striking terror into her heart, as her awaited lover turns out to be a grimacing Death who embraces her with its bony fingers pulling at her hair, a reminder that her beauty will soon vanish, as the ominous inscription above her head warns: "This is your end." The sinister dark background and the sterile gravel stage, replacing the more colorful woodland scene of the earlier version, form an eerie setting in which the skeleton of Death emerges as a fleeting, luminescent apparition. Baldung's nude maiden is even more voluptuous than before; her sensuous body turns slowly, and her clenched hands and sorrowful upward gaze convey the anguish she experiences at the realization of the transience of her youth and beauty and the final triumph of age and death.

It is clear from a study of Baldung's drawings, woodcuts, and paintings of Adam and Eve that the artist was preoccupied with the notion of the female nude as the temptress and seducer as much as the victim. In examples of the Fall, Adam is given a distinctly secondary role, usually behind Eve, glaring lecherously at her and fondling her breasts or thighs; in one drawing he is omitted altogether as Eve, holding the apple in her right hand be-

low the head of the serpent, glances enticingly out as if the viewer were Adam. In a chiaroscuro woodcut, dated 1511, Eve again appears as the carnal force luring the erotic intention of Adam, thus illustrating the sensual power of woman over man.

This same idea is presented with even more force in a highly original variation of the Fall recently acquired by the National Gallery of Canada (fig. 426). The painting, usually entitled *Eve, the Serpent, and Death*, has been the subject of much recent scholarship not only concerning its date (Baldung's chronology is a particularly thorny issue), but also its meaning and the identification of the figure of Death.[33] Baldung's invention here rings of sensationalism in many respects. The exaggerated sensuality of Eve with a startling emphasis on her fair flesh, the teasing tilt of her head, her alluring glance with feline eyes, her slightly pursed lips, the soft tapering of her shoulders and pronounced undulation of her thighs, and, most of all, her precarious dancing pose, all enhance her body as an object of sexual desire. With her right hand she secretly hides the forbidden fruit behind her, and with her left she delicately grasps the curving tail of the serpent which is coiled tightly around the tree as it bites the forearm of Death.

The unusual gesture of Eve is certainly erotic, and the action of the snake implies that it is Death who is her victim this time. But who is Death? In this context the male figure should be Adam, and, in fact, it is, here seen in his most gruesome state as someone consumed and destroyed by his intense carnal longings. With his left hand he spastically reaches for Eve, and with his right he instinctively plucks another apple from the tree. From his dying body hang visceral remains, veins and tendons, all suffused with reddened capillaries. Flesh rots on his skull, and blotches of blood spread across his face and limbs, creating a macabre figure of the vilest nature, comparable only to those horrifying tomb sculptures that show the condition of man's corpse two years after death. According to Cornelius Agrippa, a leading authority on witchcraft and the magic arts, it was the excitement that Eve purposefully aroused in Adam, seducing his body and ego with carnal desire, that was the true cause of original sin and the Fall and not knowledge in general (*De originali peccato*, 1529).

In this context we turn to one of Baldung's favorite and most imaginative themes, the *Witches' Sabbath* (fig. 427). His print introduces us to the new technique known as the tonal or chiaroscuro woodcut, first used by Burgkmair and Cranach (see p. 373), in which one block is cut and inked in the traditional manner for the black-and-white print and a second is prepared with much broader highlights inked in gray or some color (Baldung also used orange) and then pressed over the first state.

The result is a print that resembles something between a woodcut and a painting with pictorial patterns superimposed over a purely linear design. The chiaroscuro print involves a less-demanding technique as far as the *Formschneider* (cutter of the block) is concerned since the patterned highlights replace much of the delicate cross-hatching and shading that would be required in a print by Dürer, for instance, but the effect would be especially appropriate for Baldung's subject.

The stage and the *dramatis personae* are familiar by now. It is the deep, overgrown forest with winds and storms gathering and only the moonlight filtering through the mosses and fir trees to illumine the action. Emerging from this eerie wilderness are the dancing forms and shadows of naked, disheveled witches celebrating their Black Mass in raging abandon. This untamed, primordial Eden is the antithesis of the civilized world, and its inhabitants are wild creatures—goats, cats, amphibians, and witches. These lewd conjurors are females, reciting incantations and stirring septic stews in cauldrons that

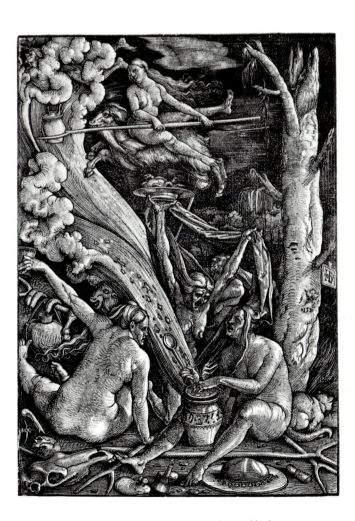

427. Hans Baldung Grien. *Witches' Sabbath*. 1510. Chiaroscuro woodcut, 14⅞ × 10¼"

boil over, sending sulphurous flames, fumes, and smoke into the night winds.

Witchcraft is prehistoric religion gone to seed and overlaid by more sophisticated sacraments involving alchemy and magic. There is a sequence in its rituals that involves roughly similar steps in many other religions: initiation, confirmation, communion, and consummation of worship. The term ''Black Mass'' means, simply, an inverted and perverted Christian Mass as known in the Catholic church, but with the witches the high priest is the devil (not Christ), the destroyer (not the Savior), the ravisher (not the true lover of charity). Summoned before the congregation or coven of twelve to thirteen women, their god is almost always a man in the guise of Satan, the fallen angel Lucifer, who gives his unholy apostles their heinous missions of poisoning and polluting the minds of common folk, unleashing sex orgies on entire communities, or channeling the raw forces of nature—air, earth, fire, and water—into devastating catastrophes.[34]

The preparation of the secret potions and ointments is the most important initial step. Concocted of putrefying animal parts and baneful herbs, these brews when rubbed into the pores or inhaled as perfumes bring on feverish trances and hallucinations that transport the participants on goats, broomsticks, and other weird devices through the midnight skies to meet their secret companions of the coven; and they are an odd lot, ranging from the very young to the very old, from sensuous temptresses to disgusting hags. Many hours later, after the spell has waned, they return to their village homes in the disguise of their ''domestic familiar,'' often a cat.

Witchcraft, its organization and rituals, assumed many different forms in the Late Middle Ages, and various catching titles—the Brethren and Sisters of the Free Spirit, the Adamites, etc.—were often taken over by those groups that had expanded into recognizable religious communities by the early fifteenth century. It was in response to such irreligious and anticlerical movements that Pope Innocent VIII called upon two Dominicans, Heinrich Krämer and Jacob Sprenger, both from the environs of the Upper Rhine, to draw up a manual for inquisitors of such heresies in the Rhineland and northern Germany that would enable the church to identify those possessed by demonic powers, to force their confessions in a quasi-legal fashion, and prescribe torturous punishments to rid the countryside of them.

The strange but fascinating encyclopedia of witchcraft was called the *Malleus Malificarum*, or *Hammer of the Witches*, and after being proclaimed authentic by a papal bull, it was published by the major presses in the Rhineland, and between 1486 and 1520 at least fourteen known editions were issued.[35] The pope appointed Al-

brecht von Bayern, the bishop of Strasbourg (1478–1506), to supervise its enforcement. It was in this environment that Hans Baldung Grien found himself in 1508 when he became a citizen of Strasbourg for the first time, and it is at this time that the first arts dedicated to witches became public.

What exactly motivated Baldung to pursue his interest with such industry and care is difficult to say, but considering his works already discussed, it would seem that witchcraft was another of the timely abnormalities of his hectic society that he found fascinating. It also seems that his obsession with such unusual themes as the satanic powers of women must stem, in part, from his conviction that Venus-Eve-Woman was truly a threatening force in man's world. According to the *Malleus Malificarum* (1: 6), we read, ''What else is woman but a foe to friendship, an inescapable punishment, a necessary evil, a natural temptation, a desirable calamity, a domestic danger, a delectable detriment, an evil of nature, painted with fair colors!''

Baldung's *Witches' Sabbath* (fig. 427), dated 1510, is one of his first and most ambitious single-sheet woodcuts

428. Hans Baldung Grien. *The Bewitched Groom*. 1544. Woodcut, 13½ × 7⅞"

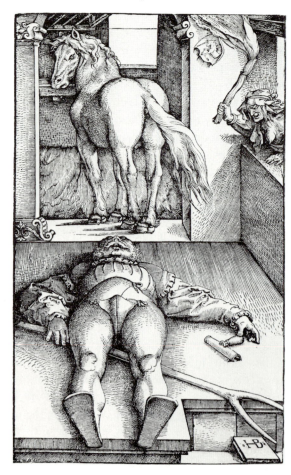

designed in Strasbourg. Printed in chiaroscuro, it is inscribed with his initials on a tablet hanging from a tree on the right. The composition, masterfully designed to convey the dramatic sense of instability and explosive motion, is dominated by a triangular group of witches in the foreground (a motif appearing in later representations of the witches mixing their brew in Shakespeare's *Macbeth*).

Two nude witches are seated right and left; a third kneels between them. One lifts the cover from a large jar marked with strange cabalistic lettering to release venomous vapors and fumes that stream upward to the left, carrying tiny bits and pieces of the concoction, including what appear to be mice. In the center an older hag screeches as she thrusts her arms upward and presents a platter of reptilian remains and grotesque birds to be added to the mixture. The third, legs spread and arms waving, lifts a chalice with the hallucinogenic broth, the "flying potion," about to be consumed.

This triangle of witches is sharply intersected by a giant, throbbing wedge formed by the heavy fumes on the left and the gnarled trunk of a dead tree on the right, a "V" shape repeated in the uplifted arms of the kneeling hag. Other prominent compositional lines are formed by the horizontals of the pitchfork in the foregound and that carried by the flying witch above. The latter carries a cauldron in the prongs of the fork and rides backward on a goat so that she has no control or care over the flight of her mount. In the top left corner another possessed hag flies among the fumes under her own power. A sixth member of the coven, just visible in the center, carries a flaming bowl on a pole, and to the left the grotesque head of a goat leers out with its leg guiding a forked pole from which a retort and distillation tubes of gut (?) hang.

Scattered across the barren foregound are a number of strange objects including human and equine skulls and bones, three more pronged forks, a hat-shaped bowl used in preparing the potion, and other ritual gadgets. To the far right, a cat is curled up behind the witch with the cauldron, very likely her "domestic familiar." Baldung's highly imaginative composition and complex iconography are not, however, without precedents. A tonal drawing signed by Altdorfer and dated 1506 (Louvre) displays a number of these same figures and objects, but, as is to be expected, Altdorfer's *Walpurgisnacht* is dramatized more by the eerie forest setting than by the violent gestures and contorted forms of the witches as we encounter them in Baldung's powerful print. The drawing, however, is evidence of an established tradition for such genre from which Baldung drew inspiration.

The most puzzling print among Baldung's *Hexenbilder*, or representations of witches, is the so-called *Bewitched Groom* (fig. 428), one of his last works. What does it mean? Various explanations have been offered. It does not seem likely that the horse has kicked the groom, or that the witch in the window has cast a spell; rather, the groom, preferring to ride with Satan on a fork than ride his stallion, has taken the magic "flying" brew and fallen backward over the step in an unconscious state.[36] His journey is a mental disillusion or hallucination, as if he were in a long nightmare from which he will later awake. If this simple explanation is acceptable, then one can say that Baldung's own beliefs in such magic rides and transported states are cynical, much as were those of Hans Sachs, the famed German songwriter of the period: "The devil's pact and ridery / Is merely myth and fantasy."

The spells of the witches, the weird happenings with mysterious revelations, the fascination with such unholy operations of the occult arts did not end with Hans Baldung Grien. We find them again in the clandestine art traffic in the bustling commercial centers of Flanders, in the secretive chambers of wealthy collectors throughout northern Europe, and in the strange many-paneled paintings resembling large church altarpieces devised by the most famous conjuror of nightmarish imagery in the Netherlands, Hieronymus Bosch.

Lucas Cranach the Elder: The Conflicts of Humanism and the Reformation

The role of Lucas Cranach the Elder in the story of Renaissance Germany is relatively easy to discuss in terms of subject matter, on the one hand, but difficult to assess as to the development and merits of his art, on the other. Early in his career he was attracted to the circles of humanists, and from that vigorous contact much of the warm spirit and freshness of his art are derived. He was also a determined painter and graphic artist for the cause of the Reformation that was spreading so rapidly through Franconia under the inspired leadership of his close friend, Martin Luther. With the sudden change in the intellectual climate of Reformation Germany after Luther's initial impact—a change which some have seen as one from a humanistic reform to a scholastic Reformation—Cranach's art, including his portraits, became more pedagogical and stifling in spirit. Be that as it may, Cranach's career was a long one that spanned some of the most crucial years in the dramatic shift in the history of northern Europe.[37]

Cranach was born in 1472 in the frontier town of Kronach in Upper Franconia.[38] Four generations of his ancestors were painters, including his father Hans, and it is no surprise that his family name was Maler or "painter." He later adopted the name Cranach after that of his hometown. After his initial training with his father, the young Cranach settled temporarily in Vienna which, along with Basel, was the chief center for humanistic studies in the North.

The great Conrad Celtes, the leader of the humanist movement, was made professor of rhetoric and poetry at the University of Vienna in 1497 by Emperor Maximilian, and his successor in that chair, Johannes Cuspinian, was a remarkable young professor who, at the age of twenty-seven, was made rector magnificus of the university in 1500, dean of the faculty in 1501, and given the title of *poeta laureatus* by the emperor. He received a patent of nobility in 1506. It was in 1500, the year Cuspinian became rector, that Lucas, who was the same age, arrived in Vienna and soon became a close friend of the professor, painting his portrait in 1502 (colorplate 59) on the occasion of his marriage to Anna, the sixteen-year-old daughter of an imperial official.

The marriage diptych with Anna on the right (fig. 429) is one of the most endearing statements of Renaissance portraiture that we have by Cranach's hand—and he painted many—in which the pantheistic spirit of the Danube school is superbly attuned to the characterization of the dignity of a refreshing young humanist.[39] The warm but serious countenance of the rector, dressed in an academic robe of black velvet, his blond hair covered by an elegant red cap, is placed high before an exuberant landscape of trees, valleys, and towering cliffs that were certainly inspired by the Danube school of landscape painting that we know Cranach emulated. But this romantic vista is dotted with people and creatures that divert our attention momentarily from the impressive face of Cuspinian turned upward as if lost in big thoughts. The cosmic totality of the Danube landscape, as if a manifestation of his thoughts, transfers its fresh spirit to the sitter and creates a feeling of immediacy in the contemplation and merging of man with nature. In a letter to a Venetian colleague, Aldus Manutius, dated 1502, Cuspinian proclaimed, "My spirit burns for cosmography" (the orderly interrelationships of all forces in nature and the world) so that, he goes on, "the whole world can be seen as a tiny picture."

This cosmic totality in nature or wholeness of parts in the world is alluded to somewhat naively in the intrusions in the landscape that illustrate the domains of the four elements: air, water, earth, and fire. The air is filled with its creatures with two birds of prey emphasized, one in each panel. Above Johann flies a dark owl carrying its victim to its hidden den in the dry tree to the left while being pursued by a host of small birds of the day, a rather familiar motif in the medieval bestiary. This owl has been described as the doctor's astrological sign, but it seems to refer more to the bird of perverted wisdom, the creature of the night, attacked by those of the spirit and overshadowed by the starlike sun that rises directly over the sitter's head. The sky above Anna Cuspinian is dis-

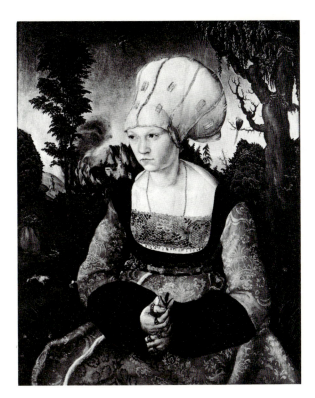

429. LUCAS CRANACH THE ELDER. *Anna Cuspinian.* c. 1502.
Right panel of a diptych (see colorplate 59), 23¼ × 17¾″.
Collection Oskar Reinhart "Am Romerholz," Winterthur

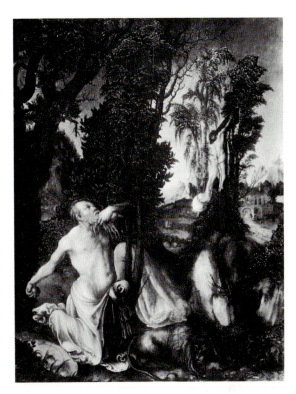

430. LUCAS CRANACH THE ELDER. *Saint Jerome as a Hermit.*
1502. Panel, 22 × 16½″. Kunsthistorisches Museum, Vienna

431. LUCAS CRANACH THE ELDER. *Saint Francis Receiving the
Stigmata.* 1502. Panel, 34⅛ × 18¾″. Kunsthistorisches
Museum, Vienna

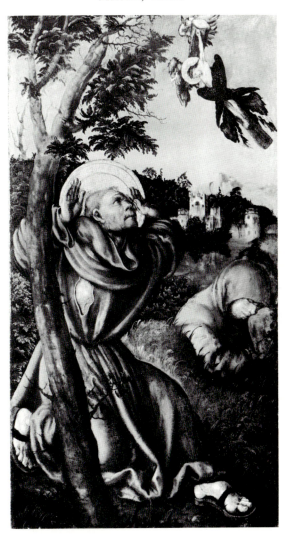

rupted by a vicious falcon who has taken a large water
fowl as prey, while in the tree behind her a colorful par-
rot, the bird of wisdom, perches intently as if to guard
the mistress. Water is represented by the large pond, a
fountain of life, that runs through both panels with its
curious nude bathers and washerwomen (?).

An overgrown Danube valley, also punctuated with an
odd assortment of figures, exemplifies "earth" with its
high hills and icy mountain peaks, while "fire" is dra-
matically presented in the burning village over the right
shoulder of the wife, perhaps an allusion to the destruc-
tion of Sodom by flames. The activities of the tiny fig-
ures in the landscape are not clear, but it may be that
Cranach footnotes his miniature cosmos with sinister
touches or blemishes in nature that, however, will be
erased by the true wisdom of divine light, the sun above
Cuspinian, and in the words of the book he carries. The
likenesses of Cuspinian and his wife have been rightly
praised as the most beautiful portraits of old Germany.
The beauty of the colorful costumes, the dignity and
freshness conveyed in the faces of this young couple—he
with his book and looking skyward, she with her carna-
tion and directly regarding her handsome husband—
make this a most felicitous first encounter in our study of
Cranach.

Cranach executed other portraits of friends in the uni-
versity circles of Vienna in the same format and type as

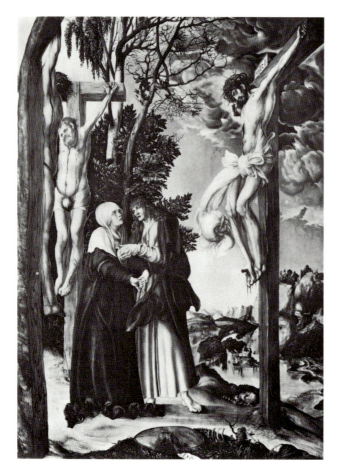

432. Lucas Cranach the Elder. *Crucifixion*. 1503. Panel, 54½ × 43″. Alte Pinakothek, Munich

433. Lucas Cranach the Elder. *Rest on the Flight into Egypt*. 1504. Panel, 27⅛ × 20⅛″. Gemäldegalerie, Staatliche Museen, West Berlin

that of the Cuspinian diptych with bust-length sitters posed on a grassy bench before a verdant landscape. He also painted a charming set of smaller panels, dating 1502, depicting *Saint Jerome as a Hermit* and a diptych with a donor and *Saint Francis Receiving the Stigmata* in a landscape (figs. 430, 431), the latter being a popular Italian saint who was considered a precursor of the pantheists of the Danube school in his devotion to intimate communion with nature. Both panels give evidence of Cranach's familiarity with the graphic works of Dürer, but the execution is sketchy with thickly brushed-in highlights for the ridges of the drapery, a technique he would soon abandon.

More original and impressive is the larger *Crucifixion* (fig. 432), dated 1503, in Munich in which Cranach places the viewer at a lower angle of vision and surprisingly arranges the three crosses to the sides along diagonal axes with the dead Christ seen alone on the right against a turbulent stormy sky with the wind whipping at his loincloth. The center is occupied by the two principal mourners, Mary and John the Evangelist, who serve as a compositional link between the two halves of the picture. A dry tree grows behind them in an otherwise verdant mountain landscape separating even more emphatically the idealized body of Christ from the grotesque forms of the dead thieves on the far left.

The charming *Rest on the Flight into Egypt* (fig. 433) may have been executed after Cranach left Vienna for Wittenberg. This theme, which as we have seen was a favorite in Germany and the Netherlands by this time, is treated in a conventional fashion by Cranach, so much so that the Holy Family appears to be posing for their portraits—both Mary and Joseph look out tenderly at the observer—with the delightful addition of a picnic party of singing and playing angels. The wild but comforting woodland with its tall pines and birches is one of Cranach's finest contributions to the Danube school tradition. He signed and dated the panel with an "L" over a "C," 1504, on a flat stone washed by the stream along the lower border.

Cranach's decision to settle in Wittenberg, far to the northwest in Saxony, was due, in part, to the reputation the capital of the elector of Saxony, Frederick the Wise, was rapidly attaining among humanist circles. Frederick, a pious and quiet benefactor of Luther's reform movement, founded a university there in 1502 that stressed the study of the humanities with special attention given to the arts. In Wittenberg and at his residences in Lochau and Torgau (a sumptuous hunting lodge) Frederick the Wise enrolled artists headed by the famed Venetian Jacopo de' Barbari, an exponent of classical themes known mostly today by his delicate engravings of standing and reclining nude goddesses.

Frederick was no hedonist, but he obviously felt that his new court should be able to rival the Italians in their familiarity with ancient Greco-Roman culture and mythology. Jacopo left Wittenberg in 1505 and Cranach was called in as court painter. Much happened to the artist over the next few years. He became an intimate friend of the humanist scholars gathered about Frederick—who praised him as the equal to Dürer—and he was enrolled in diplomatic missions, including one to the Netherlands in the fall of 1508. And, of much importance, was his close friendship with Martin Luther, who was then on the faculty of theology at Wittenberg.

For Frederick the Wise, Cranach executed a number of woodcuts, mostly religious or devotional in subject matter, and a few very curious panels of dubious artistic merit, including the *Saint Catherine Triptych* in Dresden and the *Fourteen Helpers in Time of Need* at Torgau, with a placid execution of standing or bust-length figures in frieze formation across the panels. In these his drawing becomes tighter, but the articulation of the figures is clumsy and the rich colors of his earlier palette are abandoned for an innocuous medley of watery pastel tones. It is about this time too that Cranach began experimenting with effects of pattern, beginning with a series of drawings in black and white on toned paper.

While this technique was relatively new and interesting, Cranach's attempts were not too successful. The abundance of white highlights frequently creates a flickering pattern across the surface that obscures the basic black outlines on the dark paper. A second experiment, also short-lived, was made using the woodcut medium. Some of his prints introduce us to the new technique known as the tonal or chiaroscuro woodcut. That Cranach realized this technique was an innovation is attested to by the fact that he purposefully misdated some to 1506 to gain priority over Hans Burgkmair (see p. 385), who had also developed this means of printing early. In some of these, such as the *Venus and Cupid* (fig. 434), he at times eliminated the tonal block to better exploit the sensuous lines of the classical nude, another new interest that Cranach soon put aside and returned to later in his career.

One welcome exception among these early Wittenberg works is the handsome triptych of the *Holy Kinship* (fig. 435), painted for Frederick the Wise and his family in 1509 just after the artist's return from the Netherlands. One is immediately struck by the new breadth and monumentality of his composition with the figure groups placed in a space supported by a solid architectural setting. It is very likely that Cranach had seen in Antwerp the recently executed *Holy Kinship* painted for the Confraternity of Saint Anna by Quentin Metsys (fig. 470). The arrangement of the two sisters of Mary and

434. LUCAS CRANACH THE ELDER. *Venus and Cupid*. 1509. Tonal woodcut, 10⅞ × 7½″

their children in triangular groups about the *Anna Selbdritt* (Mary–Anna–Christ Child, literally "Anna, herself, the third") seated in the center, the impressive quasi-Renaissance loggia, the ornate costumes, and the gathering of the husbands of Anna behind the balcony or parapet are all features that are distinct departures from earlier German versions of this popular theme, but are found in the work by Metsys. Cranach's modeling also seems more refined with softer highlights playing across more intricately pleated patterns of folds.

The subject matter of the Holy Kinship in the context of an imperial commission is of special interest. The German obsession with genealogies took on many forms in the arts, and it was commonplace for artists of the royal courts to design endless cavalcades or parades of ancestral members of their patrons on horseback aligned chronologically back to antiquity. Perhaps due to Frederick's sympathies for Luther and his pride in humble family ties, the elector of Saxony chose to cast his ancestry in the guise of the Holy Kinship, the *gemütliche* gathering of fathers, mothers, uncles, aunts, brothers, and cousins, and not the pompous genealogies of its regal kin in the trees or parades of nobility.

The members of the immediate Holy Family—Mary, Joseph, Anna—are discreetly isolated from the others, and they surely are not meant to be confused with actual portraits of the imperial family. But on the left wing, Alphaeus, standing proudly behind Mary Cleophae and her four sons (James the Less, Simon, Judas Thaddeus, and Joseph the Just), is Frederick the Wise himself, easily recognized from other portraits Cranach executed of

435. LUCAS CRANACH THE ELDER. *Holy Kinship Altarpiece*. 1509. Panel, 47¼ × 39″ (center); 47¼ × 17⅛″ (each wing). Städelsches Kunstinstitut, Frankfort

far left: 436. LUCAS CRANACH THE ELDER. *Duke Henry the Pious of Saxony*. 1514. Left panel of a diptych, 72½ × 32½″. Gemäldegalerie, Staatliche Kunstmuseum, Dresden

left: 437. LUCAS CRANACH THE ELDER. *Duchess Catherine of Saxony*. 1514. Right panel of a diptych, 72½ × 32½″. Gemäldegalerie, Staatliche Kunstmuseum, Dresden

opposite left: 438. LUCAS CRANACH THE ELDER. *Sibylle of Cleve*. 1526. Panel, 21⅝ × 14⅝″. Schlossmuseum, Weimar

opposite center: 439. LUCAS CRANACH THE ELDER. *Saxon Prince*. c. 1516–18. Panel, 17¼ × 13½″. National Gallery of Art, Washington, D.C. Booth Collection

opposite right: 440. LUCAS CRANACH THE ELDER. *Saxon Princess*. c. 1516–18. Panel, 17⅛ × 13½″. National Gallery of Art, Washington, D.C. Booth Collection

him. On the right panel, in the guise of Zebedeus, husband of Mary Salome and father of James the Great and John the Evangelist, sits the elector's brother, Duke John. Finally, on the balcony behind the Holy Family appear three more figures—the three husbands of Anna—and the prominent one in the center (Joachim?) wearing the gold collar is certainly meant to portray Maximilian the Great, the Hapsburg king of the Holy Roman Empire. This, then, is quite a different lineage for a royal family, but it is one that would have pleased Luther and no doubt have put a smile on his face.

A marked departure in Cranach's portrait style appears in his works of the next decade, perhaps reflecting his lingering interest in surface pattern suggested in the experimental graphic works. The decorative Mannerism that resulted from shifts in taste in the courts of Italy and the North ushered into vogue a curiously elongated figure type posed in an affected stance and bedecked with lavish items of dress. Only the heads retain the bold realism of earlier traditions, the body itself becoming little more than a symbolic pattern or advertisement of status. The draped figure is no longer vigorously modeled or plastically conceived, and the settings are abstracted to flat, planar backdrops for the decorative display of pomposity and haughtiness.

An excellent example is Cranach's wedding portrait of *Duke Henry the Pious of Saxony* and his wife *Duchess Catherine* (figs. 436, 437), signed and dated 1514. Originally joined, the couple makes a bizarre counterpart to Jan van Eyck's *Arnolfini Wedding Portrait* (colorplate 18) or the earlier Cuspinian diptych by Cranach. Lifesize figures of the couple stand uneasily before a stark background on a shallow stage. Duke Henry, a determined Protestant who loved big guns (Cranach designed some for him), stands proudly with arms akimbo and his right leg awkwardly turned outward at an angle. He wears a stunning costume with a bright red suit and stockings under a dark green cloak, both garments slashed in rows revealing the rich gold lining. The duke regards us with a stern stare as he grasps the huge hilt of a long sword, symbol of power as well as protection for the bride, although in the context of a marriage portrait it no doubt has erotic overtones as well. Catherine demurely crosses her hands over her waist and glances out with a definite complacency. She too has a dog for an attribute, but hers is the erotic little lapdog that stands so alert before Giovanna Cenami in Van Eyck's marriage portrait.

On a smaller and more intimate scale, Cranach's Mannerist court portraits can be very appealing. His three-quarter likeness of *Sibylle of Cleve* (fig. 438) as the fourteen-year-old bride of John Frederick of Saxony, dated 1526, is a charming portrait of a young lady at court, sweet, innocent, and happy. Her loose-flowing hair and the delicate floral sprig that she wears as a crown are attributes of the virginal state of the young maiden about to become a bride. The lovable paintings of a *Saxon Prince* and *Princess* in the National Gallery in Washington (figs. 439, 440) are typical of a number of Cranach's portraits of aristocratic children, a genre that was particularly popular at this time throughout northern Europe, as we shall see.

It is well known and documented that Cranach was not only sympathetic to the Protestant movement in Wittenberg, but that he was a close friend of Martin

441. Lucas Cranach the Elder. *Martin Luther Wearing a Doctor's Cap*. 1521. Engraving, 8¹⁄₁₆ × 5⅞"

Luther. Luther, in fact, was the godfather of Cranach's daughter Anna, and the artist himself was named the godfather of Luther's first son. Cranach was living in Wittenberg when on the vigil of All Saints, October 31, 1517, Luther posted his ninety-five theses on the "blackboard" of the university challenging his colleagues to debates over matters of Roman Catholic doctrines and practices. Although Luther had sent a copy of his arguments to Archbishop Albrecht von Brandenburg in Mainz, the councillors of the university there considered his views heretical, precipitating an impossible rift that culminated in the reformer's hearings and excommunication at the Diet of Worms in 1521. In grave danger of arrest or worse, Luther was spirited out of Worms by an armed escort provided by the elector Frederick. He lived for a short while in the castle of Wartburg, and then in the disguise of an aristocratic knight, Junker Jörg, Luther returned to Wittenberg. It was this occasion that

442. Lucas Cranach the Elder. *Martin Luther as Junker Jörg*. c. 1521. Panel, 20½ × 13⅜". Kunstmuseum, Weimar

prompted Dürer's famous *Lutherklage* (see p. 345), a lament that resounded throughout Saxony and Franconia.

Cranach admirably chronicled in portraits the story of Luther during this period. An engraving, dated 1520, portrays Luther in bust, three-quarter view, tonsured and wearing the habit and cowl of an Augustinian monk, the order to which he belonged (as did Erasmus and, incidently, the Brethren of the Common Life). His countenance is striking in the determined upward stare and firmly set jaw. For the occasion of Luther's defense at Worms, Cranach issued another engraved likeness (fig. 441), dated 1521, this time as a bust in profile no doubt in imitation of the Renaissance profile medallions of famous men. Furthermore, Luther here wears the headpiece of a university doctor to point out his learning and authority. In some respects, this portrait is even more impressive than the earlier. The profile allowed Cranach to exaggerate the bone structure of the face, especially the eyebrows, over which the skin seems to be tautly pulled, giving him an even more tense and determined appearance. The tensions that Luther felt on the eve of the Diet of Worms are sharply projected. He knew that he must be both the learned scholar of theology and the stern defender of his principles. This is the Luther who loudly announced, "Here I stand!"

With the return of Luther to Wittenberg incognito as the Junker Jörg, bearded and dressed as a soldier, the romance surrounding such a daring performance was inevitable and brought about cries that the "phoenix of theologians" was resurrected, and the Protestants had, in this new Luther, their earliest image of a revolutionary hero, priestly and militant. This Luther was portrayed in woodcuts and paintings (fig. 442) by Cranach too, but the characterization is less successful. While certain fea-

Colorplate 56. ALBRECHT ALTDORFER. *Danube Landscape*. c. 1520–25. Parchment on panel, 11 × 8⅝″. Alte Pinakothek, Munich

Colorplate 57. ALBRECHT ALTDORFER. *Battle of Alexander*. 1528–29. Panel, 52¼ × 47¼″. Alte Pinakothek, Munich

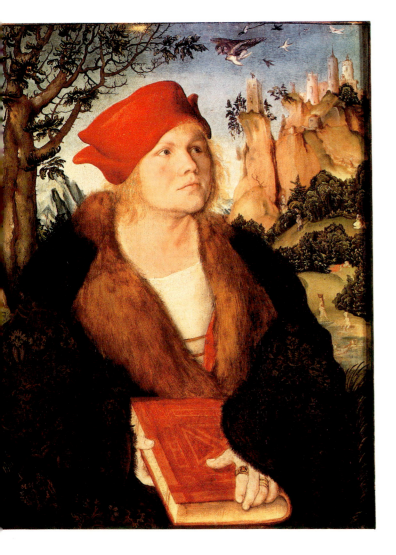

right: Colorplate 58. HANS BALDUNG GRIEN.
Death and the Maiden. 1517.
Panel, 11¾ × 5¾″.
Kunstmuseum, Basel

above: Colorplate 59. LUCAS CRANACH THE ELDER.
Dr. Johannes Cuspinian. c. 1502.
Left panel of a diptych (see fig. 429), 23¼ × 17¾″.
Oskar Reinhart Collection "Am Romerholz," Winterthur

right: Colorplate 60. LUCAS CRANACH THE ELDER.
Judgment of Paris. 1530.
Panel, 13¾ × 9½″.
Staatliche Kunsthalle, Karlsruhe

380

left: Colorplate 61.
HANS HOLBEIN THE YOUNGER.
Portrait of Sir Thomas More. 1527.
Panel, 29½ × 23¾".
The Frick Collection, New York

below: Colorplate 62.
HANS HOLBEIN THE YOUNGER.
The French Ambassadors. 1533.
Panel, 81⅛ × 82¼".
National Gallery, London

tures of his face can obviously still be discerned, especially the eyes and nose, Luther as Junker Jörg is hardly distinguishable from the countless aristocrats that Cranach portrayed, and the uniqueness and vigor of his personality, whether due to the disguise or not, are missing.

The vicissitudes of the great "painter of the Reformation" are, indeed, curious. Two portrait types for Albrecht von Brandenburg, archbishop of Mainz and cardinal of the Roman Catholic church, by Cranach are known in a number of versions and copies: Albrecht as Saint Jerome seated at a desk in the wilderness as a hermit (fig. 443) and, more traditionally, as Jerome the scholar and translator in his study. During the first decades of the sixteenth century, Saint Jerome became the favorite Church Father throughout northern Europe, and due to the ambivalence of his personality, he was heralded in both Protestant and Catholic camps. As the translator of the official Latin Bible, the Vulgate, from

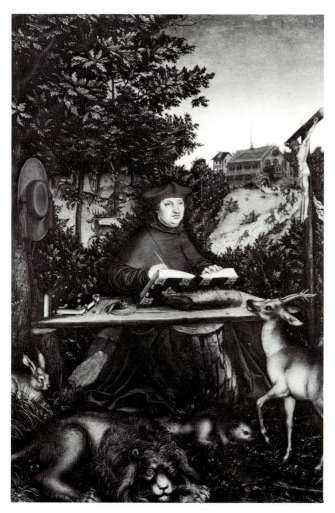

443. LUCAS CRANACH THE ELDER. *Cardinal Albrecht von Brandenburg as Saint Jerome in the Wilderness.* 1527. Panel, 22½ × 14⅝". Gemäldegalerie, Staatliche Museen, West Berlin

its original Greek and Hebrew texts, Jerome was acknowledged as the authority of Holy Writ. For the Protestants this meant that the vast store of commentaries and exegeses written by Catholic theologians over the centuries only confused and obscured the simple message of the Gospels and the Old Testament that Jerome faithfully put down in Latin. The Catholics, on the other hand, could argue that it was, after all, Jerome's Latin that voiced authority and not the new vernacular translations (Luther wrote a German translation), which were often corrupt or in error.

Similarly Jerome the Biblical scholar had been traditionally portrayed in his study busy at work on the Vulgate, as one truly devoted to the contemplative life as Dürer so admirably portrayed him (fig. 392). But in preparation for his work on the translations, Jerome had spent months in the deserts of the Holy Land learning Hebrew, and he then devoted his life to that of a hermit. This latter characterization of Jerome, usually dressed in a simple hair shirt kneeling before a crucifix and beating his chest with stones, was, as we have seen, another popular type in the North. Cranach thus portrayed both Saint Jeromes, but in them he is dressed in the red habit of a cardinal (Jerome was, in fact, elevated to the rank of cardinal in the course of time) busy perusing his books at a desk. It is known that Albrecht von Brandenburg favored reforms within the church, but he nevertheless remained a staunch supporter of his faith. There were many who were reluctant to take extreme positions in the religious conflicts precipitated by Luther, knowing that such positions were dangerous. Erasmus was one of those.

In the long run strict Protestantism was neither favorable nor profitable to the arts. Iconoclasm in general has been an issue of much interest to art historians in recent years, and much attention has been given to the Lutheran position concerning traditional religious imagery.[40] We know from his writings that Luther believed that art, if not confused with idolatry, was a useful tool for the education of a Christian. But it is simply a fact that after the polarization of the Protestant position, pictures were considered idolatrous. This confusion of narrative illustration of scripture and art as icon had been the core of the dispute since the iconoclastic movements of the Early Christian church and ultimately depended on the interpretation of the second commandment given to Moses: "You shall not make yourself a graven image, or any likeness of anything that is in heaven above, or that is in the earth beneath, or that is in the water under the earth" (Exodus 20: 4).

The counterargument, proposed already by Gregory the Great in the sixth century, that pictorial arts in churches were only narrative pictures for the illiterate to

"read," would not satisfy those who advocated the extreme position in iconoclasm. For them the emphasis was on the reading of the Word and the preaching of its meaning. Pictures were out. After Luther, this extreme attitude was voiced more and more in the Protestant church, and for the artist to continue to practice his art in the service of the church meant that his pictures must be blatantly instructive for doctrine and never be confused with verisimilitude or truthful and realistic likenesses. Art, under such restraint, had little chance for survival, let alone growth, and the story of Cranach's late religious paintings, his "Reformation pictures," demonstrates this clearly.

After Lutheranism was established as the official religion in Wittenberg and other Saxon and Franconian centers, there followed a short-lived program to introduce Lutheran subject matter in the repertoire of religious art.[41] A number of these subjects had their origins in Cranach's workshop, where one of the basic themes was that of Luther's definitions of the Law and the Gospel. Essentially Luther proclaimed that a religion which followed only the precepts of Old Testament Law—the Commandments given to Moses—with its harsh penalties for any transgression meted out by a merciless judge, was bound to end in darkness and failure in attaining man's salvation. The Gospel, representing the new dispensation of a world under grace, on the other hand, assured the faithful of salvation at the hands of a God who was forgiving and merciful.

One of the most popular examples of Lutheran painting is entitled simply the Allegory of the Law and the Gospel, a theme that was widely copied in a number of forms: panel painting, carvings for pulpits and other church furniture, woodcuts in manuals of instruction, epitaphs for tombs, etc. It is unlikely that the representation was ever destined to serve as an altarpiece in the traditional sense, however. Such pedagogical teaching with pictures could easily reduce their artistic merit to little more than propagandistic or complex folk art, and that is exactly what happened in time.

The Law and the Gospel was usually presented in a horizontal format divided into two distinct parts. A panel in Gotha (fig. 444), dated 1529, is one of the more complete statements of the original program and can be attributed to Cranach's shop. A tree in the center forms the division emphatically. The branches on the left are barren, sterile, dead, and extend toward episodes that illustrate the Old Testament story of man's fall from salvation and his ultimate damnation. In the middle ground, to the far left, the Fall of Adam and Eve in Eden appears in a woodland. Beyond them, to the right, dry and sandy deserts serve as the land of the wandering Jews, their tents pitched, and Moses, pointing to the brazen serpent (a type for the Crucifixion of Christ), denounces their sins against the prohibition of idolatry as the Israelites fall about the parched ground.

In the foreground stand three Old Testament prophets in the company of Moses who, turned inward, indicates

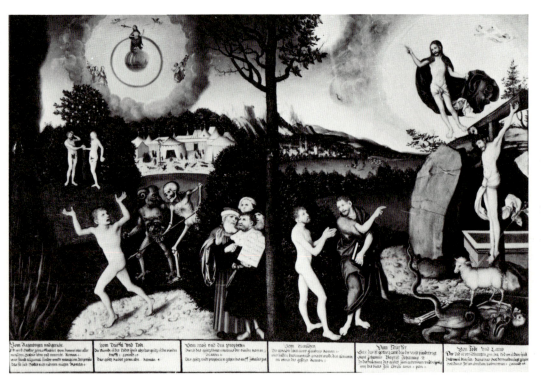

444. Lucas Cranach the Elder and workshop. *Allegory of the Law and the Gospel.* 1529. Panel, 31½ × 45¼". Schlossmuseum, Gotha

the tablets of the Law, the Word, to a nude figure pursued by figures of death and the devil. The nude figure is the familiar damned soul being cast into the flaming pit of hell in the lower left. The point is clear: the Law of the Old Testament and the punishment it metes out lead to death and damnation. To the right of the central axis the tree suddenly blossoms into the Tree of Life. Here another nude, this time an image of one of the blessed, stands in a verdant landscape in an attitude of prayer before the image of the Crucifixion of Christ, which John the Baptist explains to him much as a preacher might do to his congregation.

Cranach's fame is due foremost to his superb portraits, a special art that he maintained up to the last years of his long career. He has also intrigued art historians with his unusual treatment of mythological figures and themes where the goddesses, naked and adorned with the latest fashions in court jewelry and coiffures, romp gracefully about in forest clearings. His earliest prints (see fig. 434) and paintings of the classical nude are surprisingly similar to Italian types that he must have seen or perhaps knew through the graphic works of Jacopo de' Barbari, who was active at the elector's court until 1505. A standing *Venus and Cupid* in the Hermitage, dated 1509, is remarkably like a Venus by Lorenzo Costa in Budapest, a full-bodied nude modeled softly with an almost *sfumato* effect that is unusual in Cranach's oeuvre.

Apparently Frederick the Wise had disdain for such paintings, and it was not until the changes in taste of his later Saxon patrons, including John Frederick, that Cranach returned to such themes. But what a change has taken place in style (fig. 445). Rather than following Mediterranean types, Cranach developed his own personal conception of the ideal female nude which, in fact, is anti-classical and neo-Gothic in appearance. Venus appears as a distant kin of the nude Eve in the *Très Riches Heures* (see fig. 50) with her Gothic canon of proportions: a small head with delicate features and tapering eyes resting on a thin, sinuous neck that turns into narrow shoulders. She has a high, slender waist and small breasts, and her long legs are described as shallow, undulating silhouettes. Her pose is affected and seductive with arms slowly gyrating like those of a young Balinese dancer. To this girlish temptress, Cranach, like some court fashion designer, adds provocative touches of jewelry, baubles and bangles, broad hats and fancy coiffures that turn his ideal nude into a naive and naked *objet d'art*.

At first one does not know exactly how to respond to Cranach's lithesome young beauties, who seem to be delicate toys modeled from polished ivory with no visible skeletal structure. They assume seductive poses and have the uncomfortable habit of regarding the spectator directly with no qualms about their embarrassing nudity.

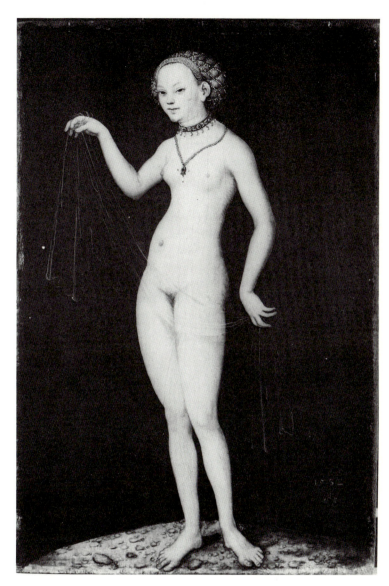

445. LUCAS CRANACH THE ELDER. *Venus.* 1532.
Panel, 14½ × 9¾". Städelsches Kunstinstitut, Frankfort

Whether Venus or any other mythological figure, they seldom wear more than a diaphanous scarf or veil which they slide this way and that in a very suggestive manner.

One of Cranach's most popular mythologies was the story of the Judgment of Paris, of which an early woodcut and a number of later paintings have come down to us, one of the best being that in Karlsruhe (colorplate 60). With the appearance of Paris as a member of the Saxon court, one is tempted to suggest that there may be some remote reference to the state of affairs in Protestant Germany concealed here.[42] The Homeric myth, a favorite of the humanists, was elaborated by Lucian in the second century (*Deorum dialogi* [*Dialogues of the Gods*]), relating in detail how the shepherd Paris was chosen to judge a pastoral beauty contest at which Mercury presided. The

contestants were Minerva, Venus, and Juno, and each, in turn, promised Paris precious rewards should he choose her. Venus offered him the love of Helen, the most beautiful woman on earth, and she won.

Cranach, however, followed more closely the legend as it was given in medieval Germanic versions in which the story unravels in a dream brought to Paris by Mercury. In the Karlsruhe panel, Paris, having attended his flocks(?), rests back on a rock near a spring. He wears a heavy suit of armor and a fashionable wine-red hat, and seems to be half asleep as Mercury, also dressed in armor (Wotan is the Nordic messenger of the gods), presents the three goddesses. They appear completely nude except for transparent midriffs and jewelry.

Although the nudes have no attributes, the first, placing her arm on the shoulder of Mercury, is very likely Minerva, who promised Paris valor and victory in warfare. The lascivious beauty who tosses a veil behind her and displays her breasts to Paris must be Venus. In the top left corner flutters a cupid who aims an arrow in her direction. The two losers stare at her; the smiling Venus smiles at us. Juno, wearing a fancy headpiece much like that of Paris, seems resigned and glances wistfully at her rival. Missing is the golden apple, the trophy that Paris was to present to the "fairest," but the upshot of the

fateful decision was well known. After abducting Helen, queen of Sparta, Paris carried her off to Troy with the help of Venus, and Menelaus, the king, enraged, initiated the epic Trojan War.

The five figures are arranged in a frieze across the foreground, which is abruptly marked off by a dark, dense wall of shrubbery. Beyond lies a distant valley with a Gothic village perched amid the foothills of high mountains in the tradition of Danube landscapes. The rearing stallion, finally, behind the tree to the left, is an erotic addition, as is the position of Paris's hand on the hilt of his sword, but the dreamy expression on his face could hardly be considered lustful. Cranach's story is indeed charming and very colorful, and the overtones of the little play are teasingly erotic, but the significance of the myth with regard to the impending Trojan War, a momentous epic in ancient history, is lost.

In a similar vein are a number of other hedonistic and mythological paintings produced by Cranach and his workshop, most notable being his *Golden Age*, *Hercules with Omphale*, and the *Fountain of Youth* (fig. 446). Cranach's son, Lucas Cranach the Younger, continued to repeat the mythologies and "Lutheran" pictures of his father in the same style for three decades after the Elder's death in 1553 at the age of eighty-one.

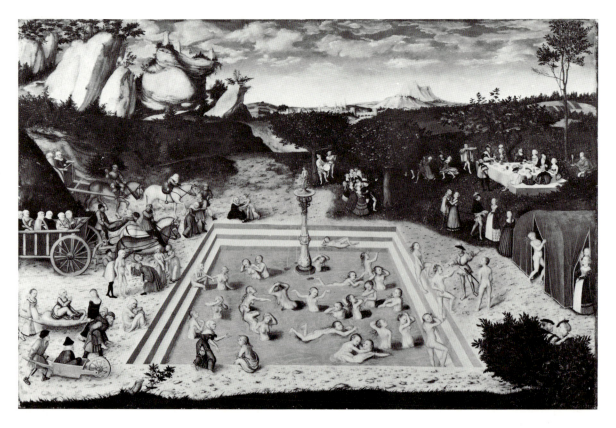

446. Lucas Cranach the Elder. *Fountain of Youth.* 1546. Panel, 47⅝ × 72⅞″. Gemäldegalerie, Staatliche Museen, West Berlin

XX.

Hans Holbein the Younger and the Renaissance Portrait

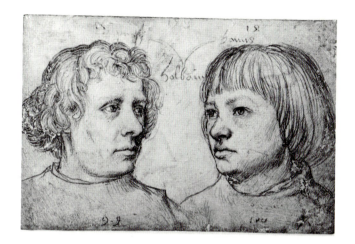

The international scope of Holbein's art—Augsburg, Basel, and London—marks him as a true representative of Renaissance Europe, especially in the realm of portraiture, in which he excelled as a realist in the long tradition of Northern art. Except for a few attempts at narration in his early years, in a style that he had learned in his father's studio in Augsburg,[43] Holbein turned away from the intense, emotional themes such as the Passion of Christ and the agonies of martyrs that were so much a part of the repertory of the Late Gothic artist to fix his attention on the sharp, objective image of Renaissance man.

Holbein had inherited his precise vision for portraiture from his father, Hans the Elder, who was particularly gifted in drawing portraits in silverpoint (over 250 survive), one of the most memorable of which is that of his two sons, Hans the Younger and Ambrosius (fig. 447). But dramatic changes in the arts were taking place, and Augsburg was not ready for them. Hans Burgkmair, Holbein's uncle,[44] had successfully combined the figure style and technique of Dürer, the romance of the Danube landscape, and the dramatic light and dark contrasts of the Nuremberg painters, as seen in his *Saint John on Patmos* (fig. 448). Patronage in Augsburg was wanting, however, and sometime between 1514 and 1515, in what would roughly correspond to his *Wanderjahre* (he was then sixteen), Hans and his brother left Augsburg and headed southwest to Basel.

The first years of the Holbeins in Basel are difficult to chronicle with accuracy. As journeymen-apprentices the variety of projects that busied them is indeed surprising (painting signboards, decorating houses, illustrating books, and aiding in the completion of altarpieces), and their contacts were promising.[45] The earliest remains of

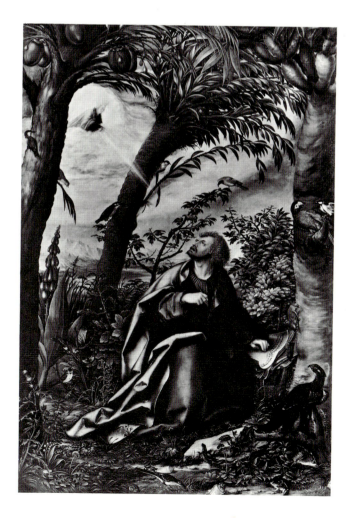

above right: 447. HANS HOLBEIN THE ELDER. *The Artist's Sons, Ambrosius and Hans.* 1511. Silverpoint, 4 × 6⅛″.
Kupferstichkabinett, Staatliche Museen, West Berlin

right: 448. HANS BURGKMAIR. *Saint John on Patmos.* 1518.
Panel, 60¼ × 49⅛″. Alte Pinakothek, Munich

Holbein's art are too fragmentary and perfunctory in design to anticipate his first notable commission, the double portrait of *Jacob Meyer zum Hasen* and *Dorothea Kannengiesser*, his wife (fig. 449), signed and dated 1516. Unlike many other double portraits of this type, the diptych does not commemorate a marriage. Meyer was a wealthy Swiss moneylender—alluded to by the coin in his left hand—and his second wife, Dorothea, whom he married in 1513, was the daughter of a Hapsburg tax collector. After taking part in the Italian wars, fought in Marignano, Meyer was elected the first "bourgeois" mayor of Basel, an unusual honor that apparently called for a special tribute in the form of a double portrait.

The differences between this and the Cuspinian double portrait (colorplate 59; fig. 429) are very instructive to study. The humanist educator from Vienna is lost in thought as he looks into the natural world about him. The more relaxed and casual appearance of the doctor is further conveyed in Cranach's looser, more painterly style with its soft, warm tonalities and more fluid brushstrokes. Holbein's Meyer, on the other hand, is very much a man of the world, full of burgher pride and self-esteem. The full-bodied busts of the couple from Basel fill the picture with gravity and stability, and they are placed in the rigid confines of a sturdy Renaissance loggia with a barrel-vaulted porch that transfers its weight and monumentality to the sitters.

Holbein's portraits have often been criticized for their photographic exactitude, and no doubt had the artist access to some such mechanical means of reproduction he would have used it, but aside from the fact that photography itself is an art, the realism achieved by Holbein

with brush in hand is an astonishing achievement and one that is quite different from the "microscopic-telescopic vision" of Jan van Eyck. To be sure, Holbein is a scientific observer, a thoroughly objective investigator, who seems to put aside personal sentiment and judgment in his rendering of the features of his sitters. There is no mysticism or emotional involvement in his confrontation with the face; it is an object to be memorized and transferred to the paper or panel accurately, and Holbein's eyes seem to miss no detail or overlook any blemish.

Holbein's reputation was now established, and Jacob Meyer was instrumental in getting the young artist a commission for the decorations of the city council chamber in 1521. According to Van Mander, Holbein painted, among other subjects, frescoes of the *Dance of Death* for the city hall, designs for which are perhaps preserved in his "little book" of the *Totentanz*, with woodcuts first published in Lyons in 1538.[46] For one of the city councillors, Hans Oberried, Holbein painted a large altarpiece, preserved in part in the Cathedral of Freiburg. For this commission or one much like it, Holbein executed one of his most famous works, *Christ in the Tomb* (fig. 450), a startling piece that has often been referred to as a portrait of a corpse.[47]

Holbein's dead Christ is at first sight frightening and repulsive. Stretched out before us, seen slightly from below, is the lifesize cadaver of a dead man recognizable as Christ only by the marks of the lance and nail wounds. Rigor mortis has set in with the gruesome head twisted backward so that the teeth in his gaping mouth and the eerie half-closed eyes are vividly close to the viewer. The body, painstakingly painted in morbid tones and exacting

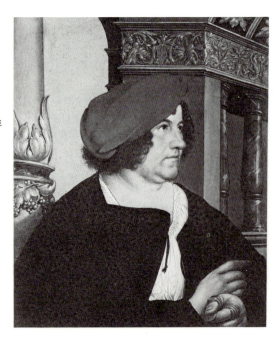

449. Hans Holbein the Younger. *Jacob Meyer zum Hasen* and *Dorothea Kannengiesser* 1516. Panel, each 15⅛ × 12¼". Kunstmuseum, Basel

450. HANS HOLBEIN THE YOUNGER. *Christ in the Tomb.* 1521. Panel, 12 × 73¾″. Kunstmuseum, Basel

detail, seems more the product of a scientist fascinated by a post-mortem examination of a corpse that suffered a violent death than an artist painting a dirge on the mourning of a martyr. Even the low tomb chamber is as cold and barren as a shelf in a morgue with only a thin shroud spread beneath the body.

It is no wonder that Holbein's dead Christ has stirred up a number of emotional and depreciatory responses from those who have seen it firsthand. Dostoevski wrote, ''This picture could rob many a man of his faith'' (*The Idiot*), and the general reaction has been to dismiss the painting as a rare example of Holbein's intense objectivity and say no more. In fact, such intensely realistic representations of the dead Christ stretched out on a slab are not at all rare. It has been pointed out that Grünewald's predella for the outer wings of the *Isenheim Altarpiece* (colorplate 53) featured just such an offensive image of the Entombment where the festered sores and gangrenous flesh are even more pungent. Yet Grünewald's corpse is definitely Christ, and the setting is not a morgue but the ground beneath the cross with the mourners grouped about the body. Grünewald's dead Christ, no matter how morbid and unpleasant, was not the model for Holbein.

Much closer to the macabre mood of his painting are the sculptures of the dead Christ in the Tomb (known as the *Grabeschristus* in German) that were by no means uncommon in German chapels and churches of the period. A very close example that Holbein could have known, executed about 1430 by an Augsburg (?) sculptor, is in the Freising Dom. Many examples of the *Grabeschristus* show the figure at the feet of mourners after the Deposition, and it seems likely that Holbein's painting would have appeared in such a context as well, perhaps as the predella of a large altarpiece with the Deposition above.

Paintings of the Passion of Christ were not to determine the later developments of Holbein's art. With Protestant unrest quelling more and more the demand for religious art, he abandoned such patronage and turned instead to portraiture. It was also during these early years in Basel that the artist strengthened his ties and friendships with the humanists who had befriended him and

who proved to be crucial contacts during the rest of his career. Foremost among these was the handsome young lawyer and professor, Bonifacius Amerbach (fig. 451), the youngest son of the printer Johannes Amerbach of Basel. Bonifacius studied law at the University of Freiburg and later at Avignon and became professor of law at Basel. He was a very close friend of Erasmus, who lived with Froben in Basel from 1521 to 1523. Later, in 1529, Amerbach rescued many of the artist's paintings that otherwise would have been destroyed by the rampaging iconoclasts, and many of these early Holbeins formed the core of a vast collection, the Amerbach Cabinet, assembled by later members of his family and today housed in the Kunstmuseum in Basel.

Holbein's portrait displays the same near-profile bust type of Jacob Meyer's, but Amerbach's countenance is more aristocratic and pensive, and his sharp features and thin lips project a sensitivity and alertness not found in the face of the earlier sitter. In place of the pretentious

451. HANS HOLBEIN THE YOUNGER. *Bonifacius Amerbach.* 1519. Panel, 11¼ × 10⅞″. Kunstmuseum, Basel

palace loggia, Holbein poses Amerbach against an airy landscape, not the colorful Danube setting of Cuspinian, to be sure, but a crisp view of the snowy peaks of the distant Alps under a deep blue sky with a cool freshness of atmosphere that complements the clarity of the young humanist's thoughts. The twenty-four-year-old Amerbach spent considerable time composing the Latin poem for the tablet hanging on the laurel tree beside him: "Though only in paint, I do not deviate from life here and my true lines give a noble portrait of my master. Fine art has formed him [Amerbach] in me just as nature let him develop after eight times three years of his life."

In 1525, when Amerbach was studying in Avignon, Holbein, traveling through France at the time, presented the young scholar with a portrait of Erasmus he had made in Basel. Holbein painted numerous likenesses of Erasmus both before and after his first trip to England, from 1526 to 1528.[48] The one type—they were all copied many times—that is considered the earliest, the so-called Longford Castle portrait, shows Erasmus, fifty-five years old, to knee-length, standing behind his desk, as was his custom in later years due to his physical condition.

More famous, and deservedly so, is Holbein's excellent *Portrait of Erasmus* in the Louvre (fig. 452), perhaps the most eloquent humanistic portrait in art history, painted about 1523–24, just before the artist left Basel for London, probably as a gift for Thomas More. According to an old inscription on the back of the panel, "This picture of Erasmus Rotterdamus was given to the Prince [Henry, son of James I] by Adam Newton." Here Erasmus is seen standing in profile against an abstract background marked only by a dark green oriental hanging with faint gold and red patterns, an addition that relieves the overly solemn color scheme and the simplicity of the setting. The great scholar is engrossed in composing his commentaries on the Gospel of Saint Mark, which were written in Basel.

More than an iconographic statement of a scholar in his study furnished with all the appropriate trappings and attributes (books, pens, inkpots, souvenirs, pets, etc.), Erasmus, head inclined slightly, is portrayed alone in a barren chamber unaware of anything other than transmitting his thoughts into writing as he weighs them carefully. One senses that he is before a profound intellect endowed with great powers of concentration and the calm confidence of a true philosopher. The features are as richly detailed as in any other portrait by Holbein. We can discern every crease and quivering line in his ailing face, every gray hair protruding from his black beret, but the total impression is so immediate and moving that we attend only the image of the dignity of the honest scholar wholly committed to his calling.

Rather than projecting the visage of a powerful de-

fender of the orthodox faith or a vigorous reformer with a cause, both heroes in their own camps, Holbein suppressed any such propaganda and superbly presents Erasmus as the epitome of many of those who wisely hesitated in the heat of the troubled circumstances in northern Europe. It is no surprise that, like Holbein, Erasmus too soon fled Basel, where Protestant agitation was drastically changing both the letter and the spirit of learning in what was the foremost intellectual capital in Europe.

In the autumn of 1526 Holbein abandoned his workshop in Basel and, leaving behind his wife and two very young children, traveled down the Rhine to Antwerp. Other than a visit with Quentin Metsys, little is known of his contacts and activities in Europe's biggest merchant port, but, like Dürer only four years earlier, he very likely met other artists and enjoyed the many sights in the bustling city. He delivered a letter to the humanist Peter Aegidius for Erasmus in which the latter complained that "here [Basel] the arts are shivering with cold."

Holbein soon sailed for England, where he joined the household of Thomas More in the country estate at Chelsea equipped with a letter of introduction from Erasmus. At the time, Thomas More was Speaker of the House of Commons. His friendship with Erasmus dated back to his student days, and he wrote *Utopia*, the ideal state, as a pendant to *In Praise of Folly* by Erasmus (finished in More's home and dedicated to him). *Utopia* was subsequently published in Latin and German editions by Froben in Basel with woodcut illustrations by Hans and Ambrosius Holbein (1518). More's renown as a scholar and humanist was augmented by his genius as an administrator and ambassador, and in 1529 he was appointed lord chancellor of England, succeeding Cardinal Wolsey. The final chapter in More's life is well known. In 1532 he resigned his post after refusing to sign an oath supporting the new law of succession to the throne and other anti-papal policies proposed by Henry VIII. In 1534 he was sent to the Tower of London, and, accused of high treason, he was beheaded in 1535.

As far as we know, More was Holbein's first patron in England, and he wrote back to Erasmus, "Your friend is a wonderful artist." Holbein's *Portrait of Sir Thomas More* is a stunning example of his mastery of aristocratic portraiture (colorplate 61).[49] More is posed against a green curtain held in place by a thick red cord that elegantly enframes his stern countenance. In his right hand More holds a letter. He wears a black velvet cloak with a sable collar and lining over a doublet of red. His graying brown hair is held neatly in place by a tight black cap. There are no attributes, but around his shoulders hangs a heavy gold chain with connecting "S-S" letters,

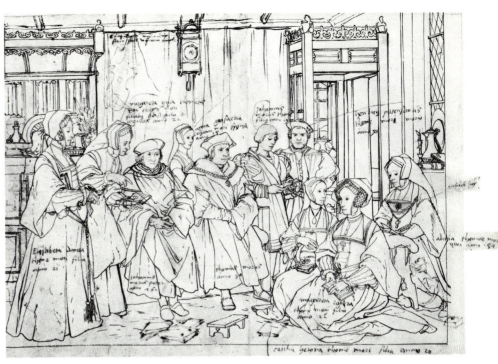

HANS HOLBEIN THE YOUNGER. *Portrait of Erasmus.*
1523–24. Panel, 16½ × 12⅝″. The Louvre, Paris

453. HANS HOLBEIN THE YOUNGER. *Family of Thomas More.* 1526. Pen drawing,
15¼ × 20⅛″. Kupferstichkabinett, Offentliche Kunstsammlung, Basel

the insignia of the supporters of the house of Lancaster revived by Henry VII, and a clasp formed of the double portcullis from which hangs the Tudor rose. It is said that Sir Thomas wore the chain constantly until he resigned, and another legend has it that when the portrait was still in the collection of Henry VIII, Anne Boleyn, the second of six wives, threw it out the palace window in a rage. It must be admitted that the "man for all seasons" has a rather fierce and piercing stare, and his strong will could easily have provoked resentments from those about him at court for whom he had little respect. Holbein captures that trait of his personality in unflinching terms.

The Frick portrait, for which there is a detailed preparatory sketch in Windsor Castle with pricks on the outlines for transfer, was an excerpt from or model for a much larger composition that included the members of More's family gathered at his estate in Chelsea. The original, a wall painting for More's library or drawing room, is preserved in copies made by Richard Locky in 1530 and in a very detailed drawing by Holbein with the figures identified and their ages added (fig. 453). The nine members of the household gathered in two groups about More, seated in the center, include his second wife, Alice Middleton, his father, son, son's fiancée, three married daughters and their families, and a foster daughter of More's, Margaret Giggs. This is very likely the earliest true family group portrait painted in the North as an independent study in which there are no overtones or indications of a devotional function, a setting in a church or chapel, or religious objects clustered about.

We see simply an intimate family gathered in a cozy room at Chelsea for the sole purpose of enjoying a tranquil reading and discussion of some piece of literature, a pastime that Holbein himself must have shared on occasion during his stay with More.

The development of the group portrait will be discussed at length later, but it should be pointed out that Holbein created a masterpiece here in what otherwise could be a most monotonous assembly of figures facing three-quarters right and three-quarters left lined in rows. Instead, Holbein arranged the left-hand figures along a sliding diagonal that continues through the seated More and joins the standing males in the back on the right. Below them, grouped in a loose triangle, sit two young ladies and More's wife, kneeling at a *prie-dieu*, relieving the rigid frieze formation one usually encounters. And Holbein cleverly varies the poses of the heads.

Holbein returned to Switzerland in 1528 and took with him the sketch of More's family as a special gift from the Englishman to his old friend. Erasmus was delighted. He wrote to More, "I cannot put into words the deep pleasure I felt when the painter Holbein gave me the picture of your whole family which is so completely successful that I should scarcely be able to see you better if I were with you." Holbein found Basel suffering even more violent birth pangs of the Reformation than the city he left two years earlier, and it was with considerable reluctance that he finally pledged his allegiance to the Protestants in order to maintain his status as a city artist.

Members of the guild, *zum Himmel*, had to petition

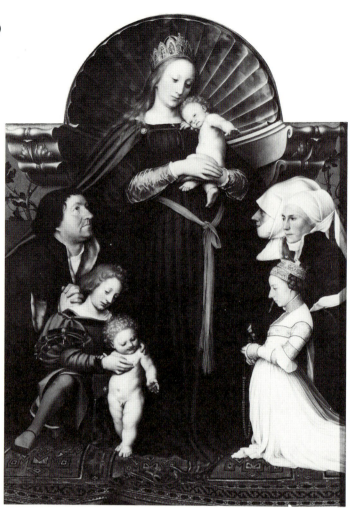

454. HANS HOLBEIN THE YOUNGER. *Madonna of Mercy and the Family of Jacob Meyer*. 1525–28. Panel, 56¾ × 39¾″. Schlossmuseum, Darmstadt

with his left hand extended as if warding off some presence and his sad eyes cast downward toward the infant counterpart at Mary's feet must have some meaning in this context, but just what is not clear.

Actually this is one of Holbein's finest ecclesiastical works. The composition has a breadth and gravity about it that certainly owes much to Italian traditions, and the somber expression projects the serious religious commitment of the Meyer family gathered under the protective mantle of the Virgin, reminiscent of the carved *Schützmantel Madonna* of Michel Erhart, executed some fifty years earlier (colorplate 49). Gothic sentiment and expression, however, are now dressed in Renaissance form.

The original frame was boldly Italianate, and the graceful postures of Meyer's two sons, especially the Michelangelesque infant, together with the full contours of the Madonna seen against the huge scallop-shelled halo formed by the ornate Renaissance niche, lend a grandiose monumentality to the group, unlike the frail vertical orientation of the earlier Gothic sculpture. Jacob Meyer can be easily recognized from his old portrait of 1516, but his pride has been humbled and he dearly grips his fingers as he prays before Mary. On the right kneel his first wife, Magdalen Baer (died 1511), in profile; his second wife, Dorothea Kannengiesser, who has lost some weight in twelve years; and his daughter Anna (born 1513) with her hair braided and secured by a bridal wreath. This last detail provides us with a clue as to the date of the altarpiece. The so-called maiden's hairband (*Jüngfernbandel*) was prescribed for young ladies, usually over sixteen, as tokens of engagement. Anna was married in 1530, and eventually she came to own the painting after Meyer's property was confiscated.

During these same years, 1528–29, Holbein produced another astonishing work, the *Artist's Wife and Two Children* (fig. 455). The painting has suffered. The heads, lifesize, are painted on paper that has been cut around their contours and pasted on a panel. The intimate triangular composition is remarkably effective in the arrangement of the three heads in descending order from the mother. Elizabeth Binzenstock tenderly holds her daughter, Katharina, who glances sadly out of the picture (was this originally a diptych?), as she lightly touches the shoulder of eight-year-old Philipp with her limp right hand.

The emotional detachment ascribed to Holbein's portraits, which are usually so mercilessly objective, is here interrupted by a haunting statement of deep sadness and weariness on the part of the sitters. All three are sorrowful and somewhat lost in their stares that disregard the viewer and the painter. Holbein certainly perceived the stranded feelings and the careworn dolor of his family, but how did he feel in portraying them so vividly?

the city council to retain legality, but all was to little avail. The iconoclasts struck harshly at Basel in 1529 with devastating consequences to any works of art left visible or unattended. Holbein was put back to work on the decorations of the council chamber, and he painted clocks on the bridge across the Rhine. The Protestant revolution had made Europe, especially Germany, a cultural desert without an oasis for the humanists, whose bright light in the early stages of reform had flickered and was gradually snuffed out.

Holbein's last major religious commission was the handsome *Madonna of Mercy and the Family of Jacob Meyer* (fig. 454), painted for his old patron. A rare commission in Basel at this time, the panel was an altarpiece very likely destined for Meyer's private family chapel outside the city walls at Weiherhaus Gross-Gundeldingen, property that Meyer had purchased in 1508. Jacob Meyer had remained true to the Catholic cause and still in 1528 was the leader of an orthodox group clinging precariously to life. No wonder, then, that he appeals here to the Madonna of Mercy. The strange gesture of the Christ Child

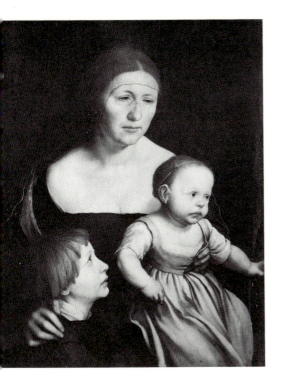

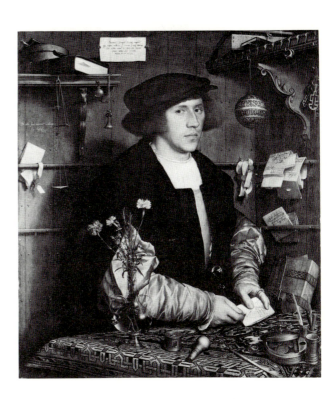

left: 455. HANS HOLBEIN THE YOUNGER. *Artist's Wife and Two Children.* 1528–29. Paper mounted on wood, 30¼ × 25¼". Kunstmuseum, Basel

right: 456. HANS HOLBEIN THE YOUNGER. *Georg Gisze of Danzig.* 1532. Panel, 37¾ × 33". Gemäldegalerie, Staatliche Museen, West Berlin

Van Mander, in his *Het Schilder-boeck* of 1604, had heard about the wife and in his account of Holbein wrote, "He was eager to leave Switzerland because he had a wife who was rather cranky, and who had so bad a disposition that he never could expect any peace or rest with her." Van Mander tells artists' stories—as did Pirckheimer concerning Dürer's wife—that cannot always be accepted at face value. An aching void pervades the face of the wife, who has prematurely aged and whose heavy-lidded eyes (some have suggested that she suffered from dropsy or some such illness) reveal that she has wept often and has nothing to look forward to at this point in her life. Before marrying Holbein, Elizabeth had been the wife of a wealthy tanner in Basel who died. She now faces another such loss. Holbein was about to return to England to settle permanently, leaving his family behind him once again.

Ironically the England to which Holbein returned in 1532 had assumed an abrupt shift in policy that disturbed the state of the arts much as it had in Basel. Aside from a few foreign artists engaged at the court of Henry VIII, mostly Italians, there was little patronage for a painter like Holbein. Henry, in his fury and vengeance over his relationships with the papacy, his wives, and his ministers, had crushed any opposition to his policies of absolute authority, severed all ties to Rome, and suppressed the enlightened circle of humanists with whom Holbein had earlier associated. Henry was excommunicated, Thomas More was beheaded, and there was little time or interest at court to be concerned with a painter who had so reluctantly given up Catholicism and had been intimate with More's circle.

There was one source for commissions that the artist could turn to, however, and that was the wealthy community of the Hanseatic League that formed a very sizable colony in London. These ambitious merchants, mostly involved in the North German steel business, were impressed by Holbein's talents and wanted portraits, the only art in vogue in England at the time. And so Holbein painted the Hanseatic businessmen in his unflinching realistic style that showed off their costly costumes and personal possessions as well as reproduced their swarthy features with an incredible accuracy that satisfied their tastes: Hermann Wedigh of Cologne, Dirk Tybis of Duisburg, the goldsmith Hans van Antwerp, Cyriacus Kale, Derich Born of Cologne, and many others. No Renaissance allegory or painterly flashiness for them, and hence Holbein found that his talents for basic realism with microscopic detail and clear outline suited their tastes perfectly.

He painted one allegory for the German community *in toto,* so to speak, in the form of a pompous *Allegory of the Triumph of Riches* (enthroned in a Renaissance chariot) *over Poverty* (in a Gothic hut drawn by asses) that covered the banqueting hall walls in the guild quarters of the Hanseatic steelyards in London. The processions were introduced with the guild motto: "Gold is the father of joy and the son of care: he who lacks it is sad, he who has it is uneasy." The grisaille figures on a blue ground survive only in original sketches by Holbein and in copies, the best by Jan de Bisschop, but the great allegory adds little to our understanding of Holbein or the artistic currents in England.[50]

A well-known example of Holbein's Hanseatic portraits is that of *Georg Gisze of Danzig* (fig. 456). The young merchant stands knee-length at a broad desk in his

office opening a letter addressed "To my brother Georg Gisze in London." The table, covered by a costly oriental carpet, is strewn with objects of his business—pens, scissors, an inkpot, a round box with coins, a seal, a mechanical clock, and, as a special touch, an elegant glass vase with graceful handles that holds three carnations.

Georg Gisze must have enjoyed collecting intricate little curios and a number of them—rings, keys, bells, scales, and a large orb—hang from the ledge of two ornate bookshelves while two bands running about the walls secure a number of documents and letters fast to the background, many of which have legible inscriptions, including one paper, taped high on the left wall that reads, "The picture you see records the features of Georg, such are his lively eyes, such is his face—thirty-four years old."

This unusual still-life background, composed almost entirely of scattered objects, letters, and other minor office paraphernalia, is somewhat distracting as far as the characterization of the sitter is concerned, but it anticipates that eye-catching genre that first became popular in seventeenth-century Dutch painting and again in nineteenth-century America with such artists as William Harnett. For the most part, the Hanseatic bust portraits are more austere with the sitter in either frontal or three-quarter view placed behind a simple parapet with only a few scattered objects before his hands and an unadorned wall or simple curtain serving as a background. On either side of the head, Holbein usually adds the date and the age of the person in an elegant Roman capital script.

During these same years, 1533–34, Holbein received a number of commissions from members of the court, among them the landed nobleman of Cornwall, John Reskimer; the falconer of the king, Robert Cheseman of Dormanswell; and the horseman of the king, Sir Nicolas Carew, who quite appropriately is dressed in a fancy suit of armor. During his previous stay in England in 1528, Holbein had painted a fine likeness of the king's astronomer, Niklaus Kratzer, who at the time belonged to the humanist circle of Thomas More and taught astronomy to the latter's daughters. This same Kratzer was very likely responsible for Holbein receiving the commission for one of his most unusual paintings, *The French Ambassadors* (colorplate 62), a true showpiece for his virtuosity and stunning characterizations.[51] In fact, it was probably the reputation of this accomplished picture, enriched in details more so than any others, that brought the artist to the attention of Henry VIII.

The big painting, nearly seven feet square, portrays two Frenchmen, one a wealthy landholder, the other a churchman, standing full-length on either side of a tiered table, or what-not, that fills the central axis. To the left stands the elegantly attired Jean de Dinteville, lord of Po-

lisy and bailly of Troyes, who served five times as French ambassador to England. He wears the chain of the Order of Saint Michael and carries a scabbard with a dagger in his right hand. His left arm rests comfortably on the top shelf of the what-not. Opposite him is Georges de Selve, dressed in the vestments of the bishop of Lavaur, who visited De Dinteville in May 1533 during his service as ambassador to the Holy See. De Selve was a well-known scholar and lover of music, and he was a friend of Kratzer. He also spoke German and was regarded by some as being sympathetic to the cause of the Reformation. The what-not, cluttered with numerous objects, is placed against a rich green brocade curtain. In the top left corner a tiny crucifix can be seen; otherwise the background is unadorned.

Holbein's painting of the *Ambassadors* has often been said to initiate an "Eyckian Renaissance" in his works, although, of course, there is no reason to believe that Holbein was consciously doing so. The wealth of detail and the delicate treatment of various textures bathed in an even light—the ermine collar and lined coat of De Dinteville, the rich fabric of De Selve's costume, the shiny marble floor—bring to mind Van Eyck's incredible microscopic style. But other than the sheer technical virtuosity, there are other aspects of the double portrait, unusual in Holbein's art, that remind one of the early Flemish painter.

In speaking of the disguised symbolism in Van Eyck's works we refer to the extrinsic and intrinsic meanings that objects and things have on many levels, as facts in nature, as symbols. It has been noted that Van Eyck expanded this symbolism beyond the individual object (a mirror, a flower, a sculptured capital, etc.) to encompass the entire painted world by cleverly juxtaposing two or more symbolic "environments" within one realistic setting. One way in which Van Eyck accomplished this was to divide his world into parts by means of magnetic axes filled with intricate eye-catching details that in themselves were symbolic too. Recall the subtle divisions in the *Arnolfini Wedding Portrait* (colorplate 18) and the *Madonna with Chancellor Nicolas Rolin* (fig. 104). In the *Ambassadors* Holbein employed a similar device, but the juxtaposition is not one of husband and wife or donor and Madonna, but surprisingly, state and church, a confrontation as old as antiquity, one that we can trace from the Justinian mosaics in San Vitale of the sixth century to the frontispieces of later medieval manuscripts. In imperial court portraiture, representatives of the church, on one side of the emperor, confront those of the state on the other, but here the juxtaposition is much more subtle.

In the *Ambassadors*, De Dinteville, lord of Polisy, represents the power of the state. His regal costume, his chain

of the Order of Saint Michael, and, most of all, his scabbard and dagger, serve as overt attributes of his station in society. Bishop De Selve, opposite him, wears the robe of a clergyman and rests his right elbow on the Bible on the upper shelf, as the representative of the church. The free central axis that links the two worlds is occupied by a high table with two tiers, and the instruments and objects displayed differentiate the upper from the lower, the domain of the heavens and that of the earth.

This is clearly presented, first of all, by the two globes. Below is an exacting reproduction of a terrestrial globe, the type designed by a German geographer, Johann Schöner, in Nuremberg in 1523. Gores, visible across its surface, mark the voyage of Magellan around the world (1520–22), and a number of continents, countries, and cities are named (Africa, Syria, Paris, etc.), including the site of Polisy, De Dinteville's estate, which Holbein added. Directly above it is the larger celestial globe with various heavenly constellations indicated: Galacia, Perseus, Pisces, etc. In keeping with this division of heaven and earth, the intricate instruments scattered across the top shelf are those used for the measuring of altitudes, positions, and times of the heavenly bodies: two sundials, one cylindrical, the other polyhedral; a quadrant and a torquetum, both used for determining angular altitudes and positions; and an unidentified object. On the lower shelf, below and to the right of the terrestrial globe, are tools and instruments of the arts (compass and square), music (lute and music book), and the sciences (book on arithmetic), many of which can be precisely identified as to date and origin.[52]

Two details are of some significance in interpreting the terrestrial zone, which is emphatically marked off from the upper level by an elegant oriental carpet. The lute has a broken string which, according to contemporary emblem books, refers to political disharmony in the world (England versus France or the Hapsburgs?), and the hymn book beneath it displays choral songs of Martin Luther published in Wittenberg in 1524. Finally, the lowest level, that of the mosaic floor, is explicitly mundane. It has been pointed out that even in this detail, Holbein has reproduced specific objects; here the floor of *opus alexandrinum* copies (?) that in the chapel of Abbot Ware at Westminster Abbey. However, it should be noted that the weight of our secular ruler, De Dinteville, is firmly planted on the very center of one of the large circular patterns of the mosaic as if he were claiming it as his domain.

More surprising is the strange amorphous shape that fills the gap between the two figures. Holbein here introduces one of the many pictorial puzzles popular in Mannerist art throughout Europe. When viewed from an acute angle from the right, below, the strange object appears as a distorted skull, secretly marking this lowest zone as that of human mortality. It is not by chance that this same macabre motif appears as the personal device of De Dinteville in the metal medallion affixed to his cap.

What can be concluded concerning the intent of Holbein's fascinating but mysterious painting? One recent theory proposes that the predominance of curious still-life details rightly belongs to the subject of *vanitas*, and that the painting is a warning against pride in learning and the arts (cf. Cornelius Agrippa, *De incertitudine et vanitate scientiarum et artium. . .[On Vanity of the Arts and Sciences]*, 1530). However, if read in an Eyckian fashion, could not these same objects differentiate the major divisions of earthly and heavenly worlds and those who govern them, reaching from the lowest, that of death, through that of the arts and sciences that imitate the ultimate harmonies of the spheres in heaven above? The broken lute string and the enigmatic references to Lutheranism in the music book could thus be seen as signs of the contemporary rifts or breaks in the harmony of church and state in this world which our two French ambassadors will attempt to repair.

In a letter of 1536 there is a vague reference to Holbein's appointment to the court of Henry VIII, and in 1537 payments to the "king's painter" are first recorded. By that time, Holbein had broken ties with his old friends of the humanist circle, what remained of them, and joined the company of Thomas Cromwell, master of the jewel house and councillor of the king, who undoubtedly secured the position for the artist. The menacing portrait of Cromwell, "our trustee and right Counsaillor," in the Frick Collection was painted about 1534 by Holbein.

A great number of portraits of Henry VIII have been attributed to Holbein, many of them copies of originals, even more copies of copies.[53] Three distinct archetypes in this complex stemma of pictures have been discerned, however, and of these, one, represented by the striking likeness in the Galleria Nazionale in Rome (fig. 457), perhaps a replica itself, was the most popular. The original was very likely a wedding portrait paired with Anne of Cleves on the occasion of their brief marriage in 1539. In turn, the portrait in Rome was an updated version, reduced to three-quarter length, of an earlier court portrait of Henry that formed part of the wall painting behind the king's throne in the Privy Chamber of Whitehall Palace glorifying the Tudor dynasty. The original survives in Holbein's fine preparatory cartoon (fig. 458) and in copies by Remi van Leemput made before a fire destroyed it in 1698.

As a dynastic portrait, the Whitehall painting included, on a slightly higher step, the likenesses of his father, Henry VII, standing opposite his mother, Elizabeth

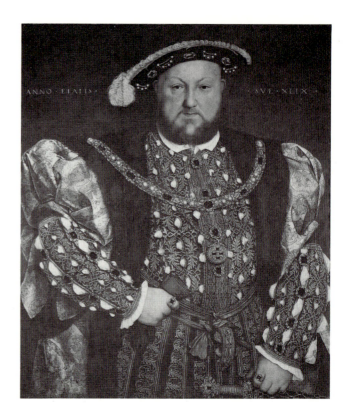

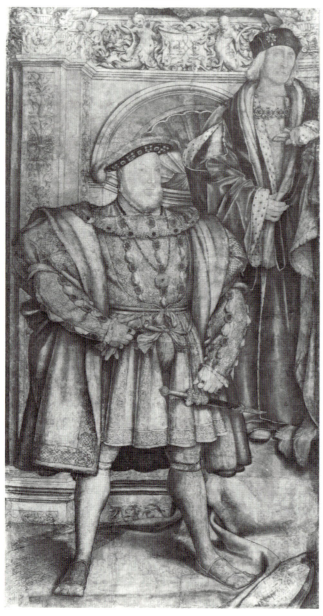

replica of 1542, where the iconic severity is further heightened, due in part to the heavy Venetian velvet surcoat that Henry wears to conceal his obesity.

The painting in Rome will suffice for our analysis of Henry's court and wedding portraits. Compared to Holbein's other portraits, that of Henry is distinguished by the massiveness of his form that fills the panel completely, crowding out any indication of natural setting. The major portion of Henry is furthermore an expansive flat shape of decorative patterns created by the lavish adornments and textures of the court costumes: the red doublet richly embroidered with gold, the broad, bulky surcoat of red velvet with gold brocades and sable trim, and the weighty bejeweled collar, rings, and ornaments on his wide beret. The iconic aspect of Holbein's portrait is underscored by the frontal-face mask that meticulously reproduces Henry's features, albeit somewhat flattened and smoothed.

With his grim, beady eyes staring out directly from his broad face, his small, pinched, pouting lips, and his moustache arcing downward to his jaw in the fashion of the menacing countenance of a Pantocrator in Byzantine art, Henry is more than a formidable overlord: the viewer is annihilated in his presence. This is the merciless imperator: supreme head of church and state. As one authority on English historical portraits recently described him, Henry is a "gouty, pig-eyed, pile of flesh, whose astounding girth is only emphasised by the layers of slashed velvets and furs that encase him."[54]

Jane Seymour, Henry's third wife (1536–37), had been lady-in-waiting to both Catherine of Aragon and Anne

of York. Below, on the right opposite Henry VIII, stood his third wife, Jane Seymour. An earlier wedding diptych of Henry and Jane Seymour executed by Holbein in 1536 portrays them in bust length with Henry facing three-quarters right (see the painting in Lugano, Thyssen-Bornemisza Collection). Aside from a few minor changes in the details of the wedding costume and the jewelry, the portraits are nearly identical except for the somewhat relaxed mien in the three-quarter likeness that hardens into a rigidly iconic image in the full-faced versions. A later type is that preserved in the Castle Howard

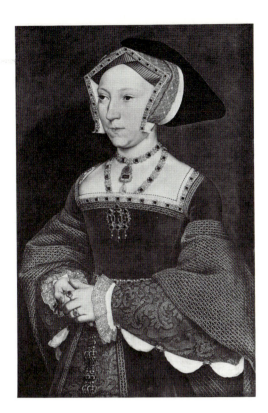

Boleyn, and was married to the king only ten days after Anne went to the block on May 19, 1536. On October 12, 1537, Jane bore Henry his long-awaited son, Edward VI, and twelve days later she died from complications following the delivery. As Holbein's portrait of *Jane Seymour* (fig. 459) shows, she was no ravishing beauty, but Jane was well liked at court for her gentle manner and calm acceptance of her role as Henry's queen in spite of the ominous history of the king's previous wives and the ends Henry went to rid himself of them, defying the pope to annul the marriage of one, devising treacherous plots to condemn the other to death for adultery.

By bearing Henry a son, Jane Seymour was dearly remembered after her untimely death, which was, ironically, her hour of triumph over the previous wives. Holbein's treatment of her features is sharp and precise while her dress—she wears no sumptuous robe trimmed in ermine—is colorfully patterned as if she were, as someone remarked, "flat as a playing card," but not the Queen of Hearts. Contemporary descriptions of Jane are sparing: "She is of middle stature, and no great beauty; so fair that one would call her rather pallid than otherwise."

Two years lapsed before Henry married again, the longest interval between wives in his career. The king had mixed feelings about his next marriage. On the one hand, he knew that he had to arrange for a person of high station who would be more Protestant than Catholic, but not too much so. On the other, Henry was vain enough to want a showpiece, a wife both cultured and attractive. In a somewhat clandestine fashion the king sent out agents to look over the prospects, and, if the reports were very favorable, Holbein was dispatched to paint the lady's portrait. The artist was kept busy. Sisters of the De Guise family at Joinville in France were highly recommended, and Holbein made two trips there to paint their likenesses. To no avail; one married James V of Scotland, another left home before Holbein arrived, and a third turned out to be but seven years old.

A most promising candidate then appeared in the person of Christina of Denmark (fig. 460), duchess of Milan, daughter of the king of Denmark, Christian II, and

461. HANS HOLBEIN THE YOUNGER. *Anne of Cleves.* 1539.
Parchment on canvas, 25⅝ × 18⅞″. The Louvre, Paris

Isabella of Spain, and niece of Charles V, the Hapsburg emperor.[55] Christina had been married by proxy at the age of eleven to the duke of Milan, Francesco Maria Sforza, who died in 1535 when she was but thirteen. Holbein portrays her in Brussels at the age of sixteen when she was living at the court of her aunt, the Austrian regent in the Netherlands, Maria of Hungary.

We know that Holbein had a mere three-hour audience to prepare Christina's portrait in Brussels, and that after completing sketches (now lost), he returned to London, where he painted the final version in just two days. The simplicity of the portrait, while no doubt due to the circumstances of the meeting and the condition of the prospective bride wearing her solemn Italian mourning robe, nonetheless is one of its artistic virtues. As a full-figure portrait, *Christina of Denmark* is one of his most monumental and impressive likenesses (compare, for instance, the standing portrait of *Catherine of Saxony* by Cranach, fig. 437).

Her presence must have stimulated the painter. Christina's long robe is a deep purplish-brown with delicate textures in the linen cuffs, the velvet sleeves, the furred edges of the silk gown, and especially the soft flesh of her

hands. She was known for her beautiful hands and tall frame. Compared to other female portraits by Holbein, Christina appears demure and cool, or, as one report tells us, "very sober, very wise, and no less gentle." The background, which has recently been cleaned, is a bright blue-green, forming a colorful backdrop to her otherwise cool and somber appearance.

There is no question but that Christina was a prize political pawn in the international marriage game, and Cromwell knew that. Her father was sympathetic to the Protestants, her uncle was a fanatic Catholic. The "widow of Milan" was cultured and talented, but wisely she rejected the offer. Henry was much too old, too fat, too treacherous for the young maiden. Christina was heard to say that "if she had two heads, she would gladly put one at the disposal of the King of England." Probably the real pressures against Henry came from much higher powers in the family. Her uncle Charles V was an ally of Henry's arch rival, Francis I of France, and Anglo-French ties were extremely strained in 1537/38. Christina became the bride of the duke of Lorraine. Once again, Cromwell's bargaining and intrigues were to no avail for his king.

Cromwell next negotiated a marriage with Anne of Cleves (fig. 461), whose portrait Holbein quickly painted on parchment in the early winter of 1539. This time the artist was sent to the ducal court of Cleves at the Schloss Düren near Düsseldorf. Anne, sister of the duke, was a fair-to-middling candidate, perhaps not as attractive as Henry had hoped, but plans for the royal wedding were followed through under Cromwell's design and took place on the feast of Epiphany, January 6, 1540. Unlike the portrait of Christina, Anne is not burdened in somber robes but in the colorful red velvets and gold brocades bedecked with ornaments of her marriage trousseau. Here again Holbein tends to flatten the image into an ornamental pattern when addressing himself to such pompous court-portrait types. Anne's face is plain but not unattractive, and her hands seem rather coarse with pudgy fingers when compared to the beautiful hands of Christina, but the elegant wedding gown transforms her into someone pretty and well mannered.

She was an excellent prospect for Henry at the moment. France was preparing to attack schismatic England so that it was necessary for Cromwell to change his diplomatic course abruptly. Cleves was one of the major principalities of the Lower Rhine, and the duke was closely allied through marriage to Saxony and the league of Lutheran princes. Finally, it seemed, Henry could find himself powerful allies against Francis I and Charles V. Alas, the political situation relaxed soon after the marriage took place, and Henry deeply regretted his hastily arranged union. Anne was not cultured, as it turned out,

462. HANS HOLBEIN THE YOUNGER. *Edward VI at Two Years.*
c. 1538. Panel, 22⅜ × 17⅜″. National Gallery of Art,
Washington, D.C. Andrew Mellon Collection

greater—Heaven and Nature could scarcely give a son whose glory should surpass that of such a father. You only equal the acts of your parent, the wishes of men cannot go beyond this. Surpass him, and you have surpassed all the kings the world ever worshipped, and none will every surpass you.''[56]

The second portrait of Edward, a profile within a small tondo, was one of Holbein's last works, executed in the fall of 1543 on the occasion of the prince's sixth birthday. The roundel has suffered from overpaint, but it is clearly an impressive achievement for its type and, in fact introduces us to another medium, the miniature, in which Holbein excelled in his last years. From Van Mander we learn that a miniaturist from Ghent, Lucas Horebout, recorded in the service of the king in 1537, introduced Holbein to this precious art form. The miniature, usually a tiny roundel resembling an enamel, was a form of keepsake jewelry that could be worn as a locket and badge or could serve as decoration for small wooden and ivory jewel boxes.[57] The charming miniature portrait became extremely popular in England. In one painted in 1543, Holbein gives us his *Self-Portrait* (fig. 463), which in turn was based on an earlier likeness painted on panel.

While Holbein's panel portraits had few followers and imitators in England, his aristocratic types transmitted through miniatures molded British taste for decades. One of the foremost of the early miniature painters was Levina Teerlinc (died 1576), daughter of a famous Bruges book illuminator, Simon Bening, but unfortunately her works are difficult to identify for certain. More famous

and her training at the court in Düsseldorf was not one devoted to the arts and literature. In every respect Anne was too domestic for Henry, who allegedly referred to her as his ''Flanders mare,'' and he found her physically repulsive immediately. Furthermore, Henry already had his eye on the ill-fated number five, Catherine Howard. After six months, a shabby annulment was granted on the grounds of non-consummation. Surprisingly, Anne of Cleves was not particularly upset, and, according to the annulment, she stayed on in England as princess royal at Richmond, where she lived in comfort and quiet until her death in 1557.

Meanwhile Henry watched his prized son, Edward VI, grow with great anticipation (the frail boy died of consumption in 1553 at the age of fifteen), and Holbein executed at least two portraits of the imminent successor to the throne. The earlier portrays Edward when two years old (fig. 462), seemingly healthy and, if not for his babyhood, rather resembling the fat-faced father himself. The likeness was a New Year's present for Henry, January 1, 1540, and the lengthy inscription below the bust must have pleased him: ''Little one! imitate your father, and be the heir of his virtue, the world contains nothing

463. HANS HOLBEIN THE YOUNGER. *Self-Portrait.* 1543.
Watercolor on vellum, diameter 1⁷⁄₁₆″.
The Wallace Collection, London

464. Nicholas Hilliard. *Young Man Among Roses*. c. 1588.
Parchment, 5⅜ × 2¾". Victoria and Albert Museum, London

was Nicholas Hilliard, active in the last years of the six-
teenth century, a goldsmith by trade who excelled in fine
jewelry and miniature painting. His *Young Man Among
Roses* (fig. 464) of about 1588 recaptures the great detail
and ornamental richness of Holbein's court portraits, but
here the characterization is sentimentalized by the liter-
ary overtones of a token to be given to the young cour-
tier's true love. The fashionable dandy, only twenty-two
years old, undoubtedly is lovesick, as an inscription testi-
fies: ''My praised faith causes my sufferings'' (Dat
poenas laudata fides), and he seems to be composing a
sonnet amid the roses. The Elizabethan genius in fash-
ioning such affected emotion is conveyed in a most
charming manner through the slim body of the young
man, who sways languorously in the faint breezes, a sty-
listic feature that links Hilliard's *Young Man Among Roses*
to contemporary currents of French and Italian Man-
nerism.

The question of Henry's role in the history of art has
not been adequately addressed here. For one thing, it
seems unlikely that his religious reform seriously em-
braced iconoclasm, and no doubt he was envious of the
ambitious cultural programs promoted by his rival across
the Channel, Francis I, and by the Hapsburgs. But there
is very little evidence that Henry VIII was instrumental,
except in the most practical ways, in the programs that
were planned for his palaces and chambers.

For instance, Henry no doubt had some strong ideas
to convey to Holbein when the artist was entrusted with
designing the frontispiece for the English Bible published
in 1536 with a portrait of the monarch enthroned hold-
ing both the sword and the Bible, the leader of state and
church in one person, but very likely this iconography
was transmitted through his advisor and spokesman,
Thomas Cromwell. In fact, it seems that Henry did not
consider Holbein as anyone more than a capable portrait-
ist to have around. From the abundant archival materials
on Henry's court it appears, in the long run, that no real
friendship or close association between Holbein and the
monarch ever existed. In fact, one can say that aside from
his personal accomplishments in music, which are very
well known, Henry VIII was simply no enlightened pa-
tron of the arts at all.

Antwerp: Quentin Metsys, Joachim Patinir, and Joos van Cleve

"On Saturday [August 4, 1520] after the feast of St Peter in Chains my host took me to see the Burgomaster's house at Antwerp. It is newly built and beyond measure large, and very well ordered, with spacious and exceedingly beautiful chambers, a tower splendidly ornamented, a very large garden—altogether a noble house, the like of which I have nowhere seen in all Germany." When Albrecht Dürer strolled about the streets, canals, and busy docks of the city on the Scheldt River he was privileged to see a great European city at its zenith (fig. 465). Indeed, Antwerp was the capital of northern Europe in the sixteenth century. It had replaced Bruges as the major international commercial center after the Zwijn harbor had silted up, restricting the size of seagoing transporters.

The Scheldt was wide and deep, and the only port comparable to Antwerp in Europe, Venice, handled in one year the traffic that flowed through Antwerp in·less than a month. Its affluence was due to economic factors and timing in matters political. Merchants from the

Hansa, Spain, Genoa, Florence, Lucca, Lisbon, and London established their international offices there, and within years the monies of the wealthy Augsburg financiers, the Fuggers, Hochstetters, and Welsers, were deposited in Antwerp to facilitate the foreign exchange in the bourse, or trade center, in the heart of town.

It is said that every important loan made in Europe in the first half of the sixteenth century was negotiated there. Every kind of merchandise, including the new, lucrative spice trade, exploited after routes to the Indies were secured, passed through Antwerp, and the money flowed not like wine but beer. For Antwerp was famed not only for business and the bourse, but equally for breweries and brothels. There was a carnival atmosphere everywhere. Dürer was impressed by the constant pageantry all about him, and he vividly described in his diary the endless parade that passed through the streets for the glorious celebration of the Feast of the Assumption of the Virgin, one of the major celebrations in the Netherlands, attended by representatives of the goldsmiths,

465. NETHERLANDISH. *View of Antwerp.* c. 1540. Panel. Musée Archéologique, Antwerp

painters, masons, embroiderers, sculptors, carpenters, fishermen, sailors, leathermakers, "indeed workmen of all kinds, and many craftsmen and dealers . . . shop-keepers and merchants . . . horsemen and foot-soldiers . . . Lords Magistrates . . . clergy, scholars, and treasurers. Twenty persons bore the image of the Virgin Mary with the Lord Jesus, adorned in the costliest manner, to the honour of the Lord God."[58]

The Netherlands of the Burgundians had rapidly been superseded by that of the Hapsburgs after Maximilian married the last heir, Mary of Burgundy, in 1477, and the double-headed eagle of the Hapsburgs was to fly from the ramparts of Antwerp for a long time thereafter. Margaret of Austria, the regent for the young Charles V from 1506 to 1530, established a small but impressive court at the family estate, *Cour de Cambray*, at Mechelen, where she gathered about her painters, poets, and musicians and amassed a glittering collection of *objets d'art* that included Van Eyck's *Arnolfini Wedding Portrait* and well-known works by other luminaries of the fifteenth century.[59]

Her successor, Mary of Hungary (1531–52), preferred residing in Brussels, but it was in busy Antwerp where the new art market was vigorously promoted for the wealthy merchants and capitalists. Artists as well as merchants arrived in droves in Antwerp, and in keeping with the demands of an efficient capitalistic society, everything, including the arts, was elaborately organized. Dürer found Antwerp's guild system awesome. And it was in Antwerp, too, that the printing of books rapidly flourished on an unprecedented scale with publishers, printers, and woodcutters abandoning their shops in the smaller villages of Holland and the Rhineland to profit from the lucrative business of the big city.

Inevitably the arts, including the illustrated book, displayed signs of decline in quality, but the production was overwhelming. The publishing house At the Four Winds, established by Hieronymus Cock in 1533, specialized in prints of works of art and antiquities;[60] Christopher Plantin arrived in 1550 from Paris and set up the famed Golden Compass presses which mass-produced books for an international clientele.[61] In general, it seemed that Antwerp was too busy with business to be much concerned with the religious upheavals that shook the foundations of the other commercial centers in northern Europe, and it was not until the last third of the century that the violent conflicts between Catholics and Protestants decimated the flourishing cultural life of the great city on the Scheldt.

The arts of Antwerp in the first decades of the sixteenth century can be described as kaleidoscopic rather than international. Receptivity, not originality, charac-

466. MASTER OF FRANKFORT. *Crucifixion.* c. 1500. Panel, 45⅝ × 30¼″ (center); 46⅞ × 14⅝″ (each wing). Städelsches Kunstinstitut, Frankfort

terizes the style of Antwerp painting, resulting in a hodgepodge of modes that are nearly impossible to sort out.[62] Alien masters, following the general pattern of Antwerp business, established large workshops, sanctioned by the guilds, that grew into assembly lines that produced works of art for the general market more so than for individual commissions. With some effort, a few basic tendencies can be discerned which include selective eclecticism and archaism in terms of style, Mannerism in matters of taste, and specialization in subject matter.

The records of the Guild of Saint Luke in Antwerp are fairly intact, and they give ample testimony to the sudden influx of foreign artists from Flanders, north France, the Rhineland, and especially Holland. With the establishment of large workshops, the individuality of the styles of these masters was concealed under a mere veneer of their manner. It is no wonder that the art historian is faced with the problem of identifying the styles of successful workshops more than those of individual artists. A good example is the work of the so-called Master of Frankfort, named after a *Crucifixion* triptych that was executed for a patrician family in Frankfort (fig. 466) sometime around 1500.

At first sight the work seems uniform throughout, but after closer study one can easily discern the degree to which selective eclecticism has formed the style of the workshop. The poses of John and Mary and to a degree the drapery patterns are ultimately indebted to Rogier van der Weyden; the treatment of the flesh, especially evident in the soft, silvery tones of the Magdalen's face, seems more dependent on Hugo van der Goes; while the rugged peasant types and the dense grouping of the figures about the cross remind one more of the hardier expression of the Ouwater-Bouts tradition. The fact that the prominent tower in the cityscape to the left is the Dom of Utrecht may or may not be significant.

Another work attributed to the same workshop, the *Festival of the Archers* (fig. 467), demonstrates the fluidity of the modes of styles available to these craftsmen. The presentation, commemorating some major celebration of the corporation of the civic guards, is more in keeping with the millefleur tapestries that usually served as decoration in banquet halls and guild chambers with its flat expanse of colorful flora and costumes. A crowded garden party with lovers arranged about the deacon or president enthroned in the center fills a strangely disjointed cityscape, a decorative pastiche of various guild halls framing a verdant park.

Another stylistic trait that characterizes much Antwerp painting has been called Mannerism, although this tendency is by no means limited to one center in the Netherlands. Essentially, Antwerp Mannerism marks the

467. Master of Frankfort. *Festival of the Archers.* c. 1492. Panel, 69¼ × 55½". Musée Royal des Beaux-Arts, Antwerp

final stage of many latent features of earlier Flemish painting that evolved naturally through the exploitation of the decorative and capricious elements in Netherlandish realism. Details of costume are elaborated and ornamental effects are exaggerated, but most of all the lyrical draperies of Rogier van der Weyden's Gothic style are overly embellished with flairs and sweeps that overwhelm any natural lines of the body parts or their movements. The result is indeed mannered if one thinks of it as a style gone to seed and losing contact with naturalism in the display of stylish modes. The actors, which they are, resemble ceramic figurines with elegant curlicues breaking the drapery contours; their heads are reduced to cute caricatures of wrinkled old men, foppish pages, and demure maidens with frizzy hair and tiny hands held in affected poses. They tiptoe and prance agilely along their carpeted stages before theatrical backdrops of lofty architectural ruins through which we catch glimpses of distant Disneyland towers and romantic landscapes painted in bluish monochrome.

When practiced by a truly gifted artist, Antwerp

468. MASTER OF THE ANTWERP ADORATION. *Adoration of the Magi.* c. 1515–20. Panel, 11½ × 8⅝". Musée Royal des Beaux-Arts, Antwerp

Mannerism can result in charming tableaux that overflow with vibrant life, as in the little *Adoration of the Magi* illustrated here (fig. 468). The tiny panel radiates with energy and color. Agitated, twitching drapery edges with pointed tips enhance the rich convolutions of the rolling contours, and the happy expressions on the faces are delightful. Graceful Mary is the epitome of complacent maidenhood with her pert, oval face, high-arched brows, tiny chin, and wide mouth smiling coyly. Fluttering ribbons of drapery and affected gestures complement the coquettish characterization of the figures.

The first Magus is a kindly old man dressed in bizarre robes who seems to be entertaining the frisky Child. The second king to the right sways foppishly like some carnival barker unveiling his show to an audience. On this small scale, Antwerp Mannerism can display the appealing daintiness and picturesque qualities of the finest miniatures, but usually the productions are big and the brushwork coarse and uneven. Designs are slavishly copied by rote and not by insight into decorative possibilities.

A word of caution should be raised here. Antwerp Mannerism is not to be confused or too closely associated with the movement known as Mannerism in Italian art, although some traits are assuredly common to both. For the most part, Italian influence is marginal in these paint-

ings, limited to details of architecture or costume. A more pronounced imitation of the grand manner of the later Italian Renaissance did appear, to be sure, in the sophisticated works of the so-called Romanists, and we shall study those artists later. As to the tendency toward specialization in subject matter, that too will become quite clear. For the present we may note that in the standard repertory, two themes are repeated with monotonous regularity: the Adoration of the Magi and the Crucifixion, the two principal subjects for the Christmas and Easter cycles.

QUENTIN METSYS

Alas, for Antwerp there was no *genius loci*, no Jan van Eyck, Rogier van der Weyden, Stephan Lochner, or Geertgen tot Sint Jans, to establish a distinctive style for the city, and given the keen rivalry among the Northern cities for cultural preeminence, this deficiency had to be

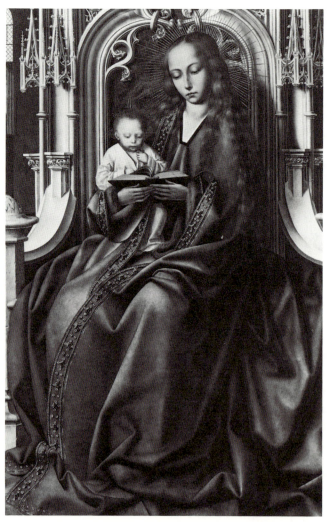

469. QUENTIN METSYS. *Madonna Enthroned.* c. 1495. Panel, 51⅛ × 33⅞". Musées Royaux des Beaux-Arts, Brussels

left: 470.
QUENTIN METSYS.
*Altarpiece of the Holy
Kinship*. 1507–9. Panel,
88⅜ × 86¼″ (center);
86½ × 36″ (each wing).
Musées Royaux des
Beaux-Arts, Brussels

below: 471.
QUENTIN METSYS.
*Altarpiece of the
Holy Kinship* (detail)

remedied. It was Quentin Metsys who filled the void as the cultural hero in painting for Antwerp, the New Rome on the Scheldt. He suddenly shown forth like the city itself, and local pride vigorously promoted a campaign to ensure that he would be heralded as the true founder of the Belgian Renaissance. Early historians praised Metsys as the "Protean or Cyclopean Apelles" who rose from the lowly ranks of a blacksmith's assistant to that of an internationally renowned genius in the fine arts, a metamorphosis as wondorous as that experienced by the city.[63]

Quentin Metsys was born in 1466 in Louvain, where he very likely received his first training as a painter in the workshop of Dieric Bouts's sons. He entered the Guild of Saint Luke in Antwerp in 1491, and he died there a wealthy man in 1530. A number of unsigned paintings of the Madonna and Child, enthroned or standing in a niche, have been attributed to his early years, and they all display traits of eclecticism and archaism.

The *Madonna Enthroned* in Brussels (fig. 469) is typical. Mary fills the throne with the monumentality of works by Robert Campin or Rogier van der Weyden, and certain delicate touches reminiscent of Van Eyck are found in the fine pearls that decorate the border of her mantle and in the features of her face. The figure seems to have been composed from two models, in fact. Mary's torso is much too large and elongated for the rest of her body, but the polished finish and the elegant flow of fully modeled drapery are impressive. The mousy-looking infant appears in other works attributed to Metsys's early career.

The *Altarpiece of the Holy Kinship* (figs. 470, 471), more commonly known as the *Saint Anna Altarpiece*, was ordered by the Confraternity of Saint Anna in 1507 for their chapel in the Church of Saint Peter in Louvain. Originally a huge Italianate frame encased the flamboyant contours of the panels, but other than some areas weakened by overcleaning, the paintings are well pre-

served and intact. The clan of Anna, a familiar subject in the Rhineland as we have seen, occupies the central panel with a joyous exuberance and impressive monumentality unusual in the pedestrian treatment generally encountered, where rows of sitting and standing relatives are mechanically lined up for a family portrait.

Rather than compare Quentin's interpretation with those of the Middle Rhine, with which it is usually con-

trasted—there is a garden with a wall and a loggia that accommodates the families—it is more interesting for our discussion of Gothic versus Renaissance to turn instead to the panel in Amsterdam by Geertgen tot Sint Jans, painted about twenty years earlier (fig. 170). One striking difference, obviously, is the shape of Metsys's altarpiece and its horizontal disposition as opposed to the verticality of the earlier. Replacing the casual and random dispersion of the figures in the deep nave of a church, Metsys presents us with a well-balanced composition in a broad loggia. Two inverted triangular groups of the sisters' families are placed symmetrically about the *Anna Selbdritt*, the traditional group of Mary, the Christ Child, and Saint Anna, that forms the central core of the composition.

The dark medieval interior is exchanged for a resplendent Renaissance porch, airy and brightly colored, with a dome seen in dramatic foreshortening above the central figures as some huge three-dimensional halo. Instead of the intricate program of disguised symbolism in Geertgen's allegory on the passing of the old to the new generations, Metsys presents a stunning tableau of an aristocratic family of elegant, self-assured, fashionably dressed, and well-mannered townspeople, if one excuses little Joseph the Just in the lower left corner, who has just ripped a page out of an illuminated missal.

There is no complex iconography here. In fact, Gothic melancholy and gloom are nowhere expressed. Rather, the light-hearted and cheerful composure of the family in the new world of the sixteenth century is what we are shown. Mary, dressed in a white-blue mantle with an elegant golden border, is the epitome of a well-groomed Renaissance lady; Anna is the warm and comforting matriarch; while her third daughter, Mary Salome, seated to the right, is somewhat coy and proud of herself as she casually glances aside. The husbands (Joachim is present to the right of Anna, the other three men are Joseph and the husbands of Mary Cleophae and Mary Salome), serious but content, know their places and remain quiet and inward as they stand behind their respective spouses. That is not to say that Metsys is not concerned with emotions—he certainly is so—but in this presentation it is the happiness and well-being of the family of Anna that is foremost, and that contentment could hardly be better expressed.

The figures are big and bulky; their draperies flow gently in softly modeled folds that glide from one lap to the other, and it is the bigness of conception that transforms Quentin's otherwise Gothic folk into proud Renaissance people. Italian influence has usually been credited with the sudden growth of Northern painting. The loggia is Italian, tie rods and all, and the impressive architecture has been compared to settings in the works of Giovanni Bellini and Cima da Conegliano. The softer illusionism in the flesh parts has been likened to Leonardo's *sfumato*.

More striking, however, is the new palette of Metsys. The pastel powder-blues, the rosés, the deep greens, and the broken colors, oranges and violets, with light greens turning into crimsons, the milky tonalities, and the blond hues in general are not commonly associated with Netherlandish painting. It is in the paintings of Vittore Carpaccio and other Venetians where these refreshing new colors appear, and considering the fame of the great Italian port city—the only rival to Antwerp—it would not be too venturesome to propose a trip to Venice for Metsys.

Other elements of Italian influence can be discerned in the sophistication of perspective and foreshortening, such as we find in the side wings in the chamber of the death of Anna, right, and the kneeling figure of Joachim, left. On the other hand, the tight execution and sharpness of detail are wholly Netherlandish. The fluttering angel above Joachim, while dressed in a Venetian broken-colored cape, owes much to Hugo van der Goes, and the head types in general are distinctively Flemish. But the most astonishing contribution of Metsys to his home tradition is the panoramic landscape that sweeps across the background of the panels.

We have discussed repeatedly landscape as a major proclivity of the artists in northern Europe, as slices of the world about them, as topographies, as fantasies, and with Metsys we meet still another variety of this confrontation of man and nature that in many respects seems to be the result of the growing awareness of the New World discoveries in the sixteenth century. Metsys does not give us a passage of nature or a dramatic close-up of the woodlands and rocky grottoes, but a trip through much broader horizons, a world view, a cosmic landscape, that includes a vista so distant that we can actually see the curvature of the earth.

It is as if we were transported from the family in the foreground setting across miles and miles of western Europe to view the Alps hovering on the horizon as from some airplane. Unlike Altdorfer's mysterious and intimate landscapes, those of Metsys have an openness and breadth that has no limits, with tiny pine trees and sharp cliffs completely subordinated to lofty towering peaks veiled in light blue on the horizon. Fantasy certainly has a role here. We frequently make out the *arco naturale*, or window-rock, and in the Alpine spectacle most local color and detail are blurred beneath a filmy silver-blue tone of atmospheric perspective. The subtle gradation of the basic colors in three zones in space—brown, green, blue—is further developed, anticipating the formula of the three-color landscapes of Joos de Momper and later

left: 472. QUENTIN METSYS. *Crucifixion.* 1510–15. Panel, 20⅛ × 14⅜″. National Gallery of Canada, Ottawa

below: 473. QUENTIN METSYS. *Madonna and Child Enthroned.* c. 1520. Panel, 53⅛ × 35⅜″. Gemäldegalerie, Staatliche Museen, West Berlin

sixteenth-century artists. This new vision of landscape, the so-called Mannerist landscape, will become a specialty and a popular commodity on the international market in Antwerp, as we shall soon see.

The *Saint Anna Altarpiece* was finished in 1509. At that time Metsys was busy at work on his second major commission, the *Lamentation Altarpiece* (colorplate 63), painted between 1508 and 1511 for the joiners' or carpenters' guild in Antwerp for their chapel in the Cathedral. The light-hearted family play of the *Holy Kinship* is replaced by tragedy with a frantic array of mourners converging around the body of Christ stretched across the foreground of the central panel. Joy and exuberance, pastel shades and airy illumination give way to weeping, wailing, and somber dark colors. Here we meet Metsys as the artist of tragedy befitting Antwerp tastes. He is a virtuoso of sentimentality, and an accomplished director of flamboyant drama with all of the traditional rhetoric and spontaneous effects of the sixteenth-century theater.

The ultimate source for Quentin's *Lamentation* was Rogier van der Weyden's *Deposition* (colorplate 20), which he no doubt studied carefully when it was still in Louvain. But aside from the idea of distributing a frieze of mourners across a shallow stage, there is little that reminds us of Rogier in the work. Mary does not repeat the swooning posture of her son, nor does the Magdalen wring her hands in that memorable hieroglyph of mourning invented by Rogier. Furthermore, the gentle and supple flow of interlaced drapery lines in Rogier's painting is sacrificed for a plethora of agitated movements and jerks among the nine mourners. The side panels, the *Feast of Herod* and the *Martyrdom of the Evangelist*, are typically Mannerist in conception with the eccentric treatment of space, the lavish costumes, and the exaggerated facial features.

In the right wing we meet the crowded and compact group of grotesque tormentors about the saint. The zesty lot with coarse bodies in spastic movements and horrid grimaces resembling the caricatures of Leonardo represent the evil throng for Metsys, and we find them again in his close-up of the *Ecce Homo* in the Prado. Interestingly, Metsys eliminates these revolting figures in his numerous representations of the *Crucifixion* (see fig. 472), where the figures are reduced to but a few of the main mourners and the action is emphatically stilled and hushed, giving the paintings the austere qualities of icons. The background, on the other hand, is exploited for a cosmic landscape filled to the far reaches with fascinating details of rolling hills and towering peaks behind the sprawling walls of a busy Jerusalem.

Quentin's workshop, which must have swelled during these years, produced a variety of devotional images of the Madonna and Child, some of which, such as that in Poznan, depend on Leonardo's compositions and other Italian models. A very popular type was that of the *Madonna and Child Enthroned* in Berlin (fig. 473), dating about 1520, with the nude Child tenderly embracing his

right: 474. Quentin Metsys. *Mary Magdalen.* c. 1520–25. Panel, 17¾ × 11⅞". Musée Royal des Beaux-Arts, Antwerp

below: 475. Quentin Metsys. *Ill-Matched Lovers.* c. 1515. Panel, 16½ × 24¾". National Gallery of Art, Washington, D.C. Ailsa Mellon Bruce Fund

ening *sfumato* reminiscent of Leonardo, but otherwise the characterization is wholly Netherlandish. The repetition of curved shapes—her shoulders and arm, the lid of the ointment jar, and the arch of the loggia and frame—contributes to an intimate portrait of a young maiden whom we find beautiful yet troubled in mind.

A similar ambivalence pervades the enigmatic *Money Changer and His Wife* (colorplate 64), signed and dated 1514.[64] The subject is unusual, and while it may seem to be an everyday genre piece, a definite moralizing tone characterizes the banker and his office. According to early descriptions the original frame was inscribed, ''You shall have just balances and just weights,'' taken from the laws of righteousness cited in Leviticus (19: 35). This admonition carries a reference to the new profession of the banker or the moneylender in the Netherlands and serves as a criticism of the changing values in a society devoted to commerce and finance.

Traditional religious values are here discarded or ignored. The husband is wholly absorbed in his task of weighing coins against gold, as much so as Saint Michael weighing souls at the Last Judgment, while his wife, dressed in archaic Burgundian costume, seems bored and looks up from her delicately illuminated Book of Hours to attend his business. One senses that she has not been reading the prayers anyway, merely flipping through the pages and looking at the pretty miniatures. Religious ritual and the routine of prayer have been replaced by the monotonous rites of the business world, and the gloomy atmosphere that surrounds them seems to reflect the dingy chamber of their worship.

The mirror placed diagonally on the table has often been compared to that in the *Arnolfini Wedding Portrait* by Van Eyck (colorplate 18) or its quotation in the *Saint Eloy* by Petrus Christus (colorplate 26), and in all three the nature of the reflection has much to tell us. With Van Eyck, the image enhanced the facts of the ceremony, the sacrament of marriage, and the purity of the bride. Christus added a moralizing message in his reflection by placing idle dandies outside the shop, representatives of lascivious living opposing those about to enter the holy state of matrimony. The reflection in Quentin's mirror gives us a view of an older man seated at a table, perhaps the client, and through the window of the office, the city streets with a distant view of a church spire, the last reminder of a fading world. However one interprets the picture, it is clear that the participants are busy but bored, the interior is dark and unkempt with account books, bills, and various objects (the round metal shape appears to be a Chinese mirror) scattered in disarray on the shelves behind them.

The *Ill-Matched Lovers* in Washington (fig. 475) is another example in the rapidly expanding repertory of sub-

mother, a variation of the ''Affectionate Madonna'' type of the Middle Ages. The sensuous appeal of Metsys's variation is enriched by the delicate treatment of the costumes, the elaborate still-life detail, and the lover's park in the background. Whatever symbolic message these details may add to the hallowed theme is overwhelmed by the sheer beauty and precise execution displayed in the textures and the soft landscape. A fresh breath of Renaissance optimism pervades Metsys's charming Madonna enjoying the warm air of the sunny environment.

Metsys's ideal of feminine beauty is even more clearly stated in the graceful and lovely *Mary Magdalen* in Antwerp (fig. 474). A certain ambivalence characterizes the beautiful young penitent in her sad, downward glance and arrested gesture. Her full oval face, small pointed chin, and soft features are slightly touched with the soft-

476. QUENTIN METSYS. *The Ugly Old Woman*. 1513. Panel,
25¼ × 17⅞″. National Gallery, London

477. QUENTIN METSYS. *Old Man in Profile*. 1513. Parchment on
canvas, 18⅞ × 14½″. Musée Jacquemart-André, Paris

ject matter that may be termed moralizing genre.[65] The
exact source for the iconography is not certain. It has
been described as a variation on the story of the Prodigal
Son at the Whores, a popular theme taken from the Bib-
lical parable that appears in many later sixteenth-century
paintings, but the male figure, ugly, old, and lecher-
ous—the archetypal "dirty old man"—in no way resem-
bles the young dandy wining, dining, and loving in
Luke's story (15: 11–32). It illustrates rather the mottoes
frequently alluded to by satirists such as Brant and Eras-
mus: "A fool and his money are soon parted" and "the
older, the sillier," or more simply, "folly finds its just
rewards."

Again the format is horizontal with half-length fig-
ures seen behind a counter strewn with objects; a deck of
playing cards to the left indicates the environment of a
brothel. The young prostitute is charming and certainly
seductive as she tenderly touches the old man's face while
allowing him to fondle her breast. The interlocking of
arms does not conceal the fact that she has secretly lifted
the money purse from her customer and now slides it
back to a grotesque jester with an obscene leer on his
face, undoubtedly her procurer or manager in this busi-
ness. Once again Metsys contrasts beauty with ugliness
in the inviting young whore and the ugly, aging lecher,
but her beauty is deceptive and the moral of the encoun-
ter is almost humorous. No doubt it seemed so to his

patrons, for it is unlikely that the Washington panel
hung in the portrait gallery of favorites that often
adorned the walls of the more exclusive houses of prosti-
tution.

Quentin's preoccupation with the grotesque is even
more manifest in two "portraits" that are sometimes de-
scribed as a diptych (figs. 476, 477), although that seems
unlikely. The *Old Man in Profile*, painted on parchment
affixed to canvas, is signed and dated 1513. Is it a por-
trait? The profile type would indicate that Metsys has re-
vived an old tradition in portraiture, one that was
especially popular in Italy in the mid-fifteenth century; in

478. WENZEL HOLLAR AFTER LEONARDO. *The Ugly Couple*.
c. 1650? Engraving, 2⅝ × 5″. Bibliothèque Royale, Brussels

fact, the strange headpiece has been described as Italian. The bold modeling of the profile head is unusual, especially in the flaccid jowls and deep eye sockets, and the ungainly profile with the misshapen nose and protruding lower lip is hardly what one would expect in a normal portrait.

Scholars are divided in opinion as to whether this man is an actual likeness, an imaginary posthumous portrait of a nobleman, or simply a caricature. Those favoring the last argument point to a seventeenth-century engraving by Wenzel Hollar (fig. 478) that reproduces the head in reverse, more or less faithfully, and is paired with the repulsive portrait of an ugly old woman dressed in rich Burgundian costume, both bust-length. The engraving is entitled *Rex et Regina de Tunis* (*King and Queen of Tunis*) and is attributed by Hollar to Leonardo da Vinci. The female head is remarkably close to the Metsys portrait, and there exists a drawing by Leonardo in Windsor Castle that has the very same features but omits the hands.

It would seem that Metsys knew the Leonardo caricature in some form or another, but the identification of the ugly woman is further complicated by other engraved copies of the same face that are labeled "Marguerite alias Maultasche," roughly translated "Margaret the sack-mouthed." Marguerite was the daughter of Henry X, duke of Carinthia and count of Tyrol. She married the duke of Moravia and died in 1369. Yet it seems impossible that this malformed female head could be seriously considered a portrait. Panofsky has suggested that it is a social satire inspired by descriptions of old women by Erasmus, who are still wishing to "play the goat . . . display their foul and withered breasts . . . industriously smear their faces with paint . . . [and] never get away from the mirror."[66] He further finds it related to depictions of the "nagging old wife," a subject of marginal interest in fifteenth-century Northern art.

The Burgundian two-horned wimple that she wears was fashionable from 1430 to 1450 and is another indication of the archaizing intention. Yet, how does one explain the closeness of the head to the drawing by Leonardo, who probably would not have known the obscure Northern source? Whatever the explanation is, the face, misshapen and malformed, repulsive yet pathetic, that emerges from the overly ostentatious costume, had a considerable afterlife and is probably best known today in John Tenniel's drawing of the Ugly Duchess for Lewis Carroll's *Alice in Wonderland*.

Quentin's accomplishments in portraiture are uneven, and, like most Antwerp painters of his generation, he seems to have avoided that market considerably. That Metsys was no Holbein is demonstrated by his mediocre portrait of Erasmus, a good version of which is in the

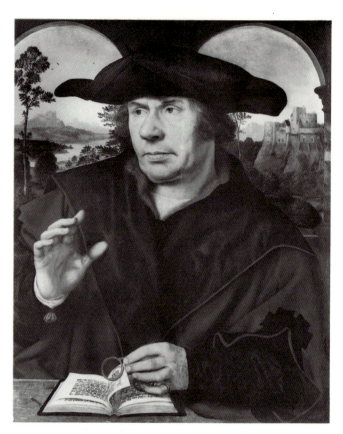

479. QUENTIN METSYS. *Man with Glasses*. c. 1515. Panel, 27⅛ × 20⅞″. Städelsches Kunstinstitut, Frankfort

Galleria Nazionale in Rome. The likeness of Erasmus was paired with one of the wealthy town clerk-humanist of Antwerp, Pieter Aegidius, as a gift to Thomas More in 1517, and both lack the warmth and depth of expression that one would expect from an artist-friend of such illustrious men.

Much more intriguing is his late portrait of an anonymous *Man with Glasses* (fig. 479), today in Frankfort. The identity of this fascinating personality remains unknown, but he must have been a scholar or teacher of some persuasion to judge by the alert and intense expression that Metsys gives him. In format and setting this portrait, as do other late examples, owes much to North Italian types, especially those of Andrea Solario (trained under Leonardo and in the service of the archbishop of Rouen from 1507–10), where the sitter is placed behind a shallow parapet within a loggia.

But to return to the former question. There has been much speculation about just what type of man this is. Is he a doctor, a humanist, a teacher who has stopped in his reading to make a point to his audience? Viewed in another light, our gentleman, undoubtedly very learned, is foremost a wholesome representative of Antwerp's Renaissance society in general. We have studied portraits placed against an abstract background in the works of Jan van Eyck and Rogier van der Weyden. We have watched the real world of the here and now gradually encroach on their personalities. Christus added the walls of a cell or

chamber behind the head; Bouts opened a window allowing the outside world to come in and establish his being more concretely on earth. With Memlinc the sitter is frequently posed out of doors in a soft summer landscape that seems to mellow his idealized features.

And now with Metsys the sitter actually responds to something happening in the outside environment. He has been interrupted or disturbed, and he quickly responds by removing his reading glasses and turning his focus outward with his right hand registering his intense reaction. Renaissance man is aware of the world about him and interacts directly with it. He no longer is an entity alone or a hero abstracted. His expression is not timeless but momentary. The world is changing, moving, challenging, and the *Man with Glasses* is part of that flux.

JOACHIM PATINIR

In the 1574 inventories of the Escorial is listed a "Temptation of Saint Anthony with three women in a landscape, the figures by Master Quentin (Coytin) and the landscape by Master Joachim." The painting (fig. 480), now in the Prado, is a large, horizontal panel with Anthony and the three women placed in the foreground of a deep, boundless landscape of rich greens and blues that seems to stretch from the fanciful broken cliffs on the left for miles across flat plains to the high horizon. The work is obviously a collaborative production, typical of many Antwerp paintings of the period. The main figures of Anthony and the temptresses (including the witch, who resembles the ugly duchess) are clearly in the style of Metsys, who signed the panel in the lower right corner, but the landscape is markedly different from that in his other works and is to be attributed to "Master Joachim," as the inventory reads.

But what are the salient differences between this panorama and those we have already seen in the paintings of Metsys? For one thing, one can easily see that the morphology of nature's forms (the external, structural features), the trees, rocks, hills, are more sharply in focus in Joachim Patinir's landscape. Brushstrokes are finer and more precise, and the jagged contours of the sharp cliffs are more detailed and varied. In particular, the mountains are given much more detail and variety.

Nowhere have we seen such fantastic towering crags and peaks that break angularly this way and that as they project upward. While they may seem Alpine, inspired by the same topography as Quentin's vistas, Patinir's mountains are set down as individual studies in stratifica-

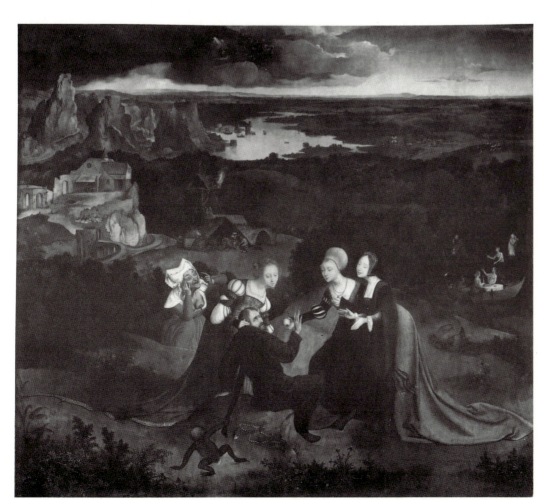

480. QUENTIN METSYS AND JOACHIM PATINIR. *Temptation of Saint Anthony.* c. 1520–24. Panel, 61 × 68⅛". The Prado, Madrid

481. JOACHIM PATINIR. *Flight into Egypt*. c. 1515. Panel,
6¾ × 8¼". Musée Royal des Beaux-Arts, Antwerp

tion and placed side by side or added one to the other,
growing into distinct crystalline structures and high rises
of incredible complexity. Is this simply an imagina-
tive elaboration of the fantasy in Northern landscape in
general, or is it actually inspired by direct study? The
countryside around Dinant, Patinir's homeland, has been
described as a stretch of "grand, broken scenery," and
perhaps the artist has merely aggrandized and magnified
features of a landscape with which he was familiar. It has
also been suggested that Patinir collected fanciful rocks in
his studio and used them for models for his soaring
mountain peaks, a practice that we know Leon Battista
Alberti recommended in his treatise on painting written
a century earlier. Whatever the source, Patinir's fantastic
rocky mountain formations became the models for gen-
erations of later Netherlandish artists.

Patinir's landscape compositions also differ markedly
from those of Metsys. Cosmic may have been the term
used to describe the backgrounds in Quentin's larger
paintings, and cosmic equally applies to Patinir, except
that the organization of space is more complex. Patinir's
panorama consists of numerous horizontal striations
punctuated by a variety of vertical elements, and he com-
poses his landscape in smaller vignettes that slide and
overlap one another. Furthermore, he employs no con-
sistent perspective scheme so that his vistas seem to float
in layers and the angle of vision can shift abruptly. With
the extremely high horizon line, the landscape is viewed
from a bird's-eye perspective, but the vertical elements,
such as buildings and walls, are viewed head on. They are
not tilted or foreshortened as they should be to conform
to the inclined plane as seen from the high vantage point.
The illumination is equally arbitrary. Metsys's three-

color code is followed to an extent, but there is little of
what one can call atmospheric perspective that increas-
ingly blurs and dims the details as we progress into the
distance. The sky is bright and clear, and there are no
cast shadows to detract from the clarity of his telescopic
view.

Very little is known about Patinir.[67] His name is listed
in the Antwerp guild records of 1515, and we know that
he died there in 1524. And yet he was famous and very
influential in his time, and his workshop production was
staggering. Some have argued that he received training
under Hieronymus Bosch, whose eerie landscape config-
urations anticipate Patinir's, and while this comparison is
apt, it is unlikely that the Antwerp landscapist actually
served as an apprentice in 's Hertogenbosch. Likewise,
the suggestion that he was a pupil of Gerard David in
Bruges is appealing, but the rich landscapes of the latter,
generally closeup views of woodlands, are very different
in conception from Patinir's remote panoramas. One
thing is clear. In his mature works Patinir did not con-
cern himself with painting the main figures, employing
instead his colleagues in Antwerp—Metsys, Joos van
Cleve, and others—to add such details.

One of Patinir's most poetic landscapes is the tiny
Flight into Egypt in Antwerp (fig. 481), generally consid-
ered one of his earliest works. The details of his world
are easily recognized: the fanciful slabs of rocks, the deep
gorge, the rising trees, and the river that winds unobtru-
sively to a high horizon. The staffage, the figure groups,
and the structural details are also repeated over and over
in his works—the rustic village, the wheat fields, the
duck pond and farmhouses, the pagan idol—all dwarfed
by the soaring pinnacles of his crystalline mountain for-
mations.

The same elements appear in the more impressive *Rest
on the Flight into Egypt* in the Prado (colorplate 65), a
theme made popular by Gerard David, it will be re-
called.[68] In the broad landscape the colorful farmyard
where the massacre of the innocents is enacted appears to
the right; the detail of the pagan idol is expanded into a
quasi-Romanesque cityscape of Heliopolis in the distant
left. The Madonna and Child, perhaps painted by Joos
van Cleve, are placed in the center foreground on a rocky
ledge with the standard paraphernalia, the wicker basket,
traveling bags, staff, and water gourd strewn before
them. The bubbling brook beside them flows past the
familiar flowering bushes and rushes, and in the lower
left, Joseph trudges wearily back to his family.

This formula is repeated endlessly in Patinir's work-
shop landscapes but becomes richer and more exotic in
both the fantastic rock formations and the flora and
fauna in depictions of other favorite landscape themes
such as the *Landscape with Saint Jerome* in the Louvre (fig.

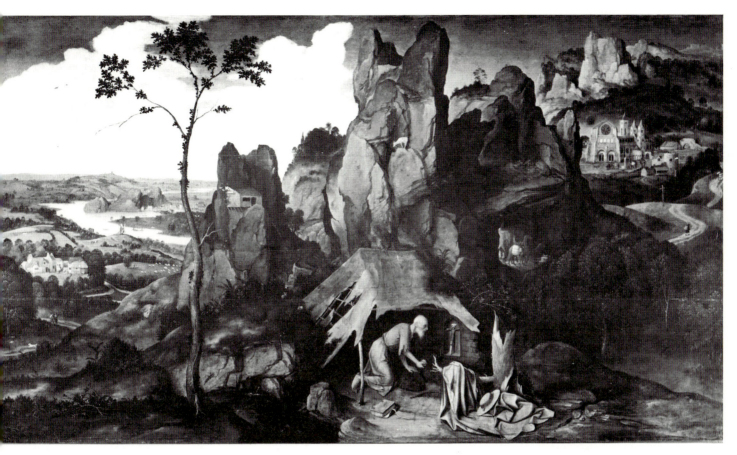

482. JOACHIM PATINIR. *Landscape with Saint Jerome.* c. 1520. Panel, 30 × 54″. The Louvre, Paris

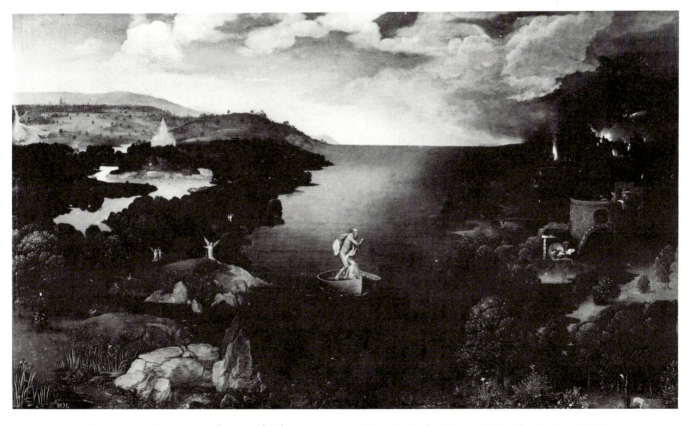

483. JOACHIM PATINIR. *Landscape with Charon's Boat.* c. 1520–24. Panel, 25⅛ × 40½″. The Prado, Madrid

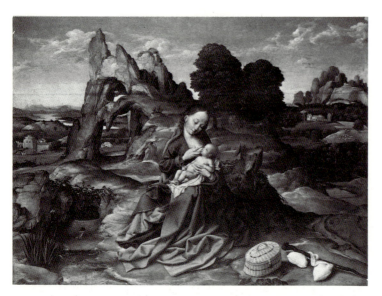

484. JOOS VAN CLEVE AND JOACHIM PATINIR? *Rest on the Flight into Egypt.* c. 1515–20. Panel, 21¼ × 26½″. Musées Royaux des Beaux-Arts, Brussels

482). An exception is his late *Landscape with Charon's Boat* (fig. 483), where Patinir presents an eerie mixture of Bosch's world and his traditional landscape motifs. The subject is unprecedented in the North. The most awesome aspect of the broad landscape is the river Styx that flows through the center of the composition forming an emphatic division between the exotic pastures of paradise and the dark, jagged peaks and canyons of Tartarus. To the left the waters shimmer in the bright sunlight, while to the right the landscape is cast in deep shadow. What is amazing is the manner in which Patinir has created a fan-

tasy of infinite space through which the river flows to a distant horizon that looks like the edge of the world.

JOOS VAN CLEVE

One of Patinir's collaborators was Joos van Cleve, an accomplished master whose many-sided talents typify the Antwerp school of his generation.[69] Van Mander described a painting of Mary by Joos that he had seen ''for which the background is a very beautiful landscape by Joachim Patenier.'' This picture has been identified as the *Rest on the Flight into Egypt* in Brussels (fig. 484), where we find one of Patinir's more pastoral landscapes discreetly composed about a doll-like Virgin with a charming face reminiscent of Memlinc's Madonnas.

The recovery of Joos van Cleve's oeuvre has been confusing, although a closely related body of works, formerly attributed to the Master of the Death of Mary, after a painting in Cologne (fig. 485), and one ''Joos van der Beke'' (after initials in three of the works), are now generally accepted as his paintings. The curious triptych in Cologne, dated 1515, with its broad central panel, presents an irregular frieze of striding apostles in various states of activity, before and behind the long bed of the Virgin. Those in the foreground move in crouched poses, their boneless bodies covered with fussy, angular drapery. The setting too is a rather derelict and deranged ensemble of walls, windows, and niches unfolded across the panel. Only the head types and the dwarfish proportions relate to the figures in other works attributed to Joos.

Far more successful are the numerous panels of the Madonna and Child, the Adoration of the Magi, and

485. JOOS VAN CLEVE. *Dormition of the Virgin.* 1515. Panel, 25⅝ × 49⅝″. Wallraf-Richartz Museum, Cologne

Colorplate 63. QUENTIN METSYS. *Lamentation Altarpiece.* 1508–11. Panel, 8' 6⅜" × 8' 11½" (center); 8' 6⅜" × 4' (each wing). Musée Royal des Beaux-Arts, Antwerp

Colorplate 64. Quentin Metsys. *Money Changer and His Wife*. 1514.
Panel, 28 × 26¾″. The Louvre, Paris

Colorplate 65. JOACHIM PATINIR. *Rest on the Flight into Egypt.* c. 1520.
Panel, 47⅝ × 69¾". The Prado, Madrid

Colorplate 66. JAN GOSSART. *Danaë*. 1527. Panel, 44½ × 37⅜″. Alte Pinakothek, Munich

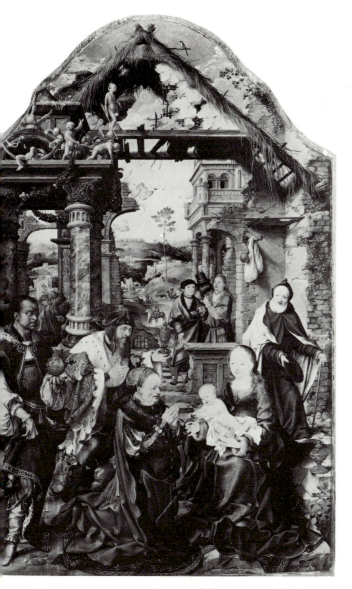

486. JOOS VAN CLEVE. *Adoration of the Magi.* c. 1513. Panel, 43¼ × 27¾". Staatliche Kunstsammlungen, Dresden

Adoration of the Magi discussed earlier (fig. 468) with precise, minuscule brushwork and delicate, enamel-like finish. The excessive fluttering of the drapery and the delicate architectural caprices, all enlivened with bright splashes of color—cherry reds, ripe greens, powdery blues—are delectible treats to the eyes, like a big box of chocolates. Our master even includes his self-portrait. He is the youngish man looking directly out at the viewer near the center of the middle ground.

These same luscious qualities characterize a number of his half-length Madonnas, which were repeated over and over again in the workshop. The *Holy Family* in New York (fig. 487) presents the Virgin and Child behind a parapet upon which are scattered delightful still-life objects which may or may not have symbolic significance. Here profundity of meaning gives way to palatability, and the fruits and wine transfer their sweet tastiness to the lovable mother breast-feeding her child. Remove the gossamer veil from Mary's head and you will recognize at once the model for Joos van Cleve's Mary: the *Lucca Madonna* by Jan van Eyck (fig. 101).

Such archaism is even more blatant in another painting

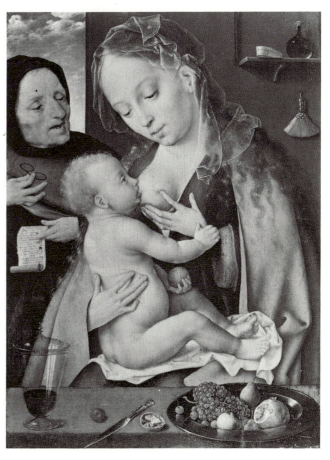

487. JOOS VAN CLEVE. *Holy Family.* c. 1513. Panel, 16¾ × 12½". The Metropolitan Museum of Art, New York. Bequest of Michael Friedsam, 1931. The Friedsam Collection

scenes of the Passion painted in the same style. Joos was prolific, but he was also an unashamed eclectic who culled motifs from his contemporaries as well as those of past masters. Eclecticism should not be too fiercely put down in our study of Antwerp painting, however, since it was the only practical answer to the fluctuating tastes of the new art patrons. One had to repeat the favorite compositions. Opulence, showy colors, and overly elaborate costumes were in vogue; pretty faces with creamy complexions and silken hair were desired; and, finally, all should be staged in a dreamy park with an abundance of flowers and a romantic Alpine vista. Joos excelled at this. He did not pretend to be a tragedian or expressionist of deep emotions, and the pictures his workshop turned out sold readily on the market.

The *Adoration of the Magi* in Dresden (fig. 486) is an excellent example of Antwerp Mannerism at its best. Joos displays an even more refined style than seen in the

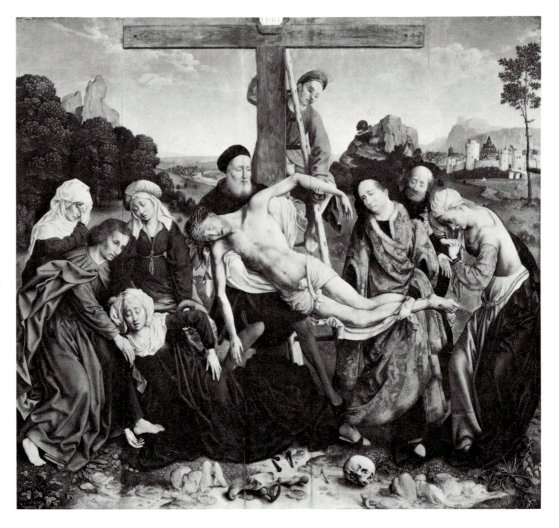

488. JOOS VAN CLEVE.
Deposition. c. 1518–20.
Panel, 45¼ × 49¾".
The John G. Johnson
Collection, Philadelphia

attributed to his workshop, the *Deposition* in the Johnson Collection in Philadelphia (fig. 488). Here Rogier van der Weyden's Prado composition (colorplate 20) is copied figure for figure across the shallow foreground. However, in keeping with contemporary taste, and apparently missing the point of Rogier's abstract golden box setting, Joos places the mourners in a broad landscape executed in the Patinir tradition.

During the first decades of the sixteenth century, the archives of the Guild of Saint Luke in Antwerp swell with the names of painters, most of whom remain unknown to us, who were followers of Metsys, Patinir, and Joos van Cleve. A few major currents, however, can be clearly discerned. More and more, the masters of the larger workshops turned directly to Italy for models and inspiration—the so-called Romanists—while, at the same time, others, whose art anticipates the spirit of much later Dutch painting, specialized in subject matter of a more secular nature. Let us now consider a few notable representatives of both of these tendencies.

Two Currents in Later South Netherlandish Painting: The "Romanists" and the "Specialists"

JAN GOSSART

By "Romanists" historians of Northern art generally refer to those painters who took inspiration for their style and compositions directly from Italian models, often of the Roman school. According to Guicciardini, Jan Gossart was "the first to bring to these lands from Italy the art of painting *historie e poesie* [historic and poetic narratives] with nude figures."[70] Gossart, born about 1478 in Maubeuge, a town in Hainaut, began his career in Antwerp, where he is listed in 1503, 1505, and 1507. He might have been trained in Mechelen. Only one work, a signed drawing of the *Mystical Marriage of Saint Catherine* (fig. 489), can be assigned with any assurance to his juvenalia, and it must suffice as evidence of his early Mannerist style.[71]

In 1508 Gossart accompanied Philip of Burgundy, the illegitimate son of Philip the Good, and his entourage on a trip to Rome, apparently serving as a special advisor to Philip, who was especially fascinated by architecture and antiquities. From his brief sojourn in Rome a scattering of drawings survive: the back view of the *Hercules Boarium*, the standing *Apollo Citharoedus*, the famous *Spinario*, various fragments and decorative pieces, and an ambitious view of the *Colosseum* (fig. 490), which is copied accurately in detail but loses something of its true monumentality in Gossart's preoccupation with the more picturesque features of the sprouting plants and other ruinous features.

After his return in 1509 Gossart continued to work for Philip and the house of Burgundy in Mechelen, Utrecht

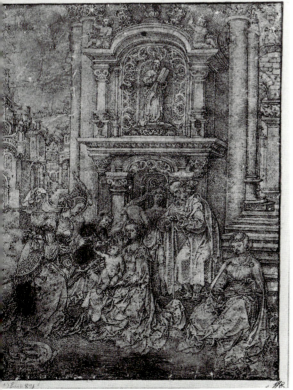

left: 489. JAN GOSSART. *Mystical Marriage of Saint Catherine.* c. 1505. Drawing, 9 × 6¾". Den Kongelige Kobberstik Samling, Copenhagen

below: 490. JAN GOSSART. *Colosseum.* 1508–9. Drawing, 7⅞ × 10⅝". Kupferstichkabinett, Staatliche Museen, West Berlin

(Philip was appointed bishop of Utrecht in 1517), and Middelburg in Zeeland. There is no evidence that Gossart executed any paintings in Italy, but something rather surprising happened to his style upon his return. Perhaps inspired by the works of the Italian Renaissance masters that he had seen, Gossart seems to have immediately abandoned the artificial trappings of tassels and tinsels, the fluttering draperies, slashed sleeves, swirling scarfs,

and capricious architecture so popular in the Antwerp art of his generation. But his emulation of the Italian manner was no simple transformation. Desiring to cleanse himself of the Mannerist superficialities, so to speak, he turned first to his own Northern tradition and revived the exemplary art of Jan van Eyck.

Gossart's archaism, in fact, constitutes an outright Eyckian Renaissance in some respects.[72] His paintings between 1510 and 1515 include three Eyckian reconstructions: the *Madonna in the Church* in the Galleria Doria Pamphili (fig. 491), the *Saint Donation* in Tournai (after the Bruges altarpiece), and the *Deësis* with busts of Mary, Christ, and the Baptist (from the Ghent altarpiece) in the Prado. He also revived Van Eyck's use of inscriptions and signatures painted to resemble letters cut from stone as well as Jan's stone-colored backgrounds for portraits. And, to some extent, Gossart consciously reintroduced Van Eyck's complex "disguised symbolism" in some of his compositions.

In returning to Van Eyck's compositions, he also emulated the Eyckian manner and technique of painting by reverting to earlier craft techniques. His pigments are finely ground and applied in many layers with oil, producing a translucent, glazed surface, highly detailed with tight brushstrokes. These standards of precision and craftsmanship were being sloughed off by many Antwerp workshops of the time, in which often a number of assistants were involved in the actual application of the paint. It was the unique finish of the earlier Netherland-

above: 491. JAN GOSSART. *Madonna in the Church* and *Antonio Siciliano and Saint Anthony.* 1513–14. Panel, each 16⅛ × 9½". Galleria Doria Pamphili, Rome

right: 492. JAN GOSSART. *Malvagna Triptych.* c. 1512. Panel, 17⅞ × 13¾" (center); 17¾ × 6⅞" (each wing). Galleria Nazionale della Sicilia, Palermo

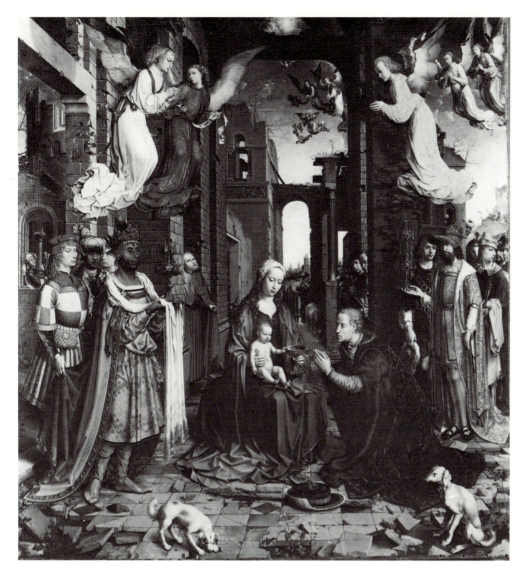

493. JAN GOSSART. *Adoration of the Magi.* c. 1507–8? Panel, 70 × 63¾". National Gallery, London

ish *ars nova* that Gossart was drawn to, and he was not alone.

Gossart's copy of Van Eyck's *Madonna in the Church* (colorplate 17) combined in diptych form with a portrait of *Antonio Siciliano and Saint Anthony* in a landscape (fig. 491) is the earliest example of this revival in Gossart's art.[73] The right panel is clearly an Antwerp product of the early sixteenth century as seen in the elegant costume of the donor, the dainty features of the elderly patron saint, and the fanciful mountain landscape in the Metsys-Patinir style. At first sight the panel with the Madonna seems an astonishing duplication of Van Eyck's famous work, but closer study reveals it to be a rather prosaic reconstruction. Mary's proportions are heavier and less graceful; the lyrical golden border is gone; her head has features more akin to Gerard David's types. The soaring Gothic interior is broadened so that more of the right side of the nave is visible, including the sculpture group above the rood screen. More telling is Gossart's elimination of the two pools of light striking the floor, indicating that he did not understand the subtle symbolic role of light in Van Eyck's painting (see p. 100).

More complex is the archaism in the *Malvagna Triptych* (fig. 492), datable around 1512, which is more than a version of Van Eyck's Dresden *Madonna and Child* (fig. 98) and appears to be an exotic elaboration of the pseudo-*Schnitzaltar* compositions of Rogier van der Weyden with simulated architectural frames elaborated into an overwhelming gingerbread setting with countless tiny crockets, pinnacles, tabernacles, hanging keystones, and canopies filled with fragile scrollwork. The female saints, Catherine, Barbara, and Mary, resemble the sedate types employed by Gerard David, and the pudgy angels disporting themselves gaily are more like Italian *putti* than Gothic types gracing the presence of the holy figures.

This curious archaistic phase culminated in one of Gossart's most memorable paintings, the *Adoration of the Magi* in London (fig. 493). One immediately senses the spiritual presence of Hugo van der Goes in this large, handsome work. Certain secondary details such as the headgear, the ornamental gifts, the cracked floor tiles, and the quotation of the Dürer dog in the foreground betray its sixteenth-century date, but for the rest we are transported to an earlier age. The blocky form of Mary

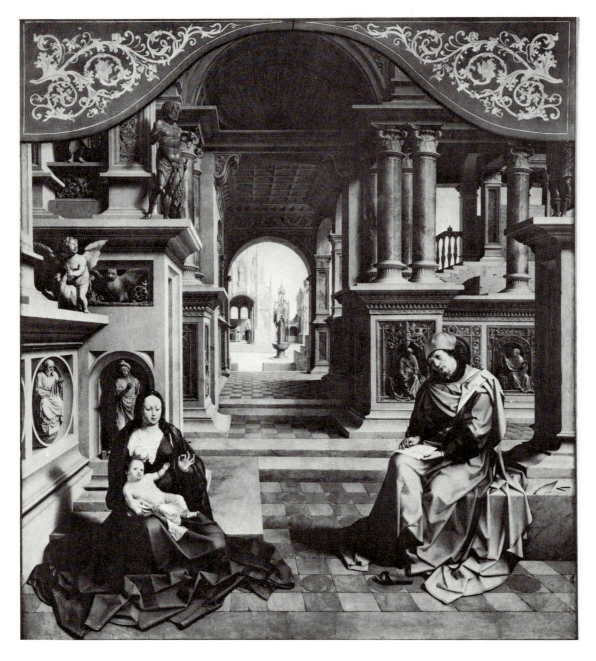

494. JAN GOSSART. *Saint Luke Drawing the Virgin*. c. 1512–15. Panel, 90½ × 80¾" National Gallery, Prague

has the solemnity of David's sedate Virgin; the Child is Van Eyck's (cf. the *Rolin Madonna*); and the exacting perspective enhances even more the cool, static clarity and formalized expression of the theme. The walls are barren, and the entourage of the Magi queue up like soldiers at attention while the kings present their gifts with the ritualistic solemnity of priests before an altar.

The concentration on perspective and static figure arrangement marks another unusual work by Gossart painted during these years, about 1512–15, the *Saint Luke Drawing the Virgin* in Prague (fig. 494). Gossart's haunting version of this popular theme is cold and remote, and only gradually are we drawn into the intimacies of the palatial studio where Mary and Saint Luke appear as isolated pieces of chess discreetly set down in the huge vaulted interior. The architecture was surely inspired by some Bramantesque interior; it reminds us of

Raphael's *School of Athens* (which Gossart could not have seen), and the sculptural decor adorning the walls and niches is overtly pagan, as if culled from details in his Roman sketchbook. The sharp perspective here focuses on the diminutive figure of Mary far beyond in the outer court; in fact, the vanishing point is at her stomach, an appropriate allusion to the text that Saint Luke, also repeated a second time just beyond the tiny *fons vitae*, is about to write down in his Gospel: ''Blessed is the fruit of your womb'' (Luke 1: 42).

In this incongruous classical environment, Gossart adds his details with care as to their symbolic role, much as Van Eyck would.[74] It has been argued that the bronze statue of Hercules high above Mary symbolizes the virtues and power of Christ; the owl in the wall plaque above her head is not a reference to evil but alludes to Minerva, goddess of Wisdom and Mary's pagan counter-

part; the antique *putto* wrestling with the goose should be read as an angel grappling with an eagle, symbolic of humility triumphing over pride.

Whether or not these "disguised symbols" are properly interpreted, one can be sure that Gossart expressly portrayed Mary as the Madonna of Humility for the occasion, seated on the floor and unadorned by regal trappings, as she is described in Luke's Magnificat: "My soul magnifies the Lord, and my spirit rejoices in God my Savior, for he has regarded the low estate of his hand-maiden . . . [and] has put down the mighty from their thrones, and exalted those of low degree" (Luke 1: 46–52). The enigmatic work, both austere and intimate, was painted for the chapel of the painters' guild in Mechelen, and Gossart admirably proclaims the dignity of their profession.

The Prague *Saint Luke* introduces us to the more blatant aspects of Gossart's Romanism, especially in the transformation of the artist's studio into some Renaissance pavilion, albeit empty and cold in its mixture of classicizing elements. Another version, usually dated 1520, differs dramatically in the rich ornamentation of the shallow architecture and the elaborate billowing of the draperies, much in keeping with current Mannerist taste (fig. 495), and the interpretation of the theme is

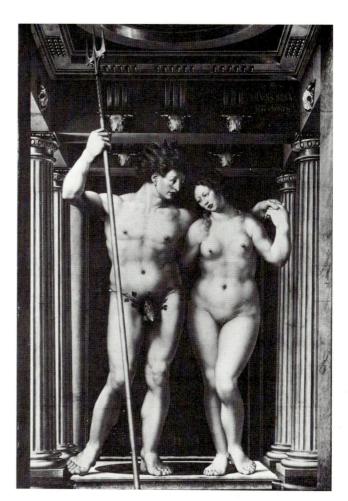

496. JAN GOSSART. *Neptune and Amphitrite.* 1516. Panel, 74 × 48¾". Staatliche Museen zu Berlin, East Berlin

entirely different with the miraculous appearance of the celestial mother before the divinely inspired artist. Luke kneels transfigured before his desk, upon which he reproduces his vision. His left arm is held out in awe, his right hand is guided and steadied by a lovely angel in full plumage. Above a circular tholos behind him appears a statue of Moses holding the tablets of the Law. Moses removed his shoes (Exodus 3: 4–5) before he could view the burning bush, a familiar image of the Virgin, and Luke, likewise, has removed his, recognizing the ground before him as hallowed. Rather than looking at something real, concrete, and human on this earth, as in the Prague version, here Luke has a mystical vision of the celestial Virgin and her Child, an idea that surely owes something to the Renaissance idea of the artist as someone divinely favored.

In Philip of Burgundy's Castle Souburg near Middelburg, an elaborate program of decorations *alla antica* was devised befitting his role as admiral of the sea. For this enterprise, which included genuine ancient statuary given to Philip by the pope during his visit to Rome, Gossart executed a large painting of *Neptune and Amphitrite* (fig. 496), signed and dated 1516 in Latin capitals

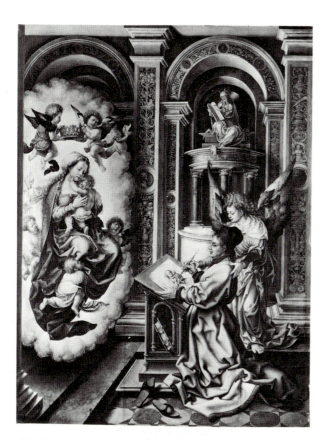

495. JAN GOSSART. *Saint Luke Drawing the Virgin.* c. 1520. Panel, 43⅛ × 32¼". Kunsthistorisches Museum, Vienna

across the base which serves as a pedestal for the statuesque figures. The muscle-bound nudes of the sea-god and his consort are very likely based on the *Adam and Eve* engraving of Dürer, which in turn descends from the *Apollo Belvedere* and the *Medici Venus*, as we have seen. The broader contours of the bodies may also have been suggested by Jacopo de' Barbari's engraving of *Mars and Venus* since the Italian artist was also called to Middelburg to assist in the decoration.

Neptune wears a laurel wreath and holds a long trident; Adam's fig leaf is replaced by an ornate conch shell, an appropriate codpiece for a sea diety. His rather effeminate facial features are accented by the glossy textures, and his polished contours give the figure the appearance of an oversized statue in ivory. The same is true of the corpulent Amphitrite. Obviously Gossart's painted figures were meant to resemble large statues placed in an austere cella of a pagan sanctuary, and to this end he designed a most interesting architectural setting formed of columns and entablatures of Doric, Ionic, and Composite orders. Egg-and-dart patterns decorate the capitals, fake guttae and bucrania embellish the architrave. A

498. JAN GOSSART. *Madonna and Child.* c. 1525–30. Panel, 24¾ × 19⅝″. The Prado, Madrid

497. JAN GOSSART. *Fall of Adam and Eve.* c. 1525–26. Black chalk and black crayon, 24¾ × 18⅛″. Museum of Art, Rhode Island School of Design, Providence. Walter H. Kimball Bequest Fund

dome covers the cella interior. These hybrid architectural elements were very likely based on sketches that Gossart had made in Rome of such structures as the Arch of Augustus and the Basilica Aemilia in the Forum.[75]

Similar architectural details appear in the semicircular exedra or tholos that serves as the tower chamber for Gossart's *Danaë* (colorplate 66), signed and dated 1527. Here the curious ensemble of classical motifs seems to be derived in part from the Temple of the Vestal Virgins in Rome, an appropriate model for Danaë's prison since it was meant to protect her virginity. Danaë's pose is not that of an antique statue, however. Zeus, it will be remembered, appeared to her in the form of a shower of gold for the seduction, and while Italian artists exploited the sensuous and suggestive lines of a reclining nude for the event, Gossart's Danaë, one of the earliest examples of the "good Danaë," assumes the attitude of modesty, *pudicitia*, in receiving divine favors, much as she is sometimes likened to the humble Virgin of the Annunciation in literature.[76] The cool, stereometric volumes of the flesh parts of her body are enhanced by the gossamer veil on her head and the rich blue of her mantle. Van Mander remarked that Gossart blues were especially attractive.

It was inevitable that Gossart would select the theme of Adam and Eve as a favorite among the Biblical subjects. As the counterparts to his nude pagan dieties, he

499. Jan Gossart. *Portrait of a Merchant.* c. 1520–25. Panel, 25¼ × 18¾". The John G. Johnson Collection, Philadelphia

500. Jan Gossart. *Portrait of "Baudouin of Burgundy."* c. 1525. Panel, 22 × 16¾". Gemäldegalerie, Staatliche Museen, West Berlin

could endow them with the same sensuous beauty and flavor them with an eroticism that no other Christian subjects would allow, especially in northern Europe. And so his nude first parents embrace, often seated on the ground, and strike suggestive postures about the tree and gyrate within each other's contours to make even more blatant his erotic intent. In a drawing of the *Fall of Adam and Eve* in the Rhode Island School of Design (fig. 497) this crisscrossing of body parts and enclosing contours is made even more sexually explicit in the gesture of Eve's right hand and that of Adam which crosses over it. Gossart's drawings in black crayon reach a high degree of refinement in shading in these mature pieces, resembling grisaille paintings, but he often is carried away, as in this drawing, with the sensations of rippling muscles and intertwining of legs and arms, movements that betray sources in Michelangelo and other Mannerist artists in Italy.[77]

Gossart's treatment of such traditional subjects as the *Madonna and Child* in half-length (fig. 498) offers a curious mixture of the saccharine and affectionate qualities of those of Joos van Cleve seasoned with pagan touches and slightly erotic overtones even in this most sacred of images. The fine example in the Prado presents Mary as a lovely, elegantly draped Danaë or Amphitrite with the same smooth face and sensuous ripeness about her, even

including the dainty little curl that falls before her ear. The pudgy Child is a miniature Hercules and embraces his mother with an almost too rapt gaze. The two are positioned before a deep niche constructed of Gossart's favorite classical motifs: a semicircle of polished columns on high bases with projecting cornices against a cold stone wall. Gossart's modeling has never been so precise and refined, nor the affected turnings of the neck, the fingers, and wrist so melodious. The stereometric abstractions of the flesh enhanced by the soft, iridescent fabrics, seen against the smooth hollow of the pagan background, make these Madonnas showpieces of Northern Mannerism.

The same sense of clarity and academic refinement characterized Gossart's portraits (figs. 499, 500; colorplate 67), which are some of the finest examples of Mannerist art in northern Europe. Gossart was commissioned to execute a number of portraits of his noble Burgundian patrons, their families, associates, and friends, among whom were Jean Carondelet, the powerful chancellor of Burgundy, the young Eleanor of Austria, Hendrik III of Nassau, Floris of Egmond, and the children of the deposed king of Denmark, Christian II.

A number of his portraits are unidentified since he rarely added specific attributes or coats of arms, but whoever they may be, they all project a similar sense of

dignity and power and are never emotional or vulnerable. They could all be princes or ladies-in-waiting, proud, handsome, assertive in expression, lofty and at times arrogant before the viewer. They are healthy representatives of their new world, confident and untroubled by any spiritual longings, and one senses they will succeed. They have no secrets, no weaknesses, no fears, and they often look directly out at us as if challenging our judgment. In short, Gossart paints his patrons just as they would like to see themselves. The stereoscopic volumes of their heads are brightly lighted so that all minor facial features or blemishes are subordinated to the smoothness of the countenance, and to this end, Gossart frequently placed them against a dark, stone-plated background with a painted frame within the actual frame to ensure their uniqueness.

The *Portrait of a Merchant* (fig. 499) in the Johnson Collection—a replica is in the National Gallery in Washington—is atypical only in that the sitter is placed in a cluttered office before a desk strewn with pens, account books, coins, and other paraphernalia of his business. Perhaps he is a high state official or accountant for the Burgundians.

More characteristic is the handsome *Portrait of "Baudouin of Burgundy"* (fig. 500). The elegantly attired nobleman is not to be confused with Baudouin, the son of Philip the Good, as the inscription placed on the back of the panel indicates, but rather with his son since the elder died in 1508, much too early for the portrait. Also problematic as to identification is the charming but saucy

young girl in the National Gallery, London, who is usually named Jacqueline of Burgundy (colorplate 67), the youngest daughter of Adolph and Anna van Bergen (whom Gossart also portrayed). The portrait of the Zeeland *meisje* has been dated about 1522 on the basis of her costume—such evidence, incidentally, is to be handled with extreme caution—at which time Jacqueline would have been about twelve years old. She had two sisters, Anna and Antonia, who might also qualify for the sitter.

She holds an armillary globe, a very costly toy, with rings that mark the positions of the major circles of the celestial spheres, perhaps a token of her father's profession. The dark stone background is bordered by a painted frame, a common device employed by Gossart, that here locks the rounded, three-dimensional forms of the girl's head and the globe into a compact, focused circle. All extraneous sense of motion is thus arrested in the narrow confines of the frame so that we concentrate solely on her alert personality and big eyes.

BERNARD VAN ORLEY

"Romanism" as a style, if it indeed can be so considered, was not promoted by Gossart, who remained a relatively individual court artist throughout his career, but by the leading painter in Brussels, Bernard van Orley.[78] Van Orley was the chief court artist of the Hapsburg rulers residing in Brussels and Mechelen, and as such served as sort of a commissioner of the arts for the Brus-

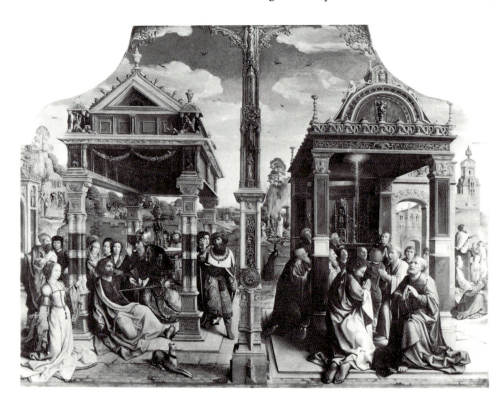

501. BERNARD VAN ORLEY. *Altarpiece of the Apostles Thomas and Matthias.* c. 1512. Panel, 55⅛ × 70⅞" Kunsthistorisches Museum, Vienna

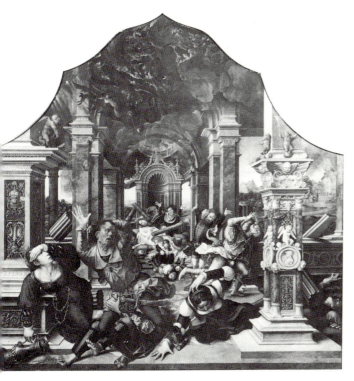

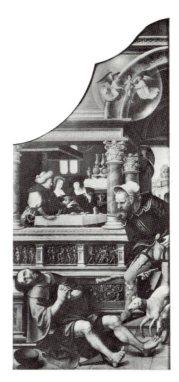

502. BERNARD VAN ORLEY. *Destruction of the Children of Job*, from the *Altarpiece of the Ordeals of Job*. 1521. Panel, 69¼ × 72½". Musées Royaux des Beaux-Arts, Brussels

503. BERNARD VAN ORLEY. *Altarpiece of the Ordeals of Job* (reverse of shutters of fig. 502)

sels town council. He was foremost an industrious and efficient entrepeneur, the director of a large painting factory, designer of vast programs for mural decorations in stained glass and tapestries, and lord of the Romanist school of painting.

Surprisingly, there is no real evidence that Van Orley had been to Rome himself, but there can be no doubt that he was familiar with the workshop practice of Raphael and had absorbed the idea of *invenzione*, or originality, in composition with the flow of drama across the painting in large, heroic figures with *contrapposto* poses and theatrical gestures. Furthermore, the idea that the master was above the tedium of applying pigments and was rather the gifted director who thought up the *concetti*, or compositions, in sketches, much as Raphael had done, was foremost in Van Orley's image of the "fine artist." Inspiration and invention were the traits of the true artist; technique and application belonged to the craftsman. Hence, an enormous split in the role of the artist occurred, and while Gossart appears to have maintained the position of the artist-craftsman, with Van Orley the idea of the "fine artist" appears.

His sources for Raphael's narrative style were plentiful in numerous prints by Marcantonio Raimondi and in the availability of Raphael's cartoons for the Vatican tapestries that were in Brussels from 1517 on for weaving. His workshop production was enormous, even by Antwerp standards, and following the demands of the market, Van Orley's atelier turned out countless variations on themes made popular by Antwerp painters. An early example of

his workshop production is the large *Altarpiece of the Apostles Thomas and Matthias* for the guild of the joiners in Antwerp, executed about 1512 (see fig. 501, center panel only). It is clear from these panels that Van Orley's idea of Raphael's narrative style had not yet been understood.

The major events—the Doubting of Thomas (on the left wing), Thomas Threatened by the King of India and Pentecost with the Calling of Matthias (in the center), and the Martyrdom of Matthias (on the right wing)— are staggered across the triptych without clarity or dramatic unity; rather, they dissolve into episodic clusters framed by elaborate architectural settings of dubious antique derivation. Exotic ornamentation abounds and overwhelms the meager narratives before them. The sharp light-and-dark contrasts may seem at first to accentuate the drama of the stories, but, as Friedländer has pointed out, they also serve "to obscure certain weaknesses in his forms, which made his work easier."[79]

Van Orley's most famous production is the *Altarpiece of the Ordeals of Job* (figs. 502, 503), commissioned by Margaret of Austria as a gift for Antoine de Lalaing, lord of Hoogstraeten. A lengthy inscription serves as an advertisement for Van Orley, giving his name, place of execution, date, monogram, and personal motto, "Elx syne tyt Orley" (Everything in its own time, Orley). The subject matter is unprecedented in Northern art, and so Van Orley was free to display his own *invenzione* in composing the unusual scenes of sudden destruction and devastation that open the Book of Job with the catastrophes

that struck Job and his family after the Lord had agreed with Satan to test the rich man's faith. The usual illustration for Job in medieval art shows him with boils seated on a dungheap and holding "Platonic" dialogues with his wife and companions. That appears only as a distant detail in the central panel, and it is rather the terrible events leading up to his state of misery in chapter one that are presented.

Van Orley was perhaps inspired by a poem attributed to Margaret of Austria, *La Vertu de patience* (*The Virtue of Patience*), in which the faiths of Job and Lazarus are the subjects. In the right wing, Job appears on the steps of his palatial residence receiving the four messengers who reported the catastrophes that befell his flocks and his seven sons and three daughters. The first related how his oxen (five hundred in number) and asses (also five hundred) were taken by the Sabeans, who then slew his servants; the second told of the fire that fell from the heavens and burned up the sheep (seven thousand); the third reported the raid upon his camels (seven thousand) by the Chaldeans; and the final messenger announced, "Your sons and daughters were eating and drinking wine in their eldest brother's house; and behold, a great

wind came across the wilderness and struck the four corners of the house, and it fell upon the young people, and they are dead; and I alone have escaped to tell you" (Job 1: 18–19).

The central panel depicts the destruction of the eldest son's house and the death of Job's children, and the left wing illustrates the taking of his oxen, sheep, asses, and camels. Recognizing the possibilities of displaying his expertise in the gruesome horror and turbulence of the high drama of the destruction of the son's house and the death of his children, Van Orley chose that episode for the central panel. The dark, stormy clouds of the great wind filled with Boschian demons sweeps through the high vaults, and while a few columns and drums are scattered here and there, the structure is amazingly intact. The children, mostly adults, are thrown about; some lie dead on the floor, others rush headlong out of the hall only to stumble and fall, although no stones seem to reach them. The scurry of the victims is full tilt, with their bodies dramatically foreshortened and twisted as they writhe about and cover their heads. The stability of the handsome architectural setting is thus shattered by the thrusting, slanting, zigzagging lines of force.

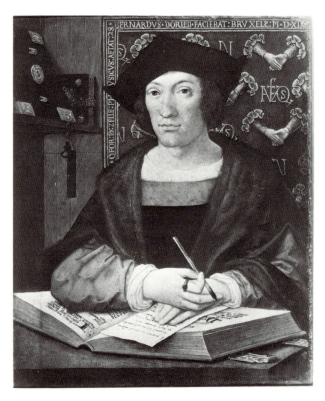

above: 504. Bernard van Orley. *Portrait of Doctor Georges de Zelle*. 1519. Panel, 15⅜ × 12⅝″. Musées Royaux des Beaux-Arts, Brussels

right: 505. Bernard van Orley (replica?). *Portrait of Charles V.* c. 1516. Panel, 28⅛ × 20¼″. Museum of Fine Arts, Budapest

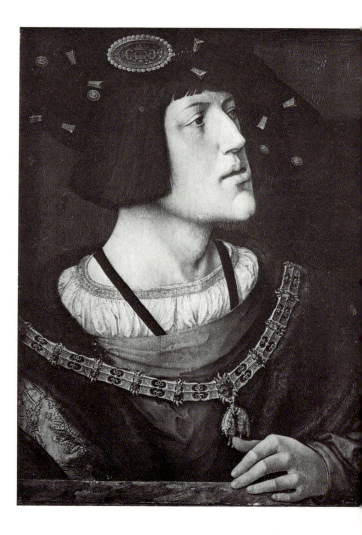

Van Orley gives no priorities to the parts of the composition. Labored excesses of ornament and pseudo-antique embellishments proliferate everywhere, and while the vigorously undulating ribbon of writhing bodies conveys something of the hyperexcitement of a Hellenistic battle frieze, there are far too many clusters of static enrichments, such as the pier to the right, to divert our attention. On the exterior of the right shutter the twisting torso of Dives, the rich man in hell, is an effective figure that Van Orley borrowed directly from Raphael's fallen Ananias in the *Conversion of Paul* cartoon for the Sistine tapestries, and the delicate frieze painted above the head of the ailing Lazarus on the left shutter was inspired by engravings of Mantegna's famous grisaille paintings of Roman triumphs.

In his numerous devotional panels, Van Orley combined Mannerism and Romanism in unequal proportions, sometimes creating truly imaginative copies such as the *Holy Family* in the Prado (colorplate 68), which is a variation of Raphael's *Holy Family of Francis I* with similar postures for the striding Child and the flying angels strewing flowers. His portraits are rather undistinguished. That of his friend, *Doctor Georges de Zelle* (fig. 504), follows the traditional scholar-businessman type by placing the sitter behind a high desk, but a portrait of the young *Charles V* (fig. 505) in Budapest is enlivened by turning the body off axis, and with the head thrust back and the lips parted, the likeness has the refreshing character of a young monarch with power and a strong will.

The vast number of paintings and drawings (mostly preparatory sketches for tapestries and stained glass)[80] attributed to Van Orley betray the unevenness of his workshop productions, but note should be made of the impressive *Last Judgment* triptych (fig. 506) that he executed for the almoners in the Cathedral of Antwerp. The givers of alms formed a charitable group of citizens who cared for the poor and the infirm, and because of this the artist turned to the apocalypse of Saint Matthew (Matthew 25: 34–41) for inspiration, where the theme of the acts of mercy serves as an illustration of the good life on earth. We shall return to this iconography in a later chapter (see p. 447).

The acts of mercy appear in cityscapes on the wings, and the central panel illustrates the traditional Last Judgment with the addition of the burial of the dead in the lower center, another function of the almoners. Following Matthew's text (24: 30–31) there then unravels the final moments of judgment in a vast plain: ''Then will appear the sign of the Son of man in heaven [the cross], and then all the tribes of the earth will mourn, and they will see the Son of man coming on the clouds of heaven with power and great glory; and he will send out his angels with a loud trumpet call, and they will gather his

506. BERNARD VAN ORLEY. *Last Judgment.* 1519–25. Panel, 8' 1⅝" × 7' 1⅞". Musée Royal des Beaux-Arts, Antwerp

elect from the four winds, from one end of heaven to the other.'' In the long tradition of this iconography Van Orley's triptych must be reckoned as one of the most successful in capturing the universal dimensions of the event. The giant circle of angels encompasses the horizon so that the rotation about the glowing form of Christ complements the great semicircle of the nude forms of the resurrected on the barren earth below. One thinks of Raphael's majestic *Disputà* in the Stanza della Segnatura in Rome, and this comparison would have pleased the artist.

PIETER COECKE VAN AELST

The successors of Van Orley present even greater problems in matters of attribution, and few have been studied properly. One of the more notable is Pieter Coecke van Aelst, who, according to Van Mander, learned the art of tapestry designing under Van Orley.[81] Aside from a great number of drawings for such projects attributable to Pieter Coecke, few tapestries can actually be assigned to his designs, although a series of woodcuts depicting *Ces moeurs et fachons de faire de Turcz* (fig. 507), published in 1553 by his wife after his death, preserve drawings Coecke had made in Constantinople that are believed by some to be intended for such tapestry projects. The woodcuts are interesting mostly for their historical and topographical features—the cityscape of Constantinople

507. Pieter Coecke van Aelst. *Turkish Sultan Before the Hippodrome,* from *Ces moeurs et fachons de faire de Turcz.* Published 1553. Woodcut

is fairly authentic[82]—and the lively parade of figures seen against a continuous landscape divided by hermae could easily be translated into a giant set of exotic hangings. For the most part, Coecke and his atelier—he settled in Antwerp by 1525—turned out numbers of stereotypical Madonnas and Adoration of the Magi panels that can be found in nearly every major museum in Europe and America today.

One of his most popular compositions was the *Last Supper* (colorplate 69), of which no fewer than forty-one copies survive, the last being executed thirteen years after Coecke's death.[83] Such assembly-line production makes it virtually impossible to evaluate the actual achievements of the ''inventor'' aside from the repeated lines of the figures and the composition. Coecke was obviously exploiting the popularity of Leonardo's famous *Last Supper* in Santa Maria della Grazie, which was well known through engravings and other copies. Coecke had been in Italy, but his version of the *Last Supper* was very likely based on an engraving in which additions to Leonardo's austere composition had already occurred (one by Fra Antonio da Monza of about 1500 adds the dog).

There are several changes and departures between Coecke's version and that of Leonardo, however. The general scheme is the same, as is the moment depicted—the betrayal of Judas—but Leonardo's simple perspective hall is elaborated by Coecke into a complex interior with carved medallions on the back wall with representations of David and Goliath, left, and the Murder of Abel, right, which may or may not have significant symbolic meaning for the Eucharist. But most of all, the ingenious groups of the apostles, who ripple excitedly outward from Christ in the fresco, are greatly weakened by

Coecke's scattering of them in twos, where they have little rapport with one another, nor do they seem concerned with Christ's announcement. Judas is emphatically isolated to make the point. Furthermore, Leonardo's deft use of chiaroscuro and softening atmosphere to enhance the mystery is not conveyed in Coecke's arbitrary and staccato-like spotlighting of the figures and their crisp, angular drapery folds.

In another endeavor, Pieter Coecke made a valuable contribution to the importation of the Italian Renaissance to the Netherlands by publishing Flemish translations of Vitruvius and Sebastiano Serlio's popular books on architecture in 1539 and 1550. Van Mander highly praised Coecke for this service since the principles of classical architecture were much in vogue: ''The right method of building has come to us, in this way, through Pieter Koeck, and we are dropping the modern style. The ugly, modern German type [Late Gothic] of architecture is most difficult of acceptance.''[84]

LAMBERT LOMBARD

Another ''Romanist'' whose interests in classical architecture and art led him to form a sort of academy of art and art theory was Lambert Lombard (1505–1566) of Liège.[85] Lombard had been to Rome too, between 1537 and 1538, where he studied antiquities with a scholarly eye. Van Mander states that ''he obtained such knowledge of these things that he could differentiate their periods and the places where they had been made.'' Lombard had also studied antiquities in Germany and France as well as monuments of the Middle Ages, and in a letter to Giorgio Vasari, the famous Italian artist and historian, he

asked the Italian expert for information concerning the works of Margaritone, Giotto, and Gaddi, in order that he might compare their works with the "stained glass that are here." In his atelier and "academy" in Liège, Lombard enrolled some of the more famous luminaries of later Netherlandish art—Frans Floris, Willem Key, Hubrecht Goltzius, and Domenicus Lampsonius.

Most of the paintings attributed to him are clearly workshop productions in which he probably contributed, as a fine artist, little more than the preparatory sketches and details of classical architecture, costumes, sculptures, and gestures of the antique figures to assure an accurate reconstruction of ancient history. A fine example of such reconstruction is *Saint Denis and Saint Paul Before the Altar of the Unknown God* (fig. 508), one of several panels that his atelier provided for the shutters of a sculptured shrine in the Church of Saint Denis in Liège about 1540. Denis, the patron saint of France, had been confused in hagiography with the philosopher Dionysius the Areopagite, whom Saint Paul converted in Athens. Hence the story was an excellent vehicle for Lombard's expertise on ancient art. According to the story, as recorded in the *Legenda Aurea*, on the very hour of Christ's death on the cross, when the sun was miraculously eclipsed by the moon, the philosophers of Athens were very perplexed by this unnatural occurrence. The very order of nature had been abruptly overturned, and the philosopher Dionysius prophesied that the world was now awaiting the true light of the heavens to shine upon mankind. To this end, the Altar of the Unknown God was set up in the precinct of the Temple of Mars, the Areopagus, where the philosophers gathered. When Paul arrived in Athens he met Dionysius, who then showed the altar to the apostle, telling him that the god "is unknown . . . he shall be in future time, and shall reign forever."[86] Paul disclosed that the mysterious deity was none other than Christ, and the philosopher was therewith converted to Christianity.

Lombard's figures are crisply outlined and stiffly articulated like toy soldiers, and, in fact, the painting resembles the "antique" compositions of Mantegna, such as his well-known *Saint Jerome Led to Execution* in the Church of the Eremitani in Padua of about 1455. The temple interior, reminiscent of Gossart's polished halls, has more intelligible orders, and before the aedicula at the end of the hall, a bronze statue of Mars elegantly stands atop an antique pedestal, and the large altar is inscribed in Greek, "The Unknown God."

FRANS FLORIS

One of the pupils in Lombard's "academy" was Frans Floris, the son of an Antwerp sculptor.[87] After a few

508. LAMBERT LOMBARD. *Saint Denis and Saint Paul Before the Altar of the Unknown God.* c. 1540. Panel, 30 × 25¼". Musée de l'Art Wallon, Liège

years in Liège, Floris returned to Antwerp, where he established a shop by 1540. Like his master, Floris then embarked on a trip to Rome to study the true art of antiquity with chalk and pen in hand.[88] Very likely he witnessed the unveiling of Michelangelo's *Last Judgment* fresco on the end wall of the Sistine Chapel in 1541, and he undoubtedly studied and sketched works by other Italian masters, including Raphael, Giulio Romano, and Tintoretto. It was Michelangelo who made the strongest impression on Floris, and it was his more turbulent *terribilità* in style that impressed him.

The atelier of Floris was very prolific—Van Mander reports that he had over 120 pupils during his career—and describes his workshop procedure: "After he had sketched with chalk the subject he had in mind, Floris allowed the pupils to proceed, saying: 'Now put such and such faces in here.' He had a number of examples on panels always at hand. In this way, his pupils developed a certain bold ability, so that they could lay out large canvases themselves and could make original compositions and paint according to their inspirations."

An example of the collaborative manner in which his larger works were carried out can be studied in the *Last Judgment* in Vienna (fig. 509), dated 1565. The composi-

509. FRANS FLORIS. *Last Judgment*. 1565. Canvas, 64½ × 87⅛″. Kunsthistorisches Museum, Vienna

tion is a copy of an earlier triptych (Brussels) here squeezed into one large horizontal panel figure for figure, including the old man (a self-portrait?) holding a stone block and base inscribed with his signature and the date. The sensationalism of Floris is most ruthlessly displayed in the gruesome form of the satanic demon twisted into violent *contrapposto* dominating the center of the panel. This huge weight lifter is bulging with strained muscles that ripple down his back and swell into knots in his legs. His backbone is a sharp serrated blade, his feet have menacing talons, and capping the muscle-bound torso is a fearsome human face turned into a kind of werewolf. The figures are Michelangelesque and assume contorted postures not unlike those of the damned in the famous fresco in the Sistine Chapel. A boundless, almost spasmodic, energy pervades the large foreground figures with their nude bodies interlocked and drastically foreshortened. They spill out of the frame in their wild movements, and although there is a sense of spontaneity and vigor in the brushwork, the whole ensemble has the artificial appearance of a giant pastiche pasted together in a hurry.

HERRI MET DE BLES

Between 1530 and 1550 a great diversity of subject matter is found in Antwerp painting. Running counter to the mainstream of the Romanists were the numerous side currents of the ''specialists,'' artists who narrowed their course to only a few subjects that had popular appeal. Among these, landscape must certainly be considered a prime commodity for the market. Patinir's success had made the point, and following his death in 1524,

scores of talented painters turned more and more to his example. Many of these were accomplished masters—Matthys Cock, Jan van Amstel, Cornelis Metsys, Lucas Gassel, and anonymous artists such as the Master of the Female Half-Lengths—but one stands out as a truly original contributor to the tradition, Herri met de Bles.[89] I will not attempt to disentangle the webs of confusion that veil his true identity, but rather present the artist as he is generally understood by most authorities.

Born sometime around 1510 at Bouvignes near Dinant, Patinir's hometown on the Maas, Met de Bles is believed to have been a nephew of the famous landscapist but, however, would have been too young to have been his apprentice. He is listed as a free master in Antwerp in 1535, and he apparently spent his entire career there, though it has been suggested that Met de Bles later settled in Italy, where he was called *Civetta*, or little owl, because it was said that he always hid an owl somewhere in his landscapes as a secret signature. His name, ''Met de Bles,'' means ''with the white forelock,'' apparently a distinguishing feature of the painter.

One of his largest landscapes appears as the setting for the *Road to Calvary* in Princeton (colorplate 70).[90] The subject is but a pious excuse to create a spectacular landscape, much as Patinir had done with the *Rest on the Flight*. The foreground procession of people who stream from the giant turreted gate of Jerusalem is minuscule, and within the city walls Met de Bles scatters more tiny figures, mere specks at times, who act out the various episodes of the Passion from the Entry into Jerusalem in the farthermost gate beyond the city square through the parade of townspeople accompanying the thieves and Christ to Golgotha, situated on the far left. One need

Colorplate 67. JAN GOSSART. *Portrait of Jacqueline of Burgundy?* c. 1522. Panel, 14⅝ × 11″. National Gallery, London

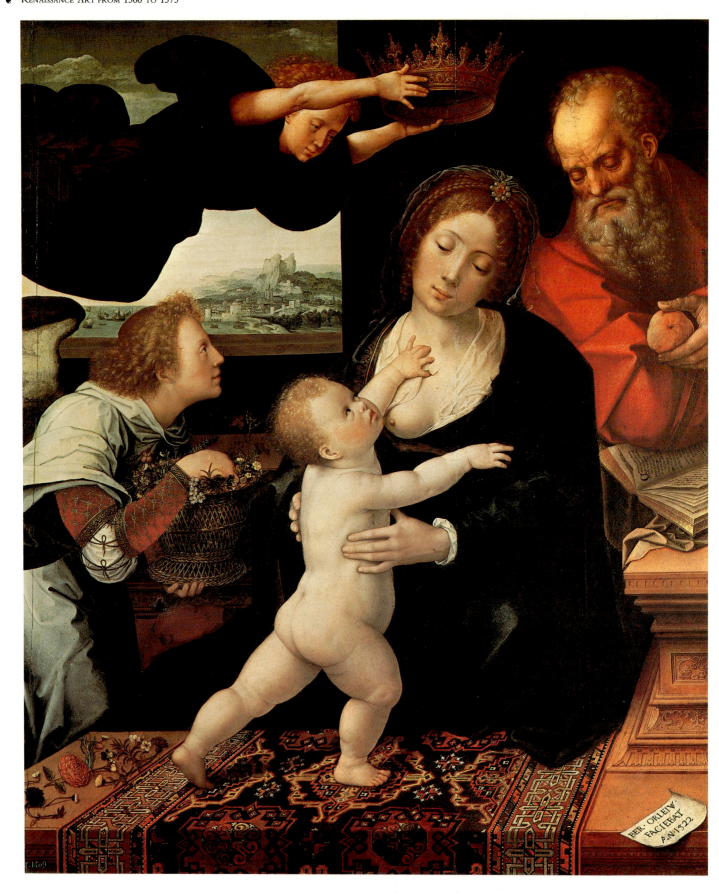

Colorplate 68. Bernard van Orley. *Holy Family*. 1522. Panel, 35⅜ × 29⅛″. The Prado, Madrid

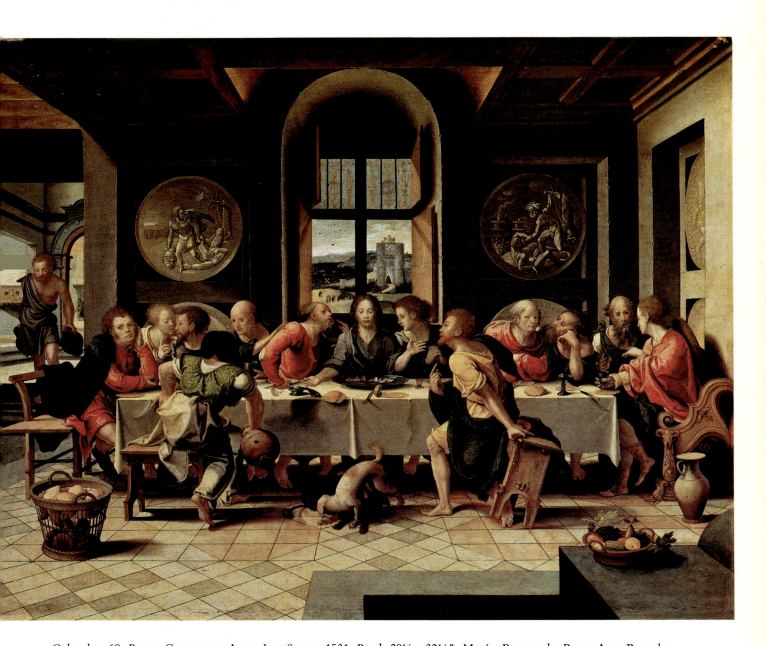

Colorplate 69. PIETER COECKE VAN AELST. *Last Supper*. 1531. Panel, 29½ × 32¼″. Musées Royaux des Beaux-Arts, Brussels

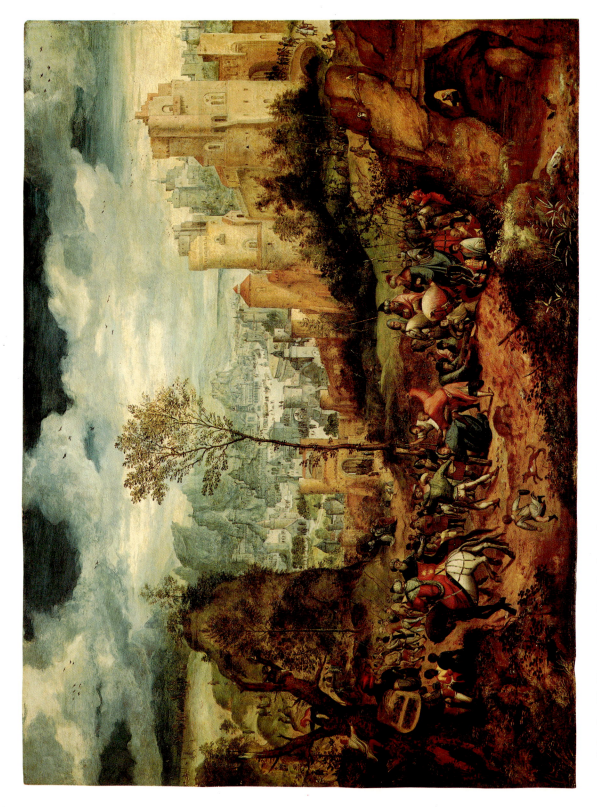

Colorplate 70. HERRI MET DE BLES. *Road to Calvary*. c. 1535. Panel, 32¼ × 44⅞". The Art Museum, Princeton University. Gift of the Friends of the Art Museum

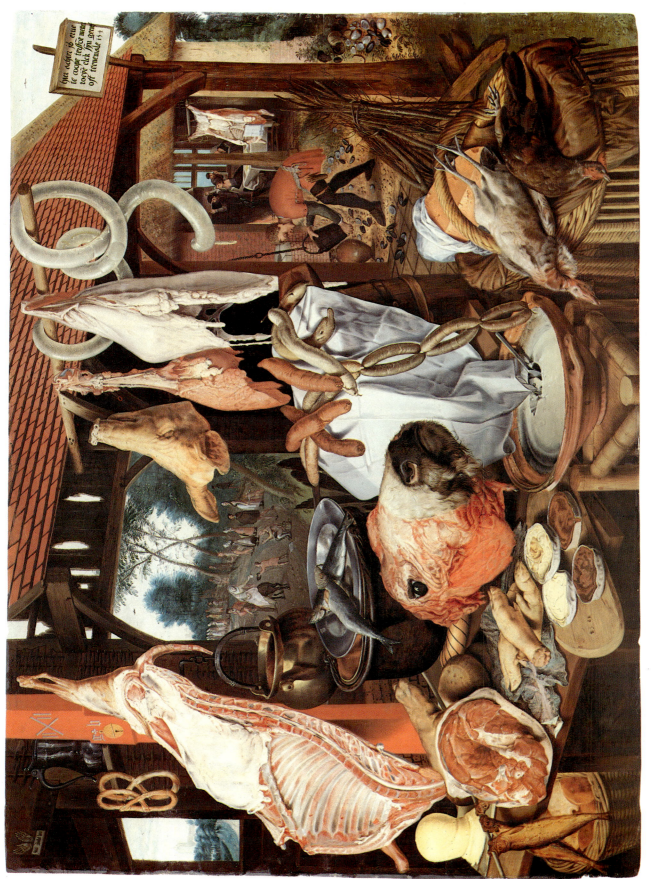

Colorplate 71. PIETER AERTSEN. *Butcher's Stall*. 1551. Panel, 48⅜ × 65¾". Uppsala University Collection, Uppsala

437

left: Colorplate 72. MASTER OF ALKMAAR. *Feeding the Hungry.*
First panel of the *Seven Acts of Mercy* (see fig. 517). 1504.
Panel, 39¾ × 21¼″. Rijksmuseum, Amsterdam

below: Colorplate 73. JACOB CORNELISZ VAN OOSTSANEN. *Crucifixion.* c. 1510.
Panel, 41 × 34⅝″. Rijksmuseum, Amsterdam

Colorplate 74. JAN MOSTAERT. *West Indies Landscape*. c. 1545. Panel, 33⅞ × 59⅞″.
Dutch government, on extended loan to the Frans Hals Museum, Haarlem

left: Colorplate 75.
LUCAS VAN LEYDEN.
Card Players. c. 1515.
Panel, 14 × 18″.
Collection Earl of Pembroke,
Wilton House, Salisbury

below: Colorplate 76.
LUCAS VAN LEYDEN.
Moses and the Worship of the Golden C.
c. 1530. Panel, 36⅝ × 26⅜″ (center
35⅞ × 11¾″ (each wing).
Rijksmuseum, Amsterdam

only compare the treatment here to the more traditional representations that follow Schongauer's formula (fig. 290) to realize that Met de Bles presents primarily a tour de force in cosmic landscape. One needs a magnifying glass to see it all. Jerusalem is expanded in almost cartographic fashion to include blocks of suburbia that lie just inside its sprawling walls.

The lofty mountains fill the far reaches of the broad valley with fanciful rock masses and peaks much like those in Patinir's landscapes, and there can be no doubt that Herri met de Bles took his inspiration from his uncle's works, but there are remarkable differences as well. One senses an aura of moistness filling the valley in place of the cool, dry, and crisp atmosphere that appears in Patinir's panoramas. Furthermore, the landscape lacks the firm architectonic structure of Patinir's striated, horizontal layers. It seems to roll, and Met de Bles sprinkles his elements along a loose, undulating "S" curve that is strung out from Golgotha to the gateway in the valley. He avoids flat, level expanses and contrived geometric contours.

The fabric of nature thus undulates as a spongy, organic ground, and the three-color gradation is softly veiled beneath a mellow golden light. The filmy mountains beyond the city hover like mirages on the horizon, and there are few bright local colors to detract from the neutral brownish tones so that even the figures seem to be part of the landscape. His technique too partakes of this softer, atmospheric view of nature; the brushstrokes are tiny but loosely applied and blended so that no sharp highlights or dark shadows appear.

The *Road to Calvary* offers us an excellent opportunity to study the working procedures of these early landscapists. Formerly, the figures would be the primary concern and the first stage in the preparation of the composition. The landscape would be added afterward as a backdrop, usually following some standard formula. Such is not the case here. Preparatory sketches for the *Road to Calvary* are preserved that form a sequence clearly indicating that Met de Bles's habit was to first sketch the layout of the landscape, omitting the figures entirely, to assure a unity and totality to the view (fig. 510). Then more detailed drawings were made of the two sides of the landscape in which he elaborated the figure groups and further delineating the smaller particulars such as the grotto to the right and the details of the city beyond. Hence it is clear that Met de Bles thought in terms of a landscape with

above: 510. AFTER HERRI MET DE BLES? *View of Jerusalem.* c. 1535. Drawing, 7 × 10¾". Kupferstichkabinett, Staatliche Museen, West Berlin

left: 511. HERRI MET DE BLES. *The Copper Mine.* 1540s. Panel, 32⅝ × 44⅞". Uffizi, Florence

512. MARINUS VAN REYMERSWAELE. *Saint Jerome*. 1521. Panel,
29½ × 39¾". The Prado, Madrid

figures and not figures with a landscape. In a number of his panoramas Met de Bles dropped the religious stories entirely and in order to maintain some narrative context freely added details of wanderers (often in the guise of the Walk to Emmaus) or miners at work deep in the mountains, such as those in *The Copper Mine* in the Uffizi (fig. 511).

Landscape is assuredly the most distant focus from the study of man that one can take. Pantheism replaces humanism if, indeed, there are any religious commitments to contend with at all, but alongside the Romanists another breed of specialists cropped up that not only challenged their entire philosophy of art—ideal man as the measure of all things—but emerged triumphant in the end as the truer expression of a Netherlandish, especially a Dutch, contribution to art history.

Moralizing satires in the guise of genre pictures emerge rather indifferently in the general developments of the sixteenth century. In fact, there is still much controversy over their origins and intentions. Aside from the abrupt change in subject matter, curious stylistic changes assure us that this art was a reaction to the workshop procedures of the Romanists. They insist on tight, laborious detail; they prefer pristine, enamel-like finishes; their expertise is technique on a miniature scale and not broadly applied paint for decoration. For the most part, these paintings display half-length figures seen close up to the picture plane in cramped interiors relieved here and there by a sudden telescopic view into the far distance. The figures are posed in contorted, uncomfortable postures, and their moods are deliberately sour or sardonic, their gestures threatening or intimidating, their environments unsavory and unkempt.

MARINUS VAN REYMERSWAELE

One of the most striking of these specialists is Marinus van Reymerswaele, a painter from a village in Zeeland and a somewhat maverick personality from what we know. There is something disturbing in his works that mirrors the turbulence more than the prosperity of the time. *Saint Jerome* was one of his most popular themes (see fig. 512). How different the archetypal scholar and humanist appears here. Jerome looms out at us from his cramped study as some fanatical preacher of doom. The basic attributes are all here—the books, the pens, the skull—but no longer do we see a mellow old scholar comfortably at work in the cozy confines of a warm, sunlit study, as in Dürer's engraving. Reymerswaele's Jerome is not a personification of the contemplative life, but rather the emaciated prophet of doomsday as he glances harshly out, opens his dry lips as if to utter a stream of condemnations, and gestures menacingly toward the skull that lies before a Bible opened to an illumination of the Last Judgment.

In this picture, the still-life attributes become elements in a genre we know as the *vanitas* theme, where the message is one of *memento mori*. One cannot escape the threatening Jerome. He is close by, his clawlike hands and spindly fingers nervously rap the tabletop, and with his bulging eyes and taut veins a ferocious intensity is painfully conveyed. In terms of the execution of paint and the finesse of details, Reymerswaele is an exacting virtuoso of highest merit.

He is well known for his curious half-length compositions of tax collectors in disheveled accounting houses

513. MARINUS VAN REYMERSWAELE. *The Banker and His Wife*. 1538. Panel, 33¾ × 45⅞". Museo Nazionale, Palazzo del Bargello, Florence

that are undoubtedly satirical, although it has been argued that the near-caricature heads of the vile antagonists across the table from us are actually portraits of patrons.[91] In one related work, *The Banker and His Wife* (fig. 513), Reymerswaele borrows a scheme made famous by Metsys (colorplate 64). The poses, the costumes, and the disarrayed accoutrements are similar; only the mirror is missing and the facial expressions are intensified. Banking and tax-collecting were two of the most hated professions among the citizenry; their offices were considered reception rooms for hell. Unlike the blander businessman in Metsys's work, this one is fiercely obsessed with the counting of coins; his wife is not merely bored but actively pursues her occupation by checking out the accounting books before her. She is intent on finding the client guilty.

Where would these pictures hang and for what purpose? They certainly do not glorify the profession, but could they not still serve it? The absurdly archaic costumes, the obvious sardonic expressions, and the fierce concentration on the act itself could well find a home in the offices of reputable lenders and bankers as warnings to their clients of the charlatans that abound in their business.

JAN SANDERS VAN HEMESSEN

The interchangeable meanings of such genre are exemplified in numerous works of Reymerswaele's contemporary, Jan Sanders van Hemessen, active in Antwerp from 1519 to 1550 and thereafter in Haarlem.[92] He painted such themes as the Calling of Matthew to exploit the concern over tax-collecting, and in an unusual work in the museum of the University of Michigan (fig. 514),

the *Parable of the Unmerciful Servant*, he depicts a Biblical episode from Matthew (18: 21–35) that has a threatening message concerning debts and debtors.[93] The parable relates the story of an ancient king who granted a servant pardon from an enormous debt the latter had incurred. Then, confronted by a fellowman who owed him but a few denarii, the servant pressed charges and had the debtor cast into prison. Upon hearing of the servant's cruel judgment, the king became furious, summoned him, and turned him over to torturers until he should pay all that was owed the king.

While cast as an image of the Last Judgment, the lesson illustrated here underscores the act of forgiveness and, hence, is related to the theme of the acts of mercy, also found in Matthew's apocalypse. The king is clearly the counterpart of Christ the Judge; the unmerciful servant is mankind in general. The imprisonment of the servant's debtor, which so riled the king, appears as some cartoonist's word-box in the landscape outside the window, and the reminder is that repeated daily in the Lord's Prayer: "Forgive us our debts as we forgive our debtors."

The tiny landscape is evidence of Van Hemessen's awareness of archaeological interests prevalent in the Netherlands. The classical ruins there recall very accurately the remains of the Forum of Nerva in Rome as it was then known. Van Hemessen might have copied the motif from a print by Hieronymus Cock published in 1551 (fig. 515) or even more likely borrowed the detail from a topographic drawing by the Haarlem artist Maerten van Heemskerck (fig. 548); either source would be evidence of a late date for the work.

A much earlier and more influential painting by Van Hemessen is the *Prodigal Son* in Brussels (fig. 516),

514. JAN VAN HEMESSEN. *Parable of the Unmerciful Servant.* c. 1550. Panel, 31⅞ × 60⅝". University of Michigan Museum of Art, Ann Arbor

515. HIERONYMUS COCK. *Forum of Nerva*, from *Praecipua aliquot Romanae . . .* , Antwerp, 1551. Engraving

signed and dated 1536. Here the *mise-en-scène* is much the same, with large half-length figures crowded about a table, but the actors have changed. The story is loosely based on Luke's account (15: 11–32) of the errant son who asked his father for his inheritance, then abandoned his home to follow a wanton path of "loose living." After wasting his money, he returned home and was forgiven by his father, who then held a celebration for the lad's homecoming much to the chagrin of an older brother, who accused the prodigal of consorting with harlots.

Van Hemessen had a variety of secondary sources to turn to for his painting. As we have seen, Quentin Metsys treated the theme of the ill-matched lovers (fig. 475) as a representation of the wiles of the prostitute and the lecherous old man, and other such subjects, called "loose living," became very popular in prints and in other arts of the period. Van Hemessen very likely turned to a popular theatrical production entitled *Acolastus*, which was performed frequently in Antwerp. The staged performance takes place in a brothel visited by the young prodigal Acolastus during his wandering years. According to the expanded story, the young man first purchased fancy clothes with his new riches; he then indulged in eating heartily and drinking; he ordered the best musicians to play before his table and danced the hours away. He tried his luck at gambling and lost all of his money, and, finally, he spent the night with a prostitute in a brothel. The next morning, unable to pay for it all, he was accosted and sent running, his glamorous clothes having been ripped from him. This sequence of activities provided the artist with what was to become one of the most popular genre themes down through the seventeenth century: the Prodigal Son at the Whores.[94]

To the left of an oval table strewn with foods, wine, glasses, and jugs sits the richly attired Acolastus, holding a jug of wine in one hand and placing his other arm

516. JAN VAN HEMESSEN. *Prodigal Son*. 1536. Panel, 55⅛ × 78″. Musées Royaux des Beaux-Arts, Brussels

about the comely harlot Lais, entreating her, "Come kiss me now." Her servant Syra sits behind him, and crouching nearby is a cat, a common attribute of the prostitute. The ugly old procuress sits to the right, and another harlot keeps company with a gambler while other participants of the raucous night's activities are gathered around, including the bagpiper, who plays his squeeling music before the lustful company.

Here the interlocking, angular movements of the cramped figures and the abrupt juxtaposition of head types and costumes create a colorful pattern that weaves in and around the table. Beyond the columns of the interior and in the antechamber to the left, four other episodes of the story unravel. To the left, the prodigal is attacked by the harlots and driven from the brothel. In the distant landscape the fate of the son is shown as he wallows among the swine in a farmer's pigsty, and directly behind the partygoers appears the palatial mansion of the prodigal's father with two more scenes. To the right is the departure of the son at the beginning of the story; to the left is his return. Thus the little scenes begin and end at the home of the father, moving clockwise around the main theme, the Prodigal Son at the Whores.

PIETER AERTSEN

In the conversion or inversion of religious and secular themes, a final step was taken by another Dutch painter, Pieter Aertsen, who was active in Antwerp for thirty years. Aertsen's *Butcher's Stall* (colorplate 71), dated 1551, has been called the earliest example of Mannerist inversion of still life in Northern painting.[95] At first one is overwhelmed by the lavish display of lifesize specimens of coarse foodstuffs piled high and wide on a broad table in the foreground. Aertsen's meats are not exactly mouth-watering, but the abundance of slaughtered and semi-dressed cuts of beef, pork, and poultry is so vivid and real that one is shocked to see such objects blatantly displayed right before him. Aertsen's illusion of the marketplace is so uncanny and lifelike that we pause and look about the assortment of meats much as the housewives of Antwerp carefully perused the offerings for the weekend in the big meat hall in the center of town. If you like to cook, then you've come to the right painter.

But is there more than foodstuffs in Aertsen's big still life? First let us look. From left to right: herrings on a skewer, well-smoked no doubt; a mound of butter; a side of a hog, very fresh; a pot of suet; tasty pig's feet on cabbage; meat pies; the head of a cow; a bowl of fat (needed for cooking); a hog's head; hanging entrails (including the heart); shanks; a stuffed intestine; sausages; a cheese; and two chickens. After checking these offerings we soon note that there is some activity beyond the open

display case. To the right we look past a man (the butcher?) in a small court into a chamber with a fire and a company of men and women banqueting. To the far right hangs a gigantic carcass of beef, and all over the ground are scattered oyster and mussel shells. A sign in the top right reminds us that we can purchase this property: "Behind here is an inheritance [farmland] for sale by the rod at one's need, or altogether, 154 rods."

In the center, directly above two fish crossed on a platter, is a view of the countryside. A woman seated on a donkey carrying a child is led by an older man. This is the Flight into Egypt, and the Holy Family distributes alms along the way. Beyond them a procession of people can be seen moving toward a church which is just visible in the opening in the shed to the far left. A few other details are curious. In the rafters to the left are two pretzels and a carafe of wine, references to the Eucharistic foods (pretzels were popular as bread during Lent). Higher is a plaque with the armorials of Antwerp (two hands crossed), suggesting that the panel may have been a civic commission.

Here, as in the Van Hemessen picture just discussed, the lesson is given in a concealed, circuitous manner. The bread and wine, the crossed fish, the Holy Family, and the people going to church are all elements of a hidden allegory on "spiritual food" for salvation through Christ and the church. Conversely, the loose company playing with fire as they drink and eat mussels and oysters, both acclaimed aphrodisiacs in the Netherlands, allude to the vices of gluttony and lust. A middleman, dressed as a butcher, stands beside a well drawing water (the water of life?), and he, in turn, offers you his wares, good food for the body and the sustenance of our temporal lives. Both foods are needed, spiritual and temporal, but the abuse of eating and drinking as footnoted in the tavern scene is the wrong course for man to follow. Which portion of this farmland will you buy?

In a study of the iconography of Aertsen's *Butcher's Stall*, Kenneth Craig made an interesting observation concerning the commission of the work. The butcher hall, or *vleeshal*, was the largest and most prominent secular building next to the bourse in Antwerp in Aertsen's day. We tend to forget the priorities of civic structures in our supermarket and shopping-mall world, but the business of eating was one that focused on the market about the *vleeshal*, not just in Antwerp but in all towns. The great *vleeshal* in Haarlem, built later, was decorated with bulls' heads in sculpture. As a civic center, the meat market had many functions other than just serving the merchants and their customers. Would not a picture like Aertsen's be a fitting tribute or advertisement to hang prominently on the wall of the Antwerp butchers' guild room?

XXIII.

Holland: Amsterdam, Delft, and Haarlem

In Chapter VII, the contributions of painters from the North Netherlands to the arts generally referred to as "Flemish" were noted, and with some hesitation were described as "Dutch" ingredients. These elements also distinguished the style of Geertgen tot Sint Jans (Chapter VIII), and during the course of the sixteenth century the vague distinctions between a Northern and Southern—a Dutch and Flemish—style gradually become more discernible, although those labels are admittedly somewhat arbitrary and misleading.

CORNELIS BUYS THE ELDER(?)

An unusual painting was acquired by the Rijksmuseum in 1918, the *Seven Acts of Mercy* (fig. 517; colorplate 72) from the Church of Saint Lawrence in Alkmaar, the famous town of cheeses lying some fifteen miles north of Amsterdam. The altarpiece, painted in seven panels placed side by side, had hung in the church in Alkmaar since its dedication in 1504. Somehow it escaped the devastations of iconoclasm and the confiscation of Dutch paintings by the Spaniards although once, on the night of June 24, 1582, an inside conspiracy arranged by a newly appointed churchwarden made it possible for two outsiders with professed Protestant sympathies to sneak into the church and douse the altarpiece with black paint. The townspeople were outraged, the guilty party was apprehended and tried, and the painting was immediately cleaned and restored to its position.

While it has suffered through a few clumsy restorations, the large work is in very good shape today. The *Seven Acts of Mercy*, however, merits more attention and study than it receives considering its uniqueness and quality. In many respects it is more "Dutch" than any other painting hanging alongside it, if one dares to isolate those qualities of spirit in this highly confused world of early-sixteenth-century art. Indeed, it may be in part due to its thoroughly Dutch character that it escaped the ravages of the iconoclasts and the eyes of the Spaniards because it displays so few traits that we generally associate with traditional religious imagery. Only in the central panel do we find holy figures in much abbreviated form in a Last Judgment, reduced to small busts of Mary and John the Baptist on either side of Christ as Man of Sorrows seated on a faint rainbow, his feet on an orb. There are no clouds of glory filled with trumpeting angels; there are no rows of judges and saints encircling Christ; no Saint Michàel weighing the souls; and no heaven and hell. But there is a marvelous cityscape that is very much a part of this lower world.

The narratives are direct and the message is innocent and sincere, for here groups of common citizens gather before their homes and in public buildings to demonstrate their charity. They are dressed in everyday costumes, and they move slowly offering a hand of welcome, a loaf of bread, a cup of water in gestures that are straightforward and familiar. In the first panel, bread is distributed to the poor, the blind, and the crippled by a husband and wife before their home. As in each panel, Christ appears in the crowd to illustrate the lines of the text, "Truly, I say to you, as you did it [an act of mercy] to one of the least of these my brethren, you did it to me" (Matthew 25: 40). Christ looks out at the viewer as if addressing him directly as the program of good works begins.

The second panel, across the street from the first, illustrates "I was thirsty and you gave me drink." To judge by the columned porch, the two sculptures on the second story, and the elegant mantle the husband wears, this must be the residence of some wealthier city official. The clothing of the poor and naked is the subject of the third panel, and, next, the centerpiece, with the Deësis forming the core of the Last Judgment hovering above the city walls shows two hooded men lowering a coffin, marked with the double cross of the Confraternity of the Holy Ghost, into a church graveyard, the burial of the poor following the example of Tobias. The gravedigger, a priest and his assistant, and five hooded mourners stand behind.

In the fifth painting a husband and wife invite pilgrims into their home as the charitable act, "I was a stranger and you welcomed me." Down the street is a

517. MASTER OF ALKMAAR. *Seven Acts of Mercy*. 1504. Panel, each 39¾ × 21¼″. Rijksmuseum, Amsterdam

high city gate where more travelers and pilgrims are greeted by another townsman. "I was sick and you visited me" takes place in a hospital with beds lined along the left wall. Friends stand about comforting the infirm. Since the patrons of the altarpiece were members of the Confraternity of the Holy Ghost, a charitable association that provided hospital care, this panel is of special interest, and we shall return to it briefly later. The final act of mercy, "I was in prison and you came to me," takes place in an austere courtyard before a prison of barred cells. Outside, two prisoners are being tortured. Visitors stand before a wooden barrier and appear to be gathering coins to benefit the incarcerated.

The panels to the left of the churchyard in the central section give us a charming view of step-gabled houses along tiny streets that lead to the city square with a city hall and shops; to the right the alleys continue with a glimpse of a distant towered city gate and in the final two panels large civic buildings, a hospital and a prison, come flush with the surface. The streets are not crowded or congested in any way. A few small dogs sniff and roam about, a stork sits silently on its nest atop a steep roof, and the townspeople gather in small groups here and there; otherwise all is quiet and orderly, peaceful and proper.

The cobbled streets and alleys are swept clean, the house fronts and stoops are bleached from repeated scrubbing, and, in general, a sense of propriety pervades the artist's conception of the little Dutch village. The miniature town has the charm of a carefully arranged Lionel train set. "Cleanliness is next to godliness," as the proverb goes, could hardly be better exhibited in this tidy and comforting neighborhood. Everyday good works characterize the activities of its people, who fulfill their social goals and responsibilities. Humility and honesty are virtues that speak to us from the streets of the *Seven Acts of Mercy*.

The painting is almost artless, and yet how effectively the mood and meaning of charitable acts toward one's neighbors are presented. To be sure, the artist's style is stilted and provincial by the standards of the period. The figures are like little mechanical mannequins. Their arms and legs are tubular and they move stiffly as if on hinges or tight sockets. The small heads seem to have been turned on a lathe with a thin wedge affixed for a nose, a delicate slit for a mouth, but these wooden dolls move in a defined space and cast clear-cut shadows from the focused light that animates and brightens the expanded tableaux.

As we have seen, the theme of the Seven Acts of Mercy is related to the Last Judgment as it was, for instance, in Bernard van Orley's huge triptych for the almoners of Antwerp (see p. 429). But here the emphasis has shifted from the apocalyptic to the everyday as was appropriate for the patrons, the Confraternity of the Holy Ghost, who also maintained a hospital in the city. The interior in the sixth panel gives us a good idea of what these establishments looked like, and very likely the three men in the company of Christ in the foreground, theirs being the only heads in the panels that are given distinctive features, are portraits of the regents or officials in charge of the hospital.

The identity of the painter of the *Seven Acts of Mercy* is puzzling. The fact that the painting was executed for a church in Alkmaar has led some to speculate that he was probably a local artist, considering the provincial features of the style, and that he might be one Cornelis Buys the Elder, whom we know was active in Alkmaar between 1490 and 1524.[96] Additional bits and pieces of evidence tend to support this identification. A Utrecht historian, Arnoldus Buchelius, tells us that Buys was the first teacher of Jan van Scorel, whom we shall return to in a following chapter, and this would imply that he was a master of some repute. Furthermore, Van Mander writes that Buys was the brother of Jacob Cornelisz van Oostsanen, a prolific painter in Amsterdam, and since both artists share a master's mark of great similarity (two "As" crossed with a "V"—it appears on the escutcheon on the staircase of the first panel), this evidence reinforces the identification.

At the beginning of the sixteenth century, Antwerp was certainly the capital, the hub, of generative forces for

the new styles, as we have seen. The Dutch cities that we usually think of as capitals, such as Amsterdam, were little more than sprawling villages by comparison. The Golden Age of Dutch art is surely the seventeenth century, at which time Amsterdam was the leading port in Europe, surpassing even Antwerp. But at the end of the fifteenth century Amsterdam was a small town. Its inhabitants numbered around 12,000; Haarlem, according to a 1494 census, counted 2,426 houses. The first indication of a Guild of Saint Luke, the painters' union, dates as late as 1496 in Haarlem. Is it possible, then, to compare these Northern centers with Antwerp? We might first look at Amsterdam for this comparison. Haarlem had an older and more complex heritage at work inside its city walls, one that in some respects stifled the inevitable changes and transformations in the arts.

JACOB CORNELISZ VAN OOSTSANEN

The first major name that appears in the art history of Amsterdam is Jacob Cornelisz van Oostsanen, the brother of Cornelis Buys, who may or may not be the Master of Alkmaar.[97] Jacob Cornelisz was something of a Jack-of-all-trades, excelling in designing woodcuts, stained glass, embroideries, as well as painting frescoes, portraits, and altarpieces. His activity in Amsterdam can be followed from 1507 (a dated woodcut) until his death in 1533. An excellent example of his mature painting is

the *Crucifixion* in the Rijksmuseum (colorplate 73) of about 1510. The work is packed with details, so much so that the tiny corpus of Christ raised on a very tall cross seems almost forgotten in the drama of Golgotha. It is also a very colorful picture painted in heavy impasto with bright colors and a predominance of lavish and flashy decorative touches in the grainy brocades, shiny ornaments, headgears, and stippled metalwork, many of which are raised high in gold paint.

What can one say about the influences at work on our Amsterdam painter? The complexity of the historiated *Crucifixion* reminds one at first of those busy pieces produced in the Middle Rhine at the end of the century (cf. fig. 229), but the flavor of this activity is somehow quite different. The fanciful costumes, especially the headpieces, and the flying drapery of the angels, the richness of color, and the obsession with filling the surface are traits that we have associated with Antwerp Mannerism of this same period, and, to be sure, such Late Gothic energies were not limited to Antwerp. And yet there are features here that we do not associate with Antwerp.

Golgotha is a large expanse of ground that rises steeply in the painting, and there is a clearer sense of organizing figures in space. The secondary events—the Garden of Gethsemane, Christ Taking Leave of His Mother in the top left, the Carrying of the Cross at the top right—are larger elements and more integral parts of the picture than the far-off narratives that often appear in the back-

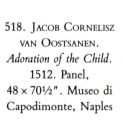

518. JACOB CORNELISZ VAN OOSTSANEN. *Adoration of the Child.* 1512. Panel, 48 × 70½". Museo di Capodimonte, Naples

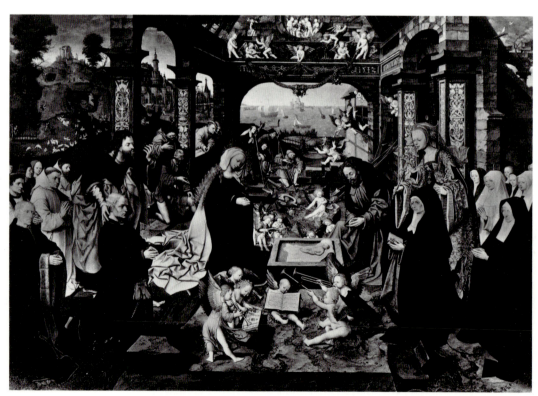

519. Jacob Cornelisz van Oostsanen. *Self-Portrait*. 1530. Panel, 24⅜ × 19⅜". The Toledo Museum of Art. Gift of Edward Drummond Libbey

grounds of Antwerp representations of the Passion. The figures too are different. They are dainty and precious types, to be sure, but Jacob Cornelisz emphasizes the diminutive qualities of his figures more in their demure postures and gentle gestures. Their movements are not so impulsive; their facial expressions are quiet and restrained, lacking the caricature and grotesque distortions of many Antwerp examples.

These differences point to a center nearby. If Geertgen tot Sint Jans had gone Mannerist, would he not have painted in a similar vein? The answer to this, I believe, is yes. Haarlem is but twelve miles west of Amsterdam, and hence the latter can be considered as part of the environs of the Spaarnstad. The original version of this Crucifixion type could well be the lost central panel of Geertgen's great altarpiece for the Knights of Saint John (see p. 176). The doll-like heads and refined poses of the mourners also point to a Geertgenesque origin, and surely the effective manner in which the marginal episodes of the Passion are added in the space pockets behind the cross brings to mind the Haarlem master's narrative style as we saw it in the *Burning of the Bones of Saint John the Baptist* (fig. 171). That is not to say that Jacob Cornelisz had his training in Haarlem—Zaandam, his hometown, is nearly as close to Haarlem as it is to Amsterdam—but it was the Haarlem tradition of Geertgen transformed by the contemporary tastes for Mannerist elaboration and decoration that shaped his style.

Another exemplary work by Jacob Cornelisz van Oostsanen is the radiant *Adoration of the Child* in the Museo di Capodimonte in Naples (fig. 518), dated on the elaborate entablature 1512. Beneath all the glitter one can discern the lines, the tempo, and the temper of Geertgen's Infancy pictures, but riding on the surface are numerous extra figures, angels, architectural details, and a telescoped landscape that distinguish the style of the painter from Amsterdam. Countless angels, like hordes of kindergarten playmates, invade the center of the picture and wildly sing, play instruments, and dance about the austere trough of the tiny Christ as if celebrating his birthday. One sweet infant with wings holds up a sheet of music that can almost be read. Joseph's carpentry tools are scattered about them, and the stable itself is transformed into a rollicking structure with elaborate piers decorated with fancy Renaissance scroll patterns.

The Naples *Adoration* is not simply a devotional picture, however, but a broad piece, like a triptych, that served as an ex-voto or what the Dutch call a *memorietafel* for members of a large family, who kneel to the sides. The painting, according to the most recent study,[98] was done for the Boelens family chapel in the Carthusian monastery of Saint Andrew in Amsterdam, its official title being *Portus Salutis Sancti Andreae*. Bethlehem, rather than being a sleepy settlement in the hills, is here fashioned as a busy port town in keeping with the title of the monastery, *Portus Salutis* or Port of Salvation, and the view seen in the distance may well be one of the earliest known representations of Amsterdam.

A unique example of Jacob's portraiture is his *Self-Portrait* of 1530 (fig. 519) in the Toledo Museum of Art. The same facial features appear in another, signed and dated 1533—the year of his death—in the Rijksmuseum. In what is perhaps the earliest known self-portrait of an artist standing before an easel with brush in hand as an independent work, the painting has special significance for the Renaissance. Formerly an artist might add his self-portrait in the painting as a casual observer of the scene, as Saint Luke painting the Madonna, or as an outright bust portrait, but here he is distinguished as an artist. The profession of the painter has definitely risen in ranks, and like the courtier, the bishop, the wealthy financier, or the humanist scholar, the artist can proudly proclaim his status as a man of distinction in society. The portrait that he is completing on the easel is undoubtedly that of his wife.

Aside from Leiden, which will be treated in the next chapter, practically nothing is known concerning the artistic activities of the towns to the south of Haarlem. A few names of painters appear in archives here and there, but no works can be convincingly attributed to them. Partly this is because so many pieces were lost to the rav-

520. MASTER OF THE VIRGO INTER VIRGINES. *Annunciation*.
c. 1490. Panel, 22⅝ × 18⅞". Museum Boymans-van
Beuningen, Rotterdam

521. MASTER OF THE VIRGO INTER VIRGINES. *Entombment*.
c. 1500. Panel, 21¾ × 21¾". Royal Institute, Liverpool

ages of the image-breakers of iconoclasm (*beeldenstorm* in Dutch), and those that escaped that barbaric catastrophe were often carried home by the Spanish during the war of independence.

MASTER OF THE VIRGO INTER VIRGINES

Delft in south Holland apparently had a monastic workshop that produced a series of charming grisaille miniatures for Books of Hours during the second half of the fifteenth century, but that is not certain. However, printing presses were established early in the city that printed books with fine woodcut illustrations. These date in the 1480s, and while the illustrations are mostly copies of woodcuts designed in centers outside Delft, one local designer (active 1483 to 1498) stands out as a forceful personality who imbues his figures with strained facial expressions and expressionist distortions to their thin, wispy bodies.[99] This unusual style, in turn, can be found in a number of panel paintings datable between 1480 and 1510, a few of which furthermore bear evidence of Delft patronage. This gifted artist remains anonymous, and he has been named, rather speciously, the Master of the Virgo inter Virgines after a painting of that subject in the Rijksmuseum.[100]

The *Annunciation* in Rotterdam (fig. 520) is an example of the Virgo Master's mature style, and since it displays the coat of arms of the Van den Bergh family, an old clan in Delft, its association with that city is more

certain. The interpretation is wholly original. The Annunciate's chamber is isolated from the right half of the painting by an emphatic Gothic pier. To the left the interior with the bed barely visible is darkened, and the mysterious Madonna emerges from the shadows like a luminescent apparition. Her body is frail and her mantle wraps about the attenuated body in loose, arcing folds that break around the knees into softly kneaded patterns. The tester and bedding unravel slowly behind her as if a cocoon were being released. Mary's tiny hands barely issue from the flared cuffs of her dark dress. The outer mantle breaks far back on her head, revealing a high hairline and an elongated head with small features and a distinctive hollowness. Her flesh has a luminous quality about it that adds to the spectral appearance of her face.

Her chamber has the aura of a haunted room with no illumination save the faint rays of light that enter carrying the tiny dove that glows like a hummingbird. Higher in the beams of the Holy Spirit the minuscule form of a nude infant can be discerned, an archaism that revives an Early Christian belief that the body of the Christ Child, the embryo, was formed in heaven and not in Mary's womb. The right half of the interior changes its appearance entirely with a window and a wide, unadorned doorway opening to a deep porch and garden. Everything is still and quiet even there, however, and Gabriel, seemingly aware that he is an intruder, softly tiptoes toward the Virgin.

The Master of the Virgo inter Virgines paints a differ-

ent world with different people, and one senses a deeply emotional personality at work fashioning this mysterious *Annunciation*. The haunting sensation of sadness is even more evident in his masterpiece, the *Entombment* in Liverpool (fig. 521). Here the loneliness that enshrouds Mary and Gabriel in the *Annunciation* turns into a deep heartache reflected in the grieving faces overcast with a disturbing tension and further conveyed in the weirdly contorted bodies, ill-proportioned but overwhelming in the sensation of exhaustion that has turned them into weakened forms that seem to have been drained of any skeletal structure or resiliency.

The episode itself is ambiguous: it is neither the deposition of the body nor the lamentation but some poignant moment between the two when Joseph of Arimathea, Nicodemus, and the Magdalen bring the frail body of Christ to the Marys and Saint John. A noticeable tension is thus set up between the two groups of mourners that is heightened by the stark, empty space between them. The left-hand mourners fall into a strange undulating triangular shape formed by the projecting leg of John and the nearly vertical stance of the Mary on the far left. Dark blue and red patterns of color are contained within the softly arcing mantles, and the grieving heads seem almost disassociated from their writhing bodies. The figures to the right are held within a loose oval slightly tilted along the axis of Christ's body.

The composition of the Virgo Master is as eccentric and original as the sentiment and iconography. The landscape setting is barren and somber in its large expanses of browns and ochers that resemble desolate dunes or mounds of sand, aspects of some primeval terrain with the undulations like some giant amoeba changing its protrusions to echo the shapes of the figures.

The Master of the Virgo inter Virgines remains a most enigmatic personality in spite of numerous attempts to pin down his sources of inspiration. His pessimism reminds us of Bosch, as do some of the grimaces and intense expressions in the male faces. His melancholic and sorrowful mood and the phosphorescent flesh tonalities recall Hugo van der Goes, but still there is something intensely personal and subjective in both style and expression that evades us.

JAN MOSTAERT

The vigor of the Haarlem school of painting sustained its tradition, and it continued to dominate the arts during the first decades of the sixteenth century, if not in quality then in quantity, and the paintings of Geertgen tot Sint Jans are to be reckoned as the single most important contribution to early Dutch painting. The lovable style of the Haarlem painter, in fact, softened the impact of the

522. JAN MOSTAERT. *Adoration of the Magi*. c. 1510–15. Panel, 19¼ × 13¾". Rijksmuseum, Amsterdam

Mannerism that swept through the Netherlands, and this can only be explained by the widespread appeal of his art, in particular his smaller devotional pieces. Most of Geertgen's followers were imitators since it is very doubtful that he had any apprentices or assistants during his short career.

Jan Mostaert of Haarlem is the first notable follower of Geertgen for whom we have good documentary evidence and a sizable oeuvre.[101] His name first appears in the city records of 1498, and then regularly in the guild lists (he was appointed deacon in 1507) until 1549 with a lacuna between 1516 and 1526, when it is believed he was in the employ of Margaret of Austria as a court painter, although it is not likely that he spent much time in Mechelen. Further, Van Mander reports, Mostaert, being a man of noble birth, handsome, eloquent, and polite, was esteemed by the nobility and became the painter of "Lady Margaret." He then illustrates with an amusing anecdote how Mostaert was visited by lords of all degrees at his home and studio in Haarlem. We know that his immediate ancestors were millers, but the period of service for Margaret of Austria is well documented. For Margaret the artist was restricted mostly to portraits of the royal family, but he is best known for his devotional panels and portraits executed for the lesser members of the Dutch aristocracy as well as a few exceptional representations of Renaissance themes.

A fine example of Mostaert's early devotional works, about 1510–15, is the *Adoration of the Magi* in the Rijks-

museum (fig. 522). One is first impressed by the delicate, doll-like qualities of the figures and the precise, minute brushwork in the heads, the costumes, and especially in the wispy landscape background. The treatment of the head of Mary at once brings to mind the refined, youthful Madonnas of Geertgen tot Sint Jans, although her head is not so stereometrically conceived and her chin does not recede so sharply into the contour of her face. The features—the ridge of her nose, the tapered eyes and brows, the delicate lips—are highlighted with faint strokes of white and not the sketchy warm reds that animate Geertgen's faces.

Her costume is much more elaborate with a bright red mantle covering an elegant brocaded dress with tiny pendants of pearls hanging from the sleeves, and her auburn hair is covered by a soft, white veil that arbitrarily falls in thin, phosphorescent edges about the cheeks. The folds about the right arm of the second king are typical of Mostaert's drapery style. Long creases are indicated by shallow, vertical ridges that loop up and down in an arbitrary fashion with long plaits highlighted in white. Thus Mostaert departs from the time-honored Rogerian formulae with its intricate, hooked pockets and contrapuntal curves and overlaps that Geertgen followed.

The main foreground group is elevated on a high platform and accented by a fragile arch or portal decorated with tiny narratives in grisaille that serve as types for the Adoration. On the pier above Mary appears the Dream of Joseph in Prison (an Old Testament type for the birth of Christ), and above it is an abbreviated version of the Vision of Augustus and the Tiburtine Sibyl (the prophetic vision of the king to come related by Voragine). In the cornerstone an Old Testament type for the Adoration is introduced, the Three Heroes of David, and across the lintel unravels a floral scroll with the Tree of Jesse, another familiar type for the birth of Mary. All three Old Testament stories are found as types in the *Speculum humanae salvationis*. This curious porch and arch thus constitute a regal setting for the Madonna and Child through which we look upon the crumbling ruins of the palace of David.

Mostaert was an innovator in landscape, and the filmy expanse of hills in the background is an excellent example of his more romantic, fairyland vistas of far distance with elfin-like figures moving hurriedly about the ruins and in the village square. Executed with what would seem to be a hairbrush, the details are extremely fine and the rambling landscape is bathed with a soft, atmospheric haze that tints his Lilliputian world with a greenish-blue tonality. His skies are very distinctive too with a broad expanse of pure white rising into regularly scalloped contours against a light blue sky.

Numerous portraits have been attributed to Mostaert

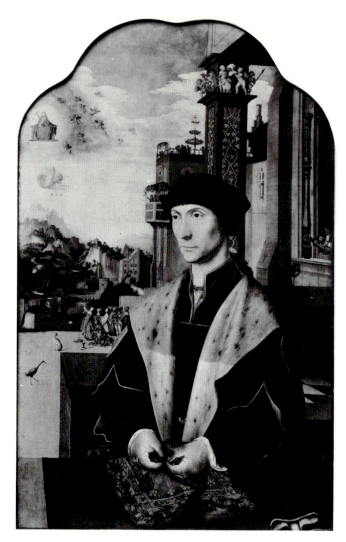

523. JAN MOSTAERT. *Portrait of Abel van den Coulster.* c. 1500–1510. Panel, 35¼ × 22". Musées Royaux des Beaux-Arts, Brussels

ranging from those of ancient nobility, such as that of *Jacoba of Bavaria* in Copenhagen (perhaps after Van Eyck) to replicas of Philip the Fair, Margaret of Austria's husband, Philibert II of Savoy, and her ward Charles V, to lesser Dutch aristocrats and burghers. The royal portraits are all copies after originals painted for Margaret, but the others are taken from life and then imbued with an aristocratic flavor through the settings. Such is the case in the fine *Portrait of Abel van den Coulster* in Brussels (fig. 523). A coat of arms in the architecture and the initials "A" and "C" on the cushion beneath his hands identify the sitter, who was a knight of a well-known Haarlem family.

The handsome, thin-faced nobleman is shown three-quarter length standing behind a wall or parapet. His face is sharply delineated but devoid of expression, and our interests are soon diverted to the secondary aspects of the painting. The foreground is composed of broad, geometric planes resembling building blocks, and, as in many of Mostaert's works, the exact architectural makeup is not clear. In the tall buildings beyond, several

tiny people can be seen looking from a window, pergola, and terrace, gesturing upward to the miraculous appearance of Mary enthroned with her Child in a radiant aureole surrounded by hosts of angels in the top left.

In the broad courtyard in the background, Mostaert introduces one of his favorite themes, the Vision of Augustus and the Tiburtine Sibyl, below the apparition of the *ara coeli*. The golden aureole merges with the white clouds, which again rise to scalloped edges against the blue sky. Beyond the court Mostaert unravels a charming and poetic landscape with tufted hills executed with minute brushstrokes. The elegant costume and the romantic setting more than the personality of Abel van den Coulster characterize the sitter as a refined and pious aristocrat.

Mostaert was not a Renaissance artist in the sense of reviving ancient art forms and styles, to be sure, but his interest in the lands of America and the discovery of primitive peoples and societies there (recall Dürer's fascination with Mexican artifacts) did prompt him to explore new themes in a most unusual manner. Reports of the Spanish explorations must have reached him through his contacts with the court of Margaret of Austria, the aunt of Charles V, and as we shall see, Mostaert was not hesitant to expand his repertory of subject matter in wholly new directions. One of his interests was the reconciliation of pagan and Christian interpretations of man's origins in light of the New World discoveries.

The unusual *First Family* in Williamstown (fig. 524) illustrates Mostaert's interpretation of the Christian story of man's beginnings, for here we find Eve nursing and caring for her children. The history of man does not begin in Eden; that was an eternal springtime and paradise. Only after the expulsion of the first parents did historical time begin. Adam must forever toil and Eve must bear her children in pain and care for them. It is now that man must use fire for the changing seasons, must plant and harvest for his nourishment, must build shelters, must tend to his own needs in every respect: to defend himself against the elements, the animals, and, ultimately, his neighbors.

In the early morning light, the sun just breaking through the clouds on the horizon, Eve sits nursing her infant before the rock-hewn portal of a dark, primitive stone shelter and cave. Our primeval Madonna is dressed in animal skins and glances wearily down at her suckling child. To her left are her three other children, also wrapped in skins. The eldest, Cain, vigorously reaches down for an apple lying on a stone ledge before them, while his brother Abel cuddles in his arms protectively the third child of Eve.

In the mouth of the cave the faint glow of embers can be seen. Above the gray slabs that form the primitive en-

524. Jan Mostaert. *First Family*. c. 1520–25. Panel, 14⅛ × 10⅝". Sterling and Francine Clark Art Institute, Williamstown, Mass.

try to the shelter is a slanting hilltop, where the silhouettes of Cain and Abel making their offerings to God can be discerned. Further to the left, on the same plateau, the tragedy following the offerings is enacted with Cain striking down Abel with the jawbone of an ass. The peaceful morning of life outside Eden thus has sinister forbodings for Eve and her children. Adam is curiously missing, but it may be that he appeared in a companion panel tilling the ground, as he should, or that the Williamstown panel has been cut down and is incomplete, although there are apparently no physical evidences of this on the edges of the wood. The subject matter is thus very unusual, although it was common in manuscript and woodcut illustrations to append the labors of the first parents to cycles that depicted the Creation, the Fall, and the Expulsion of Adam and Eve.

Surely, Mostaert's painting is more than a simple narrative, however. From classical times, two types of primitivism were described.[102] The one, "hard primitivism" (Lucretius and Vitruvius), related how in the first stages of history man emerged from a wild, barbaric existence in the forests and gradually bettered his environment and human state. The other, "soft primitivism" (Ovid), saw the process as devolutionary rather than evolutionary, the fall from the Golden Age of the pure primitive that was happiness and eternal springtime through successive stages to the Iron Age of discord and warfare. Mostaert's first family belongs to the Silver Age as illustrated in the

popular *Ovide moralisé* of the day. Now man must find shelter, fire must burn to keep him warm, and strife breaks out in the "first murder" of Abel by his brother Cain. Paradise is lost. Curiously, in Mostaert's representations of the Last Judgment, heaven is not envisioned as a resplendent Gothic structure but as a verdant woodland, the paradise of Eden regained. That Mostaert entertained such ideas as that of the lost primitive paradise is most assuredly demonstrated in one of the most unusual paintings of the mid-sixteenth century, his so-called *West Indies Landscape* (colorplate 74).

Mostaert's *West Indies* is, in fact, an imaginary view of the Zuni pueblos in New Mexico. Van Mander was fascinated by the picture, which was then in the possession of Mostaert's grandson, Nicolas Suycker, and described it as a "landscape in West India in which are many nude figures, a protruding cliff, and strangely constructed houses and huts." The unusual painting has only recently stirred the attention (and the imagination) of scholars, and while it has been identified as the conquests of Cortes in central Mexico (1519), the landing of Columbus on the island of Goanin (1492–93), and the invasion of Brazil by the Portuguese (c. 1550), all evidence points to the explorations of Coronado in the American Southwest in search of the Seven Cities of Gold (1540), believed to be located about the Zuni village of Cibola in New Mexico near the Arizona border.[103] It has been argued that Mostaert's landscape was based on sketches made at some site, but this is not likely. Such drawings are rare and usually record only exotic objects, strange animals, costumes, tools, and the like, not landscape panoramas. Mostaert's landscape was no doubt fashioned after a literary or oral description.

Fairly complete accounts of Coronado's expedition come down to us in the form of his own letters written to Charles V and diaries, and the painting of the strange new lands fits the descriptions recorded by one member of the expedition named Pedro de Castañeda. He described the terrain around Cibola as filled with cliffs, and he mentioned the ladders that reached from one level of the cliffs to another, the simple huts and shrines built atop them. The tall, naked natives who lived in large straw cabins built into the earth like smokehouses with parts of the roofs projecting above the ground were encountered in the region of the Colorado River.

But more important is one dramatic event that happened to Coronado as the conquistadores approached Cibola. Indians hurled rocks down at the captain from high cliffs at the entrance to the village; Coronado was felled and would not have survived had not two of his officers hastened to rescue him and ward off the advancing Indians. That episode appears at the foot of the striated cliffs in Mostaert's painting. It was no doubt a garbled report that reached Mostaert's ears, one that mixed the elements of different incidents and observations in the campaign, but this is typical of most history paintings of Mostaert's day. The attack on Coronado, a memorable happening, would serve as a touchstone to bestow some authenticity on the reconstruction. The accounts were probably brought to the artist by the "noble visitors" whom Van Mander mentions.

That the landscape was not based on drawings is quite clear. The fanciful cliffs of Cibola are much like those rock masses in the landscapes of Patinir, where one can also find the "window-rock" that rises in the center of the hilly region in the center of the landscape. The breeds of animals are not buffaloes and mountain sheep that Castañeda and others report (there does appear to be a jack rabbit, however), but the conventional animal staffage in any Dutch bucolic scene. Certain exotic touches—the monkey perched on a post and the parrot just beyond—could well have been added by the artist as curios to further enhance his New World landscape, but in general the divisions of the panorama, the clustering of trees and the rock masses, even the three-colored division of the space, are features that we associate with Mannerist landscape and not topographical renderings.

Yet there is one aspect of the American scene that does merit our special attention. The historical moment depicted in the right middle ground, the stoning of Coronado, is but a minor detail in the painting and not a momentous occurrence. The natives and their primitive abodes were of much more concern to the painter. Here the Indians appear as dedicated family groups banded together in a time of emergency. In the lower left corner a wife beseeches her husband not to join the others in battle; an old bearded man, the elder of the tribe, leads the tall warriors; and in general it is the courage and spontaneity of their coming together in time of grave need to protect their land from the regimented Spanish army that marches in with huge cannons on the far right that is the overriding message in Mostaert's painting. This was the invasion of the primitive and tranquil paradise of the Indians by the armed conquistadores.

In many respects the atrocities committed by the soldiers in the New World stirred as much reaction in Europe as the discoveries themselves, and the reports of the massacres and the maiming of the primitive peoples became a very crucial issue at the court of Charles V in Spain. In fact, it was in part for that reason that Coronado was dismissed from his post when he returned to Mexico in 1542. The conquistadores were outraged to discover that there were no cities of gold to be found, only simple adobe dwellings and pastures. In Mostaert's so-called history picture we have one of the earliest commemorations of the "noble savage" in art history.

XXIV.

Lucas van Leyden

Most of what we know of Lucas van Leyden has been reconstructed from Carel van Mander's lengthy biography of him in *Het Schilderboeck*.[104] For Van Mander, Lucas was a *Wonderkind*: "I know of none who was the equal of the gifted Lucas van Leyden (of whom I now propose to write), who seemed to be born with brush and burin in hand and with a natural talent for painting and drawing. Nearly incredible are the stories told by those who still know, that when he was but a child of nine he produced engravings of his own composition, extremely well-done and subtle . . . he was born in Leyden in the year 1494 . . . His father,

Huygh Jacobsz., was also an outstanding painter in his time. Lucas, a born master, studied first under his father, and then under Cornelis Engelbrechtsz."

Whatever his sources were for the life of Lucas, Van Mander errs and confuses, and it has taken years of scholarship to sort out fact from legend. For one thing, it is now generally believed that Van Mander made him too precocious, and that Lucas was probably born about 1488–89 and not 1494. Secondly, concerning his training, no paintings by his father, Hugo (Huygh or Huych) Jacobsz, are known, and no influences of Cornelis Engelbrechtsz can be traced with certainty. By seeking possible sources for Lucas's earliest style—a print, to be discussed below, is dated 1508—it has been hoped that works by one of the many accomplished anonymous masters, artists active roughly between 1470 and 1500, might provide a solution for the problem of Hugo Jacobsz.

We know a few pertinent facts about Hugo. He was trained by Brother Tymanus, a painter for the monastery of Hieronymusdal near Leiden that was one of the important centers of art in the environs.[105] He rented a house on the monastic properties, and very likely the young Lucas would have grown up in a company of young apprentices in various crafts. Unfortunately, no works can be attributed to Brother Tymanus or Hieronymusdal with certainty. We also have information, albeit very ambiguous, that Hugo Jacobsz came from Gouda and apparently worked there on commissions at times.

One convincing argument, it seems to me, would make Hugo Jacobsz the painter of a set of panels (Rotterdam and Philadelphia) that once formed a large polyptych dedicated to the life of John the Baptist, dating about 1500–1510. The altarpiece is believed to have been painted for the Church of Saint John in Gouda, and that would account for Hugo's associations with the city, which is only sixteen miles southeast of Leiden.[106]

The panel in Philadelphia (fig. 525) illustrates the meeting of John and Christ (John 1: 35–42), when the Baptist turns to two of his disciples and points to Christ,

525. HUGO JACOBSZ? *Meeting of Saint John the Baptist and Christ.* c. 1500–1510. Panel, 48 × 37⅝″. The John G. Johnson Collection, Philadelphia

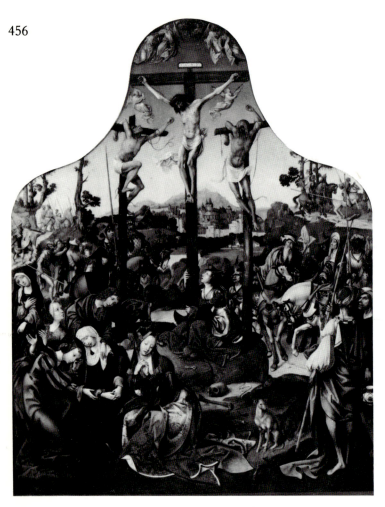

526. CORNELIS ENGELBRECHTSZ. *Crucifixion.* c. 1510–20. Panel,
70⅞ × 57½″. Stedelijk Museum "De Lakenhal," Leiden

who was walking by, saying, "Behold, the Lamb of God." Two features of this unusual painting support its association with the father-teacher relationship. For one thing, the rather heavy figures clustered in well-organized groups or pools in space are much like those who stand about in the works of Lucas. But even more convincing, the ambitious treatment of deep landscape organized with well-marked coulisses along a winding road and the splotches of leaves that are tossed naturally against the sky are reminiscent of the Haarlem manner of painting landscape, and this we find too in the early works of Lucas.

Little can be said about the supposed training under Cornelis Engelbrechtsz other than that we do know his paintings, and, furthermore, he was a prolific painter of high quality who had a workshop in Leiden in which his sons served as apprentices. Engelbrechtsz is the first Leiden artist whom Van Mander discusses. He briefly mentions two works executed by the Leiden artist for the Augustinian convent of Marienpoel in Oestgeest near Leiden. These are two large triptychs, one a *Lamentation*, the other a *Crucifixion* (fig. 526), both painted for the regent of the order, Jacob Maertensz, who appears in the predella of the *Crucifixion* altarpiece in the company of nuns of the convent. Jacob died in 1526, and the altarpiece has been dated between 1510 and 1520, too late to allow for the assistance of the young Lucas had he, in fact, been apprenticed to Engelbrechtsz.

The handsome shrine has a tall saddle-backed central panel which is filled with numerous figures in an effortless fashion, considering its Mannerist style. There is no convincing evidence, however, that Engelbrechtsz had received his training in Antwerp, and, as we have seen, the style of the so-called Antwerp Mannerists was by no means restricted to that city, although the major market for their paintings was there.

The Mannerist style is evident throughout. The surface is crowded with writhing, agitated figures dressed in fanciful costumes; the draperies whip about their forms in rich swirls and arbitrary turnings; the expressions display the same overly rhetorical gestures of grief or brutality; and the saddened faces of the mourners are sentimentalized to the point of being nearly caricatures. The heartsore countenance of the Virgin with her turning body and lean face is especially characteristic of Engelbrechtsz. But there is true quality in Engelbrechtsz's art, and one can sense an accomplished master at work at once. His technique is extremely refined and the colors are warm with areas of bright hues here and there glistening in their several glazes. [107]

No matter how refined and monumental his style may be, there is little in the art of Cornelis Engelbrechtsz that relates to the early works of Lucas van Leyden. Taking a cue from Van Mander's remark that Lucas grew up as a child in the company of young artists and craftsmen, we should perhaps reconstruct his beginnings in the monastery of Hieronymusdal, where his father was a painter and where he would have experienced the technical habits from those trained in the shop of Brother Tymanus. Alas, too little is known, but it is evident that the young Lucas was exposed to a number of art mediums other than painting, and that he had ready access to models and examples in the form of prints.

With the exception of a series of genre and Biblical pictures in crowded half-length compositions, Lucas's paintings date late and are, for the most part, relatively unrelated in style to his graphics. His career ended, in fact, with a number of large paintings that have unusually advanced, nearly Baroque, traits about them. On the other hand, the study of the development of his style in engravings is facilitated by the fact that many are dated and form a series from 1508 to 1530 that show a remarkably consistent evolution. Let us begin with them.

Although Van Mander exaggerated his precocity by some five years, there can be no doubt concerning the genius of the young artist. A few observations should be

made concerning Lucas's graphic style in general before we track his development by examples.[108] At first sight a print by Lucas, when compared to one by Dürer, has marked differences in tonality. His prints are foremost soft and silvery, with subtle shading creating a remarkably painterly quality that differs from the hard lines and schematic techniques of other engravings, including Dürer's. There are few sharp light-and-dark contrasts, and his engravings often resemble more the works of a draftsman drawing on toned paper than a converted goldsmith cutting precise, dark lines and contours into a copperplate. The lines of the burin are very fine, scratched into the plate lightly, and he employed a dry ink, not an oily one, so that the impression is matte rather than shiny and the lines are more granular than precise.

Because of this refinement in technique, the engravings of Lucas wore down rapidly and, furthermore, the plates were difficult to ink and print evenly. On the other hand, Lucas attained through his tonal techniques a surprising sense of atmospheric perspective and subtle chiaroscuro effects. Vasari especially praised Lucas for his landscapes with atmospheric perspective, and both he and Van Mander develop a dialogue concerning a supposed competition that arose between the Dutchman and Albrecht Dürer. Indeed, there probably is some truth to this rivalry, although it is clear that Dürer was followed by Lucas and not vice versa.

It is not only technique and style that distinguish the prints of Lucas from others, however. His range of thematic materials was vastly different from that of Dürer or the Italians; his choice of narrative moment is original, provocative, and often puzzling; his concentration on the everyday character of his religious themes and his unusual genre subjects mark Lucas as an exceptional artist in the Dutch tradition.

His first dated print, the *Mohammed and the Monk Sergius* of 1508 (fig. 527), an unusual if not highly eccentric subject, has yet to be explained adequately. The story is related in the *Travels of Sir John Mandeville*, a fourteenth-century account of various experiences in the Near East, the Holy Land, and even China, that was popular during the late fifteenth and early sixteenth centuries as a colorful travelogue.

Mohammed was an ardent follower of a certain hermit who resided near Mount Sinai, and he spent many hours listening to him, much to the chagrin of his servants and soldiers. One devised a plot wherein after Mohammed had fallen asleep from drinking too much wine, his sword would be stolen and his mentor murdered by it. The sword would then be replaced in Mohammed's scabbard, and upon his awakening, their leader would think that he had committed the act in a drunken stupor. And

so it happened, and Mohammed, in horror at his terrible act, then proclaimed complete abstinence for himself and his followers.

The curious legend was cited as an exemplum of the wanton habits of the Moslems and an admonition against intemperance in general. It has been suggested that the young Lucas executed the print for the occasion of the joyous entry of Maximilian I in Leiden in 1508, since the emperor was engaged in campaigns against the Turks and was also a prohibitionist of sorts.[109] Whether or not this was the intent of Lucas—to gain imperial approval and perhaps patronage—is questionable, but the moralizing content of the unusual story must certainly have been a factor in his decision to engrave it. The print is a masterpiece of his youth, displaying the uncanny qualities of subtle tonalities and atmospheric perspective in the gradations of the deep landscape setting. It was extremely popular, and the Italian engraver Raimondi appropriated the colorful landscape background for his own print of the scurrying bathers in Michelangelo's *Battle of Cascina*. Vasari highly praised it.

The landscape is especially effective with a three- or fourfold division of space marked off by carefully placed

527. LUCAS VAN LEYDEN. *Mohammed and the Monk Sergius.* 1508. Engraving, 11⅜ × 8½"

trees and subtle gradations of tones from the darker foreground with its dense cross-hatching to the wispy, light touches that describe the faint far distance. How delicately Lucas modeled the trees in line; each, near and far, is shaded with different contour lines in the trunks already at this early stage in his development and not merely crosshatched. Leaves too are clearly differentiated as to types, with those in the left middle ground tossing about in clumps, much in the fashion of those of Geertgen tot Sint Jans. Only in the organization of the foreground figures are we aware that Lucas is experimenting. The attempts at foreshortening in the seated Mohammed and the sleeping monk, the hermit of the story, are clumsy and inaccurate; the stride of the stealthy soldier replacing the sword is stiff and awkward.

But what is unusual in this moment of action is precisely what distinguishes Lucas from other artists. It is not the dramatic act of killing or the horrid response of false guilt but rather the strange moment in between, when the viewer is presented with an action that was neither just initiated, nor completed, nor its consequences revealed. Those off-moment actions are psychologically disturbing even if we know the outcome of the story. It is not a *fait accompli* but an unraveling drama that engages the spectator. The story is, in fact, initiated in the far distance, where one of Mohammed's followers hires a soldier to perform the heinous act, and then is continued in the middle ground under the trees to the left, where the conspirator reveals his plan to a group of followers. It is a curious print in many respects, a daring display of originality on the part of the young Lucas. The static aspects of the story are foremost; the rhetorical drama is set aside.

In another engraving of about the same date, *David Playing the Harp Before Saul* (fig. 528), Lucas presents two large figures, filling the surface, in a cramped throne room. Here again his line work is superbly graduated to effect a three-step division in the narrow space. Lucas selected an unusual moment to illustrate the story of the mad king about to cast his lance at David, who plays his harp to soothe Saul's melancholy. Much as in Rembrandt's haunting painting in the Hague, the actual violence is not depicted, but rather the moment before the hurling of the lance, when Saul is brooding over his jealousy of the youth. His slackened jaw, hanging lower lip, and unfocused eyes betray his insanity. For the figures of Saul and the viewers behind the throne, Lucas borrowed types from Dürer's woodcut of the *Martyrdom of John the Evangelist* in the *Apocalypse* series.

In 1509 Lucas engraved eight roundel prints illustrating the Passion of Christ, a project that busied many graphic artists before him, including Schongauer, Israhel van Meckenem, and Dürer. Again Lucas's refined technique gives his designs a pronounced painterly and tonal appearance. In some prints, such as the *Carrying of the Cross* (fig. 529), he departs from the traditional iconography of the event to present secondary figures, here John the Evangelist and the two Marys, on a sharply contoured hill in the left foreground and relegates the major figure, Christ stumbling under the weight of the cross, to the middle distance in a lighter tone. Golgotha is not even included. The tensions set up in the drama are thus shifted from physical pain to psychological anguish in the immediate followers of Christ.

In a number of prints dating 1509 and 1510, Lucas treated subjects that are generally classified as "genre," meaning in this sense subject matter of everyday life that has no overt mythological or religious overtones. These include images of knights and ladies promenading, pilgrims resting, beggars, an amorous couple strolling in a dark, mysterious chamber, a nude woman picking fleas from a dog, and a *Milkmaid* (fig. 530). This last print is often cited as the first true bucolic genre scene in Dutch art, but even in this seemingly innocent pastoral motif moralizing overtones and satire can be discerned, much as they can in many of the other so-called genre prints.[110]

The main focus is on the large cow seen in profile that fills the composition with the immediacy of Paulus Potter's *Young Bull* in the Mauritshuis in the Hague. The composition is simple and symmetrical with an earthen stage for the bovine terminated by buildings and trees and a wooden fence. To the right, at the rear of the cow, a buxom young maid, her blouse cut low to reveal her ample bosom, stands in a frontal position. Directly opposite her is a tall, coarsely featured farmhand in profile who stares at her. Behind the cow, a bull posed in the opposite direction stops abruptly to regard the cow with a questioning eye.

The innuendoes are obvious. Do the boy and the bull have the same thoughts in mind? And what about the maiden and her cow? The use of the word *melken* (to milk) has a double meaning as *lokken* (to entice) in Dutch, and the erotic overtones in such a simple bucolic pastime would be entirely in keeping with the nature of the genre. Whether or not the dry tree, the broken tree trunk, and the twisted horns on the left side of the composition near the farmhand have any further meaning for the simple encounter is up to you.

In 1510 Lucas took on an unusual project, the execution of a large, folio-size print of the *Ecce Homo* (fig. 531) in an apparent effort to rival the acclaim received by Schongauer's large *Carrying of the Cross* (fig. 290), which had become famous as a collector's item. The theme of Ecce Homo is at first a seemingly odd choice for such a special production, and it was clearly Lucas's intent to show on a grand scale his mastery of perspective and also

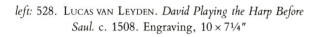

left: 528. LUCAS VAN LEYDEN. *David Playing the Harp Before Saul.* c. 1508. Engraving, 10 × 7¼″

below: 529. LUCAS VAN LEYDEN. *Carrying of the Cross*, from the *Round Passion.* 1509. Engraving, diameter 11½″

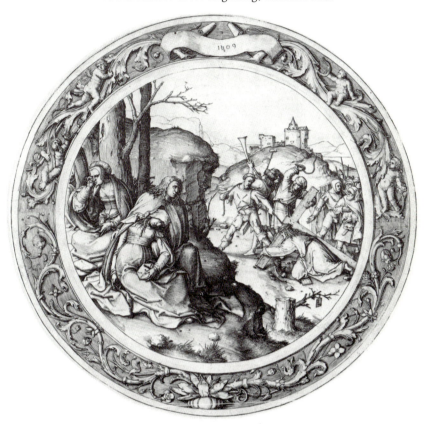

left: 530. LUCAS VAN LEYDEN. *Milkmaid.* 1510. Engraving, 4⅝ × 6″

below: 531. LUCAS VAN LEYDEN. *Ecce Homo.* 1510. Engraving, 11⅜ × 17⅞″

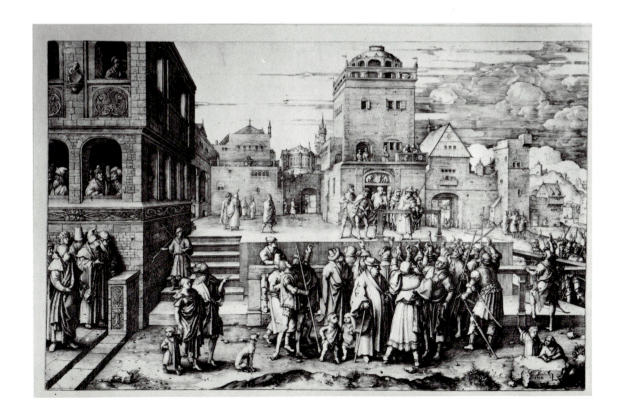

532. Lucas van Leyden.
Crucifixion. 1517. Engraving,
11⅛ × 16¼"

to provide his audience with a colorful city panorama more so than to appeal to their sense of devotion and piety. The event itself takes place on a raised podium in the center of a vast city square before the praetorium, here appropriately inspired by the old prison in Leiden, the *Gravensteen*. Other buildings about the open square have been tentatively identified as other prominent buildings in Leiden including the *Huis Lochorst*, the large Renaissance building to the left, the stepped rotunda in the far distance as the *Jerusalemskapel*, and the tower of the *Begijnhof* next to it, although these identifications are not convincing.[111]

It would seem that whatever specific influence the cityscape of Leiden had on the setting here, it was transformed into an imaginary pastiche of familiar building types. Perhaps the underlying concern was to provide an impressive tableau of architecture for the drama much as we know it was used in later paintings of the *Ecce Homo* by Pieter Aertsen, Joachim Beuckelaer, and the Master of the Brunswick Monogram as showpieces for elaborate exotic and quasi-Renaissance settings for recording everyday life in the marketplace.[112] This is, in effect, a Mannerist inversion of the same type as discussed in Aertsen's *Butcher's Stall* (colorplate 71), only here the activities of the townspeople have a more poignant role in the content of the picture. They are the many who carry on their humdrum existence without taking special note or concern of what really is happening or even listen to Christ's words, "You know not what you are doing." In fact, the religious narrative is little more than a staged play taking place in the city square (much as they did) with crowds of people watching from windows and the streets below the praetorium. While Lucas's engraving does not present us with the full-fledged genre interests

of Aertsen or Beuckelaer, the first step has been taken in that direction.

Almost as a companion piece to the large *Ecce Homo*, Lucas engraved his panoramic *Crucifixion* seven years later (fig. 532). Here again the same inversion of subject matter appears with the Calvary group set off to the left on a high hill in the middle distance. The Crucifixion group follows the traditional historiated type with the mourners to the left of the cross, the centurion Longinus plunging his lance into Christ's side, the Magdalen clutching the foot of the cross, and the two thieves to the sides.

The other actors in the drama have been scattered down the hillside among the townspeople, who are collected in pools amid the rolling fields in the foreground. In the lower left are the henchmen tossing dice and fighting over Christ's mantle; in the center the sponge-bearer stops to explain the happening to a peasant woman and her child; and further back to the right city officials on horseback make their way slowly along the path that leads to Golgotha from the distant walls of Jerusalem in the far left corner. Others simply gather about to see what all the commotion is about. A boy plays with his dog, a mother cuddles her child, a cripple hobbles by a well-dressed citizen who stops to discuss the execution with a passerby.

It is, by and large, a rather sedentary crowd that gathers, and the subtle psychology Lucas plays here is very indicative of the changing patterns of religious imagery in Holland.[113] The trivial incidents tell us so much about these people; the historiated drama has become the episodic and anecdotal occurrence. There is nothing supernatural in this act of crucifying, nothing of momentous doctrinal significance happening in the Dutch village; rather, the emphasis has shifted from Biblical pathos to

quotidian anecdote. The print was very popular, and, as Van Mander tells us, "fetched good prices in his lifetime."

Technically the *Crucifixion* is a masterpiece, although good impressions are rare because of the subtle line work in the middle distance. His lines still follow the contours, more schematic cross-hatching is employed to indicate the denser shadows, and delicate stippling is used to capture the sandy texture of the ground when raked by sunlight. The articulation of his figures has improved over the decade, and each group of observers could be easily lifted out as an individual study in its own right. Briefly, Lucas has returned to his earlier interest in landscape, and the organization of the groups within open pockets of space or on rocky rises scattered about the diagonal ravine is simply an elaboration of the Haarlem school formula for activating space that appears in his earlier works.

However, for the sprawling panorama itself that rolls like some heavy sea beneath a sky growing turbulent over the Crucifixion group, Lucas has exploited the new Mannerist devices that we associate with Patinir's school. The lofty mountain peaks that rise into the clouds on the right with hills echeloned behind them to the distant horizon are merely a tamer version of the cosmic panoramas of the Antwerp landscapists. Somehow, however, the landscape seems more orderly and controlled, with the incidental staffage of Patinir here enlarged into fascinating genre motifs that animate the terrain with vignettes of human interest more than with exotic irregularities of nature.

Aside from his interest in rendering the Passion stories as everyday occurrences, Lucas also devoted much time to another sequential drama that had grown in popularity during the late fifteenth century, the "Power of Women." The interest in this theme should not be confused, however, with a growing concern for women's liberation as one might think—unless warning can be construed as awareness—but rather it was another moralizing theme that was directed to yet another of man's shortcomings in the world, an outgrowth and elaboration of the old medieval vice of lust and *cupiditas*. The theme portrayed women in history not as heroines but as vicious, conniving, and treacherous temptresses who seduce even the most powerful and intelligent men, reducing them to humiliating morsels of ridicule. No man can escape the wiles of the sensuous woman.[114]

The "Power of Women" had a particularly colorful development in literature and in the theater whereby, in a set sequence, Old Testament heroes and learned men of antiquity were reduced to shameful idiots by the enticements of the fair lady.[115] One source often cited is the fourteenth-century Meistersinger Heinrich von Meissen,

called *Frauenlob*, who listed many examples in history to prove his contention that even the strongest and wisest of men succumbed to the power of women: "Adam was the first man woman betrayed." Lucas executed at least two sets of the "Power of Women." In one, designed between 1516 and 1519, he introduced the series with the Fall of Adam and Eve and then included Jael Killing Sisera (Judges 4: 17–22), Samson and Delilah (Judges 16: 4–22), Solomon's Idolatry (I Kings 11: 1–13), Jezebel and Ahab (I Kings 21), and Herod and Herodias (Matthew 14: 8–11). In an earlier (c. 1512), larger set of woodcuts, Lucas added examples from pagan antiquity with the *Poet Vergil Suspended in a Basket* and the *Mouth of Truth*, a story, ascribed to Vergil, of an adulterous empress who fooled her husband. Lucas also issued a print of *Aristotle and Phyllis*, about 1515, which does not seem to be part of any set, although the woodcut is the same format as the large "Power of Women."

The woodcut of *Samson and Delilah* (fig. 533) gives us an opportunity to study Lucas's performance in that related medium, and one can see at once that his success as a designer of woodcuts was due to his ability to emulate

533. LUCAS VAN LEYDEN. *Samson and Delilah*. 1512. Woodcut, 16¼ × 11⅜"

above: 534. LUCAS VAN LEYDEN. *Poet Vergil Suspended in a Basket*. 1525. Engraving, 9½ × 7½"

right: 535. LUCAS VAN LEYDEN. *Tavern Scene*. 1518–20. Woodcut, 26⅜ × 19⅛"

Dürer. The composition, with the two principals placed in the right foreground against a dark diagonal hill, is prosaic and conventional. The shading lines and cross-hatching are uneven and the subleties of his silvery tones are all but lost in the coarser contours and dense shading of the ground, the trees, and the rocks. There is little understanding of the dramatic highlights that Dürer so effectively spread across his woodcuts.

Such is not the case with his later engraving of the *Poet Vergil Suspended in a Basket* (fig. 534), signed and dated 1525. In the earlier woodcut series for the large "Power of Women," the composition of this scene follows the conventional formula by showing the crowd standing about the basket close to the picture plane, but in his engraving Lucas exhibits his genius for reinterpretation by making the episode a marginal detail in the distance to the left. By this inversion, he focuses on the large crowd of bystanders in the foreground, who react in surprise to the freakish sight.

According to the legend which developed in the course of the Middle Ages, the learned poet Vergil fell in love with a beautiful young lady, Lucretia (in some versions she is identified as the emperor's daughter), whom he saw in the balcony of her home. In order to make a fool of the highly respected Vergil, Lucretia invited him to return the following night, when she would lower a basket on a pulley and thus allow him access to her bedchamber. This Vergil did with much anticipation, but when she had lifted him halfway to his destination on the side of the building, she made fast the rope, and our poor poet hung suspended until the next day, when his game of love was rudely displayed to the townspeople. Such was the humiliation of the wise author of the *Aeneid* and all because he succumbed to the temptations of lust. The bystanders range from infants and tots to the elderly, and while the younger seem to think the whole thing humorous, the older are astonished and worried that such humiliation should come to one so wise.

While on the subject of the folly of men and the wiles of women, an unusually large woodcut, attributed to Lucas, entitled the *Tavern Scene* (fig. 535), should be considered. Around a table sit, from right to left, a young man in fancy dress, a comely harlot, and an old hag who secretly passes off coins to a boy standing in a doorway at the far left. In a window in the top right appears the bust of a fool looking in on the scene from the outside. Near

the fool a banner unravels with the words *(w)acht. hoet. varen. sal.*, roughly translated as the proverb "watch the way the wind blows," a message directed at the viewer.

For some time the print has been identified as the *Prodigal Son*, but that seems uncertain since it conforms more to the general category known as "loose living" and, in fact, is closely related if not the inspiration for Quentin Metsys's painting of the *Ill-Matched Lovers* in Washington (fig. 475).[116] In a similar manner the young prostitute gently caresses the chin of her prospect while he reaches for her breast, unaware that her left hand is exploring the purse hanging on his back.

The technique of the woodcutting is superior to that in the *Samson and Delilah* just discussed, but the hand of Lucas seems responsible for the designing of the figures, the costumes, and the architectural detail. That this was not a print for the collector, however, is apparent by its large format with two blocks printed on four sheets of paper. The print had a more popular appeal and public purpose, and the fact that only one impression survives suggests that the woodcut was one that hung on the wall of a tavern or some public building, where it could be a bawdy conversation piece.

The theme of the harlot or courtesan appears again in one of Lucas's most famous engravings, the *Dance of Mary Magdalen* (fig. 536), signed and dated 1519. As we have seen, the Magdalen was one of the most popular female saints in early-sixteenth-century art, and the reason for that is the role she played in popular legend as the sinner who became a penitent hermit through her conversion to Christianity. Practically nothing is mentioned in the Gospels concerning Mary Magdalen's life before she met Christ, and representations of the Magdalen's

early life are extremely rare in medieval art, although Voragine writes in the *Legenda Aurea* (July 22) that before her conversion she lived a life of luxury and indulgence in her castle. In the sixteenth century the Magdalen's early years were elaborated and she became a worldly courtesan who lived nights in debauchery.

In the print by Lucas the setting is the familiar garden of love with numerous amorous couples lying about and seated on the grasses of a woodland park, some embracing, others singing or drinking. Two musicians, a drummer and fifer, provide the music as the Magdalen and her partner perform a stately dance. Two fools in their midst, greeting each other across the lawn, testify to the folly of it all. One couple, to the left, seems to recognize their presence.

In the distance, beyond the two musicians, the Magdalen can be seen again, on horseback this time, enjoying the thrills of the falcon hunt. Both activities, the dance and the falcon hunt, are attributes of the pastimes of late spring in the representations of the months, and it is the time, of course, when all of nature awakens to the delights of loving and mating. In the far reaches of the landscape, just above the dancers' heads, one can barely discern the Ascension of Mary Magdalen on the Mountain of Saint-Baume, this last episode being the one most familiar in representations of her life as a penitent.[117] Here again, Lucas offers us a moralizing inversion of the traditional episodes in her life.

In his late engravings, Lucas turned more and more to the study of the male and female nude, both the pagan, Mars and Omphale, and the Biblical, Lot and his Daughters and Adam and Eve (fig. 537). It would be difficult to pin down his sources precisely in these late prints, but it

left: 536. LUCAS VAN LEYDEN. *Dance of Mary Magdalen.* 1519. Engraving, 11⅝ × 15⅞"

below: 537. LUCAS VAN LEYDEN. *Adam and Eve.* c. 1530. Engraving, 7½ × 9¾"

is clear that Lucas tried to display his virtuosity in rendering the volumetric solidity, the sensuous *contrapposto*, and the heroic proportions in his large nude figures. Also evident is his change in technique from the earlier silvery tonal touch to a much more schematized and rigid system of cross-hatching whereby the subtle shading is reduced to the point that the seated figures appear severe and cool in the transparency of their highlighted bodies.

The glorification of the sensual is apparent especially in Eve, who is seated in a rather indecorous frontal position with her limbs open to the observer. Adam, whose sleepy condition and languorous pose bring to mind Adam in the Sistine Ceiling, is also broadly highlighted. The familiar woodland setting has also been reduced to a dark screen of tree trunks for the rocky foreground stage.

If one compares this engraving, dated about 1530, to his earlier engraving of 1508, *Mohammed and the Monk Sergius* (fig. 527), the transformation of Lucas's style from that of the Late Gothic to the full-blown Renaissance can readily be appreciated. Van Mander concludes his lengthy biography of Lucas with fitting words: "The final thing he engraved was a little print, a Pallas [Pallas Athena, patron goddess of wisdom and the arts], and they say that it was finished just in time to be laid in front of him on his bed, which would seem to prove and make clear, that he loved and practiced his ingenious and fine manner of working, his art, until the very end."

Most studies of Lucas van Leyden are devoted to his accomplishments in the graphic arts and rightly so since they vividly document his development as an artist. And yet, the paintings of Lucas have exceptional merits of their own that display an unusual aspect of his mature years. The earliest paintings are half-length compositions of card or chess players and a few unusual Biblical themes that, if we can trust the dates assigned them, clearly indicate that Lucas came to painting after his graphic style had been established.

At the end of the earlier series of half-length pieces comes a version of the *Card Players* (colorplate 75) which is today in the collection of the Earl of Pembroke at Wilton House (Salisbury). Like the others, the Wilton House *Card Players* has all the marks of that frivolous genre we have become familiar with in the representations of the Prodigal Son and other "loose-living" compositions with half-length figures of men and women in contemporary dress gathered around a table. It is difficult to decide just what depth of meaning these pictures have beyond being simple genre pieces. In most of them, the action of play is suspended, the moment is one of hesitation, but in all we are given a view of the cards of one or more players and by the psychological implications of a glance of someone in the picture, here the young lady to

the right, we too are actively involved spectators of the game.

The last years of Lucas's activity are notable for a number of large paintings that reveal dramatic changes in his art from what might be called a Dutch Renaissance to a proto-Baroque style: a canvas with *Moses Striking the Rock* (1527) and three triptychs, the *Last Judgment* (1526–27), *Moses and the Worship of the Golden Calf* (c. 1530), and *Christ Healing the Blind Man at Jericho* (1531). The enormous bell-shaped *Last Judgment* (fig. 538) has recently been cleaned and restored, and the published history of the triptych along with the revelations of the underdrawings through radiographs provide the student in the field with an unusual opportunity to follow the story of a great Dutch painting from its conception on panels to its present exhibition in a modernized gallery room.[118]

With the exception of a few lacunae, the history of the triptych is well documented. It was commissioned on August 6, 1526, by the children of a reputable Leiden burgher, Claes Dircsz van Swieten, a timber merchant with noble ancestry in Holland who had served his city well as a member of the town council. The painting was a memorial for the departed leader of a family, and while it was not likely an altarpiece in the strict sense of the word, it hung along the wall in the southwestern corner of Saint Peter's near the baptismal font, very likely as an impressive example of justice over the aldermen's pew, which was situated there. This location may help explain another anomaly of the triptych. Unlike the usual *memorietafelen*, there are no portraits in the panels. The exterior of the wings portrays Saint Peter—the patron saint of Leiden—and Saint Paul seated in a vast continuous landscape with a view overlooking the sea.

The iconography of the inside with the representations of heaven and hell on either side of the *Last Judgment* has a curious twist to it. The panorama of the resurrected is surprisingly sparse and barren. Only two trumpeting angels announce the resurrection and a mere handful of angels appear on earth to guide the blessed toward heaven. Heaven on the left wing is not envisioned as a great cathedral of the heavenly city or a garden of paradise but simply as a continuation of the gray, blue, and gold divisions of the central panel. Hell is disappointingly summary as well. A giant flaming mouth of the Leviathan dominates a dark city wall atop which scamper a few small demons.

There can be little doubt that Lucas attempted foremost to display his expertise in the painting of male and female nudes in his treatment of the resurrected. In the left foreground of the central panel a well-integrated group of four figures appears. A tall angel in white directs a buxom nude lady, striding to the left in profile,

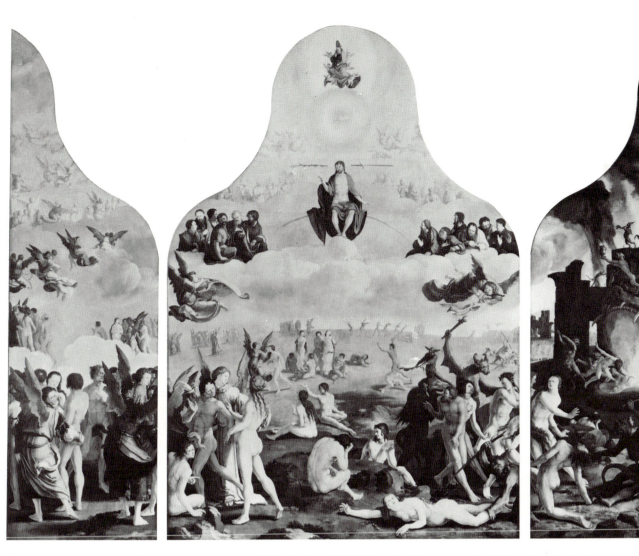

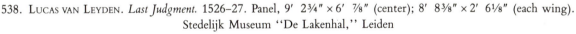

538. LUCAS VAN LEYDEN. *Last Judgment.* 1526–27. Panel, 9' 2¾" × 6' ⅞" (center); 8' 8⅜" × 2' 6⅛" (each wing). Stedelijk Museum "De Lakenhal," Leiden

and her tanned male companion toward heaven. The seated nude before them looks out and points his finger toward hell on the right panel. In the center are two male nudes, one seated in the pose of Melencolia seen from behind, and the other in an attitude of prayer. A large female nude writhes on the ground before them, attempting to disengage herself from the clutches of a strange human demon with glaring eyes and a beard. Behind this group are other nude figures of the damned who vaguely bring to mind Michelangelo's Adam and Eve in the *Expulsion* fresco of the Sistine Ceiling.

These labored studies of the nude in action have often been described as attempts on the part of Lucas to emulate the classical figures of Gossart, but other than their heroic proportions there is little about them that suggests the latter's style. They bring to mind more the dramatic friezes of figures in action executed in a painterly fashion with the merging of figure, landscape, and light that we associate with Jan van Scorel, the great painter from Utrecht who will be discussed in the next chapter. All in all, the *Last Judgment* of Lucas van Leyden is a

most impressive work in its sheer bigness and grandeur, but it is more a chilly showcase in its virtuosity and cool clarity of execution than an overpowering presentment of the horrors and joys of the end of days. Late Gothic mystery and pessimism in the drama have given way to Renaissance stately rhetoric and showmanship.

The *Moses and the Worship of the Golden Calf* in the Rijksmuseum (colorplate 76) occupies a special place within the artist's oeuvre. In many respects it is a painting outside its own time with its prophetic anticipations of the seventeenth-century rowdy playfulness of Adriaen van Ostade and David Teniers, the restful sunlit landscapes of the Dutch painters of the Roman Campagna, and the bravura and rollicking rhythms of Pieter Paul Rubens. But first the story, since it is an unusual one.

In keeping with the moralizing genre interests of the day, the theme of the painting is one of intemperance and its consequences, but the textual source is new. What we have across the triptych is a condensation of the events that took place during and after Moses ascended to Mount Sinai to receive the Tablets of the Law from the

Lord (Exodus 29–32). Upon returning from the mount after forty days, he found the Israelites eating, drinking, playing, and dancing about a golden calf set up by the priest Aaron, which they worshiped. The lascivious living and the worship of the false god made Moses hot with anger and he broke the tablets at the foot of the mountain.

In the painting the story unfolds in three stages. Along the undulating foreground are groups of Israelites feasting, drinking, and making love amid the rocky setting of their encampment. A few glance out at the viewer—a psychological touch that Lucas frequently introduced to force the spectator to identify with the activity, good or bad. In the light green meadows of the middle ground more Israelites dance in abandon about the image of the golden calf raised on a pedestal. Just beyond them, before a dense grove that marks off the foothills of Mount Sinai, are the tiny figures of Moses and Joshua returning to the camp with the former lifting the tablets in the air about to hurl them to the ground. Above the dark green trees rises the smoke-covered Sinai, and on a projecting cliff the figure of Moses appears again, kneeling this time as he receives instructions from the Lord speaking from the dark clouds.

The message the painting conveys is at first allusive, much as it is in Bosch's *Garden of Earthly Delights* where the textual source was "Thus it was in the days of Noah" (see p. 214). Even the general organization of the composition reminds us of Bosch's *Garden*. But as a picture that condemns the licentious life of intemperance, lust, and the worship of false gods through the laxity of the priesthood (Aaron), it reflects the turbulence of the Reformation period. However, it would be unwise to jump to conclusions regarding the sympathies of the painter here.

The visual presentation of the events has a new spirit about it when compared to Bosch's comparable painting. The activities of the Israelites seem so natural and inevitable, so much like everyday routines, compared to the ritualistic and fatalistic cataloguing of sins in Bosch's world. Children play joyfully, families relish the bountiful fruits of the table, old men reminisce and gossip, young lovers embrace unashamedly, and food, drink, love, and play flow freely across a foreground tableau composed with the naturalism of a family reunion. The more organized dancing in the meadows imposes a certain feigned tone to the openness of the grand picnic, however, and finally the dark thunderclouds and the icy peaks of the distant mountains are forebodings of the violent reaction of their leader.

The broad composition is striking in its natural flow of overlapping layers of floating diagonals and serpentine interweavings, devices that once again anticipate Baroque organization. Lucas's conception of landscape here is very advanced with the lingering color divisions of Mannerist landscapes flowing imperceptibly from one space to another and the echelons of mountaintops in the far distance fading from light green into pale blue with other valleys highlighted by the bright sun in between, much in the fashion of the romantic vistas of the Frankenthal school (Elsheimer, *et al.*) at the turn of the century. The painterly qualities in the fluid brushwork and the naturalism of the free-flowing composition are unlike anything we have seen before. It is as if we have stumbled into a vast valley of frolicking people under the bright sky with the sudden gathering of storm clouds threatening their joyous saturnalia. As a painter Lucas van Leyden must be reckoned as one of the true harbingers of Baroque expression.

Jan van Scorel, Maerten van Heemskerck, and Antonis Mor

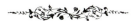

"A man who wants to become an artist must visit Rome . . . He must also have produced many paintings in the style of this school . . . , before he may be regarded honestly an artist" (Lampsonius, as quoted by Van Mander in the life of Jan van Scorel)

Jan van Scorel's life was filled with adventure. Born on August 1, 1495, the natural son of a pastor in Schoorel, a small town above Alkmaar, he was cared for as a young boy by Jan van Egmond, *stadhouder* (governor) of Holland, and was sent to a Latin school in Alkmaar. His talents as an artist were soon discovered, and according to one biographer, Arnoldus Buchelius, his benefactor placed him in the apprenticeship of Cornelis Buys (the Master of Alkmaar?). Van Mander, perhaps mixing up his patronymics, named a Willem Cornelisz of Haarlem as his first teacher, and further tells us that the young student was abused by the older master, who held Scorel practically in bondage.[119] Sometime around 1512 the young artist went to work with Jacob Cornelisz van Oostsanen, the brother of Buys, it will be recalled, in Amsterdam and there found his first professional training of merit. From Amsterdam Jan van Scorel went to Utrecht, the ecclesiastical center of the North Netherlands, about 1515–17, and apparently met Jan Gossart, who was at that time in the employ of Philip of Burgundy, bishop of Utrecht.

The uncertainties of these early years quickly pass, and from 1518 until his death in 1562 his life is richly documented and filled with surprises. Sometime late in 1518 Scorel left the Netherlands and traveled extensively through Germany—Cologne, Speyer, Strasbourg—to Basel and on to Austria (Carinthia). He then turned south and traveled to Venice, where he was introduced to pilgrims on their way to the Holy Land. He joined them, 1519–20, and visited Crete, Candia, Cyprus, and Jerusalem.

Upon returning to Italy, Scorel spent a year as the administrator of art in charge of antiquities in the Vatican under the Dutch pope Adrian VI, and he resettled in Utrecht in 1524 to resume his ecclesiastical duties there as well as to promote a large workshop of painters. He spent a few years in Haarlem, about 1527–30, and after his return to Utrecht, his atelier grew in size to rival those of Antwerp and Brussels, and he received many commissions outside Utrecht. In 1550 Scorel was called to Ghent to restore Van Eyck's famous altarpiece, and between 1550 and 1553 he devoted much of his attention to the reclamation of flooded lands in the Zijpe, a coastal region above Alkmaar, with a system of dikes to form a polder village called Nova Roma. Obviously, Jan van Scorel was not a typical churchman or artist, and his various activities—he was a very learned humanist, musician, and poet as well—reveal a many-sided personality.

According to Van Mander, Scorel visited Nuremberg during his travels in 1518, where he met Dürer, who "took an interest in Scorel's views. . . . Soon Scorel departed for Steyer in Carinthia, where his work was in great demand by most of the nobility. He stayed with a baronet, a great lover of pictures, who rewarded him well and wanted him to marry his own daughter." The earliest signed and dated altarpiece by Scorel resulted from this association.

A triptych with the *Holy Kinship* (fig. 539) in the parish church at Obervellach in Carinthia has the crests of the families Frangipani and Lang on the reverse and is dated 1519. Apollonia Lang, wife of Christophoro Frangipani, owned properties in the region of Obervellach, and it was no doubt for the church in the village just below their castle, Falkenstein, that the altarpiece was painted. The central panel displays seventeen members of the Holy Kinship, the family of Anna and her three husbands (see p. 82), many of whom are in the guise of members of the Frangipani-Lang families, gathered casually in an open field before the village (Nieder-Falkenstein?) with its church in the background. On a hill beyond is a castle, very likely Falkenstein itself. The wings are decorated with saints in landscapes, Christopher to the left, Apollonia to the right, as the patron saints of husband and wife.

The portraits have yet to be identified with certainty.

his own death the year after, 1527, when, as Van Mander mentioned, it "was placed as a memorial in the Dome Church in Utrecht by friends."

The central panel is broad to accommodate the spectacular view of the city below in the valley of Kidron to which Christ on the donkey in the company of the twelve apostles rides. The contrast between the brightly painted entourage on the left descending the steep road from the Mount of Olives and the glowing expanse of Jerusalem below is dramatic. The darker tones in the costumes, the trees, and the silhouettes of the crowds carrying branches to meet Christ form an emphatic repoussoir for the distant landscape. It would seem that Scorel had some knowledge, perhaps through prints, of Michelangelo's painting of the Deluge on the Sistine Ceiling, where similar throngs of fleeing people form the same compositional device. The draperies are rich and boldly modeled in broad, fluid strokes, and the poses are varied, some remarkably foreshortened.

The strong diagonal repoussoir allowed Scorel to place the viewer high, and avoiding any complex middle-distance projection, his next task was to reproduce the panorama of distant walls, towers, and monuments of the Holy City. The apostles, as the original pilgrims of Christ, come excitedly upon the long-awaited view of Jerusalem, and suddenly there it lies before them, radiant and splendorous with light as the New Jerusalem described by John in the Book of Revelation. This heavenly abode was also the goal of the deacon Lochorst and his family. They are presented on the outsides of the two wings, five in all, kneeling in front of their patron saints before a heavenly aureole where the Coronation of Mary, to whom the Cathedral was dedicated, appears in a funnel of light. The side wings inside are painted in paler tones and present other saints venerated in Utrecht: Saint Agnes, Pope Cornelius (in the guise of Adrian VI?), and Saint Anthony on the left, Saints Sebastian, Gertrude of Nivelles, and Christopher on the right. Of these five figures, Saint Agnes is the most striking in her charming classical pose and the sheer gauzelike chiton that she wears.

The fascinating view of Jerusalem was "done from life," as Van Mander reports, meaning that its model was a sketch Scorel had made of Jerusalem when he was there from a point east of the city on the Mount of Olives. Below we see the great Golden Gate and the sprawling city walls. Beyond lie the broad temple square, the Dome of the Rock, the Holy Sepulcher, the Portal of Saint Stephen (to the right), and the Monastery of Sion rising in the top center beyond the city walls and the citadel. To the far right stretches the valley of Kidron. The sketch made by Scorel was seen in 1584 in Delft by Christianus Adrichomius, who wrote a description of Je-

rusalem; the painting was used for a large woodcut of Jerusalem printed by Herman Beerntz van Borculo in 1538.[120]

The Lochorst triptych was Scorel's first major altarpiece in Utrecht, and his activity there was interrupted temporarily by unrest in the city brought on by the duke of Guelders that was, however, relatively short-lived. In the interim Scorel settled in Haarlem, where he had good friends among the Knights of Saint John, especially the commander Simon Saenen van Zanen. He also joined the Haarlem Confraternity of Pilgrims to Jerusalem, and for their chapel he painted another set of portraits (fig. 541).

The portraits of the Haarlem *Ridderlijke Broederschap van den Heiligen Landen* follow the same formula as the earlier group portrait he had painted for the pilgrims in Utrecht, but there are definite improvements in the placement of the heads, the psychological rapport, and the intent of the series as a representation of the actual procession of the brothers in Palm Sunday parades. Perhaps Scorel was inspired by the more activated group portraits of the Knights of Saint John that Geertgen tot Sint Jans had presented in the panel of the *Burning of the Bones of Saint John the Baptist* (fig. 171) for the high altar of their church in Haarlem. Alois Riegl's important study of Dutch group portraiture traced the evolution of these popular paintings from Geertgen through Scorel and down to the seventeenth-century masterpieces by Frans Hals and Rembrandt.[121]

The difficulties in turning a gallery of portraits, a rather monotonous project, into a work of art with dramatic content are manifold. As Riegl points out, democratic equality was foremost, and hence heads were usually lined up in series, three-quarters right or left, around a table or, as in the case of Scorel, before a balustrade as if seen in a procession. No one should be slighted, and the results can often amount to little more than a prosaic montage of busts placed one beside the other. In his earlier portraits of the pilgrims, Scorel, in fact, did just that, forming a lifeless frieze of heads with inscriptions below to identify them. The series could go on forever across the horizontal format with the only unifying aspect being the general direction in which the pilgrims face. Some variation was introduced by placing one row slightly behind the other or by having some heads look out toward the spectator, but in both of these variations Scorel was hesitant. In fact, the heads are cramped into their narrow confines so tightly that they are scalped, so to speak.

Why do the Haarlemers strike us as being a more convincing and lifelike group? For one thing, there is more space, and the double row of stately members of the confraternity moves more comfortably, as if seen proceeding down the aisle of a church. The back wall has wainscot-

rock in the upper right was a favorite landscape motif for Scorel, and the distant château seen beneath the arch of the bridge bears a resemblance to the castle on the hill in the Obervellach triptych. But it is romanticized and would have been just a quick impression sketched by Scorel as he crossed the mountains into Italy.

Once in Venice, Scorel would have been struck with a new world of light and color sparkling with a clear brightness rarely experienced on the canals of Utrecht. Like Dürer and others before him, he was impressed by the sensuous character of Venice and Venetian art with its painterly qualities and beautiful nudes reclining amid mellow woodlands, and this inspired him to paint the *Death of Cleopatra* (colorplate 77). The formula is certainly the well-known Venetian type, like that typified in Giorgione's Dresden *Venus*, with its orderly distribution of softly rounded landscape forms. The darker foreground is framed firmly on the left with big tree trunks rising from a hillock. The middle ground, bathed in soft sunlight, is framed by spongy trees on the right. A road winding through a bland Italian village leads us then to the hazy mountain peaks on the horizon.

This simple organization is the classical formula realized by Giorgione, Titian, and their countless followers, among whom we can now count Scorel. How different his brushwork is here when compared to the tighter, more precise strokes of the Obervellach painting. The reclining nude too is clearly a variation of the sensuous types of Venice.

When we return with Scorel to Utrecht we will find that his experience of Venetian art was indeed significant. His palette will brighten, his brushwork will remain broad and loose, and his human forms will grow in size. As we shall see, his response to art in Rome then enlivened these forms and colors by quickening Scorel's sense of dramatic movement in light as well as swelling his repertory of secondary landscape features.

In Venice, Van Mander continues, Scorel met among others a chaplain of the Beguines from Gouda, who urged the painter to join a company of foreigners there on a pilgrimage to Jerusalem and the Holy Land. Being a dream voyage for most pious Northerners, Scorel accepted and went along, taking his drawing tools to sketch the various sites he would see for the first and only time. The abbot of the monastery of Sion in Jerusalem befriended Scorel and took the artist on excursions along the Jordan so that he might record the various holy places and villages, including the city of Jerusalem itself. The following year Scorel returned to Italy via Rhodes, where he was welcomed and entertained by the Grand Master of the Knights of Saint John.

Shortly after his return to Venice, Scorel set out again to visit the cities and landmarks in Italy and arrived in Rome, where he was warmly received by the new Dutch pope, Adrian VI. Adrian was not known to have been an art-loving administrator nor a particularly popular pope, but Scorel's reputation as an artist must have been considerably enhanced by his pilgrimage to Jerusalem, and the new pope appointed him director of antiquities in the Vatican. Unfortunately, no drawings or paintings can be attributed to this short period of Scorel's life, but evidence of his interests in Rome and its monuments is found in his later works, and it must be assumed that his portfolios swelled with sketches after the antique as well as studies of Renaissance compositions that filled the churches there. No doubt it was in Rome where the idea of the academic atelier, such as that of Raphael, first impressed him.

Adrian died in 1523, and Scorel left for Utrecht. His Latin upbringing, his contacts with the papacy, bolstered by his pilgrimage to the Holy Land, made Scorel a valuable member of the ecclesiastical community in Utrecht, and in 1525 he was appointed to a vicariate of Saint John's. One of his first commissions was to paint the portraits of pilgrims to the Holy Land who had a brotherhood in Utrecht which included ecclesiastics, Scorel himself among them. A series of bust portraits are lined up mechanically, one after the other, against a neutral background. An inscription beneath each records the name and date of the pilgrimage. We will return to such group portraits soon.

Van Mander tells us that in Utrecht Scorel lived for a time "with a deacon from Oudemunster, named Lochorst, who came to the court and who was a great lover of art. He made several paintings in water-color, and also in oil, for this gentleman; among others . . . a Palm Sunday subject, in which Christ is represented mounted on a donkey on His way to Jerusalem. The view of the city was done from life. There are children in it, and Jews, who are spreading wreaths and cloth, and other details. This painting, which had wings, was placed as a memorial in the Dome Church in Utrecht by friends of the deacon."

Lochorst had not been a pilgrim to Jerusalem, but he came from a long line of church dignitaries in Utrecht, and he intended to place a *memorietafel* in their honor and his in the center of the nave over the family tombs. The subject matter was appropriate for a city of churchmen boasting its ties with the Holy Land, since the *Entry of Christ into Jerusalem* (colorplate 78) was a type of triumphal joyous entry that was awarded emperors who visited the city (Charles V, Philip II), and as the first event in the Passion cycle, one related to the triumphant *adventus* of an ancient emperor, it was viewed as a victory over death. The triptych was ordered in 1526 by Herman Lochorst, canon of the Dom (Cathedral), perhaps in anticipation of

his own death the year after, 1527, when, as Van Mander mentioned, it "was placed as a memorial in the Dome Church in Utrecht by friends."

The central panel is broad to accommodate the spectacular view of the city below in the valley of Kidron to which Christ on the donkey in the company of the twelve apostles rides. The contrast between the brightly painted entourage on the left descending the steep road from the Mount of Olives and the glowing expanse of Jerusalem below is dramatic. The darker tones in the costumes, the trees, and the silhouettes of the crowds carrying branches to meet Christ form an emphatic repoussoir for the distant landscape. It would seem that Scorel had some knowledge, perhaps through prints, of Michelangelo's painting of the Deluge on the Sistine Ceiling, where similar throngs of fleeing people form the same compositional device. The draperies are rich and boldly modeled in broad, fluid strokes, and the poses are varied, some remarkably foreshortened.

The strong diagonal repoussoir allowed Scorel to place the viewer high, and avoiding any complex middle-distance projection, his next task was to reproduce the panorama of distant walls, towers, and monuments of the Holy City. The apostles, as the original pilgrims of Christ, come excitedly upon the long-awaited view of Jerusalem, and suddenly there it lies before them, radiant and splendorous with light as the New Jerusalem described by John in the Book of Revelation. This heavenly abode was also the goal of the deacon Lochorst and his family. They are presented on the outsides of the two wings, five in all, kneeling in front of their patron saints before a heavenly aureole where the Coronation of Mary, to whom the Cathedral was dedicated, appears in a funnel of light. The side wings inside are painted in paler tones and present other saints venerated in Utrecht: Saint Agnes, Pope Cornelius (in the guise of Adrian VI?), and Saint Anthony on the left, Saints Sebastian, Gertrude of Nivelles, and Christopher on the right. Of these five figures, Saint Agnes is the most striking in her charming classical pose and the sheer gauzelike chiton that she wears.

The fascinating view of Jerusalem was "done from life," as Van Mander reports, meaning that its model was a sketch Scorel had made of Jerusalem when he was there from a point east of the city on the Mount of Olives. Below we see the great Golden Gate and the sprawling city walls. Beyond lie the broad temple square, the Dome of the Rock, the Holy Sepulcher, the Portal of Saint Stephen (to the right), and the Monastery of Sion rising in the top center beyond the city walls and the citadel. To the far right stretches the valley of Kidron. The sketch made by Scorel was seen in 1584 in Delft by Christianus Adrichomius, who wrote a description of Je-

rusalem; the painting was used for a large woodcut of Jerusalem printed by Herman Beerntz van Borculo in 1538.[120]

The Lochorst triptych was Scorel's first major altarpiece in Utrecht, and his activity there was interrupted temporarily by unrest in the city brought on by the duke of Guelders that was, however, relatively short-lived. In the interim Scorel settled in Haarlem, where he had good friends among the Knights of Saint John, especially the commander Simon Saenen van Zanen. He also joined the Haarlem Confraternity of Pilgrims to Jerusalem, and for their chapel he painted another set of portraits (fig. 541).

The portraits of the Haarlem *Ridderlijke Broederschap van den Heiligen Landen* follow the same formula as the earlier group portrait he had painted for the pilgrims in Utrecht, but there are definite improvements in the placement of the heads, the psychological rapport, and the intent of the series as a representation of the actual procession of the brothers in Palm Sunday parades. Perhaps Scorel was inspired by the more activated group portraits of the Knights of Saint John that Geertgen tot Sint Jans had presented in the panel of the *Burning of the Bones of Saint John the Baptist* (fig. 171) for the high altar of their church in Haarlem. Alois Riegl's important study of Dutch group portraiture traced the evolution of these popular paintings from Geertgen through Scorel and down to the seventeenth-century masterpieces by Frans Hals and Rembrandt.[121]

The difficulties in turning a gallery of portraits, a rather monotonous project, into a work of art with dramatic content are manifold. As Riegl points out, democratic equality was foremost, and hence heads were usually lined up in series, three-quarters right or left, around a table or, as in the case of Scorel, before a balustrade as if seen in a procession. No one should be slighted, and the results can often amount to little more than a prosaic montage of busts placed one beside the other. In his earlier portraits of the pilgrims, Scorel, in fact, did just that, forming a lifeless frieze of heads with inscriptions below to identify them. The series could go on forever across the horizontal format with the only unifying aspect being the general direction in which the pilgrims face. Some variation was introduced by placing one row slightly behind the other or by having some heads look out toward the spectator, but in both of these variations Scorel was hesitant. In fact, the heads are cramped into their narrow confines so tightly that they are scalped, so to speak.

Why do the Haarlemers strike us as being a more convincing and lifelike group? For one thing, there is more space, and the double row of stately members of the confraternity moves more comfortably, as if seen proceeding down the aisle of a church. The back wall has wainscot-

Jan van Scorel, Maerten van Heemskerck, and Antonis Mor

"A man who wants to become an artist must visit Rome . . . He must also have produced many paintings in the style of this school . . . , before he may be regarded honestly an artist" (Lampsonius, as quoted by Van Mander in the life of Jan van Scorel)

Jan van Scorel's life was filled with adventure. Born on August 1, 1495, the natural son of a pastor in Schoorel, a small town above Alkmaar, he was cared for as a young boy by Jan van Egmond, *stadhouder* (governor) of Holland, and was sent to a Latin school in Alkmaar. His talents as an artist were soon discovered, and according to one biographer, Arnoldus Buchelius, his benefactor placed him in the apprenticeship of Cornelis Buys (the Master of Alkmaar?). Van Mander, perhaps mixing up his patronymics, named a Willem Cornelisz of Haarlem as his first teacher, and further tells us that the young student was abused by the older master, who held Scorel practically in bondage.[119] Sometime around 1512 the young artist went to work with Jacob Cornelisz van Oostsanen, the brother of Buys, it will be recalled, in Amsterdam and there found his first professional training of merit. From Amsterdam Jan van Scorel went to Utrecht, the ecclesiastical center of the North Netherlands, about 1515–17, and apparently met Jan Gossart, who was at that time in the employ of Philip of Burgundy, bishop of Utrecht.

The uncertainties of these early years quickly pass, and from 1518 until his death in 1562 his life is richly documented and filled with surprises. Sometime late in 1518 Scorel left the Netherlands and traveled extensively through Germany—Cologne, Speyer, Strasbourg—to Basel and on to Austria (Carinthia). He then turned south and traveled to Venice, where he was introduced to pilgrims on their way to the Holy Land. He joined them, 1519–20, and visited Crete, Candia, Cyprus, and Jerusalem.

Upon returning to Italy, Scorel spent a year as the administrator of art in charge of antiquities in the Vatican under the Dutch pope Adrian VI, and he resettled in Utrecht in 1524 to resume his ecclesiastical duties there as well as to promote a large workshop of painters. He spent a few years in Haarlem, about 1527–30, and after his return to Utrecht, his atelier grew in size to rival those of Antwerp and Brussels, and he received many commissions outside Utrecht. In 1550 Scorel was called to Ghent to restore Van Eyck's famous altarpiece, and between 1550 and 1553 he devoted much of his attention to the reclamation of flooded lands in the Zijpe, a coastal region above Alkmaar, with a system of dikes to form a polder village called Nova Roma. Obviously, Jan van Scorel was not a typical churchman or artist, and his various activities—he was a very learned humanist, musician, and poet as well—reveal a many-sided personality.

According to Van Mander, Scorel visited Nuremberg during his travels in 1518, where he met Dürer, who "took an interest in Scorel's views. . . . Soon Scorel departed for Steyer in Carinthia, where his work was in great demand by most of the nobility. He stayed with a baronet, a great lover of pictures, who rewarded him well and wanted him to marry his own daughter." The earliest signed and dated altarpiece by Scorel resulted from this association.

A triptych with the *Holy Kinship* (fig. 539) in the parish church at Obervellach in Carinthia has the crests of the families Frangipani and Lang on the reverse and is dated 1519. Apollonia Lang, wife of Christophoro Frangipani, owned properties in the region of Obervellach, and it was no doubt for the church in the village just below their castle, Falkenstein, that the altarpiece was painted. The central panel displays seventeen members of the Holy Kinship, the family of Anna and her three husbands (see p. 82), many of whom are in the guise of members of the Frangipani-Lang families, gathered casually in an open field before the village (Nieder-Falkenstein?) with its church in the background. On a hill beyond is a castle, very likely Falkenstein itself. The wings are decorated with saints in landscapes, Christopher to the left, Apollonia to the right, as the patron saints of husband and wife.

The portraits have yet to be identified with certainty.

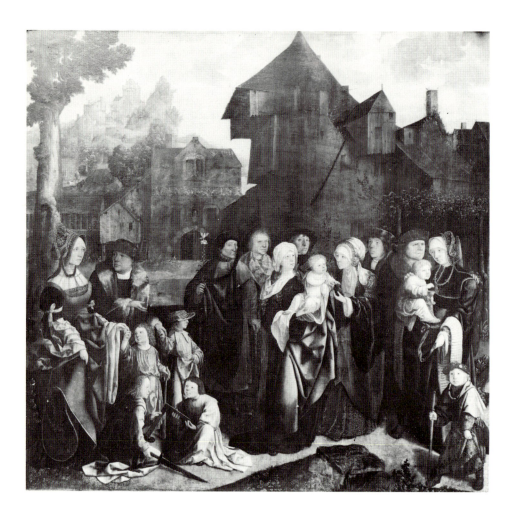

left: 539. JAN VAN SCOREL. *Holy Kinship.* 15 Panel, 44½ × 55½". Parish church, Obervellach, Germany

below: 540. JAN VAN SCOREL. *Valley in the Al* c. 1520. Drawing, 8⅛ × 6¹/₁₆". British Museum, London

Joseph, the Dantesque man holding a flowering staff, has been tentatively identified as Christophoro Frangipani. Apollonia, who died the year the altarpiece was completed, perhaps is Saint Anna. However, of the three husbands of Anna, the central one, Cleophas, looks younger than the rest and he regards the viewer directly. This very likely is our artist, Jan van Scorel.

As we have seen, this particular subject matter was essentially a Biblical family portrait, and here Scorel has translated that holy clan into a gathering of living relatives. Usually, the Holy Kinship is placed in a garden, a loggia, or, as in the painting by Geertgen tot Sint Jans, within an elaborate church interior. Perhaps to avoid any specific symbolic associations, Scorel arranges them in a loose, undulating frieze in a common village square. The date and signature appear on a rock in the right foreground, and Scorel identifies himself as *pictorie artis amator*—lover of the art of painting.

Scorel would have been twenty-four at the time; behind him would have been his experiences in the Amsterdam workshop of Jacob Cornelisz, the possible influence of Jan Gossart, and the meeting with Dürer. It is interesting to speculate what influences were at work in his early style as we see it in the Obervellach altarpiece. Certainly the rich costumes, the curvilinear draperies, even the head types of figures such as Saint Apollonia, superfi-

cially remind us of his teacher Jacob Cornelisz; the two scenes from the Passion on the exteriors (not illustrated here), the Flagellation and the Carrying of the Cross, are compositionally related to any number of Dutch and Rhenish paintings of the period. The precious, doll-like qualities of the female figures disappear in Scorel's next works, and so we should accredit them here to his training in Amsterdam.

The landscape setting, on the other hand, is not Jacob's. A well-measured sequence of buildings and hills appears behind the casual foreground frieze, and the horizon line that runs through all three panels is relatively low. The curious pitched building to the right in the middle ground perhaps was inspired by Dürer's rustic farmhouses in his engraving of the *Prodigal Son* (fig. 372), but otherwise nothing of his art appears here. Certainly Gossart's influence, if there was any to speak of, has completely disappeared. In short, aside from a few reminders of Jacob Cornelisz van Oostsanen, Scorel's early work explains little and is relatively undistinguished.

That same year, 1519, Scorel left Carinthia and traveled through the mountains to Venice. A signed drawing, *Valley in the Alps* (fig. 540) is a picturesque study of a bridge over a deep ravine in the high mountains executed with fresh, vigorous pen strokes. The hanging

541. JAN VAN SCOREL. *Haarlem Jerusalem Brotherhood.* 1528–29. Panel, each 45⅛ × 108¾″. Frans Hals Museum, Haarlem

ing with armorials hanging above their heads. Secondly, they have a goal. A retainer appears at the far left holding a plaque on which a grisaille "drawing" of the Holy Tomb is displayed; it is, in fact, a copy of one that Scorel "made from life." As for a third, the psychological rapport of the pilgrims to each other and to the spectator, the changes are subtle but effective. They form a devoted and determined group of individuals, representatives of the best men in their community, and they behave accordingly. The first two, leading the procession, stare de-

terminedly toward their destination; the fourth gestures quietly and briefly glances out to see if we are following them. The fifth looks back into the crowd, and the remaining pairs alternate their focus in a natural and random manner, much as just such a group on parade would do.

The mechanical regimentation is thus relaxed; the purpose is more than a presentation of portraits added to portraits; and the psychological involvement with the viewer is heightened. These may seem small steps in the evolution of the group portrait, but they are important if we are to consider them works of art. The painter included himself among the Haarlem brothers. He is the third from the right, and he looks out at us: "I am Jan van Scorel, painter and canon of Saint Mary's at Utrecht . . . pray that I might proceed in virtue," reads the inscription on the sheet of paper below him.

For the Knights of Saint John, Scorel painted an appropriate subject, the *Baptism of Christ* in the Jordan (fig. 542). Scorel had made sketches as he traveled along the river in Jerusalem, but it is not likely that the handsome landscape setting here reproduces any specific site. Rather, his vista of the valley opens into a broad panorama of distant plains and mountains filtered through cool greens and blues that remind us of the classicizing backgrounds in works by Poussin. Tiny figures are sprinkled randomly (in one group John is preaching) not so much to activate the space cells as simply to enhance the sweeping flow of the natural forms with accents. There is hardly anything mechanical in his unraveling expanse of forests and hills other than a few subtle focal points— rising trees, a château, a city along the banks—to lead

542. JAN VAN SCOREL. *Baptism of Christ.* c. 1528. Panel, 47½ × 61⅝″. Frans Hals Museum, Haarlem

543. JAN VAN SCOREL. *Mary Magdalen.* c. 1530. Panel,
26⅜ × 30⅛″. Rijksmuseum, Amsterdam

our relaxed journey through the sunlit valley of the Jordan.

The foreground, on the other hand, is quite unconventional and is staged with a dramatic tree trunk in the center to mark the figures of John and Christ. The colorful group of men to the right dressing themselves are descendants of Michelangelo's soldiers on the riverbank in the *Battle of Cascina,* while the two women standing to the left are, as Van Mander noted, as refreshing and graceful as the ladies in a painting by Raphael. One, dressed in a sheer chiton that reveals her fair body, pauses to look up at the Holy Ghost in the form of a dove fluttering in the branches above Christ. One of the male bathers has noticed it too. The poses of the baptized and the ideal forms of their bodies attest to Scorel's understanding of Renaissance figure painting, but it is the warm Venetian light that bathes them and gives the soft landscape its texture and depth.

Jan van Scorel resettled permanently in Utrecht in 1530. Renowned as the leading painter in the North Netherlands, he soon established a huge atelier that was unrestricted by local guild regulations, and over the next decade his working procedures grew more and more like those of the leading artists in Rome, the followers of Raphael, with whom he was familiar. Aside from the more ambitious projects that he found himself engaged in, Scorel took time to paint more personal pictures of subjects more intimate and endearing than the histories of saints. One such panel is the enchanting *Mary Magdalen* (fig. 543) in the Rijksmuseum, painted about 1530.

Legend has it, and it would be marvelous to believe this story, that the enigmatic Magdalen is a portrait of his mistress Agatha van Schoonhoven, with whom Scorel lived for many years while being a canon of Saint Mary's. Some of the same melancholy that characterized the lovely young Magdalen portrayed by Quentin Metsys can be found here (see fig. 474). The Magdalen is placed before a deep landscape; she holds an ointment jar and is dressed in finery. But how different this characterization is from Metsys's in terms of the actual presentation of the penitent sinner. Scorel's is dressed in rich Venetian costume, perhaps associated with that of the courtesan as a reminder of her early life. The ointment jar is an attribute of her heartache and emotional fervor at the death of Christ when she applied the balm to his wounds.

The landscape, beautifully organized in the Venetian fashion, culminates in the fanciful hanging cliff on the left in the far distance, and here very likely alludes to her hermitage on Sainte-Baume in southern France, where she lived out her life. The visage, immediate and monumental, has the awesome presence of the Mona Lisa, even to the slight suggestion of the smile at the corner of her lips. Alas, Mary Magdalen is not Agatha, since an inscribed portrait of the latter in the Galleria Doria Pamphili in Rome shows facial features that do not match those of the saint. Also, radiographs of the underdrawing of the head show that it was carefully reworked before the paint was applied. The shape of the nose has been changed, and the staring eyes were once downcast.

In recent years much valuable material has been published concerning the procedures of Scorel's large workshop, and it is important for our study of his late works. Briefly, the following steps can be reconstructed.[122] Upon receiving a commission, an artist first provided a *patroon,* or model, of the painting (the subject matter, of course, depended on the nature of the dedication and the destination and function of the work, as we shall see). The *patroon* took the form of a contract sketch or drawing and a written description of the iconographic program. If and when approved, the next step after signing the contract was to hire a carpenter or joiner to construct the housing and frame for the altarpiece and to prepare the panels and join them together. This step is often ignored or forgotten by art historians since we are accustomed to viewing works of art in museums and not in their original physical placement as part of a larger scheme of decoration. In one contract we learn that the carpenter was given a full year to complete his part of the commission.

A major issue in altarpieces of the sixteenth century was size; they grow bigger and bigger, often, as we read, so that they can be seen clearly from the entrance of a church or chapel. Lifesize figures are stipulated; many figures are wanted; and iconographic notes prescribe the

inclusion of some specific landmark or landscape and, of course, portraits of the patrons and their saints. The master of the shop then begins with the preliminary drawing, often reworked from the contract sketch, which is enlarged to form the underdrawing for the panel. This can appear in various states of complexity and detail.

According to Van Mander, a true master, the fine artist, was one so gifted and sure that he could lay out the entire composition quickly and freely. For very large works a grid for the underdrawing would be laid in to facilitate placing of smaller sketches into the proper spot at the final transfer of the design to the panel. This underdrawing, in its complete form for transfer, is called the *cartoon*. Interestingly, certain details of the cartoon may be only cursorily indicated, as portraits, for instance, since these parts would be added later in the painting stage with the aid of a detailed study independent of the overall design.

Time was often a factor. In instances where the altarpiece was to be completed within a relatively short time span—and most were—assistants, apprentices, or other artists would be allowed to participate in the actual painting. In some examples the underdrawing has cryptic words added in certain areas indicating color—paint this shape ''green''—which strikes one today as being dangerously close to the paint-by-number kits one can buy at art stores.

All such details should be stipulated in the contract, including in many cases the exact nature of the pigments and the extent to which the participation of the master is required in the actual painting. Generally, the finished work would be presented by the patron to a jury of experts to examine and judge its merits. For these reasons it was often important to know as much about the preparation of the painting, the underdrawings and the chemistry of the pigments in the layers of paint, as possible, because by necessity these large works were collaborative affairs to be studied not wholly as individual accomplishments, as anyone who has researched the Vatican frescoes of Raphael or the large Medici paintings of Rubens well knows. Such collaborative workshop practices did not begin in the sixteenth century, as we have seen, but it becomes more and more an issue of our judgment of a master's style, as much so as the necessity of a good cleaning or careful restoration for peeling off the layers of foreign intervention that may discolor the original paint surface.

A good example of Scorel's workshop production, one in which he himself was directly involved in most of the painting, is the *Lamentation* in Utrecht (fig. 544). The grouping of the figures placed directly beside the heroic body of Christ—John the Evangelist, the Virgin who holds the body, Mary Magdalen, and the canon dressed in white—might have been inspired by the geometric placement of the mourners about the corpse in Geertgen's memorable *Lamentation* for the High Altar of Saint John's Church in Haarlem (colorplate 29). The burying of the bad thief and the detail of the crown of thorns alongside Christ's hand also may be derived from the same composition. Behind this bold foreground group, Scorel places an unobtrusive frieze of two women (the other Marys) and two men (Joseph of Arimathea and Nicodemus) that marks the nearer figures from the activity on Golgotha with its three stark crosses rising into the upper frame. The pious donor kneels in prayer and glances past his vision. A strong diagonal across the foreground setting isolates the canon's head and the distant landscape from the rest. This is, in fact, a late example of the earlier *Vesperbilder* where the death of Christ was contemplated in early evening prayers.

The *Lamentation* is relatively big, and radiographs indicate that Scorel used a grid system to transfer the cartoon to the panel. The execution is even and masterful, suggesting that the master himself applied the surface coats. The colors, fitting this somber theme, are cool and mysterious: blues, whites, and olive greens, with the gradation of tones in the landscape more mechanically

544. JAN VAN SCOREL. *Lamentation*. c. 1535. Panel, 65½ × 54⅜″. Centraal Museum, Utrecht

545. JAN VAN SCOREL AND SHOP. *Finding of the True Cross*. 1541. Panel, 7' 7¼" × 8' 6¼" (center); 7' 7¼" × 49¼" (each wing).
Grote Kerk, Breda

conceived as if to enhance the stark material presence of the vision more so than its illusionary qualities.

From October 14, 1541, to January 29, 1542, Jan van Scorel was in Breda, where he conducted official business to negotiate Utrecht's claims over certain church properties in Guelderland with the prince of Orange, René de Châlon. Church affairs, however, mixed with personal business, and he further contracted a commission, most likely for the altar in the Chapel of the Holy Cross in the Grote Kerk in Breda. The patron probably was René de Châlon himself. The large work, the triptych of the *Finding of the True Cross* (fig. 545), still hangs in Breda. It was one of the larger of several works that Scorel had contracted within a few years in the south. Three altarpieces of about 1540 were ordered for the abbey in Marchiennes alone. The Breda project therefore was one in which his atelier would be involved—a collaborative endeavor—and very likely the paintings were executed in Scorel's workshop in Utrecht and later shipped to Breda.

The central panel illustrates the finding of the three crosses in Jerusalem by the empress Helena, mother of Constantine the Great, in the fourth century. Following the legend as recorded in Voragine's *Legenda Aurea*, Helena was led to a spot near Golgotha where the crosses were believed to have been buried. The area, where later the church of the Martyrium was erected, was excavated and the crosses found. A sketch by Scorel exists that perhaps served as the contract drawing for the main picture, but he departed from his original design and followed instead a more Italianate model.

The agitated poses of the men excavating the site, their muscular torsos twisted in violent *contrapposto* positions, dominate the foreground much in the style of Italian Mannerist compositions. The painting has been much restored, but the modeling of these heroic bodies is highly exaggerated and the harsh patterns that the crosses, legs, and torsos create in the foreground are irregular and confusing. Rhetorical gestures abound, especially emphatic in the old man looking in on the right, while the prosaic group of Helena and her attendants is stiff and unfocused on the left, a mere intrusion in the melee. A second row of observers appears before the strange triumphal arch. If the finding of the true cross was a confusing and puzzling pursuit, then Scorel has captured that spirit.

Probably due to the poor condition of the triptych, the colors are much too dark and inharmonious, and the composition as a whole seems rigidly conceived with an unnecessary compression of space. The overall impression is one of a workshop piece hastily and unevenly executed, and the wings display an even more confused design. Here again, Scorel's composition seems more a pastiche of various Mannerist motifs than a unified composition.

The backgrounds of the three panels are related to an extent. The bridge upon which the triumphant Constantine charges on his white stallion leads to the triumphal arch in the background of the central picture, and the grove of trees to the right is continued in the landscape behind Helena in the distance of the right wing. Other than a dramatic display of muscles, buttocks, and arms straining and twisting, Scorel's *Finding of the True Cross* fails to present a meaningful "history" either in the telling of the narrative (cf. that of Piero della Francesco) or in the reconstruction of the local color and historic landmarks of Jerusalem and Rome.

MAERTEN VAN HEEMSKERCK

Sometime during the years 1527 and 1529, when Jan van Scorel was residing in Haarlem, he took as an assistant-pupil an eccentric painter, Maerten van Heemskerck,

who had had something of an ill-fated beginning as an apprentice, first with one Cornelis Willemsz of Haarlem (could this be Willem Cornelisz, Scorel's teacher?), then a Jan Lucas van Delft, before studying with the master from Utrecht.[123] Van Mander's report is interesting: "At this time, Jan Scorel was famous for the new, extraordinary method of painting which he had imported from Italy, and which especially pleased Maerten. So he went to Haarlem and worked under this master. With his usual zeal, Maerten practised so much that finally he surpassed the master, and, so well did he assimilate the style of the master, that it was very difficult to see differences between their works. The master, who was afraid that his reputation was at stake, in the opinion of some people, sent his pupil away; for he was jealous."

Heemskerck was nearly thirty years old at the time of this association, Scorel was but three years older, and there is very likely some truth in what Van Mander tells us. One of Heemskerck's earliest paintings, the *Rest on the Flight into Egypt* (fig. 546) in Washington is usually attributed to Scorel, and the reasons are clear. The composition is very close to the *Mary Magdalen* (fig. 543) by Scorel, so much so that it is "difficult to see differences between their works," as Van Mander stated.

The Magdalen is now the Virgin holding an active, Herculean child. The pose and the treatment of the head, stereometric and strongly modeled, the hairdo, and the costume are all remarkably close, and the compositional elements have simply been shifted from right to left, with the gnarled tree trunk forming the left margin, the classical landscape the right.

However, a few stylistic traits give us clues for the Heemskerck attribution. The contours are harsher, more linear, and the lighting effects are more abrupt as if a spotlight were cast upon Mary. The draperies seem to be of stiffer material with tubular folds and sharply highlighted ridges. Furthermore, the integration of the figures with the landscape is more abrupt and less unified than in Scorel's work. Surprisingly, in the landscape Heemskerck achieves an even greater sense of the antique with his softly sketched ruins and impressionistic trees amid softly rolling hills much in the fashion of Pompeiian landscape. In this rustic vista he places curious little windswept figures that huddle in crouched positions as they race about the terrain, hallmarks of Heemskerck's landscapes of this early period.

When and under what circumstances Maerten was received as a master in the Haarlem Guild of Saint Luke are uncertain, but we know that by 1532 he had attained the status, and, following the example of his illustrious teacher, Jan van Scorel, he planned an extensive trip to Rome, where he remained for more than three years. Before leaving Haarlem, Heemskerck presented the guild

with a "gift" in the form of a masterpiece to be placed over the altar of the guild chapel in Saint Bavo, *Saint Luke Painting the Virgin* (colorplate 79).

Van Mander leaves us a lengthy description of this altarpiece, which he highly admired. Below the throne of Mary a sheet of vellum is painted that is inscribed: "This panel has been given in memory of Maerten Heemskerck, who painted it. In honor of Saint Luke he has made it and donated it to his fellow painters. We should thank him by day and by night for his kind gift which is here before us; and let us pray, with all our fervor, that God's grace will be with him always. Finished on 23 May, in the year 1532."

We have seen several times how significant the theme of the "artist in his studio" in the guise of the Evangelist Luke, the spiritual ancestor of all Christian artists, was for the guild painters. How different this portrayal is from those of Rogier van der Weyden (colorplate 21) or Jan Gossart (figs. 494, 495). A quick glance, left to right across the huge painting, will reveal how Heemskerck's interpretation differs. But first it should be noted that the setting is barren, with a blank wall behind the evenly placed figures as if they were part of a deeply cut frieze. Even more surprising, Saint Luke executes his icon at night with an internal torchlight providing the only illumination about Mary, although its rays follow very arbitrary paths.

The Madonna and Child are nearly identical to their counterparts in the Washington *Rest on the Flight*. Mary's costume is richer and more oriental in appearance (Van

546. MAERTEN VAN HEEMSKERCK. *Rest on the Flight into Egypt.*
1532. Panel, 22¾ × 29½". National Gallery of Art,
Washington, D.C. Samuel H. Kress Collection

547. Philip Galle after Heemskerck. Title page of the *Clades*
or *Inventiones Heemskerckianae ex utroque testamento*. 1569.
Engraving

Mander called it "Indian"), and her throne is adorned
not with lions' heads but with those of the evil harpies
she has subdued with their claws forming the feet of the
legs. On the austere dais, to the side of the Virgin,
stands a winged eros-angel figure holding a torch,
dressed in a classical chiton, a "lovely" figure, Van Man-
der remarked, and one that very likely stems from some
Late Antique sarcophagus relief, perhaps borrowed from
one of Scorel's Roman sketches.

The left edge of Luke's panel marks the center of the
painting, and originally, according to Van Mander and an
early drawing, the panel had an arched projection with a
parrot on this axis. The parrot was lost when the paint-
ing was cut in two (and subsequently rejoined) and the
projection removed. The exotic bird very likely was a
symbol of Mary's perpetual virginity, although by Van
Mander's time it was also associated with poetic elo-
quence since its call resembled "Ave."[124] The torchlight
picks out the features of a tall antique herm with a
bearded mask-face that serves as Luke's easel. With the
aid of a maulstick Luke's right hand is steadied as he
carefully paints in the upper torso of the Child in Mary's
arms. Her head is already painted in, and one can see that
Luke's icon is a repetition of the numerous busts of Mary
and the Child that we have seen.

Heemskerck's portrait of Saint Luke is very unusual.
He is an elderly man wearing glasses and, appropriately
as a Near Eastern type, he wears a colorfully patterned
smock under a heavy woolen mantle; his head is covered
by a Phrygian cap. This can by no means be considered a
self-portrait of the artist, Maerten van Heemskerck. Ac-
cording to Van Mander, Heemskerck posed a local baker

for the head of Saint Luke, but this seems unlikely. Per-
haps he is a generalized portrait of the elder of the guild,
perhaps not.

The chair upon which the painter sits is even more un-
usual. Here Heemskerck transforms the traditional sym-
bol of the Evangelist, the ox, into an antique relief that
resembles the bull in scenes of the Rape of Europa, but
the haloed figure astride the beast is certainly Luke, an
unconscious revival on Heemskerck's part of much ear-
lier medieval portraits of the Evangelists transported to
the heavens by their animal symbols.

Finally, the handsome figure behind Luke wearing a
laurel wreath and extending his arms in a rhetorical ges-
ture is also a problem. In Gossart's Vienna *Saint Luke*
(fig. 495) an angel appears behind the Evangelist in a
similar fashion as an embodiment of divine inspiration.
Van Mander noted that he looked like a poet and that he
was undoubtedly a self-portrait of the artist "as he
looked at the time." Many who have studied the paint-
ing agree with Van Mander, although one describes him
as the personification of *furor poeticus*, or the inspiration
of the poet, as described by Cesare Ripa in his famous
handbook on sixteenth-century iconography (*Iconologia*).

In fact, this enigmatic figure is a very important clue
to aspects of art theory in Heemskerck's day. Certainly
the figure represents artistic inspiration, and due to its
antique guise, should he not be the prototype of all art-
ists, pagan or Christian—Apelles? Is this not Apelles in-
spiring Saint Luke? The classical awakening in the
Christian? And in keeping with Van Mander's logical
conclusion, should he not also be a self-portrait of
Heemskerck as Apelles? On the title page for a book of
Heemskerck engravings (*Clades* or *Inventiones Heems-
kerckianae ex utroque testamento*, 1569) by Philip Galle
(fig. 547), a portrait of the bearded Heemskerck (taken
from his *Self-Portrait Before the Colosseum*, fig. 555) ap-
pears on the socle of a column or obelisk amid antique
ruins, and on the face next to it is the inscription "Mar-
tinus Heemskerck, Pictor, alter nostri Saeculi Apelles"
(Maerten Heemskerck, painter, the new Apelles of our
time).

In the same engraving the device of Heemskerck can
be seen, a winged hand with a brush on the back of a
turtle, derived from Renaissance hieroglyphs, that reads
"paint [hand with brush] neither too fast [wings] nor
too slow [turtle]." Van Mander knew of this device and
described it as follows: "This illustrates the advice of
Apelles, to be not too slow in work, and to not overload
the mind with too much work." Thus quickness with
the brush must temper and be tempered by patience is
the advice of Apelles, and perhaps that is what our "ar-
tistic inspiration-Apelles-Heemskerck" is announcing to
Saint Luke. The final statement of this classical type of

the artist in his studio was made by a compatriot of the Haarlem artist a century and a quarter later in Delft, Jan Vermeer.

There has been much speculation over Heemskerck's reception and activities in Rome between 1532 and 1536, but the fact remains that he stayed over three years, suggesting that his life there was fruitful and exciting. For Heemskerck, Rome *was* the academy of art. He sketched everything from distant views of the Roman ruins and medieval monuments to details of objects and Renaissance compositions. These sketches fortunately are preserved in part in two copious sketchbooks in the print cabinet in Berlin,[125] and aside from providing ample material for reconstructing Heemskerck's knowledge of antiquities, numerous drawings of Old Saint Peter's, at the time being rebuilt, are invaluable pieces of evidence for medievalists. One of Heemskerck's sketches, that of the *Forum of Nerva* (fig. 548), might have provided Jan van Hemessen with the landscape detail inserted in the latter's *Parable of the Unmerciful Servant* (see p. 443; fig. 514), and other detailed drawings were copied by Heemskerck in works such as the *Saint Luke Painting the Virgin* in Rennes, where the *casa di Fabio Sassi* appears as the studio of the Evangelist, including the sculptures in the niches.

If we are to believe Van Mander, Heemskerck also executed works in Rome, "he had earned much money," and he was also introduced to the proper patrons. "Maerten was the guest of a cardinal to whom he had a letter." Unfortunately, we have no certain works of the Roman sojourn aside from drawings, but when he returned home, 1536–37, "he had changed his style of painting; it no longer resembled that of Scorel," Van Mander tells us. He certainly had changed, and the paintings that follow are those of an inspired eccentric who transformed the antique and the Netherlandish idiom into a new brand of Mannerism.

Over the next years, Heemskerck painted a number of pagan themes.[126] Van Mander had seen in the house of the connoisseur Pauwels Kempenaer a "little oblong picture by Heemskerck of a Bacchanalia or Bacchic festival. . . . This picture was frequently reproduced in prints; it is really the best of all the pictures he painted after he returned from Rome. The work is very 'morbido'; the nudes are in a blending of soft shades. One can see in this picture all kinds of amusements that the pagans loved." The painting, signed in Latin, is without date, but must have been executed shortly after his return in 1537 (fig. 549). Van Mander's appraisal of the smoothly painted nudes is most generous. The figures, many of whom are awkwardly proportioned and articulated, are artificial and waxlike, and the work, if not signed, would probably be catalogued today as a weak copy of a *Triumph of*

548. MAERTEN VAN HEEMSKERCK. *Forum of Nerva*, from the Roman sketchbook. 1533–35. Drawing, 8¼ × 10⅛″. Staatliche Museum, West Berlin

Bacchus by Giulio Romano or some other follower of Raphael.

At first sight the *Triumph of Bacchus* resembles some painted sarcophagus relief of antiquity with the frivolous triumphant procession of Bacchus, satyrs, and bacchantes returning from India, and, indeed, some such pagan sculpture must be considered an ultimate influence for Heemskerck's broad panel. The wild parade moves from the right with the corpulent Bacchus in a drunken stupor falling back into the arms of a smirking satyr as he rides on a chariot atop a wine barrel for a throne. In one hand he carries a beaker of wine, in the other he raises aloft a cornucopia, for Bacchus is the god of vegetation, especially grapes. Before his wagon, across the immediate foreground, four muscular nude athletes cavort and perform acrobatics, each quite apparently inspired by antique statue types. Wine is drunk, music is played on trumpets, pipes, tambourines, castanets, and two flints struck together. Nudes leap, turn somersaults, walk on stilts, as they make their way in joyous abandon to the left where, down in a dip in the terrain, a ruinous triumphal arch stands decorated with sculptured satyrs. The lighting is arbitrary throughout, suggesting that the individual figures were culled from various sources by Heemskerck to give it the appearance of the *maniera antica*.

Some of these details can be found in the Berlin sketchbooks such as the striking nude athlete on the far right carrying a thyrsus, the large broken foot which he sketched in the Porticus of Octavia, and details of torsos resembling the *Apollo Belvedere*. Other motifs derive from the Temple of Vesta at Tivoli, here as the Temple of

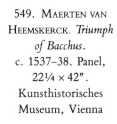

549. MAERTEN VAN HEEMSKERCK. *Triumph of Bacchus*. c. 1537–38. Panel, 22¼ × 42″. Kunsthistorisches Museum, Vienna

Bacchus, and the cult statue within it resembles the early *Bacchus* by Michelangelo. An engraving by Cornelis Bos, dated 1543, repeats the composition with minor additions and changes, and it has been described as "after Giulio Romano," a likely source for Heemskerck.

As an example of antique revival, Heemskerck's *Triumph of Bacchus* is fascinating; as a work of art it falls apart as a colorful pastiche of ancient and Italian Renaissance motifs. The feeling of bas-relief is conveyed through the brownish tones, but that only enhances its merits as an interesting, self-conscious reconstruction and not an original creative copy. To be sure, since Bacchus is the personification of drunkenness, the painting has certain moralizing overtones made all the more specific by the prominent erotic details scattered about and, in general, by the wanton and lustful behavior of the participants of the bacchanal. The infant members of the throng also could allude to the childlike mentality to which man descends in the state of inebriation. Yet these are part and parcel of the pagan theme and in no special way indicate a sixteenth-century Dutch sentiment at work here.

The *Triumph of Bacchus* is something of an oddity in Heemskerck's oeuvre, even when compared to his other mythologies.[127] But his reputation after returning from Italy rapidly grew, and his commissions were widespread in Holland, from Delft to Amsterdam, and for the most part they called for large altarpieces involving scenes of the Infancy or the Passion of Christ. In these works a distinctive style appears, one that is certainly manneristic and betrays influences of every sort from his sketches in Rome, but with Heemskerck the Mannerism reaches a feverish pitch and expresses itself as a highly personalized style that can only be called Heemskerck Mannerism.

Of these commissions none is so impressive in its monumentality or characteristic of his developed style as the enormous *Altarpiece of Saint Lawrence*, today covering the wall of the right transept of the church in Linköping, Sweden.[128] The triptych is made up of ten large panels with subject matter ranging from the Last Supper to the Ascension with two exterior panels devoted to the story of Saint Lawrence, his distribution of riches to the poor and his martyrdom. At a late stage in its completion, a Nativity scene was substituted for one of the Agony in the Garden on the exterior.

The work took five years to complete. On August 5, 1538, an assistant of Heemskerck was paid for a trip to Alkmaar by the churchmasters there to measure the area above the altar where the altarpiece was to be placed. Six weeks later Heemskerck appeared in Alkmaar to finalize the contract.

The *Altarpiece of Saint Lawrence* was the pride of Alkmaar—the largest of its kind in the North Netherlands—and it remained over the high altar until it was dismantled and hidden away during the iconoclastic revolts. Due to the vicissitudes of Alkmaar's religious affiliations, however, the great shrine was sold by the city to a German merchant in 1581 for a very low price. As it was being shipped to the Hanseatic port of Nisjni-Novgorod, the ship was captured and the goods confiscated by Swedish royal troops. The panels were presented to the Lutheran church in Linköping to serve as the high altarpiece. A giant monument of some embarrassment for the Lutherans—it was claimed that a portrait of Luther appeared in the wings—the painting was moved to a side wall, where it remains to this day in very good condition.

Criticism of the Linköping altarpiece, as we should now call it, has been harsh. One Swedish scholar wrote that considering the artistic merits of the work, "Holland has not lost much and Sweden has gained but little." Others have criticized its poor quality, which is a misunderstanding, complaining that its cold and forced expression relies too heavily on the antique and the

workshop of Raphael and other Italians, which in many ways it does. G. J. Hoogewerff explained the strained emotionalism as the result of Heemskerck's response to the precarious religious atmosphere in Alkmaar at mid-century, especially provoked by the conflicts with the Anabaptists, and there may be some truth in that judgment since in no other work does Heemskerck's emotional violence reach such an extreme. Heemskerck's monumental work is a product of a very troubled period in Dutch history.

The central panel, signed and dated 1540, is a tour de force in expressing the pathos and agony of the Crucifixion (fig. 550). The general composition is readily recognizable as a variation on the Haarlem historiated *Crucifixions* well known since the time of Geertgen tot Sint Jans, but its overly cramped and crowded design, its writhing and anguished figures, are nowhere found in earlier Haarlem art. No one can mistake this for anything but a mature production of Heemskerck. The explosive *horror vacui*, the nervous edges of the drapery, the knotty muscles and twisted faces, the dissonant color scheme with slippery metallic hues and, as Friedländer noted, "poisonous iridescence," all of these exaggerations epitomize the style of the Haarlem Mannerist.

In the Linköping altarpiece, Heemskerck pulls out all the stops, so to speak. The thieves are contortions from toe to head, their arms reach out as if in convulsions, and they cry loudly in pain; the anxious horsemen have trouble controlling their rearing stallions; the soldiers break into vicious battle as they cast dice for Christ's robe.

If the composition follows a Northern Gothic formula, the figures do not. Quotations from his Italian studies are numerous. The two thieves are wildly distorted variations on the sons of the *Laocoön* twisting in the coils of the serpent; the mourners seem to echo Michelangelo's *Pietàs*; and other figures such as the soldiers very likely are taken from studies that Heemskerck made of Raphael's workshop compositions. But no one would ever mistake these for figures painted by an Italian. The skeletal structures are warped and attenuated. The flesh parts are sinewy and taut, and the stretched muscles ripple in lines of knots along the legs, rib cages, and shoulders. The drapery that covers the body is not simply diaphanous but is drenched with oil so that it clings spastically to the protruding joints and hangs down in tatters.

Heemskerck's heads too are grossly exaggerated. Female saints have broad foreheads when seen full face with eyes set wide apart and cheeks that taper rapidly to a pointed chin. His profiles are thin, masklike caricatures of the classical, and all of this explodes on the surface of the Linköping *Crucifixion* with bits and pieces flying everywhere. There is no true sense of figures in space;

550. MAERTEN VAN HEEMSKERCK. *Crucifixion*. 1540. Panel, 18′ 8″ × 13′ 4″. Cathedral, Linköping, Sweden

there is so much vibration and disruption of the surface patterns that little focus or unity can be discerned; and the clamor is ear-splitting. But the finish is exacting and polished; his virtuosity is as uncanny as the figures are wild. If it were the sheer torture and horror of the Crucifixion that Heemskerck wished to express, then he succeeded.

It has been noted often that Mannerist painters excel in portraiture, and in this distinction Heemskerck is no exception. How different are his portraits from those of his rival in Haarlem, Jan Mostaert! The elegant, precious people that Mostaert portrays are minutely recorded likenesses of bland personalities with fairytale narratives tucked here and there behind them. This detached, courtly sentiment gives way in Heemskerck's portraits to robust, vigorous characterizations that in many ways anticipate the hardy portraiture of the seventeenth century. In them we have our first taste of what culminates in Frans Hals.

Two of his earliest portraits, those of *Pieter Bicker* and his wife *Anna Codde* (figs. 551, 552), are masterpieces in this comforting mode of his personal expression. The exact models for the genre-like portraits are difficult to trace, but the bold modeling of the features and the lively encounter with the spectator they effect mark them as mostly Heemskerck's own invention. Heemskerck planned the two likenesses as a unity in marriage. The interior setting is continuous through both panels. Pieter

right: 551.
Maerten van Heemskerck.
Portrait of Anna Codde.
1529. Panel, 33¼ × 25⅝″.
Rijksmuseum, Amsterdam

far right: 552.
Maerten van Heemskerck.
Portrait of Pieter Bicker.
1529. Panel, 33¼ × 25⅝″.
Rijksmuseum, Amsterdam

below: 553.
Maerten van Heemskerck.
Family Portrait. c. 1540. Panel,
46½ × 55⅛″. Staatliche
Kunstsammlungen, Kassel

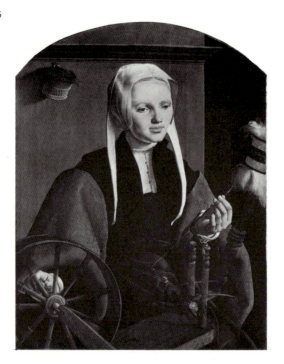

above: 554. Maerten van
Heemskerck. *Parable of the Unmerciful
Servant*. c. 1554. Engraving,
10⅛ × 7¾″

Bicker is a bold businessman, proud if not slightly haughty with his jaw rigidly set as he stares directly at the viewer. Anna is portrayed as the virtuous wife at the spinning wheel, an activity that is productive for the family and one that also gives her time to think and reflect on religious matters. The spinning wheel is, in fact, an attribute of the virtuous housewife. The domestic and business associations of the two portraits are quite unlike anything we have seen before: they represent the honest, *burgerlijk* wife and husband.

Perhaps Heemskerck's most surprising and successful experiment in domestic portraiture is the *Family Portrait* in Kassel (fig. 553), a masterpiece that inspired Rembrandt in his memorable *Family Portrait* in Braunschweig.

One scholar has commented that the broad panel is little more than two wings of an altarpiece with donor portraits shoved together, but how wrong this is. Heemskerck gives us rather a happy family group drawn closely together through the love of the children. How refreshing the smiles of the little brother and sister are; they are like ripening fruit of the solid marriage of a good-natured father and a warm, considerate mother who is god-fearing and loving, to judge by her attributes, the Rosary beads and the infant, who resembles more the Christ Child in a painting of a rustic Madonna.

The composition is carefully organized about the children, and yet it seems so candid, reminding us of a modern family snapshot, a bit posed, especially the husband who regards us a bit stiffly, and yet so natural and spontaneous. The little sister has been joking with her brother, the mother smiles warmly, and the father reaches over to silence his daughter's giggling. The background, which has been recently cleaned, is a bright blue sky filled with freely painted clouds that add a heightened luminosity to the family about the table.

A word should be given to Heemskerck's numerous designs for engravings, which number over six hundred. These works have been little studied, but they hold many secrets not only for the expansion of subject matter in the sixteenth century but for the sources for numerous baffling iconographies of the seventeenth, particularly those of Rembrandt. Heemskerck's engravings were standard stock in most Dutch ateliers of the Baroque period, and a number of enigmatic subjects that seem to defy identification can be found to be based on Heemskerck's designs. One reason for this is the manner in which Heemskerck conceived of expanded cycles of familiar stories.

What we usually see are the epitomized narratives, the most poignant moments, the easily recognized events in the stories, but with Heemskerck all the episodes leading up to the culmination and those constituting the denouement are included (see fig. 554). Those off moments, often of extreme psychological interest as the prints of Lucas van Leyden have demonstrated (or the late paintings of Rembrandt), could be chosen especially for the expanding repertory of New Testament parables—the prodigal son, the Good Samaritan, the unmerciful servant, Dives and Lazarus, etc.—and human-interest stories of the Old Testament—the lives of Joseph, Ahab, Susanna, Lot, Esther, Jonah, Judith, *et al.* A few of these Heemskerck executed and printed himself, but many of his serials were engraved by Dirck Volkertsz Coornhert, Philip Galle, and others.[129] Rembrandt owned many of Heemskerck's prints.

Maerten never forgot Rome. Periodically he departed from his violent Mannerist Passion stories and mused and

555. Maerten van Heemskerck. *Self-Portrait Before the Colosseum*. 1553. Panel, 15¾ × 19¾". Fitzwilliam Museum, Cambridge

remembered times past, the enjoyment he had sitting among the ruins of Rome in bright sunshine sketching the incomparable remains of the classical past, of gazing on the grandeur of ancient Roman monuments, and of the elevating spirit it all nurtured in the soul of a young painter from Haarlem. Such a sentiment is captured in a late *Self-Portrait* painted in 1553 (fig. 555).

Heemskerck aged well. This is the same man we saw over twenty years earlier posed as Apelles in his Saint Luke altarpiece, and he remembers too as he looks at us. To the right is the glorious Colosseum. Its ruins command over half of his characterization, as probably they did of his memories of the days in Italy. Before the ruins sits a young artist, pen in hand, sketching the monument before him. That too is his self-portrait. Unfortunately, Heemskerck's distant dream to bring all of this north was doomed, as it was with so many others before and after him, and as he grew older his visual recollections dimmed and became confused.

His last essays on the world of the classical past are uneven and often of poor quality: Apollo and the Muses, the Feast of the Gods, life on the Helicon. Van Mander's biography paints a strange portrait of Heemskerck. While praising him for his assimilation of ancient art, he reminds us again and again that Heemskerck was a troubled person. He worried about his companions, he made enemies, he was overly thrifty and miserly, he was fainthearted and easily frightened. But Van Mander ends his biography by telling us that Heemskerck had a warm spot in his heart. Before his death he had an obelisk placed on his father's grave in the cemetery at

556. Anthonis Mor. *Fernando Alvarez de Toledo*. 1549. Panel, 42½ × 32⅞″. Hispanic Society of America, New York

Heemskerck, and it is still there.[130] He was buried in the Grote Kerk (Saint Bavo) in Haarlem, and Van Mander concludes by remarking that he was, after all, very generous in his old age: "Among the gifts was a piece of land, the revenue of which was to be spent as wedding gifts for young couples who married upon his grave."

ANTONIS MOR

If we may consider Heemskerck the unruly and temperamental child of Jan van Scorel, then Antonis Mor appears as a most proper, aristocratic offspring of the same master. Mor became Scorel's apprentice after the latter's return to Utrecht. Just when is not known, but it has been suggested that he assisted Scorel on the altarpieces for the abbey of Marchiennes about 1540, and that he very likely became a specialist in portraiture while still in Scorel's atelier.[131] In 1547 Mor is registered at Antwerp as a master, and very soon thereafter we have evidence of his employ at the royal courts in Brussels, Augsburg, and later at Rome (1550), Madrid (1551), Lisbon (1552), and London (1554). He apparently maintained a household in Utrecht and always considered that city his true home in spite of his international life in the court centers.

Mor's patrons were for the most part the illustrious of the Catholic aristocracy. In Brussels he served Maria of Hungary, regent of the Netherlands, and Antoine Perrenot de Granvelle, archbishop of Mechelen. For the Hapsburgs in Spain he was called to paint portraits of Philip II and other members of the court, and in 1554 he traveled to London to execute the likenesses of Philip and his English wife, Mary Tudor. Although his oeuvre is not entirely restricted to portraiture, he was, then as now, a court portraitist par excellence, the successor of Holbein. Mor thus provides us with a picture hall of fame for the mid-sixteenth century, and he had no peers in the North.

Mor's likeness of *Fernando Alvarez de Toledo*, third duke of Alba (fig. 556), dated 1549, is a splendid example of his achievements in aristocratic portraiture. He has broken from Scorel's mold already in this compelling portrait; in fact, he has now cast his own, which will be widely imitated over the next half-century. How does one paint aristocracy, especially Spanish-Hapsburg aristocracy? Would Holbein have imbued them with the same lofty and arrogant nobility? I doubt it. Henry VIII was, after all, quite a special case among Holbein's English patrons. Mor paints with the same unflinching objectivity, to be sure, but these noblemen are more than very important people; they are heroic and austere and are not meant for your eyes and mine, but rather for their peers at court.

Mor's people belong in royal galleries, not in homes or even museums. The icy reserve and secret resentments these men project are statements of their high status as cultivated products par excellence of the ceremonies of the strict Spanish court. They all display a singular superiority among men; but they are distinct individuals and not idealized types. Mor's brush records with fidelity the frankness of their features, but he properly poses them as heroes on pedestals, and every gesture is ritualized and controlled.

The military prowess of the duke is established in his elegant suit of armor, resplendent and polished, unblemished and perfect. Over his shoulder is draped a ceremonial scarf and about his shoulders hangs the collar of the Golden Fleece, the most aristocratic of all orders reaching back to Philip the Good. His baton is held firmly in his right hand as if to underline the power and authority of his presence. Yet in the face, Mor applies sensitive brushstrokes that capture textures and minute details with the precision of Holbein or Van Eyck.

The head is no mask but a fabric of flesh covering a strong skeletal armature. One can detect the bone structure about the eyes, in the upper jaw with the fringe of beard marking the rise of the cheekbone, in the slight protrusions of the forehead, and in the intricacy of the unique pattern of cartilage in the ear. The flesh tints are pale, indeed almost iridescent, and the eyes stare out

with a frosty glare. The duke of Alba, Don Fernando Alvarez de Toledo, is austere, handsome, highly intelligent, elite, and lord of his world.

On July 24, 1554, Philip II married Queen Mary Tudor of England in London, and Mor accompanied the royal entourage for the state wedding. His *Portrait of Mary Tudor* (colorplate 80), painted for the occasion, is well known. Holbein had painted Mary's profile eleven years earlier, when she was twenty-seven and finally recognized by her father, Henry VIII, as one in line for the succession to the throne. Much had happened in the intervening years, however. Following the death of Edward VI in 1553, Mary became queen of England, and she immediately set about to restore Roman Catholicism. Her marriage to Philip II, son of the arch rival of Henry VIII, created a tumultuous stir in England, and a revolution was plotted against her by Sir Thomas Wyatt. The revolt failed, and over the next three years 277 traitors to Mary Tudor were burned. Many know her as "Bloody Mary" because of her fierce and determined stance against the leaders of the uprising, but historians have painted a balanced picture of Mary as a sensitive, well-educated lady who spent most of her life away from her father's court, unrecognized by him. Now as queen—she holds the Tudor rose as a scepter—Mary appears courageous and determined to keep her calling intact.

How does Mor paint her on the eve of her bitter retributions? Mary Tudor is now a member of the Hapsburgs, and as such she assumes the haughty dignity and arrogant mien of her new family of polished aristocrats. Her slight smile tells us little, other than that she has succeeded for the time anyway, but the likeness of the queen has the verve and boldness of Mor's other Spanish portraits. Her features are delineated with the same sharpness and precision; her pose is stiff and ceremonial. Mary Tudor is not relaxed. She is no queen mother. Mary died four years after sitting for this portrait, childless, embittered, and disappointed with her marriage.

Fortunately Antonis Mor too leaves us a self-portrait (fig. 557), and how does this self-evaluation compare with that of Maerten van Heemskerck's (fig. 555), Scorel's other pupil? The erect bearing and the suppression of any gesture, except for the hand that holds the palette, follow the mold of the aristocrats. We can be sure that he dressed as an elegant courtier, and that his surroundings were cold and immaculate as they appear here. Everything is proper, everything is under control. We are looking upon the prince of painters.

557. ANTHONIS MOR. *Self-Portrait*. 1558. Panel, 44½ × 34¼".
Uffizi, Florence

And what about the empty panel on the easel? It is prepared, but there is no underdrawing visible to guide his brush, although his maulstick is poised. Heemskerck reflected back on his youth by showing himself busy sketching the Colosseum in his earlier years; Jacob Cornelisz posed himself before an easel (fig. 519) finishing a portrait of his wife. There is nothing on Mor's panel but a piece of paper with lines of Greek letters. The Greek, in fact, is a poem composed for him by his close friend Domenicus Lampsonius,[132] the proud and very learned author of the many poems cited by Van Mander in his biographies, and it is addressed to the viewer on behalf of the artist himself: "Oh Splendid! Who is this likeness? It is the most famous of painters who surpasses Apelles and Zeuxis and all others, ancient and modern. Yes, he is the one who made this portrait, by his own hand from a mirror. Oh Excellent artist! Here is the painted Mor— now Mor shall speak."

The Theatrum orbis terrarum *of Pieter Bruegel the Elder*

"No one except through envy, jealousy or ignorance of that art will ever deny that Pieter Bruegel was the most perfect painter of his century. But whether his being snatched away from us in the flower of his age was due to Death's mistake in thinking him older than he was on account of his extraordinary skill in art or rather to Nature's fear that his genius for imitation would bring her into contempt, I cannot easily say." These lines were written, "with grief," in the album of friends, the *Album Amicorum*, in 1574 by the famous Antwerp cartographer, geographer, and archaeologist, Abraham Ortelius.[133]

The great scholar, named *geographus regius* or royal geographer by Philip II, was a friend and associate of Pieter Bruegel. After years of collecting and trafficking in old maps—he mounted them on canvas, colored them, and sold them as works of art—Ortelius produced his own maps. One, an eight-leafed map of the world printed in 1564 is known today in a single example (University of Basel), but in his huge *Theatrum orbis terrarum* published in 1570, one year after the death of Bruegel, he brought together in the first modern historical atlas known in Europe over seventy copper engravings printed on fifty-three double folio pages that presented not only his own "Theater of the Orb of the World" but reproduced contributions of some forty-six earlier cartographers.

What is surprising about the epitaph composed by Ortelius is that he is the only contemporary source—he was the same age as Bruegel—who describes the painter as an unmatched genius in his art. Mention of Bruegel can be found in Vasari's *Lives* (1565), in Guicciardini's history (1567), Lampsonius's verses (1572), and Van Mander's *Het Schilder-boeck* (1604), and while all praise him, his art is described as that of a second Hieronymus Bosch. Van Mander's characterization is typical and sums up the attitude of over three hundred years of criticism of his art: "He practiced a good deal in the manner of Jeroon van den Bosch, and made many similar, weird scenes and drolleries. For this reason, he was often called Pier den Droll. Indeed, there are very few works from his

hand that the beholder can look at seriously, without laughing. However stiff, serious, and morose, one may be, one cannot help laughing, or smiling."[134] More recent scholarship has uncovered a Bruegel closer to that described by Ortelius, but like any genius in the arts, Bruegel's personality is elusive and complex, and one should scrutinize the many faces he presents and reflects.

Before considering the characterization of Bruegel as the second Bosch, a brief account of his biography is necessary. Generally it is accepted that Bruegel was born in or near Breda, the seat of the Counts of Nassau, the House of Orange, sometime between 1524 and 1530 (probably 1527). He died in Brussels "in the flower of his age" in 1569. According to Van Mander, Bruegel worked first with Pieter Coecke van Aelst, whose daughter, Mayken, he married in 1563. No convincing evidence can be found to support this association as far as style is concerned, but we do encounter his name in records in Mechelen and in the Antwerp guild in 1550, the year Coecke died. Between 1551 and 1554 Bruegel traveled in the Alpine countries and visited Italy as far south as Sicily. He spent time in Rome, Bologna, and other centers there before returning to Antwerp. This Alpine and Italian experience will be treated later when we turn to Bruegel's landscapes.

Once settled in Antwerp, Bruegel was employed at Hieronymus Cock's At the Four Winds publishing house, where he provided designs for engravings. Over forty of these are known, dating between 1555 and 1563, when he moved to Brussels and married Coecke's daughter. He had two sons, both of whom were painters. Pieter the Younger is known for his exacting copies of his father's popular anecdotal paintings, and Jan, called "Velvet" Bruegel, became a distinguished painter in his own right and worked as an assistant to Pieter Paul Rubens, specializing in still life.[135] With the exception of Cardinal de Granvelle, councillor to Margaret of Parma, who was then regent of the Netherlands, Bruegel's patrons were mostly scholars, connoisseurs, and wealthy businessmen, including the geographer Ortelius, the

Antwerp banker Niclaes Jonghelinck (who owned no fewer than sixteen paintings by Bruegel), and the German merchant Hans Franckert.

Prints after Bosch or in his manner were much in demand in Antwerp, and it was that market that brought Bruegel a number of commissions for designs in Bosch's style. Some of these, such as *Big Fish Eat Little Fish*, 1556 (fig. 566), were attributed to Bosch directly in Cock's prints; others, including a series of the Seven Vices, were inscribed "Bruegel inventor." Bruegel's encounter with the world of Bosch was by no means restricted to prints, however, and throughout his short career, he periodically returned to the weird imagery of demons and hybrids made so popular by the enigmatic artist from 's Hertogenbosch. Three of these date to 1562 and later: the *Fall of the Rebel Angels* (fig. 558), *Dulle Griet* (illustrating the nagging housewife who was so fierce that she could plunder the mouth of hell), and the *Triumph of Death* (fig. 559).

Bruegel's *Fall of the Rebel Angels*, dated 1562, presents a pandemonium of Boschian hybrids with bloated fish, amphibians, crustaceans, lizards, bats, insects, and other scaly deformities with heads of birds, mice, dogs, bovines, stags, and human features, all intertwined in a squirming snake pit. Under a great disk of golden light, the angels, unlike their malformed adversaries, are lithesome, serene, and agile as they glide effortlessly about wielding swords and lances, their graceful white mantles miraculously unstained by the filth below them. Only

Michael, in the very center, is armored, and his huge wings and long blue cape cover the vanquished while he attacks a huge lizard-like dragon with seven heads, each with a crown, that was sent to devour the Woman of the Apocalypse in the account given in chapter twelve of the Book of Revelation.

In these frightening hybrids and tall, white-robed angels we are transported back to the Late Gothic age. How unlike the Herculean demons of Frans Floris (fig. 509) these malformed creatures of Bosch's nightmare world are. And yet there are important differences between Bosch's hybrid monsters and those of Bruegel. For the most part, after careful study, they can be recognized as identifiable creatures grafted one to the other. Their bodies do not really fuse into distinct creatures; they lack the wholeness of the weird, nightmarish forms that hatch in Bosch's swamps and deserts. With their brightly colored bodies and strange appendages, they are often more humorous than frightening, and in that respect they are not such vivid manifestations of the sinister, malignant forces in nature. Therein, of course, lies the incomparable power of Bosch's creativity in conjuring up fantastic creatures of the inner man that are manifest in surrealistic forms.

The bitter taste of Bosch's apocalyptic pictures is fully captured in Bruegel's *Triumph of Death* in the Prado (fig. 559), but it is not the surrealistic world of demons and hybrid creatures that is projected here, it is Death. Bruegel fashions a hellish apocalyptic end for the world,

558. Pieter Bruegel the Elder. *Fall of the Rebel Angels*. 1562. Panel, 46 × 63¾". Musées Royaux des Beaux-Arts, Brussels

559. PIETER BRUEGEL
THE ELDER. *Triumph of
Death*. c. 1562. Panel,
46 × 63¾″. The
Prado, Madrid

one in which allusive demons of the mind plaguing inner man are conspicuously absent. Rather, Bruegel returns to more traditional medieval themes of death to catalogue the destruction of the world and the dismal end of all life on earth. The end comes quickly at the hands of Death in the form of a skeleton as the cruel, vengeful executioner who takes a gruesome delight in his work. His terrain is no fiery pit or burning citadel of sin; it is the scorched, barren earth, devoid of any life as far as the eye can see. The broad expanse of a ravished countryside is laid out from a high angle of vision.

To the left of center a cavalry of skeletons charge out from a brackish ravine to cut down any survivors. A nearer corral of carnage is marked off by a polluted pond filled with dead fish and floating bodies, to the left, and a numberless army of skeleton warriors waiting their turn encamped on the right, their shining skulls forming a weird cobbled pavement of a wasteland. To the far left a circular turret forms the foundation for a graveyard, where skeletons ring huge bells tolling the time of death to the hands of a giant clock. Along a parapet is a row of white-shrouded skeletons, the elders and administrators giving commands before their ruinous town hall, directing their armies to finish off their horrendous mission.

Below, to the left, a starved old nag pulls a cart full of bones while its rider rings more death bells. Before the hooves falls an old woman who is about to cut a thread from her spindle, very likely an allusion to the string of the Fates which has now been terminated along with ev-

erything else.[136] Another skeleton rides on a swift russet horse clearing the way with a huge scythe, perhaps a reminder of the Horsemen of the Apocalypse, and to the right a giant boxed enclosure, a weird kind of people trap, is opened to swallow up the masses being herded into it like a death van. On either side of this horrifying trap the countless troops of Death stand regimented behind tall shields in the form of coffin lids.

Staggered across the foreground is a jagged frieze of the victims, close enough to recognize now, who are each, in turn, being claimed by the agents of Death. Here Bruegel turns from the devastation and destruction of the Apocalypse to a more gameful form of death, for this frieze of agony and torture is a most ingenious variation on the medieval theme of the Dance of Death. In Holbein's woodcut series, Death comes in the form of his victim's counterpart: a skeletal nobleman claims the prince as his partner, the robed bones of a monk traps the clergy, one dressed as a peasant engages the farmer, and so on.

This ghastly promenade dances directly before us in Bruegel's painting. To the left, the mighty king is claimed by two of his courtiers, one of whom gleefully robs the aristocracy of its barrels of coin; then a skeleton wearing a cardinal's hat pulls his victim along, dressed in a blue mantle. This selection of partners culminates in the group of merrymakers in the lower right. Their gaming table has been overturned by Death dressed up as a court jester; and next to the gamesters, a pair of lovers,

still unaware of what is happening, entertain themselves by singing and playing on a lute as another grinning skull approaches with a hurdy-gurdy to accompany them.

The terrifying vision of the horrors of death, both in the apocalyptic and mocking dance versions, was familiar to the citizens of Antwerp at mid-century and later after the religious wars and the encampments of the Spanish soldiers ended the peace and prosperity of the Netherlands. That Bruegel here condemns one or the other factions is not at all clear, but undoubtedly the furies of warfare that devastated the city and the countryside during these years were foremost in his mind. The pessimism may be Boschian, but the cruel presentation is much too real to be seen as the influence of his works.

We now confront Bruegel in his own idiom, one distinct from that so far encountered. This is no Last Judgment in the traditional sense, but it is one nonetheless. Nothing survives the ravages of war, not the green fields of the meadow, not the fish in the waters, not the animals of the woods, and not the human inhabitants, no matter what their calling in life might have been. Death destroys all and everything in its own image. A smoldering terrain of dry, pulverized particles of earth is left, for even the bones shall return to dust. Admittedly this is a shocking way to introduce the *theatrum orbis terrarum* of Pieter Bruegel to the reader, but there it is. What came before fortunately has its beauty, freshness, humor, and life, but even when smiling, Bruegel seems to be doing so ironically.

Thanks to the researches of Max Dvořák, Charles de Tolnay, and Otto Benesch, among others, the image of Pier den Droll has been replaced by Bruegel the philosopher in art, and for good reason.[137] His friends and associates were members of the intellectual circles in Antwerp—Ortelius and Coornhert, foremost among them—and the same aloof and objective views of matters political, religious, and scientific that mark their works and ideas also pervade the paintings of Bruegel. According to Van Mander,

> He did a great amount of work for a merchant by the name of Hans Franckert, a noble and worthy man who liked to chat with Breughel. He was with him every day. With this Franckert, Breughel often went on trips among the peasants, to their weddings and fairs. The two dressed like peasants, brought presents like the other guests, and acted as if they belonged to the families or acquaintances of the bride or of the groom. Here Breughel delighted in observing the manners of the peasants eating, drinking, dancing, jumping, making love, and engaging in various drolleries, all of which he knew how to copy in color very

comically and skillfully, and equally well with watercolor and oils; for he was exceptionally skilled in both processes. He knew well the characteristics of the peasant men and women of the Kampine and elsewhere. He knew how to dress them naturally and how to portray their rural, uncouth bearing while dancing, walking, standing, or moving in different ways. He was astonishingly sure of his composition and drew most ably and beautifully with the pen. He made many little sketches from nature.

From this one might judge that Bruegel, like so many of the upper-middle-class city dwellers of Antwerp, took jaunts on occasion to enjoy the simplicity and humor of the rustic scene where beer was cheap and parties were raucous and fun to watch. However, there is something much deeper in Bruegel's interest in and studies of peasants. In his *theatrum mundi* the peasant was the basic focus, since, being close to the earth, indeed, part of it from an economic and social point of view, he was the prime matter from which this stuff called humanity could be formed. With Bruegel there appears a philosophy that is not unrelated to the Netherlandish idea of *Elckerlijk* (*Jedermann* in German, Everyman in English), but not so much as a general medieval personification of some virtue or vice but as a true representative of mankind in general.

The late-fifteenth-century philosopher Sebastian Franck had written that "All men one man. Who sees one natural man, sees them all."[138] The key words here are "natural man," one uncontaminated by the sophistications of advanced society but who rather finds his place in the orderly scheme of natural things. Like the seasons, the weather, the crops, the animals, this man is caught up in the mechanical clockwork of nature that once put into operation by some higher power is left to follow its unerring course forever. Religion explains little in this mechanistic universe. A sophisticated sense of pantheism is reflected in Bruegel's *theatrum mundi*, one in which man is but an anonymous particle of some smaller, some larger cosmos; there is no problem of soul and spirit, for nature itself is that soul and spirit.

Later we will study Bruegel's landscapes, in which the sense of the mechanical rotation of a circular universe that has a temperament—the weather and seasons—is astonishingly conveyed. The flora and fauna, including man, are but more complex particles of a living and breathing, a waxing and waning, a growing and dying universe. For this reason, Bruegel's people are anonymous entities. As Benesch writes: "What style of figure representation would have better fitted this general, anonymous, automaton-like world than the stiff, thin-limbed, disklike, archaic figure style of the painters of

above: 560. PIETER BRUEGEL THE ELDER OR
ROELANDT SAVERY. *Two Woodcutters.*
c. 1600? Crayon and ink drawing,
5⁵/₁₆ × 5³/₈″. Kupferstichkabinett,
Staatliche Museen, West Berlin

right: 561. PIETER BRUEGEL THE ELDER.
Kermis. c. 1566. Panel, 44⅞ × 64½″.
Kunsthistorisches Museum, Vienna

the Late Middle Ages? This is the main reason why Bruegel harked back to Hieronymus Bosch and the mode of the fifteenth century.''[139]

So how does Bruegel study "Everyman"? As Van Mander informed us, he joined them, he observed them, and then he put down his impressions in sketches. A number of so-called *naer het leven* (after live models) pen drawings have been traditionally attributed to Bruegel. Now they are thought to be mostly by the hand of a follower, Roelandt Savery,[140] but, nevertheless, these fresh sketches cannot be far from the mode of recording the peasants that Bruegel initiated.

A good example is the drawing of *Two Woodcutters* (fig. 560). The sketch is executed in black crayon touched with brown ink and has color notations in the margins: "black hat, black scarf, walnut-brown coat, green knickers . . . " The study is restricted entirely to the costume; their personalities are of no interest. In fact, they turn their backs to us as in so many of Bruegel's works as if to maintain their anonymity. Bruegel thus is interested in man as an aspect of the natural world and nothing more. They are not heroic figures in action or idealized representatives of the honest worker of the fields; they are simply general human types and their dignity and self-esteem do not enter in. With very few exceptions Bruegel's sketches never approximate portraits—he never painted a portrait—but simply record human beings who might as well be clumps of bushes or draft animals.

Bruegel's paintings of peasant life fall into two general categories. The large-figure compositions seen more or less at eye level are devoted to special events such as a kermis or a marriage as if he were painting a series for some

programmatic decoration. The other type is the panoramic view, where, looking down from some high watchtower, he catalogues their activities with an eye for the anecdotal because it is in their playing and working that Bruegel finds their wisdom manifest. The large-figure paintings date later, but we shall consider them first since they more clearly demonstrate the transformation of the *naer het leven* sketches into the image of the peasant. These panels are approximately all the same size (46 by 64 inches), and very likely they formed pendants or even larger programs.

Bruegel goes to the country village to observe the activities at a fair or church holiday, the *Kermis* (fig. 561). How many Dutch proverbs are hidden in the pockets of activity there! The setting is the village square: a tavern to the left and houses that follow the dirt road to the church in the background. The large diagonal of the flat roadway is clearly marked out with the rooftops forming a sturdy perspective focus on the church steeple and the peasants establishing a bold frieze of figures across the foreground. To the right one couple, dressed in simple costumes that Bruegel must have sketched as he did in the *naer het leven* drawings, enters the scene. Bruegel is not interested in intricate details but in the broader patterns of colors that these large areas of unadorned fabric create.

They are big, monumental figures, husky and robust, and they move with a jerky and awkward gait as they hurry to join the dancers in the middle of the road. At times, as here, Bruegel seems to exaggerate the clumsy movements of the rustic types by accentuating the positions of their arms and legs. The left leg of the male figure is awkwardly foreshortened and hardly fits his torso.

Colorplate 77. JAN VAN SCOREL. *Death of Cleopatra*. c. 1523. Panel, 14⅛ × 24″. Rijksmuseum, Amsterdam

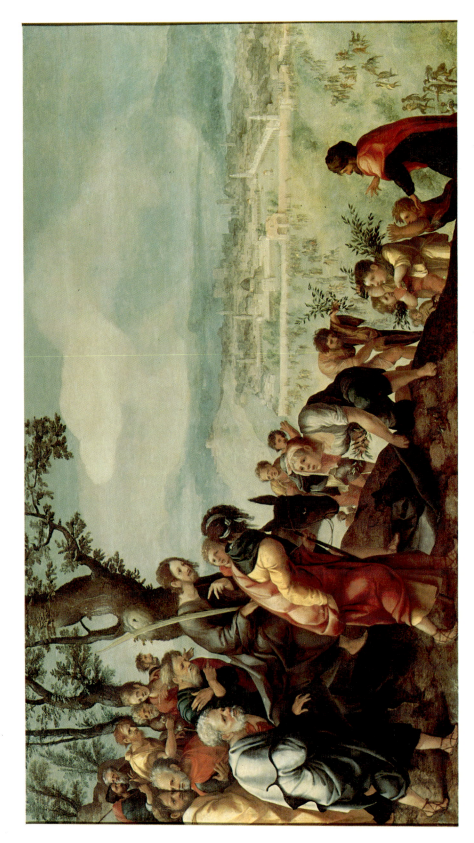

Colorplate 78. Jan van Scorel. *Entry of Christ into Jerusalem.* 1526–27. Panel, 31⅛ × 57⅞". Centraal Museum, Utrecht

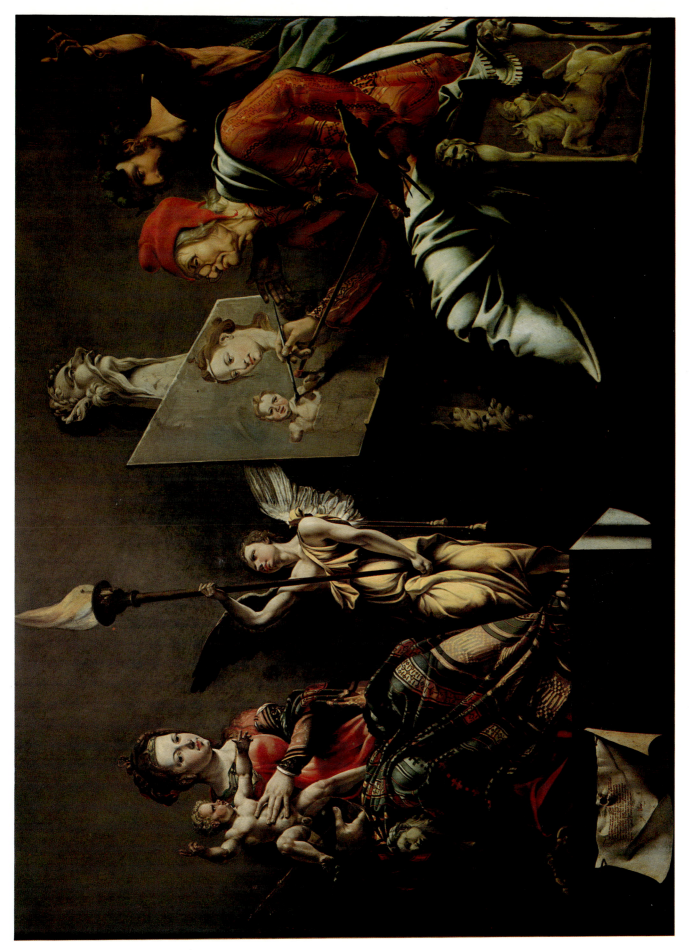

Colorplate 79. MAERTEN VAN HEEMSKERCK. *Saint Luke Painting the Virgin*. 1532. Panel, 66⅜ × 91⅛". Frans Hals Museum, Haarlem

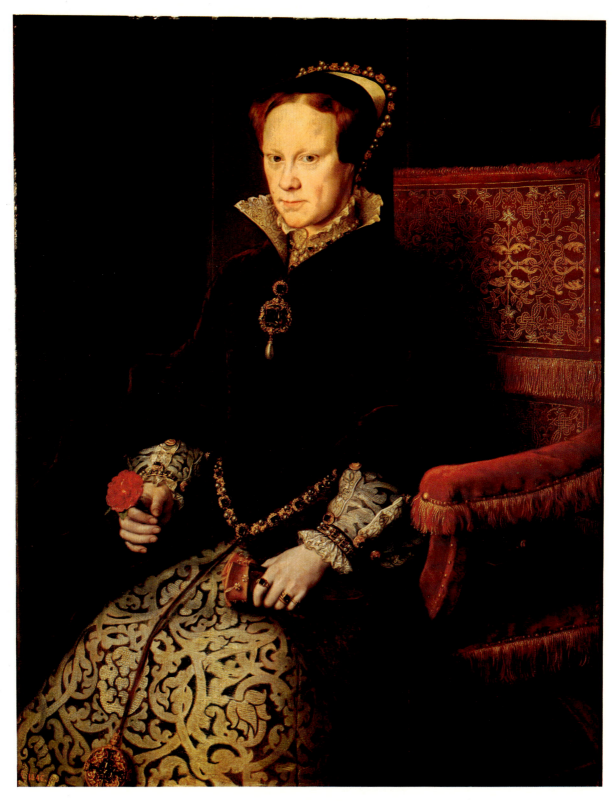

Colorplate 80. Anthonis Mor. *Portrait of Mary Tudor*. 1554.
Panel, 42⅞ × 33″. The Prado, Madrid

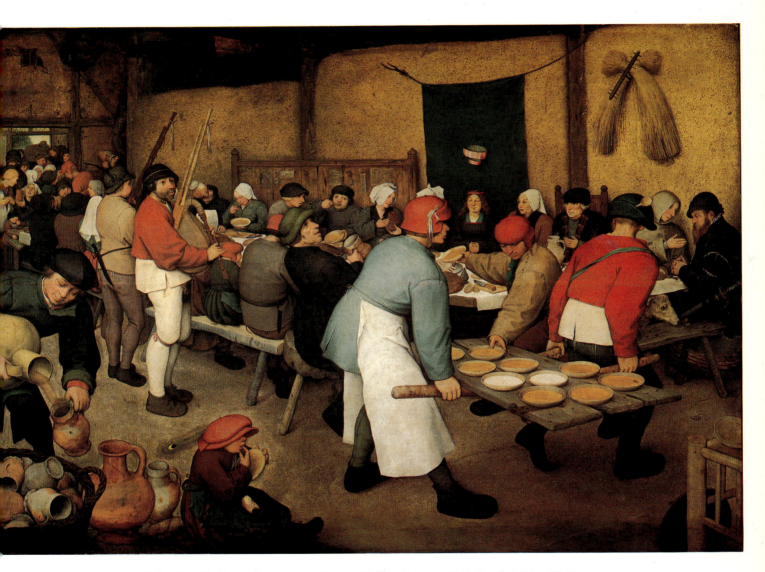

Colorplate 81. PIETER BRUEGEL THE ELDER. *Wedding Feast*. c. 1566. Panel, 44⅞ × 64⅛″.
Kunsthistorisches Museum, Vienna

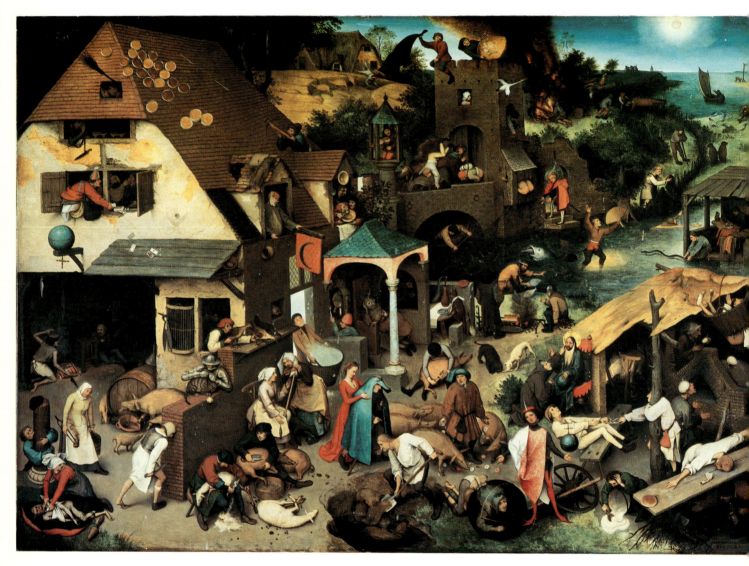

Colorplate 82. Pieter Bruegel the Elder. *Netherlandish Proverbs*. 1559.
Panel, 46 × 64⅛″. Gemäldegalerie, Staatliche Museen, West Berlin

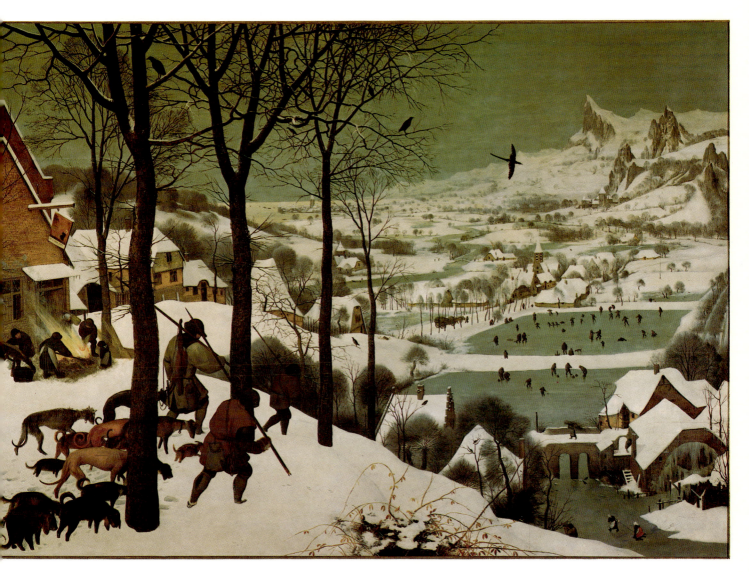

Colorplate 83. PIETER BRUEGEL THE ELDER. *Hunters in the Snow*. 1565.
Panel, 46⅛ × 63¾". Kunsthistorisches Museum, Vienna

Colorplate 84. PRIMATICCIO? *Ulysses Reunited with Penelope*. c. 1545. Panel, 45¼ × 48½″.
The Toledo Museum of Art. Gift of Edward Drummond Libbey

Colorplate 85. JEAN COUSIN THE ELDER. *Eva Prima Pandora*. c. 1538.
Panel, 38 × 59″. The Louvre, Paris

562. PIETER BRUEGEL THE ELDER.
Wedding Dance. 1566. Panel, 27 × 62″.
Detroit Institute of Arts

To the left a table is prepared for the deaf, dumb, and blind, since they should join in the fun too. Three are gathered about the oaken table with their beer jugs before them as they grope for one another and make noises.

In contrast, a husky bagpiper sits on the near side of the table blaring out, with puffed cheeks, the whining, squealing music for the dancers; a friend offers him a huge earthen pot of beer. Beside them two children are dancing, a detail that may well be meant to illustrate the proverb, "the more the piper pipes, the more the young dance," providing a leitmotif for the rest of the painting. Crowds gather around, younger couples swing carelessly, here and there a few trifling acts of romance can be seen. In the crowd, near the center, stands one dressed as a jester cheering the dancers on, while further back, others buy tasty cakes at stalls. The predominance of earth colors—browns, blacks, russets, muddy greens and grays—conveys the earthy quality of these swarthy workers and husky women who can work like horses and eat like livestock, and who are having fun this day.

Someone had too much to drink at the kermis, danced too many rounds with the same girl, perhaps became a little too familiar, and lo and behold he finds himself a married man. A copy of a *Wedding Procession* in Brussels after Bruegel could well form the next step in the unraveling of the village drama, but soon the ceremonies are over and in Bruegel's famous *Wedding Feast* (colorplate 81) a celebration follows the church ceremony in the big barn on the manorial estate near the village. The last sheaves of wheat hang tied to the wall to the right, indicating that the time is early autumn. The barn has been outfitted in a makeshift fashion to accommodate a long row of tables and a special place of honor for the new

bride—it is her victory in this context—with a green blanket (the color of love) forming a cloth of honor behind her and a peppermint crown of paper to distinguish her as queen of the day. The beautiful, blushing bride is neither beautiful nor blushing but sits content like a cat musing over her catch. To the right sit her parents, to the left her in-laws with the groom, probably the moon-faced glutton who continues to eat. Approximately twenty guests have gathered—laws were passed limiting the number—and others crowd about the entry at the far left.

The huge barn provides ample space for the festive gathering, and Bruegel marks it out, as he did in the previous painting, with a broad diagonal sweep of earthen floor blocked out by the unadorned walls of hay. Musicians have been called in to perform on their bagpipes; one stops to glare at the rice pudding being brought in on an unhinged door serving as a great tray. In the lower left, another peasant fills the jugs with beer to be passed about.

Few of the heads are particularized. The bearded nobleman seated to the far right next to the village priest has been considered a self-portrait of the artist by many, but for the most part the faces are moon-shaped, the eyes like disks. Many have their backs turned to us, and a splendid example of their general anonymity can be seen in the little boy or girl, sitting in the foreground eating pudding, with a large red cap all but concealing any facial features.

The final celebration takes place in the open air behind the barn with the *Wedding Dance* (fig. 562). The queen's throne of honor has been moved to a table beneath trees in the background, where the mothers of the bride and

groom chat. Beer still flows and mugs are distributed; the pipers have settled to the side in the right foreground. Happy couples stomp and swing their arms, the males prancing like barnyard roosters prominently displaying their large codpieces. The bride has left her dais and can now be seen joyously romping in the center of the picture—she has a wreath in her hair—but she is not dancing with her husband. He seems to be missing in the crowd. Some older folk stand by idly, others are clustered in groups conversing or telling jokes, some of the younger have wandered off to the fields to hug and kiss,

above: 563. PIETER BRUEGEL THE ELDER. *Kermis at Hoboken*. c. 1559–60. Engraving, 11¾ × 16⅛"

564. PIETER BRUEGEL THE ELDER. *Carnival and Lent*. 1559. Panel, 46½ × 64¾". Kunsthistorisches Museum, Vienna

565. PIETER BRUEGEL THE ELDER. *Children's Games*. 1560. Panel, 46½ × 63⅜". Kunsthistorisches Museum, Vienna

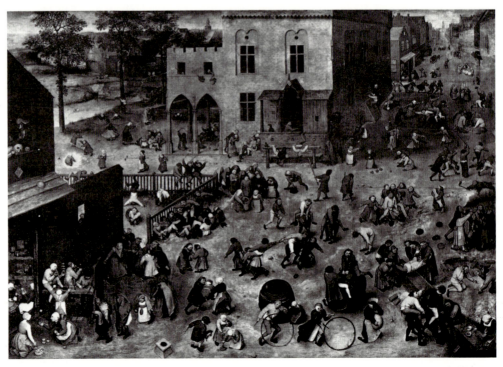

and here and there a male participant turns his back to relieve himself of all the beer.

Bruegel's pictures are fun and they do make us smile, but this is not primitive folk art by any means. The rhythmic manner in which the artist fills the broad field with the serpentine movements of the dancers swirling about leads us back through the crowd from the undulating frieze of big figures in the foreground, unadorned forms with monumentality that is not sacrificed by fuzzy Gothic draperies or minutely detailed costumes. His modeling is simple, his drapery curves in large arcs; there is little to detract from the beat of stomping feet that move clumsily but with vigor. If one were to substitute the swirling peasant bodies with fleshy, sensuous nudes and loosen the brushwork, the composition would approximate the bacchanals of Rubens.

In support of the idea that these paintings by Bruegel follow a program illustrating peasant activities are the large number of prints that come down to us with just such serial themes, the village fair, the peasant wedding, the wedding feast, and the wedding dance, that predate the paintings and very likely were the immediate sources for Bruegel.[141] In some examples it would seem that those depicting peasant fairs were intended to be advertisements or mementoes for the cities and villages where the celebrations were notoriously raucous. Such is the case with one print designed by Bruegel that illustrates the *Kermis at Hoboken* (fig. 563). A verse in Flemish below the picture tells us that "the peasants delight, during such feasts, to dance, jump, and drink themselves blind-drunk like beasts. They can't let the time for such a Kermess go by, even if, the rest of the year, they'd have to hunger and die."[142]

Are these peasant pictures merely humorous satires or are there any serious messages concealed here? Some scholars think the latter. The *Wedding Feast* has been described as an allegory of gluttony, the *Wedding Dance* as one of lust,[143] but surely Bruegel is not condemning here. Bruegel, in fact, seems to be sympathetic, and his interest in such genre themes very likely extended beyond the mere depiction of the animal behavior of man in general to more subtle illustrations of what might be called the wisdom of the peasant as it reveals itself in such forms as the pun, the proverb, and the parable.

This brings us to Bruegel's second category of peasant life, the panoramas with anecdotal activities. *Carnival and Lent* (fig. 564) offers a village panorama that in many ways seems to be an extension of the *Kermis at Hoboken*. The occasion is the celebration of Carnival or Mardi Gras as Ash Wednesday approaches, and the activities in the square relate to the holiday spirit that still marks this popular Catholic holiday. The main attraction is the battle of Carnival and Lent in the foreground. Haggard

Lent is dressed as a nun and carries an oven shovel with two herring as a lance. On her low wagon are pretzels, waffles, and mussels, the meager fare for Lenten repasts.

Lent's opponent is a corpulent Prince Carnival with the attributes of gluttony about him, the meat-pie hat, beer jugs for shoes, and a skewer with a pig's head, chicken, and other cuts of meat serving as a lance. His chariot, a beer barrel, is pushed along by two costumed jesters and followed by mummers. One interpretation has it that the left side of Bruegel's picture represents the Lutheran sect in the Netherlands that was challenging the traditional observances of the Catholics on the right. Thus gluttony faces hypocrisy, and the painting becomes an allegory on religious dissension within a typical community. This makes little sense, for Bruegel takes no sides.[144]

A similar village scene provides the stage for *Children's Games* (fig. 565). Here, at some distance from the city square which appears at the end of a long street to the right, groups of youngsters are scattered about and within buildings playing various games (some eighty-five have been identified). Many are simple pastimes such as blowing bubbles, turning somersaults and cartwheels, swinging on a fence, trundling hoops, walking on stilts, flying kites, swimming, climbing trees, etc., while others involve several players such as leapfrog, tag, tug-of-war, knucklebones, blindman's bluff, running the gauntlet, and other more competitive stints. Some, however, are games of imitation, aping the rituals of adults in miniature fashion. In the lower left a row of tots forms a Baptismal procession; higher, at the corner of the red fence, is a mock marriage with a wedding procession; and other games such as playing shopkeeper are found here and there.

A number of textual sources could be cited to point out the underlying meanings of many of these games, and, for the most part, the charades that children play were seen as reflections of the follies of man himself, implying that we all play games from childhood to death and there is little difference in them no matter what age we may be. That this was Bruegel's intent is made explicit when we observe these children carefully. The children are all adults. Their faces are those of their elders, and hence they are miniature grownups playing their games still, walking on stilts in their conceit, playing king of the hill in their pride, and looking at the world upside down in their folly.

Parades, games, and tricks are thus reflections of peasant wisdom and humor, but their more profound thoughts and judgments are often communicated in the form of proverbs and parables. By definition a proverb is a short, pithy saying, often metaphoric in form, which expresses some common truth gained through experience

and observation, an adage familiar to all. Such bits of wisdom are well known in the Bible, of course, and also in classical literature. Christ spoke in parables and proverbs, and for the Middle Ages the traditional methodology for scriptural interpretation was the fourfold system of the literal, allegorical, tropological, and eschatological levels of meaning, which is suited to gaining insight into the wisdom of a proverb.

The important point is that the proverb is not an opinion based on abstractions but one derived from everyday experience. Erasmus was a famous collector of proverbs and in the 1533 edition of his *Adagiorum Chiliades* over four thousand witty sayings are indexed. Rabelais's *Gargantua and Pantagruel* of 1534 has an entire book devoted to numerous proverbial activities in his description of fool's paradise. Numerous collections of Netherlandish proverbs were published in Antwerp in the sixteenth century, since there was a regular mania for dialogues in the form of proverbs to illustrate the follies of man. There is, in short, no lack of textual sources for Bruegel's illustrations of proverbs.

How fitting that Bruegel should choose this form of peasant wisdom over more academic lore, since as Folly in the famous treatise by Erasmus when looking down at the earth from on high remarked, "There is no show like it . . . God, what a theater. How strange are the actions of fools." Or, if we should want to rely on Biblical authority, the preacher in Ecclesiastes speaks in proverbs in describing the vanity of vanities in a world where the number of fools is infinite. More probably, Bruegel turned to already compiled lists of such *absurda* published in the tracts on the *verkeerde wereld* or the world-turned-upside-down that were popular.

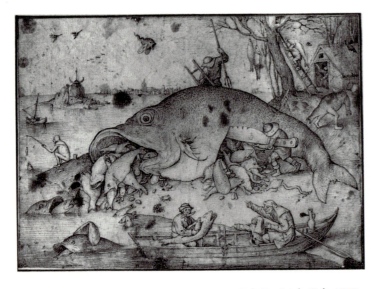

566. Pieter Bruegel the Elder. *Big Fish Eat Little Fish*. 1556.
Pen drawing, 8½ × 11⅞". Albertina, Vienna

Bruegel's illustrations of proverbs can take on various forms. Often they are smuggled into a more conventional theme as a genre footnote; in other instances he selects one and illustrates it outright, as in *Big Fish Eat Little Fish* (fig. 566). In the engraving after Bruegel's drawing, the Latin adage is printed below the picture with its Flemish equivalent. The basic proverb is simply "Big Fish Eat Small Fish," which is the main subject, but the Flemish text is meant to issue from the mouth of the father in the boat who speaks to his son, "Ecce" or Behold: "See, my son, I have known this for a very long time—that the large fish gobble up the small." The proverb is self-explanatory in that marine life was considered a prime example of cannibalism and thus a footnote on man's inhumanity to man: gluttons prey on the small man with a voracious appetite, big corporations swallow up the small merchant, large nations gobble up the smaller ones.

Later Bruegel painted the *Blind Lead the Blind* (fig. 567), taken from the Gospels (cf. Matthew 15: 14; Luke 6: 39): "And if a blind man leads a blind man, both will fall into a pit." In this example there seems to be no place for humor. The tragic blind men are painted with such care that scholars have recognized specific eye diseases such as glaucoma, cataracts, atrophy of the eyeball, etc. Their leader has fallen and so will they. Again, the lesson has little to do with physical infirmities as such but rather with "spiritual" blindness, especially that of their leader. Neither the townspeople in the huts to the left nor the clergy in the more distant church will be able to rescue them. The meaning is universal and timeless.

The most ambitious presentation of proverbial wisdom ever created is Bruegel's famous *Netherlandish Proverbs* (colorplate 82) in which nearly one hundred individual proverbs are illustrated amid the activities of a typical Flemish village. It is a giant puzzle or game of charades for those who wish to read his picture. The setting is familiar by now. Numerous peasants, clerics, men of more noble ranks, are scattered about the streets of a small Flemish village and in the landscape beyond. At first it appears to be just another genre representation of peasant activities, but as we move slowly through the streets, alleys, and meadowlands, the groups break up into small vignettes, each with its own little story.

A number of studies have been devoted to Bruegel's pictorial sources for the cryptic sayings, and, for the most part, as Yoko Mori and others have clearly pointed out,[145] these are to be found mainly in the marginal images of Late Gothic art: the drolleries of manuscripts, the humorously carved misericords (the small supports on the undersides of the hinged seats in choir stalls), as well as in popular prints.

Two aspects of this curious iconography are interest-

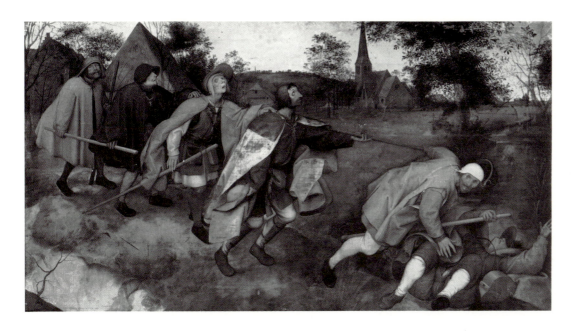

left: 567. PIETER
BRUEGEL THE ELDER.
Blind Lead the Blind.
1568. Canvas,
33⅞ × 60⅝″. Museo
Nazionale di
Capodimonte, Naples

below: 568. FRANS
HOGENBERG. *The Blue
Cloak.* c. 1558.
Engraving,
12¾ × 20⅝″

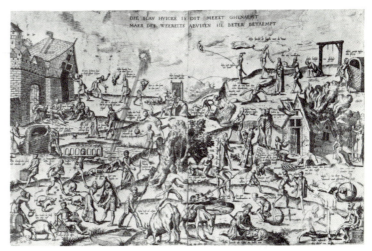

ing to mention in connection with Bruegel's more immediate sources. A year or so before Bruegel painted his picture, a print engraved by Frans Hogenberg was issued, about 1558, that presented on a broadsheet a number of isolated proverbs scattered haphazardly across a wide landscape (fig. 568). The inscription above the landscape identifies it as the "Blue Cloak" or *Blau Huick*: "This is generally called the Blue Cloak, but it would be better named the follies of the world." The pictorial motif of *The Blue Cloak* is found in the lower center of the print with a young woman, fancifully dressed, placing the cloak over the head of an old man. The meaning is clear: the adulterous wife fools the gullible old cuckold, and the cloak is blue because as an inversion of its traditional symbolism as the color of the theological virtue faith, it here represents deceit, and from it springs the countless other follies of man.

In Bruegel's painting the two central figures in the village square are a pretty young woman dressed in a lascivious red gown placing a blue mantle over the head of her crippled old husband, and hence the direct inspiration of Bruegel's unusual painting would seem to have been Hogenberg's print or one much like it. But how different is Bruegel's interpretation from that of the engraver! The print is clearly a pastiche of motifs and a mechanical cataloguing of stories to be read left to right, up and down, as if it were a pictographic text. This perfunctory mode of illustrating sequential episodes is commonplace, but Bruegel's painting has the naturalism of a busy marketplace on a bright morning in a Flemish town.

Many of his proverbs are, in fact, lost amid the natural unraveling of everyday activities. Further, there seems to be some hidden focus in Bruegel's painting, and that central image is the busy inn dominating the left half of the composition. It forms a microcosm of the world at large. The two signboards are significant, as are the proverbs that accompany them. The upside-down world of the orb to the left and the crescent moon above the entrance are targets of peasant defecation: "He s . . . s on the world" and "He p s on the moon."

The falseness of the upside-down world and the follies that follow deceit eddy outward from these two points in rapid waves. Opposite, in the right foreground, the image of the imperial orb appears again; in one case it is held on the lap of a Christ. A kneeling monk reaches up to affix a false white beard on his face. The church is hypocritical and deceitful. Directly below stands a youthful nobleman with another globe that he balances precariously on his thumb, a reference to the instability of the secular powers in governing this world. Beneath him is a cripple who crawls inside a giant transparent orb with a cross, a personification of the crippled machinations of a false, deceitful, and unfaithful world. It is the fool who controls it here.

From there the proverbs unravel as if it were just another Monday morning in the village. In the lower left corner a man dressed in blue attacks a column with his

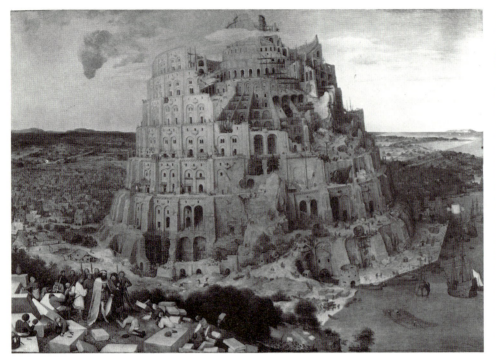

569. PIETER BRUEGEL THE ELDER. *Tower of Babel*. 1563. Panel, 44⅞ × 61″. Kunsthistorisches Museum, Vienna

570. PIETER BRUEGEL THE ELDER. *Tower of Babel* (detail of fig. 569)

teeth, a pillar-biter: "He bites the column," an image of hypocrisy. Two women enter. One in yellow, "carries my drinking water in one hand, but a burning rod in the other," the nagging wife; and below her a vicious old woman "ties the devil to a cushion," an image of the fierce Dulle Griet who can even rob the portals of hell and scare the devils. Before them an ailing peasant, playing soldier, "beats his head against a wall," the ambitious idiot. On the brick wall above, a hero dressed in armor has a cat in his grips, a true scaredy-cat or coward who "puts on armor to bell the cat."

From there we can move on to countless others; to name but a few: above on the roof with pies, "He shoots one arrow after the other, but hits nothing," the fool who cannot see beyond his nose; down in the street, "He fills in the mudhole after the calf has drowned"; "He casts roses (pearls) before the swine"; "One man shears the sheep, the other tries the pig," the dolt who understands nothing; "Two dogs fight over one bone," jealousy; in the polluted stream, "The big fish eat the little"; and on the far horizon, right, "The blind lead the blind."

Bruegel studied the peasant from his high *Tower of Babel* (figs. 569, 570), and what a folly that was. Man challenged God by building an edifice to his heaven, only to be struck down and forever plagued by the babel of countless languages imposed on him. Surely Bruegel was well aware of the confusion of tongues in the world. The first polyglot Bible in six languages was published by Plantin in Antwerp in 1566. The tower itself is a magnif-

icent display of contemporary engineering techniques and building devices here appropriated for the construction of some telescoping Colosseum which has weathered in its years of building and is doomed to fall or disintegrate like some ancient ziggurat.

Interestingly, this mighty edifice is the only reference in Bruegel's art to classical ruins. Unlike so many others before him who had visited Italy, Bruegel did not sketch the antiquities, only the landscape of the Alps and the mountainous coast of southern Italy. He visited Rome but there are no drawings of the Forum of Nerva, the Arch of Constantine, or even the important new buildings erected on the Vatican hill. He sketched the Ripa Grande in the Tiber, but little more of the eternal city.

On the other hand, his sketches of the mountains and the seacoast are so numerous that we can almost plot his itinerary. Why only mountains? Was it because he found their resplendent forms easier to put down rapidly with his pen without worry over meticulous detail? That certainly is not true since he painted a magnificent view of the *Harbor of Naples* (fig. 571) that was no doubt based on very detailed drawings made on the spot and is as accurate and animated as any topographical view.

Bruegel, in the tradition of Patinir and Met de Bles, was fascinated by the diverse shapes of mountains, their dizzying heights, and the awesome majesty of endless echelons of towering peaks, one behind the other, reaching up into the clouds. It is as if Bruegel were in search of his own Mount Sinai, where the laws of this *theatrum orbis terrarum* might be revealed to him. Never has an art-

ist been so enthralled by the music of the mountains as Bruegel; his sketches have the lofty structure of a fugue by Bach and, at times, the majestic drama of a Beethoven symphony. There is good evidence that Bruegel made a grand tour of the Alps, and if one can project himself back to the mid-sixteenth century, that surely must qualify as a heroic mission in itself. Van Mander puts it rather coarsely: "While he visited the Alps, he had swallowed all the mountains and cliffs, and, upon coming home, he had spit them forth upon his canvas and panels."

From his lofty perch Bruegel looks down at a world with people scattered like ants far beneath his feet. Is there some guiding principle to it all? Is there a reason behind their actions and movements; is there a pattern to this cosmic carpet? Bruegel's concept of Godhead, one must admit, is quite different from the divinity envisaged by Jan van Eyck and Rogier van der Weyden.

Bruegel's God does not seem to assume the shape of man or his personality; for Bruegel the higher power is something that resides in his landscapes, and the meaning of life and the patterns of being that emerge through a study and contemplation of nature in its most basic form—the essence of nature—are what he wants to capture. This is revealed in a study of the earth itself and the various forms that grow out of it: the plants, water, animals, man are all offspring of the earth. Nature, one might say, is an animate organism itself. A new philosophy of nature appears in Bruegel's landscapes just as it does in Western thinking during the course of the sixteenth century, and this study is grounded not in the ideal world of abstractions but in scientific investigations of the *orbis terrarum* as well as the solar system and, to some extent, in the discoveries of explorers of the New World.

In this light, Bruegel's associations with the leading intellectuals in Antwerp should be considered seriously. His friend, the cartographer and geographer Abraham Ortelius, who wrote that Nature feared Bruegel's genius, would certainly have been a source for his knowledge of the physical makeup of the earth, its varied features, and its position in some greater system. We should remember Ortelius when we look at Bruegel's sweeping panoramas of the globe and realize that it is not just by chance that the earth often shows a curvature on the horizon.

While one can scientifically describe the physical makeup and the mechanism of this world set in motion, there remains a mysterious Godhead that gives it life and soul. And what is this world "life and soul" for Bruegel? Reaching back to basic principles devised by pre-Socratic philosophers, to an early system loosely called hylozoism, the basic elements of the earth—fire, water, earth, and air—are already living things; they breathe, grow, and die, just like flora, fauna, and man. Matter and life cannot be separated. Earth is not a dead substance, but an animate organism—just as the alchemists also insisted—and for Bruegel it has not only life but personality with moods and feelings. These moods and feelings express themselves in such phenomena as the weather and the change of seasons.

Bruegel is one of the first landscapists to concern himself with presenting accurate climatic conditions beyond the most obvious snow covering or sprouting branch. Weather is the outward display of the moods of this primary life. And there is a pattern to it. It is cyclical because once the higher power has put earth into being and sent it into its orbital path, it goes round and round forever. Nature, in this most elemental form, thus guides and rules man: the rains come regularly, the seasons change cyclically, the crops grow in rotation, and man too has his own circle from infancy to death. Nature, not man, is the measure of all things. For Bruegel, as Benesch succinctly put it, "One great mechanism is the content of the universe."[146]

571. PIETER BRUEGEL THE ELDER. *Harbor of Naples.* c. 1552–54. Panel, 16⅛ × 27½". Galleria Doria Pamphili, Rome

574. PIETER BRUEGEL THE ELDER. *Gloomy Day*. 1565. Panel, 46½ × 64⅛". Kunsthistorisches Museum, Vienna

575. PIETER BRUEGEL THE ELDER. *Hay Harvest*. 1565. Panel, 46 × 63⅜". National Gallery, Prague

The next in the series is the *Gloomy Day* (fig. 574), which has been called February and/or March, although the major activity here, the pruning of trees, and the fierce cold winds sweeping through the valley are usually associated with the former month. It is still cold and the damp winds blow the heavy storm clouds rapidly across the late afternoon sky, but one senses that a thaw has set in. The mood of the weather has changed abruptly and this is conveyed in the brisk, strong winds in the sky. A spring storm is brewing on the right and driving rain will soon drench the valley. Boats on the river are tossed about like corks on the choppy waves, and only a single white sea gull dares to fly in the darkened sky.

June is the month for gathering hay (fig. 575). This is one of Bruegel's most delightful and refreshing landscapes, and one can feel the warmth and moisture in the ground and air. Gone are the stark clusters of trees and the sharp breaks in the landscape; instead, we see rolling meadows of spongy green and yellow where the hay has been cut. Here the rolling character of the landmasses and the blending of the yellow and green colors of the distance are more natural in extension. A single tree to the right forms the framing device in the foreground, the relatively unobtrusive rocky cliffs opposite on the left slopes stop our view of the middle distance, and the faint details of the distant valley bring us to a smoothly contoured terrain on the horizon. The sky is bright and sparkling, although a slight haze conveys the feeling that the warm sun is drawing moisture from the ground into the air once more. Rubens was impressed by this painting, and he borrowed the charming motif of the three bouncing girls in the left foreground for his summer landscape, the *Return from the Fields* in the Pitti Palace.

August, the fourth in the series, is the time for the harvest of wheat (fig. 576), and it is hot and sleepy at midday in Bruegel's world. The freshness of early summer gives way to mugginess and the scorching heat of a steamy August day with the noontime sun turning the scene into a bleached terrain of white and golden yellow under a cloudless sky. The farmers have stopped their labor to rest or eat their lunch under a tree that offers little shade in the right foreground. Nature, after exerting herself at full speed these past few months, seems to grow slothful now that the work of the season nears to an end. Everything stops. Neatly trimmed fields of wheat form solid geometric blocks that mark off the bright foreground, and from this high plateau we look down across an expanse of green marked into squares by rows of trees and roads. No dramatic peaks interrupt Bruegel's peaceful terrain on this hot, lazy day.

There seems to be a lacuna in the series at this point, and we next come to November (fig. 577) with the herds returning from the mountain pastures to the village barns because it is now turning cold. A dark blue-gray storm gathers menacingly in the steely skies to the right. It will soon be dark, and the peasants hasten to lead the cumbersome bovines down the path to the village. The wind picks up in gusts, and signs of late autumn rain appear in the muddy browns of the foreground. Green and bright yellow are no longer colors in nature's wardrobe, and we sense that the farmers too are preparing for another long winter in heavier attire—note especially the bossman on the speckled horse. The anonymous workers trudge on, the three in the lower right being fine translations into paint of the *naer het leven* sketches discussed earlier, only here the costumes have no local color. They are the same tans and browns as the earth to which these figures now seem to return.

trating the months of the year for the wealthy banker Niclaes Jonghelinck that presumably were intended to hang together in a special room of his residence in Antwerp. The idea of such continuous landscape decoration reaches back to antiquity. The landscape-month series was, of course, a much beloved part of the calendars in Books of Hours, perhaps best represented in the famous miniatures of the *Très Riches Heures* (figs. 55–57), and it is to this tradition that Bruegel's belong.

One vexing problem is raised, however. Only five landscapes in this group survive; Jonghelinck's inventory lists the "twelve months" (*de Tweelf maenden*) and so it has been assumed that seven panels are missing. Some have suggested that only six were originally planned, that each painting represents two months, in which case only one has been lost.[147] There is one issue, however, which, to my knowledge, has never been addressed. In the calendar cycles in miniatures, at least four illustrations were devoted to courtly scenes. January in the *Très Riches Heures* is placed in a palatial banquet hall; April is an engagement party in a garden behind a castle; May is a procession of lovers on horseback before a towering arbor. In the tradition of the "Months" there has always been this alternation between the activities of the courtiers, who assume large proportions in the picture, and the working peasants who are reduced in size and scattered randomly in deeper landscapes.

The five landscapes by Bruegel illustrate only peasants working, which is surely in keeping with Bruegel's sentiments. It would be difficult, in fact, to imagine Bruegel designing a royal court event or, for that matter, presenting nobility in any major context. Another possibility then arises (but I do not highly recommend it). Perhaps panels of other series, such as the marriage cycle with the wedding banquet and the outdoor dancing, might have been involved. The measurements of these panels are nearly identical and they all date in the mid-1560s. Whatever the facts are, the problem remains: Which months are represented in the five paintings?

Hunters in the Snow (colorplate 83) has usually been identified as December and rightly so since it is the time for preparation of the winter feast. The singeing of the pig that takes place near the farmhouse to the left is one of the traditional activities for December, and the predominance of the hunters in the foreground further supports this identification. Hunters, in fact, appear in December in the *Très Riches Heures*. Snow lies heavily on the hilly ground, smothering the normal pastimes of the peasants, and the hunters return wearily with their hounds, tails between legs, down the hillside to the village along the steep slopes.

Nature has her moods and today it is cold, icy, and heavily overcast. There are no shadows cast across the white expanses; the air is still and crisp; tree branches can snap in this frosty weather; and while everything is caught in the spell of the cold, life is astir and the peasant activities continue. The hill descends to a broad valley of polders forming rectangular skating rinks for the children who are at play on the ice. A road continues through the valley beneath towering mountains covered with snow. The sharp, rocky peaks are not, of course, part of the Flemish scene, but were appropriated by Bruegel from his Alpine sketches, since, as we shall see, this landscape is carefully composed and not based on an actual topographical view.

The colors are somber. Black and dark brown silhouettes and tree trunks break up the flat expanse of white. The house fronts are deep russet; icy ponds are gray; the cloudless sky is a ruffled plain of green-gray. How cold it is, and how effectively Bruegel expresses this quiet, somber mood as a oneness in nature through the hunched silhouettes and the grid of horizontal, vertical, and diagonal lines that frame our view.

When compared to the world landscapes of Patinir and his school it is apparent that Bruegel imposed a rigid compositional scheme on his panorama. Everything is static yet carefully interlocked so that we do not rush through his landscape. As in the others, Bruegel observes the terrain from a bird's-eye perspective. We are high in the trees and look across to the blackbirds, who do not keep their perch long on the icy twigs. One flies off and invites us to follow its glide across the deep valley. The left foreground initiates a stark diagonal that cuts across the picture, and the evenly placed trees, like so many perspective posts, lead us into the valley below at a measured pace.

This drive is reinforced by the diagonal pitch of the rooftops to the left. The valley, thus framed solidly, leads along the ponds through the middle distance, where we briefly attend to the playing children, to the right where the diagonal movement continues to the foothills of the mountains that rise dramatically on the right margin. From there the direction shifts to the left again, and we are led to the distant harbor on the horizon.

In many respects this organization is simply a manipulation of the classical landscape formula of Italy that we have seen before where a repoussoir on one side directs us to the middle ground where we focus on another framing device that diverts our attention in the opposite direction to the far distant horizon. Here the static aspects of that movement are so strongly stated that we sense a deceleration in our response, that the earth has fallen asleep under the heavy blanket of winter, and, deprived of warmth and energy, man must move slowly through the cold evening of winter as best he can. It is late, and soon all will be huddled in their cottages.

574. PIETER BRUEGEL THE ELDER. *Gloomy Day*. 1565. Panel,
46½ × 64⅛″. Kunsthistorisches Museum, Vienna

575. PIETER BRUEGEL THE ELDER. *Hay Harvest*. 1565. Panel,
46 × 63⅜″. National Gallery, Prague

The next in the series is the *Gloomy Day* (fig. 574), which has been called February and/or March, although the major activity here, the pruning of trees, and the fierce cold winds sweeping through the valley are usually associated with the former month. It is still cold and the damp winds blow the heavy storm clouds rapidly across the late afternoon sky, but one senses that a thaw has set in. The mood of the weather has changed abruptly and this is conveyed in the brisk, strong winds in the sky. A spring storm is brewing on the right and driving rain will soon drench the valley. Boats on the river are tossed about like corks on the choppy waves, and only a single white sea gull dares to fly in the darkened sky.

June is the month for gathering hay (fig. 575). This is one of Bruegel's most delightful and refreshing landscapes, and one can feel the warmth and moisture in the ground and air. Gone are the stark clusters of trees and the sharp breaks in the landscape; instead, we see rolling meadows of spongy green and yellow where the hay has been cut. Here the rolling character of the landmasses and the blending of the yellow and green colors of the distance are more natural in extension. A single tree to the right forms the framing device in the foreground, the relatively unobtrusive rocky cliffs opposite on the left slopes stop our view of the middle distance, and the faint details of the distant valley bring us to a smoothly contoured terrain on the horizon. The sky is bright and sparkling, although a slight haze conveys the feeling that the warm sun is drawing moisture from the ground into the air once more. Rubens was impressed by this painting, and he borrowed the charming motif of the three bouncing girls in the left foreground for his summer landscape, the *Return from the Fields* in the Pitti Palace.

August, the fourth in the series, is the time for the harvest of wheat (fig. 576), and it is hot and sleepy at midday in Bruegel's world. The freshness of early summer gives way to mugginess and the scorching heat of a steamy August day with the noontime sun turning the scene into a bleached terrain of white and golden yellow under a cloudless sky. The farmers have stopped their labor to rest or eat their lunch under a tree that offers little shade in the right foreground. Nature, after exerting herself at full speed these past few months, seems to grow slothful now that the work of the season nears to an end. Everything stops. Neatly trimmed fields of wheat form solid geometric blocks that mark off the bright foreground, and from this high plateau we look down across an expanse of green marked into squares by rows of trees and roads. No dramatic peaks interrupt Bruegel's peaceful terrain on this hot, lazy day.

There seems to be a lacuna in the series at this point, and we next come to November (fig. 577) with the herds returning from the mountain pastures to the village barns because it is now turning cold. A dark blue-gray storm gathers menacingly in the steely skies to the right. It will soon be dark, and the peasants hasten to lead the cumbersome bovines down the path to the village. The wind picks up in gusts, and signs of late autumn rain appear in the muddy browns of the foreground. Green and bright yellow are no longer colors in nature's wardrobe, and we sense that the farmers too are preparing for another long winter in heavier attire—note especially the bossman on the speckled horse. The anonymous workers trudge on, the three in the lower right being fine translations into paint of the *naer het leven* sketches discussed earlier, only here the costumes have no local color. They are the same tans and browns as the earth to which these figures now seem to return.

ist been so enthralled by the music of the mountains as Bruegel; his sketches have the lofty structure of a fugue by Bach and, at times, the majestic drama of a Beethoven symphony. There is good evidence that Bruegel made a grand tour of the Alps, and if one can project himself back to the mid-sixteenth century, that surely must qualify as a heroic mission in itself. Van Mander puts it rather coarsely: "While he visited the Alps, he had swallowed all the mountains and cliffs, and, upon coming home, he had spit them forth upon his canvas and panels."

From his lofty perch Bruegel looks down at a world with people scattered like ants far beneath his feet. Is there some guiding principle to it all? Is there a reason behind their actions and movements; is there a pattern to this cosmic carpet? Bruegel's concept of Godhead, one must admit, is quite different from the divinity envisaged by Jan van Eyck and Rogier van der Weyden.

Bruegel's God does not seem to assume the shape of man or his personality; for Bruegel the higher power is something that resides in his landscapes, and the meaning of life and the patterns of being that emerge through a study and contemplation of nature in its most basic form—the essence of nature—are what he wants to capture. This is revealed in a study of the earth itself and the various forms that grow out of it: the plants, water, animals, man are all offspring of the earth. Nature, one might say, is an animate organism itself. A new philosophy of nature appears in Bruegel's landscapes just as it does in Western thinking during the course of the sixteenth century, and this study is grounded not in the ideal world of abstractions but in scientific investigations of the *orbis terrarum* as well as the solar system and, to some extent, in the discoveries of explorers of the New World.

In this light, Bruegel's associations with the leading intellectuals in Antwerp should be considered seriously. His friend, the cartographer and geographer Abraham Ortelius, who wrote that Nature feared Bruegel's genius, would certainly have been a source for his knowledge of the physical makeup of the earth, its varied features, and its position in some greater system. We should remember Ortelius when we look at Bruegel's sweeping panoramas of the globe and realize that it is not just by chance that the earth often shows a curvature on the horizon.

While one can scientifically describe the physical makeup and the mechanism of this world set in motion, there remains a mysterious Godhead that gives it life and soul. And what is this world "life and soul" for Bruegel? Reaching back to basic principles devised by pre-Socratic philosophers, to an early system loosely called hylozoism, the basic elements of the earth—fire, water, earth, and air—are already living things; they breathe, grow, and die, just like flora, fauna, and man. Matter and life cannot be separated. Earth is not a dead substance, but an animate organism—just as the alchemists also insisted—and for Bruegel it has not only life but personality with moods and feelings. These moods and feelings express themselves in such phenomena as the weather and the change of seasons.

Bruegel is one of the first landscapists to concern himself with presenting accurate climatic conditions beyond the most obvious snow covering or sprouting branch. Weather is the outward display of the moods of this primary life. And there is a pattern to it. It is cyclical because once the higher power has put earth into being and sent it into its orbital path, it goes round and round forever. Nature, in this most elemental form, thus guides and rules man: the rains come regularly, the seasons change cyclically, the crops grow in rotation, and man too has his own circle from infancy to death. Nature, not man, is the measure of all things. For Bruegel, as Benesch succinctly put it, "One great mechanism is the content of the universe."[146]

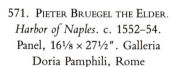

571. PIETER BRUEGEL THE ELDER. *Harbor of Naples.* c. 1552–54. Panel, 16⅛ × 27½". Galleria Doria Pamphili, Rome

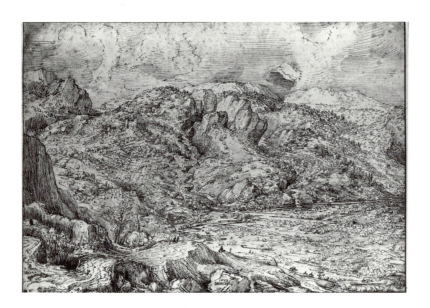

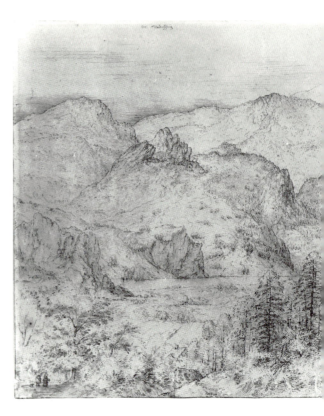

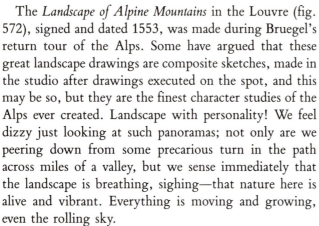

above: 572. PIETER BRUEGEL THE ELDER. *Landscape of Alpine Mountains*. 1553.
Pen drawing, 9¼ × 13½". Cabinet des Dessins, The Louvre, Paris

right: 573. PIETER BRUEGEL THE ELDER. *Mountain Landscape "Waltersspurg."*
c. 1553–54. Pen drawing, 12⅝ × 10⅝". Bowdoin College Museum,
Brunswick, Maine. Bequest of James Bowdoin III

The *Landscape of Alpine Mountains* in the Louvre (fig. 572), signed and dated 1553, was made during Bruegel's return tour of the Alps. Some have argued that these great landscape drawings are composite sketches, made in the studio after drawings executed on the spot, and this may be so, but they are the finest character studies of the Alps ever created. Landscape with personality! We feel dizzy just looking at such panoramas; not only are we peering down from some precarious turn in the path across miles of a valley, but we sense immediately that the landscape is breathing, sighing—that nature here is alive and vibrant. Everything is moving and growing, even the rolling sky.

Bruegel uses a variety of pen strokes in the foreground area that adjoins the rugged road leading down the hillside to the left. His strokes are bold and heavy and create a sturdy ground for our entry. Below, the strokes are fainter and sketchier as the geology changes from bedrock to velvety meadowland. In the foothills and rising slopes of the mountain range Bruegel then uses tiny pen dots to suggest the vibrating life moving in the tiny trees like particles of energy exploding amid the darker tones of the hillside.

By varying the direction and intensity of the strokes and scattering the tiny dots like random punctuation across the panorama, Bruegel achieved an incredible sensuous effect through texture in his landscape. Just as in oriental landscapes, each variety of brushwork or pen stroke here seems to have an appropriate vitality to give the different forms in nature. Rocks and cliffs are treated

with darker, longer lines, the grassy meadows with yet a different, softer application, the flowering trees with little more than dots. Bruegel's landscapes thus appeal more to our senses than our intellect or curiosity. And man is found here and there—look carefully and you will find two fortified castles, five villages, and a waterwheel—but he is merely a minor outgrowth, almost a tiny blemish, of this pulsating world.

A landscape sketch in Bowdoin has been identified as Waltersspurg on the Vorder Rhein on the basis of an inscription added later to the top edge (fig. 573). Bruegel's technique is especially revealing in the contrasts between the pen strokes in the foreground and those in the distant river valley below the mountains. What appears at first sight to be a softly textured glimpse of nature filtered through a slight haze is on closer inspection a highly differentiated study of the effects of light on vegetation and rocky masses breaking through rounded hills.

In the foreground the dense pine trees are sketched with sharp, packed horizontal strokes in parallel; to the left the deciduous varieties are rendered with fainter parallel strokes on the undersides and fleeting dots along the crowns of clumps of leaves in an almost impressionistic fashion. In the hills beyond, the sharper cliffs take on long, regular vertical strokes to contrast with the subtle dotting technique that describes the bushy hillsides. In each formation the strokes follow the contours of the structure much as they do in the landscape drawings of Van Gogh.

In 1565 Bruegel executed a series of landscapes illus-

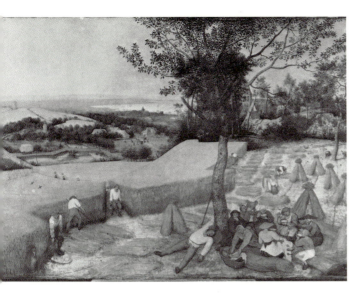

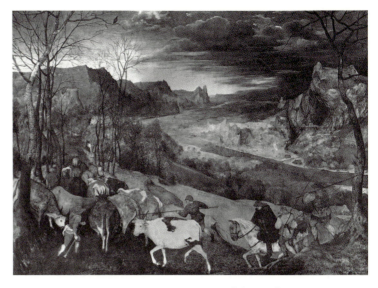

576. PIETER BRUEGEL THE ELDER. *Wheat Harvest*. 1565. Panel, 46½ × 63¼″. The Metropolitan Museum of Art, New York. Rogers Fund, 1919

577. PIETER BRUEGEL THE ELDER. *Return of the Herd*. 1565. Panel, 46 × 62⅝″. Kunsthistorisches Museum, Vienna

Bruegel's composition is masterfully laid out. Again we find trees and mountains on the borders that serve as frames for the broad panorama, but the sense of movement and space is mostly achieved through the repeated diagonals of the landscape. The river makes the division cutting across the rusty foreground; on its far banks the tones in the hills and mountains gradually change from a frosty brown to a steel-blue almost imperceptibly. And once again fantastic rock formations impose their cold forms and jagged shapes on the earth. Prospects for the winter look desolate.

Bruegel's "Months" are some of the most memorable landscapes in Western art history. In spite of the fact that they were hastily painted—in many areas the thin surface coats reveal the sketchy underdrawings—they are masterfully composed, and how subtly these formal means lead our eyes through the landscape at the proper tempo for each season. It all seems so intuitive and spontaneous. Bruegel's sense of scale is awesome, from the flat fields of August to the towering mountaintops of November, the figures are staggered with a keen awareness of scale. Finally, the conditions of climate are incredibly conveyed. How universal is that common topic of every man's conversation: "How's the weather today?"

There remain two paintings that I should like to discuss in the context of Bruegel's landscapes, and they are exceptional in that they illustrate familiar narratives. Bruegel painted a number of traditional religious subjects that appear as everyday events in the happenings of village life. The Nativity scene becomes *Mary and Joseph Arriving for the Census* at a local inn in Bethlehem (Brussels); the *Adoration of the Magi* is treated as a colorful winter cityscape with large, wet flakes of snow falling across the town square, and the three kings are nearly lost in the

hubbub of curious peasants gathering about the entourage of the Magi (Winterthur). The famous *Massacre of the Innocents* in Vienna is another winter scene with the colorful silhouettes of the red-coated soldiers of Herod attacking mothers protecting their children in the frosty market square of Bethlehem.

Bruegel allows nature to comment, especially in his awesome version of the *Carrying of the Cross* (fig. 578). On a cold, damp Friday afternoon in early spring, crowds of townspeople tramp through muddy fields outside the city walls of Jerusalem toward the hill of the skull, Golgotha, where executions normally take place, and it is all quite a noisy spectacle for everyone except the victims. For many of the children it will be their first crucifixion. It has been raining and mudholes pock the quagmire of slush and stones that forms the broad road up the hill, where a packed circle of onlookers has already gathered at the spot where three crosses will be raised for the crucifixions of two thieves and Christ.

The *Carrying of the Cross* or *Road to Calvary*, also owned by Jonghelinck, is one of Bruegel's most astonishing paintings, for here humorous anecdote turns to epic tragedy, and the presentation of this grave episode in the Passion cycle contains an especially poignant message, a most disconcerting statement about raw human behavior. Bruegel has posed the question: What would it really be like if the Crucifixion were to take place this very Friday in the place of execution outside of Brussels? What would we see? How would the people react? What would be the sentiments of these scores of Flemish observers of a public execution if it were Christ facing death?

As if to make this question blatant, Bruegel has composed his *Road to Calvary* with a sharp rocky foreground

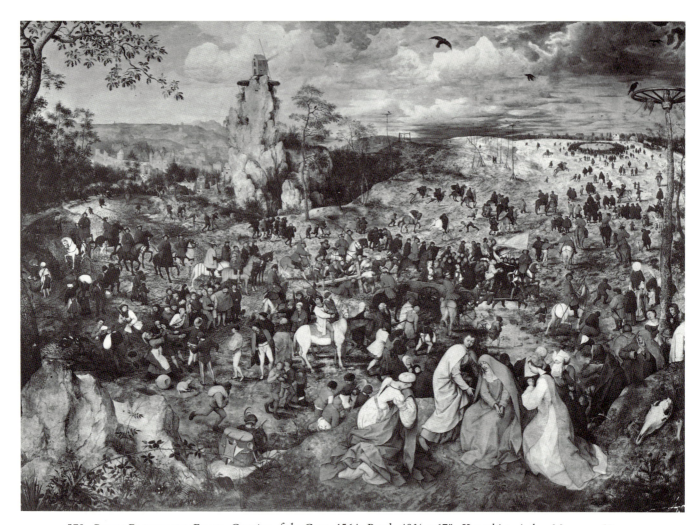

578. PIETER BRUEGEL THE ELDER. *Carrying of the Cross*. 1564. Panel, 48¾ × 67″. Kunsthistorisches Museum, Vienna

ledge behind which we stand and look over into a broad plain below. The holy figures, the Virgin, John the Evangelist, the Magdalen, and another of the Marys, are artificially posed there in the conventional arrangement of the mourners under the cross in Crucifixion paintings. Here the poses, in fact, hark back ultimately to Rogier van der Weyden's *Deposition* in the Prado (colorplate 20) in the strained gesture of the Magdalen and the swooning postures of the Virgin and Saint John. Even the draperies of these figures are archaic, displaying the intricate angular overlaps and hard creases of Rogier's types.

Anyone viewing Bruegel's painting would recognize these figures as old-fashioned and purposefully anachronistic intrusions into the panorama that unfolds beyond. They remind the viewer that this is an event of momentous consequence for the church, for the very doctrines and devotions that the townspeople daily follow by rote. But, in truth, this crucifixion will be just another gory attraction for the mobs and it will give the children a special recess from their chores to play games, fight, wade in puddles, snatch what they can from unwary spectators, and see an exciting happening.

The hordes, for their part, seem to be more interested and concerned about the two thieves being transported in a horse-drawn cart than they are about the man who struggles and falls under the weight of the heavy wooden cross he is forced to carry. Can you find him? He is on his knees, wearing a purple mantle, directly in the center of the picture behind the cart. Ironically, a priest rides in the wagon with the thieves, administering last rites.

No one helps Christ in his agonizing ordeal. Simon of Cyrene, who usually lifts the end of the cross to reduce its weight, has been arrested and pulled to the side. He stands in the lower left between soldiers while his wife battles them furiously for his release. Spectators notice, but then they turn away and continue on. Behind, follow the mounted soldiers, red-coated members of the civic guard who momentarily stop to see what all the fuss with the little man and his wife may be about. A peddlar sitting comfortably on a slope just below the holy group turns his head to watch the commotion as well.

Everyman is here and will not miss any of the action taking place; he will join the others to witness the gruesome finale and then be on his way. Bruegel knows mob psychology and these are the reactions of Everyman. But the picture is a landscape, and what does nature say? It

has been a warm and sunny morning, the sun still shines brightly on the distant rooftops of Jerusalem to the far left, but over the hill of Golgotha a storm is gathering, one that will soon bring wind, rain, lightning, and darkness. Nature in the springtime is resurrected, reborn, and the leaves and buds on the trees and the weeds sprouting in the foreground give evidence of the return of a cycle of life, not the end of one. The sky announces that contradiction, but then the weather will change again shortly.

In the *Carrying of the Cross* Bruegel reveals his genius again in composition, although at first sight it may seem little more than an expansive, horizontal frieze of many figures in a landscape. One can find the framing devices. A dry tree on the right marks the foreground. Atop it is fixed a cartwheel for the dead to be offered to birds of prey. Bits of carrion still hang from the spokes. Another tree, a flowering oak, establishes the left margin, and just off center, to the left, one of the Mannerist cliff masses forms a focus in the middle ground.

But here Bruegel does not follow the conventional three-distance formula for organizing space in easy steps. Rather, the composition is based on the repetition of circular movements throughout—large circles, small circles, embracing and echoing each other—for this picture of the death of Christ represents one of the most fundamental cycles of life and nature to be found. The cycles or circles are broadly established in the enormous arcing road that swings from Jerusalem's walls around and up to the site of Golgotha. It thus begins with a circle, the

walls of the city, and culminates with another, the circular crowd gathered on the hilltop on the opposite side. The curious cliff that rises so abruptly in the center of the landscape serves as a giant hub for the movement in general.

And as if to telescope nature into everyday routines once again, Bruegel places atop the rocky needle an inaccessible windmill whose blades will pick up the fury of the winds and through their spinning motion convert nature's energy into human use. So nature moves in cycles, as do the year, the seasons, the activities of man, the life of man. The death of Christ is another cycle completed. Surely there is a moral in Bruegel's genre-like Passion painting, but we cannot say whether or not the elemental forces express disconcern or any sentiment translatable in terms of human emotion.

Bruegel's works show a surprising disregard for classical mythologies just as his impressions of Italy were unusually void of the wonders of antiquity that inspired all others. But he did paint one impressive mythological theme, the *Fall of Icarus* (fig. 579), which in some respects is more ironic than his *Carrying of the Cross*, albeit the irony is very subtle. By now we are familiar with Bruegel's exceptional inventiveness in landscape composition, and while there is some dispute as to the authorship of the Brussels painting here illustrated—some believe Bruegel's work survives only in copies—there can be no question about the "inventor."

Bruegel realized the momentous implications of the myth, the flight of Daedalus and his son Icarus across the

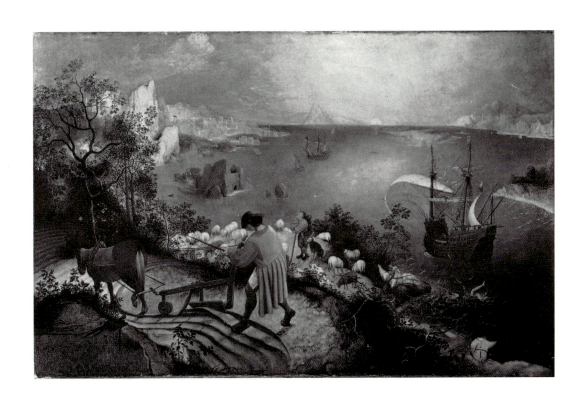

579. PIETER BRUEGEL THE ELDER (replica?). *Fall of Icarus.* c. 1555–56. Panel transferred to canvas, 29 × 44⅛″. Musées Royaux des Beaux-Arts, Brussels

skies in their escape from Crete, since he again fashions his composition in a series of large, generous arcs that sweep across the picture culminating in the broad horizon with its own slight curvature. The story he tells, however, is an odd one. Daedalus and his wax wings do not appear in the skies anywhere. Perhaps the panel has been cut down, perhaps not, but that would not account for the fact that the sun is setting and is not near its zenith, when it would have been hot enough to melt the wax wings of the hapless Icarus. But Icarus is in the picture. In the lower right corner the lower legs and feet of the daring son can be seen as he plunges into the sea.

Bruegel's story is based on verses of book eight in the *Metamorphoses* of Ovid, where we read how the artist Daedalus made the wings of wax and feathers while his son, ''artless'' Icarus, was often in the way, and then how the father warned the son not to fly too high or near the sun lest the wax melt, which, of course, the foolish Icarus did. Ovid continues: ''Far off, below them, some stray fisherman, attention startled from his bending rod, or a bland shepherd resting on his crook, or a dazed farmer leaning on his plough, glanced up to see the pair float through the sky, and taking them for gods, stood still in wonder.'' The fisherman with his rod, the shepherd resting on his crook, and the ploughman are the three figures in the foreground of the painting, but they do not see the fallen Icarus. Auden, in his poem, *Musée des Beaux Arts*, understood Bruegel's intent:

In Brueghel's *Icarus*, for instance: how everything
 turns away
Quite leisurely from the disaster; the ploughman may
Have heard the splash, the forsaken cry,
But for him it was not an important failure;

Perhaps Bruegel is commenting on the vanity of scientists in his painting and the consequences of their pride in their devices and inventions. And yet there may be even more, considering Bruegel's interest in simple peasant wisdom as expressed in their proverbs. Perhaps, in fact, Bruegel is telling us that the coarse chaff of the peasant can match the sweet wheat of the mythographers even in this story. If one looks closely in the left margin of the painting, halfway up, within the copses beside the furrowed fields, one can make out the shiny pate of a recumbent man, a dead man, and this assuredly is meant to express the old Netherlandish saying, ''No plow stops over the death of any man,'' or over Bruegel's Everyman, a clever footnote that reveals, after all, that peasant wisdom can be as profound as that of the ancients.

The pessimism that underlines many of Bruegel's works has led to much speculation over his personal religious affiliations. Was he sympathetic to the Protestant cause that was turning the Netherlands into a violent battleground or did he remain loyal to the Catholic church? One cannot really say on the basis of his patronage since we know that among his admirers was Cardinal de Granvelle. He was apparently a highly respected citizen in a city fully committed to the Catholic position in the turmoil. Yet Van Mander remarked how Bruegel ''made many skilful and beautiful drawings [for engravings]; he supplied them with inscriptions which, at the time, were too biting and too sharp, and which he had burned by his wife during his last illness, because of remorse, or fear that most disagreeable consequences might grow out of them.'' It is a fact that some of his drawings for Cock had changes made in them—a papal tiara was turned into a simple pointed hat—and many scholars have found anti-Catholic references in some of his paintings. The white-bearded Herod in the *Massacre of the Innocents* has been identified as the duke of Alba, and other slanderous details have been pointed out in other works, but it would be difficult to assess Bruegel's stand here.

Perhaps Bruegel enjoyed and shared the company of the liberal intellectuals in Antwerp and Brussels who refused to make staunch commitments but rather took the extremes and absurdities of the religious conflicts in their stride. There was a semi-religious organization in Antwerp called the Family of Love (*schola caritatis*), an intellectual and international fellowship of scholars and others devoted to peace in troubled times. The Family was a secret organization, not favored by the church or state because it was pledged to promote friendship among all religions, Christianity, Judaism, Islam, whatever. They had no rites or rituals, no ceremonies, and they did not ban membership in any religious group since they argued that it was acceptable so long as it did some good. Christopher Plantin, the printer, belonged, and so did Bruegel's friend, Abraham Ortelius. We do not know if Bruegel enrolled in the Family of Love, but very likely he would have found their organization compatible. We simply do not know; it is like trying to determine Rembrandt's religious beliefs and affiliations.

Fontainebleau and the Court Style in France

The turn of the century was relatively undistinguished in the art history of France. Jean Perréal, court painter for Charles VIII, Louis XII, and Francis I, is the only outstanding name that appears in the annals, and while we know a considerable amount about his life, very few works can be attributed to him.[148] He accompanied the monarchs on their campaigns in Italy, and in 1502 he very likely met Leonardo da Vinci. Like so many others of the period, Perréal fancied himself more than just a painter. He was a learned poet, philosopher, and astronomer, and his services were much in demand in the court circles. Margaret of Austria commissioned Perréal to design the tomb of her husband, Philibert II of Savoy, in the royal church of Brou at Bourg-en-Bresse, and he was active as the *valet de chambre* to Francis I until his death in 1530.

His role as a portrait painter is clear in many documents, and one certain work by Perréal, the *Portrait of Louis XII* (fig. 580), painted about 1512–14, listed in the collection of Henry VIII in inventories of 1543, is perhaps a typical example of his style. The portrait of Louis XII would be difficult to place were it not for the documentation, since it has little stylistic affinity with those of any other painter in France of his period (the Master of Moulins was a near contemporary), but it is a competent, if not somewhat prosaic, variation on the three-quarter bust portrait so ubiquitous in northern Europe around 1500. If anything, it strikes one as being a bit retardataire and conventional. Perréal's fame, it must be reckoned, was not wholly due to his achievements as a painter.

Contacts with Italy were of extreme importance for the next few decades in France, however, and it was in the person of Francis I, king of France (1515–47), that a surprising development took place in and around Paris, more specifically at the royal hunting lodge, Fontainebleau, that gives French art of the mid-sixteenth century and later a special niche in our study of the Renaissance in the North, and, at the same time, sounds a fitting swan song for the cultural developments there.

The longing for a Latin kingdom in France can be

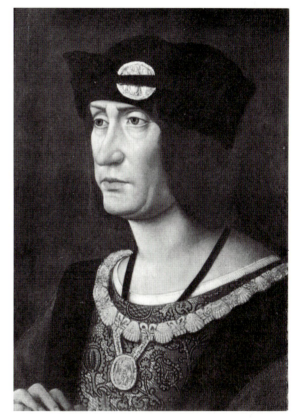

580. Jean Perréal. *Portrait of Louis XII*. c. 1512–14. Panel, 12 × 9″. Royal Collections, Windsor Castle. Crown Copyright Reserved

traced to King René and his ties to Naples, but, as we have seen, his Renaissance, while poetic and exotic, was short-lived (see p. 249). Charles VIII had invaded Italy in 1494 and had returned with twenty-two skilled craftsmen to assist in the building of his château at Amboise on the Loire. But it was with the expeditions of Francis I that the wholesale importation of Italian Renaissance art and artists took place, for Francis, a self-styled connoisseur, was intent on establishing a glorious court center that would equal any of those of his rivals in Europe. In many respects the concern for an art for the monarchy was a revival of the great Valois court culture of the four-

teenth and fifteenth centuries, and Francis was determined that his fountain of culture would flow with waters from the source: Italy.

Francis I thus initiated a regular program of recruitment to those ends. The pride of Italy, Leonardo da Vinci, spent his last years at Cloux under Francis's patronage (1516–19), although the great Florentine contributed little in his old age. Andrea del Sarto endured a hapless year in France under his sponsorship. The famed metal sculptor, Benvenuto Cellini, became a director of many of Francis's programs, and, as for architects, Sebastiano Serlio and Giacomo da Vignola both worked for the French king.

Serlio, the lesser architect, was actually one of the most formidable influences in the North. His treatise on architecture, dedicated to Francis I in 1540, is filled with Vitruvian principles, and it is there that the conversion of Gothic buildings into Italian Renaissance structures down to details of chimneys and gateways spread the quasi-classical style of Serlio throughout northern Europe.[149] We have already encountered one influence of Serlio, highly praised by Van Mander, in the translations into Flemish of Serlio's works by Pieter Coecke van Aelst (see p. 430). The accomplishments of the art of painting under Francis I are relatively obscured because of the loss of so much, but it can nevertheless be considered momentous, and Fontainebleau, his favorite residence, served as the filter through which much of the Italianism passed on its way north during the course of the sixteenth century.

Much more is known in the history of literature, and this should briefly be mentioned with regard to the other arts at Fontainebleau. Thanks in part to the open-minded interests of Francis's sister, Marguerite of Navarre, her own literary contributions and those of her court poet, Clément Marot, paved the way for the school of the Pléiade, the learned and scholarly poets and literati under Henri II so well known in French literature.[150] Essentially, the poetry of the Pléiade was a direct reflection of what was being nurtured in the arts under Francis I in its establishment of a literary ideal based on the classics with proper linguistic patterns derived from antiquity but with an emphasis on the inherent beauty and lyricism of the French tongue, especially in the bucolic flavor of the poets added to the mythologies of the ancients.

It was in their poetry that Diana became the image of the goddess par excellence, ranking even over Venus, and where the strange but beautiful associations of the countryside, the grotto, the wooded pond, and the romantic forest became the setting. Later we will study more closely the image of Diana as the court artists portrayed her. If more were known about Fontainebleau, an extremely important tree in the genealogy of French culture could be traced, one that has its roots in its own romantic Gothic past, its nourishment from an Italian sun, and its final fruition in the French classical Baroque expression of Poussin and Versailles.

Fontainebleau was appropriately named, and its allusive history in some respects further enhances its role in French art history. After the defeat of Francis I by the Hapsburg Charles V at the Battle of Pavia in 1525, the French monarch was for two years held captive in Madrid. The circumstances of the truce and the king's release are unclear in detail, but by 1527, Francis I was in his Parisian residence. It was at that time that he decided to raise his imperial image across Europe, and he chose as his showplace the old Gothic castle at Fontainebleau, on the Seine near Paris, amid the quiet woodlands and refreshing ponds.

The master mason, Gilles Le Breton, was assigned the project of converting the old-fashioned lodge into a Renaissance palace without removing too much of the original walls. A new entrance, the Porte Dorée, was added to the Cour de l'Ovale of the old castle, and behind the keep a long, low corridor was remodeled in a quasi-classical idiom to become the famed Galerie François Ier. A large wing on the north side of the château, the Cour du Cheval Blanc, was also constructed, and these parts of the new Fontainebleau survive in ground plan if not entirely in elevation. The exterior of the Galerie was rebuilt under later monarchs, as were the ballroom, the chambers for the king, the queen, and the king's mistress, the Duchesse d'Etampes.[151] While much of the structure has thus either disappeared or been completely remodeled and absorbed in later buildings, much of the internal decoration survives or can be reconstructed on the basis of engravings made between 1542 and 1548 and in numerous preparatory drawings.

It is the interior decoration that concerns us here, and together with the fragmentary remains and the reconstructions much can be put back in place reliably. One must remember that sumptuous tapestries once lined the walls, and that a number of Italian masterpieces, including paintings by Leonardo, Raphael, Andrea del Sarto, Titian, Parmigianino, Giulio Romano, Bronzino, and other artists collected by the monarchs, embellished the chambers. Under Primaticcio, soon to be discussed, bronze and plaster casts were brought to Fontainebleau, including those of the *Apollo Belvedere, Laocoön, Marcus Aurelius, Trajan's Column*, and Michelangelo's *Pietà* in Saint Peter's. The emulation of the Italian scene was so complete that Vasari was led to call Fontainebleau the "Second Rome."

According to an old tradition, the Italian poet Aretino sent Francis I a drawing of "Mars Led to Venus by Cupids and Graces," an allegory on the marriage of Francis

581. Rosso Fiorentino. Galerie François Ier. 1533–40. General view. Château of Fontainebleau

to the sister of Charles V, Eleanor, as a personal recommendation for the Florentine Mannerist painter Rosso Fiorentino to head his new project.[152] Accordingly, Francis employed Rosso, from 1530 until the artist's death in 1540, to be director of the decorations at Fontainebleau, and while little survives that was actually touched by his hand, much of the program of decoration for the Galerie is surely Rosso's invention.

The style of Rosso, Florentine Mannerism, is best known from the frequently reproduced *Moses Defending the Daughters of Jethro* in the Uffizi, painted before Rosso came north, and has been characterized as violently anticlassical with exaggerated poses and harsh gestures with little regard for anatomical clarity or Renaissance concepts of figures in space. His art explodes with the force of a spiritual expressionist, and any formal organization is shattered by the arbitrary juxtaposition and cramping of arms, torsos, and heads into an angular surface pattern. If Rosso's style then seems to break completely with the idealism of the High Renaissance—and that is what Francis wanted—while he was active in Italy, it suddenly mellowed when he arrived at Fontainebleau, and there his proclivities for the capricious and the alarming were channeled into a highly decorative mural art filled with invention, fresh and frivolous.

The Galerie François Ier (fig. 581) must have struck the Italian decorator and his assistants as an oddity with its extreme length and low ceiling. A longitudinal scheme of decoration was devised by Rosso that first divided the wall elevation horizontally in two parts, the lower half filled with simpler paneling and the upper combining high-relief stucco figures and frames bordering painted panels at regular intervals or bays. The effect

is highly original and very sumptuous, and while models for the general layout have been traced to High Renaissance schemes of decoration that Rosso would have known in Italy, the effect is totally new. The bold combination of large stucco reliefs in the form of standing nude figures, elaborate cartouches, and fanciful strapworks in between is new in the high relief and prominence of the stuccowork (fig. 582). Considered a hallmark of Rosso's Fontainebleau style are the stucco strapwork embellishments. These unusual additions resemble thick pieces of leather rolled, folded, and cut into fantastic shapes of infinite variety. Inspired in part by Michelangelo's moldings and Italian engraved designs, this capricious strapwork became part of the Mannerist vocabulary that spread throughout the North.

The upper level, divided on each wall into seven large bays or compartments, is sumptuous in the diversity of Mannerist decor of every sort. The large standing caryatids in high stucco relief present an amazing variety of nude forms as the main framing devices. Some of them

582. Rosso Fiorentino. *Male Nude*. 1533–40. Stuccowork decoration in fig. 581

583. Primaticcio. *Four Nymphs*. 1541–44. Stucco wall decoration in the Chambre de la Duchesse d'Etampes, Fontainebleau

seem to have been inspired by Michelangelo's grisaille prophets and sibyls seated on huge thrones with *putti* on the Sistine Ceiling, but in style they are closer to the caryatids painted as frames in Parmigianino's ceiling at Santa Maria della Steccata in Parma (1531–39) or those designed by Giulio Romano for the Sala di Constantino in the Vatican (1520–24). These lively and attractive stucco figures were very likely designed and executed under the direction of an important assistant, Primaticcio, but while the separation of hands involved in the actual execution of the sculptures, the paintings, and other areas of the decoration is difficult if not impossible to determine, particularly in light of numerous restorations, the authority behind it all was undoubtedly Rosso.

If the decoration of the gallery is complex, allusive, and whimsical, the iconographic program presented is even more baffling. One thing is clear: in the twelve narrative paintings marking each bay (*travée*), a complex pictorial encomium or panegyric to the monarch, Francis I,

was foremost. But rather than conforming to the elaborate but decipherable programs that we find in Italian High Renaissance mural schemes, that of Fontainebleau presents an ensemble of large paintings with hidden clues and patterns of motifs that not even the best Sherlock Holmes of the iconographers can unravel adequately.[153]

Some meaning can be discerned in the sequence of paintings if one reads them in parallel, that is, in pairs across the gallery and not in longitudinal series down the walls. The first two sets of themes, admittedly difficult to identify with certainty, appear to present Francis I as godsent to the throne, a promoter of the arts, an enforcer of national unity, and a symbol of the cosmocrator: the Banishment of Ignorance opposite a divine adventus or birth of the monarch; the unity of his state and the glorification of his leadership (the hieroglyph of *l'elephant fleurdelysé*). The next pairs present a more personal biography in allegorical forms of filial piety and personal tragedies; the final sets illustrate the proper upbringing of the youth and the frustrations of warfare.

The paintings have been heavily restored and repainted (a set of tapestries in Vienna copies them, 1540–50), but from what remains the style displays more Italian Mannerist surprises than profound narration. The very incomprehensibility of the iconography invites us to dwell on the richness of the detail and the decoration more than on the complex propaganda of the court presented, and it is the unusual combination of the secondary figures in stucco and the ornament that surround the central pictures that enhances our trip down the gallery. While the idea of juxtaposing high stucco reliefs and cartouches with capricious strapwork was undoubtedly Rosso's, the designing and execution of these parts, especially the full-standing nude figures, were given to his talented assistant Primaticcio, his successor at Fontainebleau after 1540.

Primaticcio's figure style gave the Fontainebleau school its distinctive Mannerist character. Born in Bologna in 1504, Primaticcio had worked with Giulio Romano at Mantua and had encountered Raphael's style in its more graceful Mannerist idiom of Parmigianino before he left Italy to assume his post under Rosso in 1532.[154] His stucco caryatids are the very essence of the Fontainebleau style in both sculpture and painting (see fig. 583). These willowy figures have long, smoothly textured limbs that taper elegantly in the fashion of Parmigianino's female saints. A certain nonchalance seems to enter their sensuous postures and turnings, and their gently tapering shoulders move gracefully into long necks, like those of swans, that are joined to small heads with distinctive classical profiles. There is nothing abrupt in the movements of these marvelous figures; they sway effortlessly into place amid the profusion of decoration

584. After Primaticcio. Ceiling of the Galerie d'Ulysse, Fontainebleau. c. 1545. Engraving by Jacques Du Cerceau

about them, giving the whole ensemble the magnificence of chryselephantine (ivory and gold) jewelry and metalwork magnified to grandiose proportions.

Much of the painted decoration of Primaticcio has been lost or poorly restored, but extant drawings and engravings after his designs are in complete contrast to the more forceful style of Rosso, where the emphasis is on harsh line and dramatic articulation and modeling. In the Galerie d'Ulysse, filled with intricate ceiling and wall decor in a snowflake pattern of fields, fifty-eight mythological stories appear. The decoration is lost today, but the overall scheme is preserved in an engraving by a later architect and decorator, Jacques Du Cerceau (fig. 584). A few of the pictures further survive in preparatory sketches and engravings, and one painting, attributed to Primaticcio himself, is apparently a variation on the Galerie scene of *Ulysses Reunited with Penelope* (colorplate 84).

The erotic overtones in much of Primaticcio's art are here captured in the shaded intimacy of the bedroom scene and in the delicacy of gesture by which Ulysses lightly touches the face of his beautiful wife. Their stares also convey the inner thoughts and desires of a husband and wife at long last together again (*Odyssey* 23: 297–309). Ulysses resembles some mighty but drowsy river god awakening peacefully, and the pearly surface of Penelope's flesh and her delicate Grecian profile are aspects of Primaticcio's ideal of feminine beauty.

Primaticcio supervised a large workshop until his death in 1571, and he was no doubt recognized as the mastermind behind many of the programs at Fontaine-bleau after Rosso's death. The bucolic was as much a part of the court interests as the mythological, and the desire for landscape settings required specialists in that category of representation. Some of these were Flemings, who had an international reputation for the painting of landscapes, but the most impressive was another Italian, Niccolò dell'Abbate, born and trained in Modena, who joined Primaticcio in 1552 and assisted him in the decoration for the Galerie d'Ulysse and other chambers.

A number of Niccolò's paintings survive to give us an idea of his contribution to the rich repertory of art at Fontainebleau, which had by then become the residence of Henri II. In many respects, this second phase or generation of activity at the French court represents the epitome of the style as we know it today. If one combines the lithesome nudes of Primaticcio with the sensuous landscapes of Niccolò dell'Abbate, the true character of French art of the sixteenth century is capsulized. Only the taste for the erotic and the fanciful appears to be genuinely French, the figure style is wholly Italian Mannerism, while the Netherlandish or Northern contribution appears to be nil. However, in the landscapes of Niccolò a spiritual kinship seems to exist with the Netherlandish specialists of the time, and some authorities have even claimed the influence of the Patinir school in Niccolò's delight in painting lofty mountain peaks that echelon on and on to the distant horizon and in his romantic fantasy harbors bathed in sunshine. Whatever, Niccolò's landscapes are refreshing additions to the graceful, long-legged beauties of Primaticcio who inhabit them.

585. NICCOLÒ DELL'ABBATE. *Eurydice and Aristaeus*. 1557. Panel, 74½ × 93½″. National Gallery, London

The landscape with *Eurydice and Aristaeus* (fig. 585) is typical of the French interest in combining the bucolic and the mythological. Aristaeus, son of Apollo and Cyrene, was worshiped as the protector of shepherds and their flocks, the bees, the grapevines, and the olive groves. Roaming in his fields one day, he spied the fair Eurydice, wife of Orpheus, and fell in love with her. Later, aided by one of her companions, Aristaeus found her in a grove and pursued her. Eurydice, in wild flight from her seducer, was accidentally bitten by a serpent and died in the meadows. Hence, the prologue for the familiar tragedy of Orpheus and Eurydice in Hades.

The story in Niccolò's painting unfolds with the tiny porcelain-like figures of lightly clad nymphs in the foreground. The frieze of little figures caught in three acts of the tragedy forms a colorful accent to the dreamlike landscape that unfolds behind them. A dark green row of trees and shrubs forms the coulisse for the drama, and behind it several layers of wispy greens, browns, and blues glide gently downward from the left margin, where a dark tree enframes the whole vista. Towers, rooftops, and obelisks, painted in light blue touched with white, sparkle along the softly sloped hills that fade into a bright blue sea. The general effect is one of combining the impressionism of ancient Roman landscapes

with the richly varied panoramas of the Mannerist landscapes of the North. The bucolic mood is superbly captured, so much so that the tragic ending of the story is, indeed, our last thought.

Not all leading painters in France worked at Fontainebleau. Jean Cousin the Elder, painter, decorator, and theoretician, worked independently in Paris for most of his life. His *Eva Prima Pandora* (colorplate 85) is typical of the subject matter in vogue: the fatal temptations of the sensuous woman (Pandora was very popular at Fontainebleau). Here an ideal goddess appears in the guise of Eve, who, in turn, is in the guise of Pandora,[155] the first woman on earth, according to Greek mythology, sent by Zeus to bring misery to Prometheus and man in general by opening her box of human ills (Hesiod, *Works and Days*).

The left arm of the nude rests on the skull of Adam, and she carries an apple branch identifying her as Eve; a serpent coils about her left arm as she reaches back to remove the lid from the urn filled with the miseries of mankind about to be released. The setting for the sinister nude is a dark grotto that opens to a distant landscape with a city bathed in sunlight. Cousin's reclining Eve has the graceful, attenuated proportions of Primaticcio's females, with supple lines flowing down a languorous

586. JEAN CLOUET? *Portrait of Francis I.* c. 1525. Panel, 38 × 29″
The Louvre, Paris

portraitists of this period left a definite mark on the development of that art in France over the next centuries.

A *Portrait of Francis I* (fig. 586), painted about 1525 to judge by the monarch's age, has been traditionally attributed to the leading court portraitist, Jean Clouet. The likeness of the monarch displays the general stylistic features of other imperial portraits we have seen, and yet, in some respects, it seems closer in spirit to Fouquet's *Portrait of Charles VII* (fig. 249), painted nearly a century earlier. Francis has an enormous body that is much too broad in the chest and arms, which are completely lost beneath heavy layers of resplendent golden sleeves. His hands are large, his head is tiny in comparison, and the features of his face are limited to a few sharp outlines of his long nose, pursed lips, and feline eyes. The delicately embroidered coat and the elegant chain of the Order of Saint Michael hang on a massive mannequin with a wooden neck. The few drapery patterns are lifeless and artificial and only the darkened hands reveal any attempts to model flesh in light and dark.

The cold, inanimate abstraction of Francis I suddenly changes when we turn to the so-called three-color drawings in chalk also attributed to Jean Clouet. The *Portrait of Admiral Bonnivet* (fig. 587), about 1516, is a masterpiece of understatement. The pale pastel hues merely suggest his countenance as if we had but a fleeting im-

body void of any harsh modeling. Her tiny head is turned to display a somewhat exaggerated classical profile.

Cousin's figure has sometimes been called the first female nude in French painting. Some have dated the work before 1538, when Cousin moved from Sens to Paris, but it has been pointed out that one of the artist's important commissions in the capital was the decoration for the *entrée joyeuse* of Henry II at Paris in 1549 where the theme of the celebration was *Lutetia Nova Pandora*, or Paris as the new Pandora. Cousin's painting then may be related to the representation of Paris that decorated the triumphal arch for the occasion, which he was entrusted to design, and thus the work may date a decade later than usually assigned. It has also been noted that the landscape setting reminds one more of Leonardo da Vinci than of Niccolò or the Flemish landscapists, and this should be kept in mind when we turn to the portraits of the French school.

A court art requires court portraiture, and Fontainebleau was no exception. French court portraits have a certain distinctive, indefinable quality about them. Perhaps it is their grace and understatement, their incompleteness, that sets them apart; perhaps it is the nonchalance of the sitters, but, whatever it is, the French

587. JEAN CLOUET. *Portrait of Admiral Bonnivet.* c. 1516. Pastel drawing, 9⅞ × 7⅝″. Musée Condé, Chantilly

588. FRANÇOIS CLOUET. *Diane of Poitiers at Her Bath*. c. 1550. Panel, 36¼ × 32". National Gallery of Art, Washington, D.C. Samuel H. Kress Collection

pression of the man, an instant glimpse, and no more. The hands are now missing; there is no background curtain to anchor the head in space; and the shoulders drift off into delicate, sketchy lines that finally disappear in the paper. The portrait seems only a preparatory sketch, a quick reminder of the man's features, and not a finished product. And yet, such fleeting likenesses of the men and women of the court abound, and it is known that they were collected in lots.

The chalks or pastels are limited to a few colors: black for the general outline of the costume and hair, brown and red for the flesh parts. The contours are sketchy and spontaneous, unsustained as they break unevenly here and there, especially around the face. Fine strokes, at less than a forty-five degree angle, are applied in parallel with regular breaks in their continuity to suggest highlights (a technique also employed by Leonardo da Vinci). There are no cross-hatchings or conventional chalk smudges for shading but simply an endless pattern of parallel lines that give the face an impressionistic quality so unlike the more fully painted examples we are accustomed to seeing. Surprisingly, the portrait of the admiral has a freshness and life that the more studied and glazed likenesses lose in their compactness and detail.

We know too little about Jean Clouet. He was highly praised in his time, and the many chalk portraits in collections in Paris and Chantilly in this style are too gener-

ously attributed to him. Others executed such portraits as well; in fact, the French *gentilhomme* of this period created a broad market. Clouet's son, François, not only continued his father's portrait tradition but even appropriated his nickname, Janet, at court. With François Clouet the problems of attribution become even more acute, and a number of works assigned to him betray a diversity of influences ranging from Italy to the Netherlands.[156]

One of the certain works by the younger Clouet is the enigmatic portrait of *Diane of Poitiers at Her Bath* (fig. 588) in Washington, signed "FR. JANETII OPUS" and dating about 1550. That the nude lady seen in half-length in her bathtub is Diane of Poitiers has not been accepted by all authorities of French painting. It has also been suggested that she is Marie Touchet, mistress of Charles IX, but one can be certain that she is a royal mistress. Diane of Poitiers was a court heroine of sorts, and, as her name implies, she became the object of a number of works of art where she is presented in the guise of the goddess Diana, the favorite of all deities at court. As the goddess of hunting, this is understandable as that was a favorite sport.

There are baffling questions regarding both the style and the iconography of this unusual piece. As to the style, one can note that the rather bland face of the lady is in keeping with the French tradition we have studied so far, as are the bright curtains that veil her bathtub and the summary treatment of the flesh parts in general. The pose of the nude lady is that of Leonardo's *Mona Lisa*, and the direct source was very likely one of the many variations of the nude *Mona Lisa*, one of which was surely in the collection at Fontainebleau. The head of the child reaching up for a grape beside her right arm, on the other hand, has the cherubic features of Italian Mannerism, and the room beyond with the maid has been likened to the backgrounds of Titian's reclining nudes. The maid to the left nursing the baby in swaddling clothes looks more like a Flemish procuress than a nurse at Fontainbleau, however, and the second chamber has much in common with the interiors, albeit cleaner and more elegantly furnished, by Hemessen or the Master of the Brunswick Monogram.

The nude lady with the enigmatic Leonardesque smile is a court mistress beyond doubt, and she very likely is Diane of Poitiers. She holds a red carnation, a flower most often associated with a betrothed woman in marriage portraits, and this may refer to the fact that she was considered not only Henri II's mistress in the modern sense but his true object of love and devotion and was therefore elevated as the equal of the king's bride. What we have in this curious painting, I believe, is a portrait of "the mistress as bride."

left: 589. JEAN DUVET. *Vision of the Seven Candlesticks*, from the *Apocalypse* series. c. 1560. Engraving, 13¾ × 8¼"

right: 590. JACQUES BELLANGE. *Three Marys at the Tomb*. c. 1602–17. Etching, 17½ × 11⅜"

The secular Renaissance dedicated to the French monarchy at Fontainebleau was paralleled by a sincere strain of religious mysticism in the arts. Marguerite of Navarre, the liberal-minded sponsor of the poet Clément Marot, was at the same time a quiet mystic much devoted to the Gothic religious spirit. Marot rewrote the Psalms and at times conjured up images that darkly reflect the melancholy and sorrows of a more macabre world of religious strife. Michel Colombe and other sculptors of the early sixteenth century brought to perfection that spiritual quietism and resignation that we see so beautifully expressed in *détente* monuments, such as the *Entombment* group in Solesmes (fig. 345), and while the sun of the proud monarchy shone brightly on the kaleidoscopic landscape of Fontainebleau by day, the nights in France were still disturbed by the Late Gothic dream.

Occasionally the religious fervor of the past explodes upon the setting like skyrockets, as it does in the art of Jean Duvet. Duvet, in the tradition of the medieval craftsman, was trained as a goldsmith, and he grew up in the town of Langres, a zealous religious center. Duvet is best known for his many engravings of the *Apocalypse* (fig. 589) that were published in Lyon in 1561. The cycle was inspired by Dürer's book, and borrowings from German illustrations are evident throughout, as in the disposition of the elaborate candlesticks and the positions of John and God the Father in *John's Vision of the Seven Candlesticks* (cf. fig. 362). The precision and clarity of Dürer's design, however, are lost in the explosive and highly manneristic style of Duvet. He also attempts to redefine the large figures in a classical idiom, with profiles and muscular torsos that twist in space with the energy of Michelangelo's.

Scale is arbitrary in Duvet's prints, and spatial relationships are purposely violated and denied so that the surface swirls with pattern about the big figures in an uncanny *horror vacui*. Often the figures are strange adaptations of Raphael's types, and always there is quick movement and tense vibration that disturbs any classical clarity. Not surprisingly, Duvet's engravings have been frequently likened to the ecstatic Neoclassical drawings of William Blake, the English poet and mystic of a much later date, and while there is something instructive in this comparison, any similarity between them is not due to influences or models, but simply to the kindred spirit that such mystical outpourings frequently exhibit in any day or age.

This tendency, this more spiritual brand of Mannerism, culminates in France in the highly original etchings of Jacques Bellange, active in Nancy in the first years of the seventeenth century. Bellange's works often appear audacious and bizarre in the sensuous turnings of lithesome female forms, always draped in sheer diaphanous gowns, who glide and sway in a never-never land.

His *Three Marys at the Tomb* (fig. 590) is typical of Bellange's ethereal and erotic world of butterfly women. They are shimmering, tapering figures who seem to have no weight to support; their fingers are elegant and graceful, their mien hesitant and affected. The breasts are high and small; their stomachs are attenuated and swelled so

as to exaggerate the sensuous protrusion of the hips and thighs. The hair is pulled up into a strange coiffure that continues the graceful lines of their swan necks supporting small heads. Bellange exploits the frontal view of the female figure so that he can give the fullest possible erotic appearance to his fairytale nymphs. Those seen from the back or the side are masterful abstractions with delicate, changing tonalities and swelling profiles that are wholly arbitrary as far as the treatment of the draped figure is concerned.

The three Marys appear as dreamy courtesans quietly dancing in some royal garden or grotto; in fact, they are placed in a huge cave so that the lighting effects are even more eerie and dramatic. The two in the foreground are seen from the back resembling profiles of birds ready for flight, and they frame the foreshortened form of the angel, who addresses them from the empty sarcophagus. The angel too is a sensuous female more reminiscent of Leda or Danaë than a messenger of the Lord.

All the Mannerist traits are here carried to the extreme: the near and the far, the light and the dark contrasts, the natural lines and the arbitrary, all blended into one swaying image of flickering light across the sheet. Whether Bellange's ephemeral style, the very quintessence of Late Mannerist expression, as Otto Benesch describes it,[157] is intended to convey some ultra-mystical experience or a precious sublimation of mixed erotic longings is difficult to assess, but surely there can be no question concerning the extreme sophistication of his art.

In French sculpture of the mid-sixteenth century a wavering between the courtly Mannerism of Primaticcio and neo-Gothic spiritualism is more subtly displayed. The finest French translations of Primaticcio's glossy style are found in the sculptures of Jean Goujon, who was for a long time active at Rouen, where he was engaged in making funerary monuments and architectural projects. He is best known for his sculptured reliefs of *Nymphs* for the Fontaine des Innocents in Paris (fig. 591), 1548–49. Six tall narrow reliefs of swaying nymphs carrying water jugs originally decorated two facades of the fountain that met at a corner. The tall proportions of the figures admirably fit the vertical slabs, and their turning postures accented by the beautifully flowing lines of the drapery hugging their thin bodies capture the bubbling and joyous movement of water issuing from the fountain. Their heads are fine classical types, enhanced by their smiles, and the lithesome forms turn in a delicate serpentine fashion. Beneath the film of soft drapery that descends in long curves, the treatment of moving body parts is amazing considering the shallowness of the reliefs. As figures for a public fountain they make joyous and highly ornamental additions.

591. JEAN GOUJON. *Nymphs*. 1548–49. Stone, each 76¾ × 28¾". Fontaine des Innocents, Paris

592. JEAN GOUJON. *Caryatids*. 1550–51. Sculpture, height about 74¾". The Louvre, Paris

More interesting as archaeological studies but far less as sculptures are the *Caryatids* Goujon designed for the small room on the ground floor of Lescot's wing of the Louvre (fig. 592). According to Vitruvius, caryatids were appropriate supports only for small galleries such as this, and while the architectonic function of the draped maidens captures the spirit of the famous ladies of the Erechtheum on the Acropolis, the monotonous repetition of vertical drapery folds and the regularity of their design make these Grecian maidens appear cold and Neoclassical in spirit.

Much more successful are the three caryatids, Graces, nymphs, or Virtues that support the *Monument to the Heart of Henri II* (fig. 593) by Germain Pilon, which just may be one of the finest examples of draped female figures in the Louvre. The monument, executed in 1560, today has a nineteenth-century replacement for the original urn carried on the heads of the nymphs, and the base was designed by an Italian sculptor. The original urn contained the heart of the king and was thus displayed as a secondary funerary monument.

Here the ideal of Primaticcio has been fully realized in sculpture-in-the-round with a refreshing originality. The figures carry no attributes, and while we identify them as the Graces Aglaia (Brilliance), Euphrosyne (Joy), and Thalia (Bloom), the three sister attendants of Venus, as befitting a tomb, they could also be seen as the three Theological Virtues, Faith, Hope, and Charity, for it is *caritas* (love) who offers her heart to God in medieval representations. Pilon groups the three maidens in the traditional Renaissance manner for the Graces, their backs to each other and holding hands as if slowly turning. Their facial features and proportions are those of Primaticcio's female figures, but Pilon's treatment of the cascading drapery is a remarkable tour de force in the rendering of soft, silken fabric from stone so that their chitons turn and overlap in a rich variety of fluttering patterns that, however, does not detract from the beauty of the bodies beneath their complex turnings. The three ladies smile slightly as they glance down from their pedestals as if appreciating the viewer's veneration of the monarch.

A late work by Pilon, the *Mater Dolorosa* or Madonna of Sorrows (fig. 594), returns us to the emotional world of Gothic spirituality. The seated Madonna has been extracted from the narrative context of a Crucifixion or Lamentation, and the seven swords that normally pierce her heart in such iconic representations are omitted here since the figure of Mary beautifully conveys the sense of pathos and mourning without artificial iconographic aids. Mary's thin, limp hands crossed over her heart and the long lines of grief modeled along her slender face, barely visible under the enshrouding hood of her mantle, express poignantly the deep heartache that has aged and

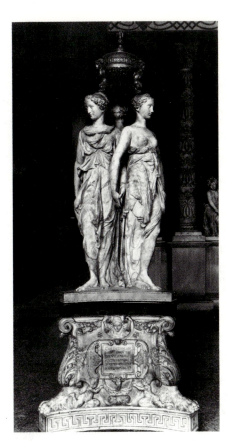

593. GERMAIN PILON. *Monument to the Heart of Henri II*. 1560. Marble, height 59". The Louvre, Paris

594. GERMAIN PILON. *Mater Dolorosa*. c. 1580. Terra cotta, height 70⅛". The Louvre, Paris

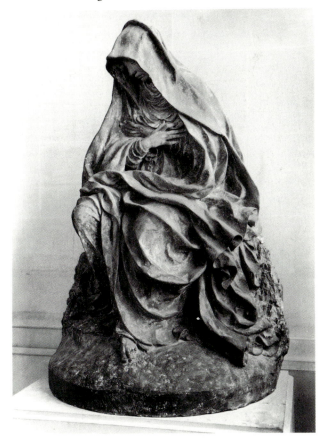

522

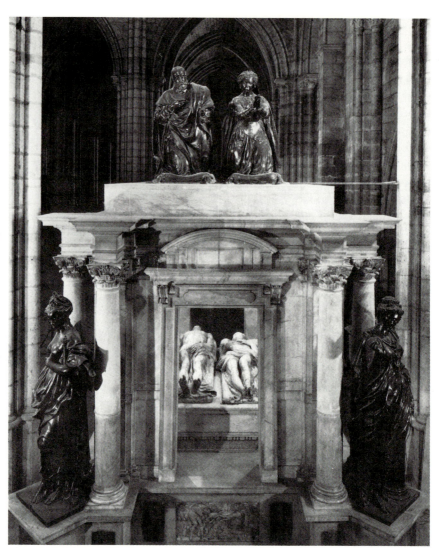

right: 595. GERMAIN
PILON AND
PRIMATICCIO? *Tomb of
Henri II.* 1563–70.
Abbey Church of
Saint Denis, Paris

below: 596. GERMAIN
PILON AND
PRIMATICCIO? *Tomb of
Henri II* (detail of
fig. 595)

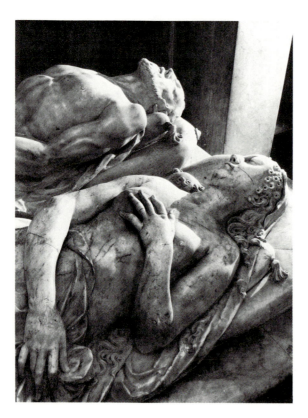

emptied her so. Pilon's Virgin is no Renaissance ideal clad in transparent draperies, but a universal embodiment of a mother's loss over the death of her child. Mary's head is bent downward as she views the mortal remains of her son, but the drapery builds upward in the traditional symbolic form of the pointed arch, the architectural form that one associates with lofty aspiration and hope.

Pilon's most ambitious project was the tomb of Henri II and his wife, Catherine de'Medici, in Saint Denis (figs. 595, 596). The architecture of the huge oblong edifice was designed by Primaticcio, but the sculptures are the products of Pilon's imagination and genius. There are three groups of sculpture adorning the classical mausoleum. Outside, atop the tomb, are the bronze figures of the king and queen kneeling in prayer as they would have appeared in life, bedecked in their finest robes of state. At the four corners, below, stand bronze figures of the four Cardinal Virtues that Henri, as his father before him, promoted for a good monarchy. The base of the tomb carries bas-reliefs symbolic of Henri's personality and deeds, and finally, within the structure, are the mar-

ble *gisants* that lie atop the tomb proper, the king and queen once again represented, but now in death.

It is the third group, the *gisants*, that particularly interests us. The tomb figures in Late Gothic sculpture were usually presented in one of two ways (or both as here):[158] as recumbent images of the deceased (*gisants*) as they appeared alive—*representacion au vif*—or as decaying corpses—*representacion de la mort*. The more common one, *au vif*, was a hushed state portrait placed on its back, so to speak, but the other, *de la mort*, was intended to represent the appearance after death with varying degrees of realism or propriety. In instances of the so-called double-decker tombs, both types appeared in combination, the state portrait, *au vif*, lying above, while below the same person, *de la mort*, would be represented *en transi*.

In Pilon's *gisants* of Henri and Catherine the solution was a compromise, but one with sublime results. The two figures are nude and draped in shrouds decorously, and all life has left their bodies. But even in death, they appear as idealized figures of beauty. Henri's body has the elegant proportions of the dead Christ held in the arms of Mary in Michelangelo's *Pietà* in Saint Peter's (of which there was a cast at Fontainebleau). The body of Catherine has the form and pose of the famous *Medici Venus*, only here she sleeps. The strength and beauty of the two figures are thus preserved, and their mortal remains do not horrify us as corpses in the state of decomposition, but rather as noble and handsome forms that beautify their souls even though their breath has ceased. They have the elegance and beauty of Gothic *détente* sculptures in their relaxed sleep of death.

An exceptional example of such funerary statuary is found in the *Tomb of René de Châlon* in the Church of Saint Peter in Bar-le-Duc (fig. 597), attributed to Ligier Richier of Lorraine. The standing image is that of Death and not an actual portrait of René after his death; but the meaning is the same. The grotesque skeleton statue stands firmly and proudly, carrying his shield and gazing upward at the bony hand holding his heart. The decomposition of the body is nearly complete. But this is death activated, and in the context of a tomb it is not to be viewed as the gruesome death that reaps death as in Bruegel's painting or in *The Dance of Death* by Holbein. This is the dead René de Châlon, and after the flesh of his body has rotted away, his soul still holds up his heart in love—*caritas*—to God.

597. LIGIER RICHIER?
Tomb of René de Châlon. After 1544.
Polished stone, height 69".
Church of Saint Peter, Bar-le-Duc,
France

Notes

PART ONE

1. E. Panofsky, *Gothic Architecture and Scholasticism*, Latrobe, Pa., 1951; cf. O. von Simson, *The Gothic Cathedral*, New York, 1956.
2. M. Meiss, *Painting in Florence and Siena After the Black Death*, Princeton, 1951.
3. B. W. Tuchman, *A Distant Mirror: The Calamitous 14th Century*, New York and Toronto, 1978.
4. E. Panofsky, *Early Netherlandish Painting*, Cambridge, Mass., 1953, I, 68 ff. (also published in Icon Editions, New York, 1971).
5. W. Pinder, *Die deutsche Plastik vom ausgehenden Mittelalter bis zum Ende der Renaissance* (Handbuch der Kunstwissenschaft, no. XVII), Wildpark-Potsdam, 1924, 92 ff.; E. Panofsky, "Imago Pietatis," *Festschrift für Max J. Friedländer*, Leipzig, 1927, 261–68.
6. O. Pächt, "The 'Avignon Diptych' and its Eastern Ancestry," *Essays in Honor of Erwin Panofsky*, New York, 1961, I, 403 ff.
7. J. Brink, "Simone Martini's 'Orsini' Polyptych," *Jaarboek van het Koninklijk Museum voor Schone Kunste*, Antwerp, VII, 1976, 15 ff.
8. R. van Marle, *Iconographie de l'art profane au moyen-âge et à la Renaissance et la décoration des demeures*, The Hague, 1931, II, 197 ff., 373 ff.
9. Panofsky, *Early Netherlandish Painting*, I, 30, n. 1.
10. For the "Autobiography of Charles IV" see Czech translation by J. Pavel, Prague, 1940 (discussed by A. Friedl, *Master Theodoricus*, Prague, 1956, 29, n. 30); E. Bachmann, ed., *Gothic Art in Bohemia*, New York, 1977, 6–23; for Bohemian art and the International Style in general, see especially the comprehensive catalogues for the 1978 Kunsthalle Cologne exhibition, *Die Parler und der Schöne Stil 1350–1400: Europäische Kunst unten den Luxemburgen*, ed. A. Legner, 5 vols.
11. F. Pet̕as, *Medieval Mosaic*, London, n.d., 8 ff.
12. A. Matějček and J. Pešina, *Czech Gothic Painting, 1350–1450*, Prague, 1950; J. Pešina, "Hauptprobleme der böhmische Malerei der Zeit Karls IV (Zum heutigen Stand der Forschung)," *Acta Historiae Artium*, Budapest, XXVI, 1980, 3–11.
13. Matějček and Pešina, *Czech Gothic Painting*, cat. nos. 3–21, pp. 45–50.
14. Friedl, *Master Theodoricus*.
15. V. Denkstein and F. Matous, *Gothic Art in South Bohemia*, Prague, 1955, 100 ff.; F. Bucina and L. Stehlik, *Gotische Madonnen*, Prague, 1958; T. Müller, *Sculpture in the Netherlands, Germany, France, and Spain 1400 to 1500* (The Pelican History of Art, no. XXV), Baltimore, 1966, 39–42. For the view of John Huss see A. Kutal, *Gothic Art in Bohemia and Moravia*, Prague, 1952, 108 ff.
16. For historical sources see *The Chronicles of Froissart*, trans. by J. Bourchier, New York, 1895, and *The Chronicles of Enguerrand de Monstrelet*, trans. by T. Johnes, London, 1843. For general history see J. Calmette, *Charles V*, Paris, 1945, and the following books by R. Vaughan: *Valois Burgundy*, London, 1975; *Philip the Good, the Apogee of Burgundy*, New York, 1970; and *John the Fearless: The Growth of Burgundian Power*, London, 1966.

17. G. Ring, *A Century of French Painting, 1400–1500*, London, 1949, cat. no. 1, p. 191. See Ring's catalogue for other paintings discussed in this chapter; Panofsky's chapters on the "International Style" and "Sculpture and Panel Painting About 1400" in *Early Netherlandish Painting*, I, 51–89; C. D Cuttler, *Northern Painting from Pucelle to Bruegel*, New York, 1968, 11–25; *Die Parler und der Schöne Stil 1350–1400: Europäische Kunst unten den Luxemburgen*, 5 vols., Cologne, 1978.
18. M. Meiss, *French Painting in the Time of Jean de Berry: The Late Fourteenth Century*, London, 1967, 74 ff. (This and other books by Meiss referred to in this chapter are in the series *National Gallery of Art: Kress Foundation Studies in the History of European Art*.)
19. C. R. Sherman, *The Portraits of Charles V of France* (Monographs on Archaeology and the Fine Arts Sponsored by the College Art Association of America, no. XX), New York, 1969, 43, fig. 35.
20. Meiss, *The Late Fourteenth Century*, 3.
21. M. Meiss, *French Painting in the Time of Jean de Berry: The Boucicaut Master*, London, 1968. Also see Panofsky, *Early Netherlandish Painting*, I, 53–61; Cuttler, *Northern Painting*, 36–39. For the Rohan Hours see M. Meiss, *The Rohan Master*, New York, 1973.
22. For the Master of the Paremont de Narbonne, see Meiss, *The Late Fourteenth Century*, 99–130.
23. Meiss, *The Late Fourteenth Century*, 151 ff.; Panofsky, *Early Netherlandish Painting*, I, 42–50.
24. Translated in E. G. Holt, *A Documentary History of Art*, Garden City, N.Y., 1957, I, 131.
25. C. P. Parkhurst, Jr., "The Madonna of the Writing Christ Child," *Art Bulletin*, XXIII, 1941, 292 ff.
26. M. Meiss, *French Painting in the Time of Jean de Berry: The Limbourgs and Their Contemporaries*, New York, 1974. Also see Panofsky, *Early Netherlandish Painting*, I, 62 ff.
27. Meiss, *The Limbourgs and Their Contemporaries*, 184 ff.
28. For the projects in sculpture and painting, consult Müller, *Sculpture in the Netherlands, Germany, France, and Spain* and his extensive bibliography for the sculptures at the Chartreuse de Champmol, 7 ff. The paintings are studied by Ring, *A Century of French Painting*, cat. nos. 51, 52, pp. 70–73; Panofsky, *Early Netherlandish Painting*, I, 83 ff.; Cuttler, *Northern Painting*, 21–25; Meiss, *The Limbourgs and Their Contemporaries*, passim; A. Châtelet, *Early Dutch Painting*, New York, 1981, 12 ff. (originally published in French, *Les Primitifs hollandais*, Fribourg, 1980). For the archival documentation on the Carthusian monastery and its art see C. Monget, *La Chartreuse de Dijon d'après les documents des archives de Bourgogne*, Montreuil-sur-Mer, 1898–1905.
29. H. Huth, *Künstler und Werkstatt der Spätgotik*, Augsburg, 1923, and reprint Darmstadt, 1967, with additions; S. Thrupp, "The Guilds," *Cambridge Economic History of Europe*, Cambridge, Eng., 1971, III, 230–80. For the role of the sculptors' guilds in Germany, see especially M. Baxandall, *The Limewood Sculptors of Renaissance Germany*, New Haven and London, 1980, 106–16.
30. A. Hyma, *The Christian Renaissance*, Grand Rapids, Mich., 1924,

and *The Brethren of the Common Life*, Grand Rapids, 1950; R. R. Post, *The Modern Devotion*, Leiden, 1968. See also Thomas à Kempis, *The Founders of the New Devotion; Being the Lives of Gerard Groote, Florentius Radewin and Their Followers*, trans. by J. P. Arthur, London, 1905.

31. Panofsky, *Early Netherlandish Painting*, I, 110 ff.

32. For these consult A. Stange, *Deutsche Malerei der Gotik*, Berlin and Munich, 1934, I and II (esp. II, 132 ff. for Master Bertram), and *German Painting XIV to XVI Centuries*, London, 1950; S. Waetzoldt, "German Art," *Encyclopedia of World Art*, New York, 1962, VI, 168–77; C. Sterling, "Die Malerei um 1400," *Die Ausstellung Europaïsche Kunst um 1400*, Kunsthistorisches Museum, Vienna, 1962, 66–78; Cuttler, *Northern Painting*, 53–64.

33. *The Golden Legend of Jacobus de Voragine*, trans. by G. Ryan and H. Ripperger, London, New York, and Toronto, 1941, I, 214. For paintings by the Master of Saint Veronica and other contemporary Cologne artists, see *Vor Stefan Lochner*, exh. cat., Wallraf-Richartz Museum, Cologne, 1974, 36 ff.; Stange, *Deutsche Malerei*, III, 50 ff.

34. *Vor Stefan Lochner*, 93 ff. For the iconography of the Holy Kinship, see M. Lejeune, "De legendarische Stamboom van Sint Servaas," *Publications de la Société historique et archéologique dans le Limburg à Maastricht*, Liège, 1941, 283–332; Panofsky, *Early Netherlandish Painting*, I, 327, n. 1; J. Snyder, "The Early Haarlem School of Painting–II," *Art Bulletin*, XLII, 1960, 128 ff.

35. B. Martens, *Meister Francke*, Hamburg, 1929; Reineke's thesis was discussed by A. Stange, *Kindlers Malerei Lexikon*, Zurich, 1965, II, 438–50; also see Stange, *Deutsche Malerei*, III, 6–20.

PART TWO

1. F. de Hollanda, *De Pintura Antigua*, 1548. Cf. translation in E. G. Holt, *Literary Sources of Art History*, Princeton, 1947, 208–9 (this text is omitted in Holt's revised edition, cited in n. 24, Part I).

2. For all early source materials, consult W. H. J. Weale, *Hubert and Jan van Eyck; Their Life and Work*, London, 1908. The documents, given in the original languages, are conveniently gathered in *Jan en Hubert van Eyck—Documenten*, Utrecht, 1954. For an English summary, see G. T. Faggin, *The Complete Paintings of the Van Eycks*, New York, 1968.

3. For a discussion of the inscription see E. Dhanens, *Het Retable van het Lam Gods (Kunstpatrimonium van Oostvlaanderen, no. VI)*, Ghent, 1965, 10–17; Panofsky, *Early Netherlandish Painting*, I, 205–7; M. J. Friedländer, *Early Netherlandish Painting*, New York and Washington, 1967 (originally published as *Die altniederländische Malerei*, Berlin, 1924), I, 30–32, 100 ff. For a recent interpretation see L. B. Philip, *The Ghent Altarpiece and the Art of Jan van Eyck*, Princeton, 1971, 44 ff. She reads FICTOR HUBERTUS for PICTOR HUBERTUS in the first line and suggests that Hubert was the sculptor of the original frame and not the painter of the panels. Cf. E. Dhanens, *Hubert en Jan van Eyck*, Antwerp, 1980.

4. L. von Baldass, *Jan van Eyck*, London, 1952, discusses the attribution of this and other Eyckian paintings in his catalogue; F. Lyna, "L'oeuvre présumée de Jean van Eyck," *Scriptorium*, XVI, 1962, 93 ff., reads the name DU MONT in the Hebraic letters on the hat of the sleeping guard. Cuttler, *Northern Painting*, 86, suggests that the artist was Adam Dumont, a later court painter to Philip the Good.

5. L. Clysters, *Kunst en Mystiek: De Aanbidding van het Lam*, Tongerloo, 1935, finds the influence of Hildegard of Bingen in the iconography, while E. Dhanens, *Van Eyck: The Ghent Altarpiece (Art in Context)*, New York, 1973, 88–100, suggests the text, *De Victoria Verbi Dei*, of Rupertus von Deutz (died c. 1130) was followed in the program (see also her "Bijdrage Betreffende het Lam-Godsretabel te Gent," *Aachner Kunstblätter*, XLI, 1971, 100 ff.). Cf. Philip, *The Ghent Altarpiece*, 53 ff.

6. Panofsky, *Early Netherlandisł. Painting*, I, 205–30.

7. Philip, *The Ghent Altarpiece*, 25 ff.

8. J. Bruyn, *Van Eyck Problemen*, Utrecht, 1957, 18 ff. Cf. Faggin, *The Complete Paintings*, 99, no. 36.

9. P. Coremans, *L'Agneau mystique au laboratoire (Les Primitifs flamands, Contributions, no. II)*, Antwerp, 1953; J. R. J. van Asperen de Boer, "A Scientific Re-examination of the Ghent Altarpiece," *Oud-Holland*, XCIII, 1979, 141–214.

10. J. Snyder, "Jan van Eyck and Adam's Apple," *Art Bulletin*, LVIII, 1976, 511–15.

11. See especially Weale, *Hubert and Jan van Eyck*, and O. Kurz, "Van Eyck," *Encyclopedia of World Art*, V, 323–31.

12. Much attention has been given to the "Hand G" miniatures in the *Turin-Milan Hours*: P. Durrieu, *Heures de Turin*, Paris, 1902; M. Dvořák, *Das Rätsel der Kunst der Brüder van Eyck*, Munich, 1925 (see especially the last chapter, "Die Anfänge der holländischen Malerei"); Baldass, *Jan van Eyck*, 90 ff., 285 ff.; Panofsky, *Early Netherlandish Painting*, I, 232 ff.; F. Lyna, "Les Van Eyck et les 'Heures de Turin et de Milan,'" *Bulletin des Musées Royaux des Beaux-Arts de Belgique, Miscellanea Erwin Panofsky*, IV, 1955, 7–20; A. Châtelet, "Les enluminures eyckiennes des manuscrits de Turin et de Milan-Turin," *Revue des Arts*, VII, 1957, 155–64; Faggin, *The Complete Paintings*, 85–87; L. M. J. Delaissé, "The Miniatures Added in the Low Countries to the Turin-Milan Hours and Their Political Significance," *Kunsthistorische Forschungen–Otto Pächt zu Ehren*, Salzburg, 1972, 135–49; Châtelet, *Early Dutch Painting*, 27–46.

13. E. Panofsky, "Who is Jan van Eyck's Timotheos?" *Journal of the Warburg and Courtauld Institutes*, XII, 1949, 80 ff.

14. R. W. Scheller, "Als Ich Can," *Oud-Holland*, LXXXIII, 1968, 135–38.

15. M. Meiss, "Light as Form and Symbol in Some Fifteenth-Century Paintings," *Art Bulletin*, XXVII, 1945, 175 ff.; C. J. Purtle, *The Marian Paintings of Jan van Eyck*, Princeton, 1982, 144–56.

16. For dating the Dresden triptych see J. Snyder, "The Chronology of Jan van Eyck's Paintings," *Album Amicorum Jan G. van Gelder*, The Hague, 1973, 293–97; S. Blum, *Early Netherlandish Triptychs*, Berkeley, 1969, 7 ff.; Purtle, *Marian Paintings*, 127–43.

17. For recent discussions for rejecting the painting on scientific evidence, see U. Hoff and M. Davies, *The National Gallery of Victoria, Melbourne (Les Primitifs flamands, Corpus, no. XII)*, Brussels, 1971, 48 ff.

18. C. de Tolnay, "Flemish Paintings in the National Gallery of Art," *Magazine of Art*, XXIV, 1941, 200 ff.; Panofsky, *Early Netherlandish Painting*, I, 193 ff.; J. L. Ward, "Hidden Symbolism in Jan van Eyck's Annunciations," *Art Bulletin*, LVII, 1975, 196–220; Purtle, *Marian Paintings*, 40–58.

19. E. Michel, *Catalogue raisonné des peintures flamands du XVe et du XVIe siècle: Musée National du Louvre*, Paris, 1953, 115–19; Panofsky, *Early Netherlandish Painting*, I, 192 ff.; J. Snyder, "Jan van Eyck and the Madonna of Chancellor Nicolas Rolin," *Oud-Holland*, LXXXII, 1967, 163–71; H. Roosen-Runge, *Die Rolin-Madonna des Jan van Eyck*, Wiesbaden, 1972; Purtle, *Marian Paintings*, 59 ff.; A. van Buren, "The Canonical Office in Renaissance Painting II: More About the Rolin Madonna," *Art Bulletin*, LX, 1978, 617–33.

20. D. Carter, "Reflections in the Armour in the Canon van der Paele Madonna," *Art Bulletin*, XXXVI, 1954, 60–62; D. Farmer, "Further Reflections on a van Eyck Self-portrait," *Oud-Holland*, LXXXIII, 1968, 159–60.

21. Panofsky, *Early Netherlandish Painting*, I, 201–3; cf. P. Schabacher, "*De Matrimonio ad Morganaticam Contracto*: Jan van Eyck's 'Arnolfini' Portrait Reconsidered," *Art Quarterly*, XXXV, 1972, 375–98.

22. M. Meiss, "'Nicholas Albergati' and the Chronology of Jan van Eyck's Portraits," *Burlington Magazine*, XCIV, 1952, 137 ff.

23. E. Panofsky, "A Letter to Saint Jerome: A Note on the Relation-

ships between Petrus Christus and Jan van Eyck,'' *Studies in Art and Literature for Belle da Costa Greene*, Princeton, 1954, 102–8. For the signature and date see E. P. Richardson, ''The Detroit Saint Jerome by Jan van Eyck,'' *Art Quarterly*, XIX, 1956, 227–35. For the iconography of the still life, see I. Bergström, ''Medicina, Fons et Scrinium: A Study in van Eyckian Symbolism,'' *Konsthistorisk Tidskrift*, XXVI, 1957, 1–20.

24. Friedländer, *Early Netherlandish Painting*, I, 61 ff., 86 ff.; Panofsky, *Early Netherlandish Painting*, I, 187–89; H. J. J. Scholtens, ''Jan van Eyck's 'H. Maagd met den Kartuizer' en de Exeter-Madonna te Berlijn,'' *Oud-Holland*, LV, 1938, 49–62; P. Schabacker, *Petrus Christus*, Utrecht, 1974, no. 23, pp. 123–25; *Catalogue of the Frick Collection*, vol. I, *Paintings: American, British, Dutch, Flemish and German*, Princeton, 1968, 203 ff.

25. Panofsky, *Early Netherlandish Painting*, I, 192 and esp. n. 1, for the controversy over the Philadelphia and Turin panels; Faggin, *The Complete Paintings*, 88 ff. for copies; Baldass, *Jan van Eyck*, 276 ff., states that the brown habit was that of the ''reformed Franciscans,'' who were not established in Flanders in the early fifteenth century, and that the original was ''executed during Jan's journey to Portugal,'' before 1430. The work is usually dated late, about 1438.

26. M. J. Friedländer, *Early Netherlandish Painting from Van Eyck to Bruegel*, London, 1956, 4.

27. The earlier literature on Robert Campin is polemic and confusing, to say the least. The theories of E. Renders (*La Solution du problème van der Weyden–Flémalle–Campin*, Bruges, 1931) and his followers that the oeuvre of the Master of Flémalle is that of ''early'' Rogier van der Weyden is no longer acceptable (but cf. the recent scholarship of M. Frinta, *The Genius of Robert Campin*, The Hague, 1966, which tends to reverse the priorities). For a balanced account see C. de Tolnay, *Le Maître de Flémalle et les frères van Eyck*, Brussels, 1939; Panofsky, *Early Netherlandish Painting*, I, 153 ff.; and M. Davies, *Rogier van der Weyden*, London, 1972. There is no longer any reason to doubt that the Master of Flémalle and Robert Campin are one and the same artist.

28. The literature on the *Mérode Altarpiece* is extensive—see M. Laszlo and R. Nachtigall, *Literature on the Mérode Altarpiece*, The Metropolitan Museum of Art, New York, 1974. Volume XVI (n.s.) of the *Bulletin of the Metropolitan Museum of Art*, December 1957, is devoted to the work (pp. 117–44).

29. C. I. Minott, ''The Theme of the Mérode Altarpiece, *Art Bulletin*, LI, 1969, 267–71.

30. O. von Simson, '' 'Compassio' and 'Co-redemptio' in Rogier van der Weyden's *Descent from the Cross*,'' *Art Bulletin*, XXXV, 1953, 1–16. See also S. Blum, ''Symbolic Invention in the Art of Rogier van der Weyden,'' *Konsthistorisk Tidskrift*, XLVI, 1977, 103–22. The documents on Rogier are conveniently gathered and discussed by T. Feder, ''A Reexamination through Documents of the First Fifty Years of Rogier van der Weyden's Life,'' *Art Bulletin*, XLVIII, 1966, 416–31, and Davies, *Rogier van der Weyden*, 187–90.

31. C. Eisler, *New England Museums* (*Les Primitifs flamands, Corpus*, no. IV), Brussels, 1961, 71–93.

32. J. Breckenridge, ''*Et Prima Vidit*: The Iconography of the Appearance of Christ to His Mother,'' *Art Bulletin*, XXXIX, 1957, 9–32.

33. K. M. Birkmeyer, ''The Arch Motif in Netherlandish Painting of the Fifteenth Century,'' *Art Bulletin*, XLIII, 1961, 1–20, 99–112.

34. P. Rolland, ''Het drieluik der Zeven Sacramenten van Rogier van der Weyden,'' *Annuaire du Musée Royal des Beaux-Arts d'Anvers*, 1942–47, 99 ff.; Panofsky, *Early Netherlandish Painting*, I, 282, n. 1. I wish to thank Chiyo Ishikawa for her suggestions concerning the iconographic traditions and meaning of Rogier's *Seven Sacraments* altarpiece (to be presented in a forthcoming study).

35. M. J. Friedländer, ''Noch Etwas über das Verhältnis Roger van der Weydens zu Memling,'' *Oud-Holland*, LXI, 1946, 11–19.

36. O. Kurz, ''A Fishing Party at the Court of William VI, Count of

Holland, Zeeland and Hainaut,'' *Oud-Holland*, LXXI, 1956, 117–31; F. Lugt, *Musée national du Louvre–Inventaire général des dessins des écoles du Nord: Maîtres des anciens Pays-Bas nés avant 1550*, Paris, 1968, 5–6; Châtelet, *Early Dutch Painting*, 197; Dhanens, *Hubert en Jan van Eyck*, 162 ff.

37. For the workshop of the Master of the Hours of Catherine of Cleves, see G. J. Hoogewerff, *De Noord-Nederlandsche Schilderkunst*, The Hague, 1936, I, 447 ff.; J. Plummer, *The Hours of Catherine of Cleves*, New York, 1966; L. M. J. Delaissé, *A Century of Dutch Manuscript Illumination*, Berkeley and Los Angeles, 1968; and Châtelet, *Early Dutch Painting*, 204–8, with references to more recent studies of the miniatures.

38. C. van Mander, *Het Schilder-boeck*, Haarlem and Alkmaar, 1604 and 1618. Of the six parts that comprise the 1618 edition, only the book on the Netherlandish and German painters has been translated into English—*Carel van Mander, Dutch and Flemish Painters*, trans. by C. van de Wall, New York, 1936 (see 25–26 for the biography of Ouwater). For the *Raising of Lazarus* see Panofsky, *Early Netherlandish Painting*, I, 320; J. Snyder, ''The Early Haarlem School of Painting–I,'' *Art Bulletin*, XLII, 1960, 40–48; D. de Chapeaurouge, ''Ouwaters Lazaruserweckung als politischer Dokument,'' *Pantheon*, XXXV, 1977, 108–15; Châtelet, *Early Dutch Painting*, 209–11.

39. W. Schöne, *Dieric Bouts und seine Schule*, Berlin and Leipzig, 1938, 23 ff.; Friedländer, *Early Netherlandish Painting*, III; Panofsky, *Early Netherlandish Painting*, I, 314–19; Châtelet, *Early Dutch Painting*, 75–84, 211–14.

40. The documents on Bouts's commissions are given fully in Schöne, *Dieric Bouts* (see the catalogue).

41. Panofsky, *Early Netherlandish Painting*, I, 264–65; ''Town Hall Last Judgments'' in C. Harbison, *The Last Judgment in Sixteenth-Century Northern Europe*, New York, 1976, 51–64.

42. Cf. A. Riegl, *Das holländische Gruppenporträt*, Vienna, 1931, 2 ff.

43. For the controversies concerning Christus's background and training, see Friedländer, *Early Netherlandish Painting*, I, 81 ff.; Panofsky, *Early Netherlandish Painting*, I, 309–13; O. Pächt, ''Die Datierung der Brüsseler Beweinung des Petrus Christus,'' *Belvedere*, 9/10, 1926, 155–66; Schabacker, *Petrus Christus*, 19–22; J. Upton, ''Devotional Imagery and Style in the Washington Nativity by Petrus Christus,'' *Studies in the History of Art*, National Gallery of Art, Washington, VII, 1975, 49, n. 1, *passim*.

44. J. Duverger, ''Brugse schilders ten tijde van Jan van Eyck,'' *Bulletin des Musées Royaux des Beaux-Arts de Belgique, Miscellanea Erwin Panofsky*, IV, 1955, 83 ff., 109–19.

45. Upton, *Studies in the History of Art*, VII, 1975, 53 ff.

46. Cf. M. McNamee, S. J., ''Further Symbolism in the Portinari Altarpiece,'' *Art Bulletin*, XLV, 1963, 142 ff.

47. H. J. J. Scholtens, ''Jan van Eycks 'H. Maagd met den Kartuizer' en de Exeter-Madonna te Berlijn,'' *Oud-Holland*, LV, 1938, 49 ff.

48. M. A. Lavin, ''The Altar of Corpus Domini in Urbino: Paolo Uccello, Joos van Ghent, Piero della Francesca,'' *Art Bulletin*, XLIX, 1967, 1–24.

49. Friedländer, *Early Netherlandish Painting*, III, 49 ff.; *Juste de Gand, Berruguette et la Cour d'Urbino*, exh. cat., Musée des Beaux-Arts, Ghent, 1957, 38–60; D. Carter, ''Justus of Ghent, Berruguette, and the Court of Urbino,'' *Art Quarterly*, XXI, 1958, 41–46.

50. For Hugo van der Goes see Friedländer, *Early Netherlandish Painting*, IV; Panofsky, *Early Netherlandish Painting*, I, 330–40; F. Winkler, *Das Werk des Hugo van der Goes*, Berlin, 1964.

51. Panofsky, *Early Netherlandish Painting*, I, 331–32.

52. R. A. Koch, ''Flower Symbolism in the Portinari Altarpiece,'' *Art Bulletin*, XLVI, 1964, 70–77.

53. Especially McNamee, *Art Bulletin*, XLV, 1963, 142 ff.

54. R. M. Walker, ''The Demon in the Portinari Altarpiece,'' *Art Bulletin*, XLII, 1960, 218–19.

55. W. Stechow, *Northern Renaissance Art 1400–1600: Sources and Docu-*

ments, Englewood Cliffs, N.J., 1966, 17.

56. R. and M. Wittkower, *Born Under Saturn*, London, 1963, 108–13.

57. Cf. A. Wauters, *Hughes van der Goes, sa vie et ses oeuvres*, Antwerp, 1864, who first brought attention to the Ofhuys diary. A painting by Emile Wauters, *Hugo van der Goes Soothed by Musicians*, in Antwerp's Musée Royal des Beaux-Arts, was especially admired by Van Gogh.

58. L. Behling, *Die Pflanze in der mittelalterischen Tafelmalerei*, Weimar, 1957, 36–38, 64 ff.; Koch, *Art Bulletin*, XLVI, 1964, 70 ff.

59. Panofsky, *Early Netherlandish Painting*, I, 324–30; J. Snyder, "The Early Haarlem School of Painting–II," *Art Bulletin*, XLII, 1960, 113–32; Châtelet, *Early Dutch Painting*, 93–120, 218–27.

60. R. A. Koch, "Geertgen tot Sint Jans in Bruges," *Art Bulletin*, XXXIII, 1951, 259–60.

61. Snyder, *Art Bulletin*, XLII, 1960, 125, 131–32; W. Schöne, *Über das Licht in der Malerei*, Berlin, 1954, 124 ff.; D. M. Hoffman, "Our Lady of the Sanctus," *Liturgical Arts*, XVIII, 1950, 43–45.

62. Panofsky, *Early Netherlandish Painting*, I, 328 ff.

63. *Ibid.*

64. H. Dussart, ed., *Fragments inédits de Romboudt de Doppere: Chronique brugeoise de 1491 à 1498*, Bruges, 1892, 49; see K. B. McFarlane, *Hans Memling*, Oxford, 1971, 28–45, on the reputation of Memlinc in recent scholarship; Panofsky, *Early Netherlandish Painting*, I, 347, "that very model of a major minor master . . ."; V. Denis, "Memling," *Encyclopedia of World Art*, IX, 729–35; G. T. Faggin, *L'Opera completa di Hans Memling, Classici dell'arte*, Milan, 1960.

65. W. H. J. Weale, *Hans Memlinc*, London, 1901, 79.

66. V. Hull, *Hans Memlinc's Paintings for the Hospital of Saint John in Bruges*, New York, 1979.

67. E. F. von Bodenhausen, *Gerard David und seine Schule*, Munich, 1905; Friedländer, *Early Netherlandish Painting*, VI B, 77 ff.

68. E. Gans and G. Kisch, "The Cambyses Justice Medal," *Art Bulletin*, XXIX, 1947, 121–23.

69. Friedländer, *Early Netherlandish Painting*, VI B, 127; F. Winkler, *Die flämische Buchmalerei des XV. und XVI. Jahrhunderts*, Leipzig, 1925, 134 ff.

70. O. Pächt, *The Master of Mary of Burgundy*, London, 1948; Winkler, *Die flämische Buchmalerei*, 103 ff.

71. The bibliography on Bosch is conveniently gathered in W. S. Gibson, *Hieronymus Bosch: An Annotated Bibliography*, Boston, 1983. See especially: C. de Tolnay, *Hieronymus Bosch*, Basel, 1937 (Eng. trans.); L. von Baldass, *Hieronymus Bosch*, Vienna, 1943; J. Combe, *Jérôme Bosch*, Paris, 1946; D. Bax, *Ontcijfering van Jeroen Bosch*, The Hague, 1949 (Eng. trans., *Hieronymus Bosch: His Picture-Writing Deciphered*, Rotterdam, 1979); L. B. Philip, *Hieronymus Bosch*, New York, 1956; R. L. Delevoy, *Bosch*, Geneva, 1960; P. Gerlach, "Jeronimus van Aken alias Bosch," *Bijdragen bij gelegenheid van de herdenkingstentoonstelling te 's-Hertogenbosch*, 's-Hertogenbosch, 1967; P. Gerlach, "Les sources pour l'étude de la vie de Jérôme Bosch," *Gazette des Beaux-Arts*, LXXI, 1968, 109–16; P. Reuterswärd, *Hieronymus Bosch*, Stockholm, 1970; H. Heidenreich, "Hieronymus Bosch in Some Literary Contexts," *Journal of the Warburg and Courtauld Institutes*, XXXIII, 1970, 176–87; R. H. Marijnissen, *Hieronymus Bosch*, Brussels, 1972; W. Gibson, *Hieronymus Bosch*, Washington, 1973; C. Wertheim-Aymès, *The Pictorial Language of Hieronymus Bosch*, Horsham, 1975; W. Fraenger, *Hieronymus Bosch*, Dresden, 1975.

72. Publication in preparation by J. S. Ironside, "The Underdrawings of Hieronymus Bosch," Ph.D. dissertation, Bryn Mawr College, Bryn Mawr, Pa., 1974.

73. L. B. Philip, "The *Peddler* by Hieronymus Bosch, A Study in Detection," *Nederlands Kunsthistorisch Jaarboek*, IX, 1958, 1–81; I. Zupnick, "Bosch's Representation of *Acedia* and the Pilgrimage of Everyman," *Nederlands Kunsthistorisch Jaarboek*, XIX, 1968, 115–32.

74. For this quotation and the others from sixteenth- and seventeenth-century sources see J. Snyder, *Bosch in Perspective*, Englewood Cliffs, N.J., 1973.

75. L. B. Philip, "The Prado *Epiphany* by Jerome Bosch," *Art Bulletin*, XXXV, 1953, 267–93.

76. S. Ringbom, *Icon to Narrative: The Rise of the Dramatic Closeup in Fifteenth-Century Devotional Painting*, Abo, 1965, esp. 155 ff.

77. M. Bergman, *Hieronymus Bosch and Alchemy: A Study on the St. Anthony Triptych (Acta universitatis stockholmiensis, no. XXXI)*, Stockholm, 1979. For other studies on Bosch and alchemy and astrology see Combe, *Jérôme Bosch*; J. van Lennep, *Art et alchimie*, Brussels, 1966; C. D. Cuttler, "The Lisbon *Temptation of Saint Anthony* by Jerome Bosch," *Art Bulletin*, XXXIX, 1957, 109–26; C. D. Cuttler, "Witchcraft in a Work of Bosch," *Art Quarterly*, XX, 1957, 129–40; A. Pigler, "Astrology and Jerome Bosch," *Burlington Magazine*, XCII, 1950, 132–36.

78. J. Grauls, "Taalkundige toelichting bij het Hooi en den Hooiwagen," *Gentsche Bijdragen tot de Kunstgeschiedenis*, V, 1938, 156–75.

79. W. Fraenger, *The Millennium of Hieronymus Bosch*, London, 1952.

80. L. S. Dixon, *Alchemical Imagery in Bosch's Garden of Delights*, Ann Arbor, 1981. For astrological interpretations see A. Spychalska-Boczkowska, "Materials for the Iconography of Hieronymus Bosch's Triptych of the Iconography of the Garden of Delights," *Studia Muzealne*, Poznan, V, 1966, 49–95, and "The Crab, the Sun, the Moon and Venus: Studies in the Iconography of Hieronymus Bosch's Triptych, the Garden of Earthly Delights," *Oud-Holland*, XCI, 1977, 197–231. For a fine analysis of the garden as an allegory of lust and its moralizing tradition see W. S. Gibson, "The Garden of Earthly Delights by Hieronymus Bosch: The Iconography of the Central Panel," *Nederlands Kunsthistorisch Jaarboek*, XXIV, 1973, 1–26.

81. E. H. Gombrich, "Bosch's *Garden of Delights*: A Progress Report," *Journal of the Warburg and Courtauld Institutes*, XXXII, 1969, 162–70.

82. Fraenger, *Millennium*, 148.

83. E. H. Gombrich, "The Earliest Description of Bosch's *Garden of Delights*," *Journal of the Warburg and Courtauld Institutes*, XXX, 1967, 403–6; O. Kurz, "Four Tapestries after Hieronymus Bosch," *Journal of the Warburg and Courtauld Institutes*, XXX, 1967, 150–62.

84. O. Förster, *Stephan Lochner*, 3d ed., Bonn, 1952, and *Encyclopedia of World Art*, IX, 215–17; A. Stange, *Deutsche Malerei der Gotik*, Berlin and Munich, 1961, III, 94 ff.

85. Stange, *Deutsche Malerei der Gotik*, IV, 91 ff.

86. A recent theory holds that the work was executed by a follower of Simone Martini, about 1370–80, for Vézelay, where the Magdalen's relics were housed (see G. Piccard, *Der Magdalenenaltar*, Wiesbaden, 1969).

87. Stange, *Deutsche Malerei der Gotik*, IV, 148 ff.

88. W. Worringer, *Form in Gothic*, London, 1927, 53.

89. O. Pächt, "Gestaltungsprinzipien der westlichen Malerei des 15. Jahrhunderts," *Kunstwissenschaftliche Forschungen*, II, 1933, 75 ff.

90. H. Reiners, *Die kölner Malerschule*, Munich, 1925; Stange, *Deutsche Malerei der Gotik*, V (see also Stange's brief summary of the Cologne artists and other painters in *German Painting XIV to XVI Centuries*); Stange, *Kritisches Verzeichnis der deutschen Tafelbilder vor Dürer*, 2 vols., Munich, 1970; H. M. Schmidt, *Der Meister des Marienlebens und sein Kreis (Beiträge zu den Bau- und Kunstdenkmälern im Rheinland, no. XXII)*, Düsseldorf, 1978.

91. E. Buchner, *Martin Schongauer als Maler*, Berlin, 1941; J. Baum, *Martin Schongauer*, Vienna, 1948; F. Winzinger, "Martin Schongauer," *Encyclopedia of World Art*, XII, 793 ff.; C. Minott, *Martin Schongauer*, New York, 1971.

92. P. Schabacker, "The Holy Kinship in a Church; Geertgen and the Westphalian Master of 1473," *Oud-Holland*, LXXXIX, 1975, 225–42.

93. H. Hempel, *Das Werk Michael Pachers*, 4th ed., Vienna, 1943; K. Noehls, "Michael Pacher," *Encyclopedia of World Art*, X, 896–99; Cuttler, *Northern Painting*, 284–87; N. Rasmo, *Michael Pacher*, London, 1971.

94. For the painters discussed below, consult Ring, *A Century of French Painting, 1400–1500*; A. Châtelet and J. Thuillier, *French Painting from Fouquet to Poussin*, Geneva, 1963, 31–93; G. Muehsam, *French Painters and Paintings from the Fourteenth Century to Post-Impressionism*, New York, 1970.

95. M. J. Friedländer, "Le Maître de Saint Gilles," *Gazette des Beaux-Arts*, XVII, 1937, 222–28; W. Hinkle, "The Iconography of the Four Panels by the Master of St. Gilles," *Journal of the Warburg and Courtauld Institutes*, XXVIII, 1965, 110–44. See also Ring, *A Century of French Painting*, cat. nos. 239–49.

96. K. G. Perls, *Jean Fouquet*, Paris, 1940; P. Wescher, *Jean Fouquet and His Time*, New York, 1947, and *Encyclopedia of World Art*, V, 511–14; Ring, *A Century of French Painting*, cat. nos. 120–47; T. Cox, *Jehan Foucquet*, London, 1931.

97. M. Huillet d'Istria, *Le Maître de Moulins*, Paris, 1961; cf. A. Châtelet, "A Plea for the Master of Moulins," *Burlington Magazine*, CIV, 1962, 517–24.

98. Châtelet and Thuillier, *French Painting*, 38 ff.; Ring, *A Century of French Painting*, cat. nos. 91–95.

99. For an extensive bibliography on the identity of the painter of the Avignon *Pietà*, see Ring, *A Century of French Painting*, cat. no. 206.

100. Holt, *A Documentary History of Art*, I, 298–302.

101. A. M. Hind, *An Introduction to a History of Woodcut*, New York, 1963, I, 64–140. For a basic study of graphic arts in general, consult the following texts (which frequently overlap the mediums of woodcut, engraving, drypoint, etc.): A. Bartsch, *Le peintre-graveur*, Vienna, 1803–21 (now being reissued by W. Strauss, *The Illustrated Bartsch*, in over 140 vols.); M. F. A. G. Campbell, *Annales de la typographie néerlandaise au XVe siècle*, The Hague, 1874; W. M. Conway, *The Woodcutters of the Netherlands in the Fifteenth Century*, Cambridge, Eng., 1884; W. Schreiber, *Manuel de l'amateur de la gravure sur bois et sur métal au XVe siècle*, Berlin and Leipzig, 1891–1910; P. Heitz, ed., *Einblattdrucke der fünfzehnten Jahrhunderts*, Strasbourg, 1899–1942 (100 vols.); C. Dodgson, *Catalogue of Early German and Flemish Woodcuts in the British Museum*, London, 1903 and 1911; M. Lehrs, *Geschichte und kritischer Katalog des deutschen, niederländischen und französischen Kupferstichs im 15. Jahrhundert*, Vienna, 1908–34 (9 vols.); M. J. Schretlen, *Dutch and Flemish Woodcuts of the Fifteenth Century*, London, 1925; A. Blum, *The Origins of Printing and Engraving*, New York, 1940; F. Hollstein, *Dutch and Flemish Etchings, Engravings, Woodcuts*, Amsterdam, 1949–82 (26 vols.); F. Hollstein, *German Engravings, Etchings, and Woodcuts*, Amsterdam, 1954–80 (28 vols.); R. S. Field, *Fifteenth Century Woodcuts and Metalcuts from the National Gallery*, Washington, 1965; A. Shestack, *Fifteenth Century Engravings of Northern Europe*, Washington, 1967; *The Lessing J. Rosenwald Collection: A Catalogue of Gifts of Lessing J. Rosenwald to the Library of Congress, 1943–1975*, Washington, 1977.

102. R. A. Koch, "New Criteria for Dating the Netherlandish *Biblia Pauperum* Blockbook," *Studies in Late Medieval and Renaissance Painting in Honor of Millard Meiss*, Princeton, N.J., 1977, 283–86; A. Henry, "The 40-Page Blockbook *Biblia Pauperum*—Schreiber Editions I and VIII Reconsidered," *Oud-Holland*, XCV, 1981, 127–50.

103. Delaissé, *A Century of Dutch Manuscript Illumination*; R. G. Calkins, "Parallels Between Incunabula and Manuscripts from the Circle of the Master of Catherine of Cleves," *Oud-Holland*, XCII, 1978, 137–60.

104. For a summary see Blum, *The Origins of Printing and Engraving*; T. Musper, "Die Datierung und Lokalisierung der ältesten gedruckten Bücher und Laurens Janszoon Coster," *Die graphischen Künste*, n.f.III, 1938, 41–52; J. Poortenaar, *Coster–niet Gutenberg*, Naarden, 1947.

105. J. Snyder, "The Bellaert Master and *De proprietatibus rerum*," *The Early Illustrated Book: Essays in Honor of Lessing J. Rosenwald*, Washington, 1982, 41–62.

106. R. A. Koch, "Martin Schongauer's Dragon Tree," *Print Review V: Tribute to Wolfgang Stechow*, New York, 1976, 114–19.

107. Shestack, *Fifteenth Century Engravings of Northern Europe*, 1 ff.; cf. H. Lehmann-Haupt, *Gutenberg and the Master of the Playing Cards*, New Haven, 1966.

108. I. Schüller, *Der Meister der Liebesgärten, ein Beitrag zur frühholländischen Malerei*, Amsterdam and Leipzig, 1932; Dhanens, *Hubert en Jan van Eyck*, 155–68.

109. A. Shestack, *Master E. S.—Five Hundredth Anniversary Exhibition*, exh. cat., Philadelphia Museum of Art, 1967.

110. Shestack, *Master E. S.*, cat. no. 68. For another example of mother-of-pearl design based on an engraving of Master E. S., see R. Koch and C. Sommer, "A Mother-of-Pearl Carving after the Master E. S.," *Journal of the Walters Art Gallery*, V, 1942, 119–21.

111. E. Flechsig, *Martin Schongauer*, Strasbourg, 1951; Shestack, *Fifteenth Century Engravings*, 33 ff., and *The Complete Engravings of Martin Schongauer*, New York, 1969; C. Minott, *Martin Schongauer*.

112. Shestack, *Fifteenth Century Engravings*, cat. no. 87. For the elephant's trip through Holland, see p. 273.

113. A. Stange, *Der Hausbuch Meister (Studium zur deutschen Kunstgeschichte*, no. 316), Strasbourg, 1958; J. Hutchison, "The Housebook Master and the Folly of the Wise Man," *Art Bulletin*, XLVIII, 1966, 73–79, and *The Master of the Housebook*, New York, 1972, especially 5–10 and the catalogue entries.

114. E. Panofsky, "Imago Pietatis," *Festschrift für Max J. Friedländer zum 60. Geburtstage*, Leipzig, 1927, 261 ff.

115. General texts on Northern sculpture include: W. Pinder, *Die deutsche Plastik vom ausgehenden Mittelalter bis zum Ende der Renaissance*, Berlin, 1914; M. Devigne, *La Sculpture mosane du XIIe au XVIe siècle*, Paris and Brussels, 1932; D. Roggen, "Beeldhouwkunst, Einde der XIVde en XVde eeuw," *Geschiedenis van de vlaamsche Kunst*, Antwerp and The Hague, I, 1937, 236 ff.; G. Troescher, *Die burgundische Plastik des ausgehenden Mittelalters*, Frankfort, 1940; J. Borchgrave d'Altena, *Les Retables brabançons*, Brussels, 1943; K. H. Clasen, *Die schönen Madonnen*, Königstein, 1951; D.P.R.A. Bouvy, *Middeleeuwsche Beeldhouwkunst in de Noordelijke Nederlanden*, Amsterdam, 1947; *Middeleeuwse Kunst der Noordelijke Nederlanden*, exh. cat., Rijksmuseum, Amsterdam, 1958, 188–226; *Flanders in the Fifteenth Century: Art and Civilization*, exh. cat., Detroit Institute of Arts, 1960, 229–309; H. Wilm, *Die gotische Holzfigur*, 3d ed., Stuttgart, 1962; W. Paatz, *Süddeutsche Schnitzaltäre der Spätgotik*, Heidelberg, 1963; Müller, *Sculpture in the Netherlands, Germany, France, and Spain*; G. von der Osten and H. Vey, *Painting and Sculpture in Germany and the Netherlands 1500 to 1600 (The Pelican History of Art*, no. XXXI), Baltimore, 1969; P. Quarre, *La Sculpture en Bourgogne à la fin du moyen âge*, Fribourg, 1978; M. Baxandall, *The Limewood Sculptors of Renaissance Germany*, New Haven and London, 1980.

116. H. Huth, *Künstler und Werkstaat der Spätgotik*, Augsburg, 1923; Baxandall, *Limewood Sculptors*, 95–122.

117. R. Koch, "Two Sculptures after Rogier's 'Descent from the Cross' in the Escorial," *Journal of the Walters Art Gallery*, XI, 1947, 39 ff.

118. J. Leeuwenberg, "De tien bronzen plorannen in het Rijksmuseum te Amsterdam," *Gentse bijdragen tot de Kunstgeschiedenis*, XIII, 1951, 13–59; for a summary of these arguments see *Flanders in the Fifteenth Century*, Detroit Institute of Arts, 1960, 264–67.

119. Bouvy, *Middeleeuwsche Beeldhouwkunst in de Noordelijke Nederlanden*, 104 ff.

120. P. T. A. Swillens, "De Utrechtsche beeldhouwer Adriaen van Wesel," *Oud-Holland*, LXIII, 1948, 149–63; J. Leeuwenberg, "Het werk van den Meester der Musiceerende Engelen," *Oud-Holland*, LXIII, 1948, 164–79; *Middeleeuwse Kunst der Noordelijke Nederlan-*

den, exh. cat., Rijksmuseum, Amsterdam, 1958, 201–6; Müller, *Sculpture*, 89 ff.; W. Halsema, G. Lammens, and G. de Ward, *Adriaen van Wesel*, exh. cat., Rijksmuseum, Amsterdam, 1980.

121. See especially Baxandall, *Limewood Sculptors*, 12, 245 ff.

122. Müller, *Sculpture*, 79 ff.; Baxandall, *Limewood Sculptors*, 248–51.

123. Baxandall, *Limewood Sculptors*, 7 ff.

124. *Ibid.*, 135–42.

125. For the basic studies on Riemenschneider's development, see the books by J. Bier: *Tilman Riemenschneider: Die frühen Werke*, Würzburg, 1925; *Die reifen Werke*, Augsburg, 1930; *Die späten Werke in Stein*, Vienna, 1973; *Die späten Werke in Holz*, Vienna, 1978.

126. Baxandall, *Limewood Sculptors*, 266–74.

127. See especially *ibid.*, 143–63, 191–202.

128. *Ibid.*, 296–301.

PART THREE

1. The basic literature on Dürer is found in E. Panofsky, *The Life and Art of Albrecht Dürer*, 2 vols., Princeton, N.J., 1943, and in the catalogue *Ausstellung des Germanischen Nationalmuseums Nürnberg: 1471–Albrecht Dürer–1971*, Munich, 1971. See especially: H. Wölfflin, *Die Kunst Albrecht Dürers*, Munich, 1905 (reissued in Eng. trans., *The Art of Albrecht Dürer*, London, 1971); C. Dodgson, *Albrecht Dürer–Engravings and Etchings*, London, 1926; F. Winkler, ed., *Dürer, des Meisters Gemälde, Kupferstiche und Holzschnitte (Klassiker der Kunst*, no. IV), 4th ed., Stuttgart and Leipzig, 1928; F. Lippmann and F. Winkler, *Zeichnungen von Albrecht Dürer in Nachbildungen*, 7 vols., Berlin, 1883–1929; H. Tietze and E. Tietze-Conrat, *Kritisches Verzeichnis der Werke Albrecht Dürers*, 2 vols., Augsburg and Basel, 1928–38; F. Winkler, *Die Zeichnungen Albrecht Dürers*, 4 vols., Berlin, 1936–39; W. Waetzoldt, *Dürer and His Times*, London, 1950; H. Tietze, *Dürer als Zeichner und Aquarellist*, Vienna, 1951; W. M. Conway, *The Writings of Albrecht Dürer*, New York, 1958; N. Rupprich, *Dürer–Schriftlicher Nachlass*, 3 vols., Berlin, 1956–69; J. Bialostocki, "Albrecht Dürer," *Encyclopedia of World Art*, IV, 512–31; C. White, *Dürer–The Artist and His Drawings*, New York, 1971; C. W. Talbot, *Dürer in America–His Graphic Works*, exh. cat., National Gallery of Art, Washington, 1971; C. R. Dodwell, ed., *Essays on Dürer*, Manchester, 1973; W. Hütt, *Albrecht Dürer: Die gesamte graphische Werk*, 2 vols., Berlin, 1970–71; W. Strauss, *The Complete Drawings of Albrecht Dürer*, New York, 1974; W. Strauss, *Albrecht Dürer–Woodcuts and Woodblocks*, New York, 1980.

2. Panofsky, *Dürer*, 85.

3. Panofsky, *Dürer*, 171; R. Klibansky, E. Panofsky, and F. Saxl, *Saturn and Melancholy*, London, 1964; Talbot, *Dürer in America*, no. 59, 145–46; R. and M. Wittkower, *Born Under Saturn*, London, 1963. For alchemistic interpretations, see G. F. Hartlaub, "Arcana Artis–Spuren altchemischer Symbolik in der Kunst des 16. Jahrhunderts," *Zeitschrift für Kunstgeschichte*, VI, 1937, 289 ff.; J. H. Read, "Durer's *Melencolia*: An Alchemical Interpretation," *Burlington Magazine*, LXXXVII, 1945, 283–84.

4. Strauss, *Dürer–Woodcuts*, 445.

5. *Carel van Mander, Dutch and Flemish Painters*, trans. by C. van de Wall, 41.

6. White, *Dürer–The Artist and His Drawings*, 52.

7. K. A. Strand, *Woodcuts to the Apocalypse in Dürer's Time*, Ann Arbor, 1968.

8. F. Juraschek, *Das Rätsel in Dürers Gotteschau*, Salzburg, 1955.

9. Cf. R. Chadraba, *Dürers Apokalypse*, Prague, 1964; M. Dvořák, "Dürers Apokalypse," *Kunstgeschichte als Geistesgeschichte*, Munich, 1924, 193–202, who argues that Dürer's illustrations were directed at the popes of Rome, just as John's text was at the early emperors of Rome.

10. Panofsky, *Dürer*, 107 ff.

11. Holt, *A Documentary History of Art*, I, 334 ff.

12. Panofsky, *Dürer*, 151–71; Talbot, *Dürer in America*, 143 ff.

13. W. Strauss, *The Book of Hours of the Emperor Maximilian the First*, New York, 1974.

14. P. Troutman, *Albrecht Dürer–Sketchbook of His Journey to the Netherlands, 1520–1521*, New York and Washington, 1971.

15. See C. C. Christensen, *Art and the Reformation in Germany*, Athens, Ohio, and Detroit, 1979, 190 ff.

16. Panofsky, *Dürer*, 44.

17. Luther, *Commentary on Psalm CXI*; see Christensen, *Art and the Reformation*, 54 ff., for "Luther's Theology and the Uses of Religious Art."

18. Christensen, "Excursus: Dürer's *Four Apostles*–A Reformation Painting," *Art and the Reformation*, 181–206; G. Pfeiffer, "Albrecht Dürer's *Four Apostles*: A Memorial Picture from the Reformation Era," *Social History of the Reformation*, Columbus, Ohio, 1972, 271 ff.

19. Conway, *Writings of Albrecht Dürer*, 212.

20. For the *Isenheim Altarpiece* see G. Scheja, *The Isenheim Altarpiece*, New York, 1969, and P. Schmitt, *Der Isenheimer Altar*, Stuttgart, 1967. For Grünewald in general: A. Burkhard, *Matthias Grünewald: Personality and Accomplishment*, Cambridge, Mass., 1936; W. K. Zülch, *Der historische Grünewald*, Munich, 1938, and *Grünewald*, Leipzig, 1956; E. Ruhmer, *Grünewald–The Paintings*, New York, 1958 (with two essays by J. K. Huysmans). O. Benesch, *The Art of the Renaissance in Northern Europe*, Cambridge, Mass., 1945, discusses the influences of the writings of Saint Bridget, pp. 24–40.

21. Sandrart's text is translated in Stechow, *Northern Renaissance Art 1400–1600*, 126–29. Also Holt, *A Documentary History of Art*, I, 354–58.

22. Cf. E. Wind, "Albrecht of Brandenburg as Saint Erasmus," *Journal of the Warburg Institute*, London, 1937, I, 142 ff.

23. For the drawings see G. Schoenberger, *The Drawings of Mathias Gotharts, called Grünewald*, New York, 1948; L. Behling, *Die Handzeichnungen des Mathis Gothart Nithart gen. Grünewald*, Weimar, 1955.

24. O. Benesch, *Der Maler Albrecht Altdorfer*, Vienna, 1940; A. Stange, *Malerei der Donauschule*, Munich, 1964; *Die Kunst der Donauschule 1490–1540: Ausstellung des Landes Oberösterreich*, exh. cat., Stift St. Florian and Schlossmuseum Linz, 1965; E. Ruhmer, *Albrecht Altdorfer*, Munich, 1965. For Altdorfer's drawings and graphic arts, see F. Winzinger, *Albrecht Altdorfer–Zeichnungen*, Munich, 1952, and *Albrecht Altdorfer–Graphik*, Munich, 1963.

25. A. Burkhard, *The St. Florian Altar of Albrecht Altdorfer*, Munich, 1970.

26. Christensen, *Art and the Reformation*, 45 ff. and 192.

27. H. Wölfflin, *Principles of Art History*, New York, n.d. (first Ger. ed. 1915); *Italien und das deutsche Formgefühl*, Munich, 1931.

28. K. Martin, *Die Alexanderschlacht*, Munich, 1969. R. Janzen, *Albrecht Altdorfer–Four Centuries of Criticism*, Ann Arbor, 1980; see esp. 61–90 of this interesting study for "Altdorfer and Ideologies."

29. For Paracelsus and alchemy in general, consult L. Thorndike, *A History of Magic and Experimental Sciences from the Twelfth to the Sixteenth Century*, London and New York, 1923–41; J. H. Read, *Prelude to Chemistry*, 2nd ed., London, 1939; E. J. Holmyard, *Alchemy*, Harmondsworth, Eng., 1957, esp. 161–72.

30. See Hartlaub article cited in note 3, Part Three.

31. For Hans Baldung Grien, see O. Fischer, *Hans Baldung Grien*, Munich, 1939; K. Oettinger and K. A. Knappe, *Hans Baldung Grien und Albrecht Dürer in Nürnberg*, Nuremberg, 1963; T. A. Brady, Jr., "The Social Place of a German Renaissance Artist: Hans Baldung Grien (1484/5–1545) at Strasbourg," *Central European History*, VIII, 1975, 293–315; M. Mende, *Hans Baldung Grien: Das graphische Werk*, Unterschneidheim, 1978; *Hans Baldung Grien in Kunstmuseum Basel*, exh. cat., Basel, 1978; A. Shestack, "An Introduction to Hans Baldung Grien," *Hans Baldung Grien–Prints and*

Drawings, exh. cat., National Gallery of Art, Washington, and Yale University Art Gallery, New Haven, 1981, 3–18; G. von der Osten, *Hans Baldung Grien: Gemälde und Dokumente*, Berlin, 1982.

32. See J. Wirth, *La jeune fille et la mort: Recherches sur les thèmes macabres dans l'art germanique de la Renaissance* (Centre de Recherches d'Histoire et de Philologie de la IVe Section de l'École Pratique des Hautes Études, V, Hautes Études Médiévales et Modernes, no. XXXVI), Geneva, 1979.

33. R. A. Koch, *Hans Baldung Grien–Eve, The Serpent and Death* (Masterpieces in the National Gallery of Ottawa, no. II), Ottawa, 1974; A. K. Hieatt, "Hans Baldung Grien's Ottawa *Eve* and Its Context," *Art Bulletin*, LXV, 1983, 290–304, and "Eve as Reason in a Tradition of Allegorical Interpretations of the Fall," *Journal of the Warburg and Courtauld Institutes*, XLIII, 1980, 221–26.

34. G. Radbruch, "Hans Baldungs *Hexenbilder*," *Elegantiae Juris Criminalis*, 2nd ed., Basel, 1950, 30–48; and G. F. Hartlaub, *Hans Baldung Grien–Hexenbilder*, Stuttgart, 1961; *Hans Baldung Grien*, exh. cat., Washington, 1981, no. 18, 114–19.

35. *The Malleus Malificarum of Heinrich Kramer and Jacob Sprenger*, trans. and notes by the Rev. Montague Summers, New York, 1971. Also see M. Chrisman, *Strasbourg and the Reformation*, New Haven, 1967.

36. W. Strauss, "The Wherewithal of Witches," *Source*, II, 1983, 20–21. For interesting comments on the perspective of the *Bewitched Groom*, see E. H. Gombrich, "Illusion and Visual Deadlock," *Meditations on a Hobby Horse and Other Essays*, London and New York, 1971, 158–59.

37. For a summary see Christensen, *Art and the Reformation*, 110 ff.; C. Harbison, *Symbols in Transformation: Iconographic Themes at the Time of the Reformation*, Princeton, N.J., 1969 (see also the essay by E. Panofsky, "Comments on Art and Reformation," 9–14); E. Battisti, "Reformation and Counter-Reformation," *Encyclopedia of World Art*, XI, 902 ff.

38. W. Schade, *Cranach*, New York, 1980; W. H. Köhler and F. Steigerwald, *Lucas Cranach–Gemälde, Zeichnungen, Druckgraphic*, exh. cat., Staatliche Museen, Berlin-Dahlem, 1973; H. Lüdecke, *Lucas Cranach d. Ä.*, Berlin, 1972; E. Ruhmer, *Cranach*, London, 1963; K. Schütz, *Lucas Cranach d. Ä. und seine Werkstatt*, exh. cat., Kunsthistorisches Museum, Vienna, 1972; H. Ladendorf, *Lucas Cranach d. Ä., der Künstler und seine Zeit*, Berlin, 1953, 82–98.

39. See esp. Benesch, *Art of the Renaissance in Northern Europe*, 56 ff.

40. Christensen, *Art and the Reformation*, 42–65; D. Freedberg, "The Structure of Byzantine and European Iconoclasm," in A. Bryer and J. Herrin, eds., *Iconoclasm*, Birmingham, 1977, 165–77.

41. *Ibid.*, 124 ff.; O. Thulin, *Cranach–Altäre der Reformation*, Berlin, 1955, 126 ff.; D. L. Ehresmann, "The Brazen Serpent: A Reformation Motif in the Works of Lucas Cranach the Elder," *Marsyas*, XIII, 1966–67, 32–47; C. Harbison, *The Last Judgment in Sixteenth-Century Northern Europe*, New York, 1976, 95 ff.; K. M. McClinton, "The Lutheran Reform: Paintings of Lucas Cranach the Elder," *Response in Worship, Music, and the Arts*, IV, 1962, 2–6; H. von Hintzenstern, "Lucas Cranach d. Ä.: Altarbilder aus der Reformationszeit," *Evangelische Verlagsanstalt*, Berlin, 1972, 88 ff.; C. O. Kibish, "Lucas Cranach's *Christ Blessing the Little Children*," *Art Bulletin*, XXXVII, 1955, 196–203.

42. H. B. Wehle, "A Judgment of Paris by Cranach," *Metropolitan Museum Studies*, New York, 1929–30, II, 1 ff.

43. A. Stange and N. Lieb, *Hans Holbein der Ältere*, Munich and Berlin, 1960; *Hans Holbein der Ältere und die Kunst der Spätgotik*, Ausstellung Augsburg-Rathaus, Augsburg, 1965.

44. K. Feuchtmayr, *Das Malerwerk Hans Burgkmair von Augsburg*, Augsburg, 1931; A. Burkhard, *Hans Burgkmair*, Leipzig, 1934; *Augsburger Renaissance*, Ausstellung Augsburg, Augsburg, 1955.

45. P. Ganz, *The Paintings of Hans Holbein*, London, 1950.

46. Carel van Mander, *Dutch and Flemish Painters*, trans. by C. van de Wall, 83–95.

47. H. Klotz, *Hans Holbein-Christus im Grabe*, Stuttgart, 1968, 6 ff.

48. Ganz, *Paintings of Hans Holbein*, cat. nos. 55–60, p. 235; Benesch, *Art of the Renaissance in Northern Europe*, 62 ff.; G. Marlier, *Erasme et la peinture flamande de son temps*, Damme, 1954, esp. 71–111; *Erasmus en zijn Tijd. Tentoonstelling Ingericht ter Herdenking van de Geboorte 500 Jaaren Geleden*, Museum Boymans-van Beuningen, Rotterdam, 1969, esp. nos. 237, 269, 277, 346–51.

49. Ganz, *Paintings of Hans Holbein*, no. 41, pp. 231–32; *The Frick Collection*, I, New York, 1968, 228–33; S. Morison, *The Likeness of Thomas More*, London, 1963. For the family portrait see Ganz, nos. 175–76, 276–84; Benesch, *Art of the Renaissance in Northern Europe*, 65.

50. Ganz, *Paintings of Hans Holbein*, nos. 177–78, 284–89.

51. M. F. S. Henry, *Holbein's Ambassadors–The Picture and the Men: A Historical Study*, London, 1900; C. G. Heise, *Hans Holbein d.J.–Die Gesandten*, Stuttgart, 1955; M. Levey, *National Gallery Catalogues: The German School*, London, 1959, 47–54; H. G. Villiers, *Hans Holbein the Younger–The Ambassadors in the National Gallery* (Gallery Books, no. 18), London, n.d.

52. Levey, *National Gallery Catalogues: German School*, 48 ff.

53. Ganz, *Paintings of Hans Holbein*, nos. 94, 96, 106, 119, 248 ff.; for the Whitehall Palace portrait see no. 179, p. 289 ff.; R. Strong, *Holbein and Henry VIII*, London, 1967.

54. Strong, *Holbein and Henry VIII*, 39.

55. Levey, *National Gallery Catalogues: German School*, 54–57, and *Holbein's Christina of Denmark*, National Gallery Publications, London, 1968; G. W. O. Woodward, *The Six Wives of Henry VIII*, National Portrait Gallery, London, n.d., 17.

56. Strong, *Holbein and Henry VIII*, 17.

57. For a survey of British miniaturists, see E. Auerbach, *Tudor Artists*, London, 1954; G. Reynolds, *Nicholas Hilliard and Isaac Oliver*, Victoria and Albert Museum Handbooks, London, 1947 (no. 38, p. 29 for the *Young Man Among Roses*); E. Auerbach, *Nicholas Hilliard*, Boston, 1961.

58. For Dürer's descriptions of Antwerp see W. M. Conway, *Literary Remains of Albrecht Dürer*, Cambridge, Eng., 1889, 96 ff.

59. G. de Boom, *Marguerite d'Autriche-Savoie et la Pré-Renaissance*, Paris, 1935; J. Strelka, *Der burgundische Renaissancehof Margarethes von Österreich*, Vienna, 1957; E. Duverger and D. Duverger-van de Velde, "Jean Lemaire de Belges en de Schilderkunst," *Jaarboek 1967 Koninklijk Museum voor Schone Kunsten*, Antwerp, 1967, 37–74; G. Ring, "Wiedergefundene Bilder aus dem Sammlungen der Margarete von Österreich," *Monatshefte für Kunstwissenschaft*, VII, 1914, 263–65. For the inventories of Margaret of Austria see H. Zimerman, "Urkunden und Regesten aus dem K. und K. Haus-, Hof- und Staats-Archiv in Wien," *Jahrbuch der kunsthistorischen Sammlungen des allerhöchsten Kaiserhauses in Wien*, III, 1885, lxxxii–clxii.

60. C. Karpinski, "At the Sign of the Four Winds," *Bulletin of the Metropolitan Museum of Art*, XVII, 1959, 8–17; T. A. Riggs, *Hieronymus Cock: Printmaker and Publisher*, New York and London, 1977.

61. For Plantin see R. Nash, "Plantin's Illustrated Books," *De gulden passer*, XXXIV, 1956, 144–56; C. Clair, *Christopher Plantin*, London, 1960; L. Voet, *The Golden Compasses: A History and Evaluation of the Printing and Publishing Activities of the Officina Plantiniana at Antwerp*, Amsterdam, 1969; J. J. Murray, *Antwerp in the Age of Plantin and Brueghel*, Norman, 1970.

62. F. J. van den Branden, *Geschiedenis der Antwerpsche Schilderschool*, Antwerp, 1883; Friedländer, *Early Netherlandish Painting*, XI.

63. A. van Fornenbergh, *Den Antwerpschen Protheus ofte Cyclopschen Apelles*, Antwerp, 1658, and F. Fickaert, *Metamorphosis ofte Wonderbaere Vernaderingh' ende Leven Mr. Quinten Massys*, Antwerp, 1648. For Metsys see L. von Baldass, *Gotik und Renaissance im Werke des Quentin Metsys*, Vienna, 1933; K. G. Boon, *Quentin Massys*, Amsterdam, 1942; H. Broadley, "The Mature Style of Quentin

Massys,'' Ph.D. dissertation, New York University, 1961; Friedländer, *Early Netherlandish Painting*, VII; L. Silver, ''Quentin Massijs: 1466-1530,'' Ph.D. dissertation, Harvard University, Cambridge, Mass., 1974; A. de Bosque, *Quentin Metsys*, Brussels, 1975.

64. S. Sulzberger, ''Considérations sur le chef-d'oeuvre de Quentin Metsys: *Le prêteur et sa femme*,'' *Bulletin de Musées Royaux des Beaux-Arts de Belgique*, 1965, 27-34. Cf. Marlier, *Erasme et la peinture flamande*, 217 ff., and de Bosque, *Quentin Metsys*, 190 ff.

65. L. Silver, ''The Ill-Matched Pair by Quentin Massys,'' *Studies in the History of Art*, National Gallery of Art, Washington, VI, 1974, 105-23.

66. Panofsky, *Early Netherlandish Painting*, 355-56; de Bosque, *Quentin Metsys*, 228-31; Marlier, *Erasme et la peinture flamande*, 222 ff.

67. R. A. Koch, *Joachim Patinir*, Princeton, 1968; Friedländer, *Early Netherlandish Painting*, IXb, 99-138.

68. Cf. M. L. Dufey-Haeck, ''La thème du repos pendant la fluite en Egypte dans la peinture flamande de la second moitie du XVe au milieu du XVIe siècle,'' *Revue belge*, XLVIII, 1979, 45-76.

69. Friedländer, *Early Netherlandish Painting*, IXa, 17-47; L. von Baldass, *Joos van Cleve*, Vienna, 1925.

70. L. Guicciardini, *Descrittione di tutti i Paesi Bassi*, Antwerp, 1567, 98.

71. Friedländer, *Early Netherlandish Painting*, VIII; G. von Osten, ''Studien zu Jan Gossart,'' *De Artibus Opuscula, XL: Essays in Honor of Erwin Panofsky*, New York, 1961, 454-75; G. Glück, ''Mabuse and the Development of the Flemish Renaissance,'' *Art Quarterly*, VIII, 1945, 116-38; H. Pauwels, H. R. Hoetick, and S. Herzog, *Jan Gossaert genaamd Mabuse*, exh. cat., Museum Boymans-van Beuningen, Rotterdam, 1965 (there is also a French edition).

72. H. F. Pauwels, ''Jan Gossart en van Eyck,'' *Bulletin Boymans-van Beuningen Museum*, Rotterdam, XIX, 1968, 4-15.

73. The Van Eyck panel must have been accessible in the Netherlands at the end of the century. Another fine replica was painted by the Master of 1499 (Antwerp, Musée Royal des Beaux-Arts) with a pendant of the abbot Chrétien de Hondt of the Abbey of the Dunes near Furnes (1495-1509) kneeling in a domestic interior—see *Flanders in the Fifteenth Century*, exh. cat., Detroit Institute of Arts, 1960, 171-74. This and other borrowings from Gerard David suggest that Gossart had a close connection with the Bruges-Ghent school in his youth.

74. E. de Jongh, ''Speculaties over Jan Gossaerts Lucas-madonna in Prag,'' *Bulletin Boymans-van Beuningen Museum*, Rotterdam, XIX, 1968, 43-46.

75. S. Herzog, ''Tradition and Innovation in Gossart's Neptune and Amphitrite and Danaë,'' *Bulletin Boymans-van Beuningen Museum*, Rotterdam, XIX, 1968, 25-41.

76. M.M. Kahr, ''Danaë: Virtuous, Voluptuous, Venal Woman,'' *Art Bulletin*, LX, 1978, 46 ff.

77. H. Schwartz, ''Jan Gossaert's Adam and Eve Drawings,'' *Gazette des Beaux-Arts*, XLII, 1953, esp. 132.

78. A series of lectures held for the Van Orley quincentenary celebration in Brussels in 1942 was published in *Bernard van Orley, 1488-1541*, Brussels, 1943. Otherwise see Friedländer, *Early Netherlandish Painting*, VIII, 51 ff. and 116-17; L. von Baldass, ''Die Entwicklung des Bernart van Orley,'' *Jahrbuch der Kunsthistorischen Sammlungen in Wien*, XIII, 1944, 141-91; H. Wayment, ''A Rediscovered Master: Adrian van den Houte of Malines and the Malines/Brussels School. III: Adrian's Development and His Relation with Bernard van Orley,'' *Oud-Holland*, LXXXIV, 1969, 266-68; G. de Tervarent, ''Les sources littéraires de van Orley,'' *Les Énigmes de l'art du moyen-âge*; Paris, 1941, 55-72; *Le Siècle de Bruegel*, exh. cat., Musées Royaux des Beaux-Arts de Belgique, Brussels, 1963, 40-44.

79. Friedländer, *Early Netherlandish Painting*, VIII, 54.

80. *Ibid.*, 73-81; M. Crick-Kuntziger, ''Bernard van Orley et la décor mural en tapisserie,'' *Bernard van Orley, 1488-1541*, Brussels, 1943.

81. G. Marlier, *La Renaissance flamande: Pierre Coeck d'Alost*, Brussels, 1966; A. Corbet, *Pieter Coecke van Aelst*, Antwerp, 1950; Friedländer, *Early Netherlandish Painting*, XII, 32-39; *Le Siècle de Bruegel*, exh. cat., Brussels, 1963, 83-87.

82. Marlier, *La Renaissance flamande*, 69 ff.; S. Casson, ''Les fouilles de l'Hippodrome de Constantinople,'' *Gazette des Beaux-Arts*, III, 1930, 216 ff.

83. Marlier, *La Renaissance flamande*, 101 ff.; W. Krönig, ''Das Abendmahlsbild des Pieter Coecke,'' *Miscellanea Prof. Dr. D. Roggen*, Antwerp, 1957, 161-77.

84. *Carel van Mander, Dutch and Flemish Painters*, trans. by C. van de Wall, 74-75, and n. 6.

85. *Ibid.*, 81; for Lombard see A. Goldschmidt, ''Lambert Lombard,'' *Preuss. Jahrbuch*, XL, 1919, 206-40; Friedländer, *Early Netherlandish Painting*, XIII, 28-33; *Lambert Lombard et son temps*, exh. cat., Liège, 1966 (with essays); W. Krönig, ''Lambert Lombard, Beiträge zu seinem Werk,'' *Wallraf-Richartz Jahrbuch*, XXXVI, 1974, 105-58.

86. J. de Voragine, *The Golden Legend*, trans. by G. Ryan and H. Ripperger, London, New York, and Toronto, 1941, 618.

87. Friedländer, *Early Netherlandish Painting*, XIII, 34-39; C. van de Velde, *Frans Floris: Leven en werken*, Brussels, 1975; D. Zuntz, *Frans Floris*, Strasbourg, 1929.

88. C. van de Velde, ''A Roman Sketchbook of Frans Floris,'' *Master Drawings*, VII, 1969, 255-86.

89. L. von Baldass, ''Die niederländische Landschaftsmalerei von Patenir bis Bruegel,'' *Jahrbuch der kunsthistorischen Sammlungen in Wien*, XXXIV, 1918, 140 ff.; Friedländer, *Early Netherlandish Painting*, XIII, 23-27; E. Gérard, *Dinant et la Meuse dans l'histoire du passage*, Lammersdorf, 1960; H.G. Franz, *Niederländische Landschaftsmalerei im Zeitalter des Manierismus*, Graz, 1969, 78-92; E. and L. Larsen, ''Quelque notes à propos de Herry de Pateneir et Henri Bles,'' *Oud-Holland*, LVII, 1940, 21-28.

90. R. A. Koch, ''A Rediscovered Painting, 'The Road to Calvary,' by Herri met de Bles,'' *Record of the Art Museum Princeton University*, XIII, 1954, 31-51.

91. H. van Werveke, ''Aantekeningen bij de zogenaamde Belastingspachter en Wisselnaar van Marinus van Reymerswaele,'' *Gentse Bijdragen tot de Kunstgeschiedenis*, XII, 1949-50, 43-58.

92. Friedländer, *Early Netherlandish Painting*, XII, 44-52; P. Wescher, ''Jan van Hemessen und Jan van Amstel,'' *Jahrbuch Berliner Museum*, XII, 1970, 34-60; Marlier, *Erasme et la peinture flamande*, 280-95; Marlier, *La Renaissance flamande*, 277 ff.; B. Wallen, ''The Portraits of Jan Sanders van Hemessen,'' *Oud-Holland*, LXXXVI, 1971, 70-87.

93. J. Snyder, ''The Parable of the Unmerciful Servant by Jan Sanders van Hemessen,'' *University of Michigan Museum of Art Bulletin*, I, 1965-66, 3-13.

94. K. Renger, *Lochere Gesellschaft*, Berlin, 1970, 27 ff., 51 ff.; H.C. Slim, *The Prodigal Son at the Whores*, Irvine, 1976.

95. K. Craig, ''Pieter Aertsen and the Meat Stall,'' *Oud-Holland*, XCVI, 1982, 1-15; K. Moxey, '' 'The Humanist' Market Scenes of Joachim Beuckelaer: Moralizing Exempla or 'Slices of Life,' '' *Jaarboek van het Koninklijk Museum voor Schone Kunsten–Antwerpen*, 1976, 109-88, esp. 142-49, and *Pieter Aertsen, Joachim Beuckelaer and the Rise of Secular Painting in the Context of the Reformation*, New York, 1974 (Moxey criticizes a too stringent interpretation of Mannerist inversion in Aertsen's painting, stressing the secularization of the imagery). For Aertsen see also J. Sievens, *Pieter Aertsen*, Leipzig, 1908; R. Genaille, ''L'Oeuvre de Pieter Aertsen,'' *Gazette des Beaux-Arts*, XLIV, 1954, 267-88.

96. Friedländer, *Early Netherlandish Painting*, X, 24-29; G.J. Hoogewerff, *De Noord-Nederlandsche Schilderkunst*, The Hague, 1937, II, 346 ff.; *Middeleeuwse Kunst der Noordelijke Nederlanden*, exh. cat., Rijksmuseum, Amsterdam, 1958, 89-90; J. Bruyn, ''De Abdij

van Egmond als opdrachtgeefster van kunstwerken in het begin van de zestiende eeuw," *Oud-Holland,* LXXXI, 1966, 145–72, 197–227, esp. 199 ff.

97. Friedländer, *Early Netherlandish Painting,* XII, 53–64; Hoogewerff, *De Noord-Nederlandsche Schilderkunst,* III, 89–96; K. Steinbart, *Die Tafelgemälde des Jacob Cornelisz.* (*Studien zur Deutschen Kunstgeschichte,* no. 221), Strasbourg, 1922. Sara Lehrman of Bryn Mawr College is preparing a monograph on Jacob Cornelisz.

98. H.J.J. Scholtens, "Het te Napels bewaarde Kersttafereel van Jacob Cornelisz van Oostsanen," *Oud-Holland,* LXXIII, 1958, 198–211.

99. Schretlen, *Dutch and Flemish Woodcuts of the Fifteenth Century* (under "Delft").

100. Friedländer, *Early Netherlandish Painting,* V, 38–44; Hoogewerff, *De Noord-Nederlandsche Schilderkunst,* II, 240 ff.; *Middeleeuwse Kunst,* exh. cat., Amsterdam, 1958, 65–70; K.G. Boon, *De Meester van de Virgo inter Virgines* (*Oud Delft,* no. 2), Rotterdam and The Hague, 1963; Châtelet, *Early Dutch Painting,* 145 ff.

101. Friedländer, *Early Netherlandish Painting,* X, 11–23; *Middeleeuwse Kunst,* exh. cat., Amsterdam, 1958, 84–89; Hoogewerff, *De Noord-Nederlandsche Schilderkunst,* II, 449 ff.; F. Winkler, "Zur Kenntnis und Würdigung des Jan Mostaert," *Zeitschrift für Kunstwissenschaft,* XIII, 1959, 177–214; M. Thierry de Bye Dólleman, "Jan Jansz. Mostaert, schilder, een beroemd Haarlemmer," *Jaarboek van het Centraal Bureau voor Genealogie,* XVII, 1963, 123–36; J. Snyder, "The Early Haarlem School of Painting–III: The Problem of Geertgen tot Sint Jans and Jan Mostaert," *Art Bulletin,* LIII, 1971, 444–58; J. Duverger, "Jan Mostaert, Ereschilder van Margareta van Oostenrijk," *Festschrift für Wolfgang Krönig,* Düsseldorf, 1971, 113–17.

102. See esp. A. Lovejoy and G. Boas, *Primitivism and Related Ideas in Antiquity,* Baltimore, 1935; H. Levin, *The Myth of the Golden Age in the Renaissance,* Bloomington, Ind., 1969; E. Panofsky, *Studies in Iconology,* New York, 1962, 40 ff.

103. J. Snyder, "Jan Mostaert's West Indies Landscape," *First Images of America,* Berkeley, Los Angeles, and London, 1976, I, 495–502.

104. For the translation of C. van Mander, *Het Schilder-boeck,* in this chapter, see R. Vos, "The Life of Lucas van Leyden by Karel van Mander," *Nederlands Kunsthistorische Jaarboek,* XXIX, 1978, 463–507. For Lucas in general see Vos, *Lucas van Leyden,* Bentveld, 1978; Friedländer, *Early Netherlandish Painting,* X; Friedländer, *Lucas van Leyden,* Berlin, 1963; Hoogewerff, *De Noord-Nederlandsche Schilderkunst,* III; F. Dülberg, *Lucas van Leyden,* Haarlem, 1912. For the influence of Albrecht Dürer, see J. Held, *Dürers Wirkung auf die niederländische Kunst seiner Zeit,* The Hague, 1931. Good reproductions of the prints of Lucas are in J. Lavalleye, *Pieter Bruegel the Elder and Lucas van Leyden: The Complete Engravings, Etchings, and Woodcuts,* New York, 1967.

105. J.D. Bangs, *Cornelis Engelbrechtsz.'s Leiden,* Assen, 1979, 92–96.

106. I.Q. van Regteren Altena, "Hugo Jacobsz.," *Nederlands Kunsthistorisch Jaarboek,* VI, 1955, 101–17; cf. W.S. Gibson, "Lucas van Leyden and His Two Teachers," *Simiolus,* IV, 1970, 90–99.

107. W.S. Gibson, *The Paintings of Cornelis Engelbrechtsz.,* New York and London, 1977; Friedländer, *Early Netherlandish Painting,* X, 34–45; Hoogewerff, *De Noord-Nederlandsche Schilderkunst,* III, 144 ff.; Bangs, *Cornelis Engelbrechtsz.'s Leiden,* 1–34.

108. J.P. Filedt Kok, *Lucas van Leyden–Grafiek,* Amsterdam, 1978, 73–83; E.S. Jacobowitz, *The Prints of Lucas van Leyden,* exh. cat., National Gallery of Art, Washington, 1983, 19–23; P. Parshall, "Lucas van Leyden's Narrative Style," *Nederlands Kunsthistorisch Jaarboek,* XXIX, 1978, 185–238.

109. C. Harbison, "The Problem of Patronage in a Work by Lucas van Leyden," *Oud-Holland,* LXXXIII, 1968, 211–16.

110. L. Wuyt, "Lucas van Leyden's *Melkmeid,* Een Proeve tot Ikonologische Interpretatie," *De Gulden Passer,* LII–LIII, 1974–75, 441–53.

111. *The Prints of Lucas van Leyden,* exh. cat., Washington, 1983, 96 and n. 6. Also see H. van de Waal, "Some Possible Sources for Rembrandt's Etching, *Ecce Homo,*" *Steps Toward Rembrandt,* Amsterdam and London, 1974, 184 ff.

112. See esp. K. Moxey, *Jaarboek van het Koninklijk Museum voor Schone Kunsten Antwerpen,* 1976, 109–86.

113. Bangs, "The Focus of Popular Piety," *Cornelis Engelbrechtsz.'s Leiden,* 58–67.

114. L. Silver and S. Smith, "Carnal Knowledge: The Late Engravings of Lucas van Leyden," *Nederlands Kunsthistorisch Jaarboek,* XXIX, 1978, 239–98.

115. *The Prints of Lucas van Leyden,* exh. cat., Washington, 1983, 102 ff.; S.L. Smith, "To Women's Wiles I Fall: The Power of Women 'Topos' and the Development of Medieval Secular Art," Ph.D. dissertation, University of Pennsylvania, 1978; J.C. Hutchinson, "The Housebook Master and the Folly of the Wise Man," *Art Bulletin,* XLVIII, 1966, 73–78.

116. *The Prints of Lucas van Leyden,* exh. cat., Washington, 1983, 195–97; L. Silver, *Studies in the History of Art,* National Gallery of Art, Washington, 1974, 105–23.

117. R.A. Koch, "La Sainte-Baume in Flemish Landscape Painting of the Sixteenth Century," *Gazette des Beaux-Arts,* LXVI, 1965, 273–82.

118. P.F.J.M. Hermesdorf, M.L. Wurfbain, K. Groen, J.R.J. van Asperen de Boer, and J.P. Filedt Kok, "The Examination and Restoration of the *Last Judgment* by Lucas van Leyden," *Nederlands Kunsthistorisch Jaarboek,* XXIX, 1978, 311–424.

119. *Carel van Mander, Dutch and Flemish Painters,* trans. by C. van de Wall, 158–67; for Scorel see *Jan van Scorel in Utrecht,* exh. cat., Centraal Museum, Utrecht, 1977; Friedländer, *Early Netherlandish Painting,* XII, 65–88; M.A. Faries, "Jan van Scorel–His Style and Its Historical Context," Ph.D. dissertation, Bryn Mawr College, Bryn Mawr, Pa., 1972, and "Jan van Scorel–Additional Documents from the Church Records in Utrecht," *Oud-Holland,* LXXXV, 1970, 2–24; *Jan van Scorel,* exh. cat., Centraal Museum, Utrecht, 1955; G.J. Hoogewerff, *Jan van Scorel,* The Hague, 1923, and *De Noord-Nederlandsche Schilderkunst,* IV; C.H. de Jonge, *Jan van Scorel,* The Hague, 1940.

120. *Jan van Scorel in Utrecht,* exh. cat., Utrecht, 1977, 85.

121. A. Riegl, *Das holländische Gruppenporträt,* Vienna, 1931, 2 ff.

122. M.A. Faries, "Underdrawings in the Workshop Production of Jan van Scorel–A Study with Infrared Reflectography," *Nederlands Kunsthistorisch Jaarboek,* XXVI, 1975, 89–228; H. Huth, *Künstler und Werkstatt der Spätgotik,* rev. ed., Darmstadt, 1967, passim.

123. Friedländer, *Early Netherlandish Painting,* XIII, 40–45; R. Grosshans, *Maerten van Heemskerck: Die Gemälde,* Berlin, 1980; Hoogewerff, *De Noord-Nederlandsche Schilderkunst,* IV, 290–387.

124. E.K.J. Reznicek, "De reconstructie van 't *Altaer van S. Lucas* van Maerten van Heemskerck," *Oud-Holland,* CXX, 1955, 233 ff.

125. C. Hülsen and H. Egger, *Die Römischen Skizzenbücher von Marten van Heemskerck im Königlichen Kupferstichkabinett zu Berlin,* 2 vols., Berlin, 1913–16.

126. I.M. Veldman, *Maerten van Heemskerck and Dutch Humanism in the Sixteenth Century,* Maarsen, 1977, 145 ff.

127. Veldman, *Maerten van Heemskerck, passim.*

128. B. Cnattingius, *Maerten van Heemskerck's St. Lawrence Altarpiece in Linköping Cathedral: Studies in its Manneristic Style* (*Antikvariskt arkiv,* no. 52), Stockholm, 1973; A.L. Romdahl, "Das Altarwerk Marten Heemskercks für die Laurentiuskirche zu Alkmaar," *Oud-Holland,* XXI, 1903, 173 ff.

129. F.W. Hollstein, *Dutch and Flemish Etchings, Engravings, and Woodcuts,* Amsterdam, n.d., VIII, under Heemskerck.

130. Veldman, *Maerten van Heemskerck,* 143–54.

131. Friedländer, *Early Netherlandish Painting,* XIII, 63–69; Hoogewerff, *De Noord-Nederlandsche Schilderkunst,* IV, 245–52; L.C.J. Frerichs, *Antonio Moro,* Amsterdam, 1947; J.G. van Gelder, "Scorel, Mor, Bellegambe und Orley in Marchiennes," *Oud-Holland,* CXXXVII, 1973, 166 ff.

132. J. Puraye, "Antonio Moro et Dominique Lampson," *Oud-Holland*, CXIV, 1949, 175–83.

133. A.E. Popham, "Pieter Bruegel and Abraham Ortelius," *Burlington Magazine*, LIX, 1931, 187. The *Album Amicorum* is in Pembroke College, Cambridge, Eng. For the "mapping impulse" in the landscapes of Bruegel and later Dutch painters, see S. Alpers, *The Art of Describing: Dutch Art in the Seventeenth Century*, Chicago, 1983, 119–68.

134. *Carel van Mander, Dutch and Flemish Painters*, trans. by C. van de Wall, 153–57.

135. The bibliography on Bruegel is very extensive; see especially: W.S. Gibson, *Bruegel*, London, 1977; Friedländer, *Early Netherlandish Painting*, XIV; F. Grossmann, *Pieter Bruegel: Complete Edition of the Paintings*, 3rd rev. ed., London and New York, 1973 (see also Grossmann's entry on Bruegel in the *Encyclopedia of World Art*, II, 632–51); R. Marijnissen and M. Seidel, *Bruegel*, Stuttgart, 1969; B. Claessens and J. Rousseau, *Our Bruegel*, Antwerp, 1969; R. Hughes and P. Bianconi, *The Complete Paintings of Bruegel*, New York, 1967; *Le Siècle de Bruegel*, exh. cat., Brussels, 1963; W. Stechow, *Pieter Bruegel the Elder*, New York, 1969; R. Delevoy, *Bruegel*, Geneva, 1959; C.G. Stridbeck, *Bruegelstudien*, Stockholm, 1956; G. Glück, *Bruegels Gemälde*, Vienna, 1952; C. de Tolnay, *Pierre Bruegel l'ancien*, Brussels, 1935; E. Michel, *Bruegel*, Paris, 1931. For Bruegel's drawings and prints see: *Pieter Bruegel d. Ä. als Zeichner*, exh. cat., Kupferstichkabinett, Staatliche Museen, Berlin, 1975; H.A. Klein, *Graphic Worlds of Pieter Bruegel the Elder*, New York, 1963; J. Lavalleye, *Pieter Bruegel the Elder and Lucas van Leyden: The Complete Engravings, Etchings, and Woodcuts*, London, 1967; L. Münz, *Bruegel, the Drawings*, London, 1961; C. de Tolnay, *The Drawings of Pieter Bruegel the Elder*, London, 1952; R. van Bastelaer, *Les Estampes de Pieter Bruegel*, Brussels, 1908.

136. K. Moxey, "The Fates and Pieter Bruegel's Triumph of Death," *Oud-Holland*, LXXXVII, 1973, 49–51.

137. Dvořák, *Kunstgeschichte als Geistesgeschichte*, 208 ff.; de Tolnay, *Pierre Bruegel*, passim, and *Drawings*, 49 ff.; Benesch, *The Art of the Renaissance in Northern Europe*, 87–106.

138. Benesch, *Art of the Renaissance*, 110 ff.; de Tolnay, *Drawings*, 16 ff.

139. Benesch, *Art of the Renaissance*, 114.

140. F. van Leeuwen, "Figuurstudies van Pieter Bruegel," *Simiolus*, V, 1971, 139–49; J.A. Spicer, "The *Naer het Leven* Drawings: by Pieter Bruegel or Roelandt Savery?" *Master Drawings*, VIII, 1970, 3–30.

141. Y. Mori, "The Tradition and the Sources of the Peasant's World of Pieter Bruegel," *Bulletin of the Tama Art School*, Kawasaki (Japan), IV, 1978, 109–62, for an excellent survey and bibliography.

142. For the translation of the inscriptions on Bruegel's prints I have used Klein, *Graphic Worlds*. Also see A. Monballieu, "De Kermis van Hoboken, bij P. Bruegel, J. Grimmer en G. Mostaert," *Jaarboek van het Koninklijk Museum voor Schone Kunsten, Antwerpen*, 1974, 139–69.

143. E. Scheyer, "The *Wedding Dance* by Pieter Bruegel the Elder, in the Detroit Institute of Arts," *Art Quarterly*, XXVIII, 1965, 167–93; W. Gibson, "Some Notes on Pieter Bruegel the Elder's *Peasant Wedding Feast*," *Art Quarterly*, XXVIII, 1965, 194–208; S. Alpers,

"Bruegel's Festive Peasants," *Simiolus*, VI, 1972–73, 163–76, who refutes the theory of moralizing sermons in these works.

144. C.G. Stridbeck, "*Combat between Carnival and Lent* by Pieter Bruegel the Elder," *Journal of the Warburg and Courtauld Institutes*, XIX, 1956, 96–109.

145. Y. Mori, *Bulletin of the Tama Art School*, 1978, *passim*; W. Fraenger, *Der Bauernbruegel und das deutsche Sprichwort*, Zurich and Munich, 1923; J. Grauls, *Volkstaal en Volksleven in het werk van Pieter Bruegel*, Antwerp and Amsterdam, 1957; L. Lebeer, "De blauwe Huyck," *Gentsche Bijdragen*, VI, 1939–40, 161–229.

146. Benesch, *Art of the Renaissance*, 110.

147. For a summary of these arguments see F. Novotny, *Die Monatsbilder Pieter Bruegels des Älteren*, Vienna, 1948, and "Volkskundliche und kunstgeschichtliche Betrachtungsweise, Zu Pieter Bruegels *Heimkehr der Herde*," Ö. *Zeistschrift für Volkskunde*, n.s. IV, 1950, 42–53; E. van der Vossen, "De *Maandenreeks* van Pieter Bruegel den Ouden," *Oud-Holland*, LXVI, 1951, 103–16. The inventory is published in Flemish and English in B. Claessens and J. Rousseau, *Our Bruegel*, 31–32.

148. E.M. Bancel, *Jehan Perréal dit Jehan de Paris*, Paris, 1885 (reprinted Geneva, 1970); Ring, *A Century of French Painting*; Châtelet and Thuillier, *French Painting from Fouquet to Poussin*, 89–91.

149. A. Blunt, *Art and Architecture in France 1500 to 1700*, Baltimore, 1953, 44 ff.

150. O. Benesch, *Art of the Renaissance in Northern Europe*, 107 ff.

151. The earliest complete description is found in Le Père Dan, *Le Trésor des Marveilles de la maison royale de Fontainebleau*, Paris, 1642. For Fontainebleau in general see L. Dimier, *Histoire de la peinture française des origines au retour de Vouet*, Paris, 1925; L. Réau, *Les Peintres français de la Renaissance*, Paris, 1940; Châtelet and Thuillier, *French Painting from Fouquet to Poussin*, 99–115; H. Baderou, *L'École de Fontainebleau*, Geneva, 1944; S. Béguin, *L'École de Fontainebleau: Le Mannérisme à la cour de France*, Paris, 1960; H. Zerner, *The School of Fontainebleau: Etchings and Engravings*, New York, 1969; *L'École de Fontainebleau*, exh. cat., Grand Palais, Paris, 1972–73 (complete bibliographies are included in the back).

152. J. Adhémar, "Aretino Artistic Adviser to Francis I," *Journal of the Warburg and Courtauld Institutes*, XVII, 1954, 311 ff.; P. Barocchi, *Il Rosso Fiorentino*, Rome, 1950.

153. Tervarent, *Les Énigmes de l'art*, ser. IV, 28–45; S. Lövgren, "Il Rosso Fiorentino à Fontainebleau," *Figura*, I, 1951, 57 ff.; E. Panofsky, "The Iconography of the Galerie François Ier," *Gazette des Beaux-Arts*, LII, 1958, 113–77.

154. L. Dimier, *Le Primatice*, Paris, 1928.

155. D. and E. Panofsky, *Pandora's Box: The Changing Aspects of a Mythical Symbol*, New York, 1956; Muehsam, *French Painters and Paintings from the Fourteenth Century to Post-Impressionism*, 49–51.

156. For the problems of portraits in general see L. Dimier, *Histoire de la peinture de portrait en France au XVIe siècle*, Paris, 1925; I. Adler, "Die Clouet," *Jahrbuch der Kunsthistorischen Sammlungen in Wien*, n.s. III, 1929, 201 ff.; P. Mellen, *Jean Clouet*, London, 1971; Châtelet and Thuillier, *French Painting from Fouquet to Poussin*, 118–36.

157. Benesch, *Art of the Renaissance*, 122.

158. E. Panofsky, *Tomb Sculpture*, New York, n.d., 63 ff., 78 ff.

Select Bibliography

The following bibliography does not include articles and monographs on individual artists or monuments. Consult the text and notes for more specialized studies. Books that cover more than one category in the bibliography are listed only once under that which seems the most appropriate for their contents.

I. Early Secondary Sources

LEMAIRE DE BELGES, J. *La Plainte du désiré*, 1503–4 (first published 1509); *Couronne Margaritique*, 1504 (first published 1549). See *Oeuvres*, ed. J. Stecher, Louvain, 1891–92.

VASARI, G. *Le Vite de' più eccellenti pittori, scultori ed architettori*. Florence, 1550 and 1568 (ed. G. Milanesi, Florence, 1878–85).

GUICCIARDINI, L. *Descrittione di tutti i Paesi Bassi*. Antwerp, 1567 (Eng. ed., London, 1953).

VAN MANDER, C. *Het Schilder-boeck*. Haarlem and Alkmaar, 1604 and 1618. The complete edition includes the following books: *Het Leven der Doorluchtighe Nederlandtsche en Hoogduytsche Schilders* (Lives of the Netherlandish and German Painters); *Den grondt der edel vry schilderconst* (Principles of Painting); *Uytlegginghe op den Metamorphoseon Pub. Ovidii Nasonis* (Iconography according to Ovid); *Uytbeeldinghe der figueren* (Allegory). For translations of the "Lives" see H. HYMANS, *Le Livre des peintres*, 2 vols. Paris: J. Rouans, 1884–85; H. FLOERKE, *Das Leben der niederländischen und deutschen Maler des Carel van Mander*, 2 vols. Munich and Leipzig: G. Müller, 1906; *Carel van Mander, Dutch and Flemish Painters*, trans. C. van de Wall, New York: McFarlane, Warde, McFarlane, 1936.

For commentaries on the books see H. GREVE, *De Bronnen van Carel van Mander*, The Hague: Nijhoff, 1903; R. HOECKER, *Das Lehrgedicht des Karel van Mander*, The Hague: Nijhoff, 1916; H. NOË, *Carel van Mander en Italië*, The Hague: Nijhoff, 1954; H. MIEDEMA, *Den grondt der edel vry schilder-const—Karel van Mander*, Utrecht, 1973.

SANDRART, J. VON. *Teutsche Academie der Edlen Bau-, Bild- und Mahlerey-Künste*. Nuremberg, 1675 (ed. A. R. Peltzer, Munich, 1925).

For translations of excerpts from these and other early sources, see HOLT, E. G., *A Documentary History of Art*, I, Garden City, N.Y.: Doubleday, 1957; STECHOW, W., *Northern Renaissance Art 1400–1600: Sources and Documents*, Englewood Cliffs, N.J.: Prentice-Hall, 1966.

II. General Cultural Histories and Surveys

BENESCH, O. *The Art of the Renaissance in Northern Europe*. Cambridge, Mass.: Harvard University Press, 1945.

CALMETTE, J. *Les Grands Ducs de Bourgogne*. Paris: A. Michel, 1949.

CARTELLIERI, O. *La Cour des ducs de Bourgogne*. Paris: Payot, 1946.

CUTTLER, C. D. *Northern Painting from Pucelle to Bruegel*. New York: Holt, Rinehart, and Winston, 1968.

DVOŘÁK, M. *Kunstgeschichte als Geistesgeschichte*. Munich: R. Piper, 1924.

Encyclopedia of World Art. 16 vols. New York: McGraw-Hill, 1959–83.

See especially "German Art" and "Gothic Art" in vol. VI; "French Art" and "Flemish and Dutch Art" in vol. V. Numerous artists have entries with good bibliographies.

HALL, H. VAN. *Repertorium voor de geschiedenis der Nederlandsche schilderen graveerkunst sedert het begin der 12de eeuw . . .* 2 vols. The Hague: Nijhoff, 1936–49.

HUIZINGA, J. *The Waning of the Middle Ages*. London: E. Arnold, 1924.

HUTH, H. *Künstler und Werkstatt der Spätgotik*. Augsburg: Pilser Verlag, 1923.

HYMA, A. *The Christian Renaissance: A History of the "Devotio Moderna."* Grand Rapids, Mich.: Reformed Press, 1924.

LETTENHOVE, K. DE. *Histoire de Flandre: La Flandre sous les ducs de Bourgogne*. I (1383–1453), II (1453–1500). Bruges: C. Beyaert, 1898.

LEVEY, M. *High Renaissance*. Baltimore: Penguin Books, 1975.

MATHER, F. J., JR. *Western European Painting of the Renaissance*. New York: Tudor, 1948.

MICHEL, A. *Histoire de l'art*. III (*Le réalisme: Les Débuts de la Renaissance*). Paris: Colin, 1907.

The Pelican History of Art. Baltimore: Penguin Books, 1953–: no. IV (A. Blunt, *Art and Architecture in France 1500 to 1700*); no. V (M. Rickert, *Painting in Britain: The Middle Ages*); no. XIX (P. Frankl, *Gothic Architecture*); no. XXV (T. Müller, *Sculpture in the Netherlands, Germany, France, and Spain 1400 to 1500*); no. XXXI (G. von der Osten and H. Vey, *Painting and Sculpture in Germany and the Netherlands 1500 to 1600*).

PIJOÁN Y SOTERAS, J. *Summa Artés—Historia General del Arte*, XV. Madrid: Espasa-Calpe, 1963.

POST, R. R. *The Modern Devotion: Confrontation with Reformation and Humanism*. Leiden: E. J. Brill, 1968.

SWOBODA, K. M. *Geschichte der Bildenden Kunst*. III (*Die Spätgotik*), VI (*Das 16. Jahrhunderts nördlich der Alpen*). Vienna and Munich, 1978.

THIEME, U. and BECKER, F. *Allgemeines Lexikon der bildenden Künstler von der Antike bis zur Gegenwart*. 37 vols. Leipzig: Seemann, 1907–50.

WURZBACH, A. VON. *Niederländisches Künstler Lexikon*. 3 vols. Vienna: Halm, 1906–11.

III. The International Style and Bohemia

BACHMANN, E., ed. *Gothic Art in Bohemia*. New York: Praeger Publishers, 1977.

BALTIMORE, Walters Art Gallery. *International Style*. 1962.

BRUSSELS, Palais des Beaux-Arts. *Les Primitifs de Bohême*. 1966

CLEVELAND, The Cleveland Museum of Art. *Treasures from Medieval France*. 1967.

COLOGNE, Kunsthalle. *Die Parler und der Schöne Stil 1350–1400: Europäische Kunst unter den Luxembergen*. 5 vols. 1978.

COLOGNE, Wallraf-Richartz Museum. *Vor Stefan Lochner*. 1974.

DENKSTEIN, V. and MATOUS, F. *Gothic Art in South Bohemia*. Prague: Artia, 1955.

DUPONT, J. and GNUDI, C. *Gothic Painting*. Geneva: Skira, 1937.

FRIEDL, A. *Master Theodoricus*. Prague: Artia, 1956.

HAMBURG, Kunsthalle. *Meister Francke und die Kunst um 1400*. 1969.

KUTAL, A. *Gothic Art in Bohemia and Moravia*. Prague: Mánes, 1952.

MATĚJČEK, A. and PEŠINA, J. *Czech Gothic Painting, 1350–1450*. Prague: M. Melantrich, 1950.

MEISS, M. *French Painting in the Time of Jean de Berry: The Late Fourteenth Century and the Patronage of the Dukes*. London: Phaidon Press, 1967.

———. *French Painting in the Time of Jean de Berry: The Boucicaut Master*. London: Phaidon Press, 1968.

———. *French Painting in the Time of Jean de Berry: The Limbourgs and Their Contemporaries*. New York: George Braziller, 1974.

MONGET, C. *La Chartreuse de Dijon d'après les documents des archives de Bourgogne*. 3 vols. Montreuil-sur-Mer: Impr. Notre Dame des Prés, 1898–1905.

PORCHER, J. *Medieval French Miniatures*. New York: Harry N. Abrams, 1960.

SCHÜLLER, I. *Der Meister der Liebesgärten, ein Beitrag zur frühholländischen Malerei*. Amsterdam and Leipzig: Van Munster, 1932.

VIENNA, Kunsthistorisches Museum. *Die Ausstellung Europäische Kunst um 1400*. 1962.

IV. The Netherlands

AMSTERDAM, Rijksmuseum. *Triumph of European Mannerism*. 1955.

AMSTERDAM, Rijksmuseum. *Middeleeuwse Kunst der Noordelijke Nederlanden*. 1958.

BEAULIEU, M. and BAYLÉ, J. *Le Costume en Bourgogne de Philippe le Hardi à la mort de Charles le Téméraire*. Paris: Presses Universitaires de France, 1956.

BERGSTRÖM, I. *Dutch Still-Life Painting*. New York: T. Yoseloff, 1956.

BLUM, S. *Early Netherlandish Triptychs*. Berkeley: University of California Press, 1969.

BOOM, G. DE. *Marguerite d'Autriche-Savoie et la Pré-Renaissance*. Paris: Librairie E. Droz, 1935.

BORCHGRAVE D'ALTENA, J. DE. *Les Retables brabançons 1450–1550*. 2nd ed. Brussels: Editions du Cercle d'art, 1943.

BOSSCHÈRE, J. DE. *La Sculpture anversoise au XVe et XVIe siècles*. Brussels: G. van Oest, 1909.

BOUVY, D.R.P.A. *Middeleeuwsche Beeldhouwkunst in de Noordelijke Nederlanden*. Amsterdam: A.A. Balkema, 1947.

BRANDEN, F. J. VAN DEN. *Geschiedenis der Antwerpsche Schilderschool*. Antwerp: Buschmann, 1883.

BRANS, J.V.L. *Vlaamse schilders in dienst der Koningen van Spanje*. Louvain: Davidsfonds, 1959.

BRUGES, Groeningemuseum. *Anonieme vlaamse primtieven*. 1969.

BRUSSELS, Musée Communal. *Bruxelles au XVe siècle*. 1953.

BRUSSELS, Musées Royaux des Beaux-Arts de Belgique. *Le Siècle de Bruegel*. 1963.

BYVANCK, A.W. *La Miniature dans les Pays-Bas septentrionaux*. Paris: Les Editions d'Art et d'Histoire, 1937.

CHÂTELET, A. *Les Primitifs hollandais*. Fribourg: Office du Livre, 1980 (Eng. ed., New York, 1981).

CLEMEN, P. *Belgische Kunstdenkmäler*. 2 vols. Munich: Bruckmann, 1923.

CONWAY, W.M. *The Van Eycks and Their Followers*. London: Murray, 1921.

CRICK-KUNTZIGER, M. *Catalogue de tapisseries (XIVe au XVIIIe siècle): Musées royaux d'art et d'histoire de Bruxelles*. Brussels: Musées royaux, 1956.

CROWE, J.A. and CAVALCASELLE, G.B. *The Early Flemish Painters*. London: Murray, 1857.

DACOS, N. *Les Peintres belges à Rome au XVIe siècle*. Brussels and Rome: Institut historique belge de Rome, 1964.

DAVIES, M. *National Gallery Catalogues: Early Netherlandish School*. 2nd ed. London: National Gallery, 1955.

DEHAISNES, C. *Documents et extraits divers concernant l'histoire de l'art dans la Flandre, l'Artois et le Hainaut avant le XVe siècle*. 2 vols. Lille: Danel, 1886.

DELAISSÉ, L.M.J. *La Miniature flamande, le mécénat de Philippe le Bon*. Brussels and Amsterdam, 1959.

———. *Miniatures médiévales de la Librairie de Bourgogne au Cabinet des manuscrits de la Bibliothèque royale de Belgique*. Brussels: Editions de la Connaissance, 1959.

———. *A Century of Dutch Manuscript Illumination*. Berkeley and Los Angeles: University of California Press, 1968.

DENUIT, D. *Jacqueline de Bavière, princesse infortunée*. Brussels: C. Dessart, n.d.

DETROIT, Detroit Institute of Arts. *Flanders in the Fifteenth Century: Art and Civilization*. 1960.

DEVIGNE, M. *La Sculpture mosane du XIIe au XVIe siècle*. Paris and Brussels: G. van Oest, 1932.

DIJON, Musée des Beaux-Arts. *Le Grand Siècle des Ducs de Bourgogne*. 1951.

DÜLBERG, F. *Leydener Malerschule*. Berlin: Buchdr. von G. Schade, 1899.

———. *Die Frühholländer*. 3 vols. Haarlem: Kleinmann, 1903–7.

DURRIEU, P. *La Miniature flamande au temps de la cour de Bourgogne (1415–1530)*. Brussels and Paris: G. van Oest, 1921.

DVOŘÁK, M. *Das Rätsel der Kunst der Brüder van Eyck*. Munich: R. Piper, 1925.

ELST, J. VAN DER. *The Last Flowering of the Middle Ages*. Garden City, N.Y.: Doubleday, Doran, 1944.

EVEN, E. VAN. *L'Ancienne École de peinture de Louvain*. Brussels, 1870.

FIERENS, P. *L'Art en Belgique du moyen âge à nos jours*. 3d ed. Brussels: Renaissance du Livre, 1956.

FIERENS-GEVAERT, H. *Histoire de la peinture flamande des origines à la fin du XVe siècle*. 3 vols. Paris and Brussels: G. van Oest, 1927–29.

FRANZ, H.G. *Niederländische Landschaftsmalerei im Zeitalter des Manierismus*. 2 vols. Graz: Akademische Druck- u. Verlagsanstalt, 1969.

FRIEDLÄNDER, M.J. *Die altniederländische Malerei*. 14 vols. Berlin and Leiden: Cassirer, 1924–37 (Eng. ed., trans. H. Norden, New York and Washington, 1967–76): I. *The van Eycks–Petrus Christus*; II. *Rogier van der Weyden and the Master of Flémalle*; III. *Dieric Bouts and Joos van Gent*; IV. *Hugo van der Goes*; V. *Geertgen tot Sint Jans and Jerome Bosch*; VI. *Hans Memlinc and Gerard David*; VII. *Quentin Massys*; VIII. *Jan Gossart and Bernart van Orley*; IX. *Joos van Cleve, Jan Provost, Joachim Patenier*; X. *Lucas van Leyden and Other Dutch Masters of His Time*; XI. *The Antwerp Mannerists, Adriaen Ysenbrant*; XII. *Jan van Scorel and Pieter Coeck van Aelst*; XIII. *Antonis Mor and his Contemporaries*; XIV. *Pieter Bruegel*.

———. *Early Netherlandish Painting from Van Eyck to Bruegel*. London: Phaidon Press, 1956.

GASPAR, C. and LYNA, F. *Les Principaux Manuscrits à peintures de la Bibliothèque Royale de Belgique*. 2 vols. Paris: Société française de reproductions de manuscrits à peintures, 1937–47.

GERSON, H. *Van Geertgen tot Frans Hals (De Schoonheid van ons land)*. Amsterdam: Contact, 1950.

GÖBEL, H. *Wandteppiche*. Pt. I (*Die Niederlände*). 2 vols. Leipzig: Klinkhardt und Biermann, 1923.

HARBISON, C. *Symbols in Transformation: Iconographic Themes at the Time of the Reformation*. Princeton: The Art Museum, 1969.

———. *The Last Judgment in Sixteenth-Century Northern Europe*. New York: Garland, 1976.

HAUSER, A. *Mannerism: The Crisis of the Renaissance and the Origin of Modern Art*. 2 vols. New York: Knopf, 1965.

HOOGEWERFF, G.J. *Vlaamsche Kunst en Italiaansche Renaissance*. Mechelen and Amsterdam: Spieghel, 1935.

———. *De Noord-Nederlandsche Schilderkunst*. 5 vols. The Hague: Nijhoff, 1936–47.

———. *De Geschiedenis van de Sint Lucasgilden in Nederland*. Amsterdam: P.N. van Kampen, 1947.

LASSAIGNE, J. and DELEVOY, R. *Flemish Painting*. II (*Bosch to Rubens*). Geneva: Skira, 1958.

LAVALLEYE, J. *Le Portrait au XVe siècle*. Brussels: Cercle d'art, 1943.

LENNEP, J. VAN. *Art et alchimie*. Brussels: Editions Meddens, 1966.

LEURS, S., ed. *Geschiedenis van de Vlaamsche kunst.* 2 vols. Antwerp: De Sikkel, 1936–39.

LEYMARIE, J. *Dutch Painting.* Geneva: Skira, 1956.

LUGT, F. *Musée national du Louvre–Inventaire général des dessins des écoles du Nord: Maîtres des anciens Pays-Bas nés avant 1550.* Paris: Musées Nationaux, 1968.

MAETERLINCK, L. *Le Genre satirique dans la peinture flamande.* 2nd ed. Brussels: G. van Oest, 1907.

MARLIER, G. *Erasme et la peinture flamande de son temps.* Damme: Éditions du Musée van Maerlant, 1954.

MARROW, J. *Passion Iconography in Northern European Art of the Late Middle Ages and the Early Renaissance.* Kortrijk: Van Ghemmert, 1979.

NEEFFS, E. *Histoire de la peinture et de la sculpture à Malines.* 2 vols. Ghent: Impr. Eug. Vanderhaeghen, 1876.

PANOFSKY, E. *Early Netherlandish Painting: Its Origins and Character.* 2 vols. Cambridge, Mass.: Harvard University Press, 1953.

PARIS, Petit Palais. *Le Siezième Siècle européen.* 1965–66.

LES PRIMITIFS FLAMANDS. I. *Corpus de la peinture des anciens Pays-Bas méridionaux au XVe siècle:*
1. *Le Musée communal de Bruges* (A. Janssens de Bisthoven and R.A. Parmentier). 2 vols. Antwerp: De Sikkel, 1951.
2. *La Galerie Sabauda de Turin* (C. Aru and E. de Geradon). Antwerp: De Sikkel, 1952.
3. *The National Gallery, London* (M. Davies). 2 vols. Antwerp: De Sikkel, 1953–54.
4. *New England Museums* (C. Eisler). Brussels: Centre national de recherches ''Primitifs flamands,'' 1961.
5. *Le Musée national du Louvre, I* (H. Adhémar). Brussels: Centre national . . . , 1962.
6. *La Chapelle royale de Grenade* (R. van Schoute). Brussels: Centre national . . . , 1963.
7. *Le Palais ducal d'Urbin* (J. Lavalleye). Brussels: Centre national . . . , 1964.
8. *Le Musée de l'Ermitage, Leningrad* (V. Loewinson-Lessing and N. Nicouline). Brussels: Centre national . . . , 1965.
9. *Les Musées de Pologne (Gdańsk, Kraków, Warszawa)* (J. Bialostocki). Brussels: Centre national . . . , 1966.
10. *La Cathédrale de Palencia* (I. Vandevivere). Brussels: Centre national . . . , 1967.
11. *The National Gallery, London, III* (M. Davies). Brussels: Centre national . . . , 1970.
12. *The National Gallery of Victoria, Melbourne* (U. Hoff and M. Davies). Brussels: Centre national . . . , 1971.
13. *L'Hôtel-Dieu de Beaune* (P. Quarré and N. Veronee-Verhaegen). Brussels: Centre national . . . , 1973.

LES PRIMITIFS FLAMANDS. II. *Répertoire des peintures flamandes des quinzième et seizème siècles:*
1–2. *Collections d'Espagne* (J. Lavalleye). Antwerp: De Sikkel, 1953–58.
3. *Collections d'Italie* (G. Carandente). Brussels: Centre national . . . , 1968.

LES PRIMITIFS FLAMANDS. III. *Contributions à l'étude des primitifs flamands:*
1. *De Oorspronkelijke Plaats van het Lam Gods-Retabel* (A. P. de Schryver and R. H. Marijnissen). Antwerp: De Sikkel, 1952.
2. *L'Agneau mystique au laboratoire* (P. Coremans). Antwerp: De Sikkel, 1953.
3. *Identification d'un portrait de Gilles Joye attribué a Memlinc* (F. van Molle). Brussels: Centre national . . . , 1960.
4. *Les Primitifs flamands de Bruges* (J. P. Sosson). Brussels: Centre national . . . , 1966.

PUYVELDE, L. VAN. *La Peinture flamande à Rome.* Brussels: Librairie Encyclopédique, 1950.

———. *The Flemish Primitives.* Brussels: Elsevier, 1958.

———. *La Peinture flamande au siècle de Bosch et Brueghel.* Paris and Brussels: Elsevier, 1962.

RENGER, K. *Lochere Gesellschaft.* Berlin: Gebr. Mann, 1970.

RIEGL, A. *Das holländische Gruppenporträt.* 2 vols. Vienna: Öster-reichische Staatsdruckerei, 1931.

RINGBOM, S. *Icon to Narrative: The Rise of the Dramatic Closeup in Fifteenth-Century Devotional Painting.* Abo: Abo Akademi, 1965.

ROLLAND, P. *Les Primitifs tournaisiens, peintres et sculpteurs.* Brussels and Paris: Librairie nationale d'art et d'histoire, 1932.

SCHELLER, R. W. *A Survey of Medieval Model Books.* Haarlem: De Erven F. Bohn, 1963.

SMITS, C. *De Iconografie van de Nederlandsche primitieven.* Amsterdam: Spieghel, 1933.

STRELKA, J. *Der burgundische Renaissancehof Margarethes von Österreich.* Vienna: A. Sexl, 1957.

TERVARENT, G. DE. *Les Énigmes de l'art. IV.* Paris: Editions d'art et d'histoire, 1938.

TIMMERS, J. J. M. *Symboliek en Iconographie der Christelijke Kunst.* Roermond-Maaseik: Romen and Zonen, 1947.

TOLNAY, C. DE *Le Maître de Flémalle et les frères van Eyck.* Brussels: Éditions de la Connaissance, 1939.

TOVELL, R. M. *Flemish Artists of the Valois Courts.* Toronto: University of Toronto Press, 1950.

TROESCHER, G. *Die burgundische Plastik des ausgehenden Mittelalters und ihre Wirkungen auf die Europäische Kunst.* 2 vols. Frankfort: Prestel, 1940.

———. *Burgundische Malerei.* 2 vols. Berlin: Gebr. Mann, 1966.

UNTERKIRCHER, F. *Bibliothèque Nationale d'Autriche: Manuscrits et livres imprimés concernant l'histoire des Pays-Bas, 1475–1600.* Brussels: Bibliothèque Albert Iᵉʳ, 1962.

VALENTINER, W. R. *The Art of the Low Countries.* Garden City, N.Y.: Doubleday, Page, 1914.

VOLL, K. *Die altniederländische Malerei von Jan van Eyck bis Memling: Ein Entwicklungsgeschichtlicher Versuch.* 2nd ed. Leipzig: Insel-Verlag, 1928.

WAAL, H. VAN DE. *Drie eeuwen vaderlandsche geschied-uitbeelding.* 2 vols. The Hague: Nijhoff, 1952.

WEALE, W. H. J. *Hubert and John van Eyck: Their Life and Work.* London: J. Lane, 1908 (rev. ed. with M. W. Brockwell, London, 1912).

WEHLE, H. B. and SALINGER, M. *The Metropolitan Museum of Art: A Catalogue of Early Flemish, Dutch and German Paintings.* New York: The Metropolitan Museum of Art, 1947.

WHINNEY, M. *Early Flemish Painting.* New York and Washington: Praeger Publishers, 1968.

WINKLER, F. *Die altniederländische Malerei: Die Malerei in Belgien und Holland von 1400–1600.* Berlin: Propyläen-Verlag, 1924.

———. *Die Flämische Buchmalerei des XV. und XVI. Jahrhunderts: Künstler und Werke von den Brüdern van Eyck bis zu Simon Bening.* Leipzig: Seemann, 1925.

V. *France*

AUBERT, M. *La Sculpture française au moyen-âge et de la Renaissance.* Paris and Brussels: G. van Oest, 1926.

BADEROU, H. *L'École de Fontainebleau.* Geneva: Skira, 1944.

BARNES, A. C. and MAZIA, V. DE. *The French Primitives and Their Forms.* Merion, Pa.: Barnes Foundation, 1931.

BAZIN, S. *L'École provençale.* Geneva: Skira, 1944.

BÉGUIN, S. *L'École de Fontainebleau: Le Mannérisme à la cour de France.* Paris: Gonthier-Seghers, 1960.

CHÂTELET, A. and THUILLER, J. *French Painting from Fouquet to Poussin.* Geneva: Skira, 1963.

COLOMBIER, P. DU. *L'Art Renaissance en France.* Paris: Guy Le Prat, 1945.

DIMIER, L. *Histoire de la peinture de portrait en France au XVIe siècle.* 3 vols. Paris and Brussels: G. van Oest, 1924–27.

DUPONT, J. *Les Primitifs français.* Paris: Plon, 1937.

FRANCASTEL, P. *La Peinture française.* 2 vols. Paris and Brussels: Elsevier, 1955.

ISTRIA, M. H. D. *La Peinture française de la fin du moyen âge (1480–1530).* Paris: Presses Universitaires de France, 1961.

LABANDE, L. H. *Les Primitifs français: Peintres et verriers de la Provence occidentale.* Marseilles: Tacussel, 1932.

LACLOTTE, M. *L'École d'Avignon: La Peinture en Provence aux XIVe et XVe siècles*. Paris: Gonthier-Seghers, 1960.

LEMOISNE, P. A. *La Peinture française à l'époque gothique, XIVe et XVe siècles*. Paris, 1931.

MÂLE, E. *L'Art religieux de la fin du moyen âge en France*. 2nd ed. Paris: Colin, 1925.

MUEHSAM, G. *French Painters and Paintings from the Fourteenth Century to Post-Impressionism*. New York: Frederick Ungar, 1970.

PARIS, Grand Palais. *L'École de Fontainebleau*. 1972–73.

PORCHER, J. *Les Manuscrits à peintures en France du XIIIe au XVIe siècle*. Paris: Bibliothèque Nationale, 1955.

RING, G. *A Century of French Painting, 1400–1500*. London: Phaidon Press, 1949.

ROQUES, M. *Les apports néerlandais dans la peinture du sud-est de la France, XIVe, XVe, et XVIe siècles*. Bordeaux: Union française d'impression, 1963.

ROY, M. *Artistes et Monuments de la Renaissance en France*. 2 vols. Paris: Champion, 1929–34.

STERLING, C. *La Peinture française: Les peintres du moyen âge*. Paris: Bibliothèque Française des Arts, 1942.

VITRY, P. *Michel Colombe et la sculpture française de son temps*. Paris: Librairie centrale des beaux-arts, 1901.

YATES, F. *The French Academies of the Sixteenth Century*. London: Warburg Institute, University of London, 1947.

VI. *Germany*

BAXANDALL, M. *The Limewood Sculptors of Renaissance Germany*. New Haven and London: Yale University Press, 1980.

BUCHNER, E. *Augsburger Kunst der Spätgotik und Renaissance*. Augsburg: B. Filser, 1928.

———. *Das deutsche Bildnis der Spätgotik und der frühen Dürerzeit*. Berlin: Deutscher Verein für Kunstwissenschaft, 1953.

BUCHNER, E. and FEUCHTMAYR, K. *Oberdeutsche Kunst der Spätgotik und Reformationszeit*. Augsburg: B. Filser, 1924.

BUSCH, H. *Meister des Nordens: Die altniederdeutsche Malerei, 1450 bis 1550*. Hamburg: Heinrich Ellermann, 1943.

CHRISTENSEN, C. *Art and the Reformation in Germany*. Athens, Ohio, and Detroit: Ohio University Press and Wayne State University Press, 1979.

DEUSCH, W. *German Painting of the Sixteenth Century*. London, 1963.

FEULNER, A. *Die Deutsche Plastik des 16. Jahrhunderts*. Munich: Wolff, 1926.

GLASER, C. *Die altdeutsche Malerei*. Munich: F. Bruckmann, 1924.

GMELIN, H. G. *Spätgotische Tafelmalerei in Niedersachsen und Bremen*. Munich: Deutscher Kunstverlag, 1974.

HEISE, C. *Die Norddeutsche Malerei*. Leipzig: Wolff, 1918.

HELD, J. *Dürers Wirkung auf die niederländische Kunst seiner Zeit*. The Hague: Nijhoff, 1931.

LEVEY, M. *National Gallery Catalogues: The German School*. London: National Gallery, 1959.

MÜNSTER, Landesmuseum. *Westphalische Maler der Spätgotik, 1440–1490*. 1952.

PÄCHT, O. *Österreichische Tafelmalerei der Gotik*. Augsburg: B. Filser, 1929.

PIEPER, P. *Das Westfälische in Malerei und Plastik*. Münster: Aschendorff, 1964.

PINDER, W. *Die deutsche Plastik vom ausgehenden Mittelalter bis zum Ende der Renaissance*. Berlin: Athenaion, 1914.

REINERS, H. *Die kölner Malerschule*. Munich: M. Gladbach, 1925.

ST. FLORIAN and LINZ, Stift and Schlossmuseum. *Die Kunst der Donauschule 1490–1540*. 1965.

SCHMITT, O. *Reallexikon zur deutschen Kunstgeschichte*. 5 vols. Stuttgart: Metzler, 1937–67.

STANGE, A. *Deutsche Malerei der Gotik*. 10 vols. Berlin and Munich: Deutscher Kunstverlag, 1934–60.

———. *German Painting XIV to XVI Centuries*. London: Hyperion Press, 1950.

———. *Kritisches Verzeichnis der deutschen Tafelbilder vor Dürer*. 2 vols. Munich: F. Bruckmann, 1970.

THODE, H. *Die Malerschule von Nürnberg*. Frankfort: H. Keller, 1891.

WEINBERGER, M. *Nürnberger Malerei an der Wende zur Renaissance*. Strasbourg: Heitz, 1921.

WINKLER, F. *Die altdeutsche Tafelmalerei*. Munich: F. Bruckmann, 1944.

WORRINGER, W. *Die Anfänge der Tafelmalerei*. Leipzig: Insel-Verlag, 1924.

VII. *Prints and Drawings*

BARTSCH, A. *Le Peintre-graveur*. 21 vols. Vienna: Degen, 1803–21 (rev. ed., W. Strauss, *The Illustrated Bartsch*, 141 vols., New York: Abaris, 1978–).

BESANÇON, J. *Les Dessins flamands du XVe au XVIe siècle*. Paris, 1951.

BOCK, E. and ROSENBERG, J. *Die niederländischen Meister: Beschreibendes Verzeichnis Sämtlicher Zeichnungen (Staatliche Museen zu Berlin: Die Zeichnungen alter Meister im Kupferstichkabinett)*. 2 vols. Frankfort: Prestel Verlag, 1931.

CONWAY, W. M. *The Woodcutters of the Netherlands in the Fifteenth Century*. Cambridge, Eng.: Cambridge University Press, 1884.

HIND, A. M. *An Introduction to a History of Woodcut*. 2 vols. Boston: Houghton Mifflin, 1935.

HOLLSTEIN, F. *Dutch and Flemish Etchings, Engravings and Woodcuts*. 14 vols. Amsterdam: Hertzberger, 1949–56.

———. *German Engravings, Etchings and Woodcuts*. 28 vols. Amsterdam: Hertzberger, 1954–80.

LEHMANN-HAUPT, H. *Gutenberg and the Master of the Playing Cards*. New Haven: Yale University Press, 1966.

LEHRS, M. *Geschichte und kritischer Katalog des deutschen, niederländischen und französischen Kupferstichs im 15. Jahrhundert*. 9 vols. Vienna: Gesellschaft für vervielfältigende Kunst, 1908–34.

POPHAM, A. E. *Drawings of the Early Flemish School*. London: E. Benn, 1926.

———. *Catalogue of Drawings by Dutch and Flemish Artists Preserved in the Department of Prints and Drawings in the British Museum. V (Dutch and Flemish Drawings of the XV and XVI Centuries)*. London: Trustees of the British Museum, 1932.

SCHRETLEN, M. J. *Dutch and Flemish Woodcuts of the Fifteenth Century*. London: E. Benn, 1925.

ZERNER, H. *The School of Fontainebleau: Etchings and Engravings*. New York: Harry N. Abrams, 1969.

Genealogy of the House of Valois

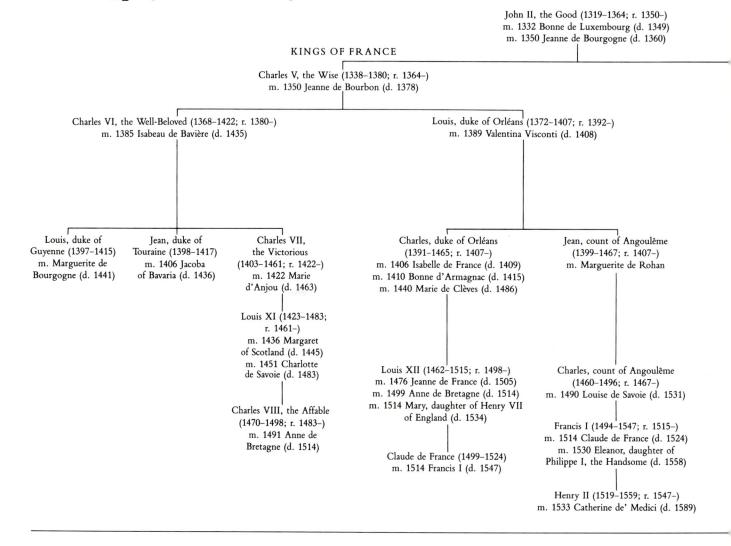

John II, the Good (1319–1364; r. 1350–)
m. 1332 Bonne de Luxembourg (d. 1349)
m. 1350 Jeanne de Bourgogne (d. 1360)

KINGS OF FRANCE

Charles V, the Wise (1338–1380; r. 1364–)
m. 1350 Jeanne de Bourbon (d. 1378)

Charles VI, the Well-Beloved (1368–1422; r. 1380–)
m. 1385 Isabeau de Bavière (d. 1435)

Louis, duke of Orléans (1372–1407; r. 1392–)
m. 1389 Valentina Visconti (d. 1408)

Louis, duke of
Guyenne (1397–1415)
m. Marguerite de
Bourgogne (d. 1441)

Jean, duke of
Touraine (1398–1417)
m. 1406 Jacoba
of Bavaria (d. 1436)

Charles VII,
the Victorious
(1403–1461; r. 1422–)
m. 1422 Marie
d'Anjou (d. 1463)

Charles, duke of Orléans
(1391–1465; r. 1407–)
m. 1406 Isabelle de France (d. 1409)
m. 1410 Bonne d'Armagnac (d. 1415)
m. 1440 Marie de Clèves (d. 1486)

Jean, count of Angoulême
(1399–1467; r. 1407–)
m. Marguerite de Rohan

Louis XI (1423–1483;
r. 1461–)
m. 1436 Margaret
of Scotland (d. 1445)
m. 1451 Charlotte
de Savoie (d. 1483)

Louis XII (1462–1515; r. 1498–)
m. 1476 Jeanne de France (d. 1505)
m. 1499 Anne de Bretagne (d. 1514)
m. 1514 Mary, daughter of Henry VII
of England (d. 1534)

Charles, count of Angoulême
(1460–1496; r. 1467–)
m. 1490 Louise de Savoie (d. 1531)

Charles VIII, the Affable
(1470–1498; r. 1483–)
m. 1491 Anne de
Bretagne (d. 1514)

Claude de France (1499–1524)
m. 1514 Francis I (d. 1547)

Francis I (1494–1547; r. 1515–)
m. 1514 Claude de France (d. 1524)
m. 1530 Eleanor, daughter of
Philippe I, the Handsome (d. 1558)

Henry II (1519–1559; r. 1547–)
m. 1533 Catherine de' Medici (d. 1589)

Timetable of the Arts, History, and Science 1300–1575

	POLITICAL	RELIGIOUS	ARTS FRANCE	ARTS BOHEMIA, AUSTRIA, GERMANY
1300				
	1308 Coronation of Edward II, king of England (d. 1327)	1308 Death of Duns Scotus (b. 1266) 1309 Babylonian Captivity begins (1309–77). Clement V is first pope of Avignon		
1310				
	1316 Philip V becomes king of France (d. 1322)	1316 Pope John XXII (d. 1334)		
1320				
	1322 Charles IV becomes king of France (d. 1328) 1327 Edward III declared king of England (d. 1377) 1328 Death of Charles IV, last of Capetians. French crown passes to Philip VI of Valois. Louis IV of Bavaria crowned emperor in Rome. Ivan I, grand duke of Russia, establishes Moscow as capital	1323 Thomas Aquinas canonized 1327 Death of Master Eckhardt (b. c. 1260)	1323–26 Jean Pucelle, *Belleville Breviary*, Paris 1325 Jean Pucelle, *Hours of Jeanne d'Évreux*, New York	

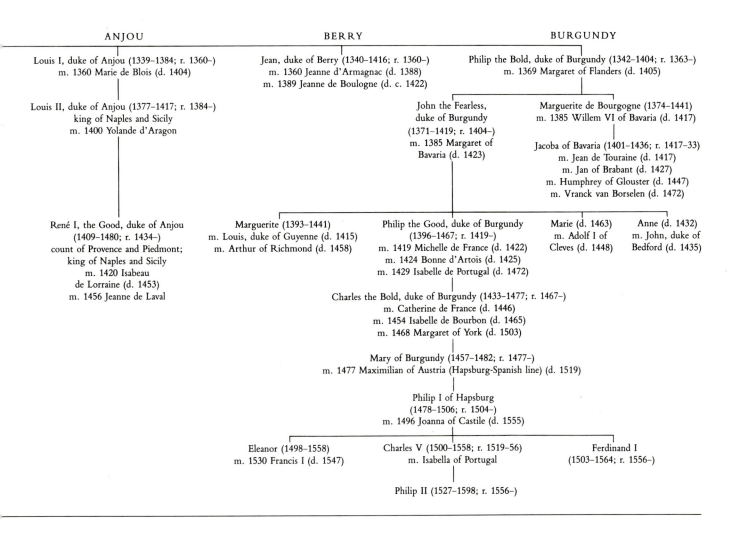

ANJOU

Louis I, duke of Anjou (1339–1384; r. 1360–)
m. 1360 Marie de Blois (d. 1404)

Louis II, duke of Anjou (1377–1417; r. 1384–)
king of Naples and Sicily
m. 1400 Yolande d'Aragon

René I, the Good, duke of Anjou
(1409–1480; r. 1434–)
count of Provence and Piedmont;
king of Naples and Sicily
m. 1420 Isabeau
de Lorraine (d. 1453)
m. 1456 Jeanne de Laval

BERRY

Jean, duke of Berry (1340–1416; r. 1360–)
m. 1360 Jeanne d'Armagnac (d. 1388)
m. 1389 Jeanne de Boulogne (d. c. 1422)

Marguerite (1393–1441)
m. Louis, duke of Guyenne (d. 1415)
m. Arthur of Richmond (d. 1458)

BURGUNDY

Philip the Bold, duke of Burgundy (1342–1404; r. 1363–)
m. 1369 Margaret of Flanders (d. 1405)

John the Fearless,
duke of Burgundy
(1371–1419; r. 1404–)
m. 1385 Margaret of
Bavaria (d. 1423)

Marguerite de Bourgogne (1374–1441)
m. 1385 Willem VI of Bavaria (d. 1417)

Jacoba of Bavaria (1401–1436; r. 1417–33)
m. Jean de Touraine (d. 1417)
m. Jan of Brabant (d. 1427)
m. Humphrey of Glouster (d. 1447)
m. Vranck van Borselen (d. 1472)

Philip the Good, duke of Burgundy
(1396–1467; r. 1419–)
m. 1419 Michelle de France (d. 1422)
m. 1424 Bonne d'Artois (d. 1425)
m. 1429 Isabelle de Portugal (d. 1472)

Marie (d. 1463)
m. Adolf I of
Cleves (d. 1448)

Anne (d. 1432)
m. John, duke of
Bedford (d. 1435)

Charles the Bold, duke of Burgundy (1433–1477; r. 1467–)
m. Catherine de France (d. 1446)
m. 1454 Isabelle de Bourbon (d. 1465)
m. 1468 Margaret of York (d. 1503)

Mary of Burgundy (1457–1482; r. 1477–)
m. 1477 Maximilian of Austria (Hapsburg-Spanish line) (d. 1519)

Philip I of Hapsburg
(1478–1506; r. 1504–)
m. 1496 Joanna of Castile (d. 1555)

Eleanor (1498–1558)
m. 1530 Francis I (d. 1547)

Charles V (1500–1558; r. 1519–56)
m. Isabella of Portugal

Ferdinand I
(1503–1564; r. 1556–)

Philip II (1527–1598; r. 1556–)

ARTS THE NETHERLANDS	ARTS ITALY AND SPAIN	MUSIC AND LITERATURE	SCIENCE, EXPLORATION, AND MISCELLANY	
				1300
	1300 Palazzo Vecchio, Florence (to 1310) 1305 Giotto (1267?–1337), *Arena Chapel*, Padua 1308 Duccio (active 1278–1318), *Maestà* (to 1311)	1307 Dante, *Divine Comedy* (to 1321)	1306 "It is not yet 20 years since someone found the art of making glasses which enable one to see well" (Brother Giordano da Rivalto, Florence)	
				1310
	1310 Orvieto facade. Giotto, *Ognissanti Madonna*, Florence 1315 Simone Martini (active 1315–1344), *Maestà*, Palazzo Pubblico, Siena	1318 Death of Heinrich Frauenlob (b. 1250)		
				1320
	1324 Paolo Veneziano (d. 1362?), *Coronation of Virgin*, Washington	1321 Dante dies (b. 1265)	1324 Death of Marco Polo (b. 1254)	

	POLITICAL	RELIGIOUS	ARTS FRANCE	ARTS BOHEMIA, AUSTRIA, GERMANY
1330	1337 Edward III assumes title of king of France. Begins the Hundred Years' War	1334 Pope Benedict XII (d. 1342). Building of papal palace at Avignon	1334 Simone Martini (1283–1344) in Avignon(?) until his death in 1344	
1340	1340 Battle of Sluis 1342 Louis of Bavaria marries Margaret of Tyrol, the "Ugly Duchess" 1346 Battle of Crécy. English victory 1347 Death of Louis IV of Luxembourg; succeeded by Charles IV of Bohemia (d. 1378). Edward III establishes Order of the Garter	1342 Pope Clement VI (d. 1352) 1349 William of Ockham dies (b. 1290)	1341 Matteo Giovanetti at Avignon (d. 1352)	
1350	1350 Death of Philip VI of France; succeeded by John II, the Good (d. 1364) 1355 Charles IV of Luxembourg and Bohemia becomes emperor of Rome 1356 Black Prince defeats French at Poitiers. John II is prisoner. Charles IV of Bohemia issues Golden Bull, settling the election of the German kings	1352 Pope Innocent VI (d. 1362)	c. 1356 *Portrait of John the Good*, Paris	1350 Master of the Vyšší Brod (Hohenfurth) Altar and his shop active in Bohemia
1360	1364 Death of John II of Valois; succeeded by Charles V (d. 1380) 1369 Philip the Bold of Burgundy marries Margaret of Flanders	1362 Pope Urban V (d. 1370)		1360 Master Theodoric (active 1348–1375), Karlštejn Castle
1370	1376 Death of Charles IV of Bohemia; succeeded by Wenceslaus 1377 Death of Edward II; succeeded by Richard II (d. 1399)	1370 Pope Gregory XI (d. 1378) 1377 Catherine of Siena preaches to return the papacy to Rome. Gregory XI returns 1378 Great Schism (to 1417). Two popes elected: Urban VI at Rome, Clement VII at Avignon	1371 Jean Bondol (active 1368–81), *Hague Bible*, for Charles V 1372 André Beauneveu (active 1360–1403) works for Charles V 1375 *Parement de Narbonne*, Paris c. 1377 Jean Bondol and Nicolas Bataille, *Angers Apocalypse Tapestries*	1375 Peter Parler (active to 1385), sculptures at Prague Cathedral 1379 Master Bertram (active 1367–1387), *Saint Peter's Altar* (Grabow), Hamburg
1380	1380 Charles V of Valois dies; succeeded by Charles VI (d. 1422) 1381 Peasant revolt in England 1384 Philip the Bold of Burgundy inherits the Netherlands	1384 Death of John Wycliffe (b. c. 1328) 1389 Pope Boniface IX at Rome (d. 1404)	c. 1384 Jacquemart de Hesdin (active 1380–1413) employed by the duke of Berry 1385 Claus Sluter (active 1375–1405) at Dijon for work on the Chartreuse de Champmol (facade, *Well of Moses, Tomb of Philip the Bold* to 1406)	c. 1388 Master of the Třeboň (Wittingau) Altar active in Bohemia
1390	1390 Byzantium loses last of Asia Minor to Turks 1399 Henry of Lancaster, son of John of Gaunt, succeeds to throne as Henry IV (d. 1413)		1394 Melchior Broederlam (active 1381–1409) and Jacques de Baerze contracted for *Retable de Champmol*, finished in 1399 1396 Jan Malouel (active 1396–1419) recorded in Paris; from 1398 worked at the Chartreuse de Champmol until death in 1415	
1400	1404 Philip the Bold of Burgundy dies; succeeded by John the Fearless (d. 1419) 1407 Louis, duke of Orléans, murdered by the Burgundians	1404 Pope Innocent VII (d. 1406) 1406 Pope Gregory XII (d. 1409) 1409 Pope Alexander V (d. 1410)	1402 Parisian miniaturist Master of 1402 c. 1409 *Hours of the Maréchal de Boucicaut*, Paris	1403? Konrad von Soest (active to 1422), *Niederwildungen Altarpiece* (or later)
1410	1411 Sigismund crowned emperor (d. 1437) 1413 Death of Henry IV; succeeded by Henry V (d. 1422) 1415 Henry V defeats French at Agincourt 1416 Death of Jean, duke of Berry 1419 John the Fearless, duke of Burgundy, murdered; succeeded by Philip the Good (d. 1463). Death of Wenceslaus of Bohemia	1410 Pope John XXIII, antipope (d. 1415) 1415 John Hus burned. Council of Constance 1417 Pope Martin V (d. 1431). End of Schism	1412 *Portrait of Louis of Anjou*, Paris 1416 Limbourg brothers die(?); last work on the *Très Riches Heures* of the duke of Berry. Henri Bellechose finishes Jean Malouel's *Martyrdom of Saint Denis*, Paris c. 1418 *Rohan Hours*, Paris	
1420	1420 Treaty of Troyes. Henry V marries Catherine of France, enters Paris 1421 Death of Maréchal de Boucicaut in England 1422 Henry V dies; succeeded by Henry VI (d. 1461). Death of Charles VI of France; succeeded by Charles VII (d. 1461). Duke of Bedford in Paris 1429 Jeanne d'Arc takes Charles VII to Reims for coronation. Philip the Good establishes the Order of the Golden Fleece			1423 *Saint Christopher* woodcut (Rylands Library) 1424 Master Francke, *Englandfahrer Altarpiece*, Hamburg
1430	1431 Jeanne d'Arc burned at Rouen. Henry VI of England crowned at Paris. First German peasant revolt at Worms 1433 Sigismund crowned Holy Roman Emperor, assumes double eagle as emblem 1435 Peace of Arras between Charles VII and Philip the Good 1436 Paris recaptured by French 1437 Death of Sigismund. Last of House of Luxembourg. Albert V succeeds king of Hungary, Bohemia, and Germany 1439 Heirs of French throne receive title of Comte du Dauphine	1431 Pope Eugene IV (d. 1447). Council of Basel (to 1449)	1434 House of Jacques Coeur, Bourges	1431 Lucas Moser, *Magdalen Altarpiece*, Tiefenbronn 1437 Hans Multscher (1400–1467), *Wurzach Altarpiece*, Berlin

ARTS THE NETHERLANDS	ARTS ITALY AND SPAIN	MUSIC AND LITERATURE	SCIENCE, EXPLORATION, AND MISCELLANY	
				1330
	1332 Taddeo Gaddi (active to c. 1366), *Life of Mary*, Baroncelli Chapel, Santa Croce, Florence 1333 Martini, *Annunciation*, Florence 1334 Martini to Avignon? 1336 Andrea Pisano (1290?–1348), south doors, Florence Baptistry 1337 Death of Giotto 1338 Ambrogio Lorenzetti (d. 1348?), *Good and Bad Government*, Siena		1338 University of Pisa founded	
				1340
	1342 Pietro Lorenzetti (1290?–1348?), *Birth of the Virgin*, Siena. Ambrogio Lorenzetti, *Presentation*, Florence 1344 Death of Martini 1345 Ferrer Bassa (1290–1348), Convent of Pedralbes 1349 Andrea Orcagna (active to 1368), Tabernacle, Orsanmichele, Florence	1341 Petrarch crowned poet in Rome 1348 Boccaccio, *Decameron* (to 1353)	1340 Queen's College, Oxford, founded 1345 Bankruptcy of Bardi and Peruzzi banking houses in Florence 1347 Black Plague begins (to 1351); approximately 75 million died 1348 University of Prague founded	
				1350
	1354 Orcagna, *Christ Enthroned with Saints*, Florence 1355 Francesco Traini (?) (active to 1363), *Triumph of Death*, Pisa		1351 Black Plague ends 1352 Corpus Christi College, Oxford, founded	
				1360
	1366? Andrea da Firenze (active 1343–1377), *Triumph of the Dominican Order*, Spanish Chapel, Santa Maria Novella, Florence	1361 Death of Philippe de Vitry, French composer (b. 1290) 1362 William Langland, *Piers Plowman* 1364 Guillaume de Machaut, Mass for Four Voices for coronation of Charles V at Reims	1360 First franc coined in France 1365 University of Vienna founded	
				1370
1378 Melchior Broederlam (active 1381–1409) enters service of Philip the Bold at ducal castle in Ypres		1373 Boccaccio, *De genealogia deorum* 1374 Death of Petrarch (b. 1304) 1375 Death of Boccaccio (b. 1313). "Robin Hood" appears 1377 Guillaume de Machaut dies (b. 1300). Musicians move from Avignon to Rome	1377 Playing cards replace dice in Germany	
				1380
	1386 Milan Cathedral begun	1385 First French court ball at wedding of Charles VI and Isabella of Bavaria 1387 Chaucer, *Canterbury Tales* (to 1400)	1386 University of Heidelberg founded 1388 University of Cologne founded	
				1390
		1396 Manuel Chrysoloras opens Greek classes in Florence		
				1400
	1401 Baptistry competition, Florence (sculpture) 1403 Ghiberti (1381?–1455), first (north) Baptistry doors, Florence (to 1424)	1400 Froissart, *Chronicles*. Death of Chaucer (b. c. 1340) 1405 Eustache Deschamps, French poet, dies (b. 1346)		
				1410
1410 Robert Campin (c. 1375–1444) acquires citizenship in Tournai	1411 Donatello (1386–1466), *Saint Mark*, Orsanmichele, Florence (sculpture). Luis Borrassa (d. 1434), *Retable of Saint Peter*, Terraso 1414 Jacopo della Quercia (1374–1438), *Fonte Gaia*, Siena. Lorenzo Monaco (d. 1425?), *Coronation Altarpiece*, Florence (to 1419) 1415 Donatello, *Saint George*, Orsanmichele, Florence	1414 Thomas à Kempis, *Imitatio Christi*	1411 Saint Andrews University, Edinburgh, founded 1416 Dutch fishermen use first drift nets	
				1420
1422 Jan van Eyck (c. 1390–1441) in the Hague (to 1424) 1425 Jan van Eyck in the service of Philip the Good 1426 Death of Hubert van Eyck 1427 Rogier van der Weyden (1399?–1464) and Jacques Daret (1404–1468) apprentices to Campin in Tournai; Jan van Eyck in Iberia (to 1429)	1420 Brunelleschi (1377–1446), Dome, Florence Cathedral (to 1436) 1421 Brunelleschi, San Lorenzo, Florence 1422 Ca' d'Oro, Venice (to c. 1440) 1423 Gentile da Fabriano (d. 1427), *Adoration of the Magi*, Florence 1425 Ghiberti, "Gates of Paradise," Baptistry, Florence (to 1450). Masaccio (1401–1428), Brancacci Chapel, Santa Maria del Carmine, Florence 1428 Death of Masaccio (b. 1401)	1428 Alain Chartier, *Espérance ou consolation des trois vertus*	1426 University of Louvain founded	
				1430
1432 Van der Weyden is master in the Tournai guild. Dedication of the Ghent altarpiece by the Van Eycks 1434 Jan van Eyck, *Arnolfini Wedding Portrait*, London 1435 Rogier van der Weyden in Brussels, *Saint Luke*(?), Boston; *Deposition*(?), Madrid 1437 Jan van Eyck, Dresden *Mary Altarpiece* 1439 Jan van Eyck, *Portrait of Margaretha van Eyck*, Bruges; *Madonna by the Fountain*, Antwerp	1431 Lucca della Robbia (1399–1482), Cantoria, Florence (to 1438) 1433 Donatello, Cantoria, Florence (to 1439) 1435 Masolino (1383?–1446), Baptistry frescoes, Castiglione d'Olona; Alberti (1404–1484), *De Pictura* (later: *Della pittura*, *De re aedificatoria*, *De statua*) 1436 Paolo Uccello (1396/7–1475), *Sir John Hawkwood*, Florence	1430 Beginnings of the "Dutch" school of music (Gilles Binchois, Guillaume Dufay)	1430 "Mad Marjorie," great cast-iron gun 1432 Gonzalo Cabral discovers the Azores 1437 All Soul's College, Oxford, founded	

	POLITICAL	RELIGIOUS	ARTS FRANCE	ARTS BOHEMIA, AUSTRIA, GERMANY
1440				
		1447 Pope Nicolaus V (d. 1455)	1445 Master of the Aix Annunciation	1444 Konrad Witz (active 1400–1447), *Altarpiece of Saint Peter*, Geneva 1447 Stephan Lochner (active 1410–1451), *Presentation*, Darmstadt
1450				
	1450 Francesco Sforza assumes title of duke of Milan (d. 1466) 1451 Mohammed II becomes sultan of Turkey (d. 1481) 1452 Frederick III is crowned emperor 1453 End of Hundred Years' War. Turks capture Constantinople 1454 René of Anjou declared king of Sicily and Provence 1455 War of Roses in England. Lancaster versus York (to 1485) 1457 Turks sack the Acropolis	1450 Jubilee Year in Rome 1458 Aeneas Sylvius Piccolomini becomes Pope Pius II (d. 1464)	1451 Jean Michel, Tonnerre *Entombment* 1452 Jean Fouquet (1415/20–1477/85), *Hours of Etienne Chevalier*, Chantilly (to 1460) 1454 Simon Marmion (1425–1489), *Saint Bertin Altarpiece*, Berlin (to 1459); Enguerrand Charonton (1410?–1461), *Coronation of the Virgin*, Villeneuve-les-Avignon c. 1457 Master of René of Anjou, *Livre de cuer d'amours espris*	1453 Gutenberg's 42-line Mazarin Bible (first printing) 1456 Hans Multscher, *Sterzing Altarpiece* (sculpture)
1460				
	1461 Edward, son of Richard of York, crowned Edward IV, king of England (d. 1483). Death of Charles VII of France; succeeded by Louis XI (d. 1483) 1464 Cosimo de' Medici becomes ruler of Florence 1467 Death of Philip the Good of Burgundy; succeeded by Charles the Bold (d. 1477) 1469 Lorenzo de' Medici is ruler of Florence (d. 1492)	1464 Pope Paul II (d. 1471)	1461 Nicolas Froment (active 1460–1490), *Raising of Lazarus*, Florence	1463 Master of the Life of Mary, *Mary Altarpiece*, Munich 1466 Master E.S., *Einsiedeln Madonna* (engraving) 1467 Nicolaus Gerhaerts van Leyden (active 1462–1484), *Crucifixion*, Baden-Baden
1470				
	1477 Maximilian, son of Frederick III, marries Mary of Burgundy. Death of Charles the Bold at Battle of Nancy	1471 Pope Sixtus IV (d. 1484)	1476 Nicolas Froment, *Altarpiece of the Burning Bush*, Aix-en-Provence	1470 Martin Schongauer's (1440/5–1488) early engravings 1471 Michael Pacher (1435–1498), *Saint Wolfgang Altarpiece* (to 1479). Birth of Albrecht Dürer in Nuremberg (d. 1528) 1473 Schongauer, *Madonna and Child in a Rose Arbor*, Colmar c. 1477– Veit Stoss (1447–1542), *Dormition Altarpiece*, Cracow (sculpture)
1480				
	1482 Peace of Arras between Louis XI of France and Hapsburgs. Mary of Burgundy dies; Maximilian inherits Netherlands 1483 Death of Edward IV. His sons murdered by Richard of Gloucester, who claims throne as Richard III (d. 1485). Death of Louis XI; succeeded by Charles VIII of France (d. 1498) 1485 Henry Tudor murders Richard III; succeeds as Henry VII (d. 1509) 1486 Maximilian I elected German king (d. 1519) 1488 Flemish towns revolt against Maximilian	1481 Spanish Inquisition begins under Torquemada 1484 Pope Innocent VIII (d. 1492) issues *Summis desiderantes* against witchcraft	c. 1483 Master of Moulins, *Nativity of Cardinal Rolin*, Autun c. 1498 Master of Moulins, *Moulins Triptych* (?), Moulins	1480 Michael Wolgemut (1434–1519) active in Nuremberg (Dürer's teacher). Housebook Master active in Rhineland 1486 Dürer apprenticed to Wolgemut in Nuremberg 1489 Bernt Notke (1440–1509), *Saint George Altar*, Stockholm (sculpture)
1490				
	1492 Spanish conquer Granada and oust Moors. Piero de' Medici is ruler of Florence 1493 Maximilian succeeds Frederick III as Holy Roman Emperor. Bundschuh peasant revolt in Alsace and sw Germany 1494 Charles VIII of France invades Italy (Florence and Rome) 1495 Charles VIII crowned king of Naples 1496 Philip the Fair, son of Maximilian, marries Juana, heiress of Spain 1498 Charles VIII succeeded by Louis XII of Bourbon 1499 Louis XII in Italy	1492 Roderigo Borga becomes Pope Alexander VI (d. 1503). Spanish Jews ordered out by Torquemada 1498 Savonarola burned in Florence	1499 Josse Leiferinxe (Master of Saint Sebastian), *Saint Sebastian Altar*	1490 Dürer's *Wanderjahre* begins 1493 *Nuremberg Chronicle* (Schedel) 1494 Dürer's first trip to Venice 1497/8 Dürer's *Apocalypse* (woodcuts) 1498 Tilman Riemenschneider (1460–1531), *Last Supper Altar*, Rothenburg (sculpture)
1500				
	1500 Ludovico Sforza imprisoned in France. Diet of Augsburg divides Germany into six states 1504 Treaty of Lyon, Louis XII cedes Naples to Spanish (to 1707) 1506 Death of Philip the Fair 1507 Margaret of Austria is regent of the Netherlands 1508 League of Cambrai against Venetians 1509 Henry VIII, prince of Wales, succeeds as king of England	1500 Jubilee Year in Rome 1503 Francesco Todeschini Piccolomini is Pope Pius III; Giuliano della Rovere is Pope Julius II (d. 1513) 1506 Johann Tetzel sells indulgences in Germany 1507 Pope Julius II proclaims indulgences for rebuilding of Saint Peter's in Rome 1508 Julius II confirms that German king is automatically Holy Roman Emperor 1509 Persecution of Jews in Germany		1500 Dürer's *Self-Portrait*, Munich 1504 Dürer's *Adam and Eve* (engraving); Cranach (1472–1553), *Rest on the Flight*, Berlin 1505 Dürer's second trip to Venice; *Feast of the Rosary*, Prague 1507 Albrecht Altdorfer (1480?–1538), *Satyr Family*; Pieter Vischer (1455–1529), *Saint Sebaldus Shrine*, Nuremberg (sculpture) 1509 Lucas Cranach, *Holy Kinship Altarpiece*, Frankfort
1510				
	1513 Treaty of Mechelen on invasion of France. Christian II, king of Denmark and Norway (to 1523). Peasant revolt in Black Forest 1515 Francis I succeeds as king of France (d. 1547). Archduke Charles of Austria is governor of Netherlands 1516 Charles V is king of Spain 1518 Peace of London 1519 Death of Maximilian I; Charles V is Holy Roman Emperor. Hernando Cortez received by Montezuma in Mexico	1512 Fifth Lateran Council: immortality of the soul 1513 Giovanni de' Medici is Pope Leo X (d. 1521) 1514 Albrecht of Brandenburg is archbishop of Mainz 1515 Prohibition of publishing books without consent of papacy 1517 Martin Luther posts 95 theses on door of Palastkapel in Wittenberg. Zwingli begins Swiss Reform movement in Zurich		1510 Hans Baldung Grien (1484–1545), *Witches' Sabbath* (woodcut) 1512 Baldung Grien, *Coronation Altarpiece*, Freiburg (to 1516) 1513 Dürer's *Knight, Death, and the Devil* (engraving) 1514 Dürer's *Melencolia I*, *Saint Jerome* (engravings) 1515 Matthias Grünewald (1470/80–1528), *Isenheim Altarpiece*, Colmar 1516 Hans Holbein (1497/8–1543), *Jacob Meyer and Wife*, Basel 1517 Stoss, *Rosary*, Nuremberg (sculpture)

ARTS THE NETHERLANDS	ARTS ITALY AND SPAIN	MUSIC AND LITERATURE	SCIENCE, EXPLORATION, AND MISCELLANY
			1440
1441 Jan van Eyck dies (b. 1390?) 1444 Campin (b. c. 1375) dies. Petrus Christus (?–1472/73) in Bruges 1446 Christus, *Edward Grymestone*, London; *Carthusian*, New York c. 1448 Van der Weyden, *Last Judgment*, Beaune 1449 Christus, *Saint Eloy*, New York	1440 Fra Angelico (1387–1455), San Marco frescoes, Florence 1445 Donatello, *Gattamelata*, Padua; Domenico Veneziano (1390–1461), *Saint Lucy Altarpiece*, Florence 1446 Alberti, Palazzo Rucellai, Florence (to 1451) 1447 Andrea del Castagno (1390–1457), *Last Supper*, Florence. Ghiberti, *Commentaries*	1440 Platonic Academy founded in Florence	1441 Portuguese start first slave trade near Cape Blanc, west Africa 1447 Biblioteca Medicea Laurenziana founded by Cosimo de' Medici in Florence
			1450
1450 Jubilee Year. Van der Weyden in Rome 1457 Dieric Bouts (b. c. 1410–1475) in Louvain	1450 Alberti, facade of San Francesco, Rimini 1453 Piero della Francesca (1420/22–1492), *True Cross* frescoes, Arezzo 1454 Mantegna (1431–1506), *Saint James* frescoes, Eremitani, Padua (to 1457) 1459 Benozzo Gozzoli (c. 1420–1498), Medici-Riccardi frescoes, Florence c. 1461 Filarete, *Commentaries*	1450 Death of Alain Chartier, French poet (b. 1385) 1456 François Villon, *Le Petit Testament*	
			1460
1464 Bouts, *Last Supper Altarpiece*, Louvain (to 1467) 1465 Hans Memlinc (1430/5–1494) in Bruges 1467 Hugo van der Goes (1440–1482) in Ghent 1468 Alexander Bening (active to 1519) in Ghent; beginning of the late Bruges-Ghent miniature tradition	1465 Nuno Goncalves (active c. 1450–1471) in Portugal, painter to Prince Henry the Navigator. Piero della Francesca, *Portraits of Federigo Montefeltro and wife*. Andrea del Verrocchio (1435–1488), *Doubting Thomas*, Orsanmichele, Florence	1464 Nicholas of Cusa dies (b. 1401) 1465 First printed music	
			1470
1470 Bouts, *Justice of Emperor Otto III*, Brussels (to 1475) 1472 Joos van Ghent (1410–1475), *Communion of the Apostles*, Urbino c. 1476 Van der Goes, *Portinari Altarpiece*, Florence 1478 Van der Goes enters the "Red Cloister" 1479 Brussels replaces Arras as tapestry center; Memlinc, *Saint Catherine Altarpiece*, Bruges	1474 Mantegna, Camera degli Sposi frescoes, Mantua 1475 Antonio del Pollaiuolo (1433–1498), *Saint Sebastian*; Antonello da Messina (1422/30–1479), *Crucifixion*, London 1477 Pedro Berruguete in Urbino c. 1478 Botticelli (1444/7–1510), *Primavera*, Florence	1471 Thomas à Kempis, Dutch mystic, dies (b. 1380). Jacob Obrecht, *Saint Matthew's Passion* 1474 Death of Guillaume Dufay (b. 1399). William Caxton prints first books in English in Bruges	1473 Fuggers finance Hapsburgs
			1480
1480 *Hours of Mary of Burgundy* (?) 1482 Master of Virgo inter Virgines, woodcuts. Death of Van der Goes (b. 1440) 1484 Gerard David (1450/60–1523) in Bruges 1485 Jacob Bellaert, *Bartholomaeus Anglicus*, Haarlem (woodcuts) c. 1486 Geertgen tot Sint Jans (active c. 1475–c. 1495), *Saint John Altarpiece*, Vienna 1487 Memlinc, *Diptych of Martin Nieuwenhoven*, Bruges 1489 Memlinc, *Saint Ursula Shrine*, Bruges	1481 Perugino (1446–1523), *Giving of the Keys to Peter*, Sistine Chapel fresco program, Vatican (Botticelli, Ghirlandaio, et al.) 1482 Verrocchio, *Colleoni*, Venice	1480 Georg Faust, German magician, is born 1484 Joannes de Tinctoris, *De inventione et usu musicae*. Rudolf Agricola, Heidelberg humanist, dies 1485 *Malleus maleficiarum* 1486 Antoine de Sale, *Cent nouvelles nouvelles*. Breydenbach, *Pilgrimage to the Holy Lands*	1485 Witch hunt begins in Rhineland
			1490
1494 Memlinc dies (b. 1430/35) 1498 David, *Judgment of Cambyses*, Bruges	1490 Bartolomé Bermejo (active 1440–1500), *Pietà*, Barcelona 1495 Leonardo (1452–1519), *Last Supper*, Milan. Vittore Carpaccio (1450/5–1522/6), *Saint Ursula* cycle, Venice 1496 Juan de Flandes (d. 1519?) court painter in Spain. Gentile Bellini (1428/30–1516), *Procession of True Cross*, Venice 1498 Michelangelo (1475–1564), *Pietà*, Saint Peter's, Vatican (sculpture) 1499 Signorelli, *Last Judgment* frescoes, Orvieto	1490 Beginning of ballet at Italian courts 1494 Sebastian Brant, *Ship of Fools*. Deaths of Giovanni Pico della Mirandola (b. 1463) and Angelo Poliziano (b. 1454) 1495 *Elckerlijk* (Everyman) by Peter Dorland of Diest 1497 Conrad Celtis, humanist, in Vienna 1498 *Reineke de Vos* by Hinrek van Alkmaar. Philippe de Commines, *Mémoires* 1499 W. Pirckheimer, *Bellum Helveticum*. Death of Marcilio Ficino (b. 1433). *Mariken van Nieuwmeghen*, Dutch miracle play	1490 First orphanages in Holland 1492 First trip of Columbus 1493 Second voyage of Columbus 1494 Luca di Pacioli, *Algebra* 1495 Syphilis epidemic begins in Naples, transmitted by French soldiers 1497 Vasco da Gama rounds Cape of Good Hope. Amerigo Vespucci travels through Gulf of Mexico 1498 Third voyage of Columbus. John Cabot explores Greenland and Labrador
			1500
1500 Antwerp Cathedral completed 1502 David, *Baptism Triptych*, Bruges (to 1507) 1504 Philip the Fair commissions Bosch (c. 1453–1516) to paint a Last Judgment; Master of Alkmaar, *Seven Acts of Mercy*, Amsterdam 1507 Quentin Metsys (c. 1465–1530), *Holy Kinship*, Brussels (to 1509) 1508 Metsys, *Lamentation Altarpiece*, Antwerp. Jan Gossart (?–1532) in Rome. Lucas van Leyden, *Mohammed* (engraving) 1509 David, *Virgo inter Virgines*, Rouen	1501 Michelangelo, *David*, Florence (sculpture) 1502 Bramante, Tempietto, Rome 1503 Leonardo, *Mona Lisa*; Pintoricchio (1454–1513), frescoes in the Piccolomini Library, Siena; Michelangelo, *Bruges Madonna* (sculpture) 1505 Giovanni Bellini (1428–1516), *Madonna and Saints*, San Zaccaria, Venice 1506 Bramante, design for Saint Peter's. Laocoön unearthed in Rome 1509 Raphael (1483–1520), Stanze frescoes, Vatican (to 1512)	1500 Erasmus, *Adagia* 1502 Ambrogio Calepino, *Cornucopiae*, polyglot dictionary 1508 Ludovico Ariosto, *Cassaria*, Italian comedy	1500 Pedro Alvarez Cabral discovers Brazil. First postal service, Brussels to Vienna 1501 Gaspar Corte Real explores Greenland, Labrador 1502 Fourth voyage of Columbus. University of Wittenberg founded 1505 Christ's Church College, Cambridge, founded 1506 Jacob Fugger imports East Indies spices 1509 Slave trade to the New World begins
			1510
1510 Van Leyden (c. 1489–1533), *Milkmaid* (engraving); Gossart, *Malvagna Triptych*, Palermo 1512 Jacob Cornelisz van Oostsanen (1470–1533), *Nativity*, Naples 1514 Metsys, *Money Changer and Wife*, Paris 1515 Joachim Patinir (?–1524) in Antwerp guild. Joos van Cleve (1485?–1540/41), *Dormition*, Cologne 1516 Death of Bosch (b. c. 1453); Gossart, *Neptune and Amphitrite*, Berlin 1518 Bernard van Orley (1491?–1542), court painter in Mechelen 1519 Van Orley, *Dr. Zelle*, Brussels	1510 Giorgione (1477/8–1510), *Fête Champêtre* (?), Paris 1511 Michelangelo, Sistine ceiling completed 1513 Raphael, Villa Farnesina frescoes, Rome 1515 Raphael appointed director of architecture at the Vatican 1517 Andrea del Sarto (1486/7–1531), *Madonna of the Harpies*, Florence; Raphael, *Transfiguration*, Rome 1519 Death of Leonardo (b. 1452); Michelangelo, *Medici Tombs*, Florence (to 1534)	1510 Erasmus, *Instituto Christiani principis* 1511 Erasmus, *In Praise of Folly* 1512 Copernicus, *Commentariolus* (earth and planets orbit around sun) 1516 Ariosto, *Orlando Furioso*. Thomas More, *Utopia*. Machiavelli, *The Prince* 1517 Teofilo Folengo, *Opus maccaronium*, satirical poems. Hans Sachs farces. Ulrich von Hutton, "King of Poets"	1513 Balboa sights the Pacific Ocean 1514 Portuguese reach Canton, China. Juan de Ponce de Leon explores Florida 1517 Collège des Trois Langues, Louvain, founded 1518 Adam Riese writes first book on practical arithmetic, Germany 1519 Magellan begins global voyage. Cortez in Mexico

POLITICAL	RELIGIOUS	ARTS FRANCE	ARTS BOHEMIA, AUSTRIA, GERMANY
1520			
1520 Charles V crowned at Aachen 1522 Sultan Suleiman I takes Rhodes from Knights of Saint John 1523 Christian II deposed by Danes 1524 French driven out of Italy 1525 Battle of Pavia, Francis I is prisoner in Spain 1527 Sack of Rome by Charles V; 4,000 killed	1520 Thomas Münzer begins Anabaptist movement in Germany 1521 Diet of Worms, Luther excommunicated 1522 Pope Adrian VI of Utrecht (d. 1523) 1523 Pope Clement VII (d. 1534)	c. 1527 Francis I begins the program at Fontainebleau	1520 Dürer's trip to the Netherlands 1521 Holbein, *Dead Christ*, Basel; Altdorfer, *Birth of the Virgin*, Munich 1525 Dürer, *Teaching of Measurements with Rule and Compass* 1526 Dürer, *Four Apostles*, Munich 1527 Holbein, *Sir Thomas More*, New York (Holbein in England) 1528 Deaths of Dürer (b. 1471) and Grünewald (b. 1470/80) 1529 Altdorfer, *Battle of Alexander*, Munich
1530			
1530 Charles V crowned Holy Roman Emperor at Bologna by Clement VII, last to be crowned by a pope. Francis I marries Eleanor, sister of Charles V	1530 Confession of Augsburg. Melanchthon versus papacy 1531 First English Bible c. 1532 John Calvin reforms in France 1534 Cardinal Alessandro Farnese is Pope Paul III (d. 1549). Luther completes German Bible 1536 Death of Erasmus (b. 1465). Calvin's *Christianae religionis Instituto*	1530 Rosso Fiorentino (1494–1540) at Fontainebleau, Galerie Francois Ier 1531 Primaticcio (1504–1570) at Fontainebleau	1532 Cranach, *Venus*, Frankfort 1533 Holbein, *Ambassadors*, London 1538 Holbein, *Dance of Death* (published at Lyon) 1539 Holbein, *Henry VIII*, Rome
1540			
1541 Turks conquer Buda 1544 Peace of Crépy between Charles V and Francis I 1545 Truce of Adrianople between Charles V and Suleiman 1546 Peace of Ardres 1547 Henry VIII dies; succeeded by Edward VI (d. 1553). Francis I dies; succeeded by Henry II (d. 1559). Ivan IV is first Russian tsar 1549 England declares war on France	1540 Thomas Cromwell executed. Order of Jesus confirmed by papacy 1542 Pope Paul III establishes the Inquisition in Rome 1545 Council of Trent (to 1563) 1546 Martin Luther dies (b. 1483) 1547 Council of Trent moves to Bologna (to 1549) 1548 Ignatius of Loyola's *Exercitia spirituali* published	1540 Giacomo da Vignola, Sebastiano Serlio, Benvenuto Cellini in France. Primaticcio to Rome for casts of antiquities. Death of Rosso (b. 1494) 1546 Pierre Lescot, court of Louvre 1548 Jean Goujon (1520–1572), *Fountain of the Nymphs*, Paris. Jean Cousin (1500–1589/90) decorator for entry of Henri II in Paris	1543 Death of Holbein (b. 1497/8) 1544 Baldung Grien, *Bewitched Groom* (woodcut)
1550			
1550 Peace of Bologne between English and French 1551 Philip II becomes sole heir of Charles V 1553 Death of Edward VI; succeeded by Mary I (d. 1558) 1554 Mary I marries Philip II. Henry II of France invades Netherlands 1556 Charles V abdicates to Philip II. Truce of Vaucelles between Henry II and Philip II 1557 England and France at war 1558 French take Calais. Death of Mary I; succeeded by Elizabeth (d. 1603). Ferdinand I is Holy Roman Emperor 1559 Henry II killed; succeeded by Francis II of France. Margaret of Parma, sister of Philip II, is regent in Netherlands	1550 Giovanni Maria del Monte is Pope Julius III (d. 1555) 1551 Second session of Council of Trent (to 1552) 1554 English restoration of Roman Catholicism under Mary Tudor 1555 Gian Pietro Carafa is Pope Paul IV (d. 1559). Diet of Augsburg 1556 Archbishop Cranmer burned 1559 Giovanni de' Medici is Pope Pius IV (d. 1565). Death of Menno Simons, Anabaptist. General Synod of Calvinists at Paris	1552 Niccolò dell'Abbate (1512–1570) at Fontainebleau 1556 Cousin's book on perspective in French 1558 Niccolò dell'Abbate, *Eurydice and Aristaeus*, London 1559? Jean Duvet (1481/5–1561), *Apocalypse* (engravings)	1553 Death of Cranach (b. 1500)
1560			
1560 Francis II dies; succeeded by Charles IX (d. 1574) 1562 Huguenot wars begin 1564 Granvelle recalled from Netherlands. Death of Ferdinand I; succeeded by Maximilian II (d. 1567) 1565 Philip II issues religious edict in Netherlands opposing William of Orange 1567 Duke of Alba arrives in Netherlands as military governor 1568 Executions in Brussels 1569 Cosimo de' Medici made grand duke of Tuscany by Pope Pius V	1562 Third session of Council of Trent 1564 Calvin dies (b. 1509) 1565 Pope Pius V (d. 1572) 1566 Iconoclasm in the Netherlands	1560 Germain Pilon (1535–1590), *Heart of Henri II*, Paris 1561 Philippe de l'Orme, treatise on architecture 1563 Pilon and Primaticcio, *Tomb of Henri II*, Paris (to 1570)	
1570			
1571 Battle of Lepanto, end of Turkish naval supremacy 1572 Dutch War of Independence; William of Orange is stadhouder 1573 Haarlem resists Spanish siege. Alba recalled 1574 Death of Charles IX; succeeded by Henry III of France 1575 Conference of Breda, Philip II refuses Dutch concessions 1576 Spanish Fury in Antwerp. Pacification of Ghent, unity of Dutch provinces. Maximilian II dies; succeeded by Rudolf II 1577 Perpetual Edict of Don Juan refused by William of Orange 1578 Death of Don Juan; succeeded by Alessandro Farnese, duke of Parma, as governor of Netherlands 1579 Union of Utrecht, foundation of Dutch Republic with seven north provinces. South Netherlands taken by Philip II	1572 Saint Bartholomew Massacre of French Protestants at Paris. Mennonites tolerated in the Netherlands. Ugo Buoncampagni is Pope Gregory XIII (d. 1585)	1576 Jacques A. Du Cerceau, *Les plus excellents bâtiments de France*	
1580			
		1580 Pilon, *Mater Dolorosa*, Paris	

ARTS THE NETHERLANDS	ARTS ITALY AND SPAIN	MUSIC AND LITERATURE	SCIENCE, EXPLORATION, AND MISCELLANY
			1520
1521 Van Orley, *Job Altarpiece*, Brussels; Maerten van Reymerswaele (1497?–1570?), *Saint Jerome*, Munich 1522 Pieter Coecke van Aelst (1502–1550) to Italy 1523 Jan van Scorel (1495–1562) to Venice, Holy Land, Rome; director of antiquities of the Vatican 1525 Scorel, Lochorst *Entry into Jerusalem*, Utrecht (to 1527) 1526 Van Leyden, *Last Judgment*, Leiden 1527 Gossart, *Danaë*, Munich	1520 Death of Raphael (b. 1483) 1521 Rosso (1494–1540), *Deposition*, Volterra 1522 Correggio (1494–1534), *Night Nativity*, Dresden 1525 Correggio, Dome of San Giovanni Evangelista, Parma 1526 Pontormo, *Deposition*, Florence; Titian (1477/89–1576), *Pesaro Madonna*, Venice 1527 Giulio Romano (1492/9–1546), Palazzo del Te, Mantua (to 1534)	1524 Johannes Walther, *Geystlich Gesangk-Büchleyn* (Luther's hymns). Petrus Apianus, *Cosmographia*, text on geography 1527 Baldassare Castiglione, *Il Cortegiano*. Paracelsus lectures at University of Basel 1528 Sebastian Franck, *Vice of Drinking*. Paracelsus, *Die kleine Chirurgia*, on surgery	1520 Royal Library of France, Fontainebleau, founded 1524 Verrazano discovers Bay of New York
			1530
1530 Death of Metsys (b. c. 1465) 1531 Coecke van Aelst, *Last Supper*, Brussels 1532 Maerten van Heemskerck (1498–1574) to Italy; *Saint Luke Painting the Virgin*, Haarlem 1533 Coecke van Aelst in Constantinople. Deaths of Van Leyden and Gossart 1536 Jan van Hemessen (c. 1500–1563/64), *Prodigal Son*, Brussels 1537 Lambert Lombard (1506–1566) in Italy 1538 Heemskerck, *Crucifixion Altarpiece*, Linköping 1539 Coecke van Aelst translation of Vitruvius	1534 Baldassare Peruzzi (1481–1536), Palazzo Massimo alle Colonne, Rome 1535 Parmigianino (1503/5–1540), *Madonna with the Long Neck*, Florence 1537 Sebastiano Serlio, *Trattato di Architettura* 1538 Titian, *Venus of Urbino*, Rome	1530 Georg Agricola, *De re metallica*, mineralogy 1531 Clément Marot, *Adolescence Clémentine*, poems 1532 Rabelais, *Pantagruel*. Otto Brunfels, *Book of Herbs* 1534 Rabelais, *Gargantua* (Book II of *Pantagruel*) 1536 Death of Johannes Secundus (Jan Everaerts), Dutch poet (b. 1511) 1539 *Gentse Spelen*. Georg Forster, *Frische teutsche liedlein*, secular songs	1532 Pizarro in Peru 1534 Jacques Cartier explores Labrador and Newfoundland 1537 Gerard Mercator, map of Flanders 1539 Olaus Magnus, map of the world
			1540
1540 Reymerswaele, *Banker and His Wife*, Florence 1541 Scorel, *Finding of the True Cross*, Breda 1547 Abraham Ortelius registered in Antwerp guild 1549 Antonis Mor (c. 1517–1576), *Fernando Alvarez de Toledo, Duke of Alba*, New York	1541 Michelangelo, *Last Judgment*, Sistine Chapel unveiled 1545 Benvenuto Cellini (1500–1574), *Perseus and Medusa*, Florence (sculpture) 1546 Farnese Bull unearthed in Rome. Bronzino (1502–1572), *Exposure of Luxury*, London 1547 Michelangelo appointed architect of Saint Peter's	1541 Marot, Psalms in French 1542 Andreas Vesalius, *De humani corporis fabrica*, anatomy 1547 Death of Pietro Bembo, poet (b. 1470). First prediction of Nostradamus, French astrologer 1549 Joachim du Bellay, *Defense et illustration de la langue Française*	1540 Cardenas discovers Grand Canyon, Arizona 1541 Coronado seeks seven cities of gold in Arizona and New Mexico 1542 University of Pisa founded 1543 Death of Copernicus (b. 1473) 1545 Hansa moves from Bruges to Antwerp
			1550
1550 Ghent altarpiece cleaned by Scorel and Blondeel. Death of Coecke van Aelst 1551 Pieter Aertsen, *Butcher's Stall*, Uppsala 1552 Pieter Bruegel (c. 1526–1569) in Italy to 1553 1553 Publication of Coecke's *Manners and Customs of the Turks*; Heemskerck, *Self-Portrait*, Cambridge 1554 Mor, *Mary Tudor*, Madrid 1556 Bruegel, *Big Fish Eat Little Fish* (engraving for H. Cock) 1558 Mor, *Self-Portrait*, Florence 1559 Bruegel, *Carnival and Lent*, Vienna; *Netherlandish Proverbs*, Berlin	1550 Vasari (1511–1574), *Vite*. Andrea Palladio (1518–1580), Villa Rotonda, Vicenza 1554 Titian, *Danaë*, Madrid 1555 Birth of Lodovico Carracci (d. 1619) 1557 Birth of Agostino Carracci (d. 1602) 1558 Bartolommeo Ammanati (1511–1592), courtyard of the Pitti Palace, Florence 1559 Titian, *Rape of Europa*, Boston	1550 Ronsard, *Odes* 1551 Palestrina, conductor at Saint Peter's, Rome 1553 Hans Sachs, *Tristan und Isolde* 1557 Accademia di San Luca, Rome. Ronsard, *Amours* 1558 Margaret of Navarre, *Heptameron*, tales, published. J. C. Scaliger, French scholar, dies (b. 1484)	1550 Sebastian Münzer, *Cosmographia* 1551 Gesner, *Historia animalium* 1555 Spanish import tobacco 1557 Portuguese settle Macao, China. Bankruptcies in France and Spain 1558 University of Jena founded
			1560
1561 Antwerp Landjuweel 1562 Death of Scorel (b. 1495). Bruegel, *Fall of the Rebel Angels*, Brussels 1563 Bruegel moves to Brussels, marries Coecke's daughter 1565 Bruegel's landscapes of the *Months*. Frans Floris (1516–1570), *Last Judgment*, Vienna 1566 Bruegel's *Wedding Dance*, Detroit 1567 Ludovico Guicciardini, *Descrittione di tutti i Paesi Bassi* 1569 Death of Bruegel (b. c. 1526)	1560 Birth of Annibale Carracci (d. 1609) 1562 Torquato Tasso (1512/15–1594), *Saint Mark* series, Venice (to 1566) 1563 Escorial begun 1564 Death of Michelangelo (b. 1475). Tintoretto, *San Rocco* frescoes, Venice. Luis de Morales (1509?–1586), court painter at Escorial 1565 Vasari, second edition of *Vite* 1568 Giacomo Vignola, Il Gesù, Rome	1561 Antwerp Landjuweel 1562 Torquato Tasso, *Rinaldo* 1564 Johannes Sambucus, *Emblemata*. Andrea Amati makes one of first violins. Birth of William Shakespeare (d. 1616). Death of Vesalius (b. 1514) 1565 Hadrianus Junius, *Emblemata*. Death of Nostradamus, French astrologer (b. 1503)	1561 Tulips from Near East in Holland 1569 Mercator, *Map of the World*
			1570
1572 D. Lampsonius, *Effigies* 1574 Death of Heemskerck (b. 1498) 1575 Carel van Mander (1548–1606) in Rome 1577 Birth of Peter Paul Rubens (d. 1640)	1570 Palladio, Treatise on architecture. Vasari and Allori (1535–1607), studiolo of Francesco I de' Medici, Florence (paintings) 1571 Death of Cellini (b. 1500) 1573 Veronese (1528–1588), *Christ in the House of Levi*, Venice 1576 Death of Titian (b. c. 1477) 1577 Tintoretto, *Life of Christ*, San Rocco, Venice 1578 Catacombs discovered	1572 Etienne, *Thesaurus linguae graecae* 1575 Tasso, *Gerusalemme liberata* 1576 Hans Sachs dies (b. 1494) 1579 E. Spenser, *Shepherds' Calendar*. Saint John of the Cross, *Dark Night of the Soul*. First mention of *Green Sleeves*, English folk song	1570 Ortelius, *Theatrum orbis terrarum* 1574 University of Berlin founded. Conrad Dasypodius builds Strasbourg clock 1575 University of Leiden founded by William of Orange 1577 Drake begins global voyage (to 1580)
			1580

Index

Page numbers are in roman type. Figures are in *italic* type. Colorplates are designated "pl." or "pls."

Abbate, Niccolò dell', 515–16, 517; *Eurydice and Aristaeus,* 516; *585*
Abbey, Cîteaux, funerary sculpture for, 314
Abbey, Solesmes, funerary sculpture for, 313
Abbey Church of Saint Denis, near Paris, 68; altarpiece for (Master of Saint Giles), 243–44; tombs in (Beauneveu), 44; (Pilon), 522
Abbey of Saint Bertin, Saint Omer, altarpiece for (Marmion), 240
Acta Sanctorum, 152
Adagiorum Chiliades (Erasmus), 500
Adam (Dürer), 332–33; *380*
Adam (Riemenschneider), 305
Adam, from *Altarpiece of the Lamb* (Van Eyck, Jan and Hubert), 89, 91, 93, 94; *88;* pl. 16
Adam and Eve (Dürer), 316–18, 329, 332, 337, 366, 424; *348*
Adam and Eve (Lucas van Leyden), 463–64; *537*
Adamite sect, 212, 215, 368
Adoration of the Child (Van Oostsanen), 449; *518*
Adoration of the Magi (Bosch), 206–7; *197, 198*
Adoration of the Magi (Bruegel the Elder), 507
Adoration of the Magi (Dürer), 329, 335; *376*
Adoration of the Magi (Gossart), 421–22; *493*
Adoration of the Magi (Master of the Antwerp Adoration), 402, 417; *468*
Adoration of the Magi (Mostaert), 451–52; *522*
Adoration of the Magi (Van Cleve), 417; *486*
Adoration of the Magi (Van der Goes), 173–74, 176, 243; *162*
Adoration of the Magi (Van Ghent), 166, 168; *157*
Adoration of the Magi, from *Boucicaut Hours* (Boucicaut Master), 51; *40*
Adoration of the Magi, from *Columba Adoration of the Magi* (Van der Weyden), 134–35; pl. 22
Adoration of the Magi, from *Infancy Altarpiece* (Bouts), 143, 144; *139*
Adoration of the Magi, relief from *Retable de Champmol* (De Baerze), 71; *68*
Adoration of the Magi, from *"Small Bargello Diptych"* (French painter), 46; pl. 5
Adoration of the Magi, from *Très Riches Heures du Duc de Berry* (Limbourg brothers), 59–60; *53*
Adoration of the Magi Triptych with Saints John the Baptist and Christopher (Bouts the Younger?), 149–50; *147*
Adrian VI, pope, 467, 469, 470
Aegidius, Peter, 340, 388, 408
Aelst, Pieter Coecke van, 429–30, 485, 512; *Ces moeurs et fachons de faire de Turcz,* 429–30; *507; Last Supper,* 430; pl. 69
Aertsen, Pieter, 445, 460; *Butcher's Stall,* 445, 460; pl. 71
Agincourt, battle of, 48, 50, 239
Agnes Dürer (Dürer), 321; *357*
Agony in the Garden, German-Bohemian woodcut, 267; *263*
Agrippa of Nettesheim (Cornelius Agrippa), 318, 319, 367, 393

Albergati, Nicolas, 115, 116, 117, 223, 248; *111, 112*
Alberti, Leon Battista, 245, 316, 333, 410
Album Amicorum (Ortelius), 484
alchemy, 195, 210–11, 213, 364–65, 368, 503
Allegory of Maximilian I (Dürer), 339; copy after, *394*
Allegory of the Law and the Gospel (Cranach the Elder and shop), 382–83; *444*
Allegory of the Triumph of Riches over Poverty (Holbein the Younger), 391
Altarpiece of Saint Denis (Master of Saint Giles), 243–44; *243, 244;* pl. 41
Altarpiece of Saint George (Borman the Elder), 295; *310*
Altarpiece of Saint Lawrence (Van Heemskerck), 478–79; *550*
Altarpiece of Saint Martin (Master of Saint Martin), 297–98; *316*
Altarpiece of Saint Peter (Witz), 225–26; pl. 38
Altarpiece of the Annunciation (Master of the Aix Annunciation), 252, 261; *256, 257*
Altarpiece of the Apostles Thomas and Matthias (Van Orley), 427; *501*
Altarpiece of the Assumption of Mary (Riemenschneider), 307–8; *332, 333*
Altarpiece of the Baptism of Christ (David), 192; pl. 33
Altarpiece of the Church Fathers (Pacher), 238; *233, 234*
Altarpiece of the Communion of the Apostles (Van Ghent), 166, 167–68; *159*
Altarpiece of the Crucifixion (Van Ghent), 166–67, 168, 193; *158*
Altarpiece of the Deposition (Bouts), 144–45, 150, 153, 235; *140*
Altarpiece of the Fugger Chapel (Daucher?), 311; *339*
Altarpiece of the Holy Blood (Riemenschneider), 306–7; *330, 331*
Altarpiece of the Holy Kinship (Metsys), 373, 403–5; *470;* detail of, *471*
Altarpiece of the Lamb (Van Eyck, Jan and Hubert), 89–96, 97, 109, 120, 123, 165, 262, 296, 305; *85–89;* pls. 15, 16; collaboration on, 90–91, 93, 95, 96; dedication of, 93; donors of, 89, 92, 93; exterior of, 93; Iberian influence on, 95–96; iconography of, 90–93; influence of, 89, 131, 153, 173, 340, 420; interior of, 91–92; proposed reconstructions of (Philip), 94; *91, 92;* restoration of, 89, 95, 467
Altarpiece of the Magdalen (Riemenschneider), 305, 309; *329*
Altarpiece of the Ordeals of Job (Van Orley), 427–29, 447; *502, 503*
Altarpiece of the Passion (Netherlandish), 295; *309*
Altarpiece of the Seven Sacraments (Van der Weyden), 129–30; *124*
Altarpiece of the Virgin (David), 193
Altarpiece of the Virgin (Van Wesel), 298; fragment of, *317*
Altarpiece of the Virgin with Saints and Angels (Memlinc), 183–84, 191; pl. 31
Altdorfer, Albrecht, 339, 357–64, 365, 369; allegory in the work of, 362, 363; as architect, 358, 362; *Battle of Alexander,* 362–63; pl. 57;

Birth of the Virgin, 361–62; *420; Christ in the Garden of Gethsemane,* 361, 364; *417; Danube Landscape,* 357, 358; pl. 56; early years of, 357–58; expressionism in the work of, 361, 363; influence of, 363; landscapes by, 357, 358, 363–64, 404; *413, 414;* pl. 56; mysticism in the work of, 357, 359, 363; *Night Nativity,* 358–59, 364; *415;* religious beliefs of, 361; *Rest on the Flight into Egypt,* 359, 361, 365; *416;* romanticism in the work of, 357, 358, 364; *Saint Francis,* 358; *412; Saint George Slaying the Dragon,* 358; *414; Satyr Family,* 358; *413; Schöne Maria of Regensberg,* 361; *419; Susanna at the Bath,* 362; *421*
Amerbach, Bonifacius, 387, 388; *451*
Amerbach, Johannes, 387
Amiens Cathedral, 15; sculpture for, 31, 44, 293
Amour Takes the Heart of the King (Master of René of Anjou), from *Livre du cuer d'amours espris,* 249; pl. 44
Andachtsbilder motifs, 80, 86, 128, 129, 177, 178, 262, 299, 306, 349
Angelico, Fra (Giovanni da Fiesole), 124–25, 131, 218
Angers Apocalypse Tapestries (Bondol and Bataille), 48, 76; *36;* pl. 6
"Anges de Bourges, Les," frescoes from House of Jacques Coeur, 239; *237*
Animals (Master of Bellaert), woodcut from *De proprietatibus rerum* (Bartholomaeus Anglicus), 272–73, 285; *273*
Anna Cuspinian (Cranach the Elder), 370–71, 372, 375, 386, 388; *429*
Anna von Schweidnitz (Parler and shop), 26; *17*
Anne de France, 251, 252; pl. 45
Anne of Cleves, 393, 396–97; *461*
Anne of Cleves (Holbein the Younger), 396; *461*
Annunciate Angel Gabriel (Schongauer), 285–86; *295*
Annunciate Madonna (Schongauer), 285–86; *296*
Annunciate Virgin, from *Altarpiece of the Lamb* (Van Eyck, Jan and Hubert), 89, 93, 95, 120, 123; *85;* pl. 15
Annunciation (Froment), 263, 264
Annunciation (Grünewald), from *Isenheim Altarpiece,* 349, 350, 351, 352; pl. 54
Annunciation (Lochner), 219
Annunciation (Master of the Cologne Annunciation), 80; *77*
Annunciation (Master of the Virgo inter Virgines), 450–51; *520*
Annunciation (Van der Weyden), 125–26, 156; *121*
Annunciation (Witz), 225; *217*
Annunciation, from *Altarpiece of the Annunciation* (Master of the Aix Annunciation), 252, 261; *256*
Annunciation, from *Belles Heures du Duc de Berry* (Limbourg brothers), 57; *49*
Annunciation, from *Book of Hours of Marie of Guelders,* 74–76; *71*
Annunciation, from *Brussels Hours* (Hesdin and shop?), 55; *45*
Annunciation, from *Columba Adoration of the Magi* (Van der Weyden), 135; pl. 22
Annunciation, from *Hours of Jeanne d'Évreux*

(Pucelle), 20, 21–22, 45; *10*
Annunciation, from *Infancy Altarpiece* (Bouts), 143, 144; *139*
Annunciation, from *Last Judgment Altarpiece* (Van der Weyden), 133; *128*
Annunciation, from *Liber Viaticus* (Bohemian miniaturist), 28; *20*
Annunciation, from *Mérode Altarpiece* (Campin), 120–21, 225; pl. 19
Annunciation, from *Petites Heures du Duc de Berry* (Hesdin and shop), 54–55; *44*
Annunciation, from *Saint Peter Altarpiece* (Master Bertram), 78, 79; *76*
Annunciation, from *Très Riches Heures du Duc de Berry* (Limbourg brothers), 58; *51*
Annunciation, left wing of a triptych (Van Eyck, Jan), 103–4, 109, 225; *103*
Annunciation, woodcut from *Le Bois Protat* (French?), 267
Annunciation and Nativity (Christus), 155–56; *153*
Annunciation and Visitation, from *Retable de Champmol* panels (Broederlam), 71–72, 99; pl. 12
Annunciation group (polychromed by Campin), 295–96; *311*
Annunciation group (Smiling Angel Master and Master of Amiens), l5, 79, 293, 312; *2*
Annunciation of the Death of the Virgin, from the *Maestà* (Duccio), 21; *11*
Annunciation of the Rosary (Stoss), 310; *337*
Annunciation with the Fall of Eve and Gideon's Fleece, woodcut from *Biblia pauperum*, 269; *267*
Antiquités Judaïques, Les (Josephus), 244; miniature from (Fouquet), 244–45; pl. 42
Antonio de Beatus, 89, 216
Antonio Siciliano and Saint Anthony (Gossart), 421; *491*
Antwerp, Belgium, 340, 399–402, 448; the arts in, 217, 399–402, 405, 417, 418, 419, 420, 447–48
Antwerp Mannerism, 401–2, 405, 417, 448–49, 456
Apelles, 99, 100, 126, 345
Apocalypse series (Dürer), 76, 323–25, 334, 335, 458, 519; *362–64, 366, 384*
Apocalypse series (Duvet), 519; *589*
Apollo Belvedere, 316, 424, 477, 512; *350*
Apollo Citharoedus (Gossart), 419
Apprentices Fighting (Schongauer), 284–85; *292*
April, from *Très Riches Heures du Duc de Berry* (Limbourg brothers), 62–63, 278; *56*
Aristotle and Phyllis (Housebook Master), 289; *302*
Armagnac, Bonne d', 63
Armagnac, Jacques d', 244
Arnolfini, Giovanni, 111, 113, 114; pl. 18
Arnolfini Wedding Portrait (Van Eyck, Jan), 96, 102, 109, 111–13, 114, 121, 123, 126, 152, 153, 375, 392, 400, 406; pl. 18; *106*
Arrest of Christ (Schongauer), 284; *291*
Arrest of Christ, from *Book of Hours of Marie of Guelders*, 74–75; *71*
Arrest of Christ, from *Hours of Jeanne d'Évreux* (Pucelle), 20, 21, 22, 45; *10*
Ars moriendi, Netherlandish woodcut from, 269–70; *268*
Artist and His Wife Ida (Van Meckenem), 289; *304*
Artist's Sons, Ambrosius and Hans, The (Holbein the Elder), 385; *447*
Artist's Wife and Two Children (Holbein the Younger), 390, 391; *455*
Ascension of the Magdalen, fragment from *Altarpiece of the Magdalen* (Riemenschneider), 305; *329*
Ascent into the Celestial Paradise (Bosch), 217; *209*
At the Four Winds, Antwerp, publishing house, 400, 484
Aubert, David, 193
Aventinus, Johannes, 363

Babylonian Whore, The, from *Apocalypse* series (Dürer), 325; *366*
Bacchus (Michelangelo), 478
Baegert, Derik, 233; *Saint Luke Painting the*

Madonna, 233; *227*
Baer, Magdalen, 390; *454*
Baerze, Jacques de, 71, 74, 293, 295; *Retable de Champmol*, central relief of, 70, 71, 294; *68*
Baldung Grien, Hans, 353–54, 365–69; *Bewitched Groom, The*, 369; *428*; *Coronation of the Virgin*, 365; *423*; *Death and the Maiden* (1509–11), 365–66; *425*; *Death and the Maiden* (1517), 366; pl. 58; *Eve, the Serpent, and Death*, 367; *426*; *Rest on the Flight*, 365; *424*; *Witches' Sabbath*, 367–69; *427*
Bamberg Master, 235–36; *Farewell of the Apostles*, 143, 235–36; *230*
Banker and His Wife, The (Van Reymerswaele), 443; *513*
Banquet of Charles IV of Bohemia and Charles V of France in Paris, The (Parisian miniaturist), from *Grandes Chroniques de France, Les*, 43; *26*
Baptism of Christ (Van Scorel), 471–72; *542*
Baptistry, Florence, bronze door for (Pisano), 129
Barbari, Jacopo de', 372, 373, 383, 424
Bardi Chapel, Santa Croce, Florence, fresco for (Gaddi), 61
Baroncelli, Maria, 172, 186; *161, 179*
Baroque period, 481, 512; *see also* Late Gothic Baroque
Bartolo, Taddeo di, 61
Basel, Switzerland, 74, 223, 370
Bataille, Nicolas, 48; *Angers Apocalypse Tapestries*, 48, 76; *36*; pl. 6
Bather (Dürer), 322, 331–32; *379*
Battle of Alexander (Altdorfer), 362–63; pl. 57
Battle of Cascina (Michelangelo), 457, 472
Battle of Pavia, 512
Battle of the Sea Gods (Dürer), 321–22; *359*
Battle of the Sea Gods (Mantegna), 321–22; *358*
Baudouin de Lannoy, 114; *108*
Baudouin of Burgundy, 425, 426; *500*
Baussele, Erasmus van, 147; pl. 25
Bayern, Albrecht von, 368
Beaumetz, Jean de, 18, 69, 74, 267; *Crucifixion*, 69; *65*
Beauneveu, André, 44, 46, 52–53, 57, 74, 293; *Gisant Portrait of Charles V*, 44; *29*; *Psalter of Jean, Duc de Berry*, 53, 56; *42*
Beham, Barthel, 347
Bellaert, Jacobus, 272
Bellange, Jacques, 519; *Three Marys at the Tomb*, 519–20; *590*
Bellechose, Henri, 70, 122; *Martyrdom of Saint Denis with the Trinity*, 70; pl. 11
Belles Heures du Duc de Berry (Limbourg brothers), 57; *49*
Belleville Breviary (Pucelle), 22, 53, 54, 57; *12*
Bellini, Gentile, 242
Bellini, Giovanni, 316, 331, 404
Benesch, Otto, 487–88, 503, 520
Bening, Alexander, 193; *see also* Master of Mary of Burgundy
Bening, Simon, 165, 193, 397
Berruguete, Pedro, 168
Beuckelaer, Joachim, 460
Bewitched Groom, The (Baldung Grien), 369; *428*
Bible historiale (Bondol), 47–48; frontispiece from, *34*
Bible moralisée (Limbourg brothers), 57, 64
Biblia pauperum, 268–69, 270, 271; woodcut from, *267*
Bicker, Pieter, 479–80; *552*
Big Fish Eat Little Fish (Bruegel the Elder), 485, 500; *566*
Binchois, Gilles, 99
Binzenstock, Elizabeth, 390, 391; *455*
Birth of John the Baptist, from *Saint John the Baptist Altarpiece* (Van der Weyden), 129; *123*
Birth of Saint John the Baptist ("Hand G" of the Turin-Milan Hours), from *Turin-Milan Hours*, 96; *94*
Birth of the Virgin (Altdorfer), 361–62; *420*
Bisticci, Vespasiano da, 167, 168
Bladelin, Pieter, 133, 134; *129*
Blauwe Scutt, De (Van Oestvoren), 205
Bles, Herri met de, 432, 441–42, 502; *Copper Mine, The*, 442; *511*; *Road to Calvary*, 432, 441; pl. 70; *View of Jerusalem*, 441; *510*

Blind Lead the Blind (Bruegel the Elder), 500; *567*
Blondeel, Lancelot, 89
Blue Cloak, The (Hogenberg), 501; *568*
Boccaccio, Giovanni, 49, 50, 64
Bohemia, Late Gothic art of, 16, 23–32, 234
Bois Protat, Le (French?), 267; woodcut from, *261*
Boleyn, Anne, 389, 394–95
Bondol, Jean, 46, 47–48, 74; *Angers Apocalypse Tapestries*, 48, 76; *36*; pl. 6; *Presentation of a Bible to Charles V by Jean de Vaudetar, The*, 47–48; *34*
Bonifacius Amerbach (Holbein the Younger), 387–88; *451*
Book of Hours of Catherine of Cleves (Master of the Hours of Catherine of Cleves), 141; *138*; pl. 23
Book of Hours of Marie of Guelders, 74–76; *71*
Book of Hours of Maximilian, 339; drawing from (Dürer), *396*
Book of Hours of Sophia von Bylant (Master of the Saint Bartholomew Altarpiece), 230
Book of Kells, 58
Borluut, Isabelle, 93; pl. 15
Borman, Jan, the Elder, 295; *Altarpiece of Saint George*, 295; *310*
Bosch, Hieronymus, 133, 195–96, 205–17, 262, 282, 298, 369, 410; *Adoration of the Magi*, 206–7; *197, 198*; allegory in the work of, 205, 206, 209; *Ascent into the Celestial Paradise*, 217; *209*; *Carrying of the Cross*, 207–8; *199*; *Cure of Folly*, 196; *192*; death of, 195, 216; *Death of the Miser*, 205; pl. 36 (copy after, 205; *194*); early years of, 195; *Fall of the Damned*, 217; *208*; *Garden of Earthly Delights*, 195, 212–17, 466; *205–7*; pl. 35; Germanic sources for the work of, 207, 208, 216; iconography of, 195, 205, 206–7, 212–13, 217; *Inferno*, 217; *208*; influence of, 484, 485, 488; *Landloper*, 206, 212; *196*; landscape in the work of, 208–9; literary sources for the work of, 196, 205–6, 208, 210, 217; pessimism of, 207, 208, 213, 214–15, 217, 451, 487; religious beliefs of, 195, 217, 298, 325; *Ship of Fools*, 205; *195*; stylistic devices of, 207, 208, 485; surrealism in the work of, 195, 210, 212, 485; symbolism in the work of, 212, 213, 214, 217; symbolism of alchemy, astrology, and witchcraft, 195, 210–11, 212–13, 214; *Table of the Seven Deadly Sins*, 196, 205; *193*; *Terrestrial Paradise*, 217; *209*; themes and subject matter of, 196, 206, 208, 212; *Triptych of Saint Anthony*, 208–10, 353; *200–202*; *Triptych of the Haywain*, 211–12; *203, 204*
Boucicaut Hours (Boucicaut Master), 50–52; *39–41*; pl. 7
Boucicaut Master, 50; *Boucicaut Hours*, 50–52; *39–41*; pl. 7
Bouts, Aelbrecht, 143, 149
Bouts, Caterina, 143
Bouts, Dieric, 141, 143–50, 169, 182, 403; *Altarpiece of the Deposition*, 144–45, 150, 153, 235; *140*; artistic style of, 146, 148, 150, 152, 165, 228, 292, 401; death of, 143, 149; *Infancy Altarpiece*, 143, 144, 150, 152; *139*; influence of, 150, 269; on David, 187, 190; on Funhoff, 234; on Marmion, 241; on Master I.A.M., 292; on Master of Joachim and Anna, 297; on Master of Saint Giles, 242, 243; on Schongauer, 281; on Van der Goes, 170–71; on Van Ghent, 165, 166; on Wolgemut, 235; *Justice of Emperor Otto III*, 148–49, 190; *146*; landscape in the work of, 145, 147–48, 150, 236; *Last Supper Altarpiece*, 146–48, 166, 167, 235, 269; *144*; pl. 25; in Louvain, 143, 144, 145, 148, 190; *Madonna and Child* (c. 1450), 145; *141*; *Madonna and Child* (c. 1465), 145–46, 281; *142*; *Portrait of a Man*, 146; *143*; portraits by, 146, 147, 148–49, 151, 181, 409; *143, 145, 146*; pl. 25; realism in the work of, 146, 147; *Wrongful Execution of the Count*, 148–49; *145*
Bouts, Dieric, the Younger, 143, 149; *Adoration of the Magi Triptych with Saints John the Baptist and Christopher*, 149–50; *147*
Bramante, Donato, 362, 422

Brancacci Chapel, Santa Maria del Carmine, Florence, frescoes in (Masaccio), 57
Brandenburg, Albrecht von, 354, 356, 376, 381; *443*
Brant, Sebastian, 205, 274, 321, 327, 365, 407
Breisacher Altarpiece (Master H.L.), 311; *340*
Brethren and Sisters of the Free Spirit, 215, 368
Brethren of the Common Life, 32, 74, 75, 213, 217, 268, 376
Breviary of Isabella of Spain, 193
Breydenbach, Bernhard von, 274
Broederlam, Melchior, 71–73, 74; *Retable de Champmol,* painted exterior panels for, 70, 71–73, 99, 294; pl. 12
Bronzino, 512
Brotherhood of Our Lady, 195, 298
Brotherhood of the Holy Sacrament, 167, 174
Bruegel, Jan "Velvet," 484
Bruegel, Mayken, 485
Bruegel, Pieter, the Elder, 61, 246, 484–88, 497–510; in Antwerp, 484; artistic philosophy of, 487, 488; artistic technique of, 487, 504, 507; *Big Fish Eat Little Fish,* 485, 500; *566;* birth of, 484; *Blind Lead the Blind,* 500; *567;* in Brussels, 484; calendar series, 504–7; *574–77;* pl. 83; *Carnival and Lent,* 499; *564; Carrying of the Cross,* 507–9; *578; Children's Games,* 499; *565;* death of, 484; designs for engravings by, 484, 510; drawings by, 487, 488, 500, 504; *560, 566, 572, 573;* engravings by, 292, 499; *563; Fall of Icarus,* 509–10; *579; Fall of the Rebel Angels,* 485; *558; Gloomy Day,* 506; *574; Harbor of Naples,* 502; *571; Hay Harvest,* 506; *575;* humor in the work of, 484, 485, 499; *Hunters in the Snow,* 505; pl. 83; as intellectual, 487, 503, 510; *Kermis,* 488, 497; *561; Kermis at Hoboken,* 499; *563; Landscape of Alpine Mountains,* 504; *572;* landscapes by, 322, 484, 487, 502–10; *571–79;* pl. 83; Late Gothic imagery of, 485, 488, 500; marriage of, 484; *Mountain Landscape "Waltersspurg,"* 504; *573;* mythological theme of, 509–10; *Netherlandish Proverbs,* 500–502; pl. 82; patrons of, 484–85, 505, 510; peasant life as subject matter, 487–88, 497–502, 505, 510; pessimism of, 485–87, 500, 507–8, 510; philosophy of nature, 487, 488, 503, 504, 508–9; proverbs and parables as subject matter, 499–502, 510; religious philosophy of, 503, 510; religious subjects by, 507–8; *578; Return of the Herd,* 506–7; *577;* scientific investigations, influence on the work of, 503; *Tower of Babel,* 322, 502; *569, 570;* travels of, 484, 502–3; *Triumph of Death,* 485–87, 523; *559; Two Woodcutters,* 488; *560; Wedding Dance,* 497–99; *562; Wedding Feast,* 497; pl. 81; *Wheat Harvest,* 506; *576*
Bruegel, Pieter, the Younger, 484
Bruges, Belgium, 165, 166, 182, 193, 399
Brussels Hours (Hesdin), 53, 55–57, 58, 64, 245; *45, 46, 47;* pl. 9
Buchelius, Arnoldus, 447, 467
Burgkmair, Hans, 234, 339, 367, 373, 385; *Saint John on Patmos,* 385; *448*
Burgkmair, Thoman, 234
Burgundian courts, 95, 96, 119, 120, 129, 140, 141, 182, 239, 273, 400; artists of, 90, 95, 96–97, 122, 127, 267, 313, 314; commissions from, 127, 129, 425
Burning of the Bones of Saint John the Baptist (Geertgen tot Sint Jans), 181, 449, 470; *171*
Busnang, Conrad von, 301; *320*
Bust of a Man (Gerhaerts van Leyden), 301; *322*
Butcher's Stall (Aertsen), 445, 460; pl. 71
Buxheim Saint Christopher, German woodcut, 267–68; *264*
Buys, Cornelius, the Elder, 447, 448, 467; *see also* Master of Alkmaar
Byzantine art, 135, 167, 168

Cambrai, Jean de, 53, 293
Campin, Robert, 119–23, 125, 127, 222, 223; *Annunciation* group, 296; *311;* apprentices of, 119–20, 123; artistic and stylistic development of, 122, 123; artistic traits of, 124, 127; emotionalism in the work of, 122; *Entomb-*

ment Triptych, 122; *117;* genre in the work of, 120, 121, 122; iconography of, 120–21, 123; influence of, 140, 141, 156, 187, 233, 268, 403; *Mérode Altarpiece,* 120–22, 123, 125–26, 156, 225; pl. 19; *Nativity,* 122–23, 134, 156; *118;* realism in the work of, 122; *Salting Madonna,* 123; *119;* sculptural painting (polychroming) by, 296; *311;* symbolism in the work of, 120, 121, 122, 123; in Tournai, 119–20; workshop of, 119–20
Canterbury Tales (Chaucer), 273; woodcut from, 273–74; *275*
Canticum canticorum, Netherlandish woodcut from, 270, 271; *269*
Cardinal Albrecht von Brandenburg as Saint Jerome in the Wilderness (Cranach the Elder), 381; *443*
Cardinal Nicolas Albergati (Van Eyck, Jan), 115–16, 223, 248; *111, 112*
Card Players (Lucas van Leyden), 464; pl. 75
Carnival and Lent (Bruegel the Elder), 499; *564*
Carondelet, Jean, 425
Carrying of the Cross (Bosch), 207–8; *199*
Carrying of the Cross (Bruegel the Elder), 507–9; *578*
Carrying of the Cross (Grünewald), 355
Carrying of the Cross (Housebook Master), 289; *301*
Carrying of the Cross (Martini), 18
Carrying of the Cross, from *Englandfahrer Altarpiece* (Master Francke), 85; *82*
Carrying of the Cross, from *Large Passion* series (Dürer), 335, 349; *387*
Carrying of the Cross, from *Round Passion* (Lucas van Leyden), 458; *529*
Carrying of the Cross, from *Small Engraved Passion* (Dürer), 336; *390*
Carrying of the Cross, from *Small Passion* series (Dürer), 335–36; *389*
Carrying of the Cross, from *Très Riches Heures du Duc de Berry* (Limbourg brothers), 61
Carrying of the Cross to Calvary (Schongauer), 283, 289, 441, 458; *290*
Caryatids (Goujon), 521; *592*
Castañeda, Pedro de, 454
Cathedral of Saint Bavo, Ghent, altarpieces for (Van Eyck, Jan and Hubert), 89; (Van Ghent), 166, 297
Cathedral of Saint Peter, Geneva, altarpiece for Chapel of Notre-Dame des Maccabees (Witz), 225
Cathedral of Saint Sauveur, Aix-en-Provence, altarpiece for (Master of the Aix Annunciation), 252
Catherine, duchess of Saxony, 375, 396; *437*
Caxton, William, 273
Celestial Hierarchies (Dionysius the Areopagite), 217
Cellini, Benvenuto, 512
Celtes, Conrad, 370
Cenami, Giovanna, 111, 112, 113; pl. 18
Cerceau, Jacques Du, 515; engraving after Primaticcio, *584*
Ces moeurs et fachons de faire de Turcz (Van Aelst), 429–30; *507*
Châlon, René de, prince of Orange, 474; tomb of (Richier?), 523; *597*
Chapel of the Holy Cross, Karlštejn Castle, near Prague, 26, 28; *Crucifixion* (Master Theodoric), 29; *22;* interior (Master Theodoric), 28–29; *21*
Chapel of the Knights of Saint John, Haarlem, altarpiece for (Geertgen tot Sint Jans), 176, 180
Charles IV, king of Bohemia (Holy Roman Emperor), 18, 23–24, 25, 26, 28, 29, 30, 31, 41, 42, 43; *16*
Charles IV, king of France, 22, 23
Charles IV (Parler and shop), 26; *16*
Charles V, Holy Roman Emperor, 339, 340, 396, 400, 429, 452, 453, 454, 469, 512, 513; *505*
Charles V the Wise, king of France, 16, 22, 41–48, 65, 75, 277; as bibliophile, 43, 46, 64; biography of, 42–43; cultural programs of, 41, 42, 43–45; daily routine of, 42–43; death of, 46, 52; portrait paintings of, 44–45, 46–47; *30, 31, 33;* (Bondol), 47–48; *34;* por-

trait sculpture of, 44; (Liège?), *28;* (Beauneveu), *29;* statesmanship of, 41; tomb of, 44
Charles V (Liège?), 43–44; *28*
Charles V Receiving the Book from Jean Golein, from *L'Information des rois et des princes,* 46–47; *33*
Charles VI, king of France, 16, 48, 49, 52, 60, 75, 239
Charles VII, king of France, 239, 245, 248; portraits of (Fouquet), 246–47, 517; *249*
Charles VIII, king of France, 239, 252, 511
Charles IX, king of France, 518
Charles the Bold, duke of Burgundy, 135, 183, 239
Charonton, Enguerrand, 262; *Coronation of the Virgin,* 262; pl. 47
Chartres Cathedral, sculpture for, 65, 293
Chartreuse de Champmol (Carthusian monastery), Dijon, 64–73, 93; altarpiece for (Broederlam), 70–73; *68;* pl. 12; architecture of, 65; Great Cloister, *Well of Moses* monument in (Sluter and shop), 67; *60, 61;* portal of (Sluter and shop), 65–66, 293; *58, 59;* paintings for, 69, 70, 71–73; *65, 69,* pls. 11, 12; sculpture for, 65–69, 71; *58–64, 68;* tomb of Philip the Bold in (Sluter and shop), 65, 67–69; *62–64*
Château de Bicêtre, near Paris, 42, 53, 61
Château, Mehun, 53, 61
Châtelet, Marquise du, 251
Chelidonius, Benedictus, 334, 335
Cheminart, Guillaume, 313–14
Chevalier, Étienne, 245; portraits of (Fouquet), 245–46, 247–48; *246, 250*
Chevalier délibéré (La Marche), 273; woodcut from, 273; *274*
Chevrot, Jean, 129
Children's Games (Bruegel the Elder), 499; *565*
Christ and Mary (Rhenish sculptor), 25, 79–80; *15*
Christ as Man of Sorrows (Master Francke), 86; *84*
Christ Before Pilate (Koerbecke), 233; *225*
Christ Before Pilate, from the *Maestà* (Duccio), 17–18; *4*
Christ Healing the Blind Man at Jericho (Lucas van Leyden), 464
Christian II, king of Denmark, 340, 395, 425
Christina, duchess of Milan, 395–96; *460*
Christina of Denmark (Holbein the Younger), 395–96; *460*
Christine de Pisan Views the Paintings in the Castle of Fortune (French miniaturist), from *Mutacion de fortune* (Pisan), 50; *38*
Christ in the Garden of Gethsemane (Altdorfer), from *Saint Florian Altarpiece,* 361, 364; *417*
Christ in the Tomb (Holbein the Younger), 386–87; *450*
Christus, Petrus, 117, 143, 150–56, 165, 169, 187; *Annunciation and Nativity,* 155–56; *153;* artistic development of, 150, 154, 165; artistic style of, 153, 154; in Bruges, 150, 151; death of, 150; Dutch traits in the work of, 153–54; eclecticism of, 154, 155; *Lamentation,* 153; *151; Last Judgment,* 155–56; *153; Madonna and Child,* 156; *154; Madonna of the Dry Tree,* 156, 165; *155; Madonna with a Carthusian Monk,* 151, 154–55, 156; *148; Nativity,* 153–54, 171; pl. 27; *Portrait of a Carthusian,* 151, 153; *150; Portrait of a Young Lady,* 165; *156; Portrait of Edward Grymestone,* 151, 153; *149;* portraits by, 151, 153, 165, 408; *149, 150, 156;* realism in the work of, 151, 153; religious practices of, 156, 165; *Saint Eloy in His Studio,* 151–53, 406; pl. 26; secular paintings by, 151–52; *Virgin and Child in a Chamber,* 154; *152*
Church of Breisach, altarpiece for (Master H.L.), 311
Church of Mary Magdalen, Tournai, sculpture in, 295
Church of Notre Dame, Autun, panel painting for (Van Eyck, Jan), 109
Church of Notre-Dame-des-Accoules, Marseilles, altarpiece for (Lieferinxe), 265
Church of Notre Dame hors-les-Murs, Louvain, altarpiece for (Van der Weyden), 124
Church of Ognissanti, Florence, frescoes in

(Ghirlandaio and Botticelli), 116

Church of Our Lady, Bruges, altarpiece for (Memlinc), 185

Church of Our Lady of Ginderbuyten, Louvain, sculptured altarpiece for (Borman the Elder), 295

Church of Saint Anna, Augsburg, sculpture for Fugger chapel in (Daucher?), 311

Church of Saint Catherine, Cologne, altarpiece for (Lochner), 219

Church of Saint Denis, Liège, altarpiece for (Lombard), 431

Church of Saint Donatian, Bruges, 182; painting for (Van Eyck, Jan), 110

Church of Saint Dymphna, Geel, Netherlands, sculptured altarpiece for, 295

Church of Saint Jacob, Rothenburg, sculptured altarpiece for Chapel of the Holy Blood (Riemenschneider), 306

Church of Saint Jacques, Liège, portal sculpture from (Mosan sculptor), 77

Church of Saint John, Gouda, altarpiece for (Jacobsz?), 455

Church of Saint John, Hamburg, altarpiece for (Master Francke), 84

Church of Saint John, Lüneburg, altarpiece for (Funhoff), 233–34

Church of Saint Lawrence, Alkmaar, painting for (Buys the Elder), 446

Church of Saint Lawrence, Nuremberg, sculpture for (Stoss), 310

Church of Saint Martin, Colmar, painting for (Schongauer), 231

Church of Saint Peter, Bar-le-Duc, tomb sculpture in (Richier?), 523

Church of Saint Peter, Hamburg, altarpiece from (Master Bertram), 78–79

Church of Saint Peter, Leiden, sculptured altarpiece for, 297

Church of Saint Peter, Louvain, altarpieces for (Bouts), 146; (Metsys), 403

Church of Saint Sebaldus, Nuremberg, tomb sculpture for (Vischer the Elder), 310

Church of Saint Ursula, Cologne, altarpiece for (Master of the Life of Mary), 227–28

Church of Saint Wolfgang, Austria, altarpiece for (Pacher), 236

Church of San Marco, Florence, frescoes for (Fra Angelico), 218

Church of the Annunciata, Florence, sculpture for (Stoss), 309

Church of the Carmelites, Aix-en-Provence, altarpiece for (Froment), 262

Church of the Celestins, sculpture from? (Liège?), 44

Church of the Eremitani, Padua, fresco for (Mantegna), 431

Church of the Holy Trinity, Hof, altarpiece for (Wolgemut?), 235

Church of the Magdalen, Tiefenbronn, altarpiece for (Moser), 221

Cité des dames, La (Pisan), 50

Clades, title page from (Van Heemskerck), 476; engraving after (Galle), *547*

Clement VI, pope, 18, 23, 41

Cleve, Joos van, 410, 412, 417–18, 425; *Adoration of the Magi,* 417; *486; Deposition,* 417–18; *488; Dormition of the Virgin,* 412; *485; Holy Family,* 417; *487; Rest on the Flight into Egypt* (with Patinir?), 412; *484*

Clouet, François, 518; *Diane of Poitiers at Her Bath,* 518; pl. *85*

Clouet, Jean, 517–18; *Portrait of Admiral Bonnivet,* 517–18; *587; Portrait of Francis I,* 517; *586*

Cnoop, Cornelia, 191; *186*

Cock, Hieronymus, 400, 443, 484, 485, 510; *Forum of Nerva,* 443; *515*

Codde, Anna, 479, 480; *551*

Coeur, Jacques, 239–40, 249; House of, 239; *235, 236, 237*

Collegiate Church, Moulins, altarpiece for (Master of Moulins), 251

Collegiate Church, Neustift, altarpiece for (Pacher), 238

Collegiate Church of Saint Florian, near Linz, altarpiece for (Altdorfer), 361

Colleoni (Verrocchio), 337

Colmar, Germany, 230–31

Cologne, Germany, 74, 77, 79–81, 297, 302; school of painting, 77, 79–81, 85, 218, 222, 227–30

Cologne Cathedral, Germany, 79, 186; sculpture from (Rhenish sculptor), 25, 79–80

Colombe, Jean, 58

Colombe, Michel, 519

Colonna, Vittoria, 88

Colosseum (Gossart), 419; *490*

Columba Adoration of the Magi (Van der Weyden), 131, 133, 134–35, 183, 231; pl. 22

Combat Between the Actor and Age, woodcut from *Chevalier délibéré* (La Marche), 273; *274*

Confraternity of Corpus Domini, 166, 167, 168

Confraternity of Pilgrims to Jerusalem, 470

Confraternity of Saint Anna, 403

Confraternity of the Holy Ghost, 446, 447

Confraternity of the Rosary, 79, 178, 184, 331

Constance, Hans von, 223

Convent of Marienpoel, Oestgeest, altarpiece for (Engelbrechtsz), 456

Conversion of Paul (Raphael), 429

Coornhert, Dirk Volkert, 481, 487

Copper Mine, The (Met de Bles), 442; *511*

Cordier, Madeleine, 192; pl. *33*

Cornelisz, Willem, 467, 475

Cornelisz van Oostsanen, Jacob, *see* Oostsanen, Jacob Cornelisz van

Coronado, Francisco Vásquez de, 454

Coronation (Lochner), 219

Coronation of Mary, from *Brussels Hours* (Hesdin and shop?), 56

Coronation of Mary, from *Life of the Virgin* series (Dürer), 334; *385*

Coronation of the Virgin (Baldung Grien), 365; *423*

Coronation of the Virgin (Charonton), 262; pl. *47*

Coronation of the Virgin (Mosan sculptor), 77; *74*

Coronation of the Virgin, from *Breisacher Altarpiece* (Master H.L.), 311; *340*

Coronation of the Virgin, from *Norfolk Triptych* (Mosan master of c. 1415), 76; *73*

Coronation of the Virgin, from *Saint Wolfgang Altarpiece* (Pacher), 236

Cortes, Hernando, 340, 454

Costa, Lorenzo, 383

Coster, Laurens Janszoon, 141, 269, 271, 272

Coulster, Abel van den, 452–53; *523*

Council of Basel, 223, 225

Council of Constance, 221

Council of Trent, 82

Couronne Margaritique (Lemaire), 240

Course in the Art of Measurement with Compass and Ruler, A (Dürer), 333; woodcut from, *381*

Cousin, Jean, the Elder, 516–17; *Eva Prima Pandora,* 516–17; pl. *85*

Craig, Kenneth, 445

Cranach, Anna, 376

Cranach, Lucas, the Elder, 339, 363, 370–76, 381–84; *Allegory of the Law and the Gospel,* 382–83; *444; Anna Cuspinian,* 370–71, 372, 375, 386, 388; *429;* artistic technique of, 373; birth of, 370; *Cardinal Albrecht von Brandenburg as Saint Jerome in the Wilderness,* 381; *443;* as court painter, 373; *Crucifixion,* 372; *432;* death of, 384; *Dr. Johannes Cuspinian,* 370, 371, 372, 375, 386, 388; pl. 59; *Duchess Catherine of Saxony,* 375, 396; *437; Duke Henry the Pious of Saxony,* 375; *436; Fountain of Youth,* 384; *446;* friendship with Luther, 370, 373, 375–76; as graphic artist, 367, 370, 373, 376; *Holy Kinship Altarpiece,* 373, 375; *435;* influence of, 358, 383; *Judgment of Paris,* 383–84; pl. 60; landscape in the work of, 370, 371; Mannerist tendencies of, 375; *Martin Luther as Junker Jörg,* 376, 381; *442; Martin Luther Wearing a Doctor's Cap,* 376; *441;* mythological themes of, 373, 383–84; portraits by, 370–72, 373, 375, 376, 381, 383; *429, 435–43;* pl. 59; Reformation paintings of, 382; religious beliefs of, 373, 375; *Rest on the Flight into Egypt,* 365, 372; *433; Saint Francis Receiving the Stigmata,* 372; *431; Saint Jerome as a Hermit,* 372; *430; Saxon Prince,* 375; *439; Saxon Princess,* 375; *440; Sibylle of Cleve,* 375; *438; Venus and Cupid* (1509), 373, 383, *434; Venus and Cupid* (1532), 383; *445;* in Vienna, 370; in Wittenberg, 372, 376

Cranach, Lucas, the Younger, 384

Creation of Eve, from *Saint Peter Altarpiece* (Master Bertram), 78; *75*

Crécy, battle of, 41

Cromwell, Thomas, 396, 398

Cronycke van Hollandt, Netherlandish chronicle, 273

Crucifixion (Beaumetz and shop), 69; *65*

Crucifixion (Cranach the Elder), 372; *432*

Crucifixion (David, c. 1480), 187; *180*

Crucifixion (David, c. 1480–85), 187–88; *181*

Crucifixion (David, c. 1515–20), 193; *190*

Crucifixion (Engelbrechtsz), 456; *526*

Crucifixion (Grünewald), 355; *408*

Crucifixion (Grünewald), from *Isenheim Altarpiece,* 348, 349–50, 352, 354, 355; pl. 53; *405*

Crucifixion (Lucas van Leyden), 460–61; *532*

Crucifixion (Marmion), 242; *241*

Crucifixion (Marmion), from *Pontifical of Sens,* 241–42; *240*

Crucifixion (Martini), 18

Crucifixion (Master of Frankfort), 401; *466*

Crucifixion (Master of Saint Veronica), 80, 82

Crucifixion (Master of the Holy Kinship), 229; *220*

Crucifixion (Metsys), 405; *472*

Crucifixion (Mosan painter), 73; *70*

Crucifixion (Pleydenwurff), 234–35, 448; *229*

Crucifixion (Schongauer), 283; *283*

Crucifixion (Van der Weyden), 135–36; *132*

Crucifixion (Van Eyck, Jan), 118; *115*

Crucifixion (Van Oostsanen), 448–49; pl. 73

Crucifixion, from *Altarpiece of Saint Lawrence* (Van Heemskerck), 479; *550*

Crucifixion, from *Altarpiece of the Crucifixion* (Van Ghent), 166; *158*

Crucifixion, from *Altarpiece of the Deposition* (Bouts), 144, 145; *140*

Crucifixion, from Anglo-Saxon Psalter (Harley 2904), 135

Crucifixion, from Chapel of the Holy Cross (Master Theodoric), 29; *22*

Crucifixion, from *Englandfahrer Altarpiece* (Master Francke), 86

Crucifixion, from *Hours of Jeanne d'Évreux* (Pucelle), 21

Crucifixion, from *Le Bois Protat* (French?), 267; woodcut from, *261*

Crucifixion, from *Niederwildungen Altarpiece* (Von Soest), 82–83, 86; *81*

Crucifixion, from *Parement de Narbonne* (French painter), 44–46; *31*

Crucifixion, from *Retable de Champmol* relief (De Baerze), 71; *68*

Crucifixion, from "Small Bargello Diptych" (French painter), 46; *32*

Crucifixion Altarpiece (Van der Weyden), 135; *130*

Crucifixion Diptych (Van der Weyden), 135; *131*

Crucifixion in the Darkness of the Eclipse, from *Très Riches Heures du Duc de Berry* (Limbourg brothers), 60–61; *54*

Crucifixus (Gerhaerts van Leyden), 301; *321*

Cure of Folly (Bosch), 196; *192*

Cuspinian, Anna, 370–71, 372, 375, 386, 388; *429*

Cuspinian, Johannes, 370, 371, 372, 375, 386, 388; pl. 59

Cyriacus of Ancona, 89

Czech Miraculous Madonnas, 28, 30; *19*

Dammartin, Drouet de, 65

Danaë (Gossart), 424; pl. *66*

Dance at the Court of Herod (Van Meckenem), 290–91; *306*

Dance of Death (Holbein the Younger), 386, 523

Dance of Death (Witz), 223

Dance of Mary Magdalen (Lucas van Leyden), 463; *536*

Danse macabre, illustrated book, 276

Dante, 352

Danube Landscape (Altdorfer), 357, 358; pl. 56

Danube school of landscape painting, 357, 363–64, 365, 370, 372, 385
Daret, Jacques, 120
Daucher, Adolf, 311; *Altarpiece of the Fugger Chapel,* 311; *339*
David, Gerard, 186–93, 410, 421, 422; *Altarpiece of the Baptism of Christ,* 192; pl. 33; artistic development of, 187–88, 189, 191; in Bruges, 148, 182, 186, 187, 188; *Crucifixion* (c. 1480), 187; *180; Crucifixion* (c. 1480–85), 187–88; *181; Crucifixion* (c. 1515–20), 193; *190;* death of, 187; Dutch style of, 188; eclecticism in the work of, 187, 189; Italian Renaissance style of, 186, 190–91, 193; *Judgment of Cambyses,* 189–91; *184, 185;* landscape in the work of, 189, 191–92; *Landscapes,* 191–92; *188; Nativity* (c. 1480–85), 188, 191; *182; Nativity* (c. 1483–85), 188; *183; Nativity* (c. 1515–20), 191; *187;* portraits by, 148, 190, 191, 192; *184, 186;* pl. 33; *Rest on the Flight,* 192; *189;* self-portraits by, 187, 190, 191; *180, 184, 186; Virgo inter Virgines,* 187, 191; *186;* workshop of, 189, 191
David Playing the Harp Before Saul (Lucas van Leyden), 458; *528*
De anima (Melanchthon), 318
Death and the Maiden (Baldung Grien, 1509–11), 365–66; *425*
Death and the Maiden (Baldung Grien, 1517), 366; pl. 58
Death of Cleopatra (Van Scorel), 469; pl. 77
Death of John the Baptist (Funhoff), 234; *228*
Death of Saint Sebastian (Lieferinxe?), 265; *260*
Death of the Miser (Bosch), 205; pl. 36; drawing after, 205; *194*
Death of the Virgin (Stoss), 308–9; *334, 335*
December, from *Belleville Breviary* (Pucelle), 22; *12*
Deësis (Gossart), 420
Deguilleville, Guillaume de, 205
De Historie van Belgis (Van Vaernewyck), 89
De Leeuw, Jan, 114; *109*
Delemer, Jehan, 296
Delft, Jan Lucas van, 475
De mulieribus claris (Boccaccio), 50; illustrations from (Master of 1402), 49, 64
Denis the Carthusian, 125, 151
De occulta philosophia (Agrippa of Nettesheim), 318
De Pintura Antigua (Hollanda), 88
Deposition (Angelico), 124–25
Deposition (copy after Van der Weyden), 297; fragment of, *312*
Deposition (Martini), 18; *6*
Deposition (Master of the Banderoles), 280; *284*
Deposition (Master of the Saint Bartholomew Altarpiece), 230; *222*
Deposition (Van Cleve?), 417–18; *488*
Deposition (Van der Weyden), 124, 129, 135, 144, 145, 230, 249, 280, 350, 405, 418, 508; pl. 20
Deposition, from *Altarpiece of the Deposition* (Bouts), 144–45; *140*
Deposition, from *Book of Hours of Catherine of Cleves* (Master of the Hours of Catherine of Cleves), 141; *138*
De proprietatibus rerum (Bartholomaeus Anglicus), 272; woodcuts from (Master of Bellaert), 272, 285; *272, 273*
Deschamps, Eustache, 16
Des cleres et nobles femmes (Boccaccio), 49; illustration from (French miniaturist), 49; *37*
Descrittione di tutti i Paesi Bassi (Guicciardini), 143
Destruction of the Children of Job, from *Altarpiece of the Ordeals of Job* (Van Orley), 427, 428–29; *502*
Deutsch, Nikolaus Manuel, 365
De viris illustribus (Facio), 89, 100, 125, 130
De vita triplici (Ficino), 318
Devotio moderna, 74
De Werve, Claus, 68, 294
Dialogus creaturarum, illustrated book, 272
Diane of Poitiers at Her Bath (Clouet, François), 518; *588*
Diet of Worms, 376
Dinteville, Jean de, 392–93; pl. 62

Dionysius the Areopagite, 217
Disputà (Raphael), 429
Dixon, Laurinda, 213
Dr. Johannes Cuspinian (Cranach the Elder), 370, 371, 372, 375, 386, 388; pl. 59
Dombild, Das/Adoration of the Magi Triptych (Lochner), 218–19; *210*
Donatello, 97, 337
Doppere, Rombout de, 182
Dormition of the Virgin (Van Cleve), 412; *485*
Dormition of the Virgin (Van der Goes), 175; *165*
Dorothea Kannengiesser (Holbein the Younger), 386; *449*
Dream of Saint Ursula (Master of Saint Ursula), 229; *221*
Dresden Altarpiece (Dürer), 329; *375*
Duccio di Buoninsegna, 17–18, 21, 27, 46, 70; *Annunciation of the Death of the Virgin,* 21; *11; Christ Before Pilate,* 17–18; *4*
Duchess Catherine of Saxony (Cranach the Elder), 375, 396; *437*
Dufay, Guillaume, 99
Duke Henry the Pious of Saxony (Cranach the Elder), 375; *436*
Dulle Griet (Bruegel the Elder), 485
Dupré, Jean, 276
Durandus, Gulielmus, 121, 166
Dürer, Agnes Frey, 321, 340; *357*
Dürer, Albrecht, 89, 282, 285, 289, 316–40, 345–47, 352, 363, 453; *Adam,* 332–33; *380; Adam and Eve,* 316–18, 329, 332, 337, 366, 424; *348; Adoration of the Magi,* 329, 335; *376; Agnes Dürer,* 321; *357;* alchemy, interest in, 365; *Allegory of Maximilian I,* 339; copy after, *394; Apocalypse* series, 76, 323–25, 334, 335, 458, 519; *362–64, 366, 384;* apprenticeship of, 319, 320; artistic frustrations and conflicts of, 181, 318, 319, 339; artistic philosophy of, 318–19, 321, 326, 339, 340; artistic technique of, 319–20, 321, 323, 324, 327, 329, 338; *Babylonian Whore, The,* 325; *366;* in Basel, 321; *Bather,* 322, 331–32; *379; Battle of the Sea Gods,* 321–22; *359;* birth of, 234, 319; as businessman, 323, 334, 335, 340; *Carrying of the Cross,* from *Large Passion* series, 335, 349; *387; Carrying of the Cross,* from *Small Engraved Passion,* 336; *390; Carrying of the Cross,* from *Small Passion* series, 335–36; *389;* classical influence on, 316, 321, 322, 329, 335; *Coronation of Mary,* 334; *385;* as court artist, 339–40; death of, 333; diary entries of, 218, 336, 345, 399, 400; drawings by, 320, 321, 322, 326, 331–32, 333, 339, 340, 356; *353, 355, 357, 359, 360, 379, 383, 396, 399;* pl. 52; dualism in the personality and work of, 316, 318, 340; early training of, 234, 235, 275; engravings by, 276, 292, 316–19, 323, 326–29, 334, 336–39, 457; *348, 349, 368–73, 390–92; Erasmus of Rotterdam,* 345; *400; Eve,* 332–33; *380; Feast of the Rose Garlands,* 329, 331; *377; Four Apostles, The,* 346–47; *402; Four Horsemen,* 324–25; *363; Frederick the Wise, Elector of Saxony,* 329; *374; Great Piece of Turf,* 340; pl. 52; vs. Grünewald, 354, 356; *Harbor of Antwerp,* 340, 345; *399; Heller Altarpiece,* 333–34, 354 (copy after by Harrich, *382;* study for, *383*); *Hercules Killing the Stymphalian Birds,* 339; *396; Holy Family,* 321, 327; *355; Holy Family with the Butterfly,* 327; *370;* as humanist, 316, 318, 325, 345; influence of: on Altdorfer, 358; on Baldung Grien, 365, 366; on Burgkmair, 385; on Cranach the Elder, 372, 373; on Duvet, 519; on Gossart, 424; on Lucas van Leyden, 457, 458, 462; on Van Scorel, 467, 468; Italian influence on, 316, 318, 321, 329, 331, 332–33, 334, 469; in Italy, 316, 321, 322, 329, 331, 333, 334; *John's Vision of the Seven Candlesticks,* 324, 519; *362; Knight, Death, and the Devil,* 336–37, 339, 357; *391;* landscapes by, 322, 340, 345, 357; pl. 51; *Large Passion* series, 334, 335, 349; *387; Last Supper,* 346; *401; Life of the Virgin* series, 276, 334–35; *385, 386;* macabre in the work of, 326–27, 331; *Madonna and Child,* 329; *375;* Mannerist tendencies of, 332–33; *Man of Sorrows,* 335; *388;* marriage of, 321, 340,

391; melancholy of, 172, 318, 321; *Melencolia I,* 181, 316, 318–19, 339, 365; *349; Monstrous Pig of Landser,* 326–27; *369;* as mystic, 316, 323–24; *Nude,* 322; *360;* in Nuremberg, 319, 322, 323, 332, 365; patrons of, 329, 333, 334, 339, 340; portraits by, 329, 340; *374; Praying Hands,* 333; *383; Prodigal Son,* 328, 468; *372; Rabbit,* 340; *398;* religious beliefs of, 316, 324, 326, 336, 345, 346, 347, 361, 376; *Saint Jerome in His Study* (1492), 321, 337–38; *356; Saint Jerome in His Study* (1514), 337–39, 381, 442; *392; Saint John Before the Apocalyptic Woman,* 334; *384; Saint John Devouring the Book,* 323; *364;* scientific theories of, 316, 333; *Self-Portrait* (1484), 319–20; *352; Self-Portrait* (1498), 322–23; *361; Self-Portrait* (1500), 325–26; *367;* self-portraits by, 319–20, 321, 322–23, 325–26, 331; *352, 361, 367, 377;* pl. 50; *Self-Portrait with a Spray of Eryngium,* 321, 322–23; pl. 50; silverpoint drawings by, 319–20, 340; *352, 397; Silverpoint Sketchbook,* 340; *397; Small Engraved Passion,* 336; *390; Small Passion* series, 334, 335–36; *388, 389;* social and artistic status of, 323, 325, 329, 334, 340, 347; *Sojourn of Mary and Joseph in Egypt, The,* 276, 334–35; *386; Sol Iustitiae,* 326; *368;* in Strasbourg, 321; symbolism in the work of, 282, 317–18, 325, 328, 337, 346; travels of, 316, 319, 321, 340, 345, 388, 399–400; *Triumphal Arch of Maximilian I,* 339; *393; Triumphal Chariot of Maximilian I,* 339, 363; *395; Ulysses and Circe,* 320; *354; View of the Alps,* 322; pl. 51; *Virgin and Child with the Monkey,* 327–28; *371; Vision of Saint Eustace,* 328–29, 337; *373;* watercolors by, 320, 322, 340, 357; *353, 398;* pl. 51; *Wire-Drawing Mill,* 320; *353;* woodcuts by, 320–21, 323–25, 327, 333, 334–36, 339, 346; *354, 356, 362–64, 366, 381, 384–89, 393, 395, 401;* as writer, 316, 333; *Young Christ Among the Doctors,* 331; *378*
Duverger, Joseph, 151
Duvet, Jean, 519; *Apocalypse* series, 519; *589*
Dvořák, Max, 487

Early History of Man and the Baptism of Christ (Master of Bellaert), from *Der Sonderen Troest* (Jacobus di Theramo), 272; *271*
Earth and Its Division, The (Master of Bellaert), from *De proprietatibus rerum* (Bartholomaeus Anglicus), 272; *272*
Ecce Homo (Hay), 242
Ecce Homo (Lucas van Leyden), 458, 460; *531*
Ecce Homo (Metsys), 405
Eckhardt, Johannes (Master Eckhardt), 74, 79, 220
Eck of Mondsee, Benedict, 236
Edelheer Altarpiece (Van der Weyden), 124; pl. 20
Edward III, king of England, 42
Edward IV, king of England, 273
Edward VI, prince of England, 395, 397, 483; *462*
Edward VI at Two Years (Holbein the Younger), 397; *462*
Effigies (Lampsonius), 100
Egmond, Jan van, 467
Eleanor of Austria, 425
Elephant (Schongauer), 285; *293*
Elisabeth of Pomerania, 26
Elizabeth (wife of John of Luxembourg), 23
Elizabeth of York, 393–94
Elsheimer, Adam, 466
Enchiridion miliris Christiani (Erasmus), 336
Engelbert I of Nassau, 194
Engelbrechtsz, Cornelis, 455, 456; *Crucifixion,* 456; *526*
Englandfahrer Altarpiece (Master Francke), 84–86; *82, 83;* pl. 14
Entombment (Martini), 18
Entombment (Master of the Virgo inter Virgines), 451; *521*
Entombment (Schongauer), 284
Entombment, from *Hours of Jeanne d'Évreux* (Pucelle), 21
Entombment, from *Retable de Champmol* relief (De Baerze), 71; *68*

Entombment group (French), 313–14, 519; *345, 346*

Entombment group (Michel and Sonnette), 313; *344*

Entombment Triptych (Campin), 122; *117*

Entry of Christ into Jerusalem (Van Scorel), 469–70; pl. 78

Epistelen en Evangelien, 271

Erasmus of Rotterdam, 336, 340, 345, 376, 381, 387, 388, 389, 407, 408, 500; portraits of (Dürer), 345; *400*; (Holbein the Younger), 345, 388; *452*; (Metsys), 408

Erasmus of Rotterdam (Dürer), 345; *400*

Erhart, Gregor, 303, 311; *Madonna*, 303; *326*

Erhart, Michel, 303, 304, 305, 307; *Madonna*, 303; *326; Virgin of Mercy*, 303, 390; pl. 49

Este, Francesco d', 137–38, 139; *133*

Este, Lionello d', 137, 138

Etampes, Robinet d', 53

Étienne Chevalier, from *Melun Diptych* (Fouquet), 246, 247–48; *250*

Étienne Chevalier and Saint Stephen, from *Hours of Étienne Chevalier* (Fouquet), 245–46, 247, 248; *246*

Eugenius IV, pope, 244

Eurydice and Aristaeus (Abbate), 516; *585*

Eva Prima Pandora (Cousin the Elder), 516–17; pl. 85

Eve (Dürer), 332–33; *380*

Eve (Riemenschneider), 305

Eve, from *Altarpiece of the Lamb* (Van Eyck, Jan and Hubert), 89, 91, 93, 94; *88*; pl. 16

Eve, the Serpent, and Death (Baldung Grien), 367; *426*

Exercitium super Pater Noster, 268; woodcut from, *266*

Expulsion (Michelangelo), 465

Expulsion, from *Très Riches Heures du Duc de Berry* (Limbourg brothers), 58, 59; *50*

Eyck, Hubert van, 89, 90, 93, 95, 96, 100, 141, 283; *Altarpiece of the Lamb*, 89–96, 97, 109, 120, 123, 131, 153, 165, 173, 262, 296, 305, 340, 420, 467; *85–89*; pls. 15, 16; *Three Marys at the Tomb*, 90; copy after, *90*

Eyck, Jan van, 58, 73, 88–118, 140, 141, 182, 218, 278, 503; *Altarpiece of the Lamb*, 89–96, 97, 109, 120, 123, 131, 153, 165, 173, 262, 296, 305, 340, 420, 467; *85–89*; pls. 15, 16; *Annunciation*, 103–4, 109, 225; *103; Arnolfini Wedding Portrait*, 96, 102, 109, 111–13, 114, 121, 123, 152, 153, 375, 392, 400, 406; *106*; pl. 18; artistic development of, 102, 109, 114, 118, 122; artistic style of, 97, 119, 124, 127, 134, 170, 402; birth of, 96; vs. Bouts, 147, 148; in Bruges, 97, 119, 139, 151; *Cardinal Nicolas Albergati*, 115–16, 223, 248; *111, 112*; as court painter, 90, 95, 96–97, 114, 119; *Crucifixion*, 118; *115*; death of, 97, 117, 150, 166; drawings by, 99, 115–16; *96, 97, 112*; early training of, 96; fame and reputation of, 89, 96–97, 125, 127; at the Hague, 140, 141; *Ince Hall Madonna*, 102, 116; *100*; influence of, 119, 140, 141; on Bouts, 144; on Christus, 150, 153, 156; on David, 187, 188, 189; on Gossart, 420, 421, 422; on Memlinc, 182, 183; on Metsys, 403; on Mostaert, 452; on Ouwater, 142; on Schongauer, 283; on Van Cleve, 417; on Van der Goes, 166, 169, 170, 171, 173, 174; on Van der Weyden, 126, 131, 133; landscape in the work of, 99, 109, 147, 148, 236; *Last Judgment*, 118, 156; *115; Lucca Madonna*, 102, 417; *101; Madonna and Child with Saints and a Carthusian Monk*, 117, 150, 151, 155; *114; Madonna and Child with Saints Michael and Catherine*, 101–2, 421; *98, 99; Madonna by the Fountain*, 102; *102; Madonna in the Church*, 100–101, 102, 129, 420, 421; pl. 17; *Madonna with Canon George van der Paele*, 102, 109, 110–11, 112; *105; Madonna with Chancellor Nicolas Rolin*, 96, 109–10, 112, 113, 127, 194, 250, 392, 422; *104; Man in a Red Turban*, 109, 113–14; *107*; marriage of, 97, 114; as metalwork designer, 297; miniatures by, 96; painting technique of, 89, 97, 100, 115–16; *Portrait of Baudouin de Lannoy*, 114; *108; Portrait of Jan de Leeuw*, 114; *109; Portrait of Margaretha van Eyck*, 114–15; *110;*

Portrait of Tymotheos, 97, 99, 113–14; *95*; portraits by, 95, 97, 99, 111–16, 137–38, 146, 223, 248, 408, 482; *95, 105–12*; pl. 18; in Portugal and Spain, 90, 95–96, 114; realism in the work of, 89, 100, 103, 109, 111, 113, 118, 139, 386, 392; *Saint Barbara*, 99, 102; *96, 97; Saint Francis Receiving the Stigmata*, 118; *116; Saint Jerome in His Study*, 116–17, 150; *113*; sculptural painting (polychroming) by, 296; self-portraits by, 109, 110, 112, 113; *86, 104–7*; pl. 18; subject matter of, 97, 101, 103, 113; symbolism in the work of, 92, 93, 97, 99, 100, 102, 103–4, 109–11, 112–13, 118, 121, 227, 392, 421; theological studies of, 91, 100, 104, 110, 111, 113; vs. Van der Weyden, 118, 119, 125, 126, 127, 137–38, 139

Eyck, Margaretha van, 114–15; *110*

Fabri, Felix, 274

Fabriano, Gentile da, 130, 131, 134

Facio, Bartolommeo, 89, 100, 116, 125, 130, 134

Fall of Adam and Eve (Gossart), 424–25; *497*

Fall of Icarus (Bruegel the Elder), 509–10; replica of ?, *579*

Fall of Man (Van der Goes), 174–75; *163*

Fall of Man, from *Très Riches Heures du Duc de Berry* (Limbourg brothers), 58–59, 383; *50*

Fall of Man and the Expulsion (Wolgemut?), woodcut from *Weltchronik*, 275–76; *278*

Fall of the Damned (Bosch), 217; *208*

Fall of the Rebel Angels (Bruegel the Elder), 485; *558*

Family of Love, 510

Family of Thomas More (Holbein the Younger), 389; *453*

Family Portrait (Van Heemskerck), 480–81; *553*

Fantastic Alphabet (Master E.S.), 279; *282*

Farewell at the Tomb (Van der Weyden), 130–31; *126*

Farewell of the Apostles (Bamberg Master), 143, 235–36; *230*

Faustus, Johann, 319, 365

Feast of Herod, from *Lamentation Altarpiece* (Metsys), 405; pl. 63

Feast of the Rose Garlands (Dürer), 329, 331; *377*

February, from *Petites Heures du Duc de Berry* (Hesdin and shop), 53–54; *43*

February, from *Très Riches Heures du Duc de Berry* (Limbourg brothers), 62; *55*

Federigo da Montefeltro, 165–66, 167, 168; *159*

Feeding the Hungry, from *Seven Acts of Mercy* (Master of Alkmaar), 446; pl. 72

Fernando Alvarez de Toledo (Mor), 482–83; *556*

Festival of the Archers (Master of Frankfort), 401; *467*

Ficino, Marsilio, 318

Filarete, Antonio, 89, 244

Fillastre, Guillaume, 240, 241; *238*

Final Appearance, from *Miraflores Altarpiece* (Van der Weyden), 128; *122*

Finding of the True Cross (Van Scorel), 474; *545*

First Family (Mostaert), 453–54; *524*

Fishing Party at the Court of Willem VI (early Dutch artist), 141, 278; drawing after, *137*

Fishing Scene (Italian painter), 18, 20; *8*

Flight into Egypt (Patinir), 410; *481*

Flight into Egypt, from *Brussels Hours* (Hesdin and shop), 56; *46*

Floris, Frans, 431–32; *Last Judgment*, 431–32, 485; *509*

Flötner, Peter, 311

Fontainebleau, Château of, 511, 512–15, 516, 523; architecture of, 512; Chambre de la Duchesse d'Etampes, stucco wall decoration for (Primaticcio), 514–15; *583*; Galerie d'Ulysse, paintings for (Abbate), 516; (Primaticcio?), 515; pl. 84 (copy after by Cerceau, *584*); Galerie François Ier, 512, 513; interior design and stucco decoration for (Rosso Fiorentino), 513–14; *581, 582*; Italian art at, 512–15, 518; preparatory drawings and engravings of interior, 512, 515

Fontaine des Innocents, Paris, relief sculpture for (Goujon), 520

Forum of Nerva (Cock), 443; *515*

Forum of Nerva (Van Heemskerck), 443, 477; *548*

Fountain of Life (Spanish follower of the Van Eycks), 94–95; *93*

Fountain of Youth (Cranach the Elder), 384; *446*

Fouquet, Jean, 244–49, 250, 312; *Hours of Étienne Chevalier*, 245–46, 247, 248; *246–48; Melun Diptych*, 246, 247–48; *250*; pl. 43; *Nouans Pietà*, 249; *253; Portrait of Charles VII*, 246–47, 517; *249; Portrait of Guillaume Jouvenel des Ursins*, 248; *251, 252; Self-Portrait*, 244; *245; Taking of Jerusalem*, 244–45; pl. 42

Four Apostles, The (Dürer), 346–47; *402*

Four Horsemen (Nuremberg woodcutter), from Quentell-Grüninger Bible, 324; *365*

Four Horsemen, from *Apocalypse* series (Dürer), 324–25; *363*

Four Nymphs (Primaticcio), 514–15; *583*

Fourteen Helpers in Time of Need (Cranach the Elder), 373

Fraenger, Wilhelm, 213, 215

Francis I, king of France, 217, 396, 398, 511, 512, 513, 514, 517; *586*

Franck, Sebastian, 487

Franckert, Hans, 485, 487

Frangipani, Christophoro, 467, 468; *539*

Frederick the Wise, Elector of Saxony, 329, 372, 373, 376, 383; portraits of (Cranach the Elder), 373; *435*; (Dürer), 329; *374*

Frederick the Wise, Elector of Saxony (Dürer), 329; *374*

Fredi, Bartolo di, 73

Freiburg Cathedral, altarpiece for (Holbein the Younger), 386

French Ambassadors, The (Holbein the Younger), 392–93; pl. 62

Friedländer, Max J., 119, 146, 150, 178, 182, 427, 479

Froben, Johann, 387, 388

Froment, Nicolas, 262–64; *Raising of Lazarus*, 262; *258; Virgin in the Burning Bush*, 262–64; *259*

Fugger chapel, altarpiece for (Daucher?), 311

Fugger family, 303, 331, 399

Funhoff, Heinrich, 233–34; *Death of John the Baptist*, 234; *228*

Fust, Johann, 271

Gaddi, Taddeo, 61, 431

Galle, Philip, 476, 481; engraving after Van Heemskerck, *547*

Game of Chesse, 15th-century book, 273

Garden of Earthly Delights (Bosch), 195, 212–17, 466; pl. 35; details of, *206, 207*; exterior panels of, 213; *205*

Garden of Paradise (Rhenish Master of the Paradise Garden), 81–82; pl. 13

Gargantua and Pantagruel (Rabelais), 500

Gathering of Manna, from *Last Supper Altarpiece* (Bouts), 147–48, 235; *144*

Gattamelata (Donatello), 337

Geertgen tot Sint Jans, 141, 176–81, 249, 402, 479; abstraction in the work of, 178; artistic style of, 446; *Burning of the Bones of Saint John the Baptist*, 181, 449, 471; *171; Holy Kinship*, 179–80, 233, 297, 404, 468; *170*; importance of the work of, 451; influence of, 187, 188, 194, 229, 234, 236, 321, 449, 451, 452, 458; *Lamentation*, 176–77, 180, 297, 449, 473; pl. 29; *Madonna of the Rosary*, 178–79, 251, 331, 351; pl. 30; *Man of Sorrows*, 177–78; *167*; mysticism in the work of, 176, 177, 178–79, 182; *Night Nativity*, 84, 178, 359; *168; Saint John the Baptist in the Wilderness*, 181, 318; *172*; self-portrait by, 181; *171*; stylistic devices of, 177–78; symbolism in the work of, 179, 181, 404; *Tree of Jesse*, 179; *169*

Georg Gisze of Danzig (Holbein the Younger), 391–92; *456*

Gerhaerts van Leyden, Nicolaus, 279, 280, 298, 301, 302, 305; *Bust of a Man*, 301; *322; Crucifixus*, 301; *321; Madonna of Dangolsheim*, 301; *323; Monument of Canon Conrad von Busnang*, 301; *320*

Gérines, Jacques de, 297; *Tomb of Isabella of*

Bourbon, 297; *313*
Ghent, Belgium, 165, 166, 193
Ghent, Joos van, 165–68, 193; *Adoration of the Magi*, 166, 168; *157*; *Altarpiece of the Communion of the Apostles*, 166, 167–68; *159*; *Altarpiece of the Crucifixion*, 166–67, 168, 193; *158*; *Plato*, 168; *160*
Ghent Altarpiece (Van Eyck, Jan and Hubert), see *Altarpiece of the Lamb*
Ghirlandaio, Domenico del, 116, 134
Giorgione, 469
Giotto di Bondone, 20, 27, 431
Giovanetti, Matteo, 18; *Prophets Ezekiel, Jeremiah, Isaiah, and Moses*, 18; *7*
Gisant Portrait of Charles V (Beauneveu), 44; *29*
Gisze, Georg, 391–92; *456*
Gloomy Day (Bruegel the Elder), 506; *574*
Godfrey of Viterbo, 148
God the Father, from *Altarpiece of the Lamb* (Van Eyck, Jan and Hubert), 89, 91, 93, 109; *86*; pl. 16
Goes, Hugo van der, 125, 166, 169–76, 178, 189; *Adoration of the Magi/Monforte Altarpiece*, 173–74, 176, 243; *162*; artistic style of, 170–71, 172, 174, 175, 176; as court painter, 169; *Dormition of the Virgin*, 175; *165*; expressionist tendencies in the work of, 174, 175, 176; *Fall of Man*, 174–75; *163*; influence of: on David, 191; on Geertgen tot Sint Jans, 176; on Gossart, 421; on Master of Frankfort, 401; on Master of Mary of Burgundy, 193; on Master of Moulins, 250, 251–52; on Master of Saint Giles, 242, 243; on Master of Saint Ursula, 229; on Memlinc, 182; on Metsys, 404; on Schongauer, 281; *Lamentation*, 174–75; *164*; melancholic temperament of, 172–73, 175, 451; mysticism in the work of, 172, 175–76, 182; *Nativity*, 175, 250; *166*; *Portinari Altarpiece*, 169–72, 173, 174, 175, 186, 250, 251–52; *161*; pl. 28; realism in the work of, 169, 171; as sponsor, 193; as student, 165, 166; symbolism in the work of, 169, 171, 172, 174–75
Goethe, Johann Wolfgang von, 80, 218
Gogh, Vincent van, 169
Golden Age, Hercules with Omphale (Cranach the Elder), 384
Golden Compass, Antwerp, publishing house, 400
Goldenes Rössel/Golden Pony (Parisian goldsmith), 16–17; *3*
Golein, Jean, 47
Goltzius, Hubrecht, 431
Gonçalvez, Nuño, 261
Góngora, Luis de, 211
Gossart, Jan, 419–26, 427, 465, 467, 468; *Adoration of the Magi*, 421–22; *493*; *Antonio Siciliano and Saint Anthony*, 421; *491*; archaism in the work of, 420, 421; artistic technique of, 420–21, 425; birth of, 419; *Colosseum*, 419; *490*; *Danaë*, 424; pl. 66; drawings by, 419, 425; *489, 490, 497*; *Fall of Adam and Eve*, 424–25; *497*; Italian influence on, 419, 420, 422, 425; in Italy, 419, 420; *Madonna and Child*, 425; *498*; *Madonna in the Church*, 420, 421; *491*; *Malvagna Triptych*, 421; *492*; Mannerist tendencies of, 419, 422, 423, 425; *Mystical Marriage of Saint Catherine*, 419; *489*; *Neptune and Amphitrite*, 423–24; *496*; *Portrait of a Merchant*, 425, 426; *499*; *Portrait of "Baudouin of Burgundy,"* 425, 426; *500*; *Portrait of Jacqueline of Burgundy?*, 425, 426; pl. 67; portraits by, 425–26; *499, 500*; pl. 67; as Romanist, 419, 423–25; Roman sketchbook of, 419, 422, 424; *Saint Luke Drawing the Virgin* (c. 1512–15), 422, 479; *494*; *Saint Luke Drawing the Virgin* (c. 1520), 423, 475, 476; *495*; symbolism in the work of, 422–23
Gothardt, Mathis (called Nithardt), see Grünewald, Matthias
Gothic and Late Gothic style, 15, 45, 77–78; architecture of, 15, 23–25, 65, 79, 93, 99; characteristics of, 44, 124, 125, 130, 133, 135; flowering of, in France, 41, 42; religious philosophy, mysticism, and, 15–16, 86, 101, 125, 128; waning of, 285, 303, 308, 313; see also International Style
Goujon, Jean, 520–21; *Caryatids*, 521; *592*;

Nymphs, 520; *591*
Graf, Urs, 365
Grandes Chroniques de France, Les, illustration from (Parisian miniaturist), 43; *26*
Grandes Heures du Duc de Berry, Les (Hesdin and shop), 53, 57; *48*
Granvelle, Antoine Perrenot de, 482, 484, 510
Grasser, Erasmus, 304, 305; *Morris Dancer*, 304; *317*
Great Piece of Turf (Dürer), 340; pl. 52
Gregory the Great, pope, 86, 381
Grimani, Venetian cardinal, 217
Grote Kerk, Breda, altarpiece for Chapel of the Holy Cross of (Van Scorel), 474
Grünewald, Matthias, 282, 348–56; artistic development of, 354–55; birth of, 354; as court painter, 354; *Crucifixion*, 355; *408*; death of, 354; drawings by, 356; *411*; vs. Dürer, 354, 356; expressionism in the work of, 349, 354; *Isenheim Altarpiece*, painted panels for, 210, 348–53, 354, 355, 387; *405, 406*; pls. 53–55; *Madonna and Child in a Garden*, 355–56; *409*; Mannerist traits of, 354; *Miracle of the Snows*, 356; *410*; as mystic, 349, 351–52, 353, 354, 356; realism in the work of, 349, 355; religious beliefs of, 354; *Saint Cyriacus*, 354; *407*; *Saint Dorothea*, 356; *411*; symbolism in the work of, 352, 353
Grüninger, Johann Reinhard de, 323
Grymestone, Edward, 151, 153; *149*
Guelders, duchess of, see Marie d'Harcourt
Guelders, duke of, 470
Guersi, Guido, 348, 353
Guicciardini, Lodovico, 143, 419, 484
Guidobaldo da Montefeltro, 168; *159*
guilds, 74, 79, 80, 119, 120, 124, 126, 151–52, 176, 185, 221, 293, 390, 400, 448
Gustiniani, Michele, 102
Gutenberg, Johann, 271, 277
Guyenne, battle of, 247

Haarlem, Holland, 74, 79, 448, 449; school of painting, 141–44, 147, 150, 151, 188, 234, 269, 271, 272, 297, 451, 456, 461
Haarlem Jerusalem Brotherhood (Van Scorel), 470–71; *541*
Hackeney, Nicasius, 229
Hagenau, Nicolas, 348; *Isenheim Altarpiece*, sculptured shrine of, 348, 349, 353; *403*
Hague, The, Holland, 74, 140–41
Hals, Frans, 114, 470, 479
Hanseatic League, 79, 232, 233, 391, 392
Hapsburg court, 400, 426, 482, 483, 512
Harbor of Antwerp (Dürer), 340, 345; *399*
Harbor of Naples (Bruegel the Elder), 502; *571*
Harrich, Jobst, 333; *Heller Altarpiece* (copy after Dürer), 333–34; *382*
Hay, Jean, 242, 250
Hay Harvest (Bruegel the Elder), 506; *575*
Heemskerck, Maerten van, 474–82; as apprentice, 474–75, 482; artistic development of, 477; classical influence on, 476, 477, 478, 481; *Crucifixion*, 479; *550*; death of, 481–82; engravings by, 476, 481; *548, 554*; *Family Portrait*, 480–81; *553*; *Forum of Nerva*, 443, 477; *548*; Italian influence on, 477, 478, 479; landscape in the work of, 475; Mannerist style of, 477, 478, 479, 481; *Parable of the Unmerciful Servant*, 481; *554*; *Portrait of Anna Codde*, 479, 480; *551*; *Portrait of Pieter Bicker*, 479–80; *551*; portraits by, 479–81; *551–53*; *Rest on the Flight into Egypt*, 475; *546*; Roman sketchbooks of, 476, 477, 478; *548*; in Rome, 475, 477, 481; *Saint Luke Painting the Virgin*, 475–77; pl. 79; *Self-Portrait Before the Colosseum*, 476, 481, 483; *555*; self-portraits by, 476, 481, 483; *547, 555*; symbolism in the work of, 476; *Triumph of Bacchus*, 477–78; *549*; as writer, 481
Heilspiegel Altarpiece (Witz), 223–25; *215, 216*
Heller, Jacob, 333, 334
Heller Altarpiece, 333–34, 354; central panel of (Dürer), 333–34; copy of central panel (Harrich), *382*; panel from (Grünewald), 354; *407*
Hemessen, Jan Sanders van, 443–45, 518; *Parable of the Unmerciful Servant*, 443, 477; *514*; *Prodigal Son*, 443–45; *516*
Hendrik III of Nassau, 216, 425

Henry II, king of France, 512, 515, 517, 518; tomb of (Pilon and Primaticcio?), 522–23; *595, 596*
Henry VI, king of England, 49, 151
Henry VII, king of England, 393
Henry VIII, king of England, 388, 389, 391, 392, 393, 394, 395–97, 398, 482, 483, 511; *457, 458*
Henry VIII (Holbein the Younger), 393, 394; *457*
Henry VIII, His Father Henry VII, and Their Wives (Holbein the Younger), 393–94; *458*
Henry the Pious, duke of Saxony, 375; *436*
Hercules Boarium (Gossart), 419
Hercules Killing the Stymphalian Birds (Dürer), from *Book of Hours of Maximilian*, 339; *396*
Hesdin, Jacquemart de, 53–57, 74; *Brussels Hours*, 53, 55–57, 58, 64, 245; *45–47*; pl. 9; *Grandes Heures du Duc de Berry, Les*, 53, 57; *48*; *Petites Heures du Duc de Berry*, 53–55, 57; *43, 44*
Hildegard of Bingen, 91, 317
Hilliard, Nicholas, 398; *Young Man Among Roses*, 398; *464*
Hind, Arthur M., 267, 268, 271
Historiae (Herodotus), 190
Hofer Altarpiece (Wolgemut?), 235; pl. 40
Hogenberg, Frans, 501; *Blue Cloak, The*, 501; *568*
Holbein, Ambrosius, 385, 388; *447*
Holbein, Hans, the Elder, 234, 385; *Artist's Sons, Ambrosius and Hans, The*, 385; *447*
Holbein, Hans, the Younger, 227, 385–98, 523; allegory in the work of, 391; *Anne of Cleves*, 396; *461*; *Artist's Wife and Two Children*, 390, 391; *455*; in Augsburg, 385; in Basel, 385, 386, 387, 388, 389, 390; *Bonifacius Amerbach*, 387–88; *451*; *Christina of Denmark*, 395–96; *460*; *Christ in the Tomb*, 386–87; *450*; as court painter, 392, 393–97, 398; *Dorothea Kannengiesser*, 386; *449*; drawings by, 389, 391, 393; *453, 458*; early years of, 385–86; *Edward VI at Two Years*, 397; *462*; *Family of Thomas More*, 389; *453*; *French Ambassadors, The*, 392–93; pl. 62; *Georg Gisze of Danzig*, 391–92; *456*; *Henry VIII*, 393, 394; *457*; *Henry VIII, His Father Henry VII, and Their Wives*, 393–94; *458*; as humanist, 387, 391; influence of, 397, 398; *Jacob Meyer zum Hasen*, 386, 387; *449*; *Jane Seymour*, 395; *459*; in London, 385, 388, 390; *Madonna of Mercy and the Family of Jacob Meyer*, 390; *454*; marriage of, 390, 391; as miniature artist, 397; *463*; portrait of (Holbein the Elder), 385; *447*; *Portrait of Erasmus*, 345, 388; *452*; *Portrait of Sir Thomas More*, 388–89; pl. 61; portraits by, 385, 386, 387–89, 390, 482, 483; *449, 451–62*; pls. 61, 62; realism and objectivity in the work of, 385, 386, 387, 388, 391; religious beliefs of, 389, 391; religious paintings by, 386–87, 390, *450, 454*; *Self-Portrait*, 397; *463*; symbolism in the work of, 392–93; travels of, 388, 395, 396; woodcuts by, 386, 388, 486
Holbein, Katharina, 390; *455*
Holbein, Philipp, 390; *455*
Hollanda, Francisco de, 88
Hollar, Wenzel, 408; *Ugly Couple, The*, 408; engraving after Leonardo, 478
Holy Family (Dürer), 321, 327; *355*
Holy Family (Schongauer), 231–32; *224*
Holy Family (Van Cleve), 417; *487*
Holy Family (Van Orley), 429; pl. 68
Holy Family, from *Miraflores Altarpiece* (Van der Weyden), 128; *122*
Holy Family in a Garden (Housebook Master), 288–89, 321; *300*
Holy Family of Francis I (Raphael), 429
Holy Family with the Butterfly (Dürer), 327; *370*
Holy Kinship (Follower of the Saint Veronica Master), 82; *80*
Holy Kinship (Geertgen tot Sint Jans), 179–80, 233, 297, 404, 468; *170*
Holy Kinship (Master of 1473), 233; *226*
Holy Kinship (Van Scorel), 467–68, 469; *539*
Holy Kinship Altarpiece (Cranach the Elder), 373, 375; *435*
Holy Kinship Altarpiece (Master of the Holy

Kinship), 229; *219*
Hoogewerff, G.J., 479
Horebout, Lucas, 397
Hospital of Saint John, Bruges, paintings for (Memlinc), 183, 185, 191
Hôtel Dieu, Beaune, altarpiece for (Van der Weyden), 131
Hours of Engelbert of Nassau (Master of Mary of Burgundy), 194; *191*
Hours of Étienne Chevalier (Fouquet), 245–46, 247; *246–48*
Hours of Jeanne d'Évreux (Pucelle), 20, 21–22, 45, 53, 75; *9, 10*
Hours of Mary of Burgundy (Master of Mary of Burgundy), 194; pl. 34
Hours of Yolande de Flandre, 53
Housebook, The, secular manual, 287; drawings from (Housebook Master), 287, 288; *298, 299*
Housebook Master, 286–89, 291, 298, 321, 363; *Aristotle and Phyllis*, 289; *302; Carrying of the Cross*, 289; *301; Holy Family in a Garden*, 288–89, 321; *300; Old Bulldog Scratching Himself*, 289; *303; Planet Mercury*, 287; *298; Planet Venus*, 287; *299*
House of Jacques Coeur, 239; *235–37*
Howard, Catherine, 397
Huber, Wolf, 363; *Mondsee Landscape with Bridge*, 363; *422*
Huizinga, Johan, 16, 114
humanism (humanists), 316, 318, 325, 345, 364–65, 370, 372–73, 387, 388, 390, 391, 442
Hundred Years' War, 41, 239
Hunters in the Snow (Bruegel the Elder), 505; pl. 83
Huss, John, 32

Icones (Philostratus), 335
iconoclasm, 346, 347, 381–82, 387, 390, 398, 446, 450
Iconologia (Ripa), 476
Idiot, The (Dostoevski), 387
Ill-Matched Lovers (Metsys), 406–7, 444, 463; *475*
Imago Pietatis (Master Theodoric), 29
Imitatio Christi (Thomas à Kempis), 125, 172
Impatience of a Sick Man, woodcut from *Ars moriendi*, 269–70; *268*
Incarnation/Madonna and Child (Grünewald), from *Isenheim Altarpiece*, 349, 350, 351–52, 354; pl. 54; *406*
Ince Hall Madonna (Van Eyck, Jan), 102, 116; *100*
Infancy Altarpiece (Bouts), 143, 144, 150, 152; *139*
Inferno (Bosch), 217; *208*
Information des rois et des princes, L' (French miniaturist), 46–47; *33*
Ingelbrechts family, 121
Innocent VIII, pope, 368
In Praise of Folly (Erasmus), 388
International Style, 16, 91, 234; in Bohemia, 23–32; characteristics of, 17, 53, 70, 71, 122; emergence of, 23; Italian influence on, in France, 46, 53, 56, 57, 59, 61, 69, 70, 71, 72; in Rhenish–Mosan crescent, 74–86; in Valois courts, 41–73; waning and demise of, 50, 58; *see also* Gothic and Late Gothic style
Isabel, queen of France, 16
Isabella of Bourbon, 297
Isabella of Portugal, 95, 114
Isabella of Spain, 396
Isaiah, from *Psalter of Jean, Duc de Berry* (Beauneveu), 53; *42*
Isenheim Altarpiece, 210, 348–53, 354, 355, 387; painted panels for (Grünewald), 348–53, 354, 355; pls. 53–55; sculptured shrine of (Hagenau), 348, 349, 353; *403*
Isenmann, Caspar, 230, 280

Jacoba of Bavaria, 120, 140, 141, 278, 452; *137*
Jacob Meyer zum Hasen (Holbein the Younger), 386, 387; *449*
Jacobsz, Hugo, 273, 455, 456; *Meeting of Saint John the Baptist and Christ*, 455–56; *525*
Jane Seymour (Holbein the Younger), 395; *459*
Jan of Liège, 140
Jan of Středa, 28

January, from *Très Riches Heures du Duc de Berry* (Limbourg brothers), 61–62; pl. 10
Jean II, duke of Bourbon, 251
Jeanne d'Arc, 239
Jeanne d'Armagnac, 55
Jeanne de Boulogne, 55
Jeanne de Bourbon, queen of France, 43, 44, 45
Jeanne de Laval, 263; *259*
Jeanne d'Évreux, queen of France, 22
Jeremiah, from *Altarpiece of the Annunciation* (Master of the Aix Annunciation), 252; *257*
Jerome, Augustine, Gregory, and Ambrose, from *Altarpiece of the Church Fathers* (Pacher), 238; *233*
Jihlava Pieta/Vesperbild (Bohemian sculptor), 32; pl. 4
Joachim and Anna Meeting (Master of Joachim and Anna), 297; *315*
Johanna of Brabant, 297
Johannes of Hildesheim, 60
John, duke of Bedford, 239
John, duke of Berry, 41, 42, 49, 52–63, 75; as art collector, 22, 42, 52, 53, 55, 60, 61, 96; death of, 58; gifts from, 57; inventories of, 53, 55; marriages of, 55; as patron, 22, 46, 52–53, 55, 57, 64, 245; portraits of, 54, 56, 58, 61; (Hesdin), *44, 47;* pl. 9; (Limbourg brothers), pl. 10
John, duke of Saxony, 375; portrait of (Cranach the Elder), 375; *435*
John Frederick, of Saxony, 375, 383
John of Bavaria, bishop of Liège, 96
John of Lancaster, duke of Bedford, 49
John of Luxemburg, 23
John's Vision of the Seven Candlesticks, from *Apocalypse* series (Dürer), 324, 519; *362*
John the Evangelist Before the One Enthroned and the Seven Churches of Asia, from *Paris Apocalypse* (Dutch miniaturist), 76; *72*
John the Fearless, duke of Burgundy, 57, 70
John the Good, king of France, 18, 41–42; *25*
John the Good and Clement VI or Urban V (14th-century manuscript illumination), 18, 41; copy of, *5*
Jonghelinck, Niclaes, 485, 505, 507
Josephus, Flavius, 244
Jouvenel des Ursins, Guillaume, 248; *251, 252*
Joys of Mary, The (Memlinc), 184; *175*
Judgment of Cambyses (David), 189–91; *184, 185,* pl. 60
Judgment of Paris (Cranach the Elder), 383–84; pl. 60
Justice of Emperor Otto III (Bouts), 148–49, 190; *146*
Justice of Herkinbald (Van der Weyden), 148
Justice of Trajan (Van der Weyden), 148

Kalendrier des Bergers, illustrated book, 276
Kannengiesser, Dorothea, 386, 390; *449, 454*
Karlštejn Castle, near Prague, 78; Chapel of the Holy Cross in, 26, 28, 79; interior design and paintings for (Master Theodoric), 28–29
Kaufmann Crucifixion (Master of the Vyšší Brod Altarpiece), 27
Kermis (Bruegel the Elder), 488, 497; *561*
Kermis at Hoboken (Bruegel the Elder), 499; *563*
Kessler, Nikolaus, 321
King of the Wild Men (Master of the Playing Cards), 277–78; *280*
Kladsko Madonna (Master of the Vyšší Brod Altarpiece), 27
Knight, Death, and the Devil (Dürer), 336–37, 339, 357; *391*
Knights of Saint John, 176, 181, 469, 470, 471
Knights of the Teutonic Order, 219
Koberger, Anton, 275, 320, 323, 328
Koch, Robert, 269
Koerbecke, Johann, 232–33; *Christ Before Pilate*, 233; *225*
Koinonia (Last Supper), 167–68
Kölderer, Jörg, 339
Krämer, Heinrich, 368
Kratzer, Niklaus, 392

La Grange, Jean de, 44
Lalaing, Antoine de, 427
La Marche, Olivier de, 273

Lamentation (Christus), 153; *151*
Lamentation (Daucher?), 311
Lamentation (Engelbrechtsz), 456
Lamentation (Geertgen tot Sint Jans), 176–77, 180, 297, 449, 473; pl. 29
Lamentation (Van der Goes), 174–75, 180; *164*
Lamentation (Van Scorel), 473–74; *544*
Lamentation, from *Les Grandes Heures du Duc de Berry* (Hesdin and shop), 57; *48*
Lamentation, from *Rohan Hours* (Master of the Rohan Hours), 52; pl. 8
Lamentation Altarpiece (Metsys), 405; pl. 63
Lamentation at the Tomb (Duccio), 46
Lamentation of the Holy Trinity (Malouel), 69–70; *66*
Lampsonius, Dominicus, 100, 431, 467, 483, 484
Landloper (Bosch), 206, 212; *196*
Landscape of Alpine Mountains (Bruegel the Elder), 504; *572*
Landscapes (David), 191–92; *188*
Landscape with Charon's Boat (Patinir), 412; *483*
Landscape with Saint Jerome (Patinir), 410, 412; *482*
Lang, Apollonia, 467, 468; *539*
Large Einsiedeln Madonna (Master E.S.), 279–80; *283*
Large Garden of Love, The (Master of the Garden of Love), 278; *281*
Large Passion series (Dürer), 334, 335, 349; *387*
La Sonnette, Georges de, 313; *Entombment* group, 313; *344*
Last Judgment (Bosch), 196
Last Judgment (Bouts), 148, 234
Last Judgment (Christus), 155–56; *153*
Last Judgment (Floris), 431–32, 485; *509*
Last Judgment (Lucas van Leyden), 464–65; *538*
Last Judgment (Memlinc), 133
Last Judgment (Michelangelo), 431, 432
Last Judgment (Van Eyck, Jan), 118, 156; *115*
Last Judgment (Van Orley), 429; *506*
Last Judgment Altarpiece (Van der Weyden), 109, 131–33, 250, 281; *127, 128*
Last Supper (Dürer), 346; *401*
Last Supper (Leonardo), 430
Last Supper (Master I.A.M. of Zwolle), 292; *308*
Last Supper (Van Aelst), 430; pl. 69
Last Supper, The, from *Altarpiece of the Holy Blood* (Riemenschneider), 306–7; *331*
Last Supper, Netherlandish woodcut from *Speculum humanae salvationis*, 271; *270*
Last Supper Altarpiece (Bouts), 146–48, 166, 167, 235, 269; *144;* pl. 25
Late Gothic Baroque, 308, 309, 310, 311, 354
Late Gothic style, *see* Gothic and Late Gothic style
La Tour, Georges de, 265
La Breton, Gilles, 512
Leemput, Remi van, 393
Legenda Aurea (Voragine), 80, 82–83, 133, 172, 185, 186, 208, 221, 273, 431, 463, 474
Lemaire, Jean, 240, 242, 250
Leonardo da Vinci, 138, 208, 242, 363, 404; drawing technique of, 518; under French patronage, 512; influence of, 316, 331, 333, 337, 405, 406, 408, 430, 511, 518; landscape in the work of, 517
Lescot, Pierre, 521
Letter G, from *Fantastic Alphabet* (Master E.S.), 279; *282*
Letters of Saint Jerome, woodcut from (Dürer), 321; *356*
Leven ons Heeren (Ludolphus of Saxony), 272
Leyden, Lucas van, *see* Lucas van Leyden
Leyden, Nicolaus Gerhaerts van, *see* Gerhaerts van Leyden, Nicolaus
Liber Trium Regum (Johannes of Hildesheim), 60
Liber Viaticus (Bohemian miniaturist), 28; *20*
Lieferinxe, Josse, 264–65; *Death of Saint Sebastian*, 265; *260; Saint Irene Nurses Saint Sebastian*, 265; pl. 48
Liège, Jean de, 43, 293; *Charles V*, 43–44; *28*
Life of the Virgin series (Dürer), 276, 334–35; *385, 386*
Limbourg brothers, 46, 57–64, 69, 74, 193,

261; *Belles Heures du Duc de Berry,* 57; *49;*
Très Riches Heures du Duc de Berry, 22, 43,
51, 57–64, 75, 278, 383, 505; *50–57;* pl. 10
Lives of the Saints (Voragine), 328
Livre du cuer d'amours espris (René of Anjou),
249; miniature from (Master of René of An-
jou), 249; pl. 44
Lochner, Stephan, 182, 218–20, 221, 222, 229,
230, 231, 402; *Dombild, Das,* 218–19; *210;*
Madonna in the Rose Garden, 220; pl. 37; *Pre-
sentation in the Temple,* 219–20; *211*
Lochorst, Herman, 469–70; pl. 78
Locky, Richard, 389
Lombard, Lambert, 231, 430–31; *Saint Denis
and Saint Paul Before the Altar of the Unknown
God,* 431; *508*
Lorenzetti, Ambrogio, 73
Louis IX, king of France, 41, 42, 53
Louis XI, king of France, 244, 246, 248, 250,
251
Louis XII, king of France, 239, 511; portrait of
(Perréal), *580*
Louis de Mâle, count of Flanders, 64, 71
Louis of Anjou, duke of France, 41, 48; *35*
Louis of Orléans, 75, 76
Louvre, Paris: 14th century, 43, 63, 65; 15th
century ground plan of, *27;* 16th century,
sculpture for (Goujon), 521
Lucas van Leyden, 273, 292, 455–66; *Adam and
Eve,* 463–64; *537;* artistic development of,
456, 458, 463, 464; artistic technique of, 457,
458, 461, 463; Baroque qualities in the work
of, 456, 464, 466; birth of, 455; *Card Players,*
464; pl. 75; *Carrying of the Cross,* 458; *529;*
Crucifixion, 460–61; *532; Dance of Mary Mag-
dalen,* 463; *536; David Playing the Harp Before
Saul,* 458; *528;* early training of, 455, 456;
Ecce Homo, 458, 460; *531;* engravings by,
456–61, 462, 463–64, 481; *527–32, 534, 536,
537;* genre themes in the work of, 458, 460,
461, 462, 464, 465; landscape in the work of,
457–58, 461, 466; *Last Judgment,* 464–65; *538;*
Mannerist devices in the work of, 460, 461,
466; *Milkmaid,* 458; *530; Mohammed and the
Monk Sergius,* 457–58, 464; *527; Moses and
the Worship of the Golden Calf,* 464, 465–66;
pl. 76; paintings by, 456, 464–66; *538;* pls.
75, 76; *Poet Vergil Suspended in a Basket,* 461,
462; *534; Round Passion,* 458; *529; Samson
and Delilah,* 461–62, 463; *533; Tavern Scene,*
462–63; *535;* woodcuts by, 461–62; *533, 535*
Lucca Madonna (Van Eyck, Jan), 102, 417; *101*
Ludolphus of Saxony, 271, 272
Luigi d'Aragona, 89
Luther, Martin, 336, 345, 346, 347, 354, 361,
370, 372, 373, 375–76, 381, 382, 393; por-
traits of (Cranach the Elder), 376, 381; *441,
442*
Lutheranism, 346, 361, 382, 393

Madonna (Erhart, Michel and Gregor?), 303;
326
Madonna (Sluter and shop), from Chartreuse de
Champmol, 65–66; *59*
Madonna and Child (Bouts, c. 1450), 145; *141*
Madonna and Child (Bouts, c. 1465), 145–46,
281; *142*
Madonna and Child (Christus), 156; *154*
Madonna and Child (Gossart), 425; *498*
Madonna and Child (Malouel), 70
Madonna and Child (Memlinc), 182; *173*
Madonna and Child (North Netherlandish), 297;
314
Madonna and Child (Van der Weyden), 125; *120*
Madonna and Child, from *Dresden Altarpiece*
(Dürer), 329; *375*
Madonna and Child, from *Melun Diptych* (Fou-
quet), 246, 247–48; pl. 43
Madonna and Child Enthroned (Metsys), 405–6;
473
Madonna and Child Enthroned, from *Hours of
Étienne Chevalier* (Fouquet), 245–46; *247*
Madonna and Child in a Garden (Grünewald),
355–56; *409*
Madonna and Child in a Rose Arbor (Schon-
gauer), 231; *223*
Madonna and Child in the Courtyard (Schon-
gauer), 286, 289; *297*

Madonna and Child with Angels (Memlinc), 186;
pl. 32
*Madonna and Child with Saints and a Carthusian
Monk* (Van Eyck, Jan, and follower), 117,
150, 151, 155; *114*
*Madonna and Child with Saints Michael and
Catherine* (Van Eyck, Jan), 101–2, 421; *98,
99*
Madonna and Child with the Parrot (Schon-
gauer), 281; *285*
Madonna Aracoeli (Master of the Třeboň Altar-
piece), 30
Madonna by the Fountain (Van Eyck, Jan), 102;
102
Madonna Enthroned (Metsys), 403; *469*
Madonna Enthroned Between Saints (Cologne
painter?), 81; *79*
Madonna in the Church (Gossart), 420, 421; *491*
Madonna in the Church (Van Eyck, Jan), 100–
101, 102, 129, 420, 421; pl. 17
Madonna in the Rose Garden (Lochner), 220;
pl. 37
Madonna in the Sun, Netherlandish woodcut,
268; *265*
Madonna of Dangolsheim (Gerhaerts van Ley-
den?), 301; *323*
Madonna of Krumau (Bohemian sculptor of the
Schöne Madonnas), 31–32; *24*
Madonna of Mercy and the Family of Jacob Meyer
(Holbein the Younger), 390; *454*
Madonna of Most (Bohemian artist), 28; *19*
Madonna of the Dry Tree (Christus), 156, 165;
155
Madonna of the Long Neck (Parmigianino), 32
Madonna of the Rosary (Geertgen tot Sint Jans),
178–79, 251, 331, 351; pl. 30
Madonna with a Carthusian Monk (Christus),
151, 154–55, 156; *148*
Madonna with Canon George van der Paele (Van
Eyck, Jan), 102, 109, 110–11, 142; *105*
Madonna with Chancellor Nicolas Rolin (Van
Eyck, Jan), 96 109–10, 112, 113, 127, 194,
250, 392, 422; *104*
Maertensz, Jacob, 456; *526*
Maestà altarpiece (Duccio), 17, 18, 21, 46; pan-
els from, *4, 11*
Magdalen Altarpiece (Moser), 221–22, 223; exte-
rior of, *212*
Magnus, Albertus, 125
Mâle, Emile, 67
Male Nude (Rosso Fiorentino), 513; *582*
Maler, Hans, 370
Malleus Maleficarum (Krämer and Sprenger),
368
Malouel, Jean, 18, 46, 57, 67, 69–70, 73, 74
122; *Lamentation of the Holy Trinity,* 69–70;
66; Martyrdom of Saint Denis with the Trinity,
70; pl. 11; *Portrait of Philip the Bold,* 70; copy
after, *67*
Malvagna Triptych (Gossart), 421; *492*
Mander, Carel van, 125, 141, 147, 150, 473;
writings of: on Bouts, 141, 143; on Bruegel
the Elder, 484, 487, 488, 503, 510; on Buys
the Elder, 447; on David, 187; on Dürer,
321; on Engelbrechtsz, 456; on Floris, 431;
on Geertgen tot Sint Jans, 141, 176, 321; on
Gossart, 424; on Holbein the Younger, 386,
391, 397; on Lombard, 430; on Lucas van
Leyden, 455, 456, 457, 461, 464; on Mos-
taert, 451, 454; on Ouwater, 141, 142, 143,
176, 236; on Patinir, 412; on Serlio, 512; on
Van Aelst, 429, 430, 512; on Van Cleve,
412; on Van der Weyden, 125, 133; on Van
Eyck, Jan and Hubert, 95, 141; on Van
Heemskerck, 475–76, 477, 481, 482; on Van
Orley, 467; on Van Scorel, 467, 469, 470,
472, 475, 477
Man in a Red Turban (Van Eyck, Jan), 109,
113–14; *107*
Mannerism (Mannerists), 32, 272, 354, 375,
393; Antwerp, 401–2, 405, 417, 448–49, 456;
beginnings of, 285; characteristics of, 520;
court portraits, 375; Florentine, 513; in
French art, 513, 514, 515, 516, 518, 519–20;
Italian, 474, 515, 518; in landscape painting,
516, 404–5, 454, 466; Mannerist inversions,
291, 445, 460; in Netherlandish art, 419,
420, 423, 425, 429, 445, 448–49, 451, 454,

456, 460, 461, 466, 474, 477, 478, 479;
spread of, to North, 513
Man of Sorrows (Geertgen tot Sint Jans), 177–
78; *167*
Man of Sorrows, from *Norfolk Triptych* (Mosan
master), 76; *73*
Man of Sorrows, from *Small Passion* series
(Dürer), 335; *388*
Man of Sorrows/Schmerzensmann (Multscher),
299; *318*
*Man of Sorrows with Mary and John the Evange-
list* (Parisian goldsmith), 16; pl. 1
Mantegna, Andrea, 237, 316, 321–22, 328,
334, 429, 431; *Battle of the Sea Gods,* 321–22;
358
Manuel II, Byzantine emperor, 60
Manutius, Aldus, 370
Man with Glasses (Metsys), 408–9; *479*
Map of Rome, from *Très Riches Heures du Duc
de Berry* (Limbourg brothers), 61
Marchant, Guy, 276
Marcia Paints a Self-Portrait (French miniatur-
ist), from *Des cleres et nobles femmes* (Boc-
caccio), 49; *37*
Marcus Aurelius, 512
Maréchal de Boucicaut, 50
Margaret of Austria, 111, 240, 250, 252, 400,
427, 428, 451, 452, 453, 511
Margaret of Flanders, 64, 65; portrait of
(Sluter and shop), 65, 66; *58*
Margaret of Parma, 484
Margaret of York, duchess of Burgundy, 273
Marguerite, duchess of Moravia, 408
Marguerite of Navarre, 512, 519
Maria Baroncelli (Memlinc), 186; *179*
Maria of Hungary, 396, 482
Maria-Schnee (Madonna of the Snows) cult,
356
Marie d'Harcourt, duchess of Guelders, 74, 75,
76; *71*
Marmion, Simon, 240–42; *Crucifixion* (c.
1465), 241–42; *240; Crucifixion* (c. 1480),
242; *241; Saint Bertin Altarpiece,* 240–41; *238,
239; Temptation of Saint Anthony,* 242, 243;
242
Marot, Clémont, 512, 519
Marriage at Cana, from *Saint Wolfgang Altar-
piece* (Pacher), 236–37; *231*
Mars and Venus (Barbari), 424
Martel, Charles, 242, 244
Martens, Bella, 84
Martini, Simone, 18, 56, 61, 69, 70, 363;
Deposition, 18; *6*
Martin Luther as Junker Jörg (Cranach the
Elder), 376, 381; *442*
Martin Luther Wearing a Doctor's Cap (Cranach
the Elder), 376; *441*
Martin of Mayo, bishop, 155
Martin van Nieuwenhove (Memlinc), 182; *174*
Martyrdom of John the Evangelist (Dürer), 458
Martyrdom of Saint Apollonia, from *Hours of
Étienne Chevalier* (Fouquet), 246; *248*
Martyrdom of Saint Denis with the Trinity
(Malouel and Bellechose?), 70; pl. 11
Martyrdom of Saint Ursula, from *Shrine of Saint
Ursula* (Memlinc), 185–86; *177*
Martyrdom of the Evangelist, from *Lamentation
Altarpiece* (Metsys), 405; pl. 63
Marville, Jehan de, 65, 67, 74, 293
Mary and Joseph Arriving for the Census (Bruegel
the Elder), 507
Mary Going over the Hills to Visit Elizabeth,
from *Hours of Engelbert of Nassau* (Master of
Mary of Burgundy), 194; *191*
Mary Magdalen (Metsys), 406, 472; *474*
Mary Magdalen (Van Scorel), 472, 475; *543*
Mary Magdalen, from *Altarpiece of Saint Martin*
(Master of Saint Martin), 298; *316*
Mary of Burgundy, 297, 400
Mary of Burgundy in Devotion, from *Hours of
Mary of Burgundy* (Master of Mary of Bur-
gundy), 194; pl. 34
Mary of Hungary, 400
Mary Tudor (Mary I), queen of England, 482,
483; portraits of (Holbein the Younger), 483;
(Mor), 482, 483; pl. 80
Masaccio, 57, 97, 131
Massacre of the Innocents (Bruegel the Elder),

507, 510

Mass of Saint Giles (Master of Saint Giles), 243; pl. 41

Mass of Saint Gregory, 177, 207

Mass of Saint Gregory (Van Meckenem), 289–90; *305*

Master Bertram, 78–79, 84; *Saint Peter Altarpiece*, 78–79; *75, 76*

Master E.S., 270, 279–80, 289, 301; *Large Einsiedeln Madonna*, 279–80; *283; Letter G*, 279; *282*

Master Francke, 79, 84–86; *Christ as Man of Sorrows*, 86; *84; Englandfahrer Altarpiece*, 84–86; *82, 83*; pl. 14

Master H.L., 311; *Coronation of the Virgin*, 311; *340*

Master I.A.M. of Zwolle, 292; *Last Supper*, 292; *308*

Master of Alkmaar, 446, 467; *Seven Acts of Mercy*, 446–47; *517*; pl. 72; *see also* Buys, Cornelius, the Elder

Master of Amiens, 15; *Annunciation* group, 15, 79, 293, 312; *2*

Master of Bellaert, 272; *Animals*, 272–73, 285; *273; Early History of Man and the Baptism of Christ*, 272; *271; Earth and Its Division, The*, 272; *272*

Master of Flémalle, *see* Campin, Robert

Master of 1402, 49, 64

Master of 1473, 233; *Holy Kinship*, 233; *226*

Master of Frankfort, 401; *Crucifixion*, 401; *466; Festival of the Archers*, 401; *467*

Master of Joachim and Anna, 297; *Joachim and Anna Meeting*, 297; *315*

Master of Mary of Burgundy, 193–94; *Mary Going over the Hills to Visit Elizabeth*, 194; *191; Mary of Burgundy in Devotion*, 194; pl. 34

Master of Moulins, 250–52, 312, 511; *Moulins Triptych*, 251; pl. 45; *Nativity of Cardinal Jean Rolin*, 250–51; *254; Portrait of a Young Princess*, 251–52; *255*

Master of René of Anjou, 249; *Amour Takes the Heart of the King*, 249; pl. 44

Master of Saint Giles, 242–44; *Mass of Saint Giles*, 243; pl. 41; *Saint Giles Protecting the Hind from the Hunters of Charlemagne*, 242–43; *243; Saint Remi Gives Benediction Before Notre Dame de Paris*, 243–44; *244*

Master of Saint Martin, 297–98; *Mary Magdalen*, 298; *316*

Master of Saint Sebastian, *see* Lieferinxe, Josse

Master of Saint Ursula, 229; *Dream of Saint Ursula*, 229; *221*

Master of Saint Veronica, 80–81, 82, 84, 218, 219; *Saint Veronica*, 80–81; *78*

Master of the Aix Annunciation, 252, 261; *Altarpiece of the Annunciation*, 252, 261; *256, 257*

Master of the Amsterdam Cabinet, *see* Housebook Master

Master of the Antwerp Adoration, 402; *Adoration of the Magi*, 402, 417; *468*

Master of the Avignon Pietà, 261–62; *Pietà*, 261–62; pl. 46

Master of the Banderoles, 280; *Deposition*, 280; *284*

Master of the Brunswick Monogram, 460, 518

Master of the Cologne Annunciation, 80; *Annunciation*, 80; *77*

Master of the Death of Mary, *see* Cleve, Joos van

Master of the Garden of Love, 278; *Large Garden of Love, The*, 278; *281*

Master of the Holy Kinship, 229; *Crucifixion*, 229; *220; Holy Kinship Altarpiece*, 229; *219*

Master of the Hours of Catherine of Cleves, 141, 187, 194; *Book of Hours of Catherine of Cleves*, 141; *138*; pl. 23

Master of the Life of Mary, 227–29; *Visitation*, 228–29; *218*

Master of the Playing Cards, 277–78, 280; *King of the Wild Men*, 277–78; *280*

Master of the Rohan Hours, 52; *Rohan Hours*, 50, 52; pl. 8

Master of the Saint Bartholomew Altarpiece, 229–30; *Deposition*, 230; *222; Virgin and Child with Saint Anne*, 230; pl. 39

Master of the Tiburtine Sibyl, 272

Master of the Třeboň Altarpiece, 30; *Resurrection*, 30, 85, 223; pl. 3

Master of the Virgo inter Virgines, 450–51; *Annunciation*, 450–51; *520; Entombment*, 451; *521*

Master of the Vyšší Brod Altarpiece, 27, 28, 267; *Nativity*, 27, 28, 29, 30; pl. 2

Master Theodoric, 28, 29–30, 78, 79; Chapel of the Holy Cross, Karlštejn Castle, interior paintings for, 28–29; *21, 22*

Mater Dolorosa (Pilon), 521–22; *594*

Matthias of Arras, 23, 24, 26

Maximilian I, Holy Roman Emperor, 339, 363, 370, 375, 400, 457; *435*

Meckenem, Israhel van, 86, 289–92, 458; *Artist and His Wife Ida*, 289; *304; Dance at the Court of Herod*, 290–91; *306; Mass of Saint Gregory*, 289–90; *305; Visit to the Spinner*, 291–92; *307*

Medici, Catherine de', 522

Medici, Lorenzo de', 116

Medici family, 130, 169

Medici Madonna (Van der Weyden), see *Virgin and Child with Four Saints* (Van der Weyden)

Medici Venus, 316, 424, 523; *351*

Meersch, Elizabeth van der, 192; pl. 33

Meeting of Saint Anthony and the Hermit Paul (Grünewald), 349, 353, 354, 357; pl. 55

Meeting of Saint John the Baptist and Christ (Jacobsz?), 455–56; *525*

Meeting of the Magi at the Crossroads, from *Très Riches Heures du Duc de Berry* (Limbourg brothers), 59, 60; *52*

Meiss, Millard, 63

Meissen, Heinrich von, 461

Melanchthon, Philip, 318

Melencolia I (Dürer), 181, 316, 318–19, 339, 365; *349*

Melun Diptych (Fouquet), 246, 247–48; *250*; pl. 43

Memlinc, Hans, 182–86, 187, 193, 241, 251, 412; *Altarpiece of the Virgin with Saints and Angels*, 183–84, 191; pl. 31; in Bruges, 182, 186; in Brussels, 183; in Cologne, 183, 186; death of, 182, 186, 189; eclecticism of, 182; influence of, 189; Italian art and, 186; *Joys of Mary, The*, 184; *175*; landscape in the work of, 184; *Madonna and Child*, 182; *173; Madonna and Child with Angels*, 186; pl. 32; *Maria Baroncelli*, 186; *179; Martin van Nieuwenhove*, 182; *174; Martyrdom of Saint Ursula*, 185–86; *177*; mysticism in the work of, 182; narrative qualities in the work of, 182, 184–85, 193; popularity of, 182, 188; portraits by, 186, 252, 409; *178, 179; Shrine of Saint Ursula*, 185–86, 229; *176, 177*; as student, 183; stylistic traits of, 183, 241; *Tommaso Portinari*, 186; *178*; in Van der Weyden's studio, 135, 183

Mérode Altarpiece (Campin), 120–22, 123, 125–26, 156, 225; pl. 19

Metamorphoses (Ovid), 190, 510

Metsys, Quentin, 345, 388, 402–9; *Altarpiece of the Holy Kinship*, 373, 403–5; *470, 471*; in Antwerp, 403; artistic style of, 404; birth of, 403; *Crucifixion*, 405; *472*; death of, 403; emotionalism in the work of, 405; genre in the work of, 406, 407; grotesque subject matter of, 405, 406, 407, 408; *Ill-Matched Lovers*, 406–7, 444, 463; *475*; Italian influence on, 405, 407; *Lamentation Altarpiece*, 405; pl. 63; landscape in the work of, 404, 405, 406, 410, 420; *Madonna and Child Enthroned*, 405–6; *473; Madonna Enthroned*, 403; *469; Man with Glasses*, 408–9; *479; Mary Magdalen*, 406, 472; *474; Money Changer and His Wife*, 406, 443; pl. 64; *Old Man in Profile*, 407–8; *477*; portraits by, 408–9; *479; Temptation of Saint Anthony* (with Patinir), 409–10; *480; Ugly Old Woman, The*, 407, 408; *476*

Meyer, Anna, 390; *454*

Meyer, Jacob, 386, 387, 390; *449, 454*

Michel, Jean, 313; *Entombment* group, 313; *344*

Michelangelo Buonarroti, 58, 88, 283, 457, 465, 512; influence of, 425, 431, 432, 470, 472, 478, 479, 513, 514, 519, 523

Mies, François de, 225

Mijnnesten, Jan van, 292

Milkmaid (Lucas van Leyden), 458; *530*

Minott, Charles, 121, 232

Miracle of the Snows (Grünewald), 356; *410*

Miraculous Draught of Fishes, from *Altarpiece of Saint Peter* (Witz), 225–26; pl. 38

Miraflores Altarpiece (Van der Weyden), 127–28, 129, 144, 281, 295, 296; *122*

Mirrour of the World, 15th-century book, 273

Mocking of Christ (Grünewald), 354

Modena, Tommaso de, 29

Mohammed and the Monk Sergius (Lucas van Leyden), 457–58, 464; *527*

Molanus, Johannus, 147

Momper, Joos de, 404

Mona Lisa (Leonardo), 138, 472, 518

Monastery of Saint Andrew, Amsterdam, altarpiece for (Van Oostsanen), 449

Monastery of Saint Anthony, Isenheim, altarpiece for (Grünewald and Hagenau), 348

Mondsee Landscape with Bridge (Huber), 363; *422*

Money Changer and His Wife (Metsys), 406, 443; pl. 64

Monforte Altarpiece (Van der Goes), see *Adoration of the Magi* (Van der Goes)

Monstrous Pig of Landser (Dürer), 326–27; *369*

Montagnac, Jean de, 262

Montezuma, emperor of Mexico, 340

Monument of Canon Conrad von Busnang (Gerhaerts van Leyden), 301; *320*

Monument to Philippe Pot (French), 314; *347*

Monument to the Heart of Henri II (Pilon), 521; *593*

Monza, Antonio da, 430

Mor, Antonis, 482–83; *Fernando Alvarez de Toledo*, 482–83; *556; Portrait of Mary Tudor*, 482, 483; pl. 80; *Self-Portrait*, 483; *557*

More, Thomas, 388, 389, 391, 392, 408; portraits of (Holbein the Younger), 388–89; *453*; pl. 61

Mori, Yoko, 500

Morris Dancer (Grasser), 304; *327*

Moser, Lucas, 221–22; *Magdalen Altarpiece*, 221–22, 223; *212*

Moses, from *Well of Moses* (Sluter and shop), 67; *61*

Moses and the Worship of the Golden Calf (Lucas van Leyden), 464, 465–66; pl. 76

Moses Defending the Daughters of Jethro (Rosso Fiorentino), 513

Moses Striking the Rock (Lucas van Leyden), 464

Mostaert, Jan, 451–54, 479; *Adoration of the Magi*, 451–52; *522; First Family*, 453–54; *524; Portrait of Abel van den Coulster*, 452–53; *523; West Indies Landscape*, 454; pl. 74

Moulins Triptych (Master of Moulins), 251; pl. 45

Mountain Landscape "Waltersspurg" (Bruegel the Elder), 504; *573*

Multscher, Hans, 221, 222–23, 299, 301, 302, 303; *Man of Sorrows (Schmerzensmann)*, 299; *318; Saint Ursula*, 299; *319; Wurzach Altarpiece*, 222–23; *213, 214*

Münster, Germany, 79, 232

Münzer, Hieronymus, 89, 173

Mutacion de fortune (Pisan), 50, 64; *38*

Mystical Marriage of Saint Catherine (Gossart), 419; *489*

mysticism, 15–16, 208; of Antonines, 348, 353; change in Late Gothic, 32, 179; flowering of, 74, 79, 81, 86; in French 15th-century art, 261, 262, 264; in French 16th-century art, 519–20; in German 15th-century art, 81, 177, 178, 218, 220, 221, 230, 264, 317; in German 16th-century art, 316, 323–24, 348, 349–56, 357, 359, 363; in Germany, 91, 220, 317, 318, 349, 356; negative, 74, 79, 81, 86, 118; in Netherlandish art, 169–75, 175–76, 177, 178–79, 180–81, 182, 194, 217; in the Netherlands, 172, 176; positive, 74; Rosary devotion and, 102, 165, 178, 179, 310, 331; *see also* religious philosophy

Narrenschiff (Brant), 205, 274, 321, 365

Nativity (Campin), 122–23, 134, 156; *118*

Nativity (Christus), 153–54, 171; pl. 27

Nativity (David, c. 1480–85), 188, 191; *182*

Nativity (David, c. 1483–85), 188; *183*
Nativity (David, c. 1515–20), 191; *187*
Nativity (Master of the Vyšší Brod Altarpiece), 27, 28, 29, 30; pl. 2
Nativity (Mosan painter), 73; *69*
Nativity (Schongauer), 281; *286*
Nativity (Van der Goes), 175, 250; *166*
Nativity (Van Eyck, Jan), 103
Nativity, from *Boucicaut Hours* (Boucicaut Master), 51; *39*
Nativity, from *Englandfahrer Altarpiece* (Master Francke), 84–85; pl. 14
Nativity, from *Infancy Altarpiece* (Bouts), 143, 144; *139*
Nativity, from *Portinari Altarpiece* (Van der Goes), 169–72; pl. 28
Nativity, from *Saint Wolfgang Altarpiece* (Pacher), 236–37; *232*
Nativity, from *Wurzach Altarpiece* (Multscher), 222; *213*
Nativity Altarpiece of Pieter Bladelin (Van der Weyden), 133–34, 135, 281; *129*
Nativity of Cardinal Jean Rolin (Master of Moulins), 250–51; *254*
Neptune and Amphitrite (Gossart), 423–24; *496*
Netherlandish Proverbs (Bruegel the Elder), 500–502; pl. 82
Nicholas V, pope, 244
Nicholas of Cusa, 237, 323–24
Niederwildungen Altarpiece (Von Soest), 82–84, 86; *81*
Nieuwe Kerk, Delft, sculptured altarpiece for (Van Wesel), 298
Night Nativity (Altdorfer), 358–59, 364; *415*
Night Nativity (Geertgen tot Sint Jans), 84, 178, 359; *168*
Nood Gods (Man of Sorrows) theme, 76
Norfolk Triptych (Mosan master), 76–77; *73*
Notke, Bernt, 304–5; *Saint George and the Dragon*, 304–5; *328*
Notre-Dame de Grâce, from *Adoration* group? (French), 312; *342*
Nouans Pietà (Fouquet), 249; *253*
November, from *Hours of Jeanne d'Évreux* (Pucelle), 20, 21; *9*
Nude (Dürer), 322; *360*
Nuremberg Chronicle, woodcut from (Dürer?), 320; *354*
Nymphs (Goujon), 520; *591*

Oberried, Hans, 386
October, from *Très Riches Heures du Duc de Berry* (Limbourg brothers), 43, 63; *57*
Oestvoren, Jacob van, 205
Ofhuys, Gaspar, 172–73, 176
Old Bulldog Scratching Himself (Housebook Master), 289; *303*
Old Man in Profile (Metsys), 407–8; *477*
Olpe, Johann Bergmann von, 321, 327
Oostsanen, Jacob Cornelisz van, 273, 447, 448–49, 467, 468; *Adoration of the Child*, 449; *518; Crucifixion*, 448–49; pl. 73; *Self-Portrait*, 449, 483; *519*
Orcagna, Andrea, 92
Orléans, Charles d', 63
Orléans, Girard d', 41; *Portrait of John the Good*, 41–42; *25*
Orley, Bernard van, 426–29; *Altarpiece of the Apostles Thomas and Matthias*, 427; *501; Altarpiece of the Ordeals of Job*, 427–29, 447; *502, 503; Holy Family*, 429; pl. 68; *Last Judgment*, 429; *506; Portrait of Charles V*, 429; *505; Portrait of Doctor Georges de Zelle*, 429; *504*
Orliaco, Johan de, 348, 353
Ornament with Owl (Schongauer), 285; *294*
Orsini, Napoleone, 18
Ortelius, Abraham, 484, 487, 503, 510
Ostade, Adriaen van, 465
Ostendorfer, Michael, 361; *Pilgrimage to the Church of the Beautiful Virgin at Regensberg*, 361; *418*
Our Lady of the Dry Tree, confraternity, 156
Ouwater, Albert van, 141, 142–43, 148, 150, 152, 176, 233, 236, 269, 297, 401; *Raising of Lazarus*, 142–43, 154; pl. 24
Ovid, 190, 453, 510

Pacher, Friedrich, 236
Pacher, Leonard, 238
Pacher, Michael, 236–38, 301–2; *Jerome, Augustine, Gregory, and Ambrose*, 238; *233; Saint Wolfgang Altarpiece*, 236–37, 301–2, 361; *231, 232, 324, 325; Saint Wolfgang in Prayer*, 238; *234*
Painting in Florence and Siena After the Black Death (Meiss), 15
Palais des Papes, Avignon, paintings for, 18, 20
Palazzo Bianco, Genoa, painting for (David), 193
Palazzo Pubblico, Siena, painting in Sala di Mappamundi of (Bartolo), 61
Panofsky, Erwin, 76; writings of: on Bouts, 150, 165; on Christus, 150, 151, 155; on Dürer, 181; on Geertgen tot Sint Jans, 181; on Memlinc, 182; on Metsys, 408; on Pucelle, 21–22; on Schongauer, 230; on Van der Goes, 170, 172; on Van der Weyden, 230; on Van Eyck, Hubert, 93; on Van Eyck, Jan, 93, 97, 111, 112, 150, 155
pantheism, 357, 358, 370, 372, 442, 487
Paolo, Giovanni di, 72
Parable of the Unmerciful Servant (Van Heemskerck), 481; *554*
Parable of the Unmerciful Servant (Van Hemessen), 443, 477; *514*
Paracelsus, 364
Parement de Narbonne (French painter), 44–46; *30, 31*
Paris Apocalypse (Dutch miniaturist), 76; *72*
Parish Church, Obervellach, altarpiece for (Van Scorel), 467
Parler, John, 31
Parler, Peter, 24–26, 30, 31, 66; *Anna von Schweidnitz*, 26; *17; Charles IV*, 26; *16; Self-Portrait of Peter Parler*, 26; *18; Tomb of Ottocar I*, 25; *14*
Parler, Wenceslaus, 31
Parmigianino, 32, 512, 514
Passion Altarpiece (Memlinc), 184
Pasture, Rogelet de la, *see* Weyden, Rogier van der
Patinir, Joachim, 272, 409–12, 418, 421, 432, 441, 454, 461, 503, 505, 515; *Flight into Egypt*, 410; *481; Landscape with Charon's Boat*, 412; *483; Landscape with Saint Jerome*, 410, 412; *482; Rest on the Flight into Egypt*, 410, 432; pl. 65; *Rest on the Flight into Egypt* (with Van Cleve), 412; *484; Temptation of Saint Anthony* (with Metsys), 409–10; *480*
Pélerinage de l'âme, Le (Deguilleville), 205
Pencz, Georg, 347
Perréal, Jean, 250, 511; *Portrait of Louis XII*, 511; *580*
Perrenot, Antoine, 216
Perugino, Pietro, 242
Petites Heures du Duc de Berry (Hesdin and shop), 53–55, 57; *43, 44*
Petrarch, 42
Philbert II of Savoy, 452, 511
Philip, Lotte Brand, 94, 95, 207; *Altarpiece of the Lamb* (Van Eyck, Jan and Hubert), proposed reconstructions of, 94; *91, 92*
Philip II, king of Spain, 196, 206, 208, 211, 217, 469, 483, 484; portraits of (Mor), 482
Philip VI, king of France, 41
Philip of Burgundy, 419, 420, 423, 467
Philippe de Croy (Van der Weyden), 139; *136*
Philip the Bold, duke of Burgundy, 18, 26, 41, 46, 49, 50, 52, 64–71; death of, 57, 68; as patron, 64–65, 69, 70–71, 267, 294; portrait painting of (after Malouel?), 70; *67*; portrait sculpture of (Sluter and shop), 65, 66; *58*; tomb of (Sluter and shop), 65, 67–69, 297, 314; *62–64*
Philip the Fair, 194, 196, 452
Philip the Good, duke of Burgundy, 99, 111, 419, 426; court and politics of, 114, 115, 119, 133, 139, 140, 482; death of, 239; friendship with Van Eyck, Jan, 96–97; marriage of, 95, 114; as patron, 90, 95, 117, 119, 223, 297
Philostratus, 335
Piero della Francesca, 245, 249, 474
Pierre II, duke of Bourbon, 244, 251; pl. 45

Pietà (Master of the Avignon Pietà), 261–62; pl. 46
Pietà (Michelangelo), 479, 512, 523
Pietà, from *Miraflores Altarpiece* (Van der Weyden), 128; *122*
Piétarde, Agnes, 295
Pilgrimage to the Church of the Beautiful Virgin at Regensberg (Ostendorfer), 361; *418*
Pilon, Germain, 521–23; *Mater Dolorosa*, 521–22; *594; Monument to the Heart of Henri II*, 521; *593; Tomb of Henry II*, 522–23; *595, 596*
Pirckheimer, Willibald, 321, 325, 329, 331, 333, 345, 391
Pisan, Christine de, 42, 43, 48, 49–50, 64
Pisano, Andrea, 129
Plague Crucifix (Rhenish), 349; *404*
Plainte du désiré, La (Lemaire), 242, 250
Planet Mercury (Housebook Master), from *The Housebook*, 287; *298*
Planet Venus (Housebook Master), from *The Housebook*, 287; *299*
Plantin, Christopher, 400, 502, 510
Plato (Van Ghent), 168; *160*
pleurants, funerary sculpture, 68–69, 297, 314; *63, 64, 347*
Pleydenwurff, Barbara, 235
Pleydenwurff, Hans, 234–35, 275; *Crucifixion*, 234–35, 448; *229*
Pleydenwurff, Wilhelm, 275
Pliny, 49, 100
Poet Vergil Suspended in a Basket (Lucas van Leyden), 461, 462; *534*
Poitiers, battle of, 41
Pollaiuolo, Antonio del, 316, 321, 328
Pontifical of Sens, 241; miniature from (Marmion), 241–42; *240*
Portinari, Antonio, 172; *161*
Portinari, Guido, 172
Portinari, Margherita, 172, 251–52; *161*
Portinari, Maria Baroncelli, *see* Baroncelli, Maria
Portinari, Pigello, 172; *161*
Portinari, Tommaso, 169, 172; portraits of (Memlinc), 186; *178*; (Van der Goes), 172, 186; *161*
Portinari Altarpiece (Van der Goes), 169–72, 173, 174, 175, 186, 250, 251–52; pl. 28; *161*
Portrait of Abel van den Coulster (Mostaert), 452–53; *523*
Portrait of a Carthusian (Christus), 151, 153; *150*
Portrait of Admiral Bonnivet (Clouet, Jean), 517–18; *587*
Portrait of a Lady (Van der Weyden), 138; *134*
Portrait of a Man (Bouts), 146; *143*
Portrait of a Merchant (Gossart), 425, 426; *499*
Portrait of Anna Codde (Van Heemskerck), 479, 480; *551*
Portrait of a Young Lady (Christus), 165; *156*
Portrait of a Young Princess (Master of Moulins), 251–52; *255*
Portrait of Baudouin de Lannoy (Van Eyck, Jan), 114; *108*
Portrait of "Baudouin of Burgundy" (Gossart), 425, 426; *500*
Portrait of Charles V (Van Orley), 429; replica of?, *505*
Portrait of Charles VII (Fouquet), 246–47, 517; *249*
Portrait of Doctor Georges de Zelle (Van Orley), 429; *504*
Portrait of Edward Grymestone (Christus), 151, 153; *149*
Portrait of Erasmus (Holbein the Younger), 345, 388; *452*
Portrait of Francesco d'Este (Van der Weyden), 137–38, 139; *133*
Portrait of Francis I (Clouet, Jean?), 517; *586*
Portrait of Guillaume Jouvenel des Ursins (Fouquet), 248; *251, 252*
Portrait of Jacqueline of Burgundy? (Gossart), 425, 426; pl. 67
Portrait of Jan de Leeuw (Van Eyck, Jan), 114; *109*
Portrait of John the Good (Orléans?), 41–42; *25*
Portrait of Louis II, Duke of Anjou (French painter), 48; *35*
Portrait of Louis XII (Perréal), 511; *580*
Portrait of Margaretha van Eyck (Van Eyck, Jan),

114–15; *110*
Portrait of Mary Tudor (Mor), 482, 483; pl. 80
Portrait of Philip the Bold (copy after Malouel?), 70; *67*
Portrait of Pieter Bicker (Van Heemsckerck), 479–80; *552*
Portrait of Sir Thomas More (Holbein the Younger), 388–89; pl. 61
Portrait of Tymotheos (Van Eyck, Jan), 97, 99, 113–14; *95*
Pot, Philippe, 314; monument to (French sculptor), 314; *347*
Potter, Paulus, 458
Poussin, Nicholas, 471, 512
Prague, Bohemia, 23, 24, 43
Prayer in the Garden of Gethsemane (Schongauer), 284
Praying Hands (Dürer), 333; *383*
Přemyslide dynasty, 23, 25
Presentation (Van Eyck, Jan), 103
Presentation, from *Columba Adoration of the Magi* (Van der Weyden), 134, 135; pl. 22
Presentation and Flight into Egypt, from *Retable de Champmol* panels (Broederlam), 71, 73; pl. 12
Presentation in the Temple (Lochner), 219–20; *211*
Presentation in the Temple, from *Très Riches Heures du Duc de Berry* (Limbourg brothers), 61
Presentation of a Bible to Charles V by Jean de Vaudetar, The (Bondol), from *Bible historiale,* 47–48; *34*
Prévost, Jean, 250
Primaticcio, 512, 514–15, 520, 521; *Four Nymphs,* 514–15; *583;* Galerie d'Ulysse, Fontainebleau, ceiling and wall painting for, 515; pl. 84 (engraving after, *584*); *Tomb of Henry II,* 522; *595; Ulysses Reunited with Penelope,* 515; pl. 84
Prodigal Son (Bosch), see *Landloper* (Bosch)
Prodigal Son (Dürer), 328, 468; *372*
Prodigal Son (Van Hemessen), 443–45; *516*
Prophets Ezekiel, Jeremiah, Isaiah, and Moses (Giovanetti), 18; *7*
Protestantism, 375, 376, 381, 382, 387, 388, 389, 390, 400, 510; effect of, on the arts, 381–82, 387, 390; *see also* Luther, Martin proverbs and parables, 499–502
Psalter of Jean, Duc de Berry (Beauneveu), 53, 56; *42*
Pucelle, Jean, 20, 21–22, 23, 46, 54; *Belleville Breviary,* 22, 53, 54, 57; *12; Hours of Jeanne d'Évreux,* 20, 21–22, 45, 53, 75; *9, 10*
Purification of the Virgin (Gaddi), 61
Puyvelde, Leo, 182

Quentell, Wilhelm, 323
Quentell-Grüninger Bible, 323, 324; woodcut illustration from (Nuremberg woodcutter), 324; *365*

Rabbit (Dürer), 340; *398*
Rabelais, François, 500
Raimondi, Marcantonio, 427, 457
Raising of Lazarus (Froment), 262; *258*
Raising of Lazarus (Van Ouwater), 142–43, 154; pl. 24
Raphael, 182, 422, 472, 512; influence of, 333, 427, 429, 431, 469, 477, 479, 514, 519; workshop procedures of, 427, 473
Rationale divinorum officiorum (Durandus), 166
Rausch, Niklaus, 223
Reformation, 346, 347, 370, 382, 389, 392, 466; *see also* Luther, Martin
Reichsgedicht (Von der Vogelweide), 318
Reims Cathedral, France, 15, 31, 65; sculpture from, 15, 79, 293, 312; *2;* west facade, 15; *1*
Reineke, Heinrich, 84
religious philosophy: Adamite sect, 213, 215; apocalyptic, 323, 325; devotion of the Rosary, 102, 165, 178, 179, 310, 331; German, 15th century, 223, 225; German, 16th century, 326; Gothic, 15–16; Late Gothic, changes in, 32; *see also* Luther, Martin; mysticism; Protestantism; Reformation
Reliquary Head of Saint Fortunade (French sculptor), 312; *343*

Rembrandt van Rijn, 112, 169, 458, 470, 480, 481, 510
Renaud IV, of Guelders, 74, 76
René, duke of Anjou, 240, 249, 263, 511; *259*
Rest on the Flight (Baldung Grien), 365; *424*
Rest on the Flight (David), 192; *189*
Rest on the Flight into Egypt (Altdorfer), 359, 361, 365; *416*
Rest on the Flight into Egypt (Cranach the Elder), 365, 372; *433*
Rest on the Flight into Egypt (Patinir), 410, 432; pl. 65
Rest on the Flight into Egypt (Schongauer), 276, 281, 282; *287*
Rest on the Flight into Egypt (Van Cleve and Patinir?), 412; *484*
Rest on the Flight into Egypt (Van Heemsckerck), 475; *546*
Resurrection (Grünewald), from *Isenheim Altarpiece,* 349, 350, 351, 352–53; pl. 54
Resurrection (Master of the Třeboň Altarpiece), 30, 85, 223; pl. 3
Resurrection (Schongauer), 284
Resurrection, from *Altarpiece of the Deposition* (Bouts), 145; *140*
Resurrection, from *Englandfahrer Altarpiece* (Master Francke), 85–86; *83*
Resurrection, from *Hofer Altarpiece* (Wolgemut?), 235; pl. 40
Resurrection, from *Wurzach Altarpiece* (Multscher), 222–23; *214*
Retable de Champmol altarpiece, for Chartreuse de Champmol, 70–73; painted exterior panels for (Broederlam), 70, 71–73, 99, 294; pl. 12; relief sculpture for (De Baerze), 70–71, 294; *68*
Return from the Fields (Rubens), 506
Return of the Herd (Bruegel the Elder), 506–7; *577*
Reuwich, Erhard, 274–75; *Animal page,* 275, 277; *View of Venice,* 274; *276*
Revelationes (Saint Bridget), 58, 73, 85, 349–50, 352, 356
Reymerswaele, Marinus van, 442–43; *Banker and His Wife, The,* 443; *513; Saint Jerome,* 442; *512*
Rhenish-Mosan crescent, Late Gothic art of, 74–86
Richier, Ligier, 523; *Tomb of René de Châlon,* 523; *597*
Riegl, Alois, 470
Riemenschneider, Tilman, 305–8; *Altarpiece of the Assumption of Mary,* 307–8; *332, 333; Altarpiece of the Holy Blood,* 306–7; *330, 331; Altarpiece of the Magdalen,* 305, 309; *329*
Ripa, Cesare, 476
Road to Calvary (Met de Bles), 432, 441; pl. 70; preparatory drawing for (Met de Bles?), *510*
Road to Calvary, from *Brussels Hours* (Hesdin and shop?), 56
Robertet, François, 244
Roelofs, Eustachius, 147; pl. 25
Rohan Hours (Master of the Rohan Hours), 50, 52; pl. 8
Rolin, Jean, 109, 250–51; *254*
Rolin, Nicolas, 109, 110, 131, 250; portraits of (Van der Weyden), 131, 133; *128;* (Van Eyck, Jan), 109, 110; *104*
Romanists, 402, 418, 419–32, 442
Romano, Giulio, 431, 477, 478, 512, 514
Romping Children (Housebook Master), 289
Rosary devotion, 102, 165, 178, 179, 310, 331
Rosso Fiorentino, 513–14, 515; Galerie François Ier, Fontainebleau, interior design and decoration for, 513–14; *581, 582; Male Nude,* 513; *582*
Roudnice Madonna (Bohemian), 30; *23*
Round Passion (Lucas van Leyden), 458; *529*
Rubens, Pieter Paul, 241, 465, 473, 484, 499, 506
Rumersheim, Heinrich von, 223
Rupertus of Deutz, 91
Ruysbroeck, Jan van, 217

Sabobai and Benaiah, from *Heilsspiegel Altarpiece* (Witz), 225; *216*
Sachs, Hans, 369
Saint Ambrose, from *Book of Hours of Catherine*

of Cleves (Master of the Hours of Catherine of Cleves), 141; pl. 23
Saint Anthony Enthroned between Saints Augustine and Jerome (Hagenau), sculptured shrine of *Isenheim Altarpiece,* 348; *403*
Saint Anthony *Gasthuis* (hospital), Arnhem, painting for (Master of the Saint Bartholomew Altarpiece), 230
Saint Athanasius, 208, 210, 353
Saint Augustine, 121, 213
Saint Barbara (Van Eyck, Jan), 99, 102; *96, 97*
Saint Bernard, 121, 125
Saint Bertin Altarpiece (Marmion), 240–41; *238, 239*
Saint Bonaventura, 349
Saint Bridget, 58, 73, 85, 121, 123, 128, 134, 178, 349–50, 351–52, 356
Saint Bruno, 151
Saint Catherine Triptych (Cranach the Elder), 373
Saint Cyriacus (Grünewald), from *Heller Altarpiece?,* 354; *407*
Saint Denis and Saint Paul Before the Altar of the Unknown God (Lombard), 431; *508*
Saint Donation (Gossart), 420
Saint Dorothea (Grünewald), 356; *411*
Saint Dorothy, German woodcut, 267; *262*
Sainte Chapelle, Bourges, sculpture for (Beauneveu), 53
Saint Eloy, 152
Saint Eloy in His Studio (Christus), 151–53, 406; pl. 26
Saint Florian Altarpiece, paintings from (Altdorfer), 361; *417*
Saint Francis (Altdorfer), 358; *412*
Saint Francis Receiving the Stigmata (Cranach the Elder), 372; *431*
Saint Francis Receiving the Stigmata (Van Eyck, Jan), 118; *116*
Saint George and the Dragon (Notke), 304–5; *328*
Saint George Slaying the Dragon (Altdorfer), 358; *414*
Saint Giles monastery, Třeboň, altarpiece from (Master of the Třeboň Altarpiece), 30
Saint Giles Protecting the Hind from the Hunters of Charlemagne (Master of Saint Giles), 242–43; *243*
Saint Godeberta of Noyon, 152
Saint Irene Nurses Saint Sebastian (Lieferinxe?), 265; pl. 48
Saint Jerome, 353, 381
Saint Jerome (Altdorfer), 358
Saint Jerome (Van Reymerswaele), 442; *512*
Saint Jerome as a Hermit (Cranach the Elder), 372; *430*
Saint Jerome in His Study (Dürer, 1492), 321, 337–38; *356*
Saint Jerome in His Study (Dürer, 1514), 337–39, 381, 442; *392*
Saint Jerome in His Study (Van Eyck, Jan), 116–17, 150; *113*
Saint Jerome Led to Execution (Mantegna), 431
Saint John Before the Apocalyptic Woman, from *Apocalypse* series (Dürer), 334; *384*
Saint John Devouring the Book, from *Apocalypse* series (Dürer), 323; *364*
Saint John on Patmos (Burgkmair), 385; *448*
Saint John's Cathedral, 's Hertogenbosch, sculptured altarpiece for Chapel of the Brotherhood of Our Lady (Van Wesel), 298
Saint John the Baptist (Burgundian?), 312; *341*
Saint John the Baptist (Campin), 122
Saint John the Baptist Altarpiece (Van der Weyden), 129, 295, 296; *123*
Saint John the Baptist in the Wilderness (Geertgen tot Sint Jans), 181, 318; *172*
Saint Luke, 74, 126, 475
Saint Luke Drawing the Virgin (Gossart, c. 1512–15), 422, 475; *494*
Saint Luke Drawing the Virgin (Gossart, c. 1520), 423, 475, 476; *495*
Saint Luke Painting the Madonna (Baegert), 233; *227*
Saint Luke Painting the Virgin (Van Heemsckerck), 475–77; pl. 79
Saint Luke Portraying the Virgin (Van der Weyden), 126–27, 475; pl. 21

Saint Michael and the Dragon, from *Très Riches Heures du Duc de Berry* (Limbourg brothers), 61
Saint Peter Altarpiece (Master Bertram), 78–79; *75, 76*
Saint Remi Gives Benediction Before Notre Dame de Paris (Master of Saint Giles), 243–44; *244*
Saint Roche (Stoss), *309; 336*
Saint Ursula (Multscher), 299; *319*
Saint Veronica (Master of Saint Veronica), 80–81; *78*
Saint Vitus Cathedral, Prague, 23, 24–26, 30, 31; Golden Portal, 24, 25; *13;* sculpture from (Parler and shop), 25–26
Saint Wenceslaus, 23
Saint Wolfgang Altarpiece (Pacher): paintings from, 236–37, 301; *231, 232;* relief sculpture of, 236, 301–2, 361; *324, 325*
Saint Wolfgang in Prayer, from *Altarpiece of the Church Fathers* (Pacher), 238; *234*
Sala di Constantino, Vatican, paintings for (Romano), 514
Salins, Guigone de, 131, 133; *128*
Salting Madonna (Campin), 123; *119*
Samson and Delilah (Lucas van Leyden), 461–62, 463; *533*
Sanctae peregrinationes (Von Breydenbach), 274; woodcuts from (Reuwich), 274–75; *276, 277*
Sandrart, Joachim von, 336, 353, 354
Santa Croce, Florence, fresco in (Gaddi), 61
Santa Maria del Carmine, Florence, frescoes in (Masaccio), 57
Santa Maria della Grazie, Milan, fresco for (Leonardo), 430
Santa Maria della Steccata, Parma, ceiling painting for (Parmigianino), 514
Santa Maria im Kapitol, Cologne, sculpture in, 349
Sarto, Andrea del, 512
Satyr Family (Altdorfer), 358; *413*
Savery, Roelandt, 488; *Two Woodcutters,* 488; *560*
Saxon Prince (Cranach the Elder), 375; *439*
Saxon Princess (Cranach the Elder), 375; *440*
Scenes of Daily Life (Van Meckenem), 291–92; *307*
Schatzbehalter (Fridolin), 275, 320
Schedel, Hartmann, 275
Scheja, Georg, 350, 352
Schilder-boeck, Het (Van Mander), 125, 141, 187, 321, 391, 455, 484
Schmerzensmann theme (Man of Sorrows), 77, 177
Schnitzaltäre, carved altarpieces, 94, 281, 294, 295, 298; painting compositions based on, 144, 234, 295, 421
Schöffer, Peter, 271
Scholasticism, 15, 16
Schöne Madonna (Beautiful Madonna) sculpture, 30–32, 56, 65, 298, 301; paintings based on, 101, 361
Schöne Maria of Regensberg (Altdorfer), 361; *419*
Schongauer, Georg, 321
Schongauer, Martin, 230–32, 273, 280–86, 289, 308; *Annunciate Angel Gabriel,* 285–86; *295; Annunciate Madonna,* 285–86; *296; Apprentices Fighting,* 284–85; *292;* apprenticeship of, 230; *Arrest of Christ,* 284; *291;* artistic development of, 281, 283, 285–86; birth of, 231; *Carrying of the Cross to Calvary,* 283, 289, 441, 458; *290; Crucifixion,* 283; *289;* death of, 321; early years of, 230; *Elephant,* 285; *293;* engravings by, 276, 280–86, 288, 291, 305, 458; *285–97; Holy Family,* 321–32; *224;* influence of, 282–83, 305, 307, 321; *Madonna and Child in a Rose Arbor,* 231; *223; Madonna and Child in the Courtyard,* 286, 289; *297; Madonna and Child with the Parrot,* 281; *285; Nativity,* 281; *286; Ornament with Owl,* 285; *294;* paintings by, 230–32, 280; *Rest on the Flight into Egypt,* 276, 281, 282; *287;* symbolism in the work of, 232, 282, 283, 285, 286; technique of, 281, 282, 284; *Temptations of Saint Anthony,* 282–83, 353; *288;* travels of, 280
School of Athens (Raphael), 422
Schoonhoven, Agatha van, 472
Schwartz-Hirtz, Johann, 227–28

Schweidnitz, Anna von, 26; *17*
Scorel, Jan van, 89, 465, 467–74, 477; artistic development of, 469; *Baptism of Christ,* 471–72; *542;* birth of, 467; classical influence on, 469; death of, 467; *Death of Cleopatra,* 469; pl. 77; drawings by, 468–69, 470, 471, 474; *540;* early work of, 467–68; *Entry of Christ into Jerusalem,* 469–70; pl. 78; *Finding of the True Cross,* 474; *545;* in Haarlem, 470, 474; Haarlem Jerusalem Brotherhood, 470–71; *541; Holy Kinship,* 467–68, 469; *539;* influence of, 475; Italian Renaissance influence on, 469, 472, 474, 475; *Lamentation,* 473–74; *544;* landscape in the work of, 468–69, 471, 472; Mannerist motifs in the work of, 474; *Mary Magdalen,* 472, 475; *543;* portraits by, 467–68, 469, 470–71; *539, 541;* in Rome, 469; self-portraits by, 468, 471; *539, 541;* as student, 447, 468, 475; as teacher, 474–75, 482, 483; travels of, 467, 468–69, 475; in Utrecht, 467, 469, 470, 472; *Valley in the Alps,* 468–69; *540;* varied activities of, 467; in Venice, 468, 469; workshop procedures of, 472–73, 474
Seilern, Antoine, 122
Self-Portrait (Dürer, 1484), 319–20; *352*
Self-Portrait (Dürer, 1498), 322–23; *361*
Self-Portrait (Dürer, 1500), 325–26; *367*
Self-Portrait (Fouquet), 244; *245*
Self-Portrait (Holbein the Younger), 397; *463*
Self-Portrait (Mor), 483; *557*
Self-Portrait (Van Oostsanen), 449, 483; *519*
Self-Portrait Before the Colosseum (Van Heemskerck), 476, 481, 483; *555*
Self-Portrait of Peter Parler (Parler and shop), 26; *18*
Self-Portrait with a Spray of Eryngium (Dürer), 321, 322–23; pl. 50
Selve, Georges de, 392–93; pl. 62
Serlio, Sebastiano, 430, 512
Seven Acts of Mercy (Master of Alkmaar), 446–47; pl. 72
Seversoen, Jan, 273
Seymour, Jane, 394–95; *459*
Sforza, Battista, 168; *159*
Sforza, Francesco Maria, 396
Sforza monument (Leonardo), 337
Ship of Fools (Bosch), 205; *195*
Shrine of Saint Ursula (Memlinc), 185–86; *176, 177*
Sibylle of Cleve (Cranach the Elder), 375; *438*
Sienese painting, 17, 18, 21, 29, 46, 69, 70, 72, 73
Sigüenza, José de, 206, 208, 211, 212, 214
Silverpoint Sketchbook (Dürer), 340; drawing from, *397*
Simondi, Bernardino, 265
Sir John Hawkwood (Uccello), 337
Sistine Chapel, Vatican, Rome, frescoes for (Michelangelo), 431, 432, 465, 470, 514
Sluter, Claus, 26, 65–69, 74, 77, 141, 261, 293, 297, 312; Chartreuse de Champmol: portal sculpture for, 65–66, 93, 293; *58, 59; Tomb of Philip the Bold* in, 67–69, 297, 314; *62–64; Well of Moses* in cloister of, 67; *60, 61*
"*Small Bargello Diptych*" (French painter), 46; *32;* pl. 5
Small Engraved Passion (Dürer), 336; *390*
Small Passion series (Dürer), 334, 335–36; *388, 389*
Smiling Angel, sculpture from Reims Cathedral, 31
Smiling Angel Master, 15, 79; *Annunciation* group, 15, 79, 293, 312; *2*
Soest, Konrad von, 82–84, 85; *Niederwildungen Altarpiece,* 82–84, 86; *81*
Soft Style, 31, 298–99; see also *Schöne Madonna* (Beautiful Madonna) sculpture
Sojourn of Mary and Joseph in Egypt, The, from *Life of the Virgin* series (Dürer), 276, 334–35; *386*
Solario, Andrea, 408
Sol Iustitiae (Dürer), 326; *368*
Sonderen Troest, Der (Jacobus di Theramo), 272; woodcut from (Master of Bellaert), 272; *271*
Sorel, Agnes, 245, 247
Speculum humanae salvationis, 147, 224, 272, 452; woodcuts from, 271; *270*

Spil von Meister Aristotiles, German carnival play, 289
Spinario (Gossart), 419
Sprenger, Jacob, 331, 368
Stange, Alfred, 229, 234
Stanza della Segnatura, Rome, painting for (Raphael), 429
Stoss, Viet, 305, 308–10; *Annunciation of the Rosary,* 310; *337; Death of the Virgin,* 308–9; *334, 335; Saint Roche,* 309; *336*
Strasbourg, Germany, 74, 302, 365
Strozzi Altarpiece (Orcagna), 92
Sture, Sten, 304; tomb of (Notke), 304–5; *328*
Summa theologica (Aquinas), 15
Susanna at the Bath (Altdorfer), 362; *421*
Suso, Heinrich, 74, 86, 217, 220
Suycker, Nicolas, 454
Suzanne de Bourbon, 251, 252; pl. 45
Symbolum Apostolicum, 268
Synagogue, from *Heilspiegel Altarpiece* (Witz), 224–25; *215*

Table of the Seven Deadly Sins (Bosch?), 196, 205; *193*
Taking of Jerusalem (Fouquet), miniature from *Les Antiquités Judaïques* (Josephus), 244–45; pl. 42
Tauler, Johannes, 74, 86, 220
Tavern Scene (Lucas van Leyden), 462–63; *535*
Temple, Raymond du, 43
Temptation of Christ, from *Très Riches Heures du Duc de Berry* (Limbourg brothers), 61
Temptation of Saint Anthony (Grünewald), 349, 353, 354; pl. 55
Temptation of Saint Anthony (Marmion), 242, 243; *242*
Temptation of Saint Anthony (Metsys and Patinir), 409–10; *480*
Temptations of Saint Anthony (Schongauer) 282–83, 353; *288*
Teniers, David, 465
Tenniel, John, 408
Terrestrial Paradise (Bosch), 217; *209*
Teutsche Academie der Edlen Bau-, Bild- und Mahlerey-Künste (Sandrart), 353
Theatrum orbis terrarum (Ortelius), 484
Thienen, Renier van, 297; *Tomb of Isabella of Bourbon,* 297; *313*
Thomas à Kempis, 125, 172
Three Marys at the Tomb (Bellange), 519–20; *590*
Three Marys at the Tomb (Van Eyck, Hubert?), 90; copy after, *90*
Three Musical Angels and Saint Joseph, from *Altarpiece of the Virgin* (Van Wesel), 298; *317*
Tintoretto, 431
Titian, 469, 512, 518
Toledo, Fernando Alvarez de, 217, 482–83; *556*
Tolnay, Charles de, 206, 207, 487
Tomb of Henry II (Pilon and Primaticcio?), 522–23; *595, 596*
Tomb of Isabella of Bourbon (Gérines? and Van Thienen?), 297; figures from, *313*
Tomb of Ottocar I (Parler and shop), 25; *14*
Tomb of Philip the Bold (Sluter and shop), 67–69, 297, 314; *62; pleurants* from, *63, 64*
Tomb of René de Châlon (Richier?), 523; *597*
Tomb of Saint Sebaldus (Vischer the Elder), 310; *338*
Tommaso Portinari (Memlinc), 186; *178*
Totentanz (Holbein the Younger), 386
Tower of Babel (Bruegel the Elder), 322, 502; *569, 570*
Trajan's Column, 512
Trattato della Architettura (Filarete), 89, 244
Travels of Sir John Mandeville, 457
Treaty of Arras, 115, 247
Tree of Jesse (Geertgen tot Sint Jans), 179; *169*
Très Belles Heures de Notre-Dame (Master of the Parement de Narbonne), 52; see also *Turin-Milan Hours*
Très Riches Heures du Duc de Berry (Limbourg brothers), 22, 43, 51, 57–64, 75, 278, 383, 505; *50–57;* pl. 10
Trial of Christ, French mystery play, 67
Triptych of Saint Anthony (Bosch), 208–10, 353; *200, 201, 202*

Triptych of the Haywain (Bosch), 211–12; *203, 204*

Triumphal Arch of Maximilian I (Dürer and others), 339; *393*

Triumphal Chariot of Maximilian I (Dürer), 339, 363; *395*

Triumph of Bacchus (Romano), 477

Triumph of Bacchus (Van Heemskerck), 477–78; *549*

Triumph of Death (Bruegel the Elder), 485–87, 523; *559*

Trompes, Jan de, 192; pl. 33

Tucher, Anton II, 310

Tuchman, Barbara, 15

Turin-Milan Hours, 52; miniatures from ("Hand G" of the *Turin-Milan Hours*), 96, 141; *94*

Turkish Sultan Before the Hippodrome, from *Ces moeurs et fachons de faire de Turcz* (Van Aelst), 429–30; *507*

Two Woodcutters (Bruegel the Elder or Savery), 488; *560*

Tymanus, Brother, 455,456

Über Kunst und Altertum in den Rhein- und Main-Gegenden (Goethe), 218

Uccello, Paolo, 167, 245, 337, 363

Ugly Couple, The (Hollar, copy after Leonardo), 408; *478*

Ugly Old Woman, The (Metsys), 407, 408; *476*

Ulm, Germany, 302, 303

Ulm Cathedral, portal sculpture for (Multscher), 299

Ulysses and Circe (Dürer?), from *Nuremberg Chronicle,* 320; *354*

Ulysses Reunited with Penelope (Primaticcio?), 515; pl. 84

Underweysung der Messung mit dem Zirckel und Richtscheyt (Dürer), 333; woodcut from, *381*

Urban V, pope, 23, 30, 41

Utopia (More), 388

Utrecht, Holland, 74, 79, 286, 297, 298

Valerius Maximus, 190

Valley in the Alps (Van Scorel), 468–69; *540*

Valois courts and kings, 23, 41–73, 74, 75, 239, 293, 511

Vasari, Giorgio, 89, 100, 125, 230, 283, 309, 338, 430, 457, 484, 512

Vaudetar, Jean de, 47

Veldener, Jan, 271

Venus (Cranach the Elder), 383; *445*

Venus (Giorgione), 469

Venus and Cupid (Cranach the Elder), 373, 383; *434*

Vergil, 462

Vermeer, Johannes, 154, 477

Verrocchio, Andrea del, 337

Vertu de patience, La (Margaret of Austria?), 428

Vesperbild theme (Pietà), 32, 86, 128, 177, 261, 473

Vier Bucher von menschlicher Proportion (Dürer), 333

Vièrge Dorée, from Amiens Cathedral, 31

View of Antwerp (Netherlandish), 399; *465*

View of Jerusalem (Met de Bles?), 441; *510*

View of the Alps (Dürer), 322; pl. 51

View of Venice (Reuwich), woodcut from *Sanctae peregrinationes* (Von Breydenbach), 274; *276*

Vigils of the Dead, from *Boucicaut Hours* (Boucicaut Master), 52; *41*

Vignola, Giacomo, 512

Vijd, Jodocus, 89, 92, 93, 131; pl. 15

Virgin and Child (Van der Weyden), 139; *135*

Virgin and Child in a Chamber (Christus), 154; *152*

Virgin and Child with Four Saints (Van der Weyden), 130, 131; *125*

Virgin and Child with Saint Anne/Anna Selbdritt (Master of the Saint Bartholomew Altarpiece), 230; pl. 39

Virgin and Child with the Monkey (Dürer), 327–28; *371*

Virgin in the Burning Bush (Froment), 262–64; *259*

Virgin of Mercy (Erhart, Michel), 303, 390; pl. 49

Virgo inter Virgines (David), 187, 191; *186*

Vischer, Pieter, the Elder, 310; *Tomb of Saint Sebaldus,* 310; *338*

Vision of Saint Eustace (Dürer), 328–29, 337; *373*

Vision of the Seven Candlesticks, from *Apocalypse* series (Duvet), 519; *589*

Visitation (Master of the Life of Mary), 228–29; *218*

Visitation (Van der Weyden), 228

Visitation, from *Boucicaut Hours* (Boucicaut Master), 51; pl. 7

Visitation, from *Infancy Altarpiece* (Bouts), 143, 144; *139*

Visit to the Spinner, from *Scenes of Daily Life* (Van Meckenem), 291–92; *307*

Vita B. Pauli (Saint Jerome), 353

Vitae Patrum (Cavalca), 129, 208

Vita S. Antonii (Saint Athanasius), 208, 210, 353

Vite, Le (Vasari), 89, 100, 125, 230, 309, 484

Vitruvius, 316, 430, 453, 512, 521

Vogelweide, Walther von der, 318

Von Abtuhung de Bylder (Von Karlstadt), 346

Voragine, Jacobus de, 80, 82–83, 133, 185, 186, 208, 221, 273, 328, 452, 463, 474

Vos, Jan, 155; *114, 148*

Vostre, Simon, 276

Vrelant, Willem, 184, 193

Vyšší Brod monastery, Bohemia, altarpiece for (Master of the Vyšší Brod Altarpiece), 27

Wackerzeele, Jan de van, 99

Waning of the Middle Ages, The (Huizinga), 16, 114

Wassenhove, Joos van, *see* Ghent, Joos van

Way to Calvary (Hesdin), 57

Weale, William H.J., 182, 187

Wedding Dance (Bruegel the Elder), 497–99; *562*

Wedding Feast (Bruegel the Elder), 497; pl. 81

Wedding Procession (copy after Bruegel the Elder), 497

Well of Moses (Sluter and shop), 67; *60, 61*

Weltchronik/Nuremberg Chronicle, 275, 282; woodcut from (Wolgemut?), 275–76, 320; *278*

Wenceslaus III, king of Bohemia, 23

Wenceslaus IV, king of Bohemia (son of Charles IV), 26, 30

Wenceslaus IV, of Bohemia, 23; *see also* Charles IV, king of Bohemia

Werl, Heinrich von, 123, 223

Wesel, Germany, 232, 233

Wesel, Adriaen van, 196, 298; *Three Musical Angels and Saint Joseph,* 298; *317*

West Indies Landscape (Mostaert), 454; pl. 74

Weyden, Henri van der, 296

Weyden, Rogier van der, 73, 118, 124–39, 142, 151, 189, 190, 503; abstraction in the work of, 135–36; *Altarpiece of the Seven Sacraments,* 129–30; *124; Annunciation,* 125–26, 156; *121;* apprenticeship of, 119–20, 123; artistic concerns of, 127; artistic inventiveness of, 127, 133, 135, 139; artistic style of, 124, 126, 128, 135, 144, 170, 296, 402; in Brussels, 119, 126, 127, 148, 183, 190; *Columba Adoration of the Magi,* 131, 133, 134–35, 183, 231; pl. 22; *Crucifixion,* 135–36; *132; Crucifixion Altarpiece,* 135; *130; Crucifixion Diptych,* 135; *131;* death of, 182; *Deposition,* 124, 129, 135, 144, 145, 230, 249, 280, 350, 405,
418, 508; pl. 20; early training of, 119–20, 125, 296; emotionalism in the work of, 89, 124–25, 128, 133, 135–36, 139, 150; fame and reputation of, 89, 125, 127, 139, 308; *Farewell at the Tomb,* 130-31; *126;* iconography of, 129, 133; influence of, 119, 124, 268, 401; on Bouts, 144, 145, 150; on Bruegel the Elder, 508; on Campin, 123; on Christus, 150, 153, 156; on David, 187; on French 15th-century art, 239; on Geertgen tot Sint Jans, 177; on Gerhaerts van Leyden, 301; on German 15th-century art, 134; on Gossart, 421; on Marmion, 241; on Master of the Holy Kinship, 229; on Master of the Life of Mary, 228; on Master of the Saint Bartholomew Altarpiece, 230; on Memlinc, 133, 182, 183, 186; on Metsys, 403, 405; on Multscher, 299; on Netherlandish sculpture, 296–97; on Pleydenwurff, 234, 235; on Riemenschneider, 305, 307; on Schongauer, 230, 231, 281, 282, 283; on Van der Goes, 170, 173, 174; in Italy, 128–29, 130–31, 133, 135; *Last Judgment Altarpiece,* 109, 131–33, 250, 281; *127, 128; Madonna and Child,* 125; *120;* as metalwork designer, 297; *Miraflores Altarpiece,* 127–28, 129, 144, 281, 295, 296; *122; Nativity Altarpiece of Pieter Bladelin,* 133–34, 135, 281; *129;* perspective in the work of, 124; *Philippe de Croy,* 139; *136; Portrait of a Lady,* 138; *134; Portrait of Francesco d'Este,* 137–38, 139; *133;* portraits by, 136–38, 146, 148, 408; *133, 134, 136; Saint John the Baptist Altarpiece,* 129, 295, 296; *123; Saint Luke Portraying the Virgin,* 126–27, 475; pl. 21; sculptural painting (polychroming) by, 297; stylistic development of, 129, 130, 131, 135; vs. Van Eyck, Jan, 118, 119, 125, 127, 137–38, 139; *Virgin and Child,* 139; *135; Virgin and Child with Four Saints,* 130, 131; *125*

Wheat Harvest (Bruegel the Elder), 506; *576*

Wiesenkirche, Soest, altarpiece for (Master of 1473), 233

Wilhelm, duke of Bavaria, 362, 363

Willem I of Brabant, 297

Willem VI, king of Holland, 96, 140; portrait of (early Dutch artist), 141; *137*

Willemsz, Cornelis, 475

William of Ockham, 15

William the Silent (William I), count of Nassau, 217

Wire-Drawing Mill (Dürer), 320; *353*

witchcraft, 210, 211, 213, 364, 365, 367–69

Witches' Sabbath (Baldung Grien), 367–69; *427*

Wittkower, Rudolf, 173

Witz, Konrad, 221, 223–26, 277; *Annunciation,* 225; *217; Heilsspiegel Altarpiece,* 223–25; *215, 216; Miraculous Draught of Fishes,* 225–26; pl. 38

Wölfflin, Heinrich, 146, 362

Wolgemut, Michael, 235, 275, 319, 320–21; *Fall of Man and the Expulsion,* 275–76; *278; Resurrection,* 235; pl. 40

Wolsey, Thomas, 388

Worde, Wynkyn de, 273

Works and Days (Hesiod), 516

Worringer, Wilhelm, 135, 227

Wrongful Execution of the Count (Bouts), 148–49; *145*

Wurzach Altarpiece (Multscher), 222–23; *213, 214*

Wyatt, Thomas, 483

Young Bull (Potter), 458

Young Christ Among the Doctors (Dürer), 331; *378*

Young Man Among Roses (Hilliard), 398; *464*

Zanen, Simon Saenen van, 470

Zelle, Georges de, 429; *504*

Photographic Credits

The author and publisher wish to thank the museums, libraries, and churches for permitting the reproduction of works of art from their collections. Photographs have been supplied by the following, whose courtesy is gratefully acknowledged. Figure numbers in roman type refer to black-and-white illustrations; those in italics signify color-plates.

Copyright A.C.L., Brussels, 6, 69, 74, 85, 86, 87, 89, 94, 96, 97, 102, 104, 105, 110, 124, 136, 144, 145, 146, 151, 158, 165, 173, 174, 176, 177, 184, 185, 199, 220, 257, 309, 310, 311, 465, 467, 468, 469, 470, 471, 474, 481, 484, 502, 503, 504, 506, 516, 523, 545, 558, 579, *15*, *16*; Antikvarisk-Topografiska Arkivet, Stockholm, 328; © Arch. Photo. Paris/S.P.A.D.E.M., 7, 28, 29, 36, 58, 60, 66, 235, 245, 253, 256, 343, 344, 345, 346, 452, 461, 593, 596, 597, *6*; Archivio Fotograf. Gall. Mus. Vaticani, Rome, 350; ARXIU MAS, Barcelona, 93, 132, 139, 140, 203, 204, 205, 206, 361, 380, 483, 498, 512, 559, *20*, *35*, *65*, *68*, *80*; James Austin, London, 1; Babey/Ziolo, Paris, 587; Gaetano Barone, Florence, 32, 126, 161, 258, 351, 376, 511, 513, 557, *5*; Klaus G. Beyer, Weimar, 442; Bibliothèque Nationale, Paris, 50, 51, 52, 53, 54, 55, 56, 57, 246, 247, 248; Bildarchiv Foto Marburg, 2, 18, 71, 81, 123, 212, 226, 228, 231, 232, 319, 326, 334, 336, 338, 339, 340, 539, 581, 582; Bildverlag Freiburg, 410, 423; Bildarchiv Preussischer Kulturbesitz, Berlin, photos by Jorg P. Anders, 108, 122, 129, 148, 153, 166, 213, 214, 238, 239, 252, 265, 268, 277, 278, 280, 281, 282, 283, 323, 353, 355, 362, 365, 369, 370, 374, 384, 387, 397, 411, 412, 415, 416, 427, 428, 443, 446, 447, 473, 490, 500, 510, 548, 560, *17*, *24*, *49*, *82*; Joachim Blauel, Artothek, Planegg, West Germany, *13*, *22*, *39*, *40*, *56*, *57*, *66*; F. Bruckmann, Munich, 405; Bulloz, Paris, 39, 40, 41, 88, 118, 127, 128, 223, 259, 477, 591, *7*; Cameraphoto, Venice, 208, 209; Ludovico Canali, Rome, 457, *28*; Photo-Commissie, Rijksmuseum, Amsterdam, 300; Courtauld Institute of Art, London, 236; Daspet, Villeneuve-lès-Avignon, 8, *47*; Pasquale De Antonis, Rome, 571; Deutscher Kunstverlag, Munich, 321, 337; A. Dierick, Ghent, *25*; A. Dingjan, The Hague, 538, 542; Direktion der Bayerisches Staatsgemäldesammlungen, Munich, 417; Ursula Edelmann, Frankfurt, 407, 445, 466, 479; Editions Tel, 583; Photo Ellebé, Rouen, 186; Copyright Faksimile-Verlag, Lucerne, Switzerland, from the first complete and exact facsimile edition of *Les Très Riches Heures du Duc de Berry* (1984), printed by permission (the illustration cannot be compared to the quality of the facsimile edition), 10; J. Feuillie/© C.N.M.H.S./S.P.A.D.E.M., Paris, 595; Fournier-Gonnard, Moulins, 45; Frequin Photos, The Hague, 73, 90, 196, 520; Vladimir Fyman, Prague, 575; Gemäldegalerie der Akademie der bildenden Kunste in Wien, Photothek, 431; Germanisches National-Museum, Nuremberg, 230; Foto Grassi/Soprintendenza per i beni artistici e storici per le province di Siena e Grosseto, 4; Tom Haartsen, Ouderkerk a/d Amstel, 541; Hessische Trauhandverwaltung, 250; Ralph Kleinhempel, Hamburg, 75, 76, 82, 83, 84, *14*; Bert Koch, courtesy Verlag M. DuMont Schauberg, Cologne, *53*, *54*, *55*; Koninklijke Bibliotheek, The Hague, 34; Landesbildstelle Wurttemberg, 409; Lichtbildwerkstätte "Alpenland," Vienna, 352, 357, 383, 390, 394, 395, 399, 400, *52*; Photo Löbl, Bad Tölz/Oberbayern, 325; Lonchampt-Delehaye/ © C.N.M.H.S./S.P.A.D.E.M., Paris, 237; Hugo Maertens, Bruges, *31*; Mauritshuis, The Hague, 188; Meyer-Photo-Studio, Vienna, 324, *29*, *81*, *83*; John Mills (Photography) Ltd./Merseyside County Art Galleries, Liverpool, 521; Eric E. Mitchell, Philadelphia, *48*; Musées de la Ville de Strasbourg, 322; Musées Nationaux, Paris, 25, 30, 31, 67, 121, 137, 160, 194, 195, 222, 249, 251, 347, 360, 379, 482, 572, 586, 592, 594, *11*, *46*, *50*, *64*, *85*; Museo dell'Opera del Duomo, Siena, 11; Neues Museum, Wiesbaden, 156, 413; Panstwowy, Instytut Sztuki, Cracow, 335; Alexandr Paul/Art Centrum, Prague, 13, 14, 16, 17, 19, 20, 21, 22, 23, *2*, *3*, *4*; Hans Petersen, Hornbaek, 489; From Lotte Brand Philip, *The Ghent Altarpiece and the Art of Jan Van Eyck*, Copyright © 1971 by Princeton University Press, reprinted by permission of Princeton University Press, 91, 92; Photo Service d'Architecture de l'Oeuvre Notre-Dame, Strasbourg, 320; R. Remy, Dijon, 62; Rheinisches Bildarchiv, Cologne, 15, 77, 80, 210, 219, 221, 404, 485; Rijksmuseum, Amsterdam, 63; Rijksbureau voor Kunsthistorische Documentatie, The Hague, 475; David Robson, Salisbury, 75; Jean Roubier, Paris, 60; G. Schaffert, Verlag Foto-Drogerie Kurt Anslinger, Creglingen/Tauber, 332, 333; Toni Schneiders, Lindau, West Germany, 330, 331; Soprintendenza ai beni artistici e storici, Naples, 518, 567; Soprintendenza alle gallerie ed opere d'arte della Sicilia, Palermo, 492; Soprintendenza per i beni artistici e storici delle Marche, Urbino, 159; Staatliche Graphische Sammlung, Munich, 385, 386; Foto Strauss, Altötting, *3*; Vanhaelewyn/Bruges, *33*; A. Villani, Bologna, 190; Copyright G. Zarnecki/Courtauld Institute of Art, London, 59.

The author and publisher wish to thank the following museums, libraries, and galleries for permitting the reproduction of woodcuts, drypoints, and engravings from their collections:

The Art Institute of Chicago, 290; Bibliothèque Nationale, Paris, 263, 266, 267, 269, 274, 372, 535, 584; Bibliothèque Royale Albert Ier, Brussels, 478, 563, 568; British Library, London, 275; British Museum, London, 285, 286, 287, 289, 292, 294, 295, 297, 304, 305, 306, 307, 308, 354, 364, 388, 392, 401, 531, 589, 590; Bryn Mawr College Library, Pennsylvania, 279; Cleveland Museum of Art, Gift of the Print Club in Memory of Charles T. Brooks, 533; Germanisches Nationalmuseum, Nuremberg, 389; Graphische Sammlung Albertina, Vienna, 390, 395, 400; Hamburger Kunsthalle, 284; Koninklijke Bibliotheek, The Hague, 272, 273; Kunstmuseum, Basel, 356; Kunstsammlungen der Veste, Coburg, 441; Kupferstichkabinett, Staatliche Museen Preussischer Kulturbesitz, Berlin, 265, 268, 277, 278, 280, 281, 282, 283, 362, 365, 369, 370, 384, 387, 427, 428; Library of Congress, Washington, D.C., Lessing J. Rosenwald Collection, 271; The Metropolitan Museum of Art, New York, Fletcher Fund, 368, 373; The Metropolitan Museum of Art, New York, Gift of Felix M. Warburg and His Family, 530; The Metropolitan Museum of Art, New York, Gift of Junius S. Morgan, 363; The Metropolitan Museum of Art, New York, Rogers Fund, 288, 358, 528; Museum of Fine Arts, Boston, 381; Museum of Fine Arts, Boston, William A. Sargent Fund, 276; Nationalbibliothek, Vienna, 393; The National Gallery of Art, Washington, D.C., Gift of W.G. Russell Allen, 291; The National Gallery of Art, Washington, D.C., Rosenwald Collection, 293, 296, 349, 371, 434; National Gallery of Victoria, Melbourne, Felton Bequest, 366; The New York Public Library, Astor, Lenox and Tilden Foundations, Prints Division, 391, 418; The New York Public Library, Astor, Lenox and Tilden Foundations, Spencer Collection, 270; Philadelphia Museum of Art, 348; Rijksmuseum, Amsterdam, 300, 301, 302, 303, 507, 515, 529, 532, 534, 536, 537, 547, 554; William H. Schab Gallery, New York, 527; Staatliche Graphische Sammlung, Munich, 262, 385, 386.

Maps on pages 9–12 by Paul J. Pugliese